An American Century of Photography

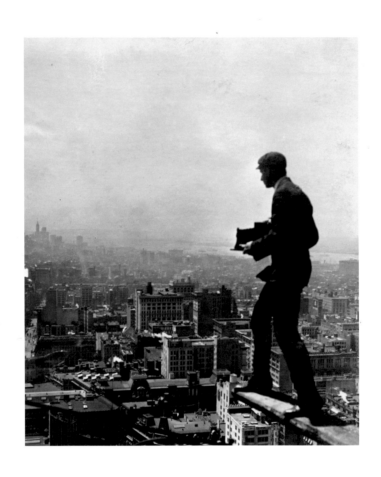

1 **Horace D. Ashton,** *Underwood & Underwood Photographer Making Views from Metropolitan Tower*, 1911, 4¼ x 3½″

2 Abelardo Morell, *Camera Obscura Image of Manhattan View Looking South in Large Room*, 1996, 18 x 22½"

3 Walker Evans, *License-Photo Studio, New York*, 1934, 7⅜ x 6″

An American Century of Photography

From Dry-Plate to Digital

The Hallmark Photographic Collection

Second Edition, Revised and Enlarged

KEITH F. DAVIS

Foreword by Donald J. Hall

Hallmark Cards, Inc.

in association with Harry N. Abrams, Inc.

This publication is one of a series from the Hallmark Photographic Collection celebrating the history and art of photography. Previous titles include *Todd Webb: Photographs of New York and Paris, 1945-1960* (1986); *Harry Callahan: New Color, Photographs 1978-1987* (1988); *George N. Barnard: Photographer of Sherman's Campaign* (1990); *Clarence John Laughlin: Visionary Photographer* (1990); *The Passionate Observer: Photographs by Carl Van Vechten* (1993); *An American Century of Photography: From Dry-Plate to Digital, The Hallmark Photographic Collection* (first edition: 1995); and *The Photographs of Dorothea Lange* (1995).

Production: Rich Vaughn

Design: Malcolm Grear Designers, Providence, Rhode Island

Tritone Separations: Thomas Palmer, Newport, Rhode Island

Color Separations: Art Lithocraft, Kansas City, Missouri

Printing: Meridian Printing, East Greenwich, Rhode Island

Binding: The Riverside Group, Rochester, New York

Library of Congress Cataloging-in-Publication Data

Hallmark Photographic Collection
An American century of photography : from dry-plate to digital : the Hallmark Photographic Collection / Keith F. Davis ; foreword by Donald J. Hall.—2nd ed., rev. and enl.
p. cm.
Accompanies a traveling exhibition.
Includes bibliographical references.
ISBN 0-8109-6378-7 (Abrams cloth) / ISBN 0-87529-811-7 (pbk)
1. Photography—United States—History—20th Century—Exhibitions.
2. Hallmark Photographic Collection—Exhibitions. I. Davis, Keith F. II. Title.
TR23.H35 1999
779'.0973—dc21 98-54099

All the works illustrated in this volume are in the Hallmark Photographic Collection. Dimensions are given in inches, height preceding width. Unless otherwise noted in caption data, all are vintage gelatin silver prints.

Notices of permission and copyright are listed on page 590.

TABLE OF CONTENTS

Foreword

The fine arts have played an important role at Hallmark Cards for many years. In large measure, of course, this is a reflection of the special nature of our business and our people. Our creative staff includes hundreds of talented men and women drawn from the leading art schools in the nation. Their work, both during and after business hours, reflects the highest standards of excellence and innovation. Our fine art programs represent one way, of several, to both encourage and give larger symbolic expression to this ongoing creative enterprise.

My father, Joyce C. Hall, began our active collecting of contemporary art in 1949 with the establishment of the Hallmark International Art Awards program. In the course of these five projects, which ran through 1960, important paintings by American and European artists were acquired and toured to leading museums across the country. This program formed the basis for the Hallmark Fine Art Collection, which now includes well over 1,000 paintings, prints, and ceramics, as well as sculptures by artists such as Alexander Calder, Louise Nevelson, Kenneth Snelson, and Deborah Butterfield. In addition to this corporate activity, the Hall Family Foundation made a major commitment to the art of modern sculpture in 1986 when it acquired an important collection of fifty-eight Henry Moore sculptures, maquettes, and working models. This purchase has been followed by acquisitions of other masterworks of twentieth-century sculpture by Constantin Brancusi, Alberto Giacometti, Isamu Noguchi, Max Ernst, Claes Oldenburg, Joel Shapiro, and others. While our corporate collections are maintained within our headquarters building, these Foundation acquisitions are on long-term loan to Kansas City's Nelson-Atkins Museum of Art.

The Hallmark Photographic Collection has grown from, and flourished within, this tradition of support for the visual arts. Developed through the impetus and insight of David Strout, this collection was begun in 1964 with the acquisition of 141 prints by Harry Callahan. These were mounted in a one-man exhibition at the newly-opened Hallmark Gallery store at 720 Fifth Avenue in New York. The exhibition space which formed the centerpiece of this store was the site of a number of significant shows over the following decade. The Callahan exhibit, which was on

view from August 18 to October 10, 1964, included 141 black-and-white prints and sixty color slides shown by continuous projection. Notable exhibitions in later years included "Carl Sandburg: A Tribute" (1968) with photographs by Edward Steichen, "Young Photographers: Students of Harry Callahan at the Rhode Island School of Design" (1969), "Henri Cartier-Bresson's France" (1971), and "André Kertész: Themes and Variations" (1973). During these years, significant prints by a number of other important photographers—including Edward Weston, Imogen Cunningham, and László Moholy-Nagy—were quietly added to our collection.

In 1973 the Hallmark Gallery's exhibition function was discontinued and the collection relocated to our corporate headquarters in Kansas City. In 1979, Keith Davis was hired to oversee the photography collection. He has guided it ever since, greatly increasing its importance and public recognition through his acquisitions, exhibitions, and publications. In the last twenty years, for example, the collection has grown from 650 photographs to nearly 4,000. In this era, at least sixty different exhibitions have been assembled and circulated to well over 200 individual bookings in leading art museums and university galleries across the U.S., and in Canada, Australia, New Zealand, England, Wales, Switzerland, and France. To accompany the most important of these exhibits, we have published eleven catalogues and books that, we trust, represent a lasting contribution to the literature of this field.

In addition to its function as a source of in-house creative inspiration, the Hallmark Photographic Collection has a vitally important public purpose. We are interested in adding a unique cultural asset to our community, the greater Kansas City area, where Hallmark Cards was founded in 1910. Most of our exhibitions have been presented at the city's Nelson-Atkins Museum of Art, and the collection serves as a study resource for local college and university students. In addition to this regional presence, we have cooperated with a great number of museums nationwide by making individual works available for loan. And, given our status as an international firm, we have made judicious public use of the collection across the country and abroad through

the many original touring exhibitions we have created. It is gratifying to note that these shows have been seen by hundreds of thousands of viewers.

Why are these projects undertaken? The reason is simple. These activities reflect a fundamental belief in the importance of the arts to our quality of life and our cultural well-being. Art—in any medium—is about the communication of ideas and emotions, the unending dynamic of change, and the power of the imagination. Art represents a synthesis of tradition and innovation—and a respect for both—in order to express fundamental truths about our time and place. Now, at the end of the twentieth century, it is more important than ever to remember that art is about individual freedom and the natural diversity of ideas in a complex world. Works of art provide new perspectives on familiar things by encouraging us to see through the eyes of others. In addition, art represents the creative voice of our past, reminding us of the values and ideas that were important to previous generations. In various ways, the best of these ideas remain a vital part of who we are today. For all these reasons, we consider the support of fine art to be a natural part of good corporate citizenship, and a way to encourage society at large to better recognize and value its creative heritage.

The first edition of this book appeared in early 1995, in celebration of the first thirty years of the Hallmark Photographic Collection. This new, dramatically expanded version provides a "snapshot" of the collection at the thirty-five year mark. We hope it will stand for some time as a definitive overview of an enormously rich and vital subject: the modern era of American photography.

When this collection was begun in 1964 we were aware of no similar corporate holding in the world. Indeed, at that time photography was taken seriously by only a handful of major institutions, most prominently the Museum of Modern Art in New York. As we all know, that situation has changed dramatically and photography is now celebrated as one of the modern era's most important artistic mediums. Most of the world's major museums have photographic programs of some kind, and interest in the medium by private collectors, scholars, and the public has

increased at a remarkable rate. It is very gratifying to look back on our start in collecting fine photography thirty-five years ago, and to the medium's phenomenal growth ever since. We have enjoyed playing a small role in photography's recent history, and look forward to continuing this involvement in the coming years. We sincerely hope that these efforts will continue to be of interest to a very broad audience, from scholars of the medium to the general museum-going public.

DONALD J. HALL
Chairman of the Board
Hallmark Cards, Inc.

Preface and Acknowledgments

Photography is like an enchanted garden where one is continually meeting the unexpected and wonderful.

CATHERINE WEED BARNES, "The Real and The Ideal," 1891

The position of pictorial photography from the philosophical standpoint is intensely interesting. One might say it has entered the art-world as radium the physical world; there is something decidedly uncanny about it, and we really don't know where we stand.

ROLAND ROOD, "Has The Painters' Judgment of Photography Any Value?" 1905

Photographs may be made to lie but they never make mistakes. We change our memories as we change our minds, but photographs do not. Our mental photographs continue to develop in the dark. They are retouched by unknown fingers while they are stored away and when we bring them again into the light of consciousness they have been altered though we suspect it not. But a photograph tells the same story until it is destroyed.

EDWIN E. SLOSSON, "The Influence of Photography on Modern Life," 1923

American culture constantly outdistances its interpreters.

DAVID RIESMAN, "Our Country and Our Culture," 1952

This volume surveys selected facets of American photography from the mid-1880s to the present. This span of slightly more than a century encompasses two-thirds of the entire history of the medium. It also represents photography's modern age, an epoch inaugurated by several technical and cultural developments: the replacement of the cumbersome wet-collodion process with the dry-plate and roll-film technologies, the introduction of the hand-camera, the rise of amateur photography, and the perfection of the halftone method of reproducing photographs on the printed page. These changes greatly increased the presence of photography in American life and provided the basis for the medium's subsequent evolution. Despite remarkable technological developments in this span of over 100 years, the medium's basic principles—beginning with its reliance on light-sensitive compounds of silver—remained substantially unchanged.

Now, however, at the turn of the twenty-first century, we are in the midst of another great technological shift. The digital image, a creation of computer technology, has become a key part of our photographic vocabulary. New electronic processes, which are replacing many of yesterday's applications of silver-based photography, allow images to be stored and manipulated with unprecedented freedom. It seems inevitable that these synthetic modes of imaging will dissolve the seemingly "natural" correspondence between visible reality and the lens-formed image. Since pictures produced by digital processes can be constructed and transformed at will, they differ radically from the camera's characteristically objective record of optical fact.[1] Despite their futuristic implications, digital images might almost be considered *pre*photographic in nature. They provide an endlessly flexible means of picture-making—like drawing or painting—but lack the "truth function" we have traditionally associated with the camera. While it is still too early to assess the cultural impact of these new technologies, it seems certain that they will change the way we use and think about photographs.

This volume is a significantly expanded and updated version of the first edition of this title. This new second edition is nearly 50 percent larger than the original 1995 edition. The entire text has been revised, and a great number of new artists, images,

and themes have been included. The endnotes and bibliography have been similarly amended and enlarged. These changes reflect both the growth of our collection in this period and my own continuing research. What has not changed is the rationale of this book: to survey the highlights of a single collection while providing an original and comprehensive vision of modern photography as a whole, as refracted through an American lens.[2]

Since its founding in 1964, the Hallmark Photographic Collection has grown to include some 3,800 works by 630 photographers. The collection focuses on American photography from its origins in 1839 to the present day. In establishing these acquisition guidelines, American photography has been defined rather broadly so as to include work done by U.S. citizens abroad and by foreign artists in the U.S. Special attention also has been paid to European-born artists who moved to the U.S. in the 1930s.[3] While we feel no need to be exhaustively encyclopedic, a considerable variety of artists, themes, and processes are currently represented. In addition to this breadth of approach, the works of a few artists have been collected in depth. For example, large holdings of prints by Harry Callahan (302), André Kertész (238), Todd Webb (161), Clarence John Laughlin (127), Dorothea Lange (89), and Carl Van Vechten (76) constitute a significant proportion of the collection. Other artists are represented by anything from a few dozen prints to a single, carefully chosen example. In addition to this continuing interest in photography of the modern era, our move into early nineteenth-century photography, in 1995, has resulted in a growing collection of works from the daguerreian, salt print, and wet-plate eras. In the coming years, it is expected that this period—roughly the first half-century of American photography—will be surveyed in a companion volume to this. Ultimately, these activities—and the Hallmark Photographic Collection as a whole—represent an attempt to refine and expand, rather than simply to confirm, our understanding of photography's history.

In addition to surveying many of the highlights of the Hallmark Photographic Collection, this book seeks to outline aspects of the cultural and artistic context from which these works arise. The text is intended to serve as an introduction (albeit, a rather lengthy one) to the history of modern American photography. While the scholarship of photography has grown enormously in recent decades, no other single-volume study has attempted to survey this period in such detail. In large measure, the text of this book is based on a close reading of the discipline's own literature—the many photographic journals published since the early 1880s. These journals—which are still underutilized by historians of the medium—provide a vast amount of information on the personalities, techniques, and issues that have been of importance to photographers. This enormous quantity of "raw" data has been combined with a broad study of the historical and critical scholarship produced in recent years. A fraction of this valuable and insightful secondary work is acknowledged in the notes and bibliography at the end of this volume.

Any attempt to survey a subject as vast as modern American photography raises a host of intellectual and methodological dilemmas, beginning with the nature of historical inquiry itself. The history of photography is not a singular or easily defined entity. Although based on a discrete set of technical processes, the medium has been put to an extraordinarily wide range of uses

since its introduction in 1839. Thus, while photography's means are easily traced, its effects are almost infinitely varied. It might seem that one could just as well propose a history of the printed word embracing all its uses, from the most trivial to the most rarified. Similarly, one might wonder what is inherently "American" about American photography. While any closely reasoned answer lies far beyond the scope of this preface, a few tentative responses may be suggested. Some of the most characteristic themes in American cultural life include the tensions between nature and technology, pragmatism and idealism, science and faith, high and popular culture, political unity and diversity, and individuality and community. These and similar themes lie at the heart of American artistic expression.

This survey of American photography emphasizes those figures who have used the medium in a deliberately self-expressive manner and, secondarily, those whose works have influenced the way society has thought of itself. These two groups—artists and skilled commercial or journalistic professionals—are not mutually exclusive, though their motivations may differ. While representing only a fraction of the medium's full range of uses, these applications nonetheless reveal much about photography's importance in both shaping and expressing the modern sensibility. The following text is divided into four chapters, each focusing on a span of roughly a quarter-century. While partly a product of narrative convenience, these divisions nonetheless reflect some of the major cultural eras in American life.

If the past is all that has happened before today, history represents our effort to make sense of that almost endless sequence of events. Inevitably, every historical narrative represents selected facets of the past as seen from a particular personal and cultural point of view. As historian Van Wyck Brooks observed in 1918: "The past is an inexhaustible storehouse of apt attitudes and adaptable ideals; it opens itself at the touch of desire; it yields up, now this treasure, now that, to anyone who comes to it armed with a capacity for personal choices."[4] The ability of the past to tell many stories, both familiar and unexpected, means that our understanding of it can never be complete or conclusive. However, our versions of the past may be made more subtle and useful by increasing our familiarity with certain primary sources and by embracing multiple, rather than singular, points of view. To this end, it is essential to value the obduracy of fact and the complexity of lived experience over the simplifying abstractions of theory. In his essay "The Sense of the Past," literary scholar Lionel Trilling addressed this task:

> The refinement of our historical sense chiefly means that we keep it properly complicated. History, like science and art, involves abstraction: we abstract certain events from others and we make this particular abstraction with an end in view, we make it to serve some purpose of our will. Try as we may, we cannot, as we write history, escape our purposiveness. Nor, indeed, should we try to escape, for purpose and meaning are the same thing. But in pursuing our purpose, in making our abstractions, we must be aware of what we are doing; we ought to have it fully in mind that our abstraction is not perfectly equivalent to the infinite complication of events from which we have abstracted.[5]

Like any other form of human narrative, written history requires a coherent structure—a beginning, middle, and end—to make "sense." While our narratives aim for lucidity, the real past is usually characterized by its raggedness and contradictions.

Actual experience seems most often to be a fog of contingencies, conflict, and muddled motives, punctuated only occasionally by a sense of logic or overarching design. It is exceedingly difficult for history to recapture this sense of the past as lived experience without itself becoming incoherent. Nonetheless, if we intend our narratives to be true to any degree to the past they purport to describe, this complexity must somehow be acknowledged.

In addition, we must strive to take the values and ideas of the past seriously, if not uncritically. Each culture is a unique puzzle of success, failure, contention, and contradiction. As one historian has observed: "The past is a foreign country whose features are shaped by today's predilections, its strangeness domesticated by our own preservation of its vestiges."[6] Rather than routinely domesticating this strangeness by interpreting the past in light of our own ever-shifting values and interests, a greater challenge lies in striving to understand it on its own terms. In part, this means allowing the past to speak for itself, in its vibrant profusion of voices.

This approach inevitably reveals the past as a rich tapestry of activity. The texture and details of this colorful fabric change continually through time—as specific personalities and issues come and go—while its essential character evolves more slowly. We are reminded that artistic invention is often an intricately collective activity—flavored, always, by individual ideas and achievement—with talents of varying magnitude contributing to the process. In seeking to describe this complex activity, however, we inevitably simplify it and change its meaning: the originality of the most progressive artists may be relatively magnified, while partial or qualified success is ignored. New artistic ideas grow from, and are an integral part of, a shared climate of thought. Innovative ideas develop from existing ones and, no matter how dominant they may become, never fully replace competing approaches. New styles and viewpoints are absorbed gradually by artists and the public, and are, in the process, modified in myriad ways. Rather than wiping the slate clean, innovative ideas take their place within an intellectual mosaic of past and present. And, in time, all once-new ideas become part of the status quo that subsequent approaches attempt to extend or overthrow. This process suggests that the central dynamic of modern art history is the tension between the forces of innovation, fragmentation, and challenge, and those of preservation, synthesis, and confirmation.

A broader view of the history of photography begins by supplementing the acclaim given the most notable figures with a new respect for a spectrum of "minor masters." Such figures are often characterized by short careers, intermittent success, a lack of public ambition, or a less than monumental creative imagination. They are, in short, recognizably human and thus integral to the fabric of history. Just as the highest peaks of a mountain range are part of an entire landscape of lesser peaks, foothills, and valleys, the pinnacles of achievement in this medium—the Stieglitzs, Steichens, Westons, and Callahans—need to be understood in the context of their time and in the company of their associates. By reintegrating our most famous artists back into the complexities of their eras, we may rediscover their work as, at once, both stranger in intention and more comprehensible in achievement than we had previously realized. In addition, an acknowledgment of the relative merits of lesser figures makes the essential multiplicity of history—its profusion of worthy narratives—more

obvious. There is much pleasure to be taken in qualified or eccentric successes. The literary critic F. W. Dupee once described an interesting but obscure writer as "a wonder, a precious anomaly, at once great and small, easy to forget but delightful to remember."[7] Photographic history is replete with such delightful figures who deserve some measure of remembrance.

What does it mean to remember the past in this way? In his book *Cultural Selection*, historian Gary Taylor observes: "Memory, the mother of the Muses, is also the mother of self: we are what we remember." Indeed, it is only in our collective memory that we can begin to find the resources to make ourselves larger, more generous, wiser. Taylor writes:

> Memory is the gene pool of culture. The future can be imagined only by creatively recombining memories of the past. The exuberance of future imaginings depends upon the complex fertility of the decomposing memorial matter in which it grows. The smaller the memorial gene pool, the more restricted the possibilities of future cultural evolution. Whenever a memory of culture dies, a future dies with it.[8]

In grappling with the past—in seeking to make it *ours* in some meaningful way—we inevitably transform it. All the more reason that our grappling should be done with with a sense of care and deference. We diminish ourselves if we use the past only to confirm what we already know, rejecting everything that does not easily fit our conceptual template. The past is a complicated tangle of issues, ideas, and insights. While some of these threads go nowhere, others lead—however sinuously—up to the present moment and beyond. As Taylor reminds us, only by seeking to understand the richness of past experience can we hope to create an equally rich future.

This book is based on a profound belief in the value of our artistic and cultural past. It also reflects an essential faith in empirical inquiry, and in the idea that social and intellectual change is almost always evolutionary, rather than revolutionary, in nature. Most fundamentally, perhaps, this book stems from a deep and abiding affection for photographs, and an equally deep respect for the men and women who make them. Beginning with a general acceptance of the existing "canon" of photographic history, this book strives to suggest some of the ways in which that familiar history may be made more nuanced and varied.[9] Only by keeping our historical sense "properly complicated" can we hope to convey the texture of lived experience, and the meaning of photographs both to their own time and to ours. The resulting history may not precisely reflect all our present assumptions and enthusiasms, but it will tell us a great deal that we need to know.

This book, and the accompanying exhibition, could not have been accomplished without the talents and assistance of many people. First and foremost, we salute the achievements of the photographers included in this volume, and gratefully acknowledge the cooperation of the artists, estates, and representatives who granted permission for works to be reproduced.

Over the years, I have conducted research in a number of major museum collections, including those of the Metropolitan Museum of Art, the Museum of Modern Art, the Museum of the City of New York, the George Eastman House, the Art Institute of Chicago, the J. Paul Getty Museum, the Los Angeles

County Museum of Art, the Center for Creative Photography, the Princeton University Art Museum, and the Royal Photographic Society. Also critical to this study were the resources of the Library of Congress, the New York Public Library, the Beinecke Library at Yale University, the library of the George Eastman House, the Kansas City Public Library, the University of Kansas Libraries, and the Linda Hall Library in Kansas City. Thanks are gratefully extended to the staffs of all these institutions for their assistance.

In several years of work on this project, information and assistance were provided by a great number of colleagues. These include: Gordon Baldwin, Tom Beck, Bonni Benrubi, Sandra Berler, Janet Borden, Doris Bry, Peter C. Bunnell, Carl Chiarenza, Patrick Clancy, Van Deren Coke, Frances Connelly, Evelyne Z. Daitz, Keith de Lellis, Gary Edwards, Kathleen A. Erwin, James Enyeart, Terry Etherton, Birgit Filzmaier, Kaspar M. Fleischmann, Jeffrey Fraenkel, John Froats, Lance Fung, Peter Galassi, Victor Germack, Sarah Greenough, Ursula Gropper, Tom Halsted, Maria Morris Hambourg, Paul Hertzmann, Susan Herzig, Tom Hinson, Donald Hoffman, Edwynn Houk, Charles Isaacs, Tom Jacobson, Estelle Jussim, Elisabeth Kirsch, Norbert Kleber, Michael Klein, Robert Klein, Cornelia Knight, Paul Kopeikin, Hans P. Kraus, Jr., Mack Lee, Janet Lehr, Harry H. Lunn, Jr., Peter MacGill, Ezra Mack, Robert Mann, Laurence Miller, Anthony Montoya, Myra Morgan, Weston J. Naef, Wendy Olsoff, Eugene and Dorothy Prakapas, Howard Read, Pam Roberts, Naomi Rosenblum, Jeff Rosenheim, Amy Rule, Janet Russek, Martha A. Sandweiss, Julie Saul, William Schaeffer, David Scheinbaum, Charles Schwartz, Rebecca Simmons, Andrew Smith, Robert Sobieszek, Chris Steele, John Szarkowski, Dominique H. Vasseur, Mike Weaver, Margaret W. Weston, Stephen White, Daniel Wolf, John Wood, and David Wooters.

For assistance above and beyond the call of duty, very special thanks are extended to Joseph Bellows, Stephen Daiter, James Danziger, Frank DiMauro, Susan Ehrens, Howard Greenberg, Jill Quasha, and Leland Rice. For his consistent support, encouragement, and undying enthusiasm for all things photographic, I am particularly grateful to George Rinhart. Mr. Rinhart's knowledge of American photography is unparalleled, and I have benefited enormously from his wise counsel over the years. For their enduring faith and support, my thanks go to my parents and wife: Joel Davis, Ruth Ann Davis, and Trish Davis. For their encouragement and assistance in earlier years, sincere thanks are also extended to Thomas Barrow, Van Deren Coke, Robert J. Doherty, David Gilmore, David Strout, Charles Swedlund, and the late Beaumont Newhall. It also seems appropriate to pay homage to Robert Taft, whose pioneering book *Photography and the American Scene* (1938) set an exceedingly high standard for the study of American photography.

The exhibition accompanying this volume will be shown at a number of major museums in 1999-2002, including the Phillips Collection, Washington, D.C.; the Seattle Art Museum; the Joslyn Art Museum, Omaha, Nebraska; the Delaware Art Museum; the Columbus Art Museum, Columbus, Georgia; and the Denver Art Museum. We are grateful to all these institutions for their interest in the exhibition and for their care in presenting it to their public.

This book has been made possible by the devoted work of many talented colleagues. The quality of this volume is due in large measure to the careful design of Malcolm Grear Designers, Thomas Palmer's fine separation work, and the skilled pressmen at Meridian Printing. Brian Wallis provided invaluable service as text editor. The meticulous index is the work of Philomena Mariani. For her efforts in coordinating the distribution of this volume, sincere thanks go to Margaret L. Kaplan, at Harry N. Abrams, Inc. For research assistance, thanks are also extended to our University of Missouri-Kansas City interns: Kevin Moore, Kelle Botkin, Beth Schmalz, Jane Aspinwall, and Rebecca Peabody. At Hallmark, Rich Vaughn, Mike Pastor, Gary Pycior, Nicki Corbett, Janice Termini, Gae Goodwin, and others provided invaluable help with both professionalism and good humor. I am particularly grateful to Pat Fundom, Fine Art Programs Registrar, for her tireless assistance in all aspects of this book and the accompanying exhibition.

This book represents one facet of the larger cultural interests of Hallmark Cards, Inc. I am profoundly grateful to William A. Hall, Irvine O. Hockaday, and Donald J. Hall for their continued guidance and support.

KEITH F. DAVIS
Fine Art Programs Director
November 1998

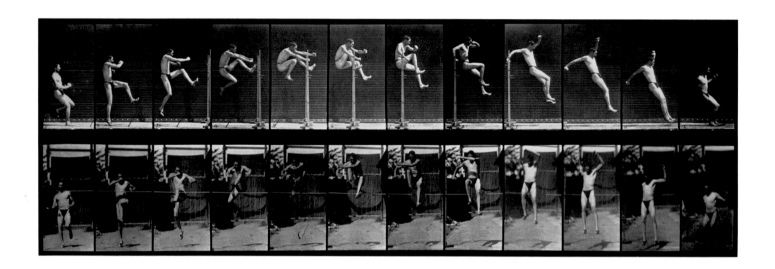

4 **Eadweard Muybridge,** *High Jump*, 1885, collotype, 5⅞ x 18¼"

CHAPTER I A Reluctant Modernism
1885-1915

American culture was transformed in the three decades between 1885 and 1915. In this time, the United States evolved from a rural and agrarian nation into one that was largely urban and industrial. The frontier—the greatest symbol of the expansive potential of American life—was declared officially closed in the census of 1890. Twenty-five years later, statistics revealed that the majority of Americans lived in cities and towns. The nation's population increased by about 50 percent in this period, and waves of immigrants arriving from Europe and Asia made American society increasingly heterogeneous. This population pushed relentlessly westward across the continent, rapidly displacing the resident Native American peoples.

The American economy grew at a remarkable rate in this era, despite the severe depression of 1893-97 and a milder downturn in 1907-08. Led by the success of such gigantic trusts as J. P. Morgan's U.S. Steel Corporation, industrial production expanded at an unprecedented pace. Since the business climate of these years encouraged an almost unbridled laissez-faire capitalism, new industries flourished. At the same time, however, the unforgiving dynamics of the marketplace drove many others into insolvency. This vigorous economic system created unprecedented wealth (and inequality) and became a powerful engine of social change. American culture gradually shifted from an ethic of scarcity and production to one of abundance and consumption. New modes of manufacture created a variety of goods cheaper and faster than ever before. The newly developed department store, in which these goods were enticingly arrayed, became a veritable cornucopia of commercial plenty. New technologies of mass production changed the nature of work, as experienced artisans were often replaced by unskilled workers performing simple, repetitive tasks. The factory wage-labor system created new jobs, but also brought new insecurities, as wage cuts and layoffs became increasingly common. These conditions sometimes drove disgruntled workers to stage militant demonstrations for reform, frightening the middle class with the specter of anarchism.

This economic dynamism and turmoil was accompanied by dramatic changes in the nature of daily life. The family was transformed by new attitudes toward work, education, relations between the sexes, leisure time, and children. The American home was changed by a variety of technological improvements, including the widespread use of electricity, running water, and central heat. New transportation systems allowed families to live farther from the workplace, prompting the growth of suburbs. This was a highly visual age in which pictures were produced in rapidly increasing numbers by the camera and printing press. The telephone, phonograph, automobile, airplane, motion picture, and wireless all contributed to a radically new world in which, it seemed, time and space themselves had been conquered.

This transition from the nineteenth century to the twentieth represented a movement from a Victorian sensibility to a modern one. The Victorian mind had been guided by a confident positivism, a faith in social progress, and a belief in the ultimate harmony of religion and science. The modern world eroded these certainties. Thinkers such as Charles Darwin, Karl Marx, Friedrich Nietzsche, Sigmund Freud, and Albert Einstein contributed to a fundamentally new vision of the mind, society, and reality itself. The cumulative effect of these ideas was to complicate formerly "simple" or "natural" explanations for things, making the world harder to understand. Scholarly disciplines became increasingly specialized, employing ever more technical or abstract languages that removed them from the realm of general public discourse.

The roots of artistic modernism lie in the profound technological, social, and intellectual transformations of the late nineteenth century. However, as historian George Cotkin has observed, this was a period of "reluctant modernism" in which the most thoughtful individuals struggled to reconcile new ideas and technologies with the values of an earlier era.[1] The result was an often uneasy balance of rationalism and intuition, daring and caution. The progressive age of the telephone, automobile, and airplane also produced a broad fascination for hypnotism, telepathy, mysticism, and the occult. This curiously mixed cultural mindset combined a sense of technological bravado with nostalgic yearnings for the simplicities of a real or imagined past. The persistent antimodernism of this period reflected a deep desire to recover emotional and spiritual values in an increasingly mechanistic and materialistic culture. The struggle to come to grips

with the modern world was eloquently expressed—whether directly or obliquely—in the most technologically advanced art of the period: photography.

A New Age

In 1889, American photographers celebrated the fiftieth anniversary of their medium with both pride and melancholy. J. Wells Champney, a respected artist and enthusiastic amateur photographer, composed one of the best analyses of photography's progress since its invention by the Frenchman Louis Jacques Mandé Daguerre.

> Can our readers picture to themselves the comic situation of a victim of the daguerreotypist of 1839, screwed to the back of a chair, his face dusted over with a fine white powder, his eyes tightly closed, obliged to sit a full half-hour in the sunlight?...
>
> Contrast this with the possibilities of to-day, when in the darkest of dark caves or cellars, or on the blackest of nights, the tyro photographer, armed with his little camera, and pistol loaded with magnesium cartridge, can obtain a picture full of vigour and marvelous in detail. This chasm has been bridged over in the fifty years since Daguerre gave before the French Academy of Sciences the secret of his wonderful process. The journey down the photographic history of those fifty years is full of wonderful struggles of mind over matter...until to-day hundreds of thousands contribute to our knowledge and happiness in the practice of photography whilst gaining their daily bread.[2]

Photography's achievements in 1889 were, indeed, astonishing. There were over sixty photographic journals and 161 photographic societies in existence across the globe. Photography had made important contributions to archaeology, astronomy, and medicine, while Eadweard Muybridge's celebrated studies of human and animal locomotion—made with exposures as rapid as $1/2,000$th second—had revealed amazing and hitherto invisible aspects of everyday life. So rapid was the pace of technical advancement, Champney observed, that in the few years since the completion of Muybridge's work, the recording of "rifle bullets and cannon-balls in flight has become an every-day matter."[3] Champney looked to the future of color photography with certainty, convinced that such processes would soon be practical. He observed photography's increasing use in publishing, with the gradual perfection of the halftone method of printing illustrations, and in business, for the advertisement of an endless variety of goods. By 1889, he reported, police were making photographic "mugshots" of criminals, the military was employing the camera to miniaturize maps and documents for secret transport, and artists were promoting their work by mailing photographs of paintings to distant clients. Most remarkably, Champney observed, the perfection of the hand camera had enabled the average American to take up photography.

But, despite this impressive inventory of applications, Champney ended his article on a bittersweet note:

> One cannot close even so incomplete a review as this of the first half-century of photography without a reference to the position it holds with regard to art. Though it would require a long essay to deal with the subject as it merits treatment, it is important to make certain confessions of blighted hopes, and at the same time to look with tempered enthusiasm into the future. As an aid to science, as a recorder, as a duplicator, photography has helped advance civilization. Of itself it has failed to occupy the place it may yet hold as a means for expressing original thought of a fine order. With its recognized qualities, and in the hands of a thoroughly trained worker perfectly familiar with the laws of chemistry and optics, and with artistic feeling and training, it may be placed on a plane where its beauties will force from all acknowledgment that it has powers which rank it as one of the finest of the graphic arts.[4]

Champney pinpointed photography's central dilemma: the awkward tension between utility and art. Against a backdrop of rapid technical progress and expanding commercial applications, several generations of photographers had struggled to prove that the camera was capable of "expressing original thought of a fine order." By definition, this artistic quest was understood to transcend the routine competence of commercial work and the quaint pleasures of the amateur snapshot. While the camera lent itself to a vast number of useful applications, photographers understood that real social prestige demanded a medium capable of high aesthetic achievement. According to the conventions of the era, "art" was the product of refined sensibilities and skills, and represented a realm of purity and contemplation distinctly removed from the mundane reality of everyday experience. By these criteria, photography was doubly damned: as a soulless, mechanical process woven inextricably into the fabric of daily life.

A Half-Century of Change

Photography had indeed made dramatic advances in its first half-century. In the daguerreotype era of the 1840s and 1850s, when the business of photography was devoted almost exclusively to portraiture, practitioners were required to master only a single, if difficult, technique. The daguerreotype process produced laterally reversed direct-positive images on highly polished sheets of silver-coated copper. These exquisitely beautiful images were protected under glass and preserved in small cases. The next great technical change came in the mid-1850s, when the daguerreotype began to give way to the glass-plate negative and paper-print processes. This new negative/positive technology allowed the easy production of multiple paper prints from a single glass negative, a distinct advantage over the one-of-a-kind daguerreotype. The development of the wet-collodion negative and the albumen print spawned a number of new applications and formats, including the ambrotype, tintype, stereograph, carte-de-visite, and cabinet card. Once professionals of the wet-plate era mastered these new forms, they were rewarded by an expanded set of commercial opportunities. For the first time, for example, photographs of celebrities and scenic views were mass-produced for a broad popular market. Many other specialized applications of photography were developed in science, publishing, and manufacturing.

Between about 1860 and 1880, photographic technology achieved a new equilibrium. The laborious wet-collodion process, which required that glass-plate negatives be hand-coated, exposed, and processed within minutes, proved remarkably flexible for a wide variety of tasks. Much brilliant work was produced by this technique, including the portraits of Mathew Brady, the Civil War images of Alexander Gardner and George N. Barnard, and the western landscapes of Carleton Watkins, Timothy O'Sullivan, and William Henry Jackson. Although minimally inconvenient in studio work, the wet-plate process required

photographers in the field to carry a portable darktent with all their solutions and processing trays.

While professionals accepted the necessity of this labor with little complaint, various researchers (often amateur photographers) sought an easier dry-plate technique. This was a formidable task. An early form of dry plate was marketed in England in 1867, but required exposures much longer than the wet plates of the day.[5] Experiments continued at an increasing pace in the 1870s, with a variety of substances put to the test. In early 1877, one writer summed up the frustrations of dry-plate work:

> We have had dry collodion, albumen, [and] gelatin emulsions, with preservatives of tannin, tea, coffee, beer, albumen, [and] tobacco, besides numerous mixtures of poisonous drugs; and developers, acid and alkali, hot and cold *ad infinitum*, till the beginner is bewildered in the mazes of the chemical nomenclature which present themselves to him as the ABC's of dry-plate photography.
>
> It is doubtless this great variety of processes, and the uncertainty of their merits, that have deterred many from practicing dry-plate work, and especially is this true of professional photographers, who find it necessary that time and effort should count, and who are disposed to adopt that process which they can have most completely under their control...[6]

This experimentation brought steadily improving results, however, and many articles on dry processes appeared in the photographic journals of 1877-78. By mid-1878, the dominance of this new technology seemed inevitable.[7] The only task remaining was for manufacturers to perfect the means of production in order to "place before professional photographers an emulsion of good quality, sensitive, and, above all, uniform in character."[8]

The commercial manufacture of dry plates began in 1878, probably by Albert Levy in New York.[9] He was followed in 1879 by John Carbutt in Philadelphia and George Eastman in Rochester. Due to their inconsistency and relative insensitivity, these plates were of primary interest only to amateurs. In 1879, for example, the veteran professional Alexander Hesler reported that a subject requiring five seconds exposure with the wet-plate process needed fifteen seconds with the dry plate. But refinements came rapidly and by 1881 the situation was reversed: dry plates were now reported to be at least eight times faster than the familiar wet-plate technique.[10]

The advantages of the dry process soon became clear: besides eliminating all the darkroom labor prior to exposure, the new plates allowed the creation of pictures that would otherwise have been impossible. In 1881, for example, Joshua Smith of Chicago made a clear image from the back of a train moving at forty miles per hour.[11] Two years later, George W. Rockwood made "instantaneous" exposures with a large 14 x 17-inch camera from the deck of a tugboat in New York harbor.[12] The new plates were so fast that, for the first time, lenses had to be equipped with shutters to facilitate exposures of a fraction of a second.

Professional photographers soon overcame their reservations about the new plates. By the end of 1883 no fewer than twenty-eight American firms were manufacturing dry plates and shipping them as far away as India and China.[13] The dry plate was easier, cleaner, and ultimately more consistent than the collodion method. Most importantly for professionals, the increased speed meant that fewer portraits would be spoiled by the motion of the sitter. Squirming children, particularly in the fading light of late afternoon, had posed a notoriously difficult subject for portraitists. It was thus a hearty endorsement for a professional such as George Rockwood to note that dry plates were "a wonderful thing for babies at 5 o'clock in the afternoon."[14]

Stopping Time

The increased sensitivity of the dry plate aided a specialized branch of photography initiated at the end of the wet-collodion era. In the 1870s and 1880s, Etienne-Jules Marey, Eadweard J. Muybridge, and Ottomar Anschütz (working, respectively, in France, America, and Prussia) all used high-speed photography to analyze human and animal motion.[15] Marey had begun work in this field as early as 1859, using a variety of nonphotographic devices. His 1873 book, *La machine animale* (published in English a year later as *Animal Mechanism*), had a considerable impact on Muybridge, an English-born landscape photographer residing in San Francisco.

Muybridge began his studies of motion under the sponsorship of former California governor Leland Stanford. By 1872 he achieved partial success by photographing a running horse so that (with significant retouching of the negative) the position of its legs could be discerned. Much better results were achieved at Stanford's Palo Alto trotting track in 1878-79, and these "instantaneous" photographs of walking and running horses received international attention.[16] One critic was prompted to exclaim:

> All of the former representations of horses in motion are reduced to worthless frauds by the latest scientific achievement in instantaneous photography. In one sense it is a pity that the labors of so many artists should have been so worthlessly consigned to the limbo of ignorance and error, but in the constant progression, such has been the fate of many theories and pet conceptions.[17]

Another noted with awe that looking at these photographs "is enough to turn your brain."[18] After publishing a selection of these images in the book *The Attitudes of the Horse in Motion* (1881), Muybridge embarked on a lecture tour of France and England. In Paris he met Marey, who introduced him to the possibilities of the dry-plate process.

Upon his return to the United States, Muybridge launched an even more ambitious photographic study of motion under the patronage of the University of Pennsylvania in Philadelphia. From the spring of 1884 to early 1886, he produced over 20,000 plates of human and animal subjects. In an outdoor studio on the university grounds he photographed people, clothed and nude, engaged in an exhaustive—and occasionally bewildering—variety of athletic and domestic activities. Simple movements such as walking, running, climbing stairs, and bending to pick up a handkerchief were recorded, as were more complex activities such as making a bed, pole vaulting, and high jumping. Muybridge also took his apparatus to the Gentlemen's Driving Park to record running horses, and to the Philadelphia Zoological Garden to document more exotic animals. The result of this labor was published in 1887 in an enormous folio of 781 collotype plates titled *Animal Locomotion*. Only thirty-seven complete copies of this expensive work were produced, but many individual prints were sold for a dollar each.

To make his sequential views, Muybridge typically used two or three batteries of twelve cameras each. The first bank of cameras

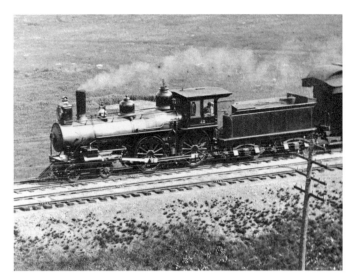

5 Francis Blake, *Engine of the New York Express. Speed: 48 miles an hour*, ca. 1886-90, 6 x 8¹/₁₆″

produced lateral views of his subject, while the second and third made foreshortened views from the front and rear. The speed of each exposure was approximately ¹/₂,₀₀₀TH of a second. This technique, as demonstrated in the plate titled *High Jump* [4], records twelve sequential instants from two vantage points; the continuous flow of real time is broken into twenty-four facets. Temporal change is thus transformed into spatial display, creating a visual "map" that is at once logical and unreal. By multiplying space and fragmenting time, Muybridge prompted viewers to consider the latent strangeness of the most ordinary actions. As the *New York Times* noted, Muybridge's images of human and animal subjects "walking, galloping, flying, working at various trades and occupations, playing, fighting, dancing, batting, wrestling, fencing, boxing, [and] crawling [reinforce] with scientific certainty the old saying that, 'having eyes, ye see not.'"[19] Indeed, these pictures generated much discussion on the nature of vision and representation—the difference between "normal" and "instantaneous" impressions, for example, and the correspondence between scientific and artistic truths.

While works such as *High Jump* suggest Muybridge's ideal of a neutral, analytical vision, other motives may also be discerned. This image has a graphic elegance the photographer undoubtedly found pleasing, since he thought of himself first and foremost as an artist. Thus, while Muybridge sought both truth and beauty in his pictures, these terms were not synonymous; he felt free to manipulate his process for the sake of narrative or aesthetic effect.[20] For example, Muybridge fabricated a few sequences in *Animal Locomotion* by splicing together units from different photographic sessions, or by posing models in simulations of movement. These eccentricities speak to the complexity of all photographic "documents"—even those produced under what appear to be rigorously scientific conditions—and the perhaps inevitable blurring of analytical and expressive impulses.

The aesthetic possibilities of high-speed photography fascinated several other Americans of the 1880s. Francis Blake was one of the most remarkable of these photographers. Born in Needham, Massachusetts, and later a resident of nearby Auburndale, Blake was a noted inventor and physicist. His high school work in mathematics was so distinguished that he was given an appointment with the U.S. Coast Survey at the age of sixteen, in

1866. In his twelve years with the Survey, Blake performed a variety of duties related to surveying, astronomy, and electrical science. Upon retiring from this position in 1878, Blake perfected a telephone transmitting device that was purchased by the fledgling Bell Telephone Company for a generous share of the firm's stock. Blake continued his electrical research as a director of the company and received twenty patents between 1878 and 1890. He was a member of many scientific and historical organizations, and in later life showed a keen interest in the fine arts.[21]

In 1886, Blake began a systematic investigation of high-speed photographic shutters.[22] The result was a focal-plane shutter of his own design allowing exposures of about ¹/₂,₀₀₀TH of a second.[23] In the course of this work, from 1886 to about 1891, Blake recorded a variety of subjects. From a bluff at the edge of his property, he stopped a speeding locomotive, enroute from New York to Boston, in an eerie state of suspended animation [5]. He also photographed a boy riding a bicycle, champion tennis players in mid-stroke, and clusters of flying birds. *Pigeons in Flight* [67], one of the best known of Blake's stop-action images, combines a still-startling rapidity of vision with an equally remarkable sense of pictorial structure. Against a backdrop of simple architectural forms, Blake depicted an elegantly arrayed flock of birds frozen in flight. From the most unpredictable of subjects, Blake created an image of delightful spontaneity and unexpected formal unity, snatching from the flux of activity before him a magically resolved instant of pictorial harmony.

Blake's pictures were included in leading exhibitions in the early 1890s and won several awards. In the Fifth Joint Annual Exhibition of Photography, held in Boston in 1892, he showed a total of forty-five images and was one of only twelve photographers to be given a medal. Later that year, this display won another award in the exhibition of the Massachusetts Charitable Mechanic Association.[24] In 1893, three of Blake's instantaneous studies earned a silver medal in the Sixth Annual Exhibit of the Photographic Society of Philadelphia.

By the middle of the 1890s, images such as these had fallen out of critical favor as interest shifted from such apparently "simple" mechanical feats to more idealized and picturesque subjects. Far more than mere technical exercises, however, Blake's stop-action images combine bold pictorial vitality with a delightful sense of whimsy. Gifted with a profoundly original mind, Blake used the camera to explore both the hidden folds of the fabric of time and the graphic possibilities of picture making itself. A perfect synthesis of analysis and intuition, his work represents a photographic vision that owed nothing to the influence of other mediums.

George Eastman and the "Camera Epidemic"

By freeing practitioners from the need to coat and process each negative on the spot, the dry plate removed much of the labor—and thus the craft—from photography. The medium was suddenly thrown open to a legion of nonprofessionals, and the modern amateur photographer was born. The potential of this market had been apparent for years. In 1876, for example, the American Optical Company introduced its '76 Pocket Camera, the smallest 5 x 8-inch format camera ever made, to meet "the growing interest in dry-plate photography."[25]

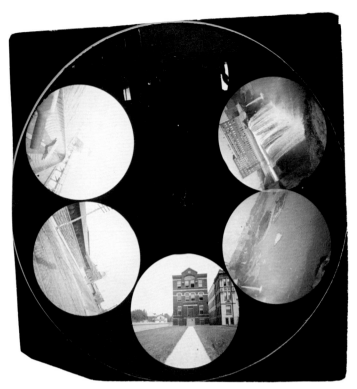

6 **Unknown Maker,** *Rochester, New York* (C. P. Stirn's Patent Concealed Vest Camera), 1886, albumen print, 5⅜ x 5⅝"

The photographic supply firm of E. & H. T. Anthony, which had been trying to promote amateur photography since the 1850s, led the effort to capitalize on this new mass market. In April 1881, the Anthony firm began a national advertising campaign under the heading "Dry Plate Photography for the Million." The text of this ad stated:

> Recent improvements have greatly simplified the practice of photography, and in consequence there is a marked revival of public interest in this interesting art. Many new methods have been devised, which render the details of manipulation extremely simple and economical. The introduction of gelatino-bromide dry plates—possessing very great rapidity of action and admitting of instantaneous exposure—which can be obtained fully prepared for use, enables the student, the tourist, or any one who may feel disposed, to engage in this popular diversion at trifling cost.

Responding to this demand, the firm marketed simple 4 x 5-inch and 5 x 8-inch camera outfits at unprecedented low prices.[26]

As other manufacturers entered this market, cameras became progressively smaller and easier to use. By early 1882, William H. Walker of Rochester, New York, was promoting his Walker Pocket Camera package to amateurs: the small 2¾ x 3¼-inch dry-plate camera was sold complete with lens, tripod, and other necessities for ten dollars. A notable breakthrough came in 1883 when the first true hand-held camera, William Schmid's Patent Detective Camera, was marketed by the Anthony firm. By eliminating the need for a tripod, this simple 3¼ x 4¼-inch device allowed pictures to be made with unprecedented spontaneity.[27] The concept of candid photography was pushed even further with the introduction of small concealed cameras. The most popular of these models, C. P. Stirn's Patent Concealed Vest Camera of 1886, was worn beneath a man's coat or vest, with the lens protruding through a buttonhole.[28] With this unusual device, six small images could be made on a circular glass-plate negative [6].

With cameras such as this entering the market, photography became a pastime for many thousands of Americans. Several major newspapers began camera columns, and dozens of hotels across the nation constructed darkrooms for vacationing enthusiasts.[29] In an 1883 article titled "Taking Photographs for Fun—The Increasing Army of Amateur Photographers," the *New York Times* noted that:

> A few years ago one would not have found a dozen of these young men who take pictures for fun. African explorers and Western travelers have always taken an apparatus of some kind but it is only recently that pictures have been taken by private persons simply for the pleasure of it. Now the supplying of amateur outfits has become one of the most important departments in the big photographic materials supply stores in the City.

The *Times* further reported that it was common to see "nicely dressed young fellows loaded down with cameras and tripods at the trains and steam-boats" on their way to the country to photograph "a bit of romantic landscape, river, or mountain side." With the availability of special lightweight camera outfits, women were also taking up the pastime.[30]

A year later, the craze for photography continuing unabated, the *Times* published a humorous editorial titled "The Camera Epidemic":

> The appearance of the cholera in Europe has to some extent diverted public attention from the spread of the camera in this country. Sporadic cases of camera of the true *lamina sicca* type have occurred in various parts of the United States at intervals during the last six or eight years, but it is only within three years that the disease has assumed an epidemic form, and only within the last year that it has become a national scourge.
>
> Unlike the cholera, the camera seems to prefer the country to the city, and its worst ravages occur in Summer resorts. In certain regions, such as the Adirondacks and the Thousand Islands, it has spread with frightful rapidity. Two years ago a case—in fact a very bad case—of camera occurred at Blue Mountain Lake, in the Adirondack region, but measures were promptly taken to isolate the patient, and the matter was carefully hushed up by the hotel keepers. Last Summer twelve cases of camera occurred within a circuit of forty miles of Blue Mountain Lake, and this Summer the disease has spread to nearly every Summer resort in Northern New York, and is raging with frightful violence. At Newport, Long Branch, and other seaside resorts the epidemic has broken out, and defies all restraint, and from all parts of the country reports are coming in to the National Board of Health which show that *camera lamina sicca* is devastating the entire region east of the Mississippi, and will almost certainly spread westward as far as the Pacific coast.

While it was noted that the afflicted "usually become wildly insane," the cause of the camera epidemic remained uncertain. The editorial concluded:

> There is no use shutting our eyes to the truth. If the camera *lamina sicca* increases next season as it has increased this it is estimated that fully 80 per cent of our entire population above the age of 10 years of age will be attacked by it.... Our only chance of safety lies in the destruction of every existing lens and the disinfection, by exposure to strong sunlight, of every dry plate.[31]

Amateur interest in photography did indeed spread quickly. In 1885, the San Francisco *Daily Chronicle* observed that

> when the mania for photography takes hold of a man it is said to exceed in strength the passion for French cooking. The camera is as constant a companion as tobacco to a smoker. One young lawyer who has the disease very bad is having a camera constructed to look like a couple of law volumes...[32]

Two years later, the noted amateur Alexander Black wrote an amusing article for *Century Magazine* describing "that gentle madness...of one who has succumbed to the curious contagion of the camera."[33] In 1890, another self-confessed sufferer began a lengthy article on amateur photography with humorous, if almost credible, hyperbole:

> According to the last census, the population of these United States approximated 50,000,000 souls. Of these, 49,000,000 are amateur photographers, and the other 1,000,000 are hesitating whether or not to toy with the art of Daguerre.[34]

Photography's explosive growth during the 1880s was the result of a conjunction of social and technical factors. The rapid expansion of the middle class created an enormous pool of consumers with money, leisure time, and artistic inclinations. For them, photography represented a thoroughly up-to-date pastime, perfectly in keeping with the progressive spirit of the age. The camera gave every man or woman the means to document their lives and surroundings, as well as the ability to express themselves aesthetically. Photography was also seen as a healthful activity, best practiced—like the concurrent fad of bicycling—in sunlight and fresh air.

On the technical side, the pivotal figure in this period was George Eastman of Rochester, New York.[35] Eastman became interested in photography in 1877, as a twenty-three-year-old bank clerk. Like other amateurs of the period, he bought a simple view camera and learned the wet-collodion process. Frustrated by the difficulties of the technique, Eastman began experimenting with various dry-plate formulas published in the photographic periodicals of the day. By the summer of 1879, he was making plates on a small scale to sell to friends. Eastman began commercial production of dry plates in September 1880, and soon these were being distributed nationally by the E. & H. T. Anthony firm. By 1883, when he constructed a new factory in Rochester, Eastman's company was well on its way to leadership in the industry.

Eastman's dominance was not easily won, however. By 1884, dry plates were widely available and price competition was driving profits downward. Eastman responded astutely by exploring new markets for photographic products and services.[36] If the dry plate could prompt a "camera epidemic," he saw that still simpler techniques would allow even more people to take up photography. After several years of effort, he introduced the first successful roll-film camera, the Kodak, in July 1888. In its leather case, the Kodak measured only 6½ inches long, 3½ inches wide, and 3¾ inches high. While the typical tripod-camera outfit could require forty pounds or more of equipment, the Kodak weighed less than two pounds. This radically simple camera sold for $25, complete with a roll of film that produced 100 circular images about 2⅝ inches in diameter. When the roll was fully exposed, the camera was mailed to Eastman's firm with $10. Technicians processed the film, made prints of all 100 images, and installed a new roll. The reloaded camera, negatives, and prints were then mailed back to the customer.

The press hailed the Kodak as the most remarkable achievement in the history of the medium.[37] Taking nothing for granted, Eastman promoted his new camera with an aggressive advertising campaign. The memorable slogan "You Press the Button— We Do The Rest" assured the public that now, for the first time, photographs could be made without any special technical expertise whatsoever.[38] By 1890, seven models of the Kodak were in production, offering a variety of formats ranging from the 2⅝-inch circular image of the original No. 1 to the rectangular 5 x 7-inch format of the No. 5. Hand cameras by other makers, with names such as "The Montauk," "The Ultimate," "The Hawkeye," "The Ferret," and "The P.D.Q." ("Photography Done Quickly"), were also available at prices from $15 to $50.[39] By the end of the decade, about 1,500,000 hand cameras were in use throughout the country.[40] This number increased further with the introduction of the simple Brownie camera, which sold for only a dollar, in the spring of 1900.[41]

Most professionals took a dim view of this growing army of amateur photographers, complaining that hobbyists were "killing the business." In truth, the technical changes of the 1880s did make life difficult for many professionals. The ease of the dry plate induced a new wave of practitioners to enter the field, and established studios were pressured to cut prices in order to compete. In early 1883, for example, the experienced Baltimore professional David Bachrach, Jr., warned his peers to "*avoid this place as you would a plague-spot*." With "about 300,000 inhabitants, no surrounding towns, [and] very little transient trade," he noted, Baltimore had the enormous total of "nearly forty photographic studios."[42] The rising number of photographers created a widespread sense of insecurity in the profession. The amateur became the target of much of this anxiety. This was not completely unjustified since many amateurs routinely gave prints away, or made pocket money by accepting occasional assignments for pay.

Successful commercial photographers recognized that the "competition" provided by the amateur was, in fact, beneficial to all. In 1885, S. D. Wardlaw, president of the Rochester Society of Photographers, addressed this subject in his talk "A Word in Defence of the Amateur." Wardlaw argued that only the mediocre professional need fear the activity of the Kodaker. Those who worked in photography for a livelihood could only gain by the public's interest in the medium, he said, since "there is no better way to instruct the public, in regard to our art, than to have them try it themselves." In fact, Wardlaw suggested, the profession had much to learn from the dedicated amateur, who came "well equipped with apparatus, armed with brains, talent, ability, a desire to achieve and with a love for the work in which they are engaged." He encouraged his peers to bring to their work "the same love and ambition to excel" that characterized the serious amateur. But, despite such enlightened sentiments, the feeling remained widespread that the amateur represented "a sharp thorn in the professional's side."[43]

Eastman's innovations forever changed the basic nature of the medium and the role of the professional. The proliferation of amateur cameras meant that professionals were no longer needed for a variety of basic tasks (e.g., routine portraits, baby pictures, records of new houses). Instead, the professional's role was to be shaped by more specialized applications that lay beyond the ability of the hobbyist. On the other hand, the sheer number of amateurs created important new categories of photographic professionals. The selling of photographic supplies changed from a wholesale to a retail activity, for example, and photo-finishing grew to be a major industry. In short, as historian Reese Jenkins

has noted, "the change from professional to amateur predominance not only transformed the photographic industry from one characterized by decentralized, handicraft modes of production in 1879 to one characterized by centralized, mechanized modes of production in 1899"—it also marked the emergence of a true mass market for photographic materials and services.[44]

A Visual Revolution

The technical advances of the 1880s greatly expanded the range of subjects open to photographic depiction. This revolution was at once temporal, spatial, and social. The high-speed work of Muybridge and Blake dissected time for scientific and aesthetic purposes. The new ease of the photographic process allowed travelers and explorers to take cameras almost anywhere and to make images under the most adverse conditions. For example, beginning in 1891, the noted Arctic explorer Robert E. Peary used a Kodak hand camera to document his journeys across the "Great Ice" of interior Greenland [7]. Many of these photographs were used to illustrate Peary's essays in the journals of the day.[45]

The sheer number of amateur cameras allowed the intimate and casual events of daily life to be recorded as never before. As a result of this democratization of vision, a vast array of aesthetic sensibilities was brought to bear on the problem of photographic picture-making. For example, the great architect Frank Lloyd Wright worked intermittently with a camera in the early years of his career.[46] Between about 1893 and 1900, Wright documented the structures and activities at a boarding school run by his aunts in Spring Green, Wisconsin.[47] Inevitably, the meaning of a picture as seemingly straightforward as *Girls Gym Class*

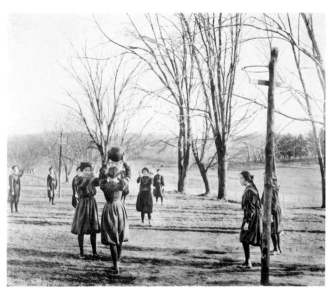

8 Frank Lloyd Wright, *Girl's Gym Class*, 1900, collotype, 7⅝ x 9⅛"

[8] is shaped by our knowledge of Wright's genius. Like his architecture, this photograph suggests a provocative union of intellect and nature: it is posed yet feels relatively spontaneous, and depicts a precisely codified activity (a game) in an organic setting. The subtle composition of this image—its play of vertical and horizontal elements—further suggests Wright's unique understanding of space and structure.

The technical and social changes of the 1880s produced a radically new class of pictures. By definition, professional practice was founded on strict conventions of technical and aesthetic competence. This approach valued refinement, clarity, and seriousness. In striving to avoid "mistakes," the majority of professionals learned to control or deny many facets of photography's inherent optical-mechanical syntax. By contrast, untutored amateurs produced a broader variety of pictures, taking pleasure in images that were casual, unusual, and amusing.

Amateur photography constitutes an entire visual universe. The themes of this work are relatively limited, but are explored in seemingly endless permutations. This curious duality—of familiarity and uniqueness—reminds us of both the specificity of every life and the variety of ways in which reality can be refracted through the camera's lens. After 120 years of amateur photography, the world contains many billions of these artless affirmations of interest and affection. These images have shaped our visual sensibilities in ways that have yet to be fully understood.

The amateur photograph has been characterized by certain visual traits. Generally speaking, these images record familiar things in fundamentally novel ways. Tilted horizons, unwanted intrusions, and off-center subjects are common in amateur pictures, as are the effects of blur, faulty focus, and double exposure. This catalogue of pictorial eccentricity increased dramatically with the introduction of the hand-camera (beginning the era of the "snapshot"). By any traditional measure, most of these images were abject failures—they were, literally, amateurish. Collectively, however, these putative mistakes underscored an important truth: the camera has its own way of seeing—and shaping—the world.

The prolific novelty of amateur photography may be at least partly suggested by the work of one hitherto unknown practitioner:

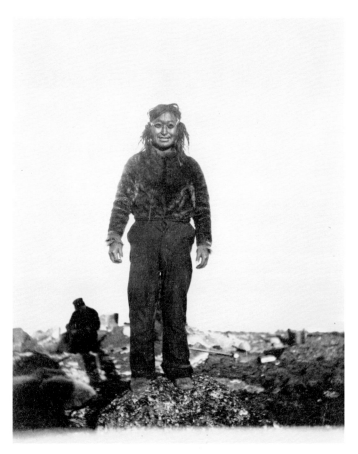

7 Robert E. Peary, *Untitled*, ca. 1891-95, 4½ x 3⅝"

9 **Henry N. Cady,** [*Self-Portrait with Anne Cady*]
Reading St. Nicholas, October 13, 1887, 4 x 3¹⁄₁₆″

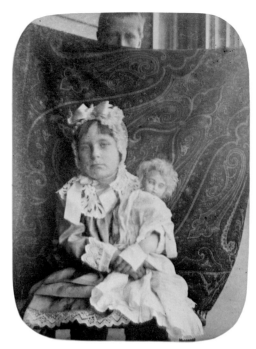

10 **Henry N. Cady,** *Alice with her doll,* June 1,
1884, 3¾ x 2¾″

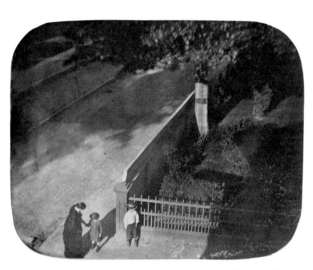

11 **Henry N. Cady,** *Lawrence and Dewees and their mother,
taken from garret window, Warren,* June 22, 1882, 2¾ x 3½″

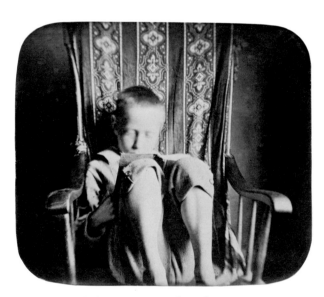

12 **Henry N. Cady,** *Lawrence reading The Young Marooners,*
August 5, 1882, 3¹⁄₁₆ x 3½″

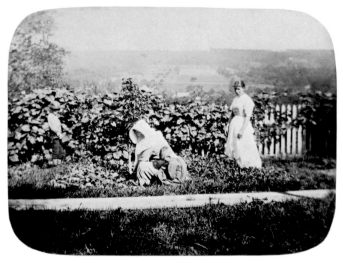

13 **Henry N. Cady,** *Gardening, Our first servant girl, "Delia,"
standing,* June 24, 1883, 2⅞ x 4″

14 **Henry N. Cady,** *With camera and opera glass: a "telephoto"
picture,* October 29, 1887, 2⅞ x 3⅞″

Henry N. Cady. One of the first wave of dry-plate amateurs, Cady began photographing in the summer of 1881. Working with a small tripod-mounted camera, Cady recorded the activities of his family in loving detail, in and around their home in suburban New Jersey, and at their summer residence in Rhode Island [9-14, 66]. These are deeply personal images. Cady photographed people he knew; they, in turn, took his camera for granted. The result is a mood of relaxed intimacy rarely seen in professional work.

The Cady household was unusually cultured. Henry Cady's most enduring passion was painting. Largely self-taught, he was an accomplished landscapist in the Luminist tradition. His oils were included in group shows at the 1893 World's Columbian Exposition in Chicago, the 1904 St. Louis World's Fair, and elsewhere. He was also a writer, illustrator, composer, and architect. Interestingly, during the period in which these snapshots were made, Cady worked in the photo-engraving business. His wife, Anne Cole Cady, was a historian and writer.[48]

Cady used the camera to document his family and surroundings. However, given his intelligence and creativity, it is not surprising that he also investigated the nature of photographic seeing itself. While casual and intuitive, this exploration resulted in a stimulating variety of approaches and effects. For example, Cady's 1882 record of his wife and two sons [11] is remarkably unorthodox in viewpoint. Two months later, the combined effects of a shallow focus and spontaneous composition produced an image that seems more dream than document [66]. By contrast, Cady's garden scene of 1883 [13] reveals a consciously artistic sensibility. A year later, when photographing his daughter on the porch, Cady chose to include his son peeking over an improvised backdrop [10]. As Cady clearly knew, the "failure" of this image as a formal portrait was more than balanced by its success as a family document. In 1887, several years before the introduction of lenses specially designed for this purpose, he experimented with telephoto photography [14].[49]

As pictures such as these reveal, the new amateur accepted—and even embraced—qualities of photographic vision that professional practice tended to reject. For these amateurs, "perfection" of technique and composition had relatively little to do with the meaning or pleasure of their pictures. Primarily, of course, images were valued for reasons of fact and emotion—the content of the scenes and the memories and associations triggered by them. In addition, however, amateurs such as Cady accepted the validity of a certain kind of pictorial eccentricity—traits that spoke directly to their interest in photography as an intriguing optical-mechanical process.

These traits may be discerned in a small portion of the era's professional practice. For example, *Tigress, Central Park* [68], was made by John Johnston, a New York City commercial photographer, in about 1889. This remarkable image combines a snapshot spontaneity with a witty meditation on the permutations of line and form. Here, the rigid grid of the foreground bars is contrasted with the softer lines of the shadows cast on the floor and back wall, and the irregular pattern of the animal's stripes. In its bold—if arguably "naive"—unconventionality, this image epitomized the new pictorial potential of the hand camera.[50]

Photographers of this era sought to reinvent everyday experience by depicting familiar things in unusual ways. For example, they quickly exploited the camera's ability to manipulate

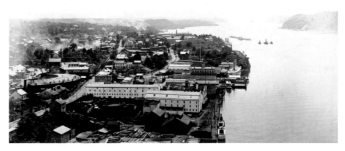

15 John G. Doughty, *Untitled aerial view*, October 16, 1885, albumen print, 4½ x 7¾"

space and scale. The first exhibition of the Boston Society of Amateur Photographers, in 1883, included "a very funny picture show[ing] a group of four persons lying upon the ground with their feet towards the camera, thus exaggerating their size."[51] Such optical distortions became a staple of amateur work.

Both amateurs and professionals took delight in looking down on the world from "bird's-eye" perspectives.[52] While many photographers made views from upper-story windows, a handful of daring cameramen went up in balloons. John G. Doughty of Winsted, Connecticut, was a pioneer in dry-plate aerial photography. He was taken aloft twice by balloonist Alfred E. Moore in the summer of 1885. Their first flight began too late in the day for satisfactory photographs; however, their second, on October 16, was completely successful. As they drifted above the Connecticut countryside at elevations of up to 6,000 feet, Doughty used his 5 x 8-inch camera to record the landscape below [15] and the clouds alongside them. This work received national recognition: Doughty issued a group of fourteen prints for public sale, and both he and Moore wrote lively accounts of their exploits for *Century Magazine*.[53] In the 1890s, W. N. Jennings also achieved fame for his balloon photographs, while William H. Eddy was recognized as the leader in kite photography.[54]

The increased sensitivity of the dry plate allowed a new world of natural phenomena to be photographed. Lightning was a particular challenge, and successful images of electrical storms were highly prized. A. H. Binden of Wakefield, Massachusetts, achieved

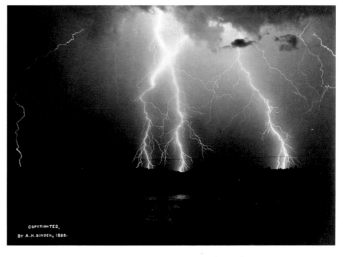

16 A. H. Binden, *Lightning Storm*, 1888, 5⅞ x 8⅛"

17 John L. Lovell, *Composite of Class of '87 Harvard*, 1887, 3⅛″ dia.

18 John L. Lovell, *Composite of Harvard "Annex,"* 1887, 3⅛″ dia.

some of the most notable results in this field. His best-known photograph [16], made on the evening of June 23, 1888, was reproduced as a wood engraving in the French science journal *La Nature* and in *The Photographic Times*.[55] Like the work of Muybridge, Binden's image was valued for revealing the unexpected complexity of familiar things.[56] The photography of lightning became a discrete—if obviously narrow—genre of work in the following decades.[57] By the early years of the twentieth century, a few photographers were magnifying the inherent abstraction of this subject by making multiple exposures on a single plate, or deliberately moving their cameras during exposure to create jagged blurs.[58]

Composite portraiture represented an even more radically abstract use of photography. This process, introduced by the French scientist Francis Galton, achieved the status of a popular fad in the last half of the 1880s.[59] Composites were created by exposing a series of portrait negatives on a single sheet of photographic paper. The result was the compression of many individual faces into one collective visage. By this technique, entire college classes were combined to form a single ghostly face [17, 18], and fifty bank presidents merged to create a generic portrait of "The King of Finance."[60] While undeniably amusing, composite portraiture was seen as something more than a mere technical gimmick. To an age fascinated by the diversity of human appearance and achievement, composite images suggested a cultural bedrock of basic human types. Presumably, commonalities of race, intelligence, achievement, and character were expressed in specific physiological traits.[61] Exactly what was it, for example, that distinguished the well-bred college student from the common laborer or petty thief? A few visionaries had even grander hopes: since children naturally resembled their parents, might not a composite photograph of all the world's races yield the face of Adam?[62]

Many other kinds of playful and abstract photographs were created in this era. Multiple-exposure portraits and self-portraits were regularly featured in the amateur photographic journals. These typically involved two or more exposures of the same subject in different postures or dress. Mr. A. J. Whalen of Pittsford,

Michigan, produced some of the most complex and amusing of these so-called "photographic freaks."[63] In the late 1890s, J. P. Blessing of Baltimore, patented a mirrored device to allow the commercial production of "photo-multigraph" portraits [19].[64] At the same time, a craze for comic photo-postcards arose; these montages featured surreal images of cowboys riding giant grasshoppers, colossal farm produce, and the like.

Science made important contributions to this new visual world. Beginning in 1896, X-ray photography was widely reported and published. While many of these early X-rays were purely descriptive (e.g., a frog or human hand), others were remarkably nonobjective. The leaders in this field included Professors A. W. Wright of Yale University, and Michael Pupin of Columbia University.[65] Various other "abstract" images were produced in this era, including photographs of the patterns of frost or chemical crystallization that, in hindsight, look surprisingly "Cubist" or "Futurist" in form.[66]

This enormous variety of images was accompanied by related advances in photographic technology. Coinciding with the introduction of dry-plate negatives was a new generation of printing papers that gradually pushed the familiar albumen print into extinction. These new papers used the sensitized salts of platinum (the platinum print or platinotype), iron (the cyanotype or blue print), or silver (the bromide and chloro-bromide prints).[67] This marked the widespread use of ready-made photographic papers. As a critic noted in 1889:

> A few years ago photographers used to sensitize their own paper...but now, ready sensitized paper is all the rage, and the modern amateur would not care to undertake all the mess, trouble, and inconvenience of floating his own paper on the dreaded silver bath.[68]

In addition to this ease of use, bromide—or "gas-light"—paper was fast enough to allow another innovation: enlarging. However, while undertaken with increasing frequency from the mid-1880s on, enlarging remained relatively uncommon well into the new century.[69]

Jacob Riis and the Social Landscape

The technical advances of the 1880s allowed photographers to record social realities that had been largely invisible to mainstream culture. Urban vice had been a broad public concern since the 1830s. In the ensuing decades, authors and activists published lurid descriptions of crime and depravity with titles such as *New York by Gas-Light* (1850) and *The Lower Depths of the Great American Metropolis* (1866).[70] By the standards of the day, these volumes were graphic and blunt, but the burden of description was carried by words rather than images.

Jacob A. Riis was the most important early exponent of photography in this movement for social reform. Born in Denmark, Riis emigrated to the United States in 1870. After working at a variety of jobs, he became a police reporter for the New York *Tribune* in 1877 and, later, for the *Evening Sun*. At the time, the New York City police headquarters was located on Mulberry Street, in the heart of a Lower East Side slum. In this neighborhood, Riis became intimately familiar with crime and misery. Overcrowded, filthy, and riddled with vice, the slum seemed to represent a perverse inversion of the American Dream.[71] Impoverished families lived in cramped, unsanitary tenements, while homeless adults and children survived on the street or in crude public shelters.

Riis responded to the disease, unemployment, and vice he saw with passionate outrage. He argued that crime and poverty could not be attributed simply to the moral failure or genetic limitations of individuals; the slum environment itself suppressed positive impulses and promoted destructive ones.[72] Through his friendship with researchers in the city's health department, Riis "came to understand, better than most reformers of his era, the fundamental logic which saw crime, ignorance, vice, and poverty as effects rather than causes."[73] Riis sought to change these conditions by educating the public and, ultimately, by shaming it into action.

Riis longed to convey the full tragedy of what he saw during his nighttime tours of the slum with city sanitation inspectors. Words could only convey a fraction of the pathos and horror that he witnessed. As he noted in his autobiography, "I wrote, but it seemed to make no impression."[74] However, in the spring of 1887 he found the solution to his dilemma in a newspaper article on the development of flash powder. Excited by the notion that "the darkest corner might be photographed" by "flashlight," Riis shared this information with Dr. John T. Nagle of the Health Department's Bureau of Vital Statistics. Nagle, himself a dedicated amateur photographer, immediately grasped the potential of this new technique. He recruited two other amateurs, Dr.

Henry G. Piffard and Richard Hoe Lawrence, both members of the Society of Amateur Photographers of New York, for technical assistance.

Within two weeks, Riis's team made the first of several nocturnal photographic excursions through the slums. Understandably, the party's unannounced late-night visits provoked much anxiety among their subjects. As Riis noted in his autobiography:

> It is not too much to say that our party carried terror wherever it went. The flashlight of those days was contained in cartridges fired from a revolver. The spectacle of half a dozen strange men invading a house in the midnight hour armed with big pistols which they shot off recklessly was hardly reassuring, however sugary our speech, and it was not to be wondered at if the tenants bolted through windows and down fire-escapes wherever we went.[75]

An article published in the New York *Sun* in early 1888 described the surreal spectacle that the group presented to its bleary-eyed subjects:

> With their way illuminated by spasmodic flashes, as bright and sharp and brief as those of the lightning itself, a mysterious party has lately been startling the town 'o nights. Somnolent policemen on the street, denizens of the dives in their dens, tramps and bummers in their so-called lodgings, and all the people of the wild and wonderful variety of New York night life have in their turn marvelled at and been frightened by the phenomenon. What they saw was three or four figures in the gloom, a ghostly tripod, some weird and uncanny movements, the blinding flash, and then they heard the patter of retreating footsteps, and the mysterious visitors were gone...[76]

Riis's amateur cameramen soon tired of these late-night expeditions and their unsavory subject matter. In January 1888, he decided to learn photography himself and, after the usual beginner's mistakes, reached an acceptable level of technical competence. (Flash powder remained a particular problem, however; Riis noted that he "twice set fire to the house with the apparatus, and once to myself."[77]) Notably, Riis was never seduced by photography itself. As he later recalled, he took up the camera strictly out of necessity: "I had to use it, and beyond that I never went." By the technical standards of his time, Riis's modest appraisal that he was "no good at all as a photographer" was at least partly correct.[78] In fact, of course, Riis became as "good" as his objectives required.

Riis's style is simply and bluntly factual. The harsh glare of the flash powder aggressively opens the dark spaces of the slums, revealing worn or soiled surfaces—as in his *Home of an Italian Ragpicker, Jersey Street*, ca. 1888-89 [20]—with pitiless clarity. Yet, despite its atmosphere of shabbiness and claustrophobia, this image reveals a surprising tenderness and pride. The young immigrant mother poses for the camera warily but forthrightly, holding her carefully wrapped infant. Amid the jumble of tubs, barrels, and mattresses lies a recently used dustpan, a detail testifying to the social value placed on cleanliness, even in this dark and airless hovel.[79]

The strength of Riis's work was derived, in large measure, from his lack of artistic ambition. He never idealized his subjects or choreographed them into particularly pleasing "compositions."[80] Indeed, he wanted his pictures to be *effective* rather than *attractive*. The power of his images stemmed precisely from

19 J. P. Blessing & Co., *Photo-Multigraph of Enos P. Baker*, 1897, 2⅝ x 6¼"

20 **Jacob A. Riis**, *Home of an Italian Ragpicker, Jersey Street*, ca. 1888-89 (print by Alexander Alland ca. 1946), 10 x 13″

their raw authenticity, and Riis understood how to use the camera's inherent realism as a tool of persuasion. Riis's human subjects were usually portrayed so that they and their surroundings are given equal emphasis. He stood close enough to depict his subjects as individuals, rather than generic "types," yet distant enough to capture a vivid sense of the space they inhabited. As a result, these portraits effectively convey Riis's belief in the relationship between character and environment. Jumbled, claustrophobic spaces and tragically constricted lives become reciprocal aspects of a single problem.

Beginning in early 1888, Riis used lantern slides of his photographs in lectures to church and civic groups.[81] He reached a larger audience when his essay "How the Other Half Lives" was published in the Christmas 1889 issue of *Scribner's*, complete with eighteen line drawings after his photographs. This article was expanded into Riis's famous book *How the Other Half Lives: Studies Among the Tenements of New York* in 1890. This volume, illustrated with eighteen line drawings and seventeen halftone reproductions, represented one of the earliest successful uses of the halftone in an American book.[82] *How the Other Half Lives* was acclaimed by such influential figures as Theodore Roosevelt, then New York City's Police Commissioner, and spurred real improvements in the city's tenements.

Riis's muckraking images were significantly different from anything done previously by either amateurs or professionals. In fact, his pictures could only have stemmed from a passionate devotion to a cause larger than either profit or personal expression. Riis sought to transform the moral life of his culture. To this end, he used the camera to bring middle- and upper-class audiences face to face with the pathos of slum life. By using the abrasive grit of fact to shock his viewers to action, Riis created a powerful model for later generations of reformers.[83]

Although Riis remains the best known of the early social documentary photographers, he was not alone. A variety of others turned their cameras on subjects of sociological interest in the 1880s and 1890s. In 1887, for example, the New York City Chief of Detectives, Thomas Byrnes, published a book of photographs of over 200 professional criminals.[84] Helen Campbell's *Darkness and Daylight: or, Lights and Shadows of New York Life*, a volume similar in concept to Riis's, was published in 1891. Campbell's substantial book includes 252 line engravings, many from photographs by O. G. Mason, the official photographer at Bellevue Hospital, with others from photographs by Riis, E. Warrin, and Frederick Vilmar.[85] In the 1890s, Sigmund Krausz made rather stiff "character studies" of the working poor in his studio in Chicago, while Alice Austen produced more naturalistic images on the streets of New York City.[86] In Hartford, Connecticut, minister John James McCook made a remarkable photographic study of tramp life.[87]

Other bodies of social documentary work from this era have yet to be fully appreciated. In the mid-1890s, for example, a remarkable set of mammoth-plate views of the working-class community of Corona, Alabama [69], were produced by Echard, a photographer about whom almost nothing is currently known. In its balance of poignancy and cool description, Echard's work seems kin to the far more celebrated photographs of Walker Evans, produced forty years later.

Photography and the Mass Media

In Riis's extensive use of photography, original prints played only a marginal role. His images were generally viewed as projected lantern slides in his lectures or, in printed form, as engravings and halftones. The engraving process required photographs to be translated by an artist into line drawings before being reproduced in magazines or newspapers. While this method preserved the most basic elements of each photograph—and allowed the image to be printed together with type—the camera's unique specificity of detail was almost entirely lost. By comparison, the halftone was produced directly from the original print, eliminating the interpretive hand of the artist-engraver. The relative clarity and low cost of the halftone made it an ideal method for translating photographs into print. The ultimate dominance of this process did not come easily, however.

The search for a successful photomechanical process had begun soon after photography's invention.[88] The reason for this quest was twofold: it was slow and costly to produce original photographs in large editions and, when this was done, incredibly laborious to hand-tip the resulting prints into an edition of books or albums. Thus, while it was conceivable to use original prints to illustrate small-edition journals or books, including them in any truly mass-market publication was simply impossible. Hand-rendered line engravings based on photographs were an imperfect solution; these were type-compatible but lacked the original's wealth of detail. Nonetheless, line engravings dominated the illustrated newspapers and journals for four decades, from the mid-1850s to the mid-1890s.

During this time a number of photomechanical processes were explored and put into limited use.[89] The woodburytype, invented in England in 1866, used a lead printing plate to produce a rich and beautiful continuous-tone image. Woodburytypes were difficult to make, however, and not type-compatible: they had to be printed separately from the text of a book or journal, and then hand tipped to the pages of each copy. The Albertype or collotype (a planographic process) and photogravure (an intaglio process) both produced continuous-tone images in ink, but were also not type-compatible in this era. Photogravure did

21 R. J. Waters & Co., *The Burning City: San Francisco, 10 am, April 18, 1906*, 8⅞ x 52½"

enjoy a long life: it served as a fine art mode of printmaking for turn-of-the-century photographers and, with the later introduction of high-speed rotary presses, as the means of producing the "rotogravure" section of newspapers in the first half of the twentieth century. In the early 1890s, photomechanical processes were of considerable interest from both the technical and aesthetic points of view. In this era, at least two major exhibitions of such processes were assembled: one in 1890 by the New York Camera Club, and another, in 1894, by the Society of Amateur Photographers of New York.[90]

The concept of the halftone is simple: by projecting a photograph through a finely gridded glass screen, a metal printing plate can be made which breaks down the continuous tones of the original image into tiny dots of varying size. When inked and printed on paper, this field of black dots simulates the full tonal scale of the photograph. Despite the simplicity of its concept, the halftone process took years and the labors of many researchers—including Stephen H. Horgan, Frederic E. Ives, and the brothers Louis E. Levy and Max Levy—to perfect. The first published halftone appeared in the March 4, 1880, issue of the *New York Daily Graphic*, but this marked only the most tentative beginning. Indeed, this image, *A Scene of Shantytown, New York*, did not even accompany a news story—it was merely used to illustrate one of "Fourteen Variations of the Graphic Process."[91] By 1881, Ives's process was being used with some regularity in the *Philadelphia Photographer*.[92] Halftones also appeared occasionally through the 1880s in journals such as *Harper's Monthly* and *The Century*, but the process was hampered by persistent difficulties well into the 1890s.[93] Only after an improved method for making ruled screens was patented in 1893 did the use of the halftone markedly increase. As photographic historian Robert Taft notes, it was not until 1897 that halftones became a regular feature of American newspapers.[94] By 1900, the halftone was the dominant photomechanical process.[95]

The advantages of the halftone were clear: it was inexpensive and type-compatible. In addition, it reproduced photographs with relatively little loss of information: unlike the wood-engraving process, which interposed the artist's hand between the original photograph and its reproduction, the halftone presented photographic information directly, without obvious alteration. As a result of these advantages, the halftone spurred a revolution in visual culture. Photographs—in the form of original prints, but especially in reproduction—became omnipresent in the modern world, shaping our notion of documentary fact as well as the language of commercial persuasion.

Realizing the public's great interest in illustrations, newspapers and journals rapidly expanded their pictorial content.[96] *Collier's*

Weekly shifted to an illustrated format in 1895, and popular journals such as *Harper's Weekly*, *Frank Leslie's Illustrated*, *Illustrated American*, *The World's Work*, and *Cosmopolitan* all made extensive use of photographic reproductions in the following years. To satisfy their enormous need for original pictures, publishers hired staff photographers, creating the first generation of modern photojournalists. This new market also spurred the establishment of independent picture agencies. George Grantham Bain started the first of these agencies, the Bain News Service, in 1895. Underwood & Underwood, the large manufacturer of stereographs, entered the photo agency business in 1901, followed slightly later by International News Photos and similar organizations. This business enjoyed exponential growth in its first decades; by 1920, nearly one hundred such enterprises were in operation in New York City alone.[97]

Turn-of-the-century illustrated journals published all manner of sensational, newsworthy, and educational photographs. Subjects of perennial interest included celebrities, sporting events, wars, political rallies, parades, expositions, and engineering feats.[98] There was always a ready market for pictures of disasters: explosions, fires, floods, and wrecks of all kinds. Such catastrophes proved highly profitable for the lucky or fleet-footed cameraman. Savvy photographers worked throughout the great San Francisco earthquake and fire of 1906 [21], aware that their images would have a ready market. Indeed, in the aftermath of the disaster, "swarms of photographers" descended on the city, all hoping to profit handsomely from their images of the ruins.[99] Public events of all kinds were attended by a frenzy of news photographers; cameras were everywhere and the acrid smoke of exploded flash powder filled the air. For some, this photojournalistic mania was one of the chief irritants of modern life. As a New York journalist noted tartly in 1906, "Half-tone engraving, flash light powders, sensational newspapers and the boll weevil hit the earth about the same time, and the combination caused a haze straightaway to cloud the sun."[100]

As a profession, news photography had an air of adventure. As one typically celebratory article of the period observed, "success in the exciting role of press photographer" was almost certain "if one has plenty of nerve, understands his tools, has the ability to turn out rapid work, [and] craves excitement and even a little danger."[101] In the perennial race to "scoop" the competition, news photographers had to be quick thinking, adaptable, and clever. These men—and, notably, a few women—traveled to all corners of the globe, climbed to the tops of skyscrapers, descended to the depths of coal mines, and encountered a broad spectrum of humanity. These pioneering photojournalists included Horace D. Ashton, A. Radclyffe Dugmore, John C.

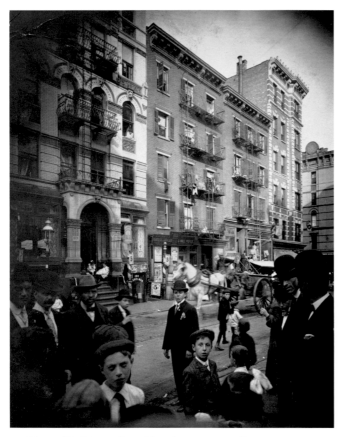

22 Horace D. Ashton, *Low Class Apartments or Tenements, New York City*, 1905, 4⅜ x 3⅝"

23 Horace D. Ashton, *Bricklayer sixteen stories from ground, New York*, 1906, 4½ x 3⅝"

Hemment, Jessie Tarbox Beals, Frances Benjamin Johnston, and James H. Hare.[102]

Ashton, an employee of the Underwood & Underwood firm, typified the adventurous spirit of this first generation of news photographers. His varied subjects included the first public flights by the Wright Brothers, immigrants arriving at Ellis Island, life in New York City's slums [22], and the upward growth of the city [23]. Ashton's dizzying view of a news photographer high above New York (probably a self-portrait) [1] exemplifies the era's notion of the cameraman as a daring and uniquely privileged observer of the vast spectacle of modern life. While Ashton continued his photographic work after 1910, he became even better known as an adventurer and author. Between 1924 and 1930, his exploits included ethnographic research in North Africa, a 4,000-mile journey by dirigible, spelunking, an Arctic expedition, and a hunting trip with the King of Yugoslavia. If photographic history has a genuine counterpart to Hollywood's Indiana Jones, it might well be Horace Ashton.[103]

One of the most versatile photographers of her day, Frances Benjamin Johnston began as a professional in 1889, and quickly established a reputation for superb journalistic, architectural, and portrait work. Her subjects included iron mines, women's factory labor, Mammoth Cave, and the 1893 World's Columbian Exposition in Chicago. In addition to working on commissions, she also regularly contributed to Bain's news service. In 1899, Johnston spent six weeks photographing the schools of Washington, D.C., producing a total of 700 views.[104] A social issue of vital importance at the time, education was widely regarded as the key to establishing moral and civic virtue. Thus, Johnston's carefully posed views portray classrooms as models of order and probity [24]. These photographs were exhibited at the 1900 Paris Exposition and resulted in commissions to document two African-American schools—Hampton Institute and Tuskegee Institute—and the Carlisle Indian School in Pennsylvania.[105] Johnston was an eloquent supporter of women photographers, and at the Paris Exposition lectured on "The Work of American Women in Photography." She later organized an exhibition of work by twenty-nine U.S. women that traveled to Paris, Moscow, and St. Petersburg.[106]

24 Frances Benjamin Johnston, *Washington, D.C., Classroom*, 1899, cyanotype, 6⅞ x 9⅜"

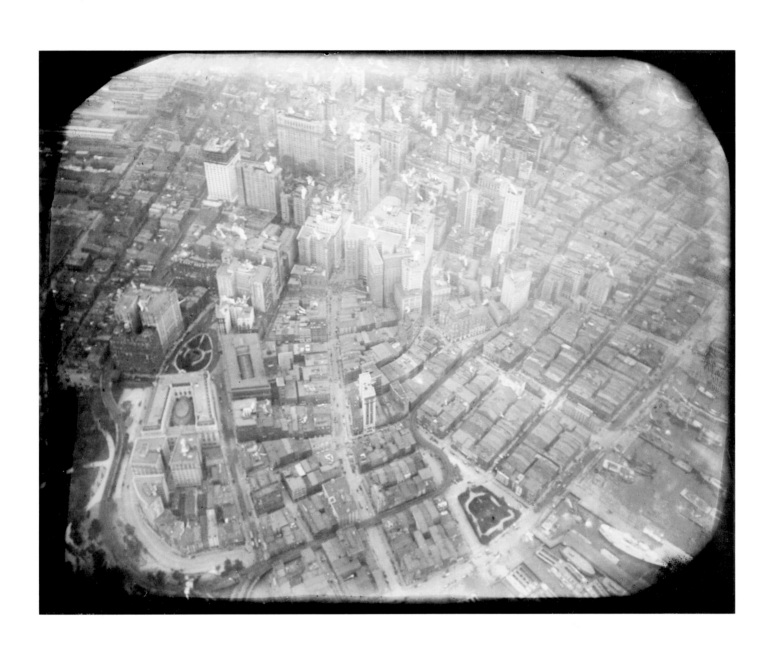

25 **James H. Hare,** *New York from balloon,* 1906, 6½ x 8½″

26 **James H. Hare,** *Orville Wright flying at Ft. Myer, Virginia,*
1908, 6 x 4"

Jessie Tarbox Beals was one of the other most renowned women photojournalists of this era.[107] As a staff photographer for the Buffalo *Courier*, Beals recorded all facets of the city's life, including politics, crime, and social issues. In St. Louis, in 1904, she was one of the official photographers of the Louisiana Purchase Exposition. Her pictures of this spectacular fair were used in *Leslie's Illustrated* and the New York *Herald* and *Tribune*. She moved to New York in 1905 and opened a successful portrait and photojournalistic practice. Her many subjects included auto racing, artists, the inauguration of President Taft in 1909, slum children, and the residents of New York's Greenwich Village. Between her commercial assignments, Beals undertook such personal projects as her 1905-06 Pictorialist interpretation of the landmarks of New York City [55].

James H. Hare was perhaps the most famous of this first generation of photojournalists. Born in England, Hare came to New York in 1889 to work for the E. & H. T. Anthony firm. In 1895, he became the staff news photographer for the *Illustrated American*, recording everything from regattas to train wrecks. He traveled to Cuba in 1898 to cover the Spanish-American War for *Collier's Weekly*. He subsequently recorded cross-country speaking tours by presidents McKinley and Roosevelt, religious sites in Jerusalem, the Russo-Japanese War, and the San Francisco earthquake of 1906. He was particularly celebrated for his photographs of early aviation. In 1906 Hare recorded Manhattan from the air during a nerve-rattling balloon ride [25]. This errant flight ended with a dunking in Flushing Bay that destroyed all but

six of his negatives. Hare was also one of several photographers to witness the first public flights by the Wright Brothers, in the summer of 1908 at Fort Myer, Virginia [26]. Hare went on to record the 1908 political conventions, the inaugurations of 1909 and 1913, and, between 1911 and 1918, the Mexican Revolution, the First Balkan War, and the First World War. After retiring in 1922, he became a popular lecturer and the subject of an admiring biography.[108]

At the same time that photographs were seen in ever-increasing numbers on the printed page, mechanization allowed the production of original prints in unprecedented quantity. For example, stereographs, which were first introduced in the 1850s, became fashionable again in the 1890s and remained popular until after the First World War. These paired images, which create a sense of spatial depth when seen in a stereoscope viewer, were produced by numerous firms. In 1901, the largest of these companies, Underwood & Underwood, was manufacturing a remarkable total of 25,000 stereographs and nearly 1,000 stereoscopes each day. These stereographs were assembled into thematic sets—ranging in size from less than a dozen to more than one hundred cards—that were marketed to the public through a sophisticated sales network.[109] They were also used widely in education [27]. Through such images, Americans were exposed to innumerable scenes of newsworthy, pictorial, or exotic interest from around the globe.

The vast majority of mass-market images—stereographs and news photographs alike—were made and viewed as simple, factual documents. The informational nature of these images served to suppress evidence of individual vision, and the actual makers of these pictures were not often identified. The impersonal style of this work—its look of artless realism—suggested to viewers of the day that the meaning of contemporary events was relatively simple and universally understandable.[110] While straightforward in style, however, the impact of these news photographs was significantly heightened by the use of captions and the creation of lively page layouts.[111] The quantity of this work—and the relative sophistication of its presentation on the page—belies the lingering misconception that modern photojournalism did not arise until decades later.

27 **Horace D. Ashton,** *Students with Stereo Viewers,* 1908, 7½ x 9⅝"

"The Peculiar Charm of Old Times"

While commercial and journalistic photographers produced endless records of the nation's technological progress, others focused on symbols of its preindustrial past. This antimodernist vision struck a powerful chord with the many Americans who found contemporary life increasingly vulgar and hectic. Because it was clear that the cultural clock could not be turned back, it was seen as vitally important to celebrate what the forces of modernity were eroding: a slower-paced way of life based on traditional notions of family and the land. This quest was at once nostalgic and idealistic. It reflected a vision of the past that was often unrealistically gentle and harmonious, while posing an implicit critique of the failings of modern society.

This retrospective vision was a logical product of the times. In part, it stemmed from the genre tradition in American art, which celebrated the familiar details of everyday life. This tradition was powerfully reinforced by the praise accorded paintings of folk subjects in the most important international salons. As art historian Lois Marie Fink has noted, in the leading exhibitions in late-nineteenth-century Paris, paintings "of the folk people of France—peasants and fishermen of *sauvage* Brittany and Normandy, farmers and shepherds of Barbizon, mothers and children of Ecouen—greeted Salon visitors en masse." She cites the comments of a critic of the time to explain the broad appeal of such rustic subjects: "Their elementary and rude character—binds them with a mysterious tie to the earth, which seems to animate them by the infusion of its own unconscious soul."[112] The essentially mystical and sacred character of this work was made

29 **William B. Post,** *Summer Days,* ca. 1894, platinum print, 5⅜ x 9⅜"

explicit in Jean-François Millet's *The Angelus* (1859), one of the era's most widely admired paintings. Purchased in Paris in 1889 for the astonishing price of $110,000, this rendition of two field workers bowed in prayer was exhibited later that year in New York City. It was received, in the words of art historian Sarah Burns, with "pious rapture."[113]

This interest in a preindustrial, earthy "soul" was a direct response to the dominant forces of the age: urbanization and industrialization. Given that the Industrial Revolution had begun in England, it is appropriate that a British photographer, Peter Henry Emerson, exerted the strongest influence on American pastoral imagery of the 1890s. Emerson achieved an international reputation for his photographs of rural life in England's East Anglia district—published in volumes such as *Life and Landscape on the Norfolk Broads* (1886) and *Pictures of East Anglian Life* (1888)—and for his writings on the art and science of photography.[114] His book *Naturalistic Photography* (1889) was widely read, and his pictures and articles were regularly featured in American photographic journals. In 1893, the young critic Alfred Stieglitz paid homage to Emerson by stating that "his teachings formed the basis of what we saw" in that year's most prestigious and successful American exhibition.[115]

Inspired by the poetic naturalism of Emerson's images, as well as the larger tradition of artistic depictions of such subjects, a number of American photographers traveled far and wide to make their own pictures of farmers and fisherfolk. Some of the most celebrated early photographs by Alfred Stieglitz and Gertrude Käsebier, for example, depict French and German peasants. America's own rural past was the subject of similar photographs by Myra Wiggins, Robert Redfield, Frances and Mary Allen, Emilie V. Clarkson [28], and others.[116] Emerson's influence was clear even when the subject was leisure rather than labor. For example, William B. Post's serene *Summer Days,* ca. 1894 [29], appears directly inspired by the Englishman's widely admired *Gathering Water Lilies,* of 1886.[117]

Rudolf Eickemeyer, Jr., devoted particular energy to an essentially Emersonian vision of pastoral subjects [30]. Eickemeyer first received public attention for his work in 1893, and for at least a decade was one of the most renowned photographers in America. Between 1900 and 1903, he published four books illustrated with halftones of his photographs: *Down South* (1900), *In and Out of the Nursery* (1900), *The Old Farm* (1901), and *Winter* (1903).[118] In the first of these, devoted to images made in

28 **Emilie V. Clarkson,** *Toil,* ca. 1891, 13⅜ x 10½"

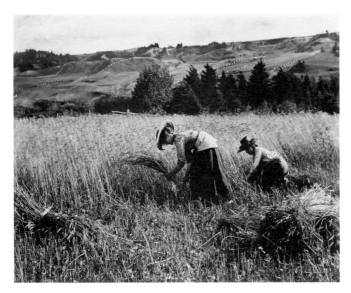

30 Rudolf Eickemeyer, Jr., *Middlefield, Massachusetts*, ca. 1900,
7⅝ x 9⅝"

1894 in rural Alabama, Eickemeyer consciously sought to portray black Americans with the same dignity that Millet had given his French peasants.[119] Eickemeyer's nostalgic volumes, which enjoyed substantial sales, mark perhaps the first instance of a photographer marketing his work directly to the public in book form.

Eickemeyer went on to become a noted portraitist of New York's intellectual and financial elite. His blend of artistry and commercial acumen is revealed in the fame of his picture *In My Studio*, 1901 [31], sometimes titled *Tired Butterfly*. Intended as a purely artistic work, this languidly erotic study of the actress and model Evelyn Nesbit was sold worldwide. The celebrity of this work was enhanced by the sensational 1906 murder of Nesbit's lover, Stanford White, by her husband, Harry Thaw, and the lurid details of Thaw's subsequent trial.

Clifton Johnson was one of the most prominent of this era's romantic documentarians. After growing up on a farm in Hadley, Massachusetts, Johnson worked as an illustrator and later owned a successful bookstore in nearby Springfield.[120] Ironically, he came to appreciate the power of photography while studying painting. During his time at the Art Students League in New York, Johnson was one of several artists hired to redraw Riis's photographs for reproduction as line drawings in *How the Other Half Lives*.[121] He subsequently embarked on a prolific thirty-year career as a writer, photographer, and folklorist.[122] His primary interest lay in rural ways of life threatened by the onslaught of modernity. While the thrust of Riis's work had been reform in the name of future good, Johnson's subject was the simplicity and beauty of a warmly remembered past. As Johnson noted:

> About "old times" there always hovers a peculiar charm. A dreamland atmosphere overhangs them. The present, as we battle along through it, seems full of hard, dry facts; but, looking back, experience takes on a rosy hue. The sharp edges are gone. Even the trials and difficulties which assailed us have for the most part lost their power to pain or try us, and take on a story-book interest in this mellow land of memories.[123]

Johnson chronicled the simple virtues of rural life while lamenting its disappearance. By the mid-1890s, the farm population of New England had been in decline for forty years. Aban-

doned farmhouses were a common sight, the result of rising property taxes and the lure of the city and the West.[124] Johnson's first book combining text and photographs, a study of Yankee farm life titled *The New England Country* (1893), was an immediate popular success. Numerous volumes followed, including *The Country School in New England* (1893), *The Farmer's Boy* (1894), and a series of "Highways and Byways" guides to various regions of the United States.

Johnson's poetic documentary style is seen in such characteristic works as *Kitchen, Chesterfield, Mass.*, ca. 1895 [75], and *Blackboard Problems, Montana*, ca. 1910 [32].[125] Johnson's deep love for his subjects made him remarkably attentive to the expressive power of details.[126] In these images, he conveys the simplicity and quiet continuities of rural life with both narrative richness and formal sophistication. In the first work, an old-fashioned kitchen stove is recorded as the literal and symbolic center of farm life.[127] The second underscores both the importance and the challenges of education. Through the relaxed intimacy of these images, Johnson evokes a feeling of great candor, as if he was recording members of his own family. Despite this appearance of informality, Johnson's photographs were carefully made. In an essay of 1901, he warned photographers of the "disadvantages of too much truth," and emphasized the importance of precise composition: "the shifting of the camera a few feet this side or that, front or back, often makes all the difference between poetry and prose."[128] Johnson worked as a poetic preservationist in a realm he understood and treasured, using carefully crafted vignettes of experience to bridge the gap between fact and memory.

While most importantly a product of the late nineteenth century, this nostalgic vision of a preindustrial America continued in diluted form well into the twentieth. For example, the most successful producer of decorative photographs, Wallace Nutting, reportedly sold nearly ten million nostalgic, hand-colored views of colonial interiors and bucolic landscapes between 1900 and 1936.[129] Nutting's many photographic books of this era owe a considerable debt to the earlier examples of Johnson and Eickemeyer.

At the same time that Johnson was working in New England, Arnold Genthe was recording another soon-to-vanish facet of American life on the West Coast. In his native Germany, Genthe

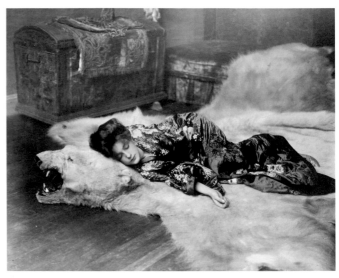

31 Rudolf Eickemeyer, Jr., *In My Studio, Evelyn Nesbit*, 1901, carbon print, 7⅝ x 9⅜"

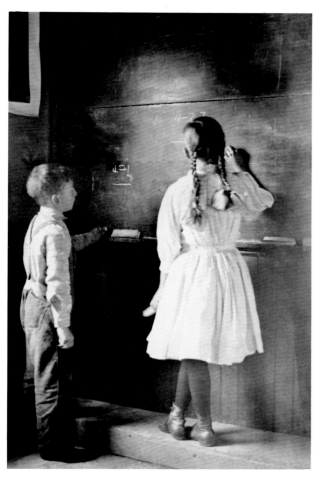

32 Clifton Johnson, *Blackboard Problems, Montana*, ca. 1910,
6½ x 4½"

had been raised in an affluent and scholarly environment. He earned a doctorate in classical philology before emigrating to San Francisco in 1895. Desiring souvenirs of America to send to his relatives in Germany, Genthe took up photography to record the exotic sights of the city's Chinatown. Using a hand camera, Genthe worked with remarkable deliberation, sometimes waiting for hours on street corners or in courtyards "for some picturesque group or character to appear."[130] The resulting synthesis of documentary and artistic concerns is exemplified in images such as *Street of the Gamblers*, ca. 1896 [76].[131] Genthe's attention to costume, the ebb and flow of movement, and the subtle variety of gesture and pose all foreshadow his later interest in dance. Genthe had precious little in common with his subjects, of course, and a certain emotional distance is evident in his pictures. He photographed as a sympathetic outsider, eager to preserve artistic vignettes of a vibrant and picturesque subject.[132]

After the destruction of Chinatown in the earthquake and fire of 1906, Genthe's photographs took on a special poignancy.[133] He published *Pictures of Old Chinatown* in 1908, and a revised edition, titled *Old Chinatown*, in 1913. In an afterword to the later edition, Genthe sadly acknowledged that his beloved subject was gone forever. In its place had arisen "a new city, cleaner, better, [and] brighter," but far less interesting. Genthe longed for "the old mellowness of dimly-lit alleys, the mystery of shadowy figures shuffling along silently." The Chinatown of 1913 lacked much of its former allure; the old buildings and alleys were gone, and the residents had become largely acculturated. Genthe observed pointedly that the "general ambition to be 'Ameri-

can' in manners [is a] force more destructive than fire."[134] His book stands as a melancholy tribute to an "exotic" culture's displacement by the rising tide of modernity.

The Vanishing North American Indian

After a trip to Colorado and New Mexico in the fall of 1900, the artist Frederic S. Remington noted sadly that the West was "all brick buildings—derby hats and blue overhauls—it spoils my early illusions—and they are my capital."[135] In the last third of the nineteenth century the American West had, indeed, been profoundly transformed: what had been uncharted territory in the late 1860s was filled with white settlers by 1900. The great survey photographers of the 1860s and 1870s had depicted the West as sublimely beautiful, but intimidating in its vastness and austerity. By contrast, landscape photographers at the end of the century, such as F. Jay Haynes, tended to record the West as domesticated space—a rich and relatively safe region to be visited, inhabited, and exploited [70].

This white occupation of the West meant that, by the 1890s, the continent's most prominent "vanishing" culture was that of the Native American Indian. Easterners had long been fascinated by Indians, and efforts to record them had been initiated in the 1830s by expeditionary artists such as George Catlin, Karl Bodmer, and Alfred Jacob Miller. From its inception, the camera was used to record Native Americans as—more often than not—ethnographic specimens or dangerous foes. By the 1890s, however, the West had been "won" and Indians were no longer viewed as an obstacle to white settlement. As a consequence, the focus of these later artistic and photographic depictions tended to shift from observation to nostalgia, from fact to symbol. The immensely popular work of artists such as Remington and Charles M. Russell represented the West in a spirit of commemoration: homages to a bolder and more heroic past.

By the 1890s, many photographers portrayed Native Americans in a similarly commemorative way, as present-day realities were neglected in favor of mythic visions of past grandeur. In addition, as an "exotic," aboriginal people, Indians took on an important symbolic role as the cultural antithesis to modernity. From this perspective, Indians represented everything that modernity seemed to deny: tradition, spirituality, intuition, unalienated labor, and an intimate union with the land.[136] As the most primal Americans, Indians appeared to embody important truths not yet grasped by mainstream American society.

In the years around the turn of the century, Native Americans were recorded by many photographers, and for a variety of reasons. Artistic photographers such as Joseph T. Keiley and Gertrude Käsebier used Indian subjects for some of their most ambitious works. Many of these, such as Keiley's *Zitkala-Sa*, 1898 [33], evoke a poetic sense of melancholy, stoic endurance, and timeless beauty.[137] Such pictures suggest a theme central to modern artistic and intellectual culture: a sense of estrangement from mainstream society, and a symbolic identification with outcast or marginalized peoples.[138] Other photographers of the era took a more documentary approach to this subject, although artistic and commercial concerns inevitably flavored the nature and meaning of their work. Some of the most active of these documentarians were Karl Moon, Frederick Monsen, John A.

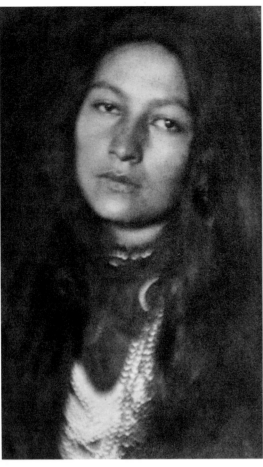

33 Joseph T. Keiley, *Zitkala-Sa*, 1898, gravure, 6¼ x 3¾"

Anderson, Charles F. Lummis, Adam Clark Vroman, Ben Wittick, Frank A. Rinehart, and Edward S. Curtis.[139]

The cultural meaning of these pictures can only be grasped within a larger context of art, science, commerce, education, and entertainment. The American public had a long-standing interest in Indian culture. As early as 1837, George Catlin displayed in New York City a large collection of paintings and drawings of Indians, as well as examples of their artifacts. This exhibition traveled to other U.S. cities over the next two years, and to London in 1840. Later in the century, millions were exposed to a popularized version of Indian culture in the Wild West shows that toured the nation, and in the ethnographic displays at various expositions. Between 1883 and 1917, Buffalo Bill Cody staged many Wild West performances in the U.S. and abroad. These presentations, featuring Indian encampments and sham battles with whites, were enormously popular. At the 1893 World's Columbian Exposition in Chicago, for example, Buffalo Bill's shows were seen by over two million patrons.[140] The 1893 Chicago exposition also included displays of archaeological and ethnographic artifacts, as well as living dioramas of Indians engaged in various traditional activities. The success of these displays prompted subsequent fairs in Atlanta (1895), Nashville (1897), Omaha (1898-99), Buffalo (1901), and St. Louis (1904) to follow suit.

While inevitably catering to white stereotypes of the "Winning of the West," these shows and expositions provided employment for hundreds of Native Americans. In the decade after 1893, a group of professional "Show Indians" toured steadily through the U.S., Canada, and Europe. While primarily entertainers, they also sought to keep aspects of their ancestral culture alive through a self-conscious process of ritual and reenactment. The authenticity of this past was clearly problematic. In varying degrees, however, it was precisely this quest to salvage a disappearing way of life that motivated most of the photographers of the era.

Public interest in the Southwest began to rise significantly in the 1880s. Over the next several decades, a number of ethnographic expeditions were organized by the federal government and even, occasionally, by private individuals. For example, John Wanamaker, the Philadelphia department store magnate, sponsored a 1913 expedition under the direction of his son, Rodman Wanamaker, and Joseph Dixon. As a result of such projects, the making of photographs and collection of Indian artifacts became increasingly systematic. In addition, individual photographers established practices in the region, and found a public market for their images of the land and its people.

Ben Wittick was one of the first professional photographers to derive a livelihood from images of the Southwest. In 1878, he was hired as the official photographer of the Atlantic and Pacific Railroad (later renamed the Atchison, Topeka and Santa Fe), with the task of documenting the forthcoming construction of the rail line from Santa Fe to California, and the regions it would traverse. In addition to this work, Wittick photographed Native American life in New Mexico and Arizona and collected Indian artifacts. In 1880, he made the first photographs of the Snake Dance at the Hopi Mesas in Arizona, a subject that would fascinate many later photographers. Wittick continued to produce his richly informational views of Native American life [34] until his death (from a rattlesnake bite) in 1903.

As the beginning of Wittick's career demonstrates, business interests played an important role in the popularization of the Southwest. The Atchison, Topeka and Santa Fe (ATSF) Railroad reached Santa Fe in 1880; five years later the Pueblos were accessible by rail from both coasts. While the railroad originally emphasized settlement of the Southwest, by 1895 it was actively promoting the area as a tourist destination. In that year the ATSF formed an advertising office and hired ethnographers, artists, photographers, and writers to publicize the attractions of the region. The Fred Harvey Company, which worked in concert with the railroad and operated the hotels and restaurants along its route, joined this promotional effort. The Harvey Company formed its own Indian Department in 1902 to buy and sell artifacts, and to publish postcards and souvenir books.[141] Karl Moon was hired as the official photographer of the ATSF and the Fred Harvey Company. In 1907, the railroad moved Moon to a gallery on the rim of the Grand Canyon, where he devoted seven years to the creation of the Fred Harvey Collection of Southwest Indian Pictures.[142] These campaigns were enormously successful in encouraging tourism and in shaping an enduring image—at once heroic and tragic—of Native American culture. As a recent author has observed, the Harvey Company, "through its tourist attractions and publications, fostered a remarkably coherent—and persistent—version of the Southwest as a region inhabited by peaceful, pastoral people, 'living ruins' from the childhood of civilization."[143]

The work of Frederick Monsen is also interesting in regard to issues of sponsorship. Early in his career, Monsen worked for several government expeditions, including the U.S.-Mexico

Boundary Geological Survey in 1886 and the Yosemite National Park Survey ten years later. Experimental by nature, Monsen was the first professional to put an ostensibly amateur tool—the hand camera—to serious use in photographing Indians in New Mexico.[144] His images combine high technical quality, an elegant graphic clarity, and a warm sense of candor [80]. Monsen's advocacy of the hand-held camera prompted George Eastman to sponsor his work in the Southwest. The result, published in the booklet *With a Kodak in the Land of the Navajo* (1909), was clearly intended to encourage the use of Eastman's products.

Adam Clark Vroman's work dates from the beginning of the modern age of Southwest tourism. A man of varied interests and refined tastes, Vroman was a merchant, collector of rare books and Indian artifacts, amateur archaeologist and historian, and photographer. Vroman's interest in the camera blossomed after he opened a book, stationery, and photographic supply shop in Pasadena, California, in 1894.[145] Between 1895 and 1904, he made his best-known photographs of the Hopi and Navajo tribes in the course of eight trips to Arizona and New Mexico.[146]

Vroman's first trip to the Southwest, in 1895, was motivated by his desire to see the Hopi Snake Dance. After travel by train and wagon across an austere landscape [35], his small party arrived at the base of the mesa to find "some forty white people camped, all to see the dance." Vroman noted that he "was not a little surprised to learn there were artists of note [as well as] authors, sculptors, newspaper correspondents from a half dozen papers, and some dozen or more ladies."[147] After climbing to the top of the mesa, Vroman and his comrades settled into their guest quarters. In *Interior of "Our Home on the Mesa,"* Vroman recorded one of his traveling companions with a group of villagers [36]. The next day Vroman and his friends were mesmerized by the otherworldly power of the Snake Dance. Although the ritual was a difficult subject to photograph, Vroman captured a richly contextual sense of the experience [77]. In the subdued light of dusk, the dancers blur into specters as they circle one of the rattlesnakes employed in the ceremony. All around them, residents and visitors watch in rapt fascination. The photographic appeal of this subject is indicated by the fact that Vroman, Monsen, and Wittick all attended the Snake Dance of 1897.[148]

Vroman's photographs are consistently objective and respectful. His images document both the dance and the mixed audience in attendance. This unbiased interest in the integrity of Native American practices, as well as their reality in 1895 as spectacles for outsiders, is notable. Vroman avoided the patronizing or romanticizing approach of later photographers by recording the present *as* the present. His work is also distinguished by an awareness of his own role as witness and participant. This self-reflexive stance is seen most cleverly in *The Mesa (from East, showing the pass)* [35], which includes the shadows cast by the photographer and his camera.

By the end of the century, many signs of traditional Indian life had been obscured through acculturation. A major goal of the Indian congress organized in conjunction with the 1898 Trans-Mississippi and International Exposition in Omaha, Nebraska, was to celebrate and preserve these disappearing customs.[149] To this end, some 545 delegates from twenty-three western tribes were brought together on the grounds of the exposition. While conceived as an educational and historical gathering,

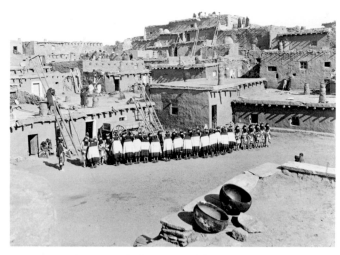

34 Ben Wittick, *Ka-K'ock-shi, Dance of the Zuni, View in Zuni Pueblo*, 1898, 6¼ x 8⅞"

35 Adam Clark Vroman, *The Mesa (from East, showing the pass)*, 1895, 6 x 8"

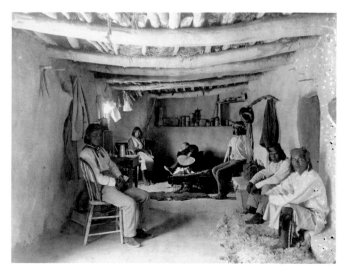

36 Adam Clark Vroman, *Interior of "Our Home on the Mesa,"* 1895, 6 x 8"

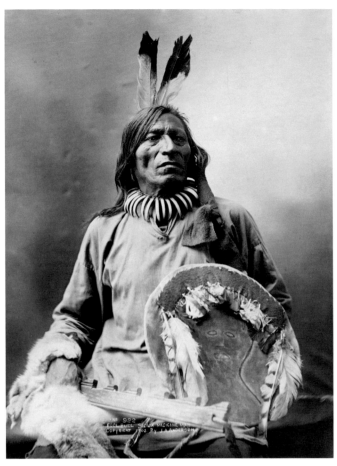

37 John A. Anderson, *Fool Bull, Sioux Medicine Man*, 1900, platinum print, 9⅛ x 6⅞″

the Indian congress soon devolved into a standard Wild West show, with tribesmen paid to stage dances and sham battles for tourists. As an ethnologist from the Smithsonian observed of the battles, there was always "a great deal of shooting & yelling & about fifty of them roll around on the ground and pretend to be dead. Success is measured by the amount of noise and by ticket sales."[150]

Frank A. Rinehart was the official photographer of the Omaha congress. With his assistant, Adolph F. Muhr (who later worked as Edward S. Curtis's printer), Rinehart made portraits of most of the participants. Platinum prints of these images were produced in some quantity for public sale. The portrait of *Thundercloud* [79] is characteristic of their approach: a sympathetic and distinguished likeness, clearly depicting an individual rather than a "type." The simple studio setting and traditional costume removes Thundercloud from an overtly present-day context, suggesting a heroic cultural past rather than the actual difficulties facing Native Americans at the turn of the century. As suggested above, this broad tendency to render Indians in idealized and "timeless" ways stemmed, in part, from the desire to evoke memories of a grander past. It is important to remember, however, that this idealizing vision was second nature to every photographer trained in commercial portraiture. In this respect, "romantic" depictions of turn-of-the-century Indians are remarkably similar in basic style to images of whites made by the leading portrait studios of the day.

A similar approach to Indian subjects is seen in the work of John A. Anderson.[151] Born in Sweden, Anderson was brought to the U.S. as a child. He grew up on a farm in northern Nebraska,

near the Rosebud Indian Reservation in South Dakota. After working as a carpenter, Anderson turned to photography, opening his own studio in 1889. He became friendly with the Rosebud Sioux and, during most of the 1890s, combined his photography business with co-ownership of a trading store on the reservation. Aware that traditional Sioux ways of life were rapidly disappearing, Anderson made a sustained effort to photograph everyday activities on the reservation. He also made formal portraits of such esteemed elders as Fool Bull [37], a medicine man who had fought in the Battle of Little Big Horn. As one of the few white photographers to live on an Indian reservation in this era, Anderson's portraits invariably communicate a special sense of intimacy and respect.

Not surprisingly, photographs of Native Americans vary in style and approach according to the time and circumstances of their production, and their intended use. Images made relatively early in this period tend to be unembellished in technique and factual in content. Photographs made for scientific and ethnographic purposes, or as essentially personal documents (such as Vroman's), are often equally straightforward in style. On the other hand, photographs made after the late 1890s—and especially those produced for popular sale or promotional use—tend to be more romanticized in feeling, emphasizing the exotic "otherness" of Indian life.

Edward S. Curtis is the photographer now most closely associated with this highly romanticized approach to Native American life. Curtis became interested in recording Indians in 1898, while working as a portrait and landscape photographer in Seattle. His early work, exemplified by his magnificent *Piegan Encampment*, 1900 [78], is both artistic and richly informative. In this crisply focused image, Curtis shows the encampment in the context of the surrounding landscape. Notably, he includes at least two wagons in the scene. Such signs of acculturation—wheeled vehicles were not endemic to Indian culture—soon were actively suppressed in his work. It is also significant that this is a gelatin silver print, the most common printing material of the era and the process most identified with straightforward record-making. Most of Curtis's later images were rendered in more luxurious processes (platinum, gravure, orotone) that carried stronger associations with artistic expression.

Curtis's interest in Indian life became all-consuming, and by 1904 he was seeking sponsorship for an extremely ambitious photographic survey of the surviving tribes of North America. He secured generous underwriting from financier J. P. Morgan and spent much of the next quarter-century struggling to complete his mammoth work *The North American Indian* (1907-30). This publication contained twenty text volumes illustrated with more than 1,500 small photogravures, and twenty additional portfolio volumes with over 700 large-format gravures. A total of 291 copies of this work were ultimately compiled.[152]

Moving away from the essential factuality of *Piegan Encampment*, Curtis deliberately merged scientific and artistic intentions in his mature work, creating a hybrid documentary-Pictorialist style.[153] In a paradoxical quest for authenticity, Curtis paid Indians to stage battles and ceremonies for his camera. Distressed at the evidence of acculturation, he frequently had his subjects change from their everyday dress of cowboy hats and blue jeans into "traditional" costumes (a few of which he apparently carried

of practitioners grew. When semi-skilled operators turned out portraits at half the going rate, established studios fought to maintain stable price levels. The arguments of these leading studio owners combined aesthetics, economics, morality, and appeals to cultural pride. These appeals stressed perfection of technique, the elevation of public taste, the refinement to be gained through study and experience, and the threat of "degeneracy" posed by poor materials and workmanship.[183] Professionals used these themes repeatedly in their appeals for a "true art" of the camera, one that would be both uplifting and profitable. An often-repeated slogan among professionals of this era was "Elevate Your Art and It Will Elevate You."[184]

From their beginning in the 1850s, American photographic journals regularly published essays on the principles and practice of art. These articles on noted painters, exhibitions, and books exerted a powerful influence on photographers and shaped their expressive vocabulary. The daguerreian era's most refined sentiments on the camera's artistic potential were summarized in the 1855 essay "Taste" by George N. Barnard, a noted professional. Barnard argued that photography could only be elevated "above the merely chemical" through the efforts of men with a rare combination of "virtues and gifts" and a tireless capacity for study and application. True art could not be achieved by following "the Juggernaut of vitiated public taste," he claimed, but only by acknowledging the timeless laws and uplifting power of history's greatest works. Without an understanding of universal artistic principles, and the sensitivity to express them, the photographer was a "mere copyist," a "mechanical slave." Real art represented the union of "the True with the Harmonious and the Beautiful" in work that resonated with "the soul of intellect."[185]

These sentiments were amplified by the respected photographer Marcus Aurelius Root, in his book *The Camera and the Pencil* (1864). Art was not one of the "mere embellishments of life," he wrote, but a moral necessity. It seemed obvious that the natural historical development of all societies was upward, from savagery to civilization. Indeed, this progress from the primitive to the refined was motivated by "the pre-ordained development of that law of beauty and harmony, whose germs are implanted into every soul." As the most obvious expression of these qualities, the arts carried great religious significance: "the cultivation of the fine arts [is] the will of God." The arts were "morally and spiritually uplifting in tendency," and thus expressed the ceaseless drive for perfection that characterized both progressive societies and healthy individuals. "American art must be America's spirit and life," Root proclaimed, "idealized and encircled with the magic halo of beauty!"[186] As the newest and most democratic art, photography seemed destined to play a central role in this great cause. Root went on to counter the common prejudice that photography was a "mere *mechanical* process," and to outline the importance to photographers of understanding the major achievements of art history. Like Barnard's essay, Root's book underscored the basic aesthetic concepts that would dominate the thinking about photography a half-century later: the need to transcend the camera's inherently mechanical nature, the guiding importance of tradition, and the deep moral and spiritual significance of art.

The piety and moral seriousness of these views reflected the high idealism of American Transcendentalist thought. In the ante-bellum writings of Ralph Waldo Emerson and Henry David Thoreau, *sight* is closely associated with *insight*: the clear perception of one's surroundings makes possible a deeper understanding of both the visible and the invisible.[187] Thus, the intense and focused viewer becomes a *seer*. The most memorable expression of this mystical state of hyperperception is contained in Emerson's 1836 essay "Nature."

> Standing on the bare ground—my head bathed by the blithe air and uplifted into infinite space—all mean egotism vanishes. I become a transparent eyeball; I am nothing; I see all; the currents of the Universal Being circulate through me; I am part or parcel of God.[188]

While it was rarely expressed in such sublime imagery, many critics of Emerson's time—and later—felt that the ultimate goal of art was to elevate man to a comparable state of transcendent virtue. American art became increasingly secular after the Civil War, but the influence of these mystical ideals lingered.

These ideas dominated the intellectual climate in which artist-amateurs of the later nineteenth century worked. The spiritual importance of amateur photography was clearly evoked in 1889 in an editorial in the first issue of the *American Amateur Photographer*:

> It has become a popular belief that all the difficulties have been removed, and that any one can take pictures. Photography has been degraded to the level of a mere sport, and many take it up, as they do lawn tennis, merely for an amusement, without a thought of the grand and elevating possibilities it opens up to them. The making of pictures is fast becoming merely an episode in a day's pleasure, not the earnest and untiring search for the beautiful. We submit that our art has a higher side than is apparent to him who uses only a detective or other small box, which, whatever their value, are far from representing all that is best and highest in photography. Indeed were this all, amateur photography would soon die of its own too-muchness.
>
> It is not saying too much to affirm that there is a moral element in the practice of the art picturesque, which should be felt and followed by every worker with the camera; the morality which springs from the purpose, single and earnest, to interpret to unseeing eyes some portion, at least, of the charm and beauty with which God has filled this home of his making...
>
> Such an earnest purpose as this lifts photography above the level of a mere pastime: it makes it an inspiration; an interpreter of the thoughts of God. He who has this purpose...will become a diligent and thoughtful seeker after the beautiful in nature, and, so far as lies in his power, an interpreter of it. He will learn to distinguish between grace and awkwardness; between the picturesque and the trivial; and this knowledge will give him a keener appreciation of nature's beauties and an added enjoyment in life. His highest aim will be to interpret aright the grace and charm of field and forest, lane and hedge-row, brook-side and sea-shore. Technical manipulation will be to him only a means to an end, and that end the interpretation of beauty.[189]

This "earnest purpose" and devotion to "beauty" were understood to elevate the artist above the mere recorder. This creative urge, characterized by the writer Enoch Root as the "informing spirit of intellect and feeling," provided the spark capable of transforming sight into insight. As Root noted in 1887:

> Nature abounds in beautiful compositions of some form or another in every locality. An old dilapidated building, with its picturesque surroundings; a group of cattle in a brook; a winding path among overhanging trees; the buttressed ledge of rocks,

included in the best exhibitions and were patronized by wealthy collectors. The need to cater to the general, unenlightened public appeared to be over. Now, artists were seen as the leaders of a cultural elite, the makers of refined objects for the most discriminating sensibilities. However, this new prestige led to conflicting notions of the meaning and role of the artist. Was he a craftsman or a visionary, businessman or bohemian? Was the artist to be understood as part of a culture of professionalism and incorporation, or as a symbol of authenticity and individuality?[175]

This was, at once, a complex and cautious time. Despite its diversity of subject matter, the art of this era was inherently conservative in its reverence for the past. The French academies were founded on an understanding of Classical and Italian Renaissance art, and a firm faith in the relevance of this exalted lineage to contemporary practice. While personal vision was valued, students were rewarded for incremental modifications to the styles of acclaimed masters. Wholesale breaks from this past were regarded with suspicion or incomprehension. This wariness of innovation was conveyed by an American essayist of 1878:

> The only kind [of originality] which is possible or desirable in a high civilization, is that of thoroughly trained artists, whose skill is cumulative, advancing step by step from the mastery of old forms to the development of new. In this case changes of form, though they may be rapid, are never discontinuous. They are not the product of undisciplined effort, but the fruit of men's labor whose power is the accumulation of generations. Such fruit ripens slowly... Novelty for the mere sake of novelty—and this is what the cry for originality amounts to—always seems purposeless and therefore feeble.[176]

It seemed axiomatic that high art was based on the greatest achievements of the past, and that it changed only gradually, in a deliberately evolutionary way.

The art world's valuation of tradition, high craft, and refinement was perfectly congruous with larger trends in American culture. As historians such as Lawrence W. Levine and John F. Kasson have described, American society in the late nineteenth century placed new emphasis on order, hierarchy, and sophistication.[177] As Levine has written, this era witnessed a shift "from popular culture to polite culture, from entertainment to erudition, from the property of 'Everyman' to the possession of a more elite circle."[178] In an effort to make the nation's culture truly "civilized," messy heterogeneity was replaced with refined homogeneity in many facets of American life. Table manners and social behavior, for example, were codified by the veritable "torrent" of etiquette manuals that appeared in the last third of the century.[179] In theaters, the plays of Shakespeare were gradually removed from programs that included magicians, dancers, and comics; in concert halls, symphonies and operas were separated from performances of popular music.

Each of these genres came to occupy narrower, more clearly delineated cultural realms. In their "impure" antebellum form, Shakespeare's plays had appealed to all social classes. The Shakespeare of the post-Civil War years—the connoisseur's Shakespeare, purified, authentic, and "serious"—was, almost by definition, of interest only to the most refined and educated Americans. At the same time, museums were separating original paintings and sculpture from mummies and mastodon bones and, later, from photographic reproductions and plaster casts. The concept of culture took on strongly hierarchical connotations,

reflecting Matthew Arnold's definition as "the best which has been thought and said in the world,...the study of perfection."[180] As connoisseurship took effect, clear distinctions were drawn between the entertaining heterogeneity of popular culture and the refinement of high culture, between common and elite tastes.

This dynamic was exemplified by the ambition and design of the great 1893 World's Columbian Exposition in Chicago. Organized to commemorate the 400th anniversary of Columbus's arrival in the New World, this exposition presented a powerful symbol of the nation's "official" ideals and values.[181] It was a massive undertaking—some 400 buildings on nearly 700 acres, filled with exhibits and shows of all kinds. The heart of the exposition was conceived as a model city, an archetype of reason, sophistication, and order. This section was composed of a series of monumental display halls, all painted pure white and in neoclassical design. While avant-garde architects such as Louis Sullivan excoriated this backward-looking sensibility, the exposition embodied a powerful—and popular—vision of cultural identity. Conceived quite literally as a spectacle [71, 72], the exposition represented a careful integration of past and present, tradition and progress, national unity and international brotherhood.[182] It was meant to demonstrate what artists had already learned—that cultural sophistication could only be derived from a European, historical model. In addition, the exposition suggested the vital relationship between high culture and social progress: the central role of aesthetic refinement in controlling and giving meaning to the rambunctious energies of the modern age.

This social dynamic of the last decades of the nineteenth century, which Lawrence Levine has termed "the sacralization of culture," exerted an overwhelming influence on all the arts in America. The result was the "genteel tradition" that the radicals of the early twentieth century found so confining. By the second decade of the new century, intellectuals had lost faith in the certainties of this Victorian vision and a new worldview was taking form. However, revolutions are never total, and important elements of this earlier ideology survived—tempered, hardened, and refined—well into the modernist era.

Photographic Aesthetics

In the 1890s, proponents of the art of photography drew inspiration from the success of American painting in its struggle from provincialism to international acclaim. Many of the arguments for the social value of artistic photography were taken directly from earlier debates among painters. In photography, as in painting and sculpture, the quest for "art" was of enormous importance. This was a matter of some complexity, as rhetoric and reality were often related in less than obvious ways. Idealistic appeals to "truth," "beauty," and the "elevation of popular taste" often masked an underlying set of more tangible professional, economic, or social concerns. For example, what was obscured by references to art's spiritual value was the fact that paintings were valuable commodities and emblems of social status. Art also had a political value, posing a symbolic model of hierarchy and order for a diverse and often unruly society.

"Art" had long been of concern to American photographers. In the daguerreotype era of the early 1850s, the business of photography became increasingly competitive as the number

works of art were admired more for technique and content than for originality.

The fortunes of painters and sculptors began to rise only in the 1830s, with the growing belief that art had a valid cultural function: to codify and promote the great themes of civic and religious life. This high purpose was exemplified in the great landscape paintings of the pre–Civil War era. In the works of Thomas Cole and Frederic Edwin Church, for example, topographic description, historical allusion, political allegory, and religious symbol were melded into complex narratives.[164] Antebellum genre painters such as William Sidney Mount and George Caleb Bingham were similarly important in evoking a collective vision of everyday American life. In this era, works of art were praised for their moral lessons and elevating influence. The highest purpose of art was to confirm and promote the virtues of democracy, religious piety, and social progress.

The modern institutions of American art began to take shape in the years after the Civil War.[165] Several art schools were founded in this period, beginning with the Yale School of Art (1866), the McMicken School of Art in Cincinnati (1867), the San Francisco Art Institute (1871), and the Art Students League in New York (1875). At Harvard, in 1874, Charles Eliot Norton inaugurated a regular academic program in the history of art. Major museums were also founded, including the Metropolitan Museum of Art and the Boston Museum of Fine Arts (both 1870). The Chicago Art Institute, begun as an academy in 1866, took its present name in 1882. Private clubs and societies also flourished, including the American Water Color Society (1866), the New York Etching Club (1877), and the Society of American Painters in Pastel (1882).[166] Many other institutions followed, until nearly every city could boast a museum, gallery, or art society of some kind.

The exhibiting and collecting of art grew at a corresponding rate. Prestigious annual exhibitions of painting and sculpture were mounted in New York at the venerable National Academy of Design and, beginning in 1878, at the Society of American Artists. In Philadelphia, similar yearly surveys were presented by the Pennsylvania Academy of Fine Arts. Concurrently, wealthy patrons such as Isabella Stewart Gardner, Henry Clay Frick, and John Pierpont Morgan began amassing great private collections. The demand for a wide variety of works of art, from the Renaissance to the present, spurred the growth of professional art dealers and the establishment of large sales galleries such as that of the American Art Association (1884).

The pace of this activity prompted the *New York Times* to observe in 1883 that art was a "crowded profession," with as many artists in the cities of New York, Chicago, and Boston as there were lawyers.[167] Census figures reveal a veritable explosion in the number of artists and art teachers in this era: from 4,081 in 1870 to 22,496 in 1890. In addition to teaching, many of these men and women were employed in the growing fields of illustration, design, and advertising.[168]

This burgeoning activity was accompanied by much discussion of the nature and quality of American art. The establishment of a truly national art was an issue of central concern in the last half of the nineteenth century.[169] But, while Transcendentalist literature found an indigenous parallel in Luminism and Hudson River School painting, European art and art theory continued to exert a powerful influence. American artists carried a heavy bur-

den of inferiority: the grand scale of European history and the past achievements of its writers, musicians, painters, and poets all combined to give the Old World artist a professional stature unknown in the New World. This feeling of inadequacy only increased after the Civil War. The American art exhibit at the 1867 Exposition Universelle in Paris, for example, was widely regarded as provincial in style and subject matter. Even the most admired American paintings were judged to be the result of mechanical description rather than poetic interpretation. In comparison with works by the leading French painters, an American critic noted that Frederic Church's monumental painting *Niagara* (1857) displayed "a cold hard atmosphere and metallic flow of water" and was, ultimately, nothing more than "a literal transcript of the scene."[170]

In the following decades, American artists were strongly influenced by this European emphasis on the artist's hand and personality over a more objective, mimetic representation of the world. In an 1880 review of "The Younger Painters of America," *Scribner's Monthly* applauded the decline of Church's generation, and the turn toward a more "sophisticated" international style.

> Now the American school of painting seems almost to have disappeared—or has, at the least calculation, lost the distinctive characterlessness which won for it its name and recognition. We are beginning to paint as other people paint.[171]

Subjects of specifically American interest declined in popularity, replaced by Barbizon-style landscapes and genre scenes of French and Italian peasants. European art was increasingly valued by American collectors, and the most ambitious American artists felt it essential to study in Düsseldorf, Munich, or Paris. "I would rather go to Europe than go to Heaven," said painter William Merritt Chase, and most of his fellow artists agreed.[172]

France exerted the greatest influence on American artists in the last third of the century. A steady stream of Americans studied in the leading Parisian studios, resulting in an international style that blurred national distinctions. As Henry James observed in 1887, "It sounds like a paradox, but it is a very simple truth, that when to-day we look for 'American art' we find it mainly in Paris, and when we find it out of Paris, we at least find a great deal of Paris in it."[173]

The result of this influence was evident at the 1889 Exposition Universelle in Paris.[174] American paintings received excellent reviews; finally, it seemed, the nation's art had come of age. Fully three-fourths of the exhibiting Americans had studied in France, and their paintings blended seamlessly in style and subject with those of the leading Europeans. Using the same technical approaches, artists of all nationalities produced portraits, landscapes, marine studies, city views, still lifes, nudes, and historical, religious, and allegorical scenes. The most popular category, genre studies, focused on colorful foreign subjects and the rustic life of European peasants. American contributions to this category included images of French shepherds, fishermen, and farmers, as well as views of Egypt and India. The battle against provincialism had been won: in the best American art, it appeared, America itself played little part.

America's growing receptivity to art resulted in a heightened social stature for artists, and new rewards and dilemmas. Successful artists were now celebrities; the popular press was filled with articles on their personal lives. These artists were routinely

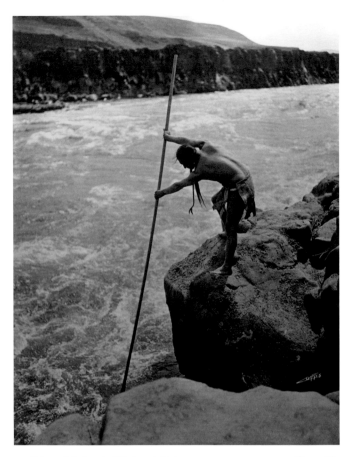

38 Edward S. Curtis, *Wishnam Fisherman*, 1909, orotone, 13⅝ x 10⅝"

with him as props). Curtis also felt free to manipulate the content of his scenes for aesthetic effect, and to retouch his negatives to remove evidence of the modern world. All such manipulations were made in an earnest effort to record a way of life that was already largely gone. In striving to recreate a proud and "authentic" past from the relatively mundane evidence of the present, Curtis created a pictorial world of half-remembered fact and romantic projection. Revealingly, he was once told by an Indian interpreter, "You are trying to get what does not exist."[154] Curtis received only lukewarm support from professional ethnographers but—in fairness—his approach was not greatly different from that of numerous other photographers of the period.[155]

Curtis's photographs were widely known in his day. He hired publicists to promote his work and was himself a tireless lecturer. By March 1905, when he presented a print exhibition and lantern-slide showing at the Waldorf-Astoria Hotel in New York, it was reported that his performances "always command an enthusiastic reception" from the public.[156] Two years later, critic Sadakichi Hartmann reported that Curtis's "huge advertising campaign" had made him "just now the most talked-of person in photographic circles." This promotional barrage prompted Hartmann to observe that

> some noise has to be made, in order to avoid too great a loss of the invested money. But it is not particularly dignified. One would prefer to see less glamor and lime-light flare connected with a serious scientific publication, as this pretends to be.[157]

To support the expensive task of producing *The North American Indian*, Curtis sold great numbers of his pictures in the form of platinum prints and "orotones." These were usually marketed in decorative frames, ready to hang, and proved popular as parlor decoration and upscale wedding gifts. Curtis's orotone process involved printing an image on a sheet of glass and sealing the back of the plate with a viscous mixture of powdered gold pigment and banana oil. These images conveyed a moody iridescence and were described in Curtis's promotional literature as being as "full of life and sparkle as an opal." The most popular of these orotones, such as *Wishnam Fisherman* [38], were sold in considerable quantity at $15 for each 11 x 14-inch framed image.[158]

Curtis began work on *The North American Indian* when popular interest in the subject seemed near its peak.[159] It is telling that one New York publisher tried to discourage Curtis from issuing his Indian photographs in 1904, saying "The market's full of 'em. Couldn't give 'em away."[160] In fact, popular enthusiasm for such images lasted into the early 1920s, when Americans' romantic fascination for Native Americans began to wane—at least temporarily. Ultimately, the importance of Curtis's photography lies precisely in its uneasy union of fact and art: a vision of the present shaped by deep nostalgia for the past.

Art and Photography

The technical and social transformations of the 1880s created a major rift between those who earned their living through photography and those who practiced it as an avocation. While wet-plate photography had been the nearly exclusive domain of the professional, the central figure of the dry-plate era was the amateur. For thousands of hobbyists, photography was no longer an arcane science requiring complex training and skills. Now that the process was relatively easy, serious amateurs began to define the nature of their activity in opposition to that of the professional. In photography, as in athletics of the period, amateurs were felt to possess pure and elevating motivations, while professionals were seen as simply mercenary. Amateurs labored out of love rather than necessity and—at least in theory—placed no price on their achievements. From this perspective, the amateur had the potential to achieve a far higher form of expression than the commercially minded professional. In essence, the amateur ideology represented a symbolic attempt to reform modernity, to add warmth and humanity to an increasingly mechanistic and impersonal world. In 1904, for example, a noted literary critic championed the amateur spirit in the hope that it would serve to "penetrate, illuminate, [and] idealize, the brute force, the irresistibly onsweeping mass, of our vast industrial democracy."[161] By turning their attention to art, the most ambitious amateur photographers engaged in a complex activity—at once a craft, a recreation, and a means of personal and social uplift.

For all its high symbolic status, fine art in the 1880s had only recently gained an honored place in American culture. Indeed, the social status of art had grown very slowly in the previous decades. In colonial America "the enjoyment, production and consumption of art was tinged with guilt" because it was associated with the superfluous wealth, rigid social structures, and "decadent" tendencies of the Old World.[162] Art suggested *artifice*, and was considered a useless distraction from the essential labor of building a new society. Well into the nineteenth century, painting remained "a precarious and humiliating occupation."[163] Artists were regarded as craftsmen rather than creators, and

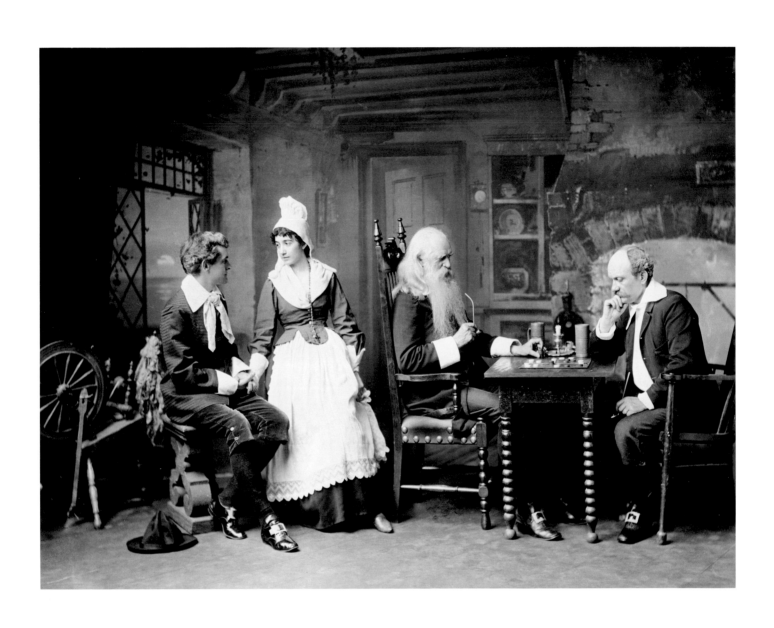

39 C.W. Motes, *Evangeline*, 1889, albumen print, 16⅜ x 21¾″

with sunlit, trailing vines over dark recesses reflected in some limpid pool; the rock-bound streamlet; the gnarled, fantastic tree trunk—pictures everywhere.

A love and study of such scenes of beauty is one of the purest joys of existence—a power to translate such, a never ending source of delight. Such study is in harmony with our highest well being. It leads man away from mere animal sense, which clogs and falls, into a clearer atmosphere, where the intellect is quickened, the mind cultured, and the soul brought into nearer relationship with the Supreme Creator of all beauty and goodness.[190]

Such sentiments powerfully shaped the artistic ambitions of the era. Even when religion was not specifically mentioned, writers of the time repeatedly defined art in terms of morality:

> Art has a vital relation to morality, but we must seek it not in its didactic teaching, but in beauty, which always exerts a refining influence, tending to soften manners and elevate character.... Here is where the moral mission of art is to be sought—in the elevating influence of pure delight filling life with joy and beauty, and by these making the world happier and better.[191]

In a coarse and materialistic age, it was expected that art would serve to refine both individual character and society at large.

The most ambitious art photographs of the Victorian era clearly demonstrate this desire to elevate and idealize. In order to transcend the inherent vulgarity of the real, many photographers worked with allegorical, literary, and theatrical subjects. By choosing to stage images of tasteful refinement, or to illustrate passages from popular poems or plays, photographers saw themselves as engaging a higher truth: an idealized vision of life, as refracted through a poetic sensibility, rather than the raw facts of everyday experience. This inherently theatrical vision was a logical product of the time; *tableaux vivant* were widely popular, and respected painters and sculptors routinely depicted literary and historical subjects.[192]

Evangeline [39], an 1889 work by the respected Atlanta professional C. W. Motes, exemplifies this trend. In that year, to encourage the refinement of its membership, the Photographers' Association of America offered a prize valued at $200 (a bronze statue of *Roman Wrestlers*) for the best collection of three photographs illustrating Henry Wadsworth Longfellow's popular poem *Evangeline* (1847).[193] Longfellow's epic paean to virtue and transcendence offered almost endless potential for artistic reinterpretation. As a spur to widespread participation in the contest, the *Photographic Times* published several pages of excerpts and offered for sale a new publication of the poem with sixteen engravings by the artist F. O. C. Darley.[194] It is revealing that Motes made no attempt at thematic originality: the passage he illustrated was one quoted by the *Photographic Times* and illustrated by Darley.[195] Instead, the success of Motes's work was a function of its polish, dignity, and grace. Ultimately, this picture was narrowly beaten out of first-place honors by the work of J. E. and O. J. Rösch of St. Louis.[196]

In the 1890s, the essential idealism of this approach continued to hold sway. However, the narrative complexity of these later pictures was streamlined; creative images were meant to be read symbolically and poetically rather than as illustrations of specific literary works. For example, Charles I. Berg's *Art*, 1895 [40], depicts a young woman with a paintbrush and palette. Most importantly, however, she is in classical garb and sits beside a Greek capital, an emblem of timeless beauty and rationality.

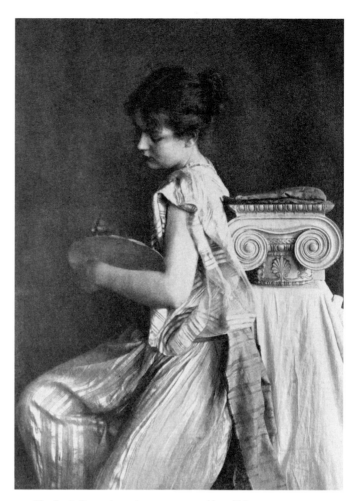

40 Charles I. Berg, *Art*, 1895, gravure, 6¾ x 4¾"

The "art" of this image is largely a product of the elevated ideas associated with its subjects, and the refined and thoughtful way in which the artist constructed the tableau.

As this general style of work demonstrates, the artistic realm was often seen as removed from—or even opposed to—the world of actual experience. This dichotomy ran counter to the nation's essentially pragmatic and materialistic character. The most astute critics of the period understood the tension between realist and idealist tendencies. In an insightful article published in 1886 in the *Philadelphia Photographer*, Charlotte Adams stated that American photography and art were derived from a national faith in "hard, positive facts." Responding to an opinion from England on photography's incapacity for art, Adams observed that English theories stemmed from a "pseudo-idealism" that had no place in American life:

> We Americans are forming a distinct school of photography as well as of art.... Our American art...is grounded, root and branch, in realism and this love for hard, positive facts, so natural to the American temperament.... Now photography, whether regarded as an art or as a mechanical process, owes its existence, in the higher sense, to the place accorded to realism in modern life; in other words, the insistence upon positive truths. It is essentially a modern thing...
>
> There will always be two factions in the artistic camp. The idealists and the realists are always at war. But, in this country, the realists now have the best of it, and the majority wins. Creative art, in its highest conventional sense, that is, in the sense of working through pure imagination and fancy, does not belong among us. Reproductive art, in the sense of depicting human life

and nature as they exist, is the foundation of the modern American art-idea. Photography is simply a form of reproductive art. Realism and reproduction are one—with the difference of the informing spirit of intellect and feeling, which in some subtle, indefinable way raises the artistic above the mechanical. [197]

Adams's essay celebrates photography's unique abilities and acknowledges its expressive limits. While the great majority of photographers would have agreed, this view came under increasing fire from the "idealist" camp in the following decade. By 1889, regular criticism of the "realist" position was appearing in the American photographic press. At first, the most radical ideas came from England. In criticizing the universal preference for overall sharpness, one critic advanced the radical opinion that "finer pictures are sometimes got with the worse rather than the better photography."[198] Similarly, photographer P. H. Emerson argued that science and art were utterly different in both method and goal. In Emerson's view, science was a matter of factual precision and intellectual analysis. Art, on the other hand, appealed to the emotions and benefited from a radical elimination of unnecessary information.[199] In addition to a careful choice of subject, lighting, and point of view, Emerson argued for a deliberate use of selective focus to suppress peripheral or background detail. The pictures and critical writings of fellow Englishmen George Davison and H. P. Robinson were also important in advancing this view, which came to dominance as the Pictorialist aesthetic.

The Rise of the Camera Club

American photographers gained a sense of community through specialized associations and journals. Professionals of the late nineteenth century were well served by such publications as *Anthony's Photographic Bulletin*, *The Photographic Times*, *The Philadelphia Photographer*, and *Wilson's Photographic Magazine*. Journals aimed at a more uniformly amateur audience began appearing in 1889 with the introduction of *American Amateur Photographer* (Brunswick, Maine) and *Photo-Beacon* (Chicago). Of the more than thirty journals published in the next decade, the most important was Alfred Stieglitz's lavish *Camera Notes* (1897–1903), the organ of the Camera Club of New York. Other notable publications of this period include *Photo-Era* (Boston), *Photo-Miniature* (New York), *Camera Craft* (San Francisco), and *Photo Mirror* (St. Louis).[200] These journals were supported by the advertising of manufacturers and distributors, reflecting the growing economic importance of the business of photography.

These publications both facilitated and encouraged a sense of collective identity among amateur photographers. Changes in American society after the Civil War resulted in a broad movement toward the formation of clubs and societies of all kinds. This trend toward social and professional association coincided with the technical changes that gave rise to modern amateur photography.[201] In 1880, fewer than ten clubs or societies dedicated to photography could be found in the United States, and all were composed largely of professional photographers or men of science. By the end of 1889, however, about seventy photographic organizations were in existence, with overwhelmingly amateur memberships.[202] A quarter of these clubs were in the New York metropolitan area. Others of note were located in Albany, Baltimore, Boston, Buffalo, Cleveland, Columbus (Ohio), Chicago,

Cincinnati, Hartford, Honolulu, Indianapolis, Louisville, Minneapolis, New Orleans, Portland (Oregon), Philadelphia, Pittsburgh, Rochester, San Francisco, Selma (Alabama), St. Louis, Syracuse, Washington, D.C., and Worcester.[203]

The Photographic Society of Philadelphia, founded in 1862, was one of the most important of these early associations.[204] Some of the most distinguished figures in American photography were members, including Coleman Sellers, Frederick Gutekunst, John Carbutt, John C. Browne, John G. Bullock, William H. Rau, and Robert S. Redfield. In 1864, the society established its publication *The Philadelphia Photographer* under the editorship of Edward L. Wilson. (The title of this influential journal was changed in 1888 to *Wilson's Photographic Magazine*.) The Photographic Society of Philadelphia remained one of the most respected organizations of its kind into the first decade of the twentieth century.

The first explicitly amateur organization, the Boston Society of Amateur Photographers, was founded in October 1882.[205] This was followed, in early 1884, by the Society of Amateur Photographers of New York and the Amateur Photographer's Club in Chicago. The New York group was the most active of these early amateur societies. It initiated the American Lantern Slide Interchange in 1885 when it showed slides borrowed from the Cincinnati Camera Club. The New York society was also a cosponsor of the important series of "Joint Exhibitions" held from 1887 to 1894 in collaboration with the Photographic Society of Philadelphia and the Boston Camera Club. In the first decade of its existence, the Society of Amateur Photographers counted among its members such noted figures as Catherine Weed Barnes, J. Wells Champney, Emilie V. Clarkson, William B. Post, and Alfred Stieglitz.[206] By 1895, the New York club had 260 members, making it one of the largest organizations of its kind in the world.[207]

The membership of American photographic clubs was typically drawn from the upper and upper-middle classes. Within these social and economic strata, members came from a variety of occupations. The Cincinnati Camera Club, for example, included "mechanics and millionaires, university professors and retired merchants, artists and architects, engineers and chemists, journalists and publishers, manufacturers and stock dealers, bankers and underwriters, lawyers and doctors." This club was unusual in actually barring professional photographers; most other organizations happily welcomed the few professionals who cared to join.[208]

The privileged status of most of the era's leading artistic amateurs is suggested in Jeanette Vogt Bernard's genre scene (and probable self-portrait) of about the late 1890s [41]. Bernard came from an artistic family; her brother Adolph Vogt was a painter of some renown.[209] Residing with her husband outside New York City, Bernard created exquisite platinum prints of rural, genre, and theatrical subjects. In addition to its function as a genre study, this fascinating image hints at complex issues of vision, representation, and status, while suggesting the role of art in everyday life. Bernard composes herself to face the day, visible primarily as a mirrored reflection: a framed "picture" alongside a series of other pictures. The central theme of the images on her folding screen—the contrast between labor and leisure—is underscored by the juxtaposition of the artist with her

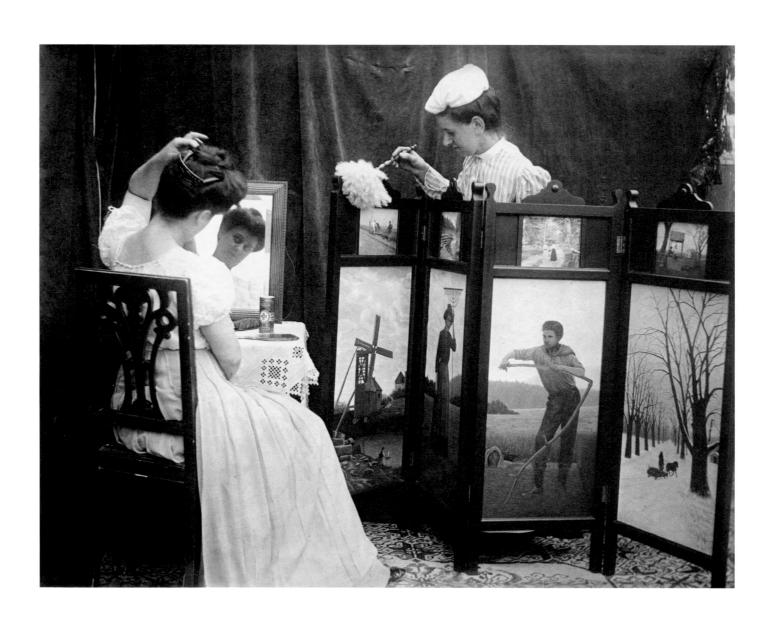

41 Jeanette Vogt Bernard, *Genre Scene*, ca. 1895-1900, platinum print, 6⅛ x 8¼″

maid. Bernard's picture suggests that art may be understood as a cerebral and spiritual—rather than physical—form of labor. While both types of work are life-enhancing, they occupy vastly different positions in the hierarchy of cultural value. Physical labor satisfies basic needs, while art serves to refine and elevate. Art-making represents a respite from commercial life; indeed, the purest artist may be the one who engages in no worldly work at all.

Women constituted an important part of club membership. In 1889, ten of the Cincinnati club's 150 members and nearly one-third of the Chicago Camera Club's 100 members were women. For a variety of reasons, however, including the demands of family and household, few of these pioneering women appear to have produced notable work over an extended period.[210] Unfortunately, none of the leading female amateurs of this period— Catherine Weed Barnes, Emma Farnsworth, Sarah J. Eddy, Emma J. Fitz, Mathilde Weil—are familiar names today.[211] On the other hand, by this time women had become a significant presence in the professional ranks; in the 1890 census, some 2,201 women listed their occupation as "photographer."[212] The most renowned of these included Frances Benjamin Johnston and Zaida Ben-Yusuf.

Without question, Catherine Weed Barnes was the most important woman in the formative years of American amateur photography. A resident of Albany, New York, Barnes took up the camera in 1886. Galvanized by her local club's refusal to accept women, Barnes joined the more progressive Society of Amateur Photographers of New York in 1888. A year later, she emerged as the strongest voice in America for the cause of women's photography. In lectures and essays, Barnes argued powerfully for equal opportunities for women. She called for the end of separate "ladies'" awards in competitions, stating bluntly that these were "not a complimentary distinction, although intended as such." She continued:

> Good work is good work, whether it be by man or woman....If the work of men and women is admitted to the same exhibition it should be on equal terms. Don't admit a woman's pictures because they are made by a woman but because they are well made.[213]

Barnes concluded her essay "Why Ladies Should be Admitted to Membership in Photographic Societies" by calling on photographic institutions "to give us a fair field and no favor," predicting that "the day is coming, and will soon be here, when only one question will be asked as to any photographic work— 'Is it well done?'"[214] Barnes was equally forthright in her defense of photography's artistic potential:

> Photography does not need to beg admission to the temple of art or be admitted to it on a painter's ticket. She is entitled to her own doorway, for a photographer is not a painter any more than an organist is a violinist.[215]

Barnes achieved national recognition as a photographer, essayist, lecturer, and editor. While her portraits and picturesque views of historical sites were frequently praised, her most ambitious photographs depicted elaborately staged tableaux illustrating passages from famous poems. Her photographic series after Alfred Tennyson's "Enoch Arden" and "Lancelot and Elaine" were widely exhibited.[216] Barnes was a popular and prolific speaker. In 1893, she delivered an important paper on "Amateur Photography" to the World's Congress of Photographers, held in conjunction with the World's Columbian Exposition in Chicago. Her lectures and essays were published in various journals of the day, including *Leslie's Illustrated* and the *American Amateur Photographer*.[217] Barnes became an editor of the *American Amateur Photographer* in 1890, and contributed a regular column under the title "Women's Work." This aspect of her career ended abruptly in 1893 when she married H. Snowden Ward, the editor of the English monthly *Practical Photographer*. After moving to London, she assisted her husband in establishing a new photographic publication, *The Photogram*, and continued her own pictorial and literary work. Though she remained a dynamic force in English amateur photography, Barnes's departure marked a significant loss to the American community.[218]

Camera clubs provided their members many benefits. Each of the better clubs maintained a library of photographic publications, darkrooms for processing negatives and prints, and a meeting room for lectures and lantern slide showings. The Chicago Camera Club, established in May 1889, was a typically progressive association. In addition to the usual features, this club had a fully equipped portrait studio and a permanent display of framed works by photographers of international renown. An attendant was on duty each weekday from 9:00 AM to 6:00 PM, and members were given keys to let themselves in after hours or on weekends. For these privileges, the club's 100 members each paid an initiation fee of $10 and annual dues of $12.[219]

Club meetings, usually held once or twice a month, had both social and educational components. The most informal gatherings, like the 1889 "Smoking Concert" of the Brooklyn Society of Amateur Photographers, offered such varied amusements as "music by members of the society, character performances, illustrations of mesmerism, and sleight-of-hand tricks."[220] The main monthly meetings usually featured a technical demonstration of some new tool or process, or a lecture by a figure of at least regional renown. In 1889, for example, the members of the Cincinnati Camera Club heard talks by photographers as diverse as Eadweard Muybridge and the Mesoamerican archaeologist Augustus Le Plongeon.[221] It was also common for painters, art historians, or designers to lecture on art or to critique members' work.

The showing of lantern slides, a popular form of education and entertainment in this era, constituted an important part of club meetings.[222] The projection of these 3¼ x 4-inch black-and-white glass positives was usually accompanied by music or narration.[223] Presentations typically featured the work of a single club photographer, a theme explored by all club members (often a celebration of their city or region), or a survey of the work of other clubs. The American Lantern Slide Interchange, begun in 1885, created a national network for the circulation of slide sets. Regional organizations, such as the New England Lantern Slide Exchange, were also established and clubs regularly exchanged sets on an individual basis. For example, a set of seventy slides titled "Illustrated Boston," representing work by that city's camera club, was a great hit with the members of the Pacific Coast Amateur Photographic Association in San Francisco. The set was shown twice at the association and again in a public hall. It was reported that the audience for this latter presentation "was very enthusiastic, but unfortunately only about seven hundred could be accommodated, and a larger number had to be turned away from the door."[224]

A highlight of every camera club's calendar was the annual outing. Most outings involved excursions to picturesque rural areas and ranged in length from one to ten days. In such bucolic surroundings, far from the noise and haste of the city, amateurs could hike, photograph, and linger over a picnic lunch. These trips were so important that clubs such as the Photographic Society of Philadelphia had designated excursion committees to research and plan them.[225]

In 1887, the Reverend W. H. Burbank, one of the founding editors of the *American Amateur Photographer*, described the pleasures of a typical outing. Travel by train and foot brought Burbank and a botanist friend to a small lake in the Hudson River valley, a scene "abound[ing] in picturesque bits."

> One of these was taken, a wide stretch of open water, rippled by a passing breeze; on the right a picturesque grouping of rocks and trees; in the near foreground a tangled growth of low bushes clearly outlined against the water, and a bit of the road, with the opposite hills in the distance...
>
> Another effective bit was a woodland vista with the leaf-strewn road running diagonally through the picture, lined on either side with trees whose branches met in graceful confusion overhead. In this bit the author did good service by posing, gun in hand, in the middle distance, where his dark figure lengthened out the perspective.

Later in the afternoon, Burbank found another site rich in the kind of "picturesque and homely" scenes he treasured:

> There was the hemlock walk where the road ran steeply down between two lines of giant hemlocks with the sunlight streaming through the branches and flecking the tree trunks with spots of light; there was the charming little vignette, showing a glimpse of the river framed in by arching trees...and there was a lonely pine towering high in air, which with the huge rock at its foot, and the river and distant hills beyond, made a charming study which well repaid the day's toil, and made the photographer happy.[226]

Photographic Exhibitions

In addition to their other activities, camera clubs took a leading role in sponsoring exhibitions. Although photographs had been presented to the public regularly before the 1880s, few of these earlier displays focused solely on aesthetic merit. At professional photography conferences, for example, original prints were displayed as advertisements of either their maker's skills or the products employed. Large public expositions, which often included photography as an example of mechanical progress, invariably emphasized technical achievements over aesthetics. Many photographs were displayed at the 1876 Philadelphia Centennial Exhibition and the 1885 New Orleans Exposition, for example, but in both cases the result was a confused jumble of pictures and hardware. Some prints were shown in special photographic departments alongside promotional displays by manufacturers; others were dispersed in myriad state or thematic installations. At New Orleans, careful viewers could find William Henry Jackson's photographs in the Colorado section and the work of Carleton Watkins in the California display. Similarly, the display halls of the 1893 World's Columbian Exposition were full of photographs made for a variety of scientific, documentary, promotional, and artistic purposes.[227] The structure and intention of these expositions strongly emphasized subject matter over inter-

pretive expression, and the few memorable examples of the photographic art were vastly outnumbered by simple topographic and documentary records.

One of the earliest exhibitions of amateur work was organized in 1883 by the Boston Society of Amateur Photographers. Over 700 prints by photographers from around the country were on display for one day, November 15, from 3:00 to 10:00 PM, at the city's Institute of Technology. Prizes were awarded by a jury composed of a professional photographer, an artist, an engraver, and a member of the Society.[228] In 1884, the camera club in Providence, Rhode Island, began mounting yearly exhibitions of amateur work. In 1885, the first annual exhibition of the Society of Amateur Photographers of New York was deemed so successful that it was pronounced "the dawn of a new era in American photography."[229] The Pacific Coast Amateur Photographic Association in San Francisco also held its first exhibition that year. In 1886, the Photographic Society of Philadelphia presented a massive international exhibition at the Pennsylvania Academy of Fine Arts. This unedited show, composed of work by both amateurs and professionals, contained over 1,700 works by 114 photographers.[230] The Camera Club of Hartford also organized its first annual exhibition in 1886, a show that included work by members of the Providence Camera Club and the San Francisco Amateur Society.[231]

In 1887, the nation's three leading photographic societies joined forces to begin the most important series of photographic exhibitions yet conceived. The Joint Exhibitions of the Photographic Society of Philadelphia, the Boston Camera Club, and the Society of Amateur Photographers of New York were held each year from 1887 to 1894 (except 1890). In addition to photographs by members of the organizing clubs, the Joint Exhibitions featured work from across the country and overseas. These shows were enormously successful in defining and promoting the art of photography.

The leading photographers of the day entered all or most of the seven Joint Exhibitions. The Philadelphians Robert S. Redfield, John G. Bullock, Clarence B. Moore, and George B. Wood won many awards, while their clubmates Alfred Clements, Edmund Stirling, John C. Browne, Charles R. Pancoast, William Rau, and Dr. Charles L. Mitchell also received consistently good reviews. Women photographers such as Catherine Weed Barnes, Emma J. Farnsworth, Frances Benjamin Johnston, Elizabeth A. Slade, and Emma J. Fitz received positive notices in one or more of the exhibits. Among the many other exhibitors receiving special mention in the photographic press were Francis Blake, William B. Post, James L. Breese, Edwin Hale Lincoln, William Henry Jackson, William A. Fraser, and Rudolf Eickemeyer, Jr. The work of Alfred Stieglitz was first given special notice in 1889, while he was living in Berlin. The English photographers Frank M. Sutcliffe, P. H. Emerson, H. P. Robinson, and George Davison repeatedly provided the highlights of the international sections of these shows.

The sixth Joint Exhibition, held in Philadelphia in 1893, was widely regarded as the best of the series. The Philadelphia club's organizing committee, chaired by Robert Redfield, assembled a show that the young Stieglitz (now back in New York) pronounced "without doubt, the finest exhibition of photographs ever held in the United States."[232] Some 1,800 prints by 200 entrants were hung, representing work from the United States,

Great Britain, Germany, Switzerland, Japan, Australia, and India. The most discussed image in the exhibition was George Davison's *The Onion Field*, which was unusual for its relatively large size, extreme softness of focus, and use of rough-textured printing paper.[233]

However, the following year's exhibition, under the direction of the New York Society, was a disappointment. Many previous award winners declined to enter due to doubts about the competence of the judges. These concerns turned out to be justified; the final exhibition was decidedly uneven, and the jury was rumored to have spent only four hours reviewing 700 pictures.[234] On the whole, the exhibition seemed to confirm the New York club's status as "the 'conservative' of the leading societies, in other words, the least progressive."[235] This discord brought the important series of Joint Exhibitions to an abrupt end.

While vital to the development of artistic photography in America, these shows represented an evolutionary step—rather than a revolutionary leap—in thinking about the medium. On the whole, the Joint Exhibitions retained the conventional subject classifications of earlier shows. For example, a leading exhibition of 1885 featured a total of twenty-five categories, including "Landscape," "Cloud Effect," "Snow Effects," "Surf," "Sail," "Animals," "Flowers," "Trees," "Microscopic," "Machinery," three portrait categories ("Full Figure," "Head," and "Group"), two architecture categories ("Exteriors" and "Interiors") and, for all-around skill, "Entire Collection."[236] The variety of work accepted for the Joint Exhibitions reflected this all-encompassing approach. Among the more than 1,300 prints hung in the 1891 display were examples of nearly all the above categories as well as such novelties as a flash image of a night-blooming cereus, archaeological studies of Yucatan ruins, and snapshots of athletic events. The anecdotal nature of the many genre studies in the show is indicated by such titles as *Smithy*, *Carting Hay*, *Stalking a Trout—Sunlight Through the Mist*, *Watching Grandma Smoke*, *Feeding the Chickens*, and *A Letter from My Boy*.[237] The inclusion of photographic apparatus and the careful documentation of the developers used for each work reflected a continued emphasis on technical concerns.

By the early 1890s, the most progressive photographers had come to regard these eclectic shows as outdated.[238] They argued that exhibitions should dispense with categories and prizes in order to focus solely on artistic achievement. The first major international photography exhibition organized on these criteria was held in Vienna in 1891. Rigorously juried by a team of respected artists, the Vienna exhibition included some 600 prints by 176 photographers. From the 350 works submitted by forty Americans, only twenty-five photographs by ten individuals were selected. Included in this elite group were John E. Dumont, George B. Wood, Alfred Stieglitz, James L. Breese, and John G. Bullock.[239]

In London, in 1892, this spirit of artistic purism stimulated the formation of the Linked Ring by a group of photographers who had resigned from the conservative Royal Photographic Society. The Linked Ring included most of Britain's leading artist-photographers—Henry Peach Robinson, George Davison, Alfred Maskell, and A. Horsley Hinton—and it extended membership invitations to a select number of international figures. The first three Americans so honored were Stieglitz, Eickemeyer, and F. Holland Day. In 1893, the Linked Ring began its own annual international Salon to compete with the Royal Photographic Society's yearly exhibition. The Linked Ring's exhibition, based on the simple principle of "no medals and rigid selection," was intended to effect the "death of the old style of show where mechanical, scientific and industrial exhibits are all jumbled up together with very little distinction."[240]

Following the lead of these groups in Vienna and London, major international photographic exhibitions were initiated in Hamburg (1893), Paris (1894), and Brussels (1895). In addition, in cities such as Milan, Antwerp, and Munich, photographic sections were added to annual painting exhibitions. The Munich Secession was one of the most important of these fin-de-siècle art exhibitions. The first Munich Secession of 1893 presented avant-garde paintings as separate from—and superior to—the stale traditionalism of the old Düsseldorf school. The 1898 Munich Secession demonstrated its progressive nature by including artistic photographs alongside paintings, sculpture, and prints. Photographers throughout the world viewed this acceptance as a triumph.

"A Photographic Epoch"

After the collapse of the Joint Exhibitions, the most advanced American amateurs pushed for an elite salon organized on the model of the Vienna exhibition. Within half a decade, this movement had transformed artistic photography in America.

Alfred Stieglitz provided one of the most powerful and persuasive voices in this reformist cause. A native New Yorker, Stieglitz had gone to Germany in 1881 to study mechanical engineering. In 1883, however, he became infatuated with photography and went on to win over 150 prizes in European competitions before the end of the decade. After his return to New York in 1890, Stieglitz became active in the amateur photography scene. In addition to the technical and artistic quality of his pictures, Stieglitz was admired for his organizational, critical, and editorial skills. From 1893 to 1896, he served as coeditor of the *American Amateur Photographer*. His own photographs were reproduced often in the journal, and he contributed short articles on technical matters. By 1896, when his club, the Society of Amateur Photographers of New York, merged with the New York Camera Club to form the Camera Club of New York, Stieglitz was perhaps the most respected figure in American amateur photography. This stature resulted in his appointment as editor of the Camera Club's new journal, *Camera Notes*. In keeping with the club's upscale image, this new journal was the most beautiful American photographic publication yet seen.[241] Published quarterly, in an edition of 800 to 1,000 per issue, *Camera Notes* combined club news, book and exhibition reviews, articles of technical or aesthetic interest, and reproductions of noteworthy photographs in both gravure and halftone. The journal's stated goal was "to keep our members in touch with everything connected with the progress and elevation of photography."[242]

From 1897 to 1902, Stieglitz had complete editorial control over all but the last three of *Camera Notes*'s twenty-four issues. In this time, the journal presented a stimulating and diversified view of photography. The Symbolist tone of *Camera Notes* was set in Stieglitz's editorial in the first issue. He stated that "in the case of the photogravures the utmost care will be exercised to

42 Gertrude Käsebier, *The Manger*, 1899, gravure, 8 x 5¾"

publish nothing but what is the development of an organic idea, the evolution of an inward principle; a picture rather than a photograph, though photography must be the method of graphic representation."²⁴³ This somewhat mystical view was underscored in subsequent essays by Stieglitz's close associates Joseph T. Keiley, William Murray, and Dallett Fuguet, as well as by F. Holland Day and others. With varying degrees of clarity and success, these writings reflected Charles Baudelaire's notion of "correspondence," Henri Bergson's ideas on the ultimate unity of motion, time, and consciousness, and a general belief in the overriding importance of artistic genius.²⁴⁴ Interspersed with such abstract thoughts were other articles—on lenses and developers, for example, or the challenges of photographing animals in the wild—that were indistinguishable from the fare of more mainstream journals.

The images featured in *Camera Notes* were equally varied, reflecting Stieglitz's desire to speak to both the most advanced artistic photographers of the day and to a broader class of serious amateurs. A notable portion of these reproductions were by the leading artistic photographers in Europe, including A. Horsley Hinton (England), J. Craig Annan (Scotland), Robert Demachy (France), and Hugo Henneberg (Austria). Most of the Americans included in *Camera Notes* were active members of the Camera Club of New York, with the notable exceptions of John E. Dumont, F. Holland Day, and Clarence H. White. In addition to reproducing his own pictures twenty-six times (in thirteen issues), Stieglitz featured the work of many others, including

Frank Eugene, Gertrude Käsebier, William B. Post, William A. Fraser, Charles I. Berg, and Emilie V. Clarkson, as well as Keiley, Murray, and Fuguet.

Overall, these pictures are remarkably diverse in subject and mood. For example, Käsebier's *The Manger*, 1899 [42], presents a graceful interpretation of a familiar sacred motif, while Edmund Stirling's *Bad News*, ca. 1899 [43], takes an unusually somber approach to a contemporary genre subject.²⁴⁵ The modern urban world is depicted in Dallett Fuguet's *The Street*, ca. 1900 [44], which presents an unconventional vision of the contrasting rhythms of landscape and cityscape.²⁴⁶ The strength of *Camera Notes*'s illustrations declined somewhat in the final three issues, which were edited by Juan C. Abel after Stieglitz's departure.

The year following the debut of *Camera Notes* was a memorable one in American photography. The first show of 1898, the Eastman Photographic Exhibition at the National Academy of Design, was innovative in several respects. Described as "the largest and most interesting photographic exhibition ever held in America, as well as the biggest and most successful piece of photographic advertising so far attempted in this country," this show was part of a campaign to promote the Eastman firm's hand cameras.²⁴⁷ The promise of $3,000 in prize money prompted the submission of more than 25,000 prints from around the world. From this total, an exhibition of 3,000 photographs—ranging from work by rank amateurs to such esteemed figures as H. P. Robinson and Stieglitz—was displayed in London and New York. (Eastman went on to sponsor other major exhibitions in England and the U.S.²⁴⁸) Eight months later, the Academy of Design hosted a significant 500-print exhibition organized by the American Institute. The first Pittsburgh Salon, also held in this year, was most notable for the inclusion of work by a talented newcomer, Clarence H. White of Newark, Ohio.

Despite the significance of these shows, the most prestigious exhibition of 1898 was the first Philadelphia Photographic Salon. Organized under the joint management of the Photographic Society of Philadelphia and the Pennsylvania Academy of Fine Arts, the exhibit was directed by a committee of the most able Society members: John G. Bullock, Robert S. Redfield, and George Vaux, Jr. These men were of a single mind in planning the exhibition, and their vision of photography was expressed clearly in the exhibition catalogue:

> The purpose of this Salon is to show only such pictures produced by photography as may give distinct evidence of individual artistic feeling and execution.
>
> For the first time in this country is presented a photographic exhibition confined exclusively to such pictures, rigidly selected by a jury, whose certificate of acceptance is the only award. A far greater general interest centres in a picture displaying artistic feeling and sentiment than in one which simply reproduces faithfully places or things in themselves interesting. In one the picture itself pleases—this is art, and can be produced by photography. In the other we think only of the object reproduced, admiring perhaps the technical excellence displayed—this is "only a photograph."²⁴⁹

This insistence on an exclusively artistic focus was reinforced by the committee's choice of jurors: photographers Redfield and Stieglitz, painters William Merritt Chase and Robert M. Vonnoh, and illustrator Alice Barber Stephens.²⁵⁰ From the more than 1,200 works submitted, this panel selected 259 images by 100

photographers. While international work was included, the show was a largely American affair. Seventy-six of the exhibitors came from the United States and, of the seven other nations represented, only England (sixteen) and Scotland (three) contributed more than a single artist. Eight of the exhibitors were professionals, the most notable being J. C. Strauss of St. Louis, Frances Benjamin Johnston of Washington, D.C., and Philadelphians Elias Goldensky and William H. Rau. Seventeen of the exhibitors were women.

The first Philadelphia Salon was a smashing success. Critics called it "remarkable," "an unqualified success," a "revelation," and of such significance that it marked "a photographic epoch."[251] Public interest was so great that the exhibit stayed open a week longer than originally scheduled, running from October 24 to November 19, 1898. The work on view provided a broad survey of the creative photography of the fin-de-siècle era. The critics' highest praise went to the ten prints displayed by Gertrude Käsebier, a newcomer to the exhibition world. As Keiley exclaimed in *Camera Notes*, of all "the revelations of the Photographic Salon, her exhibition of portraits was the greatest. Nothing approached it; such work had not even been dreamed of as possible."[252] William Merritt Chase, one of America's most celebrated painters, went even further, describing Käsebier's work as equal to "anything that Van Dyck has ever done."[253] Clarence H. White also received great praise, as did more familiar figures such as Stieglitz, Keiley, Bullock, Mathilde Weil, and Eva Watson-Schütze.[254]

The most controversial work in the 1898 salon, *The Seven Last Words of Christ*, was submitted by F. Holland Day of Nor-

44 Dallet Fuguet, *The Street*, ca. 1900, gravure, 4¼ x 6⅜″

wood, Massachusetts. The seven tightly cropped views that comprise this piece are actually self-portraits of Day—bearded, emaciated, and wearing a crown of thorns—reenacting the final agonizing minutes of the Crucifixion. The most ambitious of Day's entries in the 1898 show, *The Seven Last Words of Christ* drew both praise and criticism, and stimulated a heated debate on the nature of photographic art.

The maker of this controversial work had only recently achieved prominence in photography. A wealthy aesthete, Day had come to intellectual maturity in the late 1880s and early 1890s in a stimulating circle of artists, poets, designers, and bibliophiles. He operated a fine private press in Boston from 1893 to 1899 before turning his full attention to photography.[255] Day's essays and images began appearing in the photographic press in late 1897; his first major one-man exhibition—an enormous selection of some 250 prints—was presented at the Camera Club of New York in February 1898, and at the Boston Camera Club a month later. After this rapid rise to national prominence, Day embarked on what would be his most ambitious work in photography.

The controversy generated by *The Seven Last Words of Christ* was over Day's means, not his ends. In fact, his provocative work was a logical product of the late nineteenth century's fascination for sacred motifs. Day was one of the many thousands who witnessed the Passion Play at Oberammergau in 1890, and he carefully studied the treatment of sacred themes by the artists of his time. After the inclusion of Edouard Manet's *Dead Christ with Thorns* in the Paris Salon of 1864, painters in both Europe and America had taken a new interest in biblical subjects.[256] Remarkably, such themes accounted for nearly half the historical and literary works submitted to the Paris salons by American painters of the late nineteenth century.[257] By the mid-1890s, a few American photographers had also taken up sacred themes. The first of these seems to have been H. W. Minns of New London, Ohio, who gained "a great deal of notoriety" for his 1894 photographs of a friend posed as Christ.[258] Later, John E. Dumont of Rochester, New York, exhibited a work titled *Dead Christ and Weeping Magdalen* in the 1898 National Academy of Design exhibition. As noted above, Käsebier's *The Manger* was a highlight of the 1899 Philadelphia Salon.

While such themes were standard artistic fare in this era, controversy arose when the results seemed more real than ideal. For

43 Edmund Stirling, *Bad News*, ca. 1901, gravure, 5½ x 4⅛″

example, Thomas Eakins's 1880 painting *The Crucifixion* was shocking to viewers precisely because it conveyed "as an actual event" the physical pain of Christ's death.[259] Works such as this prompted a critic in 1901 to note the "singular phenomenon of men who are at one and the same time mystics and realists; men who attempt the daring experiment of endeavoring to express the supernatural by the natural."[260] The camera's inherent realism guaranteed that the photographic interpretation of historical or ideal subjects would always be open to criticism.[261] Painters were able to invent a past of perfect narrative and aesthetic unity; photographers could only record real people in the present. As a result, photographs of "historical" subjects inevitably presented less-than-convincing costumed models in awkwardly theatrical poses. Depicting the Crucifixion, the most hallowed of all Christian subjects, only magnified this problem. It was reported, for example, that the citizens of Mr. Minns's community were "inexpressibly shocked that any human being, especially one of their neighbors, should have posed for so sacred a subject." Minns's model, a free-thinking ("somewhat eccentric") young school teacher, responded to this criticism by noting the "admiration and pleasure" accorded such subjects in the work of the great masters. "What," he asked defiantly, if somewhat naively, "is the difference between posing for a photograph and posing for a painting?"[262]

It was in this context that Day's interest in sacred subjects came to fruition in the summer of 1898, when he staged his own Calvary on a hillside near his hometown.[263] Day himself was Christ; his friends portrayed soldiers and saints. Day went to great lengths to achieve historical accuracy: the design of the costumes was carefully researched and the cross and wooden nails were made by a Syrian carpenter. In addition, he let his hair grow and starved himself for months in order to convey the pained appearance of Christ. After photographing many figure groups outdoors, Day retired to the studio to produce *The Seven Last Words*. For these close-up self-portraits, Day rolled his head agonizingly from side to side to evoke the sublime sacrifice of the Passion. The seven images chosen for the final work were sequenced and mounted together in an elaborate architectural frame. Considering each image a finished work, Day also presented them singly [81]. He experimented with the mood of the pictures by processing some with a hand-applied glycerine developer. This technique produced unevenly vignetted prints, creating a more subjective and poetic effect than conventional processing.[264]

The display of these pictures in the fall of 1898 caused a critical furor. The art critic Sadakichi Hartmann, one of Day's most enthusiastic supporters, described this work as "full of delicacy, refinement, and subtlety, an art of deep thought and charm, [and] full of dreamy fascination."[265] But a less partisan critic probably captured the feeling of most viewers when he wrote "One hardly knows whether to admire the versatile ingenuity of Mr. F. H. Day or [to] condemn his utter want of good taste."[266] Art critic Charles H. Caffin, writing in *Harper's Weekly*, found Day's religious tableaux ambitious but "objectionable," and dismissed the entire Passion series with the pronouncement that "surely claptrap and misapprehension of the province and mission of art can go no further!"[267]

Archly self-conscious and outrageously contrived, *The Seven Last Words* is nonetheless a powerful and important work. The theme was old, but Day brought to it a new and almost vision-

45 **Dr. Charles L. Mitchell**, *A New England "North easter,"* ca. 1895, platinum print, 7¼ x 9¼"

ary intensity. This was the most adventurous artistic photography of the era, a daring attempt to prove that the medium was supple enough to do justice to the most awesome and elevated of subjects. Moreover, by casting himself as the Savior, Day immodestly suggested the role he might play in the hoped-for genesis of creative photography in America. By presenting himself as both artist and Christ, Day underscored the romantic faith that culture could be redeemed through the power of art.

One of the other most discussed works in the 1898 Philadelphia Salon was William A. Fraser's *A Wet Night, Columbus Circle* [82]. Praised by critics and general viewers alike, this was the largest and most powerful of Fraser's three nocturnal views in the exhibition.[268] While isolated experiments with night photography had been made in the 1880s, the earliest artistic bodies of night images were made by Paul Martin in London in 1895 and, soon after, by Stieglitz and Fraser in New York.[269] The timing of this work was in part a response to the beauty of electric lights, a relatively recent innovation that had transformed the look of the urban night. Fraser began his night work in January 1896, after reading Martin's articles on the subject in the *London Amateur Photographer*.[270] Between 1897 and 1899, Fraser received considerable acclaim for his pictures, which were exhibited widely—from London to Calcutta—in the form of lantern slides or (less commonly) as prints.[271]

While Fraser acknowledged the influence of Martin's work, and modestly disavowed any "claim to originality," his pictures were distinctly different from those of Martin and Stieglitz.[272] Fraser had begun by using Martin's technique of exposing the plate "a minute or two in the last departing daylight" and completing the exposure after full darkness had fallen. While this method assured that detail would be recorded in the darkest areas, it produced an artificial look and he soon rejected this trick in favor of true nighttime exposures. With this technique, Fraser found that exposure times of two-and-a-half to ten minutes sufficed, even when the only source of illumination was the full moon. During these exposures, he was careful to cover his lens whenever a lighted vehicle passed before him, and to hold the camera still in windy conditions. Fraser's preference for the effects

of snow or rain brought him out in the most unpleasant conditions and made him the object of "all sorts of chaff and uncomplimentary remarks" from friends and strangers alike.[273]

For the 1898 Philadelphia Salon, Fraser printed his three finest images as bromide enlargements, and *A Wet Night, Columbus Circle* was the centerpiece of this trio. *A Wet Night* was a technical tour de force: unusually large, beautifully atmospheric, and luminously detailed from shadows to highlights. In its rendition of moisture-laden air and wet, reflective streets, Fraser's work functioned as a photographic counterpart to Impressionist painting. Unlike Martin's photographs, which were criticized for their "somewhat hard and unatmospheric" crispness, Fraser's image was both purely photographic and delicately imprecise, leaving much to the imagination of viewers.[274] The majestic scale of this enlargement evoked an almost visceral feeling of time and place, engaging viewers much more powerfully than the smaller prints of Martin and Stieglitz. The broad appeal of Fraser's image stemmed from its masterful synthesis of a purely modern technique and subject with a poetic mood of dreamy subjectivity.

From this promising start in 1898, the Philadelphia Salon proceeded in subsequent years to mixed reviews, controversy, and collapse. The 1899 Salon, juried by photographers Gertrude Käsebier, Frances Benjamin Johnston, F. Holland Day, Clarence H. White, and Henry Troth, was generally hailed as a success. However, some grumbling arose over the decision to supplement the juried show with a group of unjuried works by the judges and other noted photographers. This perception of unfair treatment was not unfounded: at 168 prints, the invitational section was nearly as large as the juried group of 182 works. The 1900 Salon, judged by Stieglitz, Käsebier, White, Frank Eugene, and Eva Watson-Schütze [85], reduced the size of both the juried (118) and unjuried (86) sections to achieve a higher overall level of quality.

Not surprisingly, protests arose over the growing elitism of these exhibitions. Photographers with tastes more traditional—or simply more inclusive—than those of the organizers and jurors began to criticize the Salon's moody aestheticism. *Wilson's Photographic Magazine* reported that "the everlasting gray, and brown, and black" works gave the 1899 Salon a "sombre and depressing" tone. The protest against the predominance of "low-toned and dim impressionistic work" grew more forceful with the 1900 exhibition.[275] As the critic for *Photo-Era* noted:

> Over all there hung like a pall an air of gloom, of despondency, almost of decadence. There was a dreary monotony about the tier on tier of weak, fuzzy, washed-out looking photographs which listlessly stared at me from gloomy frames as only a weak, fuzzy, washed-out looking photograph can stare.[276]

In his dual position as president of the Philadelphia Photographic Society and the Salon's guiding force, Robert Redfield was pressured to broaden the scope of the exhibition. Conservative members of the society complained that the annual show represented a myopic perspective on the real achievements of modern photography. It was also clear that loyal society members were tired of regular rejection from their own salon. Dr. Charles L. Mitchell, a photochemist and avid amateur photographer, led the campaign against the salon in personal letters to Redfield and diatribes in the photographic press. Mitchell concluded a scathing review of the 1900 Salon with these words:

One cannot but feel strongly, in considering the class and the number of photographs exhibited, how narrow and limited is the field here represented. There is no architecture, but little landscape, very little *genre* work, no examples of the progress of photography in scientific application, no illustrative or decorative schemes, and mainly a collection of portrait studies—most of them bad. When photography is advancing by leaps and bounds as it is to-day, when its applications in medicine, in science, in newspaper and periodical illustration, in color work, etc., etc., is being daily extended and made more universal, it seems short sighted to confine an exhibition of photographs to the products of the disciples of one narrow, limited, and rather egotistical school. A more broad and catholic view should be taken of the matter. Let our friends of the "stained glass attitude" school of photography show their efforts, if they want to; they will at least serve to turn a merry jest and lend variety to the exhibition. But extend its scope, let all other methods of photographic expression be also given a showing, and let the walls of the Pennsylvania Academy of Fine Arts be lined with the latest and most interesting developments of photography in all its phases. It is time that there should be more variety in photographic exhibitions, and there is no organization better qualified, on account of its age, its experience, its conservative character, and its recognized high standard of work, to inaugurate such a movement than the Photographic Society of Philadelphia. But at the present time, there is getting to be too much "Bunthorne and the Lily" business about photographic salons. There is too much sentiment, too many "twenty love sick maidens" hanging on the accents of a few photographic Oscar Wildes and imitating their productions. There are too many "impressions" and too few clearly conceived, thoroughly expressed realities; too few real pictures, and too much "trash."[277]

The tone and specific terms of Mitchell's comments are revealing. Two "modern" artistic ideologies were in collision: "art-for-art's-sake" and, for lack of a better term, progressive realism. The former was characterized by optical imprecision and a poetic mood of delicacy, introspection, and dream. To its opponents, this aesthetic was associated with decadence, degeneration, sickness, and effeminacy.[278] By contrast, critics such as Mitchell advocated a more "masculine" art of objectivity, vitality, optimism, and health—an art devoted to the wonder of the world rather than the shadowy recesses of the mind.[279] Mitchell's own photographs exemplify this vision [45]. Like the painter Winslow Homer, Mitchell was drawn to the elemental aspects of nature: the sublime power of the roiling sea, the awesome rhythms of climate and season. This artistic debate was not simply about "style"; it reflected fundamentally different visions of reality.

The issue came to a head a few months later when Redfield declined to run for reelection as president. This opened the way for Mitchell, who lobbied hard among society members for his own candidate. To nearly everyone's surprise, Mitchell's faction won. In retaliation, the society's 1901 Salon was boycotted by the Stieglitz circle and most other leading international photographers. Stieglitz and Käsebier resigned their honorary memberships in the society, and Bullock and Redfield quit the board of directors. The Philadelphia Photographic Salon came to a sad end with the failure of the 1902 exhibition.[280]

This backlash against the photographic aesthetes was not limited to Philadelphia. At precisely this time, Stieglitz found himself under mounting pressure from the Camera Club of New York to make *Camera Notes* more relevant to its members. Anticipating his rupture with the Camera Club, Stieglitz organized

an exhibition in early 1902 for the National Arts Club titled "American Pictorial Photography Arranged by the 'Photo-Secession.'" (The use of this term reveals Stieglitz's debt to the Munich Secession, a movement widely understood as a revolt by younger, progressive artists against the strictures of a conservative art establishment.[281]) What began simply as a concept—a statement of rebellion and rebirth—soon became a reality. Inspired by the Linked Ring, and other progressive European artistic groups, Stieglitz gathered around himself an elite association of photographers under the banner of the "Photo-Secession." By the time his last issue of *Camera Notes* appeared, dated July 1902, Stieglitz was well along in planning a new and fully independent journal titled *Camera Work*. Together, the Photo-Secession and *Camera Work* would constitute potent weapons in the increasingly heated battle to define the art of photography in America.

The "Old" and "New" Schools of Photography

The ruptures that divided American photography in 1902 were the result of forces that had been building for years. The tensions between the science and aesthetics of photography, and the medium's various roles as profession, amusement, and artistic calling, had long been apparent. Many turn-of-the-century observers, including Dr. Mitchell, felt that photography's importance stemmed largely from the breadth of its applications in modern life. For them, the value of the process lay in both its social utility and its expressive potential. Art photographers, however, felt compelled to separate their activity from this spectrum of mundane uses, and to view their results as intrinsically superior to both the professional's and the Kodaker's. Precisely because the camera was common to all these applications, artists felt obligated to denigrate the "merely photographic" in favor of more idealized expressions. If the casual images of the Kodaker were somehow analogous to slang, and the pictures of the commercial photographer akin to flatly descriptive prose, art photographers sought the equivalent of poetry.

By the turn of the century, photography had created a universe of unusual, stimulating, and memorable images. These varied pictures—made in the name of science, journalism, commerce, art, and personal remembrance—defined the medium's full range of expressive possibilities. Published in a wide variety of photographic and general-interest publications, and collected in family albums, these pictures shaped the public's understanding of the medium as a uniquely versatile and modern technology.

Of course, no one saw equal value in all this work. Significantly, however, it was the most "progressive" photographic faction that distanced itself most vehemently from this unruly cacophony of images. With few exceptions, art photographers of the era studiously avoided incorporating any trace of the mechanical, utilitarian, or amusing in their work. While a handful of photographers and critics protested this aesthetic orthodoxy, they had little effect. For example, when a group of unconventional photographs was included in the 1904 members' show of the Camera Club of New York, they were widely regarded as a joke. However, these images—which would have fit comfortably into avant-garde exhibitions a quarter-century later—were vigorously defended by Sadakichi Hartmann:

A shocking and yet not entirely unpleasant note is struck by J. Oscoe Chase. He seems to strive for the most unconventional effects. He is interested in freaks of nature, "Luna Park at Night," and weird electrical light effects. He even tries to falsify nature. In his "Nocturne," for instance, he makes a sail (placed plumb in the center of the picture just beneath the rising moon) whiter than the sky, which is contrary to all natural laws. His "Madison Square at Night," is, despite all laughter and criticism it arouses, quite a creditable performance. I admire the way in which he has ignored all rules of composition. It is a fragment of uncouth realism which stands and falls on its own merit, and I am not ashamed to say that I wish more of this kind were done. Not for its pictorial value, but rather for its non-pictorial value, its lawlessness. Understand me right, I would like to launch the question why a photograph must always conform to artistic canons? Why should it not suffice to represent a bare fact as this or that individual eye sees it, without any obedience to conventional pictorialism?[282]

Hartmann's subsequent "Plea for Straight Photography" (the title of an important 1904 essay) was similarly prescient.

It would take some time, however, for photographers to accept that their art could be based on exploiting, rather than subverting, the medium's intrinsic optical and mechanical traits. As Hartmann observed in 1910, "In photography, pictorial expression has become infinitely vast and varied, popular, vulgar, common and yet unforeseen; it is crowded with lawlessness, imperfection and failure, but at the same time offers a singular richness in startling individual observation and sentiments of many kinds."[283] Leading photographic artists felt compelled to reject such "uncouth" and "lawless" work because it flaunted its mechanical origins. This defensiveness was a response to the most familiar and enduring criticism of the medium's claims to art. This criticism was expressed bluntly by the artist J. Pennell in 1891:

Photography is not a fine art, and never can be. The photographer is not an artist. He uses an unintelligent machine to obtain results which depend for their artistic value upon the most sensitive human intelligence and the most highly developed technical ability. The photographer, merely by calling himself one, cannot become an artist, when he has not the artistic temperament and lacks the patience to acquire the technical ability. The so-called photographer endeavors to produce by machinery what the true art worker produces by skilled handicraft. The nearer a machine-made photograph seeks to approach artistically produced art, the more glaring are its defects and the more evident its shortcomings. Photography has become the resort of people who imagine that by pointing a machine at nature they can produce a picture.[284]

Repeated endlessly, this argument stung photographers deeply, in part because nearly all of them accepted its essential truth. It was to counter this argument, then, that they sought to subvert the inherently mechanical nature of their medium, and thus prove the depth of their artistic "temperament."

As advanced photographers on both sides of the Atlantic began manipulating the medium to more subjective and expressive ends, a schism developed between the "old" and "new" schools of photography. These terms were in common use as early as 1892, when Frank Sutcliffe wrote, "There has been, as you all know, a lot of strife between what has been called the old school and the new, or the sharp and the unsharpened."[285] Champions of the new, impressionistic style dismissed the old devotion to technical precision and overall sharpness as hopelessly inartistic,

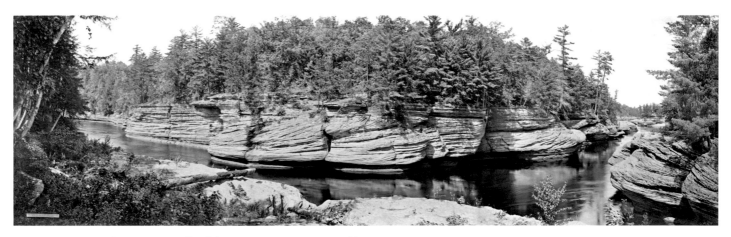

46 H. H. Bennett, *The Narrows, Dells of the Wisconsin*, 1900, 17 x 57⅛″

a method of looking at nature that is false and vicious, except for scientific purposes. Now it is no longer the photograph full of detail, sharp in outline, technically perfect, that pleases. What is aimed at is breadth of effect, the subordination of detail to the point where the picture represents the landscape as the artistic eye would see it, the preservation of atmosphere, and the avoidance of everything that is hard, unsympathetic, or destructive of the unity of the subject.[286]

These "new school" photographers sought to unite the powers of lens and mind to create images filled with poetic suggestion. At the heart of this attitude was the powerful idea that Emile Zola had so succinctly expressed in his aphorism "Art is nature seen through a temperament." The subjectivity of the artist became all-important, and photographs were understood to be art only to the degree that they revealed "the impress of the mind."[287] In Sutcliffe's memorable phrase: "A photograph gives us the naked truth, which has to be clothed by the imagination."[288]

The "old school" approach was best demonstrated in the work of the leading commercial photographers. For example, Charles D. Arnold's mammoth-plate views of the 1893 Columbian Exposition [71, 72] were meticulously crafted and minutely detailed, representing an art of majestic clarity. The remarkable technical skill of professionals of this era is also seen in the panoramic landscapes of William Henry Jackson and H. H. Bennett. Bennett's *The Narrows, Dells of the Wisconsin*, 1900 [46], for example, was printed from three mammoth-plate negatives. Through careful blending of the areas of overlap between these separate images, Bennett rendered a fully convincing, continuous scene on a single (58-inch-wide) sheet of photographic paper.[289]

William H. Rau possessed equally astounding technical abilities. A respected professional and veteran member of the Photographic Society of Philadelphia, Rau was a photographer of great sophistication. He was one of the few professionals to play a leading role in an important amateur society, an activity that underscored his interest in aesthetic issues. In his professional work, Rau was best known for his mammoth-plate railroad photographs. In 1895, after at least five years experience in this work, Rau was appointed official photographer of the Lehigh Valley Railroad.[290] In this capacity, he documented the landscape along the Lehigh Valley's line, from New York City through Pennsylvania to upstate New York. He traveled this route in a lavishly equipped passenger car, complete with a darkroom, parlor, and a roof-mounted camera platform.

Working with a large 18 x 22-inch camera, Rau produced an extensive series of images that combine familiar conventions of nineteenth-century landscape art with a boldly modern sensibility. Rau's characteristically elevated vantage point imbues his photographs with a sense of mastery and confidence that suggests his era's positivistic faith in both technology and Manifest Destiny.[291] His pictures offer a provocative blend of picturesque nostalgia and technical sophistication, of bucolic tranquillity and the irresistible dynamism of progress. These contrasts had long symbolized something essential in American culture. As early as 1820, for example, Washington Irving's "The Legend of Sleepy Hollow" celebrated the importance of the "peaceful spot" in bustling, ever-changing America. Irving observed that

> it is in such little retired…valleys…that population, manners, and customs, remain fixed; while the great torrent of migration and improvement, which is making such incessant change in other parts of this restless country, sweeps by them unobserved. They are little nooks of still water which border a rapid stream.[292]

Rau's *York Narrows, on the Susquehanna, Lehigh Valley Railroad* [73] contains a dual focus on both "the great torrent" of cultural change and (quite literally) the "little nooks of still water" symbolic of a calmer, simpler era. His monumental picture reveals quiet details along the railroad with greater precision than actual observation from a moving train would have allowed. As Rau himself stated, his goal was "choice picture finds showing that which the regular traveler flying by on a fast express cannot see."[293] While this attitude suggests a nostalgia for the slower pace of an earlier era, Rau's vision was firmly progressive. His evocation of the machine in the Edenic "garden" of the American landscape is ultimately one of optimism and rationality, a celebration of the triumph of technology over the barriers of time and space.[294]

Rau succeeded in his attempt to make "views of surpassing beauty" that also satisfied the promotional interests of his sponsor. Lehigh Valley Railroad officials were certainly pleased, since they framed over 200 of his photographs for placement in terminals and other public buildings along their route.[295] Rau's reaction to a display of railroad pictures at the 1876 Centennial describes the impact of his own images: "The photographs conveyed and revealed much better than guidebooks or conversation possibly could, the territory of wealth and beauty" that was opened to human use by the "iron bands" of the railroad.[296]

47 John G. Bullock, *Study of a Birch Tree*, ca. 1895-1900, platinum print, 7⅞ x 5⅞"

The large size and crystalline clarity of Rau's pictures distinguished them from the great majority of works shown in the photographic salons. Rau's vision—like that of his peers Arnold and Bennett—rested on a massive accumulation, rather than a suppression, of information. The most avant-garde critics of the period considered these pictures old-fashioned, painfully precise, and woefully lacking in idealizing sentiment. To us today, however, these "failings" constitute modernist virtues. For us, the strength of Rau's work stems from his use of the vocabulary of the picturesque to record a resolutely modern subject: the impact of technology on the landscape. His photographs convey a fundamental tension between idealized notions of the American landscape and the transformations wrought by industrial culture.[297]

In contrast to Rau's unashamedly commercial aesthetic, the vision of Robert Redfield, a close friend and associate of Rau's, characterizes that of the artistic gentleman-amateur of the period. Unlike Rau's large albumen prints, Redfield's more intimate views were most often printed in platinum. Redfield's work represents one of the most refined expressions of the naturalistic aesthetic of the late 1880s and 1890s. His pastoral views of village life in New England and Pennsylvania evoke an agrarian past removed from the complications of modern life. Redfield allowed his viewers imaginative entry into his pictures by presenting scenes rich in narrative appeal. For example, *Near Lake Waramaug* [74] depicts a young man arriving to meet a friend for a picnic. By choosing to represent this moment of the familiar courtship-leisure theme, Redfield allows viewers to imagine their own version of a perfect Sunday afternoon outing. The picnic was an

important motif in nineteenth-century art, suggesting a longing for intimacy with nature and the therapeutic value of rural sojourns.[298] Redfield was highly regarded for gently bucolic works such as this, and won numerous awards in the U.S. and abroad.[299]

John G. Bullock, a close associate of both Rau and Redfield, began working in photography in the early 1880s. He assisted Redfield in organizing the exhibitions directed by the Photographic Society of Philadelphia from 1886 to 1900, and his work was similar to his friend's in both subject and style. However, *Study of a Birch Tree* [47], which probably dates from the late 1890s, suggests the influence of "new school" thinking on Bullock's inherently conservative aesthetic. More restricted in viewpoint than his earlier pictures, this image uses a shallow and "impressionistic" focus to transform the forested background into a gently modulated tonal screen. The result is a distinctly abstract, two-dimensional rendering of a seemingly familiar subject.

Selective focus in landscape work was probably used more astutely by William B. Post than by any other American photographer of the era. Post, a respected member of the Camera Club of New York, began exhibiting his photographs in about 1893. While he worked with a variety of subjects, he was most highly praised for his water [29] and snow scenes.[300] Of the latter, *Intervale, Winter* [84] was his acknowledged masterpiece. In this image, Post used an exquisitely delicate tonal scale to sketch the outlines of pictorial space. Characteristically, he focused his camera on seemingly minor foreground elements while carefully controlling the degree of softness throughout the rest of the picture. The result is surprisingly complex, as the viewer's attention is drawn almost equally to the small but crisply rendered weeds in the lower left, and to the expansive, subtly modulated landscape beyond. Sadakichi Hartmann quite properly praised Post's "elegance and grace," his frequently "astonishing" simplicity, and his unparalleled ability to render the "delicacy and luminosity of daylight."[301]

An extreme "new school" approach to landscape is seen in the work of photographers such as Edward Steichen and Ema Spencer. Steichen's earliest mature works include forest scenes made at twilight or by the light of the moon. These prints use the lowest register of the tonal scale to evoke a sense of dreamy subjectivity, and to suggest the deepest mysteries of art and life. As Charles Caffin noted in an essay on Steichen's work:

> The lover of nature can never be satisfied with a mere record of the physical facts; to him there is, as it were, a soul within them, and he looks in pictures for its interpretation. It would not be far wrong to say that landscape art is the real religious art of the present age.[302]

While Spencer's work [83] retains elements of an earlier, picturesque naturalism, it too suppresses specific details in order to create an impression, rather than a description, of reality.

In portraiture, the "old school" style was exemplified by the work of Benjamin J. Falk.[303] Falk, who began his professional career in the late 1870s, was a pioneer in several areas, including photographing by artificial light, copyright protection, and color photography.[304] Along with Matthew J. Steffens in Chicago, and J. C. Strauss in St. Louis, Falk was revered as a leader in professional photographic portraiture in America. His luxurious studio, for many years on the fifteenth floor of New York's Waldorf-Astoria Hotel, was a city landmark.[305] Falk's portraits were widely praised as the epitome of the straightforward approach,

"unmarked by peculiarity in handling," producing a result "which is plainly a photograph, not an imitation or simulation of something else."[306] Despite his disinterest in theory (he once said, "All I try for is a good, satisfactory likeness, a pleasing effect, well posed and well lighted"), Falk's style was sophisticated and deliberate.[307] His portrait of Thomas Edison [48], one of the most famous symbols of American ingenuity and success, blends a feeling of relaxed intimacy with a larger-than-life heroicness.[308] Edison's pose is elegantly casual, his bearing modest and dignified. The clarity and subtlety of the inventor's mind is suggested by the somber richness of the image itself, a quality enhanced by the velvety tones of the platinum paper on which it is printed.

By contrast, Gertrude Käsebier's portrait of Auguste Rodin [90] exemplifies the subjectivity of "new school" portraiture.[309] This image, printed on tissue in gum bichromate, paradoxically combines a sense of both gravity and ephemerality. Rodin's substantial form fills the frame and yet is largely dematerialized by Käsebier's soft-focus, high-key rendering, and by the rippled, translucent surface of the tissue support. Rather than meticulously recording the details of his appearance, Käsebier sought instead to evoke Rodin's aura as a creative force. Rodin's inner depth is emphasized by his turned head and downcast eyes. Käsebier felt that "the full-face is the attitude a man shows to the world. He purposely keeps it inscrutable, and by long habit prevents it from revealing his true character."[310] She thus sought a pose that suggested poetic self-absorption rather than the polite, practiced artifice of one's "public" face.

48 Benjamin J. Falk, *Thomas A. Edison*, ca. 1905, platinum print, 9¼ x 6⅞"

The Logic of Pictorialism

The so-called "new school" of photography became what is now known as Pictorialism. The words "Pictorial" and "Pictorialist" had been in use since at least 1869, the publication date of H. P. Robinson's influential book *Pictorial Effect in Photography*. By the turn of the century, the word had come to describe the most advanced and self-consciously artistic photography of the day. Pictorialist works have a number of characteristic traits, including muted focus, a limited tonal range, and the use of printmaking techniques other than the common gelatin silver process. While reasonably diverse in subject matter, the majority of Pictorialist photographs were portraits, landscapes, domestic scenes, and allegorical studies. These subjects were presented in simplified and idealized ways, with great attention given to the subtleties of light and atmosphere.

Pictorialist photographs carried deeper meaning than is now generally acknowledged. In truth, Pictorialism has been something of an embarrassment to later generations of photographic modernists. Even appreciative critics, who applaud the beauty of these images, tend to consider the movement as a whole intellectually shallow. At its least sympathetic, modernist criticism has judged Pictorialism to be wrong-headed and retrograde, a willful violation of the medium's essential nature and shamelessly imitative of second-rate painting. For such critics, the Pictorialist era represents a futile—if mercifully temporary—deviation from the historical path of "real" photography.

In fact, Pictorialism was an eminently logical—and inevitable—expression of its time. As the first clearly articulated international movement in art photography, it dominated the stylistic vocabulary of the first two decades of the new century. This dominance stemmed from Pictorialism's curiously dialectical nature: it both embodied the values of the early modern era and posed a critique of them. As an uneasy union of Victorian and modern ideas—a paradoxical kind of "genteel avant-garde"—Pictorialism both exemplifies and reveals the conflicted intellectual currents of its age.

It is appropriate that the examples of "old-" and "new-school" portraiture discussed above depict, respectively, an inventor and an artist. Central to the ideology of the turn-of-the-century avant-garde was an antimodernist reaction against the mechanistic and materialistic nature of contemporary life. The scientific, industrial, and bureaucratic modern age was considered by many to be overcivilized, unreal, and devoid of sustaining values. A pervasive sense of "spiritual homelessness" stimulated in these late Victorians a profound yearning for a more intense and "real" emotional life.[311] They sought a new state of psychic harmony in the reawakening of a "primal authenticity of thought, feeling, and action," and in the rediscovery of age-old mysteries.[312] Central to this quest was an emphasis on the intuition and imagination of the artist over the rational and analytical mindset of the engineer or businessman.

The roots of this fundamentally mystical aesthetic lay in the Romantic movement of the late eighteenth and early nineteenth centuries. Romanticism had many strains and permutations, as seen in the varied works of Jean-Jacques Rousseau, Johann W. von Goethe, Samuel Taylor Coleridge, Lord Byron, Percy Bysshe Shelley, and others. At its core, Romanticism sought

the reenchantment of the world, a restoration of the mystery and wonder of existence that the Enlightenment's rationalism had stripped away. The Romantic aesthetic centered on a sense of indefinite longing, an obsession with the deepest reaches of sensation and feeling, a fascination for the infinite, a yearning for the innocence of the child or the "primitive," and a celebration of the powers of intuition and imagination. This attitude produced an intense preoccupation with the self; indeed, it represented the birth of a truly modern sense of self-consciousness.[313]

The Romantics revered the achievements of poets, musicians, and artists, and gave the notion of individual genius an almost sacred status. These creators exemplified the Romantic ideal by melding their inner and outer "worlds," the realms of idea and of fact. In 1810, the visionary artist William Blake wrote that the "world of Imagination is the world of Eternity," and that "Mental Things alone are Real."[314] For poet and critic Samuel Taylor Coleridge, writing in 1817, art represented "the power of humanizing nature, of infusing the thoughts and passions of man into everything which is the object of his contemplation."[315] In his prose and poetry of the 1850s and 1860s, Charles Baudelaire celebrated a state of hyperperception in which the things of the world resonated with larger meanings and unexpected correspondences. In this poetic realm, the world was a magical "forest of symbols" in which "perfumes, sounds, and colours answer each to each" in an ecstatic union of thought and sensation.[316] In the later nineteenth century, this aesthetic was further developed by Symbolist writers such as Stéphane Mallarmé, Paul Valéry, and Maurice Maeterlinck, and the painters Paul Gauguin, Gustave Moreau, and Odilon Redon.

Common to all this work was the idea of poetic indeterminacy: a mystical synthesis of reality and imagination, a blurring of contours and contrasts. As Mallarmé wrote, "It is not *description* which can unveil the efficacy and beauty of [the world], but rather evocation, *allusion, suggestion*."[317] For Oscar Wilde, art was "a veil, rather than a mirror," whose proper function was "lying, the telling of beautiful untrue things."[318] By the early 1890s, Symbolist ideas such as these had spread from an initially small group of radical writers and artists to a much broader international audience.[319]

Symbolist art reflected a desire for imaginative escape from the banalities of everyday life. As Wilde proclaimed:

> Modernity of form and modernity of subject-matter are entirely and absolutely wrong. We have mistaken the common livery of the age for the vesture of the Muses, and spend our days in the sordid streets and hideous suburbs of our vile cities when we should be out on the hillside with Apollo.[320]

In contrast to the "vile" city, nature was depicted as a luminous realm of mystery and grace. Similarly, the child and the "primitive" were celebrated for qualities that "civilized" adults were presumed to have lost: innocence, psychic wholeness, and a capacity for wonder. Oriental and medieval cultures held a related allure for Symbolist poets and artists. As the historian Jackson Lears has written, "Pale innocence, fierce conviction, physical and emotional vitality, playfulness and spontaneity, an ability to cultivate fantastic or dreamlike states of awareness, an intense otherworldly aestheticism: those were medieval traits perceived by late Victorians and embodied in a variety of dramatis personae," including peasants, saints, seers, and mystics.[321]

It was not only disaffected intellectuals and artists who sought a symbolic escape from the present; this desire permeated popular culture.[322] Maxfield Parrish's radiantly idealized advertising art used generic images of premodern grace and innocence—paradoxically, it would seem—to promote an array of modern consumer goods. Similarly, the popular literature of the period 1890 to 1915 included an outpouring of utopian novels, works of science fiction, and romances set in exotic locales.[323] In the latter category, one of the most popular novels of the era was Robert Hichens's *The Garden of Allah* (1904), which went through forty-four editions in the next forty years, and made the English-born author an American celebrity. As historian William Leach notes succinctly, this volume

> expresses European disenchantment with rational civilization, with conventional order and behavior. It seems to make a plea for emancipation from repression and for what Hichens called "new life" in touch with "animal" passions. In one form or another, the book was written over and over in this period by both men and women.[324]

Charles Wagner's book *The Simple Life* (1901) was also immensely popular. Wagner's plea for serenity and simplicity struck a powerful chord in Americans fearful of the complexities and relentless pace of modern life.[325]

Equally representative of the mood of this era was the "mind-cure" movement, a variety of spiritual sects and philosophies based on a shared faith in the transformative power of the mind. These beliefs, which grew out of the religious turmoil of the 1870s and 1880s, reflected a deep desire for authentic spiritual life in the modern, scientific age. Reaching beyond the teachings of established churches, these movements embraced aspects of pagan thought and of world religions such as Buddhism and Hinduism. At root, the mind-cure mentality "was wish-oriented, optimistic, sunny, the epitome of cheer and self-confidence, completely lacking in anything resembling a tragic view of life."[326] This idealistic mood of perfection and grace characterizes much classic Pictorialist image-making.

A number of scholars and philosophers also made important contributions to this cultural mindset. Sir James G. Frazer's book *The Golden Bough* (1890) highlighted the importance of myth, ritual, and magic in shaping collective memory and belief. In his books *Principles of Psychology* (1890) and *The Varieties of Religious Experience* (1902), the great American philosopher William James proposed new ways of thinking about both the mind and reality. Using the metaphor of a "stream of consciousness," James suggested the essential fluidity and subjectivity of experience, the blurring together of subject and object. The related ideas of the French philosopher Henri Bergson had an enormous impact in America. In his books *Matter and Memory* (1896) and *An Introduction to Metaphysics* (1903), Bergson described reality as an endless stream of "becoming" in which all things were related. For Bergson, rationality was a kind of dream, with intuition the source of true understanding. Such ideas are evoked in the optical softness and dreamy mood of Pictorialist images.

The quietude of classic Pictorialist photography represented a healing antidote to the frenetic pace of modern life. This was the age of "neurasthenia," the enervating neurotic malady described in George Miller Beard's book *American Nervousness* (1880). According to Beard, America was the most nervous coun-

try on earth because it was the most modern: the one most characterized by brashness, speed, and congestion. This condition extended to all facets of existence, including the average citizen's visual life. The rise of modern advertising resulted in a cacophony of images: more and larger ads in newspapers, seductive shop window displays, hectoring billboards, and blinking electric signs (as early as 1900, Madison Square was home to a garish, forty-five-foot Heinz pickle in glowing green bulbs).[327] Motion pictures began as a commercial enterprise in 1896, and within a short time movie houses across the country were showing a seemingly endless variety of films. If billboards, flickering electric signs, and hyperkinetic moving pictures were the paradigms of modern visual experience, the serenity and delicacy of Pictorialist photographs did, indeed, suggest another world. However, as a fundamental aspect of the turn-of-the-century imagination, this other world remained an intrinsically modern one.

The Arts and Crafts Influence

The antimodernist rebellion was also expressed in the Arts and Crafts revival. This movement, which grew from the ideas of John Ruskin and William Morris in England, stressed the dignity of preindustrial labor, the beauty of fine materials, and the spiritual importance of the simple life. Both a philosophy and a crusade, Arts and Crafts sought to reinstate the importance of art in everyday life, to humanize industry, and to bring modern man closer to nature.[328] The champions of this idea sought to unite beauty and utility in the design and manufacture of furniture, books, textiles, glass, and other objects. The exquisite limited-edition books produced by F. Holland Day's publishing house exemplify the ideals and refined aestheticism of this approach.[329]

This reverence for the beautifully crafted object is reflected in the care taken by Pictorialist photographers in making and reproducing their prints. The leading artist-photographers of the day used a variety of relatively uncommon processes to emphasize the expressiveness—and seductive object-quality—of each print. For example, in his 1899 retrospective at the Camera Club of New York, Stieglitz included prints made by five processes: platinum, photogravure, carbon, gum bichromate, and platinum-toned gelatin silver. While Stieglitz subsequently reduced his repertoire of processes, many others continued to employ a wide range of printmaking techniques. At a time when automatic printing machines could produce up to 245 cabinet photographs each minute, such labor-intensive approaches clearly emphasized the importance of the artist's mind and hand.[330]

Platinum was, by far, the Pictorialist's favorite printing material. Patented in 1873, the platinum print was in widespread use by the late 1880s. While the other standard printing papers of this era—the venerable albumen print and the newer gelatin silver processes—produced relatively glossy images, the platinum print had a velvety matte surface and yielded exquisitely delicate tones. In 1892, Alfred Stieglitz proclaimed platinum "the prince of all photographic printing methods."[331] Twenty years later, another writer clearly described the artistic appeal of the process:

> A platinum picture has a character of its own. No one can mistake it for anything but a photographic picture. A properly rendered platinum picture sums up the whole case for photography to be considered as an art. By no other process can the delicate

merging half-tones, the fine values, the transparency of shadows with shadow detail, the charming softness of pigmentary deposit, be so well rendered.[332]

A similar concern for physical beauty and expressiveness was given to the reproductions in the most elite photographic journals. Over the course of its existence, for example, Stieglitz's *Camera Work* used "straight photogravure,...mezzotint photogravure, duogravures, one-colour halftone, duplex halftones, four-colour halftones, and collotypes" for its illustrations.[333] Just as the halftone was becoming established as the cheapest and most practical mode of photographic reproduction, art photographers deliberately turned to the most difficult and beautiful processes. Photogravure was used for the featured illustrations of both *Camera Notes* (1897-1903) and *Camera Work* (1903-1917).[334] The process was also used by Stieglitz and others of his circle to make prints for exhibition. This dual application of gravure—as a means of original artistic expression and of reproduction—effectively gave the tipped-in plates of *Camera Notes* and *Camera Work* the status of multiple originals. As historian Estelle Jussim has noted, the process offered "snob appeal to the *cognoscenti*."

> Photogravures did not in the least resemble the popular silver chloride prints; gravures rather recalled the richness of mezzotints, the jet-black inks of lithography, the delicacy and fine lines of etching, the decorative capabilities of aquatint.[335]

Indeed, photogravure was a slow and technical process, with far more similarity to the making of etchings than halftones.[336] In the handcrafted elegance of their printing and design, *Camera Notes* and *Camera Work* exemplified the ideals of the Arts and Crafts movement.

The Arts and Crafts philosophy rested on a belief in the ultimate unity of art and life. The artistic photographer was expected to visit museums regularly in order to study great pictures. In addition, as J. Craig Annan advocated, "We must endeavor to surround ourselves in the rooms in which we chiefly live with the most beautiful objects which we can procure, and, what is equally important, we must exclude everything from our immediate surroundings which is antagonistic to beauty."[337] The photography of interiors, which was particularly popular in the 1890s, served to demonstrate the aesthetic judgment of both camera operator and home owner.

Arts and Crafts photographers devoted considerable attention to nature. In the first years of the century, for example, Rudolf Eickemeyer and Sadakichi Hartmann collaborated on photo-illustrated nature essays with titles such as "A Winter Ramble," "The Camera in the Country Lane," and "A Reverie at the Sea-Shore." Hartmann also wrote the introduction for Eickemeyer's 1903 volume *Winter*.[338] Similar photographically illustrated texts of the period include *A Journey to Nature* (1902), a series of essays accompanied by bucolic images by the Philadelphia photographer Henry Troth.[339]

Edwin Hale Lincoln focused lovingly on the details of nature, becoming the most celebrated recorder of flowers.[340] He was best known for his photographic survey *Wild Flowers of New England*, self-published in 1910-14 as a series of 400 platinum prints.[341] These flawless images, which combine a botanist's descriptive precision with an artist's sense of composition [49], suggest an aesthetic midway between the Victorian naturalism of

49 Edwin Hale Lincoln, *Stone Clover*, 1906, platinum print, 9⅜ x 7⅞"

John Ruskin and the modernist purism of Edward Weston. In this same period, the Chicago printmaker Bertha E. Jaques, a member of the Wild Flower Preservation Society, created over 1,000 cyanotype photograms of botanical specimens [50]. While often made as studies for her etchings, Jaques's photograms were exhibited as independent works of art, at the Art Institute of Chicago and elsewhere. These elegant shadow-images, made without a camera by placing the plant specimens directly on sensitized paper, exist at the juncture of the documentary and the abstract. They also serve to remind us of the photogram's lengthy vernacular history, which preceded the "discovery" of the process by the artistic avant-garde of the 1920s.

Wilson Alwyn Bentley, the "Snowflake Man" of Jericho, Vermont, was among the most dedicated of these photographer-naturalists. A farmer by trade, Bentley devoted his free time in the winter to making photomicrographs of snowflakes [51]. During the remainder of the year he recorded raindrops, frost, and dew. Bentley's fascination with "the fairy-like creations of crystaldom" began in 1885 and continued until his death forty-six years later.[342] Bentley's work became widely known through his public lectures, the sale of lantern slides of his best subjects, and, beginning in 1898, his many articles in the popular and photographic press.[343] In all this work, Bentley celebrated the beauty and infinite variety of snowflakes as a reminder of nature's inexhaustible wonder.

The Pictorialist, Symbolist, and Arts and Crafts aesthetics were all influenced by *japonisme*. This turn-of-the-century rage for all things Japanese inspired in the leading photographers an appreciation for restraint, asymmetrical compositions, and pic-

50 Bertha E. Jaques, *Goldenrod, Gone to Seed*, ca. 1906-08, cyanotype, 14½ x 5"

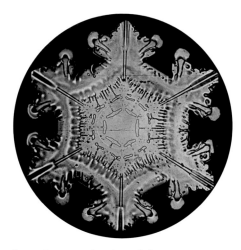

51 Wilson Alwyn Bentley, *Snowflake*, ca. 1923-24, 3″ dia.

torial flatness. American artists admired the sense of perfect placement embodied in the exquisite simplicity of Japanese gardens (first seen in this country at the 1876 Philadelphia Centennial), and the fact that the Japanese made no distinction between artist and artisan.[344] Japanese art was the subject of numerous articles in the photographic press, lantern-slide lectures at camera clubs, and even an occasional exhibition in photography galleries.[345] In addition, as a major influence on such noted Western painters as James McNeill Whistler, the Japanese aesthetic had an enormous second-generation impact on turn-of-the-century artistic thinking.

Arthur Wesley Dow was one of the most influential proponents of this aesthetic. A curator of Japanese art at the Boston Museum of Fine Arts and an important teacher and writer, Dow was also an accomplished amateur photographer [52]. His images embody the essence of his teachings on art; they unite direct perception of the world with an understanding of the graphic architecture of picture-making.

Dow did much to weave aspects of the Japanese aesthetic into the American artistic mainstream. His book *Composition*, which went through twenty editions after its initial publication in 1899, was immediately adopted as a basic text by Pictorialist photographers. *Composition* promoted the Japanese idea of *notan*: the graceful orchestration of shapes and tones within the confines of the frame, the harmonious interplay of masses and voids, shadows and highlights. Dow's emphasis on the flatness and inherent abstraction of all pictures prompted photographers to think of the camera as a fundamentally graphic—rather than illusionistic—tool. As he wrote, "The *Notan* of a pattern or a picture is the arrangement of dark and light masses [which] conveys to the eye an impression of beauty entirely independent of meaning."[346] While this emphasis on shape and structure was not in itself new, Dow's book popularized the elements of an inherently modern approach to picture-making.[347] This conscious interest in pictorial form and structure was first united with—and then gradually displaced—the narrative associations and sentiments valued by an earlier generation of photographers. Thus, Dow's ideas provided a formal vocabulary for a generation of Pictorialist photographers while pointing the way to the fully nonobjective photographs of the late 1910s and 1920s.

The Generation of 1902

By the first years of the new century, the struggle for the recognition of photography as art had effected real change. In this time, for example, the collecting of artistic photographs had begun, if only tentatively. By all accounts, the most important early collection belonged to George Timmins, a businessman and enthusiastic amateur photographer in Syracuse, New York. By mid-1896, Timmins had amassed a collection of 278 artistic photographs by seventy-seven photographers from twelve countries. An exhibition of Timmins's collection at a Syracuse art gallery in May 1896 was well received by the public.[348] In addition to his other roles, Alfred Stieglitz was also an important collector. Between 1894 and 1910, he acquired some 650 works by the leading Pictorialists of the time (most of which were later given to the Metropolitan Museum of Art).[349] William B. Post was another discerning collector; in 1898 it was reported that he was "determined to procure only the very best, willingly paying a liberal price for such work."[350]

Despite these efforts, it would be many years before photographic collecting grew beyond a small circle of wealthy practitioners.[351] As a consequence, the values of fine-art prints remained very low. In an auction of works by members of the Camera Club of New York in 1900, prints sold for prices ranging from fifteen cents to a high—for a Käsebier—of $8.25. (This sale reveals that lantern slides were valued at roughly half the level of prints, as they fetched from five cents each to a high of four dollars, for a Stieglitz.[352]) In 1904, Sadakichi Hartmann published a revealing article titled "What is the Commercial Value of Pictorial Prints?" He began with the admission that

> the pictorial print has not yet become a desirable object for the gallery and portfolio of the collector. Both art dealers and art patrons still ignore its existence. There has been a sort of interchange of prints among the pictorialists and their friends in the hope to establish a standard price, but it has not been endorsed as yet by the public. The prices quoted at photographic exhibitions are invariably too high; the public loves its money too well to pay fifty or one hundred dollars for a print.[353]

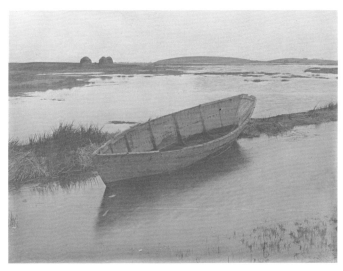

52 Arthur Wesley Dow, *Untitled (boat)*, ca. 1895-1905, cyanotype, 6⅛ x 8⅛″

There was much wishing and hoping involved in the reporting of prices for artistic photographs. While it was not uncommon for prints in major exhibitions to carry high price tags, actual sales were another matter. Stieglitz claimed to have been offered as much as forty dollars per photograph but, as Hartmann noted, "to date the price has not been paid, as Mr. Stieglitz has never found time to furnish the desired prints." By contrast, when Stieglitz bought prints from the best young photographers of the day, he was more apt to pay five dollars apiece. By this measure, Curtis Bell's sale of three prints of a single image from the 1904 Chicago Salon, at fifteen dollars each, marked a notable success.[354]

Photographic criticism reached a kind of adolescent vitality in this era, with more ambition than insight. The bulk of this writing was produced by photographers themselves. *Camera Notes* featured articles by Joseph T. Keiley, Dallet Fuguet, William M. Murray, F. Holland Day, Eva Watson-Schütze, and other practitioners with literary inclinations. Amateur photographers such as Alexander Black and J. Wells Champney also contributed essays to a variety of popular journals.[355] By 1898, however, the widespread interest in photography had prompted several professional critics—including Charles H. Caffin, Sadakichi Hartmann, and Roland Rood—to enter the field. Caffin wrote on art and photography for a variety of publications, including the *New York Evening Post*, the *New York Sun*, *Cosmopolitan*, *Century Magazine*, and *Harper's Weekly*. His pioneering book *Photography as a Fine Art* (1901) consisted of seven essays originally published in *Everybody's Magazine* and *Camera Notes*.[356] After considerable experience as an art critic, Hartmann turned to photography in 1898 with a series of articles in *The Photographic Times*. He contributed frequently to other journals, including *Wilson's Photographic Magazine*, *The Camera*, *Photo-Era*, *Camera Notes*, and *Camera Work*.[357] Rood's work was included in *Camera Work*, *American Amateur Photographer*, and other publications.[358]

The criticism of this era varied widely in depth and eloquence, from standard journalistic fare to the often brilliant work of Hartmann. At its most routine, exhibition "criticism" represented little more than an inventory of favored works, interspersed with brief and unprofound comments. Similarly, profiles of individual photographers often devoted nearly as much attention to personal anecdotes—descriptions of the artist's appearance, dress, and manner—as to the work itself. Hartmann's observation of 1900 was harsh but largely true: "Photographic criticism at present is…maudlin and insignificant, without the slightest pretense to any educational or inspirational power."[359] Despite this range of quality, the writing on photography in the turn-of-the-century era shared a basic descriptive or expressive vocabulary. The key words included: "beauty," "simplicity," "grace," "balance," "tonality," "atmosphere," "suggestion," "mystery," "harmony," "delicacy," "sympathy," "dignity," "subtlety," "charm," "luminosity," "suggestion," "repose," and "poetic." In the first decade of the twentieth century, other words—such as "vigor," "truth," "ethereal," "individuality," "spirit," and "musical"—were used with increasing frequency. Like the photographs themselves, this writing was essentially evocative, rather than analytical, in nature.

By 1902, it was clear that American art photography had arrived at a critical juncture. The collapse of the Philadelphia Salon revealed intractable conflicts over its basic nature and direc-

tion. At the vortex of these debates stood Alfred Stieglitz. Through the importance and variety of his activities, Stieglitz had established himself as the central figure in American photography. However, this role was not achieved without challenges from rivals such as F. Holland Day. In 1895-96, Day became the most dynamic new talent in American photography and the third American to be invited to join the exclusive Linked Ring. Stieglitz featured Day's work in the second issue of *Camera Notes* in 1897, and the Boston aesthete regularly contributed both images and essays to the journal. By 1899, Day was actively promoting the concept of an American association modeled on the Linked Ring. Spurning Day's invitations, Stieglitz declined to join this effort.

After retiring from his publishing business in 1899, Day devoted his full energy to photography. He traveled to London in 1900 and began organizing "The New School of American Photography," an exhibition which conspicuously excluded such established figures as Stieglitz and Eickemeyer. After failing to gain sponsorship from the Linked Ring (due largely to Stieglitz's opposition), Day's show opened under the aegis of the Royal Photographic Society. The 375 prints on display included more than 100 of his own, as well as smaller portfolios by White, Käsebier, Steichen, Watson-Schütze, and others. In early 1901 an abridged version of the exhibition opened in Paris.

Despite the success of this exhibition, Day's role as a leader in the world of art photography grew no further, due to his own personality and to Stieglitz's quiet but vigorous opposition. In part, Day's failure as a leader stemmed from the same factors that made him such a brilliant artist. His *Youth with Staff Shielding Eyes*, 1906 [87], for example, is a masterpiece of languid sensuality and Arcadian mysticism. However, its complete removal from the everyday world suggests Day's inability to deal with the frictions and disagreements of public life.

Stieglitz made his debut as an exhibition organizer in early 1901, selecting American work for the photographic section of the Glasgow International Art Exhibition. The satisfaction he took in assembling this show stood in marked contrast to the bad feeling surrounding that year's Philadelphia Salon, which he boycotted. These events hastened a shift in Stieglitz's focus, from collaborative activities to a realm of complete autonomy.

In the first months of 1902, as his relationship with the Camera Club of New York became increasingly strained, Stieglitz formed the idea for a new organization of photographic artists: the "Photo-Secession." He first used this phrase in the title of the exhibition that opened at the National Arts Club in New York on March 5, 1902. Three months later, Stieglitz resigned as editor of *Camera Notes* and began planning *Camera Work*, a new publication representing his vision alone. The first issue of this lavish quarterly (dated January 1903) appeared at the end of 1902, just as his Photo-Secession took official form. The group's first "council" included many of the era's leading Pictorialists: Eugene, Fuguet, Käsebier, Keiley, Steichen, Stieglitz, and John Francis Strauss of New York City; Bullock, Redfield, and Stirling of Philadelphia; William B. Dyer and Eva Watson-Schütze of Chicago; and Clarence H. White of Newark, Ohio.

In 1905, with Steichen's assistance, Stieglitz opened his own exhibition space, The Little Galleries of the Photo-Secession, on the top floor of the building at 291 Fifth Avenue.[360] Stieglitz aimed

his efforts at the passionate few rather than the masses. He rarely publicized his shows, and the gallery's sign on the ground floor was so small as to be "almost unnoticeable."[361] The refined spareness of these little rooms eloquently expressed Stieglitz's reverence for art. As a visitor in 1906 observed:

> The Little Galleries in New York consist of three rooms, all hung with neutral burlap, and containing a few simple but effective decorations of oak leaves and flower or grass sprays in vases. On the walls the mounted prints are disposed in a single row under plates of glass held in position by small tacks. The whole effect of extreme simplicity sets off the pictures to great advantage.[362]

By 1905, Stieglitz had established himself as an autonomous impresario of creative photography. Through the vehicles of *Camera Work*, the Photo-Secession, and "291" (as the gallery came to be known), he was free to present and promote the work of his choice. In addition, he organized numerous exhibitions of Photo-Secession work for institutions in the U.S. and abroad. These included major shows in Denver (1903), San Francisco (1903), Bradford, England (1904), Dresden (1904), Paris (1904), Pittsburgh (1904), Vienna (1904), Washington (1904), Philadelphia (1906), New York (1908), and—the culmination of this series—the celebrated "International Exhibition of Pictorial Photography" at the Albright Art Gallery in Buffalo in 1910.

The Stieglitz Circle

Stieglitz exhibited and published a moderately diverse group of photographers in these years. An inner circle of artists was reproduced often in *Camera Work* and included in nearly all his group exhibitions. The first six issues of *Camera Work* were devoted, respectively, to the work of Käsebier, Steichen, White, Frederick H. Evans, Robert Demachy, and Alvin Langdon Coburn. All would reappear in the journal with some regularity. Between 1903 and 1913, for example, Steichen's work was reproduced a total of sixty-eight times in eleven issues and a special supplement. Stieglitz also included pictures by such longtime acquaintances as William B. Post; leading Europeans such as Heinrich Kühn, Hans Watzek, and Constant Puyo; and other artists, now little-remembered, such as Ward Muir, Prescott Adamson, and A. Radclyffe Dugmore.

Gertrude Käsebier was one of the most widely admired members of Stieglitz's original Photo-Secession. She had begun studying painting in 1889, at the age of thirty-seven, and had turned seriously to photography four years later. After opening a professional portrait studio in New York in 1897, she became celebrated for her use of lighting and compositional motifs drawn from the Old Masters.[363] Her artistic breakthrough occurred at the 1898 Philadelphia Salon, where her work was praised as the best on view. In 1899, she served as a juror for the second Philadelphia Salon and sold a print of *The Manger* to the famous English actress Ellen Terry for $100, the highest price ever paid for an artistic photograph.[364] By the time Stieglitz featured her in the first issue of *Camera Work*, Käsebier was widely regarded as one of the world's finest photographers.

Käsebier's work embraced both an idealized domestic realm of tranquillity and tradition and a larger sphere of worldly, intellectual achievement. The latter is epitomized in her portrait of Rodin [90], which depicts a genius lost in thought, far removed from mundane realities. Käsebier evokes the romantic ideology

of her time by depicting Rodin, then the world's most famous living artist, as an elemental creative force whose stolid presence seems to resonate with spiritual and intellectual power. Her Rodin possesses an almost hypnotic inward intensity and seems able to infuse aesthetic life into inert matter through the mere touch of his hand. This image exemplifies Käsebier's lofty ambition to make "not maps of faces, but pictures of real men and women as they know themselves, to make likenesses that are biographies, to bring out in each photograph the essential personality that is variously called temperament, soul, humanity."[365] This photograph also reveals the essential elements of Käsebier's style: simplified arrangements of tone, an overall flatness of treatment, and a static, dignified pose.

Edward Steichen's artistic ambitions were at least as high as Käsebier's. Only twenty years old when he first received attention at the 1899 Philadelphia Salon, Steichen rapidly went on to international fame.[366] In early 1900, he left his hometown of Milwaukee, stopped in New York to see Stieglitz (who bought three prints at five dollars apiece), and then sailed for a two-year stay in Paris. Steichen was the star of the 1900 Philadelphia Salon and received extravagant praise in the following years. In his review of the 1900 Salon, Keiley exclaimed:

> The three landscapes by Eduard J. Steichen stand alone in the Salon and in the entire range of American photographic landscape work. A single glance tells the observer that they are pictures by an artist of no mean ability, and that they are entirely distinct from all other photographic landscape work. They are full of poetic originality, and display an understanding of the artistic richness of the forest—the wonderful luxuriousness of its twilight shadows—the caressing softness and silvery qualities of the grays of its mistbreath—the flowing beauty of its trunk lines—the weird enchantment of the fading light through the countless vistas of the fragrant, sombre woods.[367]

Keiley's poetic reading of Steichen's photographs perfectly evokes their Symbolist ambitions. These early images—and such later masterpieces as *Balzac by Moonlight* [89]—evoke a moody realm of mystery and perceptual indeterminacy. Steichen's 1908 study of Rodin's *Balzac* was one of several images made in two all-night photographic sessions.[368] Steichen's admiration for Rodin—whom he met in 1901 and photographed several times—is abundantly apparent in this depiction of one of the sculptor's major works. In Steichen's photograph, the white plaster cast of *Balzac* is rendered as a majestic, primal force—a potent symbol of human will and vitality. The power of images such as this was only enhanced by Steichen's technical brilliance. His exhibition prints of this era—created in gum bichromate, platinum, or combinations of the two—use a majestic size and subtlety of tone to powerful aesthetic effect.[369]

Steichen was the most notable exhibitor in Day's "New School of American Photography" show in London and Paris. In 1902, his photographs were the first to be admitted to the Paris Salon, the prestigious annual review of painting and sculpture. This recognition by the art establishment was reported in the photographic press with hyperbolic enthusiasm. The editor of *Wilson's Photographic Magazine* called the decision "epoch-making," declaring that it represented "the highest honor given to photography since Arago announced the invention of the daguerreotype in Paris in 1839."[370] Two years later, Hartmann described Steichen's reputation succinctly: "He stands in a class by himself."[371]

In these years, Steichen maintained a successful practice as a portraitist in New York and Paris, while continuing his close friendship with Stieglitz. Steichen designed *Camera Work*'s elegant cover. He also encouraged Stieglitz to open a gallery by offering the use of his former apartment at 291 Fifth Avenue. From Paris, Steichen made Stieglitz aware of the work of Rodin, Cézanne, Matisse, and other important modern painters and sculptors. Stieglitz subsequently introduced these artists to American audiences in exhibitions at 291.

Clarence H. White, the featured artist in the third issue of *Camera Work*, began photographing in the early 1890s while working in a wholesale grocery firm in Newark, Ohio. He came to national attention in the Pittsburgh and Philadelphia salons of 1898, and soon received international recognition. In 1899, White was given one-man exhibitions at the Camera Club of New York and the Boston Camera Club, included in the London Photographic Salon, and chosen as a juror for the second Philadelphia Salon. In 1900, he was featured in Day's "New School of American Photography" exhibition and elected to membership in the Linked Ring. Two years later, he won the grand prize in an international exhibition organized by Stieglitz in Turin, and became a founding member of the Photo-Secession. White moved to New York in 1906, and assisted Stieglitz in the operation of his gallery. A year later, White began his influential teaching career with a position at Columbia University.

Despite its gently domestic subject matter, White's work was surprisingly controversial. His supporters admired his masterful compositions, subtle tonalities, and refined mood. Most impressive was White's original sense of *notan*, and sympathetic critics urged amateurs to "study White carefully for what he can teach you about the proper adjustment of subjects to the spaces they occupy."[372] However, even White's supporters commented on his predilection for "a certain weird fancifulness of subject," and his detractors found his work offensively strange.[373] The editor of the *American Amateur Photographer* called his pictures "eccentric," while conservative members of the Camera Club of New York pronounced his 1899 exhibition "an outrage and an imposition."[374] A leading photographic editor fulminated against White himself, calling him "a lover of what is positively ugly," with "a degenerate taste in art."[375]

In truth, White created a remarkably original body of work from the simplest of subjects. His most notable pictures, made before he left Ohio in 1906, depict members of his family in and around their house. White's unique understanding of pictorial structure, derived largely from his appreciation for Whistler and Japanese prints, transformed commonplace domestic activities into visual poetry. A work such as *The Orchard* [86] perfectly evokes the Pictorialist ideal of the world as an enchanted garden, far removed from the complications of modern life. This memorable photograph weaves nature and culture together in a graceful ballet of warmth and fecundity.

This dreamy radiance also characterizes the work of George Seeley. Seeley was inspired to take up photography in 1902 after meeting F. Holland Day. His national debut came in the First American Salon in December 1904, a New York exhibition boycotted by the Stieglitz circle. He was unanimously hailed as the star of the show, with "a power of expression which places him in the foremost ranks of American photographers."[376] Stieglitz

promptly invited Seeley to join the Photo-Secession and featured his pictures in three issues of *Camera Work*. Seeley's photographs were included in leading international exhibitions through the early 1910s; he showed with decreasing frequency for another two decades.

The idealized nature of Seeley's work reflected the serenity of his life. He resided quietly with his parents and sister in the small western Massachusetts village of Stockbridge. He worked as an art teacher in the public schools, belonged to the Congregational Church, and was an avid ornithologist and gardener. His most frequent model was his sister and lifelong companion, Laura, and the great majority of his pictures were made close to home. As historian George Dimock has observed, Seeley's

> emotional life centered upon his parents and siblings. His photographs are transpositions of the intimate, familiar, and local into the realm of aestheticism... Seeley metamorphosizes his siblings into visionary damozels who enact some half-dreamt, half-forgotten saga wherein beauty, suffering, noble deeds, sensuous delight, and a past golden era are all vaguely intertwined. The image combines a free-floating pathos with an exquisite arrangement of formal shapes and delicate tones. Narrative, symbol, and dramatic event are strongly implied but never specified. The photograph's real content becomes the cultivation of a rarefied and indeterminate plane wherein a Keatsian synthesis of beauty and truth holds sway.[377]

These qualities are abundantly clear in *Autumn* [88], one of Seeley's most powerful allegorical images. This photograph, later chosen by Stieglitz for reproduction in *Camera Work*, creates a timeless, self-contained realm of languid aestheticism. This feeling of otherworldly ambiguity derives from such clever details as the placement of cattail shadows on an otherwise undefined background plane. These shadows make us question whether the "real" cattails in the image are actual plants in front of the figure, designs in the fabric of her gown, or themselves shadows. The answer, like the meaning of the image itself, remains uncertain. In the words of one critic of the day, Seeley's pictures "are rather representations of moods than statements of facts, and are hard to name as well as hard to describe."[378]

Baron Adolph de Meyer began exhibiting internationally in 1894 while living in Germany. His reputation grew in subsequent years as he moved between Europe and the United States. In 1907, with Coburn, de Meyer organized an exhibition of modern photography in London that included the work of several notable Americans. De Meyer's work was shown at 291 in 1907 in a two-man show with Seeley, and in a one-person exhibition in 1909. Stieglitz also included twenty-one of de Meyer's pictures in *Camera Work*. De Meyer came to New York just before the onset of World War I. Signed to an exclusive contract to work for the Condé Nast magazines *Vogue* and *Vanity Fair*, he became the first modern fashion photographer. De Meyer remained influential well into the 1920s, but the harder-edged modernism of that era caused him to fall from critical favor.

De Meyer's personal sense of elegance and style was embodied in his photographs. Best known for his serene still lifes and portraits, de Meyer always conveyed a feeling of delicate refinement. This quality was the result of his technique (the use of a special soft-focus lens) as much as his choice of subjects. Indeed, this refinement was evident even when he photographed such working-class subjects as his *Guitar Player, Seville* [92]. This

image, which was featured in the October 1908 issue of *Camera Work*, combines the era's fascination for colorful European "types" with a composition and treatment reminiscent of Old Master paintings.[379] Critics admired de Meyer's photographs while acknowledging their emphasis on beautiful surfaces and sensations. As Charles H. Caffin observed in 1912, de Meyer's work "stimulates an exquisite refinement of feeling, but stops short of that higher stimulus to rarefied intellectual content."[380]

In addition to these notable participants, Stieglitz's Photo-Secession grew to include other American and European photographers. In the U.S., members of the Photo-Secession were drawn from across the country and worked in a variety of styles. Thomas O'Conor Sloane, a resident of Orange, New Jersey, achieved national prominence in 1900 when he was included in the Philadelphia and Chicago Salons, and in a members' show at the Camera Club of New York. His gum-bichromate prints were celebrated for their refined simplicity and richness of tone [91]. Denver resident Harry C. Rubincam became a member of the Photo-Secession in 1903. He was active in the Denver and Colorado Camera Clubs and wrote articles on photography for *Outdoor Life*, *The Photographer*, *Camera Work*, and other journals. He is now best known for a remarkable series of pictures made at a circus in 1905 [94].[381] These images combine the spontaneous vision of the snapshot with a more abstract interest in the geometric forms of the ring, tent, and support poles. These are unusual in the artistic work of the period for their depiction of a public scene rather than a domestic or allegorical subject.

Anne W. Brigman, a long-time resident of Oakland, California, was one of the most romantic of the Stieglitz circle. She joined the Photo-Secession in 1903 and, like Rubincam, exhibited internationally throughout the decade. In 1907, influenced by the work of Frank Eugene, she began using a pencil and graver on her negatives to create painterly effects in her prints.[382] Brigman's best-known work of this era [93] creates a mood of poetic pantheism through the depiction of melodramatically posed figures in austere natural settings.[383] As a critic of the time noted, in Brigman's pictures

> all sense of separation between the human being and nature is gone, and both seem part of all that is beautiful in elemental conditions. In all of Mrs. Brigman's symbolic studies, you feel the one dominant thought—that to her there is one great underlying spiritual inspiration, just one for both nature and man.[384]

In its final years, the Photo-Secession attracted such young talents as Karl Struss. Struss's serious interest in photography began in 1908, when he undertook studies with Clarence White. Two years later, Struss was represented by twelve prints in Stieglitz's important "International Exhibition of Pictorial Photography" at the Albright Art Gallery in Buffalo. In 1912, Struss joined the Photo-Secession and was featured in *Camera Work*. While modest in scale and gently muted in focus, Struss's pictures of this period are remarkably sophisticated in composition. Later in life, Struss observed that "the fundamental thing in photography [is] space-filling."[385] This concern for the precise arrangement of the subject within its frame is seen clearly in Struss's exquisite *Brooklyn Bridge from Ferry Slip, Evening* [97]. He was fascinated by the structural complexity of this scene: the rectilinear foreground architecture, the semicircular element of the ferry slip, and the bridge itself, soaring overhead into the distance. He

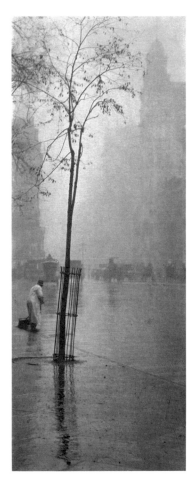

53 Alfred Stieglitz, *Spring Showers, New York*, 1901, gravure, 9 x 3⅝"

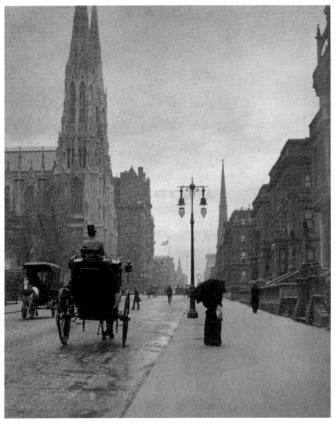

54 William J. Mullins, *Fifth Avenue*, ca. 1899, platinum print, 4¼ x 3½"

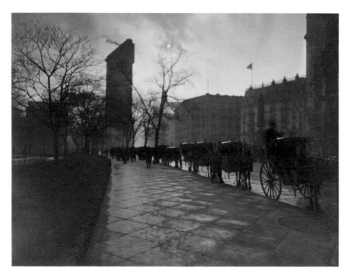

55 Jessie Tarbox Beals, *Horses, Madison Square*, 1906, 6½ x 8½"

56 Dr. Albert R. Benedict, *Waiting*, 1906, 24¾ x 14⅞"

worked at this site repeatedly, photographing at various times of day and from several vantage points. This image brilliantly evokes the tension between two overlapping artistic ideas: the romantic moodiness of classic Pictorialism, and a prototypically modern investigation of geometric structure.

The City as Subject

Struss was one of several artistic photographers in this era to devote serious attention to the city.[386] Despite Pictorialism's emphasis on domestic, landscape, and allegorical subjects, the urban scene was of interest to a number of artists from the late 1890s to the early 1910s. These include such familiar names as William A. Fraser, whose night views were a highlight of the 1898 Philadelphia Salon, and Stieglitz, who recorded New York repeatedly in these years [53]. Also notable in this regard are William J. Mullins, Jessie Tarbox Beals, Dr. Albert R. Benedict, and Paul Haviland. Mullins's *Fifth Avenue* [54], was exhibited in both the Philadelphia and Pittsburgh Salons of 1899. In an age of visual delicacy and understatement, Mullins was the greatest of photographic miniaturists. (At 4¼ x 3½-inches, this is one of his larger exhibition prints.) With jewel-like precision, this image suggests both the pace of modern city life and an overall feeling of balance and serenity. Beals's work of 1905-06 combines an interest in muted atmospheric effects with a celebration of such emblems of modernity as the Flatiron Building [55].[387] Benedict's *Waiting* [56] won first prize in the night category of the Third American Salon of 1906. His untitled view of divers [95], from the same period, is remarkably modern in both subject and composition. Indeed, this bold image would have fit comfortably in the leading exhibitions of two decades later. Haviland, a close colleague of Stieglitz's, was one of the first to find aesthetic value in such popular and commercial subjects as the Luna Park amusement center at Coney Island [57].

The era's most remarkable group of urban photographs was created by Alvin Langdon Coburn in 1912. One of photography's great prodigies, Coburn first received critical attention at the age of eighteen when his distant cousin, F. Holland Day, included nine of his prints in the "New School of American Pictorial Photography" exhibition of 1900. Over the next ten years (which he divided between the U. S. and England), Coburn received widespread recognition and praise. In 1907, for example, he was pronounced the world's greatest photographer by the famed playwright and social critic George Bernard Shaw. Stieglitz was also an admirer, and included Coburn's pictures in *Camera Work* and in exhibitions at 291.

Coburn's mature vision represents a unique synthesis of painterly, photographic, and literary influences.[388] Of great importance was his appreciation of Japanese art, gained from studies with Arthur Wesley Dow and through close examination of woodblock prints at the Boston Museum of Fine Arts. Coburn attended Dow's classes in the summers of 1902 and 1903, and thoroughly absorbed the lessons of form outlined in his book *Composition*. These visual influences were augmented by Coburn's deep interest in Symbolist thought, English literature, and religious mysticism. Coburn's portraits of leading artists and writers further enlarged his intellectual sphere; before recording such sitters as Henry James, George Bernard Shaw, William

Butler Yeats, H. G. Wells, and Henri Matisse, Coburn immersed himself in their works. In 1910-12, Coburn came to understand Post-Impressionist art through the exhibitions at 291 and the influence of the painter and teacher Max Weber.[389]

For Coburn, the vitality of these artistic ideas was best expressed in the image of the modern city. His book *New York* (1910) included heroic, soft-focus renditions of the city's bridges, streets, and skyscrapers. In 1911, he wrote that "photography born of this age of steel seems to have naturally adapted itself to the necessarily unusual requirements of an art that must live in skyscrapers."[390] By 1912, Coburn's vision of New York was uniquely dynamic and challenging. While he had earlier taken such tall structures as the Singer Building and Metropolitan Tower as his subjects, Coburn now used them as vantage points for a radically new vision.[391] Turning his camera steeply downward, Coburn produced boldly vertiginous views that were at once objective and abstract.

The House of a Thousand Windows [98] is perhaps the most remarkable of this important group of photographs. This image plays the flatness of simple geometric forms—the rectangular and triangular shapes of the foreground building and tenement block—against the spatial recession of the urban grid. The result is a curious tension between description and invention, and an almost eerie sense of pictorial vitality. The picture's powerful forms seem to vibrate within the confines of the frame, and nothing seems truly still or stable. (Note, for example, the subtle illusion that the sidewalk on the far right runs parallel to the vertical edge of the foreground skyscraper, rather than perpendicular to it.) While amateurs and commercial photographers had earlier photographed from high vantage points, Coburn was the first to explore the artistic possibilities of such perspectives. In 1913, at the Goupil Galleries in London, he exhibited enlarged platinum prints of these profoundly original images under the collective title "New York from its Pinnacles." While their immediate impact on American photographers seems to have been slight, these astonishing pictures strongly prefigured the avant-garde concerns of a decade or more later.

While his photographs of this time are only slightly less remarkable than Coburn's, Kurt W. Baasch has remained almost entirely unknown to historians. Baasch was born in Venezuela and grew up in Germany.[392] He took up photography in 1905, at the age of fourteen, and was included in a major exhibition in Dresden in 1909. He came to New York in 1911 and immediately met Stieglitz, White, and other leading figures. He also joined the Camera Club of New York, where he worked enthusiastically in the darkroom with his closest photographic friend, Paul Strand. The fruits of this labor were presented in a major one-man show at the Camera Club in the spring of 1913.[393]

Baasch's vision was boldly original. He was fascinated by modern life, and by the camera's ability to weave together realist and abstract concerns, facts and ideas. His untitled view of a small dam [58], made soon after his arrival in the U.S., is a distinctly unconventional meditation on structure and power. *Repetition* [96], which was featured in his 1913 Camera Club show, is even more remarkable. Here, Baasch distills the vast energy of urban life to a pictorial haiku. The city is reduced to the simplest vocabulary of form: the flat plane of the street and the elegant geometry of the sidewalk. The human presence is

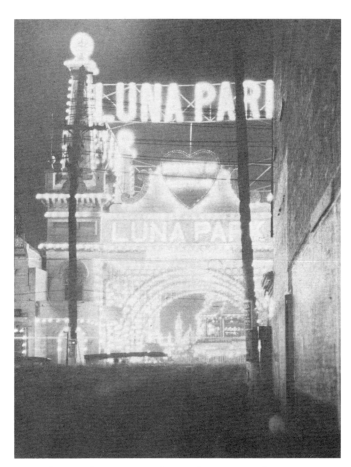

57 Paul B. Haviland, *Luna Park at Night*, ca. 1910, platinum print, 4¾ x 3¾"

58 Kurt W. Baasch, *Untitled*, ca. 1911-12, 9 x 10⅞"

59 Edward Steichen, *Jean Simpson*, 1907, Autochrome, 7 x 5"

60 Alfred Stieglitz, *Chess Game, Tutzing*, 1907, Autochrome, 3⅝ x 4¾"

conveyed by four figures, all unrelated, who pass without acknowledgment. This image carries a deeply modern poignancy; in this fleeting moment of city life, a crystalline, poetic truth is revealed. Baasch's exposure has made these strangers pictorial kin, but what they share is the privacy of solitude. The relationship of these figures—at once random and pictorially precise—says much about the pace and impersonality of the modern city.[394]

Baasch's enormous artistic talent was not matched by a desire for recognition. He worked successfully in the export trade for years, was happily married, and became a passionate gardener. Strictly for his own pleasure, through at least the early 1930s, he photographed on Sundays and holidays around his hometown of Baldwin, Long Island. His work was admired by a handful of important figures, including Strand—who remained a close friend for years—and gallery owner Julien Levy, who presented a one-man show of Baasch's work in 1933.[395]

Color

In addition to such new subjects and viewpoints, photographers of this era were excited by a dramatic technical advance: a practical means of color photography. The quest for color had occupied researchers for decades.[396] Working independently in the 1860s, James Clerk Maxwell in Scotland, and Louis Ducos du Hauron in France, developed imperfect means of color rendi-

tion based on recording a subject through three color filters and recombining the resulting trio of color separations.

In Philadelphia, Frederic E. Ives spent years working on the problem of color photography. He apparently made a color print as early as 1881, but then redirected his efforts toward additive viewing processes.[397] By 1889, his method began with the production of three black-and-white lantern slides through red, green, and violet filters, respectively. When tinted to match the color of the filter through which they had been exposed, and projected in register on a screen, these three color separations blended to form a single full-color image.[398] To allow these images to be made and viewed at home, in 1892 Ives introduced his Heliochromoscope, an optical device that functioned as both camera and viewer.[399] While cleverly designed, the Heliochromoscope was too expensive—and the process itself too complex—to be commercially practical.

Other inventors explored ways of achieving natural color that avoided the need to first make, and then visually recombine, three individual plates. In 1891, the German physicist Gabriel Lippmann successfully produced color photographs on glass by the interference method (based on the interaction of light waves reflected back on themselves—the same phenomenon that produces halos of color on an oil slick). This curious technique yields a plate that looks like a normal black-and-white negative in transmitted light, but which becomes an iridescent color positive when viewed by reflected light. Although Lippmann's process required very long exposures and was never a commercial success, the Carl Zeiss company sold outfits for its use through 1910.[400] Other inventors explored ways of building minute color filters into the sensitized plates. In 1894, Dublin professor John Joly patented a process for producing a finely ruled screen of alternating red, green, and blue-violet lines on a gelatin-coated glass plate. This was put on the market in the following year. A similar process, developed independently by James McDonough of Chicago, was marketed in 1897. Neither was a commercial success.

The Autochrome, the first practical process of color photography, was developed by the brothers Auguste and Louis Lumière of Lyons, France. The Lumières first achieved fame for their

contributions to the motion picture: their cinématographe, of 1895, was a combination camera, projector, and printer that dominated the market in the U.S. in the late 1890s. In their color experiments, the Lumières first worked with Lippmann's process. By 1904, however, they had perfected an ingenious new technique to produce direct-positive color transparencies on glass. To make each Autochrome plate, tiny grains of potato starch were dyed red-orange, green, and violet. These colored grains were mixed randomly and applied in a single layer on a sheet of prepared glass; the spaces between the grains was filled with a fine black powder. After varnishing and coating with a standard photographic emulsion, the plate was ready for use. During exposure, the microscopic grains acted as a vast array of colored filters. After processing, the plate was viewed by transmitted light. The result was a luminously beautiful color transparency.

The first public demonstration of the Autochrome, in June 1907 at the Photo-Club de Paris, was timed to the commercial introduction of the process. The plates were relatively expensive, unforgiving in exposure latitude, and difficult to view. But—initially, at least—these drawbacks paled in the face of the Autochrome's great achievement: the accurate rendition of color. The Photo-Club demonstration created enormous excitement and an immediate market for the Lumière's plates. Indeed, for many months, demand far exceeded the firm's manufacturing capacity.[401] Reports of the process were enthusiastic, and some 200 articles were published in the photographic press alone in the next year and a half.[402] Critics were ecstatic in their praise. In its October 1907 issue, *Wilson's Photographic Magazine* called the Autochrome "the greatest discovery in photography since Daguerre made his first daguerreotype. It is to photography what the discovery of perpetual motion would be to mechanics."[403] Stieglitz's response was characteristic of the artistic community: the process, he said, held "unlimited" and "revolutionary" possibilities.[404]

Many of the leading artistic photographers immediately embraced the Autochrome. Edward Steichen attended the original demonstration at the Photo-Club and taught the process to both Stieglitz (who was in Paris, but ill that day) and Coburn. All three worked feverishly in color for months [59, 60].[405] Other members of the Stieglitz circle, including Heinrich Kühn, Clarence White, Frank Eugene, Paul Haviland, Baron de Meyer, Karl Struss, and George Seeley [61], paid varying degrees of attention to the process. Examples of this work were shown in several exhibitions at Stieglitz's gallery between 1907 and 1910.

Professional photographers such as Benjamin Falk and Arnold Genthe also devoted significant effort to the process. In fact, Falk pioneered professional color photography in America: he experimented with "every known color process" prior to the Autochrome, and in September 1907 became the first in New York City to use the Lumière plates.[406] Genthe also began using the process in the fall of 1907. His earliest Autochrome images include a series of pictures of Julia Marlowe, the famous Shakespearean actress, in costume as Lady MacBeth [62].[407] Genthe presented a large exhibition of his Autochrome work in 1912 in his New York City studio. The process was also put to use in photojournalism: *National Geographic* published many Autochrome images between 1914 and 1937, and its photographers created an archive of some 14,000 plates.[408]

61 **George H. Seeley,** *Still Life with Grapes,* ca. 1908, Autochrome, 3⅝ x 4⅝″

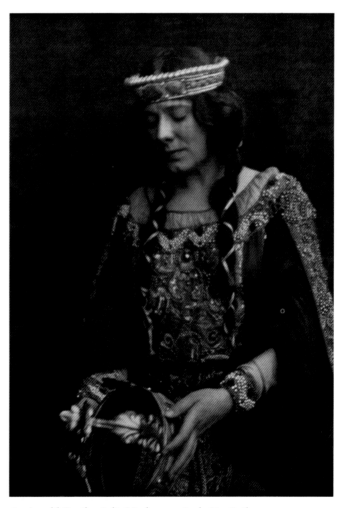

62 **Arnold Genthe,** *Julia Marlowe as Lady MacBeth,* 1907, Autochrome, 7 x 5″

Despite their initial enthusiasm, however, artistic photographers soon lost interest in the Autochrome. While Seeley may have worked with the process into the mid-1920s, few other leading Americans made significant use of it after about 1909.[409] The reasons for this disenchantment stemmed largely from the inherent limitations of the process. Long exposure times meant that photographers could not record the variety of subjects to which they were accustomed; they tended to work only on the brightest days, or—as in Seeley's case—turned largely to still lifes. And, although very beautiful, the plates were difficult to view and incapable of producing prints. Most importantly, perhaps, the Autochrome allowed little room for creative expression: the slightest over- or under-exposure produced poor results and the color itself resisted manipulation. In the end, the Autochrome was simply too inflexible to satisfy creative photographers.[410] The avant-garde's disappointment in color would linger for more than half a century.

Opponents of the Photo-Secession

The establishment of Stieglitz's Photo-Secession at the end of 1902 represented an important shift in American photography from collectivism to elitism. This movement is clearly revealed in the evolution of Stieglitz's writings. In an 1892 essay titled "A Plea for Art Photography in America," Stieglitz addressed himself to his amateur "colleagues" and wrote of "our work" as a communal enterprise.[411] Seven years later, in a *Scribner's Magazine* article on "Pictorial Photography," he observed that "there are but three classes of photographers—the ignorant, the purely technical, and the artistic." He now perceived photographic artists ("the most advanced and gifted men of their times") as intrinsically different from the general rule of photographic mediocrity.[412] However, he continued to address himself to the public at large and to devote his efforts to the cause of American amateur photography as a whole.[413]

The disagreements over the Philadelphia Salon of 1901, and the editorial direction of *Camera Notes* in 1902, marked the divorce of photographic "highbrows" from the "middlebrow" mainstream, and ended the hope for a truly collective, democratic art. In his extreme Photo-Secessionist manifesto of 1903, Stieglitz evoked the bitter struggle of the enlightened few against the ignorant many. In this document, he observed that "in all phases of human activity the tendency of the masses has been invariably towards ultra conservatism. Progress has been accomplished only by reason of the fanatical enthusiasm of the revolutionist, whose extreme teaching has saved the mass from utter inertia." All hope for collegiality was gone; progress could only be effected through "bitter strife" and "protest." For Stieglitz, the attitude of the Photo-Secession was "one of rebellion against the insincere attitude of the unbeliever, of the Philistine, and largely of exhibition authorities." He concluded: "The Secessionist lays no claim to infallibility, nor does he pin his faith to any creed, but he demands the right to work out his own photographic salvation."[414]

In many respects, these hyperbolic pronouncements masked a set of rather mundane issues. As historian Ulrich Keller has suggested, the fight for photography's status as a fine art was, in some respects, a struggle for social prestige.[415] The real debate involved more than the quality of individual photographs; per-

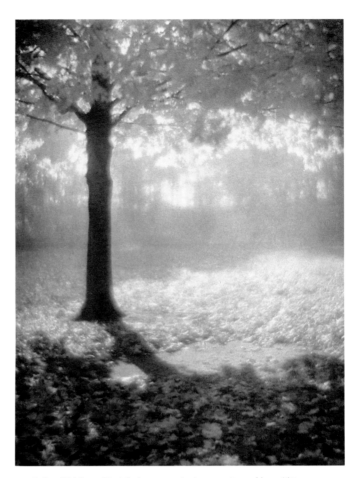

63 John Chislett, *Untitled*, 1910, platinum print, 9⅝ x 7¼"

sonalities and art-world politics took center stage. The result was a series of squabbles and turf wars that polarized the art-photography community into pro- and anti-Stieglitz camps.[416] In 1904, for example, controversy arose over plans for the photographic exhibition at that year's St. Louis World's Fair.[417] Stieglitz refused to support reasonable efforts by J. C. Strauss, a respected St. Louis professional, to secure appropriate exhibition space at the fair. Instead, Stieglitz imperiously criticized Strauss's credentials to speak for "photography," implying that he alone held that right. A flurry of criticism followed in the photographic press.

This controversy gave added importance to the first organized challenge to the Photo-Secession. In December 1903, a group headed by Curtis Bell, president of the Metropolitan Camera Club of New York, formed a national organization called the Salon Club of America.[418] In mid-1904, this group announced its sponsorship of a major exhibition, the First American Salon, to be held in December. Stieglitz released a condescending statement to the press: "The proposed exhibition will be of such a type or character that neither I nor the Photo-Secession can have any connection with it."[419] He then worked privately to dissuade other leading photographers from participating. Photographic journals were full of bitter commentary on the issue, with sentiment overwhelmingly on Bell's side.[420]

Even former supporters such as Sadakichi Hartmann were amazed by Stieglitz's arrogance and elitism. Hartmann was moved to write an unsigned essay on Stieglitz and his group in the *Photo-Beacon* under the withering title "Little Tin Gods on Wheels." In this scathing piece, Hartmann fulminated against

"their unbearable dictatorial attitude" and "incredible narrow-mindedness."

> The self-conceit of the Little Tin Gods on Wheels has become abnormal, preposterous, has grown into the very heavens. It could not even be caricatured, as no page could be large enough to convey the dimensions of their swelled heads. They think they are giants, towering high above the rest of humanity...[but] these little tin gods represent nothing but one little phase in the pictorial photography of America.

Most tellingly, Hartmann addressed by name some of the less privileged members of the Photo-Secession:

> Have you not sat at the portals of the toyshop long enough? Do you still fail to comprehend that you will never be admitted as their equals, that your work will never be considered as exalted as theirs?...Do you not see that even John G. Bullock, W. B. Dyer, Eva Watson-Schütze, R. S. Redfield and Edmund Stirling, who belong to the very council of the little T.G.O.W., are not *tony* enough to be expounded in the pages of the gray magazine?

Noting that "there is no room for the patriarchal system in America's art, nor for autocrats, high priests, inquisitors, or wholesale conscriptions, condemning people without a hearing," Hartmann called on the photographic community to "wheel away the little tin gods to the place where they belong, and with them all their self-conceit, their ridiculous pose, their long hair, big ties and clerical collars, their sham aestheticism, their dismal tonalities, their red tape, and, above all, their contemptible un-American policy."[421]

It was in this charged atmosphere that the First American Salon opened in December 1904. Some 9,100 works had been submitted, and a jury headed by artist Kenyon Cox selected 350 for display.[422] The most prolific exhibitors were Bell, Eickemeyer, Seeley, Jeanne E. Bennett, and Osborne I. Yellott. Among the numerous other participants were Day, Frank Roy Fraprie, Wilbur H. Porterfield, and John Chislett [63]. Seeley, universally regarded as the discovery of the exhibition, had been encouraged to enter by Chislett, a noted Indianapolis Pictorialist and a close associate of Bell.[423] The show received mixed reviews but was a popular success. The 1905 Salon received less enthusiastic critical notices, partly due to Seeley's absence.[424] However, this show introduced the work of such new talents as Dwight A. Davis of Worcester, Massachusetts [64], who was subsequently included in a number of major international exhibitions.[425]

While Chislett and Davis both operated well within the "conservative" aesthetic of Bell's group, their pictures were among the most subtle and elegant of the period. Both men were fascinated by the shimmering radiance of light. Just as Davis's *A Pool in the Woods* explores the muted delicacy of a quiet sylvan scene, Chislett's photograph lovingly depicts the air itself incandescent with light and warmth.[426] In this Impressionistic work, the anecdotal subjects of earlier Pictorialism were discarded for a kind of lyrical pantheism.

The merit of much of this Salon Club work, and the later acceptance of figures such as Seeley and Bennett into the Photo-Secession, makes it clear that the battle between the Stieglitz and Bell camps was more over tactics than aesthetics. The leaders of both sides were strong-willed and held positions of power in the photographic community. As is often the case in such matters, their conflict was particularly sharp because they represented

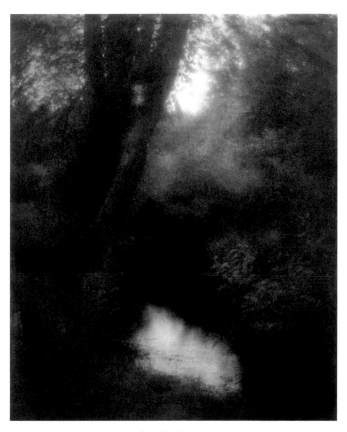

64 Dwight A. Davis, *A Pool in the Woods*, ca. 1906-08, gum-platinum print, 12½ x 10¼"

rival factions of the same movement.[427] Inevitably, several significant careers fell victim to this power struggle. Photographic history has been strongly biased in favor of the Stieglitz circle, and photographers allied with the "wrong" side—Bell's—have been largely forgotten.[428] The importance of the Photo-Secession is indisputable, but it did not represent all that is worth remembering of the art photography of the era.

As these debates make clear, Pictorialism was not a unified movement. What is more important, it did not represent a singular, rigorously defined aesthetic. While the use of muted focus was nearly universal, the degree of optical softness varied from one photographer to another. And, while landscapes and figure studies were common in the salons of this era, a number of other subjects were depicted. As a result of this intrinsic breadth of approaches, Pictorialism's contributions to the gene pool of photography's future were both essential and varied. In effect, Pictorialism mutated into increasingly divergent strains that, within a generation, would be perceived as polar opposites.

Despite this continuity, it is essentially true that "classic" Pictorialism crested as an important international movement within the first dozen years of the century. By the beginning of the First World War, it had largely run its course.[429] Like the Photo-Secession itself, Bell's American Salon movement just ran out of energy. Entries had fallen off significantly by 1907, and the program was discontinued five years later. While each of the American Salon exhibitions brought significant new talent to national attention, it was widely agreed that the overall quality was not of Photo-Secession caliber.[430] However, one of the positive results of Bell's organization was to encourage regional groups. In upstate New

York, for example, the Photo-Pictorialists of Buffalo, a group of talented amateurs led by Wilbur H. Porterfield, produced moody landscapes that were widely praised. In 1907, an exhibition of the group's work traveled to the Photographic Society of Philadelphia, the Corcoran Gallery of Art in Washington, D.C., the Art Institute of Chicago, and the Albright Art Gallery in Buffalo.[431]

Apart from Stieglitz's activities, the most significant exhibitions of the period were organized by a group headed by Clarence H. White. These included shows at the Montross (1912) and Ehrich (1914) art galleries in New York City.[432] Notable participants in these exhibitions included Coburn, Davis, Genthe, Käsebier, Mullins, Seeley, Struss, White, and Porterfield, as well as Paul L. Anderson, William B. Dyer, Edward R. Dickson, and Spencer Kellogg, Jr. These shows also provided national exposure for such young photographers as Imogen Cunningham and Paul Strand. Following the lead of Bell's original 1904 American Salon, these exhibitions made a concerted effort to create a market for artistic photographs. The Ehrich show was particularly successful in this regard, as nineteen of the eighty prints on view were sold for a total of nearly $500.[433]

By this time, however, much Pictorialist work lacked passion and originality. After visiting the Pittsburgh Salon of 1914, Wilbur H. Porterfield reported that

> the first impression one receives upon entering the hall is the general effect of harmony and consistency which pervades the entire show. Freaks are not to be found. The morbid and the decadent are, to use a stereotyped expression, "conspicuous by their absence," and one is instantly conscious of a sincerity, a dignity, and a healthy renaissance which leave absolutely no doubt that every print represents the single intention of its maker to embody in his work the best and highest that is in him.[434]

For committed Pictorialists, this was high praise. For them, artistic photography represented a quasi-spiritual quest for "the beautiful," and a continuing attempt to express "an abstract idea of a lofty or ennobling character."[435] This relatively singular notion of beauty was based on a constellation of concepts—unity, harmony, delicacy, elevating sentiment, and narrative associations—derived from the nineteenth century. In this context, words such as "faultless," "charming," "tasteful," "poetic," "picturesque," and "decorative" still had critical meaning.

However, it was becoming clear that the "harmony and consistency" of mainstream Pictorialism were the traits of an enervated art form.[436] Both the strengths and weaknesses of Pictorialism lay in its reverence for idealization and graceful accord. By the First World War, the once-provocative subjectivity of turn-of-the-century work had all too often turned into formula and cliché. Any subject—from babies to locomotives—could be pleasingly composed and rendered in a soft-focus glow. However, this style had diminishing relevance to either the specific content or "elevating" potential of the image. Routine Pictorialism continued into the 1920s and beyond, but as the aesthetic of choice for "middlebrow" camera club enthusiasts, not avant-gardists.

The gradual deviation of the photographic avant-garde from the tenets of classic Pictorialism marked an important transition. As a late Victorian style, Pictorialism embodied ideas that could not be long sustained in the twentieth century. Later Pictorialism did not represent a failed modern aesthetic so much as a highly refined premodern one typified by an adherence to communal notions of aesthetic value and the idea of the artist as an agent of moral improvement.[437] While individuality had its place in this work, it was understood that personal vision should always be subordinated to the "timeless" laws of art and to mainstream social values. As a critic of this era wrote, "To be eminent [art] must not only be individual, but must also be typical; [it] must not only represent a notable species, but also in some sense the whole genus to which it belongs."[438] By the time of World War I, this reverence for the authority of tradition, and longing for a comfortingly harmonious world, had lost avant-garde credibility. The dividing line between the Victorian and modern eras was marked by the shift from a collective and idealizing aesthetic to one based on subjective expression and deliberate breaks with the past.

Stieglitz in Transition

The culmination of Stieglitz's involvement in Pictorialism came in 1910, when he organized the "International Exhibition of Pictorial Photography" for the Albright Art Gallery in Buffalo. Conceived as a historical survey, the exhibition summarized Stieglitz's interests of the previous two decades. The nearly 500-print invitational section began with forty works from the mid-1840s by David Octavius Hill, a Scottish portraitist whose work represented for Stieglitz the first flowering of truly artistic photography.[439] All the other photographers represented by large selections of work were members of the Photo-Secession: Steichen, White, Eugene, Annan, de Meyer, Seeley, Käsebier, Keiley, Demachy, Kühn, Evans, Brigman, and, of course, Stieglitz himself.[440] The show also included a 101-print juried section with work by younger or less-renowned photographers such as Struss, Genthe, Post, Bennett, Anderson, Francis Bruguière, and Pierre Dubreuil.

The show generated great praise as well as the usual controversy. It was widely acknowledged to be "the finest exhibition of pictorial photography ever held," and even Stieglitz's opponents admired its quality.[441] However, his direction of the show opened many old wounds, and most opponents of the Photo-Secession refused to participate (including, ironically, the Photo-Pictorialists of Buffalo).[442] Despite the variety of work on view, it was clearly Stieglitz's show. One critic observed accurately that the exhibit was "primarily a monument to Alfred Stieglitz," and described him with grudging admiration as a "Napoleon of pictorial photography [who] put into the movement for internal progress and external recognition the fanaticism of a Mad Mullah, the wiles of a Machiavelli, the advertising skill of a P. T. Barnum, the literary barbs of a Whistler, and an untiring persistence and confidence all his own."[443]

This effort marked the end of Stieglitz's promotion of Pictorialist photography. Numerous rifts had formed within the Photo-Secession by this time, and both Käsebier and White had fallen out with him. In large part, the unraveling of the Photo-Secession was the result of Stieglitz's shifting enthusiasm from photography alone to the larger realm of contemporary art. After 1907, modern painting, drawing, and sculpture increasingly occupied his interest. On visits to Europe in that year, and in 1909, he was introduced by Steichen to the work of the most avant-garde artists of the day. From 1909 to 1917, photography played only a minor role in his exhibition calendar. Instead, Stieglitz showed the work of Paul Cézanne, Pablo Picasso, Georges Braque, Henri Matisse,

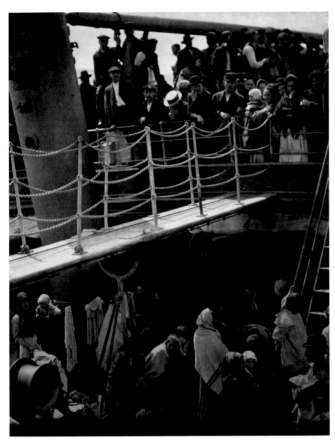

65 Alfred Stieglitz, *The Steerage*, 1907, gravure, 13⅛ x 10⅛″

Francis Picabia, and Constantin Brancusi, as well as young American painters such as John Marin, Marsden Hartley, Arthur B. Dove, and Georgia O'Keeffe. Much to the consternation of subscribers, nonphotographic works by many of these artists also appeared in the final years of *Camera Work.*

Stieglitz's own photographs suggest the variance between his artistic ideas and those of his compatriots. It is revealing that most of his early-century photographs reveal only a passing interest in the manipulated techniques and allegorical subjects he applauded in others. And, while his favored photographers generally avoided contemporary urban life, Stieglitz was strongly attracted to this subject. Notably, it was the idea of the city more than its physical and social reality that most interested him. Stieglitz's 1901 picture *Spring Showers* [53] uses meteorological conditions, rather than overt technical manipulation, to create a sense of picturesque indeterminacy. While this image had relatively clear symbolic content—the isolated tree suggesting the fragility of life and a heroic struggle for individual self realization—it is significant that its subject was present-day New York.

Numerous other pictures of this period reveal Stieglitz's interest in the vitality of modern life. Even though they were often muted by soft focus, Stieglitz's subjects included locomotives, tugboats, and skyscrapers. By 1912, this penchant for technological themes had resulted in images of office buildings under construction, a steam shovel at work, an ocean liner in New York harbor, and airplanes and dirigibles soaring overhead. In defending the creative potential of the camera in the hands of an artist like Stieglitz, a sympathetic critic suggested that "the highest expression of the imaginative and inventive genius of our time...is the machine, in all its beautiful simplicity."[444] Stieglitz clearly

agreed that the camera—as optical machine—was the paradigmatic artistic tool of the age. Further, his work suggested that the most appropriate subject of twentieth-century art was, on some level, the machine age itself.

As his nonphotographic exhibitions at 291 reveal, Stieglitz was deeply interested in that other characteristic expression of modernity: abstract art. In *The Steerage*, 1907 [65], the work he later considered the most important of his career, he produced a provocative synthesis of sociological content and abstract form.[445] Stieglitz emphasized the physical and psychological gap between the wealthy passengers on the upper deck and the poorer ones huddled below in the steerage section by composing the image so as to emphasis its division into halves. In addition, the lines of the deck, gangplank, mast, and ladder combine to create a taut pictorial geometry with its own logic and beauty. Stieglitz made this negative in the summer of 1907 on his way to Europe. (Although routinely used in history books to illustrate immigration to America, this photograph actually depicts the reverse.) However, all evidence suggests that Stieglitz did not immediately recognize its full artistic power.[446] In fact, he did not present *The Steerage* in any public form for four years, until it was reproduced as a gravure in the October 1911 issue of *Camera Work.* Significantly, this issue included the first of several abstract works by Picasso that would appear in the journal. Apparently, Stieglitz came to fully appreciate *The Steerage* only after absorbing the lessons of form contained in the most challenging art of the day.

Lewis Hine and the Human Document

While Stieglitz's interest in working-class subjects dated from his earliest use of the camera, his concern was always artistic rather than social. In 1896, he noted:

> Nothing charms me so much as walking among the lower classes, studying them carefully and making mental notes. They are interesting from every point of view. I dislike the superficial and artificial, and I find less of it among the lower classes. That is the reason they are sympathetic to me as subjects.[447]

Despite its boldly modern sense of form, *The Steerage* reflects a decidedly "Pictorialist" social sensibility: vaguely idealized, with little concern for specifics. This image reminds us that Stieglitz remained far more interested in an abstract "human condition" than in the real circumstances in which human beings lived and worked.

The work of Lewis Hine stands in marked contrast to this sort of detached aestheticism.[448] Hine's various menial jobs, endured while he struggled to put himself through school, gave him a great empathy for the working class and a firm belief in the value of education. In 1901, Hine was hired by his friend and mentor Frank A. Manny to teach nature study and geography at the Ethical Culture School in New York City. This progressive school emphasized moral conduct and the inherent dignity and creativity of man. The school's student body included many recent immigrants or first-generation Americans. In 1904, at Manny's suggestion, Hine began using the camera as an educational tool. To encourage his students to look more perceptively at their world, Hine formed the "Commerce Camera Club" and conducted photographic excursions through New York's busy

commercial areas. Hine emphasized the economic significance of what they saw, the mastery of photography as a practical skill, and the understanding of basic artistic principles. Hine's concern for aesthetics is clear; in a 1908 article, he observed that "the fundamental aim of the course is to...give the artist's point of view, for, in the last analysis, good photography is a question of art."[449] This article was illustrated with a photograph by Hine, *A Tenement Madonna: A Study in Composition*, based directly on a painting by Raphael. While few of Hine's other pictures were so clearly influenced by art-historical precedents, his work as a whole reveals a broad understanding of both art and photography.

During the first decade of his photographic career, Hine was strongly influenced by various associates. He began photographing at Ellis Island in about 1904 due, in large measure, to Manny's interest in the social issue of immigration.[450] In fact, Manny often accompanied Hine to Ellis Island to assist in the operation of his 5 x 7-inch tripod-mounted camera and magnesium-powder flash. In 1906, Hine began photographing on a freelance basis for the National Child Labor Committee, an organization headed by the Ethical Culture School's founder, Felix Adler. In his dozen years of work for the NCLC, Hine traveled thousands of miles across the country to record children working in mines, mills, workshops, and factories. Hine's career was also influenced by his friendship with Arthur Kellogg and Paul U. Kellogg, both of whom were active in the social-reform movement of the period. Paul Kellogg worked closely with Hine for thirty-five years and used his pictures in the publications he edited, including *Charities and the Commons*, *The Survey*, and *Survey Graphic*.[451] In 1907-08, Kellogg directed "The Pittsburgh Survey," the first comprehensive sociological study of an American city, and chose Hine as the project's photographer.

Hine's photographs had considerable public impact.[452] They were reproduced widely in newspaper and magazine articles, the publications of the NCLC and organizations such as the Child Welfare League, the six volumes of the *Pittsburgh Survey*, and the periodicals edited by the Kelloggs. Hine produced lantern slides and prints of his images for use in lectures and exhibitions. He controlled the meaning of his work by writing descriptive captions for his pictures and by organizing their presentation in books, exhibitions, and portfolios.

The great strength of Hine's photographs stems from their union of fact and empathy. Hine strove to convey the physical and emotional reality of his subjects and to render them memorable as both individuals and symbols. His depictions united the aims of the ethnographic image and the formal studio portrait, combining an attention to details of clothing and context with a deep respect for individual dignity.[453] The patience and warmth of Hine's approach emphasized the singularity of those who were too easily thought of only *en masse*. He evoked both the plight and the humanity of immigrants and the working poor by suggesting that despite weariness and exploitation they remained thinking, feeling beings.

The elegant simplicity of this approach is exemplified in Hine's *Albanian Woman with folded head cloth, Ellis Island*, 1905 [100]. Despite the baldly descriptive title, this woman is not reduced to a simple "type." By depicting her in half-figure, Hine created a perfect balance between costume and face, ethnicity and individuality. His viewing position may be characterized as politely familiar: close enough to monumentalize his subject, but restrained and respectful. This young woman responds with a remarkable sense of openness and engagement, looking directly into Hine's lens and—in effect—through space and time to *us*. Hine fully understood the power of the direct gaze, and knew that eye contact forced viewers to acknowledge the humanity of those who were too often unseen.

Hine applied the lessons learned in working at Ellis Island to the great body of child labor pictures he made from 1908 to 1917. His assignments for the NCLC took him thousands of miles and were accomplished under daunting conditions. His presence in factories, fields, and sweatshops was rarely welcomed by those in charge. Out of necessity, Hine devised various subterfuges, gaining entry to workplaces as a salesman or by pretending to photograph machines rather than the children beside them. Once inside, Hine worked rapidly to record his subjects and to make notes on their age, size, and working conditions. A typical image, *Spinner and Foreman in a Georgia cotton mill*, 1908 [99], made during his first year of work for the NCLC, suggests Hine's working method. On the one hand, this carefully posed photograph records a relatively clean working environment and a genial relationship between overseer and worker. However, as Hine well knew, the image's power stems from simple contrasts of scale. Dwarfed by her adult foreman and overwhelmed by an endless row of spindles, the girl's youth and frailty are made painfully clear. Hine's viewpoint is perfectly chosen to emphasize the child's vulnerability in a harsh and unforgiving world.

Hine's Ellis Island and child labor pictures suggest the basic themes of his life's work. As historian Alan Trachtenberg has observed, "Ellis Island represented the opening American act of one of the most remarkable dramas in all of history: the conversion of agricultural laborers, rural homemakers, and traditional craftsmen into urban industrial workers."[454] Thus, the movement of immigrants from the Old World to the New World was accompanied by a cultural transition from the agrarian age to that of the machine. The social-welfare movement, of which Hine was an important part, arose as an attempt to cope with the massive dislocations caused by the combined effects of immigration, urbanization, and industrialization. Hine sought the human meaning of this new world by celebrating individual worth in the face of these relentless, impersonal forces.

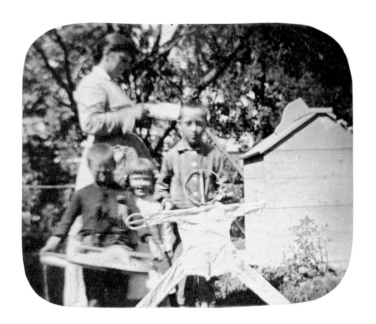

66　Henry N. Cady, *Untitled Family Group*, August 20, 1882, 2⅞ x 3½"

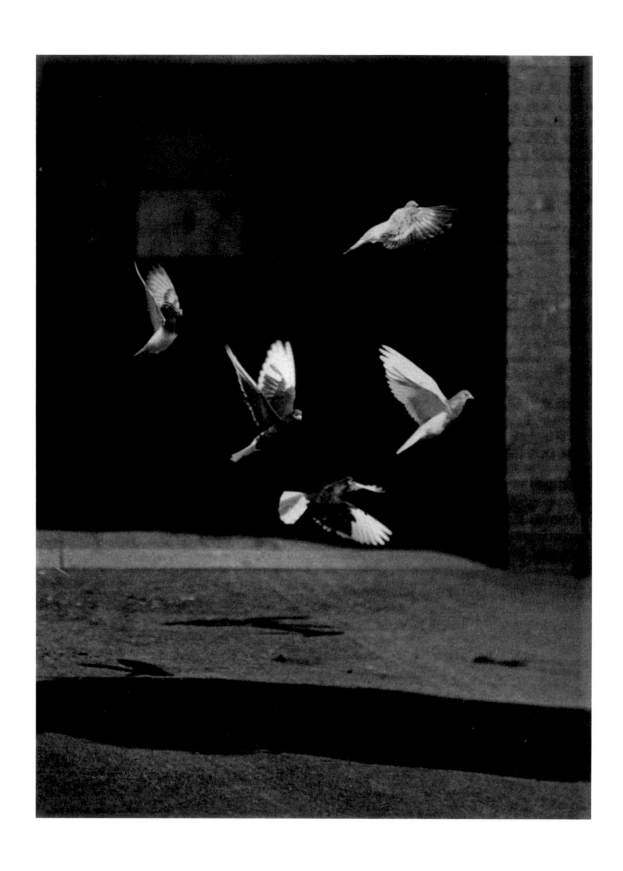

67 Francis Blake, *Pigeons in Flight*, ca. 1886-90, 8 x 6"

68 John Johnston, *Tigress, Central Park, New York*, ca. 1889, 8⅛ x 6⅜"

69 **Echard,** *West end of the village of Corona, Alabama,* ca. 1895, 19⅛ x 23⅝″

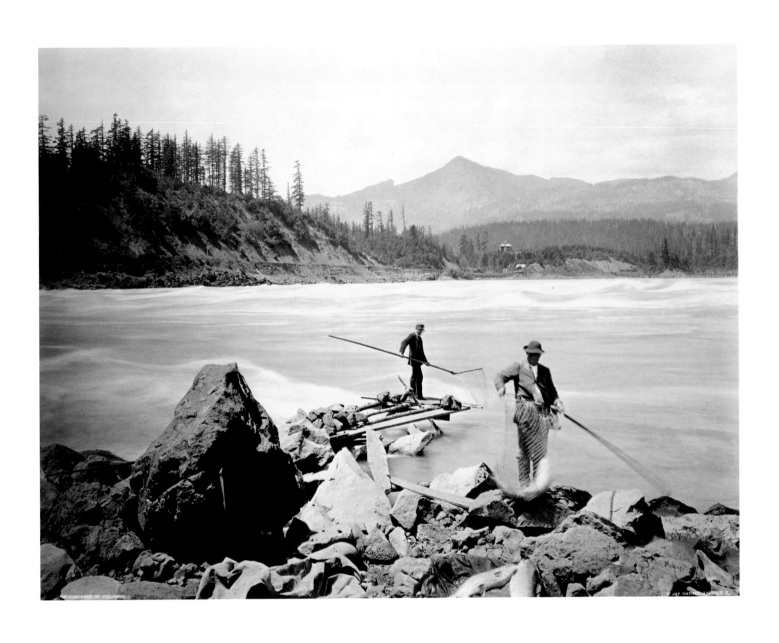

70 **F. Jay Haynes**, *Cascades of the Columbia*, ca. 1890, albumen print, 16⅜ x 21⅝"

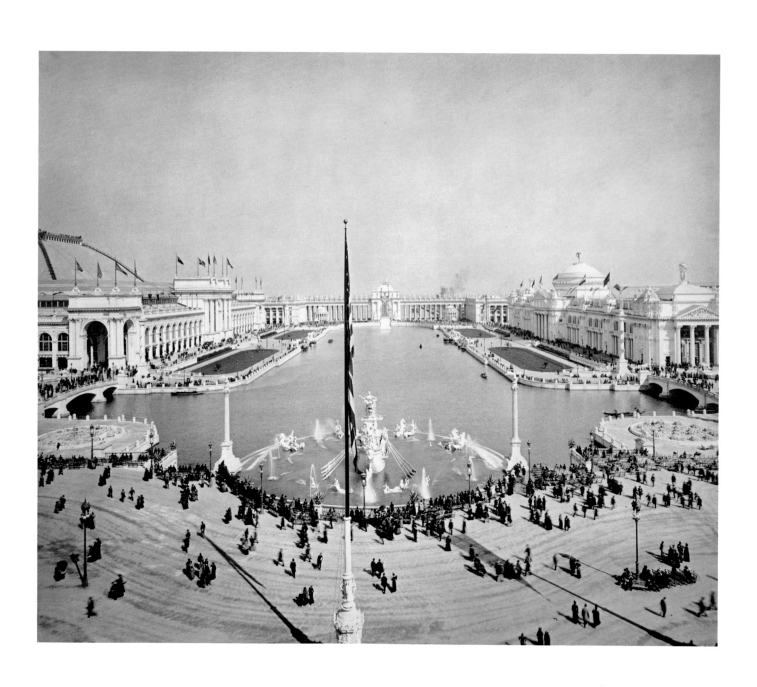

71 **Charles D. Arnold**, *Grand Basin, with the Peristyle in distance*, 1893, platinum print, 17⅜ x 20⅝″

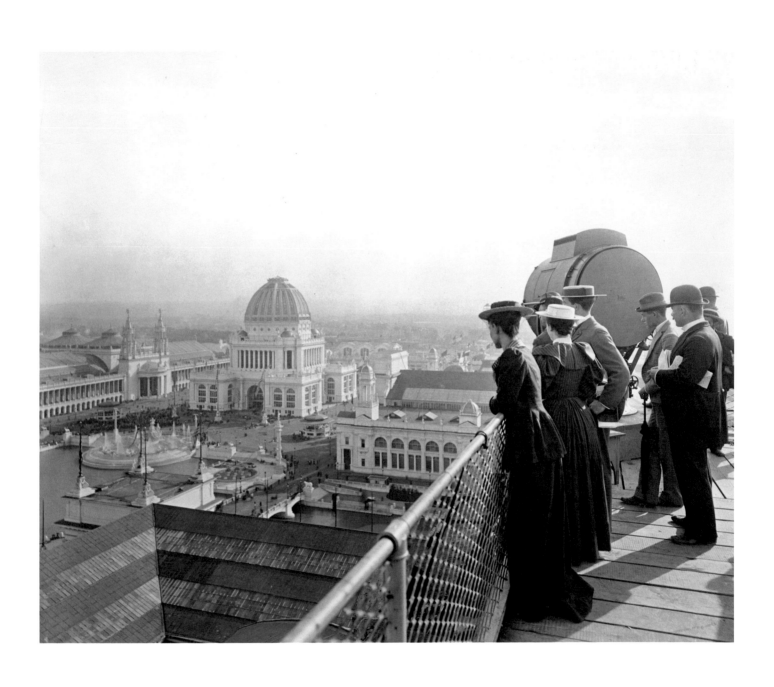

72 **Charles D. Arnold,** *Bird's-eye view from the top of the Manufactures and Liberal Arts Building*, 1893, platinum print, 16⅛ x 20⅛″

73 **William H. Rau**, *York Narrows, on the Susquehanna, Lehigh Valley Railroad*, ca. 1895, albumen print, 17 x 20⅛"

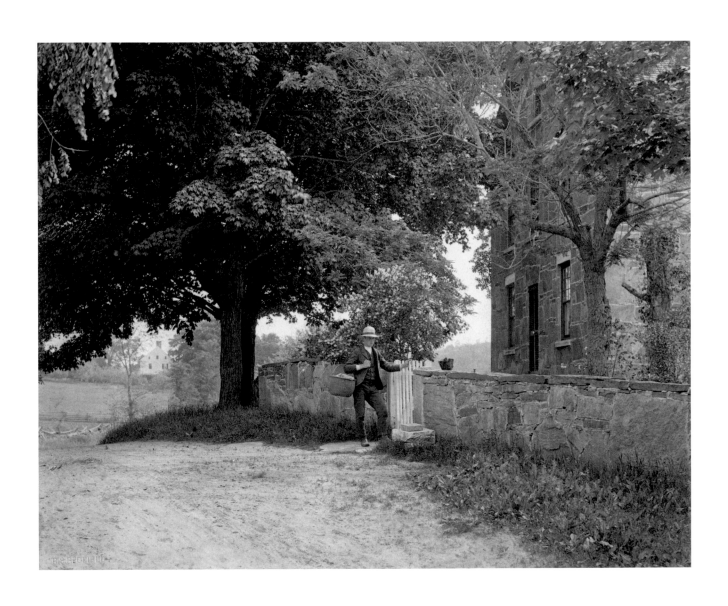

74 **Robert S. Redfield**, *Near Lake Waramaug, Connecticut*, June 10, 1890, platinum print, 7 ½ x 9 ½"

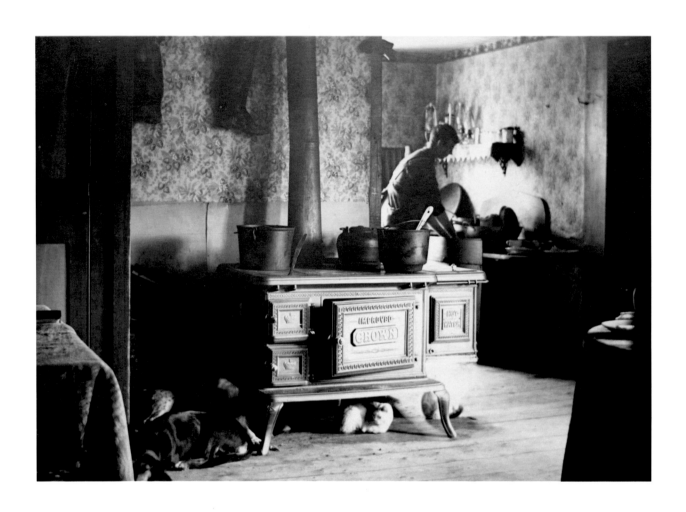

75 Clifton Johnson, *Kitchen, Chesterfield, Mass.*, 1895, 4⅝ x 6⅝″

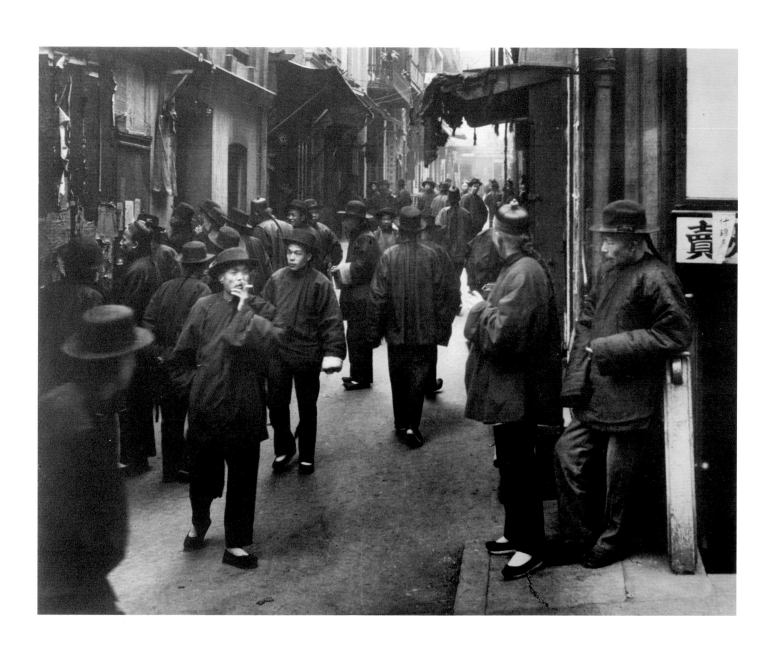

76 Arnold Genthe, *Street of the Gamblers*, ca. 1896, 9⅞ x 12½"

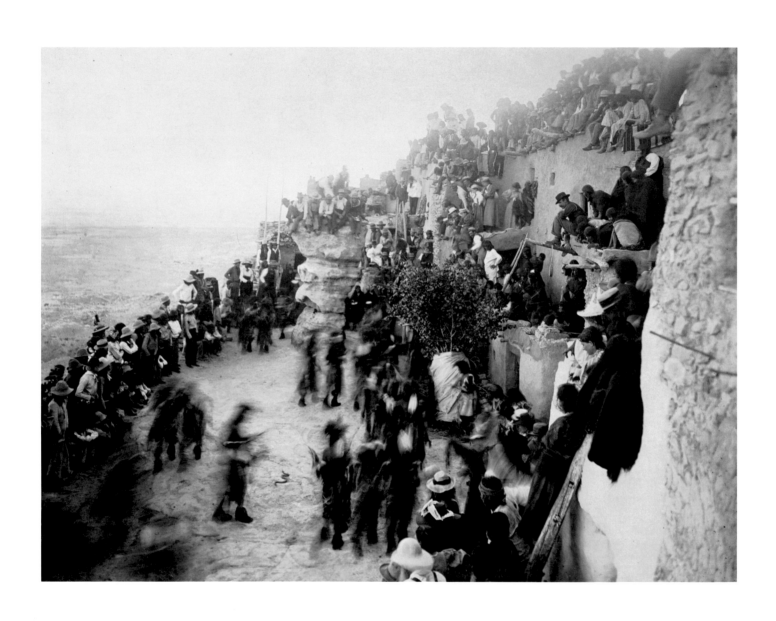

77 **Adam Clark Vroman**, *The Moqui Snake Dance (the people, the place, and the snakes)*, 1895, 6 x 8"

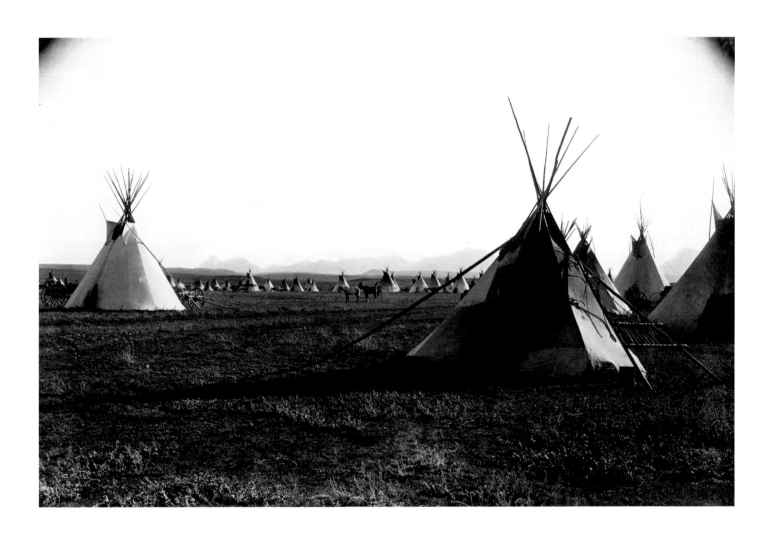

78 **Edward S. Curtis**, *Piegan Encampment*, 1900, 10¾ x 16⅜"

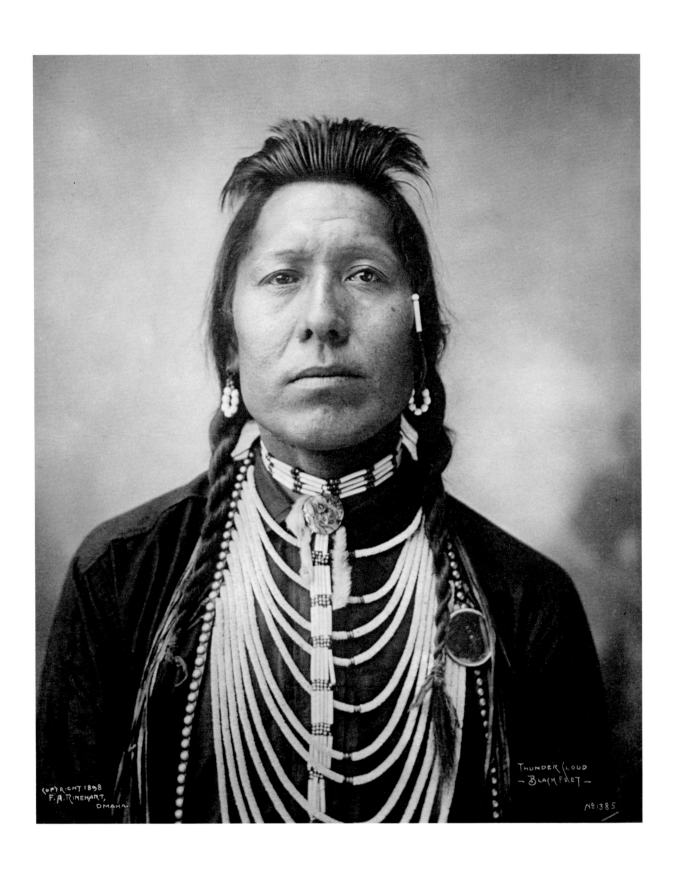

Within the image: COPYRIGHT 1898 F.A. RINEHART, OMAHA | THUNDER CLOUD — BLACKFEET — | No 1385

79 Frank Rinehart, *Thundercloud, Blackfeet*, 1898, platinum print, 8⅞ x 7⅛″

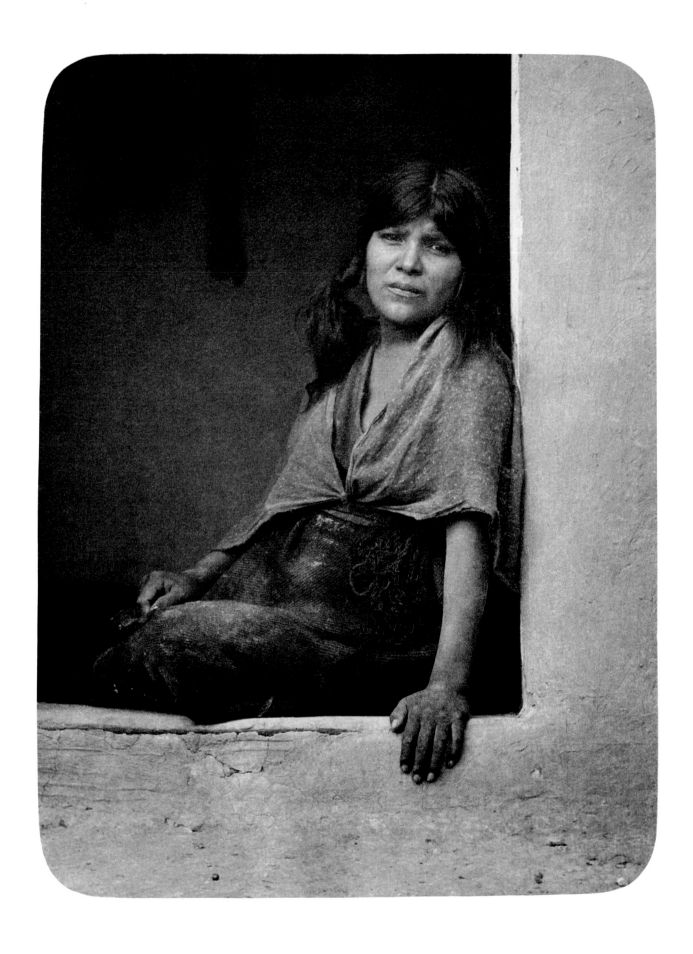

80 Frederick Monsen, *Seated Woman*, ca. 1910, 14 x 10½"

81 **F. Holland Day,** *"I Thirst,"* 1898, glycerine-developed platinum print, 3¼ x 3″

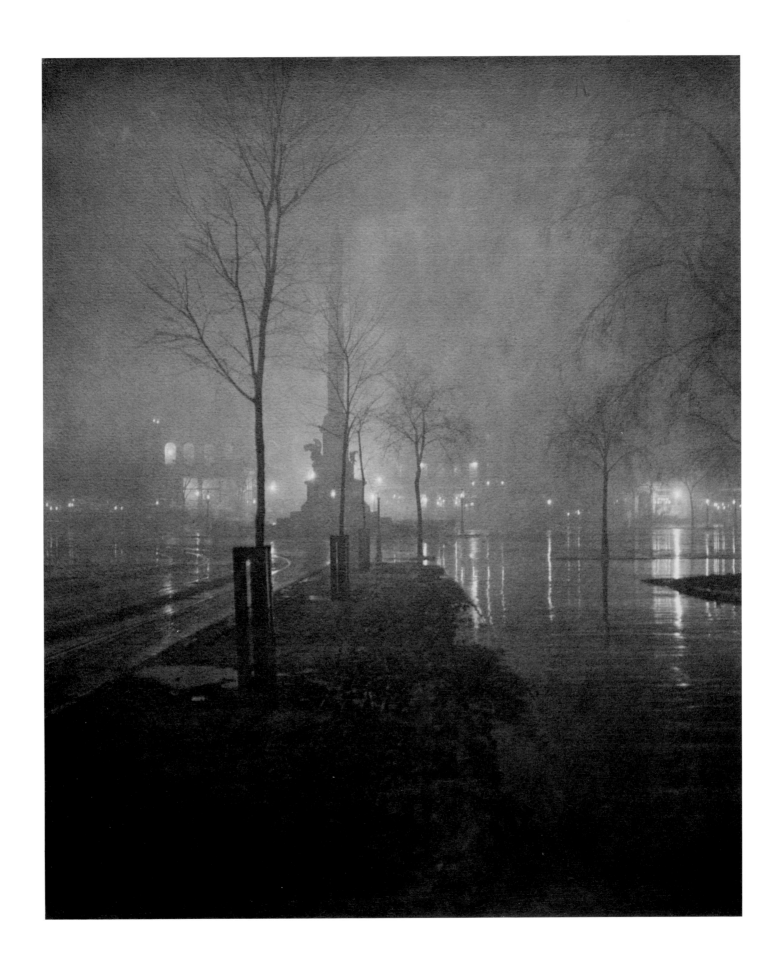

82 William A. Fraser, *A Wet Night, Columbus Circle*, ca. 1897-98, 20 x 16½"

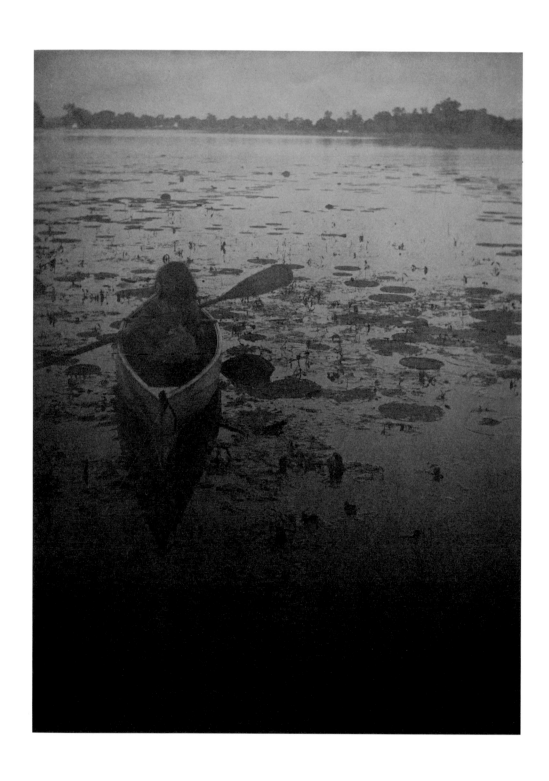

83 **Ema Spencer,** *Girl in Canoe*, ca. 1900, platinum print, 8¹⁄₁₆ x 6″

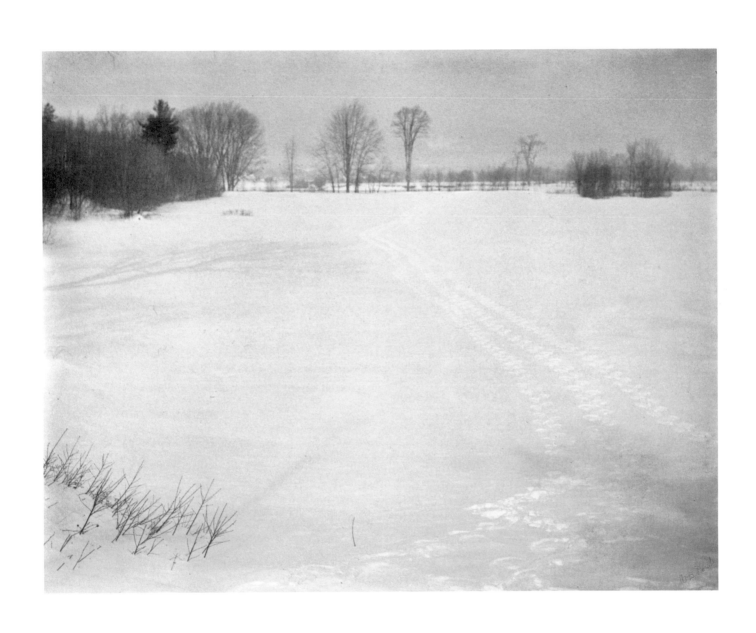

84 William B. Post, *Intervale, Winter*, 1899, platinum print, 7 ⅜ x 9 ⅛"

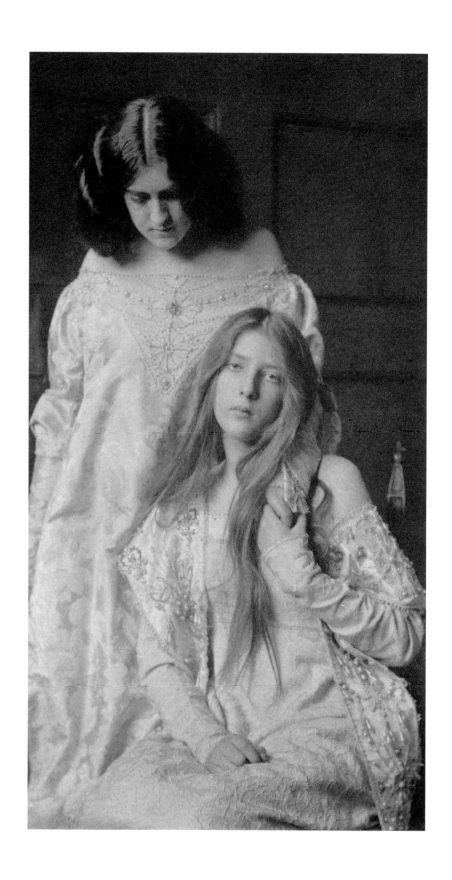

85 **Eva Watson-Schütze,** *Sisters,* ca. 1900, platinum print, 8⅛ x 4¼″

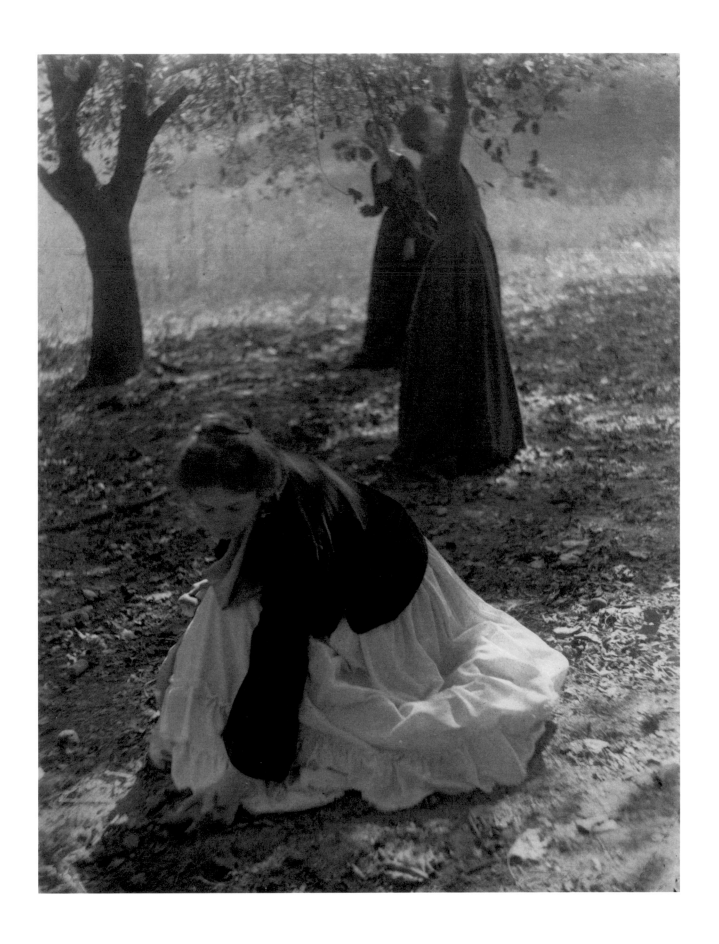

86 Clarence H. White, *The Orchard*, 1902, platinum print, 9¾ x 7⅝"

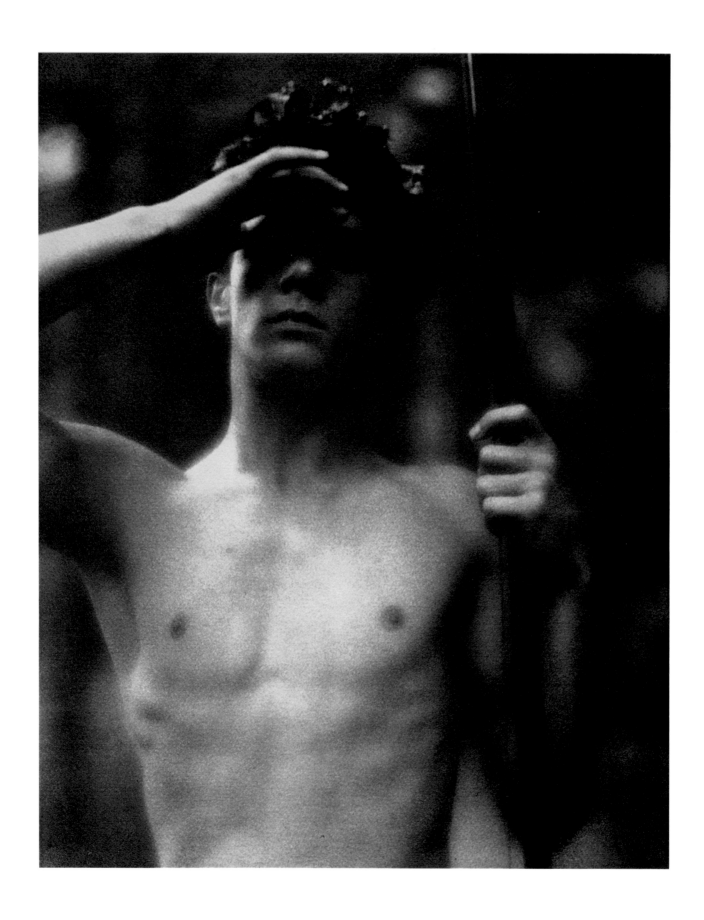

87 **F. Holland Day,** *Youth with Staff Shielding Eyes*, 1906, gum-platinum (?) print, 9⅝ x 7⅝″

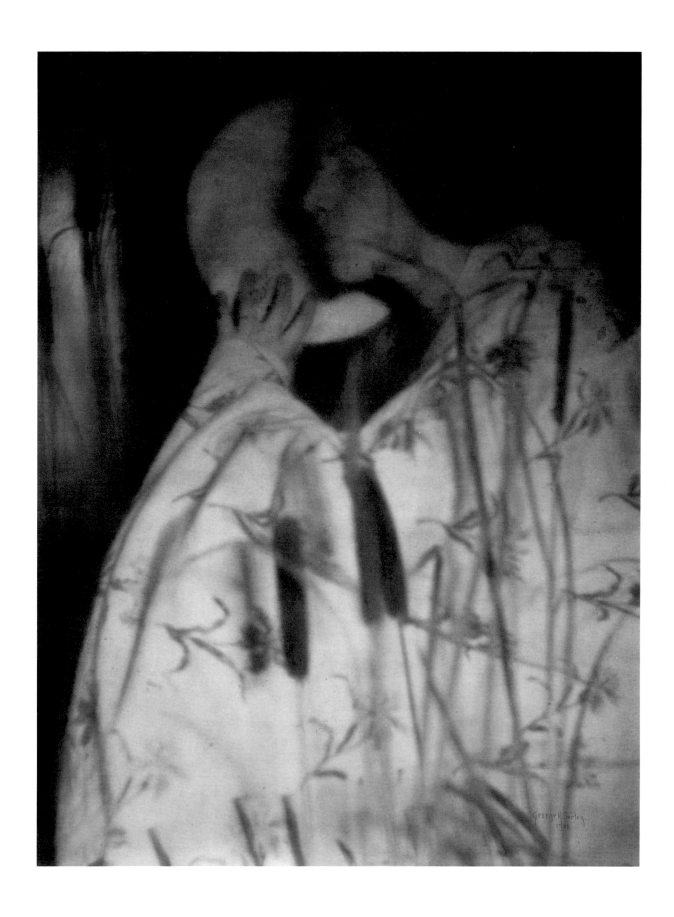

88 **George H. Seeley,** *Autumn,* 1905, platinum print, 13⅜ x 10⅜"

89 **Edward Steichen,** *Balzac by Moonlight,* 1908, gum-bichromate print, 11 x 11⅛″

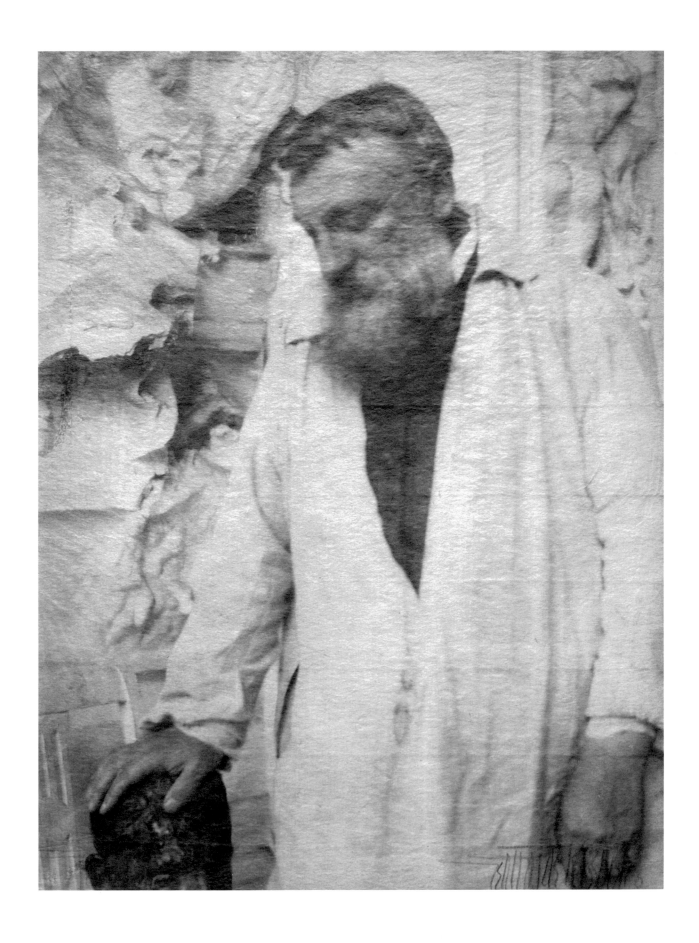

90 **Gertrude Käsebier,** *Auguste Rodin*, 1905, gum-bichromate on tissue, 12¼ x 9½″

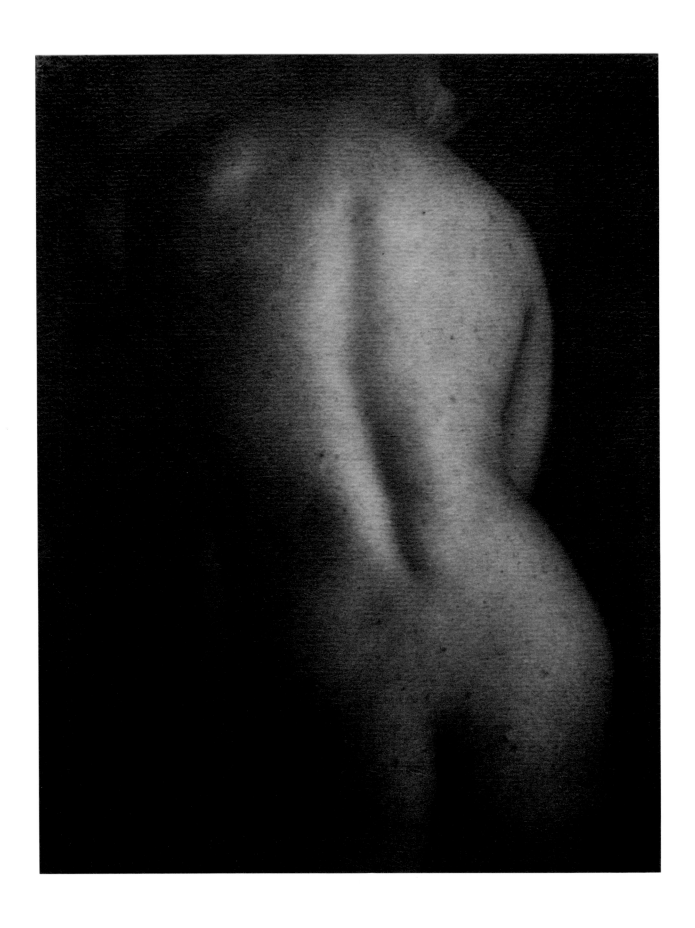

91 Thomas O'Conor Sloane, *Mme. Sato*, ca. 1908, gum-platinum print, 9⅝ x 7⅞″

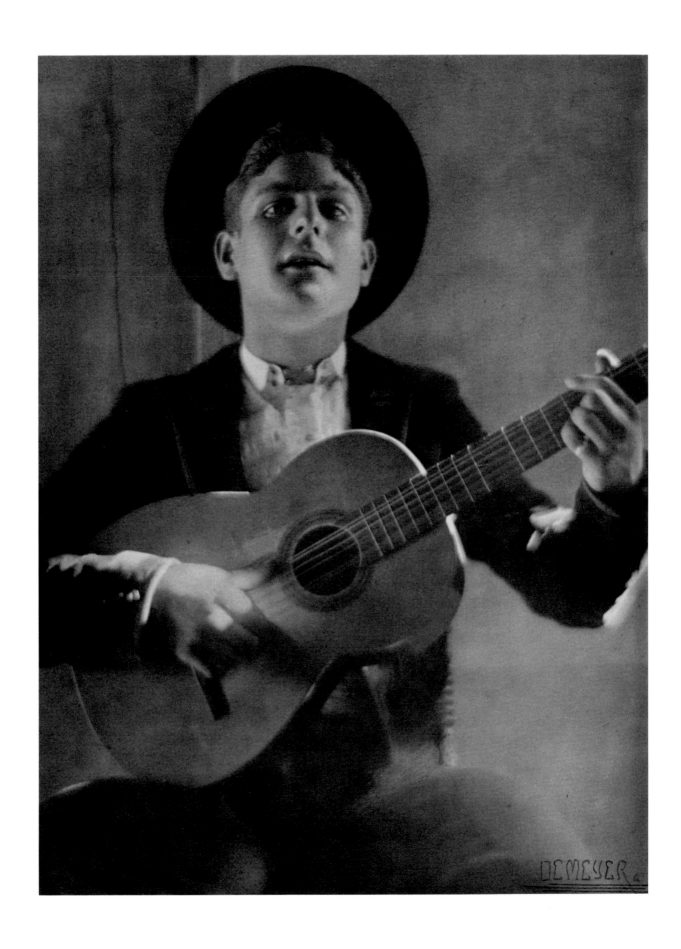

92 **Baron Adolph de Meyer,** *Guitar Player, Seville,* 1907, platinum print, 14 x 10½"

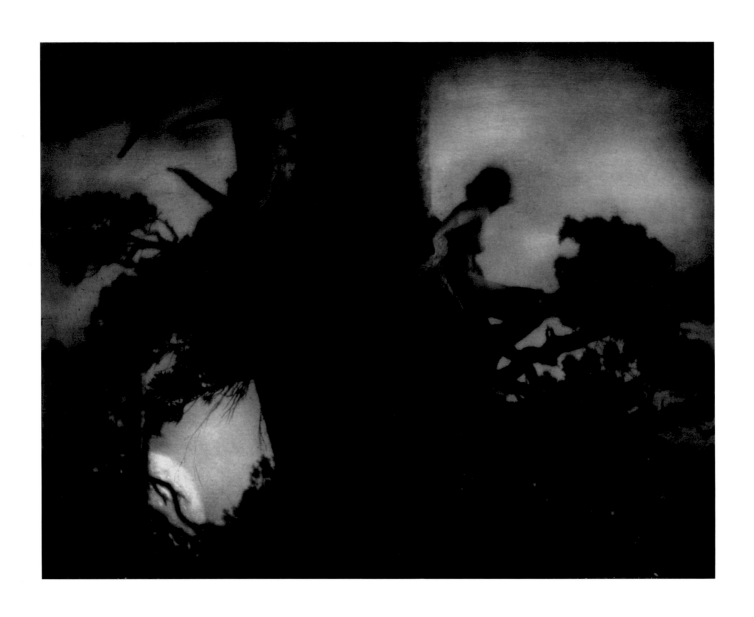

93 Anne W. Brigman, *The Pine Sprite*, 1912, platinum print, 7⅜ x 9½"

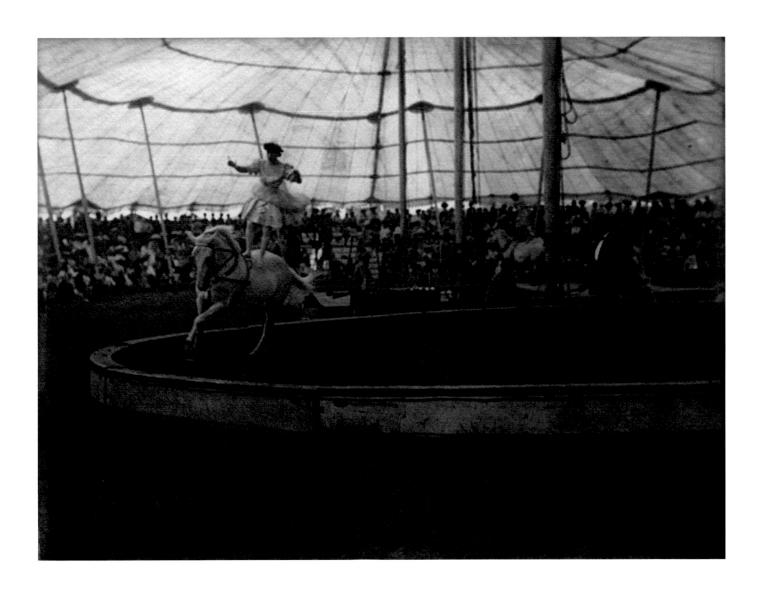

94 Harry C. Rubincam, *In the Circus*, 1905, platinum print, 6¼ x 8⅜"

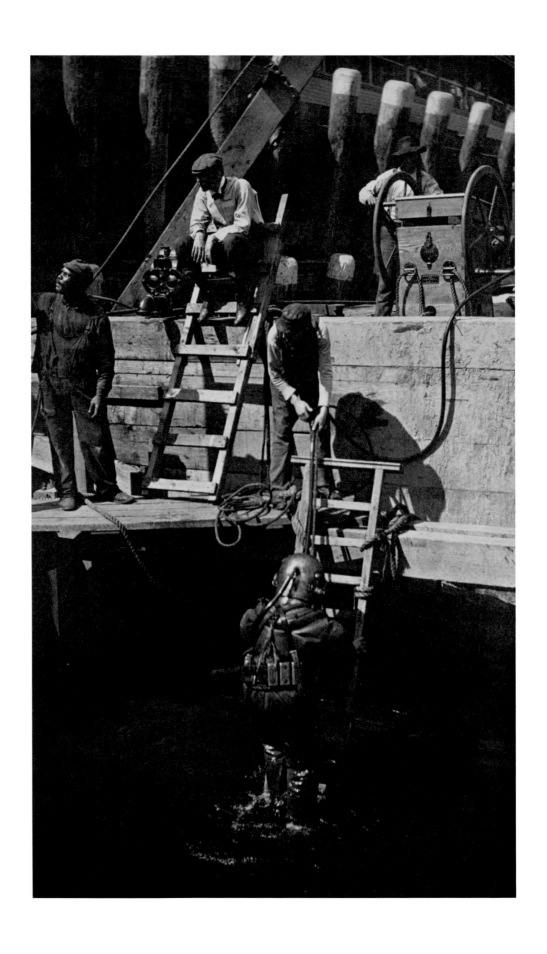

95 Dr. Albert R. Benedict, *Divers*, ca. 1907, 10¾ x 6⅜"

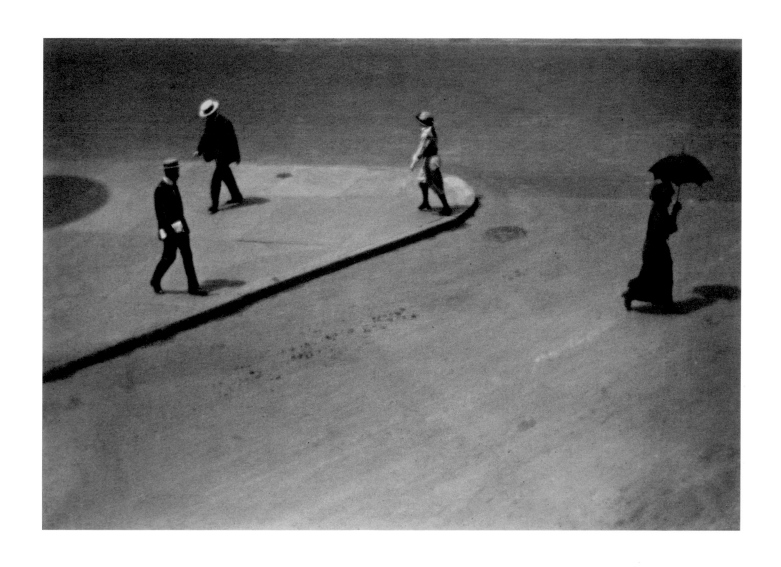

96 **Kurt W. Baasch**, *Repetition*, ca. 1912-13, platinum print, 8⅜ x 12¼″

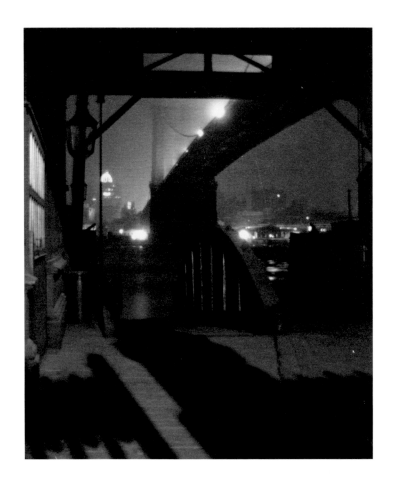

97 Karl Struss, *Brooklyn Bridge from Ferry Slip, Evening*, 1912, platinum print, 4½ x 3¾"

98 Alvin Langdon Coburn, *The House of a Thousand Windows*, 1912, platinum print, 16⅛ x 12⅜"

99 Lewis W. Hine, *Spinner and Foreman in Georgia cotton mill*, 1908, 4¾ x 6¾″

100　Lewis W. Hine, *Albanian Woman with folded head cloth, Ellis Island,* 1905, 6¾ x 4¾″

101 **Ilse Bing,** *Self Portrait with Leica,* 1931, 8¾ x 10⅝″

CHAPTER II Abstraction and Realism
1915-1940

The quarter century after 1915 produced changes of unprecedented magnitude in American life. The era began and ended with the nation on the verge of entering devastating world wars. Between these conflicts, Americans experienced the giddy boom of what Carl Van Vechten called "the splendid, drunken twenties," as well as the worst economic crisis in the nation's history. In this time, the United States underwent dramatic demographic shifts. As the nation grew from about 100 million to 131 million people, blacks migrated from South to North, and many whites left farms for factory jobs in cities. The 1920 census confirmed that the United States had become an urban nation, with fewer than half its citizens living in rural areas. This population exhibited significant ethnic diversity: by 1930, about one-third of the nation's citizens were either first- or second-generation immigrants.

This twenty-five-year period was distinguished by a series of remarkable achievements and discoveries. The characteristic hero of the age was the engineer, the analytical problem-solver who used technology to extend culture's dominion over nature. The Panama Canal, opened in 1914, was a massive demonstration of American engineering prowess. Within the country, the expansive energies of the modern age were epitomized by the soaring skyscrapers and sheer physical exuberance of New York City. The Woolworth Building, completed in 1913, reigned as the world's tallest occupied structure before being surpassed by the Empire State Building in 1931. Similarly, the great bridges of the era—New York's George Washington (1931) and San Francisco's Golden Gate (1937)—were hailed as eloquent symbols of the new age. The airplane also carried potent symbolic meaning, and the public was fascinated by such feats as the first nonstop flight across the Atlantic (1919), the solo transatlantic passages of Charles Lindbergh (1927) and Amelia Earhart (1932), Richard

E. Byrd's aerial transits of the North (1926) and South Poles (1929), and the first nonstop flight across the Pacific (1931).

Discoveries in science dramatically changed the way Americans thought about reality. Albert Einstein's general theory of relativity, published in 1916, had a marked impact in the U.S. in the 1920s. In that decade, American physicists and astronomers such as Albert Michelson, Harlow Shapley, and Edwin Hubble determined the speed of light, the distance of neighboring stars, the size of the Milky Way, the existence of galaxies outside our own, and the fact that the entire universe was expanding. The introduction of the radio telescope (1937) and electron microscope (1940) further extended the range of human perception in dramatic ways.

This era also witnessed a revolution in communications. The perfection of wireless transmissions—which were common by 1915—led to the radio boom of the 1920s. The nation's first radio station, KDKA in Pittsburgh, went on air in 1920; within two years some 500 other stations were in operation nationwide. Telephone service grew with similar rapidity, resulting in the initiation of regular transatlantic connections in 1927. After the release of the first "talkie," also in 1927, the motion-picture industry was transformed by the quick demise of silent pictures. Television was successfully demonstrated that year, but would not become a commercial reality for another two decades.

The 1920s was an age of speed, abundance, and nervous vitality. The pace of life seemed typified by the polyrhythmic sounds of jazz and the exuberance of such "animal" dances as the fox trot and jitterbug. The automobile became a key symbol of this new age of speed and efficiency. In 1915, race driver Gil Anderson established an auto speed record of 102 miles per hour. In a short time, the car profoundly changed the nature of travel

and the experience of the American landscape.[1] After establishing its first assembly line in 1913, the Ford Motor Company produced its millionth Model T in 1915, and its ten millionth in 1924. With the construction of limited-access parkways, which began in the 1920s, the population of the United States became increasingly mobile. The automobile sped the growth of suburbs and a new roadside culture of shopping centers and fast-food restaurants.

New modes of industrial organization allowed an unprecedented expansion in the variety and quality of consumer goods. This cornucopia of machine-made items was accompanied by the rise of modern advertising, which sought to orchestrate and focus the desires of the public. These forces, in combination with the provocative ideas of Einstein, Freud, and a host of iconoclastic modern artists, eroded what remained of the comforting stability of Victorian-era truths.

While exciting to many, this new world was fraught with discord and uncertainty. To traditionalists, young people of the era seemed decadent and materialistic. On a larger scale, labor unrest, racial dissent, and women's struggles for equal rights revealed the tensions lying beneath the progressive surface of American culture. Resistance to social change took various forms, including Prohibition, the anti-immigration movement, and the rise of reactionary factions such as the Ku Klux Klan.[2] A more benign reaction—though similarly expressive of a nostalgia for an idealized, premodern America—was the rising public and scholarly interest in early American culture; this was indicated, in part, by the opening of such historic recreations as Colonial Williamsburg, Greenfield Village, and Old Sturbridge Village.

This complex mood of nationalistic celebration and isolationist reaction was shattered by the stock market crash of October 1929. Wall Street's collapse rocked the national and international economies, creating the worst financial crisis in history. Within three years, 75 percent of the value of all American securities vanished. The nation's financial system came unhinged as thousands of banks failed and millions of workers were laid off or given wage cuts. National unemployment rates reached at least 24 percent in 1932, and remained painfully high throughout the decade. By some accounts, two-thirds of the nation's population was either unemployed or underemployed at the depth of the Depression.

To make matters worse, this economic crisis coincided with an ecological catastrophe, as vast sections of the agricultural heartland were plagued by droughts between 1930 and 1940. In April 1934, the Midwest was struck by the first of a series of dust storms. Relentless winds lifted powder-dry soil off the ground and deposited it far away in drifts. The effects of the Dust Bowl were devastating, and many farm families were forced to simply abandon their lands. The uncertainty and privation of this decade profoundly affected the outlook of an entire generation.

Not surprisingly, the tumultuous twenty-five years between 1915 and 1940 produced art of unprecedented vitality. In the decade before the market crash, the most progressive art was characterized by intellectual confidence, formal invention, abstraction, irony, and a general mood of estrangement from popular culture. After 1929, many artists and photographers turned to more straightforward techniques and to subjects of broad social interest. In this quarter century of boom and bust, artists explored the extremes of the modern condition: the liber-ating excitement of unfettered thought and the sobering realities of economic and political life.

"A World Bursting With New Ideas"

The second decade of the twentieth century was one of restless exploration in nearly every facet of American cultural life. Progressive and radical thinkers promoted new ideas in politics, race relations, women's rights, psychology, education, and the arts. The heyday of this "Little Renaissance" was 1913 to 1917: from the time of the Armory Show to the nation's entry into the First World War.[3] As critic Hutchins Hapgood observed in early 1913:

> We are living at a most interesting moment in the art development of America. It is no mere accident that we are also living at a most interesting moment in the political, industrial, and social development of America. What we call our "unrest" is the condition of vital growth, and this beneficent agitation is as noticeable in art and in the woman's movement as it is in politics and industry. "Art" has suddenly become a matter of important news.[4]

In the visual and literary arts, this enthusiasm for the new was expressed by an international network of artists, patrons, and partisans. Harriet Monroe's magazine *Poetry*, founded in Chicago in 1912, featured the emerging talents of such writers as Sherwood Anderson, Vachel Lindsay, Edgar Lee Masters, Carl Sandburg, and William Carlos Williams. Ezra Pound, an American poet living in London, served as foreign correspondent for *Poetry*. He provided a link between the English and American literary avant-gardes, introducing readers at home to the work of young writers such as T. S. Eliot and James Joyce. In Paris, the gatherings hosted by the writer Gertrude Stein (and her brother Leo Stein, an important collector of new art) provided a meeting place for visiting Americans and members of the French avant-garde.

New York City was the center of this international network of American avant-gardists. The vitality of New York's "Little Renaissance" stemmed from the fervent idealism of individuals with widely divergent interests. Painters, poets, photographers, musicians, playwrights, actors, critics, suffragettes, labor activists, anarchists, and all manner of bohemians and free thinkers saw themselves as part of a great movement dedicated to intellectual and social change. For a brief time, this desire to challenge the status quo in itself provided a feeling of common cause, sparking a uniquely vital moment in the nation's cultural history.

Of course, the intellectual energy of this period did not arise in a vacuum. The basic tenets of these interrelated avant-garde movements reflected the influence of such European writers as George Bernard Shaw, Henrik Ibsen, and Friedrich Nietzsche. Timely visits to America by prominent European intellectuals such as Sigmund Freud (in 1909), Carl Jung (in 1912), and Henri Bergson (in 1913) also notably affected the cultural climate. Publications such as *The Masses*, *The Smart Set*, *New Republic*, and *The Seven Arts*, and the critical writings of H. L. Mencken, Van Wyck Brooks, and Randolph Bourne, all challenged existing conventions and encouraged an openness to new ideas.[5]

The most radical changes in the visual arts were occurring in Europe but had profound effects in America. In 1908, Robert Henri and several other Realist painters known as "The Eight"

broke away from the tradition-bound National Academy of Design and mounted an exhibition of their own, more progressive work. Also in 1908, Stieglitz first showed a major European avant-garde artist at his gallery. This exhibition of drawings by Auguste Rodin was followed in the next few years by installations of work by Paul Cézanne, Pablo Picasso, Francis Picabia, Henri Matisse, and Constantin Brancusi. Between 1908 and 1917, Stieglitz also introduced the work of young American painters such as Arthur Dove, Marsden Hartley, John Marin, Max Weber, and Georgia O'Keeffe, and presented the first display of African sculpture in this country.

The Armory Show, the most important art exhibition in American history, was held at the 69th Street Armory in New York from February 17 to March 15, 1913. "The International Exhibition of Modern Art," as it was officially named, later traveled in reduced form to Chicago and Boston. Over 1,000 paintings and sculptures by European and American artists were included in the New York installation. While the majority of these were uncontroversial, American audiences were stunned by the works of Matisse, Picasso, Braque, Brancusi, Picabia, and Marcel Duchamp. Skeptics ridiculed them as "mad," but more open-minded viewers were overwhelmed by these daringly unconventional paintings and sculptures.

The Armory Show had an immediate impact on the reception of modern art in America. Leading museums took a new interest in the most challenging contemporary painting, and important private collections were begun by individuals such as John Quinn and Walter Arensberg. Several galleries specializing in the new art opened in New York, including the Daniel Gallery, the Carroll Gallery, and Marius de Zayas's Modern Gallery.[6] In fact, some 250 exhibitions of progressive American and European work were presented between 1913 and 1918 by no fewer than thirty-four New York galleries, organizations, and private clubs.[7]

This does not mean, of course, that modern art won immediate popular acclaim. With few exceptions (such as the coverage of the New York Sun), the new art was attacked in both the popular and academic press, and regularly associated with anarchy, insanity, and immorality.[8] In 1917, for example, the American Magazine of Art fulminated against the "madmen" whose works could only be understood as "the manifestations of a feverish and sickened age" and which posed a menace to "the retention of high and pure ideals."[9] In response to the Armory Show, the New York Times suggested that the new art was "surely a part of the general movement, discernible to all of the world, to disrupt, degrade, if not destroy, not only art but literature and society too."[10]

Despite the frequency of such denunciations, a growing segment of the public embraced these new forms of expression. The scope of this audience is suggested in the intelligent coverage given to modern art by Vanity Fair, a mass-market—if clearly "highbrow"—magazine. Under the editorship of Frank Crowninshield, Vanity Fair published reviews of many avant-garde exhibitions in New York, essays on European art movements such as Futurism and Vorticism, and profiles of the most notable painters, sculptors, writers, and composers of the day.[11] The magazine thus gave broad exposure to the most challenging creative ideas while refining the image of the modern artist as celebrity.

The avant-garde community in New York was energized by a pervasive spirit of experimentation. The boundaries between disciplines were blurred: visual artists wrote poetry and published literary journals, poets were inspired by modern painting, and everyone took an interest in theater, politics, and psychology. The vitality of this interchange is suggested by the profusion of small literary journals and artist-produced magazines that flourished in the middle of the decade. One of the most important of these was Stieglitz's Camera Work, which appeared steadily from 1903 through 1913, then irregularly until its end in 1917. Stieglitz's enthusiasm for Camera Work lessened, in part, because the arts were now receiving sympathetic coverage in journals such as The Smart Set (1913-23), New Republic (founded 1914), and The Seven Arts (1916-17). In the late 1910s, a flurry of eccentric and short-lived magazines—including Glebe, 291, 391, and Others—were issued by artists such as Man Ray and Francis Picabia in collaboration with a colorful assortment of friends and patrons.[12] While these fleeting experiments had little public impact, they were essential to those "in the know" and provided an outlet for the most advanced poetry, art, and criticism of the period.

This intellectual cross-pollination was, in part, a product of the active social life of the New York avant-gardists. Interconnected circles of allegiance grew up around several influential figures, including Alfred Stieglitz, Mabel Dodge, and Walter Arensberg. From the cramped domain of his gallery, Stieglitz showed the work of his favorite painters, philosophized with visitors, and espoused the modernist cause.[13] His associates in the mid-1910s included the caricaturist and theorist Marius de Zayas, the photographer and wealthy arts patron Paul B. Haviland, and, for a short time, the French Dadaist Francis Picabia.[14] Stieglitz also championed such younger photographers as Paul Strand, Charles Sheeler, and Morton Schamberg.

Stieglitz and his associates often met other avant-gardists at the apartment of Mabel Dodge. Dodge had become a supporter of the modern movement after meeting Gertrude Stein in Paris in 1911. Fascinated by Stein's challenging prose experiments (first published in Camera Work in 1912), Dodge resolved to play a role in the creative life of her age. After returning to New York, she began holding weekly "evenings" at her Greenwich Village apartment. These now-legendary gatherings—which have been described as "a combination of town meeting, bohemian Chautauqua, and cocktail party"—were attended by many of the period's leading artists, poets, actors, journalists, critics, and social reformers.[15]

Another important artistic salon met in the New York apartment of Walter and Louise Arensberg, major supporters of both the visual and literary avant-gardes. The Arensberg soirées were attended by a stimulating and talented group: the poets Wallace Stevens, William Carlos Williams, and Alfred Kreymborg; the young artists Charles Sheeler, Morton Schamberg, Charles Demuth, and Man Ray; and visiting members of the French avant-garde, including the artists Duchamp and Picabia, the composer Edgar Varèse, and the critic Henri-Pierre Roché.[16]

While remarkably diverse in experience and outlook, the members of this iconoclastic community were united by a basic set of ideas.[17] In varying degrees, all were in revolt against the Victorian world view and the genteel tradition in the arts. These were understood to represent bourgeois culture at its most stultifying: unreflective, repressive, and conformist, and built on systems of belief that had been discredited by recent science and philosophy.

Gone, too, was the faith that art should (or could) reflect any single standard of morality, truth, or beauty. The complexity of modern experience called for a corresponding diversity of artistic subjects and methods, as well as new critical standards by which to judge these achievements. Edward Steichen expressed his generation's mixture of excitement and uncertainty in a 1913 letter to Stieglitz: "One is conscious of unrest and seeking—a weird world hunger for something we evidently haven't got and don't understand....Something is being born or is going to be."[18] Or, as critic Walter Lippmann wrote of this process of transformation, "Instead of a world once and for all fixed with a morality finished and sealed...we have a world bursting with new ideas, new plans, and new hopes. The world was never so young as it is today, so impatient with old and crusty things."[19]

These modernists sought to unite the peculiar energies of the modern world with an earlier generation's antimodernist embrace of subjectivity and intuition. By reintegrating the rational and intuitive faculties, they felt, a life of mind *and* spirit could be forged from the gross materialism of American culture. The key to this quest was a liberation from all forms of restraint: social, cultural, and moral. Frankness and "realism" thus became dominant values in this generation's attempt to sweep away the timidity and repressions of the genteel tradition.[20]

Central to this quest was the inherent creative potential of each individual. While nineteenth-century American artists had placed their faith in "timeless" laws, dutiful study, and the rules of the Academy, those of the Stieglitz circle, for example, looked only to their innermost selves for inspiration and validation. Their belief in an intuitive creative force was confirmed not only by the most radical art of the European avant-garde, but also by the art of "primitives" and children.[21] Stieglitz, in particular, felt the artistic impulse to be sacred and life-affirming. He regarded artists as seers and prophets, and frequently used words such as Truth, Life, and Spirit in talking about the meaning of art. Symbolically, his lifelong fight for the recognition of photography as art represented a fundamentally Romantic notion: the self's struggle for liberation from all forms of imposed authority. As he noted in 1913, in praising the Armory Show, the key to the new art was "individual independence."[22]

Paradoxically, it might seem, a revitalized sense of artistic nationalism arose in tandem with this celebration of individual creativity. Rejecting the bland internationalism of the genteel tradition, leading artists and thinkers sought spiritual renewal in a self-consciously American art. These cultural nationalists were led by Herbert Croly, Walter Lippmann, and Randolph Bourne of the *New Republic*; James Oppenheim, Waldo Frank, Van Wyck Brooks, and Paul Rosenfeld of *The Seven Arts*; and Robert J. Coady, editor of the small magazine *The Soil*. These writers all claimed cultural independence from Europe and encouraged uniquely American subjects and styles. As a recent historian has noted, this nationalist criticism was not "analytical or historical but a kind of religious proselytizing."[23] Often using utopian or mystical rhetoric, these critics envisioned an organic relationship between the American experience and its art. Further, they argued that art had the power to heal the schisms of modern society. They sought to construct their own historical lineage—in Brooks's famous phrase, "a usable past"—on which an authentic twentieth-century aesthetic could be based.[24] Thus, the literary achievements of Emerson, Thoreau, Melville, and Whitman were celebrated, and held up as examples to contemporary writers and artists. Radical critics like Coady even praised such "lowbrow" forms of Americana as vaudeville, jazz, department stores, neon lights, motion pictures, and sports, but this broad embrace of popular culture ran counter to the spiritual idealism of Stieglitz and his circle. Ultimately, all these critics shared a "hope that from honest soul-searching, a genuine American culture might emerge, a unitary culture derived from the American plurality, self-aware, tough-minded, yet based on spiritual rather than material values."[25]

For those who felt that America's uniqueness lay in its pragmatism and analytical genius, this quest for an indigenous national aesthetic prompted a new interest in a key emblem of modernity. The machine—or at least an idealized notion of technological efficiency—became a subject of increasing intellectual and artistic interest. The avant-garde fascination for the functional beauty of the machine was paralleled by a new photographic emphasis on technical purism. Now, a decade after Sadakichi Hartmann's essay "A Plea for Straight Photography," artists sought to embrace, rather than subvert, the camera's mechanical nature.[26] As Paul Strand wrote in a 1917 essay published in both *The Seven Arts* and *Camera Work*, photography "finds its raison d'être, like all media, in a complete uniqueness of means. This is an absolute unqualified objectivity." Rejecting "tricks of process or manipulation," Strand argued that "a living expression" could only result from the photographer's genuine respect for both his subject and his medium.[27]

In hindsight, it may seem strange that photographic "purism" could have been regarded as a radical artistic stance in 1917. The great majority of commercial and amateur photographers made nothing but "straight" images, and the artistic potential of the unmanipulated photograph had long been promoted by critics such as Hartmann. In fact, however, the new purism of the late 1910s rejected the mundane factuality of commercial photography as well as the gauzy insubstantiality of most Pictorialism. Underlying this new objectivity was a faith in the correspondence between objects and ideas, and the desire to see *through* physical reality to larger truths. Stieglitz's influence is clear in Strand's description of this new objectivity as a quest for "Life," "a universal expression," and "an ever fuller and more intense self-realization." In short, the artistic goals of this new "straight" photography remained as idealistic as those of Pictorialism, but the emphasis was now on transcendent clarity rather than dreamy imprecision.

"The Trinity of Photography"

These new purist ideas found their most immediate expression in the photographs of Paul Strand, Charles Sheeler, and Morton Schamberg. Their work of 1916-17 synthesized the varied styles then understood as "Cubist," giving compelling visual form to the most provocative new concepts.[28]

Paul Strand, the youngest of the three, was the first to gain national prominence. As a student, Strand had been influenced by Lewis Hine, his teacher at the Ethical Culture School in New York, and, slightly later, by Stieglitz, whose gallery he first visited in Hine's class. The precocious Kurt Baasch, a close friend of Strand's, was also a notable influence.[29] After working through

102 **Paul Strand**, *Abstraction, Porch Shadows, Twin Lakes, Connecticut*, 1916, gravure, 9½ x 6⅝"

simplest of subjects—kitchen crockery, fruit, and the front porch of his cottage—he fashioned pictures that come boldly close to complete abstraction [102]. As he later recalled, Strand was seeking to understand "the underlying principles behind Picasso and the others in their organization of the picture's space, of their unity of what that organization contained, and the problem of making a two-dimensional area have a three-dimensional character."[30] In this period, Strand employed a similar close-up vision in tightly cropped images of automobile wheels and fenders. While the content of these images remained recognizable, the treatment of this supremely modern subject was provocatively new. Strand's third major series in this pivotal period is a group of candid street portraits begun in the fall of 1916. Using a right-angle prism on his lens, Strand recorded individual pedestrians in a powerfully unidealized manner. "Detached from their surroundings," writes photographic historian Sarah Greenough, "these people assume monolithic proportions; they have the strength, solidity, singularity, and elegiac quality of tombstones."[31]

Charles Sheeler and Morton Schamberg, working together in their native Philadelphia, also found ways to unite "straight" photography with the principles of modern art. Trained as painters, Sheeler and Schamberg became friends while studying with William Merritt Chase at the Pennsylvania Academy of Fine Arts. The lively avant-garde scene in Philadelphia, and joint visits to Europe to view works by the Old Masters, provided a rich variety of influences.[32] As Sheeler recalled, "We began to understand that a picture could be assembled arbitrarily with a concern for design, and that the result could be outside time, place, or momentary considerations."[33] While Sheeler and Schamberg were working through the influences of Cézanne, Cubism, Futurism, and Synchromism in their paintings, both became proficient with the camera. They turned to photography in 1910-11, at first only as a means of earning a living, but then as a medium of artistic expression.[34] By 1917, they were making some of the most important modernist photographs of the era.[35]

Sheeler's most notable work from this period consists of architectural studies of old barns in rural Bucks County, Pennsylvania, and details of the stone farmhouse that he and Schamberg rented there as a weekend retreat. Sheeler was fascinated by the affinities between the spare simplicity of this vernacular architecture and the formal language of modern art. On one level, his precise studies of windows, doorways, staircases, and facades celebrate the elegant functionalism of a premodern, hand-crafted aesthetic. At the same time, these photographs embody the avant-garde's quest for an artistically "usable past" by suggesting an intrinsically American lineage for modernism's reductive emphasis on form.[36]

Sheeler and Schamberg were both part of the Arensberg circle, but it was Schamberg who first absorbed the proto-Dadaist ideas of the group's most celebrated artists, Duchamp and Picabia.[37] Schamberg's 1916 paintings of mechanical forms, typically given generic titles such as *Mechanical Abstraction* or *Machine*, strongly suggest the influence of Picabia's mechanistic "portraits" of 1915.[38] Schamberg's painted machines are elegantly rendered, planar, and schematic—mere suggestions, rather than diagrams, of mechanistic function. He was most interested in the plastic and formal possibilities of this subject: the machine as aesthetic idea rather than utilitarian object.[39]

a relatively typical Pictorialist phase, Strand developed a powerfully individual vision between 1914 and 1917. Stimulated by *Camera Work*, the Armory Show, exhibitions at 291 and the Modern Gallery, and an expanding circle of art-world acquaintances, he explored the expressive potential of photography in three related bodies of work.

The first group of images, created between 1914 and about 1916, consists of street scenes contrasting bold architectural forms with the random patterns of moving vehicles and pedestrians. Playing the geometric against the organic, these photographs convey the vibrant energies of the modern city in highly distilled form. One of the most remarkable of these pictures, *Woman Carrying Child*, ca. 1915 [175], powerfully unites the central elements of Strand's mature vision: formalism and humanism. The anonymous mother and child appear painfully vulnerable in an unwelcoming environment. Splatter marks on the wall suggest an atmosphere of violence, while the dark window—just large enough to engulf the pair—forms a yawning, ominous void. The slight asymmetry of Strand's framing adds to an overall feeling of tension and anxiety. This work combines Pictorialist and modernist traits to genuinely new effect. While the mother and child theme had been a Pictorialist staple, Strand uses it here to evoke a purely modern sense of both the city and the self.

In the summer of 1916, during a vacation in rural Connecticut, Strand concentrated on purely formal concerns. From the

The intimate viewpoints and humble subjects of Sheeler's Bucks County photographs suggest—however obliquely—a range of human associations. By contrast, Schamberg's architectural photographs are devoid of such narrative possibilities. Given the present rarity of these views, it is uncertain how extensively Schamberg worked in this mode. What is clear, however, is the originality and intellectual rigor of his vision. A handful of surviving images, probably taken from or near Schamberg's Philadelphia studio in 1916-17, treats urban architecture with the same austere formalism he used in his machine paintings. In one untitled photograph [176], perhaps the most subtle and complex of this group, Schamberg reinvents the city as a Cubist construction: a maze of tightly interlocking geometric units arrayed against the negative space of a blank sky and contrasted with the organic forms of two trees. This polyrhythmic arrangement of angles, planes, masses, and edges functions both as a description of the real world and as a hermetically self-contained, two-dimensional abstraction. Schamberg's success in balancing these two levels of depiction was unsurpassed by any other photographer of his time.[40]

Strand, Sheeler, and Schamberg received considerable attention from Stieglitz and Marius de Zayas between 1916 and 1918. Strand's one-man exhibition at 291 in March 1916 presented the first photographs at the gallery since Stieglitz's own retrospective three years earlier. Stieglitz also featured Strand's pictures in the last two issues of *Camera Work* (published in October 1916 and June 1917), and awarded him first prize in the 1917 Wanamaker Photographic Exhibition, a juried contest sponsored by the progressive Philadelphia department store magnate John Wanamaker.[41] De Zayas showed "Photographs by Sheeler, Strand, and Schamberg" at the Modern Gallery in early 1917, and presented a one-man show of Sheeler's photographs later that year.[42] Thanks to Stieglitz's control of the jury in the 1918 Wanamaker Exhibition, the three swept the first five prizes. This result had been predicted by at least one less-favored entrant who glumly observed that Strand, Sheeler, and Schamberg were "*the* Trinity of Photography—Mr. Stieglitz says so."[43]

Mainstream photographers found these prizewinning pictures bewilderingly radical. One conservative critic called Sheeler's image of a window in his Doylestown house "an orgy of rectilinearity," and railed against Strand's now-famous *White Fence*: "It reminds us of the grand finale of a burlesque show, where the full strength of the company is displayed at once. We hardly see how more contrast, emphasis, eccentricity, and ugliness could be combined within the four sides of a print."[44]

However, more progressive critics found great value in these works. For example, Grancel Fitz—whose interest in the vibrant energies of modern life was clearly expressed in his *New York #2* [103], also in the 1918 show—wrote a notably clear-headed review of the exhibition.[45] He praised the Wanamaker shows for their ability to "make us *think*" and for the way they "jar us loose from our barnacled ruts of rutty, complacent thought." Stating his belief that a great picture combined "a really big idea with good execution," Fitz defended Strand's *Wheel Organization* (1917), a close-up of an automobile tire that was the most controversial of the winning pictures. After praising its technical merits, Fitz observed that the print successfully conveyed the artist's belief that "this segment of wheel expressed not only the power

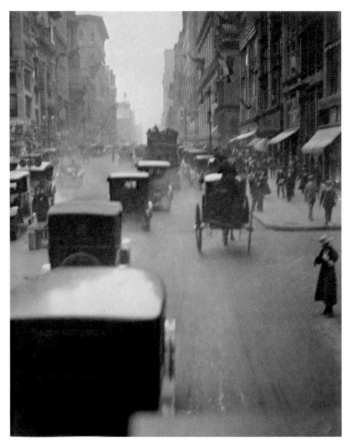

103 W. Grancel Fitz, *New York #2*, ca. 1917-18, platinum print, 11⅝ x 9⅛"

of the thing itself, but also the cohesive strength of business, [and] the spirit of the industry which produces it."[46] The debate over this image revealed the widening schism between the old Pictorialists and the young modernists: while one group valued harmonious evocations of an "ideal" world, the other created bold representations of a resolutely modern one.

New York Dada

This modern spirit found even more radical expression in the photographs of Man Ray. As a friend of Stieglitz's, a central figure in the Arensberg circle, and a close associate of Duchamp's, Man Ray was uniquely positioned in the New York avant-garde of the late 1910s. While they grow from the same general climate of ideas, Man Ray's photographs of this period differ profoundly from those of Strand, Sheeler, and Schamberg. All four used the camera to express avant-garde artistic ideas. However, Strand, Sheeler, and Schamberg took a formal approach, creating a "purist" aesthetic based largely on the structural logic of Cubism. By contrast, Man Ray's approach was fundamentally conceptual: inspired by the iconoclasm of Dada, he used the camera to challenge basic notions of artistic practice.

Man Ray (born Emmanuel Radnitsky in 1890) took an early interest in art. In 1908, he saw his first show of European avant-garde work—drawings by Rodin—at 291.[47] By 1911, Man Ray was a regular at Stieglitz's gallery and was given special encouragement by him. Stieglitz's exhibitions of the next few years, and the Armory Show of 1913, accelerated Man Ray's growth as a painter. He also had literary interests: he wrote some poetry and

assisted with a series of avant-garde journals beginning in 1913. This phase of Man Ray's career culminated in the fall of 1915, when a one-man show of his blocky, semi-abstract paintings was mounted at the Daniel Gallery.

It was in 1915 that two leading members of the French avant-garde arrived in New York: Francis Picabia and Marcel Duchamp. Both had achieved notoriety two years earlier in the Armory Show. Over the next few years they would have an enormous impact on the most progressive faction of the city's art community.[48]

During his time in New York—significant portions of 1915, 1916, and 1917—Picabia was particularly close to Stieglitz, de Zayas, and the Arensbergs. He was highly active, assisting de Zayas with his avant-garde publication 291, showing his own work at the Modern Gallery, and serving as a colorful—and highly quotable—proponent of the new art. Picabia's art reflected his belief that the machine was the key symbol of the modern condition. Using the motifs of a modern automobile, light bulb, or electric wiring diagram, Picabia created mechanistic "portraits" of both noteworthy friends and generic types. These were sternly sober in technique and playfully absurd in content. Stieglitz was depicted as a broken camera straining upward toward the word "IDEAL," for example, while a rendering of a spark plug was titled *Portrait of a Young American Girl in a State of Nudity* (1915). These drawings and paintings suggested both the human qualities of the machine and the unthinking, automatic nature of modern life. Very few critics knew what to make of them.

Marcel Duchamp's art of this period was even more ironic and difficult than Picabia's. Duchamp's painting *Nude Descending a Staircase* (1912) had been the single most controversial work in the Armory Show. For all practical purposes, this episode marked the end of his career as a painter. Spurning the sensuality of a "purely retinal" art, he turned instead to an art of ideas. In Paris, in 1913, Duchamp took perhaps the most radical step in the history of modern art: he transformed a commercially made artifact into a work of art simply by designating it as such. For Duchamp, the heart of the artistic process lay in thinking, not in making. After arriving in New York in June 1915, he found the perfect name for these curious objects—"readymades"—and continued to "create" them. A snow shovel purchased in a hardware store became *In Advance of the Broken Arm* (1915), while a typewriter cover was designated *Traveller's Folding Item* (1916). The most notorious of Duchamp's readymades was *Fountain* (1917), a porcelain urinal purchased from a plumbing supply store and submitted to the exhibition of the Society of Independent Artists, in April 1917, under the alias R. Mutt. Despite the unjuried nature of this exhibition, the organizers deemed *Fountain* both absurd and obscene, and refused to show it. A heated debate ensued on the legitimacy of this rejection and, more importantly, the nature of art itself.

Inspired by the concept of the readymade, as well as his love of chess, puzzles, puns, anagrams, and cryptography, Duchamp created art that was radically hermetic and dense with meaning. His major work of this era is *The Bride Stripped Bare by Her Bachelors, Even* (1915-23), commonly referred to as *The Large Glass*. This piece consists of abstract or mechanical forms—denoting a complex narrative of sexual desire and frustration—arrayed within a vertical sandwich of glass plates. A "bride" occupies one chamber, a group of "bachelors" another, with a variety of surrounding "machinery" that promises—but clearly fails—to effect a satisfying union. In both form and concept, this work was utterly incomprehensible to viewers of the day.

The work of Picabia and Duchamp had important affinities with the nascent Dada movement. In the wartime climate of 1914 and 1915, a group of European artists and intellectuals—including Hugo Ball, Richard Huelsenbeck, and Tristan Tzara—fled to neutral Switzerland. There, in Zurich, they created a new (and primarily literary) art dedicated to nonconformity and freedom, absurdity and anarchy. By 1916, this group had settled on the nonsensical word "dada" to describe their movement.

The American avant-garde became aware of the Zurich Dada group by early 1917. However, there was only intermittent communication between Zurich and New York for another year or more, and thus no real sense of common cause. By 1920, however, Dada had developed into an international movement and a small group in New York began using the term to describe themselves. This sense of identity was made official in April 1921, with the publication of the first (and only) issue of the journal *New York Dada*, edited by Man Ray and Duchamp. For Duchamp, the virtue of Dada lay in its function as a cultural "purgative," and its expression of "the non-conformist spirit which has existed in every century."[49] Given humanity's instinctive resistance to purgation, this was an elite and short-lived movement. The general bafflement of the art community was expressed by the poet Hart Crane, who observed: "I cannot figure out just what Dadaism is beyond an insane jumble of the four winds, the six senses, and plum pudding."[50]

Man Ray was perhaps the only American-born artist of the day who genuinely understood the meaning of Dada. Indeed, the central themes of Man Ray's entire career include freedom, the vitality of ideas, the allure of the irrational, and a rejection of familiar materials and approaches. While deeply informed by the examples of Picabia and Duchamp, Man Ray's work constitutes a profoundly original expression of the most rarefied artistic concepts of the era. Central to this aesthetic of rebellion was Man Ray's emphasis on ideas over traditional notions of technique. He made paintings with the airbrush—an overtly mechanical and commercial tool—rather than the paintbrush, and created sculpture from found objects. He also turned to photography as a mode of avant-garde expression, in part precisely because the art world had so consistently denied the camera's creative worth.

Between 1917 and 1921, Man Ray forged a novel integration of sculpture and photography. In these years, he created a series of "objects" which, like Duchamp's readymades, were made by appropriating or recontextualizing everyday artifacts. Some of the most famous of these works include *Lampshade*, 1919 (an unfurled paper lampshade), *Obstruction*, 1920 (a cluster of wooden coat hangers hung from the ceiling), and *New York*, 1920 (a vertical glass tube filled with ball bearings). Downplaying the physicality of these odd creations—as well as traditional notions of originality—Man Ray often preferred photographs of the objects to the things themselves. The camera offered an important degree of artistic control (permanently fixing one viewing angle and condition of lighting), while underscoring his interest in ideas rather than artifacts. The most notable of these photographs include *Man*, 1918 (an eggbeater), *Woman*, 1918 (a construction of polished reflectors, glass, and clothespins),

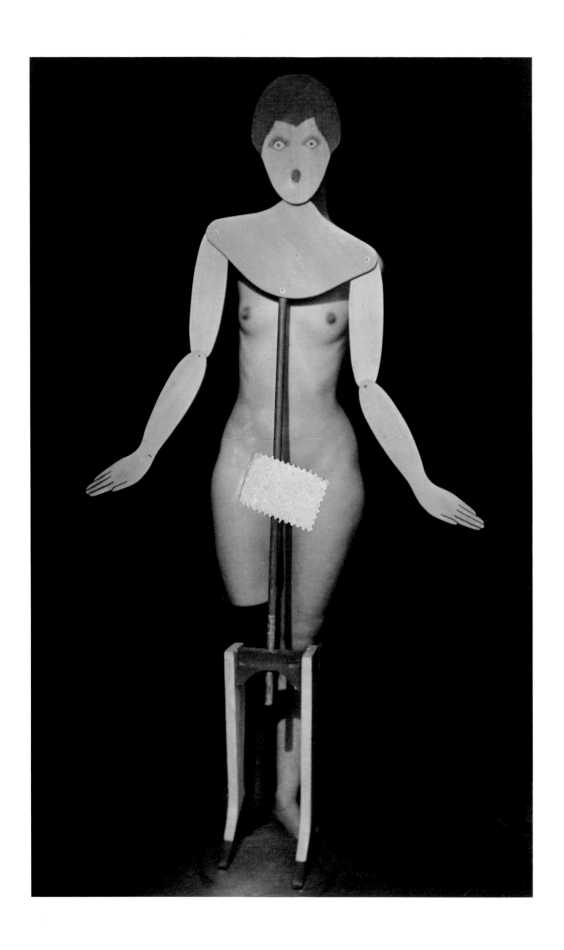

104 **Man Ray,** *Dadaphoto*, 1920, gelatin-silver print with collage, 9 x 5⅝"

and *Compass*, 1920 (a toy pistol held by a magnet). This creative spirit is seen in other notable photographs of the era, such as *Portrait*, 1920 (the poet Mina Loy, seen in profile, with a large thermometer as an earring), and *8th Street*, 1920 (a crushed tin can).

Man Ray's photographs of this period also clearly document his friendship with Duchamp. In 1920, Man Ray made at least two photographs of Duchamp's motorized sculpture *Rotary Glass Plates (Precision Optics)*, portraying it at rest and in motion. That year, the two collaborated to make *Dust Breeding*, a record of the surreal "landscape" of dust that Duchamp had allowed to accumulate on the surface of his unfinished *Large Glass*.[51] In 1921, Man Ray made an important "portrait" of Duchamp in the guise of his female alter ego Rose Sélavy. This was used by Duchamp on a "rectified readymade": a bottle of perfume with an invented brand name and the image of Rose Sélavy.

This close collaboration between Duchamp and Man Ray resulted in the publication of *New York Dada*, a slim four-page (plus cover) journal that appeared in April 1921.[52] In addition to a letter from Tristan Tzara, a poem by Marsden Hartley, and a cartoon by Rube Goldberg, *New York Dada* contained five photographs. These include the Duchamp/Rose Sélavy perfume bottle (on the cover), Alfred Stieglitz's *Dorothy True*, 1919 (a double exposure of True's face and leg), and two images of the Baroness Elsa von Freytag-Loringhoven, a celebrated eccentric and occasional artist. The most important photograph in *New York Dada* is Man Ray's image of a nude woman standing behind a mannequin cutout with a blank postage stamp covering her pubic area [104]. This image, captioned *Dadaphoto* (and later published under the title *Coat stand*) is the single richest photographic expression of the American Dada sensibility.

Man Ray's *Dadaphoto* represents a tour-de-force orchestration of the ideas and motifs of New York Dada. The central coat stand exemplifies Duchamp's notion of the readymade (significantly, his early works in this genre include a coatrack and a hatrack). The partially hidden female nude underscores a collective preoccupation with sexuality and voyeurism, themes suggested by such titles as Duchamp's *The Bride Stripped Bare by Her Bachelors, Even*, and Picabia's *Portrait of a Young American Girl in a State of Nudity*. The play between the human and the mechanical lies at the very heart of the work of this era: Picabia's machine "portraits," Duchamp's *Large Glass*, and numerous paintings and photographs by Man Ray. Man Ray's use of a dressmaker's form as a central motif in at least two paintings of the period is particularly notable in this regard.[53] In addition, the tension between image and reality—the live woman and painted cutout—suggests the themes of reproduction, simulation, and impersonation that occur with particular frequency in the work of Man Ray and Duchamp. Finally, the added collage element—the blank stamp—suggests the avant-garde's scorn for the conservatism of American society. By "censoring" his own image, Man Ray makes the photograph "safe" for public consumption while satirizing the actions of the official guardians of Victorian values.

The dense layers of meaning in *Dadaphoto* were obscure to all but a few. American critics and the public paid little attention to the Dada movement, and by early 1921 it was clear that this disregard would not be changed. In addition, the energy of the avant-garde community in New York had waned with the departure of supporters such as Walter and Louise Arensberg. Picabia was only a memory, having left New York in late 1917. Duchamp sailed for Paris in June 1921, followed a month later by Man Ray. Thus ended one of the most provocative experiments in American art.

Coburn's Vortographs

This era's other important group of avant-garde photographs was produced in London by the expatriate American Alvin Langdon Coburn. After showing his powerful "New York from Its Pinnacles" series, Coburn continued his quest for an art uniting the physical and the spiritual. His work of 1916-17 would be the most cerebral and abstract of his career. When Coburn returned to England for the last time in the fall of 1912, London was in the midst of an important series of exhibitions of modern art.[54] These exhibits spurred the formation of an indigenous avant-garde movement, the Vorticists, led by the writer and painter Wyndham Lewis and the poet Ezra Pound (both, interestingly, American born). Coburn was introduced to Vorticism by Pound, whom he met in a portrait session in October 1913.[55] The two shared many ideas on art and literature, and soon became friends.[56]

Vorticism became a coherent movement in the first half of 1914, with the organization of a group exhibition in March, and the debut of Lewis's journal *Blast*, the movement's manifesto, in July. Vorticism sought to express the technological and intellectual energy of the early twentieth century, rejecting any hint of Victorian sentimentality and romanticism. Highly nationalistic, the Vorticists also sought to create a specifically British art from the ideas of French Cubism and Italian Futurism.[57] In addition, the movement drew in important ways from the writings of Ernest Fenollosa.[58] Pound, who coined the group's name, described the characteristic Vorticist image as "a radiant node or cluster...from which, and through which, and into which, ideas are constantly rushing."[59] Vorticist art is geometric, nonrepresentational, and coolly self-contained, suggesting the efficiency and power of the machine. Hermetic and immobile, Vorticism uses "precise linear definition [to enclose] the most explosive compositions and high-pitched tonal orchestrations in static contours." Thus, "a typical Vorticist design shoots outwards in iconoclastic shafts, zig-zags or diagonally oriented fragments, and at the same time asserts the need for a solidly impacted, almost sculptural order."[60] Vorticism drew much of its intellectual energy from its paradoxical union of dynamism and stasis, and the desire to convey a torrent of energy in hard, brittle forms. Vorticism came into being just weeks before the outbreak of World War I, however, and the conflict drained the movement of vitality. Nonetheless, Pound continued to promote the Vorticist cause despite critical and public disinterest.[61]

Vorticist ideas inspired the most daring work of Coburn's career. In an important essay titled "The Future of Pictorial Photography," written for the 1916 edition of the British annual *Photograms of the Year*, Coburn articulated his radical vision of the medium's expressive possibilities. Citing the achievements of Henri Matisse, Igor Stravinsky, and Gertrude Stein, he argued that the photographer was just as capable of revolutionary creations as the avant-garde painter, composer, or writer. Anticipating the New Vision of the 1920s, Coburn asked:

Why should not the camera also throw off the shackles [of] conventional representation and attempt something fresh and untried? Why should not its subtle rapidity be utilized to study movement? Why not repeated successive exposures of an object in motion on the same plate? Why should not perspective be studied from angles hitherto neglected or unobserved? Why, I ask you earnestly, need we go on making commonplace little exposures of subjects that may be sorted into groups of landscapes, portraits, and figure studies? Think of the joy of doing something which it would be impossible to classify, or to tell which was the top and which bottom!

Later in this essay he noted that "the use of prisms for the splitting of images into segments has been very slightly experimented with, and multiple exposures on the same plate...have been neglected almost entirely." After proposing an exhibition on the theme of "Abstract Photography," Coburn concluded with a statement of confidence in the medium's "infinite possibilities [to] do things stranger and more fascinating than the most fantastic dreams."[62]

The tone of Coburn's article, and its reference to the use of prisms, points directly to his Vorticist experiments, begun in September 1916 with Pound's encouragement and collaboration.[63] The two devised a triangular arrangement of mirrors (which they named the vortoscope) that was placed over the camera lens.[64] The refracted images created by this device—even when the camera was pointed at such mundane objects as bits of wood and crystal—seemed excitingly new. Coburn's vortographs (as he called them) consist of two basic groups: portraits of Pound and completely nonobjective images. The studies of Pound were almost certainly made first, as they suggest a relatively systematic exploration of a variety of techniques, including the use of the vortoscope in concert with multiple exposures and possibly even the multiple printing of negatives.[65]

While these refracted portraits were genuinely original, Coburn saw that the most effective use of vortography lay in the production of wholly abstract images. Thus, between October 1916 and January 1917, he fulfilled his own challenge "to do something impossible to classify." The resulting images, all but one titled simply *Vortograph*, represent the first body of artistic photographs in history to embrace total abstraction.[66] Finally, it seemed, the camera had been freed from the burden of representation and could be used as a means of pure pictorial invention. The best of these vortographs [177] are quite remarkable: boldly composed, mysteriously unreal, and intensely vibrant with light and energy. These images suggest both strength and fragility, the natural and the mechanical, and a scale at once cosmic and microscopic. Ultimately, they convey the poetry of pure structure, as seen in the greatest engineering feats of the day, and as imagined at the heart of the atom. These images are, most importantly, about the *idea* of form and power, and come as close as any ever made to giving pictorial expression to thought itself.

Coburn's vortographs employ the sharp diagonals and prismatic forms of Vorticist drawing and painting. In other respects, however, they diverge markedly from the Vorticist aesthetic. While the paintings and drawings of Wyndham Lewis and his circle are hard-edged, two-dimensional, and static, the forms in Coburn's photographs are indistinct, suggestive of three dimensions, and vibrant. The forms in Vorticist paintings function on a primarily graphic level, while Coburn's shapes seem to be shifting, dissolving, and glowing "with refracted light and nuances of

shadow."[67] Thus, in truth, the artistic success of Coburn's work lies largely in its divergence from Vorticist theory.

Ultimately, the meaning of the vortographs can be found in Coburn's metaphysical inclinations: his interest in the ideas of infinity, four-dimensional reality, and the essential union of mind and matter.[68] Coburn was deeply influenced by the mystical writer Edward Carpenter, particularly the ideas of a universal or cosmic consciousness Carpenter derived from discussions with an Indian yogi. In his book *The Art of Creation: Essays on the Self and Its Powers* (1904), for example, Carpenter wrote: "It is not merely that the object is seen by the eye or touched by the hand, but it is felt at the same instant from within as a *part* of the ego; and this seeing and touching wake an infinite response—a reverberation through all the chambers of being."[69] This mystical harmony of sense and spirit, so alien to Vorticist theory, provided the real motivation for the Vortographs. While initially stimulated by his friendship with Pound, Coburn's work was in the end distinctly his own.

These revolutionary photographs, with a selection of Coburn's recent paintings, were exhibited at the Camera Club in London in February 1917. The critical response was disappointing. Pound, who had been asked to contribute an essay to the exhibition catalogue, could generate only faint praise for the work. Having decided that photography was intrinsically inferior to painting and sculpture, Pound implied that the vortographs were, at best, a weakly imitative art form. In his view, the best of Coburn's abstractions were simply "excellent arrangement[s] of shapes, and more interesting than most of the works of Picabia or of the bad imitators of Lewis."[70] Coburn's annoyance with his former collaborator was made clear in a postscript he included in the catalogue. After alluding to the myopia of those "living exclusively in the rarefied atmosphere of Vorticism," Coburn firmly defended the expressive potential of photography.

I affirm that any sort of photograph is superior to any sort of painting aiming at the same result. If these vortographs did not possess distinctive qualities unapproached by an other art method I would not have considered it worth my while to make them. Design they have in common with other mediums, but where else but in photography will you find such luminosity and such a sense of subtle gradations?[71]

These boldly original pictures provoked much discussion in photographic circles. Most viewers were intrigued by them but undecided as to their ultimate meaning. Even George Bernard Shaw, a sympathetic friend, found the images aesthetically pleasing but felt that "the sense of these 'vortographs' has not yet been worked out."[72] A lengthy review published in the *Amateur Photographer* (and reprinted in the conservative American journal *Photo-Era*) also granted the seriousness of Coburn's intentions but cited the general "perplexity" stimulated by the work. Nevertheless, this writer observed, "The show marks an entirely new departure in camera-work, and for this reason, if for no other, should engage the attention of all who are interested in photographic progress."[73] The editor of the British annual *Photograms of the Year* featured a vortograph in the 1917-18 edition, noting its haunting and "uncanny" quality.[74] Americans such as Karl Struss were less sympathetic, and saw the work as an inconsequential novelty.[75] The decidedly mixed nature of this critical appraisal has changed little in the last eighty years.[76]

The first American avant-garde was most vital in the four years leading up to the nation's entry into World War I in 1917. The war chilled the nation's enthusiasm for the new art and eroded its sustaining network of artists and patrons. The unity and patriotism demanded by the mobilization effort [178] were antithetical to the climate of exploration and provocation in which the avant-garde thrived.[77] With a significant number of artists and photographers away in military service, many ties of allegiance were broken. In 1917 Stieglitz ended *Camera Work*, closed his gallery, and had a final break with Steichen. Struss, Strand, Steichen, and other noted photographers spent time in military service and were changed by the experience in varying ways.[78] Further trauma was caused by the great influenza epidemic of 1918, which struck just as the war in Europe was ending. Morton Schamberg was one of the nearly 500,000 Americans killed by this disease.

While the war created hardships for civilian photographers, it also stimulated the development of new technologies and applications. Photographic chemicals and paper were in short supply and the embargo on German goods made fine lenses particularly scarce.[79] The cost of platinum paper skyrocketed: the paper stock itself doubled in price in a few years and by 1920 platinum was selling for $200 an ounce—twenty times its cost at the turn of the century.[80] This expense speeded the demise of this beloved process and the near-universal acceptance—even among the most refined art photographers—of gelatin silver printing papers.[81]

As would be expected, the military use of photography expanded rapidly during the war. With the mobilization effort came a great demand for documentary work (in both still and motion-picture formats), X-ray images, and such specialized applications as the transmission of photographs by wire. The most dramatic wartime use of photography involved aerial reconnaissance.[82] While most of this work was conducted from airplanes, aerial images were also made with balloons, small rockets, kites, and pigeons. By using the sharpest lenses available, photographers in airplanes at 15,000 feet altitude were able to record details on the ground with remarkable accuracy.[83] The unintended abstract beauty of these images had a significant impact on the aesthetic of postwar art photography [179].

The war stimulated the production and public circulation of great quantities of photographs. While coverage of the conflict was heavily censored by all the warring nations, each country produced officially sanctioned images for its public. Selections of these were assembled into exhibits that toured extensively during and after the war. In 1916, for example, work by British military photographers was presented in Paris at the Louvre before traveling to venues in the United States. Three years later, an exhibition by U.S. Army Signal Corps photographers opened to good reviews at the Corcoran Gallery of Art in Washington, D.C., and toured nationally.[84] Exhibitions by French and Canadian military photographers were also widely viewed. The images included in these shows ranged from the most matter-of-fact records to romantic views of snowy battlefields and silhouetted ruins at sunset.[85]

The Signal Corps, which established its photographic section in July 1917, produced the majority of American war photographs.[86] The resulting images were created for purposes ranging from the tactical (aerial reconnaissance, for example) to the political (domestic propaganda). War photographs were reproduced in great numbers in the nation's newspapers and magazines. The *New York Times* printed them regularly in its Sunday edition and its *Mid-Week Pictorial* supplement. Mass-market journals such as *Collier's*, *Leslie's*, and the *Saturday Evening Post* also made generous use of war pictures. Particularly gruesome or controversial subjects were not depicted: to maintain domestic morale the American press emphasized the enemy's dead soldiers, downed aircraft, and blasted entrenchments, not its own. After 1918, thousands of war photographs were made available to the general public. In 1919, the Signal Corps published a catalogue of some 75,000 images that could be purchased for fifteen cents each.[87] Similarly, the Keystone View Company published at least 1,500 stereographic war views, including packaged sets of 75, 100, 200, or 300 cards.[88]

Even though American losses were less severe than those of its allies, the experience of war was sobering. World War I had begun with the expectation that victory would come quickly and easily. In fact, the conflict soon became a horrific and nearly static confrontation of highly mechanized armies. This was the first war to make full use of the airplane, submarine, tank, machine gun, poison gas, and wireless. These technologies, in concert with nineteenth-century tactics and a generous dose of official stupidity, resulted in the slaughter of a shocking proportion of an entire generation. The absurdity and horror of this sacrifice called long-held values into question, and instilled in survivors a deep sense of disillusionment. To make matters worse, the world was more volatile at the end of the fighting in 1918 than it had been in 1914. The breakup of the German and Austro-Hungarian empires, the Bolshevik Revolution in Russia, and the harsh terms of the Versailles Treaty all ensured that the following decades would be fraught with political tension.

The European avant-garde responded to this shattering experience in various ways: the nihilistic absurdity of Dada, the liberating irrationality of Surrealism, and the utopian clarity of Constructivism. While Europe rebuilt itself, American society turned inward, away from the complications of international politics to a newfound prosperity and hedonism. Some artists, such as Alfred Stieglitz, retreated in disgust from the banalities of popular culture to a private, and more spiritual, artistic realm. Others sought to unite personal expression with practical realities by striking a satisfying balance between art and commerce. A handful of the most adventurous Americans, including Man Ray, emigrated to Paris, taking up residence in the heart of the international avant-garde. Each of these responses produced work of importance.

Purism and Pictorialism

Eight years after he closed 291, Stieglitz resumed mounting exhibitions, first at his Intimate Gallery (1925-29) and then at An American Place (1929-46). However, he presented only seven photography exhibitions in these years: two of Strand's work (1929, 1932), three of his own (1932, 1934, 1941), and one each by Ansel Adams (1936) and Eliot Porter (1941). Most of this twenty-one-year exhibition schedule was devoted to Stieglitz's

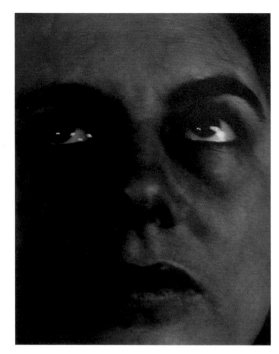

105 Marjorie Content, *Untitled (Helen Herendeen)*, 1926, 3½ x 2⅞"

favorite painters: Georgia O'Keeffe, John Marin, Arthur Dove, and Marsden Hartley.[89] This narrow focus suggests that by the mid-1920s Stieglitz had virtually ceased looking at contemporary work. Nonetheless, the spiritual "Idea" of art remained central to everything he did.

The most productive stage of Stieglitz's own artistic career began around 1917, the year he discontinued *Camera Work*, closed 291, and fell in love with the young painter Georgia O'Keeffe. Over the next decade and a half he produced a cumulative photographic portrait of O'Keeffe, whom he married in 1924. In their intensity and ambition, these approximately 500 images form perhaps the most extraordinary series in the history of photography. The success of these pictures stems from the couple's intense emotional and intellectual interaction. The resulting images represent a vital and unprecedented collaborative dialogue.

In his images of O'Keeffe, Stieglitz charged the simplest of themes—the portrait of a loved one—with unprecedented depth and universality. He explored all aspects of O'Keeffe's figure and personality: clothed and nude, whimsical and solemn, demure and brazenly sexual, coolly serene and vibrant with energy. The power of these images is derived in large measure from their intimacy. Many were made indoors, in soft natural light, with Stieglitz's large camera only an arm's length from his subject. In many cases, Stieglitz magnified O'Keeffe's hands, breasts, thighs, or neck to completely fill his 8 x 10-inch frame. These pictures remind us of the profound complexity of simple things, the inventive potential of the straight photograph, and the variety of moods that constitute a single life.

In O'Keeffe, Stieglitz found the perfect subject. Self-assured, and beautiful in an elegantly unaffected way, O'Keeffe projected a sense of self that was at once timeless and supremely modern. Born in the Midwest, and recently arrived from the plains of Texas, she seemed to embody a profoundly American simplicity and quiet passion. O'Keeffe thus represented an artistic and cultural ideal: she was bold, sensual, and independent, a person of action rather than talk, and a product of nature more than of society.[90] Stieglitz's depiction of O'Keeffe as an elemental force thus united the virtues of both nationalism and universality. In 1921, on the occasion of the first exhibition of these pictures, Paul Rosenfeld wrote:

Here, symbolized by the head and body of a woman, herself a pure and high expression of the human spirit…, there is registered something of what human life was, not only in America, but all over the globe, during the last few years; perhaps, also, something of what human life always is.[91]

While this quest for the universal resulted in some pictures that are mannered and overwrought, it accounts for the genuine profundity of so many of them. In *Georgia O'Keeffe: A Portrait*, 1918 [180], for instance, Stieglitz used his characteristic technique—soft natural light, deep focus, and a relatively long exposure—to produce an image of sculptural weight and iconic power. The simplicity of O'Keeffe's dress and pose ensure that the viewer's attention is drawn almost completely to her magnificent face and, by implication, to the quiet intensity of her inner life. Seated in front of one of her drawings, O'Keeffe is presented as an embodiment of the creative force. The drawing presents an inverted echo of the graceful shape of her arms and shoulders, subtly reinforcing O'Keeffe's dual role as both artist and work of art. In addition, the dark tones of Stieglitz's platinum print produce a feeling of great mass from flesh and fabric. As Rosenfeld observed, "Breasts and arms become like pieces of primitive sculpture, simple and gigantic. A head is heavy as a cannonball."[92] This visual weight underscores the gravity of the themes Stieglitz was exploring in this work.

Stieglitz photographed O'Keeffe for more than a decade and a half. Their lives changed significantly in this time, and Stieglitz's pictures provide telling "equivalents" of the emotional tenor of their relationship. O'Keeffe began summering in New Mexico, and learned to drive, in 1929. From this time on, she became increasingly independent of Stieglitz, who only traveled between his residence in New York City and his family's summer house at Lake George, several hours north. Not surprisingly, many of Stieglitz's later portraits, such as *Georgia O'Keeffe: A Portrait*, 1933 [181], convey a psychological reserve not found in the earlier photographs. There is respect—and love—in these images, but less passion. Appropriately, O'Keeffe's automobile—a symbol of both her modernity and her freedom—appears repeatedly as a backdrop. The bittersweet magnificence of these later portraits is a moving testament to Stieglitz's artistic honesty.

Stieglitz's O'Keeffe pictures had an enormous impact on other photographers. The first to respond to these images was Strand, who began photographing his wife-to-be, Rebecca Salisbury, soon after they met in 1920.[93] Though similar in approach to Stieglitz's pictures, Strand's reveal a distinct artistic voice. The best of these works, such as *Rebecca, New York*, 1922 [183], beautifully unite formal and emotional concerns. The tight cropping and slight blur create an image of sensuous physicality. The moody intimacy of these pictures would never be surpassed in the rest of Strand's long career. Also interesting in this context is the work of Marjorie Content [105], which reveals the impact of her close friendship with both Stieglitz and O'Keeffe.

In the fall of 1922 Stieglitz began photographing clouds, producing some 350 images over the next eight years.[94] This project

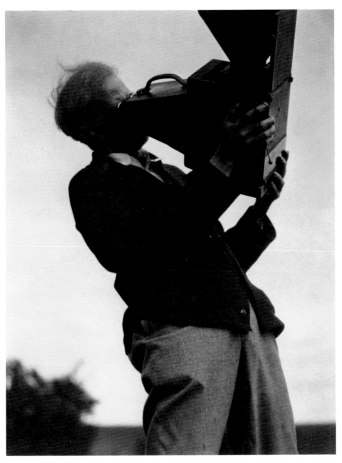

106 Paul Strand, *Alfred Stieglitz, Lake George,* ca. 1929, 4¼ x 3⅝"

107 Alfred Stieglitz, *Equivalent,* 1929, 4⅝ x 3⅝"

began with a group of rather baroque images titled "Music: A Sequence of Ten Cloud Photographs." In these works the frequent inclusion of the horizon provided a clear sense of spatial orientation. Within a year, however, Stieglitz's interest in the sky evolved markedly. In addition to shifting from his 8 x 10-inch camera to the more intimate 4 x 5-inch format, he eliminated nearly all trace of the landscape. The effect of these decisions was to radically reduce the objective naturalism of these images. To mark this conceptual reorientation, Stieglitz changed the title of this growing body of work, first to "Songs of the Sky," which retained his earlier allusion to music, and then to the more metaphysical "Equivalents."

Stieglitz later claimed that he began this series to disprove a critic's statement that his artistic success stemmed from his "hypnotic" power over human subjects.[95] This spur hardly seemed necessary, however, since the Equivalents were an outgrowth of his most basic idea: the use of the camera in a self-referential and transcendental quest. In his 1921 review of the O'Keeffe pictures, for example, Rosenfeld noted that "Stieglitz has caught many moments, some apparently the most fugitive, some apparently the most trivial...and in each of them, he has found a symbol of himself."[96] Symbolist theory, which formed the root of Stieglitz's artistic philosophy, held that the artist transforms the objective facts of the world into the subjective poetry of personal expression. Thus, the abstract forms of art—the shapes in a painting or the melody of music, for example—correspond to real but otherwise inexpressible states of mind. For Stieglitz and his circle, a work of art was "the pictorial equivalent of the emotion produced by nature."[97] The process of making these pictures

was one of private communion. Thus, Strand's portrait of Stieglitz in the act of photographing clouds [106] was understood to have dual levels of meaning, depicting both body and spirit, act and idea.

If Stieglitz's photographs of O'Keeffe convey the transcendent beauty of life through the example of a single, protean being, his Equivalents [107] are at once more abstract and more literal. In these photographs, Stieglitz looked skyward to a traditional symbol of transcendence and the infinite. There, he found tones and textures analogous to the equally evanescent and changeable states of the human soul. As richly nuanced passages of visual music, the Equivalents are metaphors of the human condition.[98] Their complex orchestration of light and dark connote "the generalizations—ideas of attraction and repulsion, struggle and unity, peace and conflict, tragedy and deliverance—that emerge from every individual experience."[99] Moreover, they suggest a profoundly mystical connection between the subjective self and the world outside it. Ultimately, the Equivalents imply that the coordinates of the soul can be mapped onto the surface of the world and, conversely, that the universe is intuitively knowable as a reflection of the self.

These mystical notions underlie Stieglitz's last important groups of photographs: views of New York City and of his family property at Lake George. These pictures, made primarily in the early 1930s, represent an attempt to find personal meaning in the realms of both culture and nature. The New York pictures were the culmination of a lifelong interest in the city. Stieglitz had photographed New York since the early 1890s, and first used his 8 x 10-inch camera to make precisely composed formal studies of its buildings in 1915. The 1915 images blend an interest in

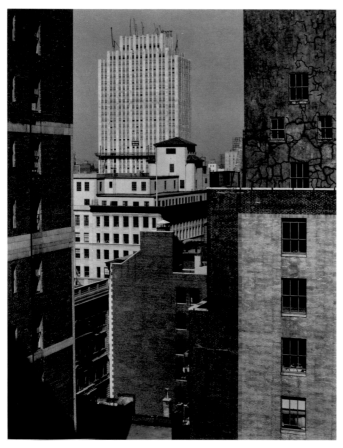

108 Alfred Stieglitz, *From An American Place, Southwest*, 1932, 9½ x 7½"

the inherent geometry of urban structures with the picturesque effects of snow, rain, and nightfall. His later city pictures, such as *From An American Place, Southwest*, 1932 [108], dispense with impressionistic effects to focus on the interplay of architectural forms, and on the way light and shadow caress and transform the works of man. From the windows of his high-rise gallery and apartment (figuratively, halfway to the clouds), Stieglitz employs a point of view that is at once aloof and all-embracing. The human vitality of the street is not seen. Instead, these pictures suggest the grand rhythms of creation and dissolution through architectural symbol: a new building rises above the skyline while an older one crackles with age.

In his Lake George images, Stieglitz used the simplest of subjects—water, sky, grass, and trees—to fashion an artistic vision of clarity, harmony, and spirituality.[100] Through his eyes, the accepted symbolism of natural forms was amplified and deepened. Poplar trees, for example, had long been seen as "green church spires of nature, pointing steadfastly upward,...like perpetual symbols of aspiration toward the light."[101] In Stieglitz's images, the spiritual meaning of poplars is deeply personal, rather than merely anecdotal.

Similarly, in his finest picture of grasses [109], Stieglitz celebrates the inherent logic of natural life, at once complexly tangled and elegantly ordered. This image, made on a summer morning in 1933, depicts the rays of the rising sun refracted through delicate droplets of dew. Stieglitz's camera is focused on the grass at the bottom of the frame, and his controlled depth of field softens the image with distance. As we read this photograph from foreground to background, we slide imperceptibly from natu-

ralism to abstraction, from physical reality to a disembodied radiance.[102] The sun's heat will soon evaporate the dewdrops in a daily cycle to be repeated endlessly. From the simplest subject matter, Stieglitz fashioned a deeply moving statement on both the brevity and comforting continuity of life.

Stieglitz's long career reveals a marked shift from collective to individual concerns, from democratic to aristocratic notions of the artist, and from a largely pragmatic to an increasingly mystical view of the world. In the first half of his artistic life, Stieglitz was devoted to making images as widely available as possible through large public exhibitions and the finest photomechanical reproduction. His last large group exhibition was mounted in 1910, and after 1917 he concentrated on making just a few exquisitely crafted prints on the most beautiful photographic papers available.[103] It was said that each of these later prints was the result of up to "one or even two hundred attempts at printing satisfactorily."[104] These precious images were exhibited infrequently and were rarely sold. At the same time, the subject of his photographs "moved steadily away from the social to the abstract, from man as the center to form as the center."[105] Despite his dedication to a democratic ideal, Stieglitz's egotism, unwillingness to compromise, and devotion to mystical absolutes meant that his work was seen and appreciated by a distinctly elite audience.

The Clarence H. White School

A more populist alternative to Stieglitz's sublime but insular aesthetic was offered by Clarence H. White. Both men were dedicated to artistic expression, but only White felt that serious photography had a place in practical life. While Stieglitz rejected all forms of compromise and commercialism, White (who, unlike Stieglitz, had to work for a living) helped train a generation of professional photographers. For his broad influence and generous encouragement of a variety of approaches, White holds a key position in the history of American photography.[106]

White's career in education began in 1907 when he was hired by Arthur Wesley Dow to teach an extension course in art photography at Columbia University; in 1910, he became a lecturer in the university's Teachers College. Continuing this relationship until his death in 1925, White taught hundreds of students, including Karl Struss, Edward R. Dickson, Jane Reece, Dorothea Lange, Doris Ulmann, and Margaret Bourke-White. White also took on teaching duties at the Brooklyn Institute of Arts and Sciences in 1908, and two years later began a summer school course in Maine with the assistance of the painter Max Weber. In 1914, with Weber's collaboration, White founded the Clarence H. White School of Photography at his home in New York City. This school was the most important of its kind in the country and attracted such notable students as Ira Martin, Clara Sipprell, Laura Gilpin, Ralph Steiner, Paul Outerbridge, and Anton Bruehl. White was assisted in his teaching duties by Weber and Paul L. Anderson, as well as by such former students as Struss, Bernard Shea Horne, Margaret Watkins, Alfred Cohn, and Arthur D. Chapman.

After a final break with Stieglitz in 1910, White became the center of a loose-knit group (which included Käsebier and Coburn) dedicated to promoting a more inclusive vision of artistic photography. This effort took various forms, including the organization of major exhibitions and the publication of a beautiful journal.

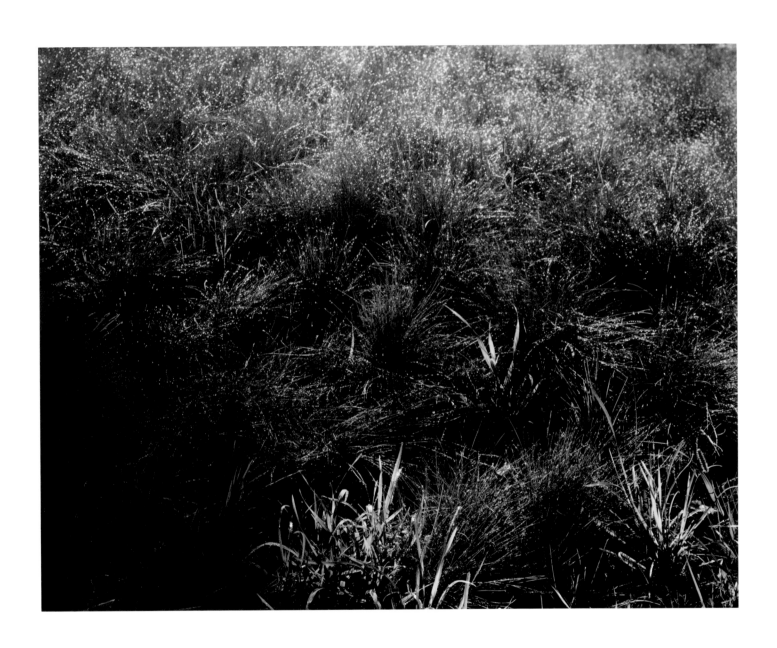

109 Alfred Stieglitz, *Grasses, Lake George*, 1933, 7¼ x 9⅜″

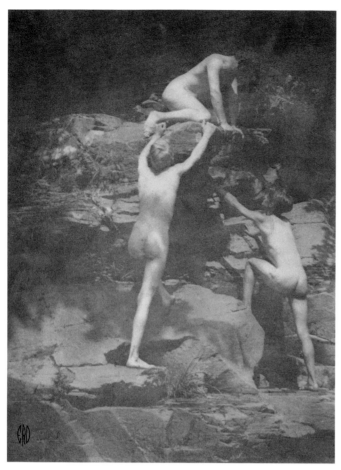

110 Edward R. Dickson, *The Swimmers*, ca. 1913, platinum print, 8½ x 6½"

111 Arthur D. Chapman, *Diagonals*, 1914, platinum print, 7⅞ x 6"

A large survey of modern photography was presented at the Montross Galleries in 1912, and in 1914 two exhibits were organized for the Ehrich Galleries, one of contemporary photography and another of nineteenth-century pioneers selected by Coburn. Between 1913 and 1917, the group published eleven issues of *Platinum Print: A Journal of Personal Expression* (the last two under the title *Photo=Graphic Art*).[107] This elegant publication (designed and printed by typographer Frederic W. Goudy) was edited by White's protégé Edward R. Dickson.[108] *Platinum Print* was, in essence, a *Camera Work* for art photographers more interested in photography than in avant-garde painting. Included in the pages of *Platinum Print* were pictures by many leading figures, with an emphasis on such central members of the White circle as Dickson [110], Chapman [111], and Horne [185]. In addition, the journal contained such valuable articles as Max Weber's "The Filling of Space."

In January 1916, the White group founded the Pictorial Photographers of America (PPA), a national organization dedicated to the cause of artistic photography. White was the first president, with Käsebier, Dickson, Chapman, and Struss also active on its board. The PPA sponsored a number of important exhibitions, beginning in October 1916 with a broad-ranging survey held under the auspices of the American Institute of Graphic Arts at the National Arts Club. In addition to works by leading Pictorialists, this exhibit included a section of historical and scientific work and an extensive presentation of color photography.[109] Another major show, a 200-print survey organized in late 1917, traveled to art museums in seventeen cities.[110] Between 1920 and 1929, the PPA published five editions of its journal *Pictorial Photography in America*, each containing useful essays and numerous reproductions.[111] In 1921 White also oversaw the establishment of the Art Center, an amalgam of seven New York arts and crafts organizations that hosted a varied series of photographic exhibitions, lectures, and workshops.[112] These overlapping activities helped forge a strong sense of common purpose among the nation's more progressive photographers.

The pragmatism of the White School's program made it useful to students of varying interests and abilities. White admired Arthur Wesley Dow's pedagogical views, and drew liberally from Dow's influential text *Composition*. White intuitively embraced Dow's emphasis on *notan* (the harmonious balance of form and tone), as well as his faith in both the unity and social utility of the arts. Max Weber, also a disciple of Dow's, played a critical role in the White School curriculum. His lectures emphasized the structural principles common to all forms of picture making. This formalism is conveyed clearly in his important 1913 essay "The Filling of Space."

> Photography is a flat space art, as is drawing, painting or printing...
> It lies within the domain of the plastic arts to reorganize forms, to reconstruct and interpret nature, to create or realize forms and visions of forms, unit by unit. And intervals between—the interval, the mind pause, the contemplation, the generating energy make yield the material whether in two or three dimensions, for matter yields in measure with and in degree of the intensity of the creative power of the artist or artisan.
> In our choice and elimination lies the very character of our personality, the very quality of our taste and expression. In our appreciation and discard, lies our sense of values, of proportion, of relationship—material and psychic...

The photographer's art lies supremely in his choice or disposition of visible objects, as prompted and guided by his intellect and his taste. His mind is his screen. He may shift objects, he may choose his position, he may vary the spaces between moveable objects, and finally he may vary the proportion and size of the rectangle bounding the picture or print.[113]

Years later, one of the White School students remembered Weber's teaching as a kind of Zen parable: "Don't go out and photograph things, photograph the in-betweenness of things."[114]

White School photographers strove for an evocative balance of worldly fact and the purely synthetic beauty of abstraction. As Weber's reference to the "screen" indicates, this approach emphasized the photograph as a two-dimensional, graphic creation. This stress on visual relationships—the subtle balancing of light and dark, mass and void—represented one of the major aesthetic differences between the White and Stieglitz circles. While just as masterful in "composing" his pictures as anyone in the White group, Stieglitz was primarily concerned with the Form (as he would have expressed it) of his subject rather than the graphic form of the image. This Form was both objective and transcendent, with the photograph simply the most appropriate transcription of its larger reality. Subject matter was thus of critical importance to Stieglitz, while White's disciples could happily photograph almost anything, beginning with the classroom of the school itself [112]. The White School's openness to a variety of stylistic approaches, and its linkage of photography to other modes of picture making, further distinguished it from the stern purism of the Stieglitz circle. As photographic historian Bonnie Yochelson has observed, Stieglitz's

> rhetoric of straight photography was metaphysical—concerning the unique powers of the camera to penetrate reality—and moral—concerning the photographer's purity of expression and honest use of his remarkable tool. To discuss the structure of photographs in terms equally applicable to other two-dimensional images denied photography's unique properties and was therefore taboo.[115]

Advocates of "straight" photography considered the White School approach too conservative, an exercise in design rather than in "real" photographic seeing. The case against the White School aesthetic was made forcefully in 1918 by Grancel Fitz:

> The work of this group is notable for the following characteristics: It is usually good in arrangement and tone, and shows an amazing facility for making pictures out of nothing. This facility is nobly abetted by the too wide-open use of soft-focus lenses, which, like charity, can cover a multitude of sins. The workers usually know how to print and mount, and seem to have, as their ideal, the exaltation of the trivial, wherefore they also make, not pictures, but exercises. Their work is as a class unforgivably anaemic. I have never seen a print, with the possible exception of one or two by Struss, which has the slightest chance to endure, nor have I seen a single print produced by this group which in its conception had a full quota of he-man guts.[116]

For the predominantly male photographers of the Stieglitz circle, the White School aesthetic was entirely too "feminine."[117] The characteristic White School pictures are, indeed, subtle rather than bold, idealist but not transcendent, and contemplative rather than provocative. These represent a kind of "romantic modernism" that sought to blend old and new ideas in an evolutionary, rather than a revolutionary, way of seeing. In these works,

112 Milton Lefkowitz, *Interior of the Clarence White School*, ca. 1925, platinum print, 3⅝ x 4⅝"

the photographers used pictorial harmony as a symbol for human accord, and sought a balance between individual expression and collective values.[118]

The White School emphasis on graphic composition—"space filling"—is abundantly clear in the work of Karl Struss [97] and Arthur D. Chapman [111]. Both photographers created highly refined formal arrangements that strike a graceful balance between description and abstraction.[119] Design itself is the subject of still lifes by Margaret Watkins [184] and Bernard Shea Horne [185]. Watkins and Horne both studied and taught at the White School, and their work typifies the compositional explorations that were encouraged in the classroom. Though they maintain reference to a world of familiar things, these highly reductive photographs were among the most experimental of the period. Both photographers were widely exhibited and published. Particular praise was given to Watkins for her ability to find the elements of abstraction in the most common subject matter: a quiet dock scene [113], for example, or the contents of her kitchen sink [184].[120] Alfred Cohn's *Shadows*, ca. 1920 [114], pushed this formal vision even further in the direction of nonobjectivity. From this disembodied image of light and shadow, it would be a relatively short step to the cameraless photogram, the most radical expression of the modernist photographic vision of the 1920s.

Paul Outerbridge was perhaps the most brilliant of the White School students. After studies at the Art Students League in New York and a brief stint in the army, Outerbridge enrolled in the school in 1921. Finding White a "great inspiration," Outerbridge made rapid progress, demonstrating a genius for visual invention and formal precision.[121] He excelled in the creation of exquisitely crafted still-life photographs depicting familiar things in strikingly unconventional ways. One of the most important of his early pictures is *Saltine Box*, 1922 [187]. This image of an inverted tin box was the second of two slightly different exposures. The first (and better known of the pair) is a tightly cropped view in which the simple metallic shape is both defined and complicated by Outerbridge's intense lighting.[122] The planes of reflected light and cast shadow, together with the stark form of the box itself, create a curious perceptual puzzle.[123] For the second picture, Outerbridge added two elements: a tabletop edge (in

113 Margaret Watkins, *The Wharf*, 1923, platinum print, 8⅛ x 6⅛"

the bottom right corner) and a fragment of one of his dark slides (in the upper right corner). These subtle changes add considerably to the image's graphic dynamism and spatial ambiguity.[124] The cool formalism of these pictures exemplified Outerbridge's belief that, at its best, photography was an "intellectual" art.[125]

Outerbridge's *Piano Study*, 1924 [186], is similarly sophisticated. Through his careful choice of viewpoint, Outerbridge created a polyrhythmic arrangement of line and shape that plays back and forth between three-dimensional description and a purely graphic abstraction. From a rather pedestrian and sentimental subject—his family's Steinway piano—Outerbridge fashioned a remarkably elegant statement on the analytical pleasures of seeing.

Outerbridge's stylistic refinement brought him recognition in the worlds of both art and commerce. His earliest commercial assignment, for the Ide Collar firm, was published as an advertisement in the November 1922 issue of *Vanity Fair*. This iconic image was also celebrated as a purely artistic achievement and included in such exhibitions as the 1923 International Salon in New York.[126] By the following year, Outerbridge's pictures had been published in *Arts and Decoration*, *International Studio*, and *Harper's Bazaar*. Capitalizing on this acclaim, and eager for new challenges, Outerbridge went to Europe in 1925. After returning to New York in 1929, he became celebrated for his pioneering work with the carbro color process.

Ralph Steiner, a classmate of Outerbridge, studied with White in 1921-22 before beginning an influential career as a photographer, picture editor, and film maker. In later life, Steiner minimized the influence of White's teaching, expressing bemused

annoyance with the program's relentless emphasis on "design, design, design."[127] It seems clear, however, that Steiner profited from these lessons.[128] His commercial work of the later 1920s made consistent use of bold forms and patterns—as well as a robust sense of humor—to create visual impact from the most familiar objects [189]. The White School embraced the application of artistic principles to commercial work, promoting the relevance of "the new, direct attitude" in photography to the needs of advertisers and art directors. As Watkins observed in her essay "Advertising and Photography," the confluence of art and business created a new visual climate in which "stark mechanical objects revealed an unguessed dignity; [and] commonplace articles showed curves and angles which could be repeated with the varying pattern of a fugue."[129] This understanding is evident in Steiner's graphic and amusing study of alarm clocks and coffee cups.

Anton Bruehl became an even more celebrated proponent of the modern style in commercial and artistic photography. Born in Australia, Bruehl was trained in engineering.[130] He came to the U.S. in 1919 to work for Western Electric Company, but left this career to study with White in 1923-24. Immensely talented, Bruehl served as an instructor at the White School in 1924-26 before beginning a successful commercial practice. His advertising photographs were reproduced frequently in *Vogue*, *Vanity Fair*, and elsewhere. His work was also included in such prestigious international exhibitions as the 1929 "Film und Foto" show in Stuttgart. Bruehl's bold, precise style is demonstrated in such personal pictures as *Hands of the Potter* [115], one of a series of images made in Mexico in 1933. Bruehl's Mexican work was exhibited at the Delphic Studios, and published in the widely praised book *Mexico* (1933). In the 1930s, working in partnership with Fernand Bourges, Bruehl became a leader in the new field of color photography.

Doris Ulmann's career reveals a very different application of White School principles. Ulmann studied and lectured at the school in its first years of operation, and was also active in the Pictorial Photographers of America. Her work of the late 1910s and early 1920s reveals her adherence to the school's design concepts and her interest in a variety of subjects, including the modern urban scene. In the work for which she is best known, however, Ulmann applied this formal intelligence to the documentation of

114 Alfred Cohn, *Shadows*, ca. 1920, 6¼ x 8⅜"

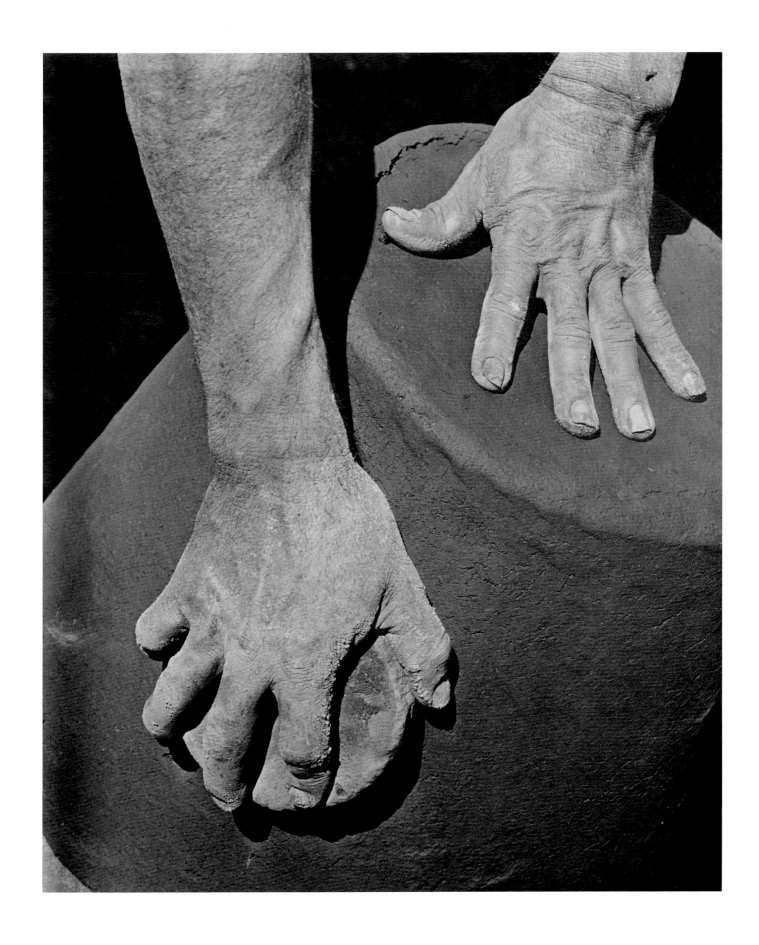

115 Anton Bruehl, *Hands of the Potter*, 1933, 17 x 14⅛"

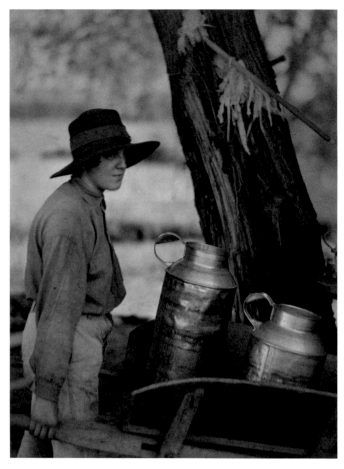

116 Doris Ulmann, *Farmerette*, ca. 1925, platinum print, 7⅞ x 6″

America's cultural past. Beginning in the mid-1920s, Ulmann traveled thousands of miles in an artistic quest to record vanishing ways of life. While the majority of this work was done in Appalachia, Ulmann also recorded Dunkard, Mennonite, and Shaker communities in Virginia, Pennsylvania, New York, and New England. She also photographed the Gullah people of South Carolina and the French Creole and Cajun communities in Louisiana.

The retrospective mood of Ulmann's photographs was enhanced by her anachronistic technique. Long after more advanced equipment was available, she worked with a 6½ x 8½-inch view camera and a soft-focus lens without a shutter. Each exposure was made by manually removing and replacing her lens cap, so her subjects had to be carefully—and self-consciously—posed. This approach, at once quaint and heroic, transformed farm laborers [116] and anonymous craftsmen [191] into icons of earthy simplicity. By synthesizing a concern for the abstract principles of pictorial design with a romantic quest for a largely premodern past, Ulmann created a body of work uniquely poised between early twentieth-century Pictorialism and 1930s social realism.

Laura Gilpin's work reveals a similar sensitivity to the vestiges of time and tradition. Gilpin studied at the White School between 1916 and 1918, and was strongly influenced by White, Weber, Anderson, and Horne.[131] She was especially dedicated to the craft of photography—using platinum paper long after American firms ceased producing it—and to the importance of pictorial design.[132] Returning to her native Colorado, Gilpin embarked on a professional career as a portrait and architectural photographer. Her interest in the American West led her to record many

of the region's most spectacular sites—including the Grand Canyon, Canyon de Chelly, Zion Canyon, and Bryce Canyon—in photographs that are delicately seen and boldly structured [190]. In later years, she devoted great energy to documenting the indigenous cultures of the Americas, with particular attention given to the archaeological ruins of the Yucatan and the lives of the Navajo and Pueblo peoples.[133]

Other expressions of the White School aesthetic are seen in the work of lesser-known photographers such as Wynn Richards, Antoinette B. Hervey, Ira W. Martin, Frances M. Bode, and Mortimer Offner. Richards studied with White in the late 1910s before embarking on a successful commercial career in Chicago and New York.[134] Her *Woman with Veiled Hat*, of about 1918 [182], uses delicate tones, a shallow depth of field, and a hint of solarization to unexpectedly dreamlike effect. The urban scene is the subject of Hervey's *New York, Lower East Side, Brooklyn Bridge*, 1915 [117], and Martin's *The Dwarfs* [118]. Both of these photographers exhibited widely beginning in the mid-1910s. Similarly, Bode's *Repetition*, 1925 [188], employs a slight downward perspective to transform a catalogue of modern industrial subjects—automobiles, rail yards, factories, and bridges—into a tapestry of rhythmic angularity.[135] After his studies at the White School, Offner portrayed leading personalities of the New York stage—including Ethel Barrymore and Tallulah Bankhead—before moving to Hollywood, where he worked as a photographer, screen writer, and director. Offner's interpretation of Lisa Duncan [119], the daughter of dancer Isadora Duncan, is characteristic of his elegantly theatrical style.[136]

Photographers of the White circle tended to be technically sophisticated. The variety of Jane Reece's work is instructive in this regard. Reece, who opened a portrait studio in Dayton, Ohio, in 1904, studied with White at Columbia in 1909. After returning to Dayton, she became an active member of the PPA and was an active salon exhibitor through 1935. In her first years in photography, Reece developed special printing techniques that she refused to divulge to others.[137] She also worked with the Autochrome color process.[138] Most remarkably, in ca. 1928-30, Reece enlarged individual frames of 16mm motion-picture film to make gelatin silver images on sheets of Japanese tissue. This was considered a nearly impossible feat, given the small size of

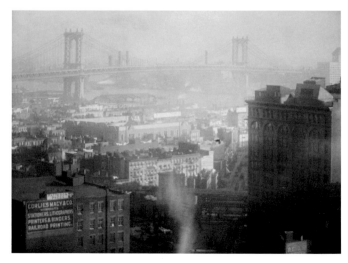

117 Antoinette B. Hervey, *New York, Lower East Side, Brooklyn Bridge*, 1915, platinum print, 9⅛ x 12¾″

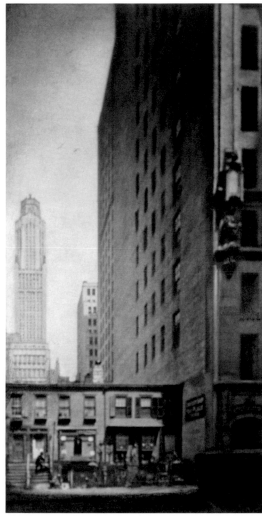

118 **Ira W. Martin**, *The Dwarfs*, ca. 1923, platinum print, 9⅜ x 4⅞″

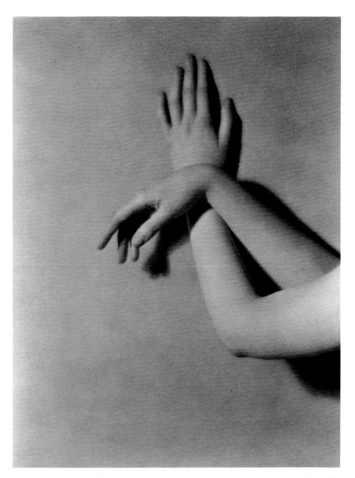

119 **Mortimer Offner**, *Lisa's Arms*, ca. 1924, platinum print, 9⅛ x 6⅞″

amateur movie film.[139] Technical challenges aside, Reece used this curious technique to create truly memorable pictures. For example, her astonishing *Adagio* [197] suggests a perfect union of Pictorialism and Surrealism—an ominous, soft-focus dream.[140]

A similar willingness to experiment is seen in the work of Guy Gayler Clark, an enormously experienced if now little-remembered figure. Trained as a painter under William Merritt Chase, George Bellows, and Robert Henri, Clark enjoyed an influential career in commercial and advertising art. In addition to writing and lecturing widely on these subjects, he served as dean of the Cooper Union Art School from 1938 until his death in 1945.[141] Clark was also an active member of the PPA and a photographer of considerable talent.[142] His urban images [120] capture the constructive energies of the period while functioning as semiabstract investigations of light and dark. The most memorable of his images is *The Sewing Basket*, ca. 1916-20 [192]. Here, through the manipulation of focus and tonality, Clark has created a remarkably bold—and even strange—picture from the most common of domestic subjects.

White's enthusiasm for artistic discovery is seen clearly in his own work. One of his most remarkable late pictures, *Croton Reservoir*, 1925 [193], was made only two months before his death.[143] While this print embodies the warmth and craftsmanship of White's most celebrated Pictorialist images, it has little in common with his earlier domestic idylls. Here, the oblique per-

spective, selective focus, and tight cropping all transform a boldly modern subject—the spillway of a large dam—into an abstract visual puzzle. Space seems to collapse on itself as foreground and background are enmeshed in a complex network of graphic incident. There is nothing sentimental or picturesque about this image. Instead, it is a provocative exploration of pure lenticular vision, as radical as any of László Moholy-Nagy's camera images of the same period. This picture suggests the generous breadth of White's aesthetic, which sought to embrace new ideas without discarding old virtues.

120 **Guy Gayler Clark**, *Untitled (construction)*, ca. 1918-20, 7½ x 9½″

The Salon Aesthetic

Photographers of this era had many opportunities to exhibit their pictures and to learn from the work of their peers. From its beginning in 1914, the Pittsburgh Salon of Photographic Art, presented in the galleries of the Carnegie Institute, was regarded as the nation's most prestigious yearly show. Important annual salons were also hosted by clubs or museums in Los Angeles, Buffalo, Portland (Maine), Portland (Oregon), Seattle, Syracuse, and San Francisco. In addition, many Americans regularly submitted work to international salons in London, Glasgow, Edinburgh, Liverpool, Paris, Turin, Montreal, Toronto, and elsewhere.[144] These exhibitions presented all manner of artistic photography: straight and manipulated, pictorial and modern. Indeed, the dominant characteristic of the photographic salons of this era was their inclusiveness.

The salon movement enjoyed considerable growth in the years between the world wars. During the 1925-26 exhibition season, for example, Americans participated in some forty-four international salons. A dozen years later, the number of such exhibitions had more than doubled to ninety-one.[145] In this twelve-year span, the number of American exhibitors grew from slightly less than 500 to just over 600.

Although scattered all across the country, these men and women had a clear sense of collective identity, thanks in large measure to the *American Annual of Photography*'s yearly listing, "Who's Who in Pictorial Photography." These exhaustive rosters provided statistics on the number of salons successfully entered and the total number of prints shown by each exhibitor. The quantitative emphasis of these rankings created a competitive climate in which photographers sought to outscore each other. In the 1925-26 season, twenty-five individuals showed in ten or more salons. Twelve years later, this mark was reached by no fewer than 122 photographers. The clear winner in this numbers game was the tireless Max Thorek of Chicago, a surgeon and dedicated artistic photographer. Thorek showed 316 prints in 82 salons during the 1937-38 exhibition season alone; between 1925 and 1950 he exhibited a staggering total of 4,021 prints in 1,111 salons.[146]

Before this inflation diluted their significance, the salons provided an important forum for most of the nation's artistic pho-

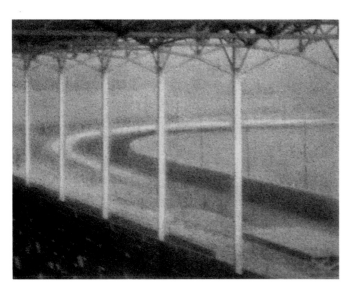

121 **F. Milton Armbrust**, *The Race Track*, ca. 1920-25, bromoil print, 4 x 5¼"

tographers. In the years after World War I, for example, some of the most noted salon exhibitors included P. Douglas Anderson, Paul L. Anderson, Charles K. Archer [194], F. Milton Armbrust [121], Anne Brigman, Dr. Amasa Day Chaffee, Imogen Cunningham, William E. Dassonville [196], Dwight A. Davis, Edward R. Dickson, James N. Doolittle, John Paul Edwards [195], Louis Fleckenstein, John Wallace Gillies, Laura Gilpin, Forman Hanna, George W. Harting, Arthur F. Kales, Dr. Rupert S. Lovejoy, Nicholas Muray, Wilbur Porterfield, Jane Reece, O. C. Reiter, Dr. D. J. Ruzicka, Clara Sipprell, Doris Ulmann, Edward Weston, and William H. Zerbe.[147] Photographers of this caliber all worked with characteristic processes or subjects. Lovejoy, for example, was considered the master of the multiple gum print. Several photographers—including Archer and Chaffee—specialized in the bromoil process. Hanna was renowned for his Arizona landscapes and nudes. Dassonville created his own printing material and by 1924 was manufacturing it for general sale. With its matte surface and velvety tones, his Dassonville Paper became a favorite of other Pictorialists of the era.

The postwar salon movement was characterized by a stimulating diversity of techniques and subjects. Sentimental images were common, but the leading salons showed more varied and progressive work than later generations have acknowledged. Harting, Gillies, and Dickson, for example, continued the Dow/White tradition of "space filling," producing consistently subtle and elegant photographs. In addition, while domestic and allegorical themes remained popular, many photographers of the late 1910s and 1920s turned their cameras on the restless energy and geometric forms of urban life.[148] Unusual perspectives and processes were also explored. For example, John Word Caldwell created a stir when he exhibited a negative print of a geometric urban subject, seen from above, in the 1928 Pittsburgh Salon.[149] Other salon exhibitors, such as the New York photojournalist William H. Zerbe, found artistic value in the newsworthy incidents of urban life.

The complexity of the postwar salon aesthetic is further revealed in the rise of "straight photography"—the use of simple bromide or chloride printing papers, coupled with a gradual acceptance of the glossy surface, and a move toward more crisply focused images. Usually defined as a reaction against Pictorialism, this "straight" approach represented an integral element of the overall salon aesthetic.[150] In 1916, for example, a writer in the *Photographic Journal of America* noted approvingly that "the straight print...stands for what it is, a simple, direct, straightforward piece of photographic craftsmanship, to which is coupled an artistic ideal of the best that the medium will allow."[151] By 1920, Clarence White observed that matte-surface bromide and chloride prints were more plentiful in salons than gum, platinum, bromoil, or any of the other techniques favored earlier.[152]

A further step was taken in 1924, when John Wallace Gillies submitted glossy bromide prints to that year's Pittsburgh Salon. These were seen to mark a "startling departure in exhibition-work." A critic reported that, "evidently taken by his audacity, the jury accepted three of these; for sheer beauty they compare favorably with anything in the show."[153] Another observer noted that in the American section of the 1924 Paris Salon "straight photography was very prominent, and there was little of that diffused work which we were led to expect."[154] This trend continued

and by the late 1920s, bromide and chloride prints greatly out-numbered all other processes; an increasing number of these prints were produced on smooth-surface paper, and with relatively sharp-focus lenses.[155]

The heterogeneous nature of the salons provided a forum not only for various processes and subjects, but for diverse groups of photographers. Notably, for example, the talents of Japanese-American photographers in the 1920s were widely recognized in the Pictorialist salons and publications. These photographers—some U.S. citizens and some temporary residents—lived primarily on the West Coast.[156] In Seattle, photographers of Japanese heritage gathered around Kyo Koike, an active exhibitor and writer on photography.[157] Koike was a founding member of the Seattle Camera Club (begun in 1924), editor of the club's bimonthly bulletin *Notan*, and the guiding spirit behind the club's five annual Salons (1925-29). Similarly important were the Japanese Camera Club of San Francisco, and the Los Angeles-based Japanese Camera Pictorialists of California. The latter organization, founded by Kaye Shimojima, included such notable members as K. Ota, K. Asaishi, and Kentaro Nakamura.

One of the most admired Japanese-American photographers was Toyo Miyatake. After studying photography in Los Angeles with Harry Shigeta, Miyatake became one of the city's leading portraitists. He befriended Edward Weston in about 1920, and subsequently arranged four successful exhibitions of Weston's work in the city's Japanese community.[158] His own photographs [198] exemplify the traits for which the Japanese-American photographers were celebrated: a reductive emphasis on line, pattern, and geometry to create elegantly formal, poetic effects.

Kentaro Nakamura's *Evening Wave*, ca. 1927 [199], was one of the best-known images produced in this era by a Japanese-American photographer. Reproduced in American, English, German, and Russian photographic journals, this work found favor with Pictorialists and modernists alike.[159] *Evening Wave* represents an eloquent blend of naturalism and abstraction. The massive swell of water suggests both tranquillity and power, providing an apt metaphor for the Japanese-American aesthetic as a whole.

It is not surprising that such work was widely admired.[160] Japanese-Americans brought to artistic photography a clear understanding of their own visual heritage, aspects of which had inspired an earlier generation of Pictorialists. Progressive Western photographers had been introduced to the idea of *notan* through Arthur Wesley Dow and the White School, but the work of the Japanese-Americans expressed such notions in first-generation form. Thus, while criticized by some as too reductive, such work was in basic harmony with the most progressive Pictorialist ideas of the time. Unfortunately, this strong sense of cultural identity led to the marginalization of these figures—and the destruction of much of their work—in the anti-Japanese climate of World War II.[161]

While the salons remained a step behind the most avant-garde work of the era, to the most traditional Pictorialists this appeared to be a very small step. Indeed, in 1930, Ira W. Martin, then president of the Pictorial Photographers of America, argued that meaningful artistic photography could only result from an embrace of contemporary life. His standard for such work would have appealed to the most radical modernist: "beautiful textures, commonplace subjects portrayed in unusual and interesting ways,

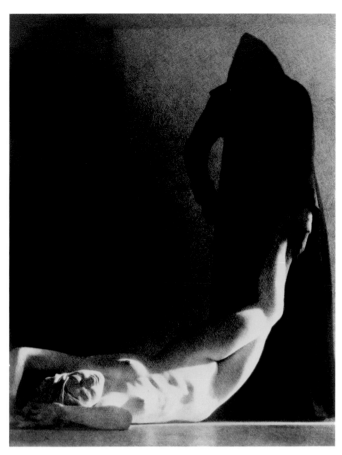

122 William Mortensen, *Fragment of the Black Mass*, 1926, 7 1/4 x 5 1/4"

steel structures, dynamic compositions…, significant shapes and forms—all done with the precise, direct reality of the age in which we now live."[162]

While many American photographers accepted this point of view and worked accordingly, others—such as the venerable Pictorialist Paul L. Anderson—rejected what they felt to be an impoverished new orthodoxy. In 1935, Anderson ridiculed

> the worm's-eye views of helical staircases; the fire-escapes; the coils of rope; the interiors of alarm clocks; the ghastly abominations of photo-montage; the rows of ploughshares; the under-exposed and over-developed things of chalk and soot; the worm's-eye views of the Empire State Building, taken with a red filter, so that the whole structure seems to be falling backward into a black sky; the bird's-eye views of the same building, which look like a Cubist's design for a child's toy; the nightmares of toy balloons and confetti![163]

For such critics, modern photography lacked humanity, replacing personal feeling with "purely mechanical"-effects.[164] Such effects denied the basic ideas of classic Pictorialism, which held that art was a matter of temperament rather than technique. Their fear of losing hard-won ground prompted traditionalists such as Anderson to exhort photographers of the 1930s to be true artists instead of heartless automatons "pouring out prints as an automatic machine pours out nuts and bolts."[165]

This familiar defensiveness on the question of photography's mechanistic nature lies at the heart of late Pictorialist work. Three of the most notable figures in this movement were William Mortensen, Max Thorek, and Adolf Fassbender. In addition to exhibiting extensively, each exerted considerable influence in their writings. Among their most important books were Mortensen's *Monsters and Madonnas* (1936), Thorek's *Creative Camera Art*

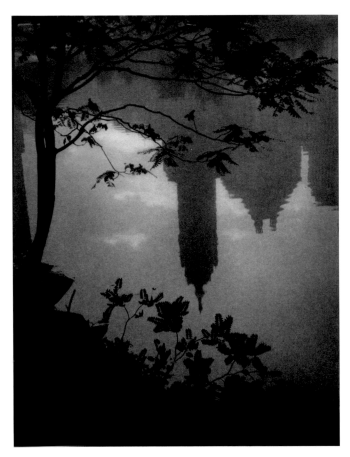

123 Adolf Fassbender, *City Symphony*, ca. 1930, 13½ x 10¾"

(1937), and Fassbender's *Pictorial Artistry: The Dramatization of the Beautiful in Photography* (1937).[166] All three advocated an aggressively non-purist approach to the medium. For them, the straight photograph was a stark record which merely provided the starting point for genuine creative expression.

Mortensen, in particular, was known for his flamboyantly manipulated style [122]. His melodramatic images began in the studio, where he created theatrical tableaux based on artistic or literary motifs. He transformed his models through makeup, pose, and lighting, and then heavily retouched his negatives and prints to create images that look more like lithographs or engravings than photographs. The high artifice of Mortensen's images reflected, in his mind, their function as intellectual creations with universal and timeless appeal. Similarly, both Fassbender [123] and Thorek [124] used retouching and paper internegatives to evoke the look of drawings or lithographs. While rejected by modernists as hopelessly retrograde, the work of these photographers was widely admired by traditionalists of the period.

The Weston Circle

The complex nature of later Pictorialism is suggested by the work of Edward Weston and his most notable associates of the early 1920s: Margrethe Mather, Johan Hagemeyer, and Tina Modotti. In addition to demonstrating the diversity of the Pictorialist aesthetic, their work underscores the essential continuity between Pictorialism and modernism.

Edward Weston's career began in 1911, when he opened his first portrait studio in the Los Angeles suburb of Tropico (now Glendale). Talented and ambitious, Weston quickly established a national reputation, winning numerous awards for his "romantic and decorative" photographs.[167] An important early influence was Margrethe Mather, who had considerable knowledge of contemporary art, literature, and social issues. Mather also served as Weston's model, studio assistant, and occasional collaborator.[168] Weston and Mather met Johan Hagemeyer in about 1917. Hagemeyer, who had left his native Amsterdam in 1911, was a worldly figure with a passion for photography, classical music, and radical politics. The two men became close and, for a time, Hagemeyer lived with Weston's family and assisted him in the studio. Together, Mather and Hagemeyer encouraged Weston's bohemian inclinations and increased his artistic sophistication.

Mather's exhibition career as a photographer was relatively short, lasting essentially only from 1917 to 1921. She was, nonetheless, a photographer of exceptional talent. Mather was singled out for the "excellent taste" of her work in the 1917 Pittsburgh Salon.[169] Later, she was praised as "a worker of strong individualism" whose pictures were deemed "refreshingly original."[170] In 1921 a critic noted that she "shows a great appreciation for the value of space and handles it admirably."[171] These qualities are apparent in *Puppet* [125], an elegant exploration of graphic space. Mather's most remarkable work may be her 1921 double portrait of Hagemeyer and Weston [200]. Besides capturing the close friendship of the two men, the picture has a strikingly original composition: the faces are radically cropped and the image's central element is the shadowed void between them. Mather's fragmentation of the figures and use of "negative space" was distinctly unusual, and more daring than Weston's pictures of this time.

Hagemeyer also received great critical praise for his work, the best of which was produced in 1921-22. In his most original photographs, Hagemeyer focused on the forms and rhythms of

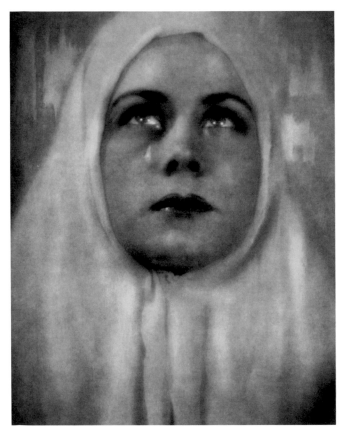

124 Max Thorek, *Europe*, 1939, 15¾ x 12¾"

urban life. His 1921 images of the jaw of a steam shovel and a detail of a truck wheel were celebrated as "very suggestive of [the] gigantic industrial enterprise...of this mechanical and constructive age."[172] Hagemeyer's work had a "decided individuality" and "a bigness" that distinguished it from that of his contemporaries.[173] In a 1922 essay, Hagemeyer himself dismissed much of the artistic photography of the day as "mediocre," and typified by "a decided similarity of idea—or rather a lack of any original idea."[174]

The originality of Hagemeyer's own ideas is revealed in two of his most celebrated pictures, *Castles of Today* [202] and *Pedestrians* [203]. The first creates a bold geometric harmony from the disparate architectural forms of the San Francisco skyline. As Hagemeyer explained in a later interview, the title of this image carried considerable meaning for him.

> I became interested in industrial subjects before I did in portraits. I started to make them with the intention of putting them in book form to show the beauty in American industrial work. I am interested in everything contemporary and believe that we should live in our own time—seeing the beauty of today instead of worshipping that of the past. Modern factories and buildings are as beautiful as old castles. They are the castles of today.[175]

Pedestrians extends this celebration of present-day life by focusing on the pulsing energy of the street. In this memorable image, Hagemeyer transforms passersby into shimmering specters—at once real and illusory—frozen in a kind of golden pictorial amber.

Despite his skill as an artistic photographer, Hagemeyer's need to earn a living forced him to turn his energies to portraiture in 1923. He opened a studio in Carmel, California, and his subsequent personal work never equaled his earlier efforts. In truth, his pictures of 1921-22 represent a brilliant artistic synthesis of new and old. While Hagemeyer's modern subject matter and rigorous formalism anticipate the finest achievements of the later 1920s, his soft-focus technique was derived from the aesthetic of the previous decade. The avant-garde's increasing penchant for optical sharpness soon made Hagemeyer's work seem old-fashioned, despite its intellectual substance and visual complexity.

While Mather and Hagemeyer created profoundly original work in the first years of the 1920s, Weston eventually grew far beyond them. From the mid-1910s, when he first began exhibiting internationally, to the late 1920s, when he came to full artistic maturity, Weston worked his way through an interest in tonal delicacy and graphic design to a precisionist rendition of volumetric form. In addition to his friendships with Mather and Hagemeyer, his early influences included *Camera Work* and the modern European paintings he saw at the 1915 Panama-Pacific International Exposition in San Francisco. In the years up to 1923, Weston's pictures were exhibited widely in the leading salons, and were praised as "sometimes startling in their originality" and as "ultra-modern" in concept.[176] Stimulated by essays written by the Stieglitz circle, Weston grew to appreciate the power of the camera to "truthfully represent natural objects [without] trick, device, or subterfuge."[177] In the fall of 1922, Weston made his first photographs of modern industry, a subject familiar to him from Hagemeyer's work. He then visited New York, where he met Strand, Sheeler, and Stieglitz. These experiences reinforced Weston's movement toward a "purist" aesthetic, though this evolution was gradual and deliberate. A good example of Weston's late Pictorialist style is his exquisite 1923 portrait

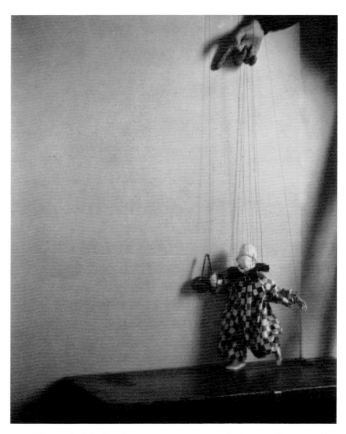

125 Margrethe Mather, *Puppet*, ca. 1921-22, platinum print, 9 x 7 ½"

of Karl and Ethel Struss [201], which blends a sense of warm intimacy with a boldly simple composition.[178]

In July 1923, Weston left Los Angeles for Mexico, seeking the freedom he felt he needed to come to maturity as an artist.[179] Accompanying him on this voyage of self-discovery was Tina Modotti, a part-time actress and a member of the Los Angeles art community. Modotti had volunteered to work as Weston's apprentice in order to learn photography herself. The two remained together in Mexico for most of the next three years, a period of great artistic importance for both of them.[180]

Modotti's photographs quickly achieved a remarkable degree of sophistication and originality. By 1925, she was producing elegant close-ups of roses and lilies, architectural details of her house in Mexico City, and forceful compositions of rows of telephone poles. One of the most beautiful of these early images, *Staircase, Mexico*, 1925 [204], is a masterful union of boldness and delicacy. Her *Campesinos*, 1926 [205], is very different in sensibility. This view of a peasant demonstration in the streets of Mexico City reflected Modotti's growing passion for politics. Before long, her commitment to leftist causes forced her to choose between art and activism. Weston advised her to "solve the problem of life by losing [yourself] in the problem of art," but Modotti could not. She responded: "I am forever struggling to mould life according to my temperament and needs—in other words *I put too much art in my life*—too much energy—and consequently I have not much left to give to art."[181] This devotion to revolutionary causes resulted in a brief period of imprisonment and Modotti's deportation from Mexico in 1930. She spent the next decade in Europe before returning to Mexico, where she died in 1942.[182]

Weston's Mexican photographs fall into several interrelated series: monumental portraits made with a hand-held camera;

crisp images of clouds, landscapes, and buildings; and boldly geometric still lifes and nudes. Common to all these photographs is a new intensity of vision, a concentration on simplified forms, and a resolutely purist use of the medium. With this approach, Weston was able to find expressive sculptural form in subjects as diverse as his enamel toilet, earthenware jugs in the marketplace, and the great pyramids at Teotihuacán.

When Weston returned to California in late 1926, he was primed for the most innovative period of his career. In the next few years, he created some of his most memorable nudes, as well as a remarkable series of close-ups of organic forms: shells, peppers, onions, eggplants, artichokes, and cabbages. At the Point Lobos nature preserve, he made similarly direct studies of rocks, gnarled cypress trees, and kelp. Through Weston's close-up vision, these objects are removed from their everyday context and their scale rendered ambiguous. Common things are seen as if for the first time, and with such microscopic precision that they take on an almost surreal intensity. As Weston wrote of his now-famous *Pepper No. 30* [207],

> It is a classic, completely satisfying,—a pepper—but more than a pepper: abstract, in that it is completely outside subject matter. It has no psychological attributes, no human emotions are aroused: this new pepper takes one beyond the world we know in the conscious mind.[183]

These monumental still lifes were inspired by a variety of influences, including Weston's love for the grandeur of Bach, the elegant simplicity of Brancusi's sculpture, and the work of several contemporary painters and photographers.[184] In 1926, the year he returned to California, Weston described his approach:

> I have recorded the quintessence of the object or the element in front of the lens, without subterfuge or evasive acts, either technically or spiritually—instead of offering an interpretation or a superficial or passing impression of it.
> Photography is not worth anything when it imitates another medium of expression, when it avails itself of technical tricks or foreign points of view.
> Incoherent emotionalism must be replaced by serene contemplation; tricky dexterity must give way to honesty...[185]

The technical aspect of Weston's philosophy—a purist use of the medium—had been advocated earlier by Stieglitz, Strand, and others. What was most distinctive about Weston's approach was his application of straight photography to an overtly mystical project: the depiction of timeless and universal life rhythms. Weston amplified these ideas in numerous statements. In 1931, for example, he wrote:

> I am not trying to express myself through photography, impose *my* personality upon nature (any manifestation of life) but without prejudice or falsification to become identified with nature, to know things in their very essence, so that what I record is not an interpretation—*my* idea of what nature should be—but a *revelation* or a piercing of the smoke-screen artificially cast over life by irrelevant, humanly limited exigencies, into an absolute, impersonal recognition.[186]

At its most basic, this "absolute recognition" involved the sublime truth that

> clouds, torsos, shells, peppers, trees, rocks, smoke stacks, are but interdependent, interrelated parts of a whole, which is Life. Life rhythms felt in no matter what, become symbols of the whole....

To see the *Thing Itself* is essential: the quintessence revealed direct without the fog of impressionism.[187]

Weston's vision of the unity of apparently disparate objects stemmed from a long and venerable philosophical tradition.[188] Nearly a century earlier, Ralph Waldo Emerson had suggested that, with close observation, "the world shall be to us as an open book, and every form significant of its hidden life and final cause."[189] What was new, however, was Weston's union of extreme objectivity of technique with an equally extreme subjectivity of purpose. While Pictorialists evoked universals by obscuring details in an Impressionistic mist, Weston found transcendence through a hyperreal magnification of visual fact—in effect, by striving to see through the surface of things to the essential forms within.

This intense concentration of vision characterized Weston's approach from about 1927 to 1934. Subsequently, however, his work grew broader in both subject and viewpoint. His later nudes often include the entire figure rather than simply details of a breast or knee, and his landscape work shifted from intimate vignettes of a single rock or tree to vistas of often sweeping scale [208, 209]. While his earlier work emphasized magnification and fragmentation, in the 1930s and 1940s Weston more often stressed the wholeness and interrelatedness of things.

This new attitude resulted, in part, from the sheer variety of his subjects. As the first photographer to receive Guggenheim Fellowships (in 1937 and 1938), Weston traveled across the western United States, recording anything that stirred his interest. The fruits of this labor (some 1,500 negatives in two years) were published in the book *California and the West* (1940). In 1941, he was commissioned to make photographs for a special limited edition of Walt Whitman's *Leaves of Grass*. For this project, Weston recorded a great number of subjects in his travels through the American South, along the Atlantic coast, and into New England.

Weston's late work is bittersweet in mood and majestic in spirit. While continuing to focus on the beauty of the natural world, his pictures of the late 1930s and 1940s contain notes of irony and surrealism, and frequent signs of death and decay. Weston's artistic vision remained undiminished until 1948, when the effects of Parkinson's disease finally forced him to put the camera aside.

Group f/64

By the late 1920s, Weston had achieved international fame. His work was widely influential and exhibited with increasing frequency. In 1929, he was chosen to help organize the American contribution to an important international exhibition, "Film und Foto," mounted in Stuttgart. His selection included twenty of his own pictures, as well as groups of prints by Imogen Cunningham, Brett Weston, and others. Between 1930 and 1932, Weston's work was shown to considerable acclaim, twice at the Delphic Studios in New York and in a one-man exhibition in San Francisco. His first book, *The Art of Edward Weston*, was published in 1932. He achieved further recognition as an essayist, writing spirited defenses of the purist approach in articles such as "Photography—Not Pictorial."[190]

Weston's celebrity made him the focus, if not the actual organizer, of a loose association of like-minded photographers called

"Group f/64." Besides Weston, the original members were Ansel Adams, Imogen Cunningham, John Paul Edwards, Sonya Noskowiak, Henry Swift, and Willard Van Dyke. These seven exhibited their work jointly at the M. H. de Young Museum in San Francisco, and invited four others to join them: Preston Holder, Consuelo Kanaga, Alma Lavenson, and Brett Weston. The photographs in the exhibition (which remained on view from November 15 to December 31, 1932) were characterized by a sharp-focus rendition of simple subjects, often seen in close-up and printed on glossy paper. The group's manifesto rejected the influence of other mediums in favor of "a simple and direct presentation [of] purely photographic means."[191] The use of filters and such basic printing techniques as burning and dodging were allowed, but anything else was rejected as illegitimate.

The members of Group f/64 worked in similar but distinctive styles. Several, for example, made close-ups of organic forms. Weston's influence can be seen clearly in the work of Noskowiak, his assistant and companion at the time. However, Noskowiak's *Leaf* [126] is distinguished from his work by its intimate scale and wholly personal balance of strength and delicacy. Lavenson's *Chrysanthemum* [210] uses a similar point of view to create an image of almost radiant luminosity. The warmth of this picture contrasts markedly with the cool objectivity of most f/64 work, and may reflect the lingering traces of Lavenson's former Pictorialist style.

Imogen Cunningham was one of the most experienced, and experimental, of the Group f/64 photographers. After working for Edward S. Curtis's firm in Seattle, she opened her own portrait studio there in 1910.[192] She moved to San Francisco in 1917, where she befriended Lange, Weston, Hagemeyer, and Mather. The originality of Cunningham's work increased markedly in about 1923, when she began exploring the artistic possibilities of multiple exposures, semi-abstract plays of light and shadow, and crisply focused views of botanical forms. Over the next decade, her bold close-ups of plants received particular praise: Weston chose several for the important "Film und Foto" exhibition, and they featured prominently in her M. H. de Young Museum retrospective in 1931. Cunningham's *Amaryllis* [206] is characteristic of this work. Utterly unsentimental, this image effortlessly unites description and abstraction while creating figure-ground tensions that are both tonal (black versus white) and spatial (mass versus pattern).

The youngest member of Group f/64 was Weston's son Brett, who became an accomplished photographer in 1925, at the age of fourteen, while living with his father in Mexico. The directness of Brett's vision echoed Edward's assertive style but, to prove his independence, the son "deliberately looked for subjects his father hadn't done."[193] Brett turned his boldly modernist vision on a variety of contemporary subjects: tin roofs, rows of concrete pipe segments, stacks of kindling wood. His 1927 industrial image [212], made after the Westons returned to California, is a forceful interpretation of a subject to which the elder Weston gave relatively little attention. This image conveys clearly the natural sympathy between a purist use of photography and the hard-edged functionality of modern machine culture.[194] This phase of Brett's work reached its artistic pinnacle in his exquisite *Car Window*, 1936 [213]. This image plays the sleekly engineered lines of a new automobile against the subtle visual effects of reflec-

126 Sonya Noskowiak, *Leaf*, 1931, 3¾ x 2⅞"

tion and transparency, further underscoring the interrelationship of modern technology and vision.

Despite their shared interests, each member of Group f/64 perceived its mission differently. At the time of the original f/64 exhibition, Cunningham was experimenting with multiple exposures and producing celebrity portraits for *Vanity Fair*, refusing to be constrained by dogma of any kind. Even Edward Weston, often perceived as the archetypal purist, rejected a too-literal definition of straight photography. When, in 1931, he photographed a shell that he had carefully positioned on the rocks at Point Lobos, his purist friends were disturbed by the "artificiality" of the gesture. However, Weston pointedly reserved the right to define for himself what was authentically photographic.[195]

For Ansel Adams, Group f/64 represented nothing less than a crusade for honest photography.[196] Adams had the fervor of a new devotee, having only recently made a definitive career choice between photography and music. He had begun photography in 1916, at the age of fourteen, during a visit to Yosemite. He used the camera periodically over the following years while training to be a professional pianist. By 1929, when he began work on *Taos Pueblo*, a collaboration with writer Mary Austin, Adams had abandoned his early Pictorialist style in favor of a simpler, crisper vision [206].[197] The twelve images of the *Taos* portfolio were printed on Dassonville's warm-toned, matte-surface paper, but Adams soon took a final step and committed himself to "the simple dignity of the glossy print."[198] In 1930, he met Paul Strand in Taos and was inspired by the beauty of Strand's negatives to devote all his creative energies to photography. By the time of his one-man exhibition at the M. H. de Young Museum in 1932, Adams's "straight" aesthetic was fully formed and promoted with an almost religious zeal. He began publishing a series of technical articles in *Camera Craft* in 1934, and issued his first book, *Making a Photograph*, the following year. These publications—and the many that followed—promoted the f/64 approach with clarity and passion.[199]

127 Ansel Adams, *Old Faithful Geyser, Yellowstone National Park*, 1942, 12⅝ x 9″

Adams's mature work is characterized by meticulous technique and a dramatic celebration of the natural world. As seen in his *Old Faithful Geyser*, 1942 [127], Adams viewed the landscape of the American West as awesome, beautiful, and—usually—pristinely untouched by man. The subsequent popularity of Adams's work was, in part, a result of this essentially Romantic vision.[200] As in classic Romantic painting, Adams sought to depict particular moments of heightened visual and emotional experience. The stop-action quality of *Old Faithful Geyser* underscores Adams's interest in the drama of highly transient effects of light and atmosphere.

Other members of Group f/64 shared Adams's urge to proselytize for purism. In 1933, Willard Van Dyke and Mary Jeannette Edwards (the daughter of John Paul Edwards) opened a gallery in Oakland at 683 Brockhurst Street, the former studio of Anne Brigman. Not surprisingly, their debut exhibition was an Edward Weston retrospective. In 1934, the gallery presented the "First Salon of Pure Photography," which recognized straight photographers beyond the membership of Group f/64. The jurors—Weston, Van Dyke, and Adams—received over 600 prints and selected work by thirty-four photographers, including Edward Quigley, Arthur Racicot, Fred P. Peel, Luke Swank, Sibyl Anikeef, William Abbenseth [128], and Paul Taylor.[201] The show then traveled across the bay for installation at Adams's gallery in downtown San Francisco. This space, opened in 1933, was inspired by the example of Stieglitz's gallery in New York, which Adams had visited earlier that year.

As the "First Salon of Pure Photography" demonstrated, the straight aesthetic was a broad-based movement, with adherents all across the country. The purism of this show had been anticipated by such exhibitions as the Brooklyn Museum's "International Photographers" of 1932. In addition to a strong selection of European avant-garde work, the Brooklyn survey included most of the leading "straight" photographers in America: Bourke-White, Cunningham, Outerbridge, Sheeler, Steichen, Edward Weston, Maurice Bratter, and Walker Evans. Kurt Baasch, who found artistic rejuvenation in the new straight aesthetic [129], was also included in this important exhibition.[202]

While enormously influential, the straight aesthetic met with significant dissent. The most eloquent opponent of the f/64 philosophy was William Mortensen.[203] Throughout the 1930s, Mortensen maintained a running debate, largely in the pages of *Camera Craft*, with several of the Group f/64 photographers. He infuriated Adams and Weston with his outrageously contrived pictures and spirited polemics. For example, in his essay "Fallacies of 'Pure Photography,'" Mortensen defined straight photography as a regressive, rather than a progressive, movement.

> There have always been purists in art just as there have been puritans in morals. Purists and puritans alike have been marked by a crusading devotion to self-defined fundamentals, by a tendency to sweeping condemnation of all who over-step the boundaries they have set up, and by grim disapproval of the more pleasing and graceful things in life.[204]

Mortensen challenged the most basic assumptions of the straight aesthetic. Was complete purity in any medium possible, or even desirable? Was it not true that Michelangelo's paintings were informed by his understanding of sculpture, while Rembrandt had utilized his knowledge of both painting and etching

128 William H. Abbenseth, *San Francisco*, 1935, 9⅝ x 7⅜"

129 **Kurt W. Baasch**, *Railroad Crossing, Baldwin, New York*, 1932, 6⅜ x 4⅝"

to mutual advantage? Mortensen found the purist's emphasis on simplicity to be hypocritical, alluding to the "technical obsession" evidenced in Adams's array of cameras, lenses, and chemical formulas. Most tellingly, he attacked the purist notion that the photographer was free to control the tones of his print for "emotional" effect, but that no further manipulations were legitimate.

> If tone is granted to be subject to control, why not line also, which has equal emotional significance? And if line, why not shapes and forms? And if shapes and forms, why not allow elision or emphasis of detail? And if all these things are allowed, what becomes of the "record of actuality"?...Sunk without a trace![205]

The purist approach was misguided, Mortensen concluded, because it valued facts over ideas, strove for a rendering of "things-as-they-are" instead of "things-as-they-are-experienced," and stressed scientific accuracy over psychological truth. Ultimately, he pronounced, the purist movement had produced little but "a series of excellent finger exercises in technique"—images that were "uniformly hard and brittle" and utterly lacking in "subjective interest."[206] This dispute over the artistic nature of the medium continued throughout the decade.[207] The fact that history has long since judged Mortensen the loser in this debate should not obscure the fact that he spoke for a significant segment of the photographic community of his day.

The New Vision

While Americans were occupied with these debates on the nature of photography, avant-garde artists in Europe were using the medium in remarkably provocative and original ways. The European "New Vision" was characterized by an exploration of the creative potential of both the optical and chemical components of the process. This experimental approach utilized a variety of expressive techniques, including photograms, photomontage, solarization, negative images, multiple exposures, aerial perspectives, and extreme close-ups. Important aspects of the New Vision aesthetic were embraced by the worlds of advertising, design, and journalism, giving these experimental strategies broad currency by the early 1930s.

Stimulated by a variety of factors, this radical approach to photography took form in Russia, Germany, and France in the years after World War I.[208] The trauma of the war produced a widespread sense that the slate of history had been wiped clean. With the stability of the Victorian past irretrievably gone, artists felt free to embrace modern experience as both the means and subject of their work.

In Russia and Germany, Constructivist art was conceived as a means of remaking society. After the Russian Revolution of October 1917, avant-garde artists used a variety of mediums—painting, graphic design, typography, architecture, film, and photography—to further what they zealously believed to be a glorious new epoch in human history. The primary aim of artists such as El Lissitzky and Aleksandr Rodchenko was not to create "art" as traditionally conceived, or to forge a distinctive personal style. Rather, they used photography—in concert with all the other means at their disposal—to effect a revolution in perception. This, they hoped, would provide the catalyst for a new social order. The idea of defamiliarization was central to this project.

By using unusual techniques and viewpoints, photographers sought to reinvent the visible world—to make familiar things newly strange—in order to prod viewers out of the ruts of habitual action and thought.[209] In revolutionary Russia, this work carried an explicitly political agenda: the creation of an ideal Communist state. The work produced in Germany tended to reflect a more science-oriented inquiry into the nature of vision and the intrinsic capabilities of materials and tools. In both countries, however, Constructivism embodied a highly utopian faith in the ability of art to transform society.

Surrealism, the dominant avant-garde movement in France in the 1920s, used the aesthetics of defamiliarization for different purposes. Extending the nihilistic and nonsensical outlook of Dada, the Surrealists placed little faith in technology, politics, or logical thought. Rather, they sought psychic freedom in dreams, automatism, and the unconscious. Chance, melancholy, and desire are frequent themes in Surrealist art, giving it a tone wholly different from Constructivism's precision and optimism.

One of the most startling expressions of the European New Vision was the photogram, an image produced directly on photographic paper without the use of the camera. While such shadow-images had been made throughout the history of photography, it was only in the years after World War I that the technique began to be used as a mode of avant-garde artistic expression. At least three independent "discoveries" of this process took place in rapid sequence. In 1918 or 1919, Christian Schad, a German painter and graphic artist living in Switzerland, produced small photograms of torn paper and fabric which reflected his interest in Cubist collage.[210] Man Ray, recently arrived in Paris from New York, began using the process in the winter of 1921-22 as a means of creating dreamlike transformations of everyday objects. In Berlin in 1922, László Moholy-Nagy, in collaboration with his wife Lucia Moholy, made photograms exploring the same themes of light and geometry that are apparent in his abstract paintings of the period.[211] Man Ray and Moholy-Nagy both worked extensively with this process for a number of years, exhibiting and publishing their images widely. Man Ray was particularly aggressive in promoting his work. In the fall of 1922, for example, his "rayographs" were reproduced in two American publications, *The Little Review* and *Vanity Fair*, and issued in a limited-edition portfolio titled *Champs Délicieux*.[212] In March, 1923, cameraless images by both Man Ray and Moholy-Nagy were included in the avant-garde journal *Broom*.[213]

The appeal of the photogram is easy to understand. The simplicity of the technique allowed remarkable pictures to be made quickly and cheaply. Artists simply arranged objects on a sheet of photographic paper and exposed it briefly to light. When processed, each area of the print was darkened in proportion to the amount of light it received. Because it was so simply done, the process had few controls. The look of the final image could be known only after it was developed, and successful effects could never be precisely duplicated. Each photogram or rayograph was a one-of-a-kind creation in which chance and intuition were as important as the artist's conscious intentions.

With this process, both Man Ray and Moholy-Nagy produced images of remarkable originality [130, 217]. As works of art, these cameraless pictures profoundly transform visual experience and violate our understanding of the codes of representa-

130 László Moholy-Nagy, *Composition with Circle*, 1922, 5 x 7"

tion. Because they are negative images, these prints present a strange inversion of visible reality: light produces darkness, and shadows register as white. The process is at once entirely objective and bafflingly abstract. When flat objects such as keys are placed on the paper, they are recorded in actual-size silhouette. However, images produced by dimensional objects, or those built up through successive layers of exposure, can be utterly indecipherable. The ambiguous pictorial space of these images—at once shallow and vast, and unsubmissive to the logic of perspective—is also confounding. Ultimately, the best photograms and rayographs unite the functions of document and dream; they both trace reality and disembody it. Mysterious and hallucinatory, the cameraless image provided a truly radical interpretation of the expressive possibilities of photography.

The Avant-garde in Germany

László Moholy-Nagy was a central figure in the German avant-garde of the 1920s. After serving in the army in his native Hungary, Moholy-Nagy decided to become a painter. He moved to Berlin in 1920 and soon became part of the city's avant-garde community. Interested in a variety of artistic mediums, Moholy-Nagy took up photography in 1922 with the technical assistance of his wife, Lucia Moholy. His first works in the medium were photograms; apparently, he did not actually use a camera until 1925.[214] In 1923, at the invitation of director Walter Gropius, he began teaching at the Bauhaus. The slogan of this school, "Art and Technology—A New Unity," was one Moholy-Nagy enthusiastically embraced. The Bauhaus offered workshops in a variety of disciplines—including typography, graphic design, printing, pottery, textiles, metal, furniture, wood and stone carving, bookbinding, and mural painting—with much emphasis placed on the use of new technologies.

While photography was never officially part of the curriculum during his tenure at the Bauhaus, Moholy-Nagy gave it considerable attention. Beginning in 1922, he wrote and lectured with missionary zeal on the potentials of the medium.[215] His views were most fully expressed in his influential book *Painting Photography Film* (1925; revised 1927). In this forward-looking volume, Moholy-Nagy praised photography's "amazing possibili-

ties, which we are only just beginning to exploit."[216] He cited three primary examples of such possibilities. First, he celebrated the picture-making potential of light-sensitive materials themselves, as revealed in the photogram and rayograph. Second, he pointed to the power of scientific photographs (such as astronomical, microscopic, and X-ray images) and unusual points of view to vastly enlarge the range of human perception. Finally, he argued passionately that the photograph, as a new standard of objective truth, held the key to momentous social changes. Through the "hygiene of the optical," he felt, society could be cleansed of its irrationalities and conflicts.[217]

> In the photographic camera we have the most reliable aid to a beginning of objective vision. Everyone will be compelled to see that which is optically true, is explicable in its own terms, is objective, before he can arrive at any possible subjective position. This will abolish that pictorial and imaginative association pattern which has remained unsuperseded for centuries....The traditional painting has become a historical relic and is finished with. Eyes and ears have been opened and are filled at every moment with a wealth of optical and phonetic wonders. A few more vitally progressive years, a few more ardent followers of photographic techniques and it will be a matter of universal knowledge that photography was one of the most important factors in the dawn of a new life.[218]

These utopian ideas provided a compelling rationale for the New Vision aesthetic.

Moholy-Nagy's broad view of photography is revealed in the pictures he selected, as well as in those he made. *Painting Photography Film* contains an eclectic assortment of photographs originally produced for scientific, journalistic, artistic, and

131 László Moholy-Nagy, *Marseilles*, 1929, 11½ x 8⅞"

133 **Gyorgy Kepes**, *Berlin*, 1930, 3 x 4¼"

132 **Martin Munkacsi**, *Street Shadows*, 1928, 11⅜ x 8⅞"

commercial purposes. These include X-rays, photomicrographs, astronomical images, photograms, extreme close-ups, aerial perspectives, negative images, multiple exposures, distortions and reflections, time exposures, and photomontages. These varied images were not intended to reflect a single style, or even to be understood as "art." Rather, they demonstrated his belief that the objectivity of photography was producing a radically new and progressive visual culture.

Moholy-Nagy's own photographic production was equally radical, embracing the photogram, photomontage, and many permutations of the camera-made image. His earliest photograms [130] display the simple geometric forms of his paintings of the period, while revealing his concern for light and transparency.[219] He was, as he said, fascinated by "the optical miracle of black into white [which results from] the dematerialized radiation of light."[220] A similar concern for light-dark relationships and pictorial structure is evident in his "straight" images.

Moholy-Nagy was intrigued by the difference between camera vision and human vision. His *Marseilles*, 1929 [131], for example, was made by photographing through a decorative iron grillwork. With the camera's lens focused on the distant street, the foreground grille is rendered grossly unsharp. A human viewer in this position would not have consciously seen this foreground subject out of focus; instead, the ever-moving and refocusing eye would have registered the entire scene, from foreground to infinity, as equally sharp. Thus, as Moholy-Nagy clearly understood, the camera produces images that are scientifically objective yet alien to normal visual experience. Similarly, to challenge common assumptions about the relationship between reality and representation, he made extensive use of neg-

ative images [214]. These tonal inversions reveal his fascination for the abstract play of light and dark that is so fundamental to photographic image-making.

Moholy-Nagy often used dramatic or unusual vantage points in his quest to reinvent visual experience. One of the most remarkable of these photographs is *Rothenburg ob der Tauber*, 1928 [215]. To make this view, Moholy-Nagy (like innumerable other tourists before and after him) climbed a narrow ladder to the top of the spire above the Rothenburg town hall.[221] Though this vantage point provided a beautiful view of the medieval village and the surrounding countryside, he aimed his camera steeply downward, ignoring the picturesque panorama in favor of the disorienting detail. The tilted frame and dizzying viewpoint charge the picture with dynamism and instability, transforming a quiet street scene into a complex arrangement of shapes, textures, and light. This image fully conveys the power of Moholy-Nagy's unconventional vision, and his fascination for a pictorial realm midway between the conventional categories of "realism" and "abstraction."

Other key proponents of the New Vision in Germany included Martin Munkacsi, Gyorgy Kepes, and Herbert Bayer. Both Munkacsi and Kepes were born in Hungary. Munkacsi worked as a news photographer in Budapest before moving to Berlin in 1927. His dynamic and spontaneous images, reproduced regularly in *Berliner Illustrirte Zeitung* and other publications, won him considerable acclaim. Munkacsi's *Street Shadows*, 1928 [132], reveals the modernity of his vision, while depicting a subject of social realist interest. Kepes studied painting at the Academy of Fine Arts in Budapest before turning to motion pictures in 1929. He moved to Berlin in 1930 at Moholy-Nagy's request, and subsequently worked as both a still and motion-picture photographer. His powerful *Berlin*, 1930 [133], clearly reflects Moholy-Nagy's interest in unusual viewpoints and contrasts of light and shadow. Bayer, who was born in Austria, was trained in painting, graphic design, and typography. He both studied and taught at the Bauhaus before moving to Berlin in 1928 to open a design studio. In the next few years, Bayer made photographs with a variety of New Vision techniques. His most memorable work of this era may be his surreal photomontages [134], which combine elements of whimsy and psychology to genuinely original effect.

The high point of the New Vision in Germany was the celebrated "Film und Foto" exhibition in Stuttgart in 1929.[222] Sponsored by the Deutsche Werkbund, an organization dedicated to the union of art and technology, this was the most important of several exhibitions of modern photography and film mounted in Germany in the 1920s. The structure of "Film und Foto" clearly reveals Moholy-Nagy's influence. In addition to presenting a survey of ninety-seven of his own photographs, Moholy-Nagy assembled an eclectic group of images for the exhibition's introductory gallery. This visual primer, based on the concepts in his book *Painting Photography Film*, contained a stimulating mix of artistic, journalistic, scientific, and advertising images. Ignoring the original uses and contexts of these photographs, Moholy-Nagy highlighted the medium itself as a richly plastic mode of communication. However, most of the "Film und Foto" exhibition was devoted to contemporary avant-garde work. This selection featured such important Europeans as Herbert Bayer, John Heartfield, Albert Renger-Patzsch, El Lissitzky, Aleksandr Rodchenko, Man Ray, André Kertész, and Florence Henri. In this context, American photographers made an impressive showing. This section, jointly assembled by Edward Steichen and Edward Weston, featured their own work as well as that of Sheeler, Outerbridge, Steiner, Cunningham, and Brett Weston. While not as technically adventurous as the Europeans, the Americans were admired for their austere precisionism.

The Avant-garde in France

The most progressive photographer in France in the 1920s was the expatriate American Man Ray. After moving to Paris in the summer of 1921, Man Ray quickly became part of the city's artistic elite, rejoining Duchamp and Picabia, and forging new friendships with such leading figures as André Breton, Paul Eluard, Tristan Tzara, and Jean Cocteau. Man Ray arrived at the time the Dada movement was evolving into Surrealism. Breton's *Manifesto of Surrealism* was issued in 1924, and Man Ray's work in photography, film, painting, and sculpture played an integral role in the stylistic development of the movement.

In Paris, Man Ray earned his living as a portrait and fashion photographer. While much of this work was routine, it nonetheless increased his interest in photography as a means of artistic expression. While developing fashion photographs in the winter of 1921-22, he inadvertently "discovered" the principle of the photogram. As he explored the pictorial possibilities of this process, which he christened "rayography," word spread of his strange and ethereal images. Within months, his rayographs established Man Ray's credentials as an avant-garde artist of international stature.

Man Ray's cameraless images range from the wholly abstract to the slyly anecdotal. To make these pictures, he employed a variety of everyday objects, including combs, keys, kitchen utensils, a gun, lace, wire springs, prisms, a magnifying glass, and a small mannequin figure. Sometimes, these items were placed in full contact with the photographic paper and were thus clearly recognizable in the final image. This relatively "realistic" mode of depiction encouraged a variety of narrative associations. At the same time, he explored more mysterious and abstract effects in images that resist anecdotal interpretation. In the greatest of these

134 Herbert Bayer, *Lonely Metropolitan*, 1932 (printed later), 5 x 3¾"

works [217], Man Ray's objects are in more tenuous contact with the photographic paper, and are thus more ambiguously rendered. These rayographs are classic Surrealist creations, at once the trace of the real and the stuff of dreams.

Man Ray explored a wide range of other photographic effects. He set up odd juxtapositions of figures and objects to be recorded, drew on his images, and printed through textured screens. Unusual viewpoints and tight croppings were also used in his effort to subvert the essential realism of the medium. In 1929, Man Ray discovered one of his most memorable effects—solarization—with the aid of his assistant and lover, Lee Miller. Produced by exposing a developing print to a brief flash of white light, this process creates a partial reversal of tone. Shadows may turn white, for example, while the midtones of the image remain unaffected. Man Ray so treasured this uncanny effect that he jealously guarded the secret of its technique for years.

Yet another technical approach is demonstrated in *Les Amoureux*, 1929 [216], which was produced by greatly enlarging a segment of a portrait of Lee Miller. Dissolving into grain, her disembodied lips become a poetic, free-floating emblem of beauty and desire. The image is at once intimate and vast, suggesting a lover's dream of union and an astronomical record of a distant galaxy.[223] Significantly, Man Ray made this photograph just after his devastating break-up with Miller. Haunted by her, he subsequently used this photograph as the basis for one of his major paintings, *A l'heure de l'observatoire—Les Amoureux* (1934).

Man Ray's photographs were highly celebrated and included in the leading exhibitions of the period. His work was also widely reproduced, appearing in the avant-garde publication *La Révo-*

lution surréaliste, the literary journal *Variétés*, illustrated magazines such as *Vu*, *Jazz*, *L'Art vivant*, and *Vanity Fair*, and the fashion magazines *Vogue* and *Harper's Bazaar*.

By the last half of the 1920s, Paris had become home to many photographers of international stature. One of the most important of these émigrés was André Kertész. In his native Hungary, Kertész had taken up photography as a hobby in 1912, without any formal art training. To escape the dull routine of his job at the Budapest stock exchange, the young Kertész spent all his free time photographing in the city and surrounding countryside. Working solely for his own pleasure, he recorded the transient events of everyday life in a fresh and spontaneous style. Hoping to earn a living doing what he loved, Kertész moved to Paris in 1925. The influences he absorbed in the next few years gave new depth to his vision without changing its essential character. On arriving in Paris, Kertész was embraced by a circle of expatriate Hungarians. These friends—artists, musicians, journalists, and poets—were interested in both the most avant-garde ideas of the day and the folk-art traditions of their native land. This complex synthesis of "high" and "low"—the provocative and the simple, the coolly formal and the warmly human—would characterize Kertész's work throughout his long career.

Kertész flourished in this new environment. His first gallery exhibition in Paris, in 1927, was a success. A year later, he was included in a major international exhibit in the city, the first "Salon Indépendant de la Photographie," with such leading figures as Man Ray and Paul Outerbridge. He was also well represented at "Film und Foto." By the time of the Stuttgart show, Kertész had established himself as a leading photojournalist, with work frequently published in *Variétés*, *Bifur*, *Berliner Illustrierte Zeitung*, and *Art et Médecine*. The most important publications with which he was associated were the *Münchner Illustrierte Presse*, under the editorship of Stefan Lorant in Munich, and *Vu*, based in Paris under the direction of Lucien Vogel. Both editors understood Kertész's style and gave him great freedom in carrying out assignments. While Kertész worked as both a professional photojournalist and as an artist, he drew little distinction between these roles. Some of his greatest pictures were produced in the course of magazine projects, and Lorant and Vogel made use of his most challenging personal images.

Kertész's photographs are varied in subject but unified in sensibility. He made portraits, candid street pictures, architectural views, and still lifes, and worked in daylight, in the rain and fog, and at night. While many of his pictures convey the simplicity of the amateur snapshot, Kertész also made extensive use of such modernist devices as the aerial view, the extreme close-up, and optical distortion. Common to all his work is an exquisite sense of timing and pictorial structure, as well as the implication that the simplest gestures and most familiar objects are resonant with meaning. *Fork*, 1928 [218], one of Kertész's most important pictures, exemplifies the transformative power of his vision. At once realistic and abstract, intimate and monumental, this image renews our sense of wonder by suggesting the inherent mystery of the simplest aspects of everyday life. *Fork* was included in such important shows as the "Salon Indépendant de la Photographie" (1928) and "Film und Foto"; Kertész also used it to illustrate an article he wrote on contemporary photography for the German magazine *Uhu* in 1929.[224]

135 Florence Henri, *Composition, Nature Morte*, 1929, 4½ x 3⅛"

Other important members of the community of expatriate photographers in Paris were Florence Henri, Ilse Bing, and Lisette Model. Though born in New York City, Henri was taken to Europe at an early age by her father. She studied painting in Berlin and Paris, and, in the summer of 1927, attended classes at the Bauhaus taught by Moholy-Nagy. This experience spurred Henri to take up photography. Her first works used mirrors to fracture and complicate space [135]. The hermetic mystery of these images is also seen in her straight photographs of the next few years. Her *Reclining Woman*, 1930 [220], for example, suggests various spatial ambiguities: a subtle disjunction between foreground and background, an uncertain orientation of the floor plane, and a curious foreshortening of the woman's arm.[225] Henri used similar points of view, at once intimate and disorienting, in other studies of female figures to create an evocative synthesis of abstraction and dreamy sensuality.

Ilse Bing received a doctorate in art history in her native Germany before taking up photography in 1928. In 1929, she purchased a Leica, the first successful 35mm camera and an invention that revolutionized the practice and aesthetic of photography. This "miniature" camera allowed pictures to be made more rapidly and unobtrusively than ever before, precisely matching the expressive interests of artists like Bing, Kertész, and Henri Cartier-Bresson. Bing was so well known for her use of this camera that she was dubbed the "Queen of the Leica" by the French photographer and critic Emmanuel Sougez.[226] Significantly, her most important self-portrait is a dual depiction of herself and her camera [101]. In late 1929, Bing viewed an exhibition of modern photography in her home city of Frankfurt. Stimulated by the work

of the French photographers—Florence Henri, in particular—Bing promptly moved to Paris, where she established a successful commercial and journalistic practice. Another superb example of her personal work is *Champ-de-Mars from Eiffel Tower*, 1931 [219], in which a dizzying perspective and bold play of geometric forms combine to suggest the adventure of modern urban life.

The Austrian-born Lisette Model was one of the numerous other photographers who matured in Paris's vital artistic climate. In 1933, she turned from an earlier interest in music to pursue a career in photography. While she received encouragement from several friends—including Henri—Model was largely self-taught. Her first important work was created in the summer of 1934, when she made a series of bluntly direct images of vacationers on the promenade at Nice [221]. These photographs provide a sardonic commentary on the lazy luxury of the rich, while revealing Model's keen eye for the eloquent, if often awkward, physicality of the body.

An American New Vision

The European New Vision had significant effect in America by the early 1930s. However, it is important to note the delayed nature of this influence. While the leading Americans knew of the work of artists such as Moholy-Nagy and Man Ray from the early 1920s on, they remained almost wholly unimpressed. In 1926, for example, Edward Weston dismissed Moholy-Nagy's work with the comment "It only brings a question—why?"[227] With few exceptions, Americans of this period embraced realist and purist uses of the medium rather than synthetic or experimental ones.[228] They had a narrower, if arguably deeper, understanding of photography's expressive potential—an understanding derived in part from the medium's long history of struggle for artistic respectability in America. By contrast, European proponents of the New Vision owed little allegiance to previous photographic traditions or debates. Indeed, for many of them, the medium was merely one of several expressive tools at their command. Unlike the majority of noted American photographers, many of the important Europeans were "amateurs" with no orthodox technical training and little experience in such professional disciplines as portraiture. Consequently, the Europeans tended to come to the medium without the conceptual limits that traditional commercial practice reinforced.

In his influential book *The Structure of Scientific Revolutions* (1962), Thomas Kuhn argues that important discoveries in the sciences result from "paradigm shifts"—changes in fundamental assumptions that allow familiar things to be seen in revolutionary ways.[229] In science, such radically transformative ideas often come from researchers who are young or new to the field—those whose views are not fully determined by what professional consensus deems "true." The New Vision of the European avant-gardists constitutes such a paradigm shift in the history of photography. Unconstrained by earlier notions of photographic art, or by embarrassment over the medium's mechanistic nature, these artists pursued photography with unparalleled freedom. Despite initial resistance from both purists and traditionalists, the logic of this New Vision was soon broadly accepted. Indeed, by the early 1930s this once-revolutionary aesthetic had become a truly international style. It was in this form—as a dominant, if still relatively fresh paradigm—that the New Vision had the greatest impact in America.[230]

As Kuhn's thesis posits, the shift effected by the New Vision depended not on the invention of wholly new approaches, but the foregrounding of familiar—but previously marginalized—techniques and effects. For example, odd vantage points and the photogram process had been used for years by amateurs everywhere. However, experienced photographers "knew" these to be merely childish amusements or evidence of artistic incompetence. It was precisely because these techniques were so familiar—and so simple—that Americans had such difficulty taking the European avant-garde work seriously.

In addition, American art photographers resisted embracing the amusing or eccentric visual effects common in the images of mass entertainment or science. By 1920, for example, the public was quite accustomed to the use of photography to produce visual tricks or to depict realities invisible to the naked eye. Early motion pictures exploited a variety of spatial and temporal illusions, including accelerated or reversed action, the disappearance of figures in mid-scene, and the use of distorting mirrors to change a person's size or shape.[231] The "cyclographs" of Frank B. Gilbreth and Lillian M. Gilbreth received considerable attention beginning in 1916 precisely because of their accuracy in tracking "invisible" movements. The Gilbreths used controlled lighting and time exposures to map the rhythms of simple human actions. To analyze a golf swing, for example, the action was performed with a small light attached to the head of the club. The result was a luminous, calligraphic tracing of the club's path through space—an image at once objective and unreal.[232] The very prevalence of such curious images played a part in forcing art photography to stay within relatively narrow confines, both during the heyday of Pictorialism and later.

Despite such resistance, an indigenous strain of unconventional and abstract photography did indeed arise in the United States. Isolated experiments by photographers like Fred R. Archer, who was reputed to have made nonobjective images of reflected light as early as 1917 [136], were probably stimulated by reports of Coburn's vortographs.[233] However, such investigations were extremely uncommon before the mid-1920s and received no encouragement from the photographic establishment.

Edward Steichen created some of the most provocative experimental photographs of this period. Made in "a time of deep, earnest soul-searching" in relative isolation in France, immediately following World War I, these images represent a critical transition in Steichen's vision.[234] To demonstrate his new commitment to photography, Steichen burned his earlier paintings, rejected the manipulations of Pictorialism, and taught himself the "basic discipline" of the medium in an exhaustive series of technical experiments.[235] To explore the camera's ability to render volume, for instance, he recorded simple forms with varying light intensities and exposure times; his monumental *Three Pears and an Apple* (1921) was the result of a thirty-six-hour exposure under dim, indirect illumination. He also studied mathematical principles of organic growth in order to understand the continuity of natural form from the microscopic to the cosmic level.[236]

As part of this process, Steichen produced a group of pictures in 1920-21 stimulated by Einstein's theory of relativity.[237] Einstein had become internationally famous in 1919 when observations

136 Fred R. Archer, *Mask*, ca. 1917-22, 9¼ x 7⅞"

of a solar eclipse confirmed a key aspect of his theory (that rays of light would be bent by a gravitational field). As a result, numerous articles on relativity appeared in popular journals and phrases such as "time-space continuum" were *au courant*. Not surprisingly, this formidable theory was described only superficially in such articles.[238] Like general readers of the day, most artists inferred from the theory little more than vague if stimulating notions concerning the interrelatedness of things and the inherent lack of fixity in the universe.

In his enthusiasm for Einstein's new concept of reality, Steichen created futuristic still lifes of glass, metal, and simple organic forms. These were recorded in tight close-up to create a feeling of mystery and monumentality.[239] Some of these photographs emphasize the disembodied effects of reflected or refracted light. Others, such as *Triumph of the Egg*, 1921 [137], are highly sculptural, suggesting the influence of Steichen's friend Constantin Brancusi. Ultimately, however, Steichen found these images unsatisfactory because viewers were "completely bewildered" by them. "Not understanding the symbolic use to which I was putting the objects," he later recalled, "they had no clue to the meaning of the pictures. I began to realize that abstraction based on symbols was feasible only if the symbols were universal. Symbols that I invented as I went along would not be understood by anyone but myself."[240] After his return to the United States in 1923, the rest of Steichen's long career would reflect the lessons of popular communication he learned in 1920-21.

Another important influence on photographic abstraction was Thomas Wilfred, a Danish-born musician, artist, and poet. He first became interested in light as an artistic medium in 1905, when he made experiments with an incandescent lamp and pieces of colored glass.[241] After moving to the U.S. in 1916, Wilfred perfected the "clavilux," a keyboard device that produced mesmerizing "symphonies" of projected light. One early viewer described the bands and veils of color produced by the clavilux as "always and constantly swirling and whirling and curling, twisting and untwisting, folding and unfolding, gliding, approaching and retreating, in [a] haunted and inexplicable space."[242] In subsequent years, Wilfred's invention received widespread attention from the general public, as well as from Moholy-Nagy and other members of the international avant-garde.[243]

Wilfred's first public performance of the clavilux took place on January 10, 1922, but photographs of his light projections were published as early as December 1920.[244] While intended as records of the kinetic performances, these images were compelling in their own right and stimulated others to create nonobjective images with the camera. One of the first photographers influenced by Wilfred was Ira Martin, an associate of Clarence White. By mid-1921, Martin made elegantly abstract photographs of patterns formed by projected or refracted light. Four of these were published in the July 1921 issue of *Vanity Fair*, bearing such florid titles as *Elégie* and *Mort de Matelot*.[245] Martin apparently regarded these abstractions only as diverting experiments, however; there is no evidence that he did further work in this vein.

Wilfred's light projections had a greater impact on Francis Bruguière. One of the most original photographers of this era, Bruguière began his photographic career in San Francisco, working in a typically Pictorialist style. However, in 1912 he began experimenting with the multiple-exposure technique. After his move to New York in 1918, his unconventional approach expanded to include abstract explorations of light itself. This interest could only have been reinforced by his 1921 assignment to photograph Wilfred's clavilux projections for *Theatre Arts Magazine*.[246]

Over the next few years, while earning a living as a portrait and theater photographer, Bruguière continued his experimental work. His "designs in abstract forms of light," as he called them, were made with several techniques. These included the recording of patterns of projected light, as well as the use of long exposures in conjunction with the movement of either his subject or his camera. Bruguière's most remarkable pictures were made by playing light across the surface of intricately cut sheets of paper [222]. These images unite the flickering patterns of light and shadow with the calligraphy of the incised surface. Since the paper functions strictly as a light modulator, the resulting images are provocatively abstract, although entirely "straight" in technique. As one critic of the period suggested, Bruguière's goal was to "give body to light, to give light solidity and weight and volume."[247]

Bruguière's exhibit at the Art Center in New York in 1927 received much attention. He moved to London a year later, where he continued his work in photography, film, painting, and stage design. Eleven of his photographs were shown at "Film und Foto" in 1929. In that year Bruguière also published the book *Beyond This Point*, an abstruse synthesis of pictures and text created in collaboration with the writer Lance Sieveking. This work, which explores the psychology of three human crises (death, jealousy, and ruin) in highly abstract form, was followed two years later by another collaborative volume, *Few Are Chosen*.[248]

One of this era's most intensive explorations of photographic abstraction was conducted by the Philadelphian Edward Quigley.

137 **Edward Steichen,** *Triumph of the Egg,* 1921, 9⅝ x 7½″

After beginning his professional practice in 1930, Quigley quickly established himself as an innovative commercial photographer and an active salon exhibitor.[249] He kept abreast of the most advanced international work and incorporated a range of modernist ideas in his pictures. In 1931, Quigley produced an important group of light abstractions [223]. These were made with the use of prisms, lenses, selective focus, and camera motion, as well as the occasional double-printing of negatives. Quigley's work of the early 1930s exemplifies the influence of the European New Vision on American photography. He used photograms, odd perspectives, extreme close-ups, reflections, multiple exposures, and bold geometric designs with great facility, creating a veritable catalogue of modernist traits.

As Quigley's work reveals, the vocabulary of European avant-garde photography was adopted in America by both the commercial and artistic worlds. The result was a pluralist climate in which f/64 purism and New Vision experimentation were united in an eclectic international style. The work of Grancel Fitz is typical of this applied modernism. After achieving renown in the late 1910s as a Pictorialist, and absorbing the influence of Stieglitz and his circle, Fitz turned to commercial photography.[250] His sophisticated style found favor with numerous corporate clients, including Chrysler, Westinghouse Electric, and Steinway Pianos. Fitz's *Glass Abstraction* [138], produced for Libby-Owens Glass, solves the difficult problem of lending dynamism and allure to a mundane—and nearly invisible—product.[251] By exploiting the material's dual qualities of reflection and transparency, Fitz created a sense of both mystery and modernity.

Harold Harvey's photographs are similarly eclectic. He began exhibiting his work in 1916, and his successive careers in illus-

139 Wendell MacRae, *Bostonian Shoppers*, 1930, 7⅞ x 9½"

tration, commercial photography, and photographic chemistry gave him a uniquely broad understanding of the medium's expressive possibilities.[252] Restlessly experimental, Harvey worked with all manner of cameras, films, papers, and toners. His *Reflections*, ca. 1930 [224], is a "straight" image of a perceptual puzzle: a rippled surface of water which both reflects light and is dissolved in it. The graininess of this greatly enlarged image (probably made with the then-new 35mm Leica) frustrates any clear reading of the photograph's content. Instead, the picture suggests itself as a metaphor for the photographic process itself: the interaction of light and light-sensitive surfaces in a process at once mundane and magical.

In the pluralistic climate of the early 1930s, formerly radical points of view become key components of a mainstream modernist aesthetic.[253] Many photographers—including Wendell MacRae [139] and William A. Strosahl [140]—created newly dynamic images by looking up or down on the world. In this artistic context, pictures that would earlier have been considered playful snapshots were now accepted as sophisticated works of art. For example, Harold Haliday Costain's *Securing the Anchor Chain* [141] was originally taken in 1919, but he apparently did not make exhibition prints of the image until about 1933, by which time the vertiginous perspective had acquired impeccable modernist credentials.[254] John Gutmann's *Triple Dive*, 1934 [225], uses an even more disorienting point of view to convey a sense of exuberant energy. Gutmann, who arrived in San Francisco from his native Germany in 1933, was fascinated by the dynamism of American culture. Applying a European sense of timing and framing to such characteristically American subjects as street life, automobiles, sports, advertising signs, and graffiti, Gutmann produced a body of work that merges documentary intentions with Surrealist inclinations.[255]

Photomontage, a key component of the New Vision aesthetic, found intermittent use in America.[256] While the technique was common in newspaper and magazine advertising, relatively few artists used it for self-expressive purposes.[257] This dearth of "serious" interest was not for lack of official encouragement. In 1932, for example, the Museum of Modern Art organized the exhibition "Murals by American Painters and Photographers," under the direction of Lincoln Kirstein.[258] He invited photographers

138 Grancel Fitz, *Glass Abstraction*, 1929, 9¾ x 7¾"

140 William A. Strosahl, *New York*, ca. 1932, 6¼ x 7″

such as Berenice Abbott, George Platt Lynes, William Rittase, Thurman Rotan, Maurice Bratter, Charles Sheeler, Stella Simon, and Luke Swank to create murals on the theme "The Post-War World." Faced with the problem of unprecedented scale, the photographers made liberal use of photomontage and multiple printing. After the show, however, few of them continued to explore these techniques. Edward Steichen, one of those who did, was commissioned to produce photographic murals for the New York State Building at the 1934 Chicago Century of Progress exposition and for a smoking lounge at Rockefeller Center. The latter work, on the theme of aviation, employed rhythmic sequences of large-scale images to create a compelling whole.[259]

In the late 1930s, Barbara Morgan actively promoted photomontage as an artistic tool. In 1938 she wrote:

> Photomontage is a "natural" of our times. It is the inevitable next step in photography. It demands and uses all the resources and knowledge of straight photography plus extra heavy doses of imagination and design.[260]

Morgan was one of the few American photographers of the era to use this technique for social or political expression. Her famous image *Hearst Over the People*, 1939 [227], was first published in the leftist journal *New Masses*, accompanying an article attacking media baron William Randolph Hearst.[261] Hearst was widely reviled as the master of yellow journalism, with the power to manipulate public opinion through his ownership of a chain of newspapers. Morgan evokes a feeling of slithery malevolence by combining an aerial view of a crowd of protesters, an "octopus" silhouette created by the photogram technique, and (as a separate print) a deliberately elongated image of Hearst's face.[262] In this era, Morgan made repeated use of such complex techniques, freely combining camera-generated and photogram images to unorthodox effect.

Morgan also made insightful use of multiple exposures and multiple printing, particularly in her extended interpretation of the work of dancer and choreographer Martha Graham. Her *Martha Graham: American Document (Trio)*, 1938 [226], uses multiple printing to evoke the kinetic and spatial complexity of dance. The result eloquently underscores the haunting universality of this passage of Graham's ballet, which was accompanied by the narration "We are three women; we are three million women. We are the mothers of the hungry dead; we are the mothers of the hungry living."[263]

Will Connell was renowned for his use of a variety of expressive techniques. Before becoming a professional photographer in 1928, Connell worked as a cartoonist, a pharmacist, and an "answer man" in the photo-supply business.[264] After some struggle in the early years of the Depression, he established himself as an advertising and color photographer. Connell was also an influential teacher and writer: he began the photography department at the Art Center School in Los Angeles in 1931, and was a regular contributor to *U.S. Camera* magazine.[265] Connell's most notable personal work was the series "In Pictures," a pointed satire of the Hollywood film industry begun in 1933. A remarkably ambitious project, "In Pictures" includes images illustrating a variety of motifs, including *Film, Sound, Politics, Star, Sex Appeal, Props, Melodrama, Publicity,* and *Critic.* After creating hundreds of thumbnail sketches of potential subjects, Connell employed elaborate studio setups and a varied cast of players to make his final pictures. To give visual form to his concepts, he used diverse technical means, including photomontage, printing from sandwiched negatives, odd viewpoints, and optical distortions. The "bite" of this work stemmed, in part, from its exuberant theatricality. Connell's artificial stage sets, one-dimensional characters, and extreme points of view cleverly aped a long list of film clichés. These works were exhibited in Paris in 1933 and, with subsequent additions, were published in book form in 1937.[266]

141 Harold Haliday Costain, *Securing the Anchor Chain*, 1919 (print ca. 1933), 10⅞ x 14″

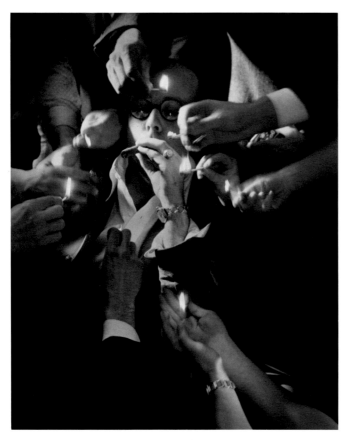

142 Will Connell, *Yes-Men*, 1937, 11⅝ x 9½"

Connell's results range from lighthearted farce to dark cyni-
cism. Critic Nicholas Ház accurately described Connell as a man
"who prefers to be humorous, droll, sarcastic, sometimes even
bitterly sardonic, to being sentimental, lyrical or romantic."[267]
The traits of arrogance, superficiality, pretension, and exploita-
tion make frequent appearances in this work. In *Yes-Men* [142],
for example, a flurry of servile hands offer matches to light the
boss's cigar. Other images, such as *Casting*, *Career*, and *Producer*,
center on the theme of sexual exploitation. However, a photo-
graph such as *Lights!* [143] functions more abstractly, suggesting
the allure of movie-making with a witty and almost balletic grace.

George Platt Lynes staged subjects for his camera in the name
of Surrealism rather than satire. As a young man, Lynes traveled
between New York and Paris, pursuing an interest in avant-garde
literature.[268] Lynes turned his creative attention to photography
in 1927. After several years of self-instruction, he achieved both
artistic and commercial success. He opened a studio in New York
in 1932, specializing in portraiture and fashion work, and his
photographs were published regularly in *Vogue*, *Harper's Bazaar*,
and *Town and Country*. Lynes's reputation as a creative artist
was established at the same time: in 1932 he was included in
two exhibitions at the Julien Levy Gallery, and in the mural exhi-
bition at the Museum of Modern Art. His personal work received
generous exposure and praise over the following decade.[269]

Lynes's expressive style was distinctly his own, a stimulating
union of technical precision and narrative ambiguities. Equally
unusual, given the cultural context of the time, much of his work
was unambiguously homoerotic. In his portraits of friends and
artists, Lynes sought to evoke the unplumbed depths of dream
and desire. He made brilliant use of the spare and indeterminate
space of the studio to contrast the physicality of his subjects

with the unreality of his stage effects. In his portrait of the painter
Paul Cadmus [144], for example, Lynes used five dangling light
bulbs to add a curious psychological charge to an otherwise
placid image.

Lynes's interests in Surrealism and literature came together
in his mythological series of 1936-40. In these images, Lynes com-
bined his interest in the nude with the challenge of casting ancient
narratives into contemporary form. One of the most notable of
these works is *Endymion and Selene*, ca. 1937-39 [228]. This
myth, which inspired a long poem by John Keats, concerns the
moon goddess Selene and a handsome young Greek shepherd.
Selene fell in love with Endymion, causing him to lapse into an
eternal sleep. The Greeks believed that whenever the moon passed
behind a cloud, Selene had come down from the heavens to visit
Endymion. Lynes visualized this story in the form of a nude male
model clutching a miniature moon while sleeping in a "land-
scape" of paper hills. The overt artifice of Lynes's interpretation
serves to celebrate the myth as an elegant literary fiction while
alluding to the eternal power of dream and the gravity of desire.

Working in the relative isolation of New Orleans, Clarence
John Laughlin used the camera in a similarly provocative and syn-
thetic manner. His vision was the product of a deep interest in art
and literature, Symbolism and Surrealism. Laughlin used multi-
ple exposures, theatrical arrangements, and lengthy captions to
bridge the gap between visible reality and a metaphysical realm
of fantasy and intuition. His aim was enormously ambitious: to
use the technological precision of lens and film to liberate the imag-
ination and to create a new fusion of objective and subjective
truths.[270] One of Laughlin's earliest mature pictures, *Pineapple as
Rocket*, 1936 [230], exemplifies the transformative impulse at the
heart of his vision.[271] This photograph is at once a record of mun-
dane household objects and an oddly compelling suggestion of
energy and flight. For the sympathetic viewer, this tension
between fact and allusion suggests a constellation of dichotomies:
stasis and motion, organic and mechanistic, the domestic and the
cosmic. Laughlin felt that this kind of imaginative seeing was
essential to any new insights into the human condition.

In the fall of 1939, as war was erupting in Europe, Laughlin
began a series of photographs titled "Poems of the Interior
World."[272] In this group, the theatricality and symbolism of his
earlier work was raised to a new level of self-conscious intensity.
These carefully choreographed photographs reveal a provocative
union of figures, props, and environment. Every image in this
series, including *The Unborn*, 1941 [231], sought to depict the
"symbolic reality" of the era: its undercurrents of confusion, fear,
and sterility.[273] Laughlin's unorthodox pictures were exhibited by
Julien Levy in 1939, but won few other admirers in the photog-
raphy establishment.

To a significant degree, the work of Laughlin and Lynes may
be best understood in terms of its overt theatricality. In the late
nineteenth and early twentieth centuries, influential playwrights
such as Henrik Ibsen, Anton Chekhov, Luigi Pirandello, and
Bertolt Brecht challenged the naturalistic conventions of the
theater. This work placed new emphasis on symbols, dreams, and
unspoken subtexts of meaning. Brecht's plays, for example, used
a strongly nonnaturalistic style to address contemporary social
issues. Masks, surreal effects, grotesque exaggerations, and actors
not pretending to "be" the characters they portrayed were all

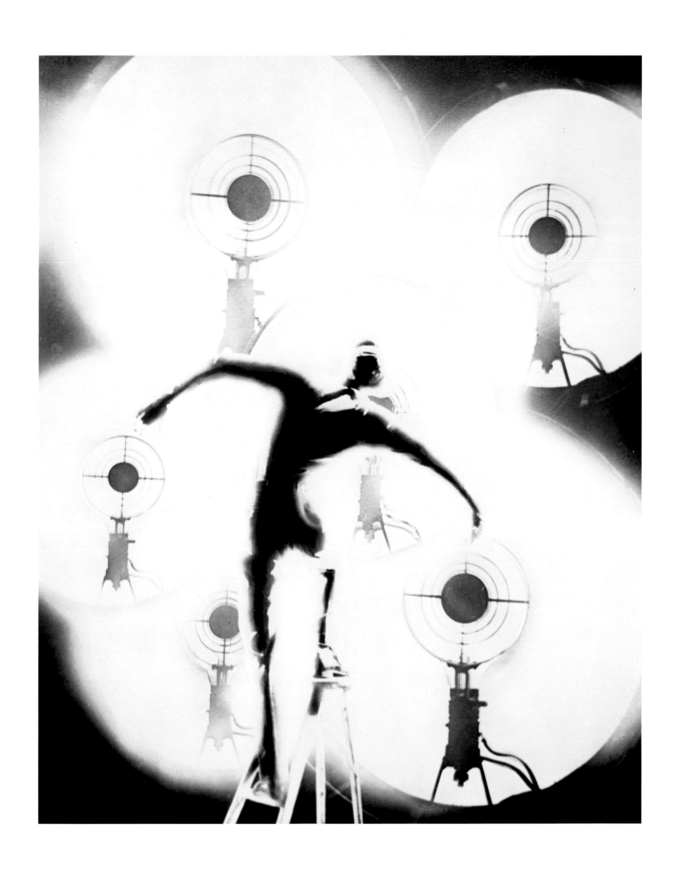

143 Will Connell, *"Lights!"*, 1937, 11½ x 9⅜"

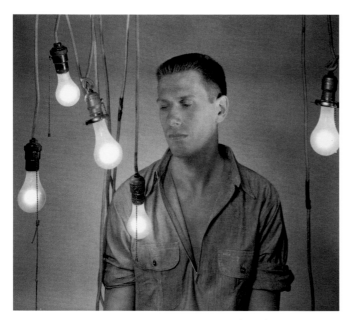

144 George Platt Lynes, *Paul Cadmus*, 1941, 7½ x 9½"

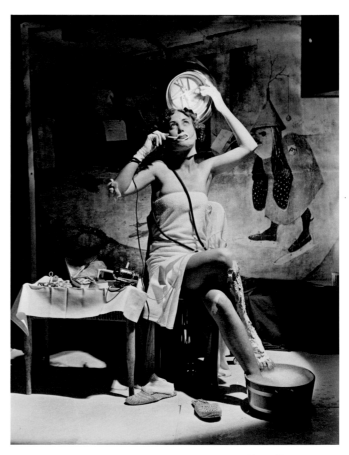

145 **Horst P. Horst**, *Electric Beauty, Paris*, 1939, 9½ x 7½"

typical of his work. Similarly, photographers such as Laughlin and Lynes used the paradoxical "reality" of artifice to address the basic dilemmas of human existence.[274]

Unlike other avant-garde art movements, Surrealism held considerable appeal for the general public. The style thus had particular currency in fashion photography. In this domain, European émigrés such as Horst P. Horst and Erwin Blumenfeld used the vocabulary of Surrealism to particularly memorable effect. Horst's *Electric Beauty, Paris* [145], parodies the beautifying process as elegant masochism, a kind of medieval torture complete with nefarious tools and a Hieronymus Bosch backdrop.[275] Erwin Blumenfeld, who came of age in Europe in the heady artistic climate of the 1920s and early 1930s, incorporated numerous Surrealistic traits in his mature work. One of his key works, *Marua Motherwell* [229], demonstrates Bluemenfeld's characteristic interests in reflection and fragmentation, a sense of dream and weightlessness, and the visual play of positive and negative.

The Art of the Machine Age

A fascination for invention and mechanization permeated the decades between the world wars.[276] Young boys collected Tom Swift books and played with Erector sets. Over 800,000 Americans read *Popular Mechanics* magazine, "with its simplified but trustworthy review of new inventions and scientific discoveries."[277] At the same time, the life of the middle class was transformed by radio, the automobile, and a host of other mechanical devices. This era's respect for power and efficiency was embodied in the figure of the engineer. As a logical problem-solver, the engineer seemed to point the way to a society untainted by the "emotional aberration" of irrational prejudices and delusions.[278] While many perceived the machine age as a decidedly mixed blessing, there was broad agreement that America's unique character was a result of its technological prowess.[279] Evidence of this engineering genius was everywhere: in automobiles, airplanes, skyscrapers, bridges, radio towers, dams, and factories. New York City, the site of the Empire State Building (1930-31) and the George Washington Bridge (1927-31), provided the most

exciting expression of these new forces and powerfully shaped the outlook of artists and intellectuals.[280] Influenced by the engineer's vision, William Carlos Williams described the poem as "a mechanism" designed "to say something as accurately...as possible."[281] According to this point of view, the artist was an aesthetic "engineer" who made precise use of his expressive tools in order to fashion a logical, functional work of art.[282]

The engineered world represented the virtues of functionality and reason. The engineer's vision of society as a "dynamic, integrated assembl[y] of component parts" reflected a political desire for cultural harmony.[283] President Herbert Hoover, himself a renowned engineer, stated this view with characteristic directness: "The attitude that marks the success of America [is] the attitude of the business man, of the engineer, and of the scientist."[284] This technological zeal shaped a new cultural and artistic aesthetic. As painter Louis Lozowick noted in 1927:

> The dominant trend in America of today, beneath all the apparent chaos and confusion is toward order and organization which find their outward sign and symbol in the rigid geometry of the American city: in the verticals of its smoke stacks, in the parallels of its car tracks, the squares of its streets, the cubes of its factories, the arc of its bridges, [and] the cylinders of its gas tanks...

As Lozowick observed, "this underlying mathematical pattern" provided the artist the means to construct "a solid plastic structure of great intricacy and subtlety."[285]

The logic and universality of this basic "mathematical pattern" resulted in a remarkable merger of elite and mass culture, art and commerce. In the "Machine-Age Exposition" of 1927 and the Museum of Modern Art's 1934 "Machine Art" exhibi-

tion, mass-produced objects such as boat propellers, ball bearings, stainless-steel sinks, lighting fixtures, chairs, and scientific instruments were presented for purely aesthetic effect.[286] Conversely, artists increasingly applied their talents to such utilitarian ends as industrial design and advertising.

Photographers shared this enthusiasm for modern engineering. Many found beauty in tightly cropped details of machinery: form divorced from function. In the early 1920s, for example, Paul Strand produced monumental studies of precision machine parts while Ralph Steiner recorded the keys of a typewriter as a White School exercise.[287] This approach is also seen in the later f/64 work of photographers such as Sonya Noskowiak [146] and Alma Lavenson [147]. Images such as these celebrate industrial culture for its rationality, efficiency, and power.

Lewis Hine, on the other hand, viewed technology almost exclusively in human terms. His 1932 book *Men at Work: Photographic Studies of Modern Men and Machines* depicted skilled workers at the center of the great drama of technology. In his introduction to this volume, Hine reminded his readers that

> cities do not build themselves, machines cannot make machines, unless back of them all are the brains and toil of men. We call this the Machine Age. But the more machines we use the more do we need real men to make and direct them.[288]

Hine viewed this labor as an expression of ingenuity, stamina, and courage. To his mind, "the motors, the airplanes, [and] the dynamos upon which the life and happiness of millions of us depend" were of significance only to the degree that they reflected the character of those who created and maintained them.[289] Hine's celebratory viewpoint was driven by his long-held interest in labor issues, as well as by a desire to present the industrial world with a positive image of itself.[290] In projects such as his documentation of the construction of the Empire State Building, Hine portrayed workers with deep respect and showed modern engineering as a heroic enterprise.

It is difficult for us, many decades later, to recapture the sincerity of Hine's faith in technology. As a consequence, his intended meanings are often misread. In his iconic *Powerhouse Mechanic*, 1921 [232], for example, Hine meant to show the dominion of man over machine.[291] However, in this carefully

147 Alma Lavenson, *Tank*, 1931, 7⅛ x 9½"

146 Sonya Noskowiak, *Train Wheels*, ca. 1935, 7½ x 9⅝"

posed photograph, the vitality of the worker and the passivity of the machine seem eerily inverted. The worker conforms to the relentless arc of the dynamo, forever frozen in a posture of servitude, while the machine commands the entire space of the photograph, alive with light and energy. Ironically, Hine's photograph seems to illustrate an important antimodernist theme of the period: the dehumanizing effects of the machine age. *Skyscrapers*, a now-forgotten 1926 ballet at the Metropolitan Opera House, presented a chilling vision of urban life as joyless, frenzied, and mechanical.[292] Fritz Lang's film *Metropolis* (1926) conveyed a grimly dystopian view of the technological future, while Charlie Chaplin's *Modern Times* (1936) presented a comic, but still troubling, vision of the monotonous routine of industrial labor. Riddled with ambiguities, Hine's photograph offers us no panacea, despite his own optimism. Ultimately it poses a question central to modern life: does our technology free us or enslave us?

Few bodies of photographic work in the 1920s or 1930s tackled such difficult moral and social questions. For the most part, the skyscraper, the railroad, the factory, and the city street were seen as timely subjects by photographers of both the avant-garde and Pictorialist persuasions. Both of these strains are evident in the work of E. O. Hoppé. The London-based Hoppé achieved international fame as early as 1909 as a portraitist and salon exhibitor.[293] The lingering elements of Pictorialism are evident in his 1927 book *Romantic America*, which displays a curious blend of realism and abstraction.[294] The result of numerous photographic excursions across the United States, *Romantic America* celebrates the picturesque appeal of subjects as diverse as the

148 E. O. Hoppé, *Ohio River from the Point, Pittsburgh*, 1926, 8 x 9⅞"

Grand Canyon and the Ford Motor Company factory. In his *Ohio River from the Point, Pittsburgh* [148], Hoppé depicts an industrial scene through the taut framework of a steel bridge. An effective contrast is established between the crisp geometry of the bridge and the impressionistic obscurity of the scene beyond. This image also illustrates Hoppé's artistic predilection for elevated vantage points and internal framing devices.[295]

Charles Sheeler was deeply fascinated by the formal logic of technology. In 1920, for example, he collaborated with Paul Strand on *Manhatta*, a short experimental film capturing the dynamism of New York's harbor and streets.[296] To finance his personal work, Sheeler began a career in advertising and commercial photography. Between 1926 and 1929 he worked with Edward Steichen at Condé Nast, contributing frequently to both *Vanity Fair* and *Vogue*. It was as a result of these commercial contacts that Sheeler obtained his most memorable photographic commission. In 1927, Vaughn Flannery, the art director of the N. W. Ayer and Son advertising firm, asked Sheeler to photograph Henry Ford's River Rouge manufacturing plant in Detroit. Ford had just introduced the Model A automobile and Flannery wanted images for a major promotional campaign. Interestingly enough, Sheeler was hired to photograph the plant rather than the car. Flannery's plan was to celebrate the monumental beauty of manufacturing itself, or, as recent scholars have noted, to present "a generic image of Ford as a quiet colossus, as *the* great American machine."[297] This subject was perfectly suited to Sheeler's interests, and his resulting photographs received worldwide recognition.[298]

Ford's River Rouge plant was the most advanced industrial operation in the world. Its twenty-three main buildings, ninety-three miles of rail line, twenty-seven miles of conveyors, and 75,000 employees all united to transform ore into autos with awesome efficiency.[299] Sheeler spent six weeks exploring the site before making thirty-two carefully considered 8 x 10-inch images. His meticulously composed views of smokestacks, coke ovens, blast furnaces, slag buggies, dynamos, and stamping presses emphasize the vast scale of the Ford complex and the precision of its operation. Workers are sometimes included as minor elements in these images, but Sheeler's real interest lay in the plant's majestic formal beauty.

The most celebrated of Sheeler's River Rouge images is his iconic *Criss-Crossed Conveyors* [235]. Here, Sheeler records aerial coal and coke conveyor lines crossing in midair, the plant's water tanks just behind them, and the towering smokestacks of Power House No. 1 in the distance.[300] The result is an astonishing study of overlapping permutations of geometric and architectonic form. This photograph, at once densely complex and elegantly resolved, is the single finest expression of the era's fascination for the industrial sublime.

At the Ford plant, as in his earlier photographs of preindustrial Bucks County, Sheeler celebrated the essential relationship between structure and function. He was thus able to find inspiration in both the massive complexity of modern industry and in the simplicity of handmade buildings and artifacts. For him, each represented the "external evidence" of deeply held beliefs and effectively ordered ways of life.[301]

Sheeler's only significant photographs outside the United States were taken in the spring of 1929 on his way to the open-

149 Maurice Bratter,: *George Washington Bridge*, ca. 1931, 9¾ x 7¼"

ing of "Film und Foto." En route to Stuttgart, Sheeler made a detour to the famed Gothic cathedral at Chartres. The experience resulted in a powerful series of fourteen photographs. Sheeler depicted Chartres as a perfect union of architectural innovation and spiritual expression. He paid particular attention to the most radical elements of the cathedral's engineering, its flying buttresses. The strongest of these views, *Chartres—Buttresses from South Porch* [234], emphasizes the structure's machinelike precision. In fact, this photograph seems to suggest an analogy between these static stone supports and the pistons of a modern engine. Sheeler understood what a later art historian would express in these words: "Power is the key word at Chartres: power in constructional engineering, power in the carving of space, power too in the whole vocabulary of forms."[302] For Sheeler, River Rouge and Chartres both represented nothing less than the physical expression of intellectual and spiritual power.

The great engineering works of the twentieth century provided ample opportunity for the expression of similar artistic ideas. For example, Sheeler's associate Maurice Bratter was one of several noted photographers who were fascinated by the George Washington Bridge.[303] In a prodigious era of bridge construction, this was the most dramatic work of its time.[304] Not only did its 3,500-foot span nearly double the previous record for a suspension bridge, but the George Washington was renowned for its radically pure form. In fact, when plans were announced to clad the towers in a decorative skin of granite, officials were forced by "widespread popular protest" to abandon the idea.[305] The bridge's sleek skeleton so powerfully embodied the functional aesthetic of the day that it seemed inconceivable to drape it in stone. Bratter's photograph [149], taken from a relatively

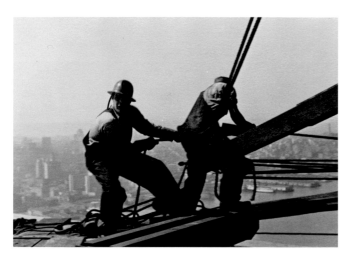

150 Peter Stackpole, *Workers on the San Francisco-Oakland Bay Bridge*, 1935, 4½ x 6⅝"

unusual viewpoint, depicts the bridge as both powerful and graceful. A few years later, Peter Stackpole documented the construction of the San Francisco-Oakland Bay Bridge [150]. This 8½-mile-long structure, built at the same time as the nearby Golden Gate Bridge (1933-37), is composed of several linked spans and a tunnel. Stackpole clambered all over the evolving framework with his small Leica camera, often working at dizzying heights. Like Hine, Stackpole paid particular attention to the human side of engineering and made many images of the project's workmen.[306]

The 1930s was also an important era in the construction of large dams. The most notable of these included the Shasta, Grand Coulee, and Fort Peck dams, as well as several built by the Tennesse Valley Authority. Most famous by far, however, was Hoover Dam.[307] At its completion in 1936, Hoover Dam claimed a number of records: in addition to being the highest dam in the world (726 feet), it held the biggest reservoir, was composed of the greatest volume of concrete, and had the largest power capacity. While most of these statistics were later surpassed, Hoover has remained a popular icon of modern engineering might.[308]

The renown of Hoover Dam is due in no small measure to Ben Glaha, the project's official photographer. As a professional engineer with a lifelong interest in photography, Glaha was uniquely qualified for this role.[309] He produced motion-picture footage and a vast body of photographs of every stage of the construction, often working under the most challenging conditions. His work was used to illustrate technical reports and was also given broad public distribution. An admirer of Sheeler, Glaha aimed for "the beauty of pure function" in even the most utilitarian of his images.[310] As Willard Van Dyke noted, "Glaha's technic is clean and precise, like the machinery he works with."[311] Glaha admired both the machines in use at Hoover Dam, and the human skills required to operate them. While the sheer scale of these machines make them dominant in many of Glaha's pictures [233], the guiding force of human intelligence is always felt.

The drama of industrial technology also formed the central theme of Margaret Bourke-White's work. In her studies at the Clarence White School, Bourke-White absorbed the lessons of "space-filling." Her early photographs characteristically use a variety of modernist traits—dynamic viewpoints, bold close-ups, and the repetition of simple elements—to give memorable aesthetic form to the most mundane subjects [151].[312] Bourke-White

first achieved national recognition for her 1927-28 photographs of the Otis Steel foundry in Cleveland. In 1929, she was hired by Henry Luce as the chief photographer for his new business magazine, *Fortune*. It was a fortuitous choice for both of them.

Sparing no cost, Luce made *Fortune* the most important business publication of its time. It was also one of the most beautiful photographic journals of the era. Large in format, and skillfully printed, *Fortune* was sold by subscription only at a dollar a copy. The magazine debuted in February 1930, just months after the stock market crash, but it maintained high production standards—and remained profitable—throughout the Depression. In large measure, *Fortune*'s appeal stemmed from its unprecedented use of modern photography. By reproducing many of its images in generous size, *Fortune* presented photographs as both information and art. Indeed, many of *Fortune*'s photographs were reproduced as full-page plates with ruled "frames," suggesting the elevated realm of the gallery or museum. This treatment was not unjustified, since many of the illustrations were indistinguishable from the most progressive artistic work of the era.[313]

Bourke-White's polished style was ideally suited to *Fortune*. Her work was bold, dynamic, and glamorous, and thus in perfect accord with the magazine's celebratory vision of the modern age.[314] Bourke-White traveled widely for *Fortune*, recording a great variety of trades and technologies. These included the watchmaking, garment, newspaper, natural gas, steel, banking, telephone, automobile, paper, aluminum, glass, meat-packing, and shipping industries. She also produced photoessays on a limestone quarry, a salt mine, a hydroelectric plant, a skyscraper, and the speakeasies of New York. In 1930 Bourke-White photographed businesses in Germany and then became the first foreigner to record the industrialization of Russia. Her work so impressed Soviet authorities that she was invited back in 1931 and 1932. Bourke-White's fame grew well beyond the photographic community; in addition to recording the greatest events of the day, she became a newsworthy figure herself.[315]

While Bourke-White was the most prominent of the *Fortune* photographers, she was by no means the only one. In the 1930s, industrial views by William M. Rittase, aerial photographs by Alfred G. Buckham, candid hand-camera images by Erich Salomon, and photomontages by Arthur Gerlach were published, in addition to work by Ralph Steiner, Ben Glaha, Walker Evans, Torkel Korling, Carl Mydans, Otto Hagel, Dmitri Kessel, William Vandivert, and a number of other notable figures.

New Ways of Seeing

The engineering advances of the 1920s and 1930s produced a remarkable expansion in the variety and sophistication of photographic applications.[316] By 1940, more Americans than ever had taken up photography as a pastime, encouraged by the availability of precision hand cameras, films with finer grain and increased speed, photoelectric exposure meters, and, after 1936, color transparency film. The refinement of panchromatic films and the introduction of infrared emulsions vastly extended the range of the camera's vision. As one commentator noted in 1940, "Whereas in 1875 we could photograph only one-third as much of the spectrum as we could see, today we can photograph more than four times as much as we can see."[317]

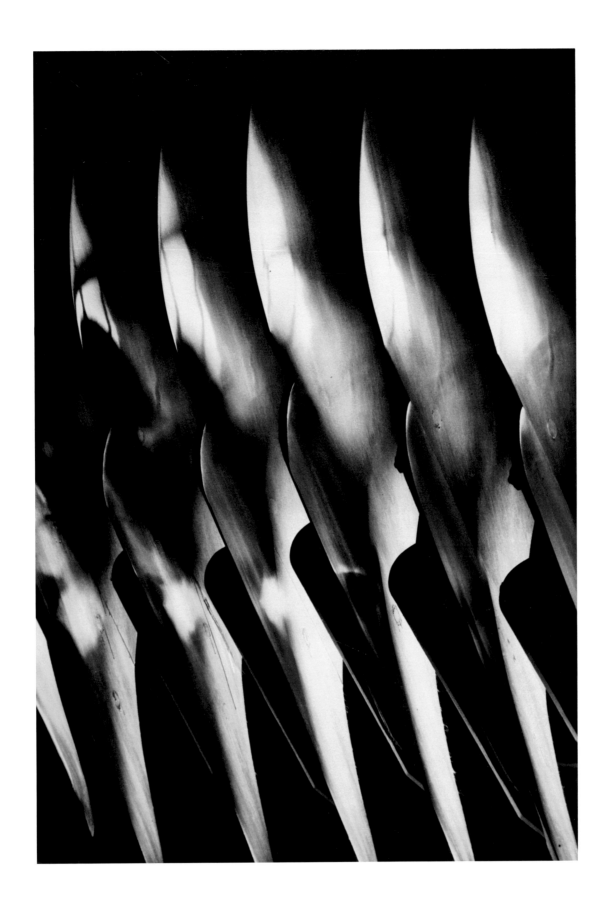

151 **Margaret Bourke-White,** *Plow Blades, Oliver Chilled Plow Company,* 1929, 13⅛ x 9″

In the professional and scientific world, new techniques made the transmission of news photographs by telephone and wireless more effective than ever, and even enabled the production of X-ray motion pictures of such medical subjects as the heart, the digestive tract, and the motion of the vocal chords during speech.[318] Advances in aerial photography permitted a variety of new applications, including surveying, map making, traffic flow studies, and the location of mineral and oil deposits. The new technology of microfilm was applied on a large scale to the copying of census records, newspapers, and other documents. At the 1932 and 1936 Olympics, photo-finish cameras were used to time athletes to a hundredth of a second, an unprecedented degree of accuracy.

The Leica—the world's first successful 35mm camera—was a product of this progressive age.[319] The simplicity of this precision-made German camera was exploited by countless American amateurs to make pictures with a new kind of spontaneity and intimacy. One of the most passionate of these nonprofessionals was Carl Van Vechten, a former critic and novelist who, in 1932, began a thirty-year project photographing artists, writers, and theater personalities [152]. The 35mm format was also used by such progressive commercial photographers as Lusha Nelson. Equally skilled with 8 x 10-inch and 35mm cameras, Nelson used the latter format to make a delightfully informal series of portraits of Alfred Stieglitz at his Lake George summer house [153].[320] Other 35mm cameras followed quickly on the heels of the Leica, including the Contax I, introduced in 1932.[321] The popular craze for the "miniature" format began in earnest in 1936, when Argus released the first inexpensive ($10) 35mm camera.[322] Within a few years, this format was well on its way to ultimate dominance of the market.

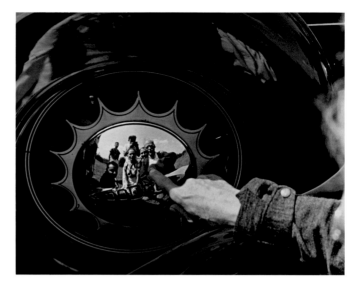

153 Lusha Nelson, *Alfred Stieglitz and Friends*, 1935, 6⅞ x 8⅞"

The technical advances of this era were vividly evident in high-speed still and motion-picture photography. Stop-action photographs of bullets in flight had been made by the light of electric sparks since the late nineteenth century.[323] During World War I, Lucien Bull of the Marey Institute in Paris built a motion-picture camera that recorded 5,000 frames per second (more than 300 times the normal rate) by the light of electric sparks. Bull used this technique to study the flight of insects and bullets.[324] By 1922, Philip P. Quayle of the U.S. National Bureau of Standards was using a related process to make crisply detailed still photographs of bullets passing through soap bubbles.[325] The U.S. Army Ordnance Department began similar research in 1919, and by 1925 Captain S. P. Meek was recording bullets in the air, and penetrating cardboard, with effective exposure times of $1/2,000,000$TH second.[326] By 1928, this work was familiar enough that one writer noted dryly that it was "not exactly a new field."[327]

High-speed photography was refined and made even more broadly known by Harold E. Edgerton, an electrical engineer long associated with the Massachusetts Institute of Technology. In 1931, Edgerton perfected the stroboscope, a device that produced single or repeated bursts of intense light more efficiently than the crude electric sparks used earlier. Over the next several decades, he employed the stroboscope to photograph a great variety of subjects, including splashing liquids, birds and bullets in flight, and athletic activities. This work was seen internationally in the 1933 exhibition of the Royal Photographic Society in London, and was widely reproduced in the following years in both scientific and popular journals. His first book, *Flash! Seeing the Unseen by Ultra High-Speed Photography*, was published in 1939. Edgerton devoted particular effort to recording the crownlike patterns created by drops of milk striking a flat surface [236]. Fascinated by the complexity of this seemingly simple action, he photographed milk drops over a period of twenty-five years. While Edgerton never achieved his goal of capturing a perfectly symmetrical coronet, his milk-drop studies remind us of the unexpected beauty hidden in the most mundane subjects.

At the opposite extreme of scale, photography was used to record the outer reaches of the universe. Photography's role in astronomical research and mapping had grown steadily since its first tentative trials in the daguerreian era. By the early twentieth

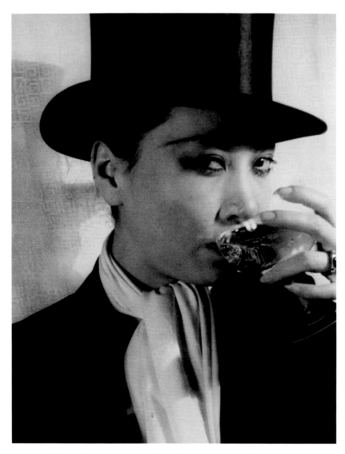

152 Carl Van Vechten, *Anna May Wong*, 1932, 13⅞ x 11"

154 Leonard B. Loeb, *Telescope*, ca. 1930, 6⅛ x 7⅞"

155 Lewis P. Tabor, *Triode*, ca. 1932-33, 13⅜ x 10⅝"

century, the process was essential to determining the location, movement, magnitude, and chemical composition of celestial objects. Photographic materials vastly extended the range of human vision: exposures of several hours allowed scientists to see far deeper into space than the unaided eye possibly could. Photography thus played a central role in an era of momentous astronomical discoveries: the proof of an important aspect of Einstein's theory in 1919, Edwin Hubble's determination of the vast size of the universe in the 1920s, and the discovery of Pluto, the solar system's most distant planet, in 1930.

The awesome power of this new scientific vision is suggested in Dr. Leonard B. Loeb's *Telescope*, ca. 1930 [154]. Loeb was best known as a professor of physics at the University of California at Berkeley, and as the author of several volumes on electricity, magnetism, and atomic structure. His circle of friends included Johan Hagemeyer, Edward Weston, and Albert Einstein. While his body of surviving photographs is relatively small, Loeb's images reveal a fascinating synthesis of New Vision artistic traits with a deep understanding of scientific and structural principles. This slightly blurred image, made by dim available light, suggests the great modern telescope as a vibrant expression of scientific and engineering genius.

The strange beauty and inherent wonder of astronomical photographs gave them an appeal outside the realm of pure science. Moholy-Nagy included such images in his book *Painting Photography Film*, and in the various exhibitions he organized. Astronomical pictures were also included in a variety of "mainstream" photographic annuals and journals.[328]

This dual appeal of astronomical images—as both information and art—is exemplified by the work of Lewis P. Tabor. After graduating from MIT with a degree in physics and chemistry, Tabor become an astronomer at the Cook Observatory of the University of Pennsylvania. He was also an accomplished artistic photographer whose works were exhibited nationally in the salons of the late 1920s and early 1930s.[329] Appropriately, Tabor's artistic work centered on the themes of light, vision, and technology. His *Triode*, ca. 1932-33 [155], for example, depicts an early amplifier vacuum tube, a key emblem of the nascent electronic age. Beginning in the late 1920s, these tubes were essential to the development of radio, television, telephone communi-

156 Lewis P. Tabor, *Solar Eclipse*, 1925, 18¼ x 17¼"

157 Albert W. Stevens, *Washington, D.C., from the air*, 1924, 4⅛ x 3¼"

cations, and a host of scientific instruments. Much of the technological future was to be derived from this device, and Tabor depicted it accordingly, in radiant, embryonic form.

The unusually impressive nature of Tabor's scientific photographs was, in some measure, a result of this keen personal interest in the medium. Tabor's astronomical images were usually made with large 20 x 24-inch glass plate negatives and extremely long exposures. For example, his untitled image of ca. 1930-31 [237] is the product of a seven-hour-and-seventeen-minute exposure through a 10¼-inch telescope. The result is almost hallucinatory: a radiant galaxy, thousands of light-years distant and composed of millions of stars, floats serenely in an ocean of even more stars, each recorded with pinpoint precision. It is significant that Tabor emphasized the aesthetic qualities of this scientific image by exhibiting it in a general photographic salon.[330] Likewise, it seems apparent that Tabor's *Solar Eclipse*, ca. 1925 [156], was printed in considerably larger size (18¼ x 17¼ inches) than the needs of science alone required. At this bold scale, the eclipsed sun—with its violently flaming corona—appears powerfully abstract. In precise conjunction with a rare and fleeting act of nature, the camera allows us to see what is otherwise unseeable. In accordance with basic New Vision ideas, the familiar is "made strange" and our sense of reality expanded accordingly.

This era's union of technical innovation and scientific research is perhaps best demonstrated in the career of Captain Albert W. Stevens of the U.S. Army Air Corps. Stevens was already well known in 1924, when he accomplished a uniquely multifaceted photographic feat. To create his aerial night image of Washington, D.C. [157], Stevens used a powerful flash to make an exposure from an airplane. The film was developed while aloft and, ten minutes later, dropped in an illuminated parachute to a party on the ground. The film was taken to a lab and printed. This print was rushed to the Washington office of A.T. & T. and placed on a wirephoto device, which converted the continuous-tone image into a field of parallel scan lines. After the transmission to New York was complete, the photograph was delivered to the city's newspapers for publication. The entire process, from exposure to final delivery, took only two hours and sixteen minutes.[331] This "factual" photograph is thus triply

abstracted from reality through the use of flash illumination, the extreme aerial perspective, and the wirephoto technology.

Stevens went on to other photographic firsts. In the mid-1930s, he pioneered high-altitude photography in a series of stratospheric balloon flights. In a 1935 ascent, Stevens reached a record height of 72,395 feet (nearly fourteen miles) above sea level. At this altitude, above 96 percent of the earth's atmosphere, he was able to record cosmic rays on specially prepared film. His photographs of the distant horizon, made with infrared film to cut through atmospheric haze, showed both the curvature of the earth and the division between the troposphere and stratosphere. Stevens's exploits were given extensive coverage by major newspapers, leading photographic publications, and the *National Geographic*, which cosponsored his flights with the U.S. Army Air Corps.[332]

Color

Among this era's most notable technical advances was the achievement of practical color photography. While the Autochrome process was exquisitely beautiful, its severe limitations prompted most photographers to give it up after a brief period of experimentation. Other techniques were explored, but their difficulty made color photography a distinctly esoteric enterprise through the early 1930s. By the end of that decade, however, amateur color transparency films were widely available, and practical (if still not truly easy) methods of making color prints were in use by professionals.

The history of color technology in this period is too intricate to recount in detail.[333] It will suffice to note that various approaches were explored in efforts to create two basic kinds of color images: transparencies on glass or film and prints on paper. Following the Autochrome, direct-positive color transparencies were produced with the Dioptichrome process, introduced in 1910 by the Frenchman Louis Dufay. An improved version of this process was marketed by Ilford under the name Dufaycolor, first in motion-picture format in 1932, and three years later as a still-camera film.[334] The German firm Agfa released its own color transparency film, Agfacolor Neue, in 1936. The best known of these modern transparency films, Kodachrome, was developed by Leopold Mannes and Leo Godowsky, Jr., professional musicians with an "amateur" interest in photographic science.[335] This was marketed by Kodak in 1935 as motion-picture film and, in August 1936, in 35mm format for still photography.[336]

Despite their often remarkable beauty, the drawbacks of color transparencies were obvious. These one-of-a-kind images were difficult to view, requiring either projection on a screen or an individual source of transmitted light. As a result, they could not be seen in the same ways, or contexts, as standard black-and-white prints.

The challenge of making color prints occupied a generation of photographic scientists.[337] One of the earliest attempts at commercial practicality in this country was provided by the Hess-Ives process, developed by the veteran researcher Frederic E. Ives of Philadelphia. Ives's Hicro-Universal Camera, marketed in 1914, used a sophisticated internal arrangement of mirrors and filters to produce three color-separation glass-plate negatives with a single exposure. One of these negatives was printed on blue (cyan-

158 **Paul L. Anderson**, *Hebe Hollister*, 1917, Hicrome (Hess-Ives) color print, 4⅛ x 3¼"

159 **H. I. Williams**, *Fruit Still Life*, ca. 1937, carbro color print, 16 x 16¼"

otype) paper; the others were printed on transparent gelatine and dyed red and yellow, respectively. When superimposed in registration and cemented together, the result was a brilliant full-color image on paper.[338] These images (variously called Hichrome or Hess-Ives prints) were featured in an important exhibition in New York in the fall of 1916, and praised by photographers such as Karl Struss.[339] While the difficulty of the process prevented any widespread use, a handful of these prints was produced in the late 1910s by Struss, Grancel Fitz, Paul L. Anderson [158], Elias Goldensky, and a few others.[340] Hess-Ives prints were also prominently included in several of the leading salons of the day.[341] Over the following years, a few other techniques—including the Raylo Process of 1923—garnered fleeting attention in the photographic press.[342]

The three-color carbro process was the first color print technique to achieve anything approaching broad use. This method, understood in principle since the late nineteenth century, was most widely practiced after 1931. In the carbro process, separation negatives are printed on sheets of bromide paper.[343] These dampened prints are placed in contact with prepared sheets of carbon tissue—dyed cyan, magenta, and yellow—which are hardened in relationship to the tones of the facing print. The resulting tissue images are then overlaid in register on a paper support to produce a full-color print. Other transfer techniques of the period include Kodak's Wash-Off Relief process—introduced in 1935 and improved and renamed the "dye-transfer" process in 1946—and the Defender Photo Supply Company's Chromatone process of 1935.

These techniques were all difficult, costly, and slow. The carbro process, for example, required careful temperature control and was best done at sixty degrees Fahrenheit.[344] In the days before air conditioning, this was often achieved by working in the cool of evening or, as Paul Outerbridge recommended, by hauling blocks of ice into the darkroom. Even under ideal conditions, it took six to ten hours to make a single carbro print.[345]

Not surprisingly, the production of color prints remained an almost exclusively commercial enterprise.[346] The great majority of the era's color prints were created for advertising. The very few made for personal, artistic expression still tended to be the work of leading commercial photographers, since only they had the necessary equipment, skills, and money. The major technical books on the subject—including Victor Keppler's *The Eighth Art: A Life of Color Photography* (1938) and Paul Outerbridge's *Photographing in Color* (1940)—were also written by experienced professionals.

This first generation of modern color practitioners included some of the most renowned names in commercial photography. Nicholas Muray, a celebrated New York portrait and advertising photographer, had made Autochrome plates in the mid-1920s for covers of *Photoplay* magazine. He inaugurated a new era in 1931, when the June issue of *Ladies' Home Journal* reproduced two of his color photographs of beach wear—the first magazine reproductions to be made from original four-color prints.[347] The first original color photograph in a Condé Nast magazine, in May 1932, was made by the team of Anton Bruehl and Fernand Bourges. Many Bruehl and Bourges images appeared in *Vogue*, *Vanity Fair*, and *House & Garden* through the mid-1930s.[348] After establishing his reputation in the 1920s in fashion and portraiture, H. I. Williams turned to a specialty in food photography [159], and became one of the most respected practitioners of the carbro process.[349] Other notable color professionals of the 1930s included Steichen, Genthe, Horst, Alfred Cheney Johnston, Lejaren à Hiller, Paul Hesse, Martin Bruehl, Valentino Sarra, James N. Doolittle [160], Arthur Gerlach, and Ruzzie Green.[350]

Technical difficulties aside, color presented a host of new pictorial problems. In composing black-and-white pictures,

160 James N. Doolittle, *Ann Harding*, ca. 1932-34, carbro color print, 13 x 10½"

161 **Nicholas Ház**, *Danger*, 1939, dye transfer (Wash-Off Relief) color print, 14 x 11"

photographers thought in terms of mass, line, and tone. In color, however, these traits were subordinated to the sheer vitality of the colors themselves: their hue, intensity, and contrast. Before this new set of concerns was fully understood, the craze for color produced many shrill and garish images. In commenting on "the weakness and slight nature of nearly all work being done in color today," William Mortensen observed in 1938 that "it does not seem to have occurred to most of the workers in color that color has any higher virtues than accuracy and abundance."[351] The faults of banal realism and chromatic surfeit were particularly common in amateur work. Indeed, as Mortensen observed, "It is a strange bit of irony...that the most intelligent and artistic use of photographic color that one can find nowadays is entirely utilitarian and commercial in motive, and is dedicated to making the public conscious of soap, cigarettes and automobiles."[352] This was true, in part, because professionals were required to do more than simply record color: they had to *use* it to make effective and satisfying pictures. As many of these photographers realized, memorable color images were often characterized by simplicity rather than excess, subtlety rather than boldness. This restrained approach is evident in exquisitely reductive works by Alfred Cheney Johnston [240] and Ruzzie Green [241].[353]

Although the making of color prints for purely personal and artistic purposes was almost nonexistent in these years, Nicholas Ház was one of the few photographers to do so. In 1939, Ház used the Wash-Off Relief process to create a series of color photograms. Conceived as "idea pictures," these wholly abstract images were given such titles as *Birth of Venus*, *Passion*, and *Danger* [161].[354] The sophistication of Ház's ideas is evident in these works, but they do not appear to have stimulated similar uses of the medium by many others of the day.[355]

American Documents

The culture of the 1930s was characterized by a passion for the real. In this era, as historian William Stott has shown, a fundamentally documentary point of view permeated all levels of American society.[356] Newsreels, "true confession" pulp fiction, radio soap operas, and movie-star fan magazines were popular expressions of the same broad movement that produced a rise in social science research, magazines such as *Life* and *Look*, John Steinbeck's *The Grapes of Wrath*, and Martha Graham's ballets "American Lyric" and "American Document." As literary critic Alfred Kazin observed of this decade, "Never before did a nation seem so hungry for news of itself."[357]

This enthusiasm for fact was a logical expression of the era. With the mania for engineering came an almost evangelical faith in rational problem-solving based on the collection and analysis of objective data. The rekindled interest in the American experience stimulated a new attention to history and the distinguishing traits of the many regional, ethnic, and religious groups that comprised the nation. The events and personalities of the day were documented by the ever-expanding mass media, with news photographers playing an increasingly important role. Finally, artists and thinkers of all stripes were converted from abstract to realist concerns by the all-encompassing reality of the Depression. The hard facts of social and economic crisis made the cerebral con-

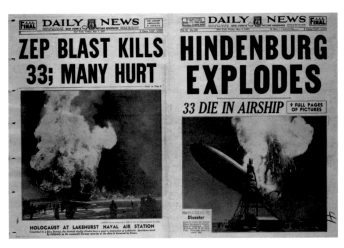

162 Robert Seelig and Charles Hoff, *Hindenburg Explosion*, 1937, halftones in *New York Daily News*, May 7, 1937; 15⅜ x 22¾ overall

cerns of the 1920s seem hopelessly effete. As one writer observed in 1937, the new realism marked a "farewell to bohemia," and a reintegration of artists into mainstream American society.[358]

The camera played a vital role in this vast fact-gathering enterprise. For several decades, press photographers and newsreel cameramen had covered all the public events of the day, creating a visual record of unprecedented depth. In 1937, the explosion of the German dirigible *Hindenburg* was recorded by scores of reporters, photographers, and motion-picture cameramen, and memorialized in screaming headlines across the nation [162]. The constant quest for sensation, scandal, and scoops produced ingenious strategies for capturing difficult or forbidden subjects. For example, Tom Howard's surreptitious image of a state-sponsored electrocution in 1928 remains one of the most dramatic news photographs of the century [163].[359] The result of careful planning, this gritty image was produced with a small glass-plate camera that had been prefocused, loaded with a single negative, and strapped to Howard's ankle. Using a cable release that ran to the pocket of his trousers, Howard exposed this plate for a total of about five seconds.

The most common form of photographic realism was portraiture, the essentially commemorative work that comprised the great bulk of professional practice. The work of a photographer such as James Van Der Zee, for example, was largely devoted to studio sittings and commissions to record social events [164]. Van Der Zee opened a studio in Harlem in 1912 and for decades pictured the residents of this vital segment of New York society. His role as the official photographer for Marcus Garvey's Universal Negro Improvement Association gave Van Der Zee a unique perspective on the struggle of black Americans for social and economic progress. His Harlem photographs typically record a dynamic society structured by the institutions of family, church, and commerce.

At the other end of the economic scale were the many celebrity images of the era. Publications such as *Vanity Fair* and *Life* presented an endless parade of talented, beautiful, or otherwise notable people for public inspection. Between 1923 and 1938, the years in which he operated his New York studio, Edward Steichen was the leader in this field. Since renouncing art-for-art's-sake after his experimental images of 1921-22, Steichen devoted himself to photography as a utilitarian and demo-

163 Tom Howard, *The Electrocution of Ruth Snyder*, 1928, 4½ x 4"

cratic art. His celebrity portraiture used dramatic pose, lighting, and composition to create a glamorous union of inner self and public persona. In his portraits of Charlie Chaplin, Gloria Swanson, Greta Garbo, and scores of other personalities of the 1920s and 1930s, Steichen deftly merged description and invention, fact and style. These photographs were praised as "dramatic and spectacular," with "an almost exaggerated realism."[360] One of the earliest of Steichen's portraits to appear in *Vanity Fair* was *Mr. and Mrs., The Sandburgs*, 1923 [238].[361] This image of Steichen's sister, Lillian, and her husband Carl Sandburg, is slightly atypical of his most famous portraits for having been made outside the studio. However, it is emblematic of his later career for its celebration of the power of the face, and its emphasis on universal emotions. At once heroic and tender, this photograph stands as a monument to the most intimate bonds of love and devotion.

164 James Van Der Zee, *Convention, Church of Christ*, 1928, 7¾ x 9¾"

165 Clarence Kennedy, *Sarcophagus, Figure of the Cardinal, Head*
(from portfolio "The Chapel of the Cardinal of Portugal"), 1932,
6⅝ x 10½"

Celebrity portraiture is, to be sure, a curious kind of "real-ist" art. These highly idealized images are typically a product of self-conscious poses, melodramatic lighting, and generous retouching. These photographs became increasingly prominent in the 1930s, in tandem with the expansion of general interest weeklies and monthlies, and the rising popularity of Hollywood films and fan magazines. For all their artificial glamour, these celebrity images satisfied a public hunger for information about a certain class of personalities. The "truth" of these images was the truth of style—the orchestration of a polished repertoire of signs indicating the virtues of beauty, sexual allure, self-confidence, gentility, grace, and wit. Along with George Hurrell, Clarence Sinclair Bull was one of the most active of the Hollywood photographers.[362] He was hired by Samuel Goldwyn to shoot publicity stills in 1920, and worked for Goldwyn and at MGM until 1958. From 1929 to 1941, he was Greta Garbo's exclusive photographer. Despite the severe limitations of the genre, Bull's creativity is seen clearly in his *Hedy Lamarr* [239], an almost startling vision of sensual intimacy.

The Art of Documentary

By about 1930, a select number of artists had begun exploring other aspects of photographic realism. For these photographers, personal style was wholly subservient to worldly fact. The camera was employed as a recording device *par excellence* in the service of projects that transcended self-expression. For example, art historian Clarence Kennedy labored for decades recording such important works of Italian Renaissance sculpture as Antonio Rossellino's *Figure of the Cardinal* [165] in Florence. Kennedy's photographs are both elegant and, in their emphasis of particular details, highly interpretive. Nonetheless, the creative hierarchy in his pictures is always clear: the artistic value of his subject far transcends what he has brought to it.[363]

This new approach, most memorably seen in the austere clarity of Walker Evans's work, was at once a reaction to, and a logical extension of, the artistic currents of the day. While this new aesthetic rested on Moholy-Nagy's celebration of the optical precision of the camera, it rejected his enthusiasm for odd vantage points and technical manipulations. For Evans and other realists of the 1930s, the now-familiar New Vision was no longer a

compelling mode of artistic discovery—it was simply a style, as easily learned or imitated as any other. At the same time, the Group f/64 approach was viewed as excessively technical and too removed from social and historical realities. Stieglitz's work was seen as melodramatic and precious, while Steichen's was denigrated for its commercialism. In contrast to these approaches, Evans's work was cerebral, restrained in expressive effect, and concerned exclusively with the cultural landscape.

Rejecting the work of most of their contemporaries, proponents of this new style looked to the past for an appropriate artistic lineage. Two historical figures, Eugene Atget and Mathew Brady, were celebrated as the progenitors of this sensibility. Atget, who recorded Paris and its surroundings in the first quarter of the century, received widespread attention in Europe and America beginning just after his death in 1927.[364] His work was exhibited at "Film und Foto" in 1929 and, a year later, at both the Weyhe Gallery in New York and the Harvard Society for Contemporary Art. Atget's burgeoning influence was made possible by the young American photographer Berenice Abbott, who (with the help of Julien Levy) rescued his work from destruction and promoted it tirelessly. Similarly, the Civil War-era photographer Mathew Brady was rediscovered at this time as a spiritual forefather of the new documentary aesthetic.

The symbolic importance of these ancestor figures is revealed in the praise given them. In reviewing a new book on Atget in 1930, Evans observed that the Frenchman had worked in quiet isolation throughout "a period of utter decadence in photography." For Evans, Atget's great gift lay in his infusion of worldly fact with a highly individual visual intelligence.

> His general note is lyrical understanding of the street, trained observation of it, special feeling for patina, eye for revealing detail, over all of which is thrown a poetry which is not "the poetry of the street" or "the poetry of Paris," but the projection of Atget's person.[365]

At about the same time, Lincoln Kirstein (who had commissioned this essay from his friend Evans) wrote in praise of Brady's "sober and sensitive eye." He observed that Brady's photographs reveal

> a sincerity, clarity and honest brilliance not found in the work of his contemporaries....Brady's plates have the esthetic overtone of naked, almost airless, factual truth, the distinction of suspended actuality, of objective immediacy not possible, even if desirable, in paint. Brady's work is an example of the camera's classic vision, austere and intense.[366]

This protomodern Brady was largely a historical fiction—a projection of the ideals of Kirstein's era rather than the product of serious scholarship.[367] To a lesser degree, Atget's work was also simplified in order to function most clearly as a symbolic model. However, this Atget and Brady—as well as Lewis Hine, who was also rediscovered at this time—served to inspire a new photographic avant-garde, one that valued both clarity and lyricism.[368]

The Photo League

The documentary production of the Depression era was related in important ways to the political climate. Spurred by the apparent failure of international capitalism, leftist political groups enlisted photographers and film makers to record the effects of

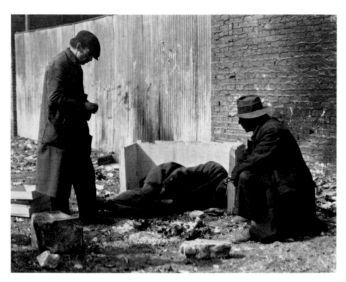

166 Consuelo Kanaga, *The Bowery (New York)*, 1935, 3⅝ x 4⅝"

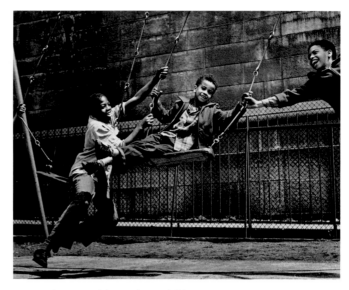

167 Walter Rosenblum, *Three Children on Swings, "Pitt Street" Series, New York*, 1938, 7⅝ x 9½"

this economic collapse and to speed the onset of a new social order.[369] The Worker's International Relief, founded in 1921 by the Communist International to support strikers and workers around the globe, organized Workers Camera Leagues in major cities in Europe and America.[370] The New York Workers Film and Photo League, founded in 1930, became the unofficial flagship for similar chapters in Los Angeles, San Francisco, Chicago, Detroit, and elsewhere. After emphasizing documentary film making in its early years, in 1935 the New York organization split into several factions. The group's more artistically inclined documentary film makers, including Leo Hurwitz and Ralph Steiner, united with Paul Strand, Ben Maddow, and others to form Frontier Films.

The still photographers of the original group, under the guidance of Sid Grossman and Sol Libsohn, reformed as the Photo League. Some of the most notable members of the Photo League in the following years were Walter Rosenblum, Lisette Model, Aaron Siskind, Morris Engel, Ruth Orkin, Louis Stettner, Jerome Liebling, Dan Weiner, Consuelo Kanaga, and Max Yavno. A self-supporting group of amateurs and professionals, the Photo League was dedicated to using the camera to record the "profound and sober" realities of their world.[371] Through the efforts of its most dedicated members, the Photo League presented classes, lectures, and exhibitions, and published a regular newsletter titled *Photo Notes*. The group also assumed responsibility for Lewis Hine's archive of prints and negatives upon his death in 1940.

While the Photo League minimized the radical origins of its parent organization, members knew that they shared "a common orientation and direction in their art, a documentary approach that was progressively left and people-oriented."[372] The League's idealistic belief in collective effort and the transformative power of socially responsible art is suggested in the words of member Elizabeth McCausland, a noted art and photography critic. When McCausland lectured at the League in 1938 on "Documentary Photography," few in attendance would have disagreed with her analysis of the recent artistic past:

> After the eccentricities of "art for art's sake," art returned to its historical roots, as the spokesman of human experience and life. After a decade or so, when subject-matter was declassé, suddenly subject-matter became the ultimate criterion of art. A painting, a sculpture, a print, a photograph MUST have *content*, and not

merely content of a personal or romantic character, but *social* content.... Precisely because it will be incredible to future ages that human beings lived in squalor and filth, congested quarters, under-fed, illiterate, sickly with anemia and venereal disease, do we need today to record these facts. They are truth. But facing the truth, we summon up forces to change the facts and make them consonant with the dignity of human life. Refusing to face the truth, we become responsible for the ugly facts and perpetuate them in a dangerous locus of infection.[373]

This passion for social justice, and a faith in the basic dignity of human life, lay at the heart of the Photo League's activities. Photo League photographers sought an emotional as well as political understanding of their subjects. As a result, their images depicted the rhythms of daily life in a deeply sympathetic manner. Even when their subject matter was gritty, as in Consuelo Kanaga's *The Bowery (New York)*, 1935 [166], their pictures encouraged an essential respect for the humanity of those depicted.

Photo League members put their ideals into practice in a series of collaborative documentary projects. In 1936, the League's Feature Group was organized by Aaron Siskind, an amateur photographer then employed as a high school English teacher. Over the four years of its existence, the Feature Group produced bodies of photographs on such themes as "Portrait of a Tenement," "Dead End: The Bowery," and "Park Avenue: North and South." The largest of these projects, "Harlem Document," was produced between 1937 and 1940 by Siskind, Harold Corsini, Jack Manning, and others, in collaboration with Michael Carter, a black writer and social worker. Other notable thematic studies of this period include Grossman and Libsohn's "Chelsea Document" and Rosenblum's "Pitt Street" [167]. The photographs from these projects were exhibited in New York and reproduced in publications such as *Fortune*, *Look*, and *U.S. Camera*.

Government Patronage

The documentary urge of the 1930s was vastly expanded by Franklin D. Roosevelt's New Deal.[374] After taking office in early 1933, at the depth of the Depression, Roosevelt created a variety of programs to put people back to work. These agencies

spurred a massive wave of official fact-gathering. Programs in all manner of historical and artistic disciplines were developed under the auspices of the Works Progress Administration (WPA) and other federal agencies.[375] In 1935, the WPA initiated remarkably varied projects in writing, theater, music, and art. The Federal Writer's Project, for example, produced some 1,200 publications. The American Guide series accounted for nearly 400 of these: studies of all forty-eight states, as well as of major cities, federal highways, tourist areas, and scenic waterways. At the same time, folklorists were hired to transcribe traditional songs, compile oral histories, and write ethnic studies.[376] The Federal Theater Project dramatized such contemporary issues as slum conditions and industrial relations in documentary plays called "Living Newspapers."[377] The Federal Music Project funded performances by orchestras, dance bands, and choral groups in communities across the nation. The Federal Art Project provided work for about 5,000 painters, sculptors, muralists, and printmakers.[378] The Index of American Design, the Historic American Buildings Survey, and the Historical Records Survey were also initiated to document the nation's art, architecture, and archives. This staggering volume of activity underscored the diversity of American life and history while engendering a renewed respect for the value of objective fact.[379]

One of the programs of the Federal Art Project, in California, supported photography as a purely self-expressive medium. In this instance, several noted photographers—including Edward Weston, his sons Brett and Chandler, Sonya Noskowiak, and Sybil Anikeef—were paid to produce exhibitions of their work for schools and museums.[380] More typically, however, photography was employed in the federal projects as a purely documentary tool. Thousands of photographs were produced for the Historic American Buildings Survey, for example, and to illustrate the American Guide publications. Photographers were also hired to document the paintings, sculptures, and prints created by government-sponsored artists.

Despite the strictly functional nature of most of this work, a few photographers—including Hansel Mieth and Berenice Abbott—were able to use government patronage to continue projects of personal interest. Born in Germany, Mieth arrived in California in 1931 after several years of restless travel. Her interest in social and labor issues grew directly from her own experiences: her first year in California was spent as a migrant "fruit tramp" with her husband, Otto Hagel. The two began photographing at this time with a simple vest-pocket Kodak, recording the shantytowns (or "Hoovervilles") erected by the homeless, and such poignant scenes as men hunting for scraps of food in a garbage dump.[381] In 1934, the director of the WPA's Youth and Recreation Project in San Francisco hired Mieth and Hagel to document living conditions in the city. They photographed throughout San Francisco but were particularly interested in the waterfront. It was here that Mieth made her powerful image *Outstretched Hands* [245], documenting the sad routine—repeated each workday morning—of unemployed men begging for jobs.[382] The power of pictures such as this landed Mieth a staff position with *Life* in 1937; Hagel worked for years as a freelancer for *Time*, *Life*, and *Fortune*.

Berenice Abbott took up photography in the early 1920s in Paris, while working as Man Ray's assistant. Rejecting Man Ray's

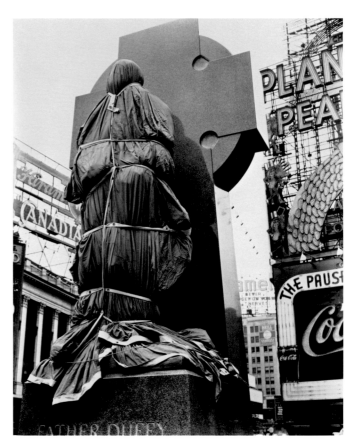

168 Berenice Abbott, *Father Duffy, Times Square, Manhattan*, 1937, 9⅛ x 7⅝"

experimental approach, she was drawn instead to the work of Eugene Atget. His poetic documentation of Paris inspired Abbott to devote similar attention to New York City. This project, begun in 1929, sought to depict "the dual personality of a great city in which the past lives side by side with the incredible present."[383] Abbott gained the salary and support staff to fully pursue this work in 1935, when her application to the Federal Art Project was accepted. Over the next four years she worked on her "Changing New York" series, using a large 8 x 10-inch camera to record the city's residences, commercial buildings, docks, bridges, highways, street vendors, churches, and cemeteries. Each of these images was accompanied by historical and technical data.

Abbott's best-known photographs from this project include *Gunsmith and Police Department*, 1937 [242], *Newsstand, 32nd Street and 3rd Avenue*, 1935 [243], and *Father Duffy, Times Square*, 1937 [168]. All use a wealth of visual detail to describe specific subjects at precisely identified moments in time.[384] The subject of Abbott's *Newsstand* is presented as both a unique example and a representative type. The notes accompanying this image indicate that the newsstand was "built in 1932 by James Stratakos and [is] still owned and operated by him." Further, its contents were "typical of what the public reads. Over 200 magazines are handled, but it is sales from the metropolitan daily newspapers which keep the business going."[385] Similarly, Abbott's *Gunsmith* photograph provides evidence of a relatively common line of business, while celebrating the hand-wrought singularity of this giant wooden pistol. By its nature, this advertising icon seems to conjure up other meanings of the word "sign," such as "omen" or "portent." A related mood is conveyed by Abbott's photograph of the Father Duffy statue in Times Square.

Tightly bound in protective fabric just prior to its public unveiling, this now-familiar statue is presented as a kind of Surrealist found object, suggesting Man Ray's influence as much as Atget's.[386]

The Farm Security Administration

While many New Deal agencies actively produced or collected photographs, the most significant of these was the Resettlement Administration (RA). This agency was founded in 1935 to oversee a variety of farm-related programs, including loans, debt adjustments, migrant camps, erosion and flood control, and cooperative resettlement communities. In 1937, the Resettlement Administration was transferred to the Department of Agriculture and gained the name by which it is best known today: the Farm Security Administration (FSA). At the end of 1942, the FSA operation was transferred yet again, this time to the Domestic Operations Branch of the Office of War Information (OWI). For all practical purposes, this program ended in 1943 with a new round of budget cuts.[387]

Rexford Tugwell, an economist from Columbia University, was the first director of the Resettlement Administration. Faced with the challenge of developing consensus on the nature of rural problems, Tugwell embraced film and photography for their powers of realism and persuasion. A documentary film unit funded Pare Lorentz's two feature-length motion pictures: *The Plow That Broke the Plains* (1936) and *The River* (1937). The noted photographers Ralph Steiner, Paul Strand, and Willard Van Dyke worked as cameramen on these projects.[388]

To assist in his department's massive educational campaign, Tugwell hired Roy Stryker, a former student and colleague from Columbia, as head of the Historical Section-Photographic of the RA's Information Division.[389] Stryker's mandate was to support the Administration's effort to make American agriculture more stable and progressive. To this end, Stryker sought photographs documenting the problems of rural America and the government's success in solving them. These photographs were circulated to various congressional committees, used in government-issued posters, booklets, and filmstrips, and published widely in the national press. Stryker also created traveling shows of these images. By the end of 1936, he had assembled twenty-three exhibits for venues as prominent as the Museum of Modern Art and that year's Democratic National Convention. The agency's most popular exhibition—on migrant workers—was requested more than eighty times in three years.[390]

This educational—and essentially propagandistic—function remained foremost in Stryker's mind throughout his tenure with the RA, FSA, and OWI. However, the rather vague outline of his mission gave Stryker considerable latitude, and he developed a sense of direction in his first year on the job. He came to view himself as a cultural historian building a visual archive for future generations. This perspective resulted in the documentation of subjects with little obvious relation to farming problems. As John Vachon later recalled, Stryker encouraged his photographers to record the details that evoked the texture of everyday life: "people, towns, road signs, railroad stations, barber shops, the weather, or the objects on top of a chest of drawers in Grundy Co., Iowa."[391] In hindsight, it seems clear that the real subject of Stryker's FSA file—which grew to include some 270,000 images

by 1943—was the relentless transformation of American life, as evidenced in the tensions between past and present, country and city, man and machine.

Despite the relative freedom enjoyed by FSA photographers, the resulting file was a clear expression of Stryker's vision.[392] He directed the activities of his staff by issuing detailed shooting "scripts"—which nonconformists like Walker Evans generally refused to follow—and by deleting pictures from the file that he did not like. Since he valued photography as a documentary and persuasive medium, Stryker distrusted images that seemed overly artistic. Art blunted photography's didactic function, he felt, by shifting its focus from content to form, collective concerns to personal expression, the timely to the timeless. To ensure that each image was anchored to a useful and unambiguous narrative, he insisted that his photographers record detailed captions for every shot. Stryker guided the overall project by both encouraging and hectoring his photographers. To Arthur Rothstein, Stryker was "an irritant, a stimulant, and a catalyst"; to Gordon Parks, he was "a baffling mixture of tormentor, teacher, and father."[393]

Stryker employed about twenty photographers between 1935 and 1943. Some worked for only a few months, and no more than about half a dozen were on the payroll at once. These photographers ranged from some of the nation's most notable artists to relative neophytes. In the fall of 1935, Stryker's department "inherited" Carl Mydans, Ben Shahn, and Walker Evans from other units of the RA. Arthur Rothstein was the first photographer personally chosen by Stryker, followed by Theo Jung and Dorothea Lange. Russell Lee replaced Mydans in the summer of 1936, and over the next few years Jung, Evans, Shahn, and Lange left or were dismissed. In its later years, the FSA staff included Marion Post Wolcott [169], Jack Delano, John Vachon, John Collier, Jr., and Gordon Parks.[394] In 1938, Edwin Rosskam was hired to design exhibitions of FSA work and to oversee the use of file images in books and magazines.[395]

The experience and talents of these photographers varied enormously. When Ben Shahn joined Stryker's staff, at age thirty-seven, he was an established painter. With advice from his friend Walker Evans, Shahn had taken up photography in 1932, largely as an adjunct to his painting.[396] Shahn's favorite camera was the small 35mm Leica with a right-angle viewer, a combination that allowed him to work quickly and candidly. This technique produced pictures characterized by their spontaneity, "asymmetrical balance, compressed space, and dramatic cropping."[397] These traits are readily apparent in Shahn's earliest pictures, such as *Accident*, ca. 1932 [170]. These formal characteristics, as well as his leftist political sentiments, give Shahn's work for the RA an unmistakable personal inflection. One of his best-known images of this period is *Sheriff during Strike, Morgantown, West Virginia*, 1935 [246].[398] This photograph reminds us how steeped in personal opinion documentary photographs can be, and how they thus can function more as "editorial comment" than as "news." In this implied confrontation between law and labor, can there be the slightest doubt as to where Shahn's sympathies lie?

The vision of the more experienced artists and photographers—Shahn, Lange, and Evans—had enormous impact on younger RA photographers like Arthur Rothstein. Rothstein was only twenty-one years old, and without professional experience in photography, when he joined Stryker's staff. He learned

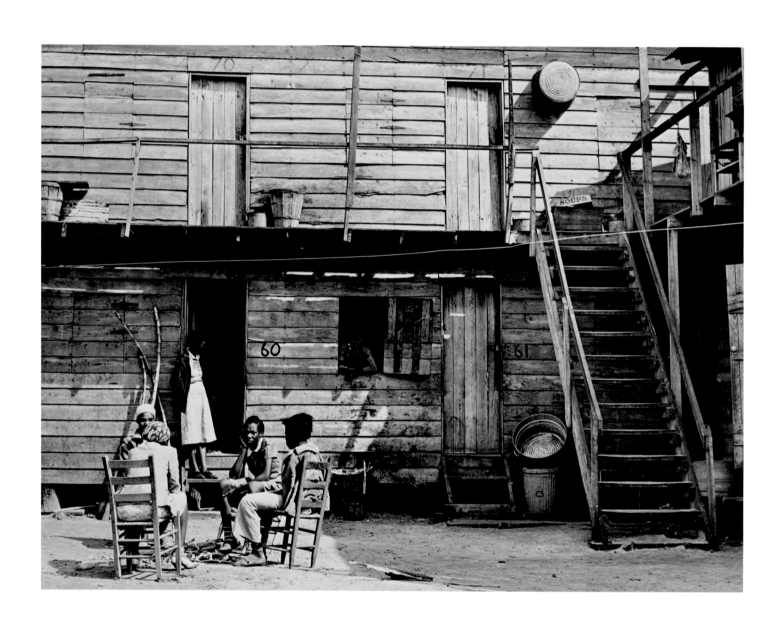

169 **Marion Post Wolcott,** *Pahokee Hotel, migrant vegetable pickers' quarters, near Homestead, Florida,* 1941, 10⅛ x 13½"

quickly, however, and followed Stryker's guidance more willingly than his seniors. By the spring of 1936, Rothstein had produced two certifiable icons of the Depression: *Farmer and Sons Walking in Dust Storm, Cimarron County, Oklahoma*, 1936 [244], and a close-up of a steer skull on a parched alkali flat in South Dakota. Both images became memorable symbols of the human and environmental effects of the Dust Bowl.

Walker Evans and Dorothea Lange

While all of Stryker's photographers made powerful and effective images, the work of Walker Evans and Dorothea Lange is particularly emblematic of this era. Both were experienced photographers when they joined the RA, with their style and working method firmly established. Apart from their disputes with Stryker, however, Evans and Lange had little in common. Evans's coolly cerebral photographs reveal layers of meaning in cultural artifacts, while Lange's center on the expressiveness of the human face and form.

Evans is perhaps both the best known and the least typical of the RA/FSA photographers. Raised in affluence, Evans rebelled against the smug prosperity of the 1920s. He developed an interest in literature as a young man, and absorbed a range of avant-garde ideas during a year in Paris and his subsequent residence in New York. After turning to photography in 1928, Evans used a small camera to produce New Vision semi-abstractions before embracing a more straightforward approach.[399] This change in direction was the result of several factors, including his admiration for the "objectivity of treatment" and "the non-appearance of the author" in the literature of Gustave Flaubert.[400]

In addition to admiring the work of Eugene Atget, Ralph Steiner, and the bluntest of Paul Strand's *Camera Work* gravures, Evans was probably also influenced by a photographer who, until recently, has gone almost completely unrecognized: his brother-in-law, Talbot M. Brewer.[401] A personnel administrator by profession, Brewer was an accomplished photographer by 1930. Fascinated by quirky expressions of vernacular and popular culture, Brewer made personal images of diners, advertising signs, and similar subjects in the U.S. and abroad. His photograph *The "Comics," Spain*, 1930 [171], represents a bemused catalogue of melodramatic clichés, while documenting the international appeal of American popular culture. The precise intelligence of his work suggests that Brewer deserves more recognition than he has hitherto received.[402]

In the early 1930s, as a result of these influences, Evans began focusing on such unfashionable subjects as advertising signs, old houses and commercial buildings, and the streets of small towns. Rejecting the brash optimism of the modern, Evans instead recorded the organic life of manmade things. His devotion to simple, vernacular subjects was part of a larger cultural interest in Americana and folk art, but his passion for these things was uniquely long-lived.[403] His use of a tripod-mounted view camera (in the 6½ x 8½-inch and then 8 x 10-inch format) necessitated a precise and contemplative mode of working. Prints from these large negatives seem magically transparent, creating an illusion of artless objectivity. In fact, this apparent simplicity was the product of a carefully considered artistic vision, and Evans was keenly aware of the difference between documentary photogra-

170 Ben Shahn, *Accident*, ca. 1932, 6¼ x 9⅞"

phy and his own "documentary style."[404] This work achieved early acclaim, thanks in part to support from Lincoln Kirstein, and was included in several prestigious exhibitions and publications.[405]

Evans thus joined Stryker's staff as an accomplished and wholly self-motivated artist. Not surprisingly, he often ignored Stryker's directions. This led to continuous friction between the two, and eventually to Evans's dismissal. However, while his time under Stryker was relatively brief, Evans made superb use of it. The majority of his photographs for the Resettlement Administration—and the most celebrated pictures of his entire career—were produced in an intense fifteen months spanning the summers of 1935 and 1936. During this period, he photographed in West Virginia and Pennsylvania before traveling through Mississippi, Louisiana, Alabama, Georgia, and South Carolina. He recorded working-class houses, barber shops, general stores [249], small-town main streets, gas stations, statues, churches, cemeteries, train stations, people at parades and picnics, a dump of rusted old cars, and, in Birmingham, Alabama, a local portrait photographer's display window.

Evans's penetrating intelligence and dispassionate clarity transforms these common subjects into deeply moving emblems of human existence. The originality of this work was evident to the most astute viewers of the period. Literary critic Lionel Trilling noted that what "immediately strikes me about [Evans's] work is its perfect *taste*, taking that word in its largest possible sense to mean tact, delicacy, justness of feeling, complete awareness and perfect respect. It is a tremendously impressive moral quality."[406] Kirstein observed, "The power of Evans's work lies in the fact that he so details the effect of circumstances on familiar specimens that the single face, the single house, the single street, strikes with the force of overwhelming numbers, the terrible cumulative force of thousands of faces, houses and streets."[407] And finally, in the radiant commonplaces of these photographs, poet William Carlos Williams observed that "It is ourselves that we see, ourselves lifted from a parochial setting. We see what we have not heretofore realized, ourselves made worthy in our anonymity."[408]

Evans's most memorable work was produced in collaboration with writer James Agee in the summer of 1936. Commissioned by *Fortune* to investigate the plight of Southern tenant farmers, Evans and Agee lived with one family in Hale County,

171 Talbot M. Brewer, *The "Comics," Spain*, 1930, 13⅝ x 10″

Alabama, and were in intimate contact with two neighboring households, for a month.[409] Agee talked at length with these subjects and made notes on every detail of the experience. Evans photographed the members of these families individually and in groups, and recorded their houses and environments [172, 248]. While many of his most powerful images are devoid of people, they poignantly evoke the human presence. His pictures of bedrooms and kitchens convey a painfully spare, but never squalid, way of life. Indeed, his photographs reveal a powerful sense of order and dignity, even in the midst of abject poverty. Through his choice of viewpoint and framing, Evans presents the simplest things—a chair, bed, towel, pair of shoes, child's grave, or grouping of kitchen utensils—as symbols of primal human realities: labor, sustenance, faith, mortality.

Rejected by *Fortune*, the Agee-Evans collaboration was published in book form by Houghton Mifflin in 1941 as *Let Us Now Praise Famous Men*. As a reflection of the coequal status of Evans's photographs and Agee's words, the book is divided into two sections: the photographs, presented full page without captions of any kind, followed by the lengthy text. The combination is both startling and effective. Evans's precise images form the perfect foil to Agee's poetic and self-reflexive writing. Ultimately, the book describes the lives of the tenant families in exhaustive detail while holding the documentary process itself up to examination. This remarkable volume received little attention when it first appeared. However, since its reissue in 1960 it has been acclaimed as one of the most important American books of its time.[410]

The definitive monograph of Evans's photographs appeared three years prior to *Let Us Now Praise Famous Men*. In 1938, Evans became the first photographer to be given a one-person exhibition at the Museum of Modern Art.[411] To accompany this show, the museum published *American Photographs*, a small but handsome book with eighty-seven reproductions and an eloquent essay by Kirstein. The images were selected and sequenced to extraordinary effect. Collectively, Evans's photographs constituted, in Kirstein's words, nothing less than the "physiognomy of a nation."[412] Unlike the many other photographic books on the United States produced in this period, Evans's work avoids nationalistic boosterism and picturesque clichés. Instead, his exacting pictures suggest the complexities and contradictions of American society through such themes as the effects of the machine age on agrarian ways of life, and the intersection of mass and folk culture. The America of *American Photographs* is a curious synthesis of vitality and exhaustion, present and past, the sublime and the mundane. While *American Photographs* had its critics, Evans's enormous influence on later generations of photographers has been largely the result of this brilliant book.[413]

The conceptual richness of *American Photographs* is signaled by the book's first image: *License-Photo Studio, New York*, 1934 [3]. On the most obvious level, this is a depiction of a simple commercial structure. While this building lacks any trace of architectural distinction, the formality of Evans's vision imbues it with an unexpected quality of presence, of character, and even a kind of whimsical grandeur. The building is covered with words: an invitation to *read* that hints that the images to follow should not simply be scanned, but rather studied—or deciphered—as parts of a narrative whole.[414] The profusion of voices in American life is suggested by the physical form of these words: stenciled, hand-

172 Walker Evans, *Sharecropper's Wife, Hale County, Alabama*, 1936, 7 1/2 x 2 5/8"

lettered, weathered, and superimposed on earlier words. It is also evident in the messages themselves, which range from official statements of fact ("1934 Plates Here") to personal confession ("Tootsie Love Fina") and a playful quotation from popular culture ("Come Up and See Me Sometime.")

Most importantly, as the repetition of the word "photos" underscores, Evans's photograph is a meditation on photography itself—its utter familiarity in modern life, and its astonishing range of applications. It is significant that this license-photo studio represents the most impersonal and thoughtless use of photography that could be imagined. Evans's pictures, on the other hand, are among the most individual and cerebral ever made. However, as Evans well knew, both bodies of work are based on a reverence for photographic fact: the camera's ability to precisely describe visual traits, to compare and contrast examples of a given species or class. License photographers produced a literal catalogue of Americans; Evans created a symbolic catalogue of America. Evans's achievement is art of the highest order. Tellingly, however, he begins by rejecting the aesthetic mannerisms of the day and by paying homage to the artless clarity of the common ID photo.

173 Dorothea Lange, *White Angel Breadline, San Francisco*, 1933,
11⅝ x 10″

Dorothea Lange's work has also powerfully shaped our collective memory of Depression-era America, as well as our understanding of what it means to make documentary photographs. The empathy so characteristic of Lange's pictures stemmed, in part, from what she described late in life as "the most important thing that happened to me."[415] At age seven, Lange was stricken with polio in her right leg, resulting in a lifelong limp. This mild disability sensitized her to the plight of others, and to the expressive language of the body.

Lange's photographic career began with entry-level positions in several New York portrait studios, including that of Arnold Genthe, and brief attendance of the Clarence White School. Lange moved to San Francisco in 1918, where she established a successful portrait practice.[416] However, the next decade was significant more for Lange's family life—her marriage to the painter Maynard Dixon and the birth of two sons—than for the originality of her work.[417]

Lange came into her own as a photographic artist in 1932-34, the most desperate years of the Depression. After weeks of watching unemployed men on the street below her second-floor gallery, Lange felt compelled to record the social tragedy around her. Her first important documentary image was made at a bread line established by a wealthy woman nicknamed the "White Angel." Lange focused on a solitary figure who appears to have turned away from the line in a mixture of shame and hopelessness [173]. His slumped shoulders, worn clothes, and battered tin cup suggested the physical and emotional state of many similar men across the nation. This man's anonymity, preserved by the obscuring brim of his hat, only emphasizes his role as the Depression's "Everyman." This image reveals the key to Lange's working method: her ability to distill complex situations to a sin-

gle, powerfully symbolic motif. Through her emphasis on such telling details, Lange eloquently evoked the larger feelings of desperation, anger, and fear that lay so heavily on the nation.

In the following months, Lange produced many powerful images of San Francisco's demonstrations, strikes, and food lines [247]. This work greatly impressed Willard Van Dyke, who exhibited Lange's photographs at his 683 Brockhurst Gallery in Oakland in the summer of 1934, and wrote a glowing profile of her for the October issue of *Camera Craft*.[418] This marked a turning point in Lange's career. In addition to the praise it garnered, the exhibit resulted in Lange's introduction to Paul S. Taylor, a professor of economics at the University of California at Berkeley. Taylor, a recognized expert on labor subjects, used one of Lange's photographs to illustrate his article in *Survey Graphic* on the San Francisco general strike.[419] A lifelong professional and personal relationship ensued, and they were married in late 1935.

Taylor's ideas gave direction and additional depth to Lange's work. He had made extensive use of the camera himself, in the years 1927 to 1934, to document his field research.[420] As a result, he fully understood the power of Lange's photographs, and their ability to give human dimension to his writing. Lange, in turn, admired Taylor's grasp of social and economic issues, and embraced his belief in the persuasive union of words and pictures. As a result, in her later service with the Resettlement Administration, Lange was the most conscientious of Stryker's photographers in writing captions for her images. Taylor and Lange made a superbly effective team in their work for the California State Emergency Relief Administration, documenting the plight of migrant workers and Dust Bowl refugees. The impact of their collaborative reports led to Lange's transfer to the western regional office of the RA in the late summer of 1935.

Lange worked under Stryker's authority until 1939, persevering through several layoffs and rehirings precipitated by chronically tight federal budgets. In addition to her work in California, she photographed in the American South and Southwest, and even traveled as far east as New York City. She often worked in tandem with Taylor, then employed as a researcher for the Social Security Board.

Repeatedly, Lange's images reveal the human cost of the Depression and Dust Bowl. She photographed people standing in fields or in front of ramshackle farmhouses, surveying desiccated land; refugees on the road west, in cars loaded with belongings, or simply on foot; and families living in crude tents or lean-to shelters in relief camps in California. She used poignant details—a glassy stare, a resigned pose, or a tight-jawed look of stubborn endurance—to suggest both a pervasive climate of hardship and the faith and determination necessary to survive. Her *Migrant Mother*, 1936 [174], made on a cold March day in a migrant pea-pickers camp near Nipomo, California, has become iconic for just these symbolic reasons. In this image, the central figure is at once destitute and resilient, weary far beyond her thirty-two years and an inspiring, modern-day Madonna.

Between government assignments, Lange and Taylor collaborated on one of the most significant documentary books of the era, *An American Exodus: A Record of Human Erosion* (1939). This volume combined Lange's photographs, the words of her subjects, and Taylor's economic and social commentary. Unlike the more subjective tone of *Let Us Now Praise Famous Men*, or

the topical journalism of *You Have Seen Their Faces* (1937) by Margaret Bourke-White and Erskine Caldwell, *An American Exodus* reflected the desire of Lange and Taylor to deal objectively with the social reality of the Dust Bowl. By adhering to the most rigorous standards of documentary practice, they sought not only to record human truths, but to effect social change.[421]

Documentary Fact and Invention

The enormous production of the RA/FSA has much to tell us about both Depression-era America and the practice of documentary photography. From its inception, Stryker's agency collected visual data for a specific political purpose: to support and promote New Deal policies. Many sympathetic to this agenda may have felt that the facts were intrinsically persuasive and only needed to be gathered in sufficient quantity to be useful. However, Stryker and his photographers took a more strategic view of this process based on their knowledge that the meanings of photographs were powerfully shaped by the captions accompanying them. Without such supplemental information, each photograph possessed the ability to tell many stories—or none at all. The caption effectively disciplined the photograph's potential for narrative promiscuity by enforcing a single (and presumably "true") meaning.

Stryker's photographers understood the complexity of the process in which they were engaged. Inevitably, each was influenced by Stryker's coaching and shooting scripts, by the images already in the file, and by their own experience and expressive ideas. Most of the photographers favored a straightforward style and avoided obviously subjective approaches. It was clear, however, that the resulting pictures were not equally powerful or persuasive. Thus, it was understood that the most memorable photographs—the ones that could transcend the specific circumstances of their making to illuminate larger issues—were the result of a deliberate, and individual, process of creation and interpretation.

Critics then and now have been concerned by the tension between an ideal of documentary objectivity and the "constructed" nature of the resulting images. The rise of documentary film-making in the 1930s, for example, gave this issue particular critical importance.[422] It did not take long for the objectivity question to rock the RA. When Arthur Rothstein recorded his steer skull in South Dakota in May 1936, he photographed it twice: first on a dry alkali flat and then a few steps away on a sparse background of scrub grass and cactus. These were powerful images and Stryker did not hesitate to place both in the RA file. However, the public "discovery" of the two versions led to a political scandal during the presidential campaign of 1936. Republicans interpreted Rothstein's relocation of the skull as a blatant fraud—making the drought appear worse than it actually was—and proof that the Democratic administration was not truthfully reporting the nation's economic condition.[423]

This debate struck at the heart of Stryker's operation. Were photographs to be used in an editorial and expressive manner—as, in essence, "positive propaganda"—or were they expected to be neutral bits of unmediated reality? The answer, despite the political brouhaha, was simple: the photographs were clearly intended to serve an instrumental and persuasive function. In addition to being fundamentally impossible, a stance of "com-

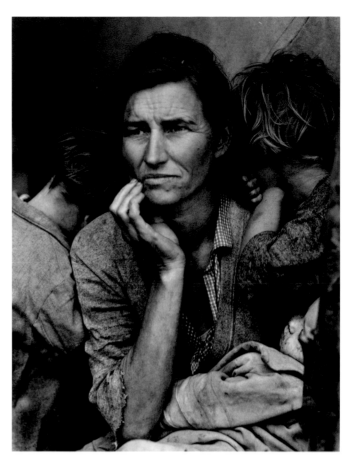

174 Dorothea Lange, *Migrant Mother, Nipomo, California*, 1936, 13⅜ x 10¼"

plete" factual neutrality would not have produced terribly powerful or useful images. An expressive point of view was thus both inevitable and essential. The concept of "good" propaganda was understood and embraced by nearly all Americans. As a characteristic essay of the time put it:

> Reduced to simple terms the issue has been whether the creative artist should become a propagandist for social, political, economic and religious ideals and thus lend his talents for the achievement of a better world or whether his function is to create haphazardly, without any social purpose, for the mere end of expressing himself.[424]

Clearly, the "achievement of a better world" was vastly more important than either amoral neutrality or "mere" self-expression.

Understanding this aspect of documentary practice allows us to better appreciate the genesis of some of the most memorable photographs of this era. Rather than a purely spontaneous and candid image, Rothstein's now-classic *Dust Storm, Cimarron County, Oklahoma* [**244**] was one of some seventy-seven photographs he made in close collaboration with his subjects, a farmer with his young sons.[425] Lange's *Migrant Mother* [**174**], the last of a half-dozen exposures at this scene, was taken at the end of a ten-minute session in which these subjects willingly cooperated by arranging themselves for her camera. To increase the aesthetic power of this image, Lange later spotted out a distracting detail from her original negative: a thumb grasping the support pole in the bottom right corner of the frame.[426] While this act violated Stryker's notion of objectivity, Lange felt it was justified on purely aesthetic grounds: it made a better *picture*. Finally, it

has even been suggested that the exquisite order of Walker Evans's photographs may stem, in part, from his intervention in the scenes depicted. For example, a comparison of his images with passages of Agee's text in *Let Us Now Praise Famous Men* suggests that Evans moved objects in the sharecroppers' houses for aesthetic effect.[427] If so, it is not surprising that his photographs convey a consistent—and artistically satisfying—sense of order. This awareness of the photographers' interventions should not decrease our respect for their achievements. In fact, it should only increase our interest in these images by reminding us of their inevitable union of fact and opinion.

The Triumph of Photography

In the 1930s, photography reached an unprecedented level of popular and critical acclaim. The camera was embraced as the paradigmatic instrument of modern perception, the emblem of a uniquely visual age. The medium's democratic appeal resulted in burgeoning sales of film, cameras, and darkroom equipment. By the end of the decade, over 5,000 camera clubs were in existence across the nation.[428] In addition to making photographs in ever-increasing numbers, Americans consumed them as never before. The Depression era's thirst for realism accelerated the use of photography in the mass media. During the 1930s alone, newspapers increased their use of photographs by 57 percent.[429] By 1935, the camera was used for 90 percent of all printed-page advertising.[430]

The most popular photographic publication of the era was *Life*, the brainchild of Henry Luce. From its first issue, dated November 23, 1936, *Life* achieved enormous success by picturing subjects of broad public interest. In the days before television, a remarkable number of people received their primary news of national and global events through its pages. The entire *Life* operation was boldly oversized. By 1937, the magazine's editors received some 12,800 photographs per week and selected about 200 for each issue. Each weekly press run of one million copies required 750,000 pounds of paper and four days of round-the-clock printing.[431] The leading photographers on the magazine's early staff included Margaret Bourke-White, Alfred Eisenstadt, Tom McAvoy, Peter Stackpole, Carl Mydans, John Phillips, Hansel Mieth, and William Vandivert. *Look*, which began in January 1937, also made extensive use of photography. These two publications spawned numerous short-lived imitations with names such as *Click*, *Foto*, and *Pic*.[432]

The print media's enormous appetite for news photographs was supplied largely by syndicated picture agencies such as Associated Press, Acme News Service, and Wide World Photos. While justly celebrated for the quality of their work, *Life*'s own photographers in 1937 contributed a mere 6 percent of the images considered by the magazine's editors each week. About half of this total came from the picture services, with amateur work comprising most of the rest.[433] Improvements in the wire transmission of photographs allowed the major picture agencies to inaugurate widespread use of this technology in 1935-36.[434]

In addition to such informational uses, photographs were presented for purely aesthetic purposes in a variety of journals. These included mass-market publications such as *Vanity Fair*, business magazines such as *Fortune*, literary journals such as the *Little Review*, international annuals such as *Modern Photography* (London), and numerous photographic monthlies.[435] Among general-interest publications, *Scribner's* and *Coronet* made particularly impressive use of photography. In August 1937, *Scribner's* introduced its "Portfolio of American Photography," featuring full-page reproductions of work by a variety of notable photographers.[436] *Coronet*, which debuted in late 1936, paid remarkably consistent attention to serious photography. Under the editorship of Arnold Gingrich, *Coronet* published artistic images by many leading American and European photographers, as well as feature articles on Stieglitz, White, Abbott, Lynes, Bourke-White, Hine, and others.[437]

For serious photographers, two of the most important publications of this decade were the *U.S. Camera* annuals and magazine, both edited by Tom Maloney.[438] The first *U.S. Camera* annual appeared in the fall of 1935, while the magazine debuted in late 1938. These large-format publications presented much more challenging work than such conservative journals as Frank R. Fraprie's *American Photography* and *American Annual of Photography*.[439] The vitality of Maloney's publications was underscored by the stature of his advisors and supporters. Edward Steichen played a central role in both the magazine and the annual, and other leading figures of the day—including M. F. Agha, Arnold Genthe, Ira Martin, Will Connell, and Paul Outerbridge—served on Maloney's editorial board.

Thanks to the special renown of a handful of figures, the publication of serious photographic books made a tentative start in this era. One of the first of these was *Steichen the Photographer* (1929), a lavish tribute written by the artist's brother-in-law, Carl Sandburg. Similarly deluxe was Merle Armitage's *The Art of Edward Weston* (1932), a limited edition of 550 copies, all signed by the artist.[440] Autobiographies by William Henry Jackson and Arnold Genthe—*The Pioneer Photographer* (1929) and *As I Remember* (1936), respectively—reached a considerably larger audience. Constance Rourke's path-breaking biography, *Charles Sheeler: Artist in the American Tradition* (1938), was perhaps the first serious art-historical study of a modern photographer.[441] Other notable volumes of this era include Lewis Hine's *Men at Work* (1932), *Roll, Jordan, Roll* (1933), with gravures by Doris Ulmann, Anton Bruehl's *Mexico* (1933), Robert Capa's *Death in the Making* (1938), Walker Evans's classic *American Photographs* (1938), Harold Edgerton's *Flash! Seeing the Unseen by Ultra High-Speed Photography* (1939), and *An American Exodus* (1939) by Lange and Taylor.[442]

This expansion of the literature of photography was accompanied by a new critical and historical sophistication. Nicholas Ház, one of the most eloquent proponents of photographic modernism, contributed numerous articles to *The Camera*, *Camera Craft*, *American Photography*, *American Annual of Photography*, and *Popular Photography*.[443] Elizabeth McCausland and others also wrote insightfully on the medium for newspapers and magazines.

The history of American photography received unprecedented attention in the 1930s. Nineteenth-century figures such as William Henry Jackson were rediscovered (he lived until 1942), and innumerable profiles were written on more recent photographers. A scholarly approach to American photography

was initiated by Robert Taft, a professor of chemistry at the University of Kansas. Rejecting the encrustations of anecdote and legend, Taft's articles on daguerreian-era photographers such as Mathew Brady and John Plumbe were characterized by careful research in primary sources.[444] Taft's work culminated in the publication of his still-remarkable book *Photography and the American Scene* (1938). Working at the same time, in his position as librarian at the Museum of Modern Art, the young Harvard-trained scholar Beaumont Newhall published *Photography 1839-1937* (1937) to accompany a large exhibition he organized for the museum.[445] An expanded version of this work was released the following year as *Photography: A Short Critical History*, which in subsequent revisions (1949, 1964, 1982) became the classic introductory text *The History of Photography*.[446] While Taft took a technical and social perspective on the medium, Newhall's was based on an art-historical model and a sympathy for the New Vision and purist sensibilities.

Photographs became increasingly prominent in commercial galleries beginning in the late 1920s.[447] Between 1929 and 1934, the Delphic Studios in New York City presented one-person shows of the work of Clara Sipprell, Doris Ulmann, Edward Weston, Anton Bruehl, Wynn Richards, László Moholy-Nagy, Ansel Adams, and Edward Quigley. Between 1935 and 1941, the Katherine Kuh Gallery in Chicago mounted exhibits of the work of Adams, Weston, Moholy-Nagy, and Kepes.[448]

The Julien Levy Gallery in New York was one of the leading showcases for photography, giving it equal billing with contemporary painting.[449] Levy's first exhibition, "American Retrospective," mounted in November 1931, featured the work of Strand, Sheeler, Steichen, White, Brigman, Käsebier, and Stieglitz. The French photographers Atget and Nadar were the subject of his third show, a month later. In the first half of 1932, Levy mounted an impressive series of exhibitions: "Surréalisme" (which combined the work of artists such as Picasso, Max Ernst, and Salvador Dali with photographs by Bayer, Man Ray, Moholy-Nagy, and others), "Walker Evans and George Platt Lynes," "Modern European Photography" (which included Bing, Kertész, Lee Miller, Moholy-Nagy, Henri, and others), "Man Ray," and "New York by New Yorkers" (featuring Abbott, Baasch, Bratter, Bourke-White, Martin, Offner, Steiner, and others). Over the next three years Levy hosted several group exhibitions as well as one-person shows by Abbott, Miller, Baasch, Cartier-Bresson, Richards, Lynes, and Brett Weston.

Museums and nonprofit galleries across the nation presented photographic exhibitions with increasing frequency in this era. In 1929, for example, the Arts Club in Chicago mounted a large survey of Man Ray's photographs. In 1930, Lincoln Kirstein assembled an exhibition of international photography for the Harvard Society for Contemporary Art. Modeled on European precedents such as "Film und Foto," Kirstein's survey included work by Stieglitz, Strand, Sheeler, Steiner, Modotti, Weston, Ulmann, Bourke-White, and Bruehl; younger Americans such as Evans and Abbott; and a selection of scientific, medical, and journalistic images.[450] Other important group shows of this period include "Modern Photography at Home and Abroad," hosted by the Albright Gallery in Buffalo, and the Brooklyn Museum's "International Photographers," both of 1932. In 1934, the Cleveland Museum of Art mounted a major exhibition of work by Steiner, Weston, Steichen, Bourke-White, Quigley, Stieglitz, and Bruehl.[451] The important exhibitions hosted in this period by the M. H. de Young Museum in San Francisco reflected the progressive vision of the museum's director, Lloyd Rollins.

The end of the decade saw several large museum exhibitions. Newhall's seminal "Photography 1839-1937" included 841 items and filled four floors of the Museum of Modern Art. This mammoth show took a catholic view of the medium's history, embracing the most refined artistic pictures as well as press photographs, X-rays, and astronomical images. This curatorial perspective, obviously indebted to the ideas of Moholy-Nagy and the example of figures such as Kirstein, was modified in Newhall's subsequent work, which shifted toward Stieglitz's more discriminating notion of photographic art.[452] The importance of Newhall's 1937 show was magnified by its tour to ten additional sites around the country.[453] Other notable exhibitions of this period include the "First International Exposition of Photography," held at the Grand Central Palace in New York in 1938; this contained a special display of FSA work titled "How American People Live."[454] Ansel Adams's "Pageant of Photography" was held at the Golden Gate Exposition, in San Francisco, in 1940. This ambitious show, surveying the medium's entire history, was accompanied by a catalogue with essays by writers as diverse as Newhall, Lange, Moholy-Nagy, Outerbridge, Edward Weston, and an astronomer from Lick Observatory.[455]

This growing interest in photographic exhibitions was followed—albeit more slowly—by the establishment of institutional collections. The Museum of Modern Art was the clear leader in this regard. Otherwise, however, the collecting of photographs remained a surprisingly reluctant or casual activity, with few institutions playing an active role. The examples of the Boston Museum of Fine Arts and the Metropolitan Museum of Art are instructive. The Boston museum's photography collection was begun in early 1924, when, at the urging of Ananda K. Coomaraswamy, its keeper of Indian art, Alfred Stieglitz's gift of twenty-seven of his own photographs was accepted. Other donations followed: prints by Offner and White, for example, and, in the 1930s, a large collection of daguerreotypes by the Boston firm of Southworth and Hawes. However, the museum did not actually purchase a photograph for its holdings until 1967.[456]

At the Metropolitan, photographs of art and architecture had been collected in great quantity for years. However, it was only in 1928 that photography was first accepted on its own artistic merit. In December of that year, thanks to the encouragement of print curator William M. Ivins, Stieglitz donated twenty-two of his photographs to the museum. In 1929, Outerbridge gave ten of his own prints. In 1933, Stieglitz provided the foundation for future growth by giving a vast collection of work by his former Pictorialist and Photo-Secession associates: a total of 419 prints. The museum's first significant purchase of photographs was also made in 1933—a group of Civil War images—and the collection grew steadily from there. Interestingly, however, it took until 1992, with the creation of the museum's Department of Photographs, for this holding to be officially recognized as an independent entity.[457]

The commercial world showed no such reluctance in embracing photography. Indeed, a remarkable concordance existed between the realms of art and commerce in the 1920s and 1930s.

Art directors and picture editors embraced photography as a dynamic expression of modern life, and purist and New Vision-inspired images were seen in all manner of publications, from *Harper's Bazaar* to *Farm Journal*.[458] Advertisers valued the modernist style for its ability to command attention through bold contrasts and unusual compositions. The power of the image-word union was effectively illustrated in a 1930 Young and Rubicam advertisement promoting its business. Under the word "IMPACT," printed in large sans-serif type, was Anton Bruehl's page-filling photograph of a boxer's fist connecting with his opponent's chin. In smaller type below this image, impact was defined as "that quality in an advertisement which strikes suddenly against the reader's indifference and enlivens his mind to receive a sales message."[459] The domesticated radicalism of the modernist photograph was ideally suited to this task.

Edward Steichen was the single most important figure in commercial photography of the 1920s and 1930s.[460] In addition to working for the Condé Nast publications *Vanity Fair* and *Vogue*, he also established fruitful relationships with such leading advertising agencies as J. Walter Thompson, N. W. Ayer & Co., and Young and Rubicam. Throwing himself into this work, Steichen achieved enormous success and influence. As historian Patricia Johnson has observed, for some fifteen years Steichen's work "appeared regularly in almost every mass-circulation magazine published in the United States."[461] In addition to influencing the overall look of commercial photography, Steichen elevated the status (and rewards) of the profession. Demanding fees of $500 to $1,000 per picture, he observed in 1932 that his greatest achievement in photography was to have raised prices.[462] A celebrity in his own right, Steichen was the model of professional success in this era.

The kinship of photographic art and commerce reflected the close ties that existed between artists, art schools, and the professional worlds of advertising and design. Many successful art directors and industrial designers had attended art schools; some maintained these ties by returning to lecture to students, or by undertaking full-time teaching duties. A handful of influential art directors were, themselves, active artists and photographers. For example, despite the quality of his own photography [120, 192], Guy Gayler Clark was best known as an art director and educator. After studying at Pratt Institute and the New York School of Art, Clark began his career as an art director in 1914 at the *New York Times*. He went on to hold important positions in this field with Street & Finney and other firms. In later years, he served as dean of the Cooper Union Art School. Similarly, despite his work in photography [140], watercolor, and painting, William A. Strosahl is best remembered as an art director. From 1930 to 1969, he held increasingly important positions with the J. Walter Thompson advertising agency, and the William Esty Company, both in New York City. He maintained his interest in photography at least through the 1930s, and even published articles on the subject.[463]

The work of Clarence White and his associates was central to this union of art and utility. White himself began accepting advertising assignments as early as 1912.[464] As noted above, many of his associates and students enjoyed prominent careers in advertising and commercial photography. White was friends with leading art directors, and brought many of them to lecture at the

White School: Heyworth Campbell of *Vogue*, for example, and Pierce Johnson of J. Walter Thompson. The opening of the Art Center, in 1921, brought the White group's photographic association—the PPA—into close alliance with groups such as the American Institute of Graphic Art, the Society of Illustrators, and the Art Directors Club. In addition to hosting regular lectures, the Art Directors Club mounted annual competitive shows of advertising art at the Art Center. These exhibits included photographs by most of the leading figures of the day, and were documented in an impressive series of publications, the yearly *Annual of Advertising Art*.[465]

Other exhibitions of this period celebrated advertising images as both utilitarian and aesthetic achievements. In 1929, the Philadelphia advertising firm N. W. Ayer & Co. began hosting an annual exhibition of contemporary American photography. These shows, held at least three years in a row, included the work of such noted figures as Abbott, Bourke-White, Bruehl, Fitz, Sheeler, Steichen, Steiner, Evans, and Outerbridge.[466] In 1931, the Art Center mounted a 200-print exhibition, "Foreign Advertising Photography," with images by de Meyer, Man Ray, Moholy-Nagy, Bayer, and Henri. An even larger exhibition of contemporary "Illustrative Photography" was displayed at Rockefeller Plaza, in New York, in the fall of 1934. This show toured to ten additional sites—art museums, universities, and at least one department store—across the nation.[467] As a result of this kind of recognition, Steichen and Bourke-White became household names, while many other professionals achieved a remarkable degree of popular renown.

The vitality of American photography in this era was only reinforced by the effects of the political and economic calamities in Europe. The global depression, the rise of German Nazism, and the beginning of World War II combined to drive waves of Europe's best and brightest to the United States. While some of these refugees stayed for only a few years, many settled permanently, adding immeasurably to the nation's cultural life. Among the photographers who came to the United States in this decade were Herbert Bayer, Ilse Bing, Ruth Bernhard, Alfred Eisenstadt, John Gutmann, Philippe Halsmann, Horst P. Horst, George Hoyningen-Huene, Lotte Jacobi, Gyorgy Kepes, André Kertész, Lisette Model, László Moholy-Nagy, Martin Munkacsi, Walter Peterhans, and Roman Vishniac.[468] In addition, editors and art directors such as Mehemed Fehmy Agha, Alexey Brodovitch, Alexander Liberman, and Stefan Lorant also emigrated in this period.

By the time of photography's official centennial in 1939, the medium enjoyed a level of popular and artistic acclaim unimaginable fifty years earlier. At this point, American photography still retained a singular—if inevitably contentious—sense of itself as a unified field. To a remarkable degree, the medium's varied practitioners—New Vision modernists and late Pictorialists, artists and advertisers, snapshooters and scientists—saw themselves as parts of a reasonably coherent whole. This era thus marked an unusual conjunction of harmony and diversity in American photography.

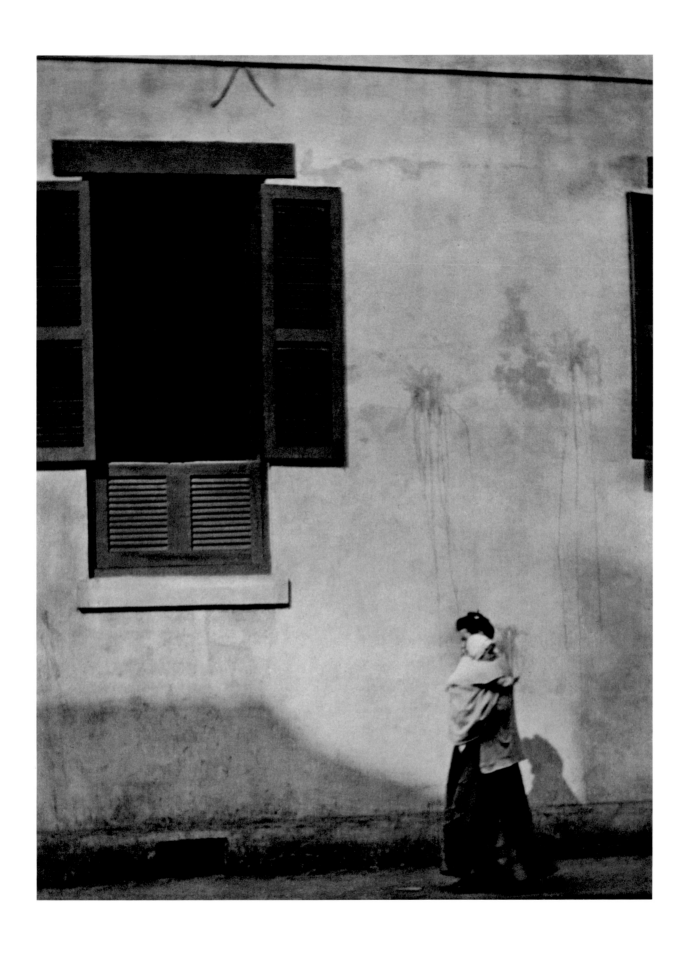

175 Paul Strand, *Woman Carrying Child*, ca. 1915, platinum print, 13⅜ x 9½"

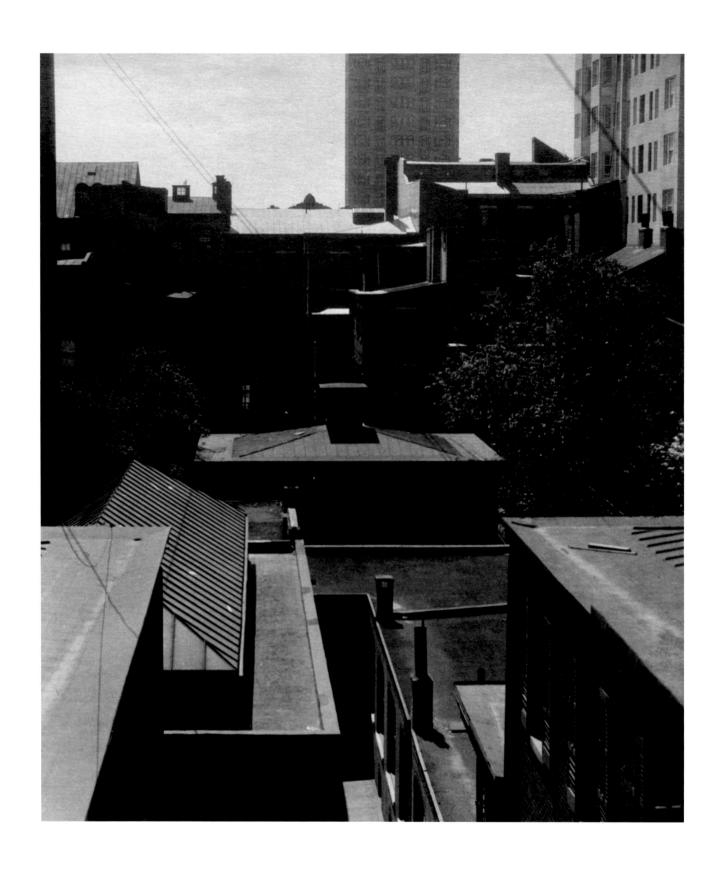

176 Morton Schamberg, *Untitled*, 1917, 8½ x 7⅜″

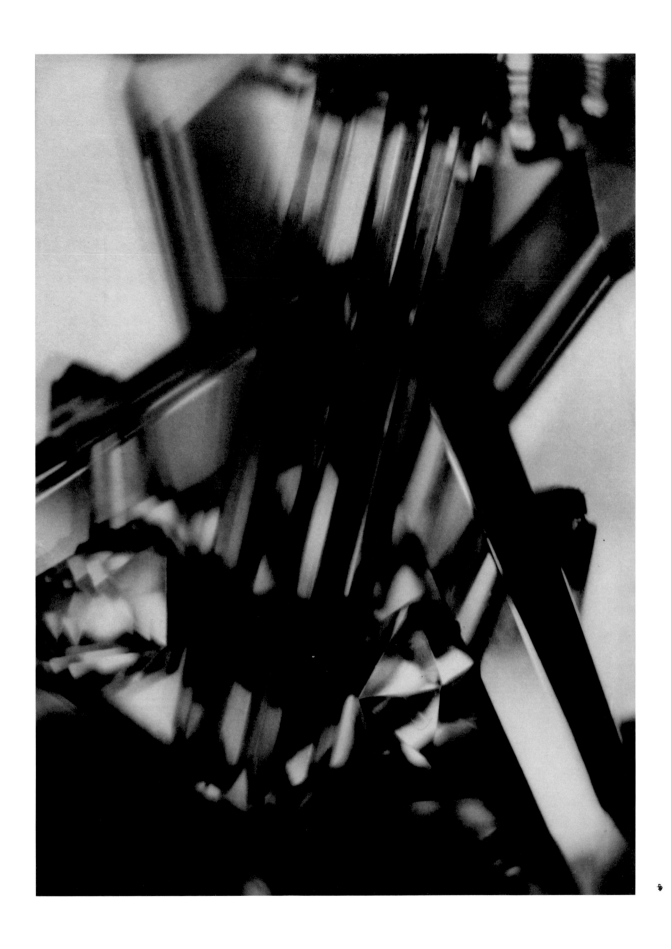

177 Alvin Langdon Coburn, *Vortograph*, 1917, 10⅞ x 8″

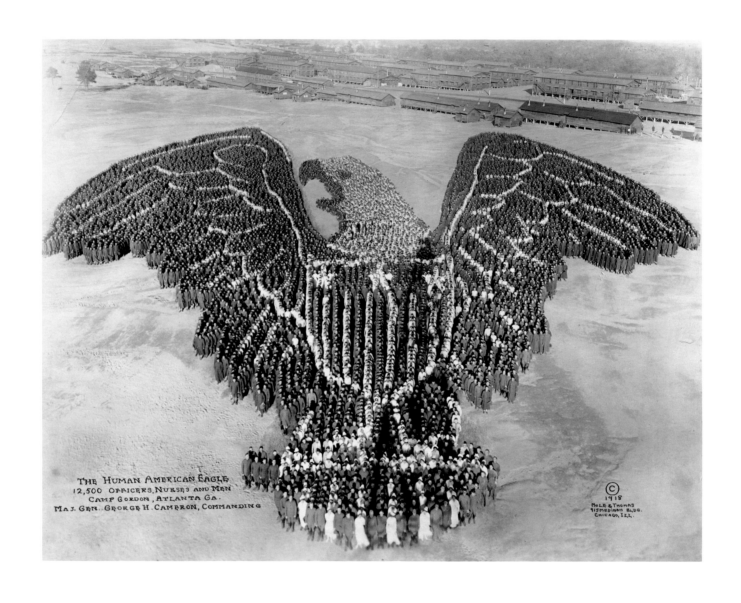

178 Mole and Thomas, *The Human American Eagle: 12,500 Officers, Nurses, and Men, Camp Gordon, Atlanta, Georgia,* 1918, 10⅛ x 13⅛"

179 U.S. Air Corps/Edward Steichen, *Untitled Aerial View*, ca. 1917-18, 9⅞ x 14″

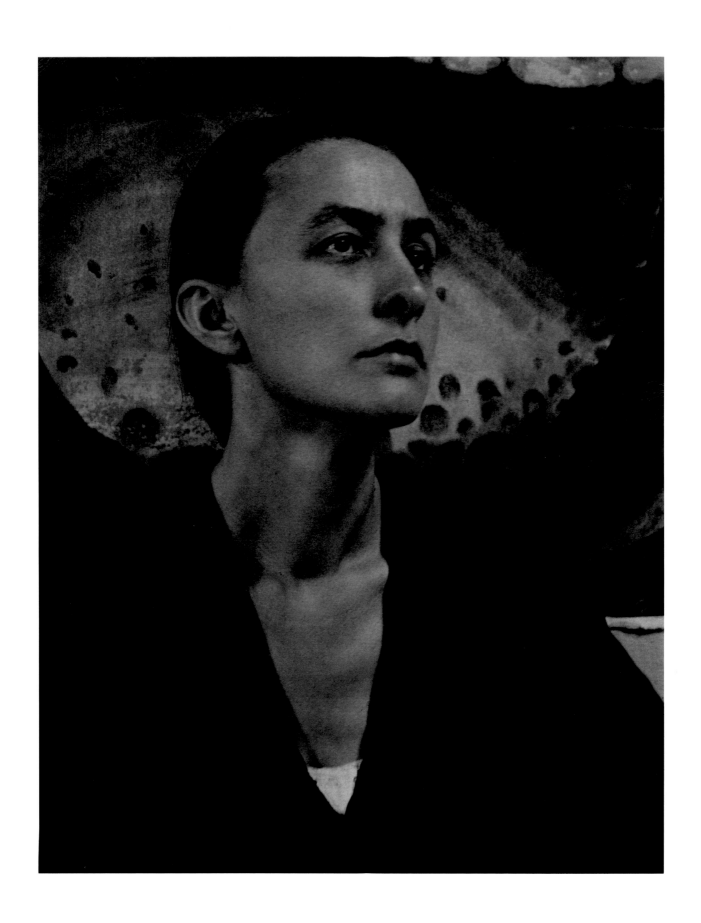

180 **Alfred Stieglitz,** *Georgia O'Keeffe: A Portrait,* 1918, platinum print, 9½ x 7½"

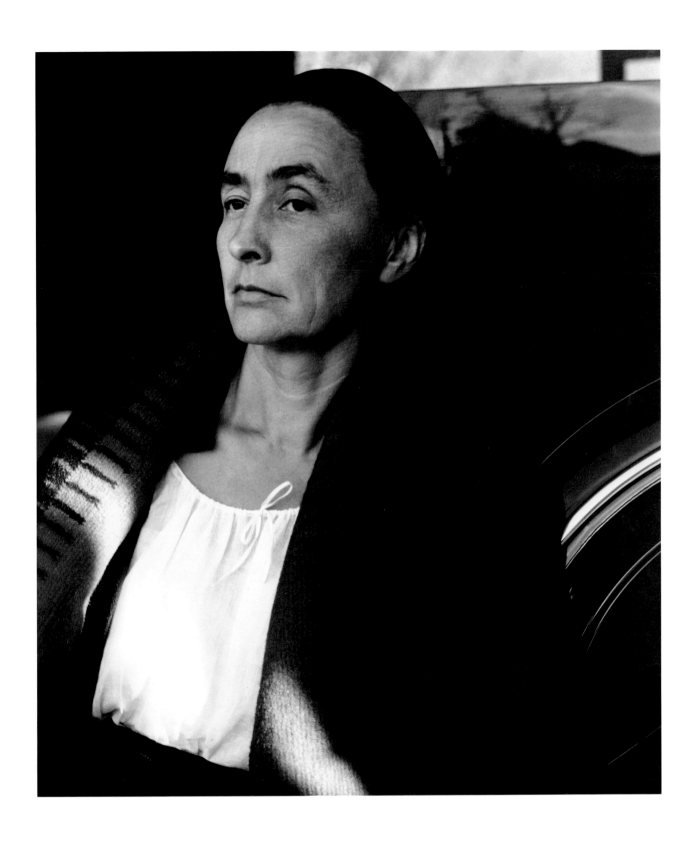

181 **Alfred Stieglitz,** *Georgia O'Keeffe: A Portrait,* 1933, 8⅝ x 7⅜"

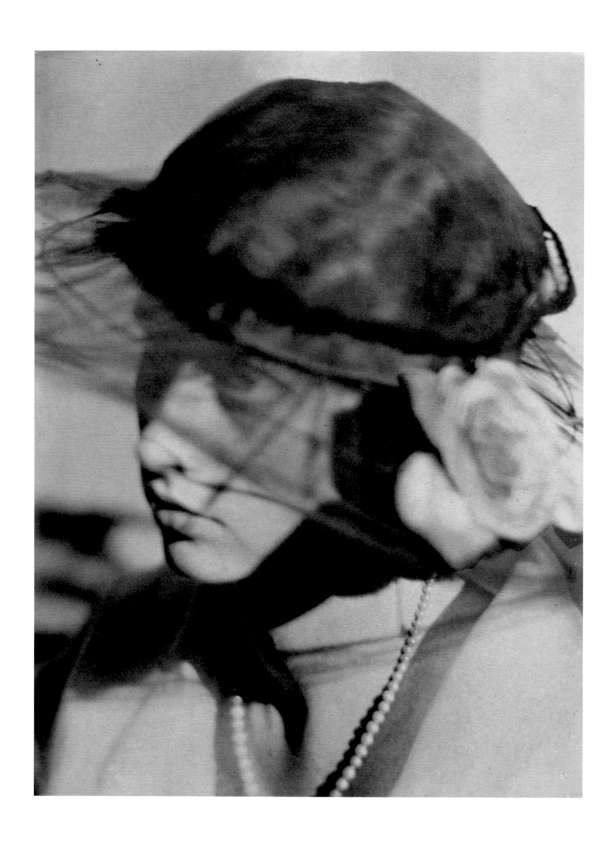

182 Wynn Richards, *Woman with Veiled Hat*, ca. 1918, 8 x 6⅛"

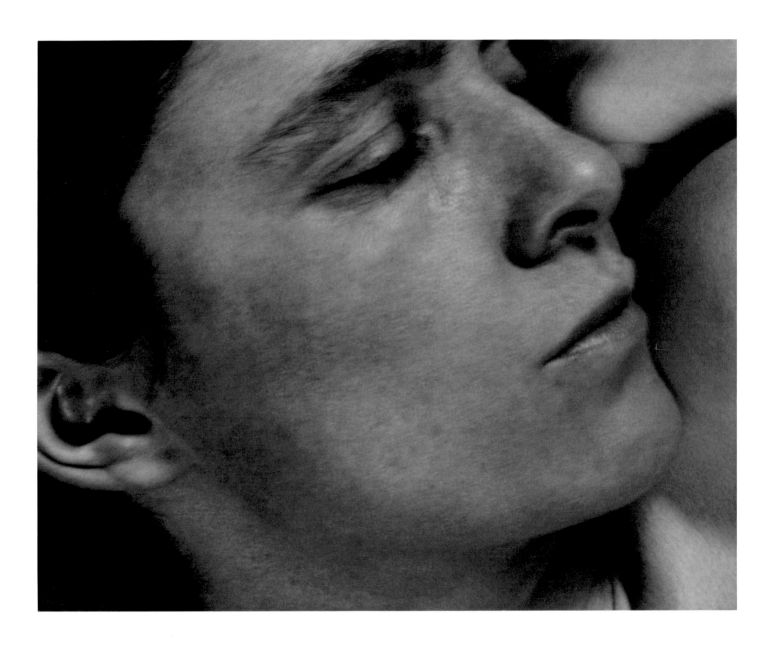

183 **Paul Strand,** *Rebecca, New York*, 1922, platinum print, 7 ¼ x 9 ¾″

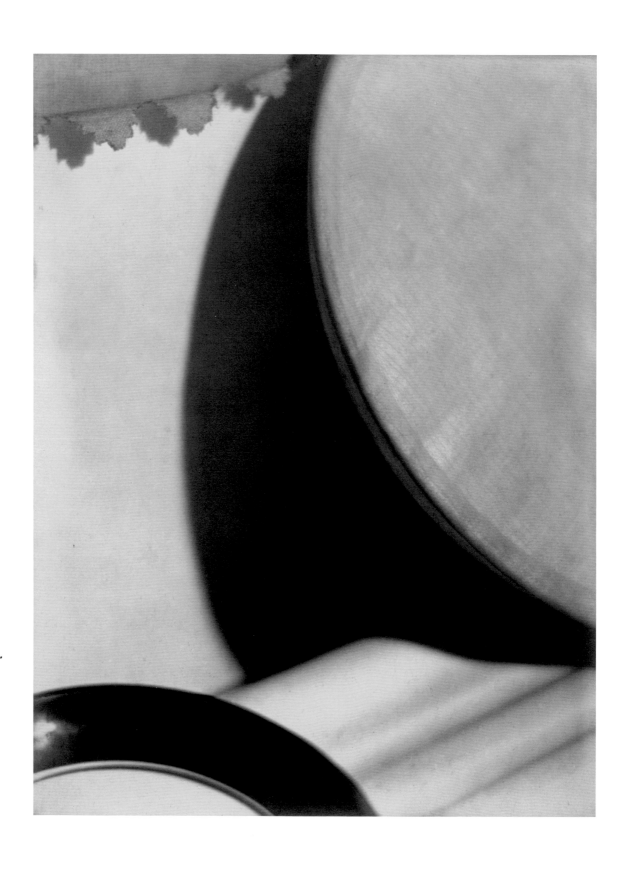

184 Margaret Watkins, *Design—Curves*, 1919, 8¼ x 6¼"

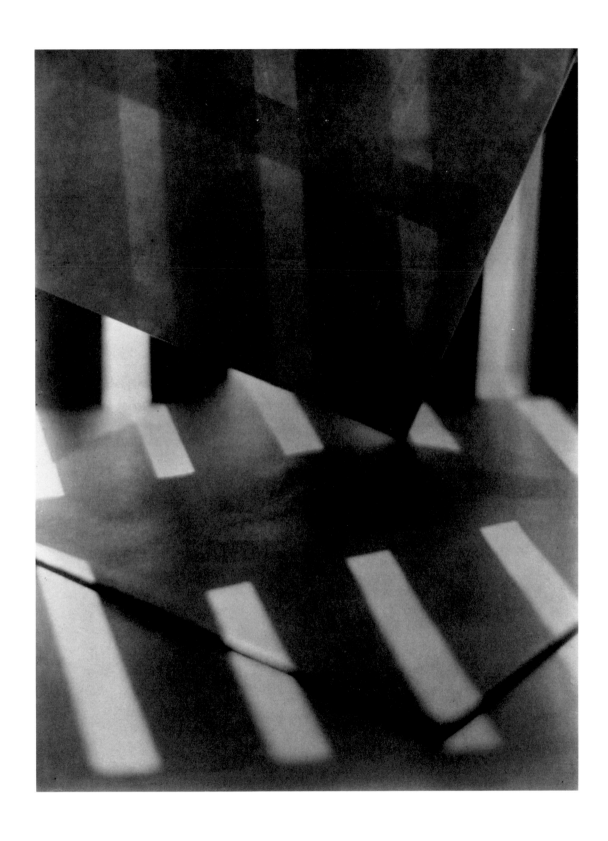

185 **Bernard Shea Horne,** *Design*, ca. 1916-17, platinum print, 8 x 6″

186 **Paul Outerbridge, Jr.,** *Piano Study*, 1924, platinum print, 4½ x 3⅝″

187 **Paul Outerbridge, Jr.,** *Saltine Box*, 1922, platinum print, 3⅜ x 4⅝″

188 **Frances M. Bode,** *Repetition*, 1925, palladium print, 9½ x 7½"

189 **Ralph Steiner,** *Untitled*, ca. 1928, 7⅝ x 9½″

190　**Laura Gilpin,** *Bryce Canyon #2*, 1930, platinum print, 9⅜ x 7⅛″

191 Doris Ulmann, *Untitled*, ca. 1925, 8⅜ x 7″

192 **Guy Gayler Clark,** *The Sewing Basket*, ca. 1916-20, 13⅝ x 10½"

193 Clarence H. White, *Croton Reservoir*, 1925, platinum print, 3½ x 4½"

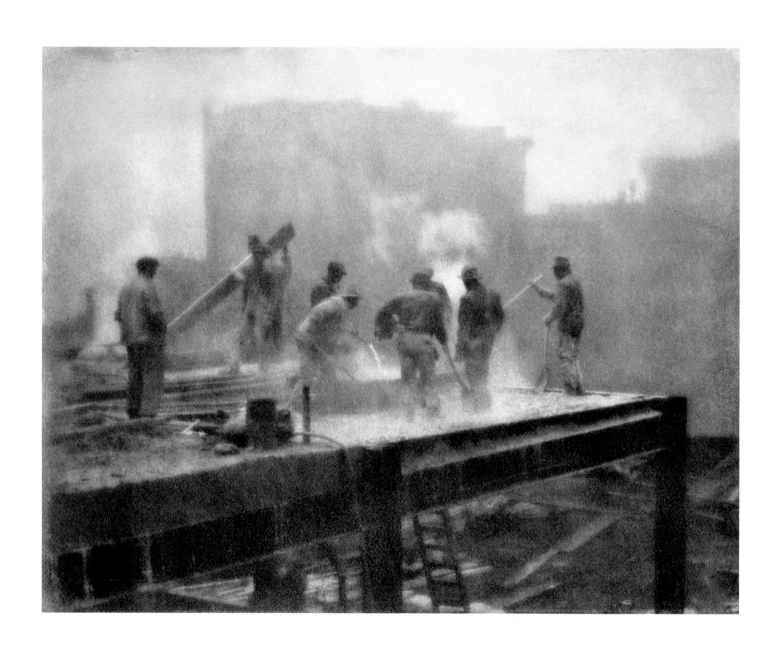

194 **Charles K. Archer,** *Men at work, Pittsburgh*, ca. 1920, bromoil print, 10⅞ x 14″

195 John Paul Edwards, *A Vale in Arcady*, ca. 1916, 9½ x 11½"

196 William E. Dassonville, *Ship Deck*, ca. 1925, 7⅜ x 10″

197 Jane Reece, *Adagio*, ca. 1928-30, 7⅛ x 9¼"

198 Toyo Miyatake, *Untitled*, 1925, 8⅞ x 12⅞"

199 Kentaro Nakamura, *Evening Wave*, ca. 1927, 12½ x 10⅛"

200 Margrethe Mather, *Johan Hagemeyer and Edward Weston*, 1921, platinum print, 7⅝ x 7⅜″

201 Edward Weston, *Karl and Ethel Struss*, 1923, platinum print, 9½ x 7½"

202 Johan Hagemeyer, *Castles of Today*, 1922, 9⅝ x 7⅜"

203 Johan Hagemeyer, *Pedestrians*, 1921, 9¾ x 7⅝"

204 Tina Modotti, *Staircase, Mexico*, 1925, platinum print, 7⅛ x 9⅜″

205 Tina Modotti, *Campesinos*, 1926, 8⅜ x 7⅞"

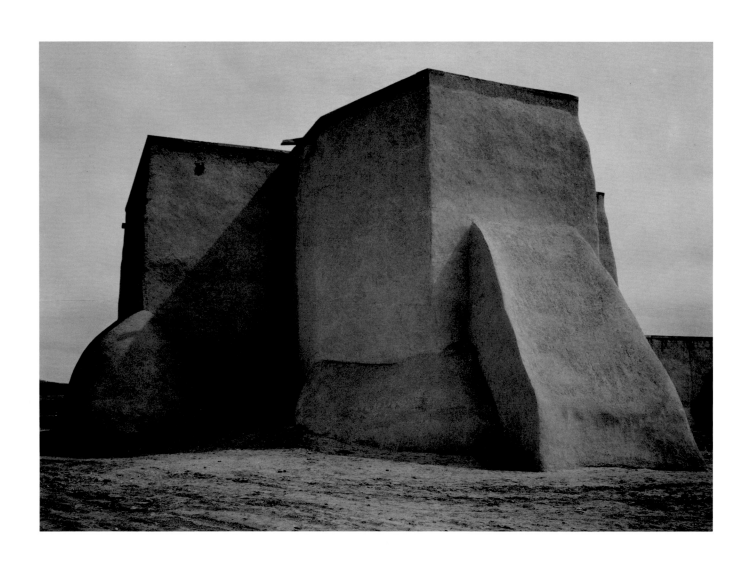

206 **Ansel Adams,** *Church at Ranchos de Taos, New Mexico,* ca. 1929, 5½ x 7″

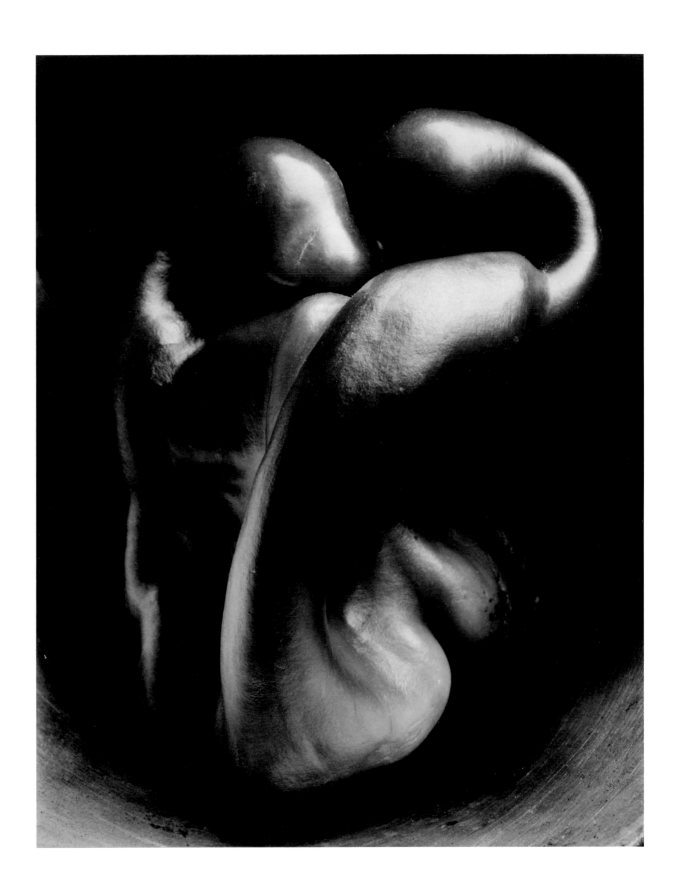

207 Edward Weston, *Pepper No. 30*, 1930, 9⅜ x 7½″

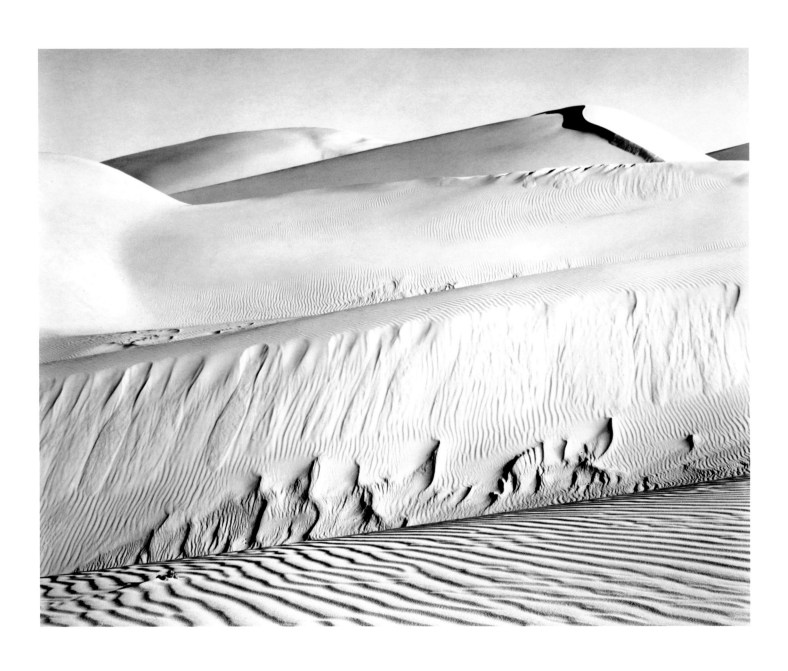

208 Edward Weston, *Sand Dunes, Oceano, California*, 1936, 7⅝ x 9⅝"

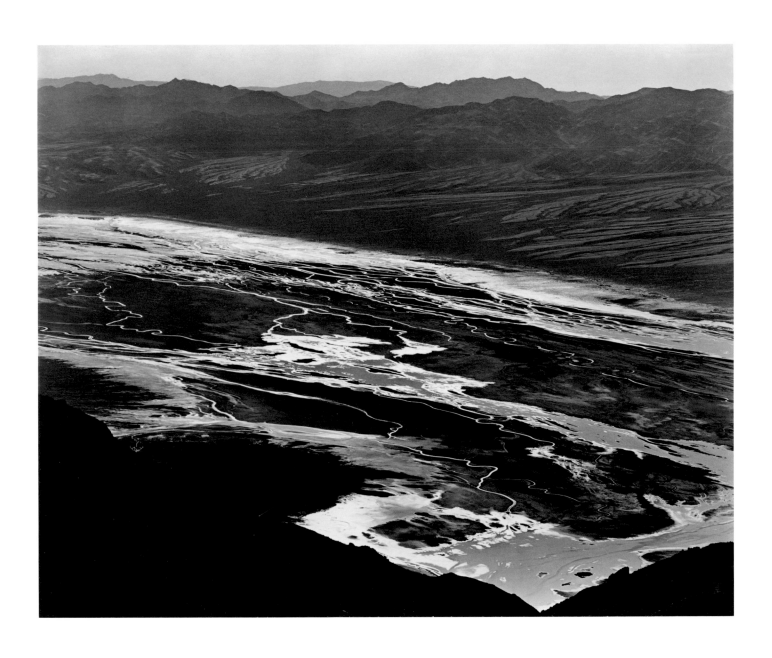

209 Edward Weston, *Dante's View, Death Valley, California*, 1938, 7⅝ x 9½"

210 **Alma Lavenson**, *Chrysanthemum*, 1931, 7⅛ x 9⅝"

211 Imogen Cunningham, *Amaryllis*, 1933, 9½ x 7½"

212 Brett Weston, *Los Angeles*, 1927, 9⅝ x 6⅞"

213 **Brett Weston,** *Car Window, Delux U.S. Company, San Francisco,* 1936, 7½ x 9⅛"

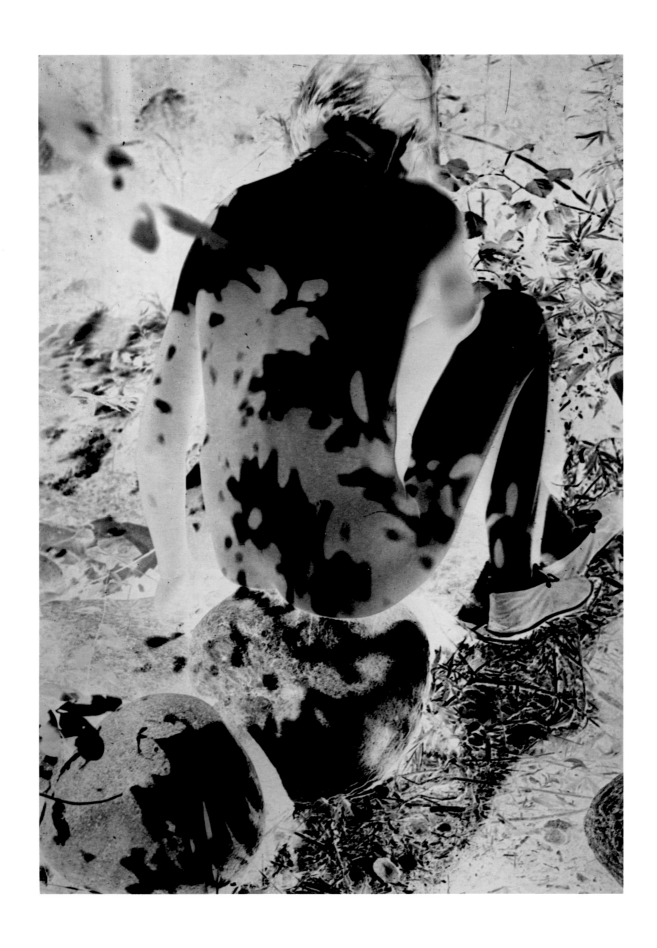

214 László Moholy-Nagy, *Nude*, ca. 1932, 14¾ x 10½″

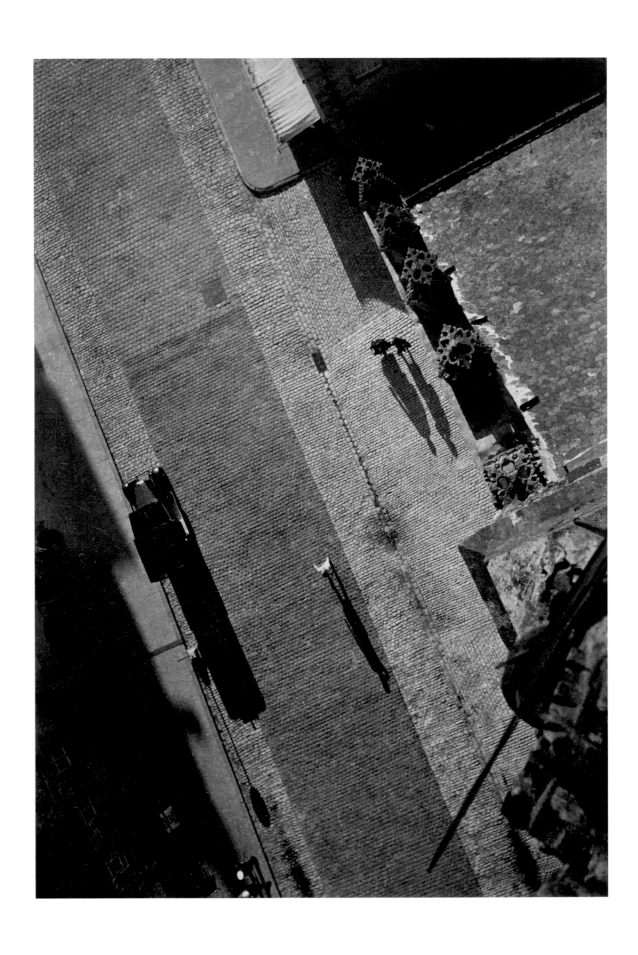

215 László Moholy-Nagy, *Rothenburg ob der Tauber*, 1928, 14½ x 10⅛″

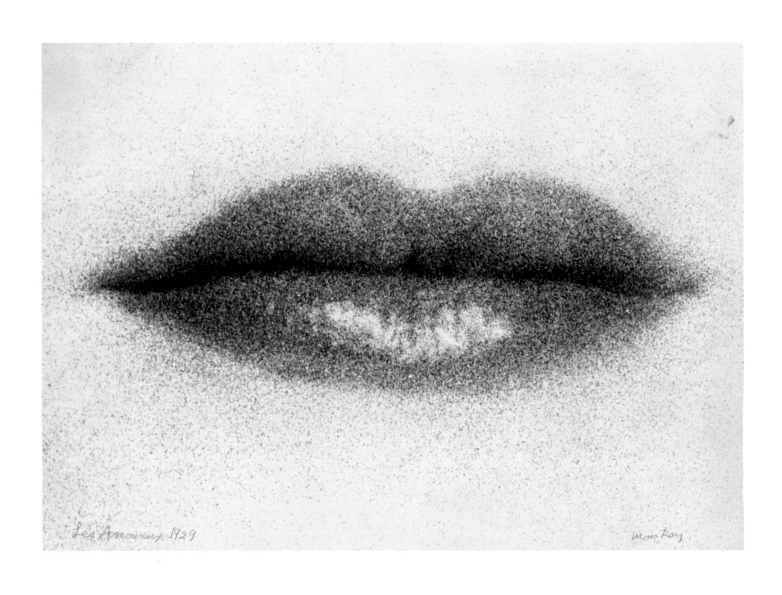

216 Man Ray, *Les Amoureux*, 1929 (print ca. 1940), 16½ x 23½"

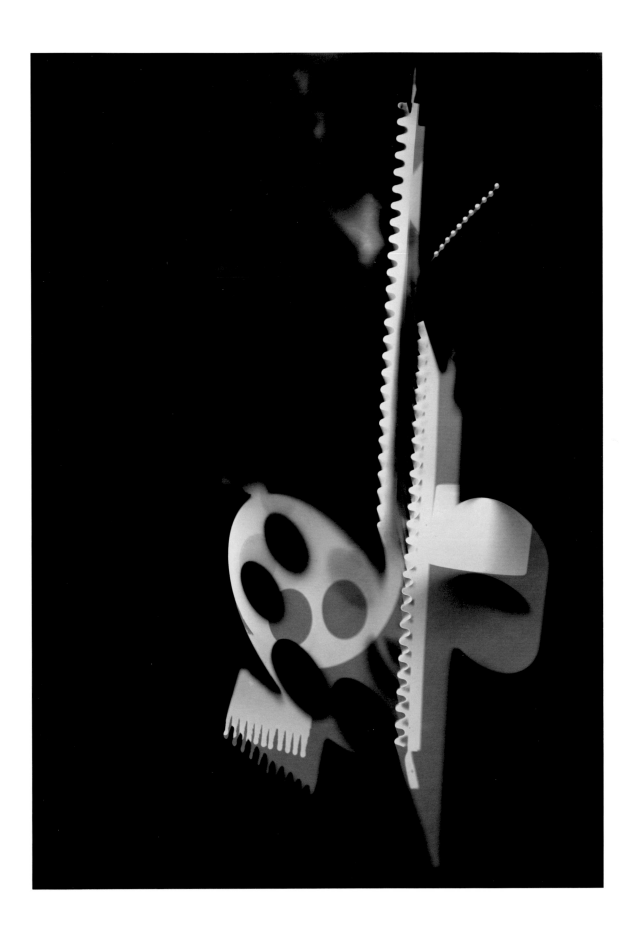

217 Man Ray, *Rayograph*, 1925, 15¼ x 10¾"

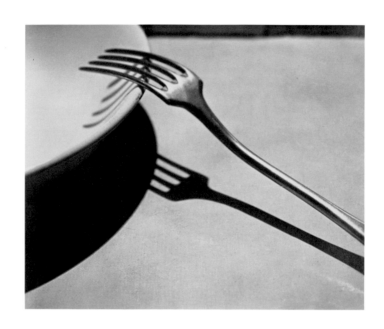

218 André Kertész, *Fork*, 1928, 3 x 3⅝″

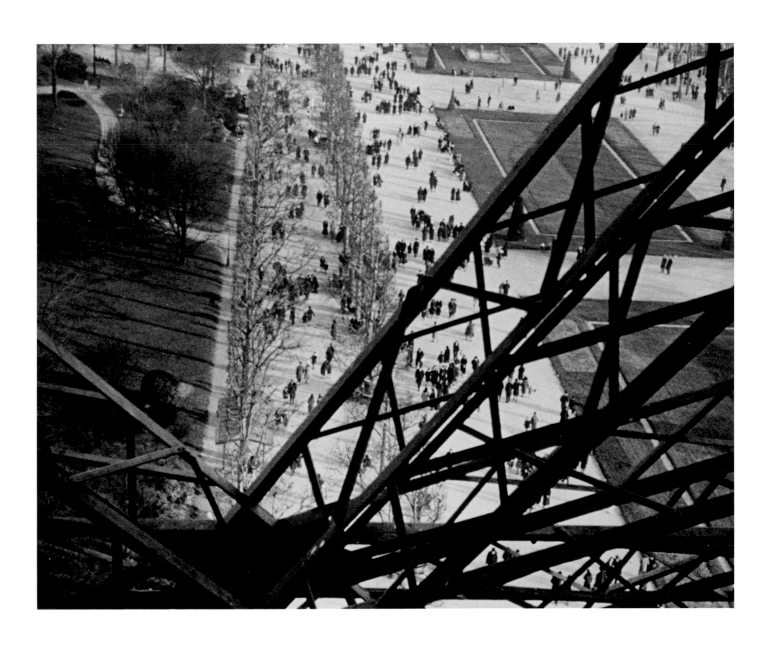

219 Ilse Bing, *Champ-de-Mars from Eiffel Tower, Paris*, 1931, 8¾ x 11⅛″

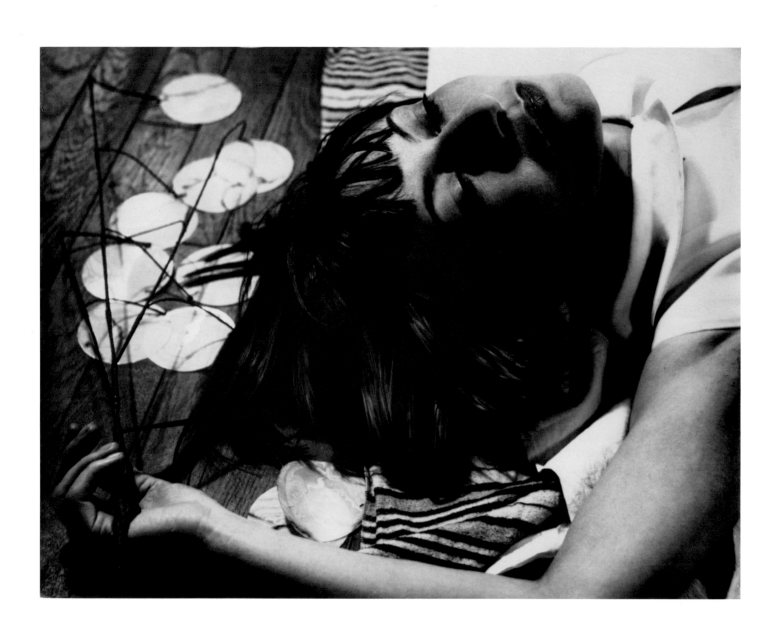

220 **Florence Henri,** *Reclining Woman,* 1930, 9 x 11¾"

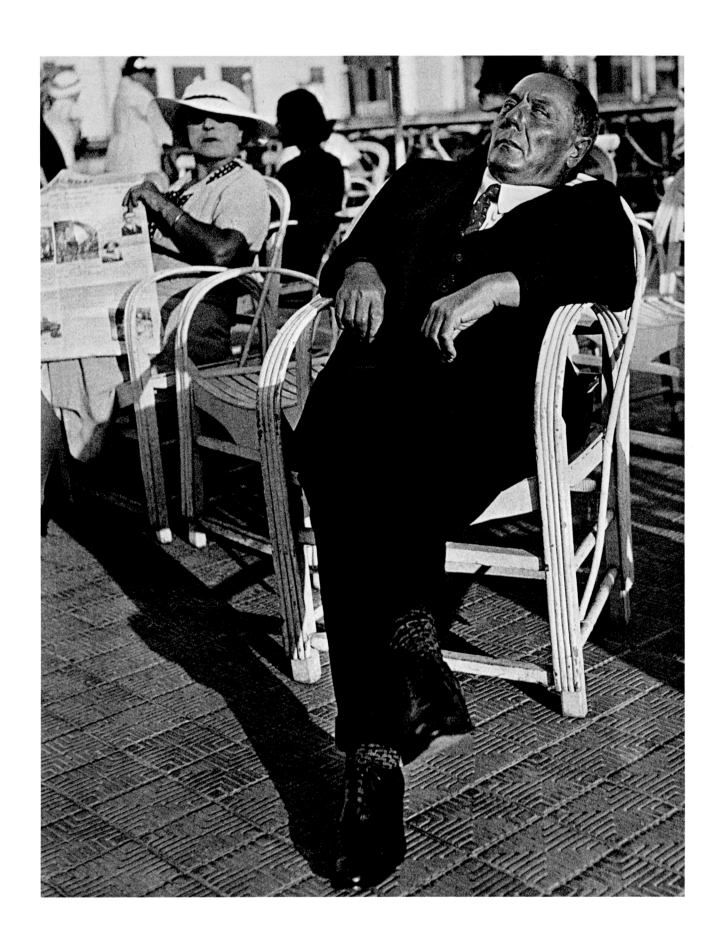

221 **Lisette Model,** *Promenade des Anglais, Nice,* 1934 (print ca. 1950s), 19½ x 15½"

222 Francis Bruguière, *Cut Paper Abstraction*, 1929, 9⅜ x 7⅛"

223 Edward Quigley, *Light Abstraction*, 1931, 12½ x 10″

224 Harold L. Harvey, *Reflections*, ca. 1930, 18¼ x 25⅛"

225 John Gutmann, *Triple Dive*, 1934, 7 ½ x 7"

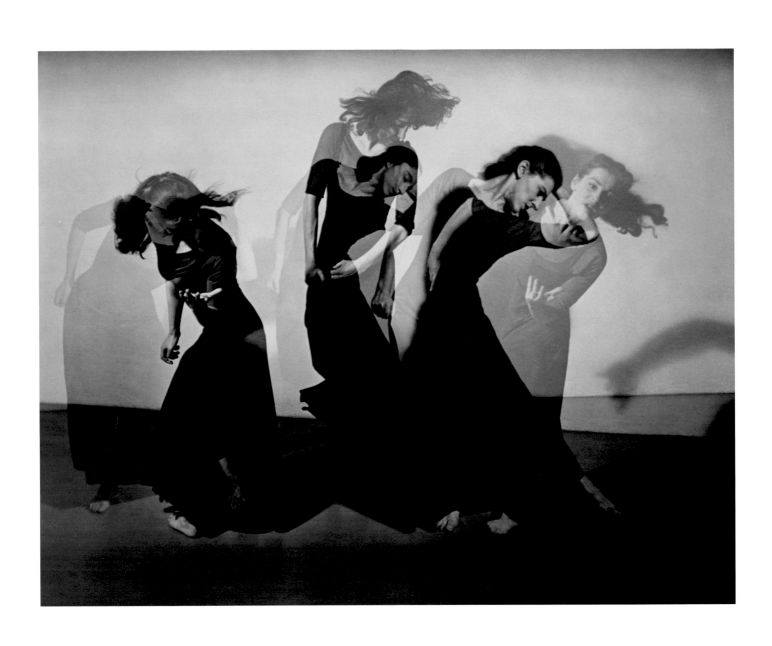

226 Barbara Morgan, *Martha Graham: American Document (Trio)*, 1938, 15 x 19⅛"

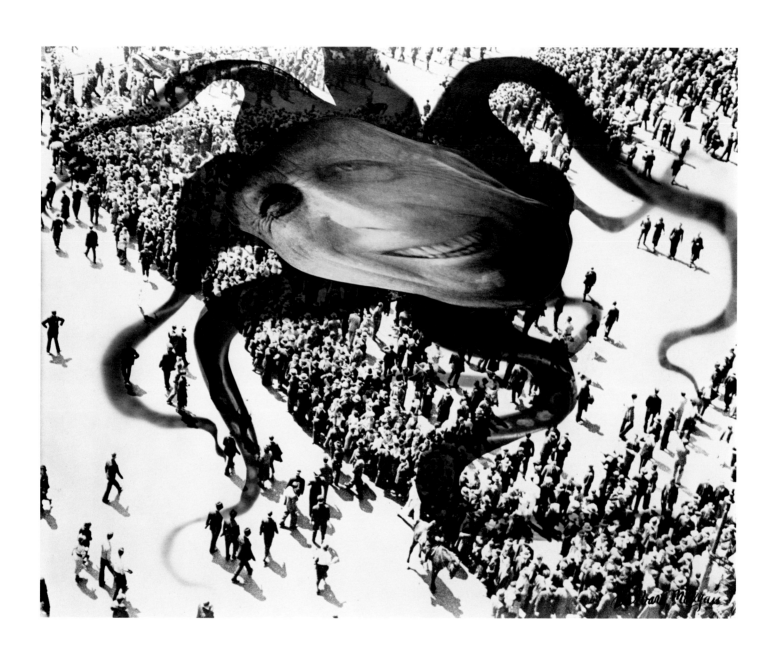

227 **Barbara Morgan,** *Hearst Over the People*, 1939, gelatin-silver photomontage, 16 x 20″

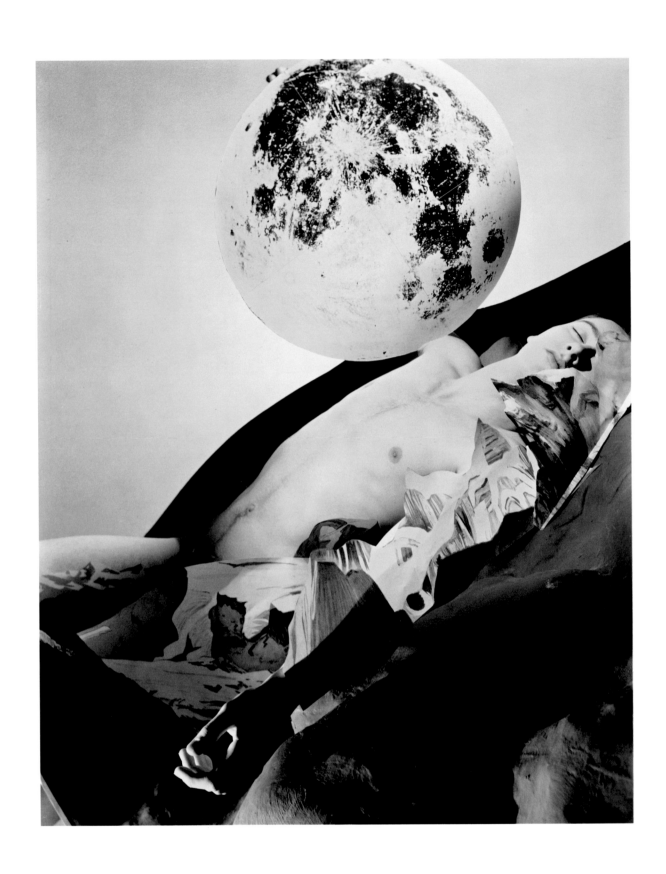

228 George Platt Lynes, *Endymion and Selene*, ca. 1937-39, 9½ x 7½"

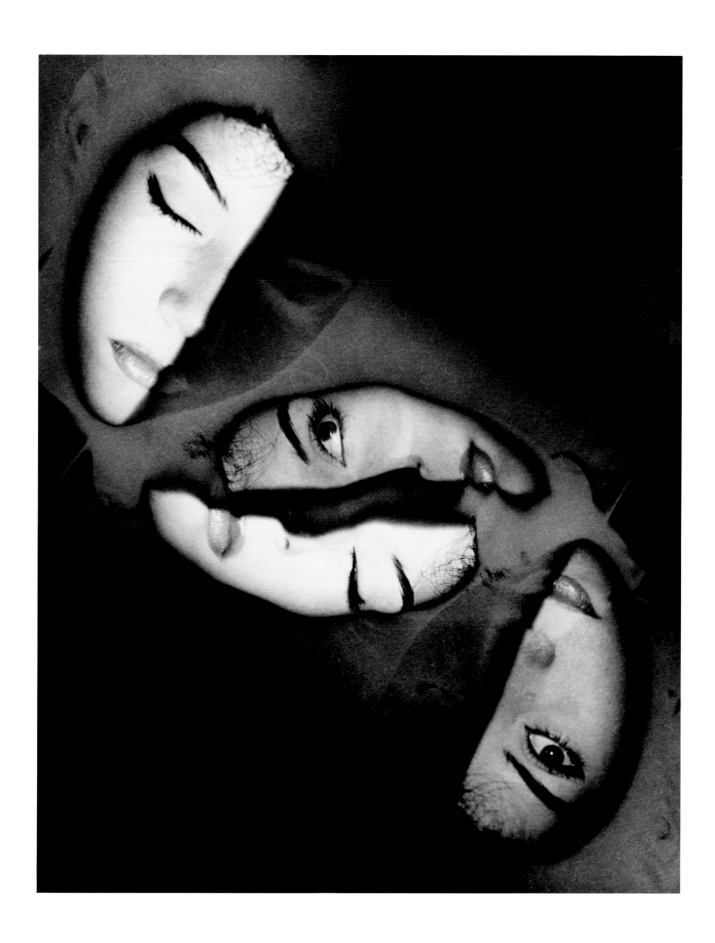

229 **Erwin Blumenfeld,** *Maria Motherwell, New York,* ca. 1941, 13⅞ x 11″

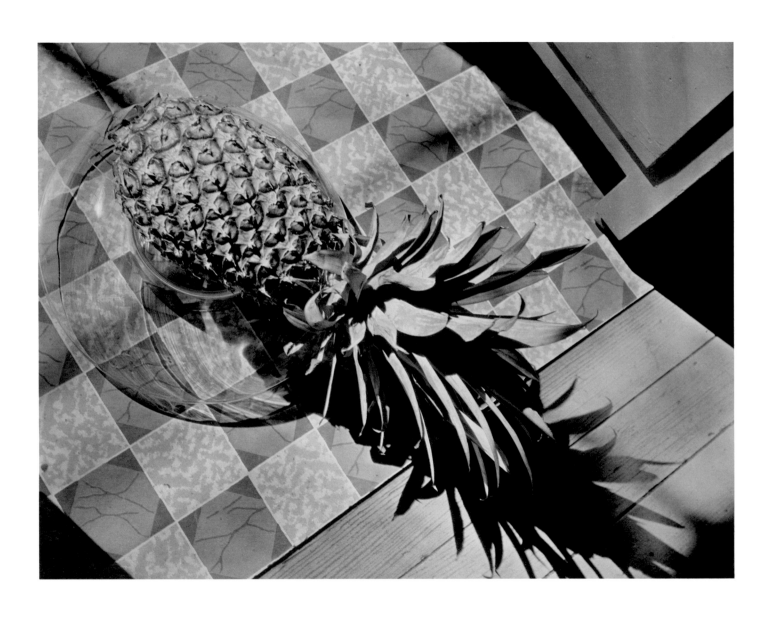

230 Clarence John Laughlin, *Pineapple as Rocket*, 1936, 7 ⅜ x 9¼"

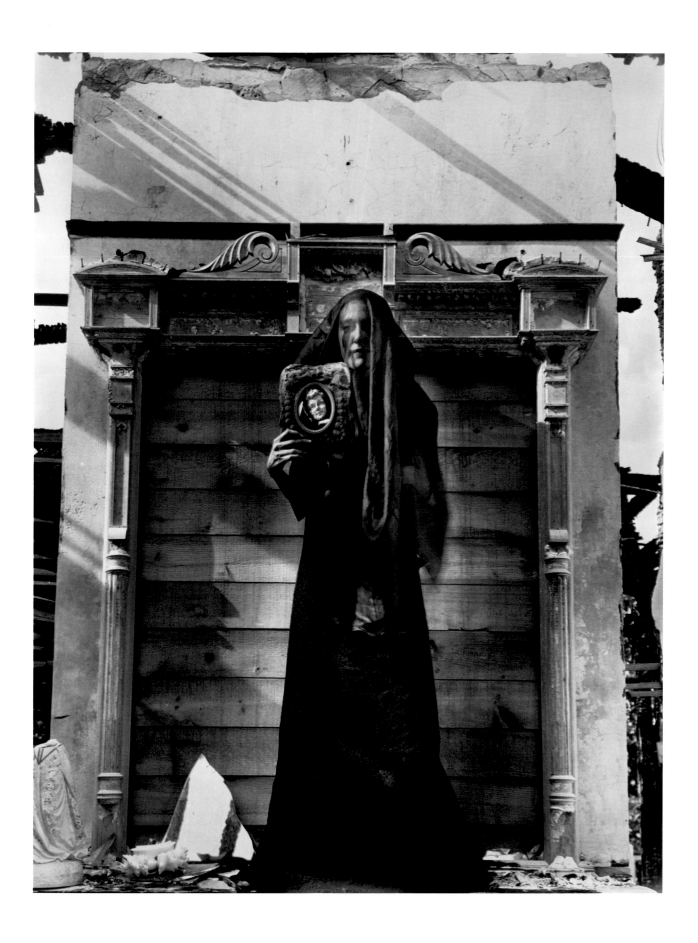

231 Clarence John Laughlin, *The Unborn*, 1941, 19¼ x 15″

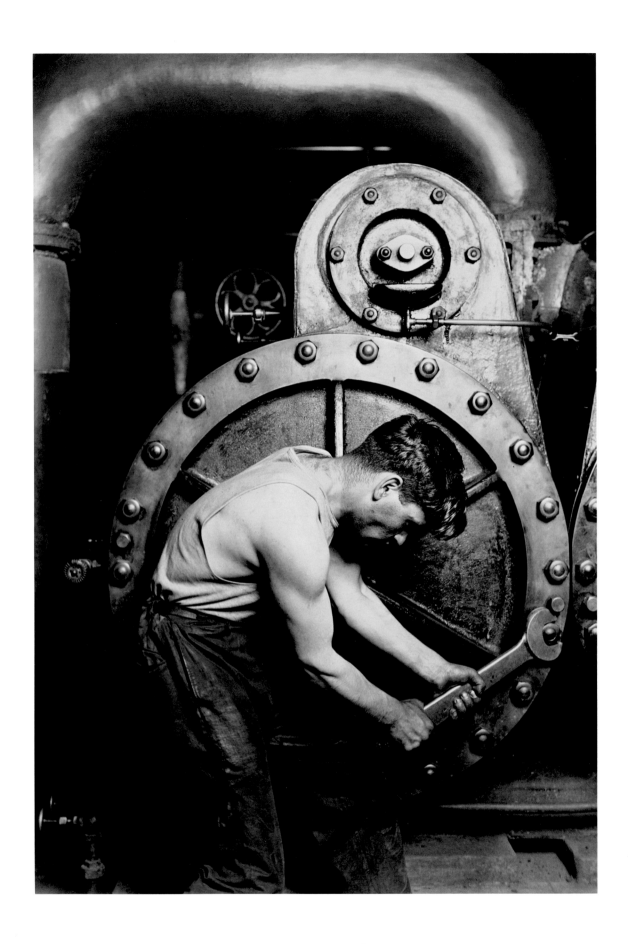

232 Lewis W. Hine, *Powerhouse Mechanic*, 1921 (print: 1939), 19⅛ x 13⅛″

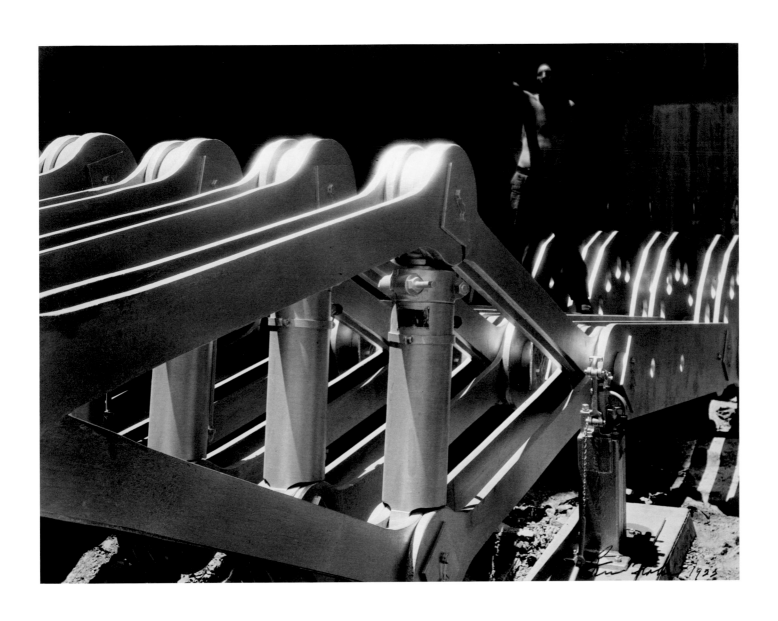

233 **Ben Glaha,** *Machinery at Boulder Dam*, 1933, 10⅜ x 13⅞"

234 Charles Sheeler, *Chartres—Buttresses, from South Porch*, 1929, 9⅝ x 7⅝"

235 Charles Sheeler, *Criss-Crossed Conveyors—Ford Plant*, 1927, 9½ x 7½"

236 Harold Edgerton, *Milk Drop Coronet*, 1936, 7½ x 9⅝"

237 Lewis P. Tabor, *Untitled astronomical photograph*, ca. 1930-31, 22¾ x 19½"

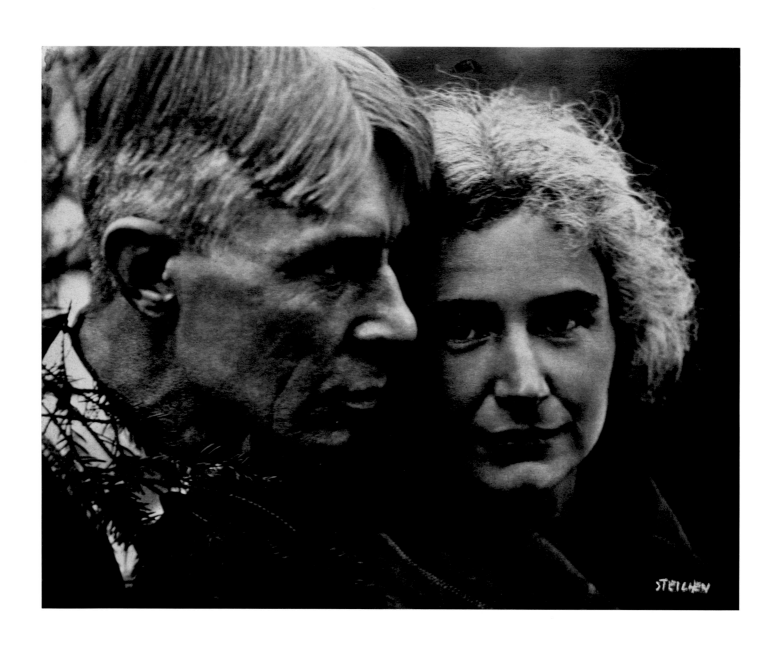

238 Edward Steichen, *"Mr. and Mrs.," The Sandburgs*, 1923, 10½ x 13½"

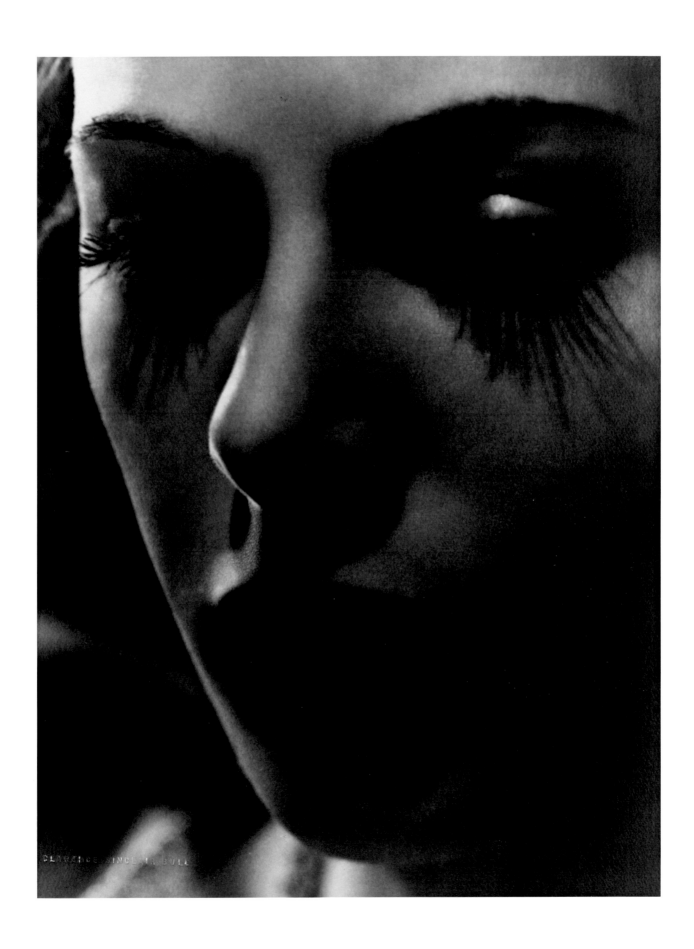

239 Clarence Sinclair Bull, *Hedy Lamarr*, 1940, 12⅛ x 9½″

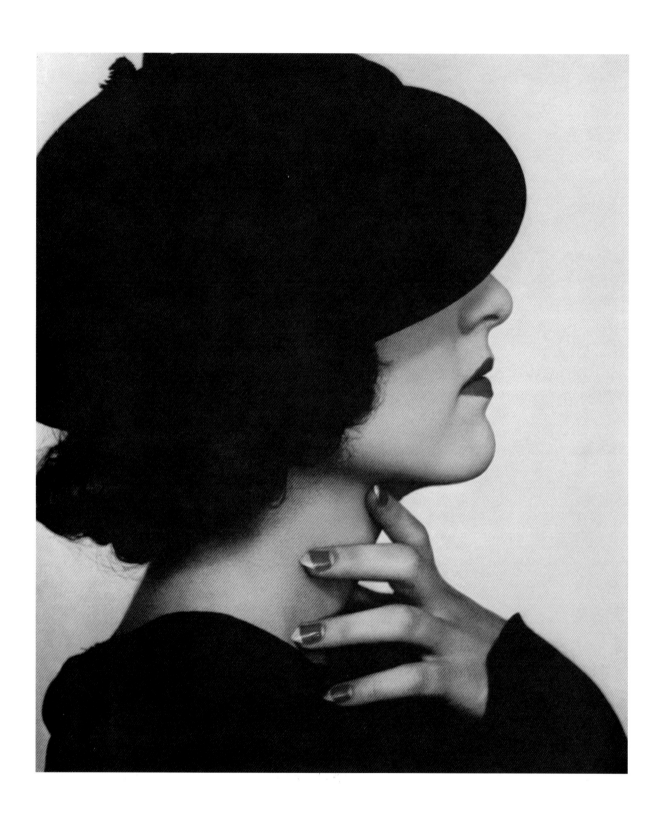

240 Alfred Cheney Johnston, *Woman with red nails*, ca. 1934, carbro color print, 7½ x 6⅜″

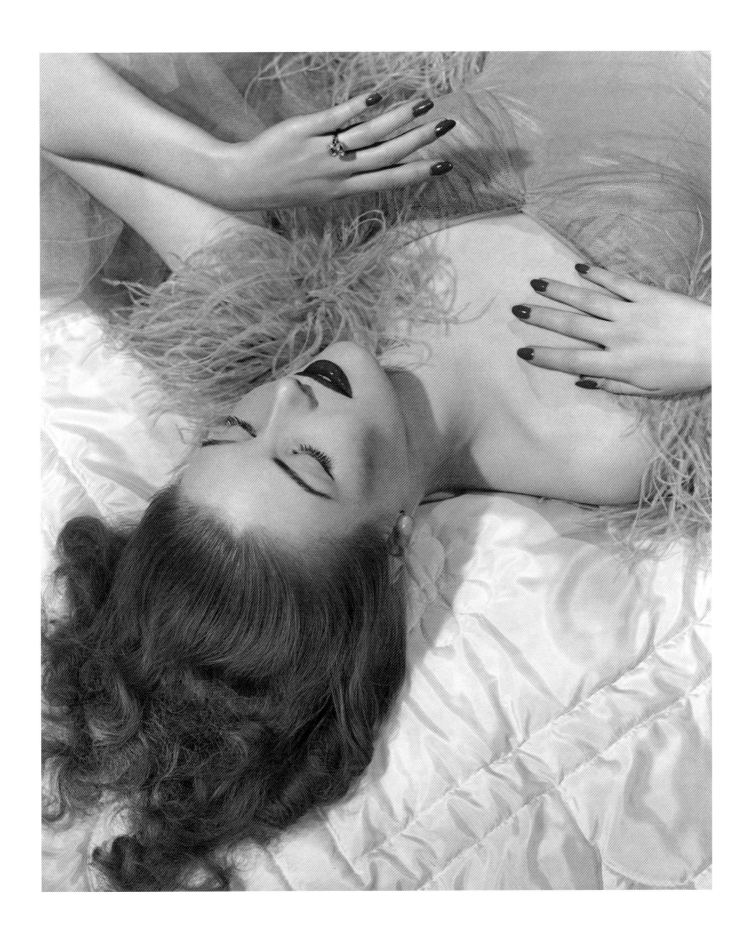

241 **Ruzzie Green,** *Colgate Palmolive ad*, 1941, carbro color print, 12⅛ x 15″

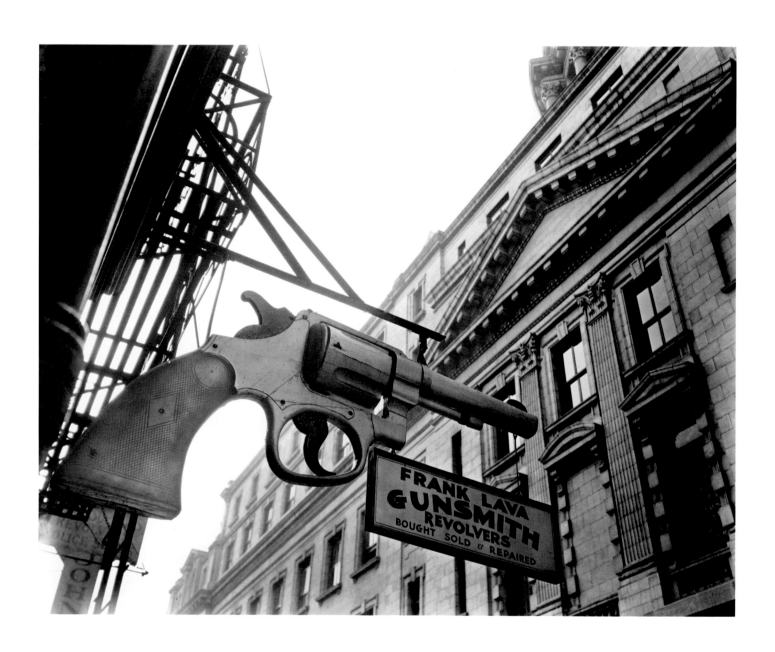

242 Berenice Abbott, *Gunsmith and Police Department*, 1937, 7⅝ x 9⅝"

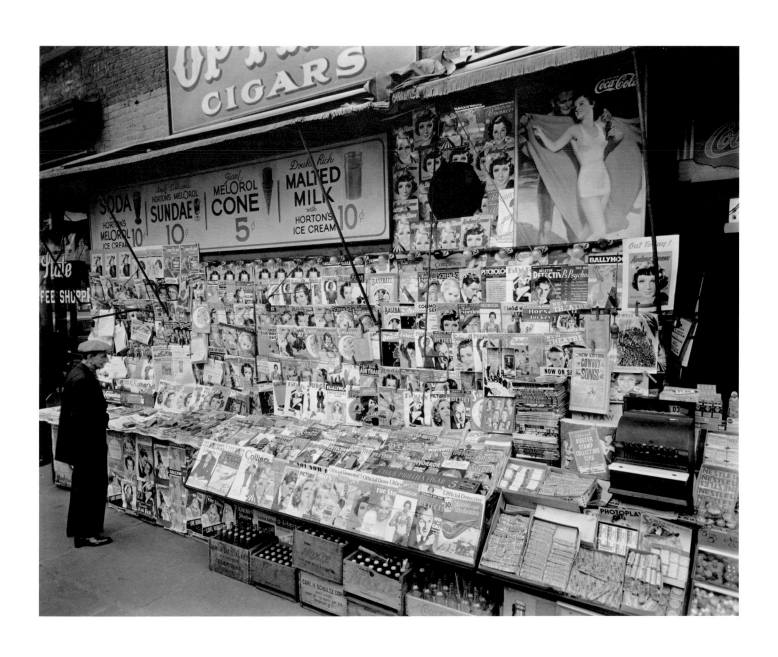

243 Berenice Abbott, *Newsstand, 32nd Street and 3rd Avenue, Manhattan*, 1935, 7⅝ x 9⅝"

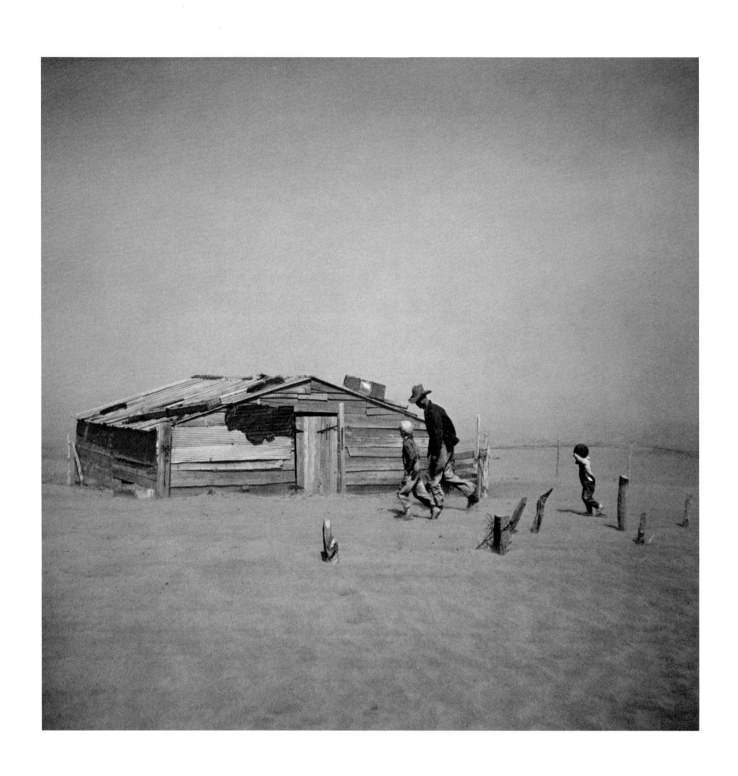

244 Arthur Rothstein, *Farmer and sons walking in dust storm, Cimarron County, Oklahoma*, 1936, 8¼ x 8¼"

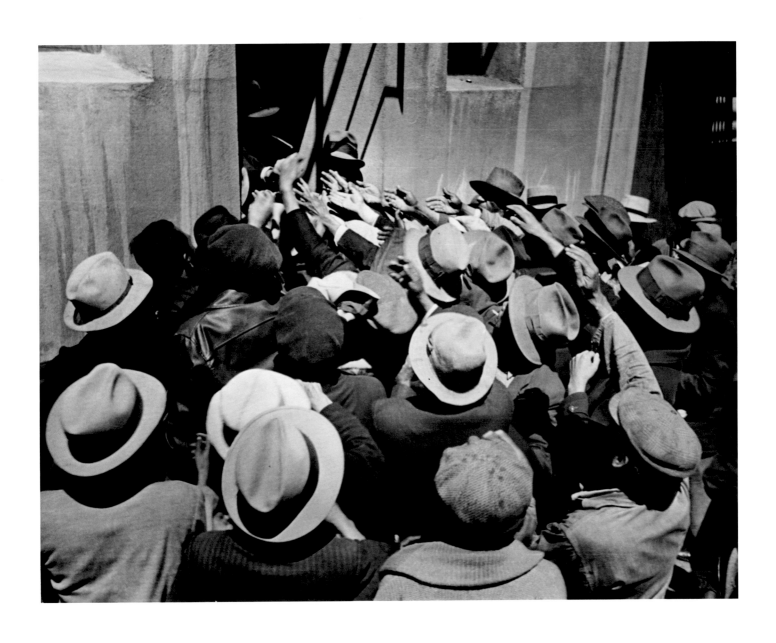

245 Hansel Mieth, *Outstretched Hands, San Francisco Waterfront*, ca. 1934, 10¼ x 13¼"

246 **Ben Shahn,** *Sheriff during Strike, Morgantown, West Virginia,* 1935, 7⅛ x 9½"

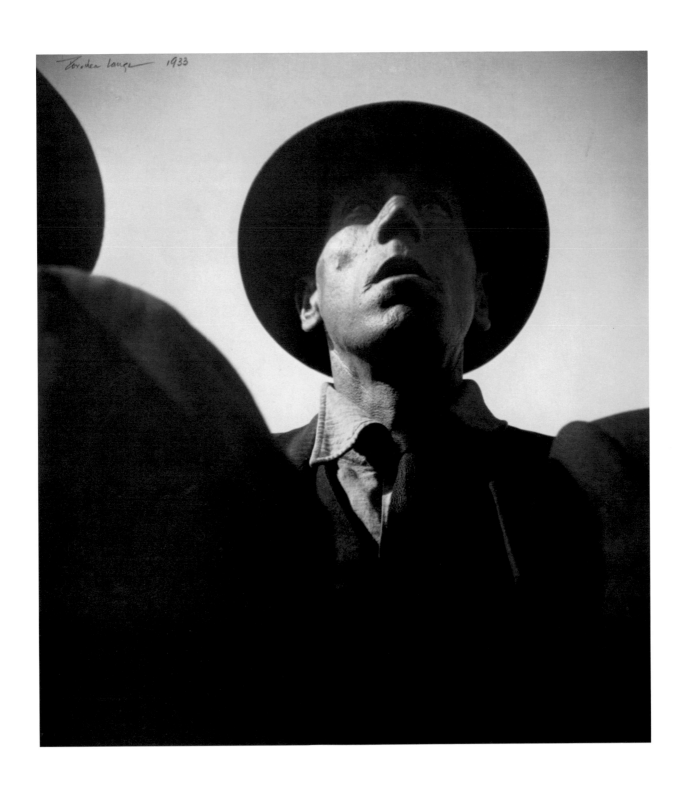

247 Dorothea Lange, *Demonstration, San Francisco*, 1933, 7¼ x 6⅝"

248 Walker Evans, *Kitchen Wall in Bud Fields's Home, Hale County, Alabama*, 1936, 7 ¾ x 9 ¼"

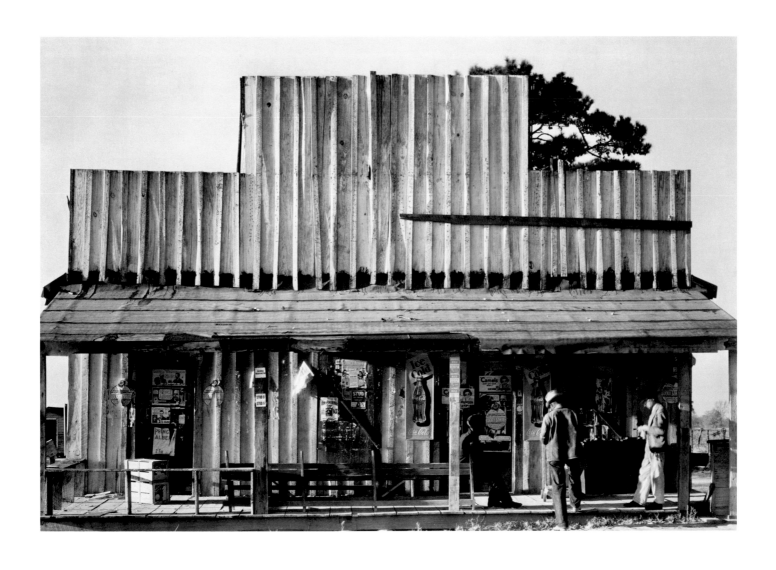

249 **Walker Evans,** *General Store, Selma, Alabama,* 1936, 6¼ x 9⅛″

250 **Louis Faurer,** *Homage to Muybridge, Philadelphia,* 1937, 6½ x 11½"

CHAPTER III

From Public to Private Concerns

1940-1965

The pace of social change in America continued to accelerate between 1940 and 1965, a period that began in the last year of the Depression and ended in the midst of the Space Age.[1] The United States achieved world leadership and unprecedented prosperity in these decades but was beset by turmoil at home and abroad. This era, which spanned the administrations of FDR and LBJ, centered on the tranquil guidance of Dwight D. Eisenhower, the hero of World War II and the last American president born in the nineteenth century.

More than anything, this quarter century was shaped by the trauma and consequences of World War II. After Nazi Germany's invasion of Poland in September 1939, the U.S. remained neutral for two years despite its sympathy for the Allied powers of Britain and France. The Japanese attack on the American naval base at Pearl Harbor, on December 7, 1941, finally pushed the U.S. into the war. Understanding that the conflict would be long and hard, Americans dedicated themselves to achieving victory; young men enlisted in enormous numbers, and the civilian population accepted the need for rationing and other sacrifices. No use of arms after 1945 would receive such overwhelming popular support. The U.S. successfully fought a two-front war, in Europe and the Pacific, emerging at the end of hostilities in the summer of 1945 as the world's leading military and economic power.

The war had broad political and social ramifications. Seven million men were called into the service, and a comparable number of women joined the industrial work force at home. The war's stimulus ended the Depression and paved the way for a postwar economy of plenty. The conflict also seemed to mark a historical turning point in philosophical and psychological terms. The war resulted in the deaths of forty million people world-wide (including 292,000 Americans) and produced massive physical destruction and political upheaval. The discovery of the full horror of the Nazi concentration camps raised profound moral questions about modern civilization, while the American use of atomic bombs on the Japanese cities of Hiroshima and Nagasaki elevated the destructive potential of war to a previously unimaginable level. As a result, the cultural climate in the following decades was one of anxiety and uncertainty.

The postwar political world was more complex and volatile than ever. America's wartime ally, the Soviet Union, became its chief adversary. Beginning in 1946, the Soviets installed puppet governments in the nations of Eastern Europe and threatened to spread their totalitarian rule around the globe. British prime minister Winston Churchill called this Soviet clampdown in Europe the "Iron Curtain," and for forty years it effectively bifurcated the continent. In 1949, the "loss" of China to communist rule further heightened American concerns, contributing to the tenseness of the ensuing Cold War. At home, hysteria over spies and traitors was cynically promoted by Senator Joseph McCarthy, who held televised congressional hearings to expose real or alleged communists in public life. A desire to contain communist expansion led to the Korean War of 1950-53, which resulted in the death or wounding of 137,000 Americans. Tensions between the U.S. and Soviet Union eased slightly by the end of the decade, only to be inflamed again in 1960, when an American U-2 spy plane was shot down over the Soviet Union. Two years later, the discovery of Soviet nuclear weapons in Cuba precipitated the Cuban Missile Crisis. By 1965, the U.S. was sending combat forces to the small Southeast Asian country of Vietnam in another effort to halt the spread of communism.

Atomic weapons became the bargaining chips of the Cold War. After the Soviet Union's first atomic test in 1949, the U.S. and U.S.S.R. began stockpiling massive numbers of both fission (atomic) and fusion (hydrogen) bombs. These weapons were awesomely destructive: while a large conventional World War II bomb contained the explosive power of one ton of TNT, each atomic bomb represented the equivalent of 20,000 tons, with the hydrogen weapon generating an incredible 5,000,000 tons of explosive force. Mutual annihilation, rather than victory, now seemed the likely outcome of future hostilities. With science running so far

ahead of man's moral capabilities, the idea of progress, and mankind's very survival, were called ominously into question.[2] In the 1950s, public concerns over the issues of war and peace were magnified, rather than alleviated, by civil-defense measures such as air-raid drills in schools and the promotion of home fallout shelters.

In the midst of these political uncertainties, the postwar era witnessed a series of memorable advances and achievements. In medicine, the development of penicillin (1941) and the polio vaccine (1955) helped save millions of lives. The scientific highlights of this era include the development of the electron microscope (1940), the installation of the 200-inch telescope at Mt. Palomar, California (1948), and the first electronic computer, a thirty-ton device with 18,000 vacuum tubes (1946). The sound barrier was first broken by a jet aircraft in 1947; within ten years, the speed record had risen to over 1,200 miles per hour. The Space Age was inaugurated in 1957, when the Soviet Union launched Sputnik I, an unmanned communications satellite. Spurred by Cold War competitiveness, the U.S. orbited its own satellite in 1958. Four years later, John Glenn became the first American astronaut to circle the earth. Manned space flights grew increasingly sophisticated in the following years, while unmanned probes beamed back remarkable close-up photographs of the moon and Mars.

The postwar baby boom produced a surge in the nation's population growth, and an expanding market for domestic products of all kinds. New homes, cars, and televisions all became relatively affordable. The automobile was a key symbol of American stylishness and prosperity, and the public took great interest in the unveiling of each year's designs. Television grew rapidly in popularity; by 1958, TV sets were in use in nearly forty-six million homes, and performers such as Milton Berle, Arthur Godfrey, and Lucille Ball were household names. The rapidly expanding middle class moved out of cities to planned communities in the suburbs. Long Island's Levittown was the most famous of these developments; begun in 1946, it grew to include over 17,000 standardized homes. This rising population was better educated than ever before, as college programs were established or expanded in every state.

The nation's legacy of racial injustice came to the political forefront in this era. The armed forces were largely desegregated during World War II and in 1947 Jackie Robinson broke the color barrier in professional baseball. In other spheres of life, change came gradually as a result of both legal decree and individual action. In 1954, the U.S. Supreme Court ruled school segregation unconstitutional in its landmark *Brown v. Board of Education* decision. Over the next decade, high schools and universities throughout the South were slowly desegregated, a process often accompanied by confrontation and controversy. The Montgomery, Alabama, bus boycott of 1955, protesting segregated seating on city buses, was a pivotal event in this history. Triggered by Rosa Parks's weary refusal to move to the back of the bus, this nonviolent protest brought the young Rev. Martin Luther King, Jr., to national prominence.

Questions of identity permeated American culture in this era. After the wrenching years of Depression and war, most Americans sought stability in an outwardly bland normalcy. However, while success in the 1950s seemed to demand conformity in both one's professional and personal life, the self was being revealed as unexpectedly multifaceted. The psychic stresses of modern life were explored in such notable sociological studies as David Riesman's *The Lonely Crowd* (1950), C. Wright Mills's *White Collar* (1951), William Whyte's *The Organization Man* (1956), and Vance Packard's *The Status Seekers* (1959). The diversity of human thought and behavior was revealed with new frankness in the publications of Alfred Kinsey and his colleagues on the sexuality of the human male (1948) and female (1953). In addition, the discomfort of many American women with their traditional roles in society and the home was suggested in Betty Friedan's pioneering book *The Feminine Mystique* (1963).

The 1950s was a decade of contrasts. The prosperous and patriotic Eisenhower era (1953-60) was also a time of widespread public concern over crime, alcoholism, juvenile delinquency, lurid comic books, violent pulp fiction, and the harmful influence of rock-and-roll music. Performers such as Elvis Presley, Marlon Brando, and James Dean epitomized a larger sense of rebellion against the strictures of polite society. Similarly, Beat poets and writers such as Allen Ginsburg and Jack Kerouac advocated a withdrawal from mainstream culture into more individualistic realms of experience. Popular publications such as *Playboy* magazine (begun in 1953) and Grace Metalious's scandalous bestseller *Peyton Place* (1957) exemplified a growing mood of sexual candor and freedom. Ironically, the perceived uniformity and conservatism of postwar American society—a product of the new power of the mass media and advertising, and the shrill patriotism of the Cold War—accelerated an opposing tendency toward introspection and cultural fragmentation. A relatively singular notion of community, shaped by the experience of the Depression and World War II, gradually gave way to the celebration of innumerable private realities.

This shift in sensibility was hastened in the early and mid-1960s. For many, the election of John F. Kennedy in 1960 promised a renewed sense of idealism and national purpose. It was, in part, the shattering of this hope that made his assassination in 1963 such a searing cultural tragedy. The magnitude of this crime seemed to demand an equally grand and complex explanation, which, for many Americans, the Warren Commission Report failed to provide. This numbing sense of loss, combined with the popular suspicion that the truth had been lost in a labyrinth of conspiracy, shook national confidence in the basic concepts of rationalism, idealism, and progress. In the following years a host of painful events—including race riots, protests over the escalating war in Vietnam, and the assassinations of Malcolm X (in 1965) and Martin Luther King and Robert Kennedy (both in 1968)—suggested that American society was somehow spinning out of control. By the mid-1960s, it was clear to even the most optimistic observers that the national unity of a quarter-century earlier had been severely strained.

In the Shadow of War

Photography made important institutional gains in the early 1940s. A new interest in the medium's history, spurred by the centennial celebrations of 1937, resulted in the founding or expansion of several important museum collections.[3] At the same time,

contemporary photographers received unprecedented scholarly recognition and public exposure.

The Museum of Modern Art played the leading role in this new era. At the end of 1940, the museum established an important precedent by becoming the first major art institution to form a full-fledged department of photography. The impetus for this move came from David H. McAlpin, a wealthy stockbroker who had begun collecting photographs with the guidance of Alfred Stieglitz and Ansel Adams.[4] McAlpin had earlier given $1,000 to the Metropolitan Museum of Art to buy photographs, a move so unusual that the museum's board of trustees had to meet to decide if the medium was, in fact, an art. McAlpin's cousin, Nelson Rockefeller, assured him that the decade-old Museum of Modern Art would be more receptive to such innovative thinking.[5] The Modern immediately formed a Committee on Photography, naming McAlpin chairman and Adams vice-chairman.[6]

Under the astute curatorship of Beaumont Newhall, the Modern's photography program sought to unite a broadly educational function with a more refined notion of connoisseurship. The department's inaugural exhibition, "Sixty Photographs" (1940-41) provided a concise overview of photographic history and art. Prints by nineteenth-century pioneers such as Brady and O'Sullivan were included, as well as Pictorialist work by White, hand-camera pictures by Cartier-Bresson and Levitt, abstractions by Moholy-Nagy and Man Ray, and purist images by Stieglitz, Weston, and Adams.[7] Newhall's goals for the department—which have come to define standard museum practice in the medium—included the creation of a dedicated photography gallery, the mounting of special exhibitions, the circulation of traveling shows, the development of a permanent holding of original prints, and the formation of a reference library of books and periodicals.[8] In a larger sense, Newhall's view of photography as an integral part of art history and his valuation of the original print as an expression of personal vision have been basic to all subsequent museum activity in the medium.[9]

During Newhall's tenure as curator (1940-47), the Museum of Modern Art presented a broad range of exhibitions. These included historical surveys such as "Photography of the Civil War and the American Frontier" (1942) and "French Photographs: Daguerre to Atget" (1945); one-person exhibitions by such younger artists as Helen Levitt and Eliot Porter (both 1943); and career retrospectives of established figures such as Strand (1945), Weston (1946), and Cartier-Bresson (1947). Like many others of his generation, Newhall was called to service during the war. During this absence, his wife, Nancy Newhall, was named acting curator, with Willard Morgan serving briefly as director of the department.[10] In 1947, the museum's photography program took a significantly new direction with the appointment of Edward Steichen as curator.

While the activities of the Museum of Modern Art dominated the photographic world in these years, it was not entirely alone.[11] In late 1940, Louis Walton Sipley established a private institution, the American Museum of Photography, in Philadelphia.[12] This diverse collection encompassed the history of photography and the photo-mechanical arts, ranging from daguerreotypes to the recent high-speed images of Harold Edgerton, with an emphasis on Philadelphia-area artists and inventors. The American Museum presented a number of significant exhibitions including, in 1941, a restaging of the 1898 Philadelphia Salon.[13] At the beginning of World War II, the Eastman Kodak Company purchased the collection of Gabriel Cromer of Paris, the world's largest private holding of historical photographs. This acquisition formed the basis for the George Eastman House, which was founded in Rochester in 1947 and opened to the public two years later. In 1951 the Eastman House added the collection of Alden Scott Boyer, a Chicago businessman who had been collecting photographic prints and ephemera since 1938.[14] The Brooklyn Museum made a commitment to artistic photography in 1940, and within two years had assembled a collection of some 400 salon prints.[15] The photography program of the Art Institute of Chicago also began in earnest in 1940, under the direction of curator Carl O. Schniewind. The Metropolitan Museum of Art continued building its collection in the 1940s. With the funds provided by David H. McAlpin, works were purchased by contemporary artists such as Paul Strand, George Platt Lynes, and Clarence John Laughlin, as well as by such major nineteenth-century figures as Hill and Adamson, Julia Margaret Cameron, P. H. Emerson, and Thomas Eakins. This archive was part of the museum's Print Department, headed in these years by William M. Ivins, Jr. (until 1946) and A. Hyatt Mayor (1946-66).[16]

In this era, the field of creative photography received prestigious institutional support from the John Simon Guggenheim Memorial Foundation. After a dozen years of underwriting scientists, poets, composers, painters, and writers, the Guggenheim Foundation first recognized photography in 1937, when Edward Weston was given a grant of $2,500 for his project "California and the West." Walker Evans was the second photographer to be so honored, in 1940, with Dorothea Lange (1941), Eliot Porter (1941), Wright Morris (1942), Jack Delano (1945), Brett Weston (1945), Ansel Adams (1946), G. E. Kidder Smith (1946), Wayne Miller (1946), and Beaumont Newhall (1947) rounding out the first decade of Guggenheim Fellows.[17] These awards were based strictly on artistic and scholarly merit, with no other requirements or conditions. This ensured that Guggenheim Fellowships would be highly respected—and coveted—by later generations of photographers.

World War II

This institutional activity was, of course, vastly overshadowed by the global crisis of the Second World War. Not surprisingly, photography played a critical and ubiquitous role in the conflict. The demand for official photographs was enormous: by the middle of the war some 10,000 photographers were employed by the Army, with another 3,000 on the Navy payroll.[18] Every branch of the military maintained its own units of photographers, motion-picture cameramen, and lab technicians.[19] The Army Signal Corps developed a special thirteen-week training course for still- and motion-picture cameramen, while the Navy maintained its own educational facility in Pensacola, Florida.[20] In order to ensure the professionalism of official war coverage, *Life* voluntarily set up a fifteen-week training course for military photographers and technicians.[21] Military inductees were often encouraged to make use of their civilian skills: David Douglas Duncan became a photographer for the Marine Corps, for example, while Victor Keppler's wartime service was spent supervising

251 **Robert Capa**, *D-Day, Omaha Beach*, June 6, 1944 (printed later), 11 x 13¾"

252 **Joe Rosenthal**, *Raising of the Flag on Iwo Jima*, February 23, 1945, 9¼ x 7⅞"

photography for the Army's newspaper, *Yank*.[22] Aerial photography had developed enormously in importance since World War I, and recruits with appropriate visual training (including photo-historian Beaumont Newhall) were charged with deciphering high-altitude images for evidence of bomb damage and troop movements.[23]

One of the most memorable facets of the military's photographic enterprise was the Naval Aviation Unit, headed by Edward Steichen.[24] Eager to contribute to the war effort, Steichen was commissioned in 1942 (at age 63) to form a select photographic unit to create images for Navy recruiting and publicity. Steichen's original team consisted of still photographers Wayne Miller, Charles Kerlee, Horace Bristol, Charles Fenno Jacobs, and Victor Jorgensen, and motion-picture cameraman Dwight Long. Most of these men were experienced professionals: Bristol and Jacobs had both worked for *Life* and *Fortune*, while Kerlee was a leading West Coast commercial photographer and teacher. The group was given unprecedented freedom to travel wherever the Navy had a presence, and it produced some of the most often reproduced images of the war [317].

In addition to these legions of military photographers, many civilian photojournalists covered the war. *Life* magazine went to particular effort and expense to put its photographers close to the action. As W. Eugene Smith later recalled, "*Life* was really the only outfit to work for if you covered a war. They had the greatest freedom, the greatest power, and the best expense accounts!"[25] In addition to Smith, *Life* employed such noted photographers as Ralph Morse, George Rodger, George Silk, Eliot Elisofon, Frank Scherschel, William Vandivert, Carl Mydans, Margaret Bourke-White, and Robert Capa. Each of *Life*'s photographers produced distinctive and powerful images. Morse and Smith worked in the Pacific theater, often under perilous conditions. Morse covered the Battle of Midway, landed with the marines at Guadalcanal, and was on the warship *Vincennes* when it was torpedoed and sunk.[26] Smith accompanied Navy pilots on combat missions and photographed battles on Saipan, Guam, Iwo Jima, and Okinawa, before being severely wounded in May 1945. Elisofon's reputation as a war photographer was established in North Africa, while Vandivert recorded the stoic determination

of British civilians in the face of bombings and blackouts.[27] Margaret Bourke-White's assignments were similarly noteworthy. Even before the U.S. entered the war, she was in Moscow taking dramatic shots of a nighttime raid by German bombers [316].[28] From 1942 to 1945, Bourke-White photographed extensively throughout England, Italy, and Germany, and became the first woman to accompany an Air Force crew on a bombing mission.[29]

By general consensus, the most famous war photographer of the time was Robert Capa. Born in Hungary as Endre Friedman, Capa changed his name in 1935, shortly before achieving international recognition for his gritty images of the Spanish Civil War. His work was regularly published in leading European magazines such as *Vu* and *Ce Soir*, and first appeared in *Life* in December 1936. By 1938—when his book of Spanish Civil War pictures, *Death in the Making*, was published—Capa was widely regarded as one of the world's top photographers.[30] After arriving in the U.S. in late 1939, and spending most of the following year working on bread-and-butter assignments for *Life*, Capa returned to wartime duty in England, North Africa, and Italy. On D-Day, June 6, 1944, he accompanied American soldiers in the landing at Omaha Beach. Under a withering barrage of fire, he exposed two rolls of 35mm film before struggling back to the landing craft. On return to England, his precious film was rush-processed in *Life*'s London lab. In the technician's haste, however, the temperature of the drying cabinet was set too high and the emulsion of the film began to melt. Before the error was discovered, all but eleven of Capa's seventy-two frames were ruined. Ironically, the emotional power of the salvaged images is only heightened by the effect of the blurred emulsion [251]. These remarkable pictures epitomize the directness of Capa's working method, an approach summarized bluntly in his oft-quoted

observation: "If your pictures aren't good enough, you're not close enough."

Despite the vast number of war photographers and the breadth of their subjects, the pictorial record that reached the public was carefully monitored and censored. Military control over war photography was maintained, in large part, through the formal accreditation of civilian cameramen and the establishment of the Photographic War Pool. The original participants in this pool included the three leading American picture agencies (the Associated Press, Acme Newspictures, and International News Syndicate) and *Life* magazine. To eliminate competition and ensure overall fairness, the pool included photographers from each organization and—with few exceptions—the resulting pictures were made available to all the participants.[31] A systematic review process ensured that photographs were released to the public only after military censors had determined that they would not aid the enemy or harm domestic morale.[32] American war photography thus served a consciously propagandistic function in the struggle for victory.[33] Photographers willingly accepted this role, regarding themselves as participants in—rather than mere observers of—the conflict.

This process of production and review, flavored by the photographers' inherently partisan role, resulted in a complex kind of documentation. Many photographers placed themselves at great risk to record the gritty truth of combat; in fact, the casualty rate for correspondents and photographers in World War II was four times higher than for military personnel.[34] However, in their quest for dramatic images, some photographers used their professional skills to enhance the drama of their subject, or even to create outright fakes. The young W. Eugene Smith, for example, simulated combat scenes by posing himself and his assistant as soldiers, and timing his exposure to the detonation of carefully placed charges of dynamite.[35] In 1943, Eliot Elisofon claimed that it was impossible to deal with the subject of war photography "without a discussion of honesty. The question of faked and staged pictures has come up at every front. I have seen many pictures in reputable publications which were without any doubt completely staged."[36]

"Artifice" existed in widely varying degrees, however, and was not always the result of a conscious effort to deceive. For example, the circumstances surrounding Joe Rosenthal's famous photograph of the flag raising on Iwo Jima [252] are well known.[37] Rosenthal, an experienced photojournalist working for the Associated Press, arrived at the crest of Mt. Suribachi in time to record the second enactment of that stirring event, as soldiers replaced a small flag, erected ninety minutes earlier, with a larger one. Rosenthal did not choreograph the action of his subjects but, depending on one's notion of historical truth, the scene he documented might be considered a "reenactment" or "re-staging" of the original flag-raising. Ultimately, the extraordinary symbolic power of this image—in which victory is achieved through patriotic cooperation—makes the specific details of its making seem incidental.

Like most other war photographers, Rosenthal aspired to make images that would inspire and motivate, not simply document and inform. In fact, the inspirational power of this image was astonishing. Only four weeks after it was made, *Life* reported that "schoolboys wrote essays about it, newspapers played it for

253 Ed Clark, *Going Home*, 1945, 12⅜ x 10⅝"

full pages and business firms had blow-ups placed in their show windows. There have been numerous suggestions that it be struck on coins and used as a model for city park statues."[38] It was featured on the covers of many magazines—including *U.S. Camera* (May 1945) and *American Photography* (July 1945)—and was awarded the Pulitzer Prize. This image's appeal was summarized by *American Photography* editor Frank Fraprie: "Every action is the spontaneous result of heroic determination and the composition, perfect in every detail, makes this *the* picture of the war, the everlasting token of a great American victory and an inspiration to every American."[39]

Just two months later, photojournalist Ed Clark took one of the most famous domestic photographs of the war years at the funeral of President Franklin D. Roosevelt [253]. Although Roosevelt had been unwell for many months, his death on April 12, 1945, at Warm Springs, Georgia, shocked the nation. Elected four times to the presidency, the beloved FDR had guided the country through twelve tumultuous years of depression and war. Now, with the end of the conflict clearly in sight, he was gone. On the following day, as Roosevelt's body was solemnly carried away, Clark recorded Navy officer Graham Jackson weeping openly as he played the mournful tune "Going Home" on his accordion. Jackson's face powerfully symbolized the connection Roosevelt had established with so many ordinary Americans.[40]

Given the didactic and persuasive intent of many war images, it is not surprising that art played an important part in their making. In fact, the modernist techniques of 1930s artistic and commercial photography were widely used in the production of war photographs. Dynamic vantage points and bold compositions were used repeatedly to dramatize and clarify the image of war.[41] For example, the New Vision predilection for simple, repeated forms was often employed to emphasize the power represented

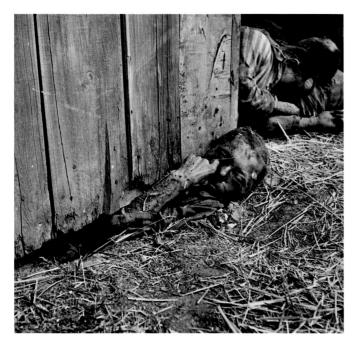

254 **William Vandivert,** *Dead Prisoner, Gardelegen,* April 17, 1945, 9¾ x 10⅜″

by rows of artillery shells, airplanes, ships, and soldiers. As the editor of *Popular Photography* observed in a 1942 essay, "Patterns for Victory":

> This war is one of huge numbers of fighting men and mass production on home fronts. Both of these things suggest repetition and vast patterns, and it is only natural that such effective photographic themes be put to good use in picturing the nation's gigantic and irresistible march to victory.[42]

This modernist penchant for unusual points of view is exemplified in Herbert Gehr's fascinating documentation of African-American soldiers on home leave [315]. Although Gehr was a *Life* staffer, he undertook this photographic project on his own initiative; none of the resulting images were published in the magazine. Gehr's use of a wide-angle lens and odd vantage points lends these photographs a curious "fly's-eye" intimacy. At the same time, the scenes are illuminated and choreographed with cinematic precision to create richly detailed narratives, a reflection of Gehr's prewar experience in film.[43]

The confluence of documentation and expression in war photography created an effective marriage of politics and art. In fact, every facet of American society had mobilized for the war effort, including the nation's artists and art institutions. Civilian painters, sculptors, designers, and printmakers formed a group called Artists for Victory and sponsored the touring exhibition "America in the War."[44] Museums presented similarly patriotic displays. The Museum of Modern Art was particularly active in this regard: in 1941-42 it mounted such shows as "Britain in the War," with work in a variety of mediums; "Two Years of War in England," with photographs by William Vandivert; and "Wartime Housing," a didactic display prepared in collaboration with the National Committee on the Housing Emergency. Without question, however, the most memorable wartime exhibitions were those created by Edward Steichen. In the fall of 1941, Steichen was encouraged by MoMA trustee David McAlpin to assemble a photographic show on the theme of national defense. After the U.S. entered the war, the exhibition theme shifted from the need for preparedness to—in Ralph Steiner's words—the "deeply moving story of what we are fighting for, and of who does the fighting."[45]

Steichen's "Road to Victory," which opened at the Museum of Modern Art on May 20, 1942, was unlike anything ever seen before; indeed, in its press releases, the museum termed it a "procession" of photographs, rather than simply an exhibition. The experience of the installation was overwhelming: at once visual and spatial, intellectual and emotional. To illustrate the great sweep of the American land and the character of its people (that is, what the war was being waged to defend), Steichen selected some 150 photographs from the files of Time-Life, the Associated Press, U.S. Steel, and the FSA. These images were printed in large scale, sequenced to powerful narrative effect, and accompanied by texts by poet Carl Sandburg. The installation of the exhibition, by artist and designer Herbert Bayer, was startlingly innovative. In his enthusiastic review, Steiner wrote:

> The photographs are displayed by Herbert Bayer as photographs have never been displayed before. They don't sit quietly against the wall. They jut out from the walls and rise up from the floors to assault your vision as you move from room to room and over a curving ramp. You are bowled over by pictures as big as all outdoors—none look less than a yard wide—one is 40 feet across.[46]

"Road to Victory" concluded with a devastatingly effective editorial use of images and text. On one side of an L-shaped wall, a large print of an exploding Navy destroyer at Pearl Harbor, with the simple text "December 7, 1941," was juxtaposed with a photograph of the Japanese Ambassador and Peace Envoy—both grinning malevolently—captioned *Two Faces.* The facing panel presented a photograph of a stern Texas farmer with the words "War—they asked for it—now, by the living God, they'll get it."[47]

Steichen's wartime educational and artistic efforts culminated in a trio of related projects in the final months of the conflict. In December 1944, the motion picture *The Fighting Lady,* created from footage by his unit's cinemaphotographer, Dwight Long, was released to notable critical praise.[48] In the same month, *U.S. Camera* published *The U.S.A. at War,* a special edition coedited by Steichen and containing numerous images by his Naval Aviation Unit. Finally, in January 1945, Steichen's second photographic extravaganza, "Power in the Pacific," opened at the Museum of Modern Art. This exhibition, consisting of enlarged images (up to 6 x 8 feet in size) by Navy, Marine, and Coast Guard photographers, was designed by the architect and photographer G. E. Kidder Smith. Like the 1942 installation, this exhibit was both powerful and popular. "Road to Victory" and "Power in the Pacific" reflected Steichen's earlier experience with photomontage and his understanding of the rhetoric of advertising, while anticipating the ambitious scale and vision of his 1955 exhibition "The Family of Man."

While Steichen continued to emphasize images that were heroic and uplifting, the content of photographs released to the public changed significantly midway through the war. In the first years of combat, military censors had forbidden the circulation of images of dead American soldiers (those of other nationalities were allowed). But in September 1943, the War Department reversed that policy, arguing that the public needed to understand the ferocity of the struggle and the sacrifices being made on its behalf. As a result, the September 20, 1943, issue of *Life* featured

a full-page image of the bodies of three American soldiers killed while storming Buna Beach in New Guinea. The photograph stirred much debate and marked the beginning of a tougher standard of reporting by the nation's press.

Despite the increasingly ghastly nature of these combat images, the pictures of Nazi concentration camps that emerged after the Allies occupied Germany were horrific beyond words. The battle-hardened troops who liberated these camps in the final weeks of the war in Europe were stunned and sickened by what they found. Under the simple heading "Atrocities," the May 7, 1945, issue of *Life* included six pages of gruesome pictures by George Rodger, Margaret Bourke-White, Johnny Florea, and William Vandivert. Particularly gut-wrenching was Vandivert's subject, a warehouse near Berlin that had held political prisoners. When forced to retreat in the face of Allied advances, German soldiers had set fire to the locked structure. Vandivert described the tragic scene represented by one of his photographs [254] in these words: "Trying to escape the flames, a young political prisoner squeezed head and arm under wooden door of warehouse. The rest of his body was burned."[49] When Vandivert arrived with the first American troops on April 17, four days after the fire, the corpses were still smoldering. Images such as these eroded what little remaining faith the American public might have had in a sanitized, glorifying image of war.[50]

Korea

This starkly realistic vision typified the photographic coverage of the Korean War (1950-53). In general, images of the Korean conflict were grittier, moodier, and less heroic than those of World War II. The reasons for this difference included the somewhat ambiguous nature of the war, and the American public's lack of enthusiasm for it. In addition, military censors were less concerned with sanitizing the pictorial record for the domestic audience. Early in the conflict, for example, it was noted that "censorship was left largely to the discretion of the publications and the men who filed the pictures and stories themselves—an unusual circumstance dictated by the unusual nature of the 'war' in which we had become involved."[51] Finally, Korea was the first conflict to be recorded primarily with 35mm cameras, and this format helped shape the visual meaning of the war.[52] The small camera produced pictures with an unprecedented intimacy and informality. These pictures also tended to be aesthetically "tough"—relatively coarse in visual texture and tonality—due to the granularity of the small, high-speed 35mm films.

The Korean conflict was recorded by a number of talented and experienced photographers. These included Max Desfor (of the Associated Press), Stanley Tretick (Acme), Charles D. Rosecrans, Jr. (International News Service), Horace Bristol (*Fortune*), and the *Life* team of Carl Mydans, Hank Walker, and David Douglas Duncan. Their pictures were seen widely during the war years in newspapers, picture magazines, photographic journals and annuals, books, and museum exhibitions. In 1951, for example, Steichen mounted "Korea—The Impact of War" at the Museum of Modern Art, with some 125 prints by the leading photojournalists.[53]

David Douglas Duncan was the most acclaimed—and expressive—of this group. Having spent three years with the

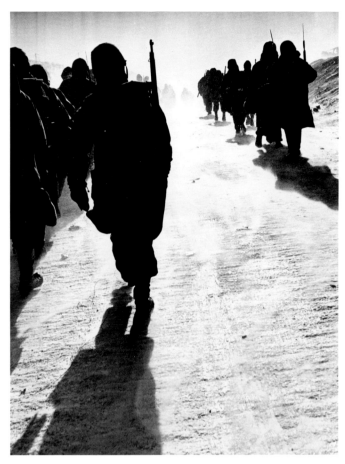

255 **David Douglas Duncan,** *Marine Withdrawal, Koto-ri, North Korea,* December 9, 1950, 13½ x 10¼"

Marine Corps in the South Pacific during World War II, Duncan came to Korea with both combat experience and a deep understanding of the ordinary man in uniform. As a consequence, his photographs focus powerfully and directly on the experience of the common soldier. Duncan stated:

> My objective always is to stay as close as possible and shoot the pictures as if through the eyes of the infantryman, the Marine, or the pilot. I wanted to give the reader something of the visual perspective and feeling of the guy under fire, his apprehensions and sufferings, his tensions and releases, his behavior in the presence of threatening death.[54]

The resulting images are deeply human. They depict real courage and devotion to duty, but are not "heroic" in any traditional or propagandistic way. Duncan's photographs record young Americans in an alien and threatening world—men who are frequently lonely, miserably hot or cold, and dazed with exhaustion [255, 256].

These pictures were presented with stark effectiveness—without captions or even page numbers—in Duncan's 1951 book *This is War!* In his introduction, Duncan evoked the ambiguity and uncertainty of the whole enterprise:

> *This is War!* is a book which happens to have been made possible by the war in Korea. It is in no way a report on the progress of that war, nor does it make any pretense of telling the reasons behind the United Nations' decision to intervene and try to stop the Communist invasion by force. There is neither climax nor ringing conclusion to this book. It is simply an effort to show something of what a man endures when his country decides to go to war, with or without his personal agreement on the righteousness of the cause.[55]

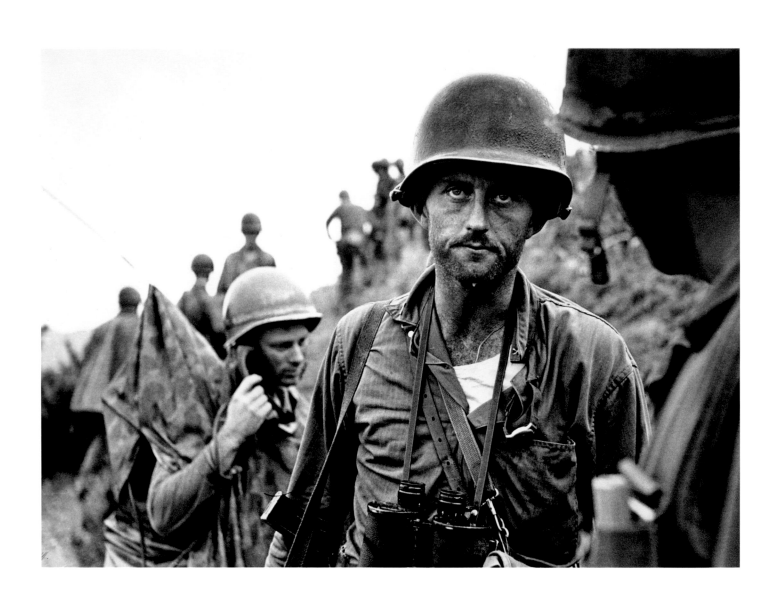

256 **David Douglas Duncan,** *Marine Capt. Ike Fenton, Naktong River Perimeter, No-Name Ridge, South Korea,*
September 9, 1950 (print: ca. 1970), 9¾ x 13½"

Thus, in both word and image, Duncan suggested important aspects of the era's cultural climate: its mood of moral uncertainty and the incomprehensibility of world events. What was most real in this newly *un*real realm of physical insecurity and emotional stress was the simple truth of the enduring individual consciousness. The complete lack of explanatory caption data in *This is War!* frustrates any attempt to understand it as a simple work of topical reportage. In truth, Duncan's book is a remarkably poetic and philosophic statement: the photographic expression of a fundamentally existentialist vision of life.

The Education Boom

In the years after World War II, the nation's colleges and universities experienced a massive rise in enrollment, thanks in large measure to the Servicemen's Readjustment Act of 1944, popularly known as the GI Bill. By 1947, over one million former military personnel were using this bill to further their education; they were followed by comparable numbers of veterans of the Korean and Vietnam eras. These young men and women studied all manner of subjects. William Garnett, for example, had worked as a commercial photographer before the war. After his discharge in 1945, he used the GI Bill to get a pilot's license and went on to become the most noted aerial photographer of the American landscape [257]. In general, the students of Garnett's generation showed a new inclination toward the arts and humanities. As a result, photography enjoyed a surge of interest, undergoing a gradual shift of emphasis from a subject of primarily technical and vocational interest to a more purely artistic one.

At the beginning of the 1946 academic year, some 200 institutions—ranging from high schools and camera clubs to trade schools and universities—were offering photographic instruction of some kind.[56] These courses varied widely in approach, from the principles of Pictorialism to highly specialized technical training. At the college and university level, photography courses could be found in remarkably diverse parts of the curriculum, including the departments of art, journalism, chemistry, physics, civil engineering, and industrial arts. The number of these programs continued to increase, with a major growth spurt in the mid-1950s. By 1966, nearly 500 colleges and universities offered courses in the medium.[57]

Only a handful of the leading postwar photography programs had been in existence for more than a few years. One of the oldest was part of the curriculum of the Art Center School of Design in Los Angeles, which had been founded in 1931. The Art Center offered professional instruction in photography, advertising, industrial design, painting, illustration, and cinema set design.[58] The faculty of the photography department included such noted figures as Will Connell, Charles Kerlee, Edward Kaminski, and Fred R. Archer (who left in 1945 to open his own school).[59] Many other leading photographers—including Ansel Adams, Clarence Sinclair Bull, Nicholas Ház, Martin Munkacsi, and Edward Steichen—came to the Art Center to lecture. In addition, the school's gallery presented a series of stimulating exhibitions, ranging from one-person shows of the work of Man Ray, Peter Stackpole, Will Connell, and others, to such group exhibitions as an international survey of scientific photography.[60] This variety suggests the breadth of the Art Center's teaching philo-

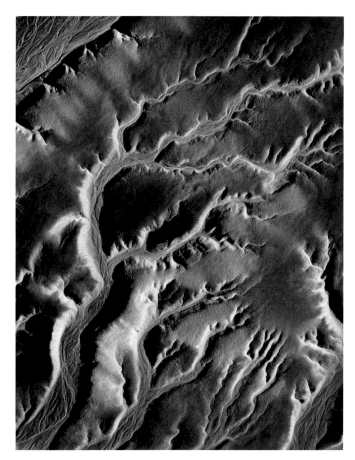

257 William Garnett, *Erosion, Death Valley, California*, ca. 1953, 13⅜ x 10½"

258 Paul Heismann, *Nude Montage*, ca. 1940-45, 13½ x 16½"

sophy, which combined a New Vision openness to experimentation with a solid mastery of commercial techniques. Paul Heismann's photomontage [258], made during his time as a student at the Art Center, exemplifies the eclecticism of this approach. The school's program was widely publicized in the late 1940s through articles in the leading photographic books and magazines.[61]

However, the most influential photographic program of this era was founded in Chicago by László Moholy-Nagy. In 1937, a group of local industrialists brought Moholy-Nagy to the city to

260 **Margaret de Patta,** *Photogram,* 1939, 7⅛ x 9⅞″

259 **Henry Holmes Smith,** *Untitled (light study),* 1946, 7 x 4⅛″

open a "New Bauhaus." The school was originally conceived as a training ground for a new generation of artists and designers who would use their skills to enhance the appeal of American commercial products.[62] While Moholy-Nagy endorsed this goal in principle, he viewed it as one of several desirable ends, all of which depended on a rigorous pedagogical process of experimentation and self-discovery. He thus encouraged each student to "forget the beaten path, quit imitating others, and give his own interests and his own personality free rein."[63] This was hardly the most efficient way to train graphic designers, and tensions inevitably arose with the school's backers. The New Bauhaus closed in early 1938, to be reborn a year later as the Chicago School of Design with more enlightened support from industrialist Walter Paepcke and his firm, Container Corporation of America.[64]

Despite continued financial problems, the School of Design became widely known. Moholy-Nagy used his art-world celebrity to tirelessly promote the institution and its principles. He wrote articles for the popular photographic press (enjoying a particularly close relationship with *Minicam* magazine), gave interviews, made recruiting trips across the country, and conducted workshops at other campuses.[65] In the summer of 1940, for example, he and four other faculty members conducted a special summer session of the school at Mills College, in Oakland, California.[66]

Attracted by Moholy-Nagy's reputation and energy, faculty members and students of considerable talent came to the School

of Design. Gyorgy Kepes, a friend of Moholy-Nagy's from Germany, was named head of the school's Light and Color Workshop. In this position, Kepes taught a variety of subjects, including photography. The young American Henry Holmes Smith, hired in 1937 as Kepes's assistant, subsequently taught the first class devoted solely to the medium. The school's initial semester, in the fall of 1937, was attended by thirty-three students, including Nathan Lerner; Arthur Siegel enrolled in the second term. Both Lerner and Siegel went on to teach at the school. Other notable instructors of this early period include Frank Levstik and James Hamilton Brown, who were hired to teach photography in 1939 and 1940, respectively. Milton Halberstadt, William Keck, Homer Page, and Margaret de Patta were all students in these years.

Not surprisingly, the collective aesthetic of these artists was heavily indebted to Moholy-Nagy's work and ideas.[67] Moholy-Nagy emphasized the photogram as "the real key to photography with the camera," and cameraless images were made by nearly everyone at the school.[68] Indeed, Smith spent most of his artistic life pursuing the expressive possibilities of such nonobjective imagery [259]. Margaret de Patta, best known as a jewelry designer, began making photograms [260] immediately after first meeting Moholy-Nagy in 1939.[69] In addition to cameraless imagery, the school encouraged experimentation with a range of New Vision techniques, including negative images, multiple exposures, and photomontage.[70] Levstik's untitled calligraphic image of ca. 1945-46 [261] is but one of many other examples of this program's wide-ranging approach to picture making.

After several lean years, the school—now called the Institute of Design—grew rapidly in the late 1940s, due in large part to the GI Bill. By 1946, returning war veterans had swelled the school's enrollment to over 500.[71] To help cope with this flood of new students, Harry Callahan, a thirty-three-year old self-taught photographer from Detroit, was hired in the summer of that year. Despite Moholy-Nagy's untimely death a few months later, the program flourished. Callahan's early students included Art Sinsabaugh, Davis Pratt, Yasuhiro Ishimoto, and Marvin Newman. Several noted photographers, including Ferenc Berko and Wayne Miller, served as visiting faculty members in the late

1940s. After Aaron Siskind was hired in 1951, the Institute of Design's photography program reached a new level of importance.[72] Although very different in experience and personality, Callahan and Siskind made a highly effective team, inspiring many of their students to prominent careers as artists, teachers, or working professionals.

The Institute of Design played a pivotal role in American photographic education. In addition to creating a lively center of activity in Chicago, the Institute's principles were spread far and wide through the publications and teachings of its faculty and graduates. Kepes published his influential book *The Language of Vision* in 1944, and went on to teach at the Massachusetts Institute of Technology. In 1947, Smith began Indiana University's photography department, which he headed for some thirty years. In the summer of 1951, three of the school's faculty members— Callahan, Siskind, and Siegel—were invited to teach at Black Mountain College in North Carolina. By the late 1950s, the Institute of Design was producing a steady stream of photographers with master's degrees, many of whom went on to become distinguished teachers in their own right.[73]

Numerous photography programs outside Chicago also achieved prominence in the years after World War II. A variety of educational options existed in the New York City area, for example. In addition to its regular series of lectures and workshops, the Photo League operated its own school.[74] After returning from the war, Walter Rosenblum began a distinguished teaching career at Brooklyn College. The New School for Social Research had an active photography program; by 1951 its faculty included Alexey Brodovitch, Josef Breitenbach, Berenice Abbott, and Lisette Model.[75] In addition, several notable figures offered private instruction in the medium, including Model, Brodovitch, and Sid Grossman.

On the West Coast, important programs were begun in 1946 at San Francisco State College, by John Gutmann, and at the California School of Fine Arts (now the San Francisco Art Institute), by Ansel Adams. The latter program grew directly from Adams's passion for teaching and his experience as a lecturer.[76] However, soon after hiring Minor White as a full-time faculty member, Adams moved into an advisory capacity, leaving the younger man in charge. Until his own departure in 1953, White ran a dynamic program; he hired Homer Page and Frederick Quandt for the department's faculty, and brought in Lisette Model, Imogen Cunningham, and Dorothea Lange for short teaching stints.[77]

From this period on, photography programs were developed across the country. Ohio University, in Athens, began offering a major in photography in 1938; a decade later, its courses covered many facets of the medium's artistic and professional practice.[78] Although it did not offer a major in photography, the program at Ohio State University, in Columbus, was similarly broad.[79] In 1949, Allen Downs and Jerome Liebling began teaching at the University of Minnesota, one of the few universities to offer photography courses in an art curriculum.[80] In the mid-1950s, the formerly technical emphasis of the Rochester Institute of Technology's curriculum was expanded to encompass the art and history of the medium, with courses taught by Minor White, Ralph Hattersley, Beaumont Newhall, and Charles Arnold.[81] At the University of Missouri, Clifton C. Edom created an influen-

261 Frank R. Levstik, Jr., *Untitled*, ca. 1945–46, 7½ x 7⅜"

tial program in photojournalism.[82] Lou Block directed the photographic curriculum at the University of Louisville.[83] Beginning in 1958, Van Deren Coke's teaching career included positions at the University of Florida, Arizona State University, and the University of New Mexico; at each of these institutions he founded important programs in the history and practice of photography.[84]

From Document to Metaphor

World War II changed the way American artists and intellectuals thought about their culture. In addition to emerging from the war as the world's leading power, the conflict gave American society new meaning.[85] For most thinkers, the horrors of Nazi totalitarianism and Soviet communism made the virtues of American democracy newly—indeed, vividly—apparent. One of the war's primary lessons was the essential inhumanity of all utopian political schemes, whether of the right or the left. Despite its many inequities and absurdities, American society seemed by comparison a beacon of vitality and promise. As the historian Arthur Schlesinger, Jr. observed dryly in 1952, "Next to Himmler, even Babbitt began to look good."[86] Such extreme comparisons aside, American culture was seen by its most insightful observers as newly worthy of respect. A long-held sense of cultural inferiority was gone. In the words of Irving Howe: "American culture, by comparison with the European product, should evoke neither apology nor what is worse, genteel chauvinism. The notion that America is uniquely a land of barbarism now seems silly."[87]

This new acceptance of America as both fact and idea was one part of a complex and even contradictory intellectual climate. The postwar world was clearly an uncertain and dangerous place. In the memorable words of Reinhold Niebuhr, Americans found themselves in "an historic situation in which the paradise of our domestic security is suspended in a hell of global insecurity."[88] In

ways that could be accommodated but not ignored, this overarching uncertainty affected the life of every citizen. In addition, of course, the "paradise" of American society was fraught with its own very real tensions and conflicts.

American photography of the late 1940s and the 1950s reflected this complex and unsettled mood. Mass-market publications such as *Life* and *Look* presented a largely progressive and optimistic vision of the nation.[89] Problems were undeniable, but the powers of human reason and technology seemed to assure a brighter future. This progressive ideology dominated the outlook of most Americans. At the same time, a growing attitude of skepticism and alienation provided a counterpoint to the optimism of "official" culture. For some, the prosperity and self-satisfaction of American society were, in themselves, cause for dissent. The increasing homogeneity of life and the banality of modern mass society were central concerns of intellectuals of the day.[90] How, such critics asked, could a culture dedicated to unreflective consumerism, quick profits, and a lowest common denominator of taste nurture a sense of individuality in its citizens or foster a truly democratic communal life? The resulting feelings of unease and estrangement were evident in a spectrum of cultural expressions, from "high-brow" interest in the philosophy of Existentialism and the angst of Abstract Expressionist painting, to the popular appeal of hard-boiled detective fiction and *film noir*.

The anxiety of this era stemmed, in large measure, from the ambiguities of allegiance and motivation felt by so many. In politics, for example, radical thought was completely discredited; in 1952, Philip Rahv noted that socialism had "virtually ceased to figure in current intellectual discussion."[91] At the same time, the excesses of Senator Joseph McCarthy's search for "reds" in American society gave the anticommunist cause a vicious and disreputable air. (The Photo League was one of several organizations that fell victim to this political witch-hunting: placed on an official list of "subversive" groups in 1947, the group was disbanded in 1951.) As a result of such dilemmas, many of the time had a vague sense of moral and intellectual weightlessness. As a leading literary critic observed in 1952:

> In his ideal form, the artist keeps a balance of opposing forces, which gives him the appearance of a suspended man. He seems to be suspended between tradition and revolt, nationalism and internationalism, the aesthetic and the civic, and between belonging and alienation.[92]

In this curiously unreal mental climate, ideas and actions often seemed equally illusory, equally arbitrary. In an essay on the oppositional stance of the era's artists, for example, writer Irving Howe observed in rapid succession: "Negativism in our age is not a whim, it is a necessity of hygiene," and "Perhaps our negativism has become mere habit."[93]

It was, in part, this chronic feeling of suspension and unreality that led a minority of Americans to seek more "authentic" experiences outside mainstream culture. The work of writers and artists became increasingly inscrutable, raw, and even offensive to the general public. Beat poets and writers rejected rhetorical elegance for a frantic, stream-of-consciousness approach. Abstract Expressionist painters like Jackson Pollock discarded traditional notions of craft in favor of seemingly random splashes of paint. In bebop jazz, Charlie Parker and his compatriots rearranged and accelerated popular tunes to create an art of unprecedented nervous energy and improvisational genius. The emerging musical genre of rock and roll was even more polarizing, becoming a potent symbol of generational rebellion.

The issue of identity lay at the heart of this cultural turmoil. While every age has pondered the meaning of the self, this subject was raised to a new level of importance in postwar America. In fact, the word "identity" only came into its current social-science use in the 1950s.[94] Psychological ideas were everywhere in the air, as the forces of modern secular culture produced a pervasive sense of rootlessness, dehumanization, and anxiety.[95] As *Life* reported in 1948, "the chief difficulty in America is an *inner one*—the modern individual is out of touch with the inner realities of life and is somehow 'lost.' He suffers from philosophical and spiritual confusions."[96] Existentialist philosophy, imported from Europe, gave intellectual form to these feelings. Alienation—the separation of individuals from sustaining personal or social relationships—became a key concept in this period.[97]

Critic Lionel Trilling described the alienation of the postwar era as the result of a historical movement from sincerity to authenticity, from a definition of self based on an orientation outward toward family and community, to one directed fundamentally inward.[98] The forces of urban life accelerated this shift in emphasis. By its nature, the secular, scientific, and democratic modern age tended to dissolve the social glue of religion, kinship, and tradition. The unprecedented mobility of Americans—by the mid-1950s the average family moved every four years—significantly reduced their sense of communal identity. The size and anonymity of the modern city effectively relieved new arrivals of the obligations and inhibitions of small-town life. The city provided the opportunity to erase the past and to remake oneself from scratch. However, this new freedom carried a price: release from the comforts and constraints of tradition often produced a sense of placelessness and moral disorientation.

Photography was one of the most basic common denominators of this increasingly diversified culture. By 1953, the nation boasted 55,000 professional photographers and another 35,000,000 amateurs (fully 7,000,000 of whom described themselves as either "serious" or "expert").[99] Images of newsworthy subjects were published in endless number in newspapers and magazines, shaping the way Americans thought about the events and personalities of the day [262]. In addition, the scientific uses of the medium were expanding dramatically. By 1950, for example, the development of human embryos had been thoroughly photographed, and "the biggest camera in the world," the 200-inch Mt. Palomar telescope, was documenting the universe with unprecedented precision.[100] This telescope increased the power of the unaided human eye by an astonishing factor of six hundred million times.[101] The camera's ability to record events in seemingly infinite detail was exemplified in the coverage of the nation's 1946 atomic bomb tests at Bikini Atoll. Cited as "the world's most photographed event," the first two of these test explosions resulted in more than 3,000,000 feet of motion picture film and 100,000 still images.[102]

The camera was widely understood to be the era's most effective medium of both information and persuasion. Unlike painting, music, or literature, the realism and directness of photography made it "the perfect propaganda form."[103] This potential was clearly recognized by the U.S. State Department's Office

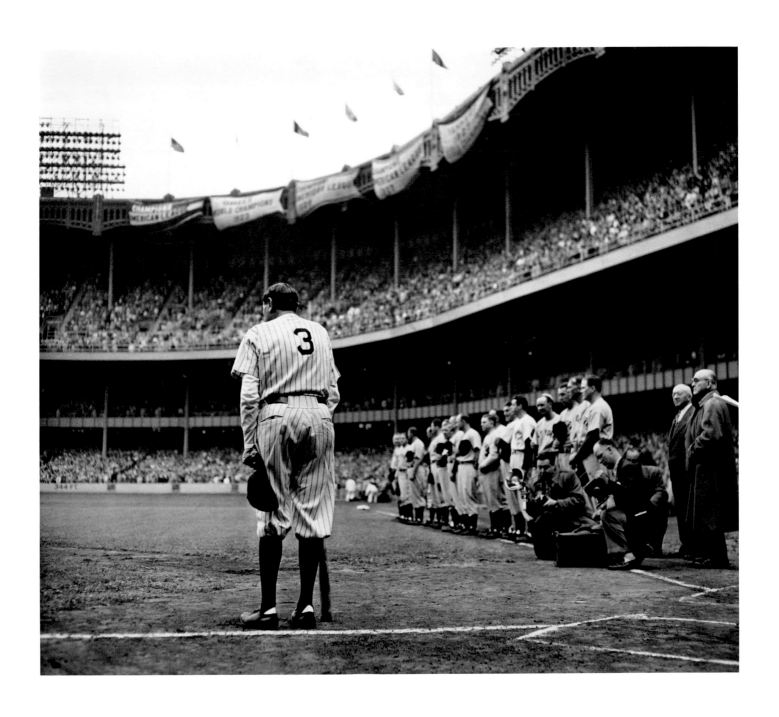

262 Nat Fein, *Babe Ruth, Yankee Stadium*, June 13, 1948, 10⅜ x 12″

of International Information which, by 1951, was printing 20,000 still photographs a week of scenes illustrating the virtues of the U.S. and its people. These images, employed in the Cold War struggle against Communism, reached an overseas audience of 90,000,000 people.[104] At home, Americans were exposed to a vastly greater number of documentary, journalistic, and advertising photographs, as well as to the all-pervasive kinetic images of film and television.

Many artistic photographers of the postwar era reacted to this picture-saturated culture by producing work of an increasingly private nature. Seeking to avoid complicity in what they considered the manipulative enterprises of politics and commerce, they used the camera in a deeply personal quest for meaning. Their goal was expression rather than persuasion, evocation rather than analysis. Since the medium's propagandistic strength lay primarily in its realism, these photographers pursued a more subjective and abstract vision. While advanced technology allowed the depiction of the most distant and exotic subjects, they turned their cameras instead on the commonplace and the elemental. Extending Stieglitz's notion of Equivalence, they sought to transcend mere record-making to evoke intangible thoughts, moods, and emotions. Only by rejecting mainstream uses of the medium, these artists felt, could photography provide truly meaningful perspectives on the world and the self.

The Surrealist Legacy

The varied stylistic currents of the 1920s and 1930s—New Vision experimentation, f/64 purism, social documentary, and Surrealism—combined in complex ways in the work of the 1940s and 1950s. Many photographers pushed previously explored approaches—such as the photogram—to new levels of refinement; others explored the aesthetic terrain between formerly divergent approaches. Surrealism, which was based on the provocative potential of synthesis and juxtaposition, remained a particularly vital aspect of the era's expressive vocabulary.

Although he came to maturity as an artist in the late 1930s, Clarence John Laughlin achieved public recognition in the following decade. Through a highly personal symbolic vocabulary and resolutely nonpurist technique—involving the use of double exposures, photomontage, and arranged subjects—Laughlin attempted to express the psychological currents of his time. His work is exhortatory in tone, intensely romantic, and deeply Southern in sensibility. It is also, at its best, remarkably multi-layered in references and meaning. Laughlin's *Mirror of Long Ago*, 1946 [263], for example, presents a complex meditation on a host of ideas: image and imagination, time and memory, opulence and decay, death and desire.[105]

The stylistic heterogeneity of postwar photography is exemplified in the life and work of Val Telberg. Born in Moscow, Telberg moved with his parents to East Asia after World War I, where he attended British, French, Japanese, and American schools in cities in China, Japan, and Korea. He studied chemistry in the United States before pursuing various careers in China and the U.S. Telberg became interested in art after moving to New York in 1938; by 1945 he had turned primarily to photography.[106] Like his life, Telberg's artistic vision was unorthodox and eclectic. By combining negatives in his enlarger, Telberg created dreamlike

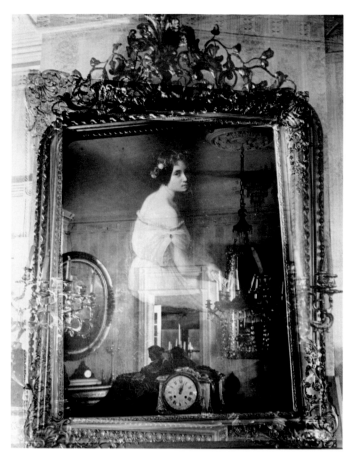

263 Clarence John Laughlin, *Mirror of Long Ago*, 1946 (print: 1981), 13½ x 10¾"

images based on the precepts of Surrealism. In describing his technique in 1949, Telberg stated: "What interests me most is not what one can see, but what goes on unseen in one's mind. The mind blends many images and my pictures attempt to do likewise."[107] In Telberg's untitled work of about 1948 [314], figurative and abstract elements are combined to mysterious and unsettling effect.

The enduring importance of these prewar modernist traits is clear in the work of artists as varied as Ruth Bernhard, Lotte Jacobi, Carlotta Corpron, and Roland G. Spedden. Bernhard, the daughter of a noted German designer and typographer, studied at the Berlin Academy of Art before arriving in the United States in 1927.[108] She began photographing in 1930, and was powerfully influenced by Edward Weston, who she met five years later. Bernhard's *Hand, Jones Beach*, 1946 [319], unites a purist interest in close perception with a Surrealist mood of dislocation and ambiguity. Jacobi, also a native of Germany, became a noted portrait photographer there before fleeing the Nazi regime in 1935 to settle in New York. In addition to her portraits, Jacobi made a series of cameraless images, which she termed "photogenics," between 1946 and 1955.[109] These images are distinguished by their formal and tonal delicacy [264]. Instead of emphasizing geometric shapes and harsh contrasts of light and dark, Jacobi created lyrical veils of tone suspended in pictorial space. Corpron took an equal interest in the subject of light. Her photographs, strongly influenced by her work with Gyorgy Kepes in 1944, utilize various New Vision techniques—ranging from straight photography to photograms, multiple exposures, and solarization—to explore the expressive possibilities of light. Her *Illusion*

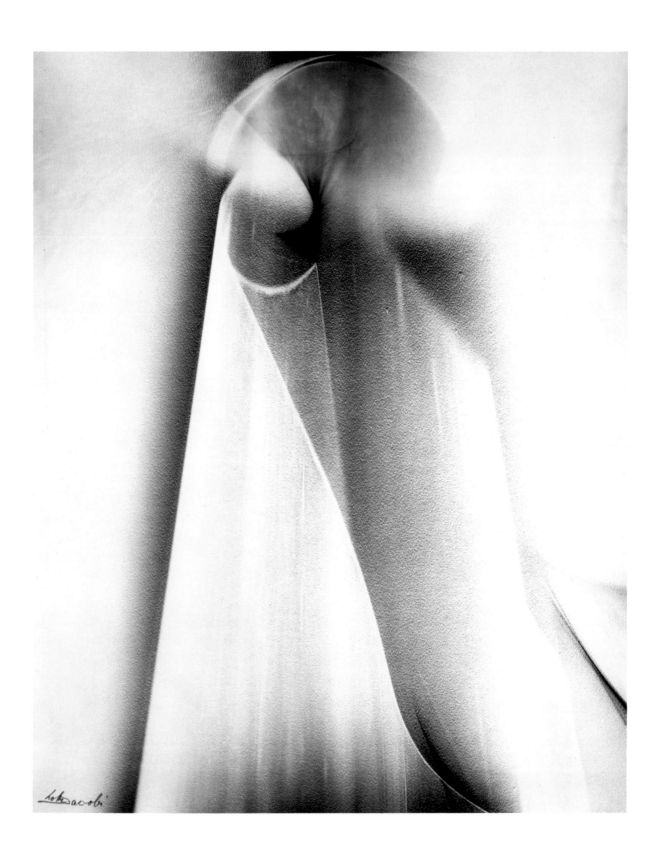

264 Lotte Jacobi, *Photogenic*, ca. 1950, 9½ x 7¾"

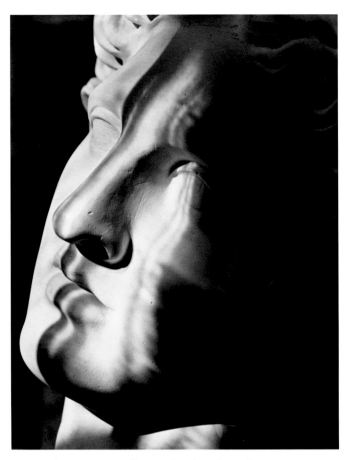

265 Carlotta Corpron, *Illusion of Male and Female*, 1946
(print: ca. 1970), 13¾ x 10⅝″

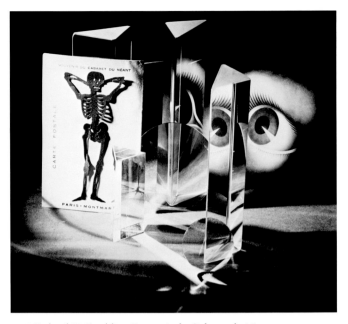

266 Roland G. Spedden, *Souvenir du Cabaret du Neant*, ca. 1940-45,
13¾ x 15¼″

of Male and Female, 1946 [265], for example, uses light less as a simple source of illumination than as an agent of transformation. Spedden, who owned a Detroit advertising agency, worked strictly for his own pleasure and exhibited his work relatively rarely. He was, however, an artist of uncommon talent and experimental bent [266]. Spedden's surreal images were produced with a variety of techniques, including complex studio setups, carefully controlled lighting, multiple exposures and multiple printing, photographing through screens or fabrics, and the creation of reticulated or solarized negatives.[110]

Frederick Sommer was one of the most remarkable artists to come to maturity in this era. His powerfully original work is the product of an uncommon intellect and a deep sense of the connectedness of all things. Born in Italy, Sommer moved with his parents to Brazil, where he studied architecture.[111] After coming to the U.S. to receive a degree in landscape architecture, Sommer returned to practice this profession in Rio de Janeiro. However, a bout with tuberculosis forced him to travel to Switzerland, and then to the American Southwest, in search of a clean, dry climate. These experiences changed Sommer profoundly, and when he settled in Arizona in 1931 his interests turned to visual art. He worked in a variety of mediums, including drawing, watercolor, and musical composition. However, his overriding interest in photography was confirmed in the mid-1930s by meetings with Stieglitz and Weston. By the end of the decade, Sommer was creating meticulously crafted photographs that merged his interests in art, literature, philosophy, and science.

Sommer's photographs were stunningly original. With his 8 x 10-inch camera, he began a series of desert views in 1941 that

were wholly unlike any previous landscapes. In these images [320], Sommer eliminated the horizon line and filled his frame with precisely detailed vistas of rock and cactus. The overall texture of these pictures creates a strange pictorial duality, at once static and agitated. These views deliberately avoid traditional compositional devices: there is no clear center of interest or pleasing balance of subordinate forms. Instead, these landscapes suggest new ways of looking at—and thinking about—both pictures and nature.[112]

Sommer's working method involves a conscious embrace of incongruity and chance. Frequently, his pictures create an unexpected—even provocative—tension between form and content: the contrast between the technical beauty of the print itself and the mundane, or even grotesque, nature of its subject. Beginning in 1939, for example, Sommer produced a group of disturbingly seductive pictures of dead coyotes and rabbits, and surreal arrangements of chicken entrails. In 1946, he began photographing carefully arranged found objects [267]. These images,

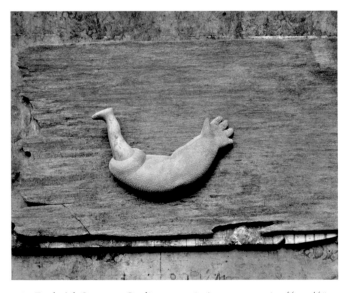

267 Frederick Sommer, *Ondine*, 1950 (print: ca. 1970s), 7⅝ x 9½″

with titles drawn from literary and mythological sources, contain elements of whimsy, allegory, and drama, but defy easy interpretation. In 1949, he began making prints from "negatives" created by such nonphotographic means as applying smoke to glass or oil paint to cellophane. In 1962, he began yet another group of photographic abstractions, using a knife to create an elegant network of cuts in large sheets of paper. The resulting forms were then carefully illuminated and photographed [321]. These images unite seemingly opposite concerns: a "painterly" interest in the abstract beauty of line and tone, and a rigorous technical purism. A sense of synthesis and discovery lies at the heart of Sommer's work, as well as a potent reminder that all photographs are, at once, both taken and made.

Callahan and Siskind

Like those of Sommer, the photographs of Harry Callahan and Aaron Siskind stem from a quest that is deeply private in sensibility and pristinely purist in means. These photographers respect the descriptive power of the "straight" photograph. However, they use this mimetic clarity not simply to replicate the world, but to reinvent it—to charge it with personal, even mythic, resonance. They sought the transcendent in the commonplace, transforming poetic vignettes of experience into emblems of a purer and more comprehensive vision of life. The influence of Callahan and Siskind stemmed, in roughly equal measure, from their dual careers as artists and teachers. Both taught—for many years, together—at the Institute of Design in Chicago and at the Rhode Island School of Design in Providence.

Harry Callahan came to photography without formal training in the arts. What he had, however, was far more important: a deep desire to express himself and an astonishingly original visual imagination. A native of Detroit, Callahan bought his first camera in 1938 and worked casually with it for a few years.[113] Through a local camera club, he became acquainted with Arthur Siegel, who had returned to Detroit after attending the 1938 session of the New Bauhaus in Chicago. At informal gatherings at Siegel's house, Callahan was exposed to a variety of modernist ideas through discussion of Moholy-Nagy's teachings and study of Siegel's library of photographic books and journals. With this background, Callahan was primed for his real breakthrough, which came in 1941 at a weeklong workshop conducted by Ansel Adams. Callahan was struck both by the brilliance of Adams's prints and by his almost spiritual attitude toward the medium. Through Adams, Callahan realized that photography could provide the means of both exploring and expressing one's life.

This encounter triggered a remarkable burst of creative energy. Over the next few years, Callahan explored most of the themes and techniques that would characterize the next half-century of his photography. His work was enormously varied, encompassing nature, the architecture and human activity of the city, and his family. To this range of subjects, he applied an equally varied set of technical approaches. He used cameras of various sizes—from the 35mm to 8 x 10-inch formats—and made extensive use of multiple exposures, high-contrast printing, and both black-and-white and color film. Remarkably, Callahan used the camera to discover the world around him while, at the same, conducting an exhaustive investigation of the grammar and

268 Harry Callahan, *Weed Against the Sky*, 1948, 7¾ x 7½"

syntax of photographic vision. From the influences of Stieglitz's sublime purism (absorbed from Adams) and Moholy-Nagy's relentless experimentation (gained, in part, through Siegel), Callahan forged a wholly original artistic voice.

While the subjects of Callahan's photographs are unremarkable, his vision is anything but common. Callahan was a homebody who found adventure in a world of familiar things: his own house, buildings in the neighborhood, trees in a nearby park. When printed on high-contrast paper, a weed in snow becomes the equivalent of a Zen drawing, irreducibly simple and perfect [268]. His images of anonymous pedestrians [322] avoid anecdote and social comment to focus instead on the spaces between them, and the linear and graphic effects of light and shadow. Callahan's multiple exposures use a simple mechanical technique to transform the solidity of familiar things into a vision of transparency and weightlessness [323]. These wholly synthetic images fold reality back on itself, suggesting temporal change and the restless vitality of urban life. Finally, Callahan's many photographs of his wife Eleanor (and, after her birth in 1950, his daughter Barbara) conflate the intimate and the universal to suggest a mythic realm of fertility and nurture [269].

While understated and emotionally restrained, Callahan's pictures reflect an attitude of deep respect for the things he depicts. Photography was central to his physical and emotional existence. While few in number, his formal statements of purpose rest on this idea of the union of art and life. In his first published essay, in 1946, Callahan wrote:

Photography is an adventure just as life is an adventure. If man wishes to express himself photographically, he must understand, surely to a certain extent, his relationship to life. I am interested in relating the problems that effect me to some set of values that I am trying to discover and establish as being my life. I want to discover and establish them through photography.[114]

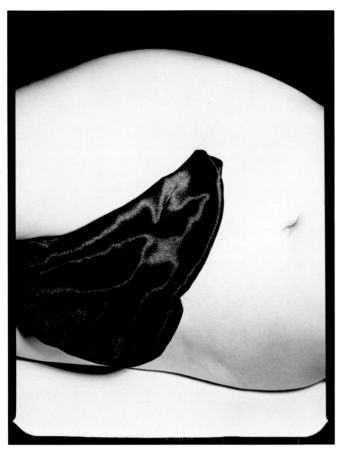

269 Harry Callahan, *Eleanor, Chicago*, ca. 1947, 4⅜ x 3⅜"

This point of view, at once simple and profound, suggests the deep coherence of sensibility the unites this large and ostensibly varied body of work.

Callahan exerted an enormous influence on other photographers through his teaching as well as his art. Hired by Moholy-Nagy at the Institute of Design in 1946, Callahan instructed largely by example. He inspired a distinguished generation of students in Chicago before moving to Providence in 1961 to head the photographic department at the Rhode Island School of Design. He spent fifteen years at RISD, training yet another generation of artists and teachers. In addition, Callahan's photographs have been widely exhibited since the late 1940s. Under Steichen's direction, for example, his prints were included in no fewer than ten exhibitions at the Museum of Modern Art between 1948 and 1962. In addition to many other group shows, Callahan's work was presented in large one-man exhibitions at the Art Institute of Chicago (1951), the Kansas City Art Institute (1956), the George Eastman House (1958), and the Hallmark Gallery in New York (1964).[115] An influential monograph of his work—beautifully sequenced by Callahan himself—was published in 1964.[116]

Aaron Siskind reached his mature style at about the same time as Callahan. In the 1930s, as a member of the Photo League, Siskind worked in a social documentary mode. However, by the end of the decade, his interest in documentary fact was gradually being replaced by a concern for formal values. This new sensibility was apparent by mid-1940, when, in describing the recent activities of the League's Feature Group, Siskind observed that

> we came to see that the literal representation of a fact (or idea) can signify less than the fact or idea itself..., that a picture or a series of pictures must be informed with such things as order, rhythm, emphasis, etc., etc., qualities which result from the perception and feeling of the photographer, and are not necessarily (or apparently) the property of the subject.[117]

His personal work of this time includes highly reductive photographs with negligible documentary content: a coil of rope against the planks of a pier, for example, or closely cropped fragments of architecture. Siskind drifted away from the Photo League in 1941 after his exhibition of architectural images, "Tabernacle City," was criticized by some in the group as socially irrelevant.[118]

Siskind came to artistic maturity in the summer of 1944. Several months later, he described this experience in an important essay titled "The Drama of Objects."

> Last year I spent the summer at the famous New England fishing village of Gloucester, and made a series of photographic still-lifes of rotting strands of rope, a discarded glove, two fish-heads, and other commonplace objects which I found kicking around on the wharves and beaches. For the first time in my life subject matter, as such, had ceased to be of primary importance. Instead, I found myself involved in the relationships of these objects, so much so that these pictures turned out to be deeply moving and personal experiences....
>
> For some reason or other there was in me the desire to see the world clean and fresh and alive, as primitive things are clean and fresh and alive. The so-called documentary picture left me wanting something....
>
> As the saying goes, we see in terms of our education. We look at the world and see what we have learned to believe is there. We have been conditioned to expect. And indeed it is socially useful that we agree on the function of objects.
>
> But, as photographers, we must learn to relax our beliefs. Move on objects with your eye straight on, to the left, around on the right. Watch them grow large as you approach, group and regroup themselves as you shift your position. Relationships gradually emerge, and sometimes assert themselves with finality. And that's your picture.
>
> What I have just described is an emotional experience. It is utterly personal: no one else can ever see quite what you have seen, and the picture that emerges is unique, never before made and never to be repeated. The picture—and this is fundamental—has the unity of an organism. Its elements were not put together, with whatever skill or taste or ingenuity. It came into being as an instant act of sight.
>
> Pressed for the meaning of these pictures, I should answer, obliquely, that they are informed with animism—not so much that these inanimate objects resemble the creatures of the animal world (as indeed they often do), but rather that they suggest the energy we usually associate with them. Aesthetically, they pretend to the resolution of these sometimes fierce, sometimes gentle, but always conflicting forces.
>
> Photographically speaking, there is no compromise with reality. The objects are rendered sharp, fully textured, and undistorted (my documentary training!). But the potent fact is not any particular object; but rather that the meaning of these objects exists only in their relationship with other objects, or in their isolation (which comes to the same thing, for what we feel most about an isolated object is that it has been deprived of relationship).
>
> These photographs appear to be a representation of a deep need for order. Time and again "live" forms play their little part against a backdrop of strict rectangular space—a flat, unyielding space. They cannot escape back into the depth of perspective. The four edges of the rectangle are absolute bounds. There is only the drama of the objects, and you, watching.
>
> Essentially, then, these photographs are psychological in character. They may or may not be a good thing. But it does seem to

me that this kind of picture satisfies a need. I may be wrong, but the essentially illustrative nature of most documentary photography, and the worship of the object *per se*, in our best nature photography, is not enough to satisfy the man of today, compounded as he is of Christ, Freud, and Marx. The interior drama is the meaning of the exterior event. And each man is an essence and a symbol...[119]

This is a remarkable essay. In addition to clearly articulating his own motivations, Siskind summarized the ideas that would define a larger movement in creative photography over the next twenty years: the shift from document to metaphor. Siskind sought a newly purified way of seeing, unconstrained by habit or convention. From this perspective, the most trivial subjects had the potential to serve as symbols of the human condition. Thus, the tension, asymmetry, and ambiguity of Siskind's pictures were understood to evoke the uncertainty, longing, and dread that characterize every life. From fragments and shards of the common world, Siskind created an artistic realm that was both beautiful and revelatory. The compositions of his pictures, which often teeter on the edge of chaos, underscore an existentialist belief that life is uncertain, meaning conditional, and survival a function of individual will.

These qualities are apparent in *Gloucester*, 1944 [324], which was featured as the lead image in "The Drama of Objects." The shallow pictorial field of this image contains two basic elements: the ends of two planks of wood (with their shadows) and the numeral 10. Despite their stark simplicity, these forms provide considerable potential for symbolic interpretation. The projecting ends of wood are vaguely threatening, the shadows ominous. Together, these elements suggest pincers or jaws about to advance across the pictorial field. The numeral can be read as emblematic of logic and symbol making: human thought in its most distilled form. Significantly, one might venture, this is the prototypical numeral: the essential sign of our system of counting (base ten), and the conjoining of digits that individually represent everything (1) and nothing (0). Poignantly, this 10 floats in a relational void, referring to nothing beyond itself. It is boldly real and yet forlornly isolated.

Pictures such as this represented a deeply personal vision of the human condition, beginning with the condition of the artist himself. The most astute critics of the time realized the self-revelatory nature of these images. For example, in a 1948 review of Siskind's work for the Photo League's journal, *Photo Notes*, critic Elizabeth Timberman observed:

> The key in which [these pictures] are set is romantic, nostalgic, conveying a sense of loneliness. It is as though human beings had departed from these objects, rather than that they had never been there. A brooding emotion carrying a feeling of loss seems to have found its visual counterpart in these abandoned, isolated fragments of still life...
>
> A process of association takes place, where forms, juxtapositions and textures give rise to a high degree of suggestivity.... The work seems always to be oscillating between the impersonal and the personal, so that what is portrayed in sand and on walls and on the street is really the face of the artist.[120]

Siskind's mundane subject matter was utterly removed from the polished, progressive world of 1950s America. His best-known pictures depict mere hieroglyphics of the human presence: torn posters, bits of graffiti, peeled paint [270]. In 1950, he began

270 Aaron Siskind, *Jerome, Arizona*, 1949, 19½ x 14¼"

an extended series of photographs of stone walls on Martha's Vineyard. These images orchestrate shape, tone, and texture to suggest a primal relationship between the most basic natural forms and mankind's inherent constructive impulses.[121] Siskind's only important group of pictures to employ the human figure, his remarkable "Pleasures and Terrors of Levitation" series, was begun in 1953.[122] By his choice of viewpoint and printing technique, Siskind removed his subjects (teenagers jumping into a lake) from their real-world surroundings [325]. Each figure is depicted in isolation, flying or falling through a space that is as psychological as it is physical. The result is a perfect poetic evocation of the philosophical notion of "suspended man." The duality of Siskind's series title suggests the contradictory feelings of exhilaration and fear generated by these existential leaps into the void.

Of all the photographers of this era, Siskind had the closest ties with the avant-garde artistic community. He was friends with many of the leading Abstract Expressionist painters, including Franz Kline, Barnett Newman, Adolph Gottlieb, Mark Rothko, Robert Motherwell, and Willem de Kooning. Siskind showed regularly at the Charles Egan Gallery in New York, which specialized in the work of this circle, and in 1948 he was given a one-man show at the avant-garde Black Mountain College.[123] In 1951, Siskind was the only photographer included in the landmark "Ninth Street Show," which served to define Abstract Expressionism as a distinct movement.[124] This acceptance reflected the high opinion these artists had for Siskind's work, as well as their shared sense of purpose.[125]

271 Ralston Crawford, *Third Avenue Elevated*, 1949, 13½ x 9⅛"

Forms of Abstraction

The diversity of photographic practice in the late 1940s and 1950s stemmed from a fundamental desire to transcend or transform reality. This quest took various forms, as photographers explored many paths from document to metaphor. The interest in abstraction did not often result in wholly nonobjective photographs, however. Most typically, personal expression was achieved by distilling or reshaping reality rather than by denying it. The variety of these approaches, and their lengthy lineage in modernist thought, underscores the importance of the idea of abstraction in this era.

As Siskind's example shows, many of the most thoughtful artists found themselves in an artistic quandary in the early 1940s. In the 1930s, this generation had largely embraced Leftist and realist modes of expression, rejecting the experimental concerns of the 1920s as hopelessly self-indulgent and elitist. However, this progressive vision was undermined by the American Left's disillusionment with Stalinist Russia, beginning with reports of the Hitler-Stalin pact of 1939. With social-documentary photography stripped of its promise of political agency, many artists looked to renewed forms of abstraction for meaning. Inspiration was drawn from the intermixed legacies of Synthetic Cubism, de Stijl, Constructivism, Bauhaus experimentation, and Surrealism. In American painting, the rebirth of interest in geo-

metric abstraction was underscored by such events as the founding of the American Abstract Artist's group (1937), the opening of the Museum of Non-Objective Art (1939), and the arrival of Piet Mondrian in New York (1940). In the work of painters such as George L. K. Morris and Ilya Bolotowsky, the ascetic purity of an earlier, European nonobjectivity was given more sensuous and personal American expression. Stuart Davis's paintings stemmed from his synthesis of Cubist ideas with a lively, even whimsical, devotion to popular culture. Artists such as these shared a basic belief in formalism, valuing the expressive potential of shape and structure over the more obvious narrative or emotional associations of subject matter.

This formalist approach was epitomized by the work of Ralston Crawford. Crawford had already achieved recognition as an avant-garde painter when he took up photography in 1938. Inspired by Precisionist artists such as Charles Sheeler, Crawford combined a highly reductive visual sensibility with an interest in the forms of American industry and technology. In his crisp, planar renderings of factories, bridges, dams, and airplanes, Crawford created a pictorial world distilled to the most basic geometry of sensation and emotion. This interest in the structural logic of the modern world is seen clearly in his photographs of New York's Third Avenue Elevated rail line [271]. Beginning in 1948, Crawford made numerous photographs of the steel supports of the El and the patterns of light and shadow they created. Some of these closely-cropped images were translated into other mediums, undergoing a further process of distillation.[126] Crawford's art increased in graphic complexity over the years, while continuing to express his basic interest in form [272]. Unfortunately, the hermetic logic of his vision was out of step with both popular and avant-garde tastes, and Crawford received only modest recognition in the last thirty years of his life.

The meaning of abstraction underwent important change in the 1940s. Never a singular idea, the varied twentieth-century movements and styles that may be described as "abstract" nonetheless share a basic set of characteristics, centering on notions of the intellectual, spiritual, or metaphysical.[127] Geometric abstraction such as Crawford's tended to emphasize the intellect, and employed a rigorous pictorial strategy of distillation and simplification. By contrast, the Abstract Expressionist painters of the 1940s and 1950s had little interest in a formal refinement purged of content. Stressing the spiritual and metaphysical, they created art based on more complex—if often implicit—notions of symbolism.[128] The first of these approaches was the product of Cubism and Constructivism; the second owed a major debt to Surrealism.[129]

In the postwar era, abstraction in art was largely defined by Abstract Expressionist painting. In truth, this term suggests a greater degree of commonality than really existed in artists as diverse in approach as Mark Rothko, Adolf Gottlieb, Willem de Kooning, Jackson Pollock, Clyfford Still, Franz Kline, Barnett Newman, and Ad Reinhardt. However, it is precisely in the variety of this work that the full range of Abstract Expressionist ideas is revealed. At root, these artists were concerned with the primal, the eternal, and the sublime. This is evidenced in their interest in tribal and "primitive" art, particularly that of American Indians, Eskimos, and Pre-Columbian peoples. A 1943 statement by Gottlieb and Rothko underscored the appeal of such work:

272 Ralston Crawford, *Duluth*, 1961, 13¾ x 16¼"

273 Van Deren Coke, *Fallen Cross*, 1961, 9¼ x 7¼"

There is no such thing as good painting about nothing. We assert that the subject is crucial and only that subject-matter is valid which is tragic and timeless. That is why we profess spiritual kinship with primitive and archaic art.[130]

In the mysterious symbolic language of centuries-old pictographs and totems, artists of the 1940s found powerful evocations of their own feelings about art and the human condition. Significantly, "primitive" art had, by this time, a relatively mainstream appeal and was the subject of several important books and exhibitions.[131]

The Abstract Expressionist quest for primacy was but one component of an eclectic blend of motivating ideas. These artists drew significant inspiration from notions of myth, ritual, magic, alchemy, and the occult. In an age of psychology, Carl Jung's ideas of the collective unconscious and universal archetypes were of particular interest. World religions such as Buddhism and Zen made smaller, but not inconsequential, contributions to this heady conceptual mix. As a result of such varied influences, the art of this era exhibits a pervasive sense of contrast and duality. Deeply inward in sensibility, it reaches far outward to embrace the timeless and universal. In equal measure, it seems, the art of the 1940s and 1950s was a product of ego and selflessness, confidence and fear, creation and destruction, the heroic and the tragic. This is an art of extremes: harsh contrasts of light and dark, pictorial fields that are either dense with incident or starkly empty.

The expressive vocabulary of this art underscores its links to Existentialism. The artistic act was understood to be at once profoundly solitary and archetypally human—a timeless struggle for creation and a quest for individual authenticity. By its nature, this art was seen to embody an unprecedented moral seriousness. In the words of Thomas B. Hess, editor of *Art News* and champion of Abstract Expressionism, this art represented "a shift from aesthetics to ethics; the picture was no longer supposed to be Beautiful, but True—an accurate representation or equivalence of the artist's interior sensation or experience."[132]

Such ideas dominated artistic thought in the postwar period. Beginning in rebellion against the artistic mainstream, Abstract Expressionism had, by the end of the 1950s, become the era's authoritative style. The high point of this influence was probably reached in 1958-59, when the Museum of Modern Art toured a large show of "New American Painting" in Europe, and the populist *Life* magazine celebrated the Abstract Expressionists as the "world's dominant artists today."[133]

Postwar photographers were similarly inclined to think about pictures in abstract terms. The idea of abstraction was central to the photographic work of this era, as revealed in the contents of every issue of *Aperture*, as well as in exhibitions such as the Museum of Modern Art's "Abstraction in Photography" (1951) and "The Sense of Abstraction" (1960), and the American Federation of Art's traveling show "Abstract Photography" (1957), curated by Aaron Siskind. Following Moholy-Nagy's precepts, it was generally understood that photographs were about more than content alone. As Gyorgy Kepes instructed in 1942, "Your subject in all pictures is never really an object. It's the light reflected from or radiating from that object. Light, then, is your photographic subject."[134] This emphasis gave legitimacy to a broad spectrum of technical and expressive approaches: objective and subjective, straight and manipulated.

Through this breadth of possibilities, the intellectual currents of the age were given uniquely photographic form. Sommer's anxious landscapes, Callahan's transcendent quietude, Siskind's anthropomorphism, the tough melancholy of "New York School" urban photography, and the evocation of religious symbolism by Minor White, Van Deren Coke [273], and others, all reflect important facets of the age's climate of sustaining ideas.[135] Basic to all this work was—as Thomas Hess observed—a fundamental sense of artistic truth: the idea that each work of art presented "an accurate representation or equivalence" of the artist's subjective self.

Minor White and Aperture

No photographer used the camera in a more deliberate quest for self-discovery than Minor White. In college, White studied botany and literature. His earliest significant photographs were architectural studies, produced in 1938-39 in Portland, Oregon, under the auspices of the WPA's art program. However, while he remained dedicated to a straightforward technical use of photography, White's artistic interests were from the start fundamentally subjective. His mature work represents a complex synthesis of Stieglitz's idea of Equivalence, Weston's purist clarity, and Adams's devotion to the natural landscape. White came to know these and other leading photographers after his discharge from the Army in 1945. He assisted Beaumont and Nancy Newhall at the Museum of Modern Art for a year before taking a teaching position at the California School of Fine Arts in 1946. His work developed rapidly in the following years.[136]

As one of his biographers has observed, White's creative life was "one sustained effort, more and more successful as time went on, to find a spiritual home."[137] Aside from a brief period of formal study in art history, at Columbia University in 1945-46, this quest was self-motivated and eclectic. Over the years, White was inspired by a variety of ideas, including Catholicism, Christian mysticism, Zen, Tao, the *I Ching*, hypnosis, astrology, the teachings of the Russian mystic G. I. Gurdjieff, and Jungian psychology.[138] The central thread of White's life was a restless quest for self-awareness and metaphysical truth; he used the camera as a "medium and catalyst for [an] intensely personal, emotional, spiritual, and mystical expression."[139] As White wrote in his journal in 1947: "Understand only yourself. The camera is first a means of self-discovery and then a means of self-growth. The artist has one thing to say—himself."[140]

To this end, White perceived the world through a language of symbol and analogy. He was attracted to elemental things: rocks, trees, water, frost, the human figure. In each of these subjects he found suggestions of larger forces, as well as evocations of his own feelings. His *Easter Sunday*, 1963 [**274**], for example, pictures the world at its most primal: rock and water, darkness and light. By using a slow shutter speed, White created an elegant calligraphy from the sun's flickering dance across an undulating surface of water. The resulting photograph is a visual haiku, intensely spiritual and at once intimate and sublime. This interest in mystical transformation underlies many of White's urban pictures as well. *Warehouse Area, San Francisco*, 1949 [**326**], was originally made as part of a series of "Movement Studies" exploring the idea of people "caught in the act of becoming something else."[141] While clearly recognizable, the blurred boy and sheet of paper create a mood of otherworldliness that is underscored by the enigmatic "face" in the doorway.

White's quest for nontraditional meanings led him to explore the expressive potential of groups of pictures. During his year in New York, White's interest in the photographic sequence was stimulated by conversations with Stieglitz and his work at the Museum of Modern Art assisting with the layout of Edward Weston's 1946 retrospective. By 1947-48, White was assembling sequences of images with titles such as "Amputations" and "Song Without Words" that, like Stieglitz's Equivalents, evoke a range of associations and emotions. As White wrote:

> A sequence of photographs is like a cinema of stills. The time and space between photographs is filled by the beholder, first of all from himself, then from what he can read in the implications of design, the suggestions springing from treatment, and any symbolism that might grow from within the subject itself.... The meaning appears in the space between the images, in the mood they raise in the beholder. The flow of the sequence eddies in the river of his associations as he passes from picture to picture.[142]

274 Minor White, *Easter Sunday, Stony Brook State Park*, 1963, 8¼ x 3″

Reflecting the fluidity of this intended meaning, White felt free to restructure his sequences to reflect his own changing ideas and moods. For example, four versions of "Song Without Words" (from 1947, 1950, 1960, and ca. 1963) contain, respectively, twenty-four, fifteen, twelve, and thirteen prints in varying order.[143] Clearly, White considered these sequences to be organic works with their own potential for growth and change.

As a corollary to the idea of equivalence, White stressed the need to "read" photographs. This reading was based on an acknowledgment of the inherent complexity of the image and its ability to trigger psychological and spiritual insight. For White, the meanings of images lay beyond mere subject matter in a realm of simile, metaphor, and symbol. Moreover, these meanings were dynamic rather than fixed, reflecting the ideas and moods of each viewer. Many photographers found this approach entirely too subjective. For example, White's friend Ansel Adams agreed that "perhaps all photographs have meanings because of conscious or unconscious connotations," but felt that "the connotations

275 Benjamen Chinn, *Untitled (Chinatown, San Francisco)*, 1948,
4¾ x 3⅝"

276 Bob Hollingsworth, *Grant Cleaning and Dyeing*, 1949, 9½ x 7½"

imposed by the photographer, or by groups of photographers, are questionable."[144] White argued that the act of "reading" images was based not on an arbitrary imposition of meaning, but on recapturing a vital "innocence of vision." In 1958, he observed:

> Most adults have to regain the ability to experience pictures directly and deeply. Contrary to their convictions that they already understand everything, most people have to reestablish the ability to let a photograph speak for itself. And paradoxes abound, one has to learn innocence of vision—by hard effort, by serious and deliberate search for meanings in photographs.[145]

Through White's overlapping roles as artist, teacher, and editor, these ideas became broadly influential.

White's ability as a teacher, and the range of his artistic interests, are revealed in the quality and variety of work produced by his students at the California School of Fine Arts.[146] His years there, 1946 to 1953, came at a particularly stimulating time in the school's history; on the painting faculty, for example, were such noted figures as Mark Rothko and Clyfford Still. This creative climate, in combination with White's pedagogic passion, produced a number of talented photographers, including Benjamen Chinn [275], Bob Hollingsworth [276], Philip Hyde [277], William Heick [280], Rose Mandel [330], and Oliver Gagliani [331]. While the work of White's students varied in style and subject matter, they shared a highly refined sense of craftsmanship and an interest in perceptual or psychological complexity. Their prints are typically modest in size, purist in technique, and private in sensibility. As such, they demonstrate both the individuality of their maker's vision and the combined influences of Adams and White.

After his move to Rochester, New York, in 1953, White became a central figure in that city's photographic community. He worked at the George Eastman House, taught at Rochester Institute of Technology, and took students-in-residence at his home. He also gave an increasing number of lectures and workshops nationwide. White developed a distinguished circle of students and associates. Carl Chiarenza [415], Jerry Uelsmann [313, 385], Kenneth Josephson [380], and Peter Bunnell were among his students at RIT; Paul Caponigro [333] studied privately with him; Nathan Lyons [332] and Walter Chappell, both then employed at the George Eastman House, became friends and collaborators. White influenced the vision of all these artists. This is seen clearly, for example, in the 1960 publication *Under the Sun: The Abstract Art of Camera Vision*, featuring the work of Lyons, Chappell, and Syl Labrot.[147] Caponigro's best-known pictures build on the lyricism of White's landscape work, finding spiritual resonance in the basic forms of nature.[148] Chiarenza has continued to explore and expand a White-inspired mode of abstraction to the present day, while Bunnell, a leading photographic historian, is White's biographer.

In addition to such personal contacts, White's influence was broadcast through the pages of *Aperture* magazine. Begun as a quarterly in 1952 by a group that also included Ansel Adams, Dorothea Lange, Barbara Morgan, and Beaumont and Nancy Newhall, *Aperture* was one of a number of avant-garde visual and literary magazines of this era.[149] As historian Jonathan Green has noted, *Aperture* was a logical expression of the bohemian currents of San Francisco in the early 1950s, with close links to the Beat movement of the period: "Both *Aperture* and the Beats,

277 Philip Hyde, *Capitol Reef*, 1963, 9⅝ x 7⅝"

278 Pirkle Jones, *Untitled*, 1947, 3⅝ x 4⅝"

in their own way, stood for an art of revelation, of individuality, of loud or quiet protest, of message, of beatitude."[150] In his position as editor and production manager, White used *Aperture* to express his own interests and ideas. When the original founders voted to discontinue it in 1954, White secured new backing and continued to publish. The result was a deliberately "precious" journal—small in size, finely designed and printed—that spoke to an elite community of photographers. (In 1957, *Aperture* had 600 subscribers; *Popular Photography*, by comparison, had about 400,000.)[151]

In conscious emulation of Stieglitz's *Camera Work*, White used *Aperture* to promote deserving work and to prod his readers to new understandings of both photography and life. In its first several years, White published images by established figures such as Strand, Callahan, Sommer, and Edward and Brett Weston. He also featured portfolios by lesser-known contemporaries, including many from the West Coast: Larry Colwell [328], Wynn Bullock [329], Pirkle Jones [278], Bob Hollingsworth, Rose Mandel, Philip Hyde, and Ruth Bernhard.[152] In addition, the journal included articles and book reviews by Ansel Adams, Van Deren Coke, Barbara Morgan, Henry Holmes Smith, Dorothea Lange, the Newhalls, Nathan Lyons, and White himself (sometimes writing under the name of his alterego, Sam Tung Wu).[153]

While *Aperture*'s tone of impassioned (if often witty) subjectivity remained consistent over these years, the journal's contents were relatively varied. In 1955, White devoted large sections of two issues to a nuts-and-bolts outline of the Zone System, a technical method pioneered by Adams for correlating the exposure and development of photographic negatives. The idea of "read-

ing" photographs, first broached in 1953 by Henry Holmes Smith, was a central focus of the journal in the period 1957-59.[154] This interest was given its fullest and most mystical treatment in a 1959 issue titled *The Way Through Camera Work*, a phrase evoking the combined influences of Zen and Stieglitz. White's photograph *Ritual Branch* [327] was featured prominently in this important number. An issue from 1958 included photographs by Lyle Bongé made under the influence of mescaline. The subsequent number was devoted to a poetic survey of architectural photography, from the 1850s to the present. Included in this issue were Richard Nickel's *Proscenium Arch, Garrick Theater* [334], and John Szarkowski's *Guaranty (Prudential) Building, Buffalo* [335], both documenting the work of architect Louis Sullivan (whose ideas on the spiritual function of art must have appealed to White).[155] This editorial variety reflected the breadth of White's passion for photography and made *Aperture* singularly important to the era's most serious practitioners.[156]

Multitude, Solitude

The psychological tenor of postwar life was perhaps most clearly evoked in the texture and rhythms of the urban scene. The image and idea of the city brought the dominant issues of the period— identity and community—into sharp focus. The city represented both the best and worst of modern life: individual achievement, social pluralism, and the forces of technological progress, as well as the corresponding notions of anonymity, alienation, and the erosion of moral and aesthetic standards. Photographers of widely varying sensibilities took the urban scene as their central motif. The themes they explored were diverse: the physical city, as an artifact shaped by the impress of innumerable lives; the symbolic city, in which issues of community and identity are reflected in solitary figures and anonymous faces; and the poetic city, in which the larger meanings of life are suggested in images of urban disjunction and flux.

Nearly all these photographers shared a basic sympathy with poet Charles Baudelaire's observations on the relationship of the modern artist to the spectacle of urban life. In the mid-nineteenth

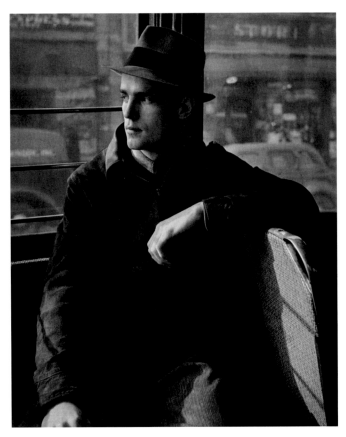

279 Edmund Teske, *Chicago*, ca. 1938-39, 9½ x 7¾"

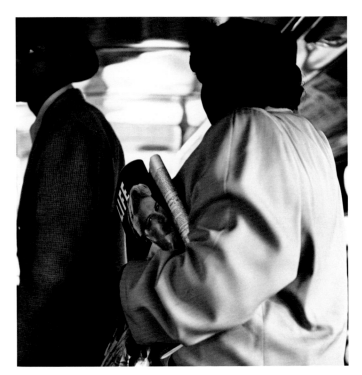

280 William Heick, *San Francisco*, 1947, 5¾ x 5⅝"

century, Baudelaire had described the seductive energy of the bustling street:

> For the perfect flâneur, for the passionate spectator, it is an immense joy to set up house in the heart of the multitude, amid the ebb and flow of movement, in the midst of the fugitive and infinite. To be away from home and yet to feel oneself everywhere at home; to see the world, to be at the centre of the world, and yet to remain hidden from the world...the lover of universal life enters into the crowd as though it were an immense reservoir of electrical energy....[157]

For Baudelaire, the key words were:

> Multitude, solitude: equal and convertible terms for the active and fecund poet. He who does not know how to people his solitude will not know either how to be alone in a bustling crowd.
>
> The poet enjoys the incomparable privilege of being able as he likes to be himself and others. Like those wandering souls which search for a body, he can enter every person whenever he wants.... The solitary and pensive walker draws from this universal communion a singular sense of intoxication.[158]

Many photographers of this era were, indeed, solitary and pensive walkers, denizens of the street in search of telling vignettes of daily life. Reflecting Baudelaire's point of view, this collective quest was at once documentary and poetic, personal and universal. Paradoxically, perhaps, the most public places yielded images of deeply intimate sensibility, as artists recognized aspects of themselves in the faces of strangers. In its most affirmative form, this vision of urban life was truly one of "universal communion."

On the other side of the emotional spectrum, however, some of the most advanced photographers of the postwar period used the city to express a less comforting vision of danger, loneliness,

and loss. From this artistic perspective, the city was all harsh angles, isolated figures, and ominous shadows. Such work reflects the same cultural climate that gave rise to the hard-boiled detective fiction and *film noir* of the 1940s and 1950s. The cheap paperback books of Mickey Spillane, Cornell Woolrich, David Goodis, and Jim Thompson, for example, combined gritty realism and lurid hallucination to evoke an atmosphere of dread and violence.[159] The most powerful of Thompson's books transcend the mystery genre to suggest the ultimate social terror: a state of moral and psychological free-fall.[160]

The classic themes of *film noir* are urban crime and corruption, uncontrolled passions, deception, and disaster.[161] The world of *film noir* is shadowy and nocturnal, populated largely by the lonely and the deviant. These films bear titles such as *The Stranger* (1946), *Fear in the Night* (1947), *I Walk Alone* (1948), *In a Lonely Place* (1950), *Night and the City* (1950), and *The Prowler* (1951). *Film noir* owes a dual debt to the documentary and expressionist traditions. Like the classic documentary films of the 1920s and 1930s, *noir* movies were grounded in reality: the use of more portable cameras produced a new sense of veracity, and a number of these films were shot on location rather than solely in the studio. However, the characteristic visual traits of *film noir*—shadows, harsh angles, and unusual perspectives—were derived from expressionist art and film. As a result of this dual influence, *film noir* evokes a particular kind of reality: the truth of subjective experience. In these films, the world is viewed from very specific points of view, and facts are filtered through sensibilities charged with emotion and opinion.

In mood, technique, and imagery, the best still photography of this period bears an obvious familial resemblance to *film noir*.[162] Still photographers were less concerned with story-telling than movie makers, of course, but their respective visions of the world had much in common. Making fresh use of new tools and techniques, still photographers also viewed contemporary life in ways that combined documentary and expressionist intentions.

This duality is telling. As historian J. P. Telotte writes of *film noir*, "the *noir* world...always seems pulled in two contrary directions, to talk and to silence, toward community...and toward the isolation of a universal otherness."[163]

Together, these poles of community and isolation mark the conceptual ground of artistic thought in this era. In various ways, much of the best postwar photography concerns itself with the uncertain relationship between individual and collective identity, public and private space. For example, many of this era's artists were fascinated by the paradoxical tension between physical intimacy and psychological distance. The congestion of the streetcar, the subway, or the city sidewalk created, by necessity, a world of silence, averted glances, and private reverie. Photographers such as Edmund Teske [279] and William Heick [280] recorded strangers on crowded streetcars. Others, such as Walker Evans, Ed Feingersh, and Arthur Leipzig, made candid pictures of subway riders.[164] Nearly every photographer, it seems, worked on the city sidewalk. Typically, these artists recorded their subjects in a state of stoic passivity, at once guarded and vulnerable.

This condition of isolation and vulnerability seemed emblematic of modern life. As critic Leo Braudy has observed, the literary presumption of the era held that "the art of fiction making demands a solitary sensibility speaking to another solitary sensibility."[165] Thus, he suggests, the broad appeal of the detective novel in the 1940s and 1950s "was due less to the interest in crime or in puzzle solving, than to the feeling that another America of family and friends and trust between strangers has been lost and that the only guardians of its empty treasury are these tender, armored professionals of loneliness."[166] As a fundamental aspect of urban life, loneliness was thus a key—if ironic—emblem of human commonality. As Thomas Wolfe wrote in *Of Time and The River* (1935), "We walk the streets, we walk the streets forever, we walk the streets of life alone."[167] Walking the streets alone symbolized both individual solitude and an existential form of universal kinship.

Harry Callahan, working in Chicago, was deeply interested in this aspect of the street—its paradoxical union of restless energy and ominous silences, of intimacy and alienation. Rejecting images that seemed simplistically narrative in content, Callahan instead focused on anonymous pedestrians "lost in thought." Moody and introspective, these pictures suggest the essential need for privacy lying at the heart of our highly rationalized, collective life [322]. At several points in his career, most notably in 1950, Callahan used a telephoto lens to isolate the faces of nameless walkers, creating images that perfectly blend specificity and universality. Another facet of the city's psychological meaning is suggested in his remarkable *Bob Fine*, ca. 1952 [336]. This minutely detailed image (a contact print from an 8 x 10-inch negative) records a figure at the end of a deeply shadowed alleyway. At once mysterious, claustrophobic, and humorous, this photograph suggests, on the most primal level, something of the emotional experience of the vast modern city.

Similar concerns are seen in the work of Callahan's finest students. Marvin Newman, for example, was one of Callahan's first graduate students at the Institute of Design.[168] For his thesis project, Newman produced a striking series of photographs of shadows cast by pedestrians on Michigan Avenue [337]. These were conceived and presented in inverted form, a simple manipulation

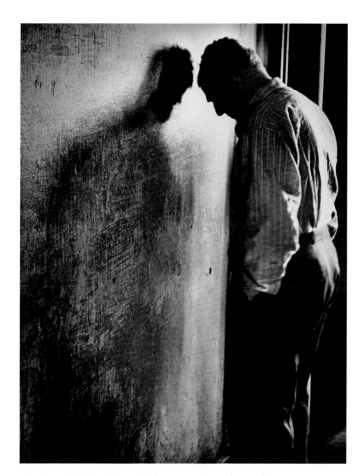

281 Jerry Cooke, *Man of Byberry*, 1946, 13½ x 10½"

that suggests the metaphysical potential of the most familiar subject matter. These existential apparitions were shown at the Museum of Modern Art in 1953. Yasuhiro Ishimoto, who received his BS degree from the Institute of Design in 1952, produced a rich body of work in the period 1950-52 (and again, during his return to Chicago in 1958-60). Ishimoto's work combines a bold graphic logic with an interest in gestures and details that speak of the universal human condition. Ishimoto's *Wall Graffiti* [338], for example, suggests with both wit and poignancy the timeless human need to leave some record of our existence.

In addition to such intuitive expressions of subjectivity, some photographers of this era dealt explicitly with the idea of the psychological. *Life* photographer Jerry Cooke produced one of the period's most searing and influential bodies of work. Commissioned in early 1946 to document the horrendous state of American mental hospitals, Cooke photographed several institutions in Ohio, as well as the dilapidated Byberry facility in Philadelphia. In May of that year, a selection of these pictures accompanied a shocking exposé, titled "Bedlam 1946," in *Life* magazine.[169] A variant selection—emphasizing aesthetic rather than strictly journalistic concerns—was featured in the year-end *U.S. Camera* annual.[170] In 1955, one of these images occupied a prominent place in "The Family of Man" exhibition. The unsettling power of these pictures stemmed from at least two sources: their allusion to the recently revealed horrors of the concentration camp and their emphasis on the labyrinthian mysteries of the mind. Cooke's *Man of Byberry* [281], for example, functions in a bleakly poetic, existential manner.[171] Here, a lost soul confronting a blank and abraded wall seems to conjure up his own

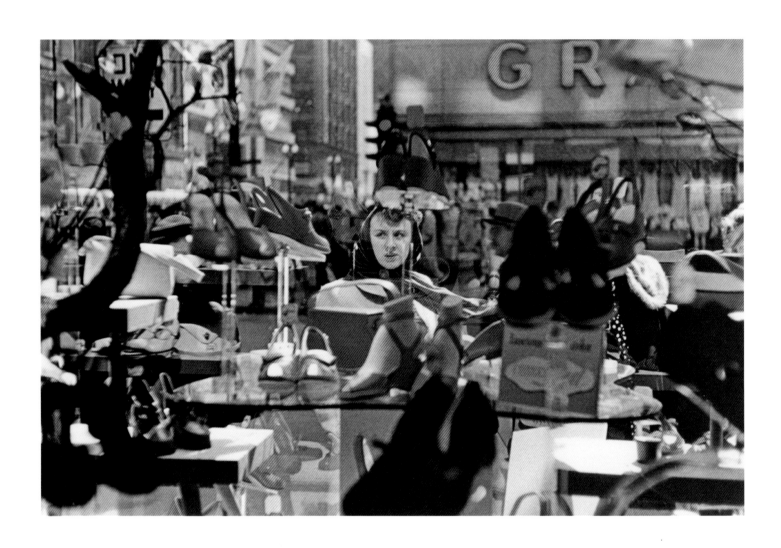

282 Arthur Siegel, *In Search of Myself*, 1951, dye transfer print, 6½ x 10"

ghostly mirror-image. While wholly ephemeral, this spectral projection seems somehow more free and vital than the man's actual, lumpen figure. Thus, in addition to its social reform agenda, this series explored one of the era's central philosophical concerns: the tragic disjunction—and essential fragility—of the human body, mind, and spirit. Notably, Cooke's series anticipated by more than a decade similar bodies of work by Richard Avedon and Diane Arbus.

Psychological concerns are also at the heart of Arthur Siegel's most important postwar work. His color photographs of anonymous pedestrians on State Street in Chicago were produced while he was undergoing Freudian analysis. In this series, titled "In Search of Myself," Siegel used strangers as emblems of his own multifaceted self [282]. The most compelling of these images utilize shop-window reflections to create a complex visual space in which lone faces or figures are immersed in a kaleidoscope of commodities.

A key expression of this highly subjective sensibility is Dave Heath's book *A Dialogue with Solitude*. Although published in 1965, Heath's book (which was actually assembled in 1961) reflects the artistic concerns of the 1950s, when most of its images were made. Like "The Family of Man," *A Dialogue with Solitude* emphasizes universal human qualities.[172] However, its focus is not on the outward commonalities of family structure or labor, but on the most inward moods and emotions. This is a profoundly bittersweet work. The faces of Heath's subjects provide a wordless narrative of loneliness and melancholy punctuated by fleeting moments of tenderness, reverie, and joy [283]. Reproduced without identifying captions, the book's images function on a purely visceral and emotional level; understanding is gained through feeling rather than reading, empathy rather than analysis.

One of the pictures in this book, elsewhere titled *Crowd Watching a Failed Resuscitation, Central Park*, ca. 1957 [339], provides a particularly eloquent summation of the psychological currents of the era. This image depicts a somber policeman and a background gallery of spectators at the site of a death. The trauma is all off-stage, as Heath fills his frame with those who linger out of duty or curiosity. The image has a strangely theatrical quality: the policeman is lit as if with a spotlight, and the whole scene seems a world unto itself, divorced from any larger frame of reference. Self-conscious of their own voyeurism and yet unwilling to leave, the viewers stand silently together, contemplating the fact of mortality. This image suggests the most profound artistic dichotomies of the era: multitude and solitude, life and death, darkness and light, hope and despair.

The New York School

In the postwar years, important urban photographs were produced in a number of cities, including Philadelphia, Chicago, San Francisco, and Los Angeles. However, due to the size and vitality of its photographic community, New York City was by far the dominant site and subject of this genre of work.[173] As a result of an influential 1992 exhibition and book, the phrase "The New York School" has become historical shorthand for the quintessentially urban style of American photography of the 1940s and 1950s.

The modern city's messy, protean vitality was conveyed most memorably by Weegee, a uniquely talented tabloid news photo-

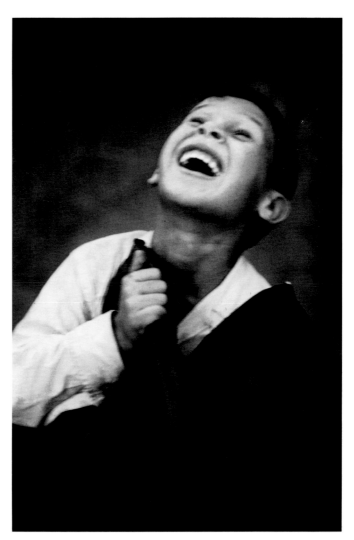

283 Dave Heath, *Chicago*, 1956, 9¾ x 6⅝"

grapher. Born Usher Fellig, in Austria, Weegee came to the U.S. with his family at the age of ten.[174] An impoverished childhood gave him an enduring instinct for survival and a hard-boiled empathy for his fellow man. After a dozen years of darkroom work for Acme Newspictures, Weegee became a freelance news photographer in 1935. He worked on retainer for the progressive newspaper *PM* and sold pictures to other New York dailies, including the *Herald Tribune*, *World-Telegram*, *Daily News*, *Post*, and *Sun*. In addition, the leading photographic syndicates distributed his images to newspapers across the country.

Early in his career, Weegee was given his nickname (after the Ouija board, a popular amusement of the period) for his seemingly uncanny ability to sense breaking news. Repeatedly, he was the first photographer to arrive on the scene of a fire, accident, or murder. While he encouraged belief in his psychic powers (when something was about to happen, Weegee said, his elbow itched), it is clear that his success lay less in portents than in sheer entrepreneurial drive.[175]

Specializing in the calamities and crimes of New York City life, Weegee typically began his workday in the evening, at police headquarters. He carefully monitored the Teletype machine, departing immediately for the scene of any noteworthy incident. Always prepared for action, Weegee kept shortwave radios tuned to the police band in both his car and apartment. In the field, he worked rapidly with his 4 x 5-inch Speed Graphic camera and

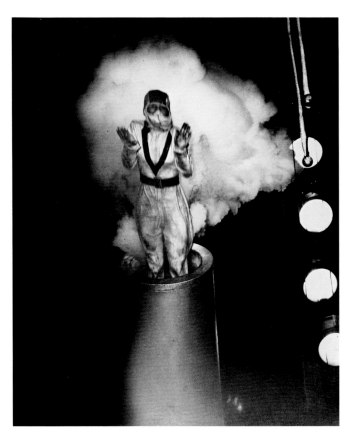

284 Weegee, *Girl Shot from Cannon*, 1943, 9⅛ x 7⅞"

Among Weegee's most famous photographs are *Accused "Cop Killer,"* 1941 [340], *The Critic*, 1943 [341], and *Girl Shot from Cannon*, 1943 [284]. The first of these is characteristic of his police work: brutally direct and unsentimental, and yet oddly lyrical in vision.[179] *The Critic* (seen here in its less common, uncropped form) records two society ladies on their way to the opera.[180] As they present well-practiced smiles to the camera, they remain unaware of their "critic," a resentful—and perhaps deranged—woman standing to their left. The resulting photograph suggests a complex dynamic between the seen and the unseen—within the image itself, and in the structure of society. *Girl Shot from Cannon*—a masterpiece of vernacular surrealism—documents a famous circus act of the day with exuberant absurdity.[181]

Weegee's work had a uniquely broad appeal, spanning the realms of the tabloid press and the art museum. When his work was first exhibited at the Museum of Modern Art in 1943, and he was invited to lecture there a year later, Weegee reveled in his celebrity status. His fame was confirmed with the publication of his first book, *Naked City* (1945), a brilliant union of text and pictures that was followed by *Weegee's People* (1946). *Naked City* was as popular with the critics as it was with the public. The *Saturday Review* called it "a magnificent album of snapshots and love letters...a wise and wonderful book," while Paul Strand praised Weegee's intensity, honesty, and "unerring sense of the moment."[182] As a mark of his professional stature, Weegee was invited to conduct a summer seminar at the Institute of Design in Chicago in 1946. By this time, Weegee was so noteworthy that when he took his students outdoors to demonstrate how to photograph a corpse (in this case, a mannequin), the session was covered by *Life* magazine.[183] Ironically, the praise lavished on Weegee for his gritty and unpretentious news photography induced him to turn to self-consciously "artistic" effects. His subsequent book—*Naked Hollywood* (1953)—had none of the raw vitality of *Naked City*, and his years in Hollywood, from 1947 to 1952, were largely wasted.[184]

The sweaty intimacy of Weegee's vision of the city stands in marked contrast to the cool formalism of Andreas Feininger's work. Feininger grew up in the heady environment of the Bauhaus, where his father, the expatriate American painter Lyonel Feininger, was one of the founding instructors. After studying architecture and structural engineering, the younger Feininger took up photography in 1927. His earliest pictures, exhibited in such prestigious exhibitions as "Film und Foto," embodied the experimental tenets of the New Vision. In 1934, Feininger developed the extreme telephoto technique that became his artistic trademark.[185] After moving to the U.S. in 1939, and joining the staff of *Life* four years later, Feininger used this technique to suggest the vast scale and dynamism of postwar America. *Life* published so many of Feininger's boldly composed photographs as two-page spreads that his friends called him "Double Truck Feininger."[186] In one of the most famous of these images, *Fifth Avenue, New York*, 1949 [285], Feininger's long lens evokes the perpetual energy of urban life by transforming the city into a congested beehive of human and mechanical activity.

Although vastly different in sensibility, Weegee and Feininger both worked in characteristically broad strokes, and for a highly public audience. By contrast, some of the most memorable pictures of this era were created for very personal reasons.

flash to create blunt records of urban trauma and vice. In his 1961 autobiography, Weegee described his stock-in-trade:

> Being a free-lance photographer was not the easiest way to make a living. There had to be a good meaty story to get the editors to buy the pictures. A truck crash with the driver trapped inside, his face a crisscross of blood...a tenement-house fire, with the screaming people being carried down the aerial ladder clutching their babies, dogs, cats, canaries, parrots, monkeys, and even snakes...a just-shot gangster, lying in the gutter, well dressed in his dark suit and pearl hat, hot off the griddle, with a priest, who seemed to appear from nowhere, giving him the last rites...just-caught stick-up men, lady burglars, etc.[176]

After gathering information for his captions, Weegee returned to his darkroom to process the evening's film and to make prints. At about 6:00 AM, he would start his rounds of the newspapers and picture agencies, selling prints as he went. In an average week, this routine earned him about one hundred dollars, a respectable income at the time.[177]

While Weegee depicted an enormous number of sensational subjects—he claimed to have photographed 5,000 murders in the first ten years of his freelance career—his endless quest for salable pictures led him to record many facets of city life. He photographed circuses, parades, theater openings, celebrities, people in nightclubs and movie theaters, the throngs at Coney Island, lovers on park benches, and the homeless. Weegee's pictures depict the city as chaotic, exhilarating, and poignant—a place of both pleasure and danger, camaraderie and solitude. With a vision at once cynical, sentimental, and voyeuristic, he recorded urban life as a grand "carnival of human comedy."[178]

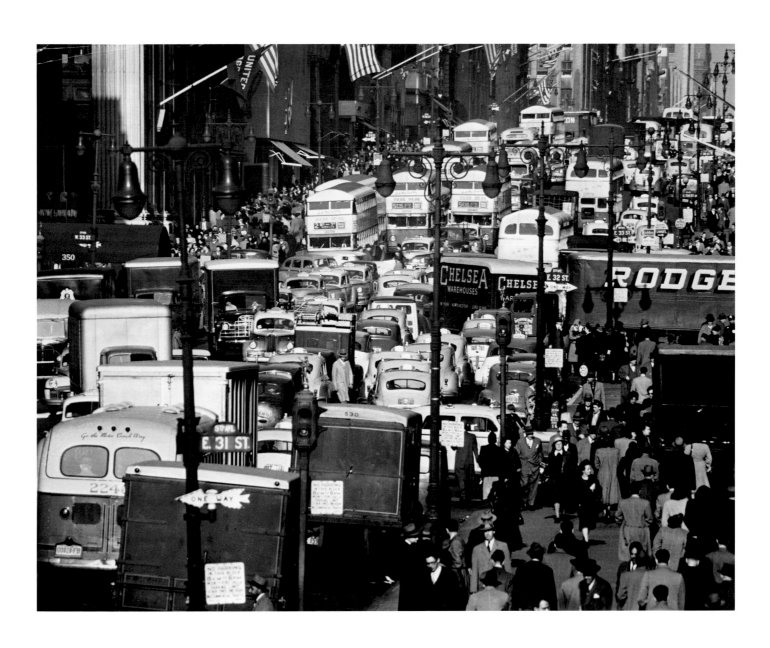

285 Andreas Feininger, *Fifth Avenue, New York*, 1949, 10⅝ x 13½"

286 Todd Webb, *Welcome Home Series: Third Avenue, New York*, 1945 (print: ca. 1980), 6¾ x 4¾"

No photographer seems more aptly described by Baudelaire's phrase "the perfect flâneur" than Helen Levitt. Indeed, her entire life's work constitutes a lyrical meditation on the "fugitive and infinite" vitality of street life. A deeply private person, Levitt photographed strictly for her own pleasure and belonged to no organized groups. She was initially influenced by her friends Walker Evans and Ben Shahn, and by the work of Henri Cartier-Bresson.[187] Later, the visual techniques of film, in which she worked both professionally and artistically, also affected her still photography.[188] Levitt used a small Leica camera, often equipped with a right-angle viewfinder. This combination allowed her to work unobtrusively—indeed, almost invisibly—in working-class neighborhoods where the rhythms of daily life were played out in full public view on sidewalks and front steps.

Levitt responded to this protean theater of the street by creating photographs that are uncontrived, lyrical, and mysterious. Fascinated by the simplest activities and the most fleeting gestures, Levitt recorded the play of children as an archetypal ballet [342].

Many of these works subtly explore the network of connections between individuals and their surroundings. In *New York*, ca. 1942 [343], for example, Levitt creates a gentle mystery from the evidence of touch, expression, and glance, while using internal framing devices to hint at the constraints of these lives.[189] Levitt received high critical praise in the 1940s: her pictures were published in *U.S. Camera* and exhibited at the Museum of Modern Art. Unfortunately, her first book did not appear for many years: *A Way of Seeing*, a selection of forty-four uncaptioned images with an eloquent essay by James Agee, was assembled in 1946 but not published until 1965.

Unlike Levitt's works, Todd Webb's views of New York center on its buildings and artifacts, which he recorded with large 5 x 7-inch and 8 x 10-inch cameras. A native of Detroit, Webb's interest in photography had been stimulated by his friendships with Harry Callahan and Arthur Siegel, and by the impact of Ansel Adams's 1941 workshop. After wartime service in the Pacific, Webb arrived in New York in late 1945 and soon became part of the city's photographic community. While he was influenced by Stieglitz, Evans, and Levitt, Webb established his own artistic voice. Among his first subjects were the simple "Welcome Home" signs posted above doorways to greet returning soldiers [286]. These warm evocations of kinship and community spoke eloquently of the nation's desire for a return to normalcy after years of war. At once public and private in meaning, these simple declarations hinted at the deep emotions of Webb's fellow veterans, and of the families who awaited them.[190] Webb also sought evidence of the human presence in storefront churches in Harlem, the Third Avenue El, graffiti, advertising signs, and shop facades.[191] As he wrote in 1954:

> I have an intense interest in and feeling for people. And often I find subject matter with no visible persons to be more peopled than a crowded city street. Every window, doorway, street, building, every mark on a wall, every sign, has a human connotation. All are signs and symbols of people—a way of living—living in our time.[192]

Webb's interest in the breadth and vitality of New York City culminated in his ambitious *Sixth Avenue*, 1948 [287], a panorama of a full city block. This work, a careful composite of eight individual views, unites a wealth of specific detail with a Whitmanesque embrace of the city's amazing expanse and vitality.[193]

This interest in the rhythms and artifacts of everyday urban life represented a deliberate artistic focus. Turning away from symbols of wealth, competition, and power—values celebrated by "progressive" American society—photographers such as Evans, Levitt, and Webb saw vernacular culture as a source of authentic emotion, natural creativity, and timeless human truths. Agee, for instance, believed that Levitt's proletarian subjects possessed "more spontaneity, more grace, than...human beings of any other kind."[194] Lincoln Kirstein noted that a central motif in

287 Todd Webb, *Sixth Avenue between 43rd and 44th Streets, New York*, 1948 (print: ca. 1980), 13 x 103"

288 Morris Engel, *Comic Book Stand, New York*, ca. 1945, 10½ x 13⅛"

Evans's work was "the naive creative spirit, imperishable and inherent in the ordinary man."[195] Such statements harbored an implicit critique of such "unreal" aspects of American life as big business, elite culture, and middle-class conformity.

Photographers influenced by the Photo League embraced a similar kind of sympathetic realism. Until its forced dissolution in 1951, the Photo League promoted a broadly humanistic vision that shaped the sensibilities of many photographers of the postwar era. For example, Morris Engel, who joined the League in the late 1930s, recorded the basic rhythms of urban life with clarity and warmth [288]. Paul Strand, a highly influential figure for League photographers, praised Engel's "compassionate understanding" of people.[196] Dan Weiner was also devoted to the poetry of the everyday [289]. While working as a commercial and fashion photographer in the years after World War II, Weiner found time to photograph for himself, using a 35mm camera to capture lyrical vignettes of street life.[197] Max Yavno took up photography in New York in the late 1930s. His early influences included fellow Photo League members Consuelo Kanaga and Aaron Siskind. Yavno's personal vision is revealed in the documentary content and formal precision of pictures such as *San Francisco*, ca. 1947-48 [290].[198] Like Yavno, Jerome Liebling created an eloquent personal synthesis of formalism and realism [291]. His studies at Brooklyn College included classes in a design program founded on Bauhaus principles and photography courses with Walter Rosenblum, a staunch exponent of the Photo League's humanist principles.[199]

While white photographers such as Siskind and his fellow Photo League members recorded life in Harlem with genuine sympathy, their vision inevitably differed from that of African-Americans such as Roy DeCarava or Gordon Parks. DeCarava, who was born and raised in Harlem, was recognized for his artistic talent at an early age. Initially drawn to painting and printmaking, he turned seriously to photography in 1947. The photographs he made were quickly recognized as something special—reticent in mood and straightforward in technique, yet "wrought with great feeling and tenderness."[200] DeCarava became the ninth photographer to receive a Guggenheim Fellowship, in 1952. Three years later, he published his first book, *The Sweet Flypaper of Life*, a small, eloquent volume produced in collaboration with the poet Langston Hughes. DeCarava's photographs powerfully unite realist and expressive concerns: their content is always clear, but they nonetheless carry richly symbolic or psychological meaning. His *Hallway, New York*, 1953 [346], for example, is at once real and remembered, depressing and beautiful. As DeCarava has recalled:

> It's about a hallway that I know I must have experienced as a child. Not just one hallway; it was all the hallways that I grew up in. They were poor, poor tenements, badly lit, narrow and confining; hallways that had something to do with the economics of building for poor people.[201]

DeCarava's love of the lower registers of the photographic scale—his celebration of the rich, velvety beauty of gray and black—is apparent here, as it is in his *Coltrane #24*, 1963 [347]. This latter image, from DeCarava's extended documentation of jazz artists, utilizes blur and underexposure to convey the passionate intensity of John Coltrane's music.

While usually less private in sensibility than DeCarava's works, the photographs of Gordon Parks are just as deeply felt. A man of extraordinarily diverse talents, Parks has achieved recognition as a photographer, writer, musician, and filmmaker. Self-educated in photography, Parks worked as a freelance fashion photographer from 1937 to 1942, and then with Roy Stryker in the final years of the FSA, 1942-43. He photographed for *Life* from 1948 to 1961, covering such varied subjects as Harlem street gangs, Paris fashions, Winston Churchill, and the civil

289 Dan Weiner, *Stickball, New York*, ca. 1947-48, 9⅜ x 6⅝"

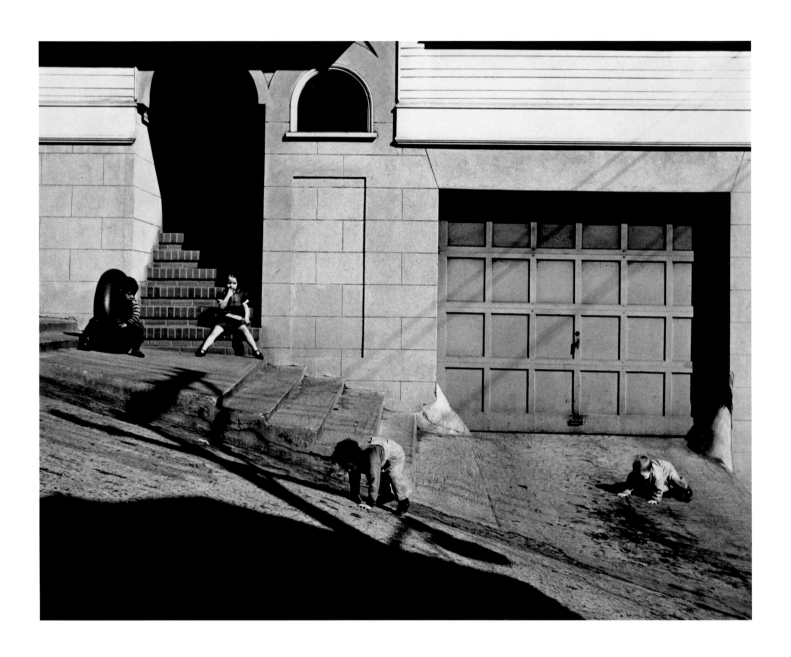

290 **Max Yavno**, *San Francisco*, ca. 1947-48, 7½ x 9½"

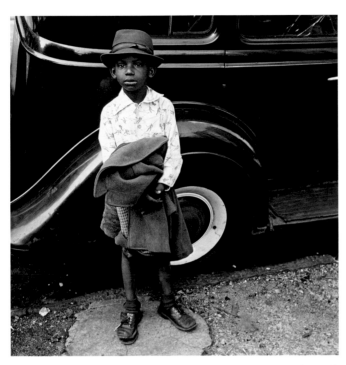

291 Jerome Liebling, *Boy and Car, New York City*, 1949, 10½ x 10½"

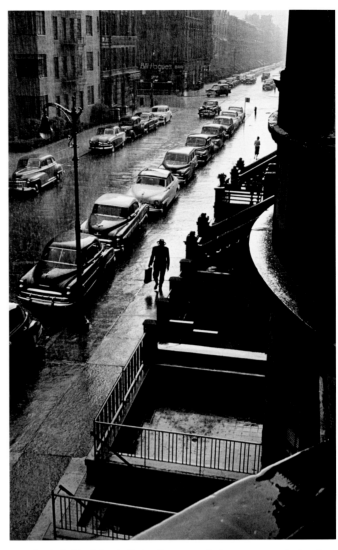

292 **Ruth Orkin**, *Man in Rain, from my window*, ca. 1950 (printed later), 8¼ x 12⅝"

rights movement. His famous image *Emerging Man*, 1952 [348], was inspired by Ralph Ellison's great book *Invisible Man* (1952). Ellison's novel explores the quest for identity of an unnamed African-American protagonist who lives alone in an underground room, his "invisibility" the result of a society that refuses to acknowledge his existence. Parks's photograph of a figure emerging from a manhole—a poetic fiction created in collaboration with Ellison—powerfully evokes this sense of both physical and emotional isolation.[202]

Pictures such as these exemplify the introspective mood of the 1950s. This new vision tended to emphasize feelings of displacement and fragmentation. Through the use of stark contrasts or juxtapositions, and various technical manipulations, the urban world was often depicted as a place of inchoate energy, eerie silence, harsh angularity, and ominous shadows. While photographers like Levitt and Webb recorded the city as a vibrant collection of neighborhoods, each structured by the bonds of kinship and acquaintance, this moodier vision suggested the power of the urban environment to isolate individuals and to erode traditional notions of identity. Thus, instead of Baudelaire's "immense reservoir of electrical energy," the city street became (in Nathaniel Hawthorne's prescient phrase) "a paved solitude" populated by David Riesman's "lonely crowd."[203] One response to this alienating environment was to turn inward, to protect the fragile inner self behind a cold, steely facade. Many of the urban photographs produced in this latter vein thus emphasize voids, isolation, and social masks.

In his comments at the symposium "What Is Modern Photography?," held in 1950 at the Museum of Modern Art, the young photographer Homer Page described these two strains of postwar work:

> There has been a trend away from the old documentary standby of objective reporting toward a more intimate, personal and subjective way of photographing. There are two trends. One trend has a positive note: it records life as healthy, vigorous and even sometimes humorous. It does this without being insipid. I think it's something new and welcome in this field which has been criticized so often for photographing despair and deprivation. I think two people particularly, Ruth Orkin and Tosh Matsumoto, are important here. The other trend leads off, I think, in the opposite direction. These people are breaking up their images—they are concerned, I think, not so much with the "what" of life, but with the "why." They ask questions rather than answer them: Louis Faurer is very good and representative. Both of these trends are healthy. The first is overly so and the second because it records the turmoil and perhaps confusion that we all feel to some extent in this world today.[204]

An astute observer of the photography scene, Page was correct in praising the work of Orkin and Matsumoto. Orkin began photographing in the late 1930s, while in high school. After moving to New York in 1944, she established herself as a freelance photojournalist, producing work for magazines such as *Life*, *Look*, *Collier's*, and *Cosmopolitan*. She also worked in film, codirecting *Little Fugitive* (1952) with Morris Engel (whom she married). Orkins's best still photographs, often made from her apartment window [292], convey the atmosphere of urban life with subtlety and gentle restraint.

Tosh Matsumoto's photographs have a similar inner quietude. Matsumoto took up photography during World War II,

294 Homer Page, *New York*, 1949, 8⅜ x 12⅞"

cisco in 1945. Page's personal work soon attracted the attention of Edward Steichen, who featured him in the 1947 Museum of Modern Art exhibition, "Three Young Photographers: Leonard McCombe, Wayne Miller, Homer Page." After winning a Guggenheim Fellowship in 1949, Page moved to New York. The pictures he made in this Guggenheim year are remarkable: formally inventive, full of fluid grace, and charged with a complex sense of psychology and emotion [294, 350, 351].

Influenced in large measure by Dorothea Lange, Page sought to rejuvenate documentary photography.[206] Citing "the present confusion of facts and values" in 1950, Page observed:

> We are not sure of war or peace, prosperity or recession; not sure what balance to strike between our freedom and our security, either as a nation or as individuals. The fundamental issues are clouded and almost certainly in transition. This makes any attempt to record conditions extremely difficult. This also makes it difficult for any pervasive documentary movement to find common footing, since such movements in the past have generated from relatively clear-cut situations such as war or depression.

However, he suggested, it was precisely this state of psychological uncertainty that demanded recording: "If confusion of values is an important part of our life today, we must analyze and record this confusion." To this end, he advocated new frames of reference, shifting the traditional documentary emphasis on specific places or groups to an embrace of larger and more abstract realities: "the rising tempo of living in cities, shifting family and marriage relationships, present standards of success (and failure), increasing standardization of food, clothes, recreation, news, etc."[207] Thus, while Page used the camera to record the texture of contemporary life, his notion of what constituted documentary fact was unusually broad and nuanced.

Louis Faurer, who Page cited as one of the most important proponents of the new sensibility in street photography, took up the camera in 1937, while studying commercial art in Philadelphia. One of his earliest pictures, *Homage to Muybridge, Philadelphia*, 1937 [250], exemplifies Faurer's unsentimental approach.[208] This image of a faceted mirror above a storefront creates an almost surreal vision of city life: space shifts abruptly from frame to frame, while the pedestrians remain immobile, forever isolated from one another.

The alienation of city life is also suggested in the work of N. Jay Jaffee [352], Louis Stettner [353], and Irving Canner [295,

293 Tosh Matsumoto, *Untitled*, ca. 1947-51, 13¼ x 5"

while held in one of the U.S. government's Japanese-American intern camps. After the war, and his move to New York, Matsumoto's photographs received high-level recognition. Steichen featured his work at the Museum of Modern Art in a four-man show in 1949 and, three years later, in "Diogenes with a Camera II." Matsumoto's pictures combine an exacting sense of pictorial geometry with gentle meditations on the rhythms of everyday city life [293, 349].

Appropriately enough, Homer Page's own photographs provide a vital link between the two approaches he described in 1950. Page's work, which has yet to receive the recognition it deserves, constitutes a brilliant synthesis of fact and poetry, warm humanism and edgy existentialism. His pictures unite the varied tendencies of postwar street photography with a unique intelligence and visual sophistication.

Page began photographing at the age of twelve.[205] After studying art and social psychology at UCLA and Berkeley, he took classes in industrial design at Moholy-Nagy's Institute of Design in Chicago. He spent the war years working in the San Francisco shipyards before opening a commercial studio in San Fran-

344].[209] In the pictures of Jaffee and Stettner, figures are physically close, yet occupy utterly private realms. Similarly, Canner's vision of the city is one of disorientation and distress. The least known of this trio, Canner was a member of the Photo League and a professional scientist. In the years 1947-51, he explored the psychology of urban life in a poetic and richly nuanced body of work. Unfortunately, his activity in photography was curtailed by the League's political problems.[210]

As Page observed, beginning in the late 1940s, a group of photographers in New York began to produce street photographs with a new sense of technical daring, making provocative use of blur, grain, and high contrast. One of the most important of this group was Sid Grossman. Deeply involved with the Photo League before the war, Grossman's work after 1945 became increasingly personal. The years 1946-48 were especially productive, as Grossman worked extensively on the streets of New York and at Coney Island. Eschewing the straightforward techniques of his earlier years, Grossman felt free to move his camera during exposures and to manipulate the tones of his prints through bleaching or dyeing.[211] This approach produced ambiguous, deeply visceral images, as charged and intense as Grossman himself [345].

Grossman was also an important teacher, conducting classes at the Photo League and privately at his home. His most talented students—such as David Vestal and Leon Levinstein—were powerfully influenced by his artistic philosophy.[212] David Vestal arrived in New York in the mid-1940s expecting to pursue a career as a painter.[213] However, a chance meeting led him to Grossman's class, and to his turn to photography. Vestal became a regular student in 1947, and continued his relationship with Grossman until the latter's death in 1956. He was also active in the Photo League. Vestal exhibited actively in the 1950s and early 1960s before becoming better known as a teacher, writer, and editor. Vestal's work is characteristically introspective and thoughtful; even his most dynamic images [296] are ultimately about very personal perceptions and moods.

Leon Levinstein, who took up photography in 1948, was also influenced by classes at the Photo League and his friendship with Grossman. Employed as an advertising layout artist, Levinstein photographed strictly for his own pleasure on weekends and holidays. His artistic interest in the human presence and touch is a poignant reflection of the solitary nature of his life: he had few friends and never married. As a result, Levinstein's work suggests a tension between engagement and estrangement, a conflicted desire to both embrace the world and to hold it at bay. The complexity of his vision is suggested in the boldness and dynamism of his best pictures [356, 357]. While such images are based on a fundamentally naturalistic aesthetic, their strength lies in their angular intensity and moody sense of introspection. In his most definitive artistic statement, written in 1955, Levinstein observed:

> The photographer should seek a deeper reality than appears on the surface. He should seek a structural truth, an essential character in whatever he photographs. It is the photographer's duty to divine and convey. He should forget about imitating or representing nature; he must apprehend a sort of essential reality in whatever he is dealing with and express in esthetic form the emotion he has felt.[214]

After garnering considerable recognition in the 1950s, Levinstein withdrew from the art world, photographing steadily but

295 Irving Canner, *Pedestrians*, ca. 1947-50, 10½ x 13½″

296 David Vestal, *New York (West 22nd Street)*, 1958, 13⅛ x 9″

keeping his work to himself. Since the early 1980s, however, his importance has been increasingly acknowledged.[215]

The new approach to urban photography was perhaps most boldly demonstrated in the work of Ted Croner. Croner arrived in New York in 1945, after service in the Army. While establishing a professional practice in photography, he developed his personal vision through studies with Alexey Brodovitch. Croner's artistic breakthrough came in highly subjective images made in cafeterias and subways. As he recalled, "They weren't pictures of people. They were pictures of the way I felt."[216] Croner often worked at night, using long exposures or camera motion to convey the strangeness and dynamism of city life. The most celebrated of his images, *Taxi, New York Night* [358], was a highlight of the Museum of Modern Art's 1948 exhibition "In and Out of Focus."[217] The sheer confidence of such unorthodox images exerted a marked influence on other photographers of the time.

Saul Leiter's photographs are similarly inventive. A painter by training, Leiter took up the camera in the late 1940s with the encouragement of Richard Pousette-Dart, W. Eugene Smith, and Sid Grossman. His *Street Scene*, 1951 [354], employs an extremely tight cropping and slow shutter speed to create a graphic poem of moody self-absorption. In another image, *New York*, ca. 1952 [355], Leiter used blur and harsh contrasts of light and dark to evoke a feeling of subjective reverie within the inhospitable geometry of the city. (Significantly, this image was originally titled *Private World* when published in 1954.[218])

This trend toward technical and compositional daring was epitomized by the work of William Klein. Klein grew up poor, the son of a New York merchant who lost nearly everything in the Depression.[219] As a child, Klein was both fascinated and repelled by the city. Most of New York, as he later recalled, "seemed foreign to me—hostile and inaccessible, a city of headlines and gossip and sensation."[220] After serving in the Army, Klein used the GI Bill to study painting in Paris; he arrived in 1948 and has lived there ever since. In Paris, Klein was exposed to a variety of provocative ideas on the nature and means of art. His first use of photography, in 1952, reflected this climate of aggressive experimentation: he made abstract photograms enlarged to mural size. Completely self-taught, Klein used the camera in similarly unorthodox ways. In 1954, his images caught the attention of Alexander Liberman, the art director of *Vogue*, who offered Klein a contract to work in New York. This marked the beginning of Klein's career as a photographer of both the city and of fashion.

Klein returned to New York for eight months in 1954-55, and used the opportunity—with *Vogue*'s blessing—to create a personal interpretation of the city. As Klein recalls:

> It was a period of incredible excitement for me—coming to terms with myself, with the city I hated and loved, and with photography. Every day for months I was out gathering *evidence*. I made up the rules as I went along and they suited me fine.

Klein's working method was as abrasive and provocative as New York itself.

> I wanted to be visible in the biggest way possible. My aesthetics was the New York *Daily News*. I saw the book I wanted to do as a tabloid gone berserk, gross, grainy, over-inked, with a brutal layout, bull-horn headlines. This is what New York deserved and would get.[221]

297 Dorothea Lange, *Argument in a Trailer Court*, 1944, 7⅝ x 9⅝"

The remarkable book that resulted, officially titled *Life is Good and Good for You in New York William Klein Trance Witness Revels* (1956), is all this and more. Klein's photographic style is astonishingly raw and muscular. His pictures, jammed with activity and abruptly cropped, are veritable explosions of graphic energy [359]. Disregarding accepted standards of "good" technique, Klein used grain, blur, contrast, wide-angle distortion, and various darkroom manipulations to achieve powerfully expressive effects. The resulting vision—in equal measure exuberant, claustrophobic, and foreboding—was unlike that of any other photographer of the period. It was also too radical for American publishers.[222] Klein's New York book was ultimately produced in Europe, followed by similar studies of *Rome* (1958), *Moscow* (1964) and *Tokyo* (1964).

Home Places

This aggressive urban vision, with its emphasis on fragmentation and alienation, found a logical complement in the work of artists such as Wright Morris, Paul Strand, and W. Eugene Smith. Although their approaches varied considerably, each of these photographers focused on the themes of tradition and community. By emphasizing the weight of history, the rhythms of everyday life, and the enduring bonds of faith and family, these photographers explored those ideas constituting the flip side of the coin of urban ambiguity and estrangement.

An essential link between these seemingly opposed artistic stances is revealed in the ideas and photographs of Dorothea Lange. Lange's FSA-era work exerted an enormous influence on photographers of that time. In addition, despite the somewhat sporadic nature of her production after the early 1940s, Lange provided a powerful example to photographers of the postwar era. Many of this younger generation—including Homer Page and W. Eugene Smith—were greatly affected by Lange's potent synthesis of fact and opinion, and her bittersweet vision of the human condition.[223] For example, in *Argument in a Trailer Court*, 1944 [297], Lange brilliantly evokes the feeling of anger, a subject at once familiar and intangible. The space between the figures becomes a crackling synapse of emotion, a charged interval

determining both the structure and meaning of the picture. This image underscores the appeal of Lange's work to postwar photographers: her ability to explore the range of human feeling in a visually powerful and unsentimental way, and the implicit understanding that the best photographs are the result of a vital synthesis of self and world.

Lange's ideas were eloquently recorded in the essay "Photographing the Familiar," written in collaboration with her son, Daniel Dixon, and published in 1952 in the second issue of *Aperture*. In this piece, Lange noted the artistic confusion of the time and the often strained attempts of photographers to produce meaningful pictures. What was needed, she argued, was a new engagement with reality, whatever its difficulties and disappointments. "Bad as it is, the world is potentially full of good photographs. But to be good, photographs have to be full of the world."[224] To this end, photographers needed to focus on what they truly knew: the putatively simple and commonplace. This apparent narrowing of subject matter and viewpoint was, she stressed, artistically liberating: universal truths could be found in the specifics of the everyday, and a richer form of self-expression could be derived from a new devotion to reality. "Moving in a world so much composed of himself,...every image [the photographer] sees, every photograph he takes, becomes in a sense a self-portrait."[225] Most importantly, Lange underscored the moral importance of art.

> Ours is a time of the machine, and ours is a need to know that the machine can be put to creative human effort. If it is not, the machine can destroy us. It is within the power of the photographer to...help make the machine an agent more of good than of evil. Though not a poet, nor a painter, nor a composer, he is yet an artist, and as an artist undertakes not only risks but responsibility. And it is with responsibility that both the photographer and his machine are brought to their ultimate tests. His machine must prove that it can be endowed with the passion and humanity of the photographer; the photographer must prove that he has the passion and the humanity with which to endow the machine.[226]

In the end, Lange suggested, the entire matter was profoundly simple: "These, then, are the issues: whether we, as photographers can make of our machine an instrument of human creation, whether we, as artists, can make of our world a place for creation."[227]

In her emphasis on familiar things, universal meanings, and a tone of high moral seriousness, Lange's words reflect the concerns of numerous photographers of the period, from Levitt and Evans in the early 1940s to Robert Frank in the later 1950s. However, Lange's ideas seem particularly germane to the work of Morris, Strand, and Smith.

Wright Morris spent his childhood in the farming town of Central City, Nebraska. At the age of nine he moved with his father to Omaha and, later, to Chicago. In 1935, at the time he decided to become a writer, Morris also took up the camera. Fascinated by the complementary powers of words and pictures, Morris explored their union in what he termed "photo-texts." In 1939-40, he made a 10,000-mile journey across America, photographing simple buildings and objects as he went. What fascinated him, as he later wrote, were "facts of a sort—artifacts. Expressive fragments that managed to speak for the whole."[228] A Guggenheim Fellowship, received in 1942, funded a second

298 Wright Morris, *Library, Central City, Nebraska*, 1947, 9⅝ x 7⅞"

cross-country excursion. The result was his book *The Inhabitants*, completed in 1942 but not published until 1946. In this volume, Morris combined photographs of vernacular structures with a fictional text evoking the lives and thoughts of the people who lived in them. The originality of this approach was clear; as one reviewer noted, "*The Inhabitants* is more than a sum of text and pictures. Properly it belongs to no existing literary classification."[229]

While *The Inhabitants* sought the underlying threads of an American identity, Morris's second photo-text was a poetic evocation of his own heritage. With the aid of a second Guggenheim, Morris spent several weeks in the spring of 1947 in the small Nebraska town in which he had been born. This time was divided between his uncle's farm and the public buildings of Central City. In *The Home Place* (1948), Morris used the simple eloquence of familiar things—chairs, doorways, tools, family photographs, a public telephone [360], well-worn library books [298]—to suggest the texture and spare comforts of a vanishing way of life. These images are about time, memory, and mortality; they carry an undercurrent of melancholy, but are never sentimental. Unfortunately, the poor sales of both *The Inhabitants* and *The Home Place* discouraged Morris from publishing a third photo-text volume for more than twenty years.[230] It is clear, however, that his exceptional ability to meld words and images provided an important model for others.[231]

Paul Strand reemerged as a still photographer in 1944, after a seven-year hiatus in which he worked solely in film.[232] In the following three decades of his career, Strand devoted himself to an artistic celebration of cultural continuity and the human meaning of place. His first body of new work—representing the landscape,

villages, and inhabitants of New England—constituted an ambitious attempt to define the essential spirit of America through the evidence of its colonial and Puritan roots. This project, conceived in collaboration with Nancy Newhall, resulted in the book *Time in New England* (1950), a powerful and innovative union of words and pictures.[233] While Newhall scoured libraries for evocative writings from 1620 to the present, Strand photographed the region's coastline, forests, farms, and churches. In these subjects he found timeless symbols of hardship, faith, and human dignity. Strand's vision is both highly formal and richly narrative. For example, his boldly composed *Baptist Church, East Jamaica, Vermont*, 1944 [361], the concluding image in *Time in New England*, suggests much about the place and its people. The church is radiant in the brilliant winter sun, glowing with character and vitality. It is simple, yet dignified; reticent, yet foursquare and unyielding; timeworn, yet enduring. Repeatedly, in pictures like this, Strand used architecture to symbolize the collective achievements and ideals of ordinary people.

Time in New England also spoke to current issues by providing an indirect commentary on the political climate of the late 1940s. The anticommunist hysteria of these years stood in marked contrast to the much earlier society evoked by Strand and Newhall, a communal culture founded on the right of political dissent and the power of individual conscience. As Strand noted pointedly in his introduction to the book:

> From the very start, New England was a battleground where intolerance and tolerance faced each other over religious minorities, over trials for witchcraft, over the abolitionists. The freedom of the individual to think, to believe, and to speak freely was an issue fought out here more than once....[234]

Strand, who held rigidly Marxist views to the end of his life, was so troubled by the political atmosphere of Cold War America that he moved to France in early 1950, just months before the publication of this important volume.[235]

In the years that followed, Strand attempted to give artistic form to his cultural and ideological ideal: an essentially preindustrial world in which nature and culture, individual and community, and past and present were in organic balance. To this end, he photographed village life in France, Italy, the Outer Hebrides islands, Egypt, and Ghana, in each case producing a book combining his images with a writer's text.[236] Strand's best photographs from this period, such as *The Family, Luzzara, Italy*, 1953 [362], represent exquisitely precise orchestrations of reality. The complexity of this small image stems from the individuality of the figures, the implied relationships between them, the rich textures of their environment, and the almost musical rhythms of the composition. In the less successful of Strand's late works, however, his "morose heroicism" and formal control tend to reduce his subjects to virtuous but one-dimensional types.[237]

Like Strand, W. Eugene Smith was motivated by deep humanistic ideals. Smith believed that photography provided "a great power for betterment and understanding," and that each photographer "must bear the responsibility for his work and its effect." As he stated in 1948, "Photography is not just a job to me. I'm carrying a torch with a camera."[238] This zeal triggered repeated fights with employers, but it made Smith the finest photojournalist of his era.[239] Smith first achieved broad public recognition in World War II, which he covered for Ziff-Davis Publi-

cations, *Life*, and as a freelancer. Badly wounded on Okinawa in May 1945, he spent two years recuperating before he returned to full-time work.

Smith was at his professional peak between 1947 and 1954, when he created the most memorable of *Life*'s photo-essays. These include "Folk Singers" (1947), "Country Doctor" (1948), "Spanish Village" (1951), "Nurse Midwife" (1951), "Chaplin at Work" (1952), and "A Man of Mercy" (1954). Uniting these varied essays was Smith's celebration of the virtues of human creativity, compassion, and endurance. His admiration for self-sacrifice is seen clearly in his most famous subjects: a small-town doctor in Colorado, an African-American midwife in the rural South, and Albert Schweitzer's charity work in Africa. In each of these essays, Smith used specific individuals or situations to suggest larger ideas. Indeed, "Spanish Village," the broadest of Smith's subjects, suggests an entire culture's life, tradition, and faith in microcosm. Like Strand, Smith sought to portray a timeless harmony of culture and nature, and to suggest life's universal rhythms.

Smith's working method was avowedly subjective. In 1948, he wrote:

> Those who believe that photographic reportage is "selective and objective, but cannot interpret the photographed subject matter" show a complete lack of understanding of the problems and the proper workings of the profession. The journalistic photographer can have no other than a personal approach, and it is impossible for him to be completely objective. Honest—yes! Objective no![240]

On another occasion he stated, "I do not seek to possess my subject but rather to give myself to it."[241] This approach demanded a complete physical and emotional immersion in each project. He sought to learn everything he could about his subject and to evoke that complexity in his photographs. Smith shot more than 2,500 negatives apiece for his "Country Doctor," "Spanish Village," and "Nurse Midwife" essays, and over 4,000 for "A Man of Mercy."[242] In the darkroom, he made liberal use of burning, dodging, and bleaching to orchestrate the tones of his prints for expressive effect. Paradoxically, perhaps, Smith sought to make photographs that were individually eloquent and, at the same time, interdependent parts of a narrative whole. For example, *Woman with Bread*, 1950 [363], from his "Spanish Village" essay, succeeds on several levels: as a purely graphic composition, as a suggestion of organic continuities (curiously, the loaves of bread echo the shapes of the stones that form the village's very foundation), and as part of the essay's larger description of the community's production of food.[243]

Smith's perfectionism, emotional involvement in his projects, and chronic disregard of deadlines created inevitable problems with his employers. Ultimately, his desire for authorial control over the presentation of his work was simply incompatible with the realities of the magazine business.[244] Although the editors of *Life* often went to unusual lengths to accommodate his demands, Smith was rarely satisfied with their use of his pictures. He ultimately resigned from the magazine in 1954 in protest over the handling of his Schweitzer essay.[245] The remainder of his career was an uneven mix of commercial assignments, personal projects, grants, and museum exhibitions, accompanied by ill health and turmoil in his personal life. Smith's ambitions remained large, however. As photographic historian William Johnson has written,

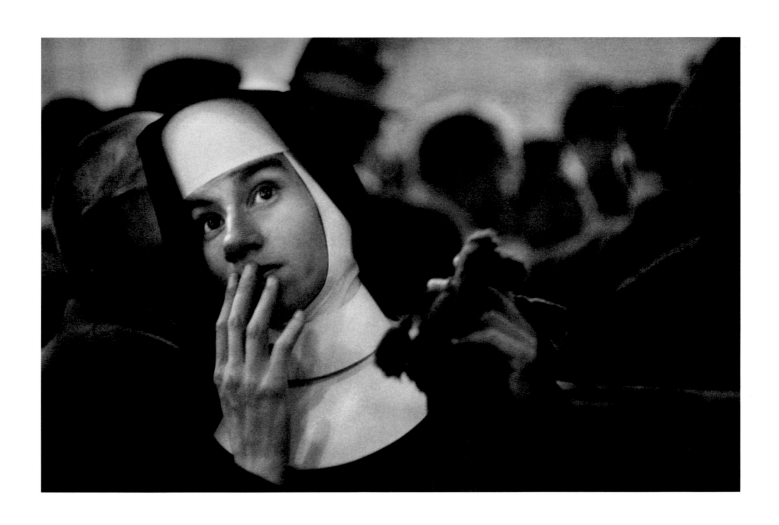

299 W. Eugene Smith, *Waiting for Survivors of the Andrea Doria Sinking,* 1956, 8½ x 13⅜"

Smith tried to force the genre of the photo-essay into "an epic poetic mode."[246] From the nearly 10,000 negatives made in the course of his "Pittsburgh" project (1955-56), Smith created an "essay" of 2,000 images which evoked the collective life of the city in astonishing scope and vitality. But, of course, no magazine could possibly accommodate such detail and complexity.[247]

During this period, Smith also covered "hard news" events such as the sinking of the Italian ocean liner *Andrea Doria* [299]. Other series included the Ku Klux Klan (ca. 1951-58), poetic visions of the city from his studio window (1957-58), Haiti (1958-59), the Japanese firm of Hitachi Limited (1961-62), and the Hospital for Special Surgery (1966-68). Smith's final project, "Minamata" (1971-75), documented the horrific effects of industrial pollution on a small Japanese city. He recorded the ominous discharges of tainted water into the ocean, the deformed children born to women who had eaten mercury-tainted fish, and the attacks on peaceful protestors by corporate security police. This work, which appeared at a time of rising environmental concerns, had enormous international impact.[248]

"The Family of Man" and The Americans

The poles of this postwar artistic sensibility—at once private and communal, celebratory and critical—are revealed in the contrast between two landmarks of 1950s photography: Edward Steichen's exhibition "The Family of Man" (1955) and Robert Frank's book *The Americans* (1959). The first has been understood to mark the culmination of a collective and populist vision; the latter represented a sharp turn toward a tougher, more subjective use of the camera.

"The Family of Man" represented a logical summation of both the ethos of postwar culture and of Steichen's own ideas and ambitions.[249] Late twentieth-century critics have mistakenly tended to view this exhibition as strongly conservative, even reactionary, in tone. In fact, "The Family of Man" had an explicitly liberal message: the barriers of hate and prejudice must be surmounted, and peoples unlike ourselves accepted as equals.[250] This message rang true for most Americans. The terrible toll of World War II and the ongoing Cold War threat of nuclear annihilation prompted a new appreciation of the unity of the human experience (refracted, inevitably, through the prism of what was most familiar: middle-class American life). It seemed clear that divisive notions of identity—whether nationalistic or ethnic—were dangerously outmoded; the very survival of mankind rested on an acknowledgment of shared values and experiences.

The stakes could not have been higher. Precisely because the world was in such grave danger, many hoped for a revolution in human understanding and the onset of a kind of cultural millennium. Some looked to the dream of world government for salvation; others sought it in a renewed sense of the sacred or a radically enlightened humanism.[251] In January 1946, *Ladies' Home Journal* editorialized:

> The atomic bomb, born in hate, has been released in a world appalled at the destruction which awaits us all unless we learn to love one another.... Out of the crucifixion of all those who died at Nagasaki and Hiroshima (as well as of our own men who died in Europe and the Pacific) may come the final redemption of the world.[252]

William Faulkner's famous Nobel Prize speech of 1950 carried a similar tone of urgency and sublimity. In refusing "to accept the end of man," Faulkner emphasized "the old verities and truths of the heart" and the profound moral duty of the artist.

> It is [the poet's] privilege to help man endure by lifting his heart, by reminding him of the courage and honor and love and pride and compassion and pity and sacrifice which have been the glory of his past. The poet's voice need not merely be the record of man, it can be one of the props, the pillars to help him endure and prevail.[253]

Many photographers—including Lange, Strand, and Smith—shared these basic sentiments. Even Ansel Adams went on record in 1948 exhorting his peers to "show the unity of all people and that people can live together in peace."[254] The unity of humankind formed the central theme of several important group projects in the postwar years. In 1946, the Photo League's major project—"America: A Family of Nations"—depicted, in essence, the unity of a world in microcosm. The first major project undertaken by Magnum, the international photographic cooperative formed in 1947, was called "People Are People the World Over." This series, published over the course of a year in *Ladies' Home Journal*, focused on the daily activities of farm families in twelve countries.[255] In scope and theme, this project represented an important precedent to "The Family of Man."

Projects such as this only reinforced Steichen's long-standing notion of photography as a universal language and a tool of mass communication. During his wartime duty in the Navy, he spoke of "photography's great opportunity to render a service to mankind," and for his "Road to Victory" and "Power in the Pacific" exhibitions at the Museum of Modern Art he used innovative design ideas to garner broad public attention.[256] Steichen extended these concepts in his role as picture editor for Tom Maloney's yearly *U.S. Camera* compilations; the 1947 annual represents a particularly clear attempt to orchestrate artistic and journalistic photographs in the service of universal truths.[257]

After he was named head of the photography department at the Museum of Modern Art in 1947, Steichen nurtured a vision of photographic communion that he called "this dream of mine." He spoke repeatedly of "recruiting the nation's photographers"—initially, all 20,000,000 of them—in a grand, populist effort to create "an image of America such as no one has ever seen."[258] While deeply attentive to the most advanced artistic uses of the medium, Steichen remained enthralled by a notion of photography as "the first universal pictorial folk art."[259] The germinal idea for "The Family of Man" probably arose in 1949, when Steichen contemplated an exhibition on the general themes of human relations and human rights. By 1950, the title and basic concept of "The Family of Man" were set; the following years were spent identifying the show's actual content and refining its narrative structure. Dorothea Lange provided invaluable guidance on both counts.[260]

The grand conception of "The Family of Man" was underscored by the show's logistics. After reviewing individual portfolios for several years, Steichen issued a worldwide appeal for work in 1954.[261] The resulting flood of images, in conjunction with the various commercial picture files he consulted, produced a pool of over 2,000,000 photographs.[262] Steichen made an initial selection of 10,000, which was pared down to a final 503

images by 257 photographers, representing scenes in sixty-eight countries. To emphasize the seamlessness of these varied works, the exhibition was composed of specially produced enlargements from the photographers' original negatives (a process overseen by Steichen's assistant, Homer Page); the photographers' own prints were not used. During its run at the Museum of Modern Art, from January 26 to May 8, 1955, the show attracted more than a quarter-million viewers (at the time, it was the second most popular show in the museum's history).[263] Four copies of the exhibition were produced for international tour—debuting "simultaneously in Europe, Asia, and Latin America"—and several smaller versions were created for travel in the U.S. and Japan.[264] By 1962, the show had made ninety-one stops in thirty-eight countries, and had been seen by over 9,000,000 people.[265] A book, reproducing all but one of the exhibition's images, was also published. Despite being something of an afterthought (it appeared four months after the show opened), this volume was an instant bestseller: in the first three weeks of its availability, a quarter-million copies were sold.[266] It remains in print today, after more than forty years and the sale of three million copies.[267]

The ambitions of "The Family of Man" were as expansive as these numbers would suggest. In his opening remarks, Nelson A. Rockefeller, the museum's chairman of the board, described the exhibition in these words:

> Here are a variety of elemental human experiences common to all the peoples of the earth. These experiences derive from a set of human relationships that are the common heritage of all.... In pattern these relationships are as varied as the shape of snowflakes, but in quality they are as immutable as the laws of gravity. In their universal applicability to all human beings, they cut across the barriers of time, place, climate, race, language, religion, nationality, ideology and culture pattern.[268]

In the exhibition, this message of universal kinship was conveyed through a highly sophisticated use of images, text, and architectural space. From the beginning, it was clear that "The Family of Man" was not a traditional photography exhibition. As critic Arthur A. Goldsmith observed, "The result is not photographic art for its own sake, but photography at work conveying information and inspiration."[269] The prints themselves varied greatly in size, from about 8 x 10 inches to 8 x 10 feet, and were presented in dazzling and unconventional ways. One reviewer noted the use of no fewer than fourteen different display techniques. These included the presentation of prints on transparent and translucent walls, on panels hung from the ceiling, on low surfaces parallel to the floor and high ones parallel to the ceiling, on the surface of curved room dividers, jutting at right angles from the wall, and mounted on vertical posts. Adding to this spectacular effect was a many-sided "merry-go-round" of photographs, freestanding silhouettes of figures mounted upright on the floor, and, at the end of the show, a giant, backlit color transparency of an H-bomb explosion.[270]

In the exhibition design of architect Paul Rudolph, each of these photographs took its place in a precisely choreographed sequence of some forty thematic sections. The exhibition's overarching theme, reinforced by text panels and captions, was illustrated by repeated juxtapositions of images emphasizing the similarities of life across the globe. The timeliness of this concept was unmistakable. As one reviewer wrote:

Although the exhibition literally begins with love and birth—after a prologue which presents visual symbols of the creation of life such as the stars—it does not end with death. A most impressive turning point is reached near the end of the series of many exhibition panels and rooms. As the spectator turns a corner into a dark room he faces an immense color transparency blow-up of a hydrogen bomb explosion. After such an intensified witnessing of life in the living and in the making, the realization that man is capable of annihilating himself brings to a sudden awareness, visually clarified, the biggest problem confronting the family of man. Facing this threat, in an opposite area, are faces from all races and stages of human life. Beyond this room is the epilogue, in which are seen men in council, the spirit of a rebirth, the images of the magic of children.[271]

The power of this narrative is only hinted at in the show's catalogue. Significantly, the image of the H-bomb explosion was not included in this volume, giving it a distinctly cheerier mood than the original exhibition.

The images composing this kaleidoscopic experience represented the visions of many of the world's most celebrated photographers. These included artists as diverse as Callahan, Capa, DeCarava, Duncan [256], Faurer, Feininger, Frank, Ishimoto, Kanaga, Lange [297], Levinstein, Levitt [342], Model, Morgan, Mydans, Orkin, Page, and Webb, as well as Diane Arbus, Richard Avedon, Irving Penn, W. Eugene Smith, Garry Winogrand, and Steichen himself. Most of the images included in "The Family of Man" were superb and powerful works; in every case, however, individual meaning was subsumed to the show's overarching thesis.

Critical response to the show was varied. While the public embraced it wholeheartedly, photographers had more complex reactions. In introducing a collection of critical responses to the show in *Aperture*, Minor White was moved to blunt sarcasm: "'The Family of Man' is a jolly good show, a statistical stopper, a box office success and for the critic proves how quickly the milk of human kindness turns to schmaltz."[272] Arthur A. Goldsmith, writing in *Popular Photography*, provided a more objective summary of criticism of the exhibition:

> Some people object that "The Family of Man" is not art at all, but a social and anthropological document, and suggest half seriously that it ought to be moved from its present location to the Museum of Natural History. Others have questioned its theme—an optimistic assumption of the "essential oneness and goodness of man." The way some pictures are linked together because of physical similarities in the subject has been criticized as superficial, and the question has been raised whether the exhibition really provides deep insight into the nature of man or whether it is primarily a vehicle for Steichen's personal opinion.[273]

For its most strident critics, "The Family of Man" was a major step backward for photography, a problem magnified by the show's very popularity. As photography critic Jacob Deschin observed, the exhibition was "essentially a picture story to support a concept [and thus] an editorial achievement rather than an exhibition of photography in the usual sense."[274] In its simple didacticism, the exhibition emulated the storytelling techniques of an earlier era: a WPA mural, for example, or a special issue of *Life* rendered in three-dimensional form. (Not surprisingly, many of the exhibition's photographs were drawn from the *Life* files.) While few photographers challenged the essential truth of Steichen's humanistic vision, they were left cold by the show's

archetypal vagueness and its rather frenetic, theatrical installation. In addition, many of those represented in the exhibition were bothered by the complete subordination of their own artistic visions to the overriding demands of Steichen's curatorial thesis. What meaning could the nuances of personal expression have in such a vast collective project?

Of all the photographers included in "The Family of Man," Robert Frank's reaction to it was perhaps the most negative. His response was based on his own unsatisfying experience with the editorial process of magazine work, and his resulting desire for a purely personal use of photography. As he stated in 1957:

> I have a genuine distrust [...of] all group activities. Mass production of uninspired photo journalism and photography without thought becomes anonymous merchandise.... I feel that only the integrity of the individual photographer can raise its level.[275]

Born and raised in Zurich, Switzerland, Frank rebelled at an early age against the quiet comforts of his homeland. After arriving in New York in 1947, he was hired by Alexey Brodovitch to work for *Harper's Bazaar* and *Junior Bazaar*. Louis Faurer, a fellow *Harper's* photographer, became a close friend and significant influence. In the next several years, Frank's work also appeared in *McCall's*, *Vogue*, *Life*, *Look*, *Time*, and *Fortune*.[276] In addition to this bread-and-butter work, Frank avidly pursued his own artistic vision, employing the spontaneity of the 35mm camera to capture lyrical or poignant vignettes of daily life.

Frank's artistic quest was a restless one. He photographed in Peru and Bolivia for six months in 1948, and spent considerable time in Europe between 1949 and 1953. In 1954, on Walker Evans's advice, Frank applied for a Guggenheim Fellowship. As he stated at the time, his goal was

> to photograph freely throughout the United States, using the miniature camera exclusively. The making of a broad, voluminous picture record of things American, past and present. This project is essentially the visual study of a civilization and will include caption notes; but it is only partly documentary in nature: one of its aims is more artistic than the word documentary implies.[277]

Frank received a Guggenheim grant in 1955 to begin this project, and a second one in 1956 to complete it. With the freedom afforded by this backing, he embarked on a journey of both cultural and personal discovery. Throughout 1955 and 1956, Frank traced a meandering route back and forth across the United States. After visits to Detroit and the Savannah-Charleston area, he drove from New York to Florida, across the south and southwest to Los Angeles, north through California, Nevada, Idaho, and Montana, and then back to New York by way of Chicago and Indianapolis.[278] In the course of this journey, he exposed about 800 rolls of 35mm film.[279] From this mass of images, he selected eighty-three to create *The Americans*, the most important photographic book of the era.

While utterly different in sensibility, Frank's work was as logically a product of the 1950s as "The Family of Man." In technique and mood, Frank's pictures epitomize the "more intimate, personal and subjective way of photographing" that Homer Page described at the beginning of the decade. Frank's images were gritty and unflattering; by limiting himself to the small 35mm camera and natural light, he rejected the technical niceties of routine professional practice for a more immediate and expressive vision.

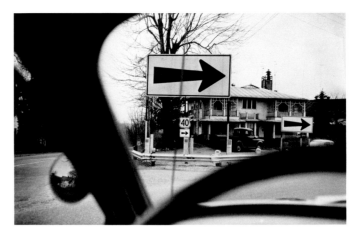

300 Elliott Erwitt, *Wyoming*, 1954, 8½ x 13½"

Equally important was the essential nature of Frank's artistic odyssey. Since the 1930s, numerous photographers—as well as artists, writers, and other researchers—had taken to the road to document America and, in the process, to discover themselves.[280] Roy Stryker alone, in his work overseeing the photographic archives of the FSA (1935-43) and Standard Oil of New Jersey (1943-50), was responsible for the production of many thousands of images from the nation's roadways. In the late 1940s, Henri Cartier-Bresson traveled throughout the U.S., producing images that anticipate significant aspects of Frank's work.[281]

The theme of travel was intimately linked to ideas of both personal and national identity. Nervous, endless movement characterized the vision of the Beat writers of the time, as expressed in such novels as John Clellon Holmes's *Go* (1952) and Jack Kerouac's *On The Road* (1957).[282] Todd Webb's Guggenheim Fellowships, received at the same time as Frank's, supported his own project to retrace the nation's first western roads: the Santa Fe and Oregon trails. Other photographers of the period, such as Frank's friend Elliott Erwitt, made reference either obliquely or directly to the national cult of the automobile and the hypnotic lure of the road [300]. Erwitt's image, from a group of pictures made during a drive west in 1954, suggests the peculiar visual experience of an automobile journey in America: an endless stream of sights, at once banal and wondrous, that merge in memory to form a curious kind of cinematic whole.[283]

Prior to 1955, Frank's artistic vision had been honed in travels in South America, Europe, and the U.S. His pictures of these years are characterized by an intuitive, fluid approach, and a moody—even melancholy—sensibility. This work was highly regarded and in 1950 he was included in the first of several exhibitions at the Museum of Modern Art. By 1954, Frank's photoessay on a Welsh miner prompted *U.S. Camera* to praise his ability to combine "intellectual insights with a poetic sense of the revealing moment," concluding that he was "one of the few artists of the photographic story."[284]

Although profoundly self-motivated, Frank was inevitably influenced by others. His friendships with Brodovitch and Faurer, and his knowledge of the work of Kertész and Bill Brandt, for example, all had significant impact. Frank's friendship with Walker Evans was particularly important, though Frank recalls being influenced as much by Evans's intelligence and uncom-

promising attitude as by his pictures.[285] Evans, in turn, was enormously encouraging; he provided assignments for Frank and supported his Guggenheim application.[286] Finally, Frank was powerfully motivated by the total devotion to their art that he saw in the Abstract Expressionist painters, such as Willem de Kooning, who lived near him in New York.[287]

While these influences contributed to Frank's work of 1955-56, they cannot explain its extraordinary quality. Frank's vision of the American cultural landscape was that of a brilliantly intuitive, fiercely independent, and highly opinionated émigré. He depicted things that progressive American society had taught itself not to see, while ignoring the most familiar signs of the nation's beauty and virtue. Rejecting his former experiences in topical journalism, Frank deliberately avoided "newsworthy" subjects, evidence of the "good life," and the wonders of high technology. Instead, he recorded people in various states of boredom, wariness, or vacancy, and a resolutely common world of cars, jukeboxes, and road-side diners. His photographs are grainy and harsh, and evoke a pervasive sense of bleakness and malaise.

Frank's seemingly simple, cheerless vision in fact embraced an extraordinary range of themes: birth and death, national and personal identity, youth and age, class and privilege, political sloganeering and power, race relations, advertising, the mass media, labor, and religion. Frank was particularly attentive to those Americans who lived outside the cultural mainstream: alienated teenagers, African-Americans, the poor, and the aged. His depictions of classic American archetypes—cowboys, movie stars, politicians, businessmen, and motorcyclists—succeed in both quoting and critiquing familiar myths. One of his cowboys, for example, is a rodeo performer photographed on a sidewalk in New York: an anachronistic "urban cowboy" reenacting, in modernist exile, a national fable of frontier individualism.

Frank's images utilize a range of expressive effects. For example, his *View from Hotel Window, Butte, Montana*, 1956 [301], evokes contradictory moods from an exceedingly simple experience. At once lyrical and melancholy, this photograph captures the simultaneous feelings of adventure and loneliness that attend most journeys. His *Look at William S.*, 1956 [364], is more complexly structured. By recording a fragment of an oddly constructed campaign poster, Frank suggests the unreality of the political process. This image is all frenetic disjunction and exclamation, with the candidate himself a generic abstraction ("HE") who slips from public view into a shadowy interior realm. In his *Movie Premiere, Hollywood*, 1956 [365], a view of an unnamed movie starlet walking past a group of fans, Frank uses selective focus to extraordinary effect. The out-of-focus celebrity becomes an elegant shell, without depth or personality. By contrast, the "real" women behind her seem doubly authentic, their faces radiant with expressions of self-consciousness and desire. This juxtaposition inverts our notion of what "should" be of central—or peripheral—importance in the image. It also gives compelling visual form to a remarkably complex notion: the idea of the modern entertainer as an empty vessel to be filled with the projected longings of an anonymous public.

Despite the strength of so many of his individual pictures, Frank's greatest achievement is his book *The Americans*.[288] In composing this book, Frank proved a brilliant editor of his own work. While many powerful pictures (such as *Look at William S.*)

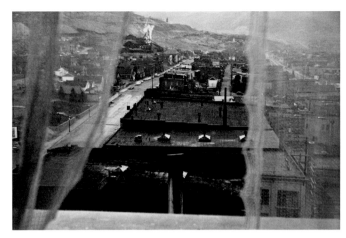

301 Robert Frank, *View from Hotel Window, Butte, Montana*, 1956 (print: ca. 1975), 8⅞ x 12½"

did not make the final cut, the book's sequence of eighty-three images forms an astonishingly rich poetic whole.[289] Frank created a visual narrative that is simpler in form, but far more complex in meaning, than any other picture series of the period. Rejecting the bold design concepts of the fashion magazines, Frank simply placed one image on each right-hand page, giving equal weight to all in his visual narrative. The repetition of certain motifs—images of the American flag, for example—lends a subtle rhythmic logic to the book.

Ultimately, the experience of *The Americans* is akin to a brilliant jazz improvisation or an impassioned reading of Beat poetry: an intuitive process of exploration in the minor chords, exhilarating, mournful, richly textured, and deeply human. Like the music and verse of the period, the book strikes a tone of "exalted suffering" by forging a new kind of beauty from alienation, dissonance, and melancholy.[290] As Frank himself stated in 1958: "It is important to see what is invisible to others. Perhaps the look of hope or the look of sadness. [It] is always the instantaneous reaction to oneself that produces a photograph."[291] Three years later, he observed:

> Black and white are the colors of photography. To me, they symbolize the alternatives of hope and despair to which mankind is forever subjected. Most of my photographs are of people; they are seen simply, as through the eyes of the man in the street. There is one thing the photograph must contain, the humanity of the moment. This kind of photography is realism. But realism is not enough—there has to be vision, and the two together can make a good photograph. It is difficult to describe this thin line where matter ends and mind begins.[292]

The moody subjectivity of *The Americans* was of little immediate interest to American publishers. The first edition of the book, published in France by Robert Delpire as *Les Américains* (1958), matched Frank's photographs with texts emphasizing the absurdity of American life.[293] In the first U.S. edition, published in late 1959 by Grove Press, these texts were dropped in favor of an introductory essay by Beat novelist Jack Kerouac.[294]

Although it sold relatively few copies, *The Americans* was enormously influential.[295] As Ralph Gibson recalls, "it hit the photographic community with the impact of a pole-axe."[296] Depending on one's point of view, the book was either inspiring or infuriating. Gibson and other younger photographers were excited by Frank's edgy, bittersweet vision. Most older practitioners were

angered by it, however, and reviews in the mainstream photographic press were largely negative. The book was reviled as "an attack on the United States," "a sad poem for sick people," and an expression of "hate and hopelessness."[297] Some of this criticism was triggered by Frank's apparently all-inclusive title. As one critic observed, "Most Americans will have a difficult time finding *their* images on these pages. A more appropriate title might have been 'My Americans' or 'Why I Can't Stand America.'"[298] Others were offended by Frank's stylistic transgressions: "So many of the prints are flawed by meaningless blur, grain, muddy exposure, drunken horizons, and general sloppiness. As a photographer, Frank shows contempt for any standards of quality or discipline in technique."[299] In the end, however, this criticism paid tribute to what was clearly a powerful and important book. The eminently mainstream *Photography Annual 1961*, for example, listed *The Americans* first among its "Books of the Year."[300]

Frank had other notable defenders. *Aperture*'s review of *The Americans* stated: "Robert Frank is a magnificent photographer with power to see, and strength to penetrate to the significance of a situation or place. He fishes for truth and frequently lands specimens far beyond the legal minimum size.... He never lies."[301] In 1957, as if in anticipation of the subsequent furor over this book, Walker Evans observed:

> [Frank] shows high irony towards a nation that generally speaking has it not.... This bracing, almost stinging manner is seldom seen in a sustained collection of photographs. It is a far cry from all the woolly, successful "photo-sentiments" about human familyhood; from the mindless pictorial salestalk around fashionable, guilty and therefore bogus heartfeeling.[302]

Evans was correct, of course, in viewing Frank's work in opposition to Steichen's blockbuster paean to "human familyhood." "The Family of Man" was essentially celebratory, optimistic, and communal; *The Americans* was critical, melancholy, and private. The two were, nonetheless, complementary aspects of a single cultural dialogue. Both were profoundly humanistic, rooted in the primacy of emotion and the meaning of everyday life. Both sought to reveal something of the universal human condition: one in the endlessly repeated rhythms of life; the other in a pervasive, existential solitude. In the end, each may be at least partially explained as an effort, through art, to find a spiritual home in a harsh and threatening world.

Art and Commerce

In the postwar years, photography was big business as never before. The medium's economic and aesthetic importance was celebrated in *Time* magazine's November 2, 1953, cover story "Two Billion Clicks." By this time, 55,000 Americans worked as professional photographers; 35,000,000 more were amateurs. This army of picture-takers was supplied with cameras, accessories, film, and darkroom materials by a dynamic, $700,000,000 industry.[303] The 35mm camera became increasingly popular in the 1950s, thanks, in part, to the success of precision imports by the Japanese firms of Canon and Nikon, and to the enduring appeal of the German-made Leica. Single-lens reflex designs were especially popular and soon eclipsed all other camera formats. This

revolution in hardware was accompanied by a host of other innovations. In 1954, for example, Ilford, DuPont, and Kodak all introduced black-and-white films with double the sensitivity of previous emulsions.[304] The quality and variety of color films also increased dramatically in this era.

The mass-circulation photographic magazines were sustained by a mutually reinforcing relationship between the public's interest in the medium and the generous advertising budgets of manufacturers and distributors. In 1953, Americans were buying a remarkable total of over 800,000 photographic magazines a month.[305] The most familiar of these were *Popular Photography*, *Modern Photography*, and *U.S. Camera*. In addition to such monthlies, picture annuals were also profitable. By the time of its twentieth anniversary, in 1955, Tom Maloney's *U.S. Camera Annual* had sold a total of 500,000 hardbound copies, while the first ten issues of Bruce Downes's magazine-format *Photography Annual* (1950-59) sold more than 3,500,000 copies.[306] This massive popular market gave rise to a host of shorter-lived publications, as well as to varied attempts to exploit the medium's appeal in other ways. In 1959, for example, ABC television aired the weekly series "Man with a Camera," starring Charles Bronson as freelance photographer Mike Kovac. The flashbulb division of General Electric sponsored the program, and critics noted with some amusement the hero's nearly continuous use of this product.[307]

The most accomplished photographers of the time played a willing role in the nexus between art and commerce. A significant number, in fact, were featured in product advertising. In the 1940s, for example, photographers as varied as Max Thorek and Edward Weston promoted Graflex cameras.[308] In the late 1940s, Eastman Kodak gave free color film to such luminaries as Weston, Strand, and Sheeler in exchange for the right to use their names and images in its advertising. A host of other photographers appeared in ads in this era, including Alfred Eisenstadt (Photrix exposure meters), Peter Stackpole (Canon cameras), the popular magazine photographer Ozzie Sweet (Heiland flash units), Lee Friedlander (G-E flashbulbs), and W. Eugene Smith (Olympus cameras).[309] The diversity of these endorsements underscores the relatively broad renown that leading photographers enjoyed.

Not surprisingly, the most celebrated photographers of the day tended to be the most visible ones: leaders in the applied realms of photojournalism, advertising, fashion, and portraiture. In 1958, *Popular Photography* magazine polled 243 leaders in the field to determine "the world's 10 greatest photographers."[310] The winners of this ballot were Ansel Adams, Richard Avedon, Henri Cartier-Bresson, Alfred Eisenstadt, Ernst Haas, Philippe Halsman, Yousuf Karsh, Gjon Mili, Irving Penn, and W. Eugene Smith. Remarkably, four of this group—Avedon, Haas, Penn, and Smith—were no more than forty years old.

From today's perspective, a retrospective ranking of the leading photographic talents of the 1950s would produce a rather different tally of names. Nonetheless, the 1958 poll underscores the fact that many of that era's most influential figures were engaged in full-time professional or commercial practice. The economic truth was that no photographer could survive on artistic work alone. There was no real market for the sale of original prints and, for most photographers, inclusion in museum exhibitions brought little beyond a modicum of peer-group prestige. A few photographers—such as Grossman, Callahan, Siskind, and

White—derived the bulk of their income from teaching. Photography programs were uncommon, however, and the number of full-time college and university instructors was small. More rarely still, creative photographers such as Levinstein eked out a living in an unrelated field, separating their art completely from financial considerations. The most entrepreneurial photographer of the era, Ansel Adams, sustained himself through a variety of overlapping activities: teaching, writing, grants, the creation of limited-edition portfolios, journalistic work for magazines such as *Life* and *Arizona Highways*, corporate and advertising assignments, and ongoing relationships with the Eastman Kodak and Polaroid companies.

The work of professional and commercial photographers was most commonly created for reproduction in a vast array of newspapers, trade publications, and glossy national magazines. In 1959, for example, the nation's highest-circulation newspaper, the *New York Daily News*, employed forty-six photographers.[311] Considerably smaller staffs were maintained by local papers across the country. More prestigious (and remunerative) were the mass-market weeklies such as *Life* and the tony fashion monthlies *Vogue* and *Harper's Bazaar*. These magazines reached a vast audience: each issue of *Life* sold 7,000,000 copies, for example, and was read by more than three times that number.

Photographers had never before had such a public forum for their work, and many flourished within this system. In 1950, Irving Penn observed:

> The modern photographer stands in awe of the fact that an issue of *Life* magazine will be seen by 24,000,000 people. It is obvious to him that never before in the history of mankind has anyone working in a visual medium been able to communicate so widely. He knows that in our time it is the privilege of the photographer to make the most vital visual record of man's existence. The modern photographer, having...the urge to communicate widely is inevitably drawn to the medium which offers him the fullest opportunity for this communication. He then works for publication, he has become in fact a journalist.... The modern photographer does not think of photography as an art form or of his photograph as an art object. But every so often in this medium, as in any creative medium, some of the practitioners are artists. In modern photography that which is art, is so as the by-product of a serious and useful job, soundly and lovingly done.[312]

The magazines provided a vast and varied market. In addition to *Life*, a host of other American periodicals regularly commissioned photographs: *Fortune, Look, Collier's, Pageant, Parade, Esquire, Saturday Evening Post, Redbook, House & Garden,* and *Ladies' Home Journal*.[313] The leading fashion magazines made particularly bold use of photography, and employed some of the era's most talented practitioners.

Inevitably, of course, the illustrated magazines could not provide a productive harmony of art and commerce for everyone, or forever. As the look of magazines became steadily codified in the postwar era, many photographers felt their vision increasingly overshadowed by that of editors and designers. As the Museum of Modern Art's photography curator John Szarkowski has noted:

> By the 1950s editors and art directors had come to think in terms of the principle of collage, even when that form was not explicitly evoked; that is, the content of a given photograph came to be less interesting than the ways in which that content could be revised by careful adjustment of the context in which the picture was placed. This was a very interesting problem, but photographers were generally not asked to contribute to the solution.[314]

Between the mid-1950s and the mid-1960s, many photographers left—or were abandoned by—the magazines. W. Eugene Smith quit *Life* in 1954 because he did not feel he had sufficient control over the use of his pictures. André Kertész, who worked unhappily for various magazines for twenty-five years, only regained a sense of artistic direction after he retired from commercial work in 1962. Even Irving Penn, who so eloquently championed the communicative potential of the mass-market magazine in 1950, eventually grew disillusioned. By 1964, he felt that the printed page had come to "something of a dead end for all of us," and argued that the original photographic print should be considered "a thing in itself, not just a halfway house on the way to the page."[315]

These disappointments coincided with a crisis in photojournalism based, in part, on the increasing dominance of television in American life.[316] One by one, the leading picture magazines folded: *Collier's* ceased publication in 1957, followed by *Coronet* in 1961, and *American Weekly* in 1963. Radical staff shakeups only postponed the inevitable, and in rapid succession three giants of the industry were dead: *Saturday Evening Post* (1969), *Look* (1971), and *Life* (1972). New publications were begun in these years, of course, and continued to employ photographers. However, the changing nature of this market and the increasing desire of photographers for greater creative autonomy significantly widened the gap between the worlds of commerce and art. In 1967, Szarkowski summarized the effects of this new climate in his essay "Photography and the Mass Media," stating flatly that "many of today's best photographers are fundamentally bored with the mass media, and do not view it as a creative opportunity."[317]

As the nature of the profession changed, many photographers evolved an increasingly bifurcated practice, dividing their time between work for hire and the creation of more personally satisfying images. If the system allowed relatively little room for the photographer to express his or her own ideas, such opportunities would simply have to be created. As a consequence, many professionals in the postwar years forged a personally sustaining balance of vocation and avocation.

Elliott Erwitt has been particularly successful in creating a body of personal work within the framework of a demanding professional practice. Since the early 1950s, Erwitt has been a highly successful freelancer, producing photographs for a variety of magazines, advertising agencies, and corporations. Erwitt has used the opportunities presented by these assignments, and the nearly endless travel involved, to make his personal pictures. For him, there is a clear distinction between self-expression and work for hire, a basic difference in attitude and motivation. Much of Erwitt's professional work has been in color, for example, while his personal work is strictly black and white. For his clients, Erwitt uses techniques that he disdains in his personal work. As he has said, "I've done lots of tricky, gimmicky stuff on commission, but that's Work and it can be fun, but it is a totally different mind-set, little more than creative obedience."[318] Erwitt's personal work is memorable precisely because it is so individual. By turns witty, poignant, ominous, and surreal [302, 366], Erwitt's pictures are the expression of a uniquely restless and humane intelligence.

302 Elliott Erwitt, *Guanajuanto, Mexico*, 1957, 6 x 9"

The New York commercial photographer O. Winston Link undertook one of the most memorable personal projects of this era. A lifelong train enthusiast, Link began an intensive documentation of the steadily vanishing steam trains of the Norfolk and Western Railway in 1955.[319] Although most of his 2,200 images were made by 1957, Link continued photographing until the line's last steam engine was replaced by a diesel locomotive in 1960. Many of these photographs were made at night, illuminated by complicated arrangements of up to fifteen flash units.[320] The narrative structure of these images can be equally complex. For example, Link's most famous image, *Hotshot Eastbound, Iaeger, West Virginia*, 1956 [367], records a succession of narrative elements, from the teenage couple huddled in the foreground car to the thundering locomotive in the background. This image emphasizes the rapid pace of technological progress through a witty conjunction of vehicles from three eras: train, auto, and airplane. Link's creativity in orchestrating this gently surreal scene is underscored by the fact that the image of the airplane on the movie screen is a product of photomontage.[321]

Fashion and Portraiture

During their heyday, the fashion magazines supported—and were the expression of—a remarkably talented creative community. Editors, graphic designers, and photographers played important roles in this process. Overseeing it all was the art director, who was responsible for conveying what, ultimately, was the real subject of the fashion magazine: the evolving dynamic of style. A handful of these art directors—most notably Alexey Brodovitch and Alexander Liberman—had particular influence in the photographic world.

Alexey Brodovitch played a central role in the history of fashion publishing. Born in Russia, Brodovitch worked as a graphic designer in Paris before arriving in the U.S. in 1930. From 1934 to 1958 he held the powerful position of art director at *Harper's Bazaar*. Brodovitch's influence was also exerted through his Design Laboratory, a series of weekly evening classes that he taught for years under various auspices.[322] Many noted photographers attended these classes, including Diane Arbus, Richard Avedon, Lillian Bassman, Ted Croner, Bruce Davidson, Louis Faurer, Robert Frank, Leslie Gill, Hiro, Saul Leiter, Leon Levinstein, Lisette Model, and Irving Penn. Over the years, Brodovitch

commissioned work by many of these students for *Harper's Bazaar*. He also published images by such important Europeans as Bill Brandt, Brassai, and Cartier-Bresson. Brodovitch's own photographs—images of the *Ballet Russes* that made provocative use of blur, grain, and contrast—were published in his legendary book *Ballet* (1945).[323] As *Ballet* demonstrates, Brodovitch rejected purist standards of technique and the conventionality of the salon-style photograph. Instead, he favored experimentation, novelty, and graphic excitement; his often-quoted command to photographers was "Astonish me!" Brodovitch's advice on achieving this was expressed with Zen-like simplicity: "When you look into your camera, if you see an image you have ever seen before, don't click the shutter."[324] Brodovitch's ideas provided a critical link between the era's most personal photography and its most lucrative commercial applications.

Alexander Liberman also made enormous contributions to the look and concept of the postwar American magazine. Like Brodovitch, Liberman was born in Russia and came of artistic age in Paris in the 1920s.[325] From 1933 to 1936, he served as art director and managing editor of *Vu*, the important Parisian illustrated magazine. This experience gave Liberman a great appreciation for the dynamism of the unposed photograph. His long and influential career in American publishing began in 1943, when he was named art director of *Vogue*; in 1962, he became editorial director of all the Condé Nast publications. Among the most celebrated photographic talents that Liberman nurtured over the years were Irving Penn and William Klein.

Other noted art directors of this period include Lillian Bassman, who worked at *Harper's Bazaar* and *Junior Bazaar* before turning to photography herself in 1947, and Henry Wolf, who followed Brodovitch at *Harper's Bazaar* (1958-61). Marvin Israel, who succeeded Wolf at *Harper's Bazaar* (1961-63), made particularly innovative use of photography. He introduced the work of Diane Arbus, Lee Friedlander, and Duane Michals, and published a series of remarkable portfolios, including, in 1962, a six-page selection of Walker Evans's twenty-year-old subway pictures.[326]

Thanks to the fresh ideas of Brodovitch, Liberman, and their associates, the look of fashion magazines began to change in the early 1940s. More inventive approaches to typography and page design called for similarly fresh uses of the camera. At that time, fashion photography in New York was still dominated by European émigrés such as Horst P. Horst and Erwin Blumenfeld at *Vogue*, and Martin Munkacsi and George Hoyningen-Huene at *Harper's Bazaar*. All were immensely talented, but by the mid-1940s their styles had become relatively polished and predictable.[327] In recalling this kind of work in 1954, one writer observed a bit uncharitably:

> At their best these pictures mingled a kind of cold chromium splendor with vivid lighting and Rembrandtesque masses of shadows. Models were impassive, sculptural, the most formidable clothes horses ever to canter between the rows of perfume and lingerie ads. Studio shots were impossibly stiff.[328]

While this viewpoint fails to suggest the real variety of this work, it does convey the era's impatience with established styles. By the end of the war, a younger generation—largely American-born—had begun to revitalize fashion photography. These photographers included Louise Dahl-Wolfe, Frances McLaughlin, Toni Frissell, George Platt Lynes, and Leslie Gill. The latter, best

known for his influential still-life photographs, also produced serene, poetic images outside the studio [303].[329] By far, however, the most influential photographers of this younger generation were Richard Avedon and Irving Penn.

As a teenager, Avedon was impressed by the dynamism of Martin Munkacsi's photographs. In 1944, after a stint in the merchant marine, he enrolled in Brodovitch's Design Laboratory. He began working for Brodovitch at *Harper's Bazaar* in 1945, at the age of twenty-two, and quickly established a reputation for provocative and inventive work.[330] The freshness of his photographs stemmed, in part, from his interest in the models he recorded, not just their clothes. As a critic noted in 1949:

> One feature that distinguishes Avedon's fashion photographs [is] the life and vitality seen in the model's face. Before he appeared on the scene, few photographers dared to make their models look human—beautiful dummies were the rule.[331]

Following Brodovitch's lead, Avedon employed various means to create a feeling of vitality and surprise. For one of his most famous fashion photographs, *Dovima with Elephants, Paris, 1955* [368], Avedon went to the menagerie of a Parisian circus with his 8 x 10-inch camera, the model Dovima, and the nominal subject of the image, a Dior evening dress. The result—a surrealistic play of contrasting sizes, shapes, and textures—brilliantly evokes a sense of otherworldly elegance.[332]

Avedon rapidly achieved celebrity status. As one critic noted in 1955, "Avedon is both in and beyond fashion."[333] His career inspired the motion picture *Funny Face* (1957), starring Fred Astaire as a fashion photographer and Audrey Hepburn as his model; Avedon worked on the film as a consultant. In the 1950s, Avedon seemed to embrace nearly all facets of the medium, working with equal facility in fashion, portraiture, advertising, and even—in his most personal images—interpretive street photography. By the end of the decade, his fashion and portrait work was created almost exclusively in the stark white space of the studio. While compositionally simple, these photographs suggested increasingly complex ideas about style and mortality.

Avedon's reputation for boldness and iconoclasm increased further in the 1960s. Two books of his photographs—*Observations* (1959) and *Nothing Personal* (1964)—generated both acclaim and controversy. Both were formidable productions—beautifully printed and oversize in format—and represented an impressive combination of creative talents. The first was designed by Brodovitch and included a text by Truman Capote; the second was designed by Marvin Israel, with an essay by James Baldwin. *Observations* included many of Avedon's most famous portraits of the period—Charlie Chaplin, Ezra Pound, Marcel Duchamp, and Marion Anderson, for example—while *Nothing Personal* had a more clearly political theme, reflecting the urgency of the era's civil rights movement.

In this period, Avedon also aggressively challenged the conventions of the photographic exhibition. In 1962 and 1964, he mounted shows of his work—at the Smithsonian Institution in Washington, D.C., and at the McCann Erickson agency in New York—that were radical experiments in collage. One critic described the McCann show as

> part circus, part Happening, part Broadway opening, and all exciting photography. Gigantic stats, contact sheets, proofs of magazine ad pages, telegrams, sample layouts, rich, full-toned

303 Leslie Gill, *Fishing Fleet, Amalfi, Italy*, 1947, 10⅞ x 13¾"

black-and-white prints, and a wall-sized (rear-projection) screen that changed pictures every three seconds...were some of the parts from which the show was made.[334]

These shows were spectacular, provocative, and unorthodox—vast "works in progress" expressing Avedon's artistic ambition and restless creative spirit.

Irving Penn was also strongly influenced by Brodovitch. He first met Brodovitch in 1935, in one of the early Design Laboratory classes at the Philadelphia School of Industrial Arts, and worked with him in various capacities over the next few years.[335] Although trained as a commercial artist, Penn began making personal photographs in the late 1930s. He took up the camera professionally in 1943, after he was hired as Liberman's assistant at *Vogue*. Following his service in the war, Penn hit his stride at *Vogue*, working with equal facility in fashion, portrait, and still-life photography.

The hallmarks of Penn's vision are unmistakable: a beautifully soft and even light, seemingly casual poses and props, a calligrapher's sensitivity to line, and a seductive technical precision. Above all, Penn's photographs are spare, serene, and elegant.[336] These qualities are apparent in his 1948 portrait of Duke Ellington [372], who is depicted in a specially constructed "corner" in Penn's studio. This device creates an unusually intimate sense of space, emphasizing—and somehow even magnifying—the physical presence of the sitter. The simple artifice of this setting only serves to underscore the essential reality of Ellington's relaxed pose and engaging expression.

Many of Penn's best-known fashion images—such as *Woman with Umbrella, New York, 1950* [369]—are remarkably abstract, evoking the aura of high style without attempting to precisely describe individual items of clothing. In his 1984 monograph on Penn, John Szarkowski eloquently described the revolutionary effect of these photographs:

> The best of the earlier [fashion] work—by de Meyer, Steichen, Beaton, Hoyningen-Huene, and others—now seems close to theater, with the dress and its model playing a role. But Penn's 1950 pictures provide no references to plot or circumstance, no suggestions of old châteaux, or perfect picnics, or delicious flirtations in Edwardian drawing rooms, or footlights, or *avant* Freudian dream worlds. They are not stories, but simply pictures.[337]

Penn discarded most of the narrative trappings of this earlier style, constructing pictures instead from his own richly expressive vocabulary of form. The sheer visual intelligence of these pictures—which are at once dynamic and restrained, descriptive and abstract—gives them an artistic interest that far transcends their original function.

Penn's expressive ambitions, like Avedon's, lay beyond the traditional scope of fashion and portraiture. With Liberman's encouragement, Penn explored the aesthetics of vernacular and ethnic dress, recording New York City workmen engaged in a variety of small trades, and the natives of Peru, West Africa, Nepal, Morocco, and New Guinea.[338] In 1949, he began an unconventional series of nudes, photographing weighty, unidealized figures from close perspectives. He printed these images by greatly overexposing the photographic paper, and then bleaching and redeveloping the image. The resulting pictures are at once earthy and ethereal. In the early 1970s, this experimental inclination led Penn to master the century-old platinum process, which he used to reinterpret earlier negatives and for much of his subsequent personal work.

In the heyday of fashion photography, a stimulating variety of styles and techniques was used. The diversity of these approaches is suggested by the work of Lillian Bassman and William Klein. After studying with Brodovitch, Bassman was hired as his assistant at *Harper's Bazaar* in 1939.[339] In this capacity, and as art director of *Junior Bazaar*, Bassman worked with Avedon, Faurer, Frank, Arnold Newman, and many other talented young photographers. In 1947 she left this position to take up photography herself. She forged a uniquely delicate and impressionistic style, employing such unusual techniques as printing through tissue to evoke a mood of graceful vitality [370].

By contrast, William Klein's fashion photographs of the same period are harsh and provocative. After his year in New York, Klein returned to Paris in 1955. He worked for *Vogue* for the next decade, producing fashion images that were uniquely bold and dynamic. As Liberman has observed:

> In the fashion pictures of the Fifties, nothing like Klein had happened before. He went to extremes, which took a combination of great ego and courage. He pioneered the telephoto and wide-angle lenses, giving us a new perspective. He took fashion out of the studio into the streets, trying anything, stopping traffic, photographing models in waxworks, repainting shop fronts, hiring actors and dwarfs. He functioned like a Fellini, sensing the glamorous and the grotesque.[340]

In his *Pedestrian Crossing, Piazza di Spagna, Rome (Vogue)*, 1960 [371], Klein makes brilliant use of the street, the telephoto lens, and chance itself to create an icon of naturalistic fiction. Historian Martin Harrison has noted that in this photograph,

> the alternating black and white stripes of the pedestrian crossing...fill the frame from top to bottom: against this Op background (a reference from his own kinetic art?) the two women cross, the black and white stripes of their dresses picking up the alternating horizontals of the road-markings. Simone d'Aillencourt steps straight at the viewer; the other model, Nina de Vos, walks out of the frame, glancing over her shoulder, registering mock surprise at the similarity of the dresses. This much is staged, but Klein has left room for accidental elements to come into play: passers-by, cropped at the thigh, move out of the frame, and a Vespa, ubiquitous symbol of Italy, intersects the models, adding a plausible note of realism.[341]

Arnold Newman, one of the most celebrated portraitists of this era, was also influenced—albeit indirectly—by Brodovitch's ideas. Newman studied art before beginning work with a Philadelphia portrait studio in 1938. While he learned photographic technique on the job, Newman came to know some of Brodovitch's students at the Philadelphia School of Industrial Arts. Newman absorbed Brodovitch's teachings through them, educating himself further through study of *Vanity Fair* magazine and Walker Evans's book *American Photographs*. On his own time, Newman experimented with the camera, recording subjects in both documentary and abstract veins. With this background, Newman spent the winter of 1941-42 in New York photographing the city's leading artists and sculptors. The success of his 1945 exhibition, "Artists Look Like This," at the Philadelphia Museum of Art, prompted a permanent move to New York a year later. Newman's fame increased steadily in the following years: his work was published in *Life*, *Harper's Bazaar*, and elsewhere, and his prints were included in important museum exhibitions.

The originality of Newman's work lies in its provocative synthesis of description and invention. Believing that a meaningful portrait is the product of a collaborative dialogue between sitter and photographer, Newman seeks to convey both literal and metaphoric truths.[342] He uses the objects and space surrounding his subjects to deliberate expressive effect, creating compositions that are at once precise and allusive, analytical and intuitive. These qualities are evident in one of his earliest mature works, *Yasuo Kuniyoshi, 14th Street Studio, New York*, 1941 [373]. This portrait of the noted painter combines an air of relaxed refinement with an exquisitely realized structural order. The nature of Kuniyoshi's art is richly suggested by the casual formality of his pose, the simple tabletop still life beside him, and the serene perfection of Newman's overall composition.

Books

The photographic book came of age in this period. Volumes with photographic reproductions had been produced in the 1920s and 1930s, of course, but these publications generally used images in an illustrative way, subordinated to a text or overarching theme. Beginning in the 1940s, a different kind of photographic book became increasingly common. These volumes gave new prominence to the aesthetics of the image and to the integrity of the maker's vision. Now, when text and imagery were combined, the former was often made subservient to the latter.

The rise of this new generation of books was yet another result of the era's conjunction of art and commerce. For publishers, the broad popular interest in photography meant an enticingly large potential market for each release. For photographers frustrated by the compromises of magazine work, the book format provided the most durable and prestigious expression of one's personal vision. These forces were complemented by improvements in the technology of printing (in both the gravure and offset lithography processes), which allowed high quality photographic books to be produced more affordably than before.

Sensing the burgeoning market for photographic books, Tom Maloney of *U.S. Camera* made an intriguing offer to his readers in early 1940. Under the auspices of "The Lens League," Maloney proposed publishing four original photography books per year,

with the titles to be chosen by popular ballot from eight possibilities.[343] While Maloney's project fell short of this ambitious goal, his initiative resulted in two important books in 1940: Edward Weston's *California and the West*, with text by Charis Wilson Weston, and Paul Outerbridge's *Photographing in Color*.[344]

Over the next few years, significant books were issued by a variety of publishers. These ranged from historical studies, such as Cecil Carnes's *Jimmy Hare* (1940) and William Henry Jackson's autobiography *Time Exposure* (1940), to artistic profiles such as Barbara Morgan's *Martha Graham: Sixteen Dances in Photographs* (1941). Several of the most important volumes of FSA images were published during this period. These included Lange and Taylor's *An American Exodus* (1940), Agee and Evans's *Let Us Now Praise Famous Men* (1941), and the compilations *Home Town* (1940), with text by Sherwood Anderson, and *12 Million Black Voices* (1941), by Richard Wright and Edwin Rosskam. In a similar documentary vein, World War II was recorded in volumes such as Ivan Dmitri's *Flight to Everywhere* (1944), and Margaret Bourke-White's *Shooting the Russian War* (1942) and *They Called it "Purple Heart Valley"* (1944).

Technical books and historical surveys also found a steady market. A number of photographers, including Willard Morgan and Andreas Feininger, produced important technical manuals and "how-to" guides. In this genre, the most important work of the era was probably Ansel Adams's five-volume Basic Photo series (1948-56): *Camera and Lens*, *The Negative*, *The Print*, *Natural Light Photography*, and *Artificial Light Photography*.[345] László Moholy-Nagy's *Vision in Motion* (1947), published just after his death, provided the definitive summary of his educational ideas. At the same time, there was a steady demand for histories and pictorial surveys. New editions of Beaumont Newhall's *The History of Photography* appeared in 1949 and 1964, and Helmut and Alison Gernsheim's study of the same title was released in 1955. At the stiff price of $17.50, Peter Pollack's *The Picture History of Photography* (1958) was also remarkably popular—its first printing sold out in just over a month.[346] Beaumont and Nancy Newhall's *Masters of Photography*, a picture book aimed at a general audience, was reprinted many times after its initial release in 1958. And, after being out of print for years, Robert Taft's landmark history, *Photography and the American Scene* (1938), was reissued in 1964.

Topical subjects such as city life, celebrities, and travel provided the basis for a number of notable photography volumes. André Kertész's *Day of Paris* (1945), produced with help from Brodovitch, was composed of poetic vignettes of prewar Parisian life. Weegee's *Naked City* (1945) and *Weegee's People* (1946) provided a grittier vision of the urban scene, while William Klein's quartet of city books—published between 1956 and 1964—depicted this subject with nearly explosive energy. The public's interest in celebrities was fed by a variety of publications: the stately vision of Yousuf Karsh's *Faces of Destiny* (1946) and *Portraits of Greatness* (1960), the whimsy of Philippe Halsman's *Jump Book* (1959), and the confrontational boldness of Richard Avedon's *Observations* (1959) and *Nothing Personal* (1964). David Douglas Duncan, a self-styled "Yankee Nomad," produced books relating to both celebrity and travel: *The Private World of Pablo Picasso* (1958), which hit the best-seller list, was followed by *The Kremlin* (1960). Laura Gilpin's *Temples in*

Yucatan (1948) was but one of a number of other books in this period documenting remote or exotic places. Clarence John Laughlin's often-reprinted *Ghosts Along the Mississippi* (1948) occupied a unique publishing niche: the surrealist travelogue.

The renown of certain photographers created a market for memoirs and picture books. The first of these categories included Robert Capa's *Slightly Out of Focus* (1947), Carl Mydans's *More Than Meets the Eye* (1959), *Weegee by Weegee* (1961), Karsh's *In Search of Greatness* (1962), Margaret Bourke-White's *Portrait of Myself* (1963), and Edward Steichen's *A Life in Photography* (1963). What these may have lacked in scholarly objectivity was more than made up for by the immediacy of dynamic lives recounted in the first-person voice. Other established figures, such as Weston, Strand, and Adams, exerted a marked influence on younger photographers through the number and quality of their books. Weston's work was commemorated in two elegant picture books: *Fifty Photographs: Edward Weston* (1948) and *My Camera on Point Lobos* (1950). Weston's writings became widely influential with the 1961 publication of the first volume of his artistic diary, *The Daybooks of Edward Weston, Part I: Mexico*, edited by Nancy Newhall. Strand's late project of photographing rural and premodern cultures resulted in a series of handsome books with essays by noted writers: *La France de Profil* (1952), *Un Paese* (1955), *Tir A' Mhurain, Outer Hebrides* (1962), and *Living Egypt* (1969). Meanwhile, in addition to his books on technique, Adams published numerous photographic volumes, including *Yosemite and the Sierra Nevada* (1948), *My Camera in Yosemite Valley* (1949), *My Camera in the National Parks* (1950), *Mission San Xavier del Bac* (1954), and *Death Valley* (1954). Nancy Newhall's deluxe biography of Adams, *The Eloquent Light*, was released in 1963.

Most books of this period combined images with texts of some kind; a few made especially memorable use of this union. Although not broadly popular, Wright Morris's *The Inhabitants* (1946) and *The Home Place* (1948) exerted a powerful influence on other photographers. The originality of Morris's approach—uniting crisply factual images with a fictional text—significantly expanded the expressive potential of the photo-book format. One of the most notable volumes of this period, *The Sweet Flypaper of Life* (1955), was a collaboration between photographer Roy DeCarava and writer Langston Hughes. Hughes's poetic text, a fictional monologue by a spirited, sympathetic grandmother, works in perfect tandem with DeCarava's deeply humane images. Although less often celebrated, John Szarkowski's *The Idea of Louis Sullivan* (1956) creates a similarly successful union of pictures and text. In this book, Szarkowski interweaves his evocative photographs of Sullivan's buildings [335] with varied comments by and about the celebrated architect. The result is an extraordinarily rich synthesis of fact and idea, past and present, stone and spirit. Here, photography is made to function, in Szarkowski's words, as "a powerful critical medium, rather than a superficially descriptive one."[347]

The postwar years saw the rise of the modern photographic monograph. Unlike the many books that derive their appeal from a particular subject or theme, the monograph focuses on the photographer's career and vision.[348] These publications were often modest in size and produced to accompany major exhibitions. The Museum of Modern Art was a pioneer in this genre, producing

Walker Evans's seminal *American Photographs* (1938), and later catalogues of the work of Strand (1945), Weston (1946), and Cartier-Bresson (1947). The market for such publications was limited, however, and relatively few artists were accorded such recognition. One of the exceptions to this rule was Aaron Siskind, whose work was collected in two books: *Aaron Siskind: Photographs* (1959) and *Aaron Siskind: Photographer* (1965). The later volume was part of an influential series of exhibition catalogues produced by Nathan Lyons under the auspices of the George Eastman House. Harry Callahan's work was also documented in two monographs of this period: an elegant catalogue titled *The Multiple Image* (1961) and a large and exquisite book, *Photographs: Harry Callahan* (1964), privately produced by two former students. Some nineteen years after it was assembled, Helen Levitt's *A Way of Seeing* was released in 1965. Against the odds, a handful of younger photographers also managed to see monographs through to completion. Dave Heath's deeply private *A Dialogue with Solitude* (1965), for example, was published by a small press in Culpeper, Virginia.

In 1960, the Sierra Club began producing luxurious, "coffee-table" photographic books.[349] These expensive volumes—a bold marriage of art, commerce, and politics—appealed to the American public's growing interest in conservation. The first of these books, *This is the American Earth*, by Ansel Adams and Nancy Newhall, was remarkably successful: some 25,000 hardback copies were sold at $15 each, and another 50,000 in a later paperback edition.[350] This was followed by *Words of the Earth* (1960), a survey of Cedric Wright's work, and Adams's *These We Inherit: The Parklands of America* (1962). The first color volume in the series, *In Wildness Is the Preservation of the World* (1962), paired photographs by Eliot Porter with the writings of Henry David Thoreau. This sold 70,000 hardback copies (at $25 each), and over 250,000 more in a less expensive paperback edition.[351] Subsequent Sierra Club books, also in color, included Porter's *The Place No One Knew: Glen Canyon on the Colorado* (1963); *The Last Redwoods* (1963), with photographs by Porter, Philip Hyde, and others; and *Not Man Apart* (1964), which matched the words of poet Robinson Jeffers with images by several photographers.

Color

The conflicting demands of art and commerce were particularly evident in the realm of color photography. Color reached a kind of awkward adolescence in this era, through a series of technical refinements and a much slower process of artistic acceptance. In a larger sense, this development in photography was part of a general "colorization" of American culture. In 1940, only a small fraction of the nation's photographs were made in color, and black-and-white reproductions greatly dominated the pages of magazines. However, color imagery became increasingly prevalent and, by the 1950s, was commonplace in both Hollywood films and mass-circulation magazines. It was in 1954, for example, that the covers of *Life* magazine shifted from a predominance of black-and-white reproductions to color.[352] Color television broadcasting was begun in 1953, although the American public was slow to purchase the expensive new sets.[353] By 1953, thirty kinds of color film were on the market, and 90 percent of the amateur movies made in America were in color.[354] In the amateur still-photography market, the use of color film surpassed that of black and white in 1964; in the commercial world, this milestone was reached in 1965.[355]

From the beginning, color photography presented a host of challenges. Unlike other technical advances of the era—the introduction of variable contrast papers, faster black-and-white films, or the Polaroid instant process, for example—color resisted being used to simply amplify or extend accepted ways of (monochromatic) seeing.[356] Color clearly had its own aesthetic. To a photographic community trained almost exclusively in black and white, color seemed garish and unnatural, suitable only to the worlds of Hollywood, advertising, and the most casual amateur. Two themes were central to this period: the basic recalcitrance of color processes and the widespread disdain of leading photographers for the color image.

Color photography was a paradox. In certain forms it was easily and widely done; in others, it was almost impossibly difficult. The color-reversal films of the late 1930s—such as Kodachrome and Dufaycolor—had proved highly popular with amateurs. Used with increasing frequency in the 1940s, these films produced 35mm slides that could be viewed by projection. Various commercial techniques were devised to allow paper prints to be made from these transparencies, including Kodak's Minicolor Print material of 1941 and the Gasparcolor process of 1944.[357] None of these were very successful. Kodacolor, a color-negative film, was introduced in 1942. After exposure, each roll of Kodacolor was mailed to Kodak for development and printing. With their various offshoots, these processes took an increasing share of the amateur market each year.

The making of relatively permanent, exhibition-quality color prints remained an enormous challenge. Through the mid-1940s, carbro, the "aristocrat" of color print processes, still reigned as the professional technique of choice.[358] Carbro was so difficult, however, that few amateurs even attempted it. In truth, the process was not widely done in the professional world either: in 1940, Paul Outerbridge reported that "about a half-dozen of the largest studios are doing practically all the [carbro] jobs" in the country.[359] Other print processes of the 1940s included Kodak's Wash-Off Relief (improved and renamed Dye Transfer in 1946), and the Chromatone, Neotone, and Duxochrome techniques. All these processes involved the production of three color-separation images; after appropriate treatment, these were transferred or recombined to create a single full-color print.

Manufacturers tried to encourage amateur use of these vexing methods. A surprising number of one-shot cameras—which made three color-separation negatives at once—were marketed, and pre-packaged kits of chemicals were readily available (the Chromatone kit sold for $7.50, for example, and allowed a print to be made in about two hours).[360] With few exceptions, though, the difficulty of these processes far overshadowed the pleasure given by the final product. By the late 1940s, these separation techniques were winnowed down to one primary survivor: Kodak's Dye Transfer process. This technique reigned for several decades as the most elite, stable, and expensive of the color print methods. As with the earlier carbro process, however, few amateurs attempted it. At the same time, manufacturers tried without success to create color papers that would allow prints to be made directly in an enlarger from a color negative or transparency.[361]

A new era in color printing began in late 1955, with Kodak's introduction of an improved Kodacolor film and its new "Type-C" (or Ektacolor) paper. Greeted as nothing less than a "revolution" in photography, this new paper promised to make color printing truly practical for the advanced amateur.[362] Color prints could now be made in about forty-five minutes in a home darkroom with temperature controls. However, while Type-C paper represented a distinct advance, the predicted revolution was slow in coming. Three years later, for example, it was observed that

> making color prints from color negatives is an undertaking not to be approached lightly. If the process eliminates the intricacies of making separation negatives and is much simpler than making dye-transfer prints, it is still sufficiently complex to call forth all the skill of an accomplished black and white printer. It is certainly not to be recommended to unskilled amateurs, for it has been known to baffle even professionals.[363]

Despite such difficulties, the introduction of Type-C printing paper marked a milestone in modern color photography. Additional printing papers gradually became available: at least five were in common use by early 1963, when the sixty-second Polacolor process was introduced by Polaroid.[364] Most importantly, photographers thought with increasing seriousness about the aesthetic potential of color. In 1955-57, for example, a flurry of articles and group discussions on color appeared in the photographic press.[365] The first yearly compilation of its kind, *Color Photography Annual 1956*, edited by Bruce Downes, appeared in the fall of 1955.[366]

Photographers of the 1940s and 1950s were understandably slow in taking color seriously, due to its almost exclusive association with the amateur and commercial worlds. Transparency film was made for the mass market, and for years only the biggest commercial studios were capable of producing stable, exhibition-quality color prints in any real quantity. Those artists and advanced amateurs who were interested in print-making found that color forced a shift in their primary involvement in the medium: from the creative excitement of *seeing* to the mechanical drudgery of *making*. It was not an enticing exchange. For nearly every photographer of the day, therefore, the calculation was simple: color was more technically demanding than black and white and less satisfying aesthetically. For small-camera devotees of the urban scene, for example, color held little appeal. As Bruce Downes observed in 1955, "color film seems so far to have baffled" them:

> The effectiveness of most available-light pictures is due to their dramatic *unreality*. The best of the available-light photographers have created a whole new world of silver-halide images—a world of interesting faces emerging from shadowy depths, of blurred, grainy, spectral figures moving across what often looks like a cavernous stage. It is a world of fantasy, full of beauty and excitement far removed from reality. But the fantasy somehow vanishes with color film, which seems to disenchant their cameras.[367]

The simple truth was that most color photographs seemed embarrassingly banal, derivative, or garish. Paul Strand found color too resistant to the artist's interpretive control.[368] André Kertész felt it was overly influenced by the history of painting, while black-and-white imagery was "pure photography...a well-developed medium that stands by itself, different from painting."[369] And, as Walker Evans acidly noted, "Many photographers are apt to confuse color with noise, and to congratulate themselves when they have almost blown you down with screeching hues alone—a bebop of electric blues, furious reds, and poison greens."[370]

The cost of color further militated against its adoption by noncommercial photographers. The expense of making exhibition prints by the carbro or dye transfer processes was prohibitive for all but the independently wealthy. Arthur Siegel was one of the very few artists of the postwar period to dedicate himself to working in color. Instead of having his work included in exhibitions, Siegel was forced to show it in slide-illustrated lectures. When pressed to make prints for a major show at the Art Institute of Chicago in 1954, Siegel could only afford to produce dye transfers of a handful of images. It took him years to pay off the cost of this meager amount of work, and he never again made a group of such prints.[371] Of course, this experience did nothing to encourage his peers to devote themselves to color. Harry Callahan shot color slides intermittently beginning in 1941, for example, but waited nearly forty years to have them printed.

In at least one other way, economics played a major role in determining the work that photographers actually saw. Color reproductions were at least four times more expensive to print than black and white, and thus appeared most commonly in only the large-circulation magazines such as *Life, Saturday Evening Post, Look, Ladies' Home Journal, Collier's, Holiday, Vogue,* and *Harper's Bazaar*.[372] Photography magazines, with comparatively smaller print runs, made far less use of color. For years, in fact, they tended to use color printing only on the front and back covers and in a handful of editorial and advertising pages.[373] Unable to make printing separations of images of their own choice, the editors of photographic publications often depended on the loan of existing plates from commercial agencies. In the 1940s and early 1950s, the color images in *U.S. Camera Annual* were nearly all of this recycled, promotional nature, provided courtesy of the larger magazines or commercial firms such as Abbott Laboratories, Dow Chemical, Coca-Cola, and Sherwin-Williams. Unfortunately, the predominance of such second-hand commercial imagery only reinforced the belief that color was unsuited to artistic work.

Not surprisingly, the Eastman Kodak Company was particularly active in promoting color. Beginning in 1946, Kodak commissioned color work from the most esteemed figures in American photography: Edward Weston, Ansel Adams, Paul Strand, and Charles Sheeler.[374] Each was given free boxes of 8 x 10-inch Kodachrome film, with no restrictions on its use. Further, if Kodak chose to run any of these images in its advertising, the artists would be paid $250 per transparency. For a short time, Weston worked with the new material enthusiastically; within a few weeks Kodak paid him $1,750 for seven images. The resulting three-page ad, headlined "Edward Weston's first serious work in color," began running in the May 1947 issues of leading photography magazines.[375] Five of Weston's color images were accompanied by copy asking the reader: "If you have been working only in black-and-white, isn't it high time you joined Edward Weston in exploring the boundless possibilities which Kodak color holds?"

Kodak found other ways to use this body of commissioned work. It made four mural-size transparencies of images by Weston and Adams for inclusion in the Museum of Modern Art's 1948 exhibition "In and Out of Focus." A portfolio of another

304 Bill Witt, *Dead Starling in Snow*, ca. 1947, carbro color print, 7¼ x 9¼″

305 Oliver Gagliani, *Untitled (Lake Tahoe)*, 1959, Type-C color print, 3⅝ x 4⅝″

six images was published in *Fortune* magazine in 1954.[376] Beginning in 1948, Kodak hired Adams to make more than a dozen panorama-format "Colorama" images. These were enlarged by Kodak's technicians to a size of 18 x 60 feet and displayed as backlit transparencies in the concourse of New York's Grand Central Station. Seen by millions of commuters and tourists, these vast images were, in Adams's own words, "aesthetically inconsequential but technically remarkable."[377]

The most influential color photographers of this era were professionals in the fields of fashion, advertising, portraiture, and photojournalism. In fact, in these disciplines nearly all the leading photographers were proficient in color. Irving Penn's work was particularly admired, but a host of other established figures were also acclaimed—including Avedon, Horst, Blumenfeld, and Arnold Newman—as well as such younger professionals as Marvin Newman and Saul Leiter. Eliot Elisofon was one of the leaders in color photojournalism. He produced noted color photo-essays for *Life*, and even served as color consultant on John Huston's film *Moulin Rouge* (1952). Ironically, Walker Evans, a caustic critic of the medium, produced some of the most memorable of *Fortune*'s color photo-essays.[378]

Ernst Haas's color photographs were widely admired in both the artistic and journalistic realms. His most notable work, a study of New York titled "Images of a Magic City," was published in *Life* in two installments in 1953.[379] The success of this series reflected Haas's grasp of the expressive nuances of color, and its essential plasticity. As Haas observed in 1956:

> In the creation of the color image we discover the fleeting and transitory nature of color and light. Colors not only originate from the breaking down of light, but are also dependent upon it. Too much light, as too little, can destroy color. It is a miraculous relationship based on give and take. There are colors which have their own illumination, and others which require illumination to be seen at all. As there exists no absolute light, there exists also no absolute color.[380]

The Museum of Modern Art exhibited Haas's color pictures in 1962.

Desite shows such as this, color photographs were not commonly seen in the august realm of the art gallery and museum

until the 1970s. Significantly, a survey of modern color photography—from a 1906 work by Arnold Genthe to a 1940 abstraction by Nicholas Ház—was mounted in 1940 by the Newark Museum.[381] After a show of Eliot Porter's work in 1943, the Museum of Modern Art included color images with some regularity in its group exhibitions. In addition to the large transparencies by Weston and Adams, for example, "In and Out of Focus" contained color abstractions by James A. Fitzsimmons. The 1950 exhibition "All Color Photography" featured an enormous number and variety of works: prints, transparencies, and tear sheets from *Life*, *Vogue*, *Holiday*, and other magazines. This exhibition included work by all the leading color photographers of the day, as well as by less expected figures such as Capa, Callahan, and Weegee. Acknowledging the miscellaneous nature of the show in his introductory statement, Steichen observed: "This exhibition may be asking more questions than there are answers, for in spite of fine individual achievements, color photography as a medium for the artist is still a riddle."[382] Another of Steichen's shows, "Always the Young Strangers" (1953), included color transparencies by R. E. Christie and color prints by John Reed. The original installation of "The Family of Man" (1955) contained a single color image: the large transparency of an H-bomb explosion. However, for reasons of economy or content, this picture was not reproduced in the accompanying catalogue or included in the touring versions of the show. In 1957, Steichen sidestepped the problem of making adequate color prints by presenting "Experimental Photography in Color" as a slide-illustrated lecture at the museum.

The scarcity of color photographs in the exhibitions of the postwar era is easily explained: only a few photographers were making color prints as purely self-expressive works. One of these, Bill Witt, had the distinct advantage of working as the carbro technician in the New York studio of Valentino Sarra. Witt used these skills to produce a small group of personal pictures in carbro [304]. These were exhibited several times, perhaps most prominently in a one-man show in Newark in 1947.[383] Color prints by William Mortensen—made by a technique of his own invention—were also published and exhibited in this era.[384] Henry Holmes Smith, who experimented with color as early as

1933, made and exhibited abstract dye transfer prints beginning in 1946.[385] Arthur Siegel's color images [282, 374] were given notable exposure in the pages of *Life* in 1950, prior to being exhibited at the Art Institute of Chicago in 1954.[386] Syl Labrot worked in color throughout the 1950s and 1960s; he is perhaps best known for the highly reductive work published in the book *Under the Sun: The Abstract Art of Camera Vision* (1960). Oliver Gagliani was one of the first to make artistic use of Type-C color paper [305]. Gagliani assembled a portfolio of his color prints in 1960, and exhibited them at the San Francisco Museum of Art (1961), Indiana University (1962), and elsewhere. From 1960 to 1963, Wynn Bullock worked almost exclusively in color, creating abstract close-ups of arrangements of tinted glass and plastic. This work was presented in such group exhibitions as "Color Abstract Photographs" (1963) at Fresno State College.[387]

By far, however, the most acclaimed artistic color photographer of the era was Eliot Porter. Porter's early interest in photography was maintained during the years he spent studying and teaching medicine at Harvard University. Porter's black-and-white pictures so impressed Alfred Stieglitz that the elderly master showed them at An American Place in the winter of 1938-39. Motivated by a desire to record birds in their natural habitats, Porter began making Kodachrome transparencies in the summer of 1939. He received a Guggenheim Fellowship for this project in 1940, and mounted the exhibition "Birds in Color" at the Museum of Modern Art three years later. Having mastered Kodak's Wash-Off Relief technique, Porter devoted himself to the improved version of the process—Dye Transfer—after its introduction in 1946.[388] In the following years, Porter became the leading proponent of artistic color photography. He exhibited widely, and his images and essays were published with increasing frequency.[389] Porter's renown reached a new level in 1962, with the appearance of *In Wildness Is the Preservation of the World*, the first of several Sierra Club books to feature his photographs.

306 Eliot Porter, *Untitled (Sky Series)*, ca. 1958, dye transfer print, 8⅝ x 8⅝"

The appeal of Porter's work stems from the basic duality of his vision. Uniting the sensibilities of the naturalist and the artist, Porter's images are straightforward in content, yet sophisticated in composition and palette [306, 375]. His best work thus presents a memorable union of factual realism and chromatic abstraction. These images are at once understandable and unexpected, seductive and challenging.[390]

New Perspectives: Into the '60s

At the beginning of the new decade, photographers found themselves in a dynamic, if uncertain, time. The preceding years had seen many changes in the technology, aesthetics, and economic structure of the medium. The world of creative photography was more varied in composition than ever, with widely disparate visions in active contention.

One of the most influential genres of work at this time was the personal document. This approach traced its lineage back through the street photographers of the postwar era to the Photo League and the FSA. These concerns were given their most eloquent and individual expression in the work of Robert Frank. The domestic edition of *The Americans*, which first appeared in bookstores in January 1960, exerted an enormous influence on photographers of that decade. Frank's technique, subjects, and penchant for travel were all echoed in the subsequent work of photographers as diverse as Elliott Erwitt, Charles Harbutt, Burk Uzzle, and Nathan Lyons. Frank's interest in those at the margins of society is seen in the photographs of teen gangs by Bruce Davidson [307] and Joseph Sterling [376], and in Danny Lyon's extended study of motorcycle riders [377]. However, Frank's influence may be seen most powerfully in the work of three of the finest young photographers of this era: Garry Winogrand, Lee Friedlander, and Diane Arbus. Like Frank, all three began their careers in the magazine world but achieved their greatest impact in books or major museum exhibitions. Their work was most memorably linked in the Museum of Modern Art's 1967 exhibition "New Documents."

Garry Winogrand's interest in photography began in 1948, when he was studying painting at Columbia University on the GI Bill. A year later, he attended Brodovitch's classes at the New School for Social Research. Winogrand began working professionally in the early 1950s, producing pictures for *Collier's*, *Sports Illustrated*, *Pageant*, and *Argosy*. He soon achieved artistic recognition, with pictures included in the leading photo annuals of the day and in "The Family of Man." Despite this early success, Winogrand sought a more personal mode of expression. After seeing Evans's *American Photographs*, he traveled across the country in 1955, spurred by the vague sense that "there were pictures to be made out there."[391] The demise of *Collier's*, his most consistent employer, and the troubled nature of his personal life accelerated this shift in Winogrand's artistic outlook. He worked increasingly for himself and was rewarded by prestigious institutional recognition. He was included in the Museum of Modern Art's exhibition "Five Unrelated Photographers" (1963), and received his first Guggenheim Fellowship in 1964 for a project "to make photographic studies of American life." After 1967, Winogrand supported his personal work with teaching stints at leading colleges and universities.

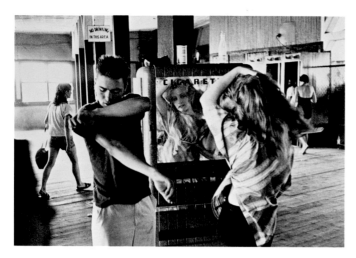

307 Bruce Davidson, *Brooklyn Gang*, 1959 (print: ca.1970), 8⅛ x 12⅛"

From the beginning, Winogrand's work was characterized by a gritty naturalism. In the early 1950s, working with fast film and available light, he created grainy, visceral images of boxers, ballet dancers, strippers, and musicians. As photography critic Arthur A. Goldsmith observed in 1954, these were "paradoxical pictures, at the same time brutal and tender, poetic and violent," with "an explosive quality of energy and emotion." As Goldsmith noted, "a recurring theme in [Winogrand's] pictures is the human body and the designs it makes, not as a posed figure but as a living organism." Winogrand himself observed that "bodies speak in attitudes, in the way they move, walk, sit, lie. They are almost as expressive as when a person opens his mouth and talks."[392]

These concerns were fully expressed in a group of aggressively physical pictures made in 1961 on the sidewalks of New York [378]. Employing close viewpoints, abrupt croppings, tilted horizons, and other visual devices, these images suggest the unpredictability of the street, its restless ebb and flow of human activity. These fragments of optical reality are shaped in equal measure by choice and chance. Moreover, a complex mood of energy, longing, and alienation envelops these pictures, a product of Winogrand's own brusque vitality and frequent melancholia.[393] The best of his subsequent work—depicting zoos, airports, press conferences, demonstrations, social gatherings, and other public activities—makes an equally remarkable use of odd juxtapositions and an unorthodox layering of visual incident.[394]

Lee Friedlander's interest in the camera began at the age of fourteen, in his hometown of Aberdeen, Washington.[395] After studies with Edward Kaminski at the Art Center School in Los Angeles, Friedlander moved to New York in 1956 to establish himself as a professional. He began a lifelong friendship with Winogrand, and came to know Evans, Frank, Levitt, and Arbus. In the following years, Friedlander worked for *Sports Illustrated*, *Esquire*, and *Holiday*, and sold portraits of jazz musicians to the Columbia, RCA, and Atlantic labels for use on album covers.[396] His warm portrayals of New Orleans musicians, made primarily in 1958-59, were the first of his personal pictures to receive artistic recognition.[397] Friedlander was awarded Guggenheim Fellowships in 1960 and 1962, and had his first one-man museum exhibition at the George Eastman House in 1963.

By the early 1960s, the subject of Friedlander's personal work had grown to encompass, in his words, "the American social landscape and its conditions."[398] From the influence of the photographers he knew in New York, and the earlier pictures of Atget, Kertész, and Weegee, Friedlander fashioned an altogether original style. With his characteristic tool—a Leica with a wide-angle lens—he explored the camera's simultaneous powers of description and invention. Friedlander's ironic vision charged the most familiar aspects of the "social landscape"—shop windows, signs, telephone booths, cars, listless pedestrians—with an ominous unease. This mood is clear in his 1962-63 images of television screens. While earlier photographers, such as Frank, had taken the TV set as an artistic subject, none made pictures as intense or eerie as Friedlander's.[399] His *Nashville*, 1963 [379], evokes television's hypnotic allure and its seductive—perhaps even malevolent—presence in virtually every American home. In 1963, six of these remarkable pictures were published in *Harper's Bazaar*, accompanied by a short text by Walker Evans describing them as "deft, witty, spanking little poems of hate."[400]

In his later work, Friedlander recorded a great variety of subjects in his seemingly continuous travels across the country. His inventive self-portraits of the late 1960s, in which his presence is typically reduced to a shadow or reflection, influenced a generation of younger photographers. By this time, Friedlander was making baroquely intricate images of controlled chaos. These pictures create unexpected pictorial wholes from the overlap and interplay of widely disparate parts. Like the free jazz of John Coltrane and Ornette Coleman, or the "combine" paintings of Robert Rauschenberg, these photographs convey a paradoxical mood of "lyrical dissonance." Above all, Friedlander's photographs underscore the pleasures of discovery. In the tradition of such great photographic *flâneurs* as Atget, Kertész, Cartier-Bresson, and Levitt, Friedlander exhibits an endless curiosity for the rich variety of the real. His densely constructed photographs are witty puzzles of disclosure, concealment, and camouflage. As photographic historian Jonathan Green has observed, they play "an elaborate game of hide-and-seek with the world."[401]

Diane Arbus's work is distinguished by an equally voracious curiosity. Arbus (née Nemerov) grew up in New York City in a sheltered realm of wealth and privilege. At the age of eighteen, she married Allan Arbus. The two became successful fashion photographers, with their work appearing in *Glamour*, *Vogue*, and other magazines. However, she became dissatisfied with commercial work and, in 1957, after brief studies with Brodovitch, she enrolled in a workshop taught by Lisette Model. This experience gave new focus to Arbus's artistic fascination for odd or "forbidden" subjects. By 1959, she was photographing Hubert's Museum, a flea circus in a dingy 42nd Street penny arcade, and Club 82, a hangout for female impersonators in lower Manhattan. Portfolios of this work were published in *Esquire* in 1960 and in *Harper's Bazaar* a year later.[402] Over the next decade, Arbus earned a considerable portion of her income from assignments for these publications, and for *Show*, *Glamour*, the *New York Times Magazine*, and the *Sunday Times Magazine* (London).

Arbus's style and subject matter evolved markedly in the early 1960s. By 1962, she had switched from 35mm to the 2¼-inch square format, a change that gave added clarity to the unsettling images of nudists, transvestites, circus performers, twins, midgets, and giants that she made in the following years. Arbus spoke eloquently about her attraction to these subjects:

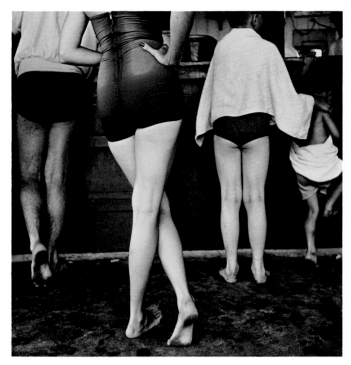

308 Yasuhiro Ishimoto, *North Avenue Beach, Chicago*, 1952 (print: 1996), 9⅜ x 9⅜"

There's a quality of legend about freaks. Like a person in a fairy tale who stops you and demands that you answer a riddle. They've passed their test in life. Most people go through life dreading they'll have a traumatic experience. Freaks were born with their trauma. They've already passed it. They're aristocrats.[403]

Her photographs of putatively normal subjects, taken on the sidewalks or in the parks of New York City, are no less disconcerting. Recorded with blunt immediacy, these individuals always seem imperfect, uneasy, or vacant. Yet, despite the "shocking" nature of many of her images, Arbus professed deep sympathy for the people she photographed. As historian Anne Wilkes Tucker has written, the ultimate power of Arbus's photographs lies

> not [in] the discovery of something foreign, but [in] the recognition of something familiar. Beyond the uniqueness of her subject's physical person, costume, lifestyle, or job are the small, ubiquitous yearnings of our common humanity: the wish to be king or queen for the day, to look like Elizabeth Taylor or Marilyn Monroe or Mickey Spillane, to love one's son, to celebrate a special occasion.[404]

Arbus viewed her subjects not as aliens, but as forlorn, forgotten cousins in the family of man.

Arbus's recurrent themes include masks, facades, the tension between appearance and meaning, and the ironies and paradoxes of representation. Ultimately, her photographs question the sta-

bility of our notions of both identity and reality. This questioning is seen even in those pictures without people. For example, an early work, *A castle in Disneyland, Cal.*, 1962 [382], presents a precisely factual record of an architectural and cultural fiction. By representing what is already a representation, Arbus suggests the uncertainty of visual truth, as well as the larger currents of fantasy and fraud that run throughout society.

Arbus's work stemmed from her fascination for secrets and for the truths that lie below surface appearances. As her close friend Marvin Israel noted, Arbus thought of herself as "the first great female private eye."[405] In style and technique, her pictures were based on the most provocative work of the preceding years by photographers such as Weegee, Faurer, and Levinstein. As she became increasingly aware of the history of photography, Arbus came to appreciate even earlier work: Brassaï's documents of nighttime Paris in the early 1930s and August Sander's catalogue of the people of Germany during the Weimar era. Her fascination for the outer fringes of society was, on some level, a reaction to her protected upbringing. It was also a logical expression of a larger countercultural resistance to the bland "normalcy" of the Eisenhower era; in the Romantic tradition, many artists and bohemians of the era held that life was only truly authentic in its most extreme manifestations. Finally, Arbus's work paralleled the "New Journalism" of Gay Talese, Norman Mailer, and Tom Wolfe, in which the flat descriptiveness of earlier styles of reportage was discarded for more subjective—even novelistic—approaches. *Esquire* magazine, one of Arbus's best clients during the 1960s, was at the forefront of this journalistic movement.

The New Formalism

A cooler strain of experimental work was also produced in this era, primarily by graduates of the Institute of Design in Chicago. After Aaron Siskind's arrival in 1951, the Institute's program had diverged significantly from Moholy-Nagy's original curriculum. While Callahan, in particular, made extensive use of such techniques as the multiple exposure and high-contrast printing, neither he nor Siskind were interested in solarization, negative images, or other aspects of the classic Bauhaus approach.[406] Instead, they emphasized graphic, tonal, and structural permutations of the "straight" photograph. This approach is reflected in the work of the Institute's most notable graduates of this era: Yasuhiro Ishimoto, Art Sinsabaugh, Joseph Sterling, Kenneth Josephson, Joseph Jachna, Charles Swedlund, and Ray K. Metzker.[407]

Yasuhiro Ishimoto's prodigious talent stemmed, in part, from the variety of his influences and interests. Born in San Francisco, Ishimoto spent his childhood and adolescent years in Japan before returning to the U.S. in 1939. After studies in agriculture and architecture, he enrolled in the Institute of Design and turned

309 Art Sinsabaugh, *Midwest Landscape #10, No. 24*, 1961, 2½ x 19⅜"

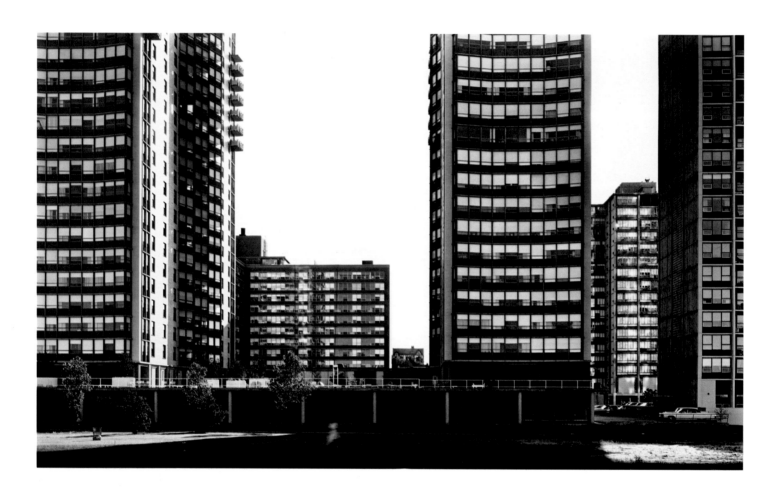

310 **Art Sinsabaugh,** *Chicago, Lake Shore Drive,* ca. 1967, 11⅝ x 19½"

to photography. He photographed in Chicago from 1948 to 1952, and again between 1958 and 1961, but otherwise lived in Japan.[408] Ishimoto's Chicago pictures are richly expressive, combining the curiosity of an astute outsider with the warm familiarity of a resident [308, 338]. These photographs are bold, muscular, and formally precise while, at the same time, deeply lyrical, humane, and tender. It is a rare and remarkable combination.

Art Sinsabaugh, one of Callahan's first students, taught at the Institute of Design between 1949 and 1957 before taking a position at the University of Illinois in Champaign. Sinsabaugh's mature work was begun when he acquired an old 12 x 20-inch banquet camera.[409] Starting in 1961, Sinsabaugh used this unwieldy format to record the flat, seemingly uneventful landscape of central Illinois [309]. Focusing on the intervals between telephone poles, houses, and trees, and the subtle undulations of the horizon itself, Sinsabaugh cropped these views to produce contact prints twenty inches long and as little as one inch high. By echoing the relentless horizontality of the land, these photographs intensified the formal relationships between the subjects within the frame. The resulting pictures are fascinating hybrids of purist, documentary, and abstract concerns. In 1964, Sinsabaugh began a three-year project documenting the city of Chicago [310]. These photographs, which utilize a greater portion of the full 12 x 20-inch format, describe the city in meticulous detail while functioning as highly abstract arrangements of graphic and geometric units.

The Institute of Design's program was highlighted in *Aperture* in 1961 when Minor White devoted an entire issue to the work of five graduate students: Sterling, Josephson, Swedlund, Jachna, and Metzker.[410] While the influence of their teachers was clear, the work of these five was both varied and original. Drawing from the example of Frank and other street photographers of the 1950s, Joseph Sterling recorded the tensions and rituals of adolescent life [376]. Kenneth Josephson experimented broadly with the effects of focus and multiple exposures, while also making highly reductive "straight" exposures of the play of light and shadow on the city street [380].[411] Joseph Jachna's thesis topic—photographs of water—involved a poetic investigation of this most elemental of substances [311], while Charles Swedlund used multiple exposures, high-contrast film, and slow shutter speeds to reinterpret the human form [312].

The Institute's rigorously formal, problem-solving approach to photography is exemplified in the work of Ray K. Metzker. His characteristic interest in contrasts of light and shadow, his strong sense of design, and his technical precision were already evident in the photographs made for his thesis project, "The Loop," in 1957-58. After relocating to Philadelphia in 1962, Metzker began a concerted exploration of the possibilities of the multiple image. In his "Double Frame" series (1964-66), Metzker printed consecutive frames of 35mm film as a single picture, evoking a sense of both connection and discontinuity in the final image.

Metzker's "Composites," begun in 1964, dramatically extended this interest. By assembling grids of individual photographs, Metzker created complex image-fields ranging in size from 12 x 12 inches to 75 x 38 inches. These works were unprecedented in both scale and effect. When viewed from a distance, a

311 Joseph Jachna, *Blurred Waterscape, Door County, Wisconsin,* 1970, 8 x 9"

work such as *Composite: Atlantic City,* 1966 [381], reads abstractly, as a rhythmic pattern of light and dark. On closer inspection, however, it is seen to be composed of many crisply descriptive images. The "Composites" function somewhat like short loops of motion-picture film, which create a hypnotic visual rhythm from the repetition of a simple action. The mystery and fluidity of these brief narratives is further enhanced in those works (such as *Composite: Atlantic City*) in which the original roll of film was double-exposed in the camera. Here, the graphic multiplicity of the overall image is combined with a delicate sense of interpenetration and disembodiment. As Metzker himself noted, these

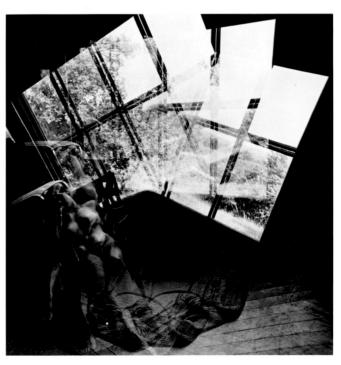

312 Charles Swedlund, *Multiple Exposure,* 1970, 7½ x 7½"

ambitious works provided a unique opportunity "to deal with complexity of succession and simultaneity, of collected and related moments."[412] Metzker continued his exploration of the graphic and optical possibilities of the photographic images in such later series as "New Mexico" (1971-72) and "Pictus Interruptus" (1976-80).

"A Form of Alchemy"

By the early 1960s, photographers were taking a new interest in constructed or manipulated images. Departing strongly from the traditions of both f/64 and postwar street photography, these willfully fictional photographs challenged long-held beliefs in the medium's fundamentally realist nature. As Robert Heinecken, a professor of art at UCLA, observed in about 1964: "We constantly tend to misuse or misunderstand the term reality in reference to photographs. The photograph itself is the only thing that is real." Instead of photographs that functioned merely as "limp translations of the world," Heinecken advocated the creation of "vital objects which create an intrinsic world of their own. (There is a vast difference between taking a picture and making a photograph.)"[413] This work represented a logical extension of various currents of the 1950s—including Minor White's concept of equivalence and the lingering strains of Surrealism—as well as the earlier example of artists such as George Platt Lynes and Clarence John Laughlin. The approach that developed from these roots was exemplified by the work of Ralph Eugene Meatyard, Jerry Uelsmann, Duane Michals, and Edmund Teske.

Meatyard's life and work represent a fascinating hybrid of the mundane and the extraordinary. Born in Normal, Illinois, Meatyard served in the Navy, married, and briefly studied philosophy on the GI Bill before settling in Lexington, Kentucky. He worked there as an optician until his sadly premature death in 1972. Meatyard first purchased a camera in 1950 to record his newborn son. Enthralled by photography, he joined the Lexington Camera Club, a progressive group led by the photographer (and later educator, art historian, and curator) Van Deren Coke.[414] With Coke's encouragement—and the stimulus of a 1956 workshop with White, Siskind, and Henry Holmes Smith—Meatyard developed a highly individual artistic vision reflecting his varied literary and philosophical interests. Beginning in the late 1950s, he worked on a number of related projects: a series of lyrical photographs of light on water; a large group of out-of-focus images; the "Zen twigs" series, utilizing an extremely shallow zone of focus; his "Motion-Sound" pictures, which employed repeated multiple exposures; and his "Romances," in which posed figures were used for symbolic effect.

In the latter group, Meatyard often used dime-store Halloween masks to create a heightened sense of ritual and ambiguity [383]. The ultimate subject of these surreal images is "the strenuous and perilous voyage from youth to old age to death."[415] Like Zen riddles, these photographs employ blatant contradictions and fictions to explore the mysteries of identity, memory, and time. As in Laughlin's earlier work, Meatyard's photographs combine real settings with unreal effects in order to create a charged hybrid: a documentary fiction. The strange power of this approach is seen in Meatyard's last major project, *The Family Album of Lucybelle Crater*, an hallucinatory meditation on that most familiar of photographic genres, the family snapshot.[416]

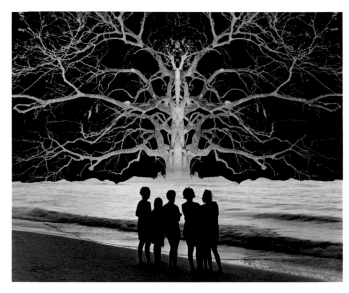

313 Jerry N. Uelsmann, *Apocalypse II*, 1967, 10½ x 13¼"

In the late 1950s, Jerry Uelsmann began making his own brand of photographic fictions. He reached his mature style after studying with Minor White and Ralph Hattersley at Rochester Institute of Technology and with Henry Holmes Smith at Indiana University. By 1959, Uelsmann was producing mysterious, allegorical photographs by printing from multiple negatives. Initially, he overlapped negatives in his enlarger to create images that resembled conventional double exposures; for example, his *Mechanical Man* (1959) superimposes a man's head on a machine. His multiple printing soon grew far more sophisticated. Instead of simply overlaying images, Uelsmann fused them seamlessly to create stunning and confounding effects. Unlike the collages and multiple exposures of other photographers, Uelsmann's composite images read as naturalistic wholes, without visible evidence of the "splices" between components. These photographs thus present "objective" records of impossible things: trees floating in midair, a human face looming out of the earth, bizarre contrasts of scale, abrupt juxtapositions of positive and negative imagery, and myriad other effects. In 1965, Uelsmann eloquently summarized his artistic philosophy in a paper titled "Post-Visualization."

> It is my conviction that the darkroom is capable of being, in the truest sense, a visual laboratory, a place for discovery, observation, and meditation.... Let us not delude ourselves by the seemingly scientific nature of the darkroom ritual; it has been and always will be a form of alchemy. Our over precious attitude toward that ritual has tended to conceal from us an innermost world of mystery, enigma, and insight.[417]

The mystical and hallucinatory nature of Uelsmann's work is evident in two photographs from 1967, *Apocalypse II* [313] and *Small Woods Where I Met Myself (final version)* [385]. Both are brilliant technical achievements. In *Apocalypse II*, Uelsmann unites a shot of people on a beach with a negative (and mirror image) rendition of a tree looming above them in the sky. The result, a quiet allusion to a nuclear blast, is mesmerizing and sinister. In *Small Woods Where I Met Myself*, Uelsmann creates a powerful meditation on the complexities of the modern self by repeating a single figure five times, in both positive and negative, within a synthetic dreamscape.

The ambiguous content of Uelsmann's pictures, coupled with their tantalizingly allusive titles, made them perfect subjects for the kind of analytical "readings" that Minor White had been advocating. Indeed, in the essays of William E. Parker and John L. Ward, Uelsmann's work received more extended study than that of any other photographer of the period.[418] These critics found Uelsmann's pictures teeming with allusions to art history, mythology, and comparative religion. These analyses drew liberally from the ideas of Carl Jung, Mircea Eliade, Joseph Campbell, Erich Neumann, and others who explored the symbolism of the "universal unconscious."

Like Meatyard and Uelsmann, Duane Michals has used the camera to depict, in his own words, "real dreams." Michals began his professional life as a graphic designer. Inspired by Frank's work, Michals first used a camera in 1958, on a trip to Russia, where he made boldly simple portraits of working-class subjects. Devoting himself to the medium, Michals achieved renown in both the professional arena—in fashion, advertising, and portraiture—and as an artist. Michals's personal work is founded on a key idea: "I believe in the imagination. What I cannot see is infinitely more important than what I can see."[419] Thus, paradoxically, he uses photography to register what would seem to be logically beyond its means: dream, memory, and desire.

An important event in Michals's life occurred in August 1965, when he visited René Magritte, the noted Surrealist artist, at his home in Brussels. Magritte's flatly descriptive paintings of physical impossibilities—a room-filling rose, loaves of bread floating in the sky like clouds, a rain of bowler-hatted men—significantly influenced photographers such as Michals and Uelsmann. In this visit, Michals paid homage to his host by documenting him in true Surrealist fashion. In *Magritte Front and Back*, 1965 [384], Michals used a double exposure to suggest a curious duality of spirit and flesh, meaning and appearance. Magritte was fascinating, in large measure, precisely because the strange originality of his inner life was cloaked by an utterly conventional exterior. This lesson—that the meaning of things may have little to do with appearances—has provided the basic motivation for Michals's art.

Edmund Teske's photographs are the product of a profoundly unconventional vision. Teske began serious use of the camera in the early 1930s. His interests and influences were very broad, encompassing painting, poetry, music, theater, Hindu mythology, and the ideas of figures such as Frank Lloyd Wright and László Moholy-Nagy. Teske left the Midwest in 1943 for Los Angeles. There, he worked for a time in Paramount Studio's still-picture department and developed numerous friendships in the film community. Teske's work came to national prominence in 1960, when he was included in the Museum of Modern Art's "Sense of Abstraction" exhibition. He exhibited widely in the following years, and exerted considerable influence on younger photographers through his teaching at Chouinard Art Institute and UCLA.

Teske's mature images employ a variety of manipulations, from the staging of subjects to multiple printing. The most original of Teske's expressive techniques was the "duotone solarization" process he perfected in 1958. Never exactly repeatable from print to print, this technique produced a partial reversal of tone, as well as painterly veils of color (a product of chemical staining).[420]

Teske used this process to create dreamlike images that are at once seductive and ominous. Teske's view of actor John Saxon on the set of the 1962 film *War Hunt*, for example, is transformed by this technique into a disturbing, almost apocalyptic, vision drenched in a wash of burnt umber [314].[421] Work such as this provided a powerful model for younger photographers eager to expand the medium's expressive syntax.

Institutions and Communities

The world of American photography changed significantly between the early 1940s and the mid-1960s. In these years, the gulf widened between the realms of art and commerce, and between popular and elite visions of the medium. The field was given a peculiar torque by the simultaneous decline of the great picture magazines and the medium's rising acceptance by art museums. At the same time, the emphasis of photographic education shifted from vocational training to self-expression. As a result of such changes, photography underwent an unprecedented process of expansion and fragmentation.

This diversification was evident in the era's photographic journals. Mass-circulation periodicals such as *Popular Photography*, *Modern Photography*, *U.S. Camera*, and *Camera 35* served the general photographic public. Catering to more specialized markets were publications such as *Infinity* (published by the American Society of Magazine Photographers), *Image* (published by the George Eastman House), *Aperture*, *Contemporary Photographer*, and the Swiss magazines *Camera* and *Du*.[422] Beginning in the early 1940s, periodicals such as *Artnews*, *Art in America*, and *Magazine of Art* also carried articles on historical and contemporary photography. Jacob Deschin was the medium's most prolific and knowledgeable newspaper critic in these years. After working for the photography magazines in the late 1930s, Deschin began writing for the *New York Times* in 1941 on a freelance basis. After serving in the military, he returned to the paper to write a regular weekly column from 1946 to 1970.[423]

Although a real market for fine-art photographs was still nearly two decades away, several noble attempts were made in the 1950s to present photography as a commercially viable art. In May 1954, Helen Gee opened Limelight Gallery in New York's Greenwich Village. Aware that a photography gallery could not hope to be self-supporting, Gee combined her exhibition space with a European-style coffeehouse. Before its close in January 1961, Gee presented a varied schedule of sixty-one individual and group exhibitions.[424] Among those featured in one-person exhibitions were Stettner, White, Vestal, Porter, Bullock, Moholy-Nagy, Levinstein, Adams, Erwitt, Parks, Arnold Newman, and W. Eugene Smith. Roy DeCarava, also in New York, ran A Photographer's Gallery, a small but dignified showcase for some of the finest work of the period, from March 1955 to May 1957. DeCarava presented seven one-person and five group exhibitions, featuring the work of Vestal, Bernhard, Levinstein, Meatyard, Coke, Callahan, Jay Maisel, Marvin Newman, and others.[425] After first showing photographs in 1955, the Carl Siembab Gallery in Boston began presenting the medium regularly in 1959. Siembab's first show, devoted to Aaron Siskind, was followed by exhibits of the work of Lyons, Chiarenza, Meatyard, Bernhard,

314 Edmund Teske, *John Saxon*, ca. 1962, duotone solarization, 13¾ x 11″

and others.[426] A number of other galleries—generally short-lived—showed photography regularly in the following years. One of the most significant of these, Norbert Kleber's Underground Gallery in New York, was in existence between 1963 and 1975. In his first two years of operation, Kleber presented one-person surveys of the work of Duane Michals, Oliver Gagliani, Lee Lockwood, Minor White, and others.[427] Also active in the early 1960s were Gallery 216 (New York), the Hicks Street Gallery (Brooklyn), the Photographer's Gallery (Provincetown, Mass.), A Photographer's Place (Philadelphia), the Princeton Gallery (Chicago), the West Bank Gallery (Minneapolis), and the Edward Cain Gallery (Denver).[428]

As a museum art, photography grew slowly through the early 1960s. In this period, the nation's most prestigious venue—by far—was the Museum of Modern Art. As director of the museum's department of photography from 1947 to 1962, Edward Steichen presented a highly influential series of exhibitions. Although best remembered for "The Family of Man," Steichen's vision was as broad as it was astute.[429] His thematic exhibitions included "Music and Musicians" (1947), "Photographs of Picasso by Mili and Capa" (1950), "Korea" (1951), "Abstraction in Photography" (1951), "Memorable *Life* Photographs" (1951), and "70 Photographers Look at New York" (1957). In addition, he presented such historical exhibitions as a survey of news photography titled "The Exact Instant" (1949), "Roots of French Photography" (1949), "Newly Acquired Photographs by Stieglitz and Atget" (1950), "Lewis Carroll Photographs" (1950), and "Forgotten Photographers" (1951).

The bulk of Steichen's prodigious energy was devoted to contemporary work, which he presented in group shows. These included: "In and Out of Focus" (1948), "50 Photographs by 50 Photographers" (1948), "51 American Photographers" (1950), "Always the Young Strangers" (1953) and "Post-War European Photography" (1953). Steichen featured his favored artists in groups of two to six: "Three Young Photographers: Leonard McCombe, Wayne Miller, Homer Page" (1947), "Four Photographers: Lisette Model, Bill Brandt, Ted Croner, and Harry Callahan" (1948), "Realism in Photography: Ralph Steiner, Wayne Miller, Tosh Matsumoto, and Frederick Sommer" (1949), the five "Diogenes with a Camera" exhibitions mounted between 1952 and 1961, and "Photographs by Harry Callahan and Robert Frank" (1962). A major survey of Steichen's own work opened at the museum in 1961, on his eighty-second birthday. His final exhibition was "The Bitter Years: 1935-1941, Rural America as Seen by the Photographers of the Farm Security Administration" (1962).

A new era at the Museum of Modern Art began in 1962, when John Szarkowski was named to succeed Steichen as curator of photography. Although relatively little known at the time, Szarkowski was uniquely qualified for this position.[430] After studying art history at the University of Wisconsin, Szarkowski worked at the Walker Art Center from 1948 to 1951. He then taught at the Albright Art School in Buffalo, New York, while working on a subtle and powerful book of his own architectural photographs, *The Idea of Louis Sullivan* (1956). A second volume of his pictures, *The Face of Minnesota* (1958), was published in celebration of the centennial of Minnesota's statehood. Strongly indebted to the example of earlier photographers such

as Evans, Lange, and Morris, Szarkowski's pictures strike a precise balance between fact and interpretation. In addition, these volumes—and such eloquent essays as "Photographing Architecture" (1959)—demonstrated Szarkowski's brilliance as a writer.[431] By the time of his appointment at the Modern, Szarkowski's understanding of photography had grown to encompass the medium's visual syntax—its unique technical and expressive characteristics. This concern was explored in his 1964 exhibition "The Photographer's Eye."

Outside the Museum of Modern Art, the most active and influential program was that of the George Eastman House in Rochester.[432] After its opening in 1949, the Eastman House presented a varied series of exhibitions, as well as publishing the journal *Image* and occasional catalogues and monographs. The early years of the museum's schedule included one-person exhibitions by Todd Webb (1953), Rose Mandel (1954), Siskind (1954), Garnett (1955), Moholy-Nagy (1956), Coke (1956), Bullock (1956), Walter Chappell (1957), Nathan Lyons (1957), and Syl Labrot (1959). Major group shows such as "Photography at Mid-Century" (1959), "Seven Contemporary Photographers" (1961), "Photography 63" (1963), and "Photography 64" (1964) were created under the direction of staff members Lyons and Chappell.

The Metropolitan Museum of Art collected photographs throughout the 1940s and 1950s under the guidance of its first two curators of prints, William M. Ivins and A. Hyatt Mayor.[433] Occasional exhibitions were mounted, including the work of Atget (1952) and D. O. Hill (1958). The Metropolitan's most prominent photographic exhibitions were six shows presented between 1959 and 1967 under the collective title "Photography in the Fine Arts." This ambitious project, the brainchild of photographer Ivan Dmitri, attempted to promote the medium to the museum-going public and to encourage its acceptance by the art establishment.[434] To this end, Dmitri assembled a panel of noted jurors and enlisted the collaboration of *Saturday Review*, which published a selection of winning images. Created in multiple editions for tour, these shows were widely popular. After its debut at the Met, for example, the first of these shows traveled to twenty-six sites and was seen by 2,000,000 viewers.[435] In all, the six exhibitions were seen by an audience of 8,000,000. Despite this popularity, and the inclusion of individual works of real merit, Dmitri's project received harsh criticism. For photographers such as Frank, Friedlander, and Winogrand, the miscellaneous nature of these exhibitions perpetuated a discredited view of the medium: "photography deprived of [its] subtleties and meanings because it is deprived of its context and motivation."[436] By this time, such massive efforts to "sell" photography to the general public were simply irrelevant to the concerns of the medium's most original practitioners.

Other museums demonstrated a commitment to photography in this era. For example, an Ansel Adams exhibition in 1946 marked the beginning of a remarkable series of photography shows at the Santa Barbara Museum of Art. One-person exhibits of many leading contemporary figures followed: Sommer (1946), Bullock (1947), Siskind (1948), Laughlin (1952), White (1954), and others. In 1957, the museum mounted an ambitious historical survey that traveled to a number of other sites in the west. The Art Institute of Chicago also presented many important photography exhibits. This program was begun in 1940 by Carl O.

Schniewind, curator of the department of prints and drawings.[437] These shows became more regular with the naming of official curators of photography: Peter Pollack (1951 to 1957) and Hugh Edwards (1959 to 1970). In these years, the Art Institute presented surveys of the work of Kertész (1946), Moholy-Nagy (1947), Evans (1947), Callahan (1951), Corpron (1953), Porter (1953), Siegel (1954), Garnett (1956), and Frank (1961).[438] Edwards also mounted surveys of historical work by William Henry Fox Talbot, Roger Fenton, P. H. Emerson, and others.[439]

Notable photographic exhibitions appeared with varying frequency at other museums. The Los Angeles County Museum of Art presented shows such as "Seventeen American Photographers" (1948) and "Photography at Mid-Century" (1950). Institutions that also mounted original shows or hosted major touring exhibits in this era include the California Palace of the Legion of Honor in San Francisco, the San Francisco Museum of Art, Yale University Art Gallery in New Haven, the Albright-Knox Gallery in Buffalo, the Brooklyn Museum, the Colorado Springs Fine Arts Center, the Detroit Institute of Arts, the Milwaukee Art Institute, the Cleveland Museum of Art, and the De Cordova Museum in Lincoln, Massachusetts. The Amon Carter Museum in Fort Worth began collecting photographs shortly after its founding in 1961. In 1962, the Worcester Museum of Art began a concerted program of photographic acquisitions and exhibitions. The Minneapolis Institute of Arts began exhibiting the medium regularly in 1964, guided by curator Carroll T. Hartwell. Smaller institutions, including several university art galleries, also began collecting and showing photography at this time.[440]

In short, this period was characterized by dynamic, if widely scattered, pockets of activity. Banding together for moral and creative support, photographers formed fraternal communities dedicated to self-education and the exhibition and promotion of the medium. Always in flux, these associations flourished or dissolved according to the energy and interests of key members. This network of photographic communities spanned the country. In San Francisco, in 1954, a group of young artists established the Photographer's Gallery, a self-supported venue in which to show—and attempt to sell—their work.[441] By 1955, this evolved into a larger association, known as The Bay Area Photographers, which included such figures as Imogen Cunningham, Ruth Bernhard, and Pirkle Jones.[442] In Kentucky, the Lexington Camera Club exerted considerable influence in the mid-1950s. Van Deren Coke, a member of the group since the age of sixteen (in 1937), began giving short courses for club members in 1952. National figures such as Nicholas Ház were also brought in to speak. In 1956, under Coke's direction, the Lexington Camera Club and the University of Kentucky's Department of Art collaborated on a major invitational exhibition, "Creative Photography 1956."[443] In Minneapolis, an active photographic community grew up around the program at the University of Minnesota, and the influence of figures such as Jerome Liebling. In addition to the exhibition program of the university's art gallery, photographs were also shown at the Minneapolis Institute of Arts and the Walker Art Center.[444] In Boston, the overlapping efforts of Carl Siembab, Carl Chiarenza, and others created an energetic circle of activity in the late 1950s. In 1963, six Boston-area photographers (Chiarenza, Paul Caponigro, William Clift, Marie Cosindas, Nicholas Dean, and Paul Petricone) joined Walter Chappell to form The Association of Heliographers. Seeking the widest audience for their work, the Heliographers focused their efforts on New York City: a members show was presented in August 1963 at the prestigious Lever House, and soon after the group opened its own gallery at 859 Lexington Avenue.[445]

In the early 1960s, the academic community made an important effort to unify its own, far-flung communities. Under the impetus of Nathan Lyons, a group of photography teachers met at the George Eastman House in the fall of 1962 to discuss the state of the profession.[446] The idea for a national organization was born; a year later, in Chicago, the Society for Photographic Education held its first annual meeting.[447] The desire to expand the audience for serious work dominated the talks at the 1962 conference. Everyone agreed that the medium suffered a woeful lack of informed criticism and was viewed superficially by most art museums and members of the public. To this end, a deeper understanding of visual literacy—accompanied by a refinement of critical terminology and methodology—was deemed essential.[448] How was the photographic image related to the science and psychology of perception? How were the meanings of photographs derived from a larger context of social thought and cultural value? Such complex issues dominated thinking in the field, but resisted definitive analysis.

By the mid-1960s, photographers found themselves in an apparently paradoxical situation. Photography seemed to be at once ubiquitous and marginalized, universally practiced and almost wholly misunderstood. As Lee Lockwood, the editor of *Contemporary Photographer*, wrote in 1963:

> What is photography? Photography is a craft, a mass hobby, a big business, an illustrator's medium, a method of selling, a device for visual recording, a way of communicating knowledge. It is also a highly expressive, fully developed art form neglected almost completely by the public.

In Lockwood's view, this neglect stemmed from the sheer ease of making pictures and the resulting "superabundance of photographic images in the daily world." This flood of photographs made it nearly impossible to view any one of them as an expression of personal thought or feeling, or as an "object of intrinsic value."[449] In truth, however, the efforts of a generation of partisans had by this time effected real change in the appreciation of photography. Progress was coming at an ever-increasing rate; the "photography boom" of the 1970s was just around the corner.

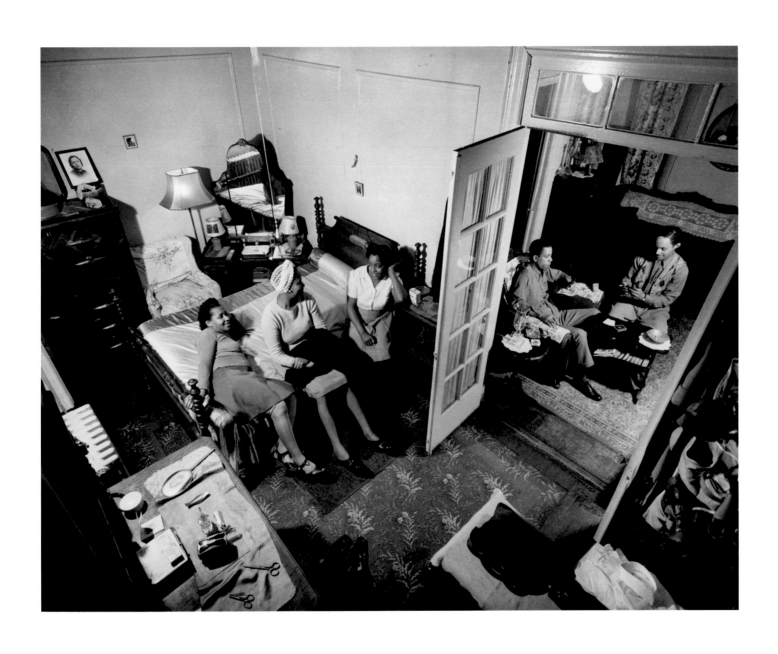

315 Herbert Gehr, *Untitled*, ca. 1943, 10⅝ x 13½"

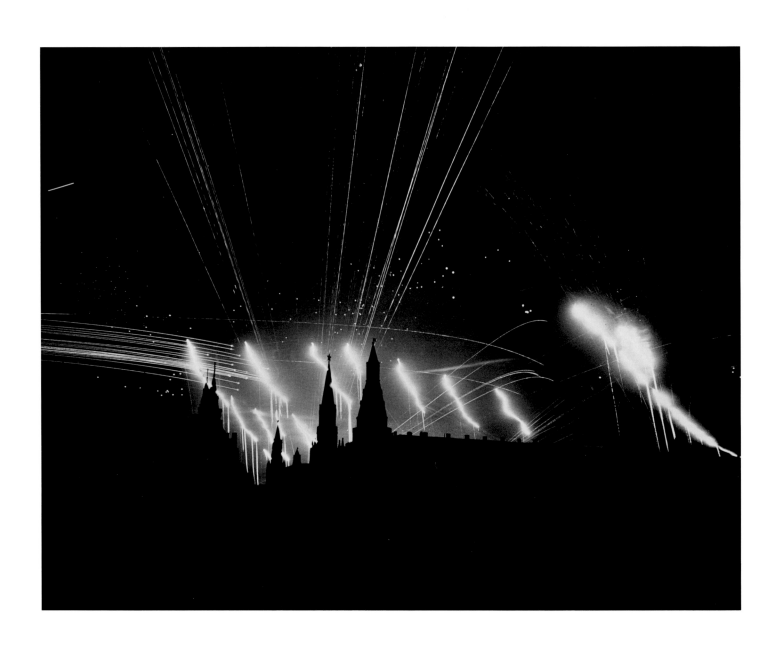

316 **Margaret Bourke-White,** *The Kremlin, Moscow, Night Bombing by the Germans,* 1941, 10½ x 13½"

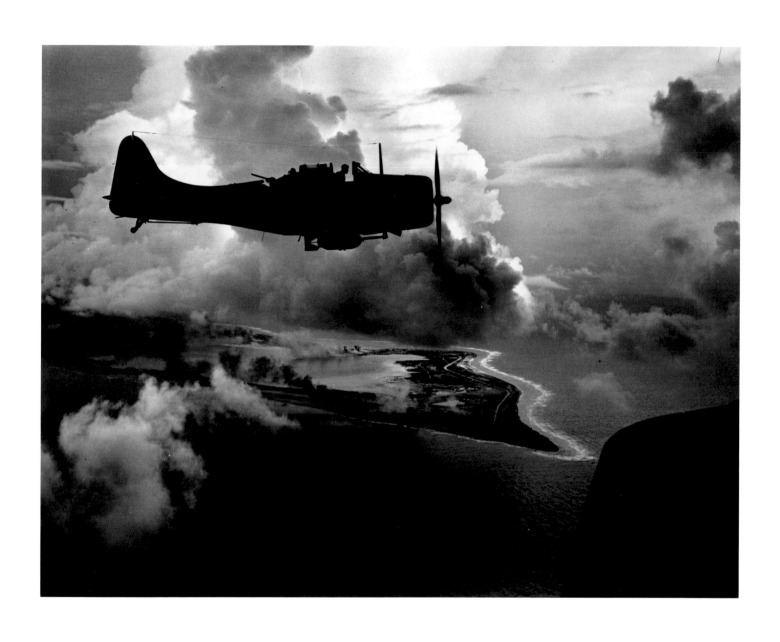

317 **Charles Kerlee,** *Dawn Attack by Douglas Dauntless Dive Bombers—Wake Island Burns Below*, December 1943, 7⅛ x 9⅝″

318 Val Telberg, *Untitled*, ca. 1948, 10½ x 9″

319 **Ruth Bernhard,** *Hand, Jones Beach, New York,* 1946, 7⅞ x 9⅞"

320 Frederick Sommer, *Arizona Landscape*, 1943 (print: ca. 1970s), 7⅝ x 9½"

321 Frederick Sommer, *Cut Paper*, 1977, 9½ x 7½"

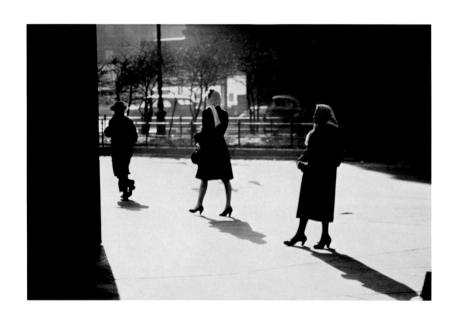

322 Harry Callahan, *New York*, 1945, 2⅞ x 4⅜″

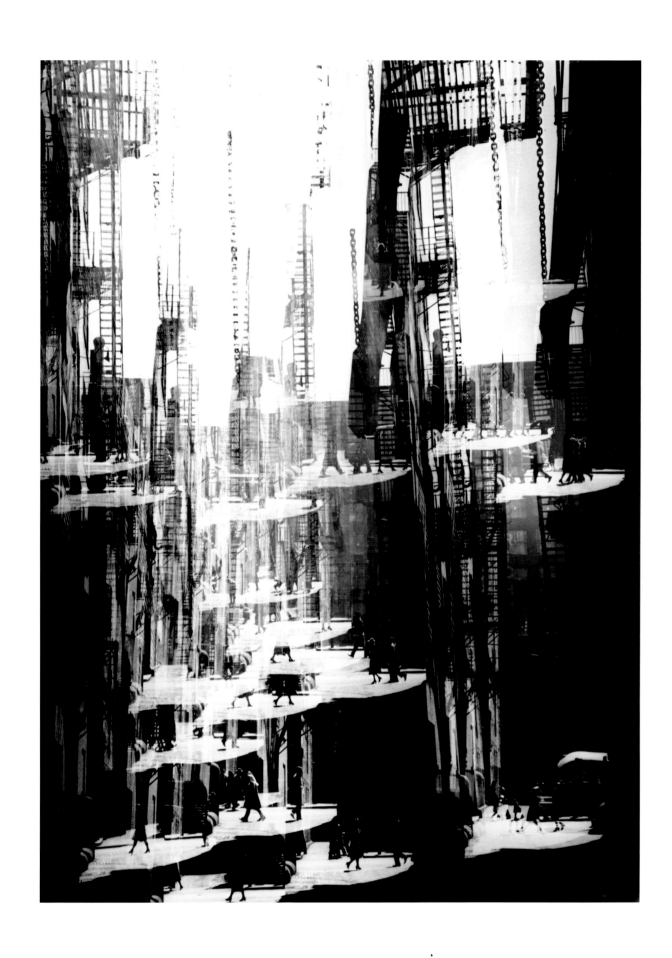

323 Harry Callahan, *Alley, Chicago*, 1948, 9½ x 7"

324 Aaron Siskind, *Gloucester*, 1944, 9½ x 7⅛"

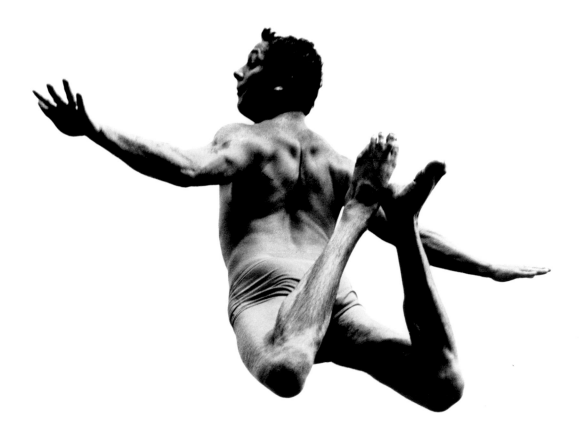

325 Aaron Siskind, *Pleasures and Terrors of Levitation* 99, 1961, 11 x 10½″

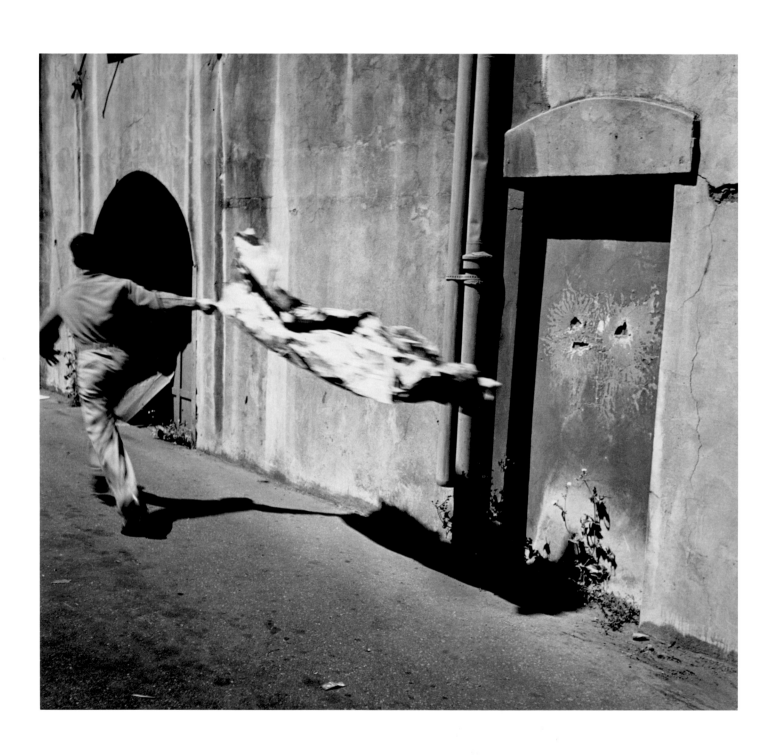

326 Minor White, *Warehouse Area, San Francisco*, 1949, 10⅜ x 11⅜"

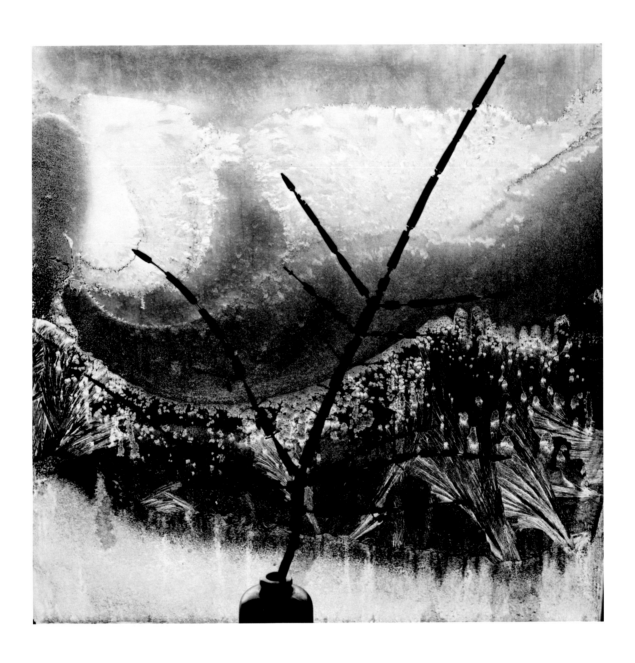

327 Minor White, *Ritual Branch, Frost on Window*, 1958, 7⅝ x 7⅝"

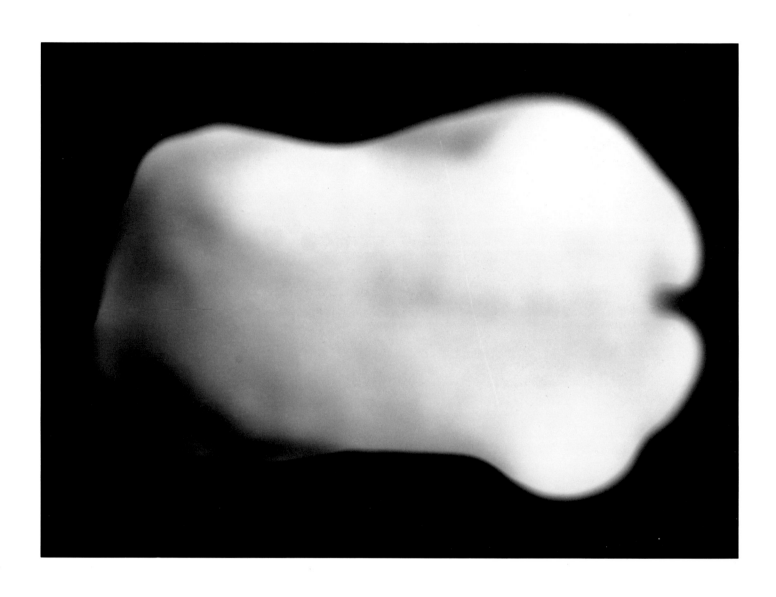

328 Larry Colwell, *Untitled (Nude)*, ca. 1954, 6½ x 9″

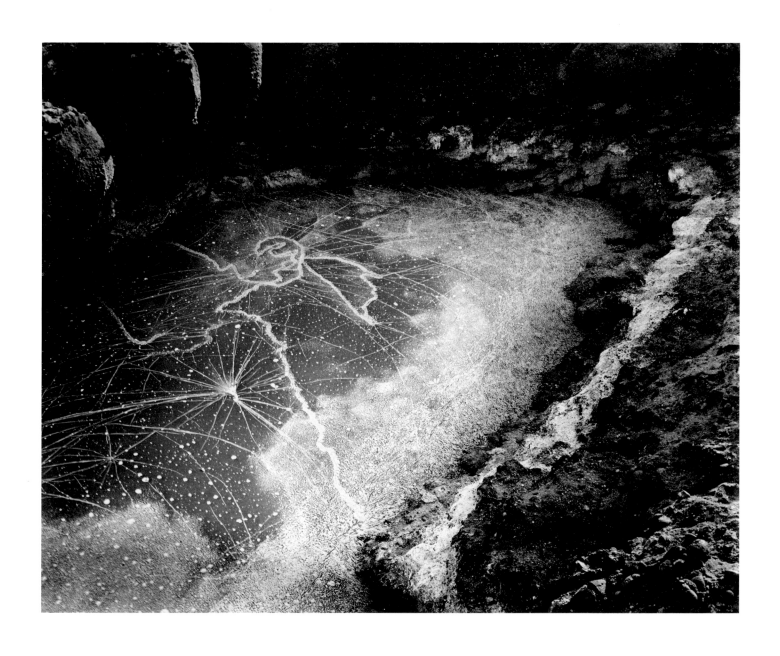

329 Wynn Bullock, *Tide Pool*, 1957, 7½ x 9½"

330 Rose Mandel, *Untitled*, ca. 1960, 7⅝ x 9⅝"

331 Oliver Gagliani, *Untitled*, 1962, 5¼ x 6¾"

332 Nathan Lyons, *Untitled*, 1958, 7½ x 9½"

333 **Paul Caponigro,** *Redding Woods,* 1968, 8⅝ x 12¼″

334 Richard Nickel, *Proscenium Arch, Garrick Theater*, ca. 1955-56, 9⅜ x 7½"

335 **John Szarkowski,** *Guaranty (Prudential) Building, Buffalo, Profile,* ca. 1952-53, 13⅜ x 8⅞"

336 Harry Callahan, *Bob Fine*, ca. 1952, 9¾ x 7¾"

337 Marvin E. Newman, *Untitled*, 1951, 9⅝ x 7¾″

338 **Yasuhiro Ishimoto**, *Wall Graffiti, Chicago*, ca. 1950-52, 7⅝ x 9⅜"

339 **Dave Heath,** *Crowd Watching a Failed Resuscitation, Central Park,* ca. 1957, 6⅜ x 9⅝″

340 Weegee, *Accused "Cop Killer,"* 1941, 13¼ x 10⅛"

341 Weegee, *The Critic*, 1943, 13⅛ x 16½″

342 Helen Levitt, *New York*, ca. 1939, 5⅞ x 8⅝"

343 Helen Levitt, *New York*, ca. 1942, 6⅜ x 8⅜″

344 Irving Canner, *Untitled*, ca. 1947-51, 7¾ x 7⅝"

345 Sid Grossman, *New York*, 1947, 7⅝ x 9¼"

346 **Roy DeCarava,** *Hallway, New York,* 1953 (print: ca. 1984), 13 x 8⅝″

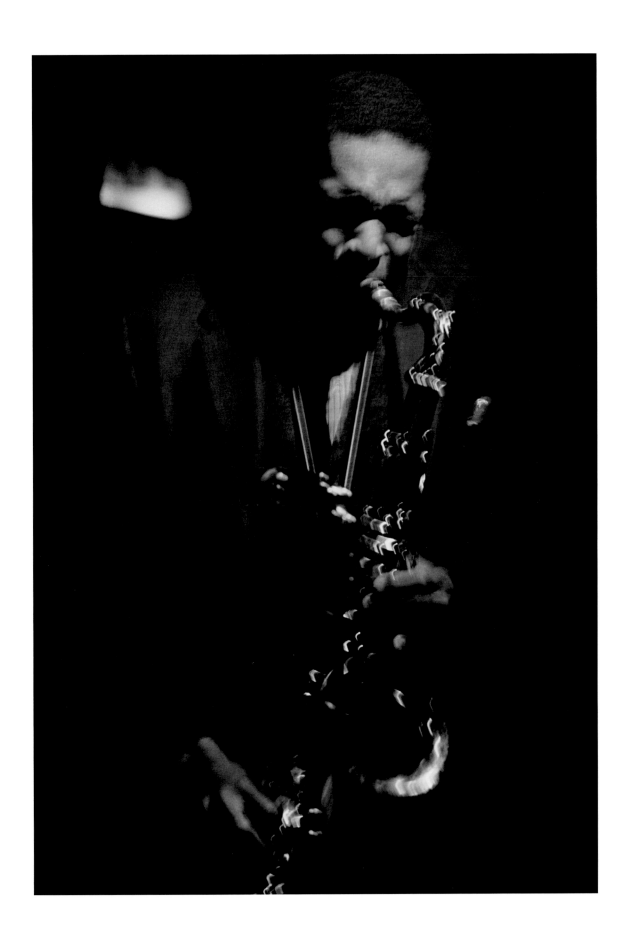

347 **Roy DeCarava,** *Coltrane No. 24,* 1963 (print: ca. 1984), 13 x 9″

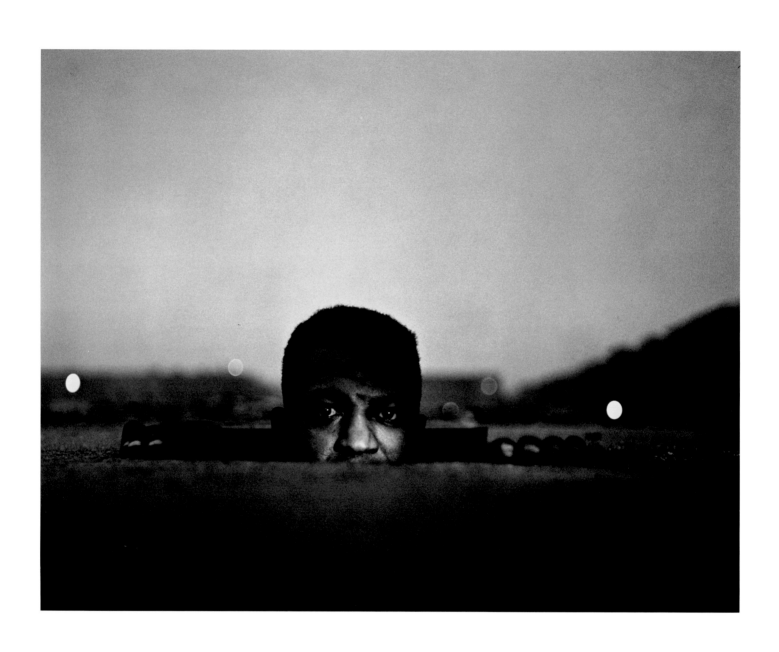

348 **Gordon Parks,** *Emerging Man,* 1952, 14⅞ x 19⅛″

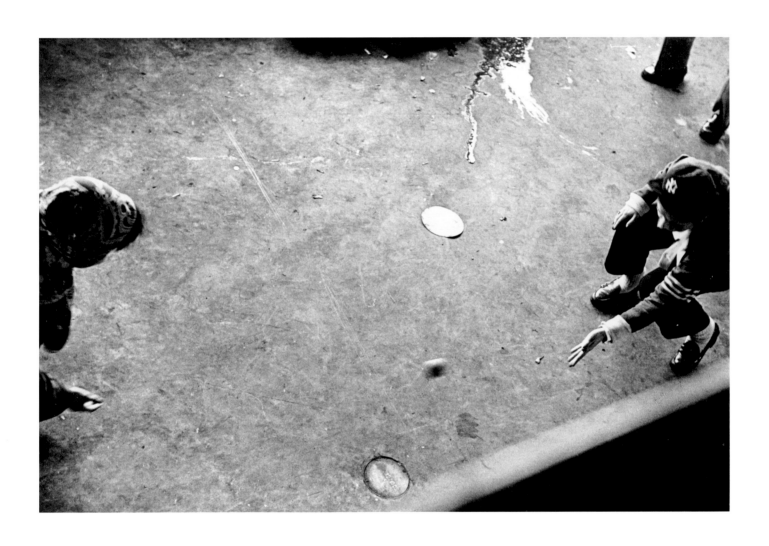

349 **Tosh Matsumoto,** *Untitled (children playing with ball),* ca. 1947-51, 5½ x 8⅜"

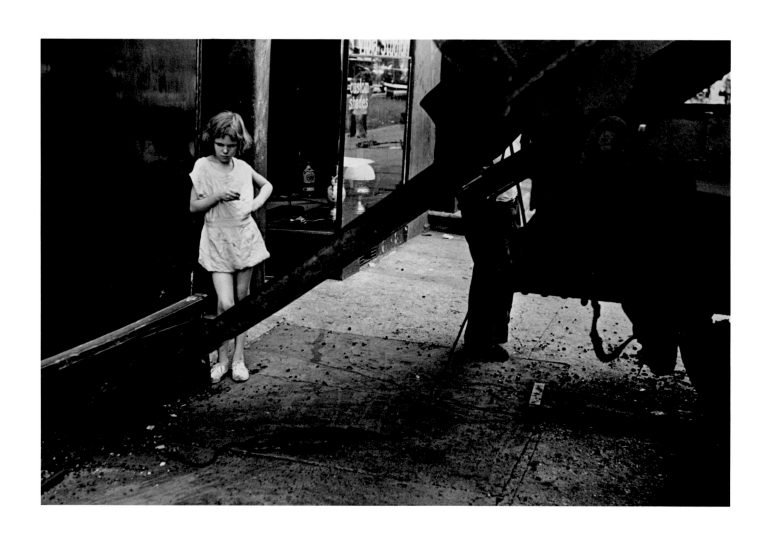

350 **Homer Page,** *New York*, 1949, 8⅜ x 12⅞"

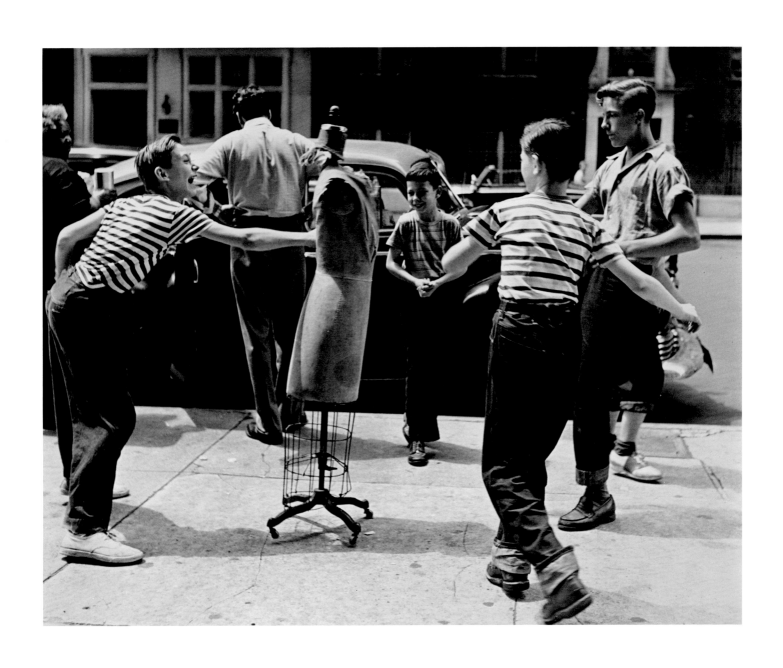

351 **Homer Page,** *New York,* 1949, 10½ x 13″

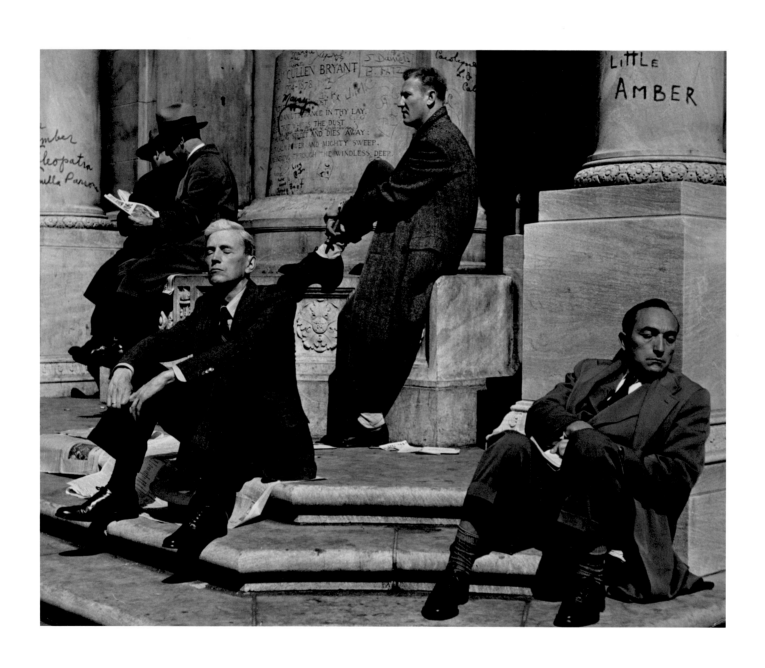

352 **N. Jay Jaffee,** *Bryant Park, New York City,* 1953, 7⅜ x 9″

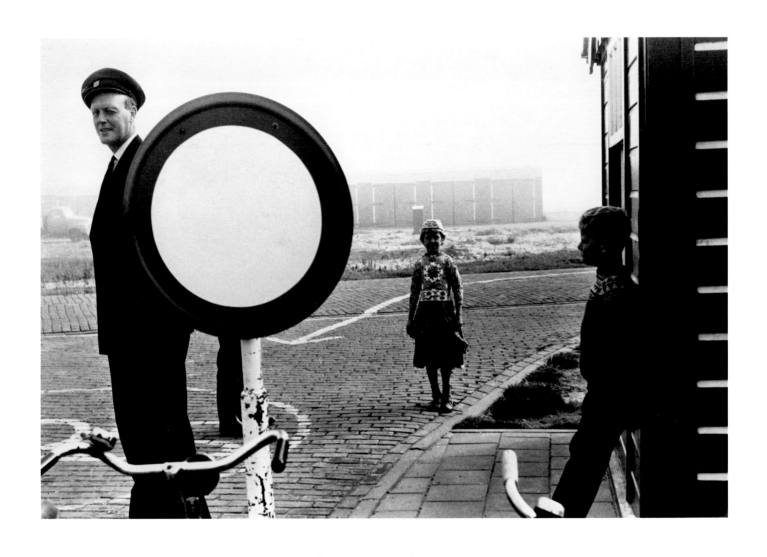

353 Louis Stettner, *Parking Lot, Volendam, Holland*, ca. 1959, 10⅜ x 15⅛″

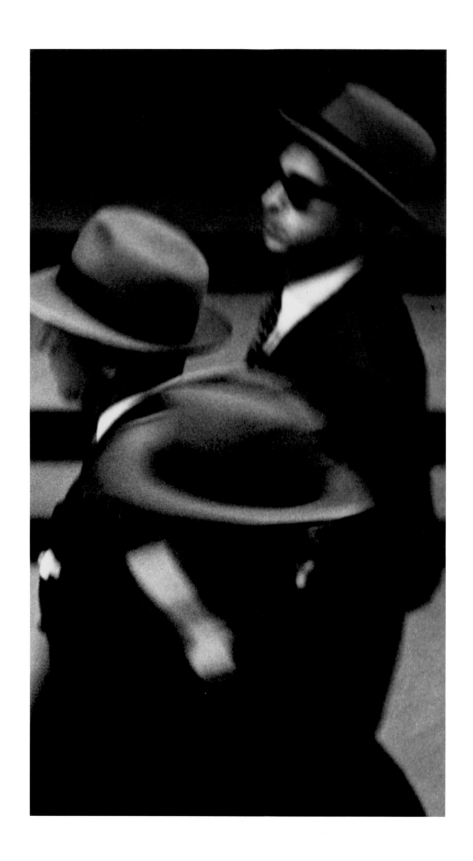

354 **Saul Leiter,** *Street Scene,* 1951, 8⅞ x 5″

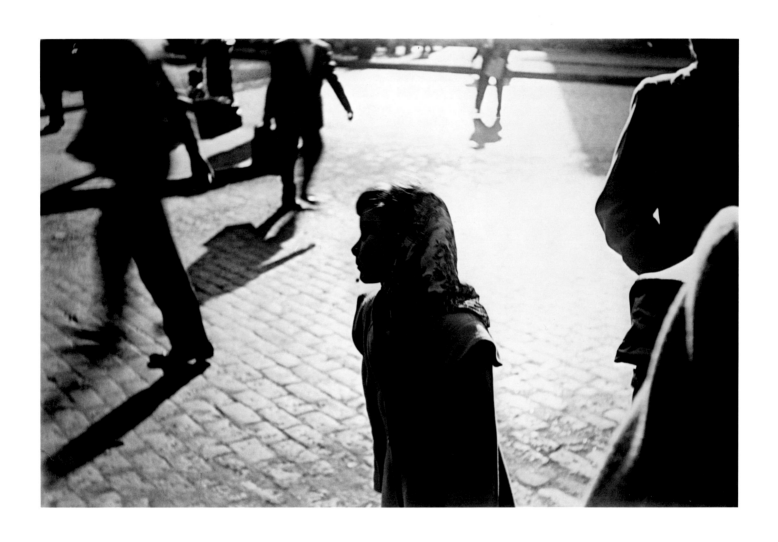

355 Saul Leiter, *New York*, ca. 1952, 11 x 16⅞″

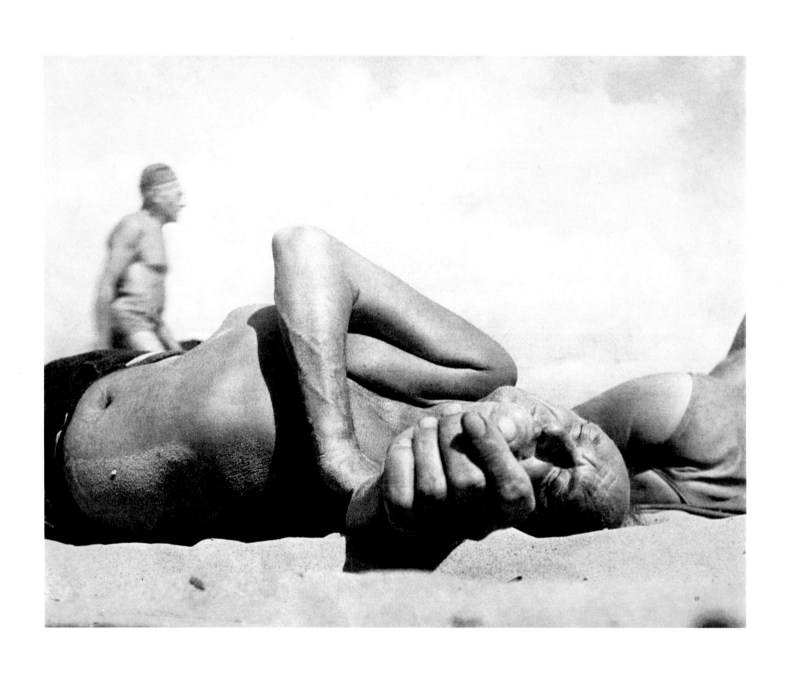

356 Leon Levinstein, *Untitled*, 1953, 10½ x 13½"

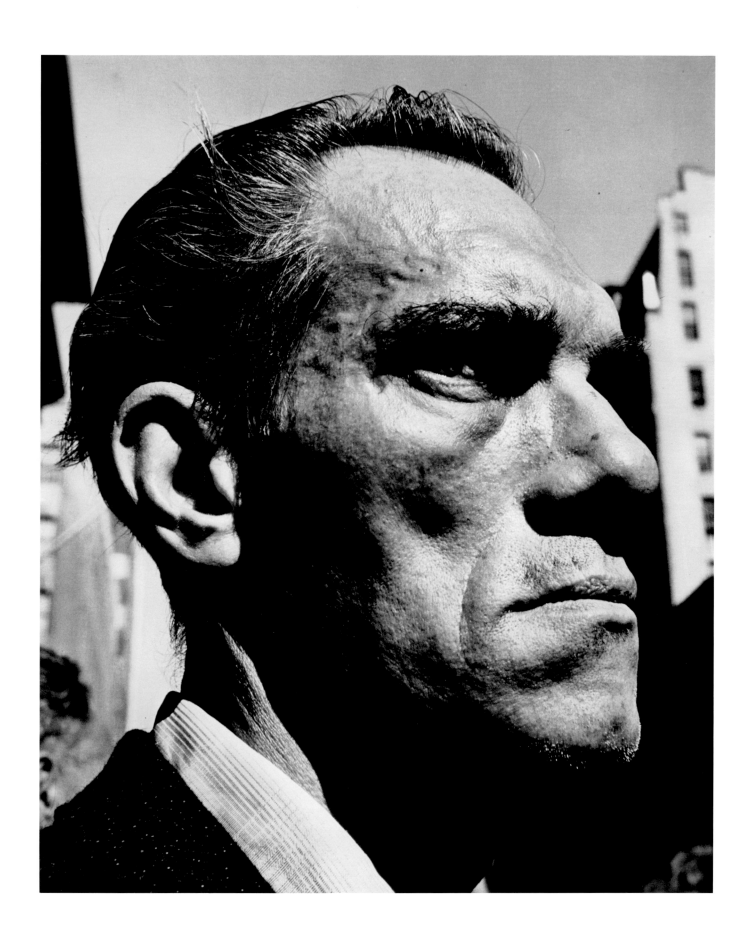

357 Leon Levinstein, *Fifth Avenue*, ca. 1959, 17 x 14"

358 Ted Croner, *Taxi, New York Night*, ca. 1947-48, 16 x 15¾"

359 William Klein, *Swing & Boy & Girl, New York*, 1955, 13⅞ x 11″

360 Wright Morris, *Telephone, Railroad Station, Central City, Nebraska,* 1947, 9⅝ x 7⅝"

361 **Paul Strand,** *Baptist Church, East Jamaica, Vermont,* 1944, 9⅝ x 7⅝"

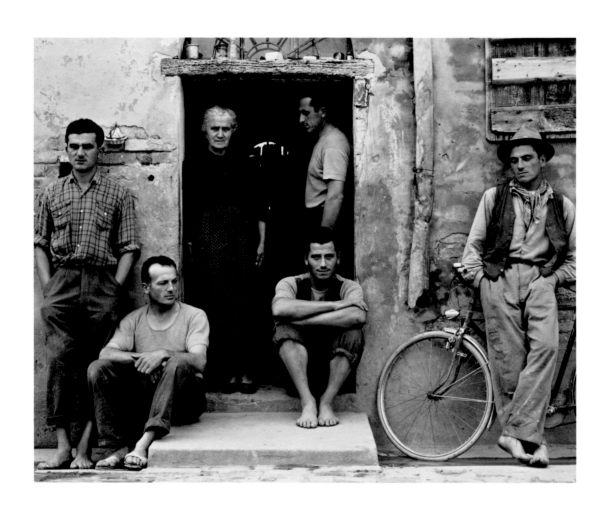

362 Paul Strand, *The Family, Luzzara, Italy*, 1953, 4⅝ x 5¾"

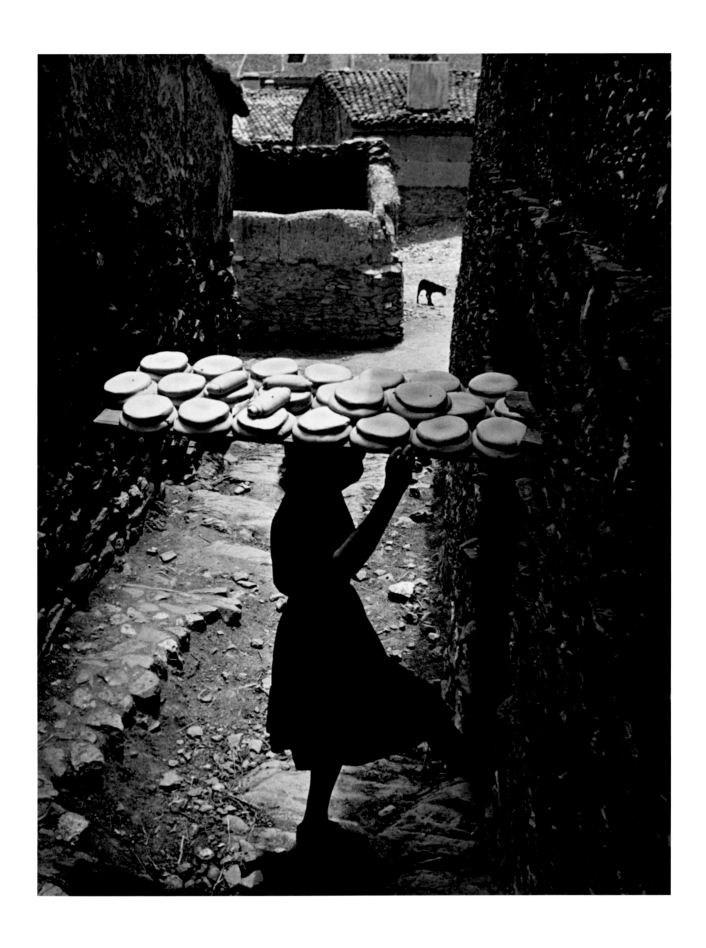

363 W. Eugene Smith, *Woman with Bread, Spain,* 1950, 13⅜ x 10⅜″

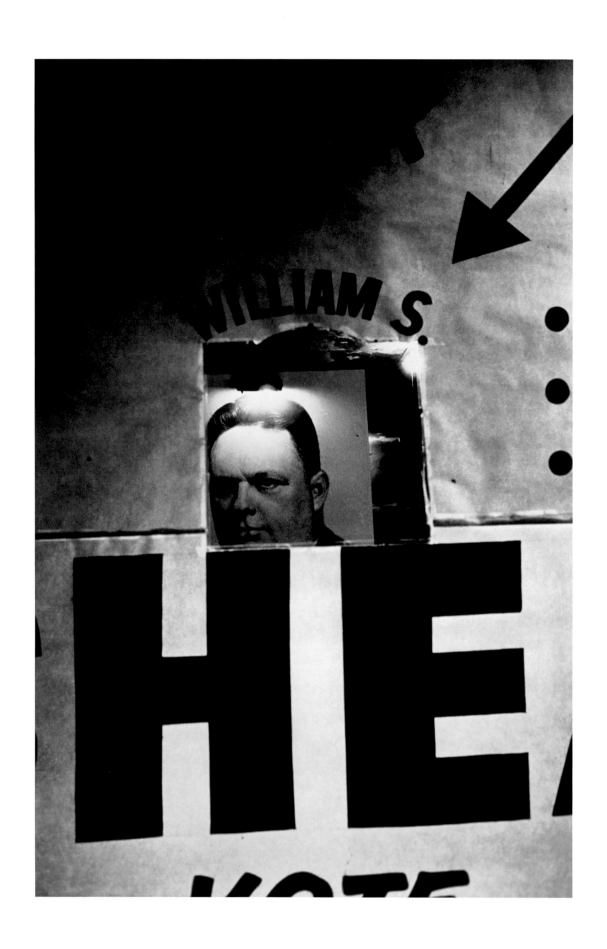

364 Robert Frank, *Look at William S.*, 1956, 11⅜ x 7½"

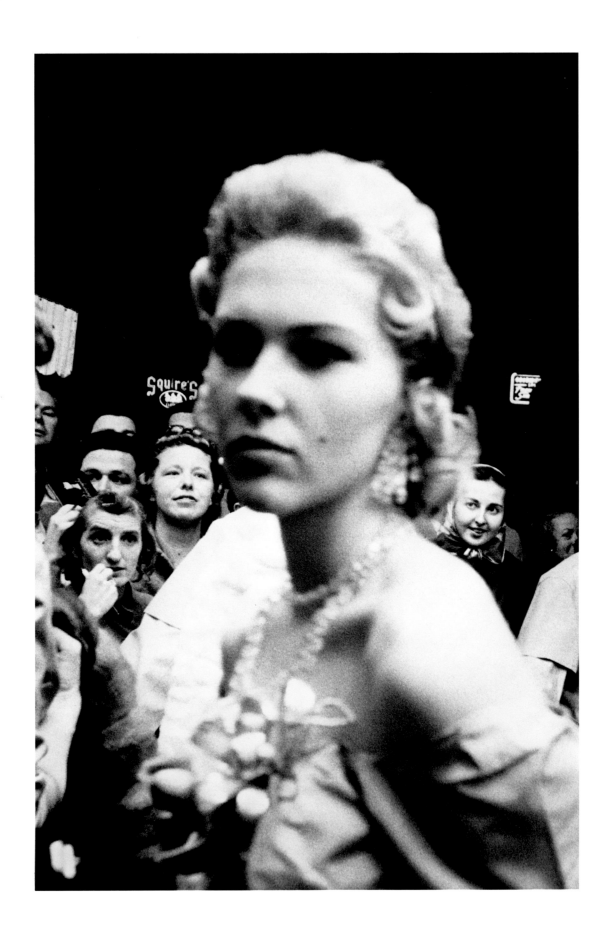

365 Robert Frank, *Movie Premiere, Hollywood*, 1956 (print: ca. 1970s), 12⅜ x 8¼″

366 Elliott Erwitt, *Fort Dix, New Jersey*, 1951, 7⅞ x 11⅞"

367 **O. Winston Link,** *Hotshot Eastbound, Iaeger, West Virginia*, 1956, gelatin silver print collage, 15⅜ x 19¼″

368 Richard Avedon, *Dovima with Elephants, Paris*, 1955 (print: ca. 1980), 10 x 8″

369 **Irving Penn,** *Woman with Umbrella, New York,* 1950 (print: 1984), 15 x 14¼″

370 Lillian Bassman, *The Wonders of Water*, 1959, 12⅞ x 9½"

371 **William Klein,** *Pedestrian Crossing, Piazza di Spagna, Rome (Vogue),* 1960, 14 x 10¾"

372 Irving Penn, *Duke Ellington, New York*, May 19, 1948, 9½ x 7⅜″

373 **Arnold Newman,** *Yasuo Kuniyoshi, 14th Street Studio, New York,* 1941, 7¾ x 9¾"

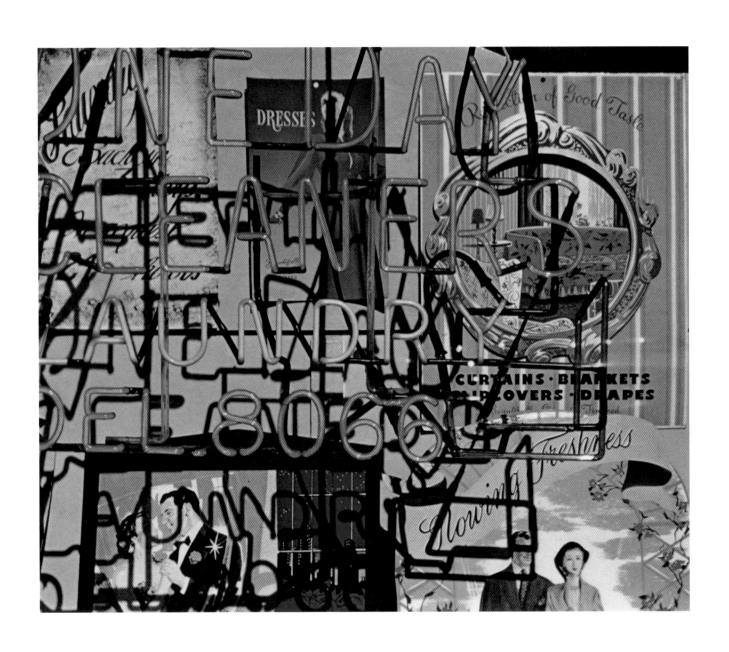

374 **Arthur Siegel**, *Drycleaners*, 1946, dye transfer print, 6 x 7½"

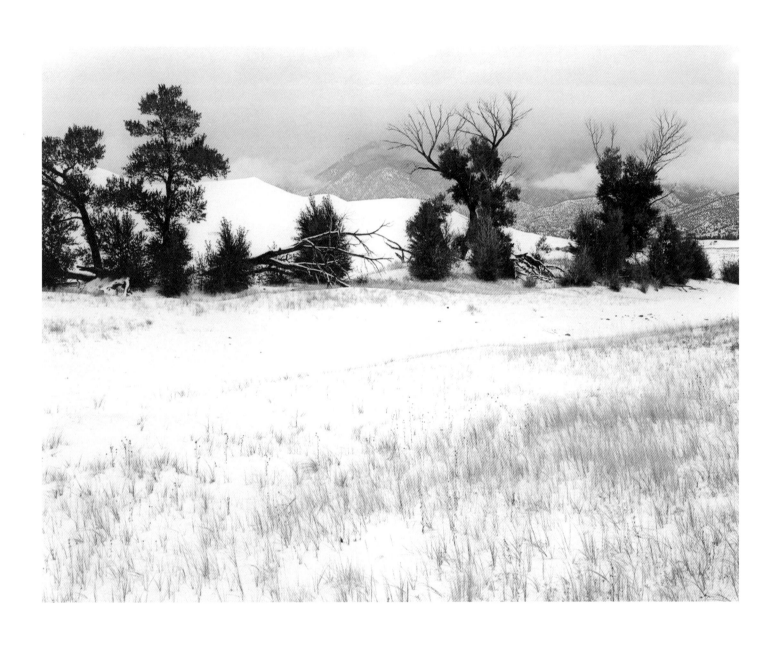

375 **Eliot Porter,** *Snow and Grasses, Colorado,* 1959, dye transfer print, 8¼ x 10⅝"

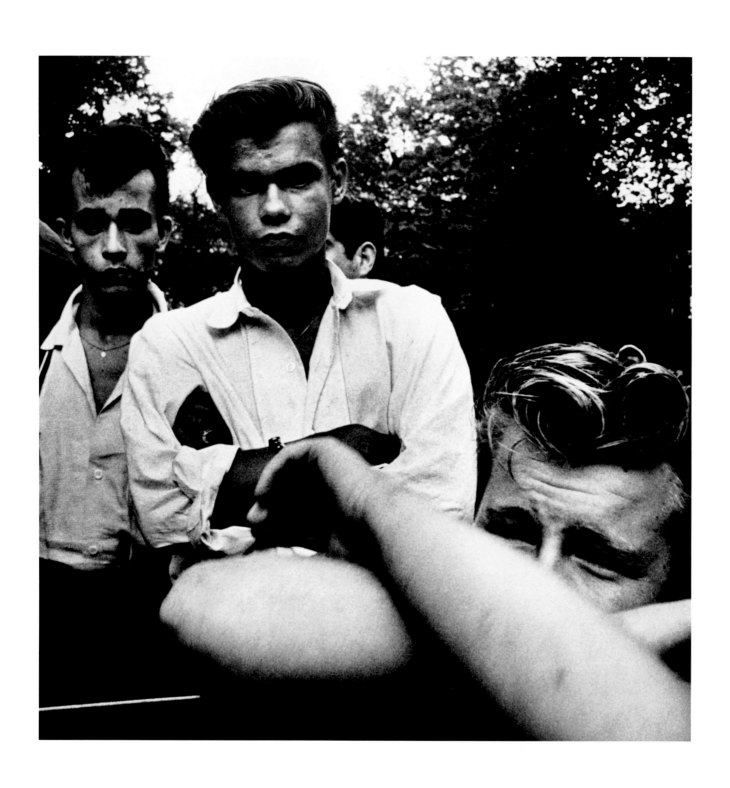

376 Joseph Sterling, *Untitled*, 1961, 7½ x 7½"

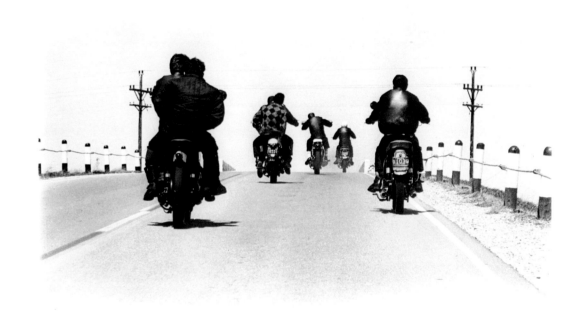

377 **Danny Lyon,** *Route 12, Wisconsin,* 1963, 3¾ x 5⅝″

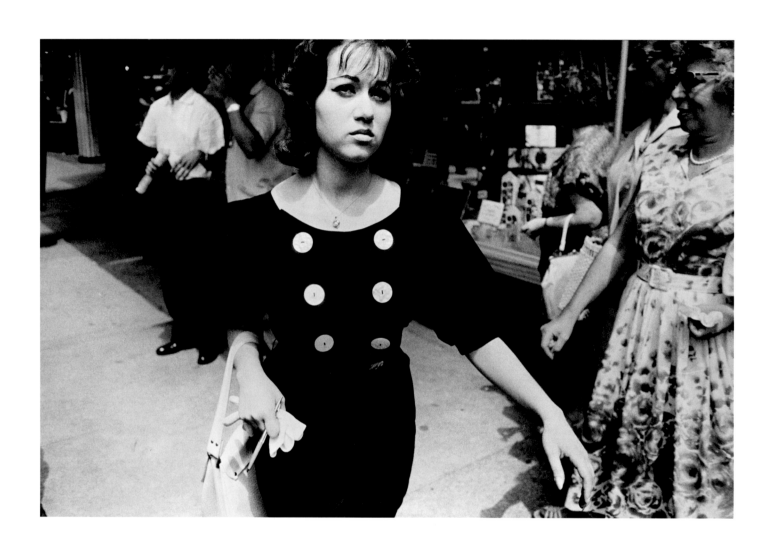

378 Garry Winogrand, *New York*, 1961, 9 x 13⅜″

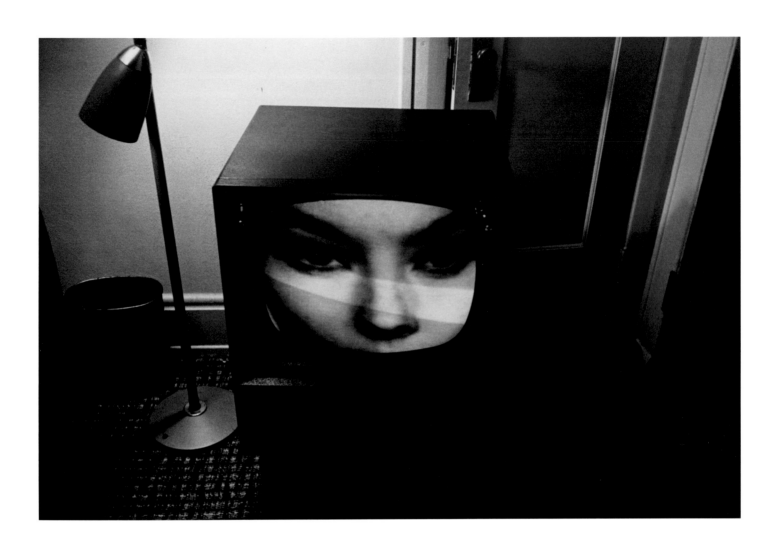

379 Lee Friedlander, *Nashville*, 1963, 6⅛ x 9¼"

380 Kenneth Josephson, *Chicago*, 1961, 5¾ x 8⅞"

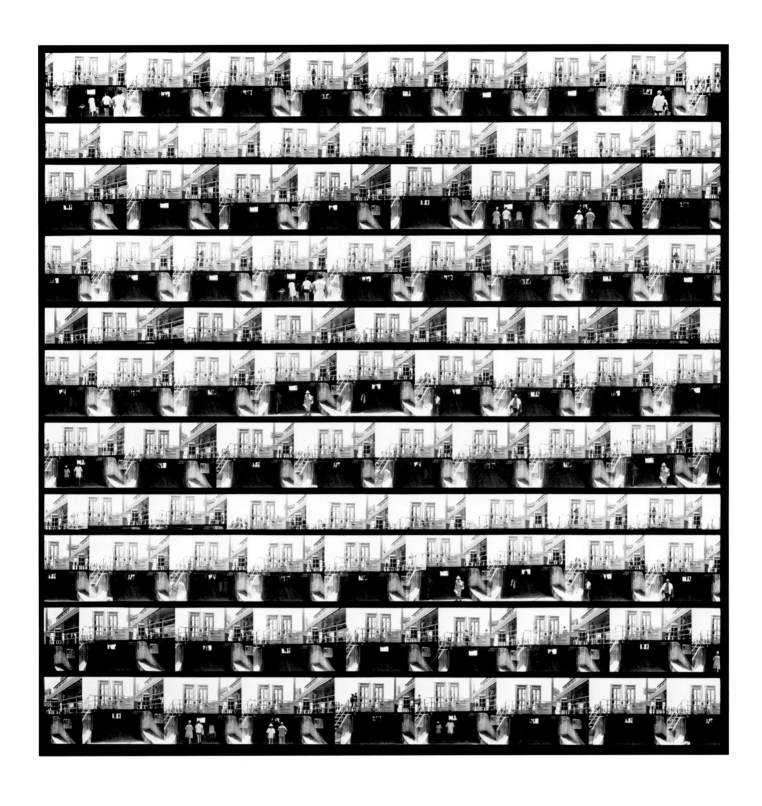

381 Ray K. Metzker, *Composite: Atlantic City*, 1966, 41 x 41″

382 **Diane Arbus,** *A castle in Disneyland, Cal.,* 1962 (print: ca. 1972), 15⅛ x 15⅛"

383 **Ralph Eugene Meatyard,** *Untitled*, 1963, 7 x 7"

384 Duane Michals, *Magritte Front and Back*, 1965 (print: ca. 1980), 4⅞ x 7¼"

385 Jerry N. Uelsmann, *Small Woods Where I Met Myself (final version)*, 1967 (print: ca. 1980), 10⅜ x 12¾″

386 NASA: *Surface of Moon, Day 018, Survey W-E*, ca. 1966-68, gelatin silver print collage, 9 x 27¾"

CHAPTER IV The Image Transformed: 1965-Present

The mid-1960s marked a turning point in American cultural life, as a series of traumatic and divisive events jolted the nation. While the assassinations of John F. Kennedy, Malcolm X, Martin Luther King, Jr., and Robert F. Kennedy seemed to threaten the very foundations of civic life, the war in Vietnam stimulated heated debate over the direction of the country and the credibility of the government. Vietnam polarized the nation: in 1970, four student demonstrators were killed by National Guardsmen at Kent State University and, a year later, an army lieutenant who had ordered the massacre of civilians at the Vietnamese village of My Lai was tried for murder. After seven long and costly years of combat, U.S. troops were brought home in 1972. The war officially ended a year later, but the communist occupation of Saigon in 1975 underscored the tragic futility of the entire enterprise. Public confidence in the nation's leaders and institutions, severely damaged by the war, were further eroded by the Watergate hearings, which led to the resignation of President Nixon in 1974.

The discord over the Vietnam War coincided with clashes over a variety of other domestic issues, including President Johnson's ambitious Great Society program and the African American struggle for equality. Despite the 1964 Civil Rights Act, which prohibited job discrimination based on gender, race, or religion, racial injustices remained widespread. This issue was highlighted by civil rights marches and protests in a number of cities throughout the 1960s. Following the precepts of Martin Luther King, Jr., these demonstrations were predominantly peaceful. However, as frustrations mounted, violent incidents took place. Riots in the Watts district of Los Angeles in 1965, and in Atlanta, Chicago, Newark, and Detroit over the next three years resulted in widespread destruction and some deaths.

This movement for racial equality was only the most prominent feature of a larger climate of rebellion against the status quo. The liberatory youth culture of the era—best encapsulated in their provocative advocacy of "sex, drugs, and rock and roll"— posed an urgent, if unfocused, challenge to the personal and social values of the previous generation. Raised in relative affluence and security, the youth of the 1960s had little in common with their parents, who had come of age during the austerity of the Depression and the patriotic unity of World War II. Instead, the rebellious mood of the 1960s grew from an eclectic synthesis of ideas from other eras: the antimodernism of the 1890s, the giddy utopianism of the mid-1910s avant-garde, the hedonism of the "splendid, drunken twenties," and the alienation of 1950s Beat culture.

This vibrant mix of ideas was expressed in a variety of ways, including the free speech, antiwar, and ecology movements. The overriding theme of this era was an increasing concern for social justice and individual rights. Various groups began to challenge traditional forms of power and modes of thought. Women pointed to a long history of social inequality in demanding an end to unfair labor practices and denigrating gender representations. Betty Friedan's *The Feminine Mystique* (1963), which virtually launched the feminist movement, argued that women's roles were unfairly centered around husbands and housework. When women did work outside the home, Friedan noted, they earned only 63 percent of what men were paid for the same positions. Thus, fair pay and equal employment opportunities were key issues when the National Organization for Women (NOW) was founded in 1966. Other milestones in the feminist movement were the publication of Kate Millet's book *Sexual Politics* in 1970, the inauguration of *Ms.* magazine in 1972, and the Supreme Court's legalization of abortion in 1973. At about the same time, the gay pride movement came to national prominence, beginning a slow process of social acceptance and increased legal protection. However, movements such as these met strong resistance from cultural conservatives, resulting in a charged climate of division and confrontation, and the "culture wars" of the 1970s and 1980s.

Meanwhile, the environmental movement, spurred by books such as Rachel Carson's *Silent Spring* (1962), made Americans aware of the dangers of industrial chemicals and by-products. As a result, the use of the pesticide DDT was banned in residential areas in 1969. Widespread public interest in ecology prompted the first Earth Day in 1970, and in subsequent years considerable media attention was devoted to such issues as acid rain, global

warming, oil spills, the erosion of the ozone layer of the atmos-
phere, and, after the partial meltdown at the Three Mile Island
generating plant in 1979, the safety of the nuclear-power indus-
try. For many, these threats to the environment—highlighted in
books such as Jonathan Schell's *The Fate of the Earth* (1982)—
took on almost apocalyptic proportions.

This overarching sense of social and environmental insecu-
rity was heightened by a sequence of political and economic crises
in the 1970s and 1980s. These included the oil embargo of 1973,
the Iran hostage crisis of 1979-81, and increases in the unem-
ployment rate, farm foreclosures, and the national debt in the
early 1980s. On a brighter note, the international political cli-
mate was transformed by the end of the Cold War, an event
marked by the fall of the Berlin Wall in 1989 and the breakup of
the Soviet Union two years later.

There were dramatic advances in this period in communica-
tion and information technologies. Television became so ubiqui-
tous a source of information and entertainment that by 1970,
95 percent of all U.S. homes had at least one television set. By
the early 1980s, over 25,000,000 subscribers were hooked up
to cable television, providing access to a bewildering variety of
new channels, including MTV, the first all-music-video station,
which went on air in 1981. But it was the electronics revolution
that brought the most remarkable technological changes. The
1971 invention of the microprocessor, or "computer chip," led
to the development of the personal computer, introduced by IBM
in 1981. This and other miniaturized technologies speeded a vast
cultural and economic shift from the manufacture of consumer
goods to the production of information. By the mid-1990s, the
internet—a universal and instantaneous means of data transfer—
had become the key symbol of this vast new electronic frontier.
The speed of electronic communications and the volume of data
available for retrieval were suddenly overwhelming. In this new
matrix of representations and simulations, the nature of real-
ity itself—the distinction between original and copy, truth and
fiction—was blurred, if not, as some have suggested, erased
entirely.

The Photography Boom

The present status of photography as a broadly accepted art of
the gallery and museum is almost entirely a function of the last
thirty years. In the two decades after World War II, photogra-
phy experienced only a very gradual rise in institutional accep-
tance. The rate of this expansion increased markedly in the late
1960s, and by the mid-1970s the field was in a period of almost
explosive growth. By the time of its official sesquicentennial in
1989, photography had achieved an artistic and scholarly status
that would have been unimaginable a generation earlier.

The reasons for the sudden growth of photographic exhibi-
tions, publications, and scholarship are complex. In addition to
the activities of a key group of artists, educators, critics, pub-
lishers, museum directors, and curators, a variety of cultural
factors were responsible. Fundamentally, however, one could
argue that the artistic status of the photograph could only be
widely accepted once it was clear that its day-to-day utility had
irrevocably declined. From this perspective, it is not a coincidence

that the broad recognition of photography's artistic value came
at precisely the moment when television supplanted the still image
as the primary source of visual information about the world.
For most Americans, this turning point was powerfully symbol-
ized by the end of *Life* magazine in 1972.

In the previous decade, photography and television had bat-
tled for market supremacy, with photography more than holding
its own. Indeed, our most vivid symbols of this era are still pho-
tographs: the blurred frames of the Zapruder film of the 1963
assassination of President Kennedy, Eddie Adams's shocking
record of the execution of a Viet Cong spy on a street in Saigon
in 1968, the NASA pictures of Neil Armstrong on the surface of
the moon in 1969, and John Filo's 1970 documents of the killings
at Kent State University.

Two of the most memorable journalistic photographs of this
tumultuous period are Charles Moore's *Birmingham Riots*, 1963
[439] and Larry Burrows's *Reaching Out, First-Aid Center Dur-
ing Operation Prairie*, 1966 [440]. Moore's powerful image
records the use of high-pressure firehoses by police to break up
a civil rights march in Birmingham, Alabama, on May 3, 1963.
Later that same day, officials unleashed police dogs on the bruised
and soggy protesters. When published in a dramatic eleven-page
photo-essay in *Life*, Moore's pictures sickened the nation and
helped galvanize national support for the civil rights movement.[1]

Similarly, Larry Burrows's Vietnam War photograph of one
wounded soldier reaching out to another has become an icon of
the era.[2] Journalists and photographers had strong opinions
about the war they covered. As critic Mark Johnstone has noted:
"This was the first large war that was depicted in highly indi-
vidual ways by photographers who wished to express their expe-
rience of the land, the people and the war, rather than showing
only the circumstances, events and victims of it."[3] Burrows, a
British citizen who covered Vietnam from 1962 until his death in
Laos in 1971, began as a firm supporter of the American cause.
However, by 1969, when his photo-essay "A Degree of Disillu-
sion" was published in *Life*, he had developed serious doubts.[4]
His ambivalence is powerfully evoked in *Reaching Out*, which
celebrates the survival of fundamental human values in a horrific
quagmire of mud and blood.[5] The complex organization of this
image was not a function of mere chance. Burrows had studied
Old Master paintings, and he tried to replicate their richness
and subtlety in his photographs.[6] This knowledge of art history
made Burrows especially sensitive to the emotional and pictorial
functions of color, which he used to consistently powerful effect.

Since the Vietnam era, however, the great majority of our
most newsworthy incidents have been seen first and most mem-
orably on television, not as still images. While this shift in the
reporting and consumption of news did not eliminate the need
for photojournalists, it fundamentally altered the nature of the
profession. At first, photographers feared the worst, wondering,
in essence, if there was life after *Life*.[7] Soon, however, new mar-
kets and opportunities were identified. Leading regional news-
papers—the *Boston Globe*, *Denver Post*, *Detroit Free Press*, and
others—gave increased prominence to photographic reportage.[8]
In this era, the best photojournalists found their niche in a newly
thoughtful exploration of the expressive and narrative potentials
of the picture story. Unable to report spot news events with the
same immediacy as television, these photographers turned their

attention to subjects with greater complexity and duration than television could accommodate.

Despite the popularity of television and the decline of the classic picture magazines in the early 1970s, the public's interest in still images endured. As a consequence, *Life* was revived in 1973 in the form of twice-annual "Special Report" thematic issues or reviews of the year. The success of the first ten numbers resulted in the resurrection of *Life* as a glossy monthly in October 1978. Freed of the necessity to convey the most immediate news of the day, the magazine found new success by playing to its original strength: the appeal of the beautifully crafted still image. As a Time-Life spokesman observed, "[This new *Life*] is coming out at a time when photographs are being treated like works of art."[9] Three months later, *Look*, another leading picture magazine that had been cancelled in 1971, was also revived. These resurrections were part of a surprising surge in magazine production. Between 1973 and 1978, the number of magazines in the U.S. rose by nearly 30 percent (from 280 to 362), with total circulation increasing from 259 to 316 million issues per month. The most celebrated and stylish new magazines of this period included *Smithsonian*, *Quest*, and *Geo*.[10] This print renaissance was attributed to two major factors: the steady popularity of magazines overseas and the economics of advertising. The rising cost of American television advertising prompted many firms in the 1970s to devote new resources to print-based campaigns. These advertising dollars strengthened existing magazines and provided the incentive to start new ones.[11]

Economics aside, the dominance of television in American life accelerated a dramatic shift in attitude toward the still image. In a relatively short time, the information-bearing function of still photography was largely superseded by television. Photographs still conveyed newsworthy information, of course, but they did so at a slower pace, and in a more contemplative mode, than the fleeting, instantaneous images of television. This utilitarian shift freed the earlier medium to be appreciated as art. Only when photography ceased to be seen first as an objective and "transparent" medium—a passive witness to reality—could it be broadly understood as a highly subjective means of making *pictures*, that is, as a medium of invention and expression. By the early 1970s, television had established a new paradigm for the "realistic" depiction of contemporary events. By its very nature, the ephemeral and disembodied television image served to highlight the beauty and variety—the insistent *objectness*—of photographic prints. Only in this new cultural climate could the photograph be broadly viewed as an object of artistic and intellectual interest.

An Expanding Field

The photography boom of the late 1960s and 1970s was demonstrated in many aspects of popular and academic culture. On the most general level, the public's fascination for the medium was reflected in the films, books, and mass-circulation journals of the day. Motion pictures of varying artistic merit—from Michelangelo Antonioni's *Blow-Up* (1966) to Louis Malle's *Pretty Baby* (1978)—used photographers as their central characters.[12] *Life* magazine's thirtieth anniversary issue, published in late 1966, featured a cover story on the medium. In 1970-72, Time-Life issued a seventeen-volume Library of Photography, a commercially successful venture that played a significant role in popularizing the history and contemporary concerns of the medium. This was followed by a series of annual Time-Life *Photography Year* books, each featuring profiles of established figures and young discoveries, reviews of major exhibitions, and reports on technical developments. In October 1974, *Newsweek* devoted a cover story to the medium, while the February 1976 *Esquire* featured a challenging survey of contemporary work titled "The Ten 'Toughest' Photographs of 1975."[13] In October 1976, *Rolling Stone* devoted almost an entire issue to Richard Avedon's portraits of leading political and cultural figures. In 1978, the U.S. Postal Service even issued a special stamp honoring photography. Before the end of the decade, two of the medium's most celebrated figures graced the covers of the leading news magazines: Avedon was profiled by *Newsweek* (October 16, 1978), while *Time* proclaimed Ansel Adams "The Master Eye" (September 3, 1979). In this same period, the business press—including *Fortune*, *Barron's*, and the *Wall Street Journal*—covered the emerging photography market, paying particular attention to the medium's investment potential.[14]

This new interest in photography was, in part, an outgrowth of the emphasis placed on the arts in President Johnson's "Great Society." In 1965, Congress established the National Endowment for the Arts (NEA) to assist and encourage a broad range of creative endeavor. The agency's Visual Arts Program was specifically mandated to support visual artists and organizations. This program first recognized photography in 1968 with a special grant to Bruce Davidson for his documentary project "East 100th Street." The NEA established a formal program in photography in 1971, when twenty-three artists were awarded a total of $47,000. Individual grants were made again in 1973 and then, beginning in 1975, on an annual basis. The size of these grants rose steadily, from an average of about $2,000 each in 1971 to $12,500 a decade later.[15] The breadth and official nature of NEA support had enormous impact on fine-art photography; by 1978, for example, an astonishing total of 253 NEA fellowships had already been given.[16] At the same time, Guggenheim Fellowships in photography were being awarded in greater number than ever before. In the first twenty years of the postwar era (1946-65), a total of thirty-nine Guggenheim Fellowships (including renewals) had been awarded. In the next two decades (1966-85), 181 were granted, a pace that continued through the 1990s.

This rising interest in photography was also clearly evident on the nation's campuses. By 1966, photography was being taught in about 270 colleges and universities, thirty-six of which offered a major in the subject.[17] In 1970, it was estimated that some 30,000 students nationwide were enrolled in photography courses of some kind.[18] As a result of this tremendous influx of students, new programs were created and established ones awarded degrees in unprecedented number. Between 1952 and 1965, for example, the Institute of Design in Chicago had granted a total of seventeen M.A. degrees in photography. Over the next five academic years (1966-70), it awarded fifty-five graduate degrees in photography, with an additional thirty-four granted between 1971 and 1975.[19] By 1982, at least fifty-nine American colleges and universities offered graduate programs in the medium.[20]

The nature of these photography courses changed markedly in this period. In 1964, such courses were twice as likely to be

found in departments of journalism as in departments of fine art.[21] The number of fine-art photography courses doubled between 1964 and 1968, and doubled again between 1968 and 1971. By contrast, the number of photography courses taught in journalism programs declined in these years.[22] While this overall expansion of photographic education was clearly a positive sign, the shift from vocational training to self-expression prompted some to question the purpose of these new programs. As *Modern Photography*'s Julia Scully asked in 1970, "Are we producing a generation of unemployable photo/artists or large numbers of young people who understand and appreciate visual communications?"[23] As if in response, Jerry Uelsmann stated in 1973, "I'm not concerned with making photographers. I'm concerned with making better people."[24] In fact, the rapid expansion of academic programs provided teaching jobs for many of these early graduates. This growth soon slowed, however, making teaching positions much harder to find for subsequent generations of photography majors.

By any measure, this was the golden age of photographic education.[25] Older programs, such as those of the Institute of Design in Chicago and Indiana University in Bloomington, remained dynamic and influential. Younger photography programs grew quickly in quality and stature: at the Rhode Island School of Design under Harry Callahan's direction, at UCLA under Robert Heinecken, at the University of Florida under Jerry Uelsmann, at the University of Illinois under Art Sinsabaugh, and elsewhere. In 1965, Minor White began a new creative photography program at MIT. In Rochester, in 1969, Nathan Lyons founded the Visual Studies Workshop, an ambitious educational program that soon included an exhibition gallery, research center, the journal *Afterimage*, and a regular series of workshops and visiting lecturers. The University of New Mexico's program in the practice and history of photography also grew rapidly in this period under the direction of Van Deren Coke. The Albuquerque campus scored a coup in 1971 with the recruitment of historian Beaumont Newhall, recently retired from the George Eastman House. Also notable in this period were the programs of the University of Iowa in Iowa City, the University of Arizona in Tucson, Purdue University in Lafayette, Indiana, and the School of Visual Arts in New York.[26] The history of photography was given the ultimate academic recognition in 1972, when Princeton University awarded the first endowed chair in the field, the David H. McAlpin Professorship, to Peter C. Bunnell. By 1980, according to photographic historian Jonathan Green, "there were photography and history of photography programs in universities in every state of the union."[27]

The enormous demand for photographic instruction outside the structure of the degree-granting institutions stimulated the rise of the workshop circuit. By 1973, Minor White—one of the circuit's most popular instructors—estimated that more than fifty photographic workshops were in operation across the country.[28] These brief hands-on sessions, usually held in the spring or summer, and no more than a week in duration, allowed budding photographers to learn from the biggest names in the field. The experience was typically intense and all-absorbing. As Uelsmann wryly observed, "Usually I feel like I've given blood five days in a row."[29] Some of the leading workshops were sponsored by academic institutions. The Visual Studies Workshop had a regular series of non-degree classes, for example, while the Oregon Photography Workshops was a program of the University of Oregon in Eugene. Most others—such as Ansel Adams's Yosemite Workshops, the Apeiron Workshops, and the Maine Photographic Workshops—were independent operations. The grandest international extension of the workshop idea was the annual Arles Festival, in France, which attracted a lively crowd of artists, publishers, curators, and students.

The most visible sign of the medium's broadening appeal was the rapid rise in photographic exhibitions beginning in the late 1960s. For the first time, commercial galleries—particularly in New York City—found it profitable to show and sell fine-art photographs. Prior to this era, all such attempts—by pioneers such as Helen Gee, Roy DeCarava, and Norbert Kleber—had been self-financed labors of love. The tide was turning, however, as established painting galleries began adding photographers to their stables. In December 1966, for example, the Robert Schoelkopf Gallery mounted the first of several exhibitions of photographs by Walker Evans. An important milestone was reached in March 1969, when Lee D. Witkin opened the Witkin Gallery with a group show of prints by Scott Hyde, George Krause, Duane Michals, George Tice, and Burk Uzzle. Surprising even himself, Witkin's "personal crusade" for the medium survived and prospered, providing a model for a new generation of commercial enterprises.[30]

By late 1968, photography exhibitions were so numerous that the mass-circulation monthly *Modern Photography* began a column devoted to exhibition reviews.[31] The first of these highlighted shows in the New York City area, but also noted two dozen other exhibitions on view across the country.[32] A few months later, it was considered remarkable that twenty-four photographic exhibitions were on view at the same time in New York City.[33] This "explosion" of photographic exhibitions was made possible, in part, by the variety of institutions displaying the medium. In New York City, photography exhibitions were hosted by the Museum of Modern Art, the Metropolitan Museum of Art, the Museum of the City of New York, the Riverside Museum, the Museum of Natural History, the Jewish Museum, and the Museum of Contemporary Crafts, as well as educational institutions such as the New School and the School of Visual Arts. Several businesses, including IBM, *Parents Magazine*, and Hallmark Cards, also maintained nonprofit galleries in which photographs were frequently displayed. The Hallmark Gallery, on the lower level of the firm's store at 720 Fifth Avenue, was particularly notable: its inaugural exhibition, a 141-print Harry Callahan retrospective in 1964, was followed in later years by surveys of the work of Steichen, Cartier-Bresson, Kertész, and others.[34]

By 1971, a major turning point had been reached. Van Deren Coke noted at the time that February 7, 1971 marked a "significant day in the history of photography." On that date, the *New York Times* featured a lengthy review by art critic Hilton Kramer of major exhibitions by Walker Evans (at the Museum of Modern Art) and Henri Cartier-Bresson (at the Hallmark Gallery). In addition, four other major photography exhibitions were chronicled in the *Times*'s listings. Never before, Coke observed, had so many important photography exhibitions been on view at once in one city. He concluded, "For those interested in measuring, testing, and divining the condition of photography at the pre-

sent time, these exhibitions and others throughout the country are important indicators of a change in the climate as far as the status of creative photography is concerned."[35]

This claim was underscored by several key events in the business of photography.[36] The Lunn Gallery, in Washington, D.C., entered the photographic market in January 1971 with an exhibition of Ansel Adams's *Portfolio V*.[37] Later that year, Castelli Graphics began its representation of a handful of leading contemporary photographers. Also in 1971, George R. Rinhart, an avid collector of photographs throughout the 1960s, began dealing privately on a full-time basis.[38] Specializing in nineteenth- and early twentieth-century material, Rinhart contributed greatly to the growth of several prominent collections of the period. Finally, in November 1971, Light Gallery opened to considerable fanfare.[39] Under the artistic direction of Harold Jones and with the financial backing of Tennyson Shad, Light Gallery provided a high-profile showcase for many leading contemporary photographers. Light's roster spanned the stylistic spectrum, from such established masters as Harry Callahan, Aaron Siskind, and Frederick Sommer to such younger figures as Thomas Barrow, Emmet Gowin, and Bea Nettles. In its ten-year history, Light also functioned as a training ground for several leading gallery owners of the next decade, including Peter MacGill and Laurence Miller.[40] With galleries such as these setting the pace, others followed; by one count, there were at least fifteen photographic galleries in New York City by 1974.[41]

While New York was the heart of the nation's art market, pioneering photography galleries emerged in cities across the country. Helen Johnston opened the Focus Gallery in San Francisco in 1966, and mounted regular exhibitions until 1985.[42] Another Bay Area resident, Simon Lowinsky, opened his first gallery in Berkeley in 1968. The Thackery & Robertson Gallery, which opened in San Francisco in 1969, initially specialized in prints and drawings; soon, however, it became known for fine nineteenth-century photographs as well. In 1969, Tom Halsted founded the 831 Gallery in the Detroit suburb of Birmingham, Michigan. A year later, Geoff Winningham opened the short-lived Latent Image in Houston. In 1974, Margaret Weston opened the Weston Gallery in Carmel, and Ursula Gropper's Grapestake Gallery began doing business in San Francisco. The pace of this activity increased in the next few years. In 1975, the Cronin Gallery was opened in Houston, and G. Ray Hawkins and Stephen White both established photographic galleries in Los Angeles. Others soon opened notable galleries, including Susan Spiritus in Newport Beach; Douglas Kenyon, Allan Frumkin, and Edwynn Houk in Chicago; Kathleen Ewing in Washington, D.C.; Jeffrey Fraenkel in San Francisco; and Scott Elliott, Marge Neikrug, Robert Freidus, Daniel Wolf, Marcuse Pfeiffer, and Eugene and Dorothy Prakapas in New York City.[43]

Photographic collecting came of age in 1979. By that year, at least two major symposia on collecting had been organized.[44] Innumerable articles and several books of varying quality had also been written on the subject.[45] The most important of these books was *The Photograph Collector's Guide* (1979) by Lee Witkin and Barbara London.[46] In addition to summary biographies of many leading historical and contemporary figures, this volume included an extensive checklist of daguerreotypists and lesser-known contemporaries, notes on technical processes,

advice on the care and preservation of photographs, and a listing of galleries and exhibition sites in the U.S. and abroad. In fact, more than 110 galleries in the U.S. were showing photographs with some regularity.[47] Photographic dealers organized themselves in 1979, founding the Association of International Photography Art Dealers (AIPAD). Daniel Wolf was named the group's first president. AIPAD's first annual photography fair, in 1980, was attended by about thirty dealers.

The auction market for photographs was also established in this era. The first major public sale of photographs in America—the Swann sale of the collection of Albert E. Marshall—had taken place in 1952. Even by the standards of the day, the sale was not a success; nearly everyone agreed that prices were "ridiculously low."[48] The 1967 sale of Will Weissberg's collection was similarly uneventful. However, the Sidney Strober sale of 1970, at Parke-Bernet in New York, drew much more interest. Some 300 people attended the sale and bidding was unexpectedly strong. At the end of the day the sale had netted nearly $70,000. Following this lead, Sotheby's (which subsequently absorbed Parke-Bernet) began holding regular photographic sales in London in 1971 (under the direction of Philippe Garner) and in New York in 1975. The first two New York sales were held under the auspices of Sotheby's Books and Manuscripts Department; an independent Photographs Department was then established under the directorship of Anne Horton. Christie's regular photographic sales, which began in New York in 1978, were organized by Dale W. Stulz. The auction market built quickly to its first peak in 1980, when such unprecedented prices were achieved as $14,850 for an Edward Steichen print and $17,600 for an Edward Weston.[49]

This frenzied market was seen by many as both a surprise and a distinctly mixed blessing. Many older artists, who had endured decades of neglect and disappointment, assumed that this new bubble of enthusiasm would soon burst. As Anton Bruehl observed in 1978, "It's good but I think all this attention to photography will die down—it's just another one of those fads, in my opinion."[50] For others, however, the new market provided a deeply satisfying sense of confirmation. As Harry Callahan observed in 1977, "To say you were a photographer was kind of ridiculous twenty years ago. But now it's getting to be a good honest business."[51] However, the sheer vitality of this market meant that it was relatively undiscriminating. For every insightful new collector there seemed to be a half dozen others whose primary interest lay in acquiring chic living room decor or—even worse—in devising investment or tax-dodge schemes. Much of the work produced for this market seemed merely clever and attractive. In a 1980 essay titled "The New Commercialism," critic Hal Fischer described the bulk of what was then being exhibited as updated "pictorialism, under the guise of avant-gardism, dictated by commercial interests."[52]

As it happened, the recession of 1980-82 deflated this first, enthusiastic phase of the market. The softer economy reshaped the field, resulting in more moderate prices at auction, and the closure of several pioneering galleries.[53] Light Gallery, which had expanded its New York space and opened a branch in Los Angeles in 1980, was forced to drastically reduce its operation in the summer of 1981.[54] Photograph Gallery, which opened to great fanfare in New York in 1981, closed in early 1982. Lunn Gallery

went private in 1983. At the George Eastman House, trustees seriously considered giving the museum's photographic collection to the Smithsonian Institution in order to solve budgetary problems.[55] Several notable journals also folded in this time, including *Photograph* (1976-1980), *Picture* (1976-1983), and the most thoughtful mass-market magazine of the era, *Camera Arts* (1980-83), which was absorbed by *American Photographer* after only twenty-two issues. However, despite ups and downs over the next decade, the market continued to gain strength.[56] At auction, several notable benchmarks were reached in the next few years, as individual prints were purchased for more than $50,000 (in 1983), $100,000 (in 1989), and $150,000 (in 1991).[57] By the fall of 1993, an exceptional Stieglitz portrait of O'Keeffe was sold at auction for $398,500.

The rising public interest in photography from the late 1960s onward spurred increasing coverage of the medium in newspapers and general-circulation magazines. One of the most visible sources of photographic reviews and criticism was the *New York Times*. Jacob Deschin, who had written regularly on photography for the *Times* since 1946, retired from this position in 1970 (although he continued writing for *Popular Photography* for several years). Deschin had been a photographic generalist, penning artist's profiles, exhibition commentary, and product reviews as needed. He was, in his own words, "a reporter for, and not a critic of, photography."[58] By 1970, however, the age of the generalist was coming to an end.

A. D. Coleman, the leading photography critic of the 1970s, sought to make connections between photographic practice and larger social and political issues. Prompted to think seriously about the medium by the books of media theorist Marshall McLuhan, Coleman began writing a weekly photography column for the *Village Voice* in 1968. He subsequently contributed to *Popular Photography*, the *New York Times*, and *Camera 35*. Coleman's essays did not reflect any precisely defined formal model, but stressed photography's communicative and cultural importance. This was a far cry from the field's lingering "critical" preoccupation with nuts-and-bolts technical matters. As he stated with some exasperation in 1974:

> The language currently applied to photographs...is derived entirely from the jargon of technique; it is a form of shop talk which pertains to the manufacturing of photographs as objects rather than to their workings or effects as images. In essence, it deals not with the creative/intellectual problems of the photographer as artist and communicator, but with the practical difficulties faced by the photographer as craftsman.[59]

By contrast, Coleman focused on such issues as censorship, racial and gender bias, art-world politics, and the growing academization of the medium.[60]

Photographic criticism was accepted as a serious and respected discipline in the 1970s. In 1971, symposia on the subject were held on both coasts, at the George Eastman House and at the Oakland Museum. Coleman was present at both gatherings; he was joined in Rochester by William Parker, Minor White, and Robert Fichter, and in Oakland by Alfred Frankenstein, Joan Murray, and Margery Mann.[61] Beginning in 1976, Coleman himself organized a series of annual gatherings on the state of photographic criticism.[62] In that same year, Coleman received the first NEA Critics' Fellowship in photography. In 1979, Yale University sponsored "Voices in Photographic Criticism," a prestigious conference that took a largely sociological and philosophical view of the subject.[63] By the end of the decade, a number of figures were writing regularly on photography for both general and academic audiences. The most prominent of these included Coleman, Mann, Gene Thornton, Shelley Rice, Ben Lifson, Andy Grundberg, Douglas Davis, Max Kozloff, Carol Squiers, Vicki Goldberg, and Charles Hagen. As might be expected, the backgrounds and critical perspectives of these writers varied considerably.[64]

With this rise of photographic journalism and criticism came a corresponding increase in publications covering the medium. The mass-market giants *Modern Photography* and *Popular Photography* continued to be widely read, while newer publications such as *American Photographer* (1978-89) also attempted to reach a relatively broad audience. Several general-interest publications paid regular attention to the medium, as demonstrated by Margaret R. Weiss's essays for *Saturday Review* and Janet Malcolm's pieces for the *New Yorker*.[65] More specialized interests were served by international journals such as *Camera* (Lucerne), *Creative Camera* (London), *Zoom* (Paris), *Printletter* (Zurich), and *Photo Communiqué* (Toronto).[66] The most valuable domestic publications included the durable *Aperture*, as well as the Friends of Photography's *Untitled* and the Society for Photographic Education's *Exposure*.[67] The most important small-circulation journal of this era was *Afterimage*, published by the Visual Studies Workshop beginning in 1972. *History of Photography*, a scholarly quarterly edited by Heinz K. Henisch of Pennsylvania State University, was begun in 1977. Other publications came and went in this period, including the glossy *Photo World*, the oversize journals *Picture* and *Photograph*, and the superb *Camera Arts*.[68] Selected aspects of photography were also covered in journals such as *Print Collector's Newsletter*, a chronicle of the fine-art print market; *Artweek*, a monthly review of the West Coast art scene; and *Picturescope*, published by the Picture Division of the Special Libraries Association.[69] Beginning in the late 1970s, several stimulating small-circulation journals were published by leading nonprofit institutions. These included *Spot*, the voice of the Houston Center for Photography, and *Views*, produced by the Photographic Resource Center in Boston.[70]

The number and quality of photographic books grew with equal rapidity in this period. A revised edition of Newhall's *History of Photography*, released in 1964, sold 3,000 copies in just a few months; by contrast, the 1949 edition had taken nearly ten years to sell as many.[71] This growing scholarly audience provided a market for such significant historical studies as Van Deren Coke's *The Painter and the Photograph* (1964), Nathan Lyons's anthology *Photographers on Photography* (1966), Richard Rudisill's *Mirror Image* (1971), William Stott's *Documentary Expression and Thirties America* (1973), and Estelle Jussim's *Visual Communication and the Graphic Arts* (1974). Important monographs on leading photographers were also published, including Minor White's *Mirrors Messages Manifestations* (1969), *Walker Evans* (1971), *Paul Strand: A Retrospective Monograph* (1971), *André Kertész: Sixty Years of Photography* (1972), *Diane Arbus* (1972), and Arnold Newman's *One Mind's Eye* (1974). Finally, an unprecedented number of photo books by younger artists were published, including Danny Lyon's *The Bikeriders* (1968), Garry Winogrand's *The Animals* (1969), and Lee Friedlander's *Self-Portrait* (1970).

By the early 1970s there was a veritable flood of photography publications on the market. These ranged from lavish coffee-table volumes and facsimile portfolios in photogravure to inexpensive exhibition catalogues.[72] Light Impressions, a Rochester firm that specialized in photographic books and archival supplies, listed some 150 titles in its 1973 mail-order catalogue. Focus Gallery's 1972-73 book catalogue included over 600 photographic titles. Margery Mann reported with some astonishment that one major publisher alone—Viking Press—was receiving five proposals a day for photography books.[73] Several conferences were organized on the subject, including "The Making of the Contemporary Photographic Book," held at the George Eastman House in May 1976.

The leading small publisher of this era was Lustrum Press, founded by photographer Ralph Gibson in 1969.[74] In addition to producing his own photographic trilogy—*The Somnambulist* (1970), *Deja-Vu* (1973), and *Days at Sea* (1974)—Gibson published such notable volumes as Larry Clark's *Tulsa* (1971), Danny Seymour's *A Loud Song* (1971), Robert Frank's *The Lines of My Hand* (1972), and Mary Ellen Mark's *Passport* (1974). Through the mid-1980s, Lustrum continued to produce artist's monographs as well as a series of valuable technical studies.[75]

One of the key traits of the 1970s "photo boom" was the medium's new interdisciplinary and academic appeal. In April 1975, for example, Wellesley College sponsored a well-attended series of lectures—collectively titled "Photography Within the Humanities"—by such varied figures as Susan Sontag, John Szarkowski, Robert Frank, W. Eugene Smith, Irving Penn, and Paul S. Taylor.[76] Many academic disciplines—including art history, American Studies, English, anthropology, and philosophy—suddenly took an interest in the photographic image. Notably, photography was given new prominence at the 1977 annual meetings of both the College Art Association and the American Studies Association.[77] Between 1974 and 1981, special photography numbers were published by a variety of scholarly journals, including *Artscanada*, *Artforum*, *Massachusetts Review*, *Kansas Quarterly*, *Art Journal*, and *Journal of American Culture*.[78] New journals that included photography or matters of visual representation in their purview included *Studies in Visual Communication*, *Critical Inquiry*, *Representations*, and *October*.[79]

This climate of interdisciplinary interest produced an increasingly broad and sophisticated discourse on photography. Beginning in the fall of 1973, the eminent cultural critic Susan Sontag published a provocative series of essays on the medium in the *New York Review of Books*. While Sontag was resolutely critical of photography's fine-art status and its potential for conveying meaning, the simple fact of her attention served to legitimize photography as a subject worthy of social and philosophical consideration. The intellectual prestige that Sontag established for photography was underscored by the book *Camera Lucida* (1981), a poetic meditation on the medium by the noted French literary critic and theorist Roland Barthes.

Collections and Institutions

Beginning in the late 1960s, photography was collected and exhibited as never before. This activity was remarkably widespread, reflecting the interests of private collectors, corporations,

major city and university art museums, and non-profit artists' spaces and galleries. Several private collectors amassed important photographic holdings during this period. The nature of these collections varied considerably. While some (such as those of Thurman F. Naylor, Fred Spira, and Matthew R. Isenburg) focused primarily on nineteenth-century material and culture, others took a predominantly aesthetic approach to the medium.

Among the most high-profile private collectors of this era were Arnold Crane, a Chicago trial lawyer, and Sam Wagstaff, a former curator of contemporary art. Crane collected avidly and broadly, giving equal attention to photographic prints and books. Indeed, in 1970, it was reported that he already owned 7,000 photographic books.[80] A formidable player in the market of the 1970s, Crane was known for acquiring the rarest individual items as well as large bodies of work by artists such as Man Ray and Walker Evans.

Before turning to photography, Sam Wagstaff had been chief curator at the Wadsworth Atheneum in Hartford and curator of twentieth-century art at the Detroit Institute of Arts. The exhibition "The Painterly Photograph," mounted at the Metropolitan Museum in early 1973, triggered his interest in the medium. Within five years he had built a superb and eclectic collection that was featured in an influential book and traveling exhibition.[81] Wagstaff approached the medium with openness, enthusiasm, and a uniquely learned intuition.[82] Above all, he saw collecting as a visual and intellectual pleasure, the happy indulgence of one's "prejudices."[83]

At once eloquent and reserved, Wagstaff was not given to lengthy pronouncements on the meaning of photographs. The only real text in the 1978 catalogue of his collection, *A Book of Photographs*, is Wagstaff's playful and poetic introduction: "This book is about pleasure, the pleasure of looking and the pleasure of seeing, like watching people dancing through an open window. They seem a little mad at first, until you realize they hear the song that you are watching." Despite their witty simplicity, Wagstaff's observations carried much truth. In 1976, he noted presciently: "Photography is not expensive enough for museums. They'll buy it when it gets high enough."[84] At the same time, in ruminating on the medium's new popularity, he said:

> I'm convinced that photography is the Esperanto of the art world. We are now at the point where we have been trained by more photographs than any other generation that's lived before. It's obviously done something to us.[85]

Wagstaff's sheer enthusiasm for the medium, and his interest in artists and images outside the established canon, had an enormous influence on other collectors of the time.

A select number of corporate collections were also initiated in this era. The Hallmark Photographic Collection was begun in 1964 with the acquisition of 141 Harry Callahan prints. In 1967, the Exchange National Bank in Chicago began a focused effort to build a comprehensive survey of the medium's history. This project was initiated by the bank's president, Samuel Wm. Sax, who had a longstanding personal interest in photography, and was assisted by Beaumont and Nancy Newhall.[86] The Polaroid Corporation, which first acquired fine photographs in the 1950s, began a formal collection of artistic work created with Polaroid materials in the late 1960s.[87] In addition, in 1978, Polaroid made

several 20 x 24-inch instant cameras available to photographers for artistic use and experimentation.[88] A number of other corporations paid notable attention to photography in this era. The Art Program of the Chase Manhattan Bank began adding photographs in 1974, for example, amassing some 2,000 prints over the next fifteen years.

The two most influential corporate collections of this era were those of Joseph E. Seagram & Sons and the Gilman Paper Company, both in New York. Seagram began collecting photographs in 1973, with an emphasis on images of architecture and urban life.[89] With the guidance of Seagram's heir Phyllis Lambert, and the curatorial vision of Richard Pare, Seagram also sponsored a three-year documentary survey of nearly 1,000 American county courthouses. This project culminated in 1978 in an exquisite book, a traveling exhibition, and the establishment of an archive of prints and negatives.[90] As an outgrowth of this interest, Lambert founded the Canadian Centre for Architecture in Montreal in 1979. The CCA published the lavish book *Photography and Architecture 1839-1939* (1982) and, since its official opening in 1989, has continued to collect and exhibit important architectural images.[91]

The Gilman Paper Company's photography collection was begun in 1974, through the initiative of chairman Howard Gilman. Pierre Apraxine, formerly on the staff of the Museum of Modern Art, was hired to curate the collection. By the late 1970s, the Gilman holding was renowned for its high standard of connoisseurship and its fresh perspective on the medium's history. In collaboration with master-craftsman Richard Benson, a lavish, hand-printed book on the collection was produced in 1985. This remarkable volume, containing facsimile reproductions of 199 works, was priced at $2,500 per copy.[92] A more affordable survey of the collection, *The Waking Dream: Photography's First Century*, was published in 1993.[93] An accompanying exhibition opened to rave reviews at the Metropolitan Museum before traveling to Edinburgh, St. Petersburg, and Washington, D.C.

Inevitably, any serious interest in photography in the late 1960s and early 1970s was informed by the programs of the leading museums: the George Eastman House, the Museum of Modern Art, and, to a slightly lesser degree, the Metropolitan Museum of Art. While distinctly different in character, the activities of these institutions exerted a profound influence on both the practice and public appreciation of photography.

The vitality of the Eastman House's program in these years was due, in large measure, to the ideas and energy of Nathan Lyons, a member of the museum's staff from 1957 to 1969. Working in close collaboration with then-director Beaumont Newhall, Lyons oversaw a varied program of exhibitions, publications, and educational activities.[94] He organized several important surveys of contemporary work, each accompanied by a catalogue: *Photography 63* (1963), *Photography 64* (1964), *Toward a Social Landscape* (1966), *The Persistence of Vision* (1967), and *Vision and Expression* (1969). His anthology *Photographers on Photography* (1966) quickly became an essential reference work. Lyons also edited a 1965 monograph on Aaron Siskind's work and the historical survey *Photography in the Twentieth Century* (1967). These publications were part of the museum's larger "extension activities," which also included the

circulation of traveling shows and the sale of educational slide sets. By 1967, the Eastman House was offering eighteen different traveling exhibitions, ranging from one-person surveys of the work of Atget, Frank, Siskind, and Edward Weston to group shows of both historical and contemporary work.[95] By early 1971, a total of twenty-seven shows were available for tour or were in the planning stages.[96] The Eastman House's slide sets, sold to schools and universities all over the world, were integral to the teaching of photography in this era. These "extension activities" vastly expanded the museum's audience. In 1967, for example, about 132,000 people visited the Eastman House, while 2,000,000 more were exposed to the museum's programs through its publications, traveling shows, and slide sets.[97] After Lyons's departure in 1969, the Eastman House continued to be highly influential thanks to the curatorial direction of Thomas F. Barrow, William Jenkins, and Robert A. Sobieszek.

After the series of five "Photography in the Fine Arts" exhibitions (1959-66) had run its course, the Metropolitan Museum took a more serious, if low-key, approach to photography. In 1966, John McKendry succeeded A. Hyatt Mayor as curator of prints.[98] Deeply interested in photography, McKendry presented such historical overviews as "Thirty Photographers" (1969) as well as the first one-person show of the work of Stephen Shore (1971).[99] The museum incorporated photography into its public education program, sponsoring such events as the 1972 lecture series "Photography: Points of View."[100] Weston Naef, hired as a curatorial assistant in 1970, became a photography specialist. Naef organized such notable exhibitions as "The Painterly Photograph, 1890-1914" (1973), "Georgia O'Keeffe: A Portrait by Alfred Stieglitz" (1978), and "After Daguerre" (1981). Particularly important were the projects "Era of Exploration" (1975), which examined the leading American landscape photographers of the post–Civil War era, and "The Collection of Alfred Stieglitz" (1978), a detailed study of the Pictorialist photographers of the Stieglitz circle.[101] After Naef's departure in 1984 for the Getty Museum, Maria Morris Hambourg took over as the museum's curator of photography.

Without question, however, the era's single most important institutional program was that headed by John Szarkowski at the Museum of Modern Art. After arriving at the museum in 1962, Szarkowski began an energetic and varied program of exhibitions and publications.[102] These projects ranged from thematic surveys such as "The Photographer and the American Landscape" (1963) to such provocative selections of contemporary work as Szarkowski's 1976 survey of William Eggleston's work. In addition to numerous group or thematic shows, MoMA presented one-person exhibitions of the work of Kertész, Lange, Brassai, August Sander, Evans, Arbus, Callahan, Atget, Adams, Penn, and others. The inherent breadth of Szarkowski's approach was expanded even further by Peter Bunnell during Bunnell's tenure as curator in the department of photographs (1966-72). Bunnell's shows "Photography as Printmaking" (1968) and "Photography into Sculpture" (1970) presented decidedly unconventional perspectives on the medium's expressive possibilities.[103]

In addition to simply showing photographs, Szarkowski proposed new ways of thinking about them. One of his first major exhibitions was "The Photographer's Eye" (1964), documented in a catalogue of the same title (published in 1966). There,

Szarkowski sought to identify the medium's essential formal traits, "what photographs look like, and...why they look that way."[104] This formalist approach was not in itself new, but Szarkowski articulated it with unprecedented clarity.[105] He described five qualities common to all photographic images: the thing itself, the detail, the frame, time, and vantage point. Ignoring traditional aesthetic hierarchies, he presented a variety of photographs—from acknowledged masterpieces to anonymous snapshots—to illustrate these five aspects of photographic vision. Szarkowski argued that the meaning of photographs lay primarily in their unique and peculiar relation to the world. Photographs have an unmatched ability to describe certain aspects of visual experience, he noted, but, paradoxically, they can only be approximations, two-dimensional translations of the fluid reality from which they are derived. Thus, by its basic optical-mechanical nature, the camera creates an uncanny pictorial realm—at once similar to, but distinctly different from, the "real" world. The result, as historian Jonathan Green has observed, is a complex tension between

> fact and artifact, belief and disbelief, reality and illusion.... The camera cannot lie, but neither can it tell the truth. It can only transform. The very nature of the medium forces a disjuncture between the photograph and the world, yet the habits of perception—our everyday use of photography—force us to see the image as a surrogate reality. *Disjuncture* yet *resemblance* are photography's defining characteristics.[106]

This sophisticated vision of photography—as a prototoypically modern medium of endless originality and fertile eccentricity—provided the underlying rationale for all of Szarkowski's activities. One of the most influential of his early exhibitions, "New Documents" (1967), featured the work of Garry Winogrand, Lee Friedlander, and Diane Arbus. By its title alone, this exhibition signaled the end of a 1930s notion of documentary photography. As Szarkowski stated in his exhibition text:

> Most of those who were called documentary photographers a generation ago...made their pictures in the service of a social cause...to show what was wrong with the world, and to persuade their fellows to take action and make it right... A new generation of photographers has directed the documentary approach toward more personal ends. Their aim has not been to reform life, but to know it... What they hold in common is the belief that the commonplace is really worth looking at, and the courage to look at it with a minimum of theorizing.[107]

This exhibition underscored what Szarkowski had written in 1963: "A good photograph is an experience; it enlivens truths, but does not prove them."[108] The tensions at the heart of this new documentary vision were most powerfully evoked in the Modern's retrospective of Diane Arbus's photographs in 1972. The disquieting intensity of Arbus's work—its subjectivity and skepticism, combined with an apparent stance of descriptive neutrality—left an indelible mark on the many viewers who passed slowly through the exhibition in eerie silence.

Szarkowski's disavowal of narrative and his emphasis on formal relationships was even more pronounced in the 1973 exhibition "From the Picture Press." This project, for which Diane Arbus worked as a picture researcher, considered tabloid news photographs as aesthetic artifacts, presenting them in essence as surrealistic found objects. Removed from their original journal-

istic context and stripped of explanatory captions, these photographs from the 1930s and 1940s did indeed echo the ambiguities and formal complexities of the most challenging work of the early 1970s. By deliberately reinterpreting these historical and vernacular images in the light of contemporary pictorial concerns, projects such as this continued a venerable modernist tradition: the search for, or wholesale invention of, a "usable" artistic past.[109]

Szarkowski's subtle eye and elegant prose made him the era's most provocative and persuasive spokesman for photography. His investigation of the medium's syntax, *The Photographer's Eye* (1966), was followed by the most admired and influential photography book of the era, *Looking at Photographs* (1973), a selection of one hundred works from the museum's collections, each accompanied by a paragraph or two of pithy prose. His essay "A Different Kind of Art," published in the *New York Times Magazine* in 1975, made a powerful argument for the uniqueness of photography's expressive means and the almost magical power of its finest achievements.[110] This was followed by such notable books and exhibitions as his brilliant presentation of the work of William Eggleston (1976), the survey *Mirrors and Windows: American Photography Since 1960* (1978), and a monumental, four-part study of the work of Eugene Atget (1981-85). Szarkowski held this influential position at the Museum of Modern Art until his retirement in 1991. His successor, Peter Galassi, is only the fourth curator of photography in the museum's history.

The influence of programs such as this spurred other museums to pay attention to photography. Beginning in the late 1960s, many museums began adding photographic exhibitions to their overall calendar; a smaller number hired curatorial specialists and established departments dedicated to the medium. As an example of the first approach, the Whitney Museum presented its first one-person photography show, a survey of David Douglas Duncan's career, in 1972. Two years later, the museum mounted a broad historical survey, "Photography in America," curated by Robert Doty. The Whitney's 1977 Biennial exhibition was the first of this series to look seriously at the medium. Included in this exhibition were "straight" images by Lewis Baltz, Robert Cumming, and Duane Michals, as well as photo-based imagery by artists such as John Baldessari and Terry Allen.[111] In 1979, the Whitney organized "Photography Rediscovered: American Photographs 1900-1930," guest-curated by David Travis of the Art Institute of Chicago.

Many other programs for the acquisition and exhibition of photographs were developed across the nation. Upon its opening in 1963, the Sheldon Memorial Art Gallery of the University of Nebraska began an active program in photography under the guidance of director Norman A. Geske.[112] The Minneapolis Institute of Arts named Carroll T. Hartwell curator of photography in 1963 and began a regular series of exhibitions a year later.[113] In 1964, the collection of photographic historians Helmut and Alison Gernsheim, then the largest holding in private hands, was purchased by the Humanities Research Center at the University of Texas in Austin. This massive collection included the world's earliest known photograph (a work of ca. 1827 by Joseph Nicéphore Niepce), and was particularly strong in Victorian-era European work. The New Orleans Museum of Art entered the field in 1973; new director E. John Bullard rapidly formed a large

and important collection.[114] David Travis's appointment as curator of photography at the Chicago Art Institute in 1973 marked the start of a new era for this important collection. The Cincinnati Art Museum expanded its attention to photography in 1974, with the creation of the Department of Prints, Drawings, and Photographs, and the appointment of Kristin L. Spangenberg as curator.[115] In 1976, the Houston Museum of Fine Arts established a department of photography overseen by historian and curator Anne W. Tucker.[116] Under the direction of curator Jane Livingston, the Corcoran Gallery began a series of contemporary photography exhibitions in 1976. The National Portrait Gallery established a dedicated photography department in 1977, with William Stapp named as its first curator. In 1978, the Chrysler Museum, in Norfolk, Virginia, began building a photography collection under the direction of curator Brooks Johnson.[117] The photography holdings of the Amon Carter Museum, in Fort Worth, Texas, became formalized in 1979 with the hiring of curator Martha A. Sandweiss. In that year, the importance of the San Francisco Museum of Modern Art's photography program was dramatically expanded with the appointment of Van Deren Coke as the department head. The National Museum of American Art, in Washington, D.C., gave formal recognition to photography in 1983 with the hiring of curator Merry A. Foresta.

This period of rapid institutional growth culminated in 1984 with the establishment of the photography department of the J. Paul Getty Museum in Malibu, California. The announcement of the new department on June 12, 1984, caught nearly the entire photography field by surprise. It was soon learned that, with the assistance of dealer Daniel Wolf, the Getty had quietly purchased all or significant parts of some of the world's most noted private photography collections, including those of Arnold Crane and Sam Wagstaff.[118] In all, some 18,000 photographs had been acquired for what experts guessed to be at least $15,000,000. Weston Naef, formerly of the Metropolitan, was named curator of the new program. By the end of the year, the Getty's collection had grown to include 25,500 individual prints, 1,500 cased images, 475 albums (containing some 40,000 prints), and about 30,000 smaller images in the stereograph and carte-de-visite formats. Regular exhibitions from the collection were begun in the fall of 1986 with an installation of Julia Margaret Cameron's work.[119] By its sheer scale and ambition, the Getty's move into photography had an enormous impact on the field. Indeed, many felt that June 12, 1984, marked photography's ultimate "arrival" as a respected and valued artistic medium.

In this same period, an unprecedented number of dedicated photography museums, resource centers, and nonprofit artists' spaces were begun. The Friends of Photography was founded in 1967 in Carmel, California, by a group that included Ansel Adams and Beaumont and Nancy Newhall. The Friends developed a broad-based program. In addition to presenting regular exhibitions in its Carmel gallery, the group organized shows for national tour, published a regular journal (*Untitled*) and several books, hosted a popular series of workshops, and awarded annual grants and awards in several categories.[120] After twenty years in Carmel, the organization moved to new headquarters in San Francisco.

Three important photography museums were founded between 1973 and 1975. The first of these, the California Museum of Photography at the University of California-Riverside, was begun in 1973 with a gift of cameras and photographic apparatus. Four years later, it received the massive Keystone View Company archive of historical stereographic negatives and prints. Other donations and purchases followed, and the museum moved into an impressive new facility in 1989.[121]

The most publicized new museum of this era, the International Center of Photography, was the brainchild of Cornell Capa, the brother of Robert Capa and a noted photojournalist in his own right.[122] Capa's career as a photography impresario began in 1966, when he started the International Fund for Concerned Photography to "encourage and assist photographers of all nationalities who are vitally concerned with their world and their times."[123] Under these auspices, Capa organized the 1967 exhibition "The Concerned Photographer" (accompanied by a book of the same title) for the Riverside Museum in New York. "The Concerned Photographer 2" appeared a few years later. The success of these projects spurred Capa to create a permanent site for the exhibition and preservation of humanistically oriented photography. He purchased a rundown mansion at Fifth Avenue and 94th Street and on November 16, 1974, opened the International Center of Photography with an exhibition of the work of Henri Cartier-Bresson. Capa's program was remarkably multifaceted, combining regular exhibitions with public lectures, symposia, weekend workshops, publications, and the maintenance of an archive of original prints. The ICP's exhibition calendar was equally varied. Sixty-one shows were presented in the museum's first three years, ranging from retrospectives of the careers of Robert Capa, W. Eugene Smith, and Gordon Parks to group exhibits such as "The Julien Levy Collection: Starting With Atget," and "Holography '75: The First Decade."

The third in this series of new photography museums, the Center for Creative Photography, was founded in 1975 on the campus of the University of Arizona in Tucson. The idea for the Center arose from a conversation between Ansel Adams and university president John P. Schaefer. The Center was established as a true archive, with the goal of collecting in depth the images and papers of major photographers. These artists included Paul Strand, Ansel Adams, Harry Callahan, Aaron Siskind, Frederick Sommer, Edward Weston, and W. Eugene Smith. Several of these individual holdings were of astonishing size. In 1981, for example, the Smith archive included 3,000 master prints, over 100,000 proof and study prints, several hundred thousand negatives, and sixty linear feet of correspondence.[124] Harold Jones was brought from New York to serve as the Center's first director; he was succeeded in 1977 by James Enyeart.

A host of other non-profit museums and galleries, dedicated either solely or primarily to photography, opened across the country in these years. The earliest of these, founded between 1971 and 1975, include Film in the Cities, St. Paul; The Light Factory, Charlotte; Light Work, Syracuse; the gallery of the Visual Studies Workshop, Rochester; CEPA Gallery, Buffalo; the Center for Photographic Arts, Chicago; the Los Angeles Center for Photographic Studies; and San Francisco Camerawork.[125] In 1977, the Boston Photographic Resource Center and the Center for Photography in Woodstock, N.Y., were founded. In 1976, Columbia College established the Chicago Center for Contemporary Photography; by 1984 this had evolved into the Museum of Con-

temporary Photography. The Houston Center for Photography was begun in 1981.[126] The Museum of Photographic Arts, in San Diego's Balboa Park, opened to the public in 1983 under the direction of Arthur Ollman.[127]

A New Pluralism

The expanding interest in photography in the late 1960s and 1970s resulted in a sweeping restructuring of the field. Increasing numbers of people were making, studying, exhibiting, and analyzing photographs. This was occurring within—and was, of course, a direct expression of—a larger context of social and technological change. The result was a radical pluralism. Hierarchies were dissolved and boundaries blurred as a broad spectrum of approaches was now deemed worthy of attention. The sheer growth of the field made it impossible for any one point of view—no matter how powerfully or cogently expressed—to truly dominate the direction of photography.

Museums attempted, with some success, to recognize and accommodate this new heterogeneity. At the George Eastman House, for example, Nathan Lyons sought to facilitate the variety of current artistic activity rather than to define or sanction it. Thus, while his 1966 catalogue *Toward a Social Landscape* surveyed five younger photographers working in the straight, small-camera tradition of Robert Frank, his next publication, *The Persistence of Vision* (1967), presented highly manipulated work by artists of the same generation. The exhibitions of the Museum of Modern Art's photography department reveal a similar heterogeneity. In 1970, for example, these included "Photography into Sculpture," "E. J. Bellocq: Storyville Portraits," "Bruce Davidson: East 100th Street," "Duane Michals: Stories," and "One Eyed Dicks," an exhibition of photographs made by an automatic bank-surveillance camera.[128] In that same year, elsewhere in New York, photographic shows ranging from the art of holography to the horrors of Hiroshima were on view.[129]

A few of the causes of this new pluralism may be suggested. Alternative approaches to photography were, to some degree, stimulated by technical changes in the medium itself. A variety of new formats—such as Kodak's 110 Instamatic and Polaroid's remarkable sx-70 camera—were introduced in the early 1970s. Easier color processes came on the market in 1973-74, stimulating an increase in noncommercial color work. Most importantly, by the early 1970s it was clear that photography was evolving from a primarily mechanical process into an electronic one. Cameras with autofocus and autoexposure features became increasingly common as the decade progressed.[130] Video technology was also becoming widespread. In commercial television production, video had replaced film by about 1960.[131] In the 1970s, video equipment became broadly affordable to amateurs and artists, giving rise to a distinctly new form of documentary and artistic expression.[132] Some technical experts ventured to predict that the future of still photography also lay in electronic circuitry and magnetic tape.[133]

Communications technology itself became a topic of lively interest in this period, thanks in large measure to the writings of the Canadian literary critic and media theorist Marshall McLuhan. McLuhan's investigation of modern media had begun with his books *The Mechanical Bride* (1951) and *The Gutenberg Galaxy* (1962). However, it was the 1964 publication of *Understanding Media: The Extensions of Man* that made him a household name in America. While many of McLuhan's views now seem rather dated, his enthusiasm for the nascent "Age of Information" influenced the thinking of an entire generation.[134]

McLuhan recognized that new systems of electronic communication—with television the most important example—were profoundly changing the way people lived and thought. McLuhan stressed that the conveyance of information was never a simple or neutral process. Content could not be divorced from vehicle; in his famous phrase, "the medium is the message." He argued that older media such as printing, photography, and film were intrinsically "hot," that is, so highly detailed, linear, and logical that they left little room for the viewer's imaginative participation. On the other hand, the low-definition television image was "cool," allowing—indeed, demanding—a nonlinear, discontinuous, and intuitive kind of involvement.

McLuhan's vision of an all-encompassing electronic environment bordered on giddy utopianism. Using the analogy of the human nervous system, he proposed that electronic communications would soon unite the entire world into an organic whole; the result would be a postindustrial "global village." While the machine age had been characterized by hierarchy, fragmentation, and superficiality, the essence of the electronic age would be decentralization, integration, and depth. To this end, McLuhan stressed the importance of hybridization.[135] Inevitably, he wrote, the blending of disparate cultures or mediums created the possibility of "energy and change," a transforming "moment of freedom and release."[136] Defenders of the older, so-called "hot" mediums rejected McLuhan's ideas as "scientific mysticism."[137] For many others, however, his writings spurred a new interest in the nature and meaning of modern forms of communication, as well as a willingness to manipulate and combine them.

This interest in new media and the creative novelty of the hybrid dovetailed neatly with concurrent changes in photographic education. Increasingly, college and university students studied the medium in departments of art alongside painters, sculptors, and printmakers. This encouraged a mutual exchange of ideas and techniques.[138] Artists working in traditional mediums felt free to incorporate the "modernity" of the photographic process in their work; photographers, in turn, painted on their images, collaged them, or turned them into sculpture. By defying old ideas of purity and propriety, both sides of the artistic aisle felt an invigorating sense of "freedom and release."

In this period, ideas of liberation and change were thick in the air. Creative photographers were influenced by a general dissolution of the boundary between "art" and "politics." Both the civil rights and feminist movements, for example, had a clear impact on artistic practice. A watershed event, and a key symbol of a new sensitivity to the politics of representation, was the 1969 Metropolitan Museum of Art exhibition "Harlem on My Mind." Intended as a photographic celebration of African-American history and culture, the show instead provoked bitter protest.[139] Many blacks saw it as patronizing and insulting, a putative cultural "portrait" to which they had not been asked to contribute. Liberal white critics such as A. D. Coleman were equally incensed. He considered the show sentimental, "a ghastly mistake," and

"a visual version of slumming."[140] A year later, the Museum of Modern Art found itself in a related, albeit far smaller, controversy when it mounted Bruce Davidson's "East 100th Street" exhibition. Davidson's humane images were, in themselves, not the central issue. More troubling were the larger ideas they were seen to represent: a white outsider—however well intentioned—interpreting black culture and, in the process, aestheticizing poverty. Coming on the heels of the Metropolitan's show, "East 100th Street" only seemed to underscore the essential "whiteness" of the art establishment. As Coleman noted bluntly in his review of the Davidson show: "It is little short of scandalous that the Museum of Modern Art has never given a one-man show to a non-white photographer."[141] Until this time, the great majority of photographers had considered themselves neutral on the matter of racial or cultural identity; all that mattered was the intrinsic quality of each artist's work. In the coming years, this kind of neutrality would increasingly be called into question.

The feminist movement had an equally clear impact in the photographic world. New attention was given to women as both the creators and the subjects of photographs. Judy Dater was one of the first photographers to be considered an explicitly feminist artist. In images rich in psychology, Dater's female subjects conveyed an essential—and even disturbing—sense of boldness and self-confidence. As such, they contrasted markedly with the endless images of idealized female bathing beauties and nudes seen in the mainstream photographic press. Dater's work was known relatively widely by 1972, the date of her first one-person show at the Witkin Gallery.[142] Her book *Women and Other Visions*, a collaboration with Jack Welpott, was published in 1975. Another notable photographic book of this period was Abigail Heyman's *Growing Up Female: A Personal Photojournal* (1974), which sought to suggest the social forces that shaped and constrained women's lives. On the other hand, Garry Winogrand's 1975 book *Women Are Beautiful* was criticized by feminists for its relentless voyeurism. Winogrand's artistic style was as bold and inventive as ever, but many critics now refused to elevate formal concerns over what they viewed as blatant sexism.

Accompanying this bold contemporary work was a concerted reappraisal of the history of women in photography. Anne Tucker's landmark book *The Woman's Eye*, published in late 1973, presented an historical survey of the work of ten leading photographers, from Gertrude Käsebier and Frances Benjamin Johnston to Judy Dater and Bea Nettles. In her essay, Tucker argued that the traditional neglect of women photographers was due to the prejudices of a patriarchal society.[143] Such biases clearly needed to be confronted and overcome. Beyond this, however, Tucker posed the important question: "Is anatomy destiny?"[144] Was there any meaningful difference between the work of male and female photographers? If so, was it a product of nature or nurture? In response, critics asked whether the benefit of focusing solely on women photographers outweighed the danger of encouraging the perception of them as a special class of "Privileged Invalids."[145] These were deep and controversial questions, with no easy answers.[146] Other important historical projects followed, including "Women of Photography," which opened at the San Francisco Museum of Art in April 1975. This large exhibition, with over 250 prints by fifty artists, was curated by photographer Anne Noggle and critic Margery Mann.[147]

As these feminist examples suggest, photographic criticism itself was deeply pluralistic in the 1970s. What was at issue in evaluating and understanding images was not simply matters of style or approach, but fundamentally different assumptions about the social role and meaning of photography. Indeed, the basic conceptual principles varied so widely between artistic camps that photographers, critics, and scholars increasingly found themselves speaking entirely different languages. As a reasonably discrete field of study, "photography" began to fragment and dissolve.

By the early 1970s, a number of critical approaches to photography could be identified. One might be termed "universal transcendentalism." This attitude is best typified by William E. Parker's essay "Uelsmann's Unitary Reality," published in *Aperture* in 1970. In this lengthy and heavily footnoted essay, Parker employed a rich set of ideas—including Jungian psychology and the pan-cultural archetypal studies of Mircea Eliade and Joseph Campbell—to suggest that art photographs could be understood (like other forms of picture making) as evidence of a universal symbolic consciousness.[148] However eloquently argued, Parker's thesis was given little credence in the following years; in an age increasingly attuned to cultural differences, talk of universal archetypes seemed irrelevant and retrograde. At the same time, Minor White continued to promote a deeply intuitive notion of photography as spiritual quest—a form of "mysterious inward pilgrimage."[149] To this end, White curated a series of group shows, each documented in a special issue of *Aperture*: "Light⁷" (1968), "Be-ing Without Clothes" (1970), "Octave of Prayer" (1972), and "Celebrations" (1974). After the third of these, A. D. Coleman was moved to write a scathing critique of White's muddled mysticism and his self-annointed status as artistic guru.[150] White's response was gentle, rambling, and unconvincing; for all practical purposes, his poetic and spiritual approach to photography had been demolished.

Szarkowski's sly formalism was the most widely influential approach in the 1970s. Szarkowski stressed the unique and essential nature of photographic vision, and the image's complex relationship to both the world and to language. Every photograph transformed and reinvented the world as a *picture*, while resisting verbal translation. A remarkably elegant writer, Szarkowski consistently cautioned against understanding pictures through words alone. As he observed in *William Eggleston's Guide*: "The meanings of words and those of pictures are at best parallel, describing two lines of thought that do not meet; and if our concern is for the meanings in pictures, verbal descriptions are finally gratuitous."[151] Szarkowski granted that photographs engaged various kinds of realities, including the facts of the world, the artist's expressive intentions, a larger cultural climate of ideas, and the viewer's interpretive insights. In the end, however, what was most important was the enduring reality of photographic form and the synthetic power of that form to unite the ideas of the artist and the richness of worldly experience in endlessly novel and provocative ways.

Szarkowski's ideas touched on some of the central critical concerns of the era: the relationship between images and the world, between words and pictures, and between art and nonart. Many other writers and thinkers contributed to this critical dialogue. For example, art historian Rudolf Arnheim applied ideas of gestalt psychology—which views perception as an active and

synthetic process—to the understanding of both art and photography.[152] Other writers, influenced by New Left and Marxist thought, viewed the medium in a fundamentally social and political manner.

The photography commentator best known outside the discipline itself was the essayist and cultural critic Susan Sontag. Between 1973 and 1977, Sontag published a series of essays on photography in the august literary journal *The New York Review of Books*. Six of these, in slightly revised form, were issued in 1977 in Sontag's book *On Photography*. This volume received enormous attention—far more than any other photography book of the period—and stimulated heated debate.[153] Most photography specialists were irritated by Sontag's approach; the literary world applauded it.[154] *On Photography* is a curious, if often brilliant, work. Sontag's writing style tends to aphoristic declamation rather than to carefully structured argument. This makes her endlessly quotable. In the initial dozen pages of the book's first essay, for example, any number of choice phrases can be found: "To collect photographs is to collect the world"; "People robbed of their past seem to make the most fervent picture takers"; "Like a car, a camera is sold as a predatory weapon"; "To photograph people is to violate them…"; "Photography is an elegiac art, a twilight art."[155] However, Sontag never quite succeeds in organizing these bold statements into a coherent vision of photography's nature or meaning. In the end, *On Photography* is most notable as a work of sensibility rather than of analysis.[156]

Sontag's attitude toward the medium—one of fascination and distrust—is nonetheless clear. She describes photography as a tool of surveillance, aggression, and power, and laments the artificiality of a world filled to the brim with photographic surrogates of itself. Her central points are moral and ethical ones. While photographs tell us many things, they are incapable of telling us anything of importance. Photographs cannot narrate; their meaning is fluid, not fixed; as substitutes for experience, they alienate us from reality. As a result, photographs can have no real constructive function. Sontag observes:

> The limit of photographic knowledge of the world is that, while it can goad conscience, it can, finally, never be ethical or political knowledge. The knowledge gained through still photographs will always be some kind of sentimentalism, whether cynical or humanist.[157]

As numerous critics pointed out, however, Sontag's complaints against photography could be applied to *all* systems of representation: all are interpretations of the real. Photography is a tool that can be used in an endless variety of ways; in this respect it is, as one reviewer noted, "no more guilty, and no more innocent, than language."[158]

In the final analysis, *On Photography* may be best understood as a metaphoric work. By the time of its publication, Sontag had realized "that I wasn't writing about photography so much as I was writing about modernity."[159] Sontag disapproved of various qualities of modern culture—its amorality, aggression, and shallowness—to which, in essence, she gave the name "photography." This "photography" is a literary and conceptual construct, and Sontag deals with it on these terms, rather than visual ones. The result is a stimulating text that provides only oblique insights into the problems of making and understanding pictures. Despite this limited success, the publication of Sontag's book was

a landmark event in the cultural history of photography. Sontag changed the way the medium was perceived in at least two important ways: she confirmed its intellectual worth and expanded its critical audience. Engaging the medium as a self-proclaimed outsider, Sontag established—in essence—that photography was too important a subject to be left to photographers. While it would not be accurate to call her a postmodernist, Sontag's writings thus paved the way for that movement's social and theoretical engagements with the medium.

Directors and Dreamers

One of the most characteristic artistic expressions of the late 1960s and early 1970s was the staged or constructed photograph. By virtue of their paradoxical status as "documentary fictions," such images highlighted the intrinsic tensions between pictures and the world, imagination and facts. This approach derived new legitimacy from the era's openness to hybrid forms of expression, and an increasing understanding of the multiple threads of photographic history. Instead of being seen as fundamentally illegitimate, manipulation was now understood as an enduring theme in the medium's history. This tendency was highlighted in A. D. Coleman's important essay "The Directorial Mode: Notes Toward a Definition," published in *Artforum* in 1976.[160] This article underscored the validity of nonpurist approaches, while giving them a memorable collective name. Now, for the first time in nearly a century, Victorian art photographers such as H. P. Robinson and Oscar Rejlander were held up as honored role models rather than as misguided, cut-and-paste sentimentalists. New recognition was also given to such modern pioneers of nonpurist work as William Mortensen, Frederick Sommer, Clarence John Laughlin, Ralph Eugene Meatyard, and Edmund Teske.[161] Other important proponents of this approach came to artistic maturity in the late 1960s and early 1970s, including Jerry Uelsmann, Duane Michals, Arthur Tress, Ralph Gibson, and Les Krims.

Uelsmann exerted a remarkable influence on the photography of this era. He reached his mature style by about 1965 and received high-level recognition in the following years. In 1967, he was given a one-person exhibition at the Museum of Modern Art and received a Guggenheim Fellowship. Three years later, he was the subject of a full-scale retrospective at the Philadelphia Museum of Art and a special monographic issue of *Aperture*. Despite its wide popularity, and his own generosity in discussing technique, Uelsmann's work inspired relatively few direct imitators. This was, in large measure, a reflection of its deeply individual character—its unique union of earlier ideas of symbolism and psychology with, in Uelsmann's own words, "an attitude of freedom and daring toward the craft of photography."[162] Nevertheless, Uelsmann was central to the creative vitality of the period: he both exemplified and enlarged the era's passion for personal expression and technical experimentation.

Duane Michals also came to artistic maturity in the last half of the 1960s. Inspired by a visit with the aging Surrealist painter René Magritte in 1965, Michals went on to make his most characteristic work in the following years. In 1966, he produced the first of his photographic sequences, or, as he called them, "photo stories." These quasi-cinematic groupings of five to fifteen images

transform simple, staged actions into the stuff of dream and myth. The themes of these works include fate, desire, memory, and mortality. An influential volume of these pictures, *Sequences*, was published in 1970. In 1974, Michals began exploring the union of words and pictures by adding texts to his images. A few of these works, such as *A Failed Attempt to Photograph Reality* (1975), consist of nothing but handwritten words (copied and recorded on conventional photographic paper). The full text of this image reads:

> How foolish of me to believe that it would be that easy. I had confused the appearance of trees and automobiles and people with reality itself, and believed that a photograph of these appearances to be a photograph of it. It is a melancholy truth that I will never be able to photograph it and can only fail. I am a reflection photographing other reflections within a reflection. To photograph reality is to photograph nothing.

It is nicely ironic, of course, that this denial of photography's essential truth function is, itself, a photograph. Michals's exploration of hybrid forms of representation led him in 1978 to begin painting on the surface of his prints. Throughout his career, Michals has used photography in an antirealist quest for larger truths. To this end, he creates pictorial paradoxes that unite the visible and the visionary. As he observed in 1971, "Photographers always photograph the facts of their lives, but we don't live in our bodies, we live in our heads."[163]

Ralph Gibson uses photography in a similarly nonliteral fashion. Influenced by the legacy of Surrealism and the writing of the celebrated Argentinean poet and essayist Jorge Luis Borges, Gibson employs the camera to suggest an otherworldly realm of fantasy and dreams.[164] Gibson's first mature work, his book *The Somnambulist* (1970), is a hallucinatory sequence of poetic, ambiguous, and disorienting images. While these photographs are essentially "straight" in technique, Gibson's close-cropped vision and nontraditional narrative sequence create a profoundly subjective sense of mystery, danger, and desire. In this artistic world, familiar things loom large and menacing, while the unexpected becomes commonplace. This vision was extended and refined in the following two volumes of Gibson's influential trilogy, *Deja-Vu* (1973) and *Days at Sea* (1974). In subsequent years, Gibson has continued to employ a highly reductive and poetic vision to create mysterious, dreamlike images from the simplest of subjects [445].

Arthur Tress took an almost scientific interest in dreams. Before turning to photography, Tress studied painting, art history, and film directing; he also traveled widely in the U.S., Mexico, Asia, and Europe. Upon returning to New York in 1968, he quickly forged a highly personal artistic style. One of his first projects was a series of photographs on the theme of "Open Space in the Inner City." While conceived as a documentary endeavor, Tress's pictures are deeply expressionistic: figures relate to the space and architecture around them in distinctly odd and ominous ways. He described this approach as "social surrealism."[165] A key image in this series is *Boy in Burnt Out Furniture Store, Newark, New Jersey*, 1969 [442], made some months after Newark had been decimated by riot and fire. In the process of exploring the areas in which the local children played, Tress found an old advertising sign in an abandoned building. Working intuitively, he leaned the sign against the wall and recruited a nearby child to stand beside it with his arm placed strategically on the image of the sofa. The resulting photograph suggests the dream of a happy domestic life shattered by the reality of a desolate world. The artistic power of this image is a function of its lyrical dissonance—its curious balance of reality and illusion, social fact and mythic invention. This finely tuned tension reflected Tress's belief that traditional documentary means were inadequate to express the "extreme social realities of these contradictory and violent times."[166]

Appropriately, this picture was featured as the centerpiece of Tress's next project, his 1972 book *The Dream Collector*. For that work, Tress literally collected—and illustrated—dreams. Deeply interested in the emotional life of children, he made an extensive study of the psychology of dreams and of Jungian notions of symbolic archetypes. He then interviewed dozens of children and cast their nocturnal visions into artistic form. The resulting images, which he called "Daymares," deal with all manner of childhood fantasies and fixations. This influential work demonstrated the paradox of a blatantly "artificial" working method employed in the service of an explicitly documentary project.[167]

Of all the photographers who produced staged or constructed images in this era, the most notorious was Les Krims. Krims achieved national renown in 1969 with major exhibitions in San Francisco, Rochester, and New York.[168] His work was controversial from the start.[169] Delighting in the outrageous, Krims recorded bizarre and unusual subjects in a deliberately blunt, "inartistic" style. The content of Krims's images varied widely, from all manner of surreal domestic tableaux (a nude woman holding a plucked chicken, for example) to portraits of midgets, records of deer hunters with their dead prey, and tongue-in-cheek "documents" of simulated crime scenes.[170] These images were deliberately provocative, and most viewers responded accordingly. In fact, in a bizarre case of life imitating art, Krims's work triggered a serious crime. In 1971, Krims was included in a group exhibition at the Memphis Academy of Arts. One viewer was so upset by Krims's pictures that he armed himself, entered the home of an Academy employee, and kidnapped a thirteen-year-old boy. The gunman's demand—that Krims's work be removed from the exhibit—was immediately met and the child was released without harm.[171] This episode received national media coverage, confirming Krims's reputation as the "bad boy" of contemporary photography.

For all its flamboyant offensiveness, Krims's work contained an important vein of humor and served to illuminate—if only by exaggerated counter-example—social mores and standards of taste. In 1971, Coleman described Krims as "a sardonic documentarian who is blending the snapshot and grotesque traditions into a unique vehicle for psychosocial commentary."[172] In truth, the precise meaning of Krims's social commentary was never clear. This was due, in part, to the wildly uninhibited nature of his expressive vision, one in which humor and aggression, rationality and uncontrolled instinct seemed hopelessly tangled.

In addition, and in hindsight perhaps most importantly, Krims's work reveals a deep ambivalence about photography itself. From the beginning, he referred to his pictures as "fictions" and exhibited blatantly staged images and ostensibly "documentary" ones side by side.[173] Thus, to a large extent, his entire career may be understood as an idiosyncratic critique of photographic "truth." The medium's documentary and vernacular tra-

ditions—family snapshots and police crime-scene photographs, in particular—were key inspirations. Krims gleefully subverted these traditions, employing a "documentary" style to create surreal parodies and narrative frauds. Further, in his sx-70 Polaroid work, begun in 1973, Krims violated the integrity of the photographic image itself by physically manipulating the emulsion of the developing print. The resulting pictures are curious photo-painterly hybrids.[174]

This use of photography as a mode of self-criticism is clear in one of Krims's more sedate images, *Large Camera Academic Art*, 1978 [387], from his series "Academic Art: 1975-1978." Here, Krims alludes to the revered purist legacy of artists such as Edward Weston, Ansel Adams, and Walker Evans, all of whom employed large 8 x 10-inch cameras to make images of great clarity and seriousness. This tradition, Krims seems to suggest, is now sterile academic orthodoxy. To this end, Krims uses his own 8 x 10-inch camera to make an aggressively simple snapshot of another, clearly nonfunctional, "large camera." In addition to its barbed commentary on photography's past, however, this image suggests the academic orthodoxies of the present. Krims, himself a professor, made this image in a college classroom. *Large Camera Academic Art* thus becomes a self-reflexive critique, suggesting that any idea—no matter how "radical"—is capable of ossifying into orthodoxy. Like Krims's best images, this photograph presents a pointed meditation on photographic style and meaning in the guise of a one-line joke.

Straight Photography: The "Social Landscape" and Beyond

While work in the "Directorial Mode" became increasingly common after the mid-1960s, "straight" uses of the medium remained highly influential. This unmanipulated work varied considerably in style and sensibility, from serene precisionism to gritty expressionism. The photographs of the "New Documents" trio—Arbus, Winogrand, and Friedlander—exerted an enormous impact on a younger generation of street or formalist photographers.[175] Others of this period, such as Evelyn Hofer, worked in more traditional documentary modes. These varied pictures were indebted to an equally diverse set of influences, including the documentary legacies of Walker Evans, W. Eugene Smith, and Robert Frank; the spontaneous aesthetic of small-camera street photography; and the immediacy of the common snapshot. In general, photographers working in "realist" styles did so with a new understanding of the complexities of representation. The camera produced "documents," to be sure, but these were often as much about the medium or the self as they were about the putatively objective world. "Straight" did not mean simple, and photography was increasingly understood not merely as a means of replicating the world but of inventing it.[176]

The continuing "classical" approach to straight photography is perhaps best demonstrated in the work of Evelyn Hofer. Born in Germany, Hofer arrived in the U.S. in 1947. She soon met Alexey Brodovitch and, like so many other young talents of the period, worked for *Harper's Bazaar*. However, her real talent emerged in her portrait and architectural photography. In both cases, Hofer's pictures are characterized by a formal elegance and crystalline clarity. Due, in part, to her friendships with artists such as Richard Lindner and Saul Steinberg, Hofer takes a "painterly"

387 **Les Krims**, *Large Camera Academic Art*, 1978 (from series "Academic Art"), 8 x 10"

approach to the organization of her images. For her, the play of lines and shapes within the frame, and the clear description of the subject before her lens, are of equal importance. This precise balance is epitomized in her *Haughwout Building*, 1965 [444]. The subject of this photograph is a historically important nineteenth-century cast-iron building in New York's Soho district.[177] Through Hofer's eyes, the lines of this old structure are revealed as somehow akin to those of an Agnes Martin drawing: austere, yet full of history, character, and tactile pleasure.

The quiet logic of this approach was overshadowed, however, by a new kind of participatory and expressionistic documentary practice. These images were stimulated, in part, by ideas from outside the realm of still photography. For example, the 1960s saw the flourishing of *cinéma vérité*. This new form of documentary filmmaking took advantage of technical innovations in sound synchronization and lightweight 16mm cameras to produce works of unprecedented rawness and immediacy.[178] The pioneers of this genre—including Robert Drew, Albert and David Maysles, and Frederick Wiseman—fully understood the peculiar nature of the reality they depicted. As Wiseman observed in 1975, "I don't think it's possible to make an objective documentary film, or an objective anything.... The whole effort is an attempt to assert some kind of control over chaos."[179] Similarly, a newly subjective form of literary reportage—what had begun in the early 1960s as the "New Journalism"—came to fruition in books such as Truman Capote's *In Cold Blood* (1965), Tom Wolfe's *Electric Kool-Aid Acid Test* (1968), and Norman Mailer's *The Armies of the Night* (1968). Capote termed his landmark 1965 book a "nonfiction novel"—a deliberate conflation of author and subject, fact and interpretation.[180] Approaching this creative process from another direction, novelists such as E. L. Doctorow and Robert Coover incorporated actual historical figures into blatantly fictional narratives. In a variety of ways, this era was both fascinated by, and suspicious of, the idea of objective description.

This essential duality is evident in the studied looseness of much of the street and documentary photography of this era. This was, as critic Max Kozloff wrote in 1980, an era of "exceeding self-consciousness" in American photography: "The artistic impulse runs through a great deal of the work we see, at full

throttle."[181] Ironically, however, the form into which this powerful artistic ambition was cast was deeply indebted to the simplest of photographic genres: the vernacular snapshot. Earlier generations of photographers—from Stieglitz to Callahan—had been inspired by the honesty and directness of the family snapshot. Not until the late 1960s, however, was this admiration so broadly or clearly expressed. Leading curators and photographers alike took profound inspiration from the snapshot.[182] On one hand, such images were seen to reveal the medium's intrinsic traits; the endless variety of amateur "mistakes" demonstrated the true richness of photography's creative vocabulary. At the same time, the snapshot's lack of artistic sophistication served to underscore the strange and obdurate reality of the world. In this era, the idea of the snapshot was central to photography's claim to both artistic originality and cultural insight. By paying homage to the medium's vernacular heritage, photographers attempted to have it all: they strove to make images that were, at once, artful and artless, self-expressive interpretations of the world and selfless inventories of raw facts. Photography thus pushed in two directions at once—toward expressionism *and* neutrality, toward personal vision *and* the transcendence of "mere" personality.

The power of this work was a function of both its style and its subjects. For many, the "New Documentary" work of this era seemed to be fundamentally neutral in vision, an art somehow uninflected by opinion. Critic Douglas Davis took this view of Diane Arbus, for example, when he praised her 1972 retrospective at the Museum of Modern Art:

> Her art had to do with what you see in her subjects, not with the way she held the camera or focused the lens or maneuvered her subjects into striking compositional structures. It is artless, this art, but it depends on finding subjects.[183]

Similarly, Garry Winogrand's famous aphorism—"There is nothing as mysterious as a fact clearly described"—was understood by some as an expression of artistic transparency.[184] But, of course, there was nothing simple about any of this work. Winogrand's words underscore the importance of *mystery* in his artistic world-view, while assuming a great deal on the part of his audience. What does it mean to "clearly describe" a fact? "Clear" to whom, and for what explanatory purpose? Are all facts equally worthy of such description? In how many different ways can a single "fact" be described? In truth, it was obvious that the choice and delineation of visual fact was a deeply subjective creative process. There was nothing "artless" about this art.

Nevertheless, the work of photographers such as Arbus, Winogrand, and Friedlander did embody an almost eerie sense of neutrality. This reserve was not a function of technique or subject matter; it was an emotional quality. The characteristic street and documentary work of the 1940s and 1950s had clearly conveyed the photographer's empathy for the subjects depicted. Viewers were encouraged to share these feelings and to engage the work emotionally. By contrast, "New Documentary" work of the 1960s and 1970s seemed devoid not only of empathy, but of human judgment and opinion of any kind.[185] Paradoxically, the world was viewed with a kind of passionate dispassion.

This carefully honed style of acute impartiality was deployed in the service of a coherent and revealing artistic world view. In this pictorial realm, hierarchies of narrative or psychological value were dismantled: people and objects were somehow all equal, and equally mute. Everything could be seen; nothing, it appeared, could be understood—at least not in traditional ways. The best photographs of this era suggest the fundamental complexity of the world by stressing its disjunctions, contradictions, and endless, irrational energies. This was, on one level, a form of social criticism. As Kozloff observed of Friedlander: "Frank's moral consciousness of the desolation of America was successfully translated by Friedlander into sequences of arresting but unrelated incidents, gaggles of parts in futile search of a whole."[186] At the same time, however, this approach reflected a persistent quest for new kinds of truth and coherence. As Szarkowski has observed, Winogrand's goal was to show "the essence of chaos," and thus to suggest something essential about modern culture: its "condition of perpetual contingency."[187] This radical state of change, potentiality, and interconnection represented a potent social dialectic: previous notions of meaning and coherence were being dissolved, just as multiple new ones were forming. Appropriately, the most thoughtful photographers understood themselves to be both "documenting" and "expressing" this condition of contingency. As Winogrand once stated with Zen-like circularity: "The way I understand it, a photographer's relationship to his medium is responsible for his relationship to the world is responsible for his relationship to his medium."[188] In order to be in any way true to experience, photographs had to be as multifaceted, fluid, and dynamic as the world itself.

This generation of photographers was deeply interested in what came to be known as the "social landscape." This phrase was apparently first used as a stylistic label in 1966, in Thomas Garver's exhibition "Twelve Photographers of the American Social Landscape" at the Rose Art Museum of Brandeis University.[189] Another group show, "Toward a Social Landscape," curated by Nathan Lyons, opened at the Eastman House at the end of that year. Friedlander and Winogrand, included prominently in both exhibitions, were also featured with Diane Arbus in the Museum of Modern Art's important 1967 exhibition "New Documents."

The social landscape was an explicitly cultural construction. These photographers were interested in the unreality of commercial culture, the cluttered geography of the sidewalk, street, and highway. The mediated nature of contemporary life is an important theme in their work. In 1969, for example, Winogrand was given a Guggenheim Fellowship for his proposal to photograph "the effect of media on events." This project, which he pursued through 1976, resulted in the book *Public Relations* (1977) and a major exhibition at the Museum of Modern Art. One of the most memorable images from this series is *Hard Hat Rally*, 1969 [441]. This astonishingly complex photograph evokes the confrontational politics of the day while emphasizing the media's complicity in these public demonstrations. Winogrand depicts reporters, photographers, and television cameramen as an integral part of a single, churning mass of humanity. In accordance with Werner Heisenberg's "uncertainty principle," there is no possibility of neutral, disinterested observation; everyone is, at once, both witness and participant.

Friedlander was also interested in the mediated nature of contemporary life. After photographing television screens in the early 1960s [379], he went on to produce a kaleidoscopic record of shop-window displays, advertising images and slogans, traffic

388 **Nathan Lyons**, *Untitled*, n.d. (from series "Notations in Passing," 1962-1974), 4½ x 6¾"

signs, telephone booths, and commemorative statues. Even the most pastoral of his images reveals his devotion to visual complexity and the primacy of cultural symbols. In *Gettysburg*, 1974 [474], for example, Friedlander depicts a quiet aspect of this Civil War battlefield through a foreground screen of budding branches. In addition to suggesting two contrasting notions of time—the seasonal cycle of nature and the linear trajectory of human history—this photograph hints at profound matters of life and death, fragmentation and union, memory and commemoration. For all its apparent "naturalness," the landscape in this photograph is an explicitly "social" one shaped by human history and symbol making.

In his own work as an artist, Nathan Lyons has been deeply interested in the complex symbolic codes of the social landscape. Between 1962 and 1974, he recorded allusive fragments of everyday experience, from shop windows and bits of graffiti to scarecrows and concrete dinosaurs. He was particularly interested in objects that were themselves images, messages, or totems: mirrors, billboards, advertising signs, commercial or vernacular photographs, works of art, posters, shop-window displays, statues, and historical sites. Photographs of such subjects were carefully sequenced in his 1974 volume *Notations in Passing*, a work notable for its emphasis on visual, rather than verbal, systems of meaning.[190] One of the key images from this sequence, *Untitled* [388], suggests Lyons's interest in the tensions between visual and verbal messages, as well as his dry wit and deeply ironic sensibility.[191]

Other photographers applied the spontaneous aesthetic of street photography to an exploration of the social landscape. Joel Meyerowitz, for example, began photographing seriously in 1962, inspired by the work of Frank and Winogrand.[192] His pictures of the next dozen years were characterized by a dense layering of visual incident and a fondness for narrative ambiguities. *New Jersey*, 1965 [389] is perhaps the most remarkable of Meyerowitz's early images. This gently surreal photograph presents a complex meditation on various codes—and overlapping "frames"—of representation.[193] Included in this scene are a mirror, a portable "stage" facade (presumably for children's puppet shows), the arched passageway between rooms (suggesting a theatrical proscenium arch), a portable screen, and the image of a view through an airplane window. Notably, the sole human being

in this scene is obstructed by the very surface that renders the projected image visible. In the end, this photograph is a wry comment on a venerable popular tradition—the ritual of the amateur slide show—as well as a studied analysis of representation itself.

The photographs of Tod Papageorge and Henry Wessel also reflect highly formal approaches to the social landscape. Papageorge became close friends with Winogrand and Meyerowitz in 1964, and often photographed in their company.[194] He went on to a distinguished career as an artist and educator; in addition, he has curated exhibitions of the work of Evans, Frank, and Winogrand. Papageorge has his own way of playing photographic form and content against one another. For example, his image of the 1976 Bicentennial celebrations in New York harbor, *New York Pier* [446], presents an apparent infinitude of information. Curiously, however, this abundance of visual data is profoundly disorienting; we seem to see *everything* but have difficulty making sense of what is so precisely rendered. Henry Wessel's pictures range from a similar kind of visual density to elegantly simple compositions of solitary figures, trees, or houses. Consistently, however, his photographs convey the radiant intensity of sunlight in the American West. Indeed, light is essential to the meaning of Wessel's pictures.[195] For example, in his *Santa Monica*, 1989 [447], the brilliant California sun transforms the visible world into an intricate play of substance and shadow, positive and negative. The hotel's flat facade is rendered monumental, while the letters of its name, the telephone booths, and even the strolling pedestrian seem to be engaged in a strange binary dance with themselves. This is a world *created*, not simply illuminated, by light.

Other important photographers of this era worked in more traditional documentary modes, subordinating formal concerns to the demands of particular subjects and themes. Danny Lyon, for example, was motivated largely by his sympathy for society's marginalized and dispossessed. In the summer of 1962, as a twenty-year-old history student at the University of Chicago, Lyon became the first staff photographer for the Student Nonviolent Coordinating Committee (SNCC), an important grassroots civil rights group.[196] His photographs of motorcyclists, made between 1963 and 1967 [377], were collected in his 1968 book *The Bikeriders*. In this volume, Lyon made no claim of impartiality. He had lived and traveled as a member of a tough Chicago motorcycle gang, and his pictures convey a clear sympathy for these social outsiders. Lyon's next book, *Conversations with the Dead* (1971), documented prison life in the hope of spurring humane reform. Projects such as these both reflected and embodied the era's antiestablishment sensibilities—the idea that life was truly authentic only in its most extreme or marginalized forms. In the countercultural mood of the period, the social outcast was regarded as a kind of existential hero, a potent emblem of nonconformity and freedom.[197]

Larry Clark's *Tulsa* (1971) was the most powerful documentary project of the era. From a shockingly intimate first-person perspective, Clark recorded a small circle of drug addicts in his hometown of Tulsa, Oklahoma. This is an utterly unromanticized vision of manic, stunted lives. Clark's photographs depict a world far off a conventional moral compass: a dark and claustrophobic realm of self-absorption, violence, and loss [390]. In the course of the book—which is composed of images made in

389 Joel Meyerowitz, *New Jersey*, 1965, 9 x 13⅜"

1963, 1968, and 1971—characters die or disappear, only to be replaced by another generation of individuals, equally aimless and self-destructive. Despite the simple poetry of Clark's photographic vision (which is indebted to the example of W. Eugene Smith as much as anyone), *Tulsa*'s power stems primarily from its overwhelming sense of rawness and immediacy. Indeed, *Tulsa* is perhaps the most refined example of the putatively "artless" style of documentary photography.

Most other street or documentary photographers focused on subjects that were less private—and inherently charged—than Clark's. For example, Dennis Stock's *California Trip* (1970) presented a gently surreal vision of West Coast life. A similar affection for American eccentricity permeates the deft 35mm images of Elliott Erwitt and Burk Uzzle.[198] Between 1971 and 1979, Texas photographer Geoff Winningham produced a series of books on the subcultures of professional wrestling, livestock and rodeo shows, and high school football.[199] Bill Owens, working in California, self-published a trio of documentary books in the mid-1970s: *Suburbia* (1973), *Our Kind of People: American Groups and Rituals* (1975), and *Working: I Do It for the Money* (1977). Owens's work was notable for its barbed humor and his attention to a segment of American society—middle-class suburban life—that "serious" photographers had largely ignored. George Tice's book *Paterson* (1972) documented the old industrial city of Paterson, New Jersey, in a somber style indebted to Walker Evans, while Steve Fitch's *Diesels and Dinosaurs* (1976) recorded the roadside commercial culture of the West with both nostalgia and gentle irony.

The elegant book *Lay This Laurel* (1973), a collaboration between writer Lincoln Kirstein and photographer Richard Benson, provides a uniquely eloquent document of American history and art. In loving detail, *Lay This Laurel* interprets Augustus Saint-Gaudens's *Shaw Memorial* (1897), a sculpture on the Boston Common honoring the first black regiment of the Civil War and its commanding officer, Robert Gould Shaw. Working in the art-historical tradition of Clarence Kennedy, Benson painstakingly photographed various details of this work [391], evoking both Saint-Gauden's genius and the human and historical importance of his subject. By celebrating this little-remembered aspect of African-American history, *Lay This Laurel* represented a timely and moving response to the social issues of the day.

As these examples reveal, many photographers of the 1970s worked on documentary projects of personal interest. In the era's pluralistic climate, such "traditional" approaches to the medium represented a deliberate choice, one that paid homage both to photography's past and to the rich variety of the American scene. Several important group projects were also undertaken in this period. For example, the Kansas Project was conceived by three photographers from that state: James Enyeart, Terry Evans, and Larry Schwarm. With special funding from the NEA, this trio produced an extensive visual record of the region's buildings, people, and landscape in 1974.[200] Similar projects were undertaken in the following few years, including the Kentucky Documentary Survey Project, the Nebraska Photographic Documentary Project, and the Long Beach Photography Survey.[201]

Photographic history itself was the subject of two notable "rephotographic" surveys of this era. In 1974, the photographer and journalist Bill Ganzel set out to locate the people and

390 Larry Clark, *Billy Mann, Tulsa*, 1968, 12½ x 8¼″

places that had been so memorably recorded by the FSA photographers of the 1930s.[202] Ganzel's quest was a mixture of social history and artistic homage. He photographed the youngest child in Arthur Rothstein's famous *Dust Storm, Cimarron County, 1936* [244], forty-one years later as a genial, middle-aged farmer. Lange's iconic *Migrant Mother* [174], Florence Thompson, was portrayed in 1979 with her three daughters at her home in Modesto, California. Through images such as these, Ganzel emphasized the human dimension of history. In addition, his then-and-now pairings underscore the specific and conditional kinds of truth that these famous photographs embody—their reality as "snapshots," not summaries, of individual lives. The Rephotographic Survey Project, begun in 1977 under the direction of Mark Klett, Ellen Manchester, and JoAnn Verburg, sought to duplicate the exact camera positions used by such great nineteenth-century landscape photographers as Timothy O'Sullivan and William Henry Jackson. This task was approached with scientific rigor and resulted in pairs of images that are virtually identical except for the difference of about a century in time. This methodology revealed much about the intentions and working methods of these pioneering cameramen—the choices they made in selecting and framing their subjects—as well as documenting the pace of environmental change in the American West.[203]

The personal nature of documentary practice in this era is evident in the work of leading photojournalists, who, from the

391 **Richard Benson**, *Memorial to Robert Gould Shaw and the Massachusetts Fifty-Fourth Regiment, Boston*, 1972, platinum-palladium print, 12¾ x 10⅛"

392 **Eugene Richards**, *Puerto Rican Wedding*, 1978, 11¾ x 8"

1970s onward, worked increasingly on self-generated projects. In addition, they often explored alternatives to the standard magazine picture story. Some exhibited their pictures in museums and galleries; others turned to photographic books as a way of presenting—and attempting to maintain authorial control over—their work. W. Eugene Smith, the master of the photo-story, published his last important work, *Minimata*, in book form in 1975.[204] Smith's impassioned humanism and desire for editorial control provided an important model for others.

Several of the finest documentary photographers of the 1970s and 1980s—including Eugene Richards, Mary Ellen Mark, and Susan Meiselas—used the book format very effectively, creating longer and more nuanced visual narratives than anything allowed in newspapers or magazines. Since 1973, Richards has published a series of books dealing with a wide range of human and social issues, from rural life in Arkansas to drug addiction in the inner city.[205] Whether photographing poverty, illness, family life, or the effects of violence, Richards is deeply attentive to the essential humanity of his subjects and to the complexity of their lives and environments. His *Puerto Rican Wedding*, 1978 [392], was made as part of a study of the evolution of his childhood home of Dorchester, Massachusetts. In this memorable image, Richards contrasts the rhythms and rituals of family life with the hard impersonality of the urban environment. Mary Ellen Mark is similarly devoted to conveying the emotional truth of harsh or little-seen aspects of life. Since the publication of her first major volume, *Passport* (1974), Mark has issued memorable books on a mental hospital, a brothel in Bombay, Mother Teresa's charitable work in Calcutta [393], and runaway children on the streets

of Seattle.[206] Susan Meiselas's first book, published in 1976, documented the lives of carnival strippers.[207] Her best-known volume, *Nicaragua: June 1978-July 1979* (1981), presented a searing record of the Sandanista revolution.[208]

In Richard Avedon's work of this period, the tensions between personal expression and documentary fact are revealed with particular clarity. Avedon's pictures are both provocative and paradoxical. He used the camera in a relentlessly "purist" manner, yet his pictures are profoundly self-expressive. The complexity of his vision is demonstrated by such powerful images as *Oscar Levant, Pianist, Beverly Hills, California*, 1972 [443]. This is at once a portrait of a noted performer and a deeply personal statement on the nature of life and society. Like many of Avedon's portraits, this image suggests a complex union of energy and entropy. These themes are especially evident in some of his more extreme subjects of the period, such as the 1969-73 series of his own father dying of cancer. At the same time, Avedon's portraits express his vision of the psychological tensions of American culture. This ambition was apparent in his choice of subjects from the early 1960s on. In 1963, for example, Avedon traveled through the South, photographing civil rights demonstrators and the racists who opposed them. He went to Vietnam in 1971 in an attempt to understand the war that had so poisoned the nation's political climate. Between 1979 and 1985, he recorded laborers in the American West, creating a controver-

sial body of work that sought to examine the myth of the frontier and the fate of the American Dream.[209] It is in this interpretive and political context that Avedon's portrait of Oscar Levant is best understood.[210] In this disturbing and enigmatic image, Levant seems to be at once laughing and screaming, living and dying. Avedon represents Levant's inner turmoil as a tragic conflict between great vitality and equally powerful demons, a powerful metaphor for the ongoing national crisis of the Vietnam era.

Technology and Process

As a logical result of this pluralistic climate, photographers took great interest in the expressive potential of new technologies and materials. Appropriately, the so-called McLuhan Generation turned its attention from the *photograph* to *photography*, that is, from the traditional finely crafted print to the means—and the meaning—of image making itself.[211] This quest took many forms. While some artists embraced high technology, others rediscovered antiquated processes or explored hybrid methods of picture making. Other, ostensibly "straight," photographers exploited the inherent traits of camera vision with new zeal and imagination. In varying degrees, these artists were all engaged in a self-reflexive investigation of the medium's potentials and contradictions.

From the early 1960s, the products of "high-tech" image-making technologies were broadly visible in American society. For example, the astonishing photographs made by NASA, the national space agency, were shown on the nightly television news and published widely in the national press. These images, particularly those made by unmanned satellites and robot landing craft, were memorable for the strangeness of both their subjects and their technical means.[212] In 1964, Ranger 7 transmitted over 4,000 photographs before crashing onto the surface of the moon. In 1965, Mariner 4 sent back images of Mars after a close fly-by. Surveyor I, which made the first soft landing on the moon in 1966, beamed back over 11,000 images in six weeks of activity. The Lunar Orbiter series, also begun in 1966, used photography to map the moon's surface in unprecedented detail. In 1975 and 1976, photographs from the surface of Mars were received from both Soviet and American spacecraft.

These space photographs were of complex creation and gave new meaning to the idea of the photographic "document." Especially interesting in this regard are the elaborate lunar panoramas made between 1966 and 1968 by the Surveyor series of craft as part of NASA's search for a site suitable for a manned landing. Using a rotating mirror assembly to scan its surroundings, each Surveyor probe made a lengthy series of still television images. These numerous exposures were beamed back to earth one at a time, rephotographed from television monitors, printed on standard gelatin-silver paper, numbered, and then assembled into complex composites on specially prepared mounts [386].[213] The results are both richly informative and weirdly abstract, a fascinating union of message and medium.

Inspired by images such as these, photographers explored the picture-making possibilities of many new technologies. Some photographed television screens, capturing both the thematic banality and the technical crudity of these omnipresent images.[214] Others explored the creative potential of commercial copying systems. These ranged from the antiquated Verifax process (devel-

393 Mary Ellen Mark, *Mother Teresa, Calcutta*, 1980, 12 x 8″

oped by Eastman Kodak in the 1940s) to more sophisticated machines made by Xerox and 3M. At the School of the Art Institute of Chicago, Sonia Landy Sheridan was a leading proponent of this approach. By 1970, her "Generative Systems" program—which sought a creative synergy of copying, video, and computer technologies—was a key facet of the Art Institute's curriculum.[215] One of the first exhibitions of artistic copy-machine work was held in 1973 in San Francisco; a major survey was mounted six years later by the Eastman House.[216]

One of the most memorable artistic applications of information technologies was achieved by William Larson. Larson's interest in the transmission and distortion of visual data had begun in 1967, while a graduate student at the Institute of Design. He devised a camera that made images by slowly scanning across its subject, the human figure. By having his models move during these exposures, Larson created curious "landscapes" of mutated human forms. In 1969, he became interested in the visual potential of the Graphic Sciences Teleprinter, a descendent of the wire-photo transmitters of the 1930s. This device transformed visual data into a sequence of sounds which were transmitted over telephone lines as electrical impulses. A companion machine reconverted this signal into pictorial form, producing an electrocarbon "drawing." In his 1971-78 "Fireflies" series, Larson utilized the peculiarities of this device to

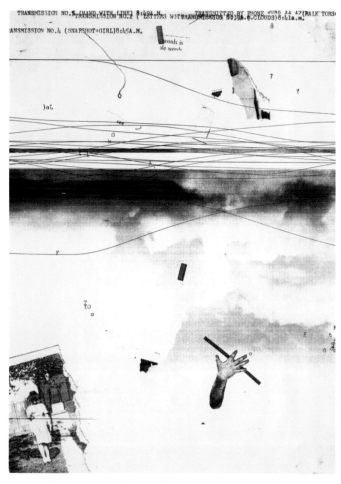

394 **William Larson,** *Electrocarbon Drawing* ("Fireflies" series), 1975, electrocarbon print, 10⅞ x 8½"

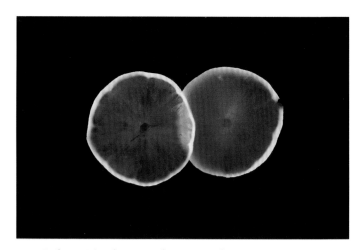

395 **Robert Heinecken,** *L Is for Lemon Slices*, 1971, hand-colored gelatin-silver print, 5 x 8"

make pictures composed of old snapshots, bits of text, and the marks made by the sounds of music and speech [394]. The results are ethereal and poetic, with the quirks of the process suggesting "the imperfect operations of memory or dreams."[217]

At the same time that such "high-tech" methods were being explored, the field of creative photography witnessed a surge of interest in antique or decidedly "low-tech" approaches. Younger photographers rediscovered and experimented with a variety of old techniques, such as hand-coloring, and the gum bichromate, platinum, palladium, kallitype, cyanotype, photogravure, phototetching, collotype, carbro, and even daguerreotype processes.[218] This revivalist work was highlighted in exhibitions such as the Fogg Art Museum's "Newly Re-Created" in 1973.[219] Other artists turned to the radiant imprecision of homemade pinhole cameras, cheap toy cameras such as the Diana, and turn-of-the-century soft-focus lenses.[220] A few did away with lens and film entirely to make images by the photogram or cliché-verre techniques.[221] In this climate of creative mix and match, processes were adapted and combined to unprecedented effect. Photographic images were printed on seashells, Plexiglas, and linen, stitched together to form quilts and soft sculptures, and collaged with images and objects of all kinds.[222]

Since they valued *process* as much as *image*, the artists that came of age in this era tended to work in a broad range of materials and styles. Between 1965 and 1975, for example, Betty Hahn used a variety of approaches, including gum bichromate on paper or cloth with the frequent addition of watercolor,

acrylic, or hand-stitching; Xeroxed images on silver fabric; the cyanotype and Van Dyke processes; simple toy cameras; and the silkscreen, lithography, and offset techniques, often with hand-applied pigments.[223] The work of artists such as Keith Smith, Robert Fichter, and John Wood was similarly unconventional.

Robert Heinecken was a leading exponent of this experimental aesthetic. Trained in printmaking, drawing, and design, Heinecken began his lengthy teaching career at UCLA in 1960. In 1962, he instituted a graduate curriculum in photography; this program soon became one of the most influential in the country. In words strongly reminiscent of Moholy-Nagy, Heinecken suggested the ways in which photography's expressive possibilities might be extended:

> The manipulation of time and space; experiments with various interpretations of motion and speed; the possibilities of repetition and changing images; the viewing condition of the print; the surface on which the image is formed; the reassembling of photographic images; the montage; and the multiple possibilities of combining photographs with other media and materials.[224]

A number of experimental photographers either taught or studied with Heinecken, including Edmund Teske, Robert Cumming, Darryl Curran, Robert Fichter, Judith Golden, Ellen Brooks, and Robbert Flick.[225]

Although known as a photographer, Heinecken rarely used conventional photographic materials, or even a camera.[226] Instead, his work took a variety of unorthodox forms: film transparencies hung several inches from the wall, photographic sculptures that could be rearranged by viewers, and hand-colored photograms of food items [395]. Heinecken was particularly interested in appropriating and transforming images from the mass media. During the mid-1960s, he made photographic prints of individual pages torn from magazines, creating enigmatic negative montages of the words and pictures on both sides of the printed sheet. In other cases, he randomly inserted pages of pornographic magazines into reconstructed copies of mainstream news journals. This media-oriented approach to photography— as a critical method for gathering, rearranging, and transforming the images generated by popular culture—had considerable influence on younger artists of the 1970s and 1980s.

Photographic experimentation was by no means confined to hybrid or hand-altered processes. In fact, artists continued to

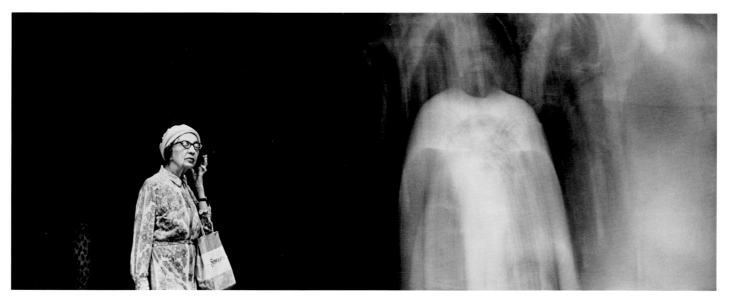

396 Donald Blumberg, *In Front of St. Patrick's Cathedral*, 1965-67, 6½ x 16½"

exploit various facets of photography's basic optical-mechanical syntax with great originality. Between 1965 and 1967, for example, Donald Blumberg created a disorienting series of pictures by the simple means of printing two adjacent frames of 35mm film as a single image. By composing each exposure so that the blank space between frames was submerged in shadow, he created an illusion of continuous space from two separate scenes. In the most mysterious of these pictures [396], Blumberg further abstracted reality by recording the people in one frame in sharp focus, and in the other as ghostly blurs. Other photographers of the time made distinctive use of the double-frame format, including Alice Wells, Eve Sonneman, Thomas Barrow, and Ray K. Metzker.

The peculiarities of lenticular vision were explored by a number of photographers. From the beginning of his career, for example, Lee Friedlander astutely grasped the abstractive power of the lens, its ability to compress space [474] and to manipulate form. In *Nude*, 1978 [397], Friedlander revels in the distortions of scale and proportion caused by the wide-angle lens. Here, surprisingly, the putative rationality of one-point perspective is conflated with the gentle surrealism of the fun-house mirror. Emmet Gowin was also fascinated by the way the lens sees. In about 1970, he began using a lens intended for a 4 x 5-inch camera on his 8 x 10.[227] The shorter lens did not fully cover this larger format, creating wide-angle, circular images that fade to black at the periphery. Surprised to be reminded that lenses cast round rather than rectangular images, Gowin went on to make poetic use of this mode of vision. Ray Metzker has consistently explored another aspect of lenticular vision: the effects of selective focus. Beginning in the late 1950s, Metzker has delighted in contrasting focused and unfocused forms within the same frame. This technique is central to his "Pictus Interruptus" series of 1976-80, and the remarkable landscape photographs he has made since the early 1980s. In images such as *Maryland*, 1987 [398], Metzker reinvents a mundane bit of nature in purely photographic terms: space is collapsed, forms are both clarified and dissolved, and the entire scene is transmuted into shimmering tones of silver.

Time and light were also manipulated by various photographers for expressive effect. In the late 1960s, for example, Roger Mertin began exploring the visual qualities of transparency and reflection. By the early 1970s, he was combining extended exposures with flash illumination to make images uniting two levels of time: the instant and the duration. In *Durand Eastman Park*, 1974 [399], for example, his flash illuminates the foreground and casts ominous shadows into the mid-ground, while the lights of a distant car are registered as an undulating, staccato trace. Richard Misrach made equally evocative use of long exposures and artificial light. Beginning in 1975, he made a series of nighttime desert photographs that are both seductive and eerie. In *Untitled*, 1977 [400], he combines a lengthy exposure—which turns the rising moon into a radiant, atmospheric orb—with selective use of a hand-held flash. The result is, as one critic has suggested of this series, "an idealized landscape in which the night is a sensual, palpable presence."[228]

Many of the best photographers of this era shared an enthusiasm for technical exploration. Ruth Thorne-Thomsen, for example, achieved recognition in the late 1970s for her mysterious and whimsical pinhole-camera images. Returning to the use of more conventional tools in the 1980s, she explored the expressive effects of camera motion in her "Messengers" series. One of the most memorable works in this group, *Messenger #20, France*, 1989 [401], records the muted features of a marble statue at Versailles.[229] Here, as in Thorne-Thomsen's earlier pinhole work, the specifics of time and place are completely subordinated to an otherworldly sense of metamorphosis and dream.

Michael Spano has taken a similarly inventive approach to photography. In the past two decades, Spano has created significant bodies of panoramic street photographs, solarized images, and photograms. In the late 1980s, he made particularly effective use of an odd, multi-lens camera originally designed for time-motion studies in industry. This device produces eight sequential exposures in the span of a few seconds on a single sheet of film. In *Fruit Cup*, 1989 [448], Spano uses this camera to reconstruct the experience of a quiet domestic scene. Between the first and last exposures, Spano moved his camera aggressively, pushing it forward and back, and turning it upside down. His resulting picture undercuts the logic of one-point perspective and the

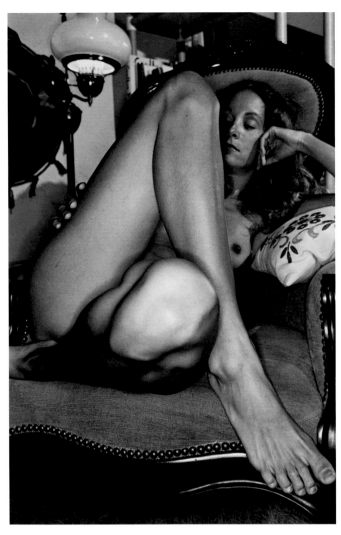

397 Lee Friedlander, *Nude*, 1978, 18½ x 12¼"

expected coherence of time and space. By fracturing this tranquil scene into eight related but disparate parts, he creates a new, exuberantly dynamic pictorial whole.

A contemporary sculptor, Petah Coyne, utilizes the camera in equally transformative ways. Fascinated by the poetics of motion, Coyne uses photography to register extended durations of time. In rural Japan, for example, Coyne made a series of hypnotic images of a group of Buddhist monks [449]. As critic Douglas Dreishpoon has written, Coyne

> was drawn to their feet, the wooden platform shoes they wore, and the strange way they shuffled across the ground, moving quickly from one spot to another, to a tree or a clearing, always praying. Bound together by some indescribable force, they moved skittishly, awkwardly. And yet in their awkwardness, they radiated an uncanny grace.

The blur of these images is essential to their emotional and expressive meaning. As Dreishpoon notes:

> Motion signifies change, transition, a world in flux. The camera taps this flux and registers its momentum. The real challenge is to remain with the subject, to move with it, to be of its pulse. To lose the pulse is to lose the image, to lose the poetry and return to the documentary.[230]

Each of these inventive approaches is based on original insights into photography's expressive means. The common

denominator of this varied work is a desire to explore and analyze photographic vision itself—its characteristic traits, its expressive syntax, and its curious relation to the notion of "truth." Most of the leading photographers of the last couple of decades have taken at least a peripheral interest in this problem. For a few of them, this self-reflexive quest to know photography *through* photography lies at the very heart of the artistic process.

Kenneth Josephson's work provides a particularly elegant and witty meditation on the puzzle of photographic vision. From his earliest mature work, Josephson has explored the paradoxes and conventions of photographic representation. An early picture such as *Chicago*, 1961 [380], for example, is less a *record* of the world than a suggestion of the power of light and lens to *create* a world. In the following years, Josephson worked on several thematic groups of pictures. His "Marks and Evidence of Events" series, begun in 1963-64, is comprised—in essence—of images of images. One of the earliest of these pictures documents a narrow path of grass flattened by the weight of a car tire. Here, Josephson plays with the idea of the *trace* as both a physical and optical phenomenon, as evidence of something at once physically real and vanishingly ephemeral. Similar concerns were explored in such later bodies of work as his "Images Within Images" and "History of Photography" series.

The most remarkable picture of Josephson's "Marks and Evidence" series is *Stockholm*, 1967 [452]. The subject of this unmanipulated photograph is easily described: an overnight dusting of snow was partially melted by the morning sun; incoming clouds then stopped the process, preserving those patches of snow that had not already been exposed to the sun. As Josephson recognized, this conjunction of object and image—the car and its shadow—provides an uncanny metaphor for photography itself. In fact, Josephson's picture documents the most primal form of the process, a natural photogram. The correspondence between the car and its shadow emphasizes both photography's ability to trace the real and its fundamental abstraction—three dimensions are reduced to two and (as in the production of a photographic negative) light and dark tones are reversed. This line of thought prompts the further realization that Josephson's photograph bears approximately the same relationship to the original scene as the shadow of snow bears to the actual car: resemblance is vastly removed from identity. The result is a deft reminder of both the comforting "realism" and the profound strangeness of the photographic image.

Thomas F. Barrow has been similarly interested in the nature and meaning of images.[231] Since the early 1960s, when he began studying with Aaron Siskind at the Institute of Design in Chicago, Barrow has worked in a number of related series. Beginning in 1963, under the influence of Siskind and Arthur Siegel, Barrow made photogram prints of the pages of fashion magazines.[232] The resulting pictures effectively turn the originals on their head: the glossy, idealized, and radiantly "positive" commercial images are transformed into grainy, ominous, negative composites. This interest in found imagery and the technologies of reproduction and transmission led Barrow to his series of television montages and Verifax matrix prints, both begun in 1968. In these works, he created dense combinations of images through the use of in-camera multiple exposures or the physical arrangement of picture fragments on the platen of the photo-copier. These works

398 **Ray K. Metzker**, *Maryland*, 1987 (from series "Earthly Delights"), 13½ x 13½"

399 Roger Mertin, *Durand Eastman Park, Lake Ontario; Rochester, New York*, 1974, 8⅝ x 12⅞"

highlight the banality of commercial culture as well as the inherent "noise" and distortions of the mediums employed. At the same time, he began creating pink-toned double-frame images that suggest the ambiguity of all photographic documents.

These series led logically to Barrow's most important body of work, his "Cancellations" of the mid-1970s. Each of these flatly descriptive records of banal places or artifacts is scarred by a deliberate, hand-scratched X [450]. This act of negation, at once simple and disturbing, creates images of considerable intellectual tension. These pictures simultaneously assert and deny their own veracity. In essence, the "Cancellations" merge two contradictory notions of photographic truth: the photograph as a transparent window on the world and as a tangible, two-dimensional cultural artifact. The result is a provocative investigation of one of the central themes in twentieth-century thought, the difference between reality and representation. The importance of this idea in modern art and philosophy is suggested by the obser-

vation of literary critic Gerald Graff that "it is characteristic of literature 'in its essence' to put a sign of cancellation upon its own apparent referentiality."[233]

John Pfahl has long been interested in issues of representation and illusion. In a 1961 visit to Denmark's Nationalmuseet in Copenhagen, Pfahl discovered an example of seventeenth-century anamorphic art. Looking through a peephole in the front of a "perspective box," Pfahl saw what appeared to be a miniature, three-dimensional room. However, another peephole revealed this to be a two-dimensional painted illusion created by the use of exaggerated perspective and an enforced single-point viewing position.[234] This playful exploration of the ambiguities of perception provided a key impetus for Pfahl's mature work. It also relates to his other enduring theme, the ways in which human culture "frames" or rationalizes nature.

Pfahl's first notable body of work, from 1969 to 1974, involved screen-printing photographs of simple natural forms on vacuum-shaped plastic surfaces. In 1974, he began his important "Altered Landscapes" series.[235] In these technically purist color pictures, Pfahl made a kind of reversed anamorphic art. With string, tape, foil, or other common materials, Pfahl created three-dimensional patterns on trees, rocks, or oblique architectural surfaces. From every perspective but one, these arrangements appeared meaningless. However, when photographed from a precisely controlled vantage point, these seemingly arbitrary marks assumed a precise two-dimensional coherence. For example, seventeen strips of blue tape placed at abruptly discontinuous points in space—on five columns and the background wall of a neoclassic facade—are resolved in Pfahl's photograph into a dashed-line right angle that appears to have been ruled directly on the surface of the print.[236] With remarkable wit and insight, these images highlight the fundamental tension between the camera's powers of realism and abstraction.

After the "Altered Landscapes," Pfahl's "Picture Windows" series was an ingeniously logical step. This body of work, produced between 1978 and 1981, documents views through strategically oriented living-room windows.[237] These images are both delightfully straightforward and dense with meaning. The familiar term Pfahl employs as the title of this series underscores an essential duality: the picture (photograph) as a "window" on the world, and the culturally constructed view (window) as "picture." If Pfahl's "Altered Landscapes" suggest glances into an illusionistic perspective box, his "Picture Windows" record the opposite view, from the inside looking out. In so doing, Pfahl provides a conceptual reinvention of photography. The source of the word *camera* is, of course, the Latin phrase *camera obscura*, or "dark room." Every camera is, in essence, a small room or chamber with an aperture at one side and an imaging surface on the other. Pfahl's "Picture Windows" make this idea literal. His camera, placed within a series of darkened rooms, records both the apertures of these chambers (the windows) and the views beyond. By artistically reframing these views, Pfahl reminds us of the basic nature of camera vision, and of the human need to structure reality through representations. A key work from this series, *1390 South Dixie Highway, Coral Gables, Florida*, 1979 [451], is doubly clever. By exploiting the ability of glass to both reflect and transmit light, Pfahl records two views at once: the houses and boats across the marina, and a reclining sunbather on the bal-

400 Richard Misrach, *Untitled*, 1977, 14¾ x 14½"

401 Ruth Thorne-Thomsen, *Messenger #20, France*, 1989, 42 x 30½"

cony just outside the louvered window. This dual perspective only emphasizes the variety of ways in which the world can be optically refashioned into images.

Hiroshi Sugimoto has created an equally compelling meditation on the nature of representation. Sugimoto began photographing the interiors of American Art Deco movie theaters in the late 1970s, using a large 8 x 10-inch camera to achieve pellucid clarity [453]. Beyond the superb documentation they provide of these vanishing architectural spaces, Sugimoto's photographs represent metaphors for the film experience itself. The exposure for each of his photographs matches the actual running time of the feature film being projected—about ninety minutes. Thus, the white rectangle of the screen represents the compression of an entire narrative—the incidents, emotions, and pleasures of a full-length film—to a single, radiant moment. By collapsing time in this way, Sugimoto effectively reverses the process of representation, returning a lengthy succession of individual images to a primal state of radiant undifferentiation. Simultaneously empty and full, Sugimoto's screens suggest both the magic of light and the infinite possibilities of vision.

Color Comes of Age

Color photography gained popularity among artists and amateurs in the late 1960s and 1970s as a result of several mutually reinforcing trends. By the mid-1960s, color had almost completely supplanted black and white in feature films, television pro-

grams, and mass-market magazines.[238] Indeed, the public became so accustomed to color that, by the mid-1980s, a poll revealed that 85 percent of television viewers would watch only color programs.[239] In response, the Turner Broadcasting System began a controversial effort to "colorize" hundreds of old motion pictures.

In still photography, the shift to color began in earnest in the early 1960s. By 1965, sales of color film had surpassed that of black-and-white film in both the amateur and professional markets.[240] By the end of the decade, 90 percent of professional work was done in color.[241] Between 1965 and 1975, portrait and wedding photographers shifted almost entirely to color.[242] Amateurs—who accounted for about 80 percent of the total photography market—turned to color with similar rapidity.[243] In 1964, 50 percent of all the film being shot was black and white; this figure dropped to 26 percent in 1970, and to 3 percent in 1988.[244] Since color-negative films were more popular than transparency films, the world-wide consumption of color paper rose accordingly. The use of color paper surpassed that of black and white in 1972; by 1977, three times as much color paper was being sold.[245] By the 1990s, black-and-white materials constituted only a small fraction of the overall photography market. The majority of these uses were in the fields of commercial, journalistic, fine art, scientific, and educational photography.

The rapid rise of color in the 1970s was, in part, a result of the introduction of simpler and cheaper processes. One of the most important of these new processes was Cibachrome, developed by the Swiss firm of Ciba-Gigy in 1963. A direct-positive printing material, Cibachrome paper allowed prints to be made directly from color transparencies. The benefits were clear: more brilliant colors, increased sharpness, and greater longevity than nearly any other product on the market. Cibachrome was made available to professionals in 1967, and to the amateur market beginning in 1975.[246] A number of other manufacturers developed new films, papers, or processing systems in this era. Kodak introduced RC Ektacolor paper in 1968; the resin (plastic) coating of this material greatly reduced the time required for washing and drying. Kodak's improved Ektaprint 3 paper came on the market in 1970. By 1971, color-negative printing papers by at least six major firms were widely available in the U.S. These allowed prints to be made in home darkrooms in an elapsed time of seven to ten minutes.[247] One of the most remarkable processes of the era, Polaroid's sx-70 system, was introduced in 1972. After each exposure, the sx-70 camera ejected a print that developed automatically, in normal daylight, in a matter of minutes. In 1976-78, a new generation of high-speed color slide and negative films was made available by Fuji, Kodak, 3M, and other manufacturers. Rated at ASA 400, these films were nearly eight times faster than the color materials available a generation earlier.[248] Kodak's Ektacolor 74, the first high-speed color printing paper, was introduced in 1977.

This rapidly rising use of color films and papers spurred new concerns over the stability of these products. Most black-and-white films and prints were known to be very durable, given correct processing and reasonable storage conditions. Color materials, on the other hand, had a poor preservation record. With a few notable exceptions—including carbro prints, dye-transfer prints, and Kodachrome transparencies—color photography had a history of relative instability. Indeed, most color

images faded (albeit at very different rates) under both display conditions and in dark storage. With color photography so broadly supplanting black and white, concerns over archival treatment and image stability became increasingly acute. A 1970 conservation seminar at the Smithsonian Institution was one of the first public gatherings to raise these issues.[249] Many seminars and symposia followed, including an important Colloquium on the Collection and Preservation of Color Photographs held at the Eastman House in late 1975.[250] Debate on this subject intensified in the following years, thanks to the efforts of researchers such as Henry Wilhelm.[251]

Collecting institutions responded to these concerns in a variety of ways. Some tried, at least initially, to avoid most kinds of color materials entirely.[252] Others simply accepted the ephemeral nature of the processes and acquired color works relatively broadly. With larger issues of photographic conservation coming to the fore in the 1970s, a number of major institutions built special storage vaults.[253] The cool temperatures and stable humidity levels of these environments greatly extended the life of all photographic materials, black and white as well as color. Going a step further, dedicated cold storage units for color prints were installed by the Art Institute of Chicago in 1982 and a handful of other museums.[254] In addition, a few collections—including the Art Institute of Chicago and the Museum of Modern Art—began a two-print approach to acquisitions. In 1984, for example, the Modern announced that every contemporary color print added to its collection would be purchased in duplicate. Both prints would be placed in temperature and humidity controlled storage. One of the prints would be used and exhibited normally, with the other held as a "backup, until such time as the first is judged to have faded significantly."[255]

While they were aware of the archival concerns surrounding color, photographers were not significantly deterred by them. Indeed, the new attractions of color far outweighed its liabilities: color was seen to mark an invigorating break with the artistic values of the past while engaging contemporary life on its own visual terms. As a result, a broad spectrum of photographers—from young students to octogenarian artists—enthusiastically embraced these new processes. One of the most unexpected of these converts was Walker Evans. In earlier years, Evans had repeatedly denounced color. As late as 1969, he had written:

> Color tends to corrupt photography and absolute color corrupts it absolutely. Consider the way color film usually renders blue sky, green foliage, lipstick red, and the kiddies' playsuit. These are four simple words which must be whispered: color photography is vulgar.[256]

By 1973, however, Evans was an enthusiastic advocate of the Polaroid sx-70 camera. Feeling rejuvenated by its sheer simplicity, he marveled, "It's the first time, I think, that you can put a machine in an artist's hands and have him then rely entirely on his vision and his taste and his mind."[257] Other photographers of this generation, such as André Kertész, also used the sx-70 to produce notable bodies of work.[258]

In this new climate of acceptance, the handful of photographers with established reputations in color were accorded additional recognition. Eliot Porter's work, for example, was seen in no fewer than fifty-five one-person exhibitions between 1965 and 1980, including a prestigious 1979 retrospective at the Metro-

politan Museum of Art. In addition, nearly a dozen books of Porter's work were published in this time.[259] Marie Cosindas, who began using color in the early 1960s, was widely recognized for her lush palette and somewhat nostalgic subject matter. She received a Guggenheim Fellowship in 1967 and was honored with one-person exhibitions at the Boston Museum of Fine Arts, the Museum of Modern Art, and the Art Institute of Chicago between 1965 and 1967.[260] A book of her work, with an essay by Tom Wolfe, was published in 1978.[261]

Notably, however, it was not such traditional work that came to define the art of color photography in the 1970s. This was accomplished by a 1976 show at the Museum of Modern Art of the work of William Eggleston, a hitherto little-known photographer from Memphis. Eggleston had begun making black-and-white photographs in about 1959, inspired by Henri Cartier-Bresson's celebrated book *The Decisive Moment*.[262] Eggleston's pictures of the 1960s suggest the further influence of Frank, Winogrand, Friedlander, and Arbus.[263] His turn to color in the late 1960s was triggered by his appreciation for the work of William Christenberry, a painter and photographer then living in Memphis, and the street pictures of Joel Meyerowitz. With this new commitment, Eggleston began a powerfully idiosyncratic interpretation of the American South. His subjects were utterly unremarkable, even banal: parked cars, a dog lapping water from a puddle, the inside of an oven, ordinary people posing warily on the street or in backyards [454], a child's tricycle on a suburban sidewalk [455]. As John Szarkowski observed, "[Eggleston] shows us pictures of aunts and cousins and friends, of local streets and side roads, local strangers, odd souvenirs, all of this appearing not at all as it might in a social document, but as it might in a diary, where the important meanings would be not public and general but private and esoteric."[264] Appropriately, perhaps, these common, miscellaneous subjects were recorded in a style that seemed almost shockingly casual. To most viewers, Eggleston's pictures appeared devoid of expressive self-consciousness or, indeed, of any trace of conventional artistry.

It was precisely this unconventionality that appealed to Szarkowski.[265] In 1976, five years after first seeing Eggleston's color pictures, Szarkowski mounted a seventy-five print exhibition of them at the Museum of Modern Art.[266] Critical responses to the show ranged from indifference to outright hostility.[267] Indeed, photography critic Gene Thornton called it "the most hated show of the year."[268] The exhibition catalogue, *William Eggleston's Guide* (1976), received more respect. This volume differed significantly from the show. More focused in both size and scope, the catalogue included forty-eight pictures, all made between 1969 and 1971.[269] Szarkowski's catalogue essay on Eggleston is one of his most sinuous and suggestive pieces of writing. In it, he recapitulates his vision of the art of photography as a whole, with the added fillip of the problem of color. Photographs, he reminds us, represent a curious and mercurial balance of fact and opinion, realism and invention. In its cumulative history, photography has created nothing less than "a new pictorial vocabulary, based on the specific, the fragmentary, the elliptical, the ephemeral, and the provisional."[270] Measured against this standard of visual invention, the vast majority of color photographs have failed for one of two basic reasons: they have been "either formless or pretty."[271] In effect, photographers had used color either

402 William Christenberry, *Window, near Stewart, Alabama*, 1988, dye-coupler print, 29 x 36¼"

403 **Michael Bishop,** *Untitled #2720 (Strand Theater),* 1979, dye-coupler print, 21⅛ x 14″

as an unnecessary addition to a fundamentally monochromatic vision or to make merely attractive pictures without real content.

In Szarkowski's view, Eggleston's importance was two-fold. On the one hand, he demonstrated the essential nature of camera vision with radical clarity by creating pictures that were explicitly about "the elliptical, the ephemeral, and the provisional." On the other hand, Eggleston had virtually reinvented color photography by refusing to treat color as either seductive or supplemental. This breakthrough stemmed from the seemingly simple understanding that "the world itself existed in color"—that "the blue and the sky *were* one thing."[272] Eggleston's use of color was radical, in large measure, because it was so consistently employed without exaggeration or undue emphasis. In the end, Szarkowski praised Eggleston's work as perhaps the ultimate expression of a deeply problematic and endlessly inventive medium. Photographs as original as Eggleston's were, Szarkowski observed,

> patterns of random facts in the service of one imagination.... A picture is after all only a picture, a concrete kind of fiction, not to be admitted as hard evidence or as the quantifiable data of social scientists. As pictures, however, these seem to me perfect: irreducible surrogates for the experience they pretend to record, visual analogues for the quality of one life, collectively a paradigm of a private view, a view one would have thought ineffable, described here with clarity, fullness, and elegance.[273]

This extravagant praise triggered a flurry of heated responses. Art critic Hilton Kramer wrote "Perfect? Perfectly banal, perhaps. Perfectly boring, certainly."[274] Despite such dismissals, however, the obstinate intelligence of Eggleston's vision exerted a powerful influence on other photographers of this era. In large measure, his work served to underscore the new logic—or "naturalness"—of color photography. In a brilliantly chromatic culture, color was no longer a marginal or esoteric pursuit. For the first time, photographers began to truly *see* the world in color. They worked accordingly, unconstrained by earlier tendencies to view things and the chromatic characteristics of those things as fundamentally different subjects.

Although he was certainly the most notorious color photographer of the 1970s, Eggleston was not the only notable artist to turn to color. For example, the painter William Christenberry began making color photographs in 1960. For many years, he used a simple Brownie camera to make reference images for his paintings; color was a natural part of his essentially documentary process. When he turned to an 8 x 10-inch camera in 1977, it was only to achieve a higher degree of visual detail; the directness of his vision did not change. Christenberry began exhibiting individual color photographs in 1971; his first solely photographic exhibition was mounted in 1973.[275]

The enduring theme of Christenberry's art is his own cultural heritage. He was born in Hale County, Alabama, in 1936, the year Walker Evans and James Agee visited there. Christenberry's artistic interest in this area was confirmed and deepened by his discovery of the book *Let Us Now Praise Famous Men* in 1960. He met Evans shortly thereafter, and the two men established a lasting friendship. Even while living and teaching in Memphis (1962-68), and in Washington, D.C. (since 1968), Christenberry has returned to central Alabama every year to record its slowly changing landscape and buildings. He has recorded many sites and structures repeatedly, capturing progressive stages of their evolution or decay. These straightforward photographs represent an extended meditation on time, memory, and mortality. For example, the abandoned farmhouse depicted in Christenberry's *Window, near Stewart, Alabama,* 1988 [402], had once been the home of his grandparents. While this personal association explains Christenberry's initial interest in the structure, his photograph achieves a universal significance.

Although Joel Meyerowitz embraced color from the beginning of his photographic career, most of his work of the 1960s was small-format black-and-white imagery in the street tradition of Cartier-Bresson, Frank, and Winogrand. By 1972, however, he had turned completely to color.[276] As he later recalled:

> When I committed myself to color exclusively, it was a response to a greater need for description.... Color plays itself out along a richer band of feelings—more wavelengths, more radiance, more sensation.... Color suggests more things to look at [and] it tells us more. There's more content [and] the form for the content is more complex.[277]

After producing an influential series of 35mm street pictures in color, Meyerowitz made a dramatic shift in both format and subject. Beginning in the summer of 1976, he used an 8 x 10-inch camera to photograph in and around his family's cottage on Cape Cod. Discarding the split-second ambiguities of his street images for a more meditative and poetic vision, Meyerowitz explored

the subtle visual rhythms of day and season. In his "Bay Sky" series [457], Meyerowitz photographed repeatedly from the same vantage point, exploring the ever-changing appearance of sand, water, and sky from morning until dusk and in all kinds of weather. The primary subject of these images is light itself. By precisely describing the most transient visual effects, these photographs celebrate a new subjectivity based on the "discovery of charged moments of luminescence in the real world."[278] This work was collected in *Cape Light* (1978), one of the most notable photography books of the era.

Stephen Shore is also fascinated by the ability of the large-format color photograph to describe evanescent visual effects. He has written: "Color film is wonderful because it shows not only the intensity but the color of light. There is so much variation in light between noon one day and the next, between ten in the morning and two in the afternoon."[279] Shore's early black-and-white work was exhibited at the Metropolitan Museum of Art in 1971. By 1972, he was working exclusively in color with an 8 x 10-inch camera. His pictures of the next few years were exhibited widely and exerted a considerable influence on other photographers. Shore depicted familiar aspects of America's roadside culture: city streets [456], the houses and factories of small towns, details of parking lots and backyards, and the empty expanse of the Western plains. Despite their apparent simplicity, Shore's photographs are the product of a rigorous formal intelligence. They are as much about the orchestration of reality and the nuances of atmosphere and color as they are about traditional documentary concerns.

This highly formal use of color in the 1970s is perhaps best demonstrated in the pictures of Michael Bishop. Although he worked in a technically "straight" manner, Bishop was primarily interested in spatial and narrative ambiguities. He used skewed perspectives and odd juxtapositions to create images that seem to oscillate between a sense of three-dimensional description and two-dimensional abstraction. By deliberately collapsing visual space [403], the boldest of Bishop's images suggest the incongruities of Surrealist collages. These images are further enlivened, of course, by the dynamism of their chromatic relationships.

Of the many photographers who turned to color in this era, one of the most enthusiastic was Harry Callahan. In fact, Callahan had begun shooting color slides as early as 1941. He worked intermittently in this format until about 1964, when critical disinterest and the inherent limitations of 35mm transparencies prompted him to devote all his energy to black-and-white prints. By 1977, however, the situation had changed completely: there was a real audience for color work and Callahan was now able to have fine dye-transfer prints made from his slides.[280] As a result, an artist widely revered as one of the masters of monochrome was rediscovered as an avid colorist. Callahan began exhibiting his color pictures—both old and new—in 1978.[281] In 1980, this aspect of his career was surveyed in two separate projects: a traveling exhibition (with a catalogue) organized by the Center for Creative Photography and the lavish book *Harry Callahan: Color 1941-1980*.[282] Characteristically, the work Callahan produced after 1977 reflected the conditions of his life. Recently retired from full-time teaching, he traveled widely in Europe, North Africa, and Asia. Callahan photographed extensively on these trips, creating images that blend his familiar visual themes—

404 **Mitch Epstein**, *Galta, Rajasthan, India*, 1978, dye-coupler print, 15 x 22"

including vernacular architecture and people on the street—with a new enthusiasm for the world's chromatic vitality [458].

The importance of color in this era is indicated by the number of photographers who embraced it as their primary means of picture-making. A host of artists previously known for their work in monochrome turned largely, if not exclusively, to color. These included photographers as diverse as Les Krims, William Larson, Richard Misrach, Roger Mertin, Arthur Tress, Leland Rice, Judy Dater, and Van Deren Coke. Even the most classical of black-and-white photographers—such as Art Sinsabaugh, Paul Caponigro, and Emmet Gowin—devoted some effort to color. At the same time, a new generation of photographers achieved renown exclusively for their work in color: John Pfahl [451], Joel Sternfeld [427], Len Jenshel, Jim Dow, Mitch Epstein [404], Jan Groover [469], and many others. Color became increasingly important in documentary and journalistic work, as well. Mary Ellen Mark's 1978-79 project *Falkland Road: The Prostitutes of Bombay* was shot entirely in color, for example, and one of the finest young documentary professionals, Alex Webb, chose to work primarily in color [459].[283] While most photographers of this era used color in relatively "straight" ways, a few made particularly notable use of unusual approaches or processes. For example, Arthur Ollman specialized in night photography, an approach made practical by the advances in high-speed color-negative films in 1976-78. Sheila Metzner, on the other hand, is known for her use of the unusual Fresson process, a tightly guarded technical secret of the Fresson family in France. The Fresson print's delicate palette and somewhat "pointillist" feeling provides a perfect expressive vehicle for Metzner's graceful, neo-Pictorialist vision [405].

This new interest in color photography resulted in several important publications and exhibitions. Books of color work by Eggleston, Meyerowitz, Callahan, and Mark all received widespread attention between 1976 and 1980. In addition, group surveys of contemporary color photography were mounted by a number of institutions.[284] Sally Eauclaire's books *The New Color Photography* (1981) and *New Color/New Work* (1984) played a notable role in documenting current artistic uses of color. The history of color photography also received new attention in this period. The FSA's pioneering use of Kodachrome in the late

405 Sheila Metzner, *Michal, Nude Back*, 1980, Fresson color print, 16 x 10¾"

1930s was first brought to public attention in 1979 by art historian Sally Stein.[285] The Eastman House's exhibition "Color as Form: A History of Color Photography" (1982), curated by John Upton, provided a timely look at the medium's technical and artistic evolution.[286] Not surprisingly, however, as artistic uses of color became increasingly prevalent in the late 1980s, projects devoted exclusively to color declined in number. In a relatively short period of time, color became too ubiquitous to be seen, in itself, as particularly noteworthy.

Art and Photography

A new interchange between art and photography had begun to develop in the mid-1960s; photographers drew from the techniques and ideas of the art world, while painters and sculptors took an increasing interest in the camera. Both sides had much to gain from this exchange. The art world saw photography as a way to escape the weight of its own history, the apparent exhaustion of autographic forms of expression and the commodity status of art objects. For photographers still defensive about the medium's lack of cultural prestige, the contemporary art world represented the highest level of intellectual seriousness. For many, calling oneself an artist rather than a photographer signalled a turn from the parochial limitations of technique to the unfettered freedom of ideas.

The growth of photography courses in university art departments encouraged a new attitude of creative heterogeneity. The result was a surge in photographic work that sought to transcend the medium's "straight" and utilitarian traditions. To this end, photographers altered their images through the use of chemical staining or hand-applied pigments; they printed on fabric, vacuum-molded plastic, and other unusual materials; they rediscovered the platinum, cyanotype, gravure, gum bichromate, and other archaic processes; and they employed variations on such conventional printmaking techniques as lithography, etching, and silkscreen. These alternative approaches had both a technical and a conceptual significance. Instead of being viewed as an essentially passive or neutral artifact, the artistic photograph was increasingly seen as a *constructed* thing. In addition, the growing importance of ideas from other disciplines gave photographers an increasingly rich conceptual arena in which to work.

Most importantly, major changes in thinking about the nature of expression and representation led to a radically new artistic climate. Photography was no longer viewed by artists and art critics as a secondary or marginal medium. Instead, it was celebrated as central to contemporary artistic practice. Significantly, however, this recognition left the "traditional" photography world more puzzled than pleased. Artists embraced photography for their own purposes, effectively ignoring the history and standards of craft that photographers themselves held in high regard. To most photographers, the medium's recognition by the art world seemed to be for all the "wrong" reasons. It was not a marriage, but a kidnapping.

Some sense of the art world's enthusiasm for photography may be gleaned from a brief review of the main lines of artistic thought after about 1960. During this time, artistic practice underwent a rapid process of expansion and diversification. The stylistic dominance of Abstract Expressionist painting gave way to a series of new approaches, including Pop, Minimal, and Conceptual Art. Pop Art, the leading movement of the early 1960s, rejected Abstract Expressionism's gestural flamboyance, as well as its tone of sublimity, subjectivity, and universalism. Instead, Pop artists turned to commercial culture and the mass media for inspiration. Following the example of the Dadaist Marcel Duchamp, Pop artists rejected traditional notions of originality; instead, their fundamental strategy was one of appropriation and recontextualization. Thus, seemingly overnight, the emphasis of avant-garde art shifted radically: from angst to irony, invention to quotation.

Three leading painters of the Pop Art era—Robert Rauschenberg, Andy Warhol, and Ed Ruscha—were particularly noted for integrating photographic imagery and techniques into their work. The photographs they employed were chosen precisely for the generic familiarity of their subjects; they were not emblems of personal "artistry," but signifiers of a collective cultural condition. Equally important, these photographs were characterized by a stylistic anonymity. Nothing, it seemed, could be more diametrically opposed to the expressive traces of Abstract Expressionist brushstrokes than the flat factuality of the ordinary news photograph or casual snapshot. Curiously, then, Pop artists embraced photography for reasons that photographers themselves could scarcely understand. Artists were interested in photography as a means of cultural, rather than personal, expression; the poetry and high craft of traditional art photography held no appeal.

Robert Rauschenberg began incorporating photographs and photographic reproductions into his paintings and "combines" (painting/sculpture hybrids) as early as the mid-1950s.[287] By 1962, he was making large silk-screen paintings consisting of collages of photographic imagery overlaid with gestural strokes of paint. Rauschenberg's choice of photographic subjects ranged from the personal and enigmatic to images of current events and personalities lifted from the daily press. For example, *Tracer* (1963) combines a variety of seemingly incongruous photographic images: military helicopters; an eagle; a street scene; and a detail of a Rubens painting of Venus, the goddess of beauty, studying her reflection in a mirror. Rauschenberg's iconic *Retroactive I* (1964) is a collage of equally disparate pictorial fragments: an astronaut, oranges, a stroboscopic photograph by Gjon Mili, a portrait of the late President John F. Kennedy, and more. As critic Robert Hughes has observed, in works such as these, Rauschenberg "strove to give canvas the accumulative flicker of a colour TV set. The bawling pressure of images...creates an inventory of modern life, the lyrical outpouring of a mind jammed to satiation with the rapid, the quotidian, the real."[288] This "aesthetic of heterogeneity" provided an enormously fertile means of evoking the vitality and complexity of contemporary experience.[289]

Like Rauschenberg, Andy Warhol was fascinated by the iconography of the mass media. His early works of 1960-62 include hand renderings of comic strips, advertisements, and the front pages of tabloid newspapers. In 1962, Warhol adopted the photo-silkscreen process to make large paintings composed of photographs taken from the popular press. Characteristic of these were his "Disaster" paintings, which present flat, repeated depictions of car wrecks, electric chairs, and other scenes of real or implied violence. In this same period, Warhol made large silkscreened renditions of Campbell's soup cans, bottles of Coca-Cola, and seemingly endless fields of dollar bills and S & H Green Stamps. The idea of mass production lay at the heart of both the subject and the means of Warhol's art.[290] He was fascinated by the sheer quantity of images in modern life and by the way meaning is flattened and abstracted through repetition. Warhol was particularly interested in the aura of fame, and the peculiar intersection of public desire and media exploitation that transformed people like Marilyn Monroe and Elvis Presley into cultural icons. Warhol—himself a celebrity—came to view this process with a mixture of fascination and cynicism. Such characteristic late works as *Lana Turner*, 1976-86 [460], suggest a media-fueled cult of celebrity that is at once reverential and ghoulish.

Ed Ruscha was similarly fascinated by popular and commercial culture. After moving from Oklahoma City to Los Angeles in 1956, Ruscha took special interest in the iconography of automobile travel. His early painting *Standard Station, Amarillo, Texas* (1963) presents a sleekly glorified vision of one of his refueling stops on the drive between Oklahoma and Los Angeles. Ruscha had used the camera to make snapshot studies for paintings such as this; he then turned his artistic attention to photography itself for its most basic, record-making function. Beginning in 1963, he issued a series of small, curious photographic books. The first of these, *Twentysix Gasoline Stations* (1963), contained banal snapshots of twenty-six gas stations along Route 66.[291] This volume was followed by a number of others, including *Various* *Small Fires and Milk* (1964), *Some Los Angeles Apartments* (1965), *Every Building on the Sunset Strip* (1966), and *Thirty-four Parking Lots in Los Angeles* (1967).[292]

The Postminimalist Era:
The Photograph as Evidence and Idea

None of the artistic movements after Abstract Expressionism could match its longevity and relative dominance. The heyday of Pop Art lasted only half a decade. The Minimalist movement—which was, in part, a reaction to the irony and "impurity" of Pop—achieved its broadest influence in the last half of the 1960s. Minimalism emphasized the *objectness* of the work of art through a radical, even primordial, formal simplicity. As demonstrated in the work of artists such as Dan Flavin, Sol LeWitt, Carl Andre, Donald Judd, Robert Morris, and Agnes Martin, Minimalism represented a concern for perceptual clarity and ontological primacy. The work of many of these artists was based on the austere logic of the square, cube, and grid. Judd's steel boxes, LeWitt's colorless latticework sculptures, and Martin's delicately ruled grid paintings all reflect this interest in the most basic structural systems.[293] In addition, Minimalism embraced the ideas of repetition and permutation: the ways in which simple forms can be extended or modified.

The severe purism of Minimalism represented a kind of formalistic "endgame." By contrast, the Postminimalist era of the late 1960s and early 1970s saw an explosive proliferation of antiformalist approaches, including Photorealism, Book Art, Conceptual Art, Earth Art, Body Art, and Performance Art. European art movements and ideas—including Italian Arte Povera, the British Art & Language group, and French semiotics—took on new importance for Americans. In addition, the student rebellions of 1968 and the pervasive antiwar sentiment of the period created an atmosphere of revolutionary fervor. The dominant artistic trends of this complex era include a dematerialization of the traditional art object and an emphasis on what lay outside the frame of the painting or the walls of the gallery.[294] Rather than making traditional commodity-objects, artists sought to explore the very idea of art, and its place and power in society.

In various ways, then, the art of this era was conceived in a spirit of rebellion and negation. New ideas required new modes of expression. As the pioneering Conceptualist Joseph Kosuth stated: "Painting itself had to be erased, eclipsed, painted out in order to make art."[295] Varied and unconventional forms of expression filled the spaces created by this "erasure." The most important of these new artistic forms was photography. The radical nature of this gesture stemmed, in part, from photography's historically low status in the artistic hierarchy. As critic Andy Grundberg has written, "Conceptual artists sought to rescue art from the dominion of the precious object, and photographs were considered ideal because they were so little valued—until, of course, Conceptual Art helped make them valuable."[296] Ironically, then, while this use of photography began in opposition to the medium's rarified, fine-print tradition, one of its ultimate consequences was to broaden the definition—and increase the value—of artistic photographs in general.

The central role of photography in the art of the Postminimalist era was anticipated by the work of Ed Ruscha. The flat-

footed factuality and repetitiveness of the images in Ruscha's small books signalled that his real aim was not "documentary" in any traditional sense. Instead, he combined a sly Duchampian humor with an interest in the homogenization of American culture and the curious nature of photographic truth. The apparent stylelessness of these photographs—their utter lack of visual sophistication—was central to Ruscha's purpose. Uninterested in art photography, he instead made a form of conceptual art from the most anonymous and mechanical of mediums: the vernacular photograph.[297] Ruscha's interest in vernacular imagery differed significantly from Szarkowski's, for example. While Szarkowski looked to anonymous photographs for their aesthetic eccentricity and invention, Ruscha valued these images precisely for their visual banality and their total lack of expressive inflection.

A similar influence was exerted by the German husband-and-wife team of Bernd and Hilla Becher.[298] The Bechers began their photographic "typologies" of workers' houses and industrial structures in 1957. They started photographing outside Germany in the early 1960s and have made repeated visits to the United States since 1968. The Bechers' pictures began to be exhibited in the late 1960s, and were championed by American Minimalist and Conceptual artists. Carl Andre, for example, wrote one of the first articles on them for a major art journal.[299] The Bechers' work epitomizes the idea of the photograph as evidence rather than expression. Each of their images is scientifically precise, without stylistic quirks of any kind. These images systematically record a wide variety of industrial forms, including mineheads, blast furnaces, coke ovens, gas tanks, and water towers. Some of these photographs are exhibited individually [461], as records of "anonymous sculpture."[300] Most often, however, related images are presented together in grids in order to emphasize the formal permutations of a given class or type of structure. The Bechers' comparative morphologies produce unexpected results. Their passive and unvarying mode of presentation highlights the surprising individuality of these anonymous structures, as well as the nearly baroque variations of form that exist within what would seem to be the narrowest of functional categories.

The work of Ruscha and the Bechers illustrates an important trait of the art of the late 1960s and 1970s: the notion of the photograph as evidence or as a mode of visual inventory. Critic Ralph Rugoff notes the predominance in this period of artistic practices "that suggest links to a forensic approach or address the art object as if it were a kind of evidence. These works emphasize the viewer's role as investigator while underscoring the cluelike and contingent status of the art object."[301] This "forensic aesthetic" was characterized by a stance of strict stylistic neutrality.[302] Similarly, curator Charles Stainback points out that a major theme in art since Pop has been "artworks that catalogue, classify, archive, and order numerous photographic events into a complete, unified piece."[303] Rejecting such traditional photographic notions as the singular "decisive moment," such works derive their meaning from the comparison and contrast of component parts, that is, from a system of formal or thematic relationships.

Conceptualism, or "Idea Art," arose in the aftermath of Pop Art and in tandem with Minimalism. In essence, the rigorously simple forms of Minimalist work represented the physical expression of organizing principles or patterns conceived in the mind of the artist. As Postminimalism displaced and dissolved the phys-

ical work of art, increased attention was given to the fundamental reality of ideas. These ideas ranged from the rigorously analytical to the playful and intuitive. As time went on, the focus of Conceptual Art tended to shift from an emphasis on language and perception to issues of personal, social, or political concern. Consistently, however, Conceptualists refused traditional notions of originality and craftsmanship to achieve a purer form of artistic communion. As art historian Thomas Crow has written, Conceptual artists sought "a transparent agreement between maker and receiver, a relationship uncorrupted by the exchange of precious goods or any mystification of the creative process."[304] The importance of this movement was confirmed in 1970, when the Museum of Modern Art mounted the exhibition "Information," an influential survey of Conceptual Art.

Photography was central to the work of such leading Conceptualists as Joseph Kosuth and Douglas Huebler. The paradoxes of representation were underlined by such key works as Kosuth's *One and Three Chairs* (1965). This piece is composed of three objects: a photographic enlargement of the dictionary definition of "chair," a photograph of a chair, and an actual chair. By comparing and contrasting these three levels of reality—words, pictures, and objects—Kosuth sought to uncover important truths about each. Different kinds of paradoxes are the subject of Douglas Huebler's *Variable Piece No. 70* (1971). The text of this work reads: "Throughout the remainder of the artist's life he will photographically document, to the extent of his capacity, the existence of everyone alive in order to produce the most authentic and inclusive representation of the human species that may be assembled in that manner."[305] Of course, Heubler's point was not to actually record the entire population of the world, but to stimulate thought on the impossible scale of this project, the meaning of visual documents, and the illusory order of the archive. The aesthetic banality of Huebler's photographs only emphasized the primacy of these larger conceptual goals.

The varied strains of Conceptual Art inspired a whole generation of artists, including John Baldessari, Robert Cumming, and William Wegman. Baldessari, the oldest of this trio, took an unorthodox approach to art beginning in the early 1960s. In 1962, for example, he assembled a thirty-minute slide show combining words and image fragments taken from magazines, newspapers, and amateur snapshots. In 1967-68, he created a series of photo-text paintings by applying photographic emulsion to canvas and printing banal snapshots in rather majestic size.[306] In the early 1970s, he created Dadaist photographic works with such self-explanatory titles as *Throwing 4 Balls in the Air to Get a Straight Line (Best of 36 Tries)* (1973). But Baldessari soon became less interested in making photographs than in choosing them from the vast image bank of popular culture. He was particularly fascinated by the theatricality and narrative ambiguities of old film stills, which were available in great quantity in Los Angeles, where he has lived and taught for many years.

By the early 1980s, Baldessari achieved widespread recognition for his witty juxtapositions and transformations of these found images.[307] *Life's Balance (With Money)*, 1989-90 [463], is characteristic of this sly and playful work. A montage of three black-and-white images with applied color, *Life's Balance* presents a fractured narrative involving such themes as public performance, arcane skills, uncertainty, and giddy decadence. Works

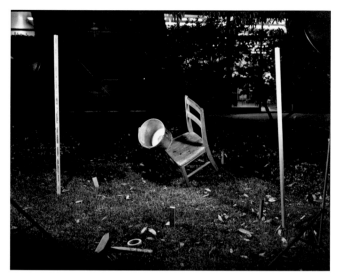

406 Robert Cumming, *Mishap of Minor Consequence*, 1973, 7⅝ x 9⅝" each

such as this function as a kind of demented rebus, suggesting all manner of potential meanings while resisting any single, "definitive" interpretation. These works reveal Baldessari's interest in the structure and ambiguities of language, as well as the basic dualities of order and chaos, meaning and nonsense.[308] Baldessari's strategy of appropriation—the selection and reconfiguration of existing images—exerted a powerful influence on his students and on a whole generation of postmodern artists.

During his M.F.A. studies in sculpture at the University of Illinois in the mid-1960s, Robert Cumming took a photography course with Art Sinsabaugh. At that time, however, Sinsabaugh's purist approach was of little interest to him.[309] Later, however, after his move to the Los Angeles area in 1970, photography began to play an integral role in Cumming's increasingly conceptual work.[310] Using his experience in sculpture, Cumming built strange objects specifically to be photographed. The resulting images include "out-and-out illusionism and magic tricks, satires on the misreading of natural phenomena, and sardonic commentaries on the history of art and photography."[311] Cumming's *Mishap of Minor Consequence*, 1973 [406], for instance, consists of two 8 x 10-inch contact prints that appear to represent Edgerton-like, stop-action images of a bucket being thrown from a falling chair. On close inspection, however, the fictional nature of this scenario becomes obvious: the strings that hold the bucket and chair in place are clearly visible. Thus, the diptych is discovered to represent sequential views of static objects rather than simultaneous records of moving ones. The result is a sly artistic paradox: a truthful deception. Curiously, the patently fraudulent nature of the "event" Cumming records is both revealed and contradicted by the precise detail of his purist technique. In the end, Cumming's clever work challenges us to simultaneously question and affirm the truth of photographic representation.

Cumming's friend William Wegman began using photography as a means of Conceptual Art in the same period. Seeking to subvert the humorless severity of Minimalist work, Wegman created an art of pseudoscientific absurdity and self-deprecating wit. His *Three Mistakes* (1971-72), for example, is a simple black-and-white photograph of three puddles of milk beside three empty glasses. By traditional standards, Wegman's photographic talent appeared as inept as the spills he recorded. In fact, of

course, the "mistakes" were deliberate and the seemingly straightforward photograph a constructed fiction. The result is a wry commentary on traditional ideas of artistic mastery, control, and ambition. Wegman went on to make photographs and videotapes of his well-trained dog, Man Ray, in a variety of farcical situations. Wegman's 20 x 24-inch Polaroids of Man Ray, Fay Ray, and other generations of weimaraners, begun in 1978, brought him remarkably wide recognition.[312] In these comic photographs, Wegman parodies celebrated motifs from the history of art while subverting the traditions of formal portraiture. Most remarkably, perhaps, Wegman consistently conveys both the dignity and individual personalities of his canine collaborators [464].

While the variety of discrete artistic movements in the Postminimalist era appears almost endless, nearly all of them seem to have made extensive use of the camera. Indeed, as the work—or act—of art became increasingly fleeting, intangible, or distant, photographic documentation became all the more central to the creative process. For many of the new artistic disciplines—such as Performance Art and Body Art—photographs provided the only artifacts that could be exhibited, reproduced, or collected. Performance and Body Art had their roots in Dada, alternative theater and dance, the Happenings of the late 1950s, and Conceptualism. In both these movements, the human body itself—often stripped to its most basic state—typically served as both the means and object of expression. A key early work in this genre is Bruce Nauman's Duchamp-inspired *Self-Portrait as Fountain* (1966). In this punning photograph, the artist depicts himself as a "fountain," spitting a delicate stream of water from his mouth. Other Performance and Body artists of this era—including Carolee Schneemann, Vito Acconci, Chris Burden, and Ana Mendieta—made effective use of photography to document private, ritualistic events.

The themes of performance and the body are central to the work of Lucas Samaras. Though he has worked in a variety of artistic mediums—including sculpture, painting, and photography—Samaras has always taken himself as his subject. As critic Peter Schjeldahl has written, Samaras is "the artist laureate of narcissism."[313] His larger theme is the modern self, which he views as multiple in nature and open to almost endless reinvention.

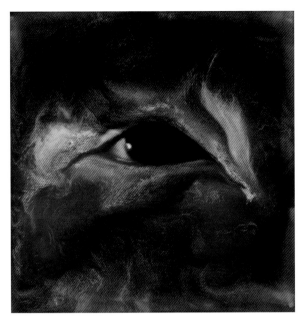

407 **Lucas Samaras,** *Untitled,* 1973, Polaroid sx-70 color print, 3⅛ x 3¹⁄₁₆"

Samaras has said: "When I say 'I,' more than one person stands up to be counted."[314] Samaras's first major series of photographs was his "AutoPolaroids" (1969-71), intensely theatrical self-portraits that depict the artist in a variety of poses, costumes, and disguises.[315] In 1973, Samaras began using the new Polaroid sx-70 process, and discovered that by kneading the developing print with his fingers he could manipulate its emulsion. This technique allowed the creation of highly expressionistic images that combine bits of photographic detail within painterly smears of color [407]. In subsequent years, Samaras applied similarly unconventional approaches to a variety of other formats. Beginning in 1978, he worked extensively with Polaroid materials in both the 8 x 10-inch and 20 x 24-inch formats. In addition to his careful attention to staging and lighting, Samaras made frequent use of multiple exposures, in-camera masking, hand-painting, and collage. As a whole, Samaras's use of photography reflects an obsessive meditation on the self and the tensions between fact and fantasy, madness and invention.

The camera was equally vital to those Postminimalist artists who created "site-specific" artworks. The huge Earthworks of artists such as Robert Smithson, Michael Heizer, Dennis Oppenheim, Nancy Holt, and Walter de Maria were often constructed in remote areas of the American West. Needless to say, photography served an important function in simply documenting such distant (and often, surprisingly ephemeral) creations. Indeed, the fame of such key works as Smithson's *Spiral Jetty* (1970)—a 1,500-foot-long spiral of earth and rock in the Great Salt Lake—depends almost entirely on his films and photographs of the site.

Other artists of this period, such as sculptor Gordon Matta-Clark, used photography as a means of both documentation and expression. Matta-Clark studied architecture at Cornell in the mid-1960s, but rejected it for an artistic career dedicated—ironically—to the "deconstruction of architecture."[316] Matta-Clark's signature work, *Splitting* (1974), involved the physical transformation of a small, abandoned house in Englewood, New Jersey. Matta-Clark sawed this nondescript dwelling in half, from rooftop to basement. He then canted one side of the structure

slightly, opening a narrow, V-shaped gap in the middle. A strange new sense of light and space was created by this violation of the normal boundaries between inside and outside. The result was an object of surprising conceptual and visual power: a vacated home, stripped of its associations of nurture and shelter, transformed into something provocative, unstable, and ephemeral. Matta-Clark memorialized this work in a series of powerful photographs, including *Splitting: Interior,* 1974 [462], a composite of three overlapping views. The twisting perspective of this photograph perfectly evokes the disjunctures of the altered house, and confirms Joseph Kosuth's observation that Matta-Clark "used the camera like he used a buzz saw."[317]

Finally, photography was central to the work of yet another important group of Postminimalist artists: the Photorealists. This movement of the late 1960s and early 1970s drew inspiration from the sheer ubiquity of photographs in everyday life and their strange status as facsimiles of the real. The leading figures in this movement included the painters Chuck Close, Richard Estes, Ralph Goings, and Robert Bechtle.[318] Unlike earlier generations of American painters, the Photorealists deliberately emphasized the photographic basis of their art. Indeed, their meticulously rendered canvases—usually of urban street scenes, storefronts, cars, and similar icons of contemporary life—were quite literally hand-painted enlargements of snapshot photographs. Not surprisingly, some critics saw these works as merely elaborate demonstrations of craft. In fact, however, in its devotion to popular culture, its stance of deadpan neutrality, and its interest in the replication of images, Photorealism constituted a logical extension of aspects of both Pop and Conceptual Art. The banality of the anonymous photograph was essential to the Photorealist project. In discussing these paintings, one supporter of the time observed: "The photograph helps equalize the surface. It has to do with a common desire to avoid interpretations about the relative value of the things depicted."[319] In taking the common photograph as their "original," rather than the world itself, Photorealist painters underscored the image-saturated nature of modern life.

As the above summary suggests, the camera became central to artistic practice in the Postminimalist era.[320] This marked the most radical and widespread use of the medium by artists since the 1920s. The result was a powerful shift in thinking about the artistic potentials of photography. These artists embraced the medium as a useful tool and as a technological and social force. Most had little or no interest in "art photography" as traditionally defined by the photographic field itself. In rejecting the primacy of this heritage, they sought to use the medium in ways that were at once simpler and more expansive.

Postmodernism and the Reign of Theory

In the Postminimalist era, the intellectual interests of artists expanded in tandem with the variety of their expressive means. Beginning in the late 1960s, artists and art theorists became increasingly drawn to ideas from the disciplines of philosophy, linguistics, literary criticism, anthropology, psychology, science, film theory, gender and race studies, and social criticism. This intense, transdisciplinary matrix of thought contributed to an artistic climate of unprecedented intellectual ambition which coalesced in the late 1970s as postmodernism. While useful, this term

is notoriously imprecise. Some critics, for example, have distinguished between "postmodernism" (a realm of art and culture), "postmodernity" (late twentieth century forms of social and economic organization), and "the postmodern" (a kind of theoretical thought and writing).[321] Postmodernism may be best grasped as an uneasy union of all these notions: a cultural "condition," a discrete era or "style" of art, and a critical perspective. It is clearly not a singular phenomenon; its traits are emphatically plural and may be found in nearly all aspects of popular and artistic culture.

This plurality is evident in the theorizing of postmodernism, a project that has been a veritable academic industry since the late 1970s.[322] In a succession of waves of highly disciplined, abstract thought, postmodernism has emerged as a complex, ever-shifting matrix of ideas that, taken as a whole, may be understood to embody important aspects of the present era's intellectual values and enthusiasms. Despite their diversity, theories of the postmodern emphasize a relatively consistent set of ideas. The postmodern condition has been understood as the state of global society at a particular historical juncture: the age of "late capitalism." This is an era of momentous changes in the structure and dynamics of culture. The most pervasive of these changes include the rise of mass electronic communications and the economic shift from the manufacture of tangible goods to the production and dissemination of information. Faster modes of transportation and communication have produced a psychological sense of "space-time compression," while the accelerated mobility of capital has eroded the importance of national borders. The end of colonialism and the breakup of various political empires have resulted in a newly multifaceted world of political, cultural, and ethnic affiliations. Finally, the success of recent social movements has resulted in powerful assertions of identity by women, African Americans, gays and lesbians, and other previously marginalized groups. This seems to be a time uniquely characterized by transformation, dissolution, and impermanence. In this climate of radical upheaval and uncertainty, all received notions are open to debate. The legacies of Western humanism and rationalism have been savagely attacked as philosophically untenable and politically oppressive. Likewise, putatively "universal" concepts have been rejected by some as the mere expression of ideological power. In the place of any singular notion of the "human condition," we find instead a seemingly endless plurality of identities, cultures, and world views.

Postmodernism is often defined in negative terms: it is what modernism is/was not. The clarity of this definition rests on a radical simplification of the actual historical diversity of modern art and culture. Often, for example, artistic modernism is effectively reduced to art critic Clement Greenberg's notions of artistic purity. In this reading—derived from Kant's *Critique of Judgement* (1790) and expressed most cogently by Greenberg in the 1950s—each artistic medium is involved in a process of analyzing and expressing its own intrinsic nature. Thus, for example, the course of modern painting is interpreted as a relentless quest for formal refinement, a systematic reduction to its "essential" traits of flatness and abstraction. While this pinched interpretation ignores the radical "impurity" of much modern art and thought, it enables the oppositional nature of postmodernism to be most clearly understood.[323] In 1982, literary critic Ihab Has-

san sketched the differences between the modern and postmodern as a series of contrasting concepts: form/antiform, purpose/play, design/chance, hierarchy/anarchy, art object/process, distance/participation, creation/decreation, synthesis/antithesis, presence/absence, centering/dispersal, selection/combination, metaphysics/irony, determinacy/indeterminacy.[324] Here, modernism's descriptors evoke a sense of authoritarianism, positivism, and totalization; the terms of postmodernism, on the other hand, suggest playfulness, pluralism, and iconoclasm.

Much has been written on postmodernism in the last quarter century.[325] Indeed, a central aspect of postmodernism is the body of critical discourse created in its name. This mountain of written commentary does not merely *describe* postmodernism; to an important degree, it *constitutes* it. Thus, postmodernism may be viewed at least in part as a collective process of critical analysis and reflection. This dynamic of thought is the result of a particular history of ideas, the overlap and mutual influence of concepts from various fields ranging from philosophy to physics. These ideas have roots in the nineteenth century, but take on special importance in the last third of the twentieth century. What follows is a brief outline of a few of the important threads of this intellectual lineage.

The legacies of Karl Marx and Friedrich Nietzsche are of foundational importance to postmodernist thought. Marx's books, often written in collaboration with Friedrich Engels, include *The German Ideology* (1846) and *The Communist Manifesto* (1848). Marx promoted a materialistic vision of society and history. He viewed human culture through the lens of economics and class structure, denying the reality of all metaphysical schemes. Marx stressed the importance of "ideology," the shared—if unarticulated—notions that give meaning to both individual existence and to society as a whole. In Marx's view, these ideas represent a form of "false consciousness," a vision of the "true" and the "natural" that allows certain groups or classes to maintain positions of social dominance. The Marxist project attempts to analyze society's actual relations of power and to sweep away the illusions of ideology in the name of a radical, utopian project of liberation and egalitarianism.

Nietzsche, in his writings of the 1880s, expressed a profoundly unsettling sense of epistemological skepticism. He posed a withering critique of Western metaphysical thought, even going so far as to posit the "death of God." Nietzsche saw life as an endless interplay of relationships of power, with all aspects of human existence and value—including ethics, law, and art—a result of this amoral striving for mastery. Nietzsche's radical skepticism even extended to the Enlightenment principles of rationality and scientific inquiry. Attacking Western civilization's basic tenets of critical reason, Nietzsche saw modern science as merely a new form of metaphysics. From this perspective, "knowledge" was not an objective entity standing outside social forces; it was wholly an expression of ideology or social power. The radical skepticism of this "antifoundationalist" vision has had an enormous influence on postmodernist thought.

In their simplest forms, the legacies of Marx and Nietzsche emphasize a powerful pair of ideas: the end of metaphysics and a resolute focus on human culture as both the engine and arena of all meaning. As a result, it is taken as axiomatic that the essential structures of meaning lie hidden behind the veils of ideology

or the illusions of such basic notions as "nature," "truth," and "reason." A relentless process of questioning and analysis is required to break through these illusions. Paradoxically, however, the ultimate goal—complete liberation or self-knowledge—is itself deeply idealistic, even mystical, in nature.

In the twentieth century, this analytical project has been central to the fields of linguistics and literary criticism. Since the 1910s, the thrust of linguistic inquiry has been the recognition that language does not merely convey or reflect meaning, it *produces* meaning. The intrinsic structure of language shapes and determines the possibilities of human understanding. These ideas were first explored by the Russian Formalists of the 1910s and 1920s, a group of linguists associated with the Futurist movement in painting. This group sought the "deep structures" of language, its essential syntactical devices and narrative codes. This formal approach led to semiotics—the science of signs—and to structuralism. Ferdinand de Saussure, the founder of semiotics, viewed language as a system of relational differences: the connection, for example, between a dog and the word "dog." The *sign*—defined as the relation between *signifier* (word or speech-sound) and *signified* (concept or image)—was revealed to be a product of social agreement or convention, not "natural" correspondence. Moreover, the word "dog" has meaning only in relation to other words: the fact that it is *not* the words "dot," "log," or "hog," for example. Two important insights are thus achieved: human thought is indelibly shaped by the structure of language and meaning is a social construct. Structuralism, which flourished in the 1960s, used the tools of semiotics to uncover the "deep structure" of all manner of cultural "texts," from literary works to myths, TV game shows, and sporting events. As critic Fredric Jameson has noted, structuralism represented an ambitious attempt "to rethink everything through once again in terms of linguistics."[326]

By the early 1970s, structuralism had largely evolved into the related literary movements of poststructuralism and deconstruction. These approaches rejected the solidity of structuralism's notion of "deep structure"; linguistic meaning was now viewed as fluid rather than fixed. Poststructuralism broke down the one-to-one correspondence between Saussure's signifier and signified, rendering the sign a fundamentally unstable and indeterminate concept. As literary critic Terry Eagleton notes, "If you want to know the meaning (or signified) of a signifier, you can look it up in the dictionary; but all you will find will be yet more signifiers, whose signifieds you can in turn look up, and so on."[327] Signifiers thus lead only to other signifiers in an endlessly circular and self-referential process. Meaning "is scattered or dispersed along a whole chain of signifiers: it cannot be easily nailed down, it is never fully present in any one sign alone, but is rather a kind of constant flickering of presence and absence together."[328]

The consequences of this idea, as revealed in the work of literary theorists Roland Barthes, Jacques Derrida, and Paul de Man, are monumental. If all concepts are a product of this roiling play of signification, there can be no bedrock of "foundational" reference, no "objective" vantage point outside the language that makes us. And, if we are wholly formed by this slippery play of signification, classical notions of the stable, autonomous self are fatally undercut. Barthes declared all literature to be "intertextual," an endless reworking of preexisting works, and in a celebrated 1968 essay announced "The Death of the Author."[329] Deconstruction exulted in revealing the ways language undermined itself; every literary work, it seemed, could be exposed as inherently contradictory, illogical, and disunified. Since reality itself was understood to be constructed by discourse, classical notions of truth, reality, knowledge, and the self were thus exploded. No representation could be considered "natural" or complete; everything was a cultural construction, an expression of ideology, politics, power. This led to a "hermeneutics of suspicion" in which all forms of logical thought were rejected as inherently repressive.

This broad philosophical and linguistic movement from consensus and rationality to radical relativism and skepticism was accelerated by parallel developments in other areas of twentieth-century thought. In science, for example, the development of the theories of relativity and quantum mechanics in the 1910s and 1920s turned Newtonian physics on its head and seemed to violate all standards of logic. Werner Heisenberg's "uncertainty principle," which postulated the fundamental limits on scientific observations of nature at the atomic level, has since become a stock metaphor for the impossibility of the very idea of objectivity. Thomas Kuhn's vastly influential book *The Structure of Scientific Revolutions* (1962) suggested that scientific practice was guided by group consensus rather than any simple quest for truth.[330] Indeed, Kuhn postulated that standards of truth were shaped by the overall framework of beliefs—or conceptual "paradigm"—shared by communities of scientists. Like poststructuralism's circular process of signification, these "truths" could only be a reflection of the investigative process itself. Subsequent critics of science have gone even further in rejecting all notions of objective, value-free inquiry.

Similar themes are evident in the work of leading twentieth-century anthropologists. The general movement in this discipline has been from universalizing notions of culture and a strongly hierarchical vision of cultural development to a nonjudgmental relativism and attention to social particularities. Culture has been accorded immense importance as the template of both individual and social identity. Franz Boas, a pioneer in modern anthropology, stressed the primacy of culture in human development ("nurture" over "nature"), while emphasizing the diversity, uniqueness, and complexity of all social systems. Margaret Mead, who studied with Boas at Columbia University, placed similar stress on the role of traditions and customs in shaping the character of both individuals and groups. Claude Levi-Strauss, a leader in the field of structural anthropology, viewed individual character as wholly formed by the surrounding culture; ironically, such systems are always invisible (that is, unquestionably "natural") to those who live within them. For Levi-Strauss, the key to individual cultures lay in the structures of language. More recently, Clifford Geertz has echoed the work of literary theorists by rejecting all totalizing systems of thought in favor of the specific truths of "local knowledge."[331]

This interest in the dynamics and power of culture has given rise to the field of cultural studies. The roots of cultural studies are buried deep in the soil of Marxist theory. In the twentieth century, the work of the Frankfurt School of philosophers—including Theodor Adorno, Max Horkeimer, Walter Benjamin, and Herbert Marcuse—was of particular importance to the development of these ideas. The Frankfurt group turned their particular

blend of Marxism and psychoanalysis on the whole realm of popular culture. A key concern of theirs was the central role of the "culture industry"—the producers and distributors of all types of cultural objects—in promoting a "false consciousness" in order to enforce social conformity.[332]

The inherently political nature of this vision of culture was heightened from the late 1960s onward. Western society—and particularly the United States of the Vietnam era—was seen by the most radical thinkers as fundamentally immoral and oppressive. In this climate, the primary role of criticism was understood to be one of resistance and emancipation. In his 1969 book *An Essay on Liberation*, the radical philosopher Herbert Marcuse excoriated the "Establishment" (symbolized most powerfully by the liberal democratic culture of the United States) for "its false and immoral comforts, its cruel affluence." For academic radicals such as Marcuse, "critical theory" was essential to the utopian project of casting off the burden of "repressive rationality" in order to construct a truly free society.[333] Theory and politics were firmly wedded in the aftermath of the failed student uprisings of 1968. Many of this generation turned from the disappointments of real-world power struggles to the safety of a rhetorical revolutionary practice, a cultural criticism that was as much symbolic as truly political in any traditional sense.[334]

This charged constellation of ideas was given new form in the 1970s and early 1980s with the American embrace of French theorists such as Jean-François Lyotard, Guy Debord, Jean Baudrillard, and Michel Foucault. Lyotard's short book *The Postmodern Condition* (1979), exerted enormous influence on the theorizing of postmodernism when it was published in English translation in 1984. Lyotard's most memorable point involves the decline of "metanarratives," the grand unifying ideas (such as the objectivity of science) that provide the foundations of (modern) Western thought. With the fall of these putatively oppressive fictions, Lyotard celebrated the rise of a new, postmodern multiplicity of thought and experience. Guy Debord's most important book, *The Society of the Spectacle* (1967), became known in the U.S. in translation in the late 1970s. Debord described the eclipse of reality by the images and illusions of the mass media. In today's capitalist, consumer culture, he observed, "All that once was directly lived has become mere representation."[335] This flood of representations constitutes a substitute for reality, a perverse expression of the "commodity fetishism" of capitalism, and a tool of social control. Similarly, Jean Baudrillard described postmodern society as dominated by signs cut loose from any real signifying function. In Baudrillard's terms, this is a world without depth or authenticity, a realm of images or replications—"simulacra"—referring only to themselves. Baudrillard conveys this sense of postmodern unreality in a writing style that is hyperbolic and given to breathtaking inversions of common sense. For example, in his book *Simulations* (1983), he pronounced:

> Disneyland is there to conceal the fact that it is the "real" country....Disneyland is presented as imaginary in order to make us believe that the rest is real, when in fact all of Los Angeles and the America surrounding it are no longer real, but of the order of the hyperreal and of simulation.[336]

Michel Foucault's work centers on the analysis of systems of knowledge, truth, and power. For Foucault, "truth" is inevitably a social construction; analysis can never be separated from politics. Foucauit was also deeply interested in the way society normalizes certain behaviors or groups, while marginalizing or stigmatizing others. For him, representation and identity were inextricably linked: to *represent* a person is, essentially, to define him. Finally, Foucault perceived power as the fundamental reality of existence, a force that permeates all aspects of life and shapes the ways we think and act.

It was in this heady intellectual context that the artistic postmodernism of the late 1970s and early 1980s arose. Two points must be emphasized. First, the impressive intellectual pedigree briefly outlined above was, in reality, constructed on an *ad hoc* basis over a period of time. These ideas did not *produce* postmodernism in any simple way; they were, in many respects, deliberately sought out and embraced in order to give more rigorous intellectual form to what had begun as rather open-ended and intuitive artistic notions. In fact, what is perhaps most remarkable is the relatively slow absorption by American theorists and artists of the implication of a vast range of ideas—from Frankfurt School Marxism to feminism—that would come to be seen as foundational to postmodern thought. Second, it bears repeating that the idea of postmodernism was from the beginning multiple and contested. The word itself had been in general circulation since the 1960s, most commonly in the context of new developments in literature and architecture.[337] This early postmodern literature was characterized by an extreme sense of self-reflexivity, a mixing of literary styles and voices, and a blurring of the boundaries between truth and invention. Postmodernist architecture, according to such influential writers as Charles Jencks, rejected modernism's reductive, purist, and elitist tendencies. Instead, it emphasized complexity, eclecticism, narrative, and paradox, and paid homage to the past through a playfully ironic recycling of historical styles and motifs.

By the late 1970s, at least three strains of artistic postmodernism were evident, all of which were seen to challenge modernist attitudes. As outlined by cultural historian Hans Bertens, these varieties of postmodernism were: a return to representation and narrative (as in architecture and painting, for example); a radical attack on representation and narrative (stimulated by literary deconstruction); and a reinvention of the artist as a kind of premodern visionary, healer, or shaman (as in the work of the German artist Joseph Beuys).[338] Each of these approaches had considerable impact on the art of the next two decades. Indeed, this period cannot be coherently understood without acknowledging these variations of "postmodernist" practice. However, it was the second approach that was seen to hold the greatest significance for photography.

The brand of postmodernism that grew from deconstructivist thought saw itself as an explicitly analytical and political practice. The first American critics to turn this critical methodology on contemporary art included Douglas Crimp, Hal Foster, Craig Owens, and Rosalind Krauss, writing primarily in the journals *Art in America* and *October*. It was Crimp's 1979 essay "Pictures," for example, that first combined the tenets of poststructuralism with a cultural interpretation of photography.[339] Owens's 1983 essay "The Discourse of Others: Feminists and Postmodernism" served an equally important critical function by merging postmodernist artistic practice with the insights of feminist

politics.[340] By 1984, two key anthologies of postmodernist essays were available: Hal Foster's *The Anti-Aesthetic: Essays on Post-modern Culture* (1983) and Brian Wallis's *Art After Modernism: Rethinking Representation* (1984).

While these essays and books encompassed a broad spectrum of critical thought, they centered on a belief in the cultural construction of knowledge, and the fundamental nexus of ideology, representation, and power. Thus, while this work was firmly situated in a particular segment of the art world, it sought to radically reorient the artistic enterprise from a putatively narrowly aesthetic activity to a broadly cultural one. To this end, the insights of poststructuralism served the important function of giving leftist cultural politics a new lease on life. If "reality" was entirely a matter of culturally generated codes, those codes had the potential to function as tools and weapons. As Bertens has observed of this era:

> Representation had acquired a sort of materiality. To control representations, which now no longer reflected reality, but instead had come to actively constitute it, was to wield power; to attack representation was to attack that power.[341]

For Foster, for example, this meant an art that was explicitly "oppositional" in nature, a form of cultural "critique which destructures the order of representations in order to reinscribe them."[342]

This emphasis on the nature and power of *representation* made photography the key postmodern medium. In the new cultural universe of all-enveloping "simulacra" and "spectacle," photography became a visual counterpart to language, the means by which "reality" itself was constituted. This vision of photography was reinforced by the rediscovery of such earlier theorists as Walter Benjamin. A cultural critic with very broad interests, Benjamin wrote several important essays on the ideological impact of photography and film in German in the 1930s. The most notable of these—"A Short History of Photography" (1931) and "The Work of Art in the Age of Mechanical Reproduction" (1936)—came to the attention of American artists and critics in translation in the 1970s.[343] Benjamin's 1936 essay, in particular, has been central to the theorizing of postmodern artistic practice. In "The Work of Art in the Age of Mechanical Reproduction," Benjamin outlined the historical transformation of cultural experience brought on by the forces of technology and commodification. According to Benjamin, the new mediums of film and photography were at the heart of a new cultural realm characterized by the mass production and dissemination of images. In this world of endless duplications, the "aura" of the traditional work of art—its sense of presence and uniqueness—was fatally undercut. The substitution of "a plurality of copies for a unique existence" results in a "tremendous shattering of tradition." As a result, "a number of outmoded concepts"—including "creativity and genius, eternal value and mystery"—are effectively swept aside.[344] Thus, Benjamin suggested the central role of photographic technologies in precipitating a decisive break in the nature of cultural experience, a rupture subsequently defined as postmodernism.

The nature and means of this new postmodern photography were outlined by the ideas of Benjamin and the deconstructivists. Beginning with a faith in the wholly mediated nature of experience, postmodernist art sought to undercut the idea of representation as in any way "natural" or unproblematic. Since all images were understood to refer only to other images, the favored artistic strategies were appropriation, pastiche, and simulation. This copying or recombination of already existing images highlighted the status of representation as a perpetual *re*-presentation. Following Barthes's notion of the "death of the author," postmodern artists sought to deny outdated modernist ideas of originality, mastery, and individual genius. Thus, ironically, the most genuinely postmodernist artists were those who were seen to reveal the "mythology" of artistic innovation and authenticity. The very idea of a unique, subjective self was considered a fiction; the artist could only function as a conduit, rather than an inventor, of images.

These and related ideas quickly came to dominate the critical discourse of art photography in the 1980s. As early as the spring of 1984, for example, critic Linda Andre described the utter dominance of postmodernist "orthodoxy in the art-photography world."[345] This dominance ensured that much of the work of this era was shaped or influenced by postmodern thought. Some artist-photographers embraced these ideas and eagerly adopted the postmodernist label; others rejected these notions wholesale and continued to work in familiar ways. Between these extremes, many others incorporated aspects of the postmodern sensibility—its irony, self-reflexivity, criticality, or eclecticism of means—into recognizably "modernist" ways of working.

Despite this broad middle ground of "weak" postmodernist practice, there was a vast gulf between "high" postmodernist theory and the work of mainstream fine-art photographers. In large measure, this reflected the difference between those with a conventional background in the medium and those trained in Conceptual Art or the most wide-ranging interdisciplinary art programs. The antagonism between these camps was heightened by the vehemence with which postmodern theorists disparaged putatively "modern" work. From this perspective, to be anything but postmodern was to be hopelessly retrograde, reactionary, and unlettered. Photographers working in traditional modes had little response to this withering dismissal. More given to picture making than theorizing, few made any real effort to engage postmodernist critics on their own rhetorical terms. The result, for a time, was a heavily one-sided critical climate and an accelerated divergence between the worlds of traditional art photography and its postmodernist, art-world cousin. In truth, the two camps held such opposing values and spoke such different languages that little common discursive ground seemed to exist.

The nature of "high" postmodern practice is best demonstrated in the work of the artists most consistently championed by the leading theorists of the period. These include James Welling, Louise Lawler, Laurie Simmons, Sarah Charlesworth, Vikky Alexander, Ellen Brooks, and Eileen Cowin. Arguably, however, the most influential artists of the postmodern era were Cindy Sherman, Richard Prince, Sherrie Levine, Barbara Kruger, and James Casebere. Each of these five worked in distinctive ways; the variety of their approaches thus suggests the expressive range of this critical aspect of postmodernist practice. Just as importantly, their work signaled a marked divergence from the modernist mainstream. Notably, while each of these artists worked in the medium of photography, none accepted the label of "photographer." While photography was viewed as a useful tool and an intensely interesting cultural subject, these artists felt little allegiance to the medium's artistic tradition. This attitude was underscored by the overall presentation and reception of their images. In the begin-

ning, at least, this work was seen exclusively in art galleries, such as the newly established Metro Pictures, rather than in photography spaces; similarly, it was covered most enthusiastically by art, rather than photography, critics. The writing of a few photography specialists, such as Andy Grundberg, began to bridge this divide, but much of the mainstream photography field continued to view this work as fundamentally alien.

Cindy Sherman is one of the most important artists of this era. By engaging ideas of myth, stereotype, representation, and identity, her pictures give particularly compelling form to the most vital postmodernist ideas. As a result, the outpouring of critical praise and commentary accorded Sherman has far exceeded that given to any other artist of this period. Sherman's rise to fame seemed nothing short of meteoric. Her work first received national notice in Douglas Crimp's 1979 essay "Pictures." Her first one-person exhibition was mounted that year in Buffalo, New York; in 1980, she also showed in New York City and in Houston. Her first retrospective, organized in 1982 by the Stedelijk Museum in Amsterdam, traveled to eight venues in Europe. In 1983, Sherman was included in the Whitney Biennial, and given cover stories in journals as diverse as *Screen* and *Artnews*. Her work has remained central to contemporary art practice ever since.

Sherman's first important body of photographs, the "Untitled Film Still" series, was produced between 1977 and 1980. Sherman used herself as the model for these sixty-nine 8 x 10-inch black-and-white photographs. With the aid of wigs, makeup, thrift-store outfits, and other props, she transformed herself into a cast of half-imagined, half-remembered "types" based on characters from 1950s B-movies, television shows, and fashion magazines [408]. Sherman's repertoire of roles includes dancer, student, working-class housewife, decadent sophisticate, and lonely professional woman. These images create a curious synthesis of authenticity and artifice, "irony and an almost sentimental sincerity."[346] Sherman earnestly and accurately recreates characters that are meaningful only for their fundamental unreality as stilted, generic abstractions. She mimics these stereotypes with both facility and sympathy, thus generating an intriguing tension between the dualities of performance and performer. As critic Peter Schjeldahl has written:

> To say that Sherman "gets inside" her characters is to state the simple truth. In each case, the "outside"—costume, wig, makeup, props—is a concise set of informational cues for a performance that is interior, the dream of a whole, specific life registering in a bodily and facial expression so right and eloquent—albeit "blank," "vacant," and "absent-minded"—as to trigger a shock of deep recognition.[347]

Sherman's "Untitled Film Stills" are remarkably complex in meaning. Since none of the images refer to scenes in actual films, they suggest the key postmodernist idea of "simulacra," copies without originals. Disconnected from any real historical "signifieds," Sherman's pictorial "signifiers" instead spark flashes of recognition all along a cultural continuum of myth and memory. In addition, Sherman's work is clearly gender specific. As Andy Grundberg has observed, these pictures relate "to female cultural roles and to female sexuality, to the glances and body language that signal availability, vulnerability, narcissism, hurt and resentment."[348] This was boldly feminist work: pictures by a female artist that dealt with cultural stereotypes of "the femi-nine." Further, the generic physical quality of Sherman's prints suggested Barthes's idea of the "death of the author" and the postmodernist "refusal of mastery." Made to resemble their mass-produced Hollywood namesakes, these unprepossessing "Film Stills" reveal none of the craft or personal inflection of traditional art photography. Except for the (all-important) context of their production and presentation, there appeared to be nothing to distinguish these prints from the work of a generation of anonymous studio tradesmen. Finally, Sherman's pictures underscore new ideas about the nature of the subject. By portraying herself as a vast troupe of characters, Sherman seemed to deny the existence of any stable, singular identity. As Douglas Crimp observed: "There is no real Cindy Sherman in these photographs; there are only the guises she assumes."[349] This work suggested the contemporary (postmodern) subject as an amalgam of cultural echoes and reflections, kaleidoscopic in its possibilities but without a unified sense of self.

Since her landmark group of "Untitled Film Stills," Sherman has continued to create images of unexpected and unsettling power. Her subsequent series include the "Rear Screen Projections" of 1980-81, which combine Sherman's characters with deliberately flattened and unconvincing cinematic backdrops; the "Centerfolds" of 1981, which utilize the elongated format of the magazine pinup; and her "History Portraits" of 1988-90, in which she depicts herself in the guise of Old Master paintings, adopting both male and female roles with the aid of elaborate costumes and makeup. Since the mid-1980s, Sherman has shown an increasing preoccupation with monsters, sex, death, and decay. In these often horrific and apocalyptic images, the symbolic body is besieged and insulted in various ways. Sherman has progressively removed herself from these scenes, choosing instead to focus on dolls and organic detritus. Despite—or perhaps because of—her own disinclination to theorizing, Sherman's work remains central to the discourse of contemporary art after twenty years in the critical spotlight.[350]

Issues of representation and originality lie at the heart of the work of Richard Prince and Sherrie Levine. While Sherman created her photographs from "nature," as it were, Prince and Levine performed the arguably more radical operation of appropriating theirs from the realm of culture. Prince began his artistic career as a painter. By 1975, he was making collages of photographs and text in the spirit of the Conceptual Art of the period. A turning point came in 1977, when Prince rephotographed advertising images of lush living room ensembles from the pages of the *New York Times Magazine*. Curator Lisa Phillips has described the significance of this decision:

> With the click of a shutter these images were his—stolen, scavenged, appropriated, ready-made. The implications of this act, simple as it may seem, were enormous. In one swift motion, Prince cast doubt on basic assumptions about the authority of photographic images, the ownership of public images, the nature of invention, and the fixed, identifiable location of the author. Where these images real? More real than the original? Where the originals fictitious? Are they in the public domain, part of a common language we all share? Where is the invention in Prince's work? And where and who is the author?[351]

Prince went on to make similar "rephotographs" of other kinds of commercial images, including fashion and cigarette advertisements. His photographs highlight both the strange, weightless

408 Cindy Sherman, *Untitled Film Still #16*, 1978, 10 x 8″

perfection of these pictures and their fundamentally mythic nature. Through Prince's photographs, images of the Marlboro Man or arrays of expensive watches are revealed, somewhat ominously, as both profoundly alienating and comfortingly familiar. According to Hal Foster, Prince seeks "to catch seduction in the act, to savor his own fascination with such images—even as they manipulate him via insinuated desire."[352] Ultimately, Prince may be best understood as a kind of cultural ventriloquist. He both "speaks through" the mythic imagery of popular culture and is himself "spoken through" by it. The result is a reminder of the strange circularity of the signifying process, and the instability of our notions of authenticity and identity.

In a complementary artistic project, Sherrie Levine achieved art world fame for her appropriations from the realm of "high" culture. By 1979, Levine was rephotographing "masterworks" from the history of photography—by Walker Evans, Edward Weston, and Eliot Porter, for example—and presenting them in otherwise unaltered form under her own name. These artistic acts of confiscation, quotation, and repetition underscored a key set of postmodernist ideas. For critic Abigail Solomon-Godeau, for example, "Levine's critical stance is manifested as an act of refusal: refusal of authorship, uncompromising rejection of all notions of self-expression, originality, or subjectivity."[353] For proponents of postmodernism, this strategy of refusal led to an enlarged understanding of history, art, and the codes of representation. In discussing Levine's copy of Edward Weston's 1926 photograph of his son's nude torso, for example, Rosalind Krauss points up the stylistic genealogy of Weston's "original" work, extending back to the traditions of Greek sculpture. She argues: "Levine's act of theft, which takes place, so to speak, in front of the surface of Weston's print, opens the print from behind to the series of models from which it, in turn, has stolen, of which it is itself the reproduction."[354] (The richness of this notion of replication is underscored by the fact that Levine's actual sources were not *original* photographs, but book reproductions or FSA copy prints.) Finally, it was not mere chance that Levine took works by celebrated male artists as her subject. In her appropriation of such works, Levine was seen as a "guerilla feminist" emphasizing the links between authorship and patriarchy, the artistic canon and the historical marginalization of women.[355]

Prince and Levine suggest that, in a world glutted with images, all depictions of "reality" are shaped by preexisting models. This idea is given particularly compelling form by James Casebere, who came to photography from a background in sculpture. In fact, before he took up the camera seriously, Casebere worked briefly as a studio assistant for Claes Oldenburg, the Pop artist known for his monumental sculptures of such everyday objects as clothespins, umbrellas, and badminton birdies.[356] This influence may be sensed in Casebere's preference for simple, familiar motifs, and his own manipulations of scale. By 1978, Casebere was using plaster and cardboard to create tabletop sculptures of generic scenes or environments. These were created explicitly for the camera; the final work of art was Casebere's black-and-white print. Since the mid-1980s, however, he has also presented this work in the form of backlit transparencies and has occasionally exhibited his sculptures as finished works.

Casebere's subjects are distinctly American: rooms in bland suburban dwellings, nineteenth-century factories and churches,

and the ghost towns and landscapes of Hollywood's Wild West. His sculptures of these stereotypical settings are at once too simplified to be "real" and too moody to be mistaken for toys. This curious slippage between reality and artifice suggests a parallel process of mental "modeling" in which myth becomes the template of memory.[357] Like Casebere's other subjects, *Tenement*, 1992 [467], is wholly synthetic yet eerily familiar. It suggests a rich lineage of social-documentary photographs by Riis, Hine, Levitt, Davidson, and many others. Unlike that work, however, Casebere's photograph emphasizes the abstraction of this "tenement," its utter lack of specificity, in order to function as a generalized signifier of poverty and of home. This work prods us to reconsider all these previous photographs of tenements, to question the constructed meaning of that category, and to imagine other ways this complex subject might be pictured.

Barbara Kruger's work reveals a similar interest in deconstructing the codes and stereotypes of representation. In her studies at Parsons School of Design in the mid-1960s, Kruger took classes with Diane Arbus and Marvin Israel. She then worked for several years as a graphic designer for the Condé Nast magazine *Mademoiselle* and other publications.[358] In this work, Kruger grew adept at manipulating typography and pictures for maximum visual impact. She also became intimately familiar with what author Kate Linker calls advertising's "choreography of seduction," or, in Kruger's own words, its "brand of exhortation and entrapment."[359]

By 1978, Kruger was applying these lessons to the production of bold, graphic works combining words and pictures. The first of these united appropriated photographs of women with single words such as "deluded" or "perfect"; soon, these texts had expanded to short phrases or slogans. These confrontational images suppress any obvious evidence of the artist's hand or personality, suggesting instead the disembodied voice of authority. As critic Allan Sekula asserted in an influential essay of 1975: "The overwhelming majority of messages sent into the 'public domain' in advanced industrial society are spoken with the voice of anonymous authority and preclude the possibility of anything but affirmation."[360] By both mimicking and transforming this mode of address, Kruger strives to exploit and undercut its effectiveness. Turning this anonymous voice on its head, Kruger gives it an accusatory, feminist tone; her texts are spoken from the position of a female "we" and addressed to a "you" that is implicitly male. These phrases are crisp, oblique, and allusive, suggesting a pervasive climate of sins and subjugations: "Who is bought and sold?," "We won't play nature to your culture," "Your gaze hits the side of my face," "Your manias become science." The themes of this work include surveillance, consumption, and all manifestations of power: physical, sexual, financial, and military. In *Untitled (You Get Away With Murder)*, 1987 [409], Kruger transforms what appears to be a World War II–era poster (for recycling?) into an evocation of individual and cultural violence. The ominous ambiguity of Kruger's work provides ample room for the free play of both the resentments and the guilty consciences of viewers.

The "high" postmodernism represented by these artists held enormous critical prestige in the art world of the early 1980s. This artistic stance rested on inherently unstable intellectual ground, however. The terms of critical discourse were in a constant state

409 **Barbara Kruger,** *Untitled (You Get Away With Murder)*, 1987, dye couper prin with silkscreen lettering, 30⅛ x 30″

of evolution, and the idea of postmodernism itself was contested from various sides, including the academic left.[361] By the mid-1980s, the orthodoxies of poststructuralism and the postmodern were under attack by a variety of literary critics.[362] Unawed by postmodern theory, some art critics also began deconstructing the presumptions of the art created in its name.[363] A handful of photography critics launched a similar critique.[364] At the same time, "high" postmodernism found itself a victim of its own success. The radical credentials of this work were undercut by its rapid absorption by the existing art establishment. Theorists of postmodernism were astonished—and dismayed—to see works by their favored artists commanding increasing prices in the marketplace, acquired by putatively conservative institutions, and exhibited side by side with "modernist" photographs.[365] In addition, the very breadth of postmodernism's influence served to dilute its conceptual strength. Aspects of the postmodernist approach (or "style") were adopted by many photographers. Uninterested in theoretical rigor, these artists took what they found interesting and rejected the rest. The result was a broadly pluralistic creative climate in which permutations of postmodernism shaded far into the terrain of more traditional practice. This process of absorption was entirely logical, of course, given postmodernism's celebration of heterogeneity. Nonetheless, this adulteration prompted postmodernist critics to undertake the increasingly unrewarding exercise of trying to distinguish between "good" and "bad" (that is, "critical" and "reactionary") postmodernist art.

By the late 1980s, it was clear that the postmodernist marriage of art and theory had gone sour. Both sides were disenchanted. Theorists found fewer and fewer artists that seemed worthy of their praise, while artists lost interest in keeping up with the increasingly rarified permutations of critical discourse.[366] This split had been inevitable. Artworks and theoretical texts both make use of a wide range of ideas, but they operate in fundamentally different ways. The theoretical enterprise is a literary one; it privileges text over imagery, speech and the other faculties over vision.[367] Artists, on the other hand, make things to be examined, even savored; the specificity of materials and the pleasures of sight are central to everything they do. Theorists tended to view works of art as illustrations for their texts, but the best pictures refused to be "useful" in any narrowly programmatic way. This artistic generation discovered for itself that pictures have their own life and cannot be fully expressed in—or subordinated to—language.

Thus, after a brief period of overlap in the late 1970s and early 1980s, the interests of artists and theorists diverged. By the late 1980s, most artists had decided that the postmodernist strategy of appropriation (as well as the associated refusals of the notions of authorship, originality, and subjectivity) was a dead end. They proceeded to work in ways that may have been informed by postmodern thought, but were not submissive to it. Theorists, on the other hand, turned their attention from the relatively narrow field of art to the much broader one of cultural politics. Feminism played an important role in this reorientation by emphasizing notions of power, the marginalized "Other," and the social construction of the individual subject. From this point of entry, theorists proceeded to deconstruct and denounce all manner of cultural sins: capitalism, imperialism, colonialism, patriarchy, racism, and the stereotypes of gender and sexual identity. This activity has taken many forms and names, from debates about "political correctness," "multiculturalism," and the "culture wars" to revisionist deconstructions of the Western literary canon (as a pantheon of "dead white males"), Eurocentric history, and the Enlightenment notions of reason and the individual self.

Ultimately, however, this theoretical enterprise—and the postmodernist world view from which it springs—remains fundamentally unsatisfying. From the beginning, postmodernist thought has been marked by profound paradoxes and contradictions. It is an overarching vision of "reality" based on the denial of all totalizing systems; it is radically egalitarian in sentiment and opaquely elitist in practice; it is an intricately (if often badly) reasoned body of literature founded on a lack of faith in both reason and the truth-function of language. To the degree that it denies any larger standards of value and truth, postmodernist theory fatally undercuts its own claims to moral and analytical insight. The extreme relativism of postmodernist thought is at once liberating and paralyzing; all things are open to debate, but no meanings can be "privileged" above others. Finally, radical attacks on the Enlightenment concepts of logic, freedom, and individuality are deeply disturbing. Critics of Western liberal humanism are entirely too confident that the dismantlement of its legacy will result in an egalitarian utopia rather than a world that is neither liberal nor humane.

Postmodernism was a vastly ambitious—and often incoherent—intellectual project. However, it was precisely its incoherence—its plurality of influences and strategies—that gives the ideas of the late 1970s and 1980s such influence. High postmodernism is dead, the victim of its own hubris and contradictions, but its legacy continues to shape our cultural landscape. This is a mixed blessing, of course, since the original movement never achieved a convincing balance of deconstructive and reconstructive energies. Postmodernism's legacy is, therefore, profoundly contradictory. We have inherited both a deeper respect for cultural difference and a sadly diminished sense of civic identity, a more nuanced understanding of images and a coarsened vision of reality. Postmodernism turned out to be considerably less than originally claimed; it was a phase of modernism (ultimately, perhaps best understood as "Late Conceptualism") instead of a radical break with it. As such, however, its discontents cannot be rejected as wholly artificial or alien. Since they arise from the historical dynamic of modern thought, postmodernism's central concerns will be with us for some time.

Studio Work

The art world's embrace of photography since the 1960s has radically changed our perspective on the medium. Prior to that time, it was possible to talk about a relatively singular photography "world" or "community." That became much more difficult in the postminimalist and postmodernist eras, which rejected both modernist notions of the medium as a discrete and unified practice, and the artistry valued by photography specialists. It was, in fact, the very notion of specialization that artists of the 1970s and early 1980s rejected. Art was to be understood as a matter of ideas rather than technique; thus, it was perfectly legitimate to use the medium without reference to its "own" artistic history

410 Leland Rice, *Untitled (White Door)*, 1973, 17⅜ x 13⅝"

and standards of craft. By discarding the basic notion of photography's expressive uniqueness, the art world distanced itself from mainstream photographic practice. Artists using the camera as their sole expressive tool refused to be called—or critically associated with—"photographers." Not surprisingly, most conventionally trained photographers viewed this as a distinctly odd and unsatisfying situation. However, this split between the realms of art and photography was never absolute. If artists and photographers came to the medium from radically different backgrounds—whether influenced by Ed Ruscha or Edward Weston— a common, if at first tentative, discursive ground did, in fact, exist. As this middle ground of shared attitudes expanded, it came to dominate creative photography in the 1990s. As with the influence of the European New Vision of the 1920s, the net effect of the art world's embrace of photography since the 1960s has been to enlarge our understanding of the medium.

One of the clearest signs of photography's incorporation into the realm of contemporary art was the dramatic rise in studio-based work. In the 1970s and 1980s, there was a sharp increase in the number of photographers working with narrative tableaux, still-life constructions, collaged or manipulated prints, and rephotographed or otherwise appropriated images. Prior to this time, only commercial photographers worked in the studio with any regularity; art photographers assumed that meaningful images could only be found in the fertile unpredictability of the outside world. The turn to the studio was the result of several overlapping trends. Just as young photographers were taught side by side with painters and sculptors in university art departments, so too did they become increasingly comfortable in the creative environment associated with these disciplines. The hybridization of

photography's expressive means reinforced the importance of the studio; a whole range of alternative processes—from gum bichromate to photosculpture—required more than a traditional darkroom to be successfully practiced. Certain technical approaches— such as the nearly immobile Polaroid 20 x 24-inch camera—also necessitated working in studios. Most important, of course, was a basic change in attitude toward the photograph: increasingly, it was seen not simply as a record of the real, but as an expressive reality in and of itself. Thus, for many artistic photographers, the locus of creativity shifted from the world to the mind. Logically, these photographers turned to the domain in which they could exert the most complete conceptual control, the studio.

However varied, this work was united by a basic set of ideas. Studio-based photographers refused to be constrained by the vagaries of chance; instead of attempting to find subjects for their camera, they created them. Moreover, by emphasizing invention rather than simple mimesis, these photographers sought to transcend the perceived limitations of the straight photograph. With few exceptions, they were thus engaged in an implicit critique of the truth-function of photography. This effort was not in itself new, of course; numerous historical precedents have already been noted in these pages. What was new was the sheer dominance of these ideas in the late 1970s and 1980s. One of the most important early exhibitions to focus on this style of work was "Fabricated to Be Photographed," organized by Van Deren Coke in 1979 for the San Francisco Museum of Modern Art.[368] By the end of the 1980s, this trend had been documented in innumerable exhibitions, catalogues, and books, including Anne H. Hoy's *Fabrications* (1987) and *The Photography of Invention* (1989) by Joshua P. Smith and Merry A. Foresta.[369]

This turn to the studio took many forms. On one hand, photographers began applying a "painterly" sense of pictorial construction to the making of otherwise straight photographs.[370] In the early 1970s, for example, Leland Rice began creating such elegantly reductive images as *Untitled (White Door)*, 1973 [410]. His pictures reflect a complex overlay of ideas and influences, including the Minimalist tenets of the time, photography's purist tradition, and Rice's admiration of the work of painters such as Mark Rothko and Richard Diebenkorn. Given the nature of this work, it is not surprising that Rice next turned to photographing the walls of painting studios. These spare images—begun in black and white in 1976 but produced in color after 1977—focus on the delicate veils of paint left behind by the spray-painting of various dimensional objects. These photographs unite a variety of artistic references, including the atmospheric beauty of Color Field painting and the forensic inclinations of Conceptualism.

No artist of this period used the studio in a more systematic process of formal investigation than Jan Groover. Groover, who began her artistic career as an abstract painter, first made serious use of the camera in the early 1970s.[371] Influenced by the Conceptual and Minimal art of the time, she produced color diptychs and triptychs of street scenes and suburban houses that focused on relationships of structure and hue. In 1978, she began working primarily indoors, making color still lifes of kitchen utensils, vegetables, and plants. These highly praised works paid homage to a variety of historical precedents—including Paul Strand's still lifes of 1916-17 and Weston's peppers of 1930—but Groover infused these traditions with a new sense of formal complexity.

These images are purist in technique and abstract in intention: spoons, bowls, and peppers are precisely described but read primarily as disembodied shapes and colors. Groover went on to explore the expressive potential of the still life with remarkable persistence, using both color and black-and-white materials and a variety of camera formats. In *Untitled*, 1989 [469], Groover creates elegant spatial and compositional tensions through the careful arrangement of architectural fragments, various small objects, and a spray-painted background. This image epitomizes the larger themes of her work by creating a compelling synthesis of order and disorder, sense and intellect, the painterly and the photographic.

Another important strain of studio practice emphasized ideas of representation and narrative rather than strictly formal concerns. David Levinthal, for example, was one of the first photographers of this era to focus exclusively on scenes of his own construction. This work was begun in 1972, while Levinthal was a student at Yale School of Art. Fascinated by the power of the camera to both document and transform, Levinthal began recording miniature toy soldiers on tabletop "landscapes." This series came to the attention of fellow student Garry Trudeau (in his pre-*Doonesbury* days), and the two collaborated on a book titled *Hitler Moves East: A Graphic Chronicle, 1941-43* (1977). Levinthal's "documents" of the eastern theater of World War II were combined with Trudeau's historical narrative of the fighting and a selection of quotes from participants. The net effect of this curious hybrid approach was to highlight the slippery nature of photographic truth, as well as the endless complexity of both history and memory. The real subject of Levinthal's photographs was not war but the conventions of war photography: the motifs and traits of representation that have been etched into our cultural memory. While early proponents of postmodernism paid little attention to this work, it seems clear that *Hitler Moves East* anticipated some of the key concerns of that movement.

In his subsequent work, Levinthal has photographed miniature toy figures in order to explore various aspects of our collective visual iconography. His "Modern Romance" series was inspired by the images of *film noir* and the look of Edward Hopper paintings. His "Wild West" pictures, begun in 1986, reflect Levinthal's childhood love of western movies and television programs. Working with the large 20 x 24-inch Polaroid instant camera, Levinthal used this device's inherently shallow depth of field to heighten the ambiguity of his subjects [411]. These images, like the frontier myths they evoke, are both artificial and iconic, a product of fact and romance, all bathed in "the golden light of nostalgia."[372] Levinthal's subsequent series include "American Beauties" (1989-90), "Desire" (1990-91), and "Mein Kampf" (1993-94).

Working on a vastly different scale than Levinthal, Sandy Skoglund creates works that may be understood as an exuberant union of Surrealism and Conceptualism. Skoglund received her M.F.A. in 1972 in painting and filmmaking; her early work was influenced by the currents of Conceptual Art and performance.[373] Inspired by the work of Ruscha, Wegman, and Baldessari, Skoglund took up the camera in 1974. First, she made boldly patterned still lifes of food. By 1979, however, Skoglund was creating room-size installations to photograph. The first of these eerie, claustrophobic images record surreal domestic spaces

411 David Levinthal, *Untitled* ("Western Series"), 1988, Polaroid print, 24 x 20″

in which every surface is covered with an evenly spaced arrangement of plastic spoons or coathangers. With her 1980 work *Radioactive Cats*, Skoglund began making the essential elements of her pictures by hand; for this image, she created over two dozen life-size plaster sculptures of cats. These were painted an unnatural lime green and recorded in a setting that suggested the wreckage of a postapocalyptic world.

Skoglund has gone on to create a series of complex sets in which every element is handmade or arranged. Her *Revenge of the Goldfish* (1981), for example, depicts a school of bright orange fish floating through a suburban bedroom in which the walls and furniture have been painted a watery blue. Similarly, *Fox Games*, 1989 [465], records a group of luminously red ceramic foxes cavorting in a strangely colorless environment. The immediate impact of these works is a function of their dramatic scale, surreal humor, and flamboyant artifice. But the larger meanings of these pictures are more subtle. It is notable, for example, that Skoglund's photographs consistently pose bizarre juxtapositions of nature and culture: goldfish in a bedroom, foxes in a restaurant, giant leaves blowing through an office, or a living room in which every surface is covered with green grass. Beyond being merely amusing or visually arresting, these hallucinatory visions provoke a larger consideration of the relationship between the natural and manmade environments. They suggest at once a dreamlike interpenetration of nature and culture, and the vast difference between these realms.

Like Skoglund, Zeke Berman also fabricates the subjects of his photographs. Trained as a sculptor, Berman originally took up the camera in order to document his dimensional works. By the late 1970s, however, he became fascinated by photography's

433

412 Patrick Nagatani and Andrée Tracey, *Old Black Magic*, 1984, Polaroid print, 24 x 20″

413 Jo Ann Callis, *View*, 1989, gelatin-silver on linen, 42 x 46″

ability to transform a "physical construction into an optical one," and turned to the camera as his primary means of expression.[374] Since that time, Berman's photographs have exploited and deconstructed familiar codes of representation through a witty use of visual puns, figure-ground ambiguities, and *trompe l'oeil* illusions. Berman's *Inversion*, 1990 [466], for example, depicts an assemblage of string, coffee cups, wood, and fabric. These elements are combined to suggest the optical principle of lenticular vision. A pair of coffee cups is depicted in refracted symmetry; strings connecting the two cups suggest the path of light rays converging through a camera's lens to create an inverted image on the film plane. The result is a disarmingly sophisticated meditation on the correspondence of representations to things.

The collaborative works of photographer Patrick Nagatani and painter Andrée Tracey also record elaborately created fictions. These pictures explore the paradoxes of representation while creating a complex mood of playfulness and anxiety. Characteristically, their photographs record sly combinations of real and painted objects. Their *Old Black Magic*, 1984 [412], for example, is a subtle synthesis of a *tromp l'oeil* painted backdrop and actual, three-dimensional objects. The mysterious unreality of the scene is underscored by the theme of the work: the popular iconography of magic, divination, and the occult. In other meticulously choreographed pictures of this period, Nagatani and Tracey explored the threat of nuclear holocaust.[375] Their unorthodox pictorial hybrids, created with the Polaroid 20 x 24-inch and 40 x 80-inch cameras, are painterly in ambition, yet resolutely "purist" in photographic means.

A related approach is seen in the work of Jo Ann Callis. In her studies with Robert Heinecken at UCLA in the early 1970s, Callis realized that it was possible to "make photographs of things inside your head."[376] As a result, however varied in process and subject matter, her pictures have emphasized inner states of thought and emotion rather than the facts of outward experience. Callis first achieved recognition in the late 1970s for her color photographs of men and women in ambiguous, introspective poses. In the early 1980s, she made black-and-white still lifes combining two to six individual images in precisely gridded arrangements. These works present everyday objects in iconic and ominous ways while hinting at a host of possible narratives. These concerns were further developed in Callis's series of "Photo-Linens," begun in 1987. These are strange, hybrid images: photographs (often of clay sculptures) that Callis has transformed into "paintings" by printing on photosensitized linen. Deeply indebted to the legacy of Surrealism, these pictures evoke an eerie sense of melodrama and anxiety. They also pose provocative questions on the nature of reality and representation. For example, *View*, 1989 [413], a key work from this series, depicts what appear to be two earlier levels of representation: a sculptural clay "curtain" and a photograph of yet another, figurative, rendering. Curiously, *View* flattens the "real" sculptural object (the "curtain"), while emphasizing the illusion of the two-dimensional photograph as a "window" on a distant, surreal landscape.

This interest in fabrication and transformation is given radically different expression in the work of Joel-Peter Witkin. Disinterested in any notion of the "decisive moment," Witkin constructs complex tableaux of figures and objects for his camera. In addition, he intentionally disrupts the medium's transparent

realism by scratching his negatives and selectively toning his prints to achieve a uniquely "distressed" look. Witkin's photographs combine this refined, if unorthodox, sense of craftsmanship with often disturbing subject matter. The result is a darkly gothic, theatrical vision of anxiety, anguish, and transgression. Witkin's focus on the themes of religion, sex, physical deformity, and death has prompted one critic to dub him "the court portraitist of purgatory."[377] The subject of Witkin's *The Sins of Joan Miro*, 1981 [468], for example, seems to be either the perpetrator or the imminent victim of some form of medieval punishment. Witkin's work combines an intuitive, often nightmarish quality with a sophisticated knowledge of the leading figures and themes of art history (as suggested in his reference in this work to Miro, the noted Surrealist painter of the 1920s). Witkin's provocative and controversial works were among the most frequently exhibited and discussed artistic photographs of the period.[378]

In the work of Doug and Mike Starn, this interest in the "distressed" physicality of the photograph was raised to an even higher level. In their celebrated work of the mid-1980s, the Starns highlighted the objectness of the photographic print in novel and provocative ways. Prints were toned blue, yellow, or brown, and were creased, torn, scratched, or punctured. These image-fragments were then crudely Scotch-taped together in collages of various sizes and nailed onto mounts or pinned directly to the wall. At the age of twenty-six, only two years after they arrived at their mature style in 1985, these twin brothers were among the stars of the 1987 Whitney Biennial, a leading showcase of avant-garde art. This enthusiastic art-world reception contrasted markedly with the attitude of photographic traditionalists, who tended to view the work with baffled disdain.[379]

The expressiveness of the Starns' work is a function of their dramatic manipulations of scale, the seductive physicality of their pictures, and their bold reinterpretation of key art-historical motifs. In addition, their work makes repeated reference to their own status as twins and to the related idea of the duplicated image. This interest in reflection and reciprocity is exemplified in *Double Rembrandt with Steps*, 1987-91 [470]. In this important work, a photograph of a Rembrandt painting is doubled—as on a playing card—and surrounded by a similarly repeated and inverted image of steps. Finally, the entire work is composed of two symmetrical halves that, like the Starns themselves, combine to form an artistic whole. The result is a pictorial puzzle with almost dizzyingly complex references—to images, ideas, things, and people.

Collaboration is also a key element in the work of David McDermott and Peter McGough. These artists carry their admiration for the past to an extraordinary length. By choice, they wear turn-of-the-century clothing and surround themselves with the artifacts of that era. They even live in houses without electricity or running water. This commitment to creative anachronism is reflected in the subject, means, and presentation of their art. *Very Popular Styled Collars, Comfortable and Sensible, Twenty-fifth Instance of April, 1911, 1991* [414], is characteristic of this approach. These depictions of pairs of starched Edwardian-era collars were made with an antique 11 x 14-inch view camera and printed and framed according to the aesthetic of that period. By highlighting these simple permutations of form, this work evokes both a long-vanished formality of style and the

414 **McDermott & McGough**, *Very Popular Styled Collars, Comfortable and Sensible, Twenty-Fifth Instance of April, 1911*, 1991, palladium prints, each 11 x 14″

Minimal art aesthetic of the late 1960s and early 1970s, with its emphasis on "primary structures." As a result, *Very Popular Styled Collars* deftly challenges notions of artistic progress by blurring the distinctions between past and present, the art of fashion and the fashions of art.

Carl Chiarenza and Adam Fuss use the control of the studio environment to create very different kinds of photographic abstractions. Chiarenza was strongly influenced by two of the major figures in American photography, Minor White and Aaron Siskind. He studied with White in the 1950s, absorbing his penchant for a straight but subjective use of the camera. Siskind was the subject of Chiarenza's doctoral dissertation, published as the definitive monograph *Aaron Siskind: Pleasures and Terrors* (1982). Chiarenza's own photography extends these related artistic traditions. Since 1979, Chiarenza has worked almost exclusively in the studio, using scraps of paper and foil to create miniature "landscapes" for his camera. Although recorded with a classically purist technique, these subjects result in photographs

415 Carl Chiarenza, *Noumenon 283/287*, 1984-85, 18¾ x 29¾" overall

that appear almost completely nonobjective. In the Stieglitz-White tradition of equivalence, Chiarenza's mysterious images suggest a range of subjective states and emotions. Often, as in *Noumenon 283/287*, 1984-85 [415], Chiarenza combines two or more images to create a complex sense of pictorial space and movement. Works such as these suggest vast scale, deep time, and a primordial sense of form coalescing from chaos.

The abstract photographs of Adam Fuss also recall specific artistic precedents: the cameraless images of Man Ray and Moholy-Nagy of the 1920s. First drawn to photography in the 1970s, Fuss has since conducted a remarkably varied exploration of the medium's technical means. "I was attracted to photography," Fuss says, "because it was technical, full of gadgets, and I was obsessed with science."[380] In one of his first mature bodies of work, created between 1984 and 1986, Fuss used a pinhole camera to make dreamlike images of statues and architectural interiors. In the late 1980s, he began a series of direct-positive color photograms on large sheets of Cibachrome paper. His *Untitled*, 1992 [471], is characteristic of the ambitious scale and hypnotic power of these works. Fuss creates these photograms by laying a sheet of photographic paper on the floor of his darkened studio. Directly above it, on the end of a long string, a flashlight with a colored gel over its face is set in circular motion. Each circuit traces a narrow band of color on the paper until the rings fuse in the center into a single glowing orb. The increasing brightness of the image from edge to center is a function of the relative speed of the light source. The curious impact of these pictures—at once grandly theatrical and oddly empty—makes them explicitly postmodern creations; they are at once sublime and entirely self-reflexive.

Patrick Clancy's work demonstrates yet another nontraditional approach to the construction of photographic images. Clancy studied painting at Yale University in the mid-1960s. In 1966, he was a co-founder of Pulsa, an avant-garde group dedicated to unorthodox hybrids of environmental, video, and performance art. In 1979, Clancy began using still photography in a protocinematic manner. These sequential images, which he termed "photoscrolls," are composed of rolls of 35mm stills presented as continuous strips 3½ inches high and as much as 100 feet long.[381] These visual sequences present complex narratives that are both geographic and symbolic; they record Clancy's movement through the world while providing densely orchestrated references to popular culture, art history, and the artist's personal life. Above all, the photoscrolls are about a fundamental heterogeneity of experience, thought, and representational means. As art historian Edward Bryant has observed: "As one moves along the gallery wall on which a photoscroll is mounted, propelled onward from one set of images to the next by the work's energies, visual phrases form themselves from groupings of affinities, dissimilarities, repetitions, disruptions, of images, shapes, colors, personal associations, colliding, clashing, or flowing in majestic silence."[382]

The idea of collage is central to both Clancy's photoscrolls and his later, more conventionally scaled pictures. *Rustler of Language*, 1990 [416], for example, is a collage of color prints and hand-applied letters. The letters spell out the work's title as well as the words "ERASED" and (in reversed form) "UPON LEAVING." This work is a dense matrix of references to art history, literary theory, and Clancy's artistic work in other mediums. One important source of ideas is the motion-study work of the nineteenth-century photographer Etienne-Jules Marey. Marey's early experiments involved measuring the human stride through the use of special shoes connected by pneumatic tubes to a recording device held by the walking or running subject.[383] *Rustler of Language* pays homage to this strange, self-reflexive act of analysis. Another key inspiration is the essay by literary critic Roland Barthes titled "The Rustle of Language." In his performance works of the 1980s, Clancy transformed Barthes's figure of speech into a symbolic human figure, a trickster character called the Rustler of Language who plays with both words and images. This persona dominates Clancy's 1990 collage. Finally, the word "ERASED" alludes to Barthes's idea that literary meaning is always recreated by the reader and is thus in a continual process of erasure and reinscription. The words used by critic

416 Patrick Clancy, *Rustler of Language*, 1990, dye-coupler composite, 47 x 35¾"

Terry Eagleton to describe Barthes's vision of literature suggest the complexities of Clancy's pictures:

> Literature is now less an object to which criticism must conform than a free space in which it can sport. The 'writable' text, usually a modernist one, has no determinate meaning, no settled signifieds, but is plural and diffuse, an inexhaustible tissue or galaxy of signifiers, a seamless weave of codes and fragments of codes, through which the critic may cut his own errant path. There are no beginnings and no ends, no sequences that cannot be reversed, no hierarchy of textural 'levels' to tell you what is more or less significant.[384]

Themes and Variations: Photography at the Century's End

The blending of modernist and postmodernist ideas—a legacy of the Postminimalist era—has produced a broadly pluralistic creative climate. Indeed, what is most characteristic of the photography of the last quarter century is its sheer heterogeneity. The best work is both personal and political in intention, purist and hybrid in technique. All of these approaches may be put to memorable use; one artist's choice of a computer, for example, does not invalidate another's preference for the most cumbersome and anachronistic techniques. In many respects, the creative flavor of this era depends precisely on this radical diversity of artistic interests and means. It is worth recalling, for example, that in the early 1980s, when Cindy Sherman was first showing her photographs, octogenarian André Kertész was still avidly at work, producing the

best pictures of the last half of his long career [417]. The apparent incongruity of this overlap suggests the real variety of photographic practice in this dynamic period. This heterogeneity makes it impossible to identify any single dominant stylistic trend in the past decade or more. Instead, the variety and complexity of recent American photography may be suggested by quickly surveying three broad artistic themes: landscape, the physical or emotional self, and the realm of intimate, familiar experience.

Landscape Photography

While the American landscape has always been an important subject for photographers, it took on new meaning in the 1960s, as concern mounted over the environmental effects of rapid population growth and industrial development. The early role of photography as a means of political persuasion in the cause of conservation was exemplified by the work of Ansel Adams, Eliot Porter, and the Sierra Club. As noted earlier, the Sierra Club began issuing large-format photographic books in 1960, beginning with *This Is the American Earth*. These volumes established Adams and Porter as the best-known landscape artists of their generation and popularized a redemptive—even sacred—sense of the American landscape.

By the 1970s, however, artistic attitudes toward the land had changed markedly. It was no longer enough to make picturesque images of nature. Now, photographers emphasized the ways in which the land was shaped, inhabited, and scarred by humanity. Once revered as a symbol of purity and moral sustenance, the land was now seen by many as evidence of human tawdriness and failure. From this perspective, the brutalization of nature

417 André Kertész, *Paris*, November 9, 1980, 9¼ x 7¾"

437

418 **Lewis Baltz,** *West Wall, Unoccupied Industrial Structure, 20 Airway Drive, Costa Mesa*
(extract from "The New Industrial Parks Near Irvine, California"), 1974, 6 x 9″

stemmed from—and symbolized—a coarsening of the human spirit and imagination. At the same time, poststructuralist theory encouraged an understanding of the very idea of "landscape" as a cultural construct, a projection of historically specific interests and values. As a result, the paradigms of landscape thought became, in themselves, integral to landscape depiction. Thus, in a variety of ways, pictures of the land became most meaningful for their evocation of what lay outside the photographic frame.

This work was motivated in part by the interdisciplinary writings of cultural historians and geographers such as D. W. Meinig, J. B. Jackson, and Yi-Fu Tuan.[385] These writers emphasized the impact of culture on the natural world and defined the landscape as a synthesis of man and nature. As Meinig wrote:

> Every landscape is a scene, but landscape is not identical with *scenery*. The very idea of scenery is limited, a conscious selection of certain prospects, locales, or kinds of country as having some attractive aesthetic qualities. Scenery has connotations of a set piece, a defined perspective...whereas landscape is ubiquitous and more inclusive, something to be observed but not necessarily admired.[386]

Reflecting this point of view, the leading photographers of this era depicted the landscape as a complex interplay of nature and culture, past and present, place and idea.

An important facet of this new attitude toward landscape photography was documented in "New Topographics: Photographs of a Man-Altered Landscape," one of the most significant exhibitions of the decade. Organized in 1975 by Eastman House curator William Jenkins, "New Topographics" featured the work of Robert Adams, Lewis Baltz, Bernd and Hilla Becher, Joe Deal, Frank Gohlke, Nicholas Nixon, John Scott, Stephen Shore, and Henry Wessel. In his catalogue essay, Jenkins acknowledged the enormous influence of Ed Ruscha. His description of Ruscha's photographic books underscored a central theme of the exhibition:

> The pictures were stripped of any artistic frills and reduced to an essentially topographic state, conveying substantial amounts of visual information but eschewing entirely the aspects of beauty, emotion and opinion. Regardless of the subject matter the appearance of neutrality was strictly maintained.[387]

Jenkins concluded his essay with the modest observation that, "If 'New Topographics' has a central purpose it is simply to postulate, at least for the time being, what it means to make a documentary photograph."[388] Thus, in part, "New Topographics" concerned itself with a stylistic approach informed by the lessons of Minimalism and Conceptualism. Something greater than style alone was at stake, however. Despite the apparent neutrality of this work, a coherent set of ideas and opinions was apparent. The seemingly nonjudgmental visions of the "New Topographics" photographers were focused on an American landscape of urban congestion, suburban sprawl, and—in the Bechers' work—industrial exploitation.[389] This exhibition presented a profoundly unromantic vision. The American landscape it revealed was poignant rather than sublime, and held little promise of redemption.

Of all the "New Topographics" artists, Lewis Baltz was the most rigorously formal. However, this formalist method served critical ends; his stance of icy neutrality suggested both the generic nature of his subjects and the values of the culture that created them.[390] One of Baltz's first artistic series, "The Tract Houses"

419 Grant Mudford, *Los Angeles*, 1978, 19¼ x 13⅛"

(1969-71), is comprised of precise views of unremarkable suburban dwellings in the process of construction. The chilling neutrality of these unpeopled scenes conveys a sense of both endless, mechanical replication and the estrangements of modern consumer culture. In Baltz's most influential series, "The New Industrial Parks Near Irvine, California" (1974-75), this vision was directed toward the kind of anonymous glass and concrete structures then being built throughout southern California. Paradoxically, the radiant clarity of Baltz's vision only increases the mystery of these buildings [418]; the elegant sterility of their facades gives no hint of what lies behind the walls.[391] These industrial buildings are almost eerily without character; like Gertrude Stein's Oakland, this seems to be a culture in which there is "no there there." In Baltz's subsequent projects—including "Maryland" (1976), "Nevada" (1977), and "Park City" (1978-80)—he applied an equally austere vision to other aspects of the American cultural landscape.[392]

This aesthetic of precisionist impartiality had a broad impact, as other photographers applied ostensibly "straight" uses of the medium to formal and critical projects. Grant Mudford, for example, created microscopically sharp images of "found" geometric forms. His work combines the Minimalist logic of the grid with an appreciation for both the alienations and incongruities of the urban landscape. The strange impurities of a popularized modernist style are suggested in Mudford's *Los Angeles*, 1978 [419], a curious union of geometric precision and rococo flamboyance.

420 **Robert Adams,** *"Frontier" Gas Station and Pike's Peak, Colorado Springs, Colorado,* 1969 (print 1990), 6 x 6"

Of all the photographers originally grouped under the "New Topographics" label, Robert Adams has remained the most passionate and committed landscape artist. Adams received a doctorate in English and taught for several years before turning seriously to photography in the mid-1960s. While he recognized the achievements of earlier landscape photographers such as Porter and Ansel Adams (no relation), he chose to make work markedly different from theirs.[393] Rejecting any simple faith in a timeless, idealized landscape, Adams creates quiet, bittersweet images that unite a sense of promise and loss, transcendence and failure. His pictures depict the American West as majestic and resilient, but nonetheless deeply scarred and diminished by the shortsightedness of its inhabitants. The high plains of Colorado, for example, where he lived for many years, may be experienced as alive with light and the sounds of wildlife despite their reality as "recklessly cultivated and overgrazed" lands pockmarked by nuclear-missile silos.[394] In both his photographs and essays, Adams mourns our moral and spiritual disconnection from the land we so ungraciously occupy.[395]

Adams's vision of the West is powerfully evoked in images such as *"Frontier" Gas Station and Pike's Peak, Colorado Springs, Colorado,* 1969 [420]. For generations, the purity and liberating potential of the frontier represented key elements of our guiding national myth. Now, however, the frontier is gone, the land domesticated, and the word itself (appropriately truncated in this photograph) has been transformed from cultural ideal to commercial logo. Poignantly, Adams contrasts the aura of the setting sun with the weak glow of an artificial light fixture. At the same time, however, Pike's Peak seems surprisingly unimpressive in stature, while the gas station presents itself as an eminently useful, even welcome, feature of the landscape. Adams's photograph poses no simple questions or answers. Instead, it prods us to consider the contrast between our myths and our realities, and to think of the land as home rather than as scenic backdrop. Adams's eloquent work ranges between angry indictment

and hopeful celebration. Not unexpectedly, his photographs of the litter and smog of Los Angeles, made in the early 1980s, are distinctly downbeat in mood.[396] On the other hand, images such as *Longmont, Colorado,* 1979 [472], suggest those moments of epiphany in which the grandeur of nature and the everyday achievements of human beings converge.

Other important bodies of landscape photographs have been motivated by a combination of aesthetic and political concerns. Emmet Gowin's aerial photographs of the Western landscape include numerous depictions of missile silos and toxic-waste reservoirs, for example. Richard Misrach and Peter Goin present unambiguously critical visions of the abuse and poisoning of the Western deserts caused by military tests of atomic and conventional weapons.[397] Projects such as these reflected the larger climate of anxiety in the 1980s over the threats of nuclear disaster and environmental catastrophe.[398] In a similar vein, John Pfahl used a key emblem of environmental controversy—the nuclear power plant—as the central motif of his "Power Places" series of the early 1980s.

The cultural and historical meanings of landscape are suggested in the radically different works of Lee Friedlander and Carrie Mae Weems. In Friedlander's *Gettysburg,* 1974 [474], the quietude of the scene contrasts dramatically with the horrific and momentous events that took place on this spot 111 years earlier. Similarly, Weems's *Sea Islands Series (Ebo Landing),* 1992 [475], uses the historic resonance of a particular place—the Sea Islands on the Georgia coast—to address the meaning of the American past. This work reflects Weems's identity as an African American while suggesting the influence of oral history and folklore on the content of her art. In a highly effective union of photographs and text, Weems evokes the historic tragedy of slavery and the fierce pride of the Africans who were brought to this country in chains. Her powerful, pointed text infuses these otherwise tranquil landscapes with a tone of outrage, mourning, and commemoration.

Other photographers, including Linda Connor, Rick Dingus, and Mark Klett, have sought to suggest even deeper reaches of cultural and geologic time. Connor's photographs of ancient rock carvings and paintings evoke the presence of prehistoric ancestors while underscoring the timeless human need to communicate by leaving one's mark [421]. Since the 1970s, she has worked all over the world, making allusive and poetic images that suggest the enduring spiritual connections between human cultures and the land on which they live. Her photography is an extended act of homage, commemoration, and sympathetic reinvention—or, in her own words, "a gesture of faith."[399] In the largest sense, Connor's subject is the timeless process of human signification, the enduring attempt to forge a sustaining balance between body and spirit, the temporal and the eternal.

Despite the unconventionality of his means, the central concern of Rick Dingus's work has also been the landscape. Dingus came to photography from a background in painting and drawing. He brought these interests together in 1976-77, when he began drawing on the surface of his black-and-white photographs. In so doing, Dingus sought a synergistic union of two distinct modes of mark making, that of the lens and that of the hand. Combined, these very different methods of representation create a curiously charged pictorial whole. By overlaying a straight photographic image with a gestural network of hand-

421 Linda Connor, *Hands, Canyon de Chelly, Arizona*, 1982, 8 x 10"

422 Rick Dingus, *Notations (Caprock Canyon, Texas)*, 1989, gelatin-silver print with graphite, 35 x 47"

rendered marks, Dingus highlights fundamental issues of representation: the pictorial play between surface and depth, and the blurring of descriptive and expressive intentions. This approach is all the more appropriate given Dingus's fascination for the vast Western landscape and the idea of both geological and mythic time.[400] His *Notations (Caprock Canyon, Texas)*, 1989 [422], for example, represents a complex meditation on various kinds of inscription, annotation, and analogy. In this image, a curious correspondence is established between the standing figure taking notes, his shadow on the ground, and the ghostly suggestion of a levitating human form created by the shadowed indentation of the rock surface. Dingus's gestural marks weave these disparate elements together into a poetic whole, creating an imaginative union of past and present, fact and idea, observer and observed.

Like Dingus, Mark Klett was strongly influenced by his experience with the Rephotographic Survey Project of 1977-79. After the official duration of this project, Klett continued to visit the sites of noted nineteenth-century photographs to make such personal images as *Around Toroweap Point just before and after sundown, beginning and ending with views used by J. K. Hillers over one hundred years earlier, Grand Canyon, 8/17/86*, 1986 [423]. Klett is keenly attentive to the various levels of time represented in this image: the present (carefully noted to the day on the print), the twenty-minute duration ("before and after sunset") between his first and last exposures, Hillers's presence on

this spot a century earlier, and the eons of geologic time necessary to create the canyon itself. Klett highlights the selectivity of Hillers's vision by recording the sweeping vista (between the two river views) that the earlier photographer had ignored. The self-reflexivity of Klett's artistic act is indicated by evidence of his own presence (his hat), and by the segmented nature of his picture, which refuses to be read as a neutral "window" on the world. In a variety of ways, then, this image emphasizes the landscape as a both a natural and a cultural construction.

Lois Conner has made extensive use of the panoramic format to create delicately nuanced interpretations of the cultural landscape. She discovered an old 7 x 17-inch banquet camera while taking an art history class at Yale in Chinese landscape painting. As Conner has recalled: "The hanging scroll and the hand scroll, used by Chinese painters for millennia, seemed like an ideal form for landscape with its exaggerated rectangle that extends the narrative."[401] Since 1984, she has used this camera almost exclusively for her work in China and other Far East countries. In the early 1990s, she also experimented with panoramic composites of up to seven individual 7 x 17-inch negatives [424]. While they carry a much greater amount of visual information, these larger images echo the frame ratio of her single views.

Much of the landscape photography of the 1970s and 1980s focuses on the interaction, or contesting powers, of nature and culture. For example, Emmet Gowin's *A Low Field with*

423 Mark Klett, *Around Toroweap Point just before and after sundown, beginning and ending with views used by J. K. Hillers over one hundred years earlier, Grand Canyon, 8/17/86*, 1986, 20 x 80"

424 **Lois Conner,** *Ngo Gach Street, Hanoi, Vietnam,* 1994, platinum print composite, 16½ x 45″

Drainage Ditches, 1992 [473], presents an aerial view of the overlay of a fractured human geometry on the undulating skin of the earth. Apart from its remarkable abstract beauty, Gowin's picture suggests an age-old dynamic of accommodation, adaptation, and transformation. While radically different in viewpoint, the photographs of Larry Schwarm also record the interplay of nature and culture. Schwarm's *Fire Near Cassoday, Kansas,* 1990 [425], for example, presents an almost apocalyptic vision of a world in flames. These grassland fires are deliberately set every year in order to ensure the optimum conditions for the next cycle of natural growth. Through Schwarm's eyes, however, this scene suggests the overwhelming forces of nature and mankind's rather tenuous control over them.

The vast, latent power of nature was a particularly potent theme in this era. Joe Deal's series "The Fault Zone," produced between 1978 and 1981, documents the path of geological faults without, of course, being able to show them. In such austere photographs as *Colton, California,* 1978 [426], Deal generates an intellectual tension between the quietude of the scene depicted and the immense, unpredictable power lurking below. The instability of the land becomes a metaphor for the transience of the life on its surface. For similar reasons, photographers were motivated to document the effects of dramatic natural catastrophes. Frank Gohlke recorded the destruction wrought by a tornado in Wichita Falls, Texas, in 1979, and both he and Gowin made repeated visits to Mount St. Helens after it erupted in a series of volcanic blasts in May 1980. Their views of the aftermath of this eruption provide an implicit critique of human hubris by depicting a landscape wiped clean (if only temporarily) of organic life.

Directly or indirectly, much of this recent landscape imagery acknowledges traditional notions of the sublime, the power of nature to inspire genuine awe by virtue of its scale, power, and mystery. This new vision of the sublime combines an awareness of the origin of the concept itself in the Romantic era, a sympathy for the skepticism of postmodern thought, and a genuine sense of wonder in the face of nature's ineffability. This complex sensibility underlies the work of such notable photographers as Joel Sternfeld. Sternfeld achieved renown for photographs such as *Approximately 17 of 41 Whales which beached (and subse-*

quently died), Florence, Oregon, June 18, 1979 [427], a record of curious spectators at the site of a baffling mass suicide of whales. Characteristically, this image strikes a charged balance between the majestic and the strange, objectivity and ominousness. Ultimately, Sternfeld's pictures suggest the abiding mystery of things, or, as he puts it, "the question of knowability." He has written:

> Experience has taught me again and again that you can never know what lies beneath a surface or behind a facade. Our sense of place, our understanding of photographs of the landscape is inevitably limited and fraught with misreading.[402]

Lynn Davis's photographs of such colossal and mysterious objects as the pyramids of Egypt and the icebergs of Greenland are deeply informed by the tradition of the sublime. These photographs make reference to specific nineteenth-century sources: the expeditionary work of Francis Frith, who recorded the monuments of Middle East in the late 1850s, and the photographs of the Arctic regions made in 1869 by the team of Dunmore & Critcherson.[403] Davis's *Iceberg #1, Disko Bay, Greenland,* 1988 [476], combines the majestic simplicity of a nineteenth-century vision with a distinctly contemporary mood of elegy. Begun at a time when her friends Robert Mapplethorpe and Peter Hujar were dying of AIDS, Davis's icebergs are symbolic of both the grandeur and ephemerality of human life.[404] No matter how large in size or commanding in presence, every iceberg is destined to melt away into the surrounding ocean, eventually to vanish without a trace.

Since the early 1980s, David Stephenson has provided a compelling reinterpretation of the notion of the sublime. Stephenson—an American who has lived in Tasmania, Australia, for many years—has produced several distinct bodies of work. In varying ways, each of these series has explored the subjective experience of immensity in light of both art-historical tradition and late twentieth-century thought. His "Cloud" images, for example, may be understood as postmodern "Equivalents," pictures that at once question and affirm the possibility of transcendent experience. Similarly, his photographs of Antarctica—a land almost completely unmarked by signs of the human presence—are both beautiful and disorienting. These pictures pay homage to the traditions of topographic and expeditionary photography, while suggesting the metaphysical yearnings at the

425 **Larry W. Schwarm**, *Fire Near Cassoday, Kansas*, 1990, dye-coupler print, 17¼ x 17¼"

426 **Joe Deal**, *Colton, California* (from "The Fault Zone" series), 1978, 11¼ x 11¼"

heart of modernist, abstract art.[405] Stephenson's fascination for infinity reaches a logical culmination in his series "Stars." In these images [498], Stephenson uses various technical approaches—including lengthy, interrupted, or multiple exposures—to interpret and transform the most timeless symbol of transcendence, the star-filled night sky. These memorable photographs are at once elegant "drawings" (recalling the metaphor behind William Henry Fox Talbot's "Pencil of Nature") and poetic meditations on eternity. These photographs effect a remarkable transformation, turning vanishingly delicate beams of ancient light (thousands or even millions of years old) into boldly contemporary, and deeply personal, artistic statements.

Our sense of the sublime is undoubtedly heightened by travel and the experience of extremity. One of the most remarkable landscape photographers of our time, Thomas Joshua Cooper, was born in California and grew up in a series of rural communities in Wyoming, New Mexico, North Dakota, and Oregon. He studied art, literature, and philosophy in college before receiving a graduate degree in photography in 1972. He went on to teach in England, the U.S., and Tasmania before settling in Glasgow, Scotland, in 1982. Since that time, Cooper has produced a body of landscape photographs that is both deeply individual and richly informed by the histories of literature, philosophy, art, and photography.[406] Cooper travels to lonely, austere places to make pictures of primal and essential things. His photographs of rocks, water, forest, and sky suggest the grand natural rhythms of creation, dissolution, and recreation [477]. At once about nothing and everything, these pictures are characterized by a mood of majestic stillness and pregnant silence. Cooper's intense observation and remarkable craftsmanship charge these fragments of nature with an almost unsettling emotional and spiritual aura. His pictures represent a mystical union of seeing and feeling, understanding and imagining; they convey a sense of ritual, pilgrimage, and commemoration.[407] Going firmly against the post-

modernist grain, Cooper is an artist utterly without irony. He uses the camera in an unabashedly spiritual quest: to discover and celebrate the resonance between our inner and outer worlds.

New Identities: Body and Self

Beginning in the early 1970s, new ideas about identity and the corporal self became increasingly dominant. The civil rights, women's, and gay liberation movements of the period all posited a vital connection between identity and physical being. At the same time, however, poststructuralist theory emphasized the "constructedness" of the self and the "death" of liberal-humanist notions of subjectivity. As a result, feminists and other theorists attacked "essentialist" ideas of biological determinism and the "naturalness" of simple, dualistic notions of sexual and gender identities. From various facets of culture—ranging from performance art to rock music—came a new interest in the ideas of theatricality, impersonation, masquerade, and sexual ambiguity. At the same time, the AIDS epidemic of the 1980s highlighted the vulnerability of the body, and spurred ideological and political interpretations of the illness. The multiculturalism of the late 1980s and 1990s placed new emphasis on the values and views represented by differences of gender, race, ethnicity, and class. For these, and other reasons, the themes of identity and the body played a central role in the art and photography of the 1980s and early 1990s.[408]

The body was a central motif in several strains of Postminimalist art. For many women artists of the 1960s and 1970s—including Carolee Schneeman, Eva Hesse, Ana Mendieta, Louise Bourgeois, Hannah Wilke, and Judy Chicago—the body served a charged and multifaceted expressive function. It was, variously, a symbol of power, mystery, frailty, otherness, mortality, and the organic. For male artists such as Chris Burden, Bruce Nauman, Lucas Samaras, and Vito Acconci, the body was sort of found

427 **Joel Sternfeld,** *Approximately 17 of 41 Whales which beached (and subsequently died),*
Florence, Oregon, June 18, 1979, dye transfer (print: 1983), 13½ x 17⅛″

object to be examined, marked, contorted, or violated. Collectively, this work suggested a quest for ontological primacy in the visceral reality of physical existence. In addition, however, the body symbolized a kind of postexistential human condition. It was seen as unheroic, vulnerable, and even abject—both the measure of all things and an endlessly changeable, even chameleon-like, form. The artistic roots of this work included Dada performances, Man Ray's photographs of Marcel Duchamp as Rrose Selavy, the Happenings of the late 1950s and early 1960s, and the influence of experimental theater and dance.[409] Not surprisingly, the body art of the late 1960s and 1970s reflected a number of ideas and approaches: performance, autobiography, shamanism, myth, sexuality, and gender.

Against the background of these artistic influences, a number of important young photographers of the 1970s turned their attention to their own bodies. One of the first of these was Arno Rafael Minkkinen. Born in Finland, Minkkinen came to the U.S. at the age of six. After majoring in philosophy, he studied photography in the early 1970s with Harry Callahan and Aaron Siskind at Rhode Island School of Design. In this period, Minkkinen photographed his own nude figure in a variety of poses and settings. These technically "straight" images are, by turns, symbolic, surreal, comic, and sublime. For example, a pivotal early work in this series, *Self-Portrait, Jamestown, Rhode Island*, 1974 [428], presents Minkkinen's figure as a bizarrely abbreviated sculptural form. In this image, the body is at once weirdly deformed and magically plastic; it appears less than fully human, yet seems to possess the superhuman ability to vanish into thin air. As a whole, Minkkinen's work represents a deeply personal dialogue with nature, an artistic meditation on the tensions between seeing and dreaming, union and alienation.

By the late 1970s, three other important photographers were using themselves as the central subject of their art: Cindy Sherman, Francesca Woodman, and Tseng Kwong Chi. While Sherman's pictures [408] received nearly immediate acclaim from proponents of postmodernism, the works of Woodman and Tseng remained relatively little known until the late 1980s. There are, nonetheless, interesting similarities between these bodies of work, each of which explored new ways of representing identity and the self.

Despite its tragic brevity, Francesca Woodman's artistic career was a remarkable one. Before her death in 1981, at the age of twenty-two, Woodman produced a body of work of some 500 photographs. Raised in an artistic family, Woodman became serious about photography at the age of fourteen through the influence of her teacher, W. Snyder MacNeil. She went on to study at Rhode Island School of Design and came to admire the works of Clarence John Laughlin, Duane Michals, and others. Inspired by this tradition of staged and allegorical photography, Woodman created deeply personal pictures. As she said, her photographs represented an obsessive quest to find "where I fit in this odd geometry of time."[410] In symbolic works such as *Easter Lily, Rome*, 1978 [478], Woodman recorded herself in lonely or distressed settings, suggesting the uncertainties of youth and gender. Due, in part, to the very simplicity of their artifice, these images tap powerful feelings of isolation, vulnerability, and psychological self-absorption.

In contrast to the studio-based, feminist perspectives of Sherman and Woodman, Tseng Kwong Chi explored the theme of cultural identity on a vast public stage. Born in Hong Kong, and a

428 Arno Rafael Minkkinen, *Self-Portrait, Jamestown, Rhode Island*, January 1974, 7¼ x 6¹⁄₁₆"

resident of New York from 1978 until his death in 1990, Tseng traveled widely in the U.S. and overseas. For his "Expeditionary Series: East Meets West," begun in 1979, Tseng recorded himself before a great variety of noted landmarks, including the Statue of Liberty, Disneyland, Niagara Falls, the Lincoln Memorial, Mount Rushmore, and the Golden Gate Bridge [479].[411] In all of these images, Tseng assumes the guise of his alter ego, a fictional emissary or self-appointed ambassador, by dressing in a Chairman Mao worker's suit complete with ID badge. In contrast to the endless variety of Sherman's artistic guises, Tseng's work is based on a laconic singularity of character. However, it is the very flatness of Tseng's fictional emissary that suggests postmodern ambiguities of intention and identity: the subject of these oddly powerful images may be read as either friend or spy, man of the world or perpetual alien.

Issues of identity are also central to such radically different bodies of work as those of Annie Leibovitz and W. Snyder MacNeil. Leibovitz achieved fame in the early 1970s for her striking celebrity portraits for *Rolling Stone* and *Vanity Fair* magazines. The appeal of Leibovitz's bold and stylish work rests on the fact that the faces of her subjects are already widely known. Leibovitz photographs people who are expert in composing themselves—creating a public "self"—for the camera. These notions of theatricality and self-presentation, a consistent theme in her work, are memorably conveyed in her iconic portrait of actress Meryl Streep [429]. Here, Leibovitz uses the most minimal of devices—an application of white make-up and the simple gesture of tugging at this "mask"—to suggest the essential plasticity of the face and the artifice of expression. Is the modern celebrity simply the sum total of her professional guises? Is there a single,

429 **Annie Leibovitz**, *Meryl Streep, New York City*, 1981, Cibachrome print, 10¼ x 10¼″

"real" face that corresponds to an "authentic" sense of identity? Leibovitz's picture suggests that the truths of appearance are, at best, multiple and ambiguous.

Approaching the theme of identity from the opposite direction, W. Snyder MacNeil has recorded the faces of friends and family members over a period of many years.[412] In addition, she has created composite images, combining her own photographs with historical portraits and snapshots. The effect of these works is to suggest the permutations of likeness through time—from one generation to the next, and in the individual process of aging. In 1977, in a further exploration of the idea of familial identity, MacNeil began making "portraits" of people close to her by recording their hands rather than their faces [480]. The haunting universality of these images was enhanced by MacNeil's unorthodox technique: each was rendered as a platinum-palladium print on a translucent sheet of velum. These memorable works heighten our awareness of the body by uniting a sense of monumentality and fragility, the generic and the particular.

A central thread in much of this body-related imagery is life's temporal trajectory: the weight of flesh and the fact of mortality. These ideas are particularly evident in the work of artists such as Chuck Close, John Coplans, Jim Dine, and Kiki Smith.

While Chuck Close came to national prominence as a leading figure in the Photorealist movement of the late 1960s, he has grown considerably beyond that group's original concerns. Between 1968 and 1970, Close produced a series of 9 x 7-foot paintings, each a careful transcription of the data from a gridded photograph. His very first painting was a self-portrait; the others record the faces of friends. More precisely, of course, these paintings depict Close's *photographs* of these faces; as a result, they are monochromatic and as emotionally neutral as common ID photographs. Fascinated by such peculiarities as the "sharp focus data within a sandwich of blur" created by the camera's limited depth of field, Close painted the forehead, eyes, and mouth of each of his giant faces in crisp detail, while the tip of the nose and the ears were out of focus.[413] These remarkable paintings explore the camera's power to transform familiar faces into strangely exotic tracts of epidermal topography.

Despite its apparent descriptive neutrality, Close's art has always been deeply personal. It is significant in this regard that Close's own face has featured prominently in his life's work. This tendency to self-portraiture increased markedly with Close's turn to the Polaroid process in 1978. Since that time, using the special 20 x 24-inch and 40 x 80-inch cameras that Polaroid made available to a select group of artists, Close has produced a major body of both black-and-white and color photographs. Some of these have served as studies for paintings or prints; most often, however, they are conceived and exhibited as finished works. As the number of Close's self-portraits steadily grows over the years, our understanding of his work shifts accordingly. It is now clear that his investigations are as much about time and mortality as about the more abstract ideas of information and representation. This notion becomes all the more apparent in the work Close has accomplished since a life-threatening illness in 1988 left him paralyzed below the shoulders.[414] Since then, Close has produced what is perhaps his most adventurous and impassioned body of work. His recent pictures stand as moving testaments to both the enduring power of vision and the transience of being [481].

430 John Coplans, *Self-Portrait (Hand)*, 1987, 39¼ x 36¼"

A somewhat more expressionistic approach to the themes of aging and mortality is seen in the self-portraits of John Coplans. Coplans turned to photography in 1980, at the age of sixty, after a varied and distinguished career as a painter, critic, scholar, curator, and museum director.[415] His greatly enlarged depictions of his own body explore the topography of flesh in astonishing detail. His back and thighs become veritable landscapes; a hand is transformed into a work of monumental sculpture [430]. The formal inventiveness of these images is remarkable, revealing Coplans's imagination to be as gymnastic as some of his poses. In recording his own body as both colossal and unidealized, Coplans reminds us of the basic reality of our physical existence as well as the inevitability of aging.

Jim Dine, one of the most renowned American artists of the late twentieth century, has only recently adopted photography into his repertoire of expressive means. In 1996-97, Dine created a series of photogravure and inkjet prints from images made with both conventional and digital cameras.[416] These moody images focus on issues of mortality and the self. Several, for example, include the artist's own face, hand, reflection, or shadow. In the most powerful of this group, *Diptych (Self-Portrait)*, 1996 [431], Dine pairs his own face with a leering skull to create a kind of postmodern *memento mori*. The result is an uneasy meditation on both the history of art and the shortness of life.

Another contemporary artist not generally known for her use of photography is Kiki Smith. Smith, who grew up in an artistic family, studied briefly to be a medical technician before turning to art.[417] Appropriately, the central theme of her work has been a deeply visceral sense of the body. In effect, Smith seeks to understand the human vessel from the inside out, and takes an almost fetishistic interest in bodily fluids, the texture of skin, and the weight of flesh. Smith's sculptures of generic figures *in extremis* are most commonly rendered in bronze or in eerily translucent

431 Jim Dine, *Diptych (Self-Portrait)*, 1996, photogravure, 19⅛ x 35¼"

beeswax. This almost alchemical process of transformation—bodies to bronze, flesh to wax—is given yet another level of meaning in Smith's photographs of her sculptures. Her *Untitled*, 1995 [432], for example, reinforces the "humanness" of her artistic works, while creating a dreamlike, funerary effect.

In the work of Robert Mapplethorpe, Andres Serrano, and David Wojnarowicz, the body takes on explicitly political and transgressive meanings. These artists, who came to prominence in the 1980s, became lightning rods for controversy in the "culture wars" of that era.[418] The accusations of obscenity and blasphemy that were directed at these three artists diverted attention from the real coherence of their art, while (ironically) increasing their name recognition outside the relatively narrow realm of the contemporary art world.

Robert Mapplethorpe, the most notorious of this trio, studied painting and sculpture before taking up the camera in the mid-1970s. He became fascinated by the history of photography and drew particular inspiration from the images of F. Holland Day, Edward Weston, Man Ray, and George Platt Lynes. Mapplethorpe mastered the traditional photographic genres of portraiture, floral still life, the nude, and erotica. It was the explicit homosexual content of his erotic images that triggered heated public debate over the issues of obscenity and public funding for the arts in the late 1980s. Despite the provocative nature of this aspect of his work, however, Mapplethorpe's vision is a fundamentally classical and formalistic one. There are no accidents in his finely crafted pictures; everything is precisely ordered to evoke a sense of utopian clarity, a complete removal from the imperfections of the ordinary world. In Mapplethorpe's *Ken Moody*, 1983 [484], this faultlessness takes on an unnerving and almost surreal intensity. Depicted in glowing, symmetrical perfection,

Moody's hairless body seems more machine than human, conveying a hyperreal sense of physical and erotic potency. Mapplethorpe's unashamedly gay perspective, and his death in 1989 from complications brought on by AIDS, ensured that his work would be central to some of the most urgent and contentious social debates of the era.

David Wojnarowicz also dealt with the themes of homoerotic desire and the AIDS epidemic. Entirely self-taught, Wojnarowicz transformed the pain of a troubled upbringing into a powerful and provocative artistic vision expressed through writing, painting, film, and photography.[419] His symbolic self-portrait, *I Was Sitting in a Coffeeshop*, 1990 [482], combines a brief text alluding to his loss of physical appeal with an image of a dead chameleon preserved in formaldehyde. In stark contrast to the idealizing vision of Mapplethorpe, Wojnarowicz's photograph conveys a disturbing, even grotesque, sense of physical decay and death.

Andres Serrano's art also focused on the issues of life and death, while, at the same time, drawing religion into the mix. The subjects of Andres Serrano's art include the most basic elements of human existence: the body's own fluids, which he recognizes as "visually and symbolically charged with meaning."[420] His large abstract photograph, *Precious Blood*, 1989 [483], is at once seductive and ominous. The intense red of this image is rich in symbolism, suggesting passion, warmth, sacrament, and sacrifice. Serrano's choice of this inherently charged subject matter underscores his ambition to deal with such complex issues as the tensions between spirit and flesh, the sacred and the profane.

By contrast, Bill Jacobson's ghostly images suggest the themes of life and death in a quietly meditative way. Jacobson's long-held interest in the reductive mystery of out-of-focus images came together in his "Interim Portraits" of 1992-93 [485]. Despite

432 **Kiki Smith**, *Untitled*, 1995, dye-coupler print, 15 x 22⅝"

their vanishingly delicate tones, these ethereal pictures have a remarkable psychological presence. As one critic has observed, "they are like shadows left by the bombs of Hiroshima, or Pompeiian bodies frozen in time."[421] While these photographs were stimulated by the tragedy of the AIDS epidemic, Jacobson has consistently stressed his interest in a larger, more universal frame of reference. He states:

> Ideally, my pictures function as a metaphor for the way the mind works: simultaneously collecting images while letting others go, fading in the way that memories fade, while alluding to the fact that, historically, photographs have always faded as well... Most photographs in the world seem to be documents of a moment we wish to hold onto forever. My work suggests that these moments, like life itself, are constantly fading into the past.[422]

The poignancy of these images thus stems, in equal measure, from what they suggest of the frailty of both life and memory.

Local Knowledge

The importance of specific environments, life experiences, and cultural traditions is central to Postminimalist and postmodernist thought. In opposition to the putatively universalizing tendencies of modernism, the intellectual currents of recent decades have clearly favored the pluralistic truths of what anthropologist Clifford Geertz terms "local knowledge." As a result, photographers have given increased attention to the details—and complexities—of the many facets of everyday experience.

For photographers such as John Szarkowski, this has resulted in close study of the physical texture and emotional resonance of intimately familiar places. After retiring from the Museum of Modern Art, Szarkowski resumed his former career as a photographer with a warm, patient investigation of his own property, a former farm in rural New York State. His photographs of the hand-hewn nineteenth-century barn that still stands on the farm were collected in the 1997 book *Mr. Bristol's Barn*.[423] These images pay homage to a vanishing way of life, to a tradition of craft, and to the timeless rhythms of nature. They also suggest a loving sense of communion with photography's own past. Pictures such as *Mr. Bristol's Barn #78*, 1994 [486], for example, cannot be fully understood apart from Szarkowski's deep understanding of the work of photographers such as Atget and Stieglitz.[424]

In varying ways, younger artists such Keith Carter, Andrea Modica, and Sheron Rupp all seek to make familiar places new again through the intensity of their perception. Carter established his reputation in the early 1980s as a photographer of the American South. A lifelong resident of Beaumont, Texas, Carter had an artistic epiphany when he realized that he "belonged to a place," indeed, to the "most exotic place" he had ever seen.[425] Since that creative awakening, Carter has produced a generous and hypnotic body of work, pictures that are composed in roughly equal measure of fact and dream. For example, in one of his signature images, *Fireflies*, 1992 [487], Carter uses a shallow depth of field to turn two young boys into graceful specters. This image is about the magic of discovery and the radiant wonder of light, themes that figure prominently in Carter's overall production. For some time, the primary subjects of Andrea Modica's work have been several rural families in upstate New York. Her photographs, such as *Treadwell, New York*, 1987 [494], present a wise, gentle vision of the rhythms of these lives, and of the tensions between childhood and adolescence. Sheron Rupp is also fascinated by the texture of life in small, rural communities. From her home in Massachusetts, Rupp has traveled widely, from Vermont to Washington, in an effort to make photographs that, in her words, "help describe where someone lives and how they live."[426] Her quietly lyrical pictures [433] remind us of the potential wonder of the most commonplace places and events.

Other photographers, such as Jed Devine and Abelardo Morell, have treated the domestic realm as an almost magical space of reverie and discovery. Devine's *Horse, Daylight*, ca. 1980 [434], for example, is at once intimate and expansive; this photograph allows us, in effect, to perceive both fact and fantasy. Similarly, Abelardo Morell's remarkable body of work is the product of a fertile innocence of vision. Formerly a street photographer, Morell's vision changed radically after the 1986 birth of his son. Housebound for lengthy periods, Morell began looking at his own surroundings with the wide-eyed curiosity of a child. The resulting pictures—a tower of toy blocks, kitchen utensils in water, a doll house, an empty paper bag—are astonishingly fresh interpretations of resolutely ordinary things.

In 1991, Morell began his series of camera obscura pictures. These images, which pay homage to the prehistory of photography, were created by turning individual rooms of his house into imaging chambers. In this process, known since the Renaissance, a small aperture acts as a crude "lens," casting a faint, inverted image on the wall of an otherwise darkened space.[427] Inside these room-size "pinhole cameras," Morell places his own camera, which he uses to record the entire scene in exposures ranging up to eight hours. This process holds considerable uncertainty. As critic Richard B. Woodward has noted: "Hostage to the whims of weather, Morell can never predict how the outdoors will look as it slowly leaks into, combines with, and is photographed against the great indoors."[428] After turning the bedroom and living room of his own home into imaging spaces, Morell has subsequently worked in dramatically positioned apartments in New York City [2]. These remarkable pictures remind us of both the technical simplicity and conceptual mystery of the image-making process.

In this same spirit of discovery, Morell has photographed books as unexpectedly allusive objects. Notably, for example, in

433 **Sheron Rupp,** *St. Albans, Vermont,* 1991, dye-coupler print, 15 x 22¼″

434 Jed Devine, *Horse, Daylight*, ca. 1980, palladium print, 7½ x 9½″

Morell's *Book: Pietà by El Greco*, 1993 [499], the pages are both revealed and obscured by light. The angle of illumination turns the illustration of this famous painting into a negative—and almost surreal—image. An interesting process of reproductive transformation is suggested: Goya's painting has been photographed, printed in ink, and then rephotographed, with each step increasingly removed from the reality of the original. Morell's photograph suggests several things: the book as a world unto itself, the creative potential of clear seeing, and the complexities of our image-saturated world.

The intimate bonds of family, friendship, and nurture are central to the work of numerous photographers of this era. For example, Emmet Gowin began photographing his extended family in the mid-1960s, inspired in part by the example of his teacher, Harry Callahan. Characteristic of this early work is Gowin's photograph of his wife and son, *Edith and Isaac, Newtown, Pennsylvania*, 1974 [488], which finds poetic universality in the intimacy of a family "snapshot." This sense of artistic continuity is underscored by the work of Fazal Sheikh, who studied with Gowin at Princeton University in the mid-1980s. Sheikh—the son of a Kenyan father and American mother—

made several trips to East Africa in 1992-93 to record the human toll of the Sudanese civil war. His quiet, elegant photographs [489] convey the enduring dignity of his traumatized subjects, while emphasizing the fundamental importance of familial bonds.

The way families change and reconfigure over time is central to the work of both Milton Rogovin and Nicholas Nixon. Rogovin, who began photographing in 1958 under the influence of Minor White, has recorded the residents of the Lower West Side of Buffalo for several decades.[429] His *Triptych*, 1973, 1985, 1991 [435], which unites three views of a man and his granddaughter made over a span of eighteen years, documents the cycle of life with poignant clarity. Nixon has photographed his wife and her three sisters annually since 1975. Each of these individual views [436] suggests much about the affection and familiarity siblings can have for one another. Together, the pictures in this continuing series provide an almost eerie visual "fast-forward" through the lives of these women, from adolescence through middle age. In its entirety, Nixon's work strikes a singular balance between formal rigor and emotional depth. His photographs of his own children, for example, are at once spontaneous, loving, and mythic.[430] One of the most remarkable pictures from Nixon's other series depicts a young student at a school for the blind touching the hand of a teacher [491]. With an astonishing economy of means, this photograph suggests a variety of profound issues: the powers of vision and touch, the beauty of black and white, the bonds of trust and nurture. Nixon's consistent use of a large 8 x 10-inch camera gives all his prints a radiant clarity and physical immediacy.

In contrast to Nixon's uncommonly fluid use of this large format, Judith Joy Ross uses an 8 x 10-inch camera to make pictures with a heightened sense of formality. For example, in her portraits of local schoolchildren [437], the self-consciousness of posing becomes an important part of the final image. These tender, generous photographs convey Ross's empathy for her subjects. They also suggest the artistic relevance of Heisenberg's "uncertainty principle," which asserts that the act of observation inevitably influences the subject being observed.

This process of mutual interaction is central to the work of both Wendy Ewald and Jeffrey Wolin. In both cases, the artists create images which are then overlaid with handwritten texts by

435 **Milton Rogovin**, *Triptych* (from series "Buffalo's Lower West Side Revisited"), 1973/1985/1991, 7³⁄₁₆ x 6⁵⁄₁₆″, 6⅞ x 6¾″, 7³⁄₁₆ x 6⅜″

436 Nicholas Nixon, *Heather Brown Sawitsky, Mimi Brown, Bebe Brown Nixon, Laurie Brown Tranchin, Allston, Mass.*, 1985, 8 x 10″

437 **Judith Joy Ross**, *Michael Bodner, A.D. Thomas Elementary School (first grade), Hazelton, PA*, 1993, 10 x 8″

or about their subjects. The result is a compelling two-way dialogue within the confines of the photographic frame. Since the mid-1970s, Ewald has taught photography to elementary-school-age students in the U.S. and overseas as a means of self-exploration. One of her more recent projects involved the establishment of a Literacy Through Photography program for the public schools in Durham, North Carolina. In the course of this work, Ewald and the students produced a series of collaborative portraits. After photographing each student, Ewald encouraged them to inscribe their image in some meaningful way. In works such as *Hello, Hello, Hello*, 1990 [**438**], this notion of speaking through one's own likeness produces a remarkable sense of immediacy.

Jeffrey Wolin inscribes narratives on the surface of his photographs in order to suggest meanings that the images alone cannot convey. In picture-text combinations such as *My Father*, 1988 [**490**], Wolin creates a powerful synergy from these very different modes of description, uniting the photographic "present" with his own memories and interpretations of the past. In his subsequent work, Wolin has used this approach to record the images and memories of survivors of the Nazi Holocaust. In writing about this later work, curator Charles Stainback has eloquently described the power of Wolin's image-text combinations:

> His work presents a doubled reflection: the photographic image as a surrogate for the person depicted, and the written word as a surrogate for that person's spoken words. Wolin calls our attention to the quality of both photographs and writing as representations—to speech and handwriting as traces of language, to the photograph as a fleeting moment in the life of the individual. His work thus forces us to go back and forth, reorganizing image and text—a process that requires us to stare into the stranger's eyes and think about not only what is pictured but also what is described.[431]

As works such as these suggest, a central issue in the photography of this era has been the complexity of even "local" truths, the difficulties of expressing in pictures what we know or feel about the people and things that are close to us. This tension between an ideal of "objective" description and the reality of endlessly subjective interpretations is central to the work of a whole generation of photographers, including Nan Goldin, Philip-Lorca diCorcia, Tina Barney, Larry Sultan, and Sally Mann. All of these artists create scenes that are complex hybrids of fact and invention, documentation and stage direction.

Tina Barney's work is typified by *The Skier*, 1986 [**493**], a scene devoid of obvious action, but full of details suggesting the rhythms and rituals of a privileged way of life. Brought up in comfort, Barney records relatively intimate scenes in the lives of upper-crust family members and friends. The "truths" of her pictures are deceptively complex. As Andy Grundberg has written, Barney's

> most important innovation...has been to blend the previously discrete notions of candid and tableau photography. While as viewers we can endlessly debate whether an incident or gesture in one of her photographs has been staged or captured "on the fly," the truth is much more engaging: like social behavior itself, her images are constructed of part-artifice and part-spontaneity.[432]

The self-consciousness of Barney's pictures is a postmodern virtue, an implicit acknowledgment of both her involvement in the scenes she records and the larger impossibility of any truly "neutral" description.

438 Wendy Ewald (with Angelica Molina), *Hello, Hello, Hello, Benson, North Carolina*, 1990, 17½ x 13⅝"

Larry Sultan's project "Pictures From Home" was inspired by his rediscovery of home movies and snapshots made by his parents during his childhood. Sultan responded to the strangeness of these nostalgic records by creating his own, deliberately ambiguous "documents" of his parents' life in retirement. With their (often puzzled) cooperation, Sultan posed his parents in situations that he felt expressed emotional, if not literal, truths about their lives [492]. When his father flatly observed, "For the most part that's not me I recognize in those pictures," Sultan responded, "Don't you think that a fiction can suggest a truth?"[433]

Sally Mann's pictures of her family reflect a clear understanding of the fluid boundary between fact and invention. She has said:

> Sometimes I think the only memories I have are those that I've created around photographs of me as a child. Maybe I'm creating my own life. I distrust any memories I do have. They may be fictions, too.[434]

Mann's provocative photographs of her own young children, begun in 1984, range in mood from the whimsical to the ominous [495]. These beautifully crafted prints combine a Victorian-era romanticism with a wholly contemporary, post-Arbus sense of edginess. This combination gives them a provocative sense of both innocence and worldliness, fantasy and reality. The result, as Mann has succinctly stated, are pictures that are intended to "tell truths, but truths 'told slant,' just as Emily Dickinson commanded."[435]

The truths sought by many artists of this generation center on the anxieties and disconnections of family life. In 1991, Museum of Modern Art photography curator Peter Galassi organized an exhibition on this theme titled "Pleasures and Terrors

of Domestic Comfort." In describing the work of photographers such as Barney and Sultan, Galassi observed:

> Often in their pictures life is unresolved, under stress, a mess of one sort or another; people are at loose ends, or awkward, or sad; very often they are alone if not also lonely. But the photographer's affection is abiding.[436]

In the work of such artists, this idea may be understood to represent a postmodernist version of a previous generation's existentialist insights. In lesser hands, however, this vision of anomie has tended toward a simplistic inversion of Steichen's earlier optimism: a hopelessly dysfunctional Family of Man.

Coda: The Digital Revolution

In 1991, *Fortune* magazine made a bold prediction: "A storm of technological innovation and new products is gathering over the world of photography [that] will blow away much that is familiar—including film, chemicals, and darkrooms—replacing it with a technology that seems both dazzling and old hat: computers."[437] Modern photography was born just over a century ago from the impact of three fundamental technical innovations: the dry-plate, the hand camera, and the halftone. Now, at the dawn of the twenty-first century, electronic technology is creating a revolution of similar magnitude in the production and dissemination of pictures.

These old and new processes operate in fundamentally different ways. In conventional photography, images are created by the action of light passing through a lens to strike a piece of light-sensitive film. The film is then chemically developed to produce a unique negative, from which reasonably identical positive prints can be made by further chemical processing. In digital photography, on the other hand, sensors convert lens-formed images into a binary numerical code that is stored electronically; this coded image may then be viewed on a computer screen or rendered in "hard copy" form by an ink-jet printer. Significantly, this binary code can be manipulated at will to create fundamental reconfigurations of the information contained in the original photograph. These alterations can range from the simple removal of unwanted details to the creation of entirely synthetic images. The digitally produced picture retains no evidence of these alterations; there are no "seams" between its component parts. The speed and flexibility of digital processes make them ideal for many applications in print journalism, advertising, and commercial illustration. Already, digital-imaging processes have thoroughly changed the look of Hollywood films, making the most fantastic special effects seem routine. In the consumer market, however, change has come more slowly. The first electronic still camera, marketed by Sony in 1984, sold poorly, though greatly improved models are now available.[438] While traditional films and processes still dominate the amateur market, the presence of electronic imaging is growing steadily.[439]

As early as the late 1970s, a handful of artists began to take serious interest in the expressive potential of the digital image. Nancy Burson and Peter Campus are among the most significant of these early electronic picture makers. Burson became fascinated by the idea of using the computer to create artificially aged "portraits"—manipulating a photograph of a missing child,

for example, to suggest what he or she might look like five years later.[440] In 1982, Burson began using the computer to create composite portraits such as *Big Brother*, 1983 [496]. This image merges the faces of Stalin, Mussolini, Mao, Hitler, and Khomeini to create a generic portrayal of twentieth-century despotism. Another noted work, *First and Second Beauty Composites*, 1982, contrasts the "ideal" look of film personalities of the 1950s and the 1970s by blending the faces of five stars from each era into single images. In works such as these, Burson produces "portraits" of ideas rather than people, visual averages that are unreal, yet eerily familiar. While the notion of composite portraiture was not new, of course [17, 18], the computer has given this nineteenth-century approach a new technical and conceptual sophistication. Since the early 1970s, the primary means of Peter Campus's art has changed roughly each decade, from video to still photography to the digital image. In computer-generated pictures such as *decay*, 1991 [497], Campus contrasts the synthetic space and definition of this electronic "world" with a fragile emblem of the natural one, a leaf.

As the title of Campus's work suggests, the digital image represents the final erosion of any remaining assumptions about the "simple" nature of representation. The creative possibilities of the digital image seem almost endless; as one artist has said, "Working with a computer is the closest thing to pure thought."[441] In this light, it is easy to draw parallels between contemporary digital work and the desire of earlier photographers, such as F. Holland Day and Alvin Langdon Coburn, to transcend the limitations of the visible. Less certain, however, is the relationship of this new medium to conventional photography. Critics have variously identified the digital revolution as either the death or the rebirth of photography.[442] What does seem certain, however, is the fundamental difference between these processes. Computer technology produces "wonderful things," says Campus,

> but they're not photographs. There isn't really even a name for them yet—people call them digital photographs, or computer-manipulated images. I don't think computer art is a medium. It's a tool, but a very sophisticated and powerful one.[443]

What particularly fascinates Campus is the ability provided by this electronic tool to "control every nook and cranny of a picture."[444] It is the all-encompassing nature of this control that distinguishes the digital image from the traditional photograph. In fact, the unlimited elasticity of the digital process suggests that it has more in common with painting or drawing than photography. In both manual and digital processes, the resulting picture is wholly synthetic. But, while the painter begins with a blank canvas and builds an image through an accumulation of marks, the electronic artist begins with a full "canvas" of one or more photographic images. On the computer screen, the component parts of a photograph become completely fluid, open to endless alteration, deletion, and recombination. The effect of this manipulation is monumental: all remaining links between the image and the world of optical and physical fact are severed. Despite all the abstractions inherent in the photographic process, it remains true that photographs represent optical fact—and thus the world—in reasonably consistent and understandable ways. This does not mean that photographs can be understood simply or taken at face value; skepticism and interpretation are always required to decipher their messages. But, however qualified and complex it might be, photography has an essential "truth function"—a connection to direct visual experience—that cannot be assumed to exist in any digital image.[445]

The power of the traditional photograph is generated, in large measure, from the dynamism of its inherent tensions. Photographers seek to shape the world into meaningful vignettes that conform, on some level, to our preconceived ideas of reality. To do this, we make a great variety of choices, beginning with where we stand and what equipment we use. However, the world is endlessly obdurate, resisting our desire for absolute clarity, balance, and closure. Photographs usually convey both more and less information than we want, slipping through our net of intentions to reveal chaos or formlessness. Successful photographs are born of this struggle between opinion and fact, desire and restraint, simplicity and complexity, achieving a hard-won balance of the things under and beyond our control. However, the digital image sidesteps this struggle entirely, disarming the world's power of resistance at a stroke, allowing us to refashion it effortlessly and endlessly. This is the difference between reality and "virtual reality." One is infinitely varied, unpredictable, dangerous, inconvenient, and instructive; the other provides considerable room for the free play of the imagination, but ultimately is only what we program it to be. As an artistic tool, the digital image is genuinely exciting; as a means of understanding the world, its potential is much less clear.

Unlike the introduction of the dry-plate in the early 1880s, the computer will not result in the overnight transformation of photography as we know it. In 1990, Americans made some 17,000,000,000 conventional photographs, a volume of activity that cannot be quickly redirected from one technology to another.[446] It seems clear that, for some time at least, a significant number of picture makers will continue to embrace traditional photography for its unique capacity to describe, interpret, and shape the world. This continuity will not be the result of simple inertia or nostalgia. At 160 years of age, photography is far from exhausted. As Nicholas Nixon has observed:

> The fictional properties of even the most utilitarian photograph suggest the difficulty of coming to a genuine understanding of the medium's paradoxes, let alone its power. As it is somewhere on a cloudy continuum between the literary and the painterly, so likewise does it hover between fact and point of view...[447]

Photography has profoundly influenced the way we look at—and think about—the world. It remains rich with aesthetic possibilities, some comfortably familiar, others deeply mysterious or unexpected. As Wright Morris has so eloquently written:

> However varying their points of view, all photographers share the common field of vision that the mind's eye, and the camera's eye, has imposed on this century. Quite beyond the telling of it, as well as the seeing of it, exceeding both our criticism and our appreciation, the camera's eye combines how we see with whatever is there to be seen. What it has in mind for us may not at all be what we have in mind for ourselves.[448]

439 Charles Moore, *Birmingham Riots*, 1963, 10½ x 13¼"

440 **Larry Burrows,** *Reaching Out, First-Aid Center During Operation Prairie,* 1966, dye transfer (printed 1993), 15½ x 23″

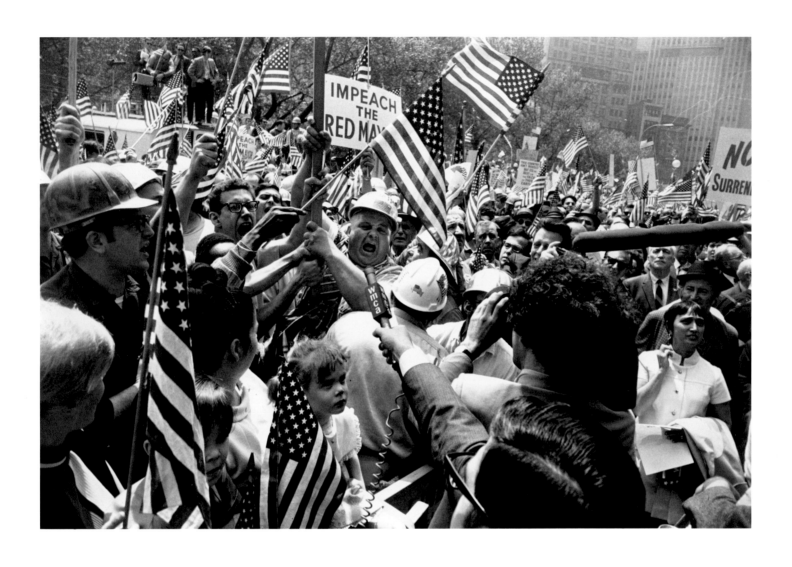

441 **Garry Winogrand,** *Hard Hat Rally,* 1969, 9 x 13½"

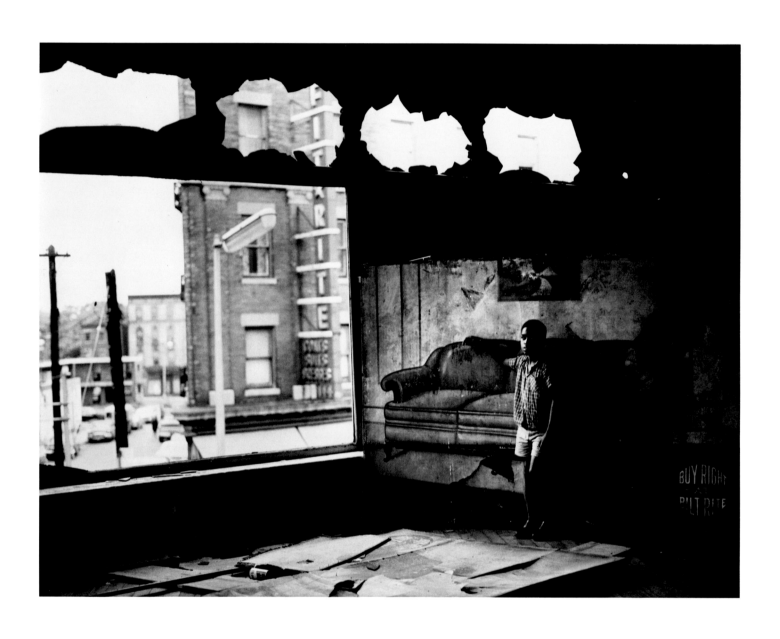

442 **Arthur Tress,** *Boy in Burnt Out Furniture Store, Newark, N.J.,* 1969, 10¼ x 13⅜"

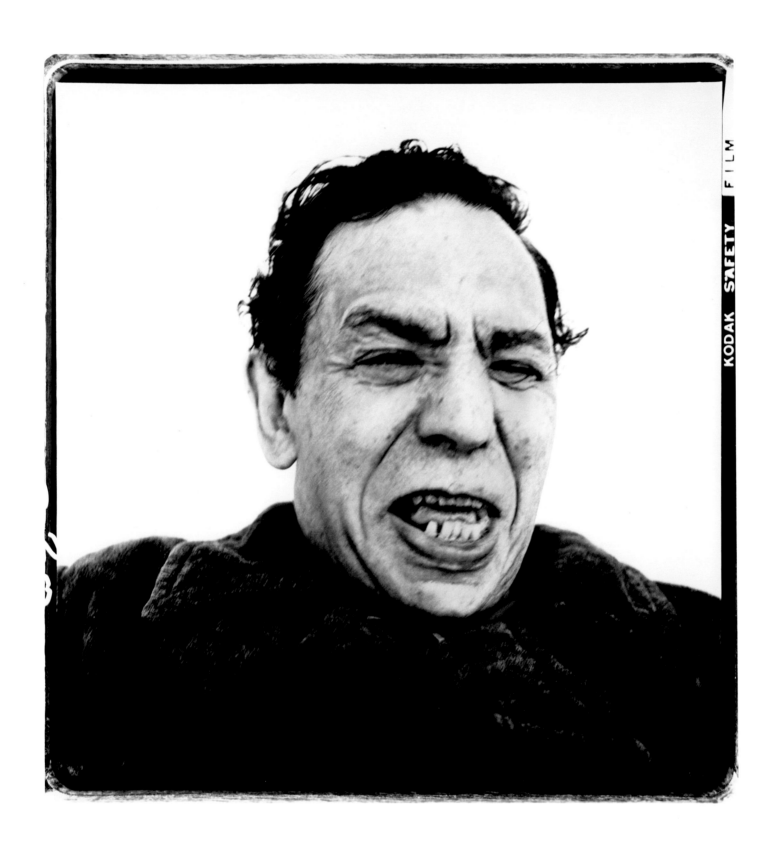

443 Richard Avedon, *Oscar Levant, Pianist, Beverly Hills, California, 4/12/72*, 1972, 16½ x 15¾″

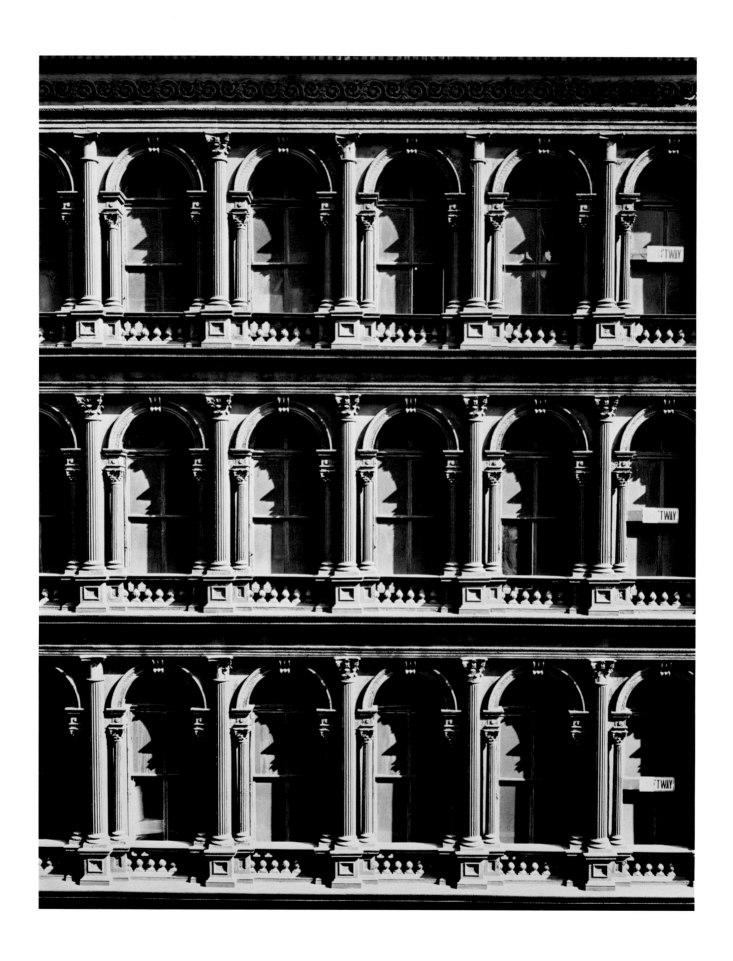

444 **Evelyn Hofer,** *Haughwout Building,* 1965 (print: ca. 1995), 16½ x 13″

445 Ralph Gibson, *Face*, 1981, 12⅜ x 8⅛″

446 **Tod Papageorge**, *New York Pier*, July 5, 1976, 10½ x 15½"

447 Henry Wessel, *Santa Monica, Ca.*, 1989, 22⅝ x 15″

448 Michael Spano, *Fruit Cup*, 1989, 45¼ x 35⅜″

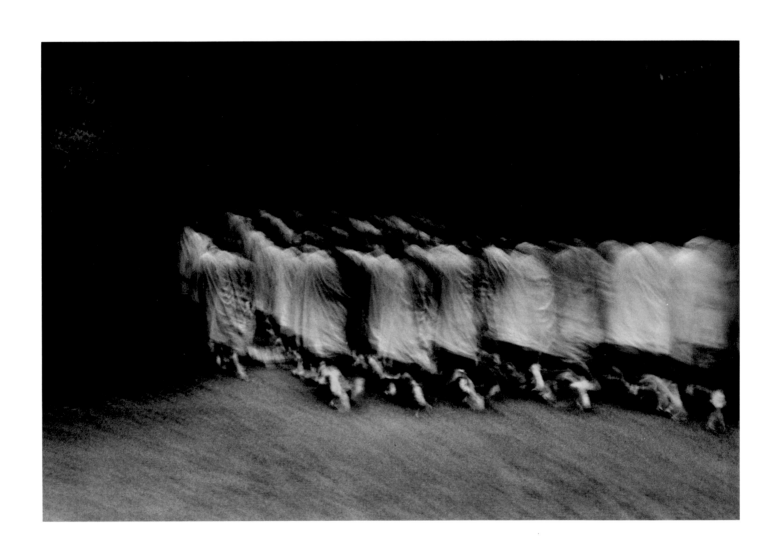

449 Petah Coyne, *Untitled #735*, 1992, 33 x 49″

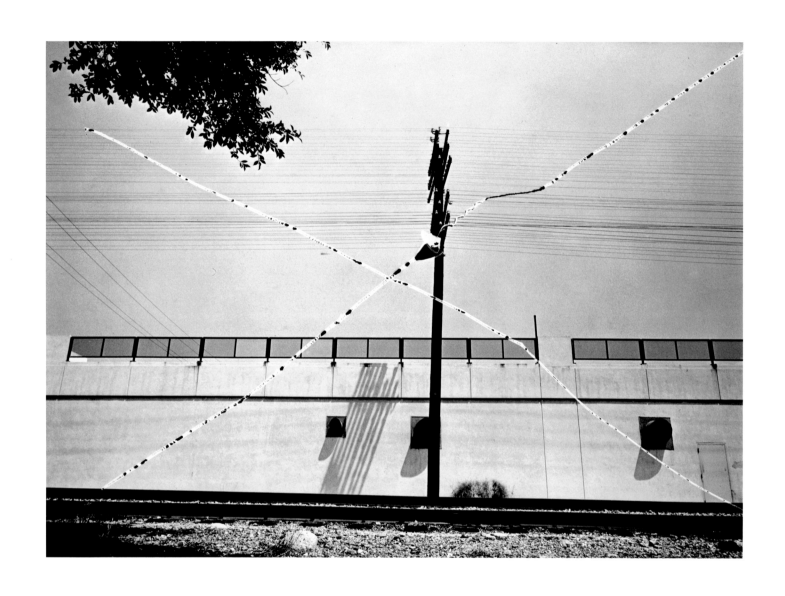

450 **Thomas F. Barrow,** *Pasadena Parallel,* 1974 (from series "Cancellations [Brown]"), 9¾ x 13½″

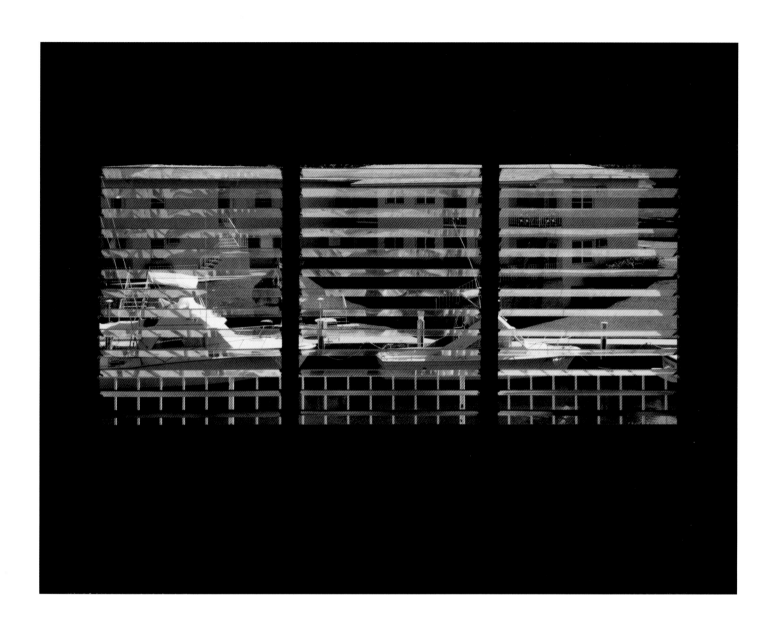

451 **John Pfahl,** *1390 South Dixie Highway, Coral Gables, Florida*, 1979 (from series "Picture Windows"), dye-coupler print, 20 x 24″

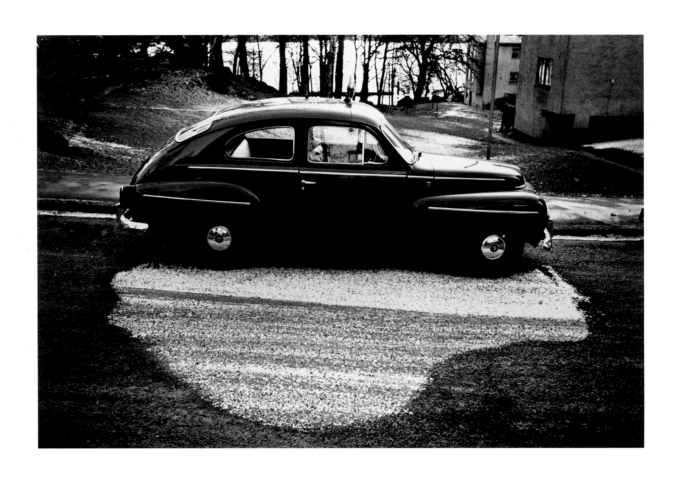

452 Kenneth Josephson, *Stockholm*, 1967, 8 x 12"

453 Hiroshi Sugimoto, *U.A. Walker, New York*, 1978, 16⅝ x 21½"

454 William Eggleston, *Jackson, Mississippi*, 1971, dye transfer (print: 1986), 13½ x 21″

455 **William Eggleston**, *Tricycle*, ca. 1971, dye transfer (print: 1980), 12 x 17½"

456 **Stephen Shore,** *La Brea Ave. and Beverly Blvd., Los Angeles, Ca.,* 1975 (print: 1998), 14 x 17½"

457 **Joel Meyerowitz,** *Provincetown,* 1977 (from "Bay Sky Series"), dye couper print, 7⅝ x 9⅝"

458 **Harry Callahan**, *Morocco*, 1981, dye-transfer print, 9⅝ x 14½″

459 **Alex Webb**, *India*, 1981, Cibachrome print, 12¾ x 19¼"

460 Andy Warhol, *Lana Turner*, 1976-86, gelatin-silver prints with thread, 27 x 21½"

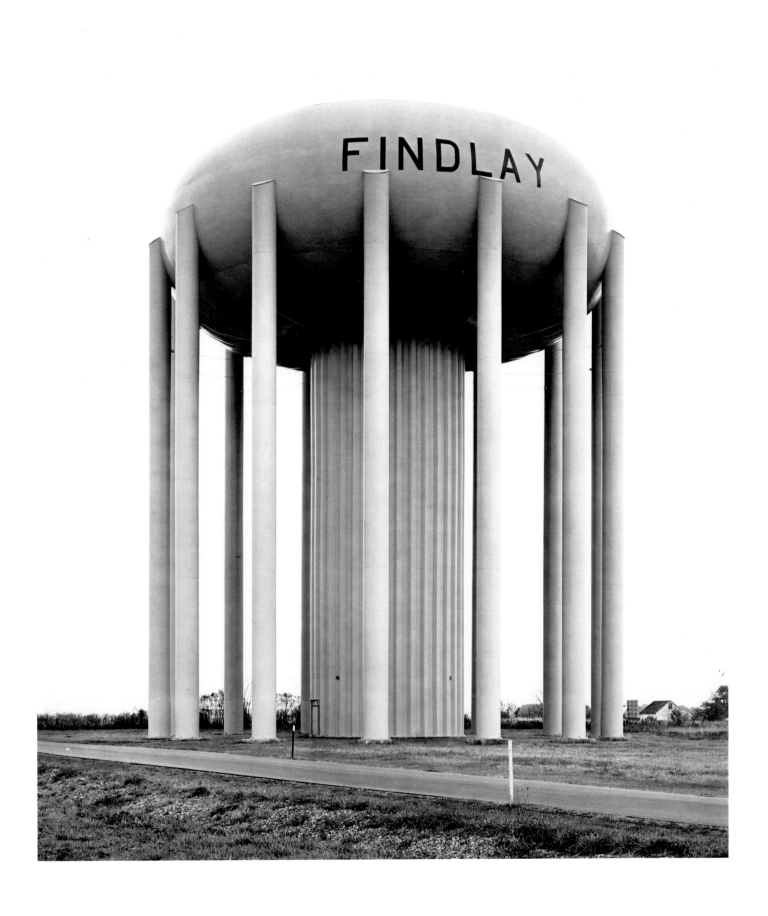

461 Bernd and Hilla Becher, *Water Tower, Findlay, Ohio, U.S.A.*, 1977 (print: 1989), 24 x 20⅜″

462 **Gordon Matta-Clark,** *Splitting: Interior,* 1974, 29¾ x 39½"

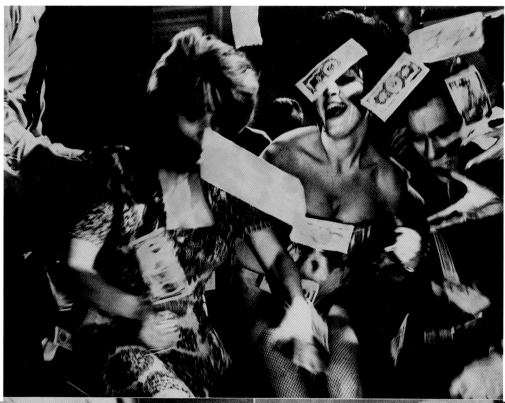

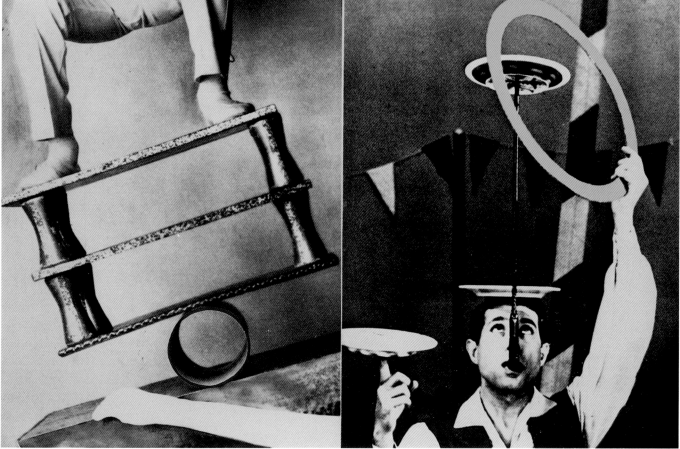

463 **John Baldessari**, *Life's Balance (With Money)*, 1989-90, photogravure with color aquatint, 49 x 40½"

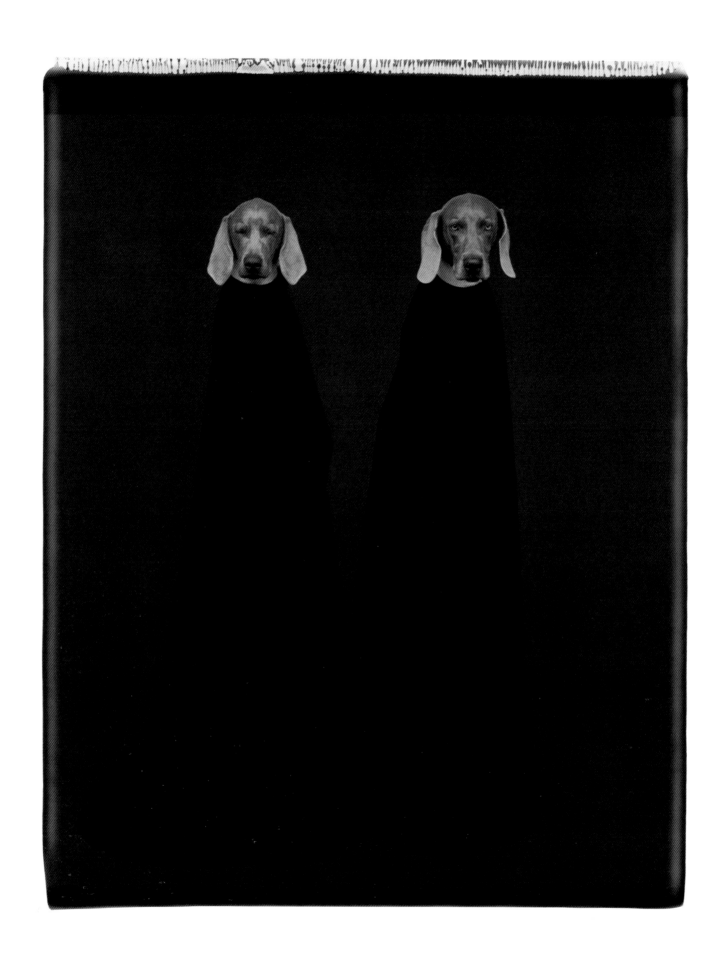

464 William Wegman, *Innocence and Guilt*, 1990, Polaroid color print, 24¼ x 20½″

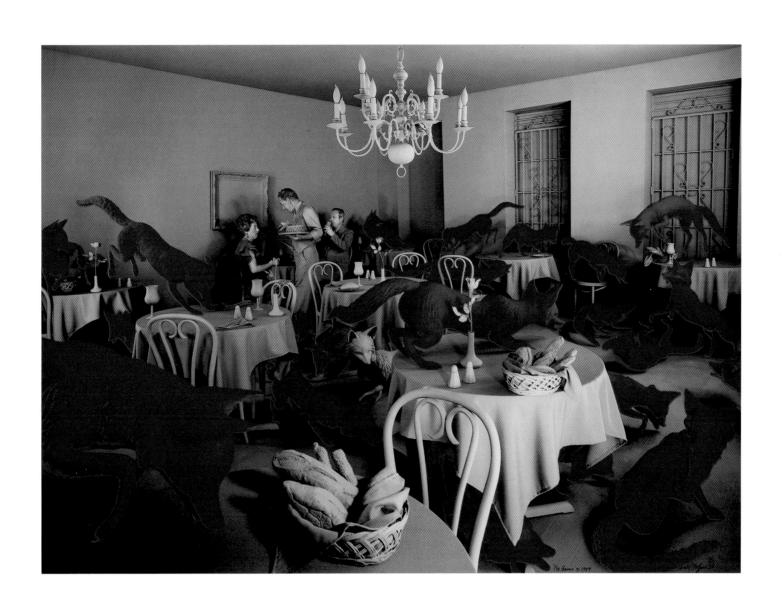

465 **Sandy Skoglund,** *Fox Games*, 1989, Cibachrome print, 47 x 63¾"

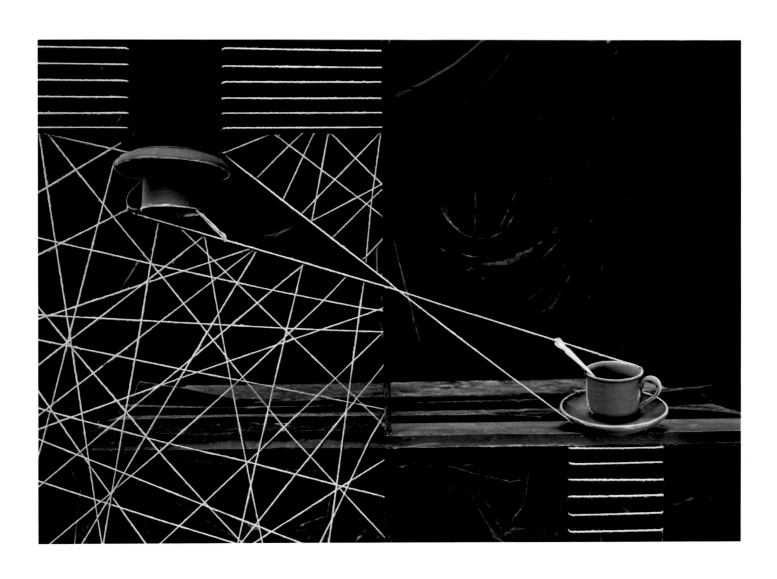

466 **Zeke Berman,** *Inversion,* 1990, 25½ x 36¾″

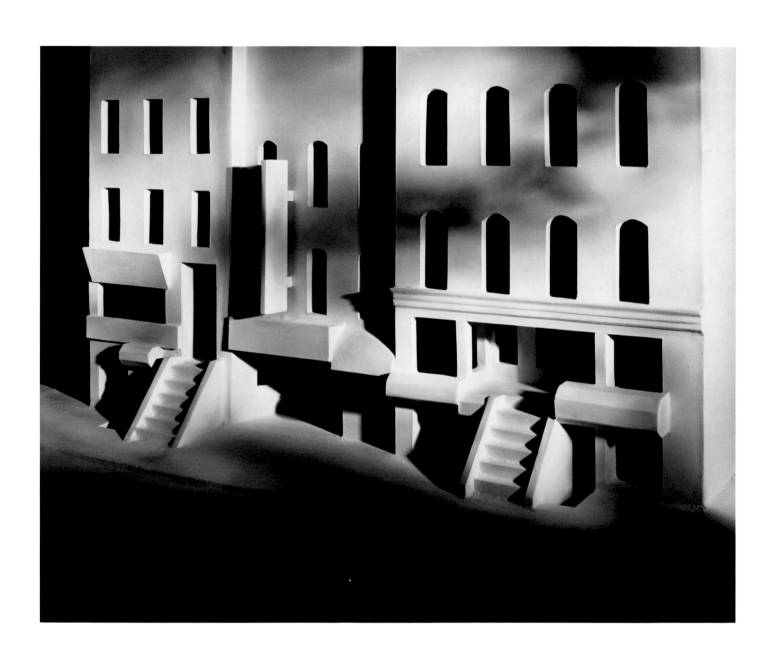

467 James Casebere, *Tenement*, 1992, 40 x 50"

468 Joel-Peter Witkin, *The Sins of Joan Miro*, 1981, 14⅝ x 14¼"

469 **Jan Groover,** *Untitled*, 1989, dye coupler print, 22¾ x 28½"

470 **Doug and Mike Starn,** *Double Rembrandt with Steps*, 1987, toned gelatin-silver prints with ortho film, tape, glue, silicone, and plexiglass (printed 1991), 26½ x 26½" overall

471 **Adam Fuss,** *Untitled*, 1992, Cibachrome print, 64 x 49½"

472 Robert Adams, *Longmont, Colorado*, 1979, 14½ x 14½"

473 **Emmet Gowin,** *A Low Field with Drainage Ditches, near the Department of Energy,*
Savannah River Nuclear, South Carolina, 1992, 9½ x 9⅜"

474 Lee Friedlander, *Gettysburg*, 1974, 7½ x 11″

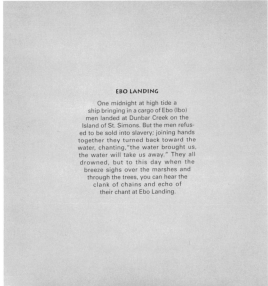

EBO LANDING

One midnight at high tide a
ship bringing in a cargo of Ebo (Ibo)
men landed at Dunbar Creek on the
Island of St. Simons. But the men refus-
ed to be sold into slavery; joining hands
together they turned back toward the
water, chanting,"the water brought us,
the water will take us away." They all
drowned, but to this day when the
breeze sighs over the marshes and
through the trees, you can hear the
clank of chains and echo of
their chant at Ebo Landing.

475 **Carrie Mae Weems,** *Sea Islands Series (Ebo Landing),* 1992, two gelatin-silver print with text panel, 60 x 20" overall

476 **Lynn Davis,** *Iceberg #1, Disko Bay, Greenland,* 1988, 28 x 28″

477 **Thomas Joshua Cooper,** *Archipelago, At the End of the World (The Edge of the Celtic World, No. 2);*
The Northernmost Point, The Gord, Isle of Unst, the Shetland Islands; From the Western Isles to the
Shetlands, North Northwest to North Northeast, 1989-1995, 16¼ x 23⅛"

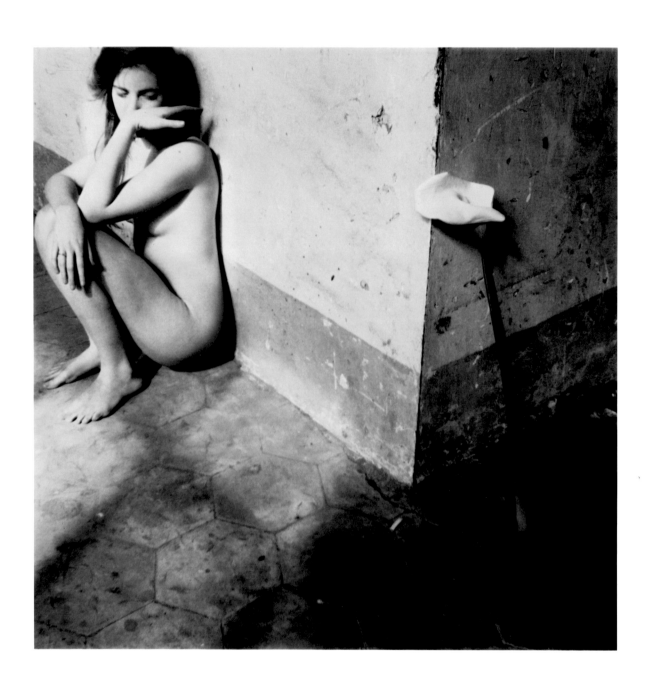

478 Francesca Woodman, *Easter Lily, Rome*, 1978, 6¼ x 6¼"

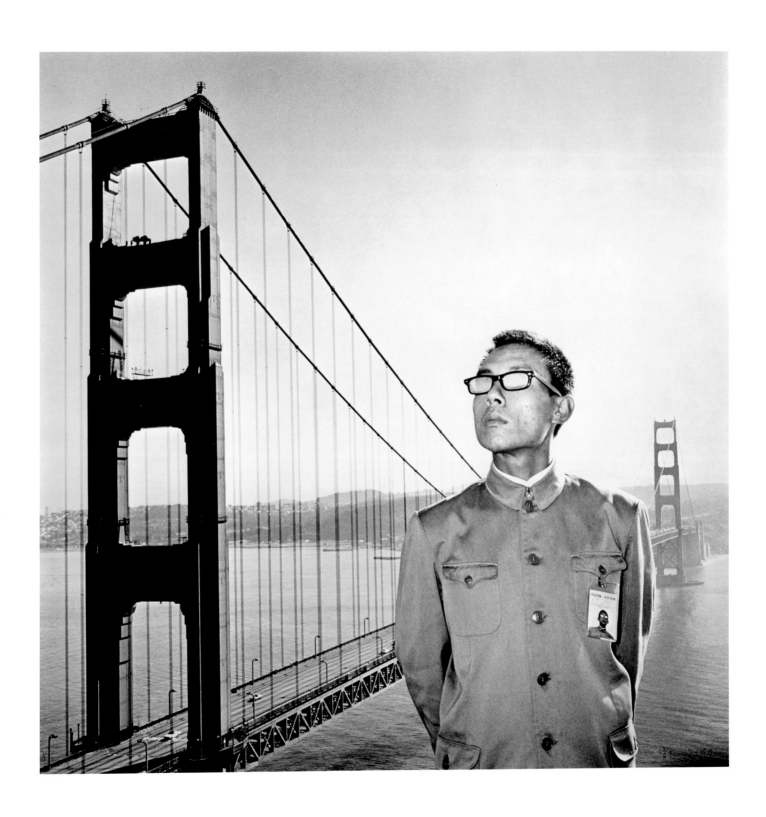

479 **Tseng Kwong Chi,** *San Francisco, Golden Gate Bridge* (from "Expeditionary Series, East Meets West"), 1979, 36 x 36″

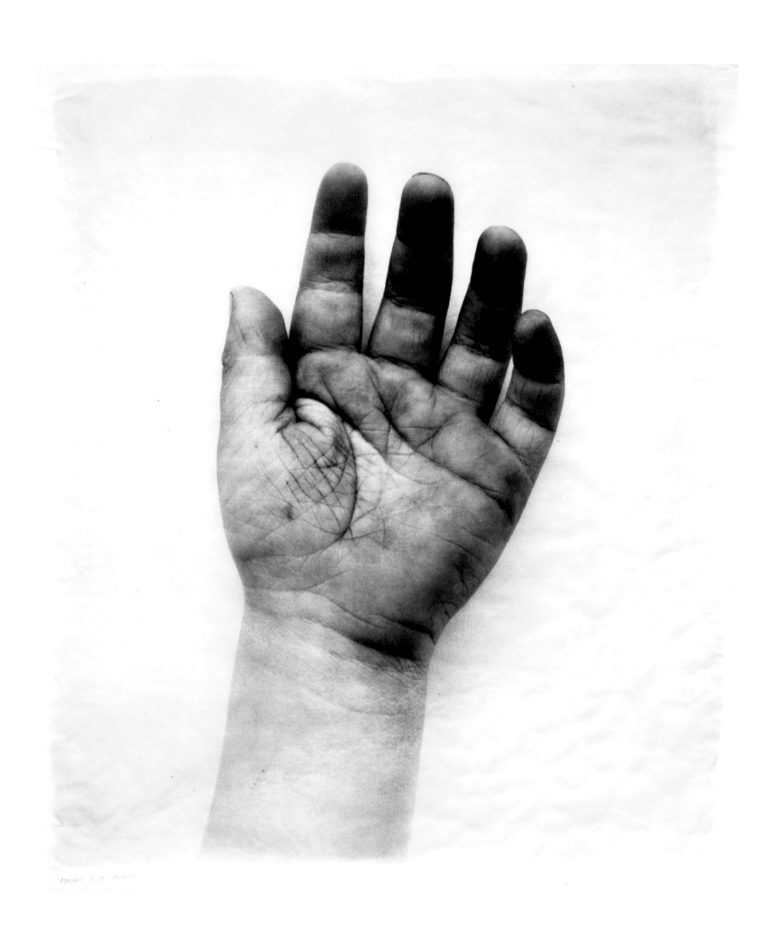

480 W. Snyder MacNeil, *Adrian Sesto*, 1977, platinum and palladium on vellum (print: 1987), 18¾ x 16½″

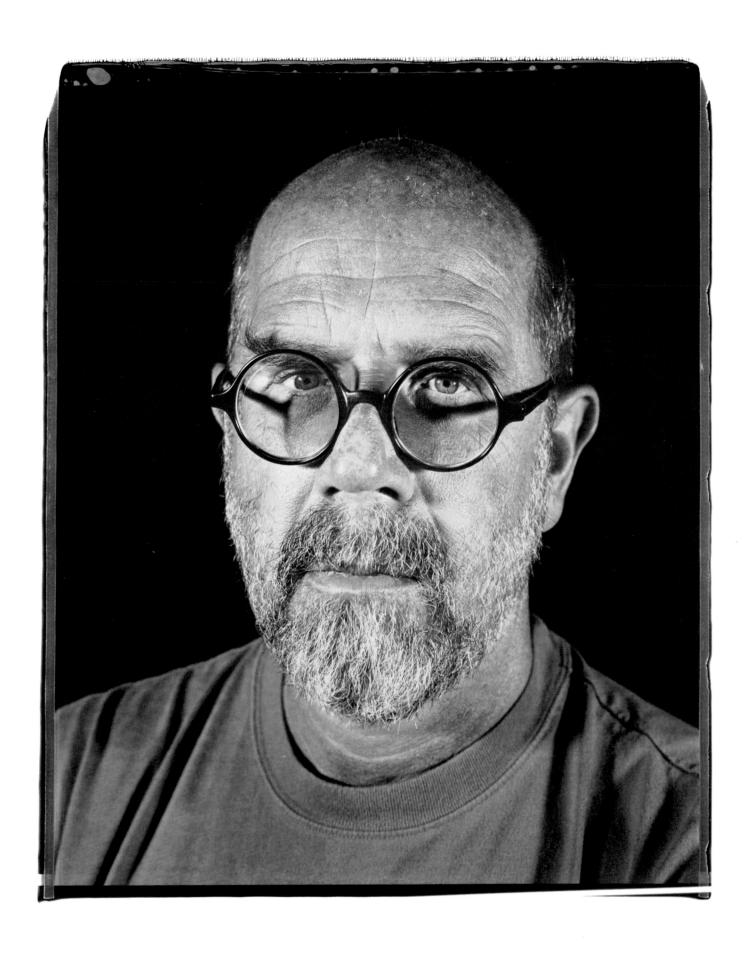

481 Chuck Close, *Self-Portrait*, 1996, ink-jet print, 38⅝ x 32″

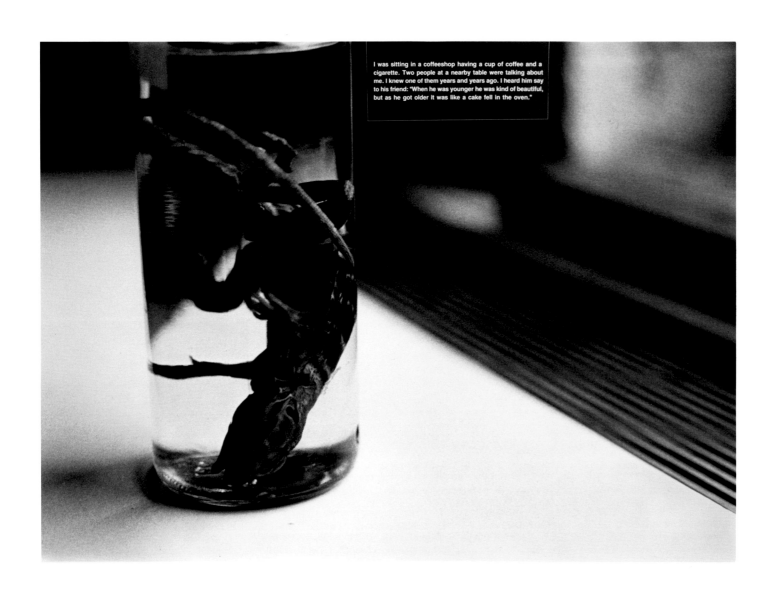

Inside the image: I was sitting in a coffeeshop having a cup of coffee and a cigarette. Two people at a nearby table were talking about me. I knew one of them years and years ago. I heard him say to his friend: "When he was younger he was kind of beautiful, but as he got older it was like a cake fell in the oven."

482 David Wojnarowicz, *I Was Sitting in a Coffeeshop*, 1990, 13¾ x 19⅛″

483 **Andres Serrano,** *Precious Blood*, 1989, Cibachrome print, 40 x 27½"

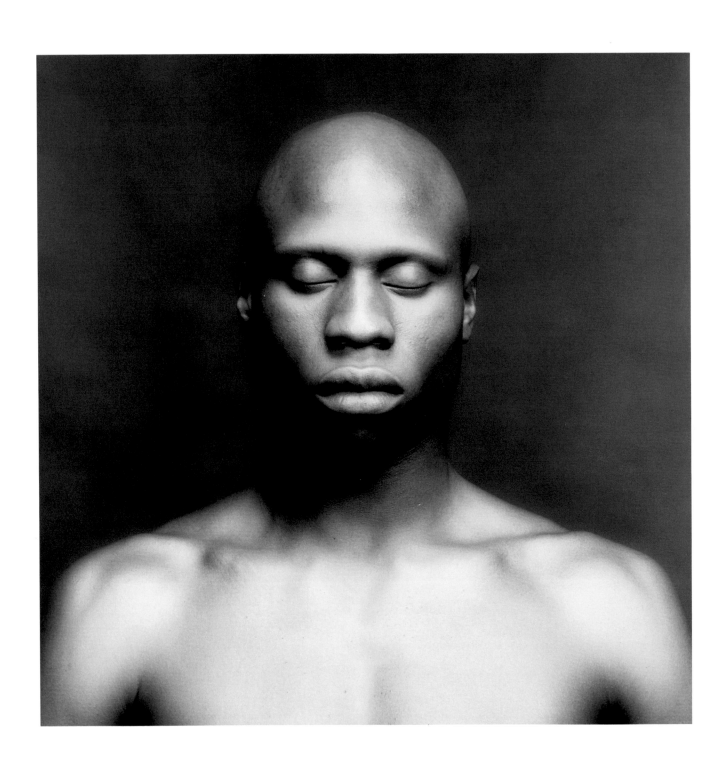

484 Robert Mapplethorpe, *Ken Moody*, 1983, 15⅛ x 15¼"

485 **Bill Jacobson,** *Interim Portrait #384*, 1992, dye-coupler print, 24 x 20″

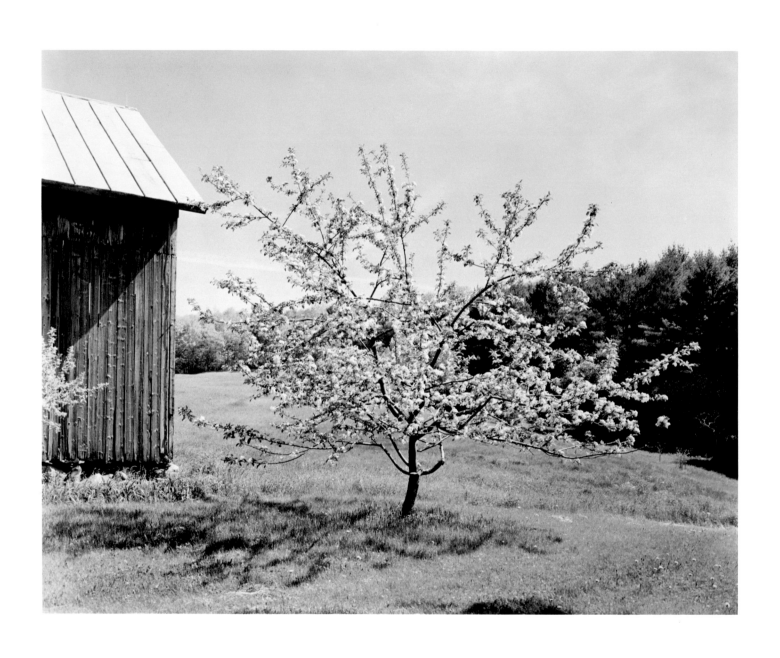

486 **John Szarkowski,** *Mr. Bristol's Barn #78,* 1994, 15¼ x 19⅜"

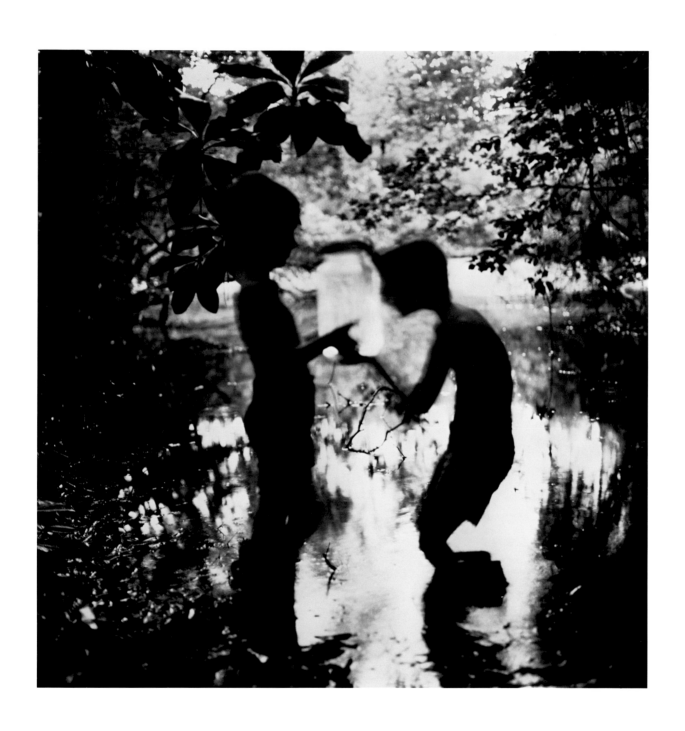

487 Keith Carter, *Fireflies*, 1992, 15 x 15"

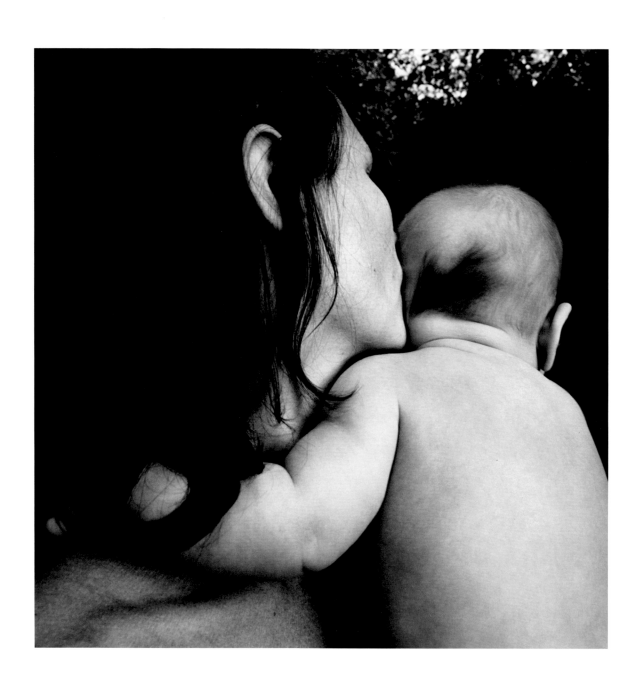

488 Emmet Gowin, *Edith and Isaac, Newtown, Pennsylvania,* 1974 (print 1982), 6¼ x 6¼"

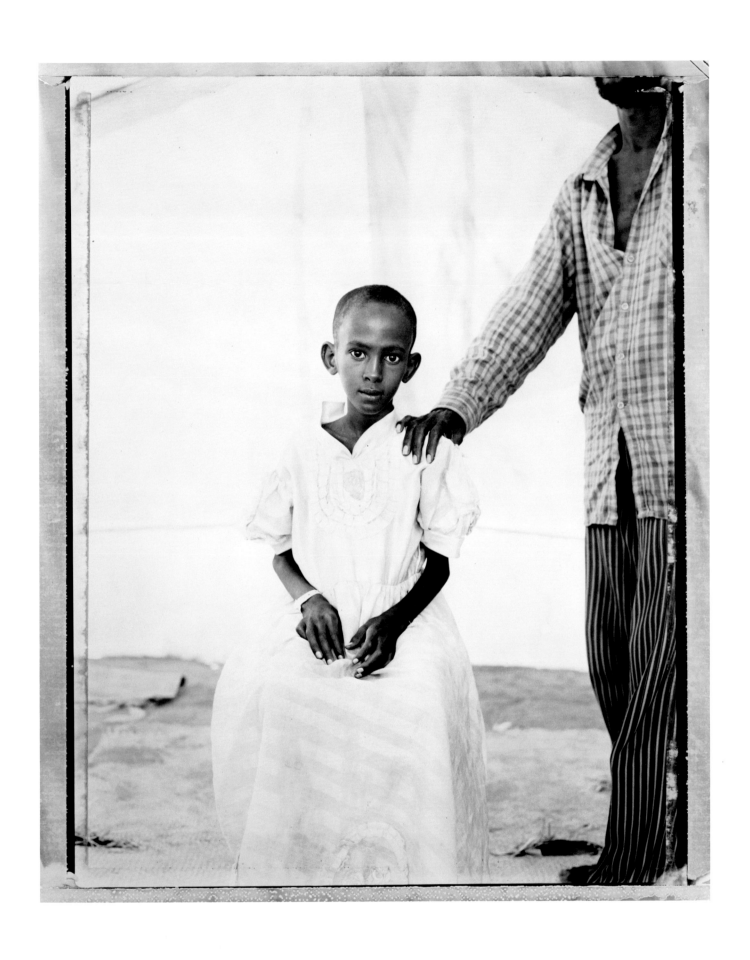

489 **Fazal Sheikh,** *Hadija and her father, Somali refugee camp, Mandera, Kenya,* 1993, 21¼ x 17½"

490 Jeffrey Wolin, *My Father*, 1988, gelatin-silver print with ink, 14¾ x 18¾"

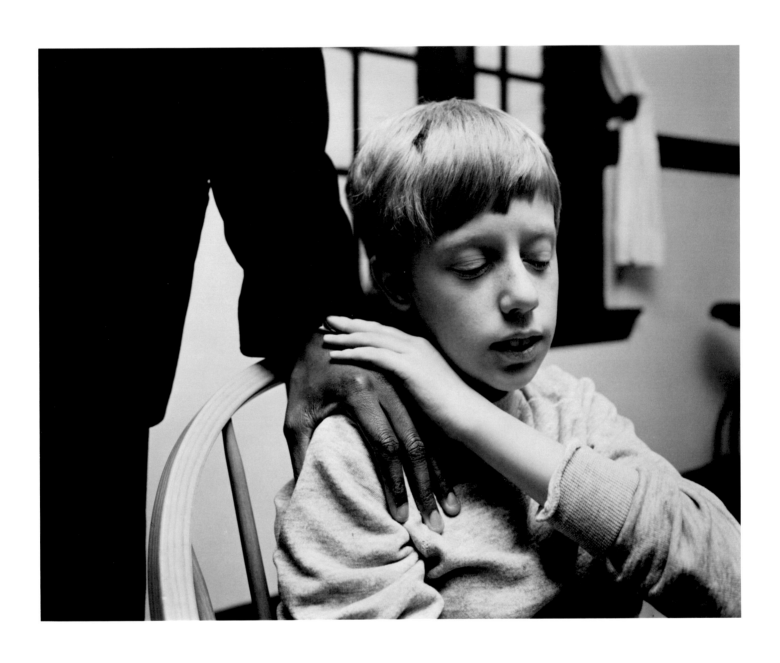

491 Nicholas Nixon, *Joel Geiger, Perkins School for the Blind,* 1992, 7⅝ x 9⅝"

492 **Larry Sultan,** *My Mother Posing for Me* (from series "Pictures From Home"), 1989, dye coupler print, 17¼ x 21¼"

493 **Tina Barney,** *The Skier,* 1986, dye coupler print, 28¾ x 36⅝″

494 **Andrea Modica,** *Treadwell, New York,* 1987, platinum print, 7⅝ x 9½"

495 Sally Mann, *Gorjus*, 1989, 19½ x 23¾"

496 Nancy Burson, *Big Brother*, 1983, 12 x 14¾″

497 Peter Campus, *decay*, 1991, 23 x 18½"

498 **David Stephenson,** *No. 802* (from series "Stars"), 1995, 30⅛ x 30″

499 **Abelardo Morell**, *Book: Pietà by El Greco*, 1993, 17⅞ x 22½"

Endnotes

Preface and Acknowledgments

1 This phrase is carefully chosen. The photograph is wholly objective in its record of "optical fact." However, this is not at all the same as narrative truth, and thus requires extensive interpretation to become meaningful. Despite this gap, many photographs do indeed reveal historical "truths" that other forms of depiction—such as paintings—cannot. Arguments that photographs are essentially like all other kinds of pictures rest on mistaken assumptions that the objectivity of the optical-chemical process (evidence) and the subjectivity of narrative (meaning) are, or should be, one and the same.

2 The title of this book makes deliberate reference to "The American Century," Henry Luce's influential editorial in the February 17, 1941, issue of *Life*. In this essay, Luce stated proudly: "America is already the intellectual, scientific and artistic capital of the world" (p. 65). Despite his obvious hubris and chauvinism, Luce was correct. It seems clear that American photography has enjoyed a similar dominance in the period surveyed by this book. However, given the international nature of most modern artistic movements, the works and ideas discussed in this book bear more than passing relevance to the work produced elsewhere in the world.

3 Following conventional usage, the words "America" and "American" are used throughout this volume to describe the United States of America and its citizens and residents. No attempt has been made to deal with the photography of the Americas, an enormously rich topic that lies far beyond the scope of this study.

4 "On Creating a Usable Past," *The Dial* (April 11, 1918): 339.

5 Lionel Trilling, *The Liberal Imagination* (New York: Viking Press, 1950), pp. 188-89.

6 David Lowenthal, *The Past is a Foreign Country* (Cambridge: Cambridge University Press, 1985), p. xvii.

7 Cited in Morris Dickstein, *Double Agent: The Critic and Society* (New York: Oxford University Press, 1992), p. 106.

8 Gary Taylor, *Cultural Selection* (New York: Basic Books, 1996), pp. 15, 253-54.

9 It should go without saying that this book does not pretend to be the "final word" on the subject. As long as people care about this history, it will continue to be explored and enlarged. It is earnestly hoped that this book will serve as an inspiration and stimulus to this process of discovery.

CHAPTER I A Reluctant Modernism 1885-1915

1 George Cotkin, *Reluctant Modernism: American Thought and Culture, 1880-1900* (New York: Twayne Publishers, 1992).

2 J. Wells Champney, "Fifty Years of Photography," *Harper's New Monthly Magazine* 74 (June-November 1889): 357. For a brief biography of Champney, see "J. Wells Champney," *Camera Notes* 6 (December 1903): 196-97.

3 Champney, "Fifty Years of Photography," p. 364.

4 Ibid., p. 366.

5 Beaumont Newhall, *The History of Photography* (New York: Museum of Modern Art, 1982), p. 123.

6 "Dry or Wet," *Photographic Times* 7 (March 1877): 51.

7 See, for example, "The Future of Wet-Plate Photography," *Photographic Times* 8 (September 1878): 200-02.

8 Ibid., p. 202.

9 Levy was advertising his plates by December 1878; see p. 280 of that month's *Photographic Times*. The Scovill Manufacturing Company offered dry plates in sizes ranging from 3¼ x 4¼" to 8 x 10" in July of that year (*Photographic Times* 8 [July 1878]: 146). However, Scovill did not manufacture these plates themselves; they were "specially made for us by a very careful manipulator." It appears likely that this unnamed "manipulator" was Levy.

10 Robert Taft, *Photography and the American Scene: A Social History, 1839-1889* (1938; New York: Dover Publications, 1964), pp. 369-71.

11 Ibid., p. 374.

12 William Welling, *Photography in America: The Formative Years 1839-1900* (New York: Thomas Y. Crowell, 1978), p. 286.

13 *Philadelphia Photographer* 21 (February 1884): 49.

14 Welling, *Photography in America*, p. 271.

15 For an excellent survey of Marey's career, see Marta Braun, *Picturing Time: The Work of Etienne-Jules Marey (1830-1904)* (Chicago: University of Chicago Press, 1992). For an early report of Anschütz's work in the American photographic press, see *Philadelphia Photographer* 23 (November 20, 1886): 686-88.

16 While this work is firmly entrenched in photographic history and lore, details of the production remain somewhat vague. It has been generally assumed that the sophisticated electrical and mechanical engineering required for this series was largely Muybridge's own creation. In fact, on the reverse of his 1878 series of photographs, Muybridge billed himself as "Inventor and Patentee in the United States, England, France, Etc. of the Automatic Electro-Photographic Apparatus." However, Terry Ramsaye, in his 1926 history of the motion picture, denies Muybridge's central role in this effort. According to Ramsaye, the complex timing and triggering mechanisms were the work of John D. Isaacs, a brilliant young engineer with the Southern Pacific railway, and Muybridge was merely a photographic technician. See Terry Ramsaye, *A Million and One Nights* (1926; repr. New York: Touchstone Books, 1986), pp. 21-49. My thanks to George Rinhart for bringing this reference to my attention.

17 *California Spirit of the Times* (May 8, 1880); repr. in Beaumont Newhall, *Photography: Essays & Images* (New York: Museum of Modern Art, 1980), p. 142.

18 *Philadelphia Photographer* 16 (January 1879): 22.

19 For a contemporary review of this work, see "New Publications," *New York Times* (March 5, 1888): 3.

20 See Marta Braun, "Muybridge's Scientific Fictions," *Studies in Visual Communication* 10:3 (Summer 1984): 2-21.

21 A short biography of Blake is included in the *National Cyclopaedia of American Biography* (New York: James T. White, 1955), vol. 22, pp. 25-26.

22 The following has been informed by the opportunity to read a chapter on Blake's photography from a forthcoming biography by Mr. Elton W. Hall. I am grateful to Mr. Hall, and to Chris Steele, of the Massachusetts Historical Society, for the opportunity to view this work in progress.

23 Blake noted that this work was done with Mr. John G. Hubbard, "who has been my almost constant companion and coadjutor." For technical data on this work, see Blake's article "Photographic Shutters," *American Amateur Photographer* 3 (February 1891): 67-73. Included as the frontispiece of this issue is a variant of *Pigeons in Flight*. This essay, first presented as a lecture at the Boston Camera Club on April 14, 1890, was also published in *Anthony's Photographic Bulletin* 22 (March 14, 1891): 144-46; 22 (March 28, 1891): 174-77; and 22 (April 25, 1891): 234-36.

24 For a listing of Blake's subjects see *Report of the Eighteenth Triennial Exhibition of the Massachusetts Charitable Mechanic Association held...October and November, 1892* (Boston: Rockwell and Churchill, 1893), pp. 175-76, 182. In the Photographic Exhibition of this fair, Blake exhibited a total of thirty-six instantaneous images of tennis players: Mr. E. L. Hall, Jr. ("winner of the Longwood and several other tennis tournaments"), Mr. R. D. Sears ("Champion of the United States, 1881-1889, and Double Championship, 1882-1889"), Dr. James Dwight ("Double Championship of the United States, 1882, 1883, 1884, 1886, 1887"), and Mr. Thomas Pettitt ("Professional Court Tennis Champion of the World, Professional Lawn Tennis Champion of America"), as well as five views of "'Cow Pony' at Sharp Canter," two views of "Pigeons in Flight," and one each of "Boy on Bicycle" and "Engine of New York Express. Speed, forty-eight miles an hour." The jurors of this exhibition presented Blake a silver medal for "especial excellence in instantaneous work" with the official comment:

> Mr. Blake's exhibit is worthy of especial mention from a scientific point of view, showing the wonderful possibilities of photography in the taking of express trains going at full speed, horses running, birds flying, etc., etc. Next we may look for the photographing of persons at a distance, speech, and possibly our very thoughts. Some of Mr. Blake's pictures were made in the one-thousandth part of a second.

My thanks to Chris Steele of the Massachusetts Historical Society for bringing this citation to my attention.

25 *Photographic Times* 6 (March 1876): 65. This camera remained unchallenged in this niche for several years. See *Philadelphia Photographer* 17 (November 1880): 346-48.

26 The 4 x 5-inch model sold for $10. William and Estelle Marder, *Anthony: The Man, the Company, the Cameras* (Amesbury, Mass.: Pine Ridge Publishing, 1982), pp. 240-43.

27 Eaton S. Lothrop, Jr., *A Century of Cameras: From the Collection of the International Museum of Photography at George Eastman House* (Dobbs Ferry, N.Y.: Morgan & Morgan, 1973), pp. 21-22, 26.

28 Ibid., pp. 29-31. This camera was introduced in October 1886; by the end of 1890, some 18,000 had been sold.

29 Photographic columns were included in major daily papers in New York, Boston, Chicago, Philadelphia, Detroit, and elsewhere. For a brief summary of this activity, see *Photographic Times* 18 (October 21, 1888): 489. On the availability of darkrooms for hotel guests, see the listings in *American Amateur Photographer* 2 (May 1890): 212, and 2 (September 1890): 368.

30 *New York Times* (November 11, 1883): 5.

31 *New York Times* (August 20, 1884): 4. On this subject, see Robert E. Mensel, "'Kodakers Lying in Wait': Amateur Photography and the Right of Privacy in New York, 1885-1915," *American Quarterly* 43 (March 1991): 24-45.

32 Reprinted in *Philadelphia Photographer* 22 (November 1885): 366.

33 Alexander Black, "The Amateur Photographer," *Century Magazine* 34 (September 1887): 722-29; repr. in Beaumont Newhall, *Photography: Essays & Images*, pp. 148-53.

34 *Wilson's Photographic Magazine* 27 (April 5, 1890): 230.

35 For an excellent summary of Eastman's role in this period, see Reese Jenkins, "Technology and the Market: George Eastman and the Origins of Mass Amateur Photography," *Technology and Culture* 16:1 (January 1975): 1-19.

36 Jenkins notes (ibid., pp. 12-13) that by 1887 merely 11 percent of Eastman's business came from the sale of dry plates. As Jenkins observes, "By 1887 the Eastman company had largely failed with both the production of dry plates and with the roll film system but maintained its financial integrity through its pioneering production of bromide paper and the provision of a developing and printing service."

37 *Philadelphia Photographer* 25 (October 20, 1888): 634.

38 This phrase quickly became one of the best-known slogans in business history. It is amusing to note that Eastman's competitors coined such derisive

retorts as "You jab the jigger and we'll finish the mess." See Colin Ford, *The Story of Popular Photography* (North Pomfret, Vt.: Trafalgar Square Publishing, 1989), p. 64.

39 "Hand Cameras," *American Amateur Photographer* 2 (April 1890): 136-43, and 2 (May 1890): 170-73. See also "Detectives at the Convention," *American Amateur Photographer* 1 (September 1889): 94-96.

40 *American Amateur Photographer* 11 (August 1899): 324.

41 For a short history of the Brownie, see Eaton S. Lothrop, Jr., "The Brownie Camera," *History of Photography* 2:1 (January 1978): 1-10.

42 "Beware of Baltimore," *Philadelphia Photographer* 20 (April 1883): 101.

43 Harry R. Terhune, "A Ramble with the Camera in the Lower Delaware Valley," *Outing* 12 (July 1888): 340.

44 Jenkins, "Technology and the Market," p. 18.

45 See, in particular, Peary's article "Photography on the Greenland Ice-Cap," *Outlook* (May 30, 1896): 987-89. Here, Peary reports that in 1891 he took along two No. 4 Kodak cameras, each loaded with the standard 100-shot roll of film. This film was subsequently developed by William Rau, of Philadelphia. In 1895, Peary took a single No. 4 Kodak specially fitted with a 250-shot roll.

46 For his later thoughts on the medium, see "Frank Lloyd Wright talks about photography," *Popular Photography* 34 (February 1954): 40-41, 118.

47 The Hillside Home School was owned and run by Wright's aunts, Ellen and Jane Lloyd-Jones. It was opened in 1886 on property owned by Wright's grandfather. Wright's nieces, nephews, and younger sisters all attended the school, and he designed at least two structures for its campus. In addition to the standard works on Wright, see Maria Morris Hambourg et al., *The Waking Dream: Photography's First Century* (New York: Metropolitan Museum of Art, 1993), p. 332.

48 This biographical information is drawn from an exhibition catalogue of his paintings: Cay Wade et al., *Henry Newell Cady: Warren, Rhode Island 1849-1935, From the Collection of Robert and Marjorie Catanzaro* (Florence: Palazzo Strozzi, 1985).

49 The first such lenses were designed in 1889. See Rudolf Kingslake, "The Development of the Telephoto Lens," *Image* 2:4 (April 1953); repr. in *Image* 25:3-4 (September-December, 1982), p. 49.

50 Although the size of this print suggests that it may have been made from a whole-plate (6½ x 8½-inch) negative, it seems most likely that the original image was made with a hand camera in smaller format, and then enlarged for commercial issue.

51 *Philadelphia Photographer* 20 (December 1883): 416.

52 For two of many examples of such images in late nineteenth-century photographic journals, see *Wilson's Photographic Magazine* 33 (October 1896): 449; and *American Annual of Photography 1898*, p. 130.

53 Alfred E. Moore, "Amateur Ballooning," and John G. Doughty, "Balloon Experiences of a Timid Photographer," *Century* (September 1886): 670-79 and 679-94.

54 See *American Annual of Photography 1901*, pp. 242-45; *Photo-Miniature* 5 (July 1903), a special issue devoted to aerial photography; and H. H. Slawson, "Kite and Balloon Photography," *Complete Photographer*, no. 34 (August 20, 1942): 2175, 2177-81.

55 *Photographic Times* 19 (February 1889): 66-67. Binden had sent this photograph to Mr. J. Jackson, Librarian of the French Geographical Society, in Paris, who in turn had forwarded it to M. Gaston Tissandier, the editor of *La Nature*.

56 The *Photographic Times* noted that M. Tissandier was "especially interested in the demonstration by the photograph of the numerous ramifications of the bolt, which various authorities state do not accompany 'zig-zag' lightning as a rule." Ibid. An earlier report of this work noted that Binden's pictures proved "the fact (before suspected) that the flashes have a sinuous, or rotary motion, being twisted like rope, or ribbon, during its progress to the earth." *Photographic Times* 18 (July 27, 1888): 359.

57 See articles such as "Photographing Lightning," *American Annual of Photography 1898*, pp. 116-20; and "The Photography of Lightning," *American Annual of Photography 1909*, pp. 54-57.

58 For the work of James Cooke Mills, see "Lightning Flashes with Moving Camera," *American Photography* 2 (April 1908): 190-92.

59 For example, see Galton's articles on the subject in the May 23, 1878 issue of *Nature*, and vol. 8 (1879) of the *Journal of the Anthropological Institute of Great Britain and Ireland*; as well as his book *Inquiries into human faculty and its development* (New York: Macmillan, 1883), which includes an albumen print of a composite portrait as a frontispiece, and an appendix describing the process.

sition (Philadelphia: Pennsylvania Academy of the Fine Arts/Harry N. Abrams, 1989), p. 7.

[173] H. Barbara Weinberg, "Cosmopolitan Attitudes: The Coming of Age of American Art," in Blaugrund, ed., *Paris 1889*, p. 33.

[174] For background on this important exhibition, see Blaugrund, ed., *Paris 1889*; Fink, *American Art at the Nineteenth-Century Paris Salons*; and Fink's article "American Art at the 1889 Paris Exposition: The Paintings They Love to Hate," *American Art* 5:4 (Fall 1991): 34-51.

[175] Burns, *Inventing the Modern Artist*, pp. 38-39.

[176] "Originality in American Art," *American Architect and Building News* 3:106 (January 5, 1878): 3; quoted in Fink, *American Art at the Nineteenth-Century Paris Salons*, p. 285.

[177] See Lawrence W. Levine, *Highbrow/Lowbrow: The Emergence of Cultural Hierarchy in America* (Cambridge, Mass.: Harvard University Press, 1988); the chapter "William Shakespeare and the American People: A Study in Cultural Transformation," in Levine's *The Unpredictable Past: Explorations in American Cultural History* (New York: Oxford University Press, 1993), pp. 139-71; and John F. Kasson, *Rudeness & Civility: Manners in Nineteenth-Century Urban America* (New York: Hill and Wang, 1990).

[178] Levine, "William Shakespeare and the American People," p. 164.

[179] Kasson, *Rudeness & Civility*, p. 5.

[180] Matthew Arnold, *Culture and Anarchy: An Essay in Political and Social Criticism* (London: Smith, Elder and Co., 1869), pp. viii, xvi. For a recent reprint and analysis of this important work, see Samuel Lipman, ed., *Culture and Anarchy by Matthew Arnold* (New Haven: Yale University Press, 1994).

[181] Much has been written on this subject. For an introduction to these issues, see Alan Trachtenberg, *The Incorporation of America: Culture and Society in the Gilded Age* (New York: Hill and Wang, 1982), pp. 208-34; Carolyn Kinder Carr and Robert W. Rydell, *Revisiting the White City: American Art at the 1893 World's Fair* (Washington, D.C.: Smithsonian Institution, 1993); and Julie K. Brown, *Contesting Images: Photography and the World's Columbian Exposition* (Tucson: University of Arizona, 1994).

[182] Carr and Rydell, *Revisiting the White City*, p. 20

[183] For example, Mathew Brady, one of the most renowned and awarded daguerreotype portraitists of the day, published the following notice in *Humphrey's Journal* in 1853:

> Address to the Public—New York abounds with announcements of 25 cent and 50 cent Daguerreotypes. But little science, experience, or taste is required to produce these, so called, cheap pictures. During the several years that I have devoted to the Daguerrean Art, it has been my constant labor to perfect it and elevate it. The results have been that the prize of excellence has been accorded to my pictures at the World's Fair in London, the Crystal Palace in New York and wherever exhibited on either side of the Atlantic...
>
> Being unwilling to abandon any artistic ground to the producers of inferior work, I have no fear in appealing to an enlightened public as to their choice between pictures of the size, price, and quality, which will fairly remunerate men of talent, science, and application, and those which can be made by the merest tyro. I wish to vindicate true art, and leave the community to decide whether it is best to encourage real excellence or its opposite; to preserve and perfect an Art, or permit it to degenerate by inferiority of materials which must correspond with the meanness of the price.

[184] For example, this giant motto loomed above the displays at the 1870 National Photographer's Association meeting in Cleveland. See the installation photograph reproduced in Stanley B. Burns, *Forgotten Marriage: The Painted Tintype and the Decorative Frame 1860-1910* (New York: Burns Collection, 1995), p. 75.

[185] *Photographic and Fine Art Journal* 8(May 1855): 158-59. For a more extended discussion, see Keith F. Davis, *George N. Barnard: Photographer of Sherman's Campaign* (Kansas City: Hallmark Cards, Inc., 1990), esp. pp. 29-37.

[186] M. A. Root, *The Camera and the Pencil* (1864; repr. Pawlet, Vt.: Helios, 1971), pp. 19-24.

[187] For a very useful discussion of this theme, see the first chapter of Richard Rudisill's *Mirror Image: The Influence of the Daguerreotype on American Society* (Albuquerque: University of New Mexico Press, 1971).

[188] Brooks Atkinson, ed., *The Selected Writings of Ralph Waldo Emerson* (New York: Modern Library, 1940), p. 6.

[189] "The Present Aspect of Photography," *American Amateur Photographer* 1 (July 1889): 5.

[190] Enoch Root, "The Artistic Spirit in Photography," *Philadelphia Photographer* 24 (January 15, 1887): 35.

[191] M. Remick, "The Relation of Art to Morality," *Arena* 19 (April 1898): 493; quoted in Kenneth Neal, *A Wise Extravagance: The Founding of the Carnegie International Exhibitions, 1895-1901* (Pittsburgh: University of Pittsburgh Press, 1966), p. 7.

[192] On this theme, see Malcolm R. Daniel, "Darkroom vs. Greenroom: Victorian Art Photography and Popular Theatrical Entertainment," *Image* 33:1-2 (Fall 1990): 13-19.

[193] On the enormous popularity of this poem, see Carl A. Brasseaux, *In Search of Evangeline: Birth and Evolution of the Evangeline Myth* (Thibodaux, La.: Blue Heron Press, 1988); Rita Ross, *Evangeline: An Acadian Heroine in Elite, Popular and Folk Culture* (Ph.D. diss., University of California, Berkeley, 1993); and Mark Cave, "A Celestial Brightness: 150 Years of Evangeline," *Historic New Orleans Collection Quarterly* (Spring 1997): 8-9.

[194] *Photographic Times* 19 (April 1889): 168-71.

[195] Motes's photograph is modeled closely on Darley's illustration accompanying the lines

> Soon was the game begun. In friendly contention the old men
> Laughed at each lucky hit, or unsuccessful manoeuvre,
> Laughed when a man was crowned, or a breach was made in the king-row.
> Meanwhile, apart, in the twilight gloom of a window's embrasure,
> Sat the lovers, and whispered together, beholding the moonrise
> Over the pallid sea and the silvery mist of the meadows.

Interestingly, Motes's photograph is a laterally reversed version of Darley's composition. See Henry Wadsworth Longfellow, *Evangeline: A Tale of Acadie with illustrations by F. O. C. Darley* (Boston: Houghton, Mifflin, 1893), p. 46.

[196] *Photographic Times* 19 (August 23, 1889): 419-20.

[197] Charlotte Adams, "An Answer to Mr. W. J. Stillman's Opinion of Photo Art," *Philadelphia Photographer* 23 (July 3, 1886): 386.

[198] *Wilson's Photographic Magazine* 26 (July 6, 1889): 296.

[199] "Science and Art," *Wilson's Photographic Magazine* 26 (June 1, 1889): 323-27. See also Emerson's *Naturalistic Photography* (London: Sampson Low, Marston, Searle & Rivington, 1889).

[200] These American publications took their place within a much larger body of international photographic literature. In his 1894 article "Photographic Journalism," Charles W. Canfield notes that no fewer than 143 regularly issued photographic publications were then in existence, "in thirteen different languages, in twenty-one countries, from Australia to Japan, from Finland to South Africa." Canfield, "Photographic Journalism," *American Amateur Photographer* 6 (December 1894): 549. For a concise overview of this subject, see William and Estelle Marder, "Nineteenth-Century American Photographic Journals: A Chronological List," *History of Photography* 17:1 (Spring 1993): 95-100.

[201] For a good study of this subject, see Sarah Greenough, "'Of Charming Glens, Graceful Glades, and Frowning Cliffs': The Economic Incentives, Social Inducements, and Aesthetic Issues of American Pictorial Photography, 1880-1902," in Martha A. Sandweiss, ed., *Photography in Nineteenth-Century America* (New York: Harry N. Abrams/Amon Carter Museum, 1991), pp. 259-81.

[202] In a notice announcing the formation of new photographic clubs in Iowa City, Duluth, Wheeling, and Medford (Mass.), the *American Amateur Photographer* observed that "there cannot be less than seventy-five such clubs now in active existence in the United States." *American Amateur Photographer* 1 (August 1889): 60.

[203] See "American Photographic Societies," *American Amateur Photographer* 1 (July 1889): 42-45; and the report of the November 1889 meeting of the Hawaiian Camera Club in *American Amateur Photographer* 2 (January 1890): 33.

[204] For a recent study of this important club, see Mary Panzer, *Philadelphia Naturalistic Photography, 1865-1906* (New Haven: Yale University Art Gallery, 1982). For a short contemporary history of the society, see "The Oldest American Photographic Club," *American Photography* 2 (September 1908): 486-92.

[205] *Philadelphia Photographer* 21 (January 1884): 19.

[206] "The Society of Amateur Photographers of New York," *American Amateur Photographer* 6 (April 1894): 157-69.

[207] This figure is cited in Greenough, "'Of Charming Glens, Graceful Glades, and Frowning Cliffs,'" p. 268.

[208] "The Cincinnati Camera Club," *American Amateur Photographer* 2 (February 1890): 53-54.

[209] Biographical data is drawn from Naomi Rosenblum, *A History of Women Photographers* (New York: Abbeville, 1994), p. 324.

[210] For example, while their work was exhibited and praised in the mid-1880s,

the comment, "I have not reported all the afternoon's conversation; but these were real people, and I have kept very close to their real words and manner" (p. 132). He then describes in meticulous detail the room in which this conversation had taken place.

> The sitting-room...had a vertical-patterned wall-paper of light tone, and the woodwork was a grained yellow. On the floor was a large-figured carpet, in which red, green, and black were the predominant colors. A bit of oilcloth before each of the two doors, and a braided rag mat, and a long strip of rag carpet, protected the most travelled parts of the room from wear. Two small-paned windows looked out on the roadway. Before one of them, on a stand, were two wooden boxes, with young tomato-plants sprouting in them. On another stand, against the wall, were a Bible, a photograph album, a lamp, and two pairs of spectacles [etc.]....

[127] This volume contains six photographs of stoves as sources of heat and food, or as the focus of the community's social life.

[128] "Photography and Art," *American Amateur Photographer* 13 (February 1901): 78-82; first published in the *Saturday Evening Post*.

[129] See Beverly Seaton, "Beautiful Thoughts: The Wallace Nutting Platinum Prints," *History of Photography* 6:3 (July 1982): 273. See also Joyce P. Barendsen, "Wallace Nutting, an American Tastemaker: The Pictures and Beyond," *Winterthur Portfolio* 18:2-3 (Summer-Autumn, 1983): 187-212.

[130] James A. Kaufmann, "Arnold Genthe: Gentleman Photographer," *Image* 20:3-4 (September-December 1977): 2.

[131] Remarkably, the cropping of this print shows only about half the information contained in Genthe's original negative (which was shot as a vertical). For a reproduction of this full-frame image, see Vicki Goldberg and Arthur Ollman, *Points of Entry: A Nation of Strangers* (San Diego: Museum of Photographic Arts, 1995), p. 39. Genthe's radical cropping of this image suggests his interest in the aesthetics, rather than simple factual content, of his pictures.

[132] Kaufmann, "Arnold Genthe," p. 3. Genthe's sympathy for his subject is suggested by the fact that his images were used to illustrate a 1901 article defending Chinese immigration at a time when "anti-immigration sentiment was running high in America."

[133] Ibid. Genthe's high valuation of these images is revealed in the fact that his negatives, which had been stored carefully in a vault, were among his very few possessions to survive the earthquake.

[134] *Old Chinatown: A Book of Pictures by Arnold Genthe*, with text by Will Irwin (London: Sidgwick & Jackson, 1913), pp. 205-08.

[135] Quoted in Brian W. Dippie, "The Visual West," in Clyde A. Milner II, Carol A. O'Connor, and Martha A. Sandweiss, eds., *The Oxford History of the American West* (New York: Oxford University Press, 1994), p. 691.

[136] For an extended discussion of this theme see, for example, Leah Dilworth, *Imagining Indians: Persistent Visions of a Primitive Past* (Washington, D.C.: Smithsonian Institution Press, 1996).

[137] This subject was also recorded by Käsebier. See Barbara L. Michaels, *Gertrude Käsebier: The Photographer and Her Photographs* (New York: Harry N. Abrams, 1992), pp. 29-44.

[138] Christopher Lasch, *The New Radicalism in America, 1889-1963: The Intellectual as a Social Type* (New York: W.W. Norton, 1965), p. xv.

[139] See such studies as Thomas Vander Meulen, *F. I. Monsen* (Tempe: Arizona State University, 1985); Turbese Lummis Fiske, *Charles F. Lummis: The Man and His Work* (Norman: University of Oklahoma Press, 1975); and Ward Jerome, "Karl Moon's Photographic Record of the Indian Life of Today," *The Craftsman* (April 1911): 24-32.

[140] L.G. Moses, *Wild West Shows and the Images of American Indians, 1883-1933* (Albuquerque: University of New Mexico Press, 1996), p. 137. Much of my discussion is indebted to this valuable study.

[141] See Marta Weigle and Barbara A. Babcock, eds., *The Great Southwest of the Fred Harvey Company and the Santa Fe Railroad* (Phoenix: Heard Museum, 1996), published to accompany the exhibition "Inventing the Southwest: The Fred Harvey Company and Native American Art." For a review of this exhibit, see Timothy W. Luke, "Inventing the Southwest: A Re-examined History," *Art Papers* (January-February 1997): 16-21.

[142] May Castleberry et al., *Perpetual Mirage: Photographic Narratives of the Desert West* (New York: Whitney Museum of American Art, 1996), p. 218.

[143] Dilworth, *Imagining Indians*, pp. 78-79.

[144] Monsen wrote several articles on his work, including "Picturing Indians with the Camera," *Photo-Era* 25 (October 1910): 165-72.

[145] According to Karen Current in *Photography and the Old West* (New York: Harry N. Abrams/Amon Carter Museum, 1978), p. 236, Vroman became interested in photography through the influence of Charles Lummis.

[146] See, for example, Vroman's series of articles in *Photo-Era*, "Photography in the Great South-West" 6 (January 1901): 225-32; "The Moki Pueblos" 6 (February 1901): 265-72; and "The Moki Snake Dance" 6 (April 1901): 345-52.

[147] In 1897, Vroman reported some 200 whites in attendance at this ceremony. See William Webb and Robert A. Weinstein, *Dwellers at the Source: Southwestern Indian Photographs of A.C. Vroman, 1895-1904* (New York: Grossman, 1973), p. 85.

[148] Patricia Janis Broder, *Shadows on Glass: The Indian World of Ben Wittick* (Savage, Md.: Rowman & Littlefield, 1990), p. 57. Broder observes that "by the end of the century there were so many photographers attending Indian events and their behaviour often was so intrusive that the Indians had begun to confine them to special areas, thus forcing all photographers to record the same subject from the same viewpoint."

[149] Most of the information on this congress, and Rinehart's work, is drawn from Robert Bigart and Clarence Woodcock, "The Trans-Mississippi Exposition & The Flathead Delegation," *Montana: The Magazine of Western History* 24:4 (Autumn 1979): 14-25.

[150] Quoted in Moses, *Wild West Shows*, p. 145.

[151] The following data is drawn largely from Claes H. Jacobson, "John Anderson," *Cowboys & Indians Magazine*, issue 15 (Holiday 1996): n.p.

[152] Barbara A. Davis, *Edward S. Curtis: The Life and Times of a Shadow Catcher* (San Francisco: Chronicle Books, 1985), p. 78. Even this mammoth project did not constitute the sum total of Curtis's work. For example, see Mick Gidley, "From the Hopi Snake Dance to 'The Ten Commandments': Edward S. Curtis as Filmmaker," *Studies in Visual Communication* 8:3 (Summer 1982): 70-79.

[153] For a critical appraisal of Curtis's method see Christopher M. Lyman, *The Vanishing Race and Other Illusions: Photographs of Indians by Edward S. Curtis* (New York: Pantheon Books, 1982). For a critique of Lyman's approach, see Bill Holm's review of this book in *American Indian Art* 8:3 (Summer 1983): 68-73. See also Beth Barclay DeWall, "Edward Sheriff Curtis: A New Perspective on 'The North American Indian,'" *History of Photography* 6:3 (July 1982): 223-39.

[154] Lyman, *The Vanishing Race and Other Illusions*, pp. 125.

[155] For a short comparative study of a photographer hired by the Bureau of Ethnology, see James R. Glenn, "De Lancey W. Gill: Photographer for the Bureau of American Ethnology," *History of Photography* 7:1 (January 1983): 7-22.

[156] *Wilson's Photographic Magazine* 42 (May 1905): 240.

[157] *Wilson's Photographic Magazine* 44 (August 1907): 361. However, Hartmann did not dispute the basic rationale behind Curtis's project: "I perfectly agree that Mr. Curtis's undertaking is one that cannot easily be repeated. The red savage Indian is in fact changing into a mere ordinary, uninteresting copy of the white race."

[158] Davis, *Edward S. Curtis*, pp. 66, 68.

[159] For a brief summary of this theme, see William E. McRae, "Images of Native Americans in Still Photography," *History of Photography* 13:4 (October-December, 1989): 321-42.

[160] Davis, *Edward S. Curtis*, p. 37.

[161] Bliss Perry, *The Amateur Spirit* (Boston: Houghton, Mifflin, 1904), p. 31; quoted in Gerald Graff, *Professing Literature: An Institutional History* (Chicago: University of Chicago Press, 1987), p. 86.

[162] Neil Harris, *The Artist in American Society: The Formative Years, 1790-1860* (Chicago: University of Chicago Press, 1966; repr. 1982), pp. xi. The following discussion owes a considerable debt to this superb study.

[163] Ibid., p. 69.

[164] On the latter, see, in particular, Franklin Kelly, *Frederic Edwin Church and the National Landscape* (Washington, D.C.: Smithsonian Institution Press, 1988).

[165] The following summary is indebted to Fink, *American Art at the Nineteenth-Century Paris Salons*, pp. 271-89.

[166] Burns, *Inventing the Modern Artist*, p. 28.

[167] "A Crowded Profession," *New York Times* (April 22, 1883): 8.

[168] Burns, *Inventing the Modern Artist*, p. 27.

[169] For concise studies of this complex issue, see, for example, Anne Farmer Meservey, "The Role of Art in American Life: Critics' Views on Native Art and Literature, 1830-1865," *American Art Journal* 10 (May 1978): 73-89; and H. Barbara Weinberg, "Late-Nineteenth-Century American Painting: Cosmopolitan Concerns and Critical Controversies," *Archives of American Art Journal* 23:4 (1983): 19-26.

[170] Carol Troyen, "Innocents Abroad: American Painters at the 1867 Exposition Universelle, Paris," *American Art Journal* 16 (Autumn 1984): 14.

[171] "The Younger Painters of America," *Scribner's Monthly* 20 (May 1880): 1.

[172] Annette Blaugrund, ed., *Paris 1889: American Artists at the Universal Expo-*

92 See, for example, "An American Phototypographic Process," *Philadelphia Photographer* 18 (March 1881): 89-91; and "The True Inventor of Photo-typography," *Philadelphia Photographer* 18 (June 1881): 188-89. The latter issue includes a halftone portrait of the journal's editor, Edward L. Wilson (p. 193), produced by Ives's process. For a short profile of Ives, see Howard B. Leighton, "Frederic Eugene Ives, Forgotten Pioneer in Color Photography and the Halftone," *Image* 19:3 (September 1976): 33-35.

93 Taft, *Photography and the American Scene*, p. 438. In her *Visual Communications and the Graphic Arts* (New York: R.R. Bowker, 1974), pp. 262, Estelle Jussim notes that the first book illustrated solely by halftones, Henry Goodyear's *A History of Art*, was published in 1888. The difficulty of the process resulted in the curious fact that the second edition of this volume, published in 1889, reverted largely to the earlier line-drawing engraving process. Similarly, Alexander Alland, in *Jacob A. Riis: Photographer & Citizen* (Millerton: Aperture, 1974), pp. 30, notes that "the first large-scale use of halftones occurred in a picture magazine, *Sun and Shade*, which began publication in July 1888 and had to abandon the practice a year later because of the high costs." See also Christopher R. Harris, "The Halftone and American Magazine Reproduction 1880-1900," *History of Photography* 17:1 (Spring 1993): 77-80; and Neil Harris, "Iconography and Intellectual History: The Halftone Effect," in Harris, *Cultural Excursions: Marketing Appetites and Cultural Tastes in Modern America* (Chicago: University of Chicago Press, 1990), pp. 304-17. It is worth noting that *Frank Leslie's Illustrated* made consistent use of halftones from 1892 on.

94 Taft, *Photography and the American Scene*, p. 446. For a summary of the state of affairs in 1895, see Max Madder, "Modern Photographic Processes of Illustration," *American Amateur Photographer* 7 (December 1895): 529-38.

95 It is still surprising, however, how slowly the process was adopted. In her essay "'The Tyranny of the Pictorial,'" Jussim notes (p. 44) that the first regular use of halftones in a newspaper did not occur until January 21, 1897. As late as 1899, *Wilson's Photographic Magazine* (36 [February 1899]: 64) found it newsworthy enough to note that two of the leading newspapers in New York "are now using halftones more or less regularly in their columns."

96 The following discussion is indebted to Ulrich Keller's "Photojournalism Around 1900: The Institution of a Mass Medium," in Kathleen Collins, ed., *Shadow and Substance: Essays in the History of Photography in Honor of Heinz K. Henisch* (Bloomfield Hills: Amorphous Institute Press, 1990), pp. 283-303.

97 Frederic Felix, "Getting the News Photographs," *American Annual of Photography 1921*, p. 194. Felix provides a good short description of the early evolution of this business (p. 196):

As illustrating with the half-tone process advanced to its modern plan the firm [of Underwood & Underwood] was repeatedly called upon to supply a view of some scene, place or building that would improve a book or article....The continuation of such calls for photographs induced them to develop all the possibilities of a business thrust upon them. They next provided lay-out groups, that is collections of from several to a dozen prints showing some certain customs, industry, peoples or activities, and sold them to publications wishing to illustrate special articles. Next came a collection of all the prominent men of the day, and after that they added the taking of events of news interest as they were happening daily all over the world.

98 See, for example, "Batteries of Cameras for Celebrities," *American Amateur Photographer* 18 (September 1906): 437-42.

99 See, for example, "Picture Making in San Francisco After the Fire," *American Annual of Photography 1907*, pp. 158-68.

100 *New York Sun* (July 15, 1906); cited in *American Amateur Photographer* 18 (September 1906): 437.

101 "The Work of a Press Photographer," *Camera Craft* 21 (April 1914): 164. For similar points of view, see "Adventures of a Daring Photographer," *The World's Work* 14 (May 1907): 8834-48, and "The Press Photographers," *American Annual of Photography 1915*, pp. 186-88.

102 Hemment was one of the leading photographers of the Spanish-American War. Dugmore contributed to *The World's Work* and other journals; he was also well known for his photographs of animals, and authored the book *Wild Life and the Camera* (Philadelphia: J.B. Lippincott, 1912).

103 Ashton's essays on these and other subjects were published in journals including the *New York Times*, *Scribner's*, *Scientific American*, and *Asia: Journal of the American Asiatic Assocation*. Sincere thanks to George Rinhart for sharing this information.

104 Peter Daniel and Raymond Smock, *A Talent for Detail: The Photographs of Miss Frances Benjamin Johnston, 1889-1910* (New York: Harmony Books, 1974), p. 87.

105 Johnston's work at Hampton Institute is documented in *The Hampton Album* (New York: Museum of Modern Art, 1966).

106 Constance Glenn and Leland Rice, *Frances Benjamin Johnston: Women of Class and Station* (Long Beach: Art Museum and Galleries, California State University, 1979), p. 13. In 1901-02, Johnston also wrote a series of profiles of leading women photographers for *Ladies Home Journal*. For related references see Peter Palmquist, ed., *Camera Fiends & Kodak Girls* (New York: Midmarch Arts Press, 1989).

107 The following is drawn from Alexander Alland, Sr., *Jessie Tarbox Beals: First Woman News Photographer* (New York: Camera/Graphic Press, 1978).

108 Cecil Carnes, *Jimmy Hare, News Photographer: Half a Century with a Camera* (New York: Macmillan Company, 1940). This is one of the earliest biographies of an American photographer.

109 For an early description of the Underwood & Underwood business, see *Wilson's Photographic Magazine* 31 (February 1894): 66-69. More recent studies of the stereograph in this era are "Mass Production of Stereographs," in William C. Darrah, *The World of Stereographs* (Gettysburg: W.C. Darrah, 1977), pp. 45-52; and Edward W. Earle, ed., *Points of View: The Stereograph in America—A Cultural History* (Rochester: Visual Studies Workshop Press, 1979).

110 The basic approach of early photojournalists was outlined as early as 1891 in "Photography and Illustrated Journalism," *Wilson's Photographic Magazine* 28 (June 6, 1891): 321-25. For example:

The one dominating idea [the photojournalist] has to entertain is this: The photograph or photographs must correctly tell their tale, so that he who runs may read it there. You cannot put soul or sentiment easily into a photograph, but you can arrest action so that a glance threat will tell you what was occurring at the time. The photograph must convey some idea of the culminating or central object of the gathering. For instance, take a ceremony in which a historical monument is to be unveiled by some person of eminence, with an imposing ceremonial. The photographer who undertakes to procure views of the ceremony which will accurately convey to the minds of those who are not present some idea of the grouping and general aspect of the scene, must have this object always in mind, and not be led away by attractive-looking "bits" here, there, and all over the place...

111 Though innumerable examples could be cited, an unusually powerful cinematic use of news photographs is "The President on His Tours," *The World's Work* 5 (November 1902): 2754-60. In this article, pictures and words are given equal weight: each page includes one column of text and one with three equal-size photographs. The images record President Roosevelt's expressions and gestures while suggesting the vast crowd around him. The result is a compelling sense of his physical energy and the excitement of his public appearances.

112 Lois Marie Fink, *American Art at the Nineteenth-Century Paris Salons* (Washington, D.C.: National Museum of American Art, 1990), p. 203.

113 Sarah Burns, *Inventing the Modern Artist: Art and Culture in Gilded Age America* (New Haven: Yale University Press, 1996), p. 10. This is a superb study of this important era in American art.

114 For insightful essays on very different aspects of Emerson's legacy, see, for example, John Taylor, "Aristocrats of Anthropology," *Image* 35:1-2 (Spring-Summer, 1992): 3-23; and Mary Warner Marien, "Peter Henry Emerson: The Taxonomy of a Crow's Nest," *History of Photography* 21:2 (Summer 1997): 102-09.

115 *American Amateur Photographer* 5 (May 1893): 202.

116 Clarkson's photograph *Toil* was included in the 1894 London Photographic Salon, and extensively critiqued by George Davison; see *American Amateur Photographer* 6 (November 1894): 494.

117 This image was reproduced several times in American journals, beginning at least as early as *Anthony's Bulletin Annual* for 1888.

118 For a description of these, see Roger Hull, "The Traditional Vision of Rudolf Eickemeyer, Jr.," *History of Photography* 10:1 (January-March 1986): 49-53.

119 Ibid, p. 52.

120 For a summary biography, see the *National Cyclopaedia of American Biography* (New York: James T. White, 1955), vol. 40, pp. 387-88.

121 Charles A. Madison, "Preface to the Dover Edition," *How the Other Half Lives* (New York: Dover Publications, 1971), pp. viii. Johnson's name is given here as "Clifton H. [sic] Johnson" rather than Clifton C[hester] Johnson.

122 Johnson's many publications are listed in *The National Union Catalog Pre-1956 Imprints*, vol. 282, pp. 17-25.

123 Clifton Johnson, *The New England Country* (Boston: Lee and Shepard, 1893), pp. 1.

124 See the chapter "Deserted Homes," in Johnson's *A Book of Country Clouds and Sunshine* (Boston: Lee and Shepard, 1896), pp. 173-96.

125 The first of these was reproduced in *A Book of Country Clouds and Sunshine*.

126 This attention to detail gives Johnson's volumes a sense of mimesis more characteristic of texts of the 1930s. For example, in *A Book of Country Clouds and Sunshine*, Johnson follows a lengthy transcription of a conversation with

[60] The latter, by Oliver Lippincott, was published in *Wilson's Photographic Magazine* 47 (January 1910): 16.

[61] It is significant that Francis Galton was the father of modern eugenics, a hierarchical "science" of human genetic traits.

[62] See Karl Klauser, "On 'Type Pictures,'" *Philadelphia Photographer* 23 (January 16, 1886): 34. Klauser wrote:

> We are sadly in want of a photograph of Adam, the first man, and of Eve, the first woman. If the photographers in large cities, who have access to a large and mixed population, would find time and opportunities to make a combination picture of the different races of man: the Malay, the Australian, the Negro, the Mongole, the Japanese, the Caucasian, the Arab, the Semite, the Indian, etc., the result would be a type picture of the primitive man—if not of Adam, then of one of his ancestors.

This article provides a good description of Klauser's technique for making composite portraits. See also: John T. Stoddard, "Composite Photography," *Century* (March 1887): 751-57; "Composite Photography," *Philadelphia Photographer* 24 (March 5, 1887): 163-64; "Composite Photography," *Philadelphia Photographer* 25 (January 21, 1888): 40-41; "Composite Photography," *Photographic Times* 18 (January 6, 1888): 18-19; H. P. Bowditch, M.D., "Are Composite Photographs Typical Pictures?" *McClure's Magazine* (September 1894): 331-42; and Professor Jacob Cooper, "The Platonic Ideal Elucidated by the Composite Photograph," *Methodist Review* (July-August 1900): 560-81. For a memorable commentary on this craze, see "To a Composite Photograph," *Photographic Times* 18 (June 1, 1888): 264. This satirical poem (first published in the *London World*) begins:

> O pensive faces—or should I say face?
> How many of you is it I adore?
> For this presentment of your mingled grace,
> Hath won my wayward heart for evermore.
>
> Your serious, sweet eyes look from the page,
> Surrounded by an aureole of curl;
> O fair fourteen!—upon the average,
> You really are a very pretty girl.

[63] See *Wilson's Photographic Magazine* 27 (April 5, 1890): 207-11; 28 (February 7, 1891): 87; 28 (February 21, 1891): 125; and 28 (May 2, 1891): 319.

[64] This process—as well as composite portraiture, multiple exposures, and other "trick" techniques—is discussed in Albert A. Hopkins, *Magic: Stage Illusions, Special Effects and Trick Photography* (New York: Munn & Co., 1898; repr. New York: Dover Publications, 1976), pp. 423-61.

[65] See, for example, "Roentgen or X Ray Photography," *American Amateur Photographer* 8 (February 1896): 58-63, with curiously abstract images by Professor Wright; "The New Radiography," *American Amateur Photographer* 8 (March 1896): 108-09; and "The Röntgen Process in Medicine," *Wilson's Photographic Magazine* 33 (April 1896): 174-76, with images by C. Swinton and J.W. Gifford. Pupin's contributions are mentioned in Arthur Fuchs, "Radiography," *Complete Photographer*, no. 47 (December 30, 1942): 3042-43.

[66] See, for example, "Photography and Crystallization," *American Annual of Photography 1897*, pp. 214-19, 221. This essay is illustrated with photographs of crystallation patterns produced by a variety of chemical compounds.

[67] Articles on both the platinum and cyanotype processes begin to appear in significant number in 1879. For a short overview of this era, see William Crawford, *The Keepers of Light* (Dobbs Ferry, N.Y.: Morgan & Morgan, 1979): 63-65.

[68] T. C. Hepworth, "Fifty Years of Photography," *Wilson's Photographic Magazine* 26 (May 4, 1889): 283.

[69] For an early description of an amateur enlarger, see *Philadelphia Photographer* 21 (March 1884): 72-75.

[70] For an introduction to this subject, see, for example, Paul Boyer, *Urban Masses and Moral Order in America: 1820-1920* (Cambridge, Mass.: Harvard University Press, 1978); and chapter 4, "The Reform Impulse and the Paradox of Moral Reform," in David S. Reynolds, *Beneath the American Renaissance: The Subversive Imagination in the Age of Emerson and Melville* (Cambridge, Mass.: Harvard University Press, 1988).

[71] For a colorful overview of the "underbelly" of New York City in this era, see Luc Sante, *Low Life: Lures and Snares of Old New York* (New York: Farrar Straus Giroux, 1991).

[72] In many respects, of course, Riis was representative of his time. He thus held attitudes that would not be considered particularly "enlightened" today. His mixed attitudes toward those he was trying to help, and his frequent ethnic stereotyping, are apparent in the most casual reading of his works. As Sante observes in *Low Life* (p. 34), Riis "was a moralist who ignored economic causes and who did not hesitate to judge the people he was helping by

the same lofty standards of conduct he applied to those he reproved..." See also, for example, Louis Fried, "Jacob Riis and the Jews: The Ambivalent Quest for Community," *American Studies* 20 (Spring 1979): 5-24.

[73] Peter Bacon Hales, *Silver Cities: The Photography of American Urbanization, 1839-1915* (Philadelphia: Temple University Press, 1984), pp. 168. The discussion of Riis's work in chapter 4 of this book provides an informative perspective on the larger issues of social work and the representation of urban subjects in this era. A rather different, but, I think, excessively tendentious interpretation of Riis's work is provided in Maren Stange's *Symbols of Ideal Life: Social Documentary Photography in America 1890-1950* (Cambridge: Cambridge University Press, 1989), pp. 1-29. For example, Stange observes that "the idea of photography as surveillance, the controlling gaze as a middle-class right and tool, is woven throughout Riis's lectures and writings" (p. 23). In this light, it is at least as relevant to consider how and why Riis's reform agenda was resisted by many of his subjects. For a general suggestion of the economic basis of such resistance, see Thomas Sowell, *Race and Culture: A World View* (New York: Basic Books, 1994), pp. 100-03.

[74] Jacob A. Riis, *The Making of an American* (New York: Macmillan Company, 1902), p. 267. Riis's discussion of his use of photography occupies pp. 264-72.

[75] Ibid., p. 268.

[76] "Flashes from the Slums: Pictures Taken in Dark Places by the Lightning Process," *New York Sun* (February 12, 1888); repr. in Newhall, *Photography: Essays & Images*, pp. 155-57.

[77] Riis, *The Making of an American*, p. 271.

[78] Ibid., p. 265.

[79] For an eloquent reading of this image, see Hales, *Silver Cities*, p. 192.

[80] While the slum provided a relatively common subject for writers and illustrators of this era, Riis's photographs were distinguished by their unsentimental specificity. On this subject, see, for example, David M. Fine, "Abraham Cahan, Stephen Crane, and the Romantic Tenement Tale of the Nineties," *American Studies* 14 (Spring 1973): 95-107, and chapter 4 of Hales's *Silver Cities*.

[81] For example, see *Photographic Times* 18 (February 3, 1888): 58-59, for a detailed account of Riis's presentation—titled "The Other Half—How It Lives and Dies in New York"—to the Society of Amateur Photographers of New York, on January 25 of that year. This report suggests that a significant percentage of Riis's best-known images were already made by this time.

[82] Riis's numerous other subsequent volumes include *The Children of the Poor* (1892), *A Ten Years' War* (1900), his best-selling autobiography *The Making of an American* (1901), and *The Battle with the Slum* (1902).

[83] While Riis's career continued until his death in 1914, he apparently ceased photographing by 1898. Given his merely functional interest in the medium, it is not surprising that his photographs fell into obscurity for many years. It was not until 1946 that Riis's original negatives were found by Alexander Alland. Modern prints from these glass-plate negatives were included in a number of influential exhibitions and publications, leading to Riis's rediscovery as a pioneering documentarian.

[84] *Philadelphia Photographer* 24 (April 16, 1887): 228-29.

[85] Mrs. Helen Campbell, *Darkness and Daylight; or, Lights and Shadows of New York Life. A Woman's Story of Gospel, Temperance, Mission, and Rescue Work* (Hartford: A.D. Worthington & Co., 1891), p. xii. (The copy consulted carried the date 1893 on the title page, but 1891 on the copyright page.) For information on Mason's work, see "Photography at Bellevue Hospital," *Philadelphia Photographer* 17 (July 1880): 200-01.

[86] For a summary of the activity of Krausz, Austen, and others, see chapter 5 of Hales, *Silver Cities*.

[87] See Ralph F. Bogardus and Ferenc M. Szasz, "Reality Captured, Reality Tamed: John James McCook and the Uses of Documentary Photography in *fin de siècle* America," *History of Photography* 10:2 (April-June 1986): 151-67.

[88] See, for example, David A. Hanson, "The Beginnings of Photographic Reproduction in the USA," *History of Photography* 12:4 (October-December 1988): 357-76.

[89] For a very handsome catalogue on this subject, see David A. Hanson and Sidney Tillim, *Photographs in Ink* (Teaneck, N.J.: Fairleigh Dickinson University Art Gallery, 1996).

[90] See *Photographic Times* 20 (October 24, 1890): 533-34; and *Wilson's Photographic Magazine* 32 (January 1895): 33-36.

[91] This point is emphasized in Estelle Jussim, "'The Tyranny of the Pictorial': American Photojournalism from 1880 to 1920," in Marianne Fulton, ed., *Eyes of Time: Photojournalism in America* (Boston: New York Graphic Society, 1988), pp. 44.

photographers such as E. L. Coleman of the Boston Camera Club, M. L. Corlies of the Photographic Society of Philadelphia, and R. W. DeForest of the Society of Amateur Photographers of New York, have left little historical trace. See *Philadelphia Photographer* 23 (January 2, 1886): 25; *Philadelphia Photographer* 24 (February 5, 1887): 83; and *Philadelphia Photographer* 24 (April 16, 1887): 252.

[211] See, for example, "Women and Photography," *American Amateur Photographer* 11 (1899): 118-24, 144-50.

[212] This figure is cited in Jeanne Moutoussamy-Ashe, *Viewfinders: Black Women Photographers* (New York: Writers & Readers, 1993), p. 17. Six of these 2,201 women were African Americans.

[213] *American Amateur Photographer* 2 (January 1890): 13.

[214] *American Amateur Photographer* 1 (December 1889): 224.

[215] *American Amateur Photographer* 3 (November 1891): 435.

[216] Barnes's "Lancelot and Elaine" pictures were reproduced as frontispieces in the August 1891 and October 1891 issues of *American Amateur Photographer*.

[217] Barnes's most significant essays were published in *American Amateur Photographer*. The most important of these from 1889 to 1892 include: "The Study of Interiors" (1[1889]: 91-93), "Why Ladies Should be Admitted to Membership in Photographic Societies" (1[1889]: 223-24), "Photography from a Woman's Standpoint" (2[1890]: 10-13), "Under the Sky-Light" (2[1890]: 87-88), "A Woman to Women" (2[1890]: 185-88), "Illustrating Poems by Photography" (2[1890]: 260-63), "A Photographer at the Washington Convention" (2[1890]: 347-50), "The Real and the Ideal" (3[1891]: 58-61), "Photography as a Profession for Women" (3[1891]: 172-76), "Art in Photography" (3[1891]: 179-81), "Women as Photographers" (3[1891]: 338-41), "The Buffalo Convention and Its Lessons" (3[1891]: 393-96), "Artistic Photography" (3[1891]: 434-39), "The Question of Selection" (4[1892]: 4-8), "Amateur Photography in America" (4[1892]: 344-50), "Photographic Limits" (4[1892]: 448-52), and "The Object of Photography" (4[1892]: 484-88). Barnes's articles for *Leslie's* began in October 1891; the December 12, 1891 issue of the journal announced (p. 325) that it was beginning a regular column on amateur photography edited by Barnes.

[218] Catherine Weed Barnes Ward died at her English home in Kent in 1913 at the age of sixty-two. For a brief biography, see "Catherine Weed Barnes Ward," *American Photography* 7 (October 1913): 593. On the subject of women in turn-of-the-century American photography see Madelyn Moeller, "Ladies of Leisure: Domestic Photography in the Nineteenth Century," in Kathryn Grover, ed., *Hard at Play: Leisure in America, 1840-1940* (Amherst: University of Massachusetts Press, 1992), pp. 139-60.

[219] "The Chicago Camera Club," *American Amateur Photographer* 1 (October 1889): 154-56.

[220] *American Amateur Photographer* 2 (January 1890): 33.

[221] "The Cincinnati Camera Club," *American Amateur Photographer* 2 (February 1890): 57.

[222] For concise overviews of the larger uses of lantern slides in this era, see Howard B. Leighton, "The Lantern Slide and Art History," *History of Photography* 8:2 (April-June 1984): 107-18; and Elizabeth Shepard, "The Magic Lantern Slide in Entertainment and Education, 1860-1920," *History of Photography* 11:2 (April-June 1987): 91-108.

[223] Guidelines for the New England Slide Exchange, published in *American Amateur Photographer* 2 (January 1890): 29, state that "all slides must be of the standard size of 3¼ x 4 inches." By the end of the 1890s lantern slides were also made in the 3¼ x 3¼ inch format.

[224] *American Amateur Photographer* 1 (July 1889): 38.

[225] *American Amateur Photographer* 1 (November 1889): 180.

[226] "A Photographic Outing with Mr. E. P. Roe in the Highlands of the Hudson," *Photographic Times* 17 (December 23, 1887): 646-47. See also such articles as "A Ramble with the Camera in the Lower Delaware Valley," *Outing* 12 (July 1888): 337-41; and "How to Prepare for a Photographic Outing," *Outing* 12 (September 1888): 502-03.

[227] For a superb study of this subject, see Brown, *Contesting Images*; and her article "'Seeing and Remembering': George Eastman and the World's Columbian Exposition, Chicago 1893," *Image* 39:1-2 (Summer 1996): 3-27.

[228] *Philadelphia Photographer* 21 (January 1884): 17.

[229] *Philadelphia Photographer* 22 (December 1885): 397.

[230] Kirsti Asplund Ringger, "The Photographic Society of Philadelphia Exibition of 1886," *History of Photography* 21 (Winter 1997): 283-93. This detailed study provides a reconstructed catalogue of the exhibition. According to this source, a total of 1,624 prints and 99 lantern slides were shown. See also *Philadelphia Photographer* 23 (January 1886): 82; and Mary Panzer, *Philadelphia Naturalistic Photography*, p. 5.

[231] *Philadelphia Photographer* 23 (March 20, 1886): 183-84.

[232] *American Amateur Photographer* 5 (May 1893): 201.

[233] Alfred Stieglitz, "The Joint Exhibition at Philadelphia," *American Amateur Photographer* 5 (May 1893): 201-09.

[234] *American Amateur Photographer* 6 (May 1894): 209.

[235] *American Amateur Photographer* 6 (April 1894): 153.

[236] *Philadelphia Photographer* 22 (January 1885): 23-25.

[237] F. C. Beach, "The New York May Exhibition," *American Amateur Photographer* 3 (August 1891): 283-91.

[238] See, for example, Stieglitz's "A Plea for a Photographic Art Exhibition," *American Annual of Photography 1895*, pp. 27-28.

[239] For a full listing, see "Artistic Photography at Vienna," *American Amateur Photographer* 3 (July 1891): 268-69.

[240] George Davison, "The Photographic Salon," *American Amateur Photographer* 5 (November 1893): 495, 498.

[241] For a fine study of this publication, see Christian A. Peterson, *Alfred Stieglitz's Camera Notes* (New York: W.W. Norton/Minneapolis Institute of Arts, 1993). Much of the following discussion is drawn from this work.

[242] *Camera Notes* 1 (July 1897): 3.

[243] Ibid.

[244] One of the most baffling and esoteric of these articles is William M. Murray's "The Music of Colors, the Colors of Music and the Music of the Planets," in the January 1898 issue. With the assistance of graphs and calculations, Murray demonstrated that "the characteristic elements of the harmonies of music and of light are included within the compass of the octave," proving that each musical tone corresponded to a color of the spectrum.

[245] Stirling's photograph was published in *Photo-Beacon* 12 (June 1900): 172.

[246] As reported in *American Amateur Photographer* 12 (December 1900): 565, Adamson's work represented "the celebrated Midvale Steel works during the blizzard of 1900." For another Fuguet photograph related in feeling to *The Street*, see *American Annual of Photography 1902*, p. 118. For a short study of Fuguet, see Rick Starr, "Dallet Fuguet," *Image* 18:1 (March 1975): 6-17.

[247] *Wilson's Photographic Magazine* 35 (February 1898): 89. For further data on this show, see pp. 89-92 and 113-18 of this volume.

[248] For example, in 1904-05, a major Kodak Exhibition traveled through numerous cities in England before coming to the U.S., where it was presented in nearly three dozen cities in 1905-07. See *American Amateur Photographer* 18 (November 1906): 529-32. Another Kodak Exhibition circulated beginning in 1912.

[249] From the catalogue for the first Salon. Cited in Joseph T. Keiley, "The Decline and Fall of the Philadelphia Salon," *Camera Notes* 5 (April 1902): 282.

[250] In itself, the choice of these experienced jurors signaled the Salon's intention to place itself in the artistic mainstream. For example, Chase and Vonnoh, together or singly, were on the juries of the 1897, 1898, 1899, and 1901 Carnegie International Exhibitions in Pittsburgh. Neal, *A Wise Extravagance*, pp. 235-36.

[251] Cited in Panzer, *Philadelphia Naturalistic Photography*, p. 14; *Wilson's Photographic Magazine* 25 (December 1898): 529; and *Camera Notes* 2 (January 1899): 113.

[252] *Camera Notes* 2 (January 1899): 126. Similarly, *Wilson's Photographic Magazine* (35[December 1898]: 531) pronounced Käsebier's display "perhaps the most remarkable exhibit made by any single exhibitor."

[253] *Camera Notes* 2 (January 1899): 126.

[254] Watson-Schütze exhibited under her maiden name, Eva Lawrence Watson, until her marriage in 1901.

[255] For background on his publishing career, see Joe W. Kraus, *Messrs. Copeland & Day* (Philadelphia: George S. MacManus Co., 1979).

[256] For example, see Gabriel P. Weisberg, "From the Real to the Unreal: Religious Painting and Photography at the Salons of the Third Republic," *Arts Magazine* 60 (December 1985): 58-63; and Fink, *American Art at the Nineteenth-Century Paris Salons*, pp. 168-75.

[257] Fink, *American Art at the Nineteenth-Century Paris Salons*, p. 168.

[258] For a sense of Minns's artistic ideas, see his later article, "The Ideal in Photography," *Photographic Times* 37 (August 1905): 343-47. At about the same time, a Mr. H. McMichael of Buffalo, New York, did a series of studio images of an actor dressed as Christ. See "Christ-Heads," *Wilson's Photographic Magazine* 31 (November 1894): 515-17; and "Christ in Art," *Wilson's Photographic Magazine* 32 (January 1895): 6-9.

259 From a review of the time, cited in Fink, *American Art at the Nineteenth-Century Paris Salons*, p. 172.

260 Rose G. Kingsley, "The Ideal in Modern Art," *Art Journal* (1901); cited in Gabriel P. Weisberg, "From the Real to the Unreal," p. 58.

261 For an early essay on this subject, see "The Application of Photography to Mythological and Other Ideal Subjects," *Wilson's Photographic Magazine* 28 (January 3, 1891): 10-12. Similarly, it is worth noting that in 1893 T. C. Asplund of Kansas City, Missouri, was arrested for making "indecent photographs which he called 'artist's studies.'" As reported in *Wilson's Photographic Magazine* 30 (February 1893): 65, Asplund "has in his gallery a fine collection of photo-lithographs of ancient and modern sculpture. It was his purpose to have the women pose in imitation of these different masterpieces and photograph them in the nude in that position." The "artistic" merit of the resulting photographs was given no credence at all; they were considered simply pornographic.

262 "Christ-Heads," *Wilson's Photographic Magazine* 31 (November 1894): 515.

263 For the most detailed study of this work, see Estelle Jussim, *Slave to Beauty: The Eccentric Life and Controversial Career of F. Holland Day* (Boston: David R. Godine, 1981), pp. 121-35.

264 A description of this process is given in Stieglitz and Keiley, "The 'Camera Notes' Improved Glycerine Process for the Development of Platinum Prints," *Camera Notes* 3 (April 1900): 221-37.

265 Sadakichi Hartmann, "A Decorative Photographer, F. H. Day," *Photographic Times* 32 (March 1900): 102.

266 *American Amateur Photographer* 10 (December 1898): 554.

267 Charles H. Caffin, "Philadelphia Photographic Salon," *Harper's Weekly* (November 5, 1898): 1087.

268 In *Camera Notes*, 2 (January 1899): 130, Keiley observed that

the night pictures by Mr. Wm. A. Fraser are among the most remarkable pictures in the exhibition. Technically they are faultless, and bespeak years of the most careful work. As one regards these pictures he becomes conscious that Mr. Fraser has made a most careful study of the night effects, under the conditions of fog, mist and rain. His "Wet Night, Columbus Circle," is distinctly his masterpiece. It has a charm that is all its own, a local feeling that is pronounced, and a pictorial value that is beyond dispute.

In his review of this exhibition, *Harper's Weekly* (November 5, 1898): 1087, Caffin wrote:

Among the landscapes are three pictures by Mr. William A. Fraser, of New York, which, to a layman at any rate, have a surprising interest. They represent night scenes in New York City—two of a snowy street, apparently Fifth Avenue, and the third of Columbus Circle on a wet night. The last received the Royal Society's medal...so that it is fair to assume that the picture has exceptional interest. The humidity of the atmosphere, the drippiness of the whole scene, is marvelously rendered, while the pin points and streaks of light from the lamps, the looming monument and blur of buildings beyond, combine to make a composition that is mysterious and fascinating.

269 Martin began his night work in 1895 and presented lantern slides of London by night in that year's Royal Photographic Society annual exhibition. See his *Victorian Snapshots* (London: Country Life Limited, 1939), pp. 24-29. Stieglitz exhibited a night photograph in the London Salon of 1895 and continued working in this vein for several years. Curiously, in his article "Night Photography with the Introduction of Life," in *American Annual of Photography 1898*, p. 205, Stieglitz observed that "Mr. Fraser was the first American to take up work on similar lines to those laid down by Paul Martin."

While the work of Stieglitz, Martin, and Fraser marks the first artistic exploration of night photography, innumerable references to earlier night images may be found. See, for example, John A. Frith, "Photography by Moonlight and Kerosene Lamps," *Anthony's Photographic Bulletin* 18 (October 8, 1887): 589-90. However, the night photographs made prior to 1895 were almost invariably one-shot technical feats rather than aesthetically considered bodies of work. For a contemporary discussion of the work of Martin, Stieglitz, and Fraser, see James B. Carrington, "Night Photography," *Scribner's Magazine* 22 (November 1897): 626-28.

For a good short overview of this subject, see William Sharpe, "New York, Night, and Cultural Mythmaking: The Nocturne in Photography, 1900-1925," *Smithsonian Studies in American Art* 2 (Fall 1988): 3-21.

270 *Camera Notes* 2 (January 1899): 123.

271 For example, see *Camera Notes* 2 (July 1898): 31. The print of *Wet Night, Columbus Circle* was also exhibited in May 1898 at the Camera Club of New York and in September 1898 at the American Institute; see *American Amateur Photographer* 10 (June 1898): 280, and 10 (October 1898): 461. Fraser was also known for his flower photographs; see his article "Floral Photography," *American Annual of Photography 1898*, pp. 51-56; and the repro-

ductions of his work in W. I. Lincoln, *In Nature's Image: Chapters on Pictorial Photography* (New York: Baker & Taylor Company, 1898), pp. 96-102.

272 The following quotes are taken from Fraser's article "Night Photography," *Photographic Times* 29 (April 1897): 161-63. This provides the best summary of his technique and also contains reproductions of six images.

273 In his *Photographic Times* essay (pp. 162-63), Fraser wrote:

Before starting out one's mind must be made up to bear with equanimity all sorts of chaff and uncomplimentary remarks, which are sure to be showered upon the photographer by the majority of the passers by. I have received a great deal of advice and sympathy concerning my mental make-up and condition...

This is varied by a multitude of inquiries ranging from the sublime to the ridiculous, and also indication that an interest in science is abroad on the streets of New York, as I have more than once heard John explaining to Mary as they passed that I was taking a picture by those X-rays the papers have been talking about.

One very stormy night towards the end of November, when making one of my earliest attempts, I was standing by my camera vainly (as it turned out) trying to get a bit which had pleased me, when I heard a voice outside my umbrella saying, "Say, mister, take my picture." On turning round I found it was my good friend, W. B. Post. Even he had not been able to resist the inclination to chaff a fellow-worker when he found him in what seemed a ridiculous position.

274 *Camera Notes* 3 (January 1900): 154.

275 *Camera Notes* 4 (January 1901): 225.

276 *Photo-Era* 5 (December 1900): 165.

277 *American Amateur Photographer* 12 (December 1900): 567. For the ensuing dialogue between Stieglitz and Mitchell, see *American Amateur Photographer* 13 (January 1901): 41-42, and 13 (March 1901): 140-42.

278 Burns, *Inventing the Modern Artist*, pp. 79-119.

279 This essentially optimistic and uplifting sensibility is expressed clearly in the editorial "Freshness of Feeling," in *Outlook* 54 (September 5, 1896): 423-24. This essay begins:

The primary charm of art resides in the freshness of feeling which it reveals and conveys. An art which discloses fatigue, weariness, exhaustion of emotion, deadening of interest, has parted with its magical spell; for vitality, emotion, passionate interest in the experiences of life, devout acceptance of the facts of life, are the prime characteristics of art in those moments when its veracity and power are at the highest point. A great work of art may be tragic in the view of life which it presents, but it must show no sign of the succumbing of the spirit to the appalling facts with which it deals.

280 For a lengthy history of the Philadelphia Salon from the viewpoint of the Stieglitz and Redfield camp, see *Camera Notes* 5 (April 1902): 279-307. For more objective analyses of the history of the Salon, see Panzer, *Philadelphia Naturalistic Photography*, and William Innes Homer, et. al., *Pictorial Photography in Philadelphia: The Pennsylvania Academy's Salons, 1898-1901* (Philadelphia: Pennsylvania Academy of Fine Arts, 1984).

281 In addition to various studies on the Munich Secession, see chapter 6, "Secessionism," in Robert Jensen, *Marketing Modernism in Fin-de-Siècle Europe* (Princeton: Princeton University Press, 1994). Jensen underscores the surprisingly conservative nature of the Secession movement, and its largely tangential relationship to aesthetic modernism.

282 *American Amateur Photographer* 16 (May 1904): 208.

283 "On the Possibility of New Laws of Composition," *Camera Work*, no. 30 (April 1910); repr. in Lawton and Knox, eds., *The Valiant Knights of Daguerre: Selected Critical Essays on Photography and Profiles of Photographic Pioneers by Sadakichi Hartmann* (Berkeley: University of California Press, 1978), p. 133.

284 Paper read at the London Camera Club Conference, as reported in *American Amateur Photographer* 3 (June 1891): 227.

285 Frank M. Sutcliffe, "How to Look at Photographs," *Wilson's Photographic Magazine* 29 (October 15, 1892): 619.

286 Alex Eddington, "The Modern School of Photography," *Wilson's Photographic Magazine* 35 (May 1898): 225.

287 Ibid., p. 229.

288 Sutcliffe, "How to Look at Photographs," p. 621.

289 This was by no means the largest of the multi-negative panoramas done at this time. At the 1893 World's Columbian Exposition, J. C. Strauss of St. Louis exhibited a single print, 25 inches by 15 feet in size, made from a series of 18 x 22 inch plates. The printing frame for this work was 16 feet long and weighed about 300 pounds. *Wilson's Photographic Magazine* 30 (August 1893): 362-63. The largest single-plate views of this era were produced by George R. Lawrence. In 1900, Lawrence constructed a camera that held a 10 x 6 foot film holder; his finished contact prints were 8 x 4½ feet in size. See "George R. Lawrence," *Complete Photographer*, no. 34 (August 20, 1942): 2217-21.

290 Rau provided 250 photographs for the Pennsylvania Railroad's display at the 1893 Columbian Exposition in Chicago. Brown, *Contesting Images*, p. 21.

291 For a study of this theme, see Albert Boime, *The Magisterial Gaze: Manifest Destiny and American Landscape Painting 1830-1865* (Washington, D.C.: Smithsonian Institution Press, 1991).

292 Cited in Leo Marx, *The Machine in the Garden: Technology and the Pastoral Ideal in America* (New York: Oxford University Press, 1964; repr. 1978), p. 3.

293 William Rau, "Railroad Photography: Details of a Novel Expedition Recently Fitted Out," *Philadelphia Public Ledger* (September 26, 1891); cited in *William Herman Rau: Lehigh Valley Railroad Photographs 1899* (Bethlehem: Lehigh University Art Galleries, 1989), n.p. See also Rau's articles, "Railroad Photography," *American Journal of Photography* (February 1897), and "How I Photograph Railroad Scenery," *Photo-Era* 36 (June 1916): 261-66.

294 In addition to Marx's justly celebrated study, see also John A. Kouwenhoven, *The Arts in Modern American Civilization* (1948; New York: W. W. Norton, 1967); and John F. Kasson, *Civilizing the Machine: Technology and Republican Values in America, 1776-1900* (Harmondsworth: Penguin Books, 1977).

295 Gerald R. Bastoni, "William Herman Rau (1855-1920)," in Jay Ruby, ed., *Reflections on 19th Century Pennsylvania Landscape Photography* (Bethlehem: Lehigh University, 1986), pp. 9-11.

296 Rau, "Railroad Photography: Details of a Novel Expedition," n.p.

297 For a fine study of this theme, particularly as it relates to Rau's subject, see Susan Danly and Leo Marx, eds., *The Railroad in American Art: Representations of Technological Change* (Cambridge, Mass.: MIT Press, 1988).

298 For an interesting study of this theme, see Angela L. Miller, "Nature's Transformations: The Meaning of the Picnic Theme in Nineteenth-Century American Art," *Winterthur Portfolio* 24:2-3 (Summer-Autumn 1989): 113-38.

299 For a brief biographical outline of Redfield, see Panzer, *Philadelphia Naturalistic Photography*, p. 41.

300 See Post's article "Picturing the Lily-Pond," *Photo-Era* 33 (August 1914): 73-76.

301 *Camera Notes* 4 (April 1901): 277-78.

302 Charles H. Caffin, *Photography as a Fine Art* (1901; repr. Hastings-on-Hudson: Morgan & Morgan, 1971), p. 166. For a summary of this period of Steichen's work, see Dennis Longwell, *Steichen: The Master Prints 1895-1914* (New York: Museum of Modern Art, 1978).

303 It is important to note that there was no fine line between these "schools" of portraiture. In 1902, an English observer wrote:

> The old school includes the "straight," honest photography. Thoroughly grounded in technique, and with a wide knowledge of things pictorial, the leaders of the old school hold by beautifully finished work, careful lighting, and retouching with a tendency to flatter. The old school is the more numerous and the wealthier division of the American profession. The new school is the more interesting in that it is an aggregation of individualities formed by personal effort. Between the two there is no strong line of demarcation; they blend insensibly into each other. The new school clings to its technique and does not supplant good work with eccentricity; the old school is ever trying new things—new lightings, styles, poses. And many men are equally at home with either class of work.

304 On Falk's role in copyright reform, see, for example, *Photographic Times* 18 (October 26, 1888): 511-12.

305 For a description of this space, see *Wilson's Photographic Magazine* 37 (April 1900): 161-66.

306 *Wilson's Photographic Magazine* 37 (March 1900): 97.

307 Sidney Allen, "An Exquisite Temperament—B. J. Falk," *Wilson's Photographic Magazine* 43 (April 1906): 148. This profile provides interesting insights into Falk's character.

308 The relaxed intimacy of this portrait may, in part, reflect the fact that Falk and Edison had known one another for some time. An earlier Falk portrait of the inventor had been reproduced as the frontispiece of the *American Annual of Photography 1890*.

309 Interestingly enough, Käsebier had learned the fundamentals of portraiture during an apprenticeship with Samuel H. Lifshey, a Brooklyn photographer who had earlier studied with Falk. See Barbara L. Michaels, *Gertrude Käsebier: The Photographer and Her Photographs*, pp. 26, 168 (n. 8).

310 *Wilson's Photographic Magazine* 41 (July 1904): 366.

311 Jackson Lears, *No Place of Grace: Antimodernism and the Transformation of American Culture 1880-1920* (New York: Pantheon Books, 1981), p. 42. The following summary of these ideas is significantly indebted to this fine study. See also George Cotkin, *Reluctant Modernism: American Thought and Culture 1880-1900*.

312 Lears, *No Place of Grace*, p. 91.

313 This is the theme of Peter Gay's study, *The Naked Heart: The Bourgeois Experience, Victoria to Freud* (New York: W.W. Norton, 1995).

314 Blake, "A Vision of the Last Judgment," 1810; cited in Richard Ellmann and Charles Feidelson, Jr., *The Modern Tradition: Backgrounds in Modern Literature* (New York: Oxford University Press, 1965), pp. 56-57.

315 Coleridge, "The Statesman's Manual," 1817; in ibid, p. 43.

316 Charles Baudelaire, "The Temple of Nature," in ibid., pp. 59-60.

317 Stéphane Mallarmé, "Poetry as Incantation," in ibid., pp. 110-11.

318 Wilde, "The Decay of Lying," 1889; in ibid, pp. 20, 23.

319 See, for example, Michael Marlais, "In 1891: Observations on the Nature of Symbolist Art Criticism," *Arts Magazine* 61 (January 1987): 88-93.

320 Wilde, "The Decay of Lying," pp. 18-19.

321 Lears, *No Place of Grace*, p. 142.

322 While drawn from a number of sources, the following discussion is particularly indebted to William Leach, *Land of Desire: Merchants, Power, and the Rise of a New American Culture* (New York: Vintage Books, 1993).

323 James D. Hart, *The Popular Book* (Berkeley: University of California Press, 1950), p. 171; and Neil Harris, "Utopian Fiction and Its Discontents," in Harris, *Cultural Excursions*, p. 150.

324 Leach, *Land of Desire*, p. 108.

325 The cultural context of this book and movement are outlined in David E. Shi, *The Simple Life: Plain Living and High Thinking in American Culture* (New York: Oxford University Press, 1985).

326 Leach, *Land of Desire*, p. 225.

327 Ibid, p. 47.

328 The following discussion is indebted to Christian A. Peterson's fine study, "American Arts and Crafts: The Photograph Beautiful 1895-1915," *History of Photography* 16 (Autumn 1992): 189-234. In addition, see such general studies as Marilee Boyd Meyer et al., *Inspiring Reform: Boston's Arts and Crafts Movement* (Wellesley: Davis Museum and Cultural Center, 1997).

329 For a brief summary of Copeland & Day, see John Tebbell, *A History of Book Publishing in the United States*, vol. II: *The Expansion of an Industry* (New York: R.R. Bowker, 1975), pp. 402-07. See also, James Crump, "F. Holland Day and the Appeal of Handwrought Appearances," in Kathleen Stewart Howe, ed., *Intersections: Lithography, Photography, and the Traditions of Printmaking* (Albuquerque: University of New Mexico Press, 1998), pp. 55-66.

330 See "Photographic Printing by Machinery," *American Amateur Photographer* 7 (September 1895): 407-12.

331 *American Amateur Photographer* 4 (November 1892): 495.

332 E.G. Boon, "Platinum—The Pictorial Photographer's Process," *American Annual of Photography 1913*, p. 138.

333 Jonathan Green, ed., *Camera Work: A Critical Anthology* (Millerton, N.Y.: Aperture, 1973), p. 13.

334 Stieglitz did not begin the use of fine gravure illustrations in photographic journals. The process had been put to use almost a decade earlier for the production of frontispieces in journals such as *American Amateur Photographer* and *Photographic Times*.

335 Estelle Jussim, "Technology or Aesthetics: Alfred Stieglitz & Photogravure," *History of Photography* 3 (January 1979): 87.

336 In "Modern Photographic Processes of Illustration," *American Amateur Photographer* 6 (December 1895): 529-38, it is noted:

> In the printing of photogravures great care is required. No successful method of printing by machinery has as yet been devised. A skillful printer can only pull off about 500 impressions as a day's work; hence the process, compared with others, is a very expensive one, and cannot be used for all kinds of work.

337 "Craig Annan on Picture Making," *American Amateur Photographer* 12 (April 1900): 167.

338 Roger Hull, "The Traditional Vision of Rudolf Eickemeyer, Jr.," pp. 52-55.

339 J. P. Mowbray, *A Journey to Nature* (New York: Doubleday, Page and Co., 1902). The twenty-five chapters of this book were originally published as essays in the *New York Evening Post*.

340 In a profile of Lincoln titled "A New England Flower Lover," *The Craftsman* 27 (March 1915) commented:

> It is only occasionally today that we encounter what we would call the old-fashioned flower lover, the man who seeks the flowers by brookside, on the top of a crag, blossoming timorously under a snow bank or lifting their beauty shyly through faded leaves. Mr. Edwin Hale Lincoln is such a one, and fortunately for the world he not only loves the flowers, but he leaves them to grow in peace and visits them year after year as the season for their beauty comes round, occa-

sionally gathering a few blossoms very carefully and tenderly so that the growth might not be disturbed. And these flowers he takes to his studio where he makes lovely photographic studies of them that the rest of the world may know the New England wild flowers and enjoy them with this man who undoubtedly is their greatest friend and historian. (pp. 630, 635)

[341] For a brief sketch of Lincoln's career, see Wm. B. Becker, "'Permanent Records': The Arts and Crafts Photographs of Edwin Hale Lincoln," *History of Photography* 13 (January-March 1989): 22-30.

[342] Wilson A. Bentley, "Glimpses of Snow and Frost Photography—Winter of 1904," *American Annual of Photography 1905*, p. 59.

[343] Bentley's first essay, "A Study of Snow Crystals," appeared in *Popular Science Monthly* 53 (May 1898): 75-82. Beginning in 1903, Bentley published regular updates of his work in the *American Annual of Photography*. In addition, see his article "Photographing Snowflakes," *Popular Mechanics* 37 (February 1922): 309-12; and Mary B. Mullett, "The Snowflake Man," *American Magazine* 99 (February 1925): 28-31, 173-75.

[344] Peterson, "American Arts and Crafts," p. 205.

[345] Alfred Stieglitz ended the 1908-09 exhibition season of 291 with a show of Japanese prints.

[346] Arthur Wesley Dow, *Composition: A Series of Exercises Selected from a System of Art Education* (New York: Baker and Taylor Co., 1900), p. 36.

[347] Maurice Denis's often-quoted statement of 1890 exemplifies the ideas in European art that supported Dow's later work:

It is well to remember that a picture—before being a battle horse, a nude woman, or some anecdote—is essentially a plane surface covered with colors assembled in a certain order.

Herschel B. Chipp, *Theories of Modern Art* (Berkeley: University of California Press, 1968), p. 94.

[348] For an excellent contemporary description of this collection, see *American Amateur Photographer* 8 (July 1896): 297-303. See also Christian A. Peterson, "George Timmins' Early Collection of Pictorial Photography," *History of Photography* 6 (January 1982): 21-27.

[349] This collection is documented in Weston J. Naef, *The Collection of Alfred Stieglitz: Fifty Pioneers of Modern Photography* (New York: Metropolitan Museum of Art, 1978).

[350] *Camera Notes* 2 (January 1899): 96.

[351] For a useful overview of photographic collecting, see John Pultz, "Collectors of Photography," in *A Personal View: Photography in the Collection of Paul F. Walter* (New York: Museum of Modern Art, 1985), pp. 11-24.

[352] *Camera Notes* 4 (July 1900): 49-54.

[353] Sidney Allen [pseud.], "What is the Commercial Value of Pictorial Prints?" *Photographic Times Bulletin* 36 (December 1904): 539.

[354] Ibid.

[355] See, for example, Alexander Black, "The Artist and the Camera: A Debate," *Century Magazine* 44 (October 1902): 813-22.

[356] Caffin's book, *Photography as a Fine Art* has been reprinted (Morgan & Morgan, 1971), with an introduction by Thomas F. Barrow. For a concise analysis of Caffin's career, see John Loughery, "Charles Caffin and Willard Huntington Wright, Advocates of Modern Art," *Arts Magazine* 59 (January 1985): 103-09.

[357] See Lawton and Knox, eds., *The Valiant Knights of Daguerre*. For brief analyses of Hartmann's criticism, see Alexander S. Horr, "Sadakichi Hartmann as a Photographic Writer," *Photo-Beacon* 16 (October 1904): 307-09; and Peter Plagens, "Hartmann, Huneker, De Casseres," *Art in America* 61 (July-August 1973): 67-70.

[358] Rood judged Hartmann to be one of the three most important influences on American photography in his article "The Three Factors in American Pictorial Photography," *American Amateur Photography* 16 (August 1904): 346-49.

[359] "Random Thoughts on Criticism," *Camera Notes* 3 (January 1900): 102.

[360] For a list of Stieglitz's subsequent exhibitions, see the appendix in Dorothy Norman's *Alfred Stieglitz: An American Seer* (New York: Random House/Aperture, 1973), pp. 232-35.

[361] Roland Rood, "The 'Little Galleries' of the Photo-Secession," *American Amateur Photographer* 17 (December 1905): 567.

[362] Frank Roy Fraprie, "The Little Galleries of the Photo-Secession," *American Amateur Photographer* 18 (March 1906): 120.

[363] While most critics of the time celebrated Käsebier's use of Old Master sources, Sadakichi Hartmann noted pointedly that she "*imitates*...the old masters with a rare accuracy," and was "absolutely dependent on accessories." This unusual negative review was published in the same issue of *Camera Notes* (3 [July 1899]: 16) that included laudatory essays on her work by Arthur Wes-

ley Dow and Joseph T. Keiley. See also Hartmann's "Gertrude Käsebier: A Sense of the Pictorial," *Photographic Times* 32 (May 1900): 195-99, which is also included in Lawton and Knox, eds., *The Valiant Knights of Daguerre*, pp. 198-201. For a good recent analysis of Käsebier's style, see William Innes Homer, "Käsebier and the Art of the Portrait," in *A Pictorial Heritage: The Photographs of Gertrude Käsebier* (Wilmington: University of Delaware/Delaware Art Museum, 1979), p. 19.

[364] As high as this price seemed at the time, it is worth noting that it was only four times Käsebier's "minimum charge" of $25 for a professional portrait sitting. See "A Visit to Mrs. Käsebier's Studio," *Wilson's Photographic Magazine* 40 (February 1903): 73. However, as discussed above, this kind of price was clearly the exception to the rule.

[365] Giles Edgerton [pseud. for Mary Fanton Roberts], "Photography as an Emotional Art: A Study of the Work of Gertrude Käsebier," *The Craftsman* 12 (April-September 1907): 88.

[366] In his review of the Salon, Joseph Keiley described Steichen's *The Lady in the Doorway* as

original, if not artistic or serious. I am inclined to think that Mr. Steichen himself rather regarded it as a puzzle picture, for he on more than one occasion, I am told, set it on end and asked his friends to guess what it was. There were those who termed it *ultra impressionistic*; to me it seemed ridiculously freakish.

Camera Notes 3 (January 1900): 145.

[367] *Camera Notes* 4 (January 1901): 215-16.

[368] Longwell, *Steichen: The Master Prints*, p. 154.

[369] Weston Naef describes Steichen's printing techniques in *The Collection of Alfred Stieglitz*, pp. 443-68. For a period summary of the impact of Steichen's prints see, for example, Roland Rood, "Eduard J. Steichen: A Study of the Artistic Attitude Toward Art and Nature," *American Amateur Photographer* 18 (April 1906): 157-62.

[370] *Wilson's Photographic Magazine* 39 (April 1902): 121.

[371] "The Photo-Secession Exhibition at the Carnegie Art Galleries, Pittsburgh, Pa.," *Camera Work* 6 (April 1905); repr. in Lawton and Knox, eds., *The Valiant Knights of Daguerre*, p. 99.

[372] *Camera Craft* 2 (March 1901): 417.

[373] Sadakichi Hartmann, "Clarence H. White: A Meteor Through Space," *Photographic Times* 32 (January 1900): 18-23; repr. in Lawton and Knox, eds., *The Valiant Knights of Daguerre*, p. 180.

[374] *American Amateur Photographer* 11 (November 1899): 493; and *Camera Notes* 3 (January 1900): 123.

[375] F. Dundas Todd in *Photo-Beacon* 7 (June 1900): 161-63. See also, for example, a harsh criticism of White's work in *American Amateur Photographer* 13 (April 1901): 176.

[376] Roland Rood, "The First American Salon at New York," *American Amateur Photographer* 15 (December 1904): 520.

[377] George Dimock, *Intimations and Imaginings: The Photographs of George H. Seeley* (Pittsfield, Mass.: Berkshire Museum, 1986), p. 20.

[378] Giles Edgerton, "The Lyric Quality in the Photo-Secession Art of George H. Seeley," *The Craftsman* 1 (December 1907): 303.

[379] In addition, it was almost certainly included in de Meyer's one-man show at 291 in 1909.

[380] Charles H. Caffin, "Exhibition of Prints by Baron Ad. De Meyer," *Camera Work*, no. 37 (1912); repr. in Jonathan Green, *Camera Work: A Critical Anthology* (Millerton, N.Y.: Aperture, 1973), p. 218.

[381] For variants of this image, see *Camera Work* (January 1907); and Thomas Weston Fels, *O Say Can You See: American Photographs, 1839-1939. One Hundred Years of American Photographs from the George R. Rinhart Collection* (Cambridge, Mass.: MIT Press/Berkshire Museum, 1989), p. 96. For background on Rubincam's artistic ideas, see his article "Originality in Photography," *American Annual of Photography 1904*, pp. 25-26. In this essay he wrote:

To study the pictures of those photographers admittedly artistic, is good for the amateur's welfare so long as he keeps constantly in mind the necessity for originality; but when he studies them with the idea of duplicating them, he is descending the steps of failure. Remember, then, that above all other things you must be original.

[382] Naef, *The Collection of Alfred Stieglitz*, p. 278.

[383] For an early essay on Brigman's work, see: Emily J. Hamilton, "Some Symbolic Nature Studies from the Camera of Anne W. Brigman," *The Craftsman* 12 (September 1907): 660-64; repr. in Palmquist, ed., *Camera Fiends & Kodak Girls*, pp. 181-84.

[384] Hamilton, "Some Symbolic Nature Studies," p. 184.

385 Susan Harvith and John Harvith, *Karl Struss: Man with a Camera* (Bloomfield Hills: Cranbrook Academy of Art/Museum, 1976), p. 10.

386 On this theme, see Toby A. Jurovics, "Karl Struss: Composing New York," *History of Photography* 17 (Summer 1993): 193-201.

387 Four variant views of this subject are reproduced in Alland, *Jessie Tarbox Beals: First Woman News Photographer*, plates 20-22, 24.

388 For an overview of these ideas, see Mike Weaver, *Alvin Langdon Coburn: Symbolist Photographer, 1882-1966: Beyond the Craft* (New York: Aperture, 1986).

389 The friendship between Coburn and Weber is discussed in Percy North, *Max Weber: The Cubist Decade, 1910-1920* (Atlanta: High Museum of Art, 1991).

390 "The Relation of Time to Art," *Camera Work*, no. 36 (October 1911); repr. in Green, *Camera Work: A Critical Anthology*, pp. 215-16.

391 For a brief study of the importance of these motifs, see Erica E. Hirshler, "The 'New New York' and the Park Row Building: American Artists View an Icon of the Modern Age," *American Art Journal* 21 (Winter 1989): 26-45.

392 I am grateful to George Rinhart for data on Baasch's life and work.

393 This exhibit ran from April 14 to May 11, 1913, and included six landscapes or city views and 19 portraits.

394 This remarkable picture highlights the curious—and even problematic—artistic relationship between Baasch and Strand. It is clear that this photograph was taken from the window or balcony of the Strand family home. Strand's own photograph from this vantage point is titled *People, Streets of New York, 83rd and West End Avenue, 1916*; see Maria Morris Hambourg, *Paul Strand Circa 1916* (New York: Metropolitan Museum of Art, 1998), plate 19. These works are physically comparable: both are platinum prints made from enlarged internegatives: the Strand measures 9½ x 13"; the Baasch is 8⅜ x 12¼". Several questions are thus obvious: Since Strand gave numerous early prints to Baasch, can we be sure that this is actually by the latter rather than the former? Can Baasch's picture really predate Strand's by three or four years?

Two vintage platinum prints of *Repetition* are known to exist; both were in the holdings of the Baasch family until the mid-1990s. The authorship and title of this image have been established by members of the Baasch family. Baasch made it very clear that this image was his work, and no evidence exists to the contrary. The title indicates that this picture was included in Baasch's one-man exhibition at the Camera Club of New York in early 1913 (it appears in the show's checklist). Thus, given the suggestion of summertime warmth in the image, I have dated *Repetition* ca. 1912-13.

Given the amazing sophistication of this image—and the fact that it was almost certainly taken and printed in close association with Strand—it is almost astonishing to conceive that it was made at least three years earlier than Strand's very similar image. Yet, given the information currently available, this appears true, suggesting that Baasch was much more artistically advanced than Strand and exerted a profound influence on him. However, it also raises the possibility that at least some of Strand's ca. 1916 images may have been printed from negatives made several years earlier. In either case, there is clearly more to be known about this important friendship.

395 Apparently, Baasch photographed relatively little in the 1920s. A review of his 1933 Levy exhibition notes:

Discouraged for a while by the plethora of "pictorial photography," Mr. Baasch took up his camera again in 1931, accepting as credo "an approach to things with the greatest possible freedom, without theories or notions."

Edward Alden Jewell, "Tchelitchew's Drawings," *New York Times* (Feb. 25, 1933): 18.

396 For basic background on this subject, see Brian Coe, *Colour Photography: The First Hundred Years 1840-1940* (London: Ash & Grant, 1978); and John Wood, *The Art of the Autochrome: The Birth of Color Photography* (Iowa City: University of Iowa Press, 1993).

397 On the report that Ives had shown color prints as early as 1881, see *Wilson's Photographic Magazine* 32 (January 1895): 33-36.

398 This process is described in Champney, "Fifty Years of Photography," p. 361.

399 See *American Amateur Photographer* 4 (October 1892): 447-48, and *American Annual of Photography 1893*, pp. 165-66.

400 Coe, *Colour Photography*, p. 24.

401 *Wilson's Photographic Magazine* 44 (October 1907): 433, 485. In *Art of the Autochrome* (p. 29), Wood notes that the firm was producing 6,000 plates a day by 1913.

402 Wood, *Art of the Autochrome*, p. 9.

403 "The Lumiere Autochrome Process," *Wilson's Photographic Magazine* 44 (October 1907): 433. The success of this process was all the more notable since so many other—ultimately unsuccessful—techniques had been announced. As the editor observed, "'Color photography' has been 'discov-

ered' at more or less regular intervals ever since photography was invented, until latterly it has been used by the Sunday papers to alternate with the sea-serpent as a space filler in the dull season."

404 Alfred Stieglitz, "The New Color Photography—A Bit of History," *Camera Work* (1907); repr. in Green, *Camera Work: A Critical Anthology*, pp. 124-29.

405 The Stieglitz Autochrome reproduced here was one of his earliest; it was made in Tutzing, Germany, where he had gone to visit Frank Eugene, and to teach him the process. The subject of Steichen's work, Jean Simpson, was the daughter of John Simpson, a noted attorney and art collector, and patron of Steichen's. This is inscribed "Paris October 1907" on the diascope.

406 "Exhibition of 'Autochrome' Photographs," *Wilson's Photographic Magazine* 44 (November 1907): 483. See also *Wilson's Photographic Magazine* 43 (April 1906): 147, and 44 (November 1907): 484-85.

407 Wood, *Art of the Autochrome*, p. 158.

408 Wood, *The Art of the Autochrome*, pp. 45, 53.

409 The following summary is indebted to Wood's chapter "Color Abandoned," ibid., pp. 27-37.

410 In 1908, Coburn fretted about the coming tidal wave of tasteless amateur color photographs:

These people, with their silly little enthusiasms and their entire inability to appreciate the niceties of color will produce the most appalling fried-egg results. They'll plant their cameras anywhere and everywhere; they'll photograph pink flowers against a purple sky; they'll get their colors all out of tone—blues and yellows and scarlets jumping about and hitting one another in the teeth—the whole thing screaming like Sousa's band gone mad.

"The Painters New Rival: An Interview with Alvin Langdon Coburn," *American Photography* 2 (January 1908): 14.

411 Reprinted in Sarah Greenough and Juan Hamilton, *Alfred Stieglitz: Photographs & Writings* (Washington, D.C.: National Gallery of Art, 1983), pp. 181-82.

412 Reprinted in ibid., 185-89.

413 Ulrich F. Keller, "The Myth of Art Photography: A Sociological Analysis," *History of Photography* 8 (October-December 1984): 256.

414 "The Photo-Secession," *Bausch and Lomb Lens Souvenir* (1903); repr. in Greenough and Hamilton, *Alfred Stieglitz: Photographs & Writings*, p. 190.

415 The following owes much to Ulrich Keller's essays "The Myth of Art Photography: A Sociological Analysis," and "The Myth of Art Photography: An Iconographic Analysis," *History of Photography* 9 (January-March 1985): 1-38. While somewhat overstating his case, Keller succeeds in throwing fresh light on this subject.

416 It is interesting to note the generally positive reception originally given the Photo-Secession by the mainstream photographic press. See, for example, *American Amateur Photographer* 15 (May 1903): 213, 232; and 15 (November 1903): 521-24.

417 The following discussion is drawn largely from Sarah Greenough, "Alfred Stieglitz and the Opponents of the Photo-Secession," *New Mexico Studies in the Fine Arts* 2 (1977): 13-19; and Gillian Greenhill Hannum, "Photographic Politics: The First American Salon and the Stieglitz Response," *History of Photography* 15 (Spring 1991): 61-71.

418 For background on this organization, see the articles cited above, and Gillian B. Greenhill Hannum, "The Salon Club of America and the Popularization of Pictorial Photography," Kathleen Collins, ed., *Shadow and Substance*, pp. 245-53.

419 Bell responded heatedly: "The person who has done more than any man living to injure the interests of photography in America is now engaged in the congenial task of insulting the entire photographic fraternity of America, outside of his own little clique of would-be monopolists, by a foolish slur upon the First American Photographic Salon..." *Photo-Beacon* 16 (September 1904): 287.

420 In addition, see "'Grandpa' Redivivus," *Photographic Times-Bulletin* 36 (September 1904): 415-18.

421 "Juvenal," "Little Tin Gods on Wheels," *Photo-Beacon* 16 (September 1904): 282-86.

422 *Photographic Times-Bulletin* 36 (December 1904): 534.

423 Fels, *O Say Can You See*, p. 131.

424 See Roland Rood, "The Press View of the Second American Salon," *American Amateur Photographer* 17 (December 1905): 546-56.

425 For example, Davis was included in the 1907 London and the 1908 Dresden Salons.

426 See Chislett's article, "Photographing Light," *American Annual of Photography 1910*, pp. 233-34.

427 Greenough, "Alfred Stieglitz and the Opponents of the Photo-Secession," p. 18.

428 For example, see Roger Hull's articles "Rudolf Eickemeyer, Jr., and the Politics of Photography," *New Mexico Studies in the Fine Arts* 2 (1977): 20-25; and "Myra Wiggins and Helen Gatch: Conflicts in American Pictorialism," *History of Photography* 16 (Summer 1992): 152-69.

429 In England, for example, the Linked Ring's annual Salons ceased in 1909 due to internal disagreements, giving rise to the London Salon of Photography. Founding American members of this new group included C. Yarnall Abbott, Gertrude Käsebier, and Wilbur Porterfield. These photographers, as well as F. Holland Day and Francis Bruguière, exhibited in the first of these Salons. See H. Snowden Ward, "The London Salon of Photography," *American Photography* 4 (December 1910): 692-98.

430 Anderson, "The Development of Pictorial Photography in the United States During the Past Quarter Century," *American Photography* 8 (June 1914): 330.

431 For an insightful study of this group, and a short biography of Porterfield, see Anthony Bannon et al., *The Photo-Pictorialists of Buffalo* (Buffalo: Media Study, 1981).

432 Anderson, "The Development of Pictorial Photography in the United States During the Past Quarter Century," p. 332.

433 Paul L. Anderson, "The International Exhibition of Pictorial Photography," *American Photography* 8 (April 1914): 184.

434 W. H. Porterfield, "The Pittsburgh Salon of 1914," *American Photography* 8 (March 1914): 118.

435 Paul L. Anderson, *The Fine Art of Photography* (Philadelphia: Lippincott Company, 1919), p. 15.

436 See, for example, the downbeat assessments of American Pictorialism written in the early 1910s by Frank Roy Fraprie and Wilbur Porterfield for the British annual *Photograms of the Year*.

437 For example, in the introduction to his book *The Fine Art of Photography* (1919), Paul L. Anderson counters "the popular belief that the artist must necessarily be more or less neurotic and morally loose," with the prediction that "within a few more years painters, sculptors, musicians, and other workers in the fine arts will come to be regarded as an exceptionally healthy and athletic class" (pp. 17-18).

438 William D. MacColl, "International Exhibition of Pictorial Photography at Buffalo," *International Studio* 43 (March 1911): xv.

439 Historians have subsequently treated this work of the 1840s as a collaboration between Hill and his associate Robert Adamson.

440 Naef, *The Collection of Alfred Stieglitz*, p. 190.

441 MacColl, "International Exhibition of Pictorial Photography at Buffalo," xi.

442 *American Photography* 4 (August 1910): 476. In addition, in the previous months, Stieglitz had gone out of his way to publicly denounce several conservatives in the field. While he had some cause for unhappiness with these figures, Stieglitz's responses seem extreme and deliberately insulting. See his *Photo-Secession and Its Opponents: Five Letters* (New York: privately published, 1910).

443 F. Austin Lidbury, "Some Impressions of the Buffalo Exhibition," *American Photography* 4 (December 1910): 676.

444 J. Nilsen Laurvik, "Alfred Stieglitz, Pictorial Photographer," *International Studio* 44 (August 1911): 22.

445 For Stieglitz's later recounting of the events surrounding this photograph, see *Twice A Year*, nos. 8-9 (Spring-Summer 1942/Fall-Winter 1942): 127-31.

446 For a concise study of this issue, see James S. Terry, "The Problem of 'The Steerage,'" *History of Photography* 6 (July 1982): 211-22.

447 "Alfred Stieglitz and His Latest Work," *Photographic Times* 28 (April 1896): 161.

448 For a good comparison of these photographers, see chapter 4, "Camera Work/Social Work," of Alan Trachtenberg's *Reading American Photographs: Images as History, Mathew Brady to Walker Evans* (New York: Hill and Wang, 1989), pp. 164-230.

449 Lewis W. Hine, "Photography in the School," *Photographic Times* 40 (August 1908): 230. Hine continues:

> As the study progresses and the pupils realize that a real photograph is not a "lucky hit," but the result of intelligent, patient effort, they are given instruction in the choice of subject and in the principles of composition. This is done by means of a study of good examples of art, photographs and paintings, even to the length of making sketches, from the works of these masters, for the purpose of impressing the points studied.

450 This work was begun at a time of great public interest in the issue of immigration, and in the experiences of new arrivals to America. A survey of journals of this period make it clear that Hine was by no means the first, or only, photographer to work at Ellis Island, or to document the living conditions of recent immigrants in the city. See, for example, articles in *The World's Work* such as "Americans in the Raw" 4 (October 1902): 2644-55, and "The Russian Jew Americanized" 7 (March 1904): 4555-61. The first of these articles contains photographs at Ellis Island by Arthur Hewitt, while the second is accompanied by photographs by A. W. Scott.

451 This relationship is illuminated in Daile Kaplan, *Photo Story: Selected Letters and Photographs of Lewis W. Hine* (Washington, D.C.: Smithsonian Institution Press, 1992).

452 It is worth noting the variety of ways in which Hine's photographs were reproduced. In the October 2, 1909 issue of *The Survey*, for example, eight images of child laborers in the South were reproduced in portfolio format. This dignified presentation—full-page halftones on special coated paper stock—emphasized the integrity of Hine's original vision. In this same issue, however, many other Hine images were reproduced in small size on *The Survey*'s normal, inexpensive stock. Still others were published as silhouetted vignettes—isolated figures (newsboys holding newspapers, for example) shorn of all surrounding context.

453 Miles Orvell, "Lewis Hine: The Art of the Commonplace," *History of Photography* 16 (Summer 1992): 88-90.

454 Alan Trachtenberg, "Ever—The Human Document," in *America and Lewis Hine: Photographs 1904-1940* (Millerton, N.Y.: Aperture, 1977), p. 123.

CHAPTER II Abstraction and Realism 1915-1940

1 For a contemporary analysis of this subject, see Mary Ross, "Age of the Automobile: Social Trends in the United States, 1900-1930," *Survey Graphic* 22 (January 1933): 5-10, 52.

2 For an overview of this theme, see Stanley Coben, *Rebellion Against Victorianism: The Impetus for Cultural Change in 1920s America* (New York: Oxford University Press, 1991), esp. chapter 7, "The Guardians."

3 The following discussion is indebted to such studies as Arthur Frank Wertheim, *The New York Little Renaissance: Iconoclasm, Modernism, and Nationalism in American Culture, 1908-1917* (New York: New York University Press, 1976); Edward Abrahams, *The Lyrical Left: Randolph Bourne, Alfred Stieglitz, and the Origins of Cultural Radicalism in America* (Charlottesville: University Press of Virginia, 1986); Steven Watson, *Strange Bedfellows: The First American Avant-Garde* (New York: Abbeville Press, 1991); Adele Heller and Lois Rudnick, eds., *1915, The Cultural Moment: The New Politics, the New Woman, the New Psychology, the New Art & the New Theater in America* (New Brunswick, N.J.: Rutgers University Press, 1991); William Innes Homer, *Alfred Stieglitz and the American Avant-Garde* (Boston: New York Graphic Society, 1977); Dickran Tashjian, *Skyscraper Primitives: Dada and the American Avant-Garde, 1910-1925* (Middletown, Conn.: Wesleyan University Press, 1975); and Robert M. Crunden, *American Salons: Encounters with European Modernism 1885-1917* (New York: Oxford University Press, 1993).

4 Cited in Marius de Zayas, "How, When, and Why Modern Art Came to New York," *Arts Magazine* 54 (April 1980): 106.

5 For a brief study of *The Masses* see Ross Wetzsteon, "Revolution American Style," *Village Voice* (November 15, 1988): 54-58.

6 See, for example, Elizabeth McCausland, "The Daniel Gallery and Modern American Art," *Magazine of Art* 44 (November 1951): 280-85.

7 Judith Zilczer, "'The World's New Art Center': Modern Art Exhibitions in New York City, 1913-1918," *Archives of American Art Journal* 14:3 (1974): 2-7. For a valuable firsthand recollection of this era, see de Zayas, "How, When, and Why Modern Art Came to New York," pp. 96-126.

8 See John Loughery, "The *New York Sun* and Modern Art in America," *Arts Magazine* 59 (December 1984): 77-82. For a recent collection of essays by the *Sun*'s most notable critic, see Daniel Catton Rich, ed., *Henry McBride: The Flow of Art Essays and Criticisms* (New Haven: Yale University Press, 1997).

9 "Frightfulness in Art," *American Magazine of Art* 8 (April 1917): 244.

10 *New York Times*, March 16, 1913; cited in Watson, *Strange Bedfellows*, p. 172.

11 See, for example, "The World's New Art Centre: The Most Startling Moderns Are to Be Shown in New York This Winter" (January 1915): 31; "What The New Art Has Done and the Universally Disturbing Influence of the 'Moderns'" (April 1915): 30-31; "Max Weber: A Leader in the New Art" (September 1915): 36; "Francis Picabia and His Puzzling Art" (November 1915): 42; and "At Last, The Vorticists!" (November 1916): 72. For a brief discussion of Crowninshield's career, see John Russell, "Affair to Remember," *Camera Arts* (January 1983): 54, 65, 82-84.

[12] *Glebe* (1913-14) was edited by the poet Alfred Kreymborg with the assistance of Man Ray. *291* (1915-16) was edited by Marius de Zayas with assistance from Paul Haviland and Francis Picabia; its successor, *391*, was issued intermittently (1917-24) by Picabia from Barcelona, New York, Zurich, and Paris. *Others* (1915-19) was edited by Kreymborg and financed by Walter Arensberg. Man Ray published the *Ridgefield Gazook* (1915), and collaborated with Marcel Duchamp on *Rongwrong* (1917) and with Adolf Wolff on *TNT* (1919). *The Blind Man* (1917) was edited by Duchamp, Henri-Pierre Roché, and Beatrice Wood.

[13] For example, see Judith Zilczer, "Alfred Stieglitz and John Quinn: Allies in the American Avant-Garde," *American Art Journal* 17:3 (Summer 1985): 18-33.

[14] For data on de Zayas, see Douglas Hyland, *Marius de Zayas: Conjurer of Souls* (Lawrence, Kan.: Spencer Museum of Art, 1981), and de Zayas's own reminiscence, "How, When, and Why Modern Art Came to New York." On Stieglitz's brief involvement with Picabia and the Dada movement, see Marcia Brennan, "Alfred Stieglitz and New York Dada," *History of Photography* 21 (Summer 1997): 156-61.

[15] Watson, *Strange Bedfellows*, p. 136.

[16] For short reminiscence of the Arensbergs, see Fiske Kimball, "Cubism and the Arensbergs," *Art News Annual* 24 (1955): 117-22, 174-78.

[17] For an excellent summary of these ideas, see Daniel Joseph Singal, "Towards a Definition of American Modernism," *American Quarterly* 39:1 (Spring 1987): 7-26.

[18] Quoted in Abrahams, *The Lyrical Left*, pp. 1-2.

[19] Quoted in Wertheim, *The New York Little Renaissance*, p. 6.

[20] Wetzsteon, "Revolution American Style," pp. 54-56. For a brief study of Freud's contribution to this new climate of thought, see F. H. Matthews, "The Americanization of Sigmund Freud," *Journal of American Studies* (April 1967): 39-62.

[21] Stieglitz presented one show of African art and four of children's art at 291 between 1912 and 1916. For a good summary of this era's celebration of the divine nature of instinctive creativity, see Hutchins Hapgood's essay "In Memoriam," *Camera Work*, no. 39 (July 1912), repr. in Jonathan Green, *Camera Work: An Anthology* (Millerton, N.Y.: Aperture, 1973), pp. 230-31. For more recent accounts of the "primitivist" influence on the American avant-garde, see Gail Levin, "American Art," in William Rubin, ed., *"Primitivism" in 20th Century Art: Affinity of the Tribal and the Modern* (New York: Museum of Modern Art, 1984), pp. 452-73; and Levin, "Primitivism in American Art: Some Literary Parallels of the 1910s and 1920s," *Arts Magazine* 59 (November 1984): 101-05.

[22] Quoted in "The Greatest Exhibition of Insurgent Art Ever Held," *Current Opinion* 54 (March 1913): 232.

[23] Wanda M. Corn, "Apostles of the New American Art: Waldo Frank and Paul Rosenfeld," *Arts Magazine* 54 (February 1980): 161.

[24] Van Wyck Brooks, "On Creating a Usable Past," *The Dial* (April 11, 1918): 337-41.

[25] Matthew Baigell, "American Art and National Identity: The 1920s," *Arts Magazine* 61 (February 1987): 49.

[26] S. Hartmann, "A Plea for Straight Photography," *American Amateur Photographer* 16 (March 1904): 101-09; repr. Beaumont Newhall, ed., *Photography: Essays & Images* (New York: Museum of Modern Art, 1980), pp. 185-88.

[27] *Camera Work*, no. 49-50 (June 1917); repr. Newhall, ed., *Photography: Essays & Images*, pp. 219-20.

[28] For an introduction to these ideas, see John Pultz and Catherine B. Scallen, *Cubism and American Photography, 1910-1930* (Williamstown, Mass.: Sterling and Francine Clark Art Institute, 1981).

[29] It is notable that Baasch's copy of the last issue of *Camera Work* was inscribed by Strand: "To Kurt, without whose friendship and fine feeling this book would not have happened."

[30] From an interview quoted in Homer, *Alfred Stieglitz and the American Avant-Garde*, p. 246.

[31] Sarah Greenough, *Paul Strand: An American Vision* (New York: Aperture, 1990), p. 37.

[32] On the Philadelphia arts scene in these years, see Wilford Wildes Scott, "The Artistic Vanguard in Philadelphia, 1905-1920," Ph.D. diss., University of Delaware, 1983; and Sylvia Yount and Elizabeth Johns, *To Be Modern: American Encounters with Cézanne and Company* (Philadelphia: Museum of American Art of the Pennsylvania Academy of Fine Arts, 1996).

[33] Constance Rourke, *Charles Sheeler: Artist in the American Tradition* (New York: Harcourt, Brace and Company, 1938), p. 25.

[34] The exact date of their start in photography has been unclear. In his 1963 Schamberg monograph, Ben Wolf states that this occurred in 1913. More recent sources give dates of "about 1910" (Theodore E. Stebbins, Jr., and Norman Keyes, Jr.), "after 1910" (John Pultz and Catherine B. Scallen), and "about 1912" (Carol Troyen and Erica E. Hirschler). The 1910-11 date has been used to reflect the data provided by Stebbins and Keyes (p. 2) documenting that both Sheeler and Schamberg were proficient with the camera by 1911.

[35] While Sheeler's Bucks Country photographs have been typically dated ca. 1914-17, Stebbins and Keyes make a reasoned argument that few were made until 1917. Schamberg's important architectural views bear dates of 1916 and 1917. Letters to Sheeler and Schamberg in the Stieglitz Collection at the Beinecke Library, Yale University, reveal that the two became particularly close with Stieglitz in late 1916.

[36] Karen [Davies] Lucic has extensively researched this period of Sheeler's career. See Karen Davies, "Charles Sheeler in Doylestown and the Image of Rural Architecture," *Arts Magazine* 59 (March 1985): 135-39; Karen Lucic, "Charles Sheeler: American Interiors," *Arts Magazine* 61 (May 1987): 44-47; and Karen Lucic, *Charles Sheeler in Doylestown: American Modernism and the Pennsylvania Tradition* (Allentown, Pa.: Allentown Art Museum, 1997).

[37] The best critical discussion of Schamberg's career is William C. Agee, "Morton Livingston Schamberg (1881-1918): Color and the Evolution of His Painting," *Arts Magazine* 57 (November 1982): 108-19.

[38] For a brief discussion of Schamberg's machine paintings, see Tashjian, *Skyscraper Primitives*, pp. 204-08.

[39] However, Agee has determined that these paintings "were based on real and existing machines" and are not simply artistic inventions. See Agee, "Morton Livingston Schamberg (1881-1918)," p. 117.

[40] Only five individual prints from this series are known to this writer. In addition to the work in the Hallmark Photographic Collection (dated 1917), prints of Schamberg's city views are held in the collections of the Metropolitan Museum of Art (1917), the George Eastman House (1916), the New Orleans Museum of Art (1916), and the estate of William H. Lane (ca. 1916). These latter four images are reproduced, respectively, in the following volumes: Maria Morris Hambourg and Christopher Phillips, *The New Vision: Photography Between the Wars* (New York: Metropolitan Museum of Art, 1989), plate 4; Robert A. Sobieszek, *Masterpieces of Photography from the George Eastman House Collections* (New York: Abbeville Press, 1985), p. 235; *Diverse Images: Photographs from the New Orleans Museum of Art* (Garden City, N.Y.: Amphoto, 1979), p. 87; and Theodore E. Stebbins, Jr., and Norman Keyes, Jr., *Charles Sheeler: The Photographs* (Boston: Museum of Fine Arts, 1987), p. 6.

Schamberg's deliberate working method is suggested by close examination of these five images, which together depict three distinct sites. The Hallmark and Metropolitan prints were made from nearly identical vantage points, but with radically different camera orientations. Changes in areas depicted in both prints suggest that they were probably taken weeks or months apart. The Eastman House and Lane prints were also made from similar vantage points, and utilize almost identical points of view. However, close study of these scenes reveals that they, too, were also made over a significant interval of time. Schamberg's persistence in returning to favored sites to explore their visual potential suggests the importance of these photographs in the overall evolution of his artistic vision. The New Orleans Museum image stands somewhat apart from these four views for its relatively street-level perspective and the apparent use of a telephoto lens.

[41] John Wanamaker played a significant role in promoting fine painting and photography. As William Leach reports in *Land of Desire: Merchants, Power, and the Rise of a New American Culture* (New York: Vintage Books, 1993), pp. 136-37, Wanamaker showed important Old Master and nineteenth-century paintings from his own collection in galleries in his Philadelphia and New York City stores. Deploring the way museums of the time displayed art, he gave paintings generous wall space, helping set a standard later followed by professional curators. Wanamaker's support of photography dates back to at least 1899, when he announced a competitive photographic exhibition to be judged by the noted Philadelphia photographers Rau, Bacon, and Pancoast (see *American Amateur Photographer* 11 [August 1899]: 346). His annual exhibitions appear to have been begun in 1906 (the 1919 show was identified as the 13th annual). For additional information on the Wanamaker photographic exhibitions, and Stieglitz's role as a judge, see Sarah Greenough and Juan Hamilton, *Alfred Stieglitz: Photographs & Writings* (Washington, D.C.: National Gallery of Art, 1983), p. 226.

[42] See de Zayas, "How, When, and Why Modern Art Came to New York," pp. 104-05, and 121.

[43] In the 1918 Wanamaker exhibition Sheeler was awarded first (*Bucks County House, interior detail*) and fourth (*Bucks County Barn*), Strand second (*Wheel Organization*) and fifth (*White Fence*), and Schamberg third (*Por-*

trait). The "Trinity of Photography" quote was reported by Grancel Fitz in his review, "A Few Thoughts on the Wanamaker Exhibition," *The Camera* 22 (April 1918): 202.

[44] *American Photography* 12 (April 1918): 231. For a sampling of negative responses to this show, see also W. R. Bradford's "Exhibitions I Have Met" (in which Stieglitz is parodied as "the redoubtable O. Grumblemdown"), and letters to the editor, *The Camera* 22 (April 1918): 207-10, 220.

[45] In addition to being shown at the 1918 Wanamaker exhibit, this remarkable image (obviously made from a moving vehicle) was exhibited in the Pittsburgh and Toronto salons of that year. Fitz's praise for the Wanamaker shows was no doubt influenced by his own success in them. He received seven $5 awards, and exhibited a total of fifteen prints in the 1916, 1917, 1918, and 1920 exhibitions (as documented in the Wanamaker catalogs for these years in the Paul Strand Archive, Center for Creative Photography, Tucson, Arizona).

[46] Fitz, "A Few Thoughts on the Wanamaker Exhibition," pp. 203, 205.

[47] For basic facts of Man Ray's life, see Neil Baldwin, *Man Ray: American Artist* (New York: Clarkson N. Potter, 1988).

[48] The most recent studies of this important subject are Francis M. Naumann, *New York Dada 1915-1923* (New York: Abrams, 1994); and Francis M. Naumann and Beth Vann, *Making Mischief: Dada Invades New York* (New York: Whitney Museum/Abrams, 1996).

[49] Naumann, *New York Dada*, pp. 215.

[50] Ibid., p. 203.

[51] While this photograph has been widely published as Man Ray's alone, Naumann identifies it as a collaborative effort (*New York Dada*, pp. 51, 54).

[52] All five pages of this journal are reproduced in Naumann, *New York Dada*, pp. 202-06.

[53] These paintings, *Interior* (1918) and *Aviary* (1919), are reproduced in Naumann, *New York Dada*, p. 86; and Foresta et al., *Perpetual Motif*, p. 26.

[54] For an overview of this climate see, for example, Anna Gruetzner Robins, *Modern Art in Britain 1910-1914* (London: Merrell Holberton/Barbican Art Gallery, 1997).

[55] For a good summary of this subject, see Frank DiFederico, "Alvin Langdon Coburn and the Genesis of the Vortographs," *History of Photography* 11:4 (October-December 1987): 265-96.

[56] Pound had been greatly influenced by the ideas of Ernest Fenollosa, who in turn had influenced Dow. For a useful summary of this connection, see, for example, Marianne W. Martin, "Some American Contributions to Early Twentieth-Century Abstraction," *Arts Magazine* 54 (June 1980): 158-65.

[57] The following summary is drawn largely from Richard Cork's essay in the catalogue *Vorticism and Its Allies* (London: Arts Council of Great Britain, 1974). A version of this essay is included in *Vorticism and Abstract Art in the First Machine Age* (New York: Davis & Long Company, 1977).

[58] See Martin, "Some American Contributions," pp. 158-65. For example, Martin notes that Fenollosa, in his book *The Nature of Fine Art* (1894), wrote that art is the result of a "synthetic" process that produces visual relationships in which everything is "plastic and sensitive, full, as it were, of chemical affinities, through which the just and crystalline balance can be rapidly found" (ibid., p. 159).

[59] "Vorticism," *Fortnightly Review* 102 (September 1914): 461-71; repr. Harriet Zinnes, ed., *Ezra Pound and the Visual Arts* (New York: New Directions, 1980), p. 207.

[60] Cork, *Vorticism and Its Allies*, p. 22.

[61] For example, see his essay "Affirmations," *The New Age* (January 14, 1915): 277-78.

[62] *Photograms of 1916*, p. 23. This essay was reprinted in *Photographic Journal of America* 54 (April 1917): 153-54.

[63] Coburn's vortography has often been dated to January 1917, a reflection, most likely, of his much later statement: "It was in January 1917 that I created these first purely abstract photographs." Helmut & Alison Gernsheim, eds., *Alvin Langdon Coburn: Photographer, An Autobiography* (London: Faber & Faber, 1966), p. 104. A more accurate dating of this work is revealed in Pound's letter to his father of September 22, 1916 (in Zinnes, *Ezra Pound and the Visual Arts*, p. 293), in which he states:

> Coburn and I have invented *vortography*. I haven't yet seen the results. He will bring them in tomorrow morning. They looked darn well on the ground glass, and he says the results are O.K.
>
> The idea is that one no longer need photograph what is in front of the camera, but that one can use one's element of design; i.e., take the elements of design from what is in front of the camera, shut out what you don't want, twist the "elements" onto the part of plate where you want 'em, and then fire. I think

we are in for some lark. AND the possibilities are seemingly unlimited. The apparatus is a bit heavy at present, but I think we can lighten up in time...

[64] Coburn's most complete description of the mechanics of this device is included in his *Autobiography*, p. 102. The original vortoscope was soon redesigned to make it lighter and more effective. On October 13, 1916, Pound wrote to the New York collector John Quinn:

> ...Don't know that there is much to report save that Coburn and I have invented the vortoscope, a simple device which frees the camera from reality and lets one take Picassos direct from nature. Coburn has got a few beautiful things already, and we'll have a show sometime or other.
>
> ...First apparatus clumsy, second one rather lighter. Coburn doesn't want much talk about it until he has his first show.
>
> One should see the results first, and then have explanations. At any rate it's a damn sight more interesting than photography. It would be perfectly possible to pretend that we'd discovered a new painter, only one's not in that line...

Quoted in Zinnes, *Ezra Pound and the Visual Arts*, pp. 341-42.

[65] DiFederico, "Alvin Langdon Coburn and the Genesis of the Vortographs," pp. 290-91.

[66] Ibid., p. 291. DiFederico notes that one of the Vortographs in the Eastman House collection is titled *The Eagle*. This collection includes prints from seventeen negatives with twenty-three additional duplicates and variants. In addition to making "straight" prints of his vortograph negatives, Coburn felt free to print many of these same images in reverse.

[67] Ibid., p. 292.

[68] On the general climate of these ideas see, for example, Linda Dalrymple Henderson, "Mysticism, Romanticism, and the Fourth Dimension," in Maurice Tuchman et al., *The Spiritual in Art: Abstract Painting 1890-1985* (Los Angeles: Los Angeles County Museum of Art, 1986), esp. pp. 219-26. On Coburn's specific influences and interests, see Mike Weaver, *Alvin Langdon Coburn: Symbolist Photographer* (New York: Aperture, 1986), particularly "The Symbolist Aspect," pp. 23-30, and "The Speculative or Secret Art," pp. 51-74.

[69] Carpenter, *The Art of Creation: Essays on the Self and Its Powers* (1904), p. 61; cited in Tuchman, et al., *The Spiritual in Art*, p. 224.

[70] Untitled and unsigned essay in *Vortographs and Paintings by Alvin Langdon Coburn* (London: Camera Club, 1917). One can trace Pound's declining interest in the vortographs in his letters to the American art collector John Quinn. After his enthusiastic report of October 13, 1916, Pound wrote on December 17 that Coburn's results "are at least better than bad imitations of the few inventive painters." On January 24, 1917, he wrote that the vortoscope "is an attachment to enable a photographer to do sham Picassos. That sarcastic definition probably covers the ground." (Both letters included in Zinnes, *Ezra Pound and the Visual Arts*, pp. 242, 281.) It seems likely that Pound's enthusiasm for this work rested largely on its adherence to pure Vorticist theory, in which he had great vested interest. As the work developed into an expression of Coburn's own ideas and tastes, it seems inevitable that Pound's enthusiasm would have waned.

[71] *Vortographs and Paintings by Alvin Langdon Coburn*, p. 6.

[72] *Photographic Journal of America* 54 (April 1917): 165.

[73] Anthony Guest, "A.L. Coburn's Vortographs," *Photo-Era* 38 (1917): 227-28.

[74] *Photograms for 1917-1918*, p. 18.

[75] In *American Photography* 11 (August 1917): 437, Struss wrote,

> Many of us have deplored the lack of originality in the studies hung at the annual exhibitions....Newness of vision is very rare and one looks to new workers not only for inspiration but for new methods of expression...The result of this is that many who felt that the possibilities of the medium were, in a sense, exhausted, have stopped work entirely. Others have in seeming desperation gone to all sorts of extremes (as, for instance, Coburn's highly original and amusing "Vortographs").

[76] See, for example, Mike Weaver's negative evaluation of these pictures in his Coburn monograph (pp. 9, 68, 74), and John Szarkowski's dismissal of them in *Looking at Photographs* (New York: Museum of Modern Art, 1973), p. 62.

[77] There were real consequences to dissenting from the patriotic fervor of the time. For example, *The Seven Arts* came to an end in 1917 due primarily to its antiwar articles by Randolph Bourne. See James Oppenheim, "The Story of *The Seven Arts*," *American Mercury* 20 (June 1930): 156-64.

[78] Strand, for example, worked as an X-ray technician in the Army Medical Corps.

[79] In early 1918, the U.S. Signal Corps was calling for donations of lenses from civilian photographers to be used in "a fleet of observation airplanes now being built." See "Enlist Your Lens in the Army," and "The War and Photographic Materials," *Photographic Journal of America* 55 (February 1918): 79-80.

[80] *Photographic Journal of America* 57 (April 1920): 162.

[81] By 1922, it was noted that "it is to be regretted that platinum paper is not being manufactured in America..." Henry Hoyt Moore, "The Year's Progress," *Pictorial Photography in America 1922* (New York: Pictorial Photographers of America, 1922), p. 11.

[82] In 1918, for example, the Signal Corps called for the training of one thousand men to comprise a ground force for its aerial photographic unit. See "Photographers Wanted," *The Camera* 22 (April 1918): 222.

[83] See "Photography in War," *Camera Craft* 25 (September 1918): 341-48; "Aërial Fighting-Cameras," *Photo-Era* 41 (November 1918): 247-52; and "Photography's Notable Part in the War," *Vanity Fair* (December 1918): 51, 78.

[84] "Pictorial Photographs of the A.E.F. in France," *American Magazine of Art* 11 (March 1920): 161-64.

[85] "The Year's Work," *Photograms of 1916*, pp. 5-6. Civilians also used photography to do their bit to keep the soldiers' morale high. For example, Alvin Langdon Coburn, acting as a "sympathetic neutral" in England, volunteered for the "Snapshots-from-Home League," which encouraged the making of simple records of family and friends to send to loved ones at the front. A discussion of this project, as well as of propagandistic and fraudulent uses of photography in the war, is included in John Taylor's article, "Pictorial Photography in the First World War," *History of Photography* 6:2 (April 1982): 119-41.

[86] The following discussion is indebted to Susan D. Moeller, *Shooting War: Photography and the American Experience of Combat* (New York: Basic Books, 1989), esp. pp. 106-52.

[87] *Catalogue of Official A.E.F. Photographs Taken by The Signal Corps* (Washington, D.C.: Govt. Printing Office, 1919).

[88] Major Joseph Mills Hanson, ed., *The World War Through the Stereograph* (Meadville, Pa.: Keystone View Company, 1923). Subsequent editions were published in 1926 and 1927, indicating a continued market for such images well into the 1920s.

[89] For a listing of these exhibitions, see the appendix in Dorothy Norman, *Alfred Stieglitz: An American Seer* (New York: Random House/Aperture, 1973), pp. 236-38.

[90] In his important article "On Creating a Usable Past," Van Wyck Brooks described the state of American culture in terms that suggest Stieglitz's artistic vision of O'Keeffe:

The spiritual welfare of this country depends altogether upon the fate of its creative minds. If they cannot grow and ripen, where are we going to get the new ideals, the finer attitudes, that we must get if we are ever to emerge from our existing travesty of a civilization? From this point of view our contemporary literature could hardly be in a graver state. We want bold ideas, and we have nuances. We want courage, and we have universal fear. We want individuality, and we have idiosyncrasy. We want vitality, and we have intellectualism. We want emblems of desire, and we have Niagaras of emotionality. We want expansion of soul, and we have an elephantiasis of the vocal organs. (p. 339)

[91] Paul Rosenfeld, "Stieglitz," *The Dial* 70 (April 1921): 408. Stieglitz's Anderson Galleries exhibition had an enormous impact on viewers and critics. For a particularly good summary of the importance of this exhibition, see *Photo-Miniature* 16 (July 1921): 135-39, which noted, "this exhibition...aroused more comment than any similar event since photography began, and deservedly, in that it was an exhibition of photography such as the world had never before seen....never was there such a hubbub about a one-man show."

[92] Rosenfeld, "Stieglitz," p. 406.

[93] For a good overview of this series, see Belinda Rathbone, "Portrait of a Marriage: Paul Strand's Photographs of Rebecca," in Maren Stange, ed., *Paul Strand: Essays on his Life and Work* (New York: Aperture, 1990), pp. 72-86.

[94] See Sarah Greenough, "How Stieglitz Came to Photograph Clouds," in Peter Walch and Thomas F. Barrow, eds., *Perspectives on Photography: Essays in Honor of Beaumont Newhall* (Albuquerque: University of New Mexico Press, 1986), pp. 151-65.

Stieglitz's choice of clouds was, in itself, firmly in the most established traditions of American art and photography. For a brief summary of the role of clouds in nineteenth-century American painting, see Barbara Novak, "The Meteorological Vision: Clouds," *Art in America* 68 (February 1980): 102-17; and the corresponding chapter in her book *Nature and Culture: American Landscape 1825-75* (New York: Oxford University Press, 1980). The popular photographic press was full of articles on cloud photography during Stieglitz's day. See, for example: "Hunting for Clouds," *American Photography* 17 (January 1923): 1-5; "Cloudland," *American Photography* 19 (March 1925): 121-31; and "Silver Clouds," *American Photography* 23 (June 1929): 294-96. In general, these articles approached clouds from either a traditionally picturesque (sunsets and other dramatic effects) or a meteorological (distinguishing fracto-cumulus from cirro-cumulus, etc.) point of

view. Also of interest are Alvin Langdon Coburn's illustrations for the 1912 edition of Percy Bysshe Shelley's *The Cloud*.

[95] Alfred Stieglitz, "How I Came to Photograph Clouds," *Amateur Photographer and Photography* 56 (September 19, 1923); repr. in Greenough and Hamilton, *Alfred Stieglitz: Photographs & Writings*, pp. 206-08.

[96] Rosenfeld, "Stieglitz," p. 399.

[97] This quote is from Marius de Zayas's discussion of the work of Picasso in *Camera Work*, no. 34-35 (April-July 1911): 66.

[98] This understanding was, of course, not universal. In 1924, a prominent critic related his experience with these works:

I shall not soon forget my amazement when, some months ago, Stieglitz showed me the series of cloud pictures to the making of which he devoted last summer. They were, it goes without saying, superior to anything that I had ever seen or dreamed was possible. I had not believed that such rendering of values...was possible to the camera. And, listening to Stieglitz, I tried to read into these studies something of what, according to his own confession, he had wished to express. It was hopeless. The more I looked, the more I admired, the more persistent rang the question, Why, Why, Why?...What perverse impulse drives an artist of Stieglitz's calibre to spend a precious year making—with consummate mastery—valueless documents? It seemed little short of tragic.

International Studio 79 (May 1924): 149.

[99] Harold Clurman, "Alfred Stieglitz and the Group Idea," in Waldo Frank et al., eds., *America & Alfred Stieglitz* (New York: Literary Guild, 1934), p. 271.

[100] See Graham Clarke, "Alfred Stieglitz and Lake George: An American Place," *History of Photography* 15 (Summer 1991): 78-83.

[101] *The Craftsman* 28 (May 1915): 148.

[102] It is interesting to consider this image in the tradition of Romantic and mystical thought. In 1802, the German painter Philipp Otto Runge wrote:

I throw myself on the grass sparkling with dewdrops. Every leaf and every blade of grass swarms with life, the earth is alive and stirs beneath me, everything rings in one chord, the soul rejoices and flies into the immeasurable space around me. There is no up and down any more, no time, no beginning and no end.

Cited in Henderson, "Mysticism, Romanticism, and the Fourth Dimension," p. 221.

[103] The distinctly bizarre tension between these utterly different artistic philosophies is revealed in Stieglitz's statement for his 1921 Anderson Galleries show. In it he wrote in consecutive paragraphs:

Many of my prints exist in one example only. Negatives of the early work have nearly all been lost or destroyed. There are but few of my early prints still in existence. Every print I make, even from one negative, is a new experience, a new problem. For, unless I am able to vary—add—I am not interested. There is no mechanicalization, but always photography.

My ideal is to achieve the ability to produce numberless prints from each negative, prints all significantly alive, yet indistinguishably alike, and to be able to circulate them at a price not higher than that of a popular magazine, or even a daily paper. To gain that ability there has been no choice but to follow the road I have chosen.

Repr. in Newhall, ed., *Photography: Essays & Images*, p. 217.

[104] Paul Rosenfeld, "Stieglitz," p. 405.

[105] Joseph Shiffman, "The Alienation of the Artist: Alfred Stieglitz," *American Quarterly* 3 (Fall 1951): 255.

[106] A pioneering argument for White's importance was made in Bonnie Yochelson's essay, "Clarence H. White Reconsidered: An Alternative to the Modernist Aesthetic of Straight Photography," *Studies in Visual Communication* 9 (Fall 1983): 24-44.

[107] The seven issues of the first volume of this journal were published regularly between October 1913 and February 1915. The two issues of the second volume were dated simply 1915. The two issues of *Photo=Graphic Art* are dated June 1916 and October 1917. My thanks to Joseph Bellows for sharing his run of this journal with me.

[108] Dickson was assisted by a number of White circle figures. In May 1914, Coburn was listed as "foreign correspondent" and Struss was named associate editor. The masthead of the final issue includes a substantial list of "associates," including Porterfield, Anderson, Chapman, and Seeley. For a brief outline of Dickson's life, see his obituary in *Pictorial Photographers of America 1922*, pp. 96-97.

[109] Bonnie Yochelson, "Clarence H. White, Peaceful Warrior," in Marianne Fulton et al., *Pictorialism into Modernism: The Clarence H. White School of Photography* (New York: Rizzoli, 1996): 52.

[110] These included museums in Minneapolis, Milwaukee, Chicago, St. Louis, Toledo, Detroit, Cleveland, Cincinnati, Worcester, Syracuse, and New Orleans. See *Pictorial Photography in America 1920* (New York: Tennant & Ward, 1920), p. 6.

[111] These were issued in 1920, 1921, 1922, 1926, and 1929.

[112] These organizations were the Society of Illustrators, the New York Society of Craftsmen, the Stowaways, the Art Alliance, the American Institute of Graphic Arts, the Pictorial Photographers of America, and the Art Director's Club. Yochelson, "Clarence H. White, Peaceful Warrior," p. 90.

[113] "The Filling of Space," *Platinum Print* (December 1913): 6. This essay is reprinted in Percy North and Susan Krane, *Max Weber: The Cubist Decade, 1910-1920* (Atlanta: High Museum of Art, 1991), p. 97.

[114] Ralph Steiner, quoted in Lucinda Barnes, Constance W. Glenn, and Jane K. Bledsoe, *A Collective Vision: Clarence H. White and His Students* (Long Beach: California State University Art Museum, 1985), p. 29.

[115] Yochelson, "Clarence H. White Reconsidered," p. 30.

[116] W. G. Fitz, "A Few Thoughts on the Wanamaker Exhibition," p. 203.

[117] It may not be a coincidence that White was a strong supporter of women as photographic artists and professionals. See, for example, his article "Photography as a Profession for Women," *American Photography* 18 (July 1924): 426-32.

[118] In his essay "The Exigencies of Composition" (*American Annual of Photography 1920*, p. 168), Edward R. Dickson states that

> composing the picture is merely a matter of appreciating the relation which one object bears to another within the space of our ground-glass or finder. It is the means through which we arrive at harmony, and parallels man's effort to establish through union, a fine relationship with another human.

To a much greater degree than the Stieglitz circle, the photographers of the White group continued to value aspects of a Victorian aesthetic. This is underscored in Dickson's essay, "The Pictorial Photographers of America: The Association's Work and Aim," in *Pictorial Photography in America 1920*, p. 6. Here, Dickson writes:

> Some of the advantages which photography offers are worth restating. It helps to draw one closer to nature and to seek fresh air. Through the exercise and cultivation of choice, it teaches how to decorate the home, to dress with taste, and to keep an alert eye and mind on the pressing events of the world.

[119] Chapman had been a student at the White School before serving as an instructor. His working method is outlined in his article "Travel," published in the *American Annual of Photography 1918*, pp. 235-39. *Diagonals*, his most exhibited image, was made from a Sixth Avenue elevated station close to his home. This work exemplified his feeling that "there is too much searching after things strange and unusual in themselves, and not enough analysis and selection of new viewpoints from which to record familiar things."

[120] See the portfolio of Watkins's work, "Photography Comes into the Kitchen," *Vanity Fair* (October 1921): 60.

[121] From a letter to *Popular Photography* (June 12, 1957); quoted in Graham Howe and G. Ray Hawkins, eds., *Paul Outerbridge Jr.: Photographs* (New York: Rizzoli, 1980), p. 9.

[122] This work is illustrated in John Szarkowski, *Looking at Photographs*, p. 81; Howe and Hawkins, eds., *Paul Outerbridge Jr: Photographs*, p. 36; and Elaine Dines, ed., *Paul Outerbridge: A Singular Aesthetic* (Laguna Beach: Laguna Beach Museum of Art, 1981), p. 47. The following discussion is based on information provided in *Paul Outerbridge Jr: Photographs*, p. 11.

[123] As Outerbridge himself noted,

> This abstraction created for aesthetic appreciation of line against line and tone against tone without any sentimental associations, utilizes a tin Saltine cracker box, so lighted that the shadow and reflections from its highly polished surface produced this result. Note especially the gradation at the top of the box.

Cited in *Paul Outerbridge Jr: Photographs*, p. 11.

[124] For some viewers, the form of the box flickers back and forth between positive and negative—that is, between the appearance of a projecting form and a vacant space.

[125] Paul Outerbridge, "Visualizing Design in the Common Place," *Arts and Decoration* 17 (September 1922): 320; cited in *Paul Outerbridge: A Singular Aesthetic*, p. 26.

[126] *American Photography* 17 (July 1923): 417.

[127] *A Collective Vision*, p. 27. For similar sentiments, see Judith Gerber, "Ralph Steiner: Enjoying the Interval," *Afterimage* (March 1978): 18-21. In this interview, Steiner stated that at the White School, "we had people stuffing design down our throats like you stuff a Strasbourg goose to make liver sausage."

[128] Photographs produced for his final project at the School are illustrated in Van Deren Coke and Diana C. DuPont, *Photography: A Facet of Modernism* (New York: Hudson Hills Press/San Francisco Museum of Modern Art, 1986), pp. 30-31. These semi-abstractions are entirely characteristic of the School's emphasis on design and *notan*.

[129] "Advertising and Photography," *Pictorial Photography in America: Volume 4* (New York: Pictorial Photographers of America, 1926), np.

[130] The following is drawn largely from Joe Deal, "Anton Bruehl," *Image* 19:2 (June 1976): 1-9; and the short biography included in Marianne Fulton et al., *Pictorialism into Modernism*, p. 194.

[131] For Gilpin's memory of White and the White School, see Paul Hill and Tom Cooper, "Laura Gilpin Interview," *Camera* (November 1976): 11, 27.

[132] See, for example, her essay "The Need for Design in Photography," *American Annual of Photography* 40 (1926): 154-56.

[133] See Gilpin's books *The Pueblos: A Camera Chronicle* (New York: Hastings House, 1941); *Temples in Yucatan: A Camera Chronicle of Chichén Itzá* (New York: Hastings House, 1948); *The Rio Grande: River of Destiny* (New York: Duell, Sloan & Pearce, 1949); and *The Enduring Navaho* (Austin: University of Texas Press, 1968).

[134] For contemporary profiles of Richards, see the following issues of *Abel's Photographic Weekly*: (October 3, 1931): 407, (October 17, 1931): 455, (October 24, 1931): 483, and (October 31, 1931): 511. See also, Dora Albert, "Experiment Brought Her Success," *Popular Photography* 3 (August 1938): 24-25, 67.

[135] This image was reproduced in *Camera Pictures* (1925), a collection of work by alumni of the Clarence White School.

[136] For a short summary of Offner's career, see his obituary, *New York Times* (September 16, 1965): 47. Offner's brother, Richard Offner, was a noted art historian. Offner's photographs were published intermittently in the journals of the 1920s. See, for example, the somewhat uncharacteristic work included in *Pictorial Photography in America*, vol. 4 (New York: Pictorial Photographers of America, 1926), illustration no. 48. In addition, four of Offner's city pictures are included in the 1927 edition of Carl Van Vechten's novel *Peter Whiffle*.

[137] John A. Brannick, "Jane Reece and Her Autochromes," *History of Photography* 13 (January-March 1989): 1.

[138] Ibid., pp. 1-4.

[139] In addition, the optical quality of a single motion picture frame was considerably inferior to a negative made with a still camera. Even years later, it was common knowledge that "the frames of motion picture film give notoriously poor still photos." "Magic Eye Camera," *Complete Photographer*, no. 38 (September 30, 1942): 2433.

[140] This image depicts the Great Miami River, which flows through downtown Dayton. My thanks to Dominique H. Vasseur, curator at the Dayton Art Institute, for information on this work. See his exhibition catalogue *The Soul Unbound: The Photographs of Jane Reece* (Dayton: Dayton Art Institute, 1997), p. 42. Interestingly, the print of this image in the Dayton Art Institute's collection is laterally reversed. The fact that Reece printed it both ways suggests that her motive was strictly artistic, rather than documentary. The print in the Dayton Art Institute Collection is titled *On the Bank*, and inscribed "enlarged from Cine Kodak film/contact print on Japanese Tissue." (Apparently, an enlarged internegative was made, and then contact-printed on the sensitized tissue.) The print in the Hallmark Photographic Collection is inscribed *Adagio* on the back of the mount.

[141] For a brief summary of his career see Clark's obituary, *New York Times* (April 18, 1945): 23.

[142] Clark served on the Publications Committee of the PPA's *Pictorial Photography in America 1922* (New York: Pictorial Photographers of America, 1922), and on the editorial board of *Pictorial Photography in America*, vol. 5 (New York: Pictorial Photographers of America, 1929). The latter volume includes his essay "A Goal for Photography." Clark's involvement in photography is evident as late as 1939, when he headed the jury for the Illustration section of the PPA's "Sixth International Salon of Photography," held in conjunction with the New York World's Fair.

[143] William Innes Homer, ed., *Symbolism of Light: The Photographs of Clarence H. White* (Wilmington: Delaware Art Museum, 1977), p. 28.

[144] For a good summary of these exhibitions, see Frank R. Fraprie, "Exhibitions and Exhibition Prints," *American Annual of Photography 1927*, pp. 132-35.

[145] *American Photography* 28 (April 1934): 195.

[146] *American Annual of Photography 1939*, pp. 297, 298-301. This attempt to establish artistic merit through statistical analysis was carried to a curious extreme in the *American Annual's* "Numerical Evaluation of Pictorial Achievement," which created a "Print Value Factor" for each salon and a worldwide ranking based on the resulting "Weighed Average." By this measure Thorek ranked tenth worldwide and second among Americans at the time. *American Annual of Photography 1951*, p. 200; this issue also carries Thorek's article, "Photography as an Avocation," pp. 7-32.

(Cambridge, Mass.: MIT Press, 1992). Of particular interest in the latter volume is Sally Stein's essay "'Good fences make good neighbors': American Resistance to Photomontage Between the Wars."

257 For examples of a didactic and documentary use of photomontage in print, see, for example, Charles Cross, ed., *A Picture of America* (New York: Simon and Schuster, 1932), and M. Lincoln Schuster, *Eyes on the World* (New York: Simon and Schuster, 1935).

258 *Murals by American Painters and Photographers* (New York: Museum of Modern Art, 1932). This catalogue illustrates a number of the works exhibited. The photographic section of the exhibit was coordinated by Julien Levy.

259 For an excellent article on the Rockefeller Center project, see Nicholas Ház, "Steichen's Photo-Murals at New York's Radio City," *American Photography* 27 (June 1933): 404-08. Ház reported that Steichen "received the commission exactly three weeks before the murals were to be done" and that the final work was composed of "one hundred and fifty strips, [each] seven feet by three feet" in size. The dimensions of Steichen's Chicago mural were reported to be 16 x 140 feet. It appears that John Paul Pennebaker was also commissioned to create a photomontage for the Chicago fair: see *American Photography* 28 (December 1934): 733. Alexander Alland was one of the most prolific makers of photographic murals. A brief biographical summary in *U.S. Camera Annual 1939* (n.p.) states:

> Mr. Alland specializes in Photo-Murals and Photo-Montage. Some of his murals are hung in the Newark Public Library and he has recently completed a mural of 325 square feet for the Riker's Island Penitentiary library. At present he is designing a Photo-Mural decoration for the New York State Hall of Medical Science, World's Fair, 1939.

Alland lectured on mural-making at the Photo League in 1938; see *Photo Notes* (April 1938): 1.

260 "Photomontage," in Willard D. Morgan and Henry M. Lester, eds., *Miniature Camera Work* (New York: Morgan & Lester, 1938), p. 145. See also Barbara Morgan, "Photomontage," *Complete Photographer*, no. 44 (November 30, 1942): 2853-66. In addition, see such characteristic articles of the day as Fred G. Korth, "Making Photomontages in the Enlarger," *American Photography* 31 (January 1937): 22-26; Thurman Rotan, "Photo-Patterns," *Minicam* 1 (August 1938): 26-28; Alexander King, "Cut It Out!" *Minicam* 2 (August 1939): 18-21; Will Connell, "Photo-Montage," *U.S. Camera* 1 (October 1939): 50-51, 65; and Harry K. Shigeta, "Photomontage Tells the Story," *Popular Photography* 5 (October 1939): 20-21, 113-16.

261 "Hearst Is Still Alive," *New Masses* (June 13, 1939): 3-7.

262 For comments on her technique in making this image, see Morgan's article "My Creative Experience with Photomontage," *Image* 14:5-6 (1971): 19.

263 Morgan identifies this as a product of multiple printing in her essay "Dance Photography," *Complete Photographer*, no. 18 (March 10, 1942): 1137. See, in addition, Barbara Morgan, *Martha Graham: Sixteen Dances in Photographs* (1941: repr. Dobbs Ferry, N.Y.: Morgan & Morgan, 1980); and Morgan's essay "Dance Photography," *U.S. Camera* 1 (February-March 1940): 52-56, 64. On the relation of Graham's ballet to larger documentary concerns, see, for example, William Stott, *Documentary Expression and Thirties America* (New York: Oxford University Press, 1973), pp. 123-27.

264 For a contemporary essay on Connell's career, see Wick Evans, "Will Connell...Master of Pictorial Satire," *Popular Photography* 3 (October 1938): 8-10, 68. For a late career profile, see "Will Connell: Self-Titled 'Myth,'" *U.S. Camera* 24 (January 1961): 76-81, 84, 100.

265 "Will Connell: Self-Titled 'Myth,'" p. 79.

266 *In Pictures: A Hollywood Satire* (New York: T.J. Maloney, Inc., 1937). This contains forty-eight images by Connell, as well as a fictional narrative by Nunnally Johnson, Patterson McNutt, Gene Fowler, and Grover Jones. This text, which is described in the introduction as "a separate entity," was apparently created for the *Saturday Evening Post*. For Connell's own essay on the creation of this work, see "Depression Island," *Camera Craft* 44 (July 1937): 309-15. Connell's use of photomontage in making this series is emphasized in the profile "They Thought He Was Crazy," *Minicam* 2 (February 1939): 32-38, 90-91.

267 "Picture Analysis" (of Connell's *The Find*), *American Photography* 31 (September 1937): 634.

268 The most useful biographical summary of Lynes's life is James Crump, "Photography as Agency: George Platt Lynes and the Avant-Garde," in *George Platt Lynes: Photographs from the Kinsey Institute* (Boston: Bulfinch Press, 1993), pp. 137-47.

269 Numerous articles were published on Lynes and his work in this period. See, for example, "George Platt Lynes: Photographer of Fantasy," *Popular Photography* 4 (February 1939): 24-25, 166-67; and "The Private Life of a Portrait Photographer," *Minicam* 5 (October 1941): 26-33, 97-100.

270 Most interesting in this regard was Laughlin's stated ambition "to create a mythology for our contemporary world." For an extended discussion of this and other aspects of Laughlin's career, see Keith F. Davis, ed., *Clarence John Laughlin: Visionary Photographer* (Kansas City: Hallmark Cards, Inc., 1990).

271 Laughlin's descriptive text for this image reads:

> Made to project my feeling that the form of a pineapple suggests a rocket. Here, the glass dish beneath the pineapple suggests the sphere of force around the rocket, while the pineapple leaves become the rocket blast.

272 This series first bore the title "The Burning Cities of Our Time."

273 Davis, ed., *Clarence John Laughlin*, p. 153. Laughlin writes of this group:

> I tried to create a mythology from our contemporary world. This mythology, instead of having gods and goddesses—has the personifications of our fears and frustrations, our desires and dilemmas. By means of a complex integration of human figures (never presented as individuals, since the figures are intended only as symbols of states of mind), carefully chosen backgrounds, and selected objects, I attempted to project the symbolic reality of our time, so that the pictures become images of the psychological substructure of confusion, want, and fear which have led to the two great world wars, and which may lead to the end of human society...

Laughlin's descriptive caption for *The Unborn* reads:

> Against a background in which the feeling of barrenness is intensively conveyed, the figure—with her neurotic hand, and emotionally starved face—becomes a symbol of the many women in whom the desire for children has been defeated by conditions within our society. Note how the tiny head suggests both the head of an old man, and that of a child—expressing the unrealized promises of an unborn generation. (ibid., p. 162)

274 Brecht wrote: "...less than ever does the mere reflexion of reality reveal anything about reality....So something must in fact be *built up*, something artificial, posed." Quoted in Walter Benjamin, "A Short History of Photography" (1931), in Mellor, ed., *Germany: The New Photography 1927-1933*, pp. 72-73.

275 For a variant of this image, see Martin Kazmaier, *Horst: Sixty Years of Photography* (New York: Universe Publishing, 1996), plate 44.

276 For recent surveys of this theme, see, for example, Richard Guy Wilson, Dianne H. Pilgrim, and Dickran Tashjian, *The Machine Age in America 1918-1941* (New York: Harry N. Abrams/Brooklyn Museum, 1986); and Cecelia Tichi, *Shifting Gears: Technology, Literature, Culture in Modernist America* (Chapel Hill: University of North Carolina Press, 1987).

277 Clifton Fadiman, "What Does America Read?" in Fred J. Ringel, *America as Americans See It* (New York: Literary Guild, 1932), p. 77.

278 Louis Lozowick, "The Americanization of Art," in *Machine-Age Exposition Catalogue* (New York: Little Review, 1927), p. 18.

279 For an important, and ambivalent, reading of the role of technology, see Lewis Mumford, *Technics and Civilization* (New York: Harcourt, Brace & World, 1934). For slightly later studies of this subject, see Siegfried Giedion, *Mechanization Takes Command: A Contribution to Anonymous History* (Oxford: Oxford University Press, 1948), and John A. Kouwenhoven, *Made in America* (New York: Doubleday & Co., 1948; repr. as *The Arts in Modern American Civilization*, 1967). Kouwenhoven's book is a justly famous celebration of the indigenous, "vernacular" style of American culture and art.

280 On this subject, see, for example, Peter Conrad, *The Art of the City: Views and Versions of New York* (Oxford: Oxford University Press, 1984); Merrill Schleier, *The Skyscraper in American Art 1890-1931* (New York: Da Capo Press, 1986); and Anna C. Chave, "'Who Will Paint New York?': 'The World's New Art Center' and the Skyscraper Paintings of Georgia O'Keeffe," *American Art* 5:1-2 (Winter-Spring 1991): 87-107.

281 Cited in Lisa M. Steinman, *Made in America: Science, Technology, and American Modernist Poets* (New Haven: Yale University Press, 1987), p. 40. Williams's influence on the visual arts has been widely researched; see, for example, Rick Stewart, "Charles Sheeler, William Carlos Williams, and Precisionism: A Redefinition," *Arts Magazine* 58 (November 1983): 100-14.

282 The literature on Williams's work is extensive. In addition to the above, see chapter 2 of Steinman, *Made in America*; and Dickran Tashjian, *William Carlos Williams and the American Scene 1920-1940* (New York: Whitney Museum of Art, 1978).

283 Tichi, *Shifting Gears*, p. xii.

284 Ibid., p. 170.

285 Lozowick, "The Americanization of Art," p. 18. See also Barbara Zabel, "Louis Lozowick and Urban Optimism of the 1920s," *Archives of American Art Journal* 14:2 (1974): 17-21.

286 *Machine Art* (New York: Museum of Modern Art, 1934).

C. DuPont, *Florence Henri: Artist-Photographer of the Avant-Garde* (San Francisco: San Francisco Museum of Modern Art, 1990), p. 41.

[226] Cited in Nancy Barrett, *Ilse Bing: Three Decades of Photography* (New Orleans: New Orleans Museum of Art, 1985), p. 9. For an early profile of Bing, see Mildred Stagg, "Ilse Bing: 35mm. Specialist," *U.S. Camera* 12 (May 1949): 50-51.

[227] Newhall, ed., *The Daybooks of Edward Weston: Mexico*, p. 190, entry for September 4, 1926.

[228] For an interesting essay on this theme, see Katharine Grant Sterne, "American vs. European Photography," *Parnassus* 4 (March 1932): 16-20. Sterne describes "the pervading objectivity of American art" and Americans' "dominating reverence for the external fact," and even suggests that "the Russo-German cult of *sachlichkeit* is essentially an American invention."

[229] Thomas S. Kuhn, *The Structure of Scientific Revolutions*, 2nd ed. (Chicago: University of Chicago Press, 1970).

[230] For evidence of the acceptance of the New Vision by the mainstream U.S. photographic world, see, for example, essays such as Albert Jourdan, "What Is a Photograph?" *American Photography* 26 (January 1932): 1-14; and Edwin C. Buxbaum, "Modernism in Photography," *American Photography* 26 (November 1932): 611-22.

[231] "Moving Picture Tricks," *Vanity Fair* 3 (September 1914): 63. For an important study of the film of this era, see Hugo Münsterberg, *The Film: A Psychological Study* (1916; New York: Dover Publications, 1970).

[232] See, for example, Walter Camp, "A Photographic Analysis of Golf," *Vanity Fair* 6 (August 1916): 62-63.

[233] Archer's *Reflections of a Concave Mirror* is reproduced in an essay by Nicholas Ház in *American Photography* 31 (October 1937): 716-18. Ház's text states that "this picture was made twenty years ago [and] was one of the first abstract photographs made in this country."

[234] Edward Steichen, *A Life in Photography* (Garden City, N.Y.: Doubleday & Doubleday, 1963), n.p.

[235] As Steichen later related in *A Life in Photography* (n.p.),

One of my experiments has become a sort of legend. It consisted of photographing a white cup and saucer placed on a graduated scale of tones from pure white through light and dark grays to black velvet. This experiment I did at intervals over a whole summer, taking well over a thousand negatives. The cup and saucer experiment was to a photographer what a series of finger exercises is to a pianist. It had nothing directly to do with the conception or the art of photography.

[236] In his *A Life in Photography*, Steichen reported that he was very impressed by Theodore Andrea Cook's book *The Curves of Life* (1914). For an interesting essay on this work's influence on Steichen and Weston, see Mike Weaver, "Curves of Art," in Bunnell and Featherstone, eds., *EW:100*, pp. 81-91.

[237] Steichen, *A Life in Photography*, n.p. For a summary of the many articles on Einstein and his theory that appeared just prior to Steichen's series, see *Reader's Guide to Periodical Literature, 1919-21*, pp. 472-73.

[238] See, for example, the treatment of this subject in *Vanity Fair*: "All About Relativity" (March 1920): 61; "Rhyme and Relativity: A Page of Parodies..." (August 1921): 31; "Einstein the Man" (September 1922): 62, 104; "Einstein in the Movies" (August 1923): 48, 96; "How to Prove the Einstein Theory with the Aid of a Motor" (October 1923): 79; and "The New Understanding of the Einstein Theory" (March 1925): 29, 76. With the exception of the last, these are insubstantial attempts to explain Einstein's theory, personality profiles, or parodies. The author of the March 1925 essay, J. W. N. Sullivan, noted accurately that "most of the early expositions of the theory suffer from the greatest of defects, namely, that the authors do not quite know what they are talking about." See also the very unscientific "Relativity in Photography," *Photographic Journal of America* 59 (April 1922): 166-67. These pieces remind us that complex ideas rarely find popular expression in their purest and most difficult form. Rather, it is as second- and thirdhand reports, diluted and adulterated, that such concepts have significant cultural impact.

[239] Steichen reproduced four images from this series in his *A Life in Photography*, plates 68-71. These are titled *Time-Space Continuum*; *Harmonica Riddle, France*; *Triumph of the Egg* (a variant of the work reproduced here); and *From the Outer Rim*.

[240] Steichen, *A Life in Photography*, n.p.

[241] See Donna M. Stein, *Thomas Wilfred: Lumina, A Retrospective* (Washington, D.C.: Corcoran Gallery of Art, 1971). A brief biographic sketch of Wilfred is also included in the Museum of Modern Art's catalogue *15 Americans* (1952).

[242] Virginia Farmer, "Mobile Colour: A New Art," *Vanity Fair* 15 (December 1920): 53. This appears to be one of the earliest public accounts of Wilfred's clavilux. For other early reports, see Stark Young, "The Color Organ,"

Theatre Arts Magazine 6 (January 1922): 20-32; Roderick Seidenberg, "Mobile Painting," *International Studio* 75 (March 1922): 84-86; and George Vail, "Visible Music," *Nation* 115 (August 2, 1922): 120-21, 124. Wilfred himself published an article titled "Prometheus and Melpomene" in *Theatre Arts Monthly* 12 (September 1928): 639-41. Photographs of Wilfred's projections are included in several recent sources; see, for example, Tuchman et al., *The Spiritual in Art*, pp. 227, 298-99.

[243] Given the frequency of phrases such as "clouds" and "atmosphere" in descriptions of Wilfred's performances, one wonders if this work had any influence on a series begun soon after the first published reports of the clavilux: Stieglitz's "Equivalents." In 1933 Wilfred founded the "Art Institute of Light" in New York and gave regular Friday night clavilux concerts for several years (see *Reader's Digest* [June 1938]: 70). The Museum of Modern Art included Wilfred in the 1952 exhibition "15 Americans" and mounted a retrospective of his work in 1971. For an interesting summary of this theme in art, see Kenneth Peacock, "Instruments to Perform Color-Music: Two Centuries of Technological Experimentation," *Leonardo* 21:4 (1988): 397-406.

[244] For example, in addition to its article in December 1920, *Vanity Fair* published updates on his work in the issues of March 1922 (p. 70) and May 1925 (p. 67). These three essays were accompanied by a total of eleven "abstract" photographs of projected patterns of light (one in 1920, and five each in 1922 and 1925). It is amusing to note that the 1925 essay contained the confident prediction that "ten years from now, we shall all have light organs in our homes tucked away in a corner of the drawing room, just as we now have phonographs and radios."

[245] "Experiments in Modern Photography," *Vanity Fair* 16 (July 1921): 60. The brief text accompanying these images concluded with the statement that "these photographs... represent one of the most successful attempts on the part of an American to attack the same problems in which the modernistic painter is interested, and to attack them through the camera."

[246] *Theatre Arts Magazine* 6 (January 1922): 23-26.

[247] *New York Times* (April 3, 1927): sec. 8, p. 10.

[248] Lance Sieveking and Francis Bruguière, *Beyond This Point* (London: Duckworth, [1929]); and Oswell Blakeston and Francis Bruguière, *Few Are Chosen: Studies in the Theatrical Lighting of Life's Theatre* (London: Eric Partridge Ltd., 1931). Bruguière's contributions included cut-paper and multiple-exposure images.

[249] Quigley's prominence is indicated by the frequent inclusion of his photographs in the journals of the period. For example, a broad sampling of his work was featured in the October 1935 issue of *The Camera*.

[250] For several interesting mentions of Fitz's early career, see Gray Stone, "The Influence of Alfred Stieglitz on Modern Photographic Illustration," *American Photography* 30 (April 1936): 199-206. A capsule biography of Fitz is contained in Robert Sobieszek, *The Art of Persuasion: A History of Advertising Photography* (New York: Abbeville Press, 1988), p. 194.

[251] For information on this work, see *Ninth Annual of Advertising Art* (New York: Art Director's Club, 1930), p. 75. Fitz specialized in the photography of glassware; earlier editions of this annual reproduce several examples of his work for Fostoria Glass.

[252] Harvey's first national exhibition appears to have been the 1916 International Salon of the California Camera Club; see *Camera Craft* 24 (January 1917): 2, 10. For biographic details, see "Has Harold Harvey Revolutionized Film Development?" *Popular Photography* 2 (May 1938): 55, 102-05; "Pictures While I Walk," *Popular Science* 138 (January 1941): 194-96; and the notes in Thomas Weston Fels, *O Say Can You See: American Photographs, 1839-1939* (Cambridge, Mass.: MIT Press, 1989), p. 134. For an example of Harvey's technical knowledge, see his essays on development in *The Complete Photographer*, no. 19 (March 20, 1942): 1245-48, and no. 20 (March 30, 1942): 1249-97.

[253] By 1932, for example, one critic observed that "the angle-shot is, by now, a device so common that it is viewed askance in the most advanced photographic circles." Sterne, "American vs. European Photography," p. 19.

[254] A variant exposure of this scene, printed on postcard stock, is inscribed "Anchoring at Brest, France, May 13, 1919 at 2 PM." In addition to his successful career as a commercial photographer, Costain exhibited widely in the salons of the period. *Securing the Anchor Chain* was one of his best-known salon prints. My thanks to Keith de Lellis for this information.

[255] For a similar perspective on the American scene, see the essays on Bernd Lohse in *Studies in Visual Communication* 11 (Spring 1985): 76-112.

[256] On this subject, see Cynthia Wayne, *Dreams, Lies, and Exaggerations: Photomontage in America* (College Park: University of Maryland Art Gallery, 1991); and Matthew Teitelbaum, ed., *Montage and Modern Life 1919-1942*

[184] In 1927 Weston reestablished contacts with photographers he had known for some time, including Hagemeyer, Brigman, and Cunningham. He was also powerfully affected by the work of Henrietta Shore, a precisionist painter he met in the early part of that year. Shore painted many of the subjects—including rocks, cypress trees, shells, and nudes—that Weston would embrace in the next few years. In fact, Shore introduced him to shells as an artistic subject and loaned him the first ones he photographed. See Roger Aikin, "Henrietta Shore and Edward Weston," *American Art* 6:1 (Winter 1992): 43-61.

[185] Cited in Amy Conger, *Edward Weston: Photographs from the Collection of the Center for Creative Photography* (Tucson: Center for Creative Photography, 1992), p. 17.

[186] Weston, "Statement" (1931); in Peter C. Bunnell, ed., *Edward Weston on Photography* (Salt Lake City: Peregrine Smith Books, 1983), p. 67.

[187] Newhall, ed., *Daybooks of Edward Weston: California*, p. 154; entry for April 24, 1930.

[188] See, for example, Estelle Jussim, "Quintessences: Edward Weston's Search for Meaning," in Bunnell and Featherstone, eds., *EW:100*, pp. 51-61; and Keith F. Davis, "Edward Weston in Context," in *Edward Weston: One Hundred Photographs from the Nelson-Atkins Museum of Art and the Hallmark Photographic Collection* (Kansas City: Hallmark Cards, Inc., 1982), pp. 62-65.

[189] Nathanial Kaplan and Thomas Katsaros, *The Origins of American Transcendentalism* (New Haven: College and University Press, 1975), pp. 17-18.

[190] *Camera Craft* 37 (July 1930): 313-20.

[191] "Group F. 64 Manifesto" (1932), in Therese Thau Heyman, ed., *Seeing Straight: The f.64 Revolution in Photography* (Oakland: Oakland Museum, 1992), p. 53.

[192] The best concise study of Cunningham's career is Richard Lorenz, *Imogen Cunningham: Ideas without End* (San Francisco: Chronicle Books, 1993).

[193] F. H. Halliday, "Brett Weston, Photographer," *Camera Craft* 47 (March 1940): 118.

[194] Interestingly enough, this photograph evidently struck the Russian photographer and artist El Lissitzky as prototypically American. He used this image as half of a double-printed composite on the cover of Richard Neutra's book *Amerika* (1930). See *Important Avant-Garde Photographs of the 1920s & 1930s*, Sotheby's (London) sale of 2 May 1997. Another print of El Lissitzky's composite print is included in Mike Weaver, ed., *The Art of Photography 1839-1989* (New Haven: Yale University Press, 1989), plate 259.

[195] Responses to this photograph are detailed in Conger, *Edward Weston: Photographs from the Collection*, n.p. (figure 655).

[196] In his autobiography, Adams describes the evening on which the group was formed. After he spoke on behalf of the concept with "extroverted enthusiasm,...we agreed with missionary zeal to a group effort to stem the tides of oppressive pictorialism and to define what we felt creative photography to be." Ansel Adams, with Mary Street Alinder, *Ansel Adams: An Autobiography* (Boston: New York Graphic Society, 1985), p. 110.

[197] This image, of one of the most photographed structures in the Southwest, was described by Adams in his book *Examples: The Making of 40 Photographs* (Boston: New York Graphic Society, 1983), pp. 90-93.

[198] Nancy Newhall, *The Eloquent Light* (Millerton, N.Y.: Aperture, 1980), p. 69.

[199] See also such articles as his "The New Photography," *Modern Photography 1934-35* (London: Studio Limited, 1934), pp. 9-18.

[200] For a subtle rumination on the meaning—and broad appeal—of Adams's work, see John Szarkowski's introduction to *The Portfolios of Ansel Adams* (Boston: New York Graphic Society, 1977).

[201] See John Paul Edwards, "The First Salon of Pure Photography," *Camera Craft* 41 (September 1934): 418-23.

[202] This image, or a very close variant, was one of the several works Baasch exhibited. See "Where Is Photography Going?" *Light and Shade* (April-May 1932): 10. My thanks to Joseph Bellows for bringing this article to my attention.

[203] Although Mortensen's books and articles of this era were officially credited to him alone, they were ghost- or co-written by George Dunham, a writer who taught at Mortensen's school in the 1930s and 1940s. In his last book, *How to Pose the Model* (New York: Ziff-Davis, 1956), Mortensen credited Dunham with co-authorship of all his earlier books and articles. My thanks to Michael Dawson for this information.

[204] William Mortensen, "Fallacies of 'Pure Photography,'" *Camera Craft* 41 (June 1934): 257.

[205] Ibid., pp. 260-61.

[206] Ibid., pp. 257, 263.

[207] See, for example, Albert Jourdan, "Sidelight #16: The Impurities of Purism," *American Photography* 29 (June 1935): 348-56; Weston's various essays of 1939, including "What Is a Purist?" *Camera Craft* 46 (January 1939): 3-9, and "What Is Photographic Beauty?" *Camera Craft* 46 (June 1939): 247-55; and Roi Partridge's "What Is Good Photography?" *Camera Craft* 46 (November 1939): 503-10, 540-42 (with readers' responses in the December 1939 issue, pp. 593-95).

[208] Valuable studies of this complex subject include John Willett, *Art and Politics in the Weimar Period* (New York: Pantheon Books, 1978); David Mellor, ed., *Germany: The New Photography 1927-1933* (London: Arts Council of Great Britain, 1978); Van Deren Coke, *Avant-Garde Photography in Germany 1919-1939* (San Francisco: San Francisco Museum of Modern Art, 1980); Maria Morris Hambourg and Christopher Phillips, *The New Vision: Photography Between the Wars* (New York: Metropolitan Museum of Art/Harry N. Abrams, 1989); Christopher Phillips, ed., *Photography in the Modern Era: European Documents and Critical Writings, 1913-1940* (New York: Metropolitan Museum of Art/Aperture, 1989); and Victor Margolin, *The Struggle for Utopia: Rodchenko, Lissitzky, Moholy-Nagy, 1917-1946* (Chicago: University of Chicago Press, 1997).

[209] On this theme, see, for example, Simon Watney, "Making Strange: The Shattered Mirror," in Victor Burgin, ed., *Thinking Photography* (London: Macmillan Press, 1982), pp. 154-76.

[210] While earlier studies have dated these works to 1918 or "about 1918," a recent study of Schad's career dates them all to 1919. See Tobia Bezzola, ed., *Christian Schad 1894-1982* (Zurich: Kunsthaus Zurich, 1997), pp. 66-73.

[211] It seems probable that Moholy-Nagy began his photograms after Tristan Tzara showed him samples of Man Ray's earliest rayographs. See, for example, Eleanor M. Hight, *Moholy-Nagy: Photography and Film in Weimar Germany* (Wellesley, Mass.: Wellesley College Museum, 1985), p. 49; and Neil Baldwin, *Man Ray: American Artist* (New York: Clarkson Potter, 1988), pp. 98-99.

[212] One rayograph was published in the Autumn 1922 issue of *The Little Review*; four were reproduced in the November 1922 *Vanity Fair*. Man Ray's portfolio *Champs Délicieux*, with twelve photographs of rayographs and a preface by Tristan Tzara, was published in December 1922 in an edition of forty-one.

[213] *Broom* 4 (March 1923). Rayographs were also published in *The Little Review* issue for Autumn/Winter, 1923-24.

[214] Christopher Phillips, "Resurrecting Vision: The New Photography in Europe Between the Wars," in *The New Vision*, p. 81. This essay provides an excellent overview of the entire subject.

[215] His first two important essays, "Production—Reproduction" of 1922 and "Light—A Medium of Plastic Expression" of 1923, are reprinted, respectively, in Phillips, *Photography in the Modern Era*, pp. 79-82; and Lyons, *Photographers on Photography*, pp. 72-73.

[216] László Moholy-Nagy, *Painting Photography Film* (Cambridge, Mass.: MIT Press, 1969; translation of second [1927] edition), p. 7.

[217] Ibid., p. 38.

[218] Ibid., pp. 28, 45.

[219] It appears that the dates of at least some of Moholy-Nagy's early photographs were assigned later. On its reverse, this photogram bears the date 1921, written in pencil in an unknown hand. The revised date of 1922 reflects scholarly consensus that Moholy-Nagy's photographic work did not begin until that year. The physical nature of this print (5 x 7 inches in size on printing-out-paper) is consistent with other examples of his earliest photograms.

[220] Cited in Hight, *Moholy-Nagy*, p. 51.

[221] Information derived from the author's visit to Rothenburg in 1986. Another of Moholy-Nagy's images from this vantage point, in the collection of the J. Paul Getty Museum, is reproduced as plate 50 in Hight, *Moholy-Nagy*.

[222] For essays on this exhibition, see Beaumont Newhall, "Photo Eye of the 1920's: The Deutsche Werkbund Exhibition of 1929," in Mellor, ed., *Germany: The New Photography, 1927-1933*, pp. 77-86; and Ute Eskildsen, "Innovative Photography in Germany Between the Wars," in Coke, *Avant-Garde Photography in Germany, 1919-1939*, pp. 35-46. After its debut in Stuttgart, the show traveled to Berlin, Munich, Vienna, Zagreb, Basel, and Zurich.

[223] Astronomers often view these images as negatives, thereby producing the effect seen here: dark pinpoints on a white ground.

[224] For more information on this image, see Sandra S. Phillips et al., *André Kertész: Of Paris and New York* (Chicago: Art Institute of Chicago/Metropolitan Museum of Art, 1985), p. 266. Five vintage contact prints of this image are known to exist. The print in the Hallmark Photographic Collection was originally sent by Kertész to his future wife, Elizabeth, in Budapest, and subsequently remained in the artist's collection until his death in 1985.

[225] As an added touch of unreality, Henri retouched her model's hair in the negative. She apparently made "free use of retouching" in her portraits. See Diana

147 Edwards's *A Vale in Arcady* was well known in its day. This work was reproduced in the initial publication of the Pictorial Photographers of America (1917), and won first prize in the landscape division of the 1918 "Salon of Photography, California Liberty Fair," in Los Angeles.

148 A great number of such images are reproduced in the journals of the day. The *American Annual of Photography 1917*, for example, includes pictures by Herman Gabriel, Bernard S. Horne, Blanche C. Hungerford, Thomas C. Martindale, G.H.S. Harding, and others.

149 This fascinating image, titled *Jazzmania*, is reproduced in *Camera Craft* 35 (June 1928): 257.

150 It should be noted that this term initially referred to images made with a sharply focused lens, and later to the combination of sharp images on simple, untextured silver-gelatin papers.

151 "The Straight Photograph, and Why," *Photographic Journal of America* 53 (August 1916): 340-42. As early as 1916, Edward Weston used the phrase "straight photographs" to describe his own work: pictures that were muted in focus but not retouched or otherwise manipulated. See Weston's "Photography as a Means of Artistic Expression," a 1916 lecture, in *Afterimage* (January 1976): 14.

152 Clarence H. White, "The Year's Progress," *Pictorial Photography in America 1921* (New York: Pictorial Photographers of America, 1921), p. 7.

153 *Photo-Era* 52 (June 1924): 307.

154 *American Photography* 19 (January 1925): 1.

155 See, for example, the tally of print processes in the 1926 San Francisco Salon, *Camera Craft* 33 (December 1926): 556; or in the 1928 Pittsburgh Salon, *Camera Craft* 35 (June 1928): 254. By contrast, the 1923 Pittsburgh Salon featured no fewer than a dozen techniques: "Artatone, Bromide, Bromoil, Chloride, Carbon, Carbro, Gum, Kallitype, Oil, Platinum, Palladium, and Satista, as well as the various transfers which can be made from certain of these prints." *Photo-Era* 50 (May 1923): 251.

156 Much of the following data is drawn from Dennis Reed's valuable study, *Japanese Photography in America 1920-1940* (Los Angeles: George J. Doizaki Gallery/Japanese American Cultural & Community Center, 1985).

157 See, for example, his article "Japanese Art in Photography," *Camera Craft* 32 (March 1925): 110-15.

158 These occurred in 1921 (Weston's first one-man exhibition), 1925, 1927, and 1931. These exhibitions resulted in numerous print sales, and Weston greatly appreciated the Japanese community's understanding of his work.

159 This image was reproduced in *Photograms of the Year 1927*, *Photofreund Jahrbuch 1927-28* (here mistakenly credited to H. R. Cremer), *Soviet Photography* (March 1928), *American Annual of Photography 1929*, and *Pictorial Photography in America 1929*. My thanks to Stephen White for several of these references. Helen Levitt may have been one of the many American photographers who was impressed by this image; see Sandra S. Phillips and Maria Morris Hambourg, *Helen Levitt* (San Francisco: San Francisco Museum of Modern Art, 1991), p. 47.

160 For example, in the Third International Salon of the Pictorial Photographers of America, held at the Art Center in New York in 1929, fully 33 of the 172 American prints were by Japanese photographers and provided "the keynote to the entire show." This review (*American Photography* 23 [July 1929]: 341) also suggests the resistance of some critics to the apparent domination of such exhibitions by the Japanese contingent.

161 A number of these photographers were part of the forced relocation of Japanese-Americans in the months after Pearl Harbor. Much of the personal property of these families, including artistic photographs, was consequently lost. Dennis Reed, *Japanese Photography in America, 1920-1940* (Los Angeles: George J. Doizaki Gallery/Japanese American Cultural and Community Center, 1985), pp. 75-79.

162 Ira W. Martin, "Why Should Style in Pictures Change," *Camera Craft* 37 (October 1930): 480-88. This article is illustrated with examples of his own work.

163 Paul L. Anderson, "Some Pictorial History," *American Photography* 29 (April 1935): 212, 214.

164 Alfons Weber, "The March of Progress," *Camera Craft* 38 (January 1931): 4. Weber notes that "modernism seems to have a special tendency to destroy this quality [personal feeling] in pictures and instead of a work of art it recedes to purely mechanical photography."

165 Anderson, "Some Pictorial History," p. 214.

166 The title of Mortensen's book reflected his sense of the struggle between the powers of science and technology ("Monsters") and the organic virtues of growth, life, and creative energy ("Madonnas"). In addition, the numerous other essays by these photographers are worth reading, including Thorek's "Why I Am a Pictorial Photographer," *Photo-Era* 61 (August 1928): 63-64.

167 *Photo-Era* 32 (May 1914): 236. This aspect of Weston's work is summarized in articles such as his "Notes on High Key Portraiture," *American Photography* 10 (August 1916): 407-12.

168 Weston's published portraits of Mather include *Margrethe*, in *The Camera* 20 (July 1916): 387; and *Margrethe and Plum Blossoms*, in *American Photography* 15 (March 1921): 131. Weston and Mather were both members of the Camera Pictorialists of Los Angeles by early 1914; see *Platinum Print* (May 1914): 12.

169 *Photographic Journal of America* 54 (May 1917): 189.

170 See *Photo-Era* 42 (May 1919): 225, and *Photo-Era* 46 (May 1921): 227, in regard to works shown at the Pittsburgh Salons of those years.

171 *Camera Craft* 28 (November 1921): 360.

172 *Camera Craft* 28 (November 1921): 392.

173 *Camera Craft* 29 (June 1922): 258.

174 Johan Hagemeyer, "Pictorial Interpretation," *Camera Craft* 29 (August 1922): 361-66. This essay is accompanied by reproductions of some of Hagemeyer's most significant pictures of the period, including *Pedestrians*. Hagemeyer's criticism of the state of photographic art was indicative of a restlessness for change that was shared relatively widely. For example, in his review of the 1923 International Salon, held at the Art Center in New York, John Wallace Gillies made the following observations:

> The thing which struck me most forcibly is that the prints which were hung, among the Americans, where those which fitted a pictorial formula. We have at last standardized pictorial photography. They must be so, or they will not be hung. The trend of fashion at the moment is toward sharper pictures, and so we must all make them a little sharper; not too sharp, as we move slowly, but just a little. Gradually we will get them sharper, until in about ten years we will be making them quite sharp, or as sharp as any pictorialist knows how to make a photograph, which is not very sharp. But we have a set way of making pictures. There is no question about it. Individualism has been set aside, and we have decided how it should be done. Technique is all set, the degree of diffusion is all set, and we make them just so, and they will hang. Good photography, or craftsmanship, has nothing to do with it...

American Photography (July 1923): 390.

175 From an interview published in the *San Jose Mercury* in March 1927; cited in Richard Lorenz, "Johan Hagemeyer: A Lifetime of Camera Portraits," *Johan Hagemeyer* (Tucson: Center for Creative Photography, 1982), p. 14.

176 *Photo-Era* 46 (May 1921): 228; *Camera Craft* 29 (February 1922): 62. In addition, his work in the 1919 Pittsburgh Salon prompted a reviewer to note that he was "experimenting with out-of-the-ordinary compositions" (*American Photography* 13 [June 1919]: 328). Another review of this show noted accurately that Weston's "treatment and subjects were similar to those of Margrethe Mather" (*Photo-Era* 42 [May 1919]: 226).

177 Edward Weston, "Statement," in John Wallace Gillies, *Principles of Pictorial Photography* (New York: Falk Publishing Company, 1923), p. 29. Weston quotes from the essays of John Tennant (on a Stieglitz exhibition), Paul Strand, Sherwood Anderson, Herbert J. Seligman, and Paul Rosenfeld.

178 After moving to Hollywood after World War I, Struss began a successful career as a cinematographer. Weston came to know Struss well, and made several portraits of him, either alone or with his wife. Weston gave this print directly to Struss, who held it in his personal collection until the end of his life.

179 For background on the artistic appeal of Mexico, see, for example, Henry C. Schmidt, "The American Intellectual Discovery of Mexico in the 1920's," *South Atlantic Quarterly* 77 (Summer 1978): 335-51.

180 Weston returned to California from December 1924 through August 1925. During some of this time he shared a studio with Johan Hagemeyer in San Francisco. He then went back to Mexico City until late 1926, when he returned permanently to California. Modotti remained in Mexico until early 1930, when she was deported for her political activities.

181 Tina Modotti, letter to Edward Weston, July 7, 1925; cited in Amy Stark, ed., *The Letters from Tina Modotti to Edward Weston* (Tucson: Center for Creative Photography, 1986), pp. 39-40. For an example of Modotti's political writings, see her *5,000,000 Widows, 10,000,000 Orphans, Women! Do You Want That Again* (1932; repr. La Jolla: Parenthesis Writing Series, 1996).

182 Modotti's entire photographic career seems to span the years 1923 to 1930, and only about 160 images have been firmly identified as hers. See Amy Conger, "Tina Modotti and Edward Weston: A Re-evaluation of Their Photography," in Peter C. Bunnell and David Featherstone, eds., *EW:100 Centennial Essays in Honor of Edward Weston* (Carmel: Friends of Photography, 1986), pp. 63-79.

183 Nancy Newhall, ed., *The Daybooks of Edward Weston: California* (New York: Horizon Press, 1966), p. 181; entry for August 8, 1930.

287 Steiner's photograph is dated 1921-22, while Strand's images of his motion picture camera, and various machine tools, are dated 1922-23.

288 Lewis W. Hine, *Men at Work: Photographic Studies of Modern Men and Machines* (New York: Dover Publications, 1977), n.p. This book was aimed at an adolescent audience.

289 Ibid., n.p.

290 In the article "Treating Labor Artistically," *Literary Digest* 67 (December 4, 1920): 32, it was noted that Hine

> is planning a use for his work that has a combined artistic and sociological significance...[The photographs under discussion] are the first of a series of studies which Mr. Hine is planning to make for the purpose of presenting in photographs or lantern slides in the factories themselves, both to the workers and the managers, a picture record of the significance of industrial processes and of the people engaged in them. This is to be done under arrangement with various individual companies, and the experiment has already been tried in some plants.

291 This photograph was published as the frontispiece to Hine's photoessay "Power Makers," *The Survey* 47 (December 31, 1921): 511. The tone of this photoessay—and the others by Hine of this period—leave no doubt as to his expressive intention. His other photoessays of this period include: "The Railroaders," *The Survey* 47 (October 29, 1921): 159-66; "Harbor-Workers," *The Survey* 47 (February 25, 1922): 851-58; "Postal Service in the Big City," *The Survey* 48 (July 1, 1922): 455-62; etc.

292 "Skyscrapers," *The Survey* 56 (April 1, 1926): 35-37.

293 For an early profile of Hoppé, see *Wilson's Photographic Magazine* 46 (July 1909): 300-02.

294 The following discussion is indebted to Bill Jay, "Emil Otto Hoppé, 1878-1972," and Mick Gidley, "Hoppé's Romantic America," in *Studies in Visual Communication* 11 (Spring 1985): 5-41.

295 This theme is discussed in Gidley, "Hoppé's Romantic America," pp. 26, 28. In his autobiography, Hoppé noted his interest in viewing background subjects through a foreground screen: "I must confess to a strong propensity for making use of steel bridges" for this purpose. Cited in Conrad, *The Art of the City*, p. 242.

296 For an excellent study of this film, see Jan-Christopher Horak, "Modernist Perspectives and Romantic Desire: Manhatta," *Afterimage* 15 (November 1987): 8-15.

297 Theodore E. Stebbins, Jr., and Norman Keyes, Jr., *Charles Sheeler: The Photographs* (Boston: Museum of Fine Arts, 1987), p. 27. For useful background on this project see pp. 24-33 of this volume, as well as Susan Fillin-Yeh, "Charles Sheeler: Industry, Fashion, and the Vanguard," *Arts* 54 (February 1980): 154-58; Karen Lucic, "Charles Sheeler and Henry Ford: A Craft Heritage for the Machine Age," *Bulletin of the Detroit Institute of Arts* 65:1 (1989): 37-47; and Mary Jane Jacob and Linda Downs, *The Rouge: The Image of Industry in the Art of Charles Sheeler and Diego Rivera* (Detroit: Detroit Institute of Arts, 1978).

298 These were presented in both fine-art and commercial contexts. For their use in Ford promotion see, for example, Edwin P. Norwood, *Ford Men and Methods* (Garden City, N.Y.: Doubleday, Doran & Co., 1931).

299 Stebbins and Keyes, *Charles Sheeler: The Photographs*, p. 25.

300 Sheeler's vantage point for this image can be deduced from careful study of the aerial view of the Ford plant reproduced in ibid. as figure 40, p. 26.

301 Constance Rourke, *Charles Sheeler: Artist in the American Tradition* (New York: Harcourt, Brace & World, 1938; repr. New York: Kennedy Galleries/Da Capo Press, 1969), p. 130. In discussing his work at Chartres, Sheeler observed:

> Every age manifests itself by some external evidence. In a period such as ours when only a comparatively few individuals seem to be given to religion, some form other than the Gothic cathedral must be found. Industry concerns the greatest numbers—it may be true, as has been said, that our factories are our substitute for religious expression.

This represents a relatively restrained endorsement of ideas that were widely held at the time. Calvin Coolidge, for example, pronounced that "The man who builds a factory builds a temple. The man who works there worships there." (Cited in Lucic, *Charles Sheeler and the Cult of the Machine*, p. 16). See also Henry Ford's article "Machinery—The New Messiah," *The Forum* 79 (March 1928): 363-64.

302 Jean Bony, *French Gothic Architecture of the 12th and 13th Centuries* (Berkeley: University of California Press, 1983), p. 233.

303 Margaret Bourke-White and Edward Steichen were two of several other noted photographers to photograph this bridge. For a capsule biography of Bratter, see Fels, *O Say Can You See*, p. 134. Bratter's purist images were included in several prestigious exhibits of the early 1930s. See, for example, Sterne, "American vs. European Photography," pp. 18, 20.

304 Significantly, the Brooklyn Bridge, which had been completed in 1883, had been "rediscovered" as an aesthetic achievement by this time. See Alan Trachtenberg, *Brooklyn Bridge: Fact and Symbol* (Chicago: University of Chicago Press, 1979).

305 Kouwenhoven, *Made in America*, p. 206.

306 See his article "Men at Work," *Camera Craft* 43 (July 1936): 313-18.

307 Note that this was begun as Hoover Dam. It was renamed Boulder Dam in 1933, but reverted to its original name in 1947.

308 For a good introduction to this subject, see Richard Guy Wilson, "Machine-Age Iconography in the American West: The Design of Hoover Dam," *Pacific Historical Review* 54 (November 1985): 463-93.

309 Glaha was Chief Photographer, U.S. Bureau of Reclamation. For information on his career see Willard Van Dyke, "The Work of Ben Glaha," *Camera Craft* 42 (April 1935): 166-72; and Glaha's own essays: "Boulder Dam: The Photography of Engineering Works," *U.S. Camera* 1 (January-February 1939): 18-23, 78-79, and "Progress Engineering Photography," *Complete Photographer*, no. 46 (December 20, 1942): 3006-15.

310 Glaha, "Boulder Dam," p. 18. In this essay Glaha suggests the challenge he faced in maintaining these aesthetic standards:

> I can see no reason why a photograph, even though the reason for its being made is purely utilitarian and it is to receive no distribution beyond the pages of a technical report, should not be as attractive and as technically sound as it is possible to make it. After all, its purpose is to illustrate or to analyze; and it has gone a long way toward meeting this requirement if it is visually lucid and pleasing.
>
> However, I once spent three days crawling around between the steel ribs of a huge gate photographing rivet holes. My ideals of photographic integrity and technical purity were at a low ebb at about the three hundredth hole and were practically nil when the job was over.

311 Van Dyke, "The Work of Ben Glaha," p. 166.

312 A variant of this image was published in the second issue of *Fortune* 1 (March 1930): 108.

313 In addition to publishing powerful photographs, *Fortune* also made regular use of artwork by such leading painters as Charles Burchfield, Reginald Marsh, Thomas Hart Benton, Charles Sheeler, and Diego Rivera.

314 For a parody of *Fortune's* characteristically upbeat tone, see "Mis-Fortune," *Vanity Fair* 42 (March 1934): 22-23, 62.

315 See, for example, "Germany in the Workshop," *Fortune* 2 (December 1930): 89-94, 126.

316 The following discussion is derived in part from Glenn A. Matthews, "Photography Goes Forward—A Review of a Decade of Progress," *American Annual of Photography* 1940, pp. 7-26.

317 Ibid., p. 10.

318 On the transmission of photographs by wire, see *Camera Craft* 25 (September 1918): 344-45; and "Sending Photographs by Telegraph," *Camera Craft* 32 (April 1925): 182-87. In "Photography Goes Forward," Matthews observed: "Photographs of all front page news stories are now transmitted by radio across the ocean" (p. 20).

319 For a good early article on the Leica, see C. T. Chapman, "The Small Movie-Film Cameras," *Photo-Era* 60 (June 1928): 326-33. Chapman mentions a less-known precursor of the Leica that produced images in the half-frame size: "About two years ago the Agfa Ansco Corporation brought out the Memo Camera, which used standard film and made fifty pictures of single-frame movie size to the roll." In fact, still cameras designed to shoot 35mm motion-picture stock appeared as early as 1913, when the American Tourist Multiple camera was introduced. See Brian Coe, *Cameras* (New York: Crown Publishers, 1978), pp. 111-13.

320 Nelson was an associate of Edward Steichen's at Condé Nast Publications. For more on his Stieglitz series, see Steichen's essay, "The Lusha Nelson Photographs of Alfred Stieglitz," *U.S. Camera*, no. 8 (February-March 1940): 16-19.

321 For a short history of the early Contax, see John Johanneson, "The Contax," *Camera* 35 (April-May 1968): 58-59, 83.

322 For a brief survey of this subject, see Edna Bennett, "History of 35mm, Part One: 1912 to 1936," *Camera* 35 (December-January 1960): 21-35, 80-81; and "History of 35mm, Part Two: 1936-1960," *Camera* 35 (February-March 1960): 56-67, 80.

323 The literature of this period provides conflicting accounts of this technique, with the first successful photographs by this process dated between 1884 and 1893. See, for example, "Photographing Projectiles in Flight," *Scientific American* 103 (July 10, 1910): 51, 58; and "Shooting Flying Bullets with a Camera," *Scientific American Monthly* 2 (October 1920): 147-49.

324 In "Shooting Flying Bullets with a Camera," Bull is reported to have successfully shot footage at the rate of 5,000, 10,000, and even 20,000 frames per second. A later article, "High Frequency Photography for the Analysis of Motion," *Photo-Era* 60 (June 1928): 360, states that his camera worked at a rate of 2,500 frames per second. For a report of similar research conducted in Great Britain, see "Practical Kinematography," *Photo-Era* 55 (October 1925): 207.

325 See Philip P. Quayle, "Photography of Bullets in Flight," *Journal of the Franklin Institute* 193 (May 1922): 627-40. Three of these photographs were reproduced in the *Photographic Journal of America* 59 (September 1922): 338-39, 344.

326 Capt. S. P. Meek, "Tagging a Bullet on the Wing," *Scientific American Monthly* 133 (September 1925): 158-59.

327 "High Frequency Photography for the Analysis of Motion," *Photo-Era* 60 (June 1928): 360.

328 For example, see *Modern Photography 1931* (London: The Studio, 1931), p. 116.

329 Tabor appears to have exhibited most actively from about 1927 to 1931; see the "Who's Who in Pictorial Photography" compilations in the *American Annual of Photography* for these years. Examples of Tabor's artistic work are reproduced in *American Photography* 23 (June 1929): 297; *Pictorial Photography in America* vol. 5, ill. no. 43; and *American Annual of Photography 1930*, p. 50.

330 A label on the back of this mount reads: "Exhibited Photographic Society of Philadelphia." The full caption for this image (in a label stripped into the original negative) reads: "Made with the 10.25 inch Ross-Feckner Objective at the Cook Observatory. Exposure 7h 17m, 0h34m, 40 50″."

331 The complete caption on the back of this print (on an Underwood & Underwood label) reads:

SPEEDING PHOTO TRANSMISSION AND DELIVERY—VIEW TAKEN FROM AIRPLANE OVER WASHINGTON IS DELIVERED TO NEW YORK PRESS 2 HRS. AND 16 MINS. AFTER BEING SNAPPED

PHOTO SHOWS: A scene transmitted from Washington, D.C., over the A. T. & T. transmission system, which was taken by Captain Albert W. Stevens, well-known Army Air Corps photographic expert. Exactly 10 minutes after the photo was taken, the developed film was dropped in an illuminated parachute to a waiting party on the ground. The film was then rushed to the A. T. & T. Washington office and placed on the transmission machine one hour and 17 secs. after reaching the ground. Forty-nine minutes later it was delivered to the New York press for publication.

332 See Stevens's articles "Man's Farthest Aloft," *National Geographic* 69 (January 1936): 58-94; and "Photography in the Stratosphere," *U.S. Camera Annual 1936*, pp. 186-90. On Stevens's 1934 flight to 60,613 feet, see his "Exploring the Stratosphere," *National Geographic* 66 (October 1934): 397-434. Also of interest is his later essay "Aerial Photography in Modern Military Practice," *Complete Photographer*, no. 2 (September 30, 1941): 119-34.

333 The following is drawn largely from Joseph S. Friedman, *History of Color Photography* (Boston: American Photographic Publishing Co., 1944); Louis Walton Sipley, *A Half Century of Color* (New York: Macmillan, 1951); and Brian Coe, *Colour Photography: The First Hundred Years 1840-1940* (London: Ash & Grant, 1978).

334 See, for example, "Pertinent Points About Dufaycolor," *Camera Craft* 42 (May 1935): 234-36. For a recent history of the process, see S. F. W. Welford, "Dufaycolor," *History of Photography* 12 (January-March 1988): 31-35.

335 The name Kodachrome had first been used by Kodak in 1914 for a two-color (red and green) portrait process. See Dr. C. E. Kenneth Mees, "The Kodachrome Process of Color Portraiture," *American Annual of Photography 1916*, pp. 9-21; and Jane Baum McCarthy, "The Two-Color Kodachrome Collection at the George Eastman House," *Image* 30 (September 1987): 1-12.

336 For a short history of this material, see Horst W. Staubach, "Kodachrome," in Manfred Heiting, ed., *50 Years: Modern Color Photography* (Cologne: Photokina, 1986), pp. 17-25.

337 One of the other processes of this era—the Brewstercolor technique of P. D. Brewster—is described in Harry H. Lerner, "Color Portrait—1915," *Photo Arts* (Spring 1948): 86, 110, 112, 114.

338 For a good description of the process, see Guy C. Whidden, "Color Photography Achieved," *Camera Craft* 23 (January 1916): 3-8.

339 Ives showed a group of these pictures in the exhibition of the American Institute of Graphic Arts, held at the National Arts Club in New York in the fall of 1916; see "Photography in the Making," *Photographic Journal of America* 53 (December 1916): 507. For Struss's praise of Ives's process, see his "Color Photography," *American Photography* 11 (August 1917): 437-44.

Struss apparently advocated using the process for aerial photography in World War I; see Will Connell, "About Karl Struss," *U.S. Camera*, no. 15 (April 1941): 73.

340 Anderson's subject, Hebe Hollister, was a friend and fellow member of the White circle. For another Hess-Ives image by Anderson, see the frontispiece to his book *The Fine Art of Photography* (Philadelphia: Lippincott, 1919).

341 Fitz was particularly active in this regard, exhibiting three Hess-Ives prints in the 1918 Annual Exhibition of the Toronto Camera Club, and two in that year's Los Angeles Salon of Photography. The latter exhibition gave unusual prominence to color photography, with a section of over seventy Autochromes by eleven photographers, as well as Hess-Ives prints by Fitz and Edwin D. Petersen.

342 Joseph W. Gannon, "The Raylo Process of Color Photography," *Camera Craft* 30 (July 1923): 305-10.

343 For a good outline of the process, see Paul Outerbridge, *Photographing in Color* (New York: Random House, 1940). His essay from this book is reprinted in Elaine Dines, ed., *Paul Outerbridge: A Singular Aesthetic* (Laguna Beach: Laguna Beach Museum of Art, 1981): 205-25.

344 The need for cool temperatures was cited as one of the reasons the carbro process was more popular in New York than in more southerly cities with higher summertime temperatures. See Sipley, *A Half Century of Color*, p. 103.

345 Ibid., p. 95.

346 This was despite the steady promotion of "new and simplified" color print processes for the advanced amateur. The photographic journals of this period are full of articles such as "Paper Prints from Natural Color," *Minicam* 1 (September 1937): 70-73; "Paper Prints from Natural Color Film," *Minicam* 1 (October 1937): 65-69; and "Now You Can Make Color Prints," *Minicam* 2 (May 1939): 18-19, 88-91.

347 Sipley, *A Half Century of Color*, pp. 87-89. Color images were published earlier, of course, but these were either made from transparencies or direct from camera-generated separations.

348 Ibid., pp. 90-96. Bruehl worked in advertising photography from 1928 to 1966. For an interview with Bruehl late in life, see Casey Allen, "Bruehl," *Camera 35* 23 (October 1978): 20-21, 75-77. On the difficulties of commercial color work in the 1930s, Bruehl notes in this interview:

Of course the film was very slow then; the ASA was 4 or 5. We had to use an enormous amount of light. I made my own flash equipment; the reflectors were three or four feet in diameter with one big flashbulb in the middle. I've used as many as 600 flashbulbs in one picture.... It was hard work in those days. The camera alone weighed 75 pounds and everything was on a tripod. (p. 75)

349 See Williams's articles "What Is Photogenic?" *U.S. Camera*, no. 4 (June 1939): 50-51; and "Food Photography," *Complete Photographer*, no. 29 (June 30, 1942): 1874-83.

350 Work by these figures dominates the first few *U.S. Camera* annuals. Interestingly, noncommercial color images by Genthe were published in the 1939 edition of this annual (p. 108). Several of these figures wrote on the aesthetics of color; see, for example, James N. Doolittle, "Composition and Contrast in Color Photography," *Popular Photography* 5 (December 1939): 96-97, 149-50.

351 William Mortensen, "Color in Photography," *Camera Craft* 45 (May 1938): 202. This was the first of a series of articles on the subject that Mortensen wrote for *Camera Craft* over the next few months.

352 Ibid., p. 203.

353 Johnston's image was used as the cover of the March 1935 issue of *The American Magazine*; a variant of this image was published in *U.S. Camera 1935*, facing p. 102.

354 See Ház's article, "Make Idea Pictures in Color," *Minicam* 3 (November 1939): 36-41, 142-43. In this issue, *Birth of Venus* and *Passion* are reproduced on pp. 2 and 37. As indicated on the mount of *Danger*, this series was achieved with the technical assistance of Howard C. Colton. For information on Colton, see the short biographical sketch in *Minicam* 5 (November 1941): 78; and his essay "Masking for Color Correction," *Complete Photographer*, no. 38 (September 30, 1942): 2470-71, 2473-79.

355 It is worth noting, however, that Clarence John Laughlin experimented with nonbjective color photography ca. 1943-46.

356 William Stott's *Documentary Expression and Thirties America* (New York: Oxford University Press, 1973) remains the most valuable study of this important subject.

357 Alfred Kazin, *On Native Grounds: An Interpretation of Modern American Prose Literature* (1942; repr. New York: Harcourt Brace Jovanovich, 1982), p. 486. The last chapter of this justly celebrated book studies the documentary urge of 1930s America and photography's central role in this movement.

358 Eduard C. Lindeman, "Farewell to Bohemia," *Survey Graphic* 26 (April 1937): 207-08.

359 This was reproduced on the front page of the *Daily News*, January 13, 1928. The caption read, in part: "This is perhaps the most remarkable exclusive picture in the history of criminology...The picture is the first Sing Sing execution picture and the first of a woman's electrocution." For details on this image, see Jack Price, "How Ruth Snyder was Photographed in Electric Chair," *Popular Photography* 3 (August 1938): 32; and John Faber, *Great News Photos and the Stories Behind Them* (New York: Dover Publications, 1978), pp. 44-45. For details on a similar series by William Vandivert, made in 1935 for the Chicago *Herald-Examiner*, see "William Vandivert: The Unspecialized Specialist," *U.S. Camera* 23 (April 1960): 61, 63.

360 Matthew Josephson, "Profiles: Commander with a Camera—I," *New Yorker* (June 3, 1944): 26.

361 This was reproduced in the November 1923 issue of *Vanity Fair*.

362 For a good introduction to this subject, see David Fahey and Linda Rich, *Masters of Starlight: Photographers in Hollywood* (Los Angeles: Los Angeles County Museum of Art, 1987). A brief chronology of Bull's career is included in this volume (p. 98).

363 See Kennedy's essay "Sculpture Photography," *Complete Photographer*, no. 49 (January 20, 1943): 3190-99.

364 See Maria Morris Hambourg, "Atget, Precursor of Modern Documentary Photography," in David Featherstone, ed., *Observations: Essays on Documentary Photography* (Carmel, Calif.: Friends of Photography, 1984), pp. 24-39.

365 Walker Evans, "The Reappearance of Photography," *Hound and Horn* 5:1 (October-December 1931): 125-28; cited in ibid., pp. 35-36.

366 Lincoln Kirstein, "Photography in the United States," in Holger Cahill and Alfred H. Barr, Jr., eds., *Art in America in Modern Times* (New York: Museum of Modern Art, 1934; repr. 1969), p. 86.

367 For a typically "inventive" description of Brady's war activities see, for example, the review of Julien Levy's "Retrospective Exhibition of American Photography," *Time* 18 (November 16, 1931): 26, 28, 30.

368 For evidence of Hine's "rediscovery," see Elizabeth McCausland, "Portrait of a Photographer," *Survey Graphic* 27 (October 1938): 502-03.

369 In 1932 a group of leading American writers were asked "Do you believe that American capitalism is doomed to inevitable failure and collapse?" A significant number responded in the affirmative. See "Wither the American Writer," *Modern Quarterly* 6 (Summer 1932): 11-19.

370 For an excellent summary of this subject, see the first chapter of William Alexander, *Film on the Left: American Documentary Film from 1931 to 1942* (Princeton: Princeton University Press, 1981). Also valuable is Leah Ollman's *Camera as Weapon: Worker Photography Between the Wars* (San Diego: Museum of Photographic Arts, 1991).

371 Elizabeth McCausland, "Documentary Photography," *Photo Notes* (January 1939): 6. Information on the Photo League is drawn largely from the following sources: Anne Tucker, "Photographic Crossroads: The Photo League," special supplement to *Afterimage* 5:10 (April 1978): n.p.; Anne Tucker, "Aaron Siskind and the Photo League: A Partial History," *Afterimage* (May 1982): 4-5; *Creative Camera* (July-August 1983), a double issue dedicated primarily to the Photo League, with an essay by Anne Tucker; Carl Chiarenza, *Aaron Siskind: Pleasures and Terrors* (Boston: New York Graphic Society, 1982), particularly chapters 2 and 3; and Louis Stettner, "Cézanne's Apples and the Photo League," *Aperture*, no. 112 (Fall 1988): 14-35.

372 Stettner, "Cézanne's Apples and the Photo League," p. 14.

373 From McCausland's lecture "Documentary Photography," repr. in Susan Dodge Peters, "Elizabeth McCausland on Photography," *Afterimage* (May 1985): 10-15.

374 For overviews of this vast subject, see Francis V. O'Connor, *Art for the Millions: Essays from the 1930s by Artists and Administrators of the WPA Federal Art Project* (Boston: New York Graphic Society, 1973); and Bruce I. Bustard, *A New Deal for the Arts* (Washington, D.C.: National Archives/University of Washington Press, 1997).

375 In fact, many federal agencies outside the WPA were engaged in artistic or documentary activities. For example, as noted in Bustard, *A New Deal for the Arts* (p. 11), many post office murals were done under the auspices of the Section of Painting and Sculpture of the Treasury Department.

376 See Stott, *Documentary Expression and Thirties America*, pp. 92-118. For a study of one aspect of the American Guide Series, see Christine Bold, "The View from the Road: Katharine Kellock's New Deal Guidebooks," *American Studies* 29:2 (Fall 1988): 5-29.

377 On this program, see John O'Connor and Lorraine Brown, eds., *Free, Adult, Uncensored: The Living History of the Federal Theatre Project* (Washington, D.C.: New Republic Books, 1978).

378 Bustard, *A New Deal for the Arts*, p. 9.

379 In the article "America and the Writers' Project," *New Republic* 95 (April 26, 1939): 323-25, Robert Cantwell writes

The America that is beginning to emerge from the books of the Writers' Project is a land to be taken seriously: nothing quite like it has ever appeared in our literature. It is a country of odd contraptions and strange careers....Nothing in our academic histories prepares you for it, and very little in our imaginative writing... (p. 323)

380 Brett Weston was employed for two years as supervisor of the photographic division of the Federal Art Project in Los Angeles, ca. 1935-37. "Brett Weston, Photographer," *Camera Craft* 47 (March 1940): 122.

381 For outlines of Mieth's life and work, see Robert W. Brown, "Hansel Mieth Gets Them to Pose," *Popular Photography* 8 (April 1941): 22-23, 112-14; Hansel Mieth Hagel, "On the Life and Work of Otto Hagel and Hansel Mieth," *Left Curve*, no. 13 (1988): 4-18; and Grace Schaub, "Hansel Mieth & Otto Hagel: Never Just Art," *View Camera* (January-February 1996): 20-27. Thanks to Susan Ehrens for pointing out the latter two of these.

382 On the back of this print Mieth has written: "Outstretched Hands, San Francisco, ca. 1934. Struggle for Job Handout—Before Waterfront Organization—Unions Abolished This. Otto and I felt at home on the S.F. Waterfront. We recorded the work of the stevedores and sardine fishermen and the men who went to Alaska to fish for tuna. The waterfront was the last resort of the unemployed. The struggle for a day's work was fierce."

383 Elizabeth McCausland, "The Photography of Berenice Abbott," *Trend* 3 (March-April 1935): 16; quoted in Michael G. Sundell, *Berenice Abbott: Documentary Photographs of the 1930s* (Cleveland: New Gallery of Contemporary Art, 1980), p. 3.

384 The "Changing New York" stamps on the back of each print indicate the exact date of exposure: November 19, 1935; February 4, 1937; and April 14, 1937, respectively.

385 Abbott, *New York in the Thirties* (New York: Dover Publications, 1973), p. 52. Further data on this subject is included in Yochelson, *Berenice Abbott: New York in the Thirties* (New York: Dover Publications, 1973), p. 52.

386 Aaron Siskind also photographed this wrapped statue. See Chiarenza, *Aaron Siskind: Pleasures and Terrors*, pp. 26-27.

387 For a chronology of these various agencies, see Pete Daniel, et al.., *Official Images: New Deal Photography* (Washington, D.C.: Smithsonian Institute Press, 1987); and Carl Fleischhauer and Beverly W. Brannan, eds., *Documenting America, 1935-1943* (Berkeley: University of California Press, 1988).

388 See Robert L. Snyder, *Pare Lorentz and the Documentary Film* (Reno: University of Nevada Press, 1994). On the film careers of Steiner and Strand see Scott Hammen, "Ralph Steiner's 'H$_2$O': simple significance, abstract beauty," *Afterimage* 7 (Summer 1979): 10-11, and William Alexander, "Paul Strand as Filmmaker, 1933-1942," in Stange, ed., *Paul Strand: Essays*, pp. 148-60.

389 For a useful study of the early years of their professional relationship, see Maren Stange, "The Management of Vision: Rexford Tugwell and Roy Stryker in the 1920s," *Afterimage* 15 (March 1988): 5-10.

390 Maren Stange, "Documentary Photography in American Social Reform Movements: The FSA Project and Its Predecessors," in *Multiple Views: Logan Grant Essays on Photography, 1983-89* (Albuquerque: University of New Mexico Press, 1991), pp. 207, 218.

391 Cited in Alan Trachtenberg, "From Image to Story: Reading the File," in Fleischhauer and Brannan, eds., *Documenting America, 1935-1943*, p. 58.

392 For a good summary of Stryker's own conception of this process, see Rosa Reilly, "Photographing the America of Today," *Popular Photography* 3 (November 1938): 10-11, 76-77.

393 John Durniak, "Focus on Stryker," *Popular Photography* (September 1962): 64, 94. In this article, Dorothea Lange observed, "He has a peculiar genius. He was able to transmit a sense of *freedom* plus *responsibility* to his photographers. These are the two key words..." (p. 62).

394 Hank O'Neal's *A Vision Shared: A Classic Portrait of America and Its People, 1935-1943* (New York: St. Martin's Press, 1976) contains the clearest outline of these comings and goings, as well as brief biographies of each photographer.

395 Edwin Rosskam, "Not Intended for Framing: The FSA File," *Afterimage* 8 (March 1981): 9-11.

396 This relationship is discussed in some depth in Laura Katzman, "The Politics of Media: Painting and Photography in the Art of Ben Shahn," *American Art* 7 (Winter 1993): 61-87.

397 Ibid., p. 67.

398 Shahn cropped his photographs in varying ways. See, for example, the significantly different croppings of this image included in Davis Pratt, *The Photographic Eye of Ben Shahn* (Cambridge, Mass.: Harvard University Press, 1975), and Margaret R. Weiss, *Ben Shahn, Photographer: An Album from the Thirties* (New York: Da Capo Press, 1973).

399 As Judith Keller makes clear in her *Walker Evans: The Getty Museum Collection* (Malibu: J. Paul Getty Museum, 1995), Evans made a handful of photographs in 1926-27, but began to use the camera consistently in 1928.

400 Leslie Katz, "Interview with Walker Evans," *Art in America* 59 (March-April 1971): 84.

401 The work of Steiner's that probably most influenced Evans was published in "Vanishing Backyards," *Fortune* 1 (May 1930): 78-79.

402 The quality of Brewer's work, and the nature of his impact on Evans's career, make him a significant figure in the history of American photography. Brewer apparently took up photography in the 1910s, perhaps at the time of his service in World War I. With his wife, Jane Beach Evans Brewer, Brewer lived in Spain in 1930-31, before returning to the U.S. to reside in Ossining, New York. At the personal request of Harry Hopkins, the New Deal's relief director, Brewer worked for the Resettlement Administration/Farm Security Administration from 1935 to 1942, ultimately serving as the top administrator in the agency's Qualification Section, Personnel. Brewer's role in the hiring of his brother-in-law can, at this point, only be guessed. Other aspects of this relationship merit attention. It is clear, for example, that some of Brewer's photographs were in Evans's possession at the time of the latter's death in 1975. It appears that at least some of them (those not signed or stamped by Brewer) subsequently entered the marketplace as the work of Evans. This seems particularly true of Brewer's Spanish pictures, which were misidentified as part of Evans's work in Cuba. My thanks to George Rinhart for bringing this important body of work to my attention, and for biographical data on Brewer.

403 For a good study of this theme, see Diana Emery Hulick, "Walker Evans and Folk Art," *History of Photography* 17 (Summer 1993): 139-46.

404 Katz, "Interview with Walker Evans," p. 87.

405 Kirstein reproduced Evans's early work in *Hound and Horn*, commissioned him to photograph Victorian houses outside Boston in 1930-31, and arranged a one-man show of these architectural pictures at the Museum of Modern Art in 1933. Kirstein also played an important role in Evans's 1938 retrospective and the accompanying book *American Photographs* (New York: Museum of Modern Art, 1938). Douglas R. Nickel's "American Photographs Revisited," *American Art* 6(Spring 1992): 79-97, provides a provocative perspective on the relationship between Evans and Kirstein.

406 Lionel Trilling, "Books: Greatness with One Fault in It," *Kenyon Review* 4:1 (Winter 1942): 100.

407 Kirstein, "Photographs of America: Walker Evans," in *American Photographs*, p. 191.

408 William Carlos Williams, "Sermon with a Camera," *New Republic* 96 (October 12, 1938): 283.

409 Evans was "loaned" to the *Fortune* project by Stryker with the understanding that his negatives would become part of the RA files.

410 For a thoughtful review of the first edition, see Trilling, "Books: Greatness with One Flaw in It."

411 This exhibition received wide attention and critical praise, solidifying Evans's position as one of the nation's most respected artistic photographers. See, for example, *Time* 32 (October 3, 1938): 43.

412 *American Photographs*, p. 192.

413 For critical contemporary views of this book, see, for example, S.T. Williamson, "American Photographs by Walker Evans," *New York Times Book Review* (November 27, 1938): 6; and Mary Street Alinder and Andrea Gray Stillman, *Ansel Adams: Letters and Images 1916-1984* (Boston: New York Graphic Society, 1988), p. 109. For an eloquent interpretation of *American Photographs*, see Alan Trachtenberg, *Reading American Photographs: Images as History, Mathew Brady to Walker Evans* (New York: Hill and Wang, 1989), pp. 231-85.

414 The idea of "reading" in this work is central to Trachtenberg's discussion in *Reading American Photographs*; see, in particular, p. 264.

415 Cited in Milton Meltzer, *Dorothea Lange: A Photographic Life* (New York: Farrar Straus Giroux, 1978), p. 6.

416 See, for example, Carmen Ballen, "The Art of Dorothea Lange," *Overland Monthly* 74 (December 1919): 405-08.

417 In the 1930s, Dixon painted subjects very similar in feeling to those recorded by Lange. See, for example, "Maynard Dixon Looks at Social Conflict," *Survey Graphic* 26 (February 1937): 83-85.

418 Willard Van Dyke, "The Photographs of Dorothea Lange—A Critical Analysis," *Camera Craft* 41 (October 1934): 461-67.

419 Paul S. Taylor and Norman Leon Gold, "San Francisco and the General Strike," *Survey Graphic* 23 (September 1934): 405-11. Lange's bold photograph, here titled *Workers, Unite!*, served as the frontispiece for this issue of the magazine. A similarly powerful Lange photograph was used as the frontispiece to *Survey Graphic*'s February 1935 issue.

420 Richard Steven Street, "Paul S. Taylor and the Origins of Documentary Photography in California, 1927-1934," *History of Photography* 7:4 (October-December 1983): 293-304.

421 For studies of this and other collaborative works of the 1930s, see Jefferson Hunter, *Image and Word: The Interaction of Twentieth-Century Photographs and Texts* (Cambridge, Mass.: Harvard University Press, 1981); and Carol Shloss, *Invisible Light: Photography and the American Writer: 1840-1940* (New York: Oxford University Press, 1987).

422 See, for example, Richard Griffith, "The Film Faces Facts," *Survey Graphic* 27 (December 1938): 595-600.

423 For Rothstein's remembrance of this episode, see his "The Picture That Became a Campaign Issue," *Popular Photography* 49 (September 1961): 42-43, 79; and Bill Ganzel, "Arthur Rothstein, An Interview," *Exposure* 16:3 (Fall 1978): 3-4.

424 Clyde R. Miller and Louis Minsky, "Propaganda—Good and Bad—For Democracy," *Survey Graphic* 28 (November 1939): 718.

425 For the argument on whether this photograph was, in fact, completely posed, see James Curtis, *Mind's Eye, Mind's Truth: FSA Photography Reconsidered* (Philadelphia: Temple University Press, 1989), pp. 76-89, and his endnotes to this chapter, particularly numbers 16 and 25. As Curtis observes, Rothstein's vintage prints from this negative tend to be relatively light in tone, while later prints are considerably darker.

426 Ibid., p. 67. For Lange's own reminiscence of this photograph see "The Assignment I'll Never Forget," *Popular Photography* 46 (February 1960): 42, 126; repr. Newhall, *Photography: Essays & Images*, pp. 263-64.

427 Curtis, *Mind's Eye, Mind's Truth*, pp. 34-44.

428 Glenn A. Matthews, "Photography Goes Forward—A Review of a Decade of Progress," *American Annual of Photography* 1940, p. 7.

429 Henry M. Lester, "Evaluating Readers' Interests in Pictures," *19th Art Director's Annual of Advertising Art* (New York: Longman Green, 1941), p. 78; cited in Bruce Robertson, *Representing America: The Ken Trevey Collection of American Realist Prints* (Santa Barbara: University Art Museum UCSB/University of Washington Press, 1995), p. 20.

430 Cited in Michele H. Bogart, *Artists, Advertising, and the Borders of Art* (Chicago: University of Chicago Press, 1995), p. 202. This volume provides a good overview of this subject.

431 Jack Price, "Let's Take a Look at *Life*," *Popular Photography* 1 (September 1937): 10-14, 78.

432 For example, the biweekly *Pic* billed itself as "3 Magazines in One," as it covered Hollywood, Broadway, and Sports. It was nearly wholly composed of photographs; most captions were kept to a single sentence, and no accompanying texts were longer than a few paragraphs.

433 Jack Price, "Let's Take a Look at *Life*," p. 13. Of the 12,800 pictures sent to *Life* in a typical week in 1937, only 800 were made by its own staff photographers. In addition, 5,000 were derived from the four leading picture syndicates, 1,200 from smaller agencies and free lancers, and 5,000 from amateurs. Of course, a disproportionately high percentage of the photographs produced by *Life*'s staffers were actually used in the magazine. For a brief overview of the operation of the Acme News Service, see Gray Strider, "The Inside Workings of a National News Service," *Popular Photography* 1 (July 1937): 16-17, 80-81.

434 On this technology, see A. J. Ezickson, "Wired Photos," *Complete Photographer*, no. 54 (March 10, 1943): 3515-18; and Marianne Fulton, "Bearing Witness: The 1930s to the 1950s," in Fulton, ed., *Eyes of Time: Photojournalism in America* (Boston: New York Graphic Society, 1988), pp. 108-14.

435 The latter, first issued in 1931, was published as a special autumn issue of *The Studio* (London).

436 In addition to *Scribner's* ongoing use of photography, this special portfolio was intended as an annual feature. As the March 1938 issue of the magazine shows, however, more frequent "special" use of the medium was in fact made.

437 Bonnie Yochelson notes that twenty-two such photographers were profiled in *Coronet*. (See "Clarence H. White, Peaceful Warrior," *Pictorialism into Modernism*, p. 114.

438 For background on Maloney, see Harvey V. Fondiller, "Tom Maloney and U.S. Camera," *Camera Arts* (July-August 1981): 16-23, 106.

439 The difference in viewpoint between Maloney's and Fraprie's publications is suggested by the latter's review of the 1940 *U.S. Camera Annual* (in *American Photography* 34 [February 1940]: 148-49), which reads in part:

> As usual, the pictures are for the most part startlingly objective, with the squalid and the wretched much in evidence...It's outlook is typically that of New York, and must give the rest of the country, the world, and coming generations the impression that we are a wretched but hectic race. The dreamers, the home bodies, the quietly contented, the people who see a preponderance of good and beauty around them, of whom there must still be a few left in the United States, are but sparingly represented.

440 Anne McCauley, "Writing Photography's History before Newhall," *History of Photography* 21 (Summer 1997): 96.

441 For a concise study of this work, see Joan Shelley Rubin, "A Convergence of Vision: Constance Rourke, Charles Sheeler, and American Art," *American Quarterly* 42 (June 1990): 191-222. It is generally recognized that the first art-historical monograph on a photographer was Heinrich Schwarz's *David Octavius Hill: Der Meister der Photographie* (1931). On this work, see Martin Gasser, "A Master Piece: Heinrich Schwarz's Book on David Octavius Hill," *Image* 36:1-2 (Spring-Summer 1993): 33-53.

442 The text of *Roll, Jordan, Roll* was written by Julia Peterkin. Capa's *Death in the Making* was sequenced by André Kertész. For an interesting short study of this subject, see Elizabeth McCausland, "Photographic Books," *Complete Photographer*, no. 43 (November 20, 1943): 2783-94.

443 The most interesting of these articles were profiles of leading photographers, and analyses of individual pictures. Ház had a one-man exhibition at the Brooklyn Institute as early as 1925 (see *The Camera* 30 [June 1925]: 329-30). For an amusing early profile of Ház, see *Camera Craft* 35 (January 1928): 3-9. For summaries of Ház's career and attitude toward photography, see his "Modern Photography," *Camera Craft* 44 (May 1937): 212-20; "Why Is an Abstract Picture?" *Photography* (May 1938): 4-5; and "Unique and Isolated: An Introduction to the Photographic Teachings of Nicholas Ház," *Minicam* 10 (November 1946): 54-65, 128-32. My thanks to Van Deren Coke for information on Ház's career.

444 Compare, for example, Taft's "M. B. Brady and the Daguerreotype Era," *American Photography* 28 (August 1934): 486-98, and 28 (September 1934): 548-60, or his "John Plumbe: America's First Nationally Known Photographer," *American Photography* 30 (January 1936): 1-12, with earlier essays such as C. J. Greenleaf, "Brady—The Civil War Photographer," *Photo-Era* 64 (January 1930): 13-16, or Harriet E. Alverson, "A News Photographer of the Civil War," *Camera Craft* 39 (November 1932): 456-60.

445 For a detailed study of this work, see Allison Bertrand, "Beaumont Newhall's 'Photography 1839-1937': Making History," *History of Photography* 21 (Summer 1997): 137-46.

446 On the evolution of this text, see Mary Warner Marien, "What Shall We Tell the Children? Photography and Its Text (Books)," *Afterimage* 13 (April 1986): 4-7.

447 The following data is derived in part from Hambourg, "From 291 to the Museum of Modern Art: Photography in New York, 1910-1937," in *The New Vision*; and David Travis, *Photographs from the Julien Levy Collection Starting with Atget* (Chicago: Art Institute of Chicago, 1976).

448 David Travis, *Photography in Chicago Collections* (Chicago: Art Institute of Chicago, 1982), p. 21.

449 In addition to Travis's *Photographs from the Julien Levy Collection*, see Levy's reminiscence *Memoirs of an Art Gallery* (New York: G.P. Putnam's Sons, 1977).

450 This show subsequently traveled to the Wadsworth Atheneum in Hartford and the John Becker Gallery in New York. For background on Kirstein and other important arts patrons of the 1930s, see studies such as Nicholas Fox Weber, *Patron Saints: Five Rebels Who Opened America to a New Art, 1928-1943* (New Haven: Yale University Press, 1995).

451 The Museum acquired ten Stieglitz prints from this exhibition. My thanks to Tom Hinson, curator of contemporary art at the Cleveland Art Museum, for data on this show.

452 For a discussion of this shift, and of Newhall's overall tenure at the Museum of Modern Art, see Christopher Phillips, "The Judgment Seat of Photography," *October*, no. 22 (Fall 1982): 27-63. For Newhall's own recollection of this exhibition, see his *Focus: Memoirs of a Life in Photography* (Boston: Bulfinch Press, 1993), pp. 39-53.

453 These were: the Franklin Institute, Philadelphia; Boston Museum of Fine Arts; M. H. de Young Memorial Museum, San Francisco; Milwaukee Art Institute; Addison Gallery, Andover, Mass.; Currier Gallery of Art, Manchester, N. H.; Cleveland Museum of Art; George Walter Vincent Smith Art Gallery, Springfield, Mass.; Albright Art Gallery, Buffalo, N.Y.; Memorial Art Gallery,

Rochester, N.Y. Anne McCauley, "Writing Photography's History before Newhall," p. 97.

454 Some of the public's comments on this exhibit are reproduced in Hank O'Neal, *A Vision Shared*, pp. 308-09.

455 Ansel Adams, *An Autobiography* (Boston: New York Graphic Society, 1985), p. 196.

456 These were given in late 1923 and accessioned in April 1924. McCauley, "Writing Photography's History before Newhall," p. 101, note 72; and Clifford S. Ackley, *Photographic Viewpoints: Selections from the Collection* (Boston: Museum of Fine Arts, 1982 [*MFA Bulletin*, vol. 80]), p. 3. On the state of this holding in the early 1960s, see Nicholas Dean, "Down in the Depths at the Boston Museum," *Contemporary Photographer* 5 (Winter 1964): 3-5.

457 Prior to that time, it had been part of the Print Department. For a history of this program, see Malcolm Daniel, "Photography at the Metropolitan: William M. Ivins and A. Hyatt Mayor," *History of Photography* 21 (Summer 1997): 110-16.

458 The adoption of modernist traits by commercial photographers was, at least in part, a result of their awareness of the international nature of their market. For a valuable essay on this subject (with illustrations of his own work), see Fred G. Korth, "Free-Lancing for European Magazines," *American Photography* 28 (May 1934): 305-09. See also William Strosahl, "Surrealism in Photography," *Popular Photography* 4 (June 1939): 16-17, 82-83. Strosahl was the art director of the J. Walter Thompson Company.

459 *Fortune* 2 (July 1930): 81. This photograph won an honorable mention in the next year's advertising art competition. See *Tenth Annual of Advertising Art* (New York: art director's Club, 1931), p. 48.

460 For a detailed study of Steichen's commercial career, see Patricia Johnson, *Real Fantasies: Edward Steichen's Advertising Photography* (Berkeley: University of California Press, 1997).

461 Ibid., p. 1.

462 Bogart, *Artists, Advertising, and the Borders of Art*, pp. 201, 186.

463 For example, see his article "Surrealism in Photography," noted above.

464 The following summary is indebted to Yochelson, "Clarence H. White, Peaceful Warrior"; and Bogart, *Artists, Advertising, and the Borders of Art*, esp. chapter 3, "Art Directors Club and the Art of Commerce."

465 These volumes were published beginning in 1921 by the Art Directors Club. By the late 1930s, Longmans Green & Co. was listed as the publisher.

466 This summary is indebted to Robert Sobieszek's essay "Edward Quigley and the Modernist Context," in *Edward Quigley: American Modernist* (New York: Houk Friedman Gallery, 1991), and to his book *The Art of Persuasion*.

467 For a list of participants and full tour schedule, see *Applied Photography*, no. 11 (January 1935): 31. For a review of this show, see Nicholas Ház, "Commercial Photography of Today," *American Photography* 28 (December 1934): 723-32.

468 This movement continued right up to the American entry into World War II. In 1941, for example, the photographers Josef Breitenbach and Erwin Blumenfeld were among the European artists who entered the U.S.

CHAPTER III From Public to Private Concerns 1940-1965

1 Useful cultural and historical overviews of this period include William Graebner, *The Age of Doubt: American Thought and Culture in the 1940s* (Boston: Twayne Publishers, 1991); John Patrick Diggins, *The Proud Decades: America in War and Peace, 1941-1960* (New York: W. W. Norton & Company, 1988); Lary May, ed., *Recasting America: Culture and Politics in the Age of Cold War* (Chicago: University of Chicago Press, 1989); David Halberstam, *The Fifties* (New York: Fawcett Columbine, 1993); J. Ronald Oakley, *God's Country: America in the Fifties* (New York: Dembner Books, 1986); David Farber, *The Age of Great Dreams: America in the 1960s* (New York: Farrar, Straus and Giroux, 1994); Paul Boyer, *By the Bomb's Early Light: American Thought and Culture at the Dawn of the Atomic Age* (1985; Chapel Hill: University of North Carolina Press, 1994); and Andrew Jamison and Ron Eyerman, *Seeds of the Sixties* (Berkeley: University of California Press, 1994).

2 See, for example, Norman Cousins, "Modern Man Is Obsolete," *Saturday Review* 28 (August 18, 1945): 5-9; and Sidney B. Fay, "The Idea of Progress," *American Historical Review* 52 (January 1947): 231-46.

3 The earliest known photograph at this time was an 1837 plate by Daguerre. Previously, the 1839 public announcement of Daguerre's process had been understood to mark the invention of photography.

4 Christopher Phillips, "The Judgment Seat of Photography," *October*, no. 22 (Fall 1982): 35-36.

5 "From the Birdie's Nest," *Time* (January 6, 1941): 32. See also, H. I. Brock, "Is Photography an Art?" *New York Times Magazine* (February 16, 1941): 14-15, 26.

6 Other members included Walter Clark, Laurance Rockefeller, James T. Soby, John E. Abbott, and Alfred H. Barr. For Newhall's own reminiscence, see his *Focus: Memoirs of a Life in Photography* (Boston: Bulfinch Press, 1993), pp. 64-66.

7 In a process of discovery that seems destined to be endlessly repeated, it was reported that "surprised visitors found that some of photography's finest workmanship was very old stuff." *Time* (January 6, 1941): 32. The checklist of this exhibition is included in the *Bulletin of the Museum of Modern Art* (December-January 1940-41): 5-7.

8 "Program of the Department," *Bulletin of the Museum of Modern Art* (December-January 1940-41): 4-5. See also Robert W. Brown, "Photos Join Paintings in Museum of Modern Art," *Popular Photography* 8 (February 1941): 38, 110.

9 See Beaumont Newhall, "Photography as a Branch of Art History," *College Art Journal* (May 1942): 86-90; and Phillips, "The Judgment Seat of Photography."

10 For his own account of these years, see Newhall, *Focus*, pp. 71-97.

11 For a contemporary survey of this activity, see Lydia R. Davis, "Museums and Collections of Photography," *Complete Photographer*, no. 41 (October 30, 1942): 2655-60.

12 This fascinating collection was given to the George Eastman House in 1977. For background on it, see Robert A. Sobieszek, "An American Century of Photography: 1840-1940: Selections from the Sipley/3M Collection"; and David Vestal, "Louis Walton Sipley," *Camera* (June 1978): 4, 9-10, 19-20, 29-30, 39-40.

13 *New York Times* (October 12, 1941): sec. 10, p. 5. This article reports that these prints were acquired by the American Museum after being discovered in storage "at Memorial Hall in the Philadelphia Museum of Art."

14 For a profile of Boyer, see Rachel Stuhlman, "'It Isn't Sanity, But It Sure Is Fun,'" *Image* 34:1-2 (Spring-Summer 1991): 22-28.

15 Davis, "Museums and Collections of Photography," p. 2656.

16 Malcolm Daniel, "Photography at the Metropolitan: William M. Ivins and A. Hyatt Mayor," *History of Photography* 21 (Summer 1997): 114-15.

17 Five of these photographers received two fellowships each, while Morris (1942, 1946, 1954) and Adams (1946, 1948, 1959) received three. For contemporary articles on these awards, see, for example, Arthur J. Busch, "Fellowships for Photographers," *Popular Photography* 12 (February 1943): 22-23, 82-83; and "U. S. Camera Contributors win Guggenheim Awards," *U.S. Camera* 9 (June 1946): 15-17.

18 *U.S. Camera Annual 1944*, p. 6.

19 See, for example, Sally J. Davis, "WAAC Photographers," *Popular Photography* 12 (May 1943): 32-33, 92, for a description of one of the smaller photographic units.

20 Ben Schnall, "Fort Monmouth—Signal Corps' Number 1 Photo School," *U.S. Camera* 4 (September 1941): 29-31. On the Navy's program, see "It's a Navy Show," *Minicam* 8 (March 1945): 62-72, 91.

21 Robert W. Marks, "*Life*'s School for Fighting Photographers," *Minicam* 5 (June 1942): 42-47.

22 See, for example, "Behind Enemy Lines," *U.S. Camera* 8 (May 1945): 11-13, 43, 53; and Victor Keppler, "The Yank Is Coming," *U.S. Camera* 5 (September 1942): 26-27.

23 For a brief summary of aerial photography, see Jack Hamilton, "The Rise of American Aerial Photography," *American Photography* 38 (December 1944): 20-23.

24 For a later study of this unit, see Christopher Phillips, *Steichen at War* (New York: Harry N. Abrams, 1981).

25 Quoted in Susan D. Moeller, *Shooting War: Photography and the American Experience in Combat* (New York: Basic Books, 1989), p. 216.

26 See Bruce Downes, "Camera Over the Pacific," *Popular Photography* 13 (November 1943): 19-23, 81-83.

27 See "Vandivert's England," *U.S. Camera* 5 (June 1942): 17-24, 64-65.

28 This is described in some detail in her book *Shooting the Russian War* (New York: Simon and Schuster, 1942), particularly p. 123.

29 In addition to the above volume, Bourke-White's war experience is detailed in her books *They Called It "Purple Heart Valley"* (1944), *Dear Fatherland, Rest Quietly* (1946), and *Portrait of Myself* (1963).

30 Richard Whelan, *Robert Capa: A Biography* (New York: Alfred A. Knopf, 1985), pp. 156-57. For a characteristic profile of the period, see Alexander King, "He Made Great War Pictures," *Minicam* 4 (December 1940): 52-55, 103, in which Capa is identified as "the greatest living war photographer." *Death in the Making* (New York: Covici, Friede, 1938) included photographs by Capa, Gerda Taro, and Chim; the picture captions were by Capa.

31 Moeller, *Shooting War*, pp. 182-83. See also, Ralph H. Turner, "Photographers in Uniform," in Frank Luther Mott, ed., *Journalism in Wartime* (Washington, D.C.: American Council on Public Affairs, 1943), pp. 77-82.

32 For contemporary perspectives on this process, see Rowland Carter, "Censored!" *Popular Photography* 10 (April 1942): 24-25, 99-101; and the section "Censorship," in Frank Luther Mott, ed., *Journalism in Wartime*, pp. 23-56.

33 The propagandistic function of photography was widely understood. See, for example, Vernon Pope, "Manufacturing War Propaganda with Photographs," *Popular Photography* 5 (December 1939): 20-21, 173-74; and "Photo Cartoonist Flays Nazi Regime," *U.S. Camera* 4 (July 1941): 36-37, on the work of John Heartfield.

34 Moeller, *Shooting War*, p. 183.

35 See, for example, Peter Martin, "The Kid Who Lives Photography," *Popular Photography* 13 (July 1943): 19-22, 90-91.

36 Eliot Elisofon, "War Photography," *U.S. Camera Annual 1944*, p. 266. This concern was heightened by the knowledge that fraudulent photographs had been unwittingly published by reputable journals in the prewar years. See, for example, "Foto-Fakes Exposed," *Minicam* 3 (September 1939): 18-19. This article reproduces a surprisingly convincing photograph of "skiers" actually made with wooden figurines on a flour-covered tabletop.

37 For varying summaries of the story and impact of this image, see Moeller, *Shooting War*, pp. 244-46; Marianne Fulton, ed., *Eyes of Time: Photojournalism in America* (Boston: New York Graphic Society, 1988), pp. 160-61; Vicki Goldberg, *The Power of Photography: How Photographs Changed Our Lives* (New York: Abbeville, 1991); and Tedd Thomey, *Immortal Images: A Personal History of Two Photographers and the Flag Raising on Iwo Jima* (Annapolis: Naval Institute Press, 1996).

38 *Life* (March 26, 1945): 17-18; quoted in Goldberg, *The Power of Photography*, p. 142. Goldberg notes that "this may be the most widely reproduced and re-created photograph in history: 3,500,000 posters of the image were printed for the Seventh War Loan drive, 15,000 outdoor panels and 175,000 car cards were published, and the photograph was reproduced on an issue of three-cent stamps" (p. 143).

39 Frank R. Fraprie, "The Editor's Point of View," *American Photography* 39 (July 1945): 7.

40 *Life* (April 23, 1945): 24. Curiously, in this reproduction, the photograph is credited to George Skadding.

41 For a suggestion of Kerlee's technical sophistication, see Wick Evans, "Charles Kerlee, Photo-Perfectionist," *Popular Photography* 4 (March 1939): 10-11, 98-100; and Kerlee's article "Pictures with a Purpose," *U.S. Camera* 4 (July 1941): 49-63.

42 "Patterns for Victory," *Popular Photography* 10 (April 1942): 22-23.

43 Born in Berlin, Gehr began photographing as a teenager. He worked in the German film industry in the early 1930s and then as a photojournalist in Cairo for the *New York Times*. Gehr came to the United States in 1937 and was employed by *Life* for twelve years, from 1939 to 1950. He then returned to work in film and, for professional reasons, changed his name to Edmund Bert Gerard. My thanks to Mrs. Hermine Gerard and George Rinhart for information on Gehr's life and work.

44 Ellen G. Landau, "'A Certain Rightness': Artists for Victory's 'America in the War' Exhibition of 1943," *Arts Magazine* (February 1986): 43-54.

45 Ralph Steiner, "Road to Victory," *Minicam* 5 (July 1942): 18; also cited in "Road to Victory," *U.S. Camera* 5 (July 1942): 17. For a more recent study, see Christopher Phillips, "Steichen's *Road to Victory*," *Exposure* 18:2 (1981): 38-48.

46 Steiner, "Road to Victory," p. 95.

47 Photographs of this section of the show are included in both the *Minicam* and *U.S. Camera* articles cited above.

48 This mass of footage was given narrative coherence through the editing skills of Louis de Rochemont, a noted Hollywood director and producer.

49 *Life* (May 7, 1945): 34.

50 While more eloquently stated, Susan Sontag's memory of these images may be indicative of the reaction of many of the time:

> One's first encounter with the photographic inventory of ultimate horror is a kind of revelation, the prototypically modern revelation: a negative epiphany.

For me, it was photographs of Bergen-Belsen and Dachau which I came across by chance in a bookstore in Santa Monica in July 1945. Nothing I have seen—in photographs or real life—ever cut me as sharply, deeply, instantaneously. Indeed, it seems plausible to me to divide my life into two parts, before I saw those photographs (I was twelve) and after.... When I looked at those photographs, something broke. Some limit had been reached, and not only that of horror; I felt irrevocably grieved, wounded, but a part of my feelings started to tighten; something went dead; something is still crying.

Sontag, *On Photography* (New York: Farrar, Straus and Giroux, 1977), pp. 19-20.

51 "Life's Photo Coverage in Korea," *U.S. Camera* 13 (October 1950): 31

52 For example, see "Photo Data" in David Douglas Duncan, *This Is War! A Photo-Narrative in Three Parts* (New York: Harper & Brothers, 1951), n.p., repr. in *U.S. Camera* 14 (September 1951): 52-53; and "Bristol and Korea," *U.S. Camera Annual 1954*, pp. 343, 345, 347.

53 "Impact of War," *U.S. Camera* 14 (April 1951): 51-58.

54 Bruce Downes, "Assignment: Korea," *Popular Photography* 28 (March 1951): 45.

55 Duncan, *This Is War!*, n.p.

56 See "Photographic Instructors Listed Geographically," *Minicam* 10 (August 1946): 82, 84, 86, 88-92, 94-104, 108; and Agnes Reber, "Photo Schools," *Minicam* 10 (September-October 1946): 92-4, 96-102, 104, 106, 108-10, 112.

57 H. M. Kinzer, "Photography's own education explosion," *Photography Annual 1967*, pp. 32-33. Kinzer notes in this article that "the tide began to turn [in the growth of photographic programs] in 1954."

58 From course catalogue *Photography: The Art Center School* (1939), p. 1. My thanks to Joseph Bellows for bringing this, and other data related to the Art Center School, to my attention.

59 See Lars Moen, "The Fred Archer School of Photography," *Minicam* 10 (July 1947): 27-33, 122-27.

60 *Photography: The Art Center School*, p. 47.

61 For example, see Edward Kaminski, "The Esthetic Laws of Light," in Willard D. Morgan, *1001 Ways to Improve Your Photographs* (New York: National Educational Alliance, 1947), pp. 235-39; and the articles "Portraits and the Art Center" and "Pictures and the Art Center," *Popular Photography* 19 (July 1946): 52-59, 144, 152.

62 Much of the following discussion is drawn from John Grimes, "The New Vision in the New World," and Charles Traub, "Photographic Education Comes of Age," in Traub, ed., *The New Vision: Forty Years of Photography at the Institute of Design* (Millerton, N.Y.: Aperture, 1981); and Stephen Daiter, *Light and Vision: Photography at the School of Design in Chicago, 1937-1952* (Chicago: Stephen Daiter Photography, 1994). The latter contains a particularly precise chronology. See also Stephen Prokopoff, *The New Spirit in American Photography* (Urbana-Champaign: Krannert Art Museum, 1985).

63 Quoted in Al and DeVera Bernsohn, "Moholy-Nagy: Iconoclast," *Camera Craft* 46 (August 1939): 358.

64 In 1944 the name of the school changed yet again, to the Institute of Design. In 1949 it became part of the Illinois Institute of Technology.

65 See, for example, Bernsohn and Bernsohn, "Moholy-Nagy: Iconoclast," and Moholy-Nagy's article "Making Photographs without a Camera," *Popular Photography* 5 (December 1939): 30-31, 167-69. Moholy-Nagy served as a contributing editor of *Minicam* and was frequently mentioned in the magazine; see, for example, articles such as "Make a Light Modulator" (March 1940) and "Paint with Light...the Photogram Is the Key to Photography" (September 1942), and the profiles "Photography of Tomorrow: Moholy-Nagy Creates New Vision" (January 1942) and "Reunion in Chicago" (January 1945).

66 Advertisement in *Camera Craft* 47 (May 1940): 256.

67 See, for example, such early articles as Gyorgy Kepes, "Modern Design! with Light and Camera," *Popular Photography* 10 (February 1942): 24-25, 100-01; and Nathan Lerner, "Get Space in Your Pictures," *Minicam* 5 (June 1942): 34-39, 102.

68 Moholy-Nagy, "Making Photographs without a Camera," p. 169.

69 In 1941, de Patta collaborated with Eugene Bielawski, an instructor at the school and—after 1946—her husband, on combined photogram/camera images of her jewelry.

70 See Kepes, "Modern Design! with Light and Camera," pp. 24-25, 100-01.

71 Daiter, *Light and Vision*, pp. 14, 16.

72 For studies of the photography department in this era, see S. P. Karr, "The Third Eye," *Art Photography* (September 1952): 32-36; and Harry Callahan

and Aaron Siskind, "Learning Photography at the Institute of Design," *Aperture* 4:4 (1956): 147-49.

73 A list of master's degree recipients from 1952 to 1981 is given in Traub, *The New Vision*, pp. 74-75.

74 *Photo Notes* (May 1942): 5.

75 Ann Thomas, *Lisette Model* (Ottawa: National Gallery of Canada, 1990), p. 116.

76 By 1940, Adams was one of the most active lecturers on photography. For example, after teaching at the Art Center in the spring of 1940, Adams organized the first *U.S. Camera* Yosemite Photographic Forum in the summer of that year, with such faculty members as Weston, Kerlee, and Lange. For a notice of this summer workshop, see *Camera Craft* 47 (June 1940): 310. The founding of the photography department at the California School of Fine Arts, in the summer of 1946, stemmed directly from a series of six lectures Adams gave at the school in December 1944. "The First Fifty Years," *San Francisco Art Institute Bulletin* (September-October 1996): 3.

77 See "The First Fifty Years," p. 3; and "Biographical Chronology," in Peter C. Bunnell, *Minor White: The Eye That Shapes* (Princeton: Art Museum, Princeton University, 1989), p. 5.

78 Robert L. Dishon, "Photography Is a Major," *U.S. Camera* 11 (August 1948): 16-17.

79 Reber, "Photo Schools," p. 106.

80 See Jerome Liebling, "Photography at the University of Minnesota," *Aperture* 4:3 (1956): 96-97; and James Dozier, ed., *Light of Our Past: 1947-1974, Minnesota Photographic Heritage* (Minneapolis: Film in the Cities, 1983).

81 See "The Department of Photography at the Rochester Institute of Technology," *Aperture* 5:1 (1957): 33-38.

82 On Edom's career, see articles such as Rus Arnold, "Profile: Cliff Edom," *Camera 35* 15 (June 1971): 28-31, 64, 66, 68.

83 See Van Deren Coke, "The Art of Photography in College Teaching," *College Art Journal* 19:4 (Summer 1960): 332-42. By this time, some 400 institutions offered photographic courses of some type. See *A Survey of Photographic Instruction* (Rochester: Eastman Kodak Company, 1960), p. 2.

84 The dates of these affiliations are: University of Florida, 1958-61; Arizona State University, 1961-62; University of New Mexico, 1962-70 and 1972-79.

85 The following is derived in large part from the *Partisan Review*'s 1952 symposium "Our Country and Our Culture," published in three successive issues of the journal: May-June, July-August, and September-October 1952.

86 *Partisan Review* (September-October 1952): 591.

87 Ibid., p. 575. Lionel Trilling shared this point of view, observing:

For the first time in the history of the modern American intellectual, America is not to be conceived of as *a priori* the vulgarest and stupidest nation on earth. And this is not only because other nations are exercising as never before the inalienable right of nations to be stupid and vulgar. The American situation has changed in a way that is not merely relative.

Partisan Review (May-June 1952): 319.

88 *Partisan Review* (May-June 1952): 307.

89 This optimism has been exaggerated by some scholars, however. A close reading of *Life* magazine in the postwar years reveals a consistent strain of gritty and hard-hitting pieces.

90 For example, see Bernard Rosenberg and David Manning White, *Mass Culture: The Popular Arts in America* (New York: Free Press, 1957).

91 *Partisan Review* (May-June 1952): 306.

92 William Phillips, in *Partisan Review* (September-October 1952): 589.

93 Ibid., pp. 578-79.

94 For a useful discussion of this concept, see Philip Gleason, "Identifying Identity: A Semantic History," *Journal of American History* 69:4 (March 1983): 910-31.

95 William Barrett, *Partisan Review* (July-August 1952): 422.

96 "A Life Round Table on the Pursuit of Happiness," *Life* (July 12, 1948): 97.

97 See Eric and Mary Josephson, eds., *Man Alone: Alienation in Modern Society* (New York: Dell Publishing Company, 1962).

98 Lionel Trilling, *Sincerity and Authenticity* (Cambridge, Mass.: Harvard University Press, 1971). See also Richard Sennett, *The Fall of Public Man: On the Social Psychology of Capitalism* (New York: Vintage Books, 1974).

99 "Two Billion Clicks," *Time* (November 2, 1953): 70.

100 In "Amazing Pictures of the Beginning of Human Life," *U.S. Camera* 9 (August 1946): 13, it was reported that Chester F. Reather had been making photomicrographs of human embryos for twenty-four years. *U.S. Camera*

annuals for both 1950 and 1951 reported on the 200-inch Hale telescope on Mt. Palomar.

[101] Walter Clark, "The Era of Scientific Photography 1900-1950," *U.S. Camera 1951*, p. 353.

[102] "World's Most Photographed Event," *U.S. Camera* 9 (September 1946): 21-23.

[103] Duane Featherstonhaugh, "Photography—Propaganda or Art," *American Photography* 41 (June 1947): 13.

[104] Stanley Kalish and Arthur A. Goldsmith, Jr., "Photography Fights Communism," *Popular Photography* 29 (October 1951): 40-45, 126.

[105] Laughlin wrote detailed explanatory captions for most of his pictures. This one is accompanied by the following:

Parlange Plantation

> Parlange Plantation was founded by the Marquis Vincent de Ternant, fleeing the Revolution in France. This is a composite print from two negatives of the interior of the house, showing Julie de Ternant, the tragic granddaughter of the old Marquis, who is said to have gone mad on her wedding night. Here the phantom of the lovely and ill-fated Julie rises from the great mirror in the drawing room, surrounded by the symbols of magnificence.

[106] The best biographic outline of Telberg's life is included in Van Deren Coke, *Val Telberg* (San Francisco: San Francisco Museum of Modern Art, 1983). For early surveys of his life and work, see "Art and the Subconscious: The Multi-Negative Photography of Vladimir Telberg-von-Teleheim," *American Artist* (January 1949): 42-43, 60-61; "The Work of Kathleen and Vladimir Telberg-von-Teleheim," *American Photography* 44 (October 1950): 12-17; "Val Telberg: A Portfolio," *American Photography* 47 (May 1953): 41-47; and Val Telberg, "Composite Photography," *American Artist* (February 1954): 46-47.

[107] "Art and the Subconscious," p. 60.

[108] For early profiles of Bernhard, see *Abel's Photographic Weekly* (Nov. 21, 1931): 591; (Nov. 28, 1931): 623; and (Dec. 5, 1931): 647; as well as "Out of This World," *Minicam* 8 (March 1945): 42-49, 90.

[109] In *U.S. Camera Annual 1951* (p. 280), Jacobi wrote of these images,

> After long photographic experience, I was convinced that the range of photographic media was more vast than commonly assumed. Therefore, a few years ago I asked my old painter friend, Leo Katz, who Stieglitz called "the greatest theorist in photography," to give me a summer course in my field. These pictures are the result of many years of experimentation stimulated by some of Mr. Katz's theories.

Jacobi's light abstractions were shown at least as early as the 1948 "In and Out of Focus" exhibition at the Museum of Modern Art.

[110] For information on this hitherto little-known figure, see "'The Masked Marvel,'" *Minicam* 9 (July 1946): 24-29; and Joe Munroe, "Roland G. Spedden and his world of ideas," *Minicam* 9 (August 1946): 52-61, 140. Spedden exhibited primarily in his home city, in the Detroit Institute of Arts annual photographic salon, between the years 1939 and 1946 (each of these years except 1941 and 1942). My thanks to Joseph Bellows for this information.

[111] For useful studies of Sommer's life and work, see the works listed in the bibliography as well as Lanier Graham, "The Art of Frederick Sommer," *Image* 33:3-4 (Winter 1990-91): 31-33, 43-52; and David L. Jacobs, "Frederick Sommer: A Portrait of Prisms," *Afterimage* 16 (October 1988): 14-16.

[112] It is significant that the "overall" structure of these photographs predated by several years the first similarly composed works by Abstract Expressionist painters. Max Ernst chose several of Sommer's pictures for publication in 1944 in the noted Surrealist journal *VVV*. It is unclear what impact this work may have had on painters like Arshile Gorky or Jackson Pollock.

[113] In addition to the monographs listed in the bibliography, see John Pultz, "Harry Callahan: The Creation and Representation of an Integrated Life," *History of Photography* 15:3 (Autumn 1991): 222-27, for a perspective on Callahan's early influences and themes.

[114] Harry M. Callahan, "An Adventure in Photography," *Minicam* 9 (February 1946): 28-29. For an early profile, see Tom Maloney, "The Callahan Story," *U.S. Camera* 11 (November 1948): 48-50.

[115] For a national review of the Chicago exhibition, see "One in a Thousand," *Newsweek* (May 7, 1951): 48.

[116] *Photographs: Harry Callahan* (Santa Barbara: El Mochuelo Gallery, 1964). For a list of Callahan's exhibitions and publications to 1964, see "Exhibition Catalogues," n.p.

[117] "The Feature Group," *Photo Notes* (June-July 1940): 7.

[118] Carl Chiarenza, *Aaron Siskind: Pleasures and Terrors* (Boston: New York Graphic Society, 1982), p. 48. It is interesting, however, to see that Siskind was receiving warm and intelligent criticism years later in the League's jour-

nal. See, for example Elizabeth Timberman, "Aaron Siskind," *Photo Notes* (June 1948): 10.

[119] Aaron Siskind, "The Drama of Objects," *Minicam Photography* 8 (June 1945): 20-23, 93-94. This essay is reprinted in Chiarenza, *Aaron Siskind: Pleasures and Terrors*, pp. 65-66, and (in slightly abbreviated form) in Nathan Lyons, ed., *Photographers on Photography* (Englewood Cliffs, N.J.: Prentice-Hall, 1966), pp. 96-98. For a later recollection of this turning point in his career, see Siskind's essay "In 1943 and 1944 a Great Change Took Place," in Newhall, *Essays & Images* (New York: Museum of Modern Art, 1980), pp. 305-06.

[120] Timberman, "Aaron Siskind."

[121] These photographs, in particular, suggest the general connection of Siskind's work to Existentialism. One of the most important Existentialist texts, Albert Camus's *The Myth of Sisyphus* (1942), suggested that the fate of modern man was similar to that of the legendary Sisyphus, who was doomed by the gods for eternity to pushing a large rock to the top of a mountain. Camus felt that Sisyphus's task was absurd and tragic, but also monumental and heroic, observing that "Each atom of that stone, each mineral flake of that night-filled mountain, in itself forms a world." Quoted in Richard Ellman and Charles Feidelson, Jr., *The Modern Tradition: Backgrounds of Modern Literature* (New York: Oxford University Press, 1965), p. 852.

[122] Most of these images were made in 1953-54, but the date of the work included in this volume indicates that Siskind worked intermittently on this theme through at least 1961. The earliest reproduction of these pictures appears to have been in "'The essential photographic act..,'" *Artnews* (December 1955): 36-37, which presented nine of them across a double spread.

[123] Siskind had shows at the Egan Gallery in 1947, 1948, 1949, 1951, and 1954.

[124] Bruce Altshuler, *The Avant-Garde in Exhibition: New Art in the 20th Century* (New York: Abrams, 1994), p. 167.

[125] Compare Siskind's writings with those of the leading Abstract Expressionists, as collected, for example, in Herschel B. Chipp, *Theories of Modern Art* (Berkeley: University of California Press, 1968), pp. 536-77.

[126] For a comparison of this photograph with the print derived from it, see Barbara Haskell, *Ralston Crawford* (New York: Whitney Museum of American Art, 1985), p. 113, figures 120 and 121.

[127] For a detailed study of this subject, see Maurice Tuchman et al., *The Spiritual in Art: Abstract Painting 1890-1985* (Los Angeles: Los Angeles County Museum of Art, 1986).

[128] Numerous studies deal with this complex subject. One of the most interesting and provocative is Michael Leja's *Reframing Abstract Expressionism: Subjectivity and Painting in the 1940s* (New Haven: Yale University Press, 1993).

[129] For a full-length study of the importance of Surrealism in this era, see Martica Sawin, *Surrealism in Exile and the Beginning of the New York School* (Cambridge, Mass.: MIT Press, 1995).

[130] "Statement" (1943); repr. in Herschel B. Chipp, *Theories of Modern Art*, p. 545.

[131] Note, for example, the publication of Robert Goldwater's *Primitivism in Modern Art* (1938), and exhibitions at the Museum of Modern Art such as "Prehistoric Rock Pictures in Europe and America" (1937), "Twenty Centuries of Mexican Art" (1940), and "Indian Art of the United States" (1941).

[132] Cited in Altshuler, *The Avant-Garde in Exhibition*, p. 162.

[133] Cited in ibid., p. 173.

[134] Kepes, "Modern Design! with Light and Camera," p. 100.

[135] On Siskind's anthropomorphism, it is interesting to compare his essay "The Drama of Objects" with such statements as Rothko's: "I think of my pictures as dramas; the shapes in the pictures are the performers." "The Romantics Were Prompted" (1947), in Chipp, *Theories of Modern Art*, p. 549. Religious symbolism recurs in White's work; see, in particular, plates 141-48 in Bunnell, *The Eye That Shapes*.

[136] Valuable insights into White's teaching methodology and ideas in this period are provided by his articles published in *American Photography* in 1951. These begin with "Your Concepts Are Showing," *American Photography* 45 (May 1951): 290-97.

[137] James Baker Hall, *Minor White: Rites & Passages* (Millerton, N.Y.: Aperture, 1978), p. 39.

[138] White's favorite books included Evelyn Underhill's *Mysticism: A study in the nature and development of man's spiritual consciousness* (1911), Richard Boleslavski's *Acting: The First Six Lessons* (1923), Eugen Herrigel's *Zen in the Art of Archery* (1948), Aldous Huxley's *Doors of Perception* (1954), the *I Ching*, and the works of Mircea Eliade, G. I. Gurdjieff, P. D. Ouspensky,

and Carlos Castaneda. See "Selected Books from Minor White's Library," in *Minor White: Rites & Passages*, pp. 139-41. For a short study of one of these topics, see Arnold Gassan, *Hypnosis & Minor White* (Athens, Ohio: Arnold Gassan, 1982).

[139] Jonathan Green, *American Photography: A Critical History 1945 to the Present* (New York: Harry N. Abrams, 1984), p. 58.

[140] Cited in Bunnell, *The Eye That Shapes*, p. 19.

[141] White, "Your Concepts Are Showing," p. 297.

[142] Minor White, *Mirrors Messages Manifestations* (New York: Aperture, 1969), p. 63. This is a slightly modified version of a statement from 1950 (as cited in Bunnell, *The Eye That Shapes*, p. 231).

[143] See White, *Mirrors Messages Manifestations*, pp. 42-47, 227, and 237. The version of this sequence in the Hallmark Photographic Collection was made ca. 1963, includes thirteen images, and varies significantly in structure from the sequence (dated 1960) reproduced in *Mirrors Messages Manifestations*. To a slightly lesser degree, White also exercised considerable freedom in the interpretation of single images. For example, *Warehouse Area, San Francisco*, 1949, was also presented by White as both a reversed image (*The Eye That Shapes*, plate 33), and in tightly cropped form (*Mirrors Messages Manifestations*, p. 6).

[144] Cited in Green, *American Photography*, p. 71.

[145] "Editorial: to recapture the innocence of vision," *Aperture* 6:2 (1958): 55.

[146] For White's own overview of this program, see "A Unique Experience in Teaching Photography," *Aperture* 4:4 (1956): 150-56.

[147] Nathan Lyons, Syl Labrot, and Walter Chappell, *Under the Sun: The Abstract Art of Camera Vision* (New York: George Braziller, 1960). The text of this book (which includes thirty-six reproductions) begins: "*Under the Sun* may be experienced as an illuminated journey through thirty-six states of mind, a simultaneous narrative of a search for authentic vision..."

[148] Caponigro's statements underscore the essential subjectivity of his vision:

> To penetrate and record, even if only reflectively through an idea-image, that which takes place in, over, under, around, and through nature, is to feel the intangible, the somewhere inbetween, the what is and the what I am, the interaction between visible and invisible. This is what I look for—what I am interested in. I am concerned with what grows out of interaction.

Paul Caponigro: An Aperture Monograph (Millerton, N.Y.: Aperture, 1972), p. 14.

[149] A good summary of this activity is included in Green, *American Photography*, pp. 75-79.

[150] Ibid., p. 77.

[151] Joel Eisinger, *Trace and Transformation: American Criticism of Photography in the Modernist Period* (Albuquerque: University of New Mexico, 1995), pp. 125, 143.

[152] While the images by Bullock and Colwell reproduced here were not published in *Aperture* in this period, they are highly characteristic of the work of these artists.

[153] Beginning with issue 7:4 (1959), White listed Coke, Lyons, and Smith as regional editors of the journal.

[154] The date of Smith's article coincides with White's first public interest in this notion; in 1953, White organized an exhibition in San Francisco titled "How to Read Photographs."

[155] In its publication in *Aperture* 6:4 (1958), Nickel's photograph is titled *Schiller Building, Auditorium, Chicago*.

[156] For a reminiscence on *Aperture*'s history by current editor Michael E. Hoffman, see "Forty Years After," *Aperture*, no. 129 (Fall 1992): 80-96.

[157] Charles Baudelaire, *The Painter of Modern Life and Other Essays*, trans. and ed. by Jonathan Mayne (New York: Da Capo Press, 1986), p. 9.

[158] Charles Baudelaire, *Oeuvres complètes* (Paris: Editions Gallimard, 1961), pp. 243-44; cited in Burton Pike, *The Image of the Modern City* (Princeton: Princeton University Press, 1981), p. 25. For an eloquent expression of a similar sensibility, see Alfred Kazin, *A Walker in the City* (New York: Harcourt Brace Jovanovich, 1951).

[159] A number of studies of this subject have been written, including Geoffrey O'Brien, *Hardboiled America: The Lurid Years of Paperbacks* (New York: Van Nostrand Reinhold, 1981); and Woody Haut, *Pulp Culture: Hardboiled Fiction and the Cold War* (London: Serpent's Tail, 1995).

[160] See, in particular, Thompson's *The Killer Inside Me* (1952; repr. New York: Vintage Crime, 1991); and Robert Polito, *Savage Art: A Biography of Jim Thompson* (New York: Alfred A. Knopf, 1995).

[161] The following discussion is drawn, in part, from J. P. Telotte, *Voices in the Dark: The Narrative Patterns of Film Noir* (Urbana: University of Chicago

Press, 1989). This is but one of many valuable books on this subject; others include Foster Hirsch, *The Dark Side of the Screen: Film Noir* (San Diego: A.S. Barnes, 1981); Joan Copjec, ed., *Shades of Noir* (London: Verso, 1993); R. Barton Palmer, *Hollywood's Dark Cinema: The American Film Noir* (New York: Twayne, 1994); and Nicholas Christopher, *Somewhere in the Night: Film Noir and the American City* (New York: Free Press, 1997). There are also many valuable journal articles on the subject, including James Naremore, "American Film Noir: The History of an Idea," *Film Quarterly* 49 (Winter 1995-96): 12-28.

[162] The mutual influence of film and still photography in this period has yet to be fully explored. The photographic community paid relatively close attention to the visual and narrative innovations of films in this era, from *Citizen Kane* to *Last Year at Marienbad*. See, for example, "Hollywood 'Discovers' the Amateur," *Camera Craft* 49 (February 1942): 106-07; and "A Startling Use of Technique in an Outstanding New Movie," *Modern Photography* 26 (June 1962): 28-29. A notable recent study of this subject is Jan-Christopher Horak, *Making Images Move: Photographers and Avant-Garde Cinema* (Washington, D.C.: Smithsonian Institution Press, 1997).

[163] Telotte, *Voices in the Dark*, p. 30.

[164] Evans worked extensively in the New York subway in 1938-41 with a Leica camera hidden beneath his coat. For a study of this work, see Sarah Greenough, *Walker Evans: Subways and Streets* (Washington, D.C.: National Gallery of Art, 1991). Feingersh's subway work was done ca. 1949, Leipzig's in both 1949 and ca. 1954. Others, such as Alfred Gescheidt (in ca. 1952) also photographed in this manner. For examples of work by the last three, see "Baghdad on a Subway," *Minicam* 13 (June 1949): 34-37, 119-20; Arthur Leipzig, "I See the Subway in Color," *U.S. Camera* 18 (January 1955): 66-67; and *U.S. Camera 1953*, pp. 242-43.

[165] Leo Braudy, "Realists, Naturalists, and Novelists of Manners," in Daniel Hoffman, ed., *Harvard Guide to Contemporary American Writing* (Cambridge, Mass.: Belknap Press, 1979), p. 133.

[166] Ibid., p. 103.

[167] Thomas Wolfe, *Of Time and The River* (New York: Charles Scribner's Sons, 1935), p. 155.

[168] As he related in a telephone conversation with the author in June 1994, Newman first studied photography with Walter Rosenblum at Brooklyn College. He also used the darkrooms at the Photo League before going to Chicago. Since the mid-1950s, Newman has been engaged in a successful commercial practice.

[169] Albert Q. Maisel, "Bedlam 1946: Most U.S. Mental Hospitals Are a Shame and a Disgrace," *Life* (May 6, 1946): 102-10, 112, 115-16, 118.

[170] "Insane Asylums Exposed," *U.S. Camera 1947*, pp. 138-41. Three powerful images are included here, none of which were used in the original *Life* essay.

[171] The largely poetic nature of this image may explain why Cooke felt free to print it both "correctly" and with the negative flipped in the enlarger. This vintage print is a mirror image of the version published in *U.S. Camera 1947*, p. 140. It is difficult to deduce which of these images reflects the actualities of the original scene.

[172] On the universality of Heath's themes, see Charles Hagen, "Le grand ALBUM ordinaire: An Interview with David Heath," *Afterimage* 1 (February 1974): 2-6, 13.

[173] This has been ably documented in Jane Livingston, *The New York School: Photographs 1936-1963* (New York: Stewart, Tabori & Chang, 1992).

[174] Usher Fellig's father arrived in the U.S. in 1906; the rest of the family followed in 1910. On arrival in the U.S., Usher's name was changed to Arthur. The elder Fellig worked as a pushcart vendor and a janitor; later in life he became a rabbi. The most detailed study of Weegee's career is Miles Barth et al., *Weegee's World* (Boston: Bulfinch, 1997).

[175] For an early profile of Weegee, see Rosa Reilly, "Free-Lance Cameraman," *Popular Photography* 1 (December 1937): 22.

[176] *Weegee by Weegee: An Autobiography* (New York: Ziff-Davis Publishing Company, 1961), p. 37.

[177] Ibid, pp. 21-23, 76-78.

[178] Miles Orvell, "Weegee's Voyeurism and the Mastery of Urban Disorder," *American Art* 6:1 (Winter 1992): 27.

[179] This image has been generally titled *Cop Killer* or *Booked on Suspicion of Killing a Policeman*, and dated 1939. The present title and date are taken from Barth et al., *Weegee's World*, pp. 80-81.

[180] According to the above source (p. 172), *The Critic* was titled *The Fashionable People* when first reproduced. Weegee cropped his pictures in varying

ways. See, for example, the full-frame version of *Accused "Cop Killer"* reproduced in the above work, and in John Coplans, *Weegee's New York* (Munich: Schirmer/Mosel/Grove, 1982), plate 91.

181 There has been some confusion over the date of this image. Weegee photographed this subject at least twice: in 1943 and again in 1952. The photograph reproduced here was included (in a tighter cropping) in his 1945 book *Naked City*. A work by the same title was included in the Museum of Modern Art's 1944 exhibition "Art in Progress," and dated 1943; see *Art in Progress* (New York: Museum of Modern Art, 1944), p. 226. This circus act was widely popular in 1943; for a similar rendition of this subject by the photographer Clyde Hodges, see "Speedlite Stops a Human Projectile," *Popular Photography* 13 (July 1943): 51.

182 Aaron Sussman, "The Little Man Who's Always There," *Saturday Review* 28 (July 28, 1945): 17; and Paul Strand, *Photo Notes* (August 1945): 3. For a more recent analysis of *Naked City*, see Orvell, "Weegee's Voyeurism," pp. 19-41. *Naked City* contains many of Weegee's best-known images, including the two cited above; they were, however, more tightly cropped than the prints reproduced in the present volume.

183 "Speaking of Pictures...Weegee Shows How to Photograph a Corpse," *Life* (August 12, 1946): 8-9.

184 For the flavor of Weegee's initial years in Hollywood, see "Weegee Goes Hollywood," *Popular Photography* 24 (March 1949): 51-55, 160.

185 See his article "Tele-photography," *Photo Arts* (Spring 1948): 76-83, 90.

186 Wilson Hicks, "Feininger as I Know Him," *Popular Photography* 25 (November 1949): 57.

187 See, for example, James T. Soby, "The Art of Poetic Accident: The Photographs of Cartier-Bresson and Helen Levitt," *Minicam* 6 (March 1943): 28-31, 95.

188 Levitt worked as a film editor beginning in the early 1940s, and made two highly acclaimed films later in the decade: *In the Street* (1945-46) and *The Quiet One* (1946-47). Her film career is summarized in Horak, *Making Images Move*, pp. 137-60.

189 Within the frame of the photograph itself we have, progressively, the frame of the window, the vertical "frame" of the arms of the woman in the striped shirt, and, within that, the rectangular form of the arms of the other young woman. These suggest a relentless inward spiral that seems both physical and psychological.

190 Each of these signs also emphasizes the role of the doorway as the juncture between the public world of the street and the intimate realm of the family. They remind one of Gaston Bachelard's observation on

> how concrete everything becomes in the world of the spirit when an object, a mere door, can give images of hesitation, temptation, desire, security, welcome and respect. If one were to give an account of all the doors one has closed and opened, of all the doors one would like to re-open, one would have to tell the story of one's entire life.

Bachelard, *The Poetics of Space*, trans. Maria Jolas (Boston: Beacon Press, 1969), p. 224.

191 For contemporary reviews of this work, see for example, Beaumont Newhall, "City Lens: Todd Webb's New York on Exhibition," *Artnews* (October 1946): 46-47, 73-74; and "Todd Webb's New York," *U.S. Camera 1948*, pp. 282-87.

192 Artist's statement for "Diogenes With a Camera" exhibition at the Museum of Modern Art, 1954. From manuscript in Webb archive, Center for Creative Photography, Tucson.

193 This work was shown at the Museum of Modern Art in 1953, described at considerable length in the April 1954 issue of *Modern Photography*, and (as a 4 x 24-foot enlargement) featured in the American display at the 1958 Brussels World's Fair.

194 James Agee, untitled essay, in Helen Levitt, *A Way of Seeing* (New York: Horizon Press, 1981), p. xi.

195 Lincoln Kirstein, "Photographs of America: Walker Evans," in *American Photographs* (New York: East River Press, 1975), p. 188.

196 "Metropolis," *U.S. Camera 1941*, vol. I, p. 141.

197 This photograph was reproduced in *U.S. Camera 1949*, p. 176. For other selections of Weiner's work, see *U.S. Camera 1950*, pp. 180-81; "Dan Weiner: A Portfolio," *Photography* (June 1953): 40-47, 108; *U.S. Camera 1958*, pp. 26-33; and "Dan Weiner," *Camera 35* 3:4 (1959): 234-37.

198 Yavno received his greatest recognition for photographs of San Francisco and Los Angeles in the late 1940s. These were commissioned by Houghton Mifflin and published in Max Yavno and Herb Caen, *The San Francisco Book* (Boston: Houghton Mifflin, 1948); and Max Yavno and Lee Shippey, *The Los Angeles Book* (Boston: Houghton Mifflin, 1950).

199 For an essay on his mentor, see Liebling's "Walter Rosenblum," *American Photography* 45 (May 1951): 273-81.

200 *U.S. Camera 1953*, pp. 282-83. This is one of the earliest publications of his work.

201 James Alinder, ed., *Roy DeCarava Photographs* (Carmel, Calif.: Friends of Photography, 1981), p. 14.

202 Four of Parks's images, including a variant of this photograph, were reproduced in "A Man Becomes Invisible," *Life* (August 25, 1952): 9-11. The text for this article reads in part, "with Ellison's help [Parks] re-created from the novel the scenes on these pages to show the loneliness, the horror and the disillusionment of a man who has lost faith in himself and the world." A variant of this image was reproduced in *Photography Annual 1954*, p. 224, under the title *Invisible Man*.

203 Hawthorne's phrase, from his "The Gray Champion," is a central theme in Pike, *The Image of the City in Modern Literature*.

204 "What Is Modern Photography?" *American Photography* 45 (March 1951): 151. For the sake of clarity, numerous ellipses in this original text have been eliminated.

205 Biographical details are drawn from the profile "Homer Page," in Carlton Brown, *Famous Photographers Tell How* (Greenwich, Conn.: Fawcett, 1955), pp. 76-91. For an early article on his work, see Christiana Page, "The Reluctant Reformer," *Minicam* 9 (February 1946): 50-57, 144.

206 His admiration for Lange is expressed in his eulogy "A Remembrance of Dorrie," *Infinity* (November 1965): 26.

207 "A Photo League Symposium," *Photo Notes* (Spring 1950): 17-18. Similarly, it was noted in *U.S. Camera 1951*, pp. 206-07, that "Page has sought to illustrate the effects of mass living on the individual."

208 The verso of this print is inscribed: "'Homage to Muybridge,' Chestnut St. between 10th and 11th Streets, Philadelphia, Pa." It is unclear, however, if this is the original title, since it was reproduced in *Photography 1947* (p. 65) with the title *Street Scene*.

209 Stettner's photograph, while one of his best known, is not altogether typical of his work. See Louis Stettner, *Early Joys* (New York: Janet Iffland, 1987), p. 127.

210 Canner reportedly quit photography in 1951 out of concern that his connection with the Photo League would harm his professional career. My thanks to George Rinhart for this information. Canner's *Pedestrians*—his best-known picture—was reproduced as a double-page spread in *U.S. Camera 1951*, pp. 168-69, accompanied by a short quote and technical notes.

211 Livingston, *The New York School*, p. 288.

212 For an interesting remembrance of Grossman and his influence as a teacher, see Lou Stettner, "Speaking Out," *Camera 35* 16 (October 1972): 14, 32.

213 The most complete information on Vestal's career is contained in Livingston, *The New York School*, pp. 327-29, and 376-77. In addition, see such articles of the period as Jacob Deschin, "David Vestal," *Popular Photography* 57 (November 1965): 34, 38, 40, 42, 44, 46, 48.

214 "Leon Levinstein," *U.S. Camera 1956*, p. 255. Jane Livingston notes that this statement "makes utterly transparent [Levinstein's] adherence to the ideas Sid Grossman was espousing in 1949 and 1950" (*The New York School*, p. 325). For other contemporary publications of Levinstein's work, see, for example, *U.S. Camera 1951*, p. 337; and *U.S. Camera 1952*, pp. 47, 60.

215 Helen Gee has been one of the most consistent supporters of Levinstein's work. She gave him a one-man show at Limelight Gallery in 1956, wrote the text for a portfolio of his images published in the March/April 1982 issue of *Camera Arts*, and contributed the introduction to the 1990 Photofind Gallery exhibition catalogue, *Leon Levinstein*.

216 Livingston, *The New York School*, p. 321.

217 This was the lead image in the review of the exhibition in *U.S. Camera 11* (June 1948): 17.

218 *Photography* (December 1953): 94.

219 Much of the following is based on Livingston, *The New York School*, pp. 312-16; and John Heilpern's essay in *William Klein: Photographs* (Millerton, N.Y.: Aperture, 1981).

220 Heilpern, *William Klein: Photographs*, p. 7.

221 Livingston, *The New York School*, p. 314.

222 Although it is worth noting that the New York book was given enthusiastic coverage in the U.S. photographic press; see *Modern Photography* 45 (September 1959): 52-59, 96.

223 In addition to Page's tribute to Lange, noted above, see Smith's essay "One Whom I Admire," *Popular Photography* 58 (February 1966): 86-88. It is also

interesting to note that Robert Frank made a point of visiting Lange during the course of his Guggenheim-sponsored journey across the U.S. in 1955-56.

224 Dorothea Lange and Daniel Dixon, "Photographing the Familiar," *Aperture*, no. 2 (1952): 9.

225 Ibid., p. 13.

226 Ibid., p. 6.

227 Ibid., p. 15.

228 Wright Morris, "Preface," *The Inhabitants*, 2nd ed. (New York: Da Capo Press, 1972), n.p.

229 Jacquelyn Judge, "The Inhabitants," *Popular Photography* 19 (December 1946): 218.

230 Morris's next combination of photographs and text was *God's Country and My People* (1968).

231 Robert Frank was one of the numerous younger photographers who admired these volumes. See Colin L. Westerbeck, Jr., "The Photography and Fiction of Wright Morris," in Daniel P. Younger, ed., *Multiple Views: Logan Grant Essays on Photography, 1983-1989* (Albuquerque: University of New Mexico Press, 1991), p. 280.

232 In 1940, Strand did not even own a still camera according to Elizabeth McCausland, "Paul Strand," *U.S. Camera*, no. 8 (February-March 1940): 65.

233 For valuable perspectives on this project, see, for example, John Rohrbach, "*Time in New England*: Creating a Usable Past," in Stange, ed., *Paul Strand: Essays on His Life and Work*, pp. 161-77; Eric Himmel, "Pilgrim's Progress," *Camera Arts* (November-December 1981): 10, 12, 16, 19-21; and "*Time in New England* in the Making: Excerpts from Correspondence between Paul Strand and Nancy Newhall," in Newhall, *Essays & Images*, pp. 296-303.

234 "Photographer's Foreword," *Time in New England* (New York: Oxford University Press, 1950), p. vii.

235 For insights into Strand's political views, see his "Address," *Photo Notes* (January 1948): 1-3; Mike Weaver, "Dynamic Realist," in Stange, ed., *Paul Strand*, pp. 197-207; Mike Weaver, "Paul Strand: Native Land," in Mike Weaver and Anne Hammond, *Paul Strand and Ansel Adams: Native Land and Natural Scene* (Tucson: Center for Creative Photography, 1990); and Ben Maddow, "A View from Below: Paul Strand's Monumental Presence," *American Art* 5:3 (Summer 1991): 49-67.

236 These resulted in the following books: *La France de Profil* (1952), *Un Paese* (1955), *Tir a'Mhurain* (1962), *Living Egypt* (1969), and *Ghana: An African Portrait* (1976).

237 Harold Clurman used this phrase to describe Strand's vision as early as 1934. Quoted in Himmel, "Pilgrim's Progress," p. 16.

238 James L. Collings, "Photography: Smith Carries Torch with His Camera," *Editor & Publisher* (October 2, 1948): 46; quoted in William Johnson, *W. Eugene Smith: Early Work* (Tucson: Center for Creative Photography, 1980): 16.

239 For an interesting defense of Smith, see Emily A. Mack, "The Myth Named Smith," *Camera 35* (December-January 1960): 45-47, 74-79.

240 Quoted in Glenn G. Willumson, *W. Eugene Smith and the Photographic Essay* (Cambridge: Cambridge University Press, 1992), p. 234. This book provides an excellent analysis of Smith's most notable essays and his working method.

241 Mack, "The Myth Named Smith," p. 76.

242 Willumson, *W. Eugene Smith and the Photographic Essay*, p. 238.

243 Ibid., p. 113. On the remarkable subtlety of the layout of this essay, see pp. 112-15.

244 For a contemporary appraisal of the experience of working with Smith, see, for example, David Vestal, "'...a great unknown photographer,' W. Eugene Smith," *Popular Photography* 59 (December 1966): 114-17, 124, 185.

245 *Life*'s publication of this essay included twenty-five photographs, while Smith's ideal version encompassed nearly 250. See William S. Johnson, *W. Eugene Smith: Master of the Photographic Essay* (Millerton, N.Y.: Aperture, 1981), p. 147.

246 Ibid., p. 149.

247 Smith's own eighty-seven-print version of this essay was published in *Photography Annual 1959*, pp. 96-133. Bruce Downes's recollections of working with Smith on this project are contained in Vestal, "'...a great unknown photographer.'"

248 For a recap of the outcome of this matter, see "The End of a Tragedy in Pictures," *New York Times* (August 3, 1997): E3.

249 The most detailed study of this subject is Eric J. Sandeen, *Picturing an Exhibition: The Family of Man and 1950s America* (Albuquerque: University of New Mexico Press, 1995). The following discussion is indebted to this work.

See, also, John Szarkowski, "'The Family of Man,'" in *Studies in Modern Art 4: The Museum of Modern Art at Mid-Century: At Home and Abroad* (New York: Museum of Modern Art, 1994): 12-37.

250 This point of view was clearly recognized by the young critic Hilton Kramer, who noted in a pointed review that the show's "mode of articulation has a distinct ideological cast—in this instance, a cast which embodies all that is most facile, abstract, sentimental, and rhetorical in liberal ideology." "Exhibiting the Family of Man," *Commentary* 20 (October 1955): 365.

251 For a brief survey of the world government movement of the postwar period, see Paul Boyer, *By the Bomb's Early Light* (1985; repr. Chapel Hill: University of North Carolina Press, 1994), pp. 33-45.

252 Bruce Gould, "Last Trump," *Ladies' Home Journal* (January 1946): 5; cited in Boyer, *By the Bomb's Early Light*, pp. 221-22.

253 William Faulkner, "Nobel Prize Address," in *The William Faulkner Reader* (New York: Random House, 1954): 4-5.

254 *Photo Notes* (January 1948): 5. While Adams's comments, made in support of the Photo League, are specifically directed toward the need to "photograph the truth of America," they seem germane to this discussion.

255 Most of these photographs were made by Robert Capa, George Rodger, and Chim (David Seymour). The picture editor of *Ladies' Home Journal* at this time was John G. Morris. See William Manchester, Jean Lacouture, and Fred Ritchin, *In Our Time: The World as Seen by Magnum Photographers* (New York: American Federation of Arts/W. W. Norton, 1989), pp. 430-31; and Russell Miller, *Magnum: Fifty Years at the Front Line of History* (London: Secker & Warburg, 1997), pp. 56-59.

256 *U.S. Camera 1944*, p. 5.

257 This issue begins with a picture story on the birth of a baby, and then touches on such themes as the end of the war, the construction of new houses for returning servicemen and their families, followed by a varied catalogue of political turmoil, natural disasters, and other perspectives on the human condition. Steichen's direct involvement in these publications ended with his employment at the Museum of Modern Art; the 1947 annual is thus the last to so clearly embody Steichen's ideas.

258 Gilbert Bailey, "Photographer's America," *New York Times Magazine* (August 31, 1947): 39. The same sentiments are recorded in "Steichen Heads Museum Department of Photography," *U.S. Camera* 10 (October 1947): 17, 50-51.

259 Bruce Downes, "Steichen at Mid-Century," *Popular Photography* 27 (September 1950): 115.

260 Lange's involvement is outlined with particular clarity in Szarkowski, "'The Family of Man.'"

261 Lew Parella, "The Family of Man," *U.S. Camera* 18 (March 1955): 56.

262 Jacob Deschin, "Family of Man," *New York Times* (January 30, 1955): X 17.

263 Szarkowski, "'The Family of Man,'" p. 13.

264 Parella, "The Family of Man," p. 69.

265 There is minor discrepancy in the figures given in Szarkowski, "'The Family of Man,'" p. 13, and in Sandeen, *Picturing an Exhibition*, p. 95.

266 Kramer, "Exhibiting the Family of Man," p. 364.

267 Szarkowski, "'The Family of Man,'" p. 32.

268 "Preview Address: 'The Family of Man,'" *U. S. Camera 1956*, p. 18.

269 Arthur A. Goldsmith, Jr., "The Family of Man," *Popular Photography* 36 (May 1955): 147.

270 Ibid., p. 148. In addition, this article contains a useful diagram of the exhibition.

271 "The Family of Man," *U.S. Camera* 18 (March 1955): 70.

272 "The Controversial Family of Man," *Aperture* 3:2 (1955): 8.

273 Goldsmith, "The Family of Man," pp. 148, 151.

274 Deschin, "Family of Man," p. X 17.

275 Frank, "A Statement," *U.S. Camera Annual 1958*, p. 115.

276 For a remarkably detailed list of these publications, see Stuart Alexander, *Robert Frank: A Bibliography, Filmography, and Exhibition Chronology 1946-1985* (Tucson: Center for Creative Photography/Houston Museum of Fine Arts, 1986).

277 Tucker, *Robert Frank: New York to Nova Scotia* (Houston: Museum of Fine Arts, 1986), p. 20. Frank's application was accompanied by the strongest possible list of references: Evans, Brodovitch, Liberman, Steichen, and art historian Meyer Shapiro.

278 The chronology and itinerary of these trips is reconstructed by Anne Tucker in *New York to Nova Scotia*, pp. 9-10, 94-95.

279 Ibid., p. 95.

[280] For useful overviews of this theme in photography, see, for example, Ulrich Keller, *The Highway as Habitat: A Roy Stryker Documentation, 1943-1955* (Santa Barbara: University Art Museum, 1986); and Marilyn Laufer, *In Search of America: Photography from the Road 1936-1976* (Ph.D. diss., Washington University, 1992).

[281] See John Malcolm Brinnin, "Henri Cartier-Bresson, Portrait of the Artist, ca. 1947," *Camera Arts* (January-February 1982): 14-17, 20-24, 28-29, 110-13; and Henri Cartier-Bresson, *America in Passing* (Boston: Bulfinch, 1991).

[282] Kerouac's *On The Road* was written in 1948-51, and partially rewritten between 1951 and 1956, before its publication in 1957. Frederick R. Karl, *American Fictions 1940-1980* (New York: Harper & Row, 1983), p. 200.

[283] Fourteen of these images were published in Erwitt's article, "35mm Images from a Moving Car," *U.S. Camera* 17 (September 1954): 52-55.

[284] "Robert Frank: Ben James, Story of a Welsh Miner," *U.S. Camera 1955*, p. 92.

[285] On the relationship between the work of Evans and Frank, see Leslie K. Baier, "Visions of Fascination and Despair: The Relationship Between Walker Evans and Robert Frank," *Art Journal* 41:1 (Spring 1981): 55-63; and Tod Papageorge, *Walker Evans and Robert Frank: An Essay on Influence* (New Haven: Yale University Art Gallery, 1981).

[286] See, for example, "The Congressional," *Fortune* 51 (November 1955): 118-22.

[287] For a summary of these influences, see William S. Johnson, "History—His Story," in Johnson, ed., *The Pictures Are a Necessity: Robert Frank in Rochester, NY, November 1988* (Rochester: Rochester Film & Photography Consortium, 1989), pp. 29-36.

[288] Studies of the structure and meaning of this book include John Brumfield, "'The Americans' and The Americans," *Afterimage* 8 (Summer 1980): 8-15; Jno Cook, "Robert Frank's America," *Afterimage* 9 (March 1982): 9-14; Green, *American Photography*, pp. 81-93; and George Cotkin, "the photographer in the beat-hipster idiom: robert frank's the americans," *American Studies* 26:1 (Spring 1985): 19-33.

[289] It is revealing of Frank's editing process that nearly half the thirty-three images reproduced in his portfolio in *U.S. Camera 1958*, pp. 90-115, were not included a year later in *The Americans*.

[290] Karl, *American Fictions*, p. 201.

[291] Robert Frank, "A Statement," *U.S. Camera 1958*, p. 115.

[292] Edna Bennett, "Black and White Are the Colors of Robert Frank," *Aperture* 9:1 (1961): 22.

[293] Translations of some of these texts (chosen by critic Alain Bosquet) are reprinted in Cook, "Robert Frank's America," pp. 10-11.

[294] This edition did not actually appear until January 15, 1960. See Alexander, *Robert Frank: A Bibliography*, p. 19.

[295] Stuart Alexander reports: "The edition could have been 2,600. At least 1,100 were sold. It is reported that the books were soon remaindered." Ibid.

[296] Cited in Brumfield, "'The Americans' and The Americans," p. 8.

[297] "An Off-Beat View of the U.S.A.," *Popular Photography* 46 (May 1960): 104-06.

[298] "New Photo Books," *Modern Photography* 24 (June 1960): 32. The only critic in the photographic press to avoid this line of reasoning was H. M. Kinzer, who wrote:

> In *The Americans*, one of our finest photographers has produced a slashing and bitter attack on some U.S. institutions, while completely ignoring others. However much one may quarrel with this one-sidedness (which is most assuredly intentional, and not the result of any ignorance of the "better" aspects of our culture), it is impossible to deny the sharp perception and the sheer power of most of the images in the book. It is useless to argue that Robert Frank should have devoted a part of his book to the vast and smiling American middle class, another to the champagne-and-Jaguar stratum, and so on. The fact is simply that he feels strongly about some of the things he sees in his adopted country, and wants to call them to our attention. He does it superbly.

"An Off-Beat View of the U.S.A.," pp. 104-05. In contrast to the critical hostility with which *The Americans* was received, it is interesting to note the warm response given to Klein's work in *Modern Photography* 23 (September 1959): 52-59, 96.

[299] "An Off-Beat View of the U.S.A.," p. 104.

[300] "Books of the Year," *Photography Annual 1961*, p. 198.

[301] Unsigned review, *Aperture* 7:3 (1959): 127.

[302] Walker Evans, "Robert Frank," *U.S. Camera 1958*, p. 90.

[303] "Two Billion Clicks," *Time* (November 2, 1953): 70.

[304] These emulsions were officially rated at ASA 200, but photographers reported success using them at ASAs of 400 or 800. Dr. Walter Clark, "The Path of Progress: a review of developments in 1954," *Popular Photography* 36 (April 1955): 87. These annual articles provide useful summaries of technical innovations in this era.

[305] "Two Billion Clicks," p. 73.

[306] *U.S. Camera 1955*, p. 7; *Photography Annual 1960*, p. 9. The first issue of the latter, dated 1951, was issued in 1950.

[307] See *U.S. Camera* 22 (November 1959): 57; and *Camera* 35 3 (Winter 1959): 6.

[308] *U.S. Camera*, no. 9 (May 1940): 2; *Minicam* 10 (September 1946): 91.

[309] *U.S. Camera*, no. 9 (May 1940): 18; *Popular Photography* 36 (April 1955): 103; *Popular Photography* 36 (April 1955): 101; *Modern Photography* 24 (December 1960): 36-37; *Modern Photography* 29 (September 1965): 7.

[310] "The World's 10 Greatest Photographers," *Popular Photography* 42 (May 1958): 63-66.

[311] *U.S. Camera* 22 (December 1959): 108.

[312] Transcribed comments from symposium "What Is Modern Photography?" *American Photography* 45 (March 1951): 148.

[313] Some of these, of course, featured a variety of nontopical images. In addition to its standard reportage, for example, *Life* regularly published portfolios of purely artistic images. These included work by certified masters such as Stieglitz, younger artists like Cartier-Bresson, experimental talents such as Feininger and Siegel, and previews of exhibitions at the Museum of Modern Art.

[314] John Szarkowski, *Photography Until Now* (New York: Museum of Modern Art, 1989), p. 251.

[315] Comments ca. 1964, quoted in Szarkowski, *Irving Penn*, p. 28.

[316] See Howard Sochurek, "The Crisis in Photojournalism," *Popular Photography* 52 (April 1963): 57, 92-95. For a response to this article, see George Lockwood, "Who Killed Photojournalism?" *Popular Photography* 53 (September 1963): 38.

[317] John Szarkowski, "Photography and the Mass Media," *Aperture* 13:3 (1967): n.p.

[318] Elliott Erwitt, *Personal Exposures* (New York: W.W. Norton, 1988), p. 20.

[319] Details on Link's life and work are drawn from Carolyn Carr, "Rite of Passage: O. Winston Link's Railroad Photographs of the 1950s," in *Ghost Trains: Railroad Photographs of the 1950s by O. Winston Link* (Norfolk, Va.: Chrysler Museum, 1983): 6-7. See also, John Gruber, "Link's Bright, Creative Night Views," *Vintage Rails*, no. 14 (September-October 1998): 48-59.

[320] The use of complex flash setups was common in this period. See, for example, "World's Biggest Flash Shot," *U.S. Camera* 14 (November 1951): 35-39; and "The World's Greatest Flash Picture," *U.S. Camera* 18 (January 1955): 56-57, 96. The latter describes a railroad photograph made with 6,000 flashbulbs.

[321] This appears to be the "master," original print of this famous image; no other print this size with the original montage element is known. Subsequent later prints were probably made from a copy negative of this print.

[322] For a contemporary perspective on these classes, see David Jon Ebin, "A Master Teaches the Experts," *Photography* (January 1955): 48-51, 122-23. For other comments on Brodovitch's teachings, see Irving Penn, "1935-1937 Ballet," *Infinity* (July 1965): 4-11; and Ben Rose, "A.B.," *Infinity* (June 1971): 12-13, 16-17.

[323] The enormous influence of this book is suggested in articles such as Bruce Downes, "...'resembling the after-images of memory,'" *Popular Photography* 55 (August 1964): 64-65.

[324] Owen Edwards, "Zen and the Art of Alexey Brodovitch," *American Photographer* (June 1979): 55.

[325] For a survey of Liberman's career, see Dodie Kazanjian and Calvin Tomkins, *Alex: The Life of Alexander Liberman* (New York: Alfred A. Knopf, 1993).

[326] "Walker Evans: The Unposed Portrait," *Harper's Bazaar* (March 1962): 120-25. For a brief profile of Israel, see Owen Edwards, "Marvin Israel, the Mentor, Doesn't Want to Be Famous," *Village Voice* (October 27, 1975): 103-04.

[327] Martin Harrison, *Appearances: Fashion Photography Since 1945* (New York: Rizzoli, 1991), pp. 25, 27, 30. My discussion owes a considerable debt to this fine study.

[328] "Richard Avedon: A Portfolio," *U.S. Camera 1955*, p. 54.

[329] "Leslie Gill: His Work and Influence," *Modern Photography* 23 (January 1959): 80-89.

[330] Interestingly, by late 1948, Avedon was already being described as "the most controversial figure in photography." See Jonathan Tichenor, "Richard Avedon, Photographic Prodigy," *U.S. Camera* 12 (January 1949): 35.

[331] "Richard Avedon," *U.S. Camera 1950*, p. 169.

[332] For a contemporary account of the making of this photograph, see "High Fashion in a Menagerie," *U.S. Camera* 19 (June 1956): 64-65, 104-05.

333 *U.S. Camera 1956*, p. 254.

334 John Durniak, "Avedon Show," *Popular Photography* 56 (May 1965): 52.

335 In 1955, Penn stated, "As far as I am concerned, Brodovitch is the most important influence on the printed page in our time." "Irving Penn: '...cut an incision into their lives...,'" *Photography Annual 1966*, p. 18.

336 Nonetheless, Penn's work, like Avedon's, was controversial in its day. For example, *U.S. Camera 1949* (p. 23) notes that "Irving Penn, a photographer on the staff of the Condé Nast publications, is one of the newer names in photography, and one whose work has aroused violent differences of opinion..."

337 John Szarkowski, *Irving Penn* (New York: Museum of Modern Art, 1984), p. 25.

338 These were published in *Vogue* and elsewhere. For example, sixty of Penn's small-trades images (including works titled *House Painter*, *Shoemaker*, *Deep-Sea Diver*, and *Pneumatic Driller*) were published in the July 1951 issue of *Vogue*, and in *U.S. Camera 1952*. Penn's images of international clothing and body adornment are collected in his book *Worlds in a Small Room* (New York: Grossman, 1974).

339 For a contemporary profile of Bassman, see Walter Ian Fishman, "A Woman's Camera in a Woman's World," *Popular Photography* 28 (April 1951): 36-41, 98-99.

340 Quoted in Heilpern, *William Klein: Photographs*, p. 15.

341 Harrison, *Appearances*, p. 98.

342 In 1957, Newman observed:

> Inevitably there is a great deal of the photographer in his finished product, and if it's a portrait, then you're viewing your sitter in the light of your own creative and personal life. If there isn't much you, then there isn't much of a portrait. In other words, you must be part of the picture yourself. It is a matter of joining forces with the sitter, in a sense.

Arthur Goldsmith, "Arnold Newman on Portraiture," *Popular Photography* 40 (May 1957): 126. This issue also includes the article, "On Assignment with Arnold Newman," pp. 80-85, 113. For an earlier essay on Newman's work, see "Portraits That Break the Rules," *U.S. Camera* 14 (April 1951): 36-37, 93.

343 The first list of potential titles included Ansel Adams's *The Stars and the Planets*, Toni Frissell's *Children*, and monographs of the work of Anton Bruehl and Edward Steichen. See *U.S. Camera*, no. 8 (February-March, 1940): 11.

344 These were both identified as "A U.S. Camera Book," although published by Random House, and by Duell, Sloan and Pearce, respectively.

345 This series educated several generations of photographers. These books were reprinted many times before being replaced by entirely new versions (of the first three titles) in 1980-83.

346 *Photography Annual 1960*, p. 14.

347 "Photographer's Foreword," *The Idea of Louis Sullivan* (Minneapolis: University of Minnesota Press, 1956), n.p.

348 There can be, admittedly, a very fine line between these categories.

349 The great majority of this era's photographic books retailed for less than ten dollars. For example, *The Inhabitants* (1946) was priced at $3.75, *Weegee's People* (1946) at $4.00, *This Is War!* (1951) at $4.95, and the first American edition of *The Americans* (1959) at $7.50 (all cloth-bound). Even the most lavish volumes were usually less than twenty dollars: Weston's *Fifty Photographs* (1948) and Avedon's *Observations* (1959) were both priced at $15.00, while Irving Penn's *Moments Preserved* (1960) sold for $17.50. Exhibition catalogues and smaller publications were usually under $3.00.

350 Jonathan Spaulding, *Ansel Adams and the American Landscape* (Berkeley: University of California Press, 1995), p. 313.

351 Ibid., p. 330.

352 For a chronological record of every *Life* cover, see its special sixtieth anniversary issue of October 1996.

353 Color televisions were generally available to the public by the fall of 1955. By the end of 1956, however, only one percent of households owned one. The three major networks did not shift entirely to color broadcasting until 1967. Henry Wilhelm and Carol Brower, *The Permanence and Care of Color Photographs* (Grinnell, Iowa: Preservation Publishing Company, 1993), p. 40.

354 Bryan Bunch and Alexander Hellemans, eds., *The Timetables of Technology* (New York: Touchstone, 1993), p. 384; Dr. Walter Clark, "The Photographic Year," *Popular Photography* 34 (April 1954): 127.

355 Stephen R. Milanowski, "The Biases Against Color in Photography," *Exposure* 23:2 (Summer 1985): 5. This article provides a good introduction to artistic attitudes toward color in the twentieth century.

356 Interestingly, variable contrast papers were introduced as early as 1940, but only came into general use after World War II. See Dr. Walter Clark, "1940—

A Year of Progress," *Popular Photography* 8 (January 1941): 25, 96. For early descriptions of the Polaroid process, see "A New One-Minute Process," *Minicam* 10 (May 1947): 20-24, 129; and "60 Second Miracle," *Minicam* 12 (January 1949): 47, 118.

357 On the latter, see "Gasparcolor Paper," *Minicam* 7 (October 1944): 55-56, 96.

358 Jack H. Coote, *Making Colour Prints* (London: Focal Press, 1945), p. 68.

359 *U.S. Camera*, no. 10 (June-July 1940): 75.

360 See for example, Coote, *Making Colour Prints*, pp. 29-38; and Dr. Jerome H. Leadley and Werner Stegemeyer, *Making Color Prints* (Chicago: Ziff-Davis, 1941), p. 71.

361 A remarkably stable process, Kodak's Azochrome was apparently developed in 1941 but not marketed. See Wilhelm and Brower, *Permanence and Care of Color Photographs*, p. 25.

362 See, for example, Howard C. Colton, "The Coming Revolution in Photography," *Popular Photography* 39 (July 1956): 54-57, 130-32.

363 *Popular Photography Color Annual 1959*, p. 23.

364 See Edward Meyers, "Color Printing: Time & Effort Compared," *Modern Photography* 27 (February 1963): 70-71, 93, 100; and the various articles on Polacolor in *Popular Photography* 52 (March 1963).

365 For example, see: "Color Photography Today: A Symposium," *Photography Annual 1955*, pp. 144-46, 235-36; a two-part "Symposium on Color," *U.S. Camera* 18 (May 1955):58-63, 98-99, and (June 1955): 85-91, 108-09; "Six Experts Discuss Color," *U.S. Camera* 19 (October 1956): 53, 101; and "How Creative Is Color Photography?" *Popular Photography Color Annual 1957*, pp. 14-25, 169-70.

366 This contained an historical overview by Beaumont Newhall, and the group discussion "The Future of Color: A Symposium." For background on Downes and his involvement in photography, see Joel Eisinger, *Trace and Transformation*, pp. 127-37.

367 Downes, "Color Today—An Appraisal," *Color Photography Annual 1956*, p. 30.

368 *Popular Photography Color Annual 1957*, p. 169.

369 Alexander Liberman, ed., *The Art and Technique of Color Photography* (New York: Simon and Schuster, 1951), p. 44.

370 *Fortune* (July 1954): 80.

371 John Grimes, "Arthur Siegel," in *Arthur Siegel: Retrospective* (Chicago: Edwynn Houk Gallery, 1982), n.p.

372 "Color Photography," *U.S. Camera 1949*, p. 192.

373 An unscientific survey of randomly chosen issues of three mid-1950s periodicals (*Modern Photography*, April 1954; *Popular Photography*, February 1955; and *U.S. Camera*, June 1955) revealed the following: all used color on the front and back covers, but otherwise the total of 393 pages of these three issues included a mere thirteen pages of editorial color and four pages of advertising color. Mass market magazines such as *Life* had a much higher percentage of color advertising pages.

374 The background of this project is given in Terence Pitts, *Edward Weston: Color Photography* (Tucson: Center for Creative Photography, 1986); and in Ansel Adams, *An Autobiography* (Boston: New York Graphic Society, 1985), pp. 172-75.

375 These include *Minicam*, *American Photography*, and *The Camera*.

376 "Test Exposures," *Fortune* (July 1954): 77-80.

377 Adams, *An Autobiography*, p. 174.

378 For example, see "Along the Right of Way" (September 1950): 106-13; "The Wreckers" (May 1951): 102-05; "The U.S. Depot" (February 1953): 138-43; and "These Dark Satanic Mills" (April 1956): 139-46. *Fortune* ran color photo-essays regularly in this era by Arthur Siegel, Sol Libsohn, Ezra Stoller, and many other photographers.

379 "Images of a Magic City," *Life* (September 14, 1953): 108-20; and (September 21, 1953): 116-26.

380 "Haas on Color Photography," *Popular Photography Color Annual 1957*, p. 30.

381 *U.S. Camera*, no. 10 (June-July 1940): 76.

382 Some 342 works by over seventy-five photographers were included. I am indebted to Cornelia Knight of the Department of Photography at the Museum of Modern Art for sending copies of this exhibition's press release, checklist, and introductory statement.

383 For Walter Rosenblum's review of this show at the Rabin and Krueger Gallery, see *Photo Notes* (July 1947): 3-4.

384 See, for example, "A Folio of Color from William Mortensen," *Minicam* 8 (January 1945): 55-58.

385 Leland Rice, *Henry Holmes Smith: Photographs 1931-1986, A Retrospective* (New York: Howard Greenberg Gallery, 1992), p. 29.

386 "Modern Art by a Photographer," *Life* (November 20, 1950): 78-84.

387 Most of this aspect of Bullock's work exists only in the form of his original color transparencies. His renewed interest in black-and-white imagery in 1963 was, in part, a result of the difficulty of making color prints. See Liliane De Cock and Barbara Bullock-Wilson, *Wynn Bullock, Photography: A Way of Life* (Dobbs Ferry, N.Y.: Morgan & Morgan, 1973), pp. 27, 30-31.

388 Porter's embrace of the dye-transfer process was, at least in part, a result of the fact that he was "freed by family money to pursue his...interests in fine photography without regard for fashion or fad or the demands of the marketplace." Martha A. Sandweiss, "Foreword," *Eliot Porter* (Boston: New York Graphic Society, 1987), p. 7.

389 See "Bibliography," in ibid., pp. 256-71.

390 This broad appeal does not mean that Porter's work sold widely. According to *Contemporary Photographer* (Spring 1964-65): 68, Porter's 11 x 14-inch prints were priced at $75 each, an exceedingly high level at the time.

391 John Szarkowski, *Winogrand: Figments from the Real World* (New York: Museum of Modern Art, 1988), p. 18.

392 Arthur A. Goldsmith, Jr., "Garry Winogrand," *Photography* (October 1954): 60, 95. For other reproductions of his work of this period, see *Photography Annual 1954*, p. 66, and *Photography Annual 1955*, pp. 92-93, 108-09.

393 Winogrand's mood of this period is summarized in his 1963 Guggenheim application:

> I look at the pictures I have done up to now, and they make me feel that who we are and what we feel and what is to become of us just doesn't matter. Our aspirations and successes have been cheap and petty. I read the newspapers, the columnists, some books, I look at the magazines (our press). They all deal in illusions and fantasies. I can only conclude that we have lost ourselves, and that the bomb may finish the job permanently, and it just doesn't matter, we have not loved life.
>
> I cannot accept my conclusions, and so I must continue this photographic investigation further and deeper. This is my project.

Quoted in Szarkowski, *Winogrand: Figments from the Real World*, p. 34.

394 For good analyses of Winogrand's work, see Alex J. Sweetman, "The Death of the Author: Garry Winogrand, 1928-1984," *The Archive* 26 (Tucson: Center for Creative Photography, 1990), pp. 5-12; and Carl Chiarenza, "Standing on the Corner...Reflections Upon Winogrand's Photographic Gaze: Mirror of Self or World," Part I, *Image* 34:3-4 (Fall-Winter 1991): 17-51; and Part II, *Image* 35: 1-2 (Spring-Summer 1992): 25-45.

395 Biographical details of Friedlander's life and career are drawn largely from Rod Slemmons's "A Precise Search for the Elusive," in *Like a One-Eyed Cat: Photographs by Lee Friedlander 1956-1987* (New York: Harry N. Abrams/Seattle Art Museum, 1989), pp. 111-17; and Richard B. Woodward, "Lee Friedlander: American Monument," *ArtNews* (November 1989): 140-45.

396 Many of the Atlantic covers were designed by Marvin Israel.

397 See James Thrall Soby, "Lee Friedlander," *Art in America* (Summer 1960): 66-69.

398 Artist's statement of 1963 quoted in Slemmons, "A Precise Search for the Elusive," p. 111.

399 For a very early, and purely technical, approach to this subject, see "Robert Eichberg, "Photographing Television Images," in the April, May, and June 1942 issues of *American Photography*.

400 "The Little Screens," *Harper's Bazaar* (February 1963): 126-29. Several of these were also included in "Is TV Viewing an Addiction?" *Current* (April 1963): 32-36.

401 Green, *American Photography*, p. 106.

402 "The Vertical Journey," *Esquire* (July 1960): 102-07; and "The Full Circle," *Harper's Bazaar* (November 1961): 133-37. For a full discussion of Arbus's magazine work, see Thomas W. Southall, "The Magazine Years, 1960-1971," in Doon Arbus and Marvin Israel, eds., *Diane Arbus Magazine Work* (New York: Aperture/Spencer Museum of Art, 1984), pp. 152-71.

403 "Telling It as It Is," *Newsweek* (March 10, 1967): 110.

404 Anne W. Tucker, "Arbus Through the Looking Glass," *Afterimage* (March 1985): 9.

405 "Diane Arbus," *Creative Camera* (May 1974): 164.

406 Andy Grundberg, "Photography, Chicago, Moholy, and After," *Art in America* (September-October 1976): 35.

407 These photographers received master's degrees from the Institute of Design in the following years: Newman (1952), Metzker (1959), Josephson (1960),

408 Swedlund (1961), Jachna (1961), and Sterling (1962). Sinsabaugh, the oldest of this group, returned to receive his degree in 1967.

408 He became a Japanese citizen in 1969.

409 On Sinsabaugh's life and work, see Sherman Paul, "Images of a City: Art Sinsabaugh's Chicago Landscapes," *New Letters* 39:4 (Summer 1973): 38-59; and Ralph Gibson's interview with the artist in Carol DiGrappa, ed., *Landscape: Theory* (New York: Lustrum Press, 1980), pp. 130-41.

410 *Aperture* 9:2 (1961).

411 See also, "Ken Josephson's Experiments Make Classic Pictures," *Modern Photography* 25 (May 1961): 70-73.

412 Anne Wilkes Tucker, *Unknown Territory: Photographs by Ray K. Metzker* (Houston: Museum of Fine Arts/Aperture, 1984), p. 8.

413 Robert Heinecken, "Manipulative Photography," *Contemporary Photographer* 5:4 (1967): n.p. The author's manuscript notes that this text was originally presented as a lecture at an SPE meeting "in 1963 or 1964."

414 Information on this group is contained in Coke's short essay, "The Lexington Camera Club," *Exposure* 18:2 (1981): 4-5; and in Robert C. May, *The Lexington Camera Club 1936-1972* (Lexington: University of Kentucky Art Museum, 1989).

415 Barbara Tannenbaum, "Fiction as a Higher Truth: The Photography of Ralph Eugene Meatyard," in Tannenbaum, ed., *Ralph Eugene Meatyard: An American Visionary* (Akron: Akron Art Museum/Rizzoli, 1991), p. 40.

416 Ralph Eugene Meatyard, *The Family Album of Lucybelle Crater* (Millerton, N.Y.: Jargon Society, 1974).

417 Jerry N. Uelsmann, "Post-Visualization," *Contemporary Photographer* 5:4 (1967), n.p.; also cited in William E. Parker, "Uelsmann's Unitary Reality," *Aperture* 13:3 (1967): n.p.

418 Parker, "Uelsmann's Unitary Reality," and John L. Ward, *The Criticism of Photography as Art: The Photographs of Jerry Uelsmann* (Gainesville: University of Florida Press, 1970).

419 Quoted in Shelley Rice, "Duane Michals's 'Real Dreams,'" *Afterimage* 4 (December 1976): 6.

420 This is described in "Meet the Masters: Edmund Teske," *PhotoGraphic* (July 1985): 14.

421 Saxon's character in *War Hunt* was a homicidal psychopath. (Most memorably, perhaps, this movie marked Robert Redford's feature-film debut.) This photograph was shown by Teske at least as early as March 1963, in "Six Photographers 1963" at the University of Illinois.

422 As an indication of the scale of their respective communities in the early 1960s, *Aperture* had about 800 subscribers, *Image* about 2,000, and *Contemporary Photographer* about 1,200. *Popular Photography*, by contrast, had a monthly circulation of about 400,000. See Maria Antonella Pelizzari, "Nathan Lyons: An Interview," *History of Photography* (Summer 1997): 148; and "Editorial," *Contemporary Photographer* (Winter 1964): 1.

423 Eisinger, *Trace and Transformation*, pp. 125-27.

424 For Gee's own story, and a full chronology of her shows, see Helen Gee, *Limelight* (Albuquerque: University of New Mexico Press, 1997). Other sources include Barbara Lobron, "Limelight Lives!" *Photograph* 1:3 (1977): 1-3, 30; and Helen Gee, "Limelight: Remembering Gene Smith," *American Art* 5:4 (Fall 1991): 11-19.

425 For a full chronology, see "A Photographer's Gallery Schedule of Exhibitions," in *Roy DeCarava: A Retrospective*, pp. 269-70.

426 See Lee Lockwood, "Carl Siembab," *American Photographer* 3 (December 1979): 58-63; and Stephen Prokopoff and Carl Chiarenza, *A Photographic Patron: The Carl Siembab Gallery* (Boston: Institute of Contemporary Art, 1981).

427 After opening in March 1963, Kleber's gallery moved in the winter of 1971-72 to 134 Fifth Avenue, where it was paired with a photographer's supply shop. It closed in 1975. My thanks to Mr. Kleber for kindly providing this and related information.

428 See, for example, the following issues of *Contemporary Photographer*: (Summer 1963): n.p.; (Winter 1964): 75; (Spring 1964-65): 60, 63, 68.

429 Much of the following is drawn from the biographical outline included in Steichen, *A Life in Photography*, n.p.

430 For summaries of Szarkowski's career and his tenure at the Modern, see Maren Stange, "Photography and the Institution: Szarkowski at the Modern," in Jerome Liebling, ed., *Photography: Current Perspectives* (Boston: Massachusetts Review, 1978): 65-81; Christopher Phillips, "The Judgment Seat of Photography," *October*, no. 22 (Fall 1982): 27-63; Candida Finkel, "Photography as Modern Art: The Influence of Nathan Lyons and John Szarkowski on the Public's Acceptance of Photography as Fine Art," *Expo-*

sure 18:2 (1981): 22-37; Michael Kimmelman, "John Szarkowski," *Artnews* 83 (May 1984): 68-71; and Erla Zwingle, "John Szarkowski," *American Photographer* 19 (November 1987): 80-82, 84, 86.

[431] "Photographing Architecture," *Art in America*, no. 2 (1959): 84-89.

[432] The following is particularly indebted to an unpublished chronology of American photography, 1940-1965, compiled by Sheryl Conkelton.

[433] See Daniel, "Photography at the Metropolitan," pp. 110-16.

[434] The definitive study of this subject is Miles Barth, ed., *Master Photographs from "Photography in the Fine Arts" Exhibitions, 1959-1967* (New York: International Center of Photography, 1988).

[435] Miles Barth, "Ivan Dmitri and the History of PFA," in ibid., p. 16.

[436] Cited in Nathan Lyons, "PFA and Its Controversy," in ibid., p. 27. For a typically scathing review of this project, see "Photography's 'Hole in the Head,'" *U.S. Camera 1960*, pp. 131-34, 363.

[437] For background on the Art Institute's involvement with photography, see "Hugh Edwards: Aim for the Realistic Image," *Popular Photography* 57 (July 1965): 28; and David Travis, *Photography in Chicago Collections* (Chicago: Art Institute of Chicago, 1982).

[438] As Travis notes in *Photography in Chicago Collections*, p. 14, the Art Institute opened a dedicated photography gallery, just off its main lobby, on April 23, 1951; the first exhibition was of recent work by Harry Callahan.

[439] For profiles of Edwards, see "Hugh Edwards: Aim for the realistic image," pp. 28, 34, 126; his own "Some Experiences with Photography," *Contemporary Photographer* 4 (Fall 1963): 5-8; and Charles Leroux, "Hugh Edwards," *American Photographer* 2 (April 1979): 65-69.

[440] In 1958, for example, while a graduate student at Boston University, Carl Chiarenza organized the Image Study gallery. In the early 1960s, the art galleries of both the University of Minnesota and the University of New Hampshire actively exhibited photography. The photographic collection at the University of New Mexico Art Museum was begun in 1963 with the arrival of Van Deren Coke.

[441] "Two New Galleries," *Aperture* 2:4 (1964): 41.

[442] Phiz Mozesson, "The Bay Area Photographers," *Aperture* 4:2 (1954): 74-75.

[443] This traveling exhibition, featuring the work of seventeen leading Americans, was documented in a catalogue of the same name.

[444] See James Dozier, ed., *Light of Our Past: 1947-1974, Minnesota Photographic Heritage* (Minneapolis: Film in the Cities, 1983).

[445] See *Contemporary Photographer* (Summer 1963): n.p.; and (Fall 1963): 60-61; and *Photography Annual 1965*, p. 106.

[446] For transcriptions of the talks made at this session, see "SPE Past: Statements from the 1962 Invitational Teaching Conference," *Afterimage* 4 (February 1977): 6-14.

[447] The SPE's first officers were: Lyons (Assistant Director, George Eastman House), Henry Holmes Smith (Indiana University), Robert Forth (Maryland Institute), and Sol Mednick (Philadelphia Museum College of Art).

[448] This quest is reflected in many articles in *Aperture*; see, for example, issues 10:3 (1962) and 11:2 (1964).

[449] "Editorial," *Contemporary Photographer* (Summer 1963): n.p.

CHAPTER IV The Image Transformed 1965-Present

[1] "They Fight a Fire That Won't Go Out," *Life* (May 17, 1963): 26-36. See Michael S. Durham, *Powerful Days: The Civil Rights Photography of Charles Moore* (New York: Stewart, Tabori & Chang, 1991).

[2] This image has been published with various titles or descriptions, including: *Reaching Out (After Taking Hill 484, South Viet Nam)*, and *Jeremiah Purdie, Wounded, Is Led to Helicopter After Fighting South of DMZ*.

[3] Mark Johnstone, "The Photographs of Larry Burrows: Human Qualities in a Document," in David Featherstone, ed., *Observations: Essays on Documentary Photography* (Carmel, Calif.: Friends of Photography, 1984), p. 95. A good summary of Vietnam War photography is contained in Susan D. Moeller, *Shooting War: Photography and the American Experience of Combat* (New York: Basic Books, 1989), pp. 325-413.

[4] Larry Burrows, "Vietnam: A Degree of Disillusion," *Life* (September 19, 1969): 66-75.

[5] Interestingly, this image was not included in Burrows's original photoessay in *Life*. It was first published by the magazine five years later, in the February 26, 1971 issue. John Loengard notes:

When Larry Burrows shipped his story of a firefight near the DMZ in Vietnam to New York, unprocessed, this picture was not published. A different, vertical frame taken a few moments before was paired effectively with a second Burrows photograph also taken during the battle for Hill 484.

Coming to the United States to give some lectures, Burrows went through his outtakes and put this photograph of Marine Gunnery Sergeant Jeremiah Purdie in a carousel of slides to show his audiences.

When Burrows was reported missing over Laos in 1971, his lecture slides were found in a credenza in the picture department.

John Loengard, *Life Classic Photographs: A Personal Interpretation* (Boston: New York Graphic Society, 1988), p. 163.

[6] Adam D. Weinberg, *On the Line: The New Color Photojournalism* (Minneapolis: Walker Art Center, 1986), p. 38.

[7] As Julia Scully reported, the unstated theme of the 1973 national Conference on Visual Communications at the University of Miami was "Is there life after *Life*?" Among the ideas explored at this meeting were: the need for visual material for a new Time-Life cable TV enterprise; the video cassette market; the increasing use of photographs by newspapers; and the possibilities of self-publishing. Julia Scully, "Seeing Pictures," *Modern Photograph* 37 (September 1973): 30, 66.

[8] See Marianne Fulton, *Eyes of Time: Photojournalism in America* (Boston: New York Graphic Society, 1988), pp. 231-33.

[9] *Afterimage* 6 (Summer 1978): 5.

[10] *Geo* was first launched in Germany in 1976; it debuted in the U.S. in 1979.

[11] Much of this data is drawn from Thomas Dickey, "Comeback of the Magazines," *Photography Year 1979* (New York: Time-Life Books, 1978): 26-37.

[12] Malle's *Pretty Baby* was loosely based on the work of New Orleans photographer E. J. Bellocq.

[13] Both were written by critic Douglas Davis.

[14] See, for example, "Think Positive: Photographs Have Emerged as a Promising New Speculation," *Barron's* (July 12, 1976): 11, 18-19; and "Investors in the Camera Masterpieces," *Fortune* (June 1976): 136-43.

[15] These figures are for "Major" fellowships; there was also a category for "Emerging" artists. For background on this program, see Kathleen McCarthy Gauss, "NEA's Fellowship Program: A Report," *Afterimage* 5 (March 1978): 4-5; Merry Amanda Foresta, *Exposed and Developed: Photography Sponsored by the National Endowment for the Arts* (Washington, D.C.: National Museum of American Art, 1984), esp. pp. 6-7; and Marguerite Welch, "The Best Years of Our Lives: Photography and the NEA," *Afterimage* 12 (February 1985): 3, 21.

[16] Gauss, "NEA's Fellowship Program," p. 4.

[17] "Anyone for College Photo Courses?" *Modern Photography* 30 (December 1966): 76, 78, 136, 144. For a similar survey two years later, see *Modern Photography* 33 (January 1969): 68-76. The major sources for data on photographic education in these years are the annual surveys compiled by Dr. C. William Horrell of Southern Illinois University, with funding from the Eastman Kodak Company.

[18] Julia Scully, "Campus Photo Boom!" *Modern Photography* 34 (September 1970): 54

[19] See "Graduates of the I.D.," in Charles Traub, ed., *The New Vision: Forty Years of Photography at the Institute of Design* (Millerton, N.Y.: Aperture, 1981), pp. 74-75.

[20] Gail Kaplan, "Teaching: Surveys of Schools with MFA/MA Programs in Photography," *Exposure* 20:3 (1982): 11-29.

[21] Dr. C. William Horrell, "Photography Instruction in Higher Education" (1964), offprint from *Infinity* magazine, Table II, n.p. Table III of this survey notes that 130 institutions offered courses in photojournalism, while 58 offered courses in the medium as art.

[22] "Photography Boom or Bust?" *Photography Year 1974* (New York: Time-Life Books, 1973), p. 155.

[23] Scully, "Campus Photo Boom!"

[24] "Photography Boom or Bust?" p. 156.

[25] In 1991 Michael Starenko reported that "of the approximately 140 visual arts M.F.A. programs now in existence, over 70 percent were founded in the '60s and early '70s." Starenko, "Glass Houses—The Academicization of Activism," *New Art Examiner* (February 1991): 32.

[26] See, for example, W. G. Gaskins, "Photography and Photographic Education in the USA," *Image* 14 (December 1971): 8-13.

[27] Jonathan Green, *American Photography: A Critical History 1945 to the Present* (New York: Harry N. Abrams, 1984), p. 145.

28 Jacob Deschin, "The Workshop Circuit," *Photography Annual 1974*, pp. 6, 10. In its entirety (pp. 6, 10, 12, 14, 16, 18-25, 165-68, 170-73), this article provides a good overview of the subject. For a slightly later summary, see "Summer Workshops in Photography, Film and Video," *Afterimage* 2(April 1975): 2-5.

29 Deschin, "The Workshop Circuit," p. 6.

30 Lee D. Witkin, *A Ten Year Salute: A Selection of Photographs in Celebration of the Witkin Gallery, 1969-1979* (Danbury, N.H.: Addison House, 1979), p. 10. In addition to Witkin's own reminiscence, this volume chronicles the gallery's first ten years of exhibitions. Numerous articles were written on Witkin's gallery in these early years; see, for example, Jacob Deschin, "Add New York Galleries: Best Yet," *Popular Photography* 33(October 1969): 38, 127-28.

31 These were begun in the magazine's issue of January 1969.

32 "Picture Gallery Snooping with Modern," *Modern Photography* 33(January 1969): 82-86. These columns, henceforth titled "Gallery Snooping," provide a good overview of the network of galleries and museums across the nation that exhibited photography in this era.

33 The following information is drawn largely from John Durniak, "The Double Exhibition Explosion," *Photography Annual 1970*, pp. 7-8.

34 The program was directed by Hallmark executive David Strout, who had a background in photography and academics, and who had known Harry Callahan since the late 1940s.

35 Van Deren Coke, untitled editorial, *Image* 14(March 1971): 1.

36 For contemporary perspectives on the burgeoning gallery scene at this time, see articles such as Jane Dreyfuss, "The Business of Collecting," *Modern Photography Annual 1971*, pp. 11-12, 14, 16, 18; and Jacob Deschin, "Print Collecting: Beauty & the Buck," *Photography Annual 1972*, pp. 6-8, 10, 14, 18, 20, 22, 25-26.

37 Lunn Gallery opened in October 1968 in a small space on Capitol Hill exhibiting fine prints from the late nineteenth and twentieth centuries. The gallery moved in 1969 to an address in Georgetown. The second photographic exhibit featured the work of Man Ray. I am grateful to the late Harry Lunn for this information.

38 Rinhart began selling photographs on a part-time basis in 1969. He operated a public gallery in New York ca. 1976-77. For a short profile, see Jacob Deschin, "Viewpoint," *Popular Photography* 38(February 1974): 34, 132.

39 See, for example, Natalie Rosenheck, "Room at the Top," *Popular Photography* 36(March 1972): 106, 109-10.

40 For background on the gallery and its exhibition schedule between November 1971 and December 1979, see *Light* (New York: Light Gallery, 1981).

41 "Photography," *Newsweek* (October 21, 1974): 65. In addition, see Judith Kalina, "Show and Sell in the Big Apple," *Camera 35* 17(November 1973): 46-49, 81-82, 84.

42 A history of this gallery and a list of its exhibitions is provided in Richard Lorenz and Judith Dunham, *Focus: Photographs from the Collection of Helen Johnston* (Santa Clara, Calif.: de Saisset Museum, 1989).

43 The photographic press of this era carried regular listings of galleries nationwide. In addition, see such articles as Alice Williams, "Galleries Where YOU Can Exhibit," *Camera 35* 21(June 1977): 33-35, 61-62; and Carol Schwalberg, "The Gallery Scene in Lotusland," *Camera 35* 25(October 1980): 46-51.

44 The symposium "Collecting the Photograph," presented on September 20, 1975, was organized by *Art in America*. The speakers included: John Szarkowski, Nathan Lyons, Peter C. Bunnell, Weston Naef, John Bullard, Harry Lunn, and Sam Wagstaff. For one perspective on its success, see A. D. Coleman, "Where's the Money?" *Camera 35* 19(January 1976): 29. The symposium, "Photographic Collecting, Past and Present," was held at the George Eastman House on October 12-14, 1978. There, the speakers included Beaumont Newhall, Van Deren Coke, Arnold Crane, Gerard Levy, Harry Lunn, Sam Wagstaff, and George Rinhart. Unhappy with their treatment at this affair, photography dealers began the process of organization that led to the formation of AIPAD in 1979. For a lively summary of this gathering, see Mark Haworth-Booth, "Wheeling and Dealing in Rochester," *Aperture*, no. 82 (1979): 2-7.

45 Innumerable articles on this subject can be found in the literature of the period. The earlier ones include Peter C. Bunnell, "Photographs for Collectors," *Art in America* (January-February 1968): 70-75; Jane Dreyfuss, "The Business of Collecting," *Modern Photography Annual '71*, pp. 11-12, 14, 16, 18; and Pearl Korn, "Collecting for Fun and Profit," *Camera 35* 15(December 1971): 52-62. Rising prices were the subject of regular articles; for example, see Peter Pollack, "Photo-Print Prices: Onward and Upward," *Popular Photography* 39(October 1975): 57-59, 110-11, 125. With regard to general

notions of connoisseurship, see A. D. Coleman's articles of 1980 discussing original prints, vintage prints, and limited editions: "Collecting Photographs, Part III," *Camera 35* 25(May 1980): 16, 18; "Collecting Photographs, Part IV," *Camera 35* 25(June 1980): 18-19, 76; and "Collecting Photographs, Part V," *Camera 35* 25(July 1980): 28, 70-71.

46 Others of this genre include William Welling, *Collector's Guide to Nineteenth-Century Photographs* (New York: Collier Books, 1976); Landt and Lisl Dennis, *Collecting Photographs: A Guide to the New Art Form* (New York: E. P. Dutton, 1977); Richard Blodgett, *Photographs: A Collector's Guide* (New York: Ballantine Books, 1979); and George Gilbert, *Photography: The Early Years, A Historical Guide for Collectors* (New York: Harper & Row, 1980).

47 Lee D. Witkin and Barbara London, *The Photograph Collector's Guide* (Boston: New York Graphic Society, 1979), pp. 398-400.

48 "Photo Auction," *U.S. Camera* 15(May 1952): 56-57.

49 For a history of this market from Sotheby's point of view, see the special section "Twenty Years of Photographs at Sotheby's," by Beth Gates-Warren, in the April 7-8, 1995 sales catalogue, n.p.

50 Casey Allen, "Bruehl," *Camera 35* 23(October 1978): 77.

51 Melissa Shook, "Callahan Interviewed," *Photograph* 1(July 1977): 1.

52 Hal Fischer, "The New Commercialism," *Camera Arts* (January-February 1981): 9. See also Carol Squiers, "Photography: Tradition and Decline," *Aperture*, no. 91 (Summer 1983): 72-76.

53 Numerous articles on this "deflation" in the market were written at the time. See, for example, David Trend's "Take the Money and Run, or, Life After the Photo Boom," *Afterimage* 10(March 1983): 2-3.

54 See "Circuit Overload at Light," *Afterimage* 9(October 1981): 3, 21.

55 For one of many articles on this episode, see David Trend, "Trouble in the Archives: The Eastman House Struggles to Define Itself," *Afterimage* 12(October 1984): 6-7, 19.

56 The overall strength of the art auction market was the subject of a *Time* cover story (November 27, 1989), written by Robert Hughes.

57 These prints were, respectively, Charles Sheeler's *Wheels*, 1939 ($67,100), Edward Weston's *Nautilus Shell*, 1927 ($115,000), and Tina Modotti's *Roses, Mexico*, 1925 ($165,000). In the private gallery market, an important benchmark came in 1985, when a vintage print of Paul Strand's *Wall Street* (1915) was sold for $170,000.

58 Quoted in John Durniak, "The Deschin Contribution," *Infinity* 18(October 1969): 6.

59 A. D. Coleman, "Because It Feels So Good When I Stop," *Camera 35* (October 1975): 64. In addition to this article (pp. 26-29, 64), see Norman Schreiber, "Who Is A. D. Coleman and Why Is He Saying All Those Things?" *Camera 35* (March 1972): 28-30, 72-73; and A. D. Coleman, *Light Readings: A Photography Critic's Writings 1968-1978* (New York: Oxford University Press, 1979).

60 For a summary of Coleman's themes and influence, see Joel Eisinger, *Trace and Transformation* (Albuquerque: University of New Mexico Press, 1995), pp. 248-58.

61 A. D. Coleman, "Two Conferences on Photographic Criticism: A Report and a Proposal," *Afterimage* 4(November 1976): 8.

62 For reports on the first two of these, see ibid.; "A Report on the Second Conference on Photographic Criticism," *Afterimage* 5(May-June 1977): 26-44; and A. D. Coleman, "The Second Conference on Photographic Criticism: Summing Up," *Afterimage* 5(September 1977): 4-5.

63 For a report on this session, see Catherine Lord, "In New Haven, art meets sociology," *Afterimage* 7(December 1979): 3.

64 Mann, for example, had studied philosophy and art history before turning to photography as an artist, historian, and critic. For an extended discussion of her career and ideas, see Eisinger, *Trace and Transformation*, pp. 201-09. Thornton was trained as a painter and wrote on art for *Time* before turning to photography criticism for the *New York Times* and *Artnews*. Rice, who was trained as an art historian, wrote for the *Village Voice* and other journals. Lifson received an M.A. in English literature before becoming a photographer; he wrote gracefully on the medium for the *Village Voice* from 1977 to 1982. Andy Grundberg also earned a degree in English before joining *Modern Photography* in the early 1970s. Davis and Kozloff both came to photography from the art world. Davis was the art critic for *Newsweek*, while Kozloff was an editor of *Artforum* and the author of books on Jasper Johns and other topics in modern art. Several collections of Kozloff's photography essays have been published, including *Photography & Fascination* (Danbury, N.H.: Addison House, 1979). Goldberg, a teacher and writer, was trained in

art history. Hagen studied photography at the Visual Studies Workshop and edited the journal *Afterimage* in its initial years.

[65] The latter were collected in Janet Malcolm, *Diana & Nikon* (Boston: David R. Godine, 1980).

[66] For details (including circulation figures) on these and other publications of the period, see *Printletter* (March-April 1978): 5. The dates for these are as follows: *Camera* was published 1922-81; *Creative Camera* was formed in 1968 from *Camera Owner*; *Zoom* was begun in 1970; *Printletter* began publication in 1976; *Photo Communiqué* ran from 1979 to 1988. My thanks to the staff of the Library, George Eastman House, for assistance on these details. For a recent tribute to *Camera* magazine, see Walter Binder, *Die Photozeitschrift CAMERA 1922-1981* (Zurich: Kunsthaus Zurich, 1991).

[67] *Untitled* ran from 1972 to 1994; it was continued by *See* in 1994.

[68] *Photo World* (1973-76) was transformed into *Penthouse Photo World* in 1976. *Camera Arts* was merged into *American Photographer* in 1983. The latter, in turn, was continued by *American Photo* in 1990.

[69] *Print Collector's Newsletter* was begun in 1970; in 1996 it was continued by *On Paper*. *Artweek* was begun in 1970, while *Picturescope* ran from 1953 to 1987.

[70] *Spot* was begun as *Image* in 1983 and was changed to its present title in 1984. *Views* was published from 1979 to 1994. Other notable publications of this type include the Catskill Center for Photography's *Center Quarterly*; *CEPA Quarterly*, produced by CEPA Gallery in Buffalo; *Photo Review*, an independent venture based in Langhorne, Pennsylvania; *SF Camerawork*, produced by the nonprofit artists' space San Francisco Camerawork; and *Photographic INSight*, produced by the Bristol (Rhode Island) Workshops in Photography.

[71] Nathan Lyons, "PFA and Its Controversy," in Miles Barth, ed., *Master Photographs from "Photography in the Fine Arts" Exhibitions, 1959-1967* (New York: International Center of Photography, 1988), p. 28.

[72] For a survey of some of the most notable inexpensive photography books and catalogues of the period, see Van Deren Coke's articles "Bibliography of Budget Picture Books," *Modern Photography* 33(December 1969): 48-49, 136-38, 146, 148, 158, 178; "More Photo Books for Less," *Modern Photography* 35(December 1971): 176-79; and "More More Photo Books for Less," *Modern Photography* 36(June 1972): 90-91. Beginning in 1970, Doubleday & Co. issued a series of portfolios, each containing eight photogravure reproductions and priced at $6.95. These featured the work of Jerry Uelsmann (1970), Leslie Krims (1970), Arthur Freed (1971), and Edward Weston (1971).

[73] Margery Mann, "Making Books," *Camera 35* 17(May 1973): 22, 68.

[74] For an early profile of Gibson, see Julia Scully, "Seeing Pictures," *Modern Photography* 36(January 1972): 12, 14.

[75] The latter included *Darkroom* (1977), *Darkroom 2* (1978), *Nude: Theory* (1979), and *Landscape: Theory* (1980). For an interview with Gibson and a checklist of all Lustrum Press books (with details on press run and bindings), see "History of Lustrum Press," in *Books on Photography II* (East Hampton, N.Y.: Glenn Horowitz Bookseller, 1997), pp. 45-57.

[76] The proceedings were published in Eugenia Parry Janis and Wendy MacNeil, eds., *Photography within the Humanities* (Danbury, N.H.: Addison House, 1977).

[77] For example, see Marie Czach, "CAA in LA: Photography and/as/or Art," *Afterimage* 4(April 1977): 4.

[78] *Artscanada* (December 1974); *Artforum* (September 1976); *Massachusetts Review* (1978), later issued in book form as Jerome Liebling, ed., *Photography: Current Perspectives* (Rochester: Light Impressions, 1978); *Kansas Quarterly* (Fall 1979); *Art Journal* (Spring 1981); and *Journal of American Culture* (Spring 1981).

[79] These were published, respectively, by the Society for the Anthropology of Visual Communication, the University of Chicago, the University of California–Berkeley, and the Institute of Architecture and Urban Studies at MIT.

[80] Robert F. McCullough, "Arnold Crane: 'Photographic Materials Collector' Extraordinary," *Popular Photography* 34(April 1970): 97. For another of the numerous profiles written of Crane, see Lauren Shakely, "Passion for Genius," *Aperture*, no. 90 (1983): 48-59.

[81] *A Book of Photographs from the Collection of Sam Wagstaff* (New York: Gray Press, 1978).

[82] For profiles of Wagstaff, and indications of his enthusiasms, see Vicki Goldberg, "A Passionate Collector," *Photograph* 1(Summer 1976): 8; "Developing a Visual Taste," *Horizon* (February 1978): 28-33; Owen Edwards, "The Collector Who Would Be King," *American Photographer* 1(September 1978): 20-27; Samuel Wagstaff, "Observing the Mechanical Eye," *Artnews* 79(April

1980): 68-73; "The Wagstaff 10," *American Photographer* 16(May 1986): 62-69; Nancy Versaci et al., *Hanging Out: Stereographic Prints from the Collection of Samuel Wagstaff, Jr. at the J. Paul Getty Museum* (Providence, R.I.: List Art Center, Brown University, 1984); and Weston Naef's exhibition brochure, *The Eye of Sam Wagstaff* (Malibu, Calif.: Getty Museum, 1997).

[83] Dennis and Dennis, *Collecting Photographs*, p. 43.

[84] Goldberg, "A Passionate Collector."

[85] Dennis and Dennis, *Collecting Photographs*, p. 61.

[86] The Exchange National Bank Collection is documented in *Aperture* 14:2 (Fall 1969).

[87] In the 1950s, Polaroid collected prints by the leading photographers of the 1920s to 1950s (Weston, Cunningham, etc.), under the direction of Dr. Edwin H. Land and Ansel Adams, who served as a consultant to the firm. The Polaroid collection is highlighted in publications such as Belinda Rathbone, ed., *One of a Kind: Recent Polaroid Color Photography* (Boston: David R. Godine, 1979); and Constance Sullivan, ed., *Legacy of Light* (New York: Alfred A. Knopf, 1987). See also, Peter Barr, "Polaroid: Fifty Years of Funding Art Photography," *Art New England* (April-May 1997): 32-33, 55.

[88] "Polaroid to open studio for 20 x 24 camera," *Afterimage* 6(April 1979): 3.

[89] This was begun with the assistance of the Museum of Modern Art's Advisory Service, directed by assistant curator Pierre Apraxine. See *Afterimage* 1(December 1973): 13.

[90] Richard Pare, ed., *Court House: A Photographic Document* (New York: Horizon Press, 1978). Two dozen leading contemporary photographers participated in this project.

[91] See, for example, David Harris and Eric Sandweiss, *Eadweard Muybridge and the Photographic Panorama of San Francisco, 1850-1880* (Montreal: Canadian Centre for Architecture, 1993).

[92] Pierre Apraxine, *Photographs from the Collection of the Gilman Paper Company* (New York: White Oak Press, 1985). The plates were laboriously hand-printed by Richard Benson.

[93] Maria Morris Hambourg et al., *The Waking Dream: Photography's First Century, Selections from the Gilman Paper Company Collection* (New York: Metropolitan Museum of Art, 1993).

[94] Lyons has discussed this period in several interviews. See, for example, Maria Antonella Pelizzari, "Nathan Lyons: An Interview," *History of Photography* 21(Summer 1997): 147-55.

[95] For a short article on these shows, see "Exhibit Chairmen!!" *Modern Photography* (April 1967): 122.

[96] *Image* 14:1 (January 1971): 17.

[97] These exact figures—131,902 and 1,999,200—are given in Candida Finkel, "Photography as Modern Art: The Influence of Nathan Lyons and John Szarkowski on the Public's Acceptance of Photography as Fine Art," *Exposure* 18:2 (1981): 28.

[98] For a precise summary of this period, see Malcolm Daniel, "Photography at the Metropolitan Museum: William M. Ivins and A. Hyatt Mayor," *History of Photography* 21(Summer 1997): 115-16.

[99] For a critical appraisal of the Metropolitan's program in this period, see A. D. Coleman, "Inside the Museum, Infinity Goes Up on Trial," *New York Times* (May 10, 1970); repr. in Coleman, *Light Readings*, pp. 31-35.

[100] Co-sponsored with the Museum of Modern Art, this series featured talks by John Szarkowski, Clement Greenberg, John A. Kouwenhoven, and Ansel Adams. See Judith Kalina, "Listenin' at the Met," *Camera 35* 17(May 1973): 27.

[101] The first of these was documented in Weston J. Naef and James N. Wood, *Era of Exploration: The Rise of Landscape Photography in the American West, 1860-1885* (Buffalo: Albright Knox Art Gallery/New York: Metropolitan Museum of Art, 1975).

[102] Numerous articles on Szarkowski, or interviews with him, have been published. These include: Jacob Deschin, "John Szarkowski: Photography as Interpreter," *Popular Photography* 61(September 1967): 18, 22; Maren Stange, "Photography and the Institution: Szarkowski at the Modern," in Liebling, ed., *Photography: Current Perspectives*, pp. 65-81; Candida Finkel, "Photography as Modern Art," *Exposure* 18:2 (1981); Christopher Phillips, "The Judgment Seat of Photography," *October*, no. 22 (Fall 1982): 27-63; Michael Kimmelman, "John Szarkowski," *Artnews* (May 1984): 68-71; Virginia Dell, "John Szarkowski's Guide," *Afterimage* 12(October 1984): 8-11; Andy Grundberg, "An Interview with John Szarkowski," *Afterimage* 12(October 1984): 12-13; Erla Zwingle, "John Szarkowski," *American Photographer* (November 1987): 80-86; and Hilton Als, "Looking at Pictures: John Szarkowski," *Grand Street*, no. 59 (Winter

1997): 102-21. In addition, of course, Szarkowski's shows and books have generated a vast body of critical commentary.

[103] For example, see Peter C. Bunnell, "Photographs as Sculpture and Prints," *Art in America* (September-October 1969): 56-61.

[104] John Szarkowski, *The Photographer's Eye* (New York: Museum of Modern Art, 1966), n.p.

[105] On contemporary definitions of photography's formal uniqueness see, for example, Howard Dearstyne, "The Photographer's Eye," *College Art Journal* (Spring 1955): 245-49; Bruce Downes, "Photography: A Definition," *Photography Annual 1962*, pp. 8-12; and Hans Finsler, "The Picture of Photography: The Development of Photographic Vision," *Photography Annual 1965*, pp. 14-16, 21-24.

[106] Green, *American Photography*, p. 99.

[107] John Szarkowski, "New Documents" exhibition wall text, Museum of Modern Art, 1967; cited in Martha Rosler, "In, around, and afterthoughts (on documentary photography)," in Richard Bolton, ed., *The Contest of Meaning: Critical Histories of Photography* (Cambridge, Mass.: MIT Press, 1989), p. 321.

[108] *Popular Photography* 53(July 1963): 61.

[109] In addition, of course, Szarkowski's championing of the work of Jacques Henri Lartigue (1963) and E. J. Bellocq (1970) had everything to do with contemporary artistic values. See Lee Friedlander and John Szarkowski, *E. J. Bellocq: Storyville Portraits* (New York: Museum of Modern Art, 1970). On the idea of photographs as found objects, see Mike Mandel and Larry Sultan, *Evidence* (Greenbrae, Calif.: Clatworthy Colorvues, 1977).

[110] John Szarkowski, "A Different Kind of Art," *New York Times Magazine* (April 13, 1975): 16-19, 64-68.

[111] See Shelley Rice, "The Whitney Treatment," *Afterimage* 4(March 1977): 12.

[112] This was one of the first collections to be documented in a catalogue. See Norman A. Geske, *Photographs: Sheldon Memorial Art Gallery Collections* (Lincoln: University of Nebraska Press, 1977).

[113] However, the permanent collection remained undeveloped until the mid-1970s. For an overview of this collection, see Carroll T. Hartwell, *The Making of a Collection: Photographs from the Minneapolis Institute of Arts* (Millerton, N.Y.: Aperture, 1984).

[114] E. John Bullard and Tina Freeman, *Diverse Images: Photographs from the New Orleans Museum of Art* (Garden City, N.Y.: Amphoto, 1979).

[115] Kristin L. Spangenberg, *Photographic Treasures from the Cincinnati Art Museum* (Cincinnati: Cincinnati Art Museum, 1989).

[116] For background on this program, see *Bulletin of the Museum of Fine Arts, Houston* 11(Winter-Spring 1988).

[117] See Brooks Johnson, *A History of Photography: 15 Years at the Chrysler Museum* (Norfolk, Va.: Chrysler Museum, 1993).

[118] For a characteristic contemporary report, see Lisbet Nilson, "Moving West," *American Photographer* 14(January 1985): 56-63.

[119] Weston Naef, *The J. Paul Getty Museum Handbook of the Photographs Collection* (Malibu, Calif.: Getty Museum, 1995), pp. ix-xiii.

[120] On the group's founding, see, for example, Peter Stackpole, "35mm Techniques," *U.S. Camera* 30(October 1967): 28-29, 92. For a summary of the group's first twenty years, see James G. Alinder, ed., *Light Years: The Friends of Photography, 1967-1987* (Carmel, Calif.: Friends of Photography, 1987).

[121] Data on the museum's history and holdings is contained in *Guide to the Collections: CMP Bulletin* 9:1-2 (1989). For a brief summary of the museum's history and personnel, see Cynthia Morrill, "Twenty-five Years of Seeing and Being Seen," *Foto Text* [California Museum of Photography Quarterly] (Summer 1998): 1-3.

[122] The following is drawn from numerous period sources, including Rus Arnold, "Cornell Capa," *Camera 35* 16(April 1972): 54-56, 60-63; Barbaralee Diamonstein, "Writing with Light," *Artnews* 73(September 1974): 97; Norman Rothschild, "Offbeat," *Popular Photography* 38(October 1974): 16, 22; "Being Present," *New Yorker* (January 13, 1975): 26-29; Michael Edelson, "The International Center of Photography," *Camera 35* 19(April 1975): 40-43, 45-46, 60-61; Michael Edelson, "The House on 94th Street," *Camera 35* 22(March 1978): 28-33, 72; Richard Whelan, "Cornell Capa's 'Lighthouse of Photography,'" *Artnews* 78(April 1979): 70-74; and Norman Schreiber, "The Concerns of Cornell Capa," *Camera Arts* (November-December 1980): 28, 30, 34-35, 125-27.

[123] Schreiber, "The Concerns of Cornell Capa," p. 28.

[124] Terence R. Pitts, "Center for Creative Photography," *Picturescope* 29(Winter 1981): 133.

[125] A detailed chronology of Light Work's programs since its founding in 1973 is given in its journal, *Contact Sheet*, no. 97 (1998).

[126] The dates given here are open to some interpretation. For example, Film in the Cities was begun in 1970 as an arts program for secondary school students; its photography component was initiated in 1971 and the gallery itself opened in 1977. San Francisco Camerawork was founded in 1974 as a commercial gallery in Fairfax, California; it moved to San Francisco to assume its present incarnation in 1975. LACPS was begun in the fall of 1974, but only moved into a permanent space in 1981. The Houston Center for Photography was founded in 1981; its first gallery was opened the following year. The Center for Photographic Arts in Chicago was created by Mickey Pallas; see Michael Edelson, "Showplace," *Camera 35* 18(August-September 1974): 6, 13.

[127] This was begun in 1972 as the Center for the Photographic Arts, a "museum without walls."

[128] This exhibition, curated by intern William Burbank, was composed of individual images printed on super-8 motion picture stock to create a fourteen-minute film of one-second stills.

[129] See Coleman, *Light Readings*, pp. 36-39.

[130] On the subject of autofocus, for example, see Bennett Sherman, "Techniques Tomorrow," *Modern Photography* 35(September 1971): 32, 112, 128; and "Konica Announces Auto-Focus Camera," *Camera 35* (December 1977): 18.

[131] See David B. Eisendrath, Jr., "After 35mm, What?" *Popular Photography* 51(July 1962): 35-37, 119-20, 122; and Bennett Sherman, "Techniques Tomorrow," *Modern Photography* 26(May 1962): 12-13.

[132] See, for example, "Phototronics," *Modern Photography* 38(January 1974): 36, 44; and "New Video Hardware," *Afterimage* 2(March 1975): 4-5.

[133] Such thoughts were entertained at least as early as 1962; see Eisendrath, "After 35mm, What?" and Sherman, "Techniques Tomorrow."

[134] For example, see Daniel J. Czitrom, *Media and the American Mind: From Morse to McLuhan* (Chapel Hill: University of North Carolina Press, 1982), pp. 165-82.

[135] This extended to McLuhan's style of writing. As one critic of the time noted:

> McLuhan's range is enormous; no field, no era is left untouched. He moves with superb confidence from physics to anthropology to history to literature at breathtaking speed. His method consists of what he calls a mosaic or field approach, which means in practice that a book of his is a collection of short chapters, each chapter full of "probes," which can be read or skimmed in any order whatsoever.... His style...is often mystifying. His writing gives the impression of great speed, even great haste of mind. It almost never pauses, or reflects; it is indeed a sort of electronic prose, pouring itself forth without hesitation and often without logic much as images pour forth from the television. His style is not based on the normal practices of clarity, assembly of evidence, and plain prose exposition; it is based instead on the cinematic principles of presentation and juxtaposition.

Robert D. Richardson, Jr., "McLuhan, Emerson and Henry Adams," *Western Humanities Review* 22(Summer 1968): 236.

[136] Marshall McLuhan, *Understanding Media: The Extensions of Man* (1964; repr. Cambridge, Mass.: MIT Press, 1994), pp. 49, 55.

[137] Lewis Lapham, "Introduction to the MIT Press Edition: The Eternal Now," in ibid., p. xiii.

[138] John Szarkowski has touched on this trend in his *Photography Until Now* (New York: Museum of Modern Art, 1989), pp. 272, 275.

[139] Much was written on this exhibition. For an example of the response by the mainstream photographic press, see Jane Dreyfuss, "Harlem: Sold Out by Massa Hoving???" *Modern Photography* 33(May 1969): 64-65, 98.

[140] Coleman, "Christmas Gift: 'Harlem on My Mind,'" in *Light Readings*, pp. 9-12. A positive outcome of the Harlem show was the rediscovery of eighty-three-year-old James Van Der Zee; a book on his career was published later in 1969, and he was honored with numerous individual shows in the following years.

[141] Coleman, "Bruce Davidson: *East 100th Street*," in *Light Readings*, pp. 45-48. See also, Coleman's "Roy DeCarava: 'Thru Black Eyes,'" in *Light Readings*, pp. 18-28. For a similar point of view on both Davidson and DeCarava, see Lou Stettner, "Speaking Out," *Camera 35* 16(March 1972): 18, 71.

[142] See Coleman, "Judy Dater," in *Light Readings*, pp. 106-07.

[143] Effectively, she notes that Beaumont Newhall's standard text, *The History of Photography*, mentions only ten women photographers by name. Tucker, *The Woman's Eye* (New York: Knopf, 1973), pp. 9-10.

[144] Ibid., p. 1.

[145] Lisa Kernan, in "Praise and Questions for *The Woman's Eye*," *Afterimage* 2(March 1974): 9. In addition, see slightly later articles such as Shelly Rice, "Feminism and Photography: Trouble in Paradise," *Afterimage* 6(March 1979): 5-7.

[146] More than twenty years later, Tucker recalled that *The Woman's Eye* "was widely reviewed and sold over 30,000 copies. Those knowledgeable about

photography tended to dismiss it; general book reviewers and women's publications praised it highly." Anne Wilkes Tucker, "Foreword," in Diane Neumaier, ed., *Reframings: New American Feminist Photographies* (Philadelphia: Temple University Press, 1995), p. x.

[147] See, for example, Margery Mann, "Women of Photography," *Camera 35* (August-September 1975): 36-42.

[148] William E. Parker, "Uelsmann's Unitary Reality," *Aperture* 13:3 (Summer 1970): n.p. See also John L. Ward, *The Criticism of Photography as Art: The Photographs of Jerry Uelsmann* (Gainesville: University of Florida Press, 1970).

[149] From a quote by Mircea Eliade, included by White in *Aperture* 16:1 (1971).

[150] Indeed, this two-part piece was so scathing that Coleman's editor at the *Village Voice* refused to print the second installment. This led to Coleman's resignation from the paper. The entire text, with a response by White, ran in *Camera 35* (November 1973): 32-40, 45, 76, 78. Coleman's text is also included in his *Light Readings*, pp. 140-50.

[151] John Szarkowski, *William Eggleston's Guide* (New York: Museum of Modern Art, 1976), p. 13.

[152] See Peter Galassi, "Rudolf Arnheim: An Interview," *Afterimage* 2(November 1974): 2-5; and Arnheim's "Symposium on the Nature of Photography," *Afterimage* 2(April 1975): 10-12. The latter reprints Arnheim's essay "On the Nature of Photography," from *Critical Inquiry* 1(September 1974).

[153] This book was widely reviewed, with the photographic field itself expressing considerable skepticism. For a sampling of these responses, see Sanford Schwartz, "On Photography," *Art in America* (November-December 1977): 31-32; William H. Gass, "A Different Kind of Art," *New York Times Book Review* (December 18, 1977): 7, 30-31; Michael Lesy, "An Unacknowledged Autobiography," *Afterimage* 5(January 1978): 5; Suzanne Boorsch, "On Photography. By Susan Sontag," *Print Collector's Newsletter* (March-April 1978): 23-25; Estelle Jussim, "On Photomorality," *History of Photography* 2(April 1978): 182-84; David L. Jacobs, "Sontag re-viewed," *Afterimage* 6(Summer 1978): 37; John McCole, "Walter Benjamin, Susan Sontag, and the Radical Critique of Photography," *Afterimage* 7(Summer 1979): 12-14; and Michael Starenko, "Benjamin, Sontag," *Exposure* 17:4 (1980): 20-31. For a recent perspective on this book, see "Sontag's On Photography at 20," *Afterimage* 25(March-April 1998): 6-7.

[154] Indeed, it received the 1977 National Book Critic's Circle Award.

[155] Susan Sontag, *On Photography* (New York: Farrar, Straus & Giroux, 1977), pp. 3, 10, 14, 15.

[156] *On Photography* also has a somewhat airless and old-fashioned quality. As Sanford Schwartz observed in his review of the book in *Art in America*:

> With its semi-polemical, semi-introspective manner, her book has the weight of an 18th-century essay which speculates on the nature of a certain kind of education or science, and tries to pin down its qualities.

"*On Photography*," p. 31.

[157] Sontag, *On Photography*, pp. 23-24.

[158] Boorsch, "On Photography. By Susan Sontag," p. 25.

[159] Charles Simmons, "Sontag Talking," *New York Times Book Review* (December 18, 1977): 31.

[160] *Artforum* 15(September 1976): 55-61. This is reprinted, in slightly variant form, in *Light Readings*, pp. 246-57.

[161] For example, see Ed Scully, "Pictorialism: Bodine and Mortensen," *Modern Photography* 35(January 1971): 94-99. Sommer's work was highlighted in *Aperture* 10:4 (1962), and in the 1968 catalogue *Frederick Sommer* (Philadelphia: Philadelphia College of Art, 1968). Laughlin's career was surveyed in a special double issue, *Aperture* 17:3-4 (1973), which documented a major exhibition at the Philadelphia Museum of Art. Two major publications of Meatyard's work appeared in 1974: *The Family Album of Lucybelle Crater*, published by the Jargon Society, and a double issue (18:3-4) of *Aperture*. Beginning in about 1967, the increasing visibility of Meatyard's work in one-person and group exhibits is documented in "Exhibition History," in Barbara Tannenbaum, ed., *Ralph Eugene Meatyard: An American Visionary* (Akron, Ohio: Akron Art Museum, 1991), pp. 192-94. Teske began teaching at UCLA in 1965 and was included in various group and individual exhibitions in the following years.

[162] Cited in Peter C. Bunnell, "Introduction," *Jerry N. Uelsmann*, special issue of *Aperture* 15:4 (1970): n.p.

[163] Sean Kernan, "How Do You Photograph Chance? Interview with Duane Michals," *Camera 35* 15(October 1971): 38. See also, Julia Scully, "Seeing Pictures," *Modern Photography* 35(February 1971): 22, 46; Duane Michals, "One Shot," *Camera 35* 16(December 1972): 23-24; and Shelley Rice, "Duane Michals's 'Real Dreams,'" *Afterimage* 4(December 1976): 6-8.

[164] Gibson acknowledges his debt to Borges in his essay, "The Somnambulist," *Camera 35* 14(October-November 1970): 37.

[165] Letter from the artist, June 10, 1998.

[166] Letter from the artist, undated [1994].

[167] This work was continued in Tress's subsequent books, including *Shadow* (New York: Avon, 1975) and *Theater of the Mind* (Dobbs Ferry, N.Y.: Morgan & Morgan, 1976).

[168] These shows were presented, respectively, at Focus Gallery, the Eastman House, and Witkin Gallery. The first publication of Krims's work was in *Aperture* 13:3 (1967): n.p.

[169] For example, see such early reviews as the "Gallery Snooping" columns of *Modern Photography* 33(December 1969): 38, and 34(March 1970): 32.

[170] In 1972, Krims privately published three small boxed portfolios: *The Deerslayers*, with an introduction by Alex J. Sweetman; *The Little People of America 1971*, with an introduction by A. D. Coleman; and *The Incredible Case of the Stack O' Wheats Murders*, with an introduction by Robert A. Sobieszek. On his work of this period, see "Les Krims: 'Can I Take Your Photograph?'" *Afterimage* 1(November 1972): 2-4.

[171] See A. D. Coleman, "Les Krims: Four Photographs That Drove a Man to Crime," in *Light Readings*, pp. 58-60.

[172] Ibid., p. 59.

[173] For example, his 1971 exhibition at the Eastman House was titled "Fictions" and contained works of both types.

[174] This work was published in the catalogue *Fictcryptokrimsographs* (1975).

[175] All three issued their first books in the period 1969-72, and in 1972 Arbus was the first American photographer to be featured at the Venice Biennale.

[176] Or, as Douglas Davis put it: "Photography no longer re-creates the truth (whatever that is): it invents the world." Davis, "The Ten 'Toughest' Photographs of 1975," *Esquire* (February 1976): 151.

[177] This image is reproduced with the title *Cast-iron building: Broadway and Broome Street* in V. S. Pritchett and Evelyn Hofer, *New York Proclaimed* (New York: Harcourt, Brace & World, 1965), facing p. 26.

[178] Interestingly, however, the pioneering Robert Drew had originally worked for *Life* magazine, and was inspired as much by the still images of W. Eugene Smith, Carl Mydans, and others, as he was by the tradition of newsreels and documentary film. Janet Maslin, "The Days of Hand-Held Cameras and In-Your-Face Films," *New York Times* (November 13, 1997): B1.

[179] "Frederick Wiseman," in Janis and MacNeil, eds., *Photography within the Humanities*, p. 72.

[180] For a good overview of this genre, see chapter 12, "The Nonfiction Novel," of Frederick R. Karl, *American Fictions 1940-1980* (New York: Harper & Row, 1983), pp. 560-90.

[181] Max Kozloff, "On Contemporary American Photography," in *American Photographs, 1970 to 1980: The Washington Art Consortium* (Seattle: Washington Art Consortium, 1980), p. 7.

[182] Evidence of this interest can be found throughout the literature of the period. Szarkowski's interest in vernacular images is apparent throughout his writings. Nathan Lyons's 1966 exhibition "Toward a Social Landscape" and his own photographs of this period were directly inspired by the snapshot. Emmet Gowin's early work—published in *Aperture* 16:2 (1971)—pays explicit homage to the family snapshot. This idea was documented most memorably in a special 1974 issue of *Aperture* (19:1) titled *The Snapshot*. It is important to emphasize the fact that the focus of this influential issue was on the snapshot *style* in contemporary photography rather than actual vernacular images.

[183] Douglas Davis, "Beyond the Fringe," *Newsweek* (November 13, 1972): 113.

[184] Cited in Gene Kennedy, ed., *Garry Winogrand* (El Cajon, Calif.: Grossmont College Gallery, 1976), n.p.

[185] For a protest against this kind of work, see Lou Stettner, "Modern Photography," *Camera 35* 18(December 1974): 24, 30. In this column, Stettner objects that "Humanist Realism," which he describes as "that great high road in photography," has been completely abandoned by the high photographic establishment in favor of a "Subjective Modernist" style. He calls for a return to the essential humanism of photographers such as Riis, Hine, Strand, Brassai, Model, Rosenblum, Weegee, etc.

[186] Kozloff, "On Contemporary American Photography," p. 8.

[187] John Szarkowski, *Winogrand: Figments from the Real World* (New York: Museum of Modern Art, 1988), pp. 26, 28.

[188] Garry Winogrand, *Public Relations* (New York: Museum of Modern Art/New York Graphic Society, 1977), p. 110.

[189] Green, *American Photography*, p. 106.

[190] The book does not include an introductory essay of any kind, and the photographs are reproduced without titles or dates. Aside from the minimal copy of the title and copyright pages, the book contains only a single word—"Introduction"—placed above the first photograph of the main sequence, an image of a blank roadside billboard. Note, however, that a selection of this work was presented in *Aperture* 16:2 (1971), with an introductory statement by the artist. There, Lyons notes the influence of the vernacular snapshot, "not as product, but as process—unpretentious, and yet important, aspiring to nothing—a notation in passing."

[191] For a continuation of this work, see Nathan Lyons, *Verbal Landscape/Dinosaur Sat Down* (Buffalo: Albright-Knox Art Gallery/CEPA Gallery, 1987).

[192] For Meyerowitz's comments on his early work and influences, see chapter 20, "Still Going," of Colin Westerbeck and Joel Meyerowitz, *Bystander: A History of Street Photography* (Boston: Little, Brown, 1994), pp. 373-403. For a brief portfolio of his early black-and-white work, see *The Snapshot* (*Aperture* 19:1 [1974]), pp. 36-45.

[193] This photograph was first, and most memorably, analyzed by John Szarkowski, in *Looking at Photographs* (New York: Museum of Modern Art, 1973), pp. 208-09.

[194] "Still Going," p. 378.

[195] See "Henry Wessel: An Interview by Stefan Janacek," in *Henry Wessel* (Tokyo: Gallery Min, 1987), n.p.

[196] This work is collected in Danny Lyon, *Memories of the Southern Civil Rights Movement* (Chapel Hill: University of North Carolina Press/Center for Documentary Studies, 1992).

[197] In judging the ultimate meaning of Lyon's work, Jonathan Green observes:

His social commentary mirrored the New Left's fantasies of adventurous egalitarianism, crosscultural communality, and revolutionary machismo. His work followed the long-honored American tradition of making the cultural outsider the cultural hero.

Green, *American Photography*, p. 125.

[198] Both had books published in the early 1970s: Elliott Erwitt, *Photographs and Anti-Photographs* (Greenwich, Conn.: New York Graphic Society, 1972); and Ron Bailey, *Landscapes: Photographs by Burk Uzzle* (Rochester, N.Y.: Light Impressions, 1973).

[199] These are: *Friday Night in the Coliseum* (Houston: Allison Press, 1971); *Going Texan: The Days of the Houston Livestock and Rodeo* (Houston: Mavis P. Kelsey, Jr., 1972); and *Rites of Fall: High School Football in Texas* (Austin: University of Texas Press, 1979).

[200] See James Enyeart, Terry Evans, and Larry Schwarm, *No Mountains in the Way, Kansas Survey: NEA* (Lawrence: University of Kansas Press, 1975).

[201] Bill Burke, Robert Hower, and Ted Wathen participated in the Kentucky project. The Nebraska work was done by Robert Starck and Lynn Dance; see Robert Starck and Lynn Dance, *Nebraska Photographic Documentary Project 1975-1977* (Lincoln: University of Nebraska Press, 1977). The Long Beach survey was comprised of work by Joe Deal, Judy Fishkin, Anthony Hernandez, Kenneth McGowan, Grant Mudford, and Leland Rice; see Constance W. Glenn and Jane K. Bledsoe, eds., *Long Beach: A Photographic Survey* (Long Beach: Art Museum and Galleries of California State University, Long Beach, 1980). The great majority of these projects were accomplished with funding from the NEA or state arts councils; see, for example, Foresta, *Exposed and Developed*, p. 9. Many related projects could be cited, including Jim Alinder, ed., *Twelve Photographers: A Contemporary Mid-America Document* (Kansas City, Mo.: Mid-America Arts Alliance, 1978).

[202] Bill Ganzel, *Dust Bowl Descent* (Lincoln: University of Nebraska Press, 1984). For the results of a related project, see Dale Maharidge and Michael Williamson, *And Their Children After Them: The Legacy of* Let Us Now Praise Famous Men: *James Agee, Walker Evans, and the Rise and Fall of Cotton in the South* (New York: Pantheon Books, 1989).

[203] On the results of this fascinating project, see Rick Dingus, *The Photographic Artifacts of Timothy O'Sullivan* (Albuquerque: University of New Mexico Press, 1982); and Mark Klett et al., *Second View: The Rephotographic Survey Project* (Albuquerque: University of New Mexico Press, 1984).

[204] Selections from this series were published earlier. See, for example, Smith's own sequencing of this work in *Camera 35* (April 1974): 27-51. The cover of this issue proclaimed Smith as "Our Man of the Year."

[205] These include *Few Comforts or Surprises: The Arkansas Delta* (1973), *Dorchester Days* (1978), *Exploding into Life* (1983), *Below the Line: Living Poor in America* (1987), *The Knife and Gun Club: Scenes from an Emergency Room* (1989), and *Cocaine True Cocaine Blue* (1994). For a profile of the artist, see Eric Pooley, "The Trouble He's Seen," *American Photographer* (November 1989): 36-49.

[206] These are *Ward 81* (New York: Simon and Schuster, 1979), *Falkland Road: Prostitutes of Bombay* (New York: Knopf, 1981), *Photographs of Mother Teresa's Missions of Charity in Calcutta* (Carmel, Calif.: Friends of Photography, 1985), and *Streetwise* (Philadelphia: University of Pennsylvania Press, 1988). For an extensive list of Mark's other publications and photo-essays, see "Selected Bibliography," in Marianne Fulton, *Mary Ellen Mark: 25 Years* (Boston: Bulfinch, 1991), pp. 185-91. For a profile of the artist, see Vicki Goldberg, "The Unflinching Eye: Photojournalist Mary Ellen Mark," *New York Times Magazine* (July 12, 1987): 12-18, 20, 57-58, 61.

[207] *Carnival Strippers* (New York: Farrar, Straus & Giroux, 1976).

[208] On Meiselas's struggle to control the presentation and meaning of her work, see Don Snyder, "Mixing Media," *Photo Communiqué* (Spring 1987): 28-35. In addition, see Harry Mattison, Susan Meiselas, and Fae Rubenstein, eds., *El Salvador* (New York: Writers and Readers, 1983). Meiselas's most recent book is the remarkable *Kurdistan: In the Shadow of History* (New York: Random House, 1997).

[209] This work is collected in Richard Avedon, *In the American West 1979-1984* (New York: Harry N. Abrams, 1985).

[210] At the time of this sitting, shortly before his death, Levant "was in the final stages of debilitating mental illness and drug addiction." Jamie James, "Transcending Fashion," *Artnews* (March 1994): 107.

[211] Kathleen McCarthy Gauss and Andy Grundberg, *Photography and Art: Interactions Since 1946* (New York: Abbeville Press, 1987), p. 107.

[212] Although US astronauts carried cameras aloft from the time of John Glenn's first orbital flight, there was little official interest in photography at first. Glenn carried a simple 35mm rangefinder (purchased in a local drugstore!), and shot "two rolls of sunsets, sunrises, and aerial views." It was only Walter Schirra's personal interest in the medium that prompted him to take a more serious camera—a modified Hasselblad 500C—aloft later in 1962. As Gordon Cooper recalls,

An awful lot of people in NASA really had very little interest in photography. They had a memo out that said: "If an astronaut desires, he may carry a camera with him." That's the importance they gave to photography.

Ron Schick and Julia Van Haaften, *The View from Space: American Astronaut Photography 1962-1972* (New York: Clarkson N. Potter, 1988), pp. 16, 20, 26. In addition, see compilations such as *The Photography of Space Exploration* (New York: Grey Art Gallery, 1981).

[213] On these prints, see Richard B. Woodward, "The Final Frontier?" *Aperture*, no. 130 (Winter 1993): 70-72.

[214] In addition to the work of artists such as Friedlander, Callahan, and Barrow, see, for example, George Obremski, "TV," *Camera 35* 16(January-February 1972): 33-37.

[215] See Sonia Landy Sheridan, "Generative Systems: Six Years Later," *Afterimage* 2(March 1975): 6-10.

[216] "Magic Machines" was held at the Center Gallery of the University of California Extension Center, San Francisco in late 1973; see *Afterimage* 1(December 1973): 13. The Eastman House exhibition is documented in Marilyn McCray, *Electroworks* (Rochester, N.Y.: George Eastman House, 1979). Interest in this approach seems to have declined significantly by 1980, when Sheridan's program was cut back and she took early retirement. See *Afterimage* 8(Summer 1980): 42.

[217] Paula Marincola, *William Larson: Photographs 1969-1985* (Philadelphia: Institute of Contemporary Art, 1986), p. 2. See also Skip Atwater, "William Larson: Time and Structure," *Afterimage* 4(December 1976): 4-5, 18.

[218] Many articles were published on alternative processes in this period. For a survey of hand-colored work of this era, for example, see *Picture Magazine*, no. 17 (1980). On the broad interest in gum bichromate, see "Back to Gum Prints," *Camera 35* 14(December 1969-January 1970): 26-29, 66; "View from Kramer," *Modern Photography* 34(January 1970): 46, 48; and Julia Scully, "What's New? Old Techniques!" *Modern Photography* 35(May 1971): 78-84. On the modest resurgence of interest in carbro, see "View from Kramer," *Modern Photography* 37(July 1973): 24, 44.

[219] Davis Pratt, *Newly Re-Created: Photographic Processes Revived* (Cambridge, Mass.: Fogg Art Museum, 1973). Several other exhibitions of this period could also be cited, including Van Deren Coke, ed., *Light and Substance* (Albuquerque: University of New Mexico Art Museum, 1974), and Phillip Dennis Cate, *Photographic Process as Medium* (New Brunswick, N.J.: Rutgers University Art Gallery, 1975).

[220] On these themes, see, for example, Lauren Smith, *The Visionary Pinhole* (Salt Lake City: Peregrine Smith, 1985); David Featherstone, *The Diana Show:*

Pictures Through a Plastic Lens (Carmel, Calif.: Friends of Photography, 1980); "The Shutter's an Earful and He's Got a Nose for Pictures," *Modern Photography* 34(February 1970): 18; and Howard N. Kaplan, *The Less Than Sharp Show* (Chicago: Chicago Photographic Gallery, 1977).

221 For a scholarly survey of the latter, see Elizabeth Glassman and Marilyn F. Symmes, *Cliché-verre: Hand-Drawn, Light-Printed, A Survey of the Medium from 1839 to the Present* (Detroit: Detroit Institute of Arts, 1980).

222 For example, see reports on exhibitions such as "60's Continuum," at the George Eastman House in 1972, and "Light and Lens, Methods of Photography," which circulated throughout New York state in 1973-74. Van Deren Coke, "60's Continuum," and William Jenkins, "Some Thoughts on 60's Continuum," *Image* 15(March 1972): 1-6 and 15-18. Judith Kalina, "The Medium IS the Message," *Camera 35* 18(July 1974): 52-53, 80-81.

223 See Steve Yates, *Betty Hahn: Photography or Maybe Not* (Albuquerque: University of New Mexico Press, 1995).

224 Robert Heinecken, "Manipulative Photography," *Contemporary Photography* 5:4 (1967): n.p.

225 For a good overview of this subject, see Charles Desmarais, *Proof: Los Angeles Art and the Photograph 1960-1980* (Laguna Beach, Calif.: Laguna Art Museum/Fellows of Contemporary Art, Los Angeles, 1992).

226 See Robert Heinecken, "I Am Involved in Learning to Perceive and Use Light," *Untitled*, no. 7-8 (1974): 44-46; and Charles Hagen, "Robert Heinecken: An Interview," *Afterimage* 3(April 1976): 8-12.

227 As Gowin recalls, he first paired this lens and camera in 1967, but for several years trimmed his resulting prints to eliminate the circular form. *Emmet Gowin Photographs* (New York: Knopf, 1976), p. 101.

228 Myriam Weisang, *Richard Misrach, Photographs: 1975-1987* (Tokyo: Gallery Min, 1988), n.p.

229 This series is described in Denise Miller-Clark, *Within This Garden: Photographs by Ruth Thorne-Thomsen* (Chicago: Museum of Contemporary Photography/Aperture, 1993), pp. 35-37.

230 Douglas Dreishpoon, *Petah Coyne: Photographs* (New York: Laurence Miller Gallery, 1997), p. 5.

231 The following discussion is indebted to the fine summary of Barrow's career provided in Kathleen McCarthy Gauss, *Inventories and Transformations: The Photographs of Thomas F. Barrow* (Albuquerque: University of New Mexico Press/Los Angeles County Museum of Art, 1986).

232 This mode of picture making had been explored earlier by Siegel, and was taught by Siskind as part of the Institute's classes. Ibid., p. 31. Beginning at about this time, in Los Angeles, Robert Heinecken made extensive use of this approach.

233 Gerald Graff, *Literature Against Itself* (Chicago: University of Chicago Press, 1979), p. 175. The X motif had varied meanings at this time. The importance of this motif in the earth art of the early 1970s is suggested in Lucy R. Lippard, *Overlay: Contemporary Art and the Art of Prehistory* (New York: Pantheon, 1983), pp. 52-53. For an overtly political use of the canceled image, see, for example, Malcolm Morley's 1970 painting *Race Track (South Africa)*.

234 Estelle Jussim, "Passionate Observer: The Art of John Pfahl," in Cheryl Brutvan and Estelle Jussim, *A Distanced Land: The Photographs of John Pfahl* (Albuquerque: University of New Mexico Press, 1990), p. 4.

235 Peter C. Bunnell, *Altered Landscapes: The Photographs of John Pfahl* (Carmel, Calif.: Friends of Photography, 1981). This text provides a good description of Pfahl's working method in this body of work.

236 *Blue Right Angle, Buffalo, New York*, 1978; see ibid., p. 19.

237 Edward Bryant, *Picture Windows: Photographs by John Pfahl* (Albuquerque: University of New Mexico Press, 1987).

238 In television, for example, the three major networks had switched completely to color by 1967; within three years the entire industry was broadcasting in color. Henry Wilhelm, *The Permanence and Care of Color Photographs* (Grinnel, Iowa: Preservation Publishing Company, 1993), p. 40.

239 Ibid., p. 19. Of course, it was the very familiarity of color in this era that prompted the use of black-and-white film in such notable motion pictures as Woody Allen's *Manhattan* (1979) and Martin Scorcese's *Raging Bull* (1980).

240 Stephen R. Milanowski, "The Biases Against Color in Photography," *Exposure* 23(Summer 1985): 5. This change occurred in the amateur market in 1964, and in the commercial field in 1965.

241 Julia Scully, "The Use and Abuse of Color," *Modern Photography* 33(September 1969): 50.

242 Wilhelm, *Permanence and Care of Color Photographs*, p. 17.

243 Ibid., p. 19.

244 *Creative Camera* (August 1971): 285; Peter Kolonia, "In the Dark," *Popular Photography* 97(March 1990): 36.

245 Manfred Heiting, ed., *50 Years: Modern Color Photography, 1936-1986* (Cologne: Messe- und Ausstellungs- Ges. M.b.H, 1986), pp. 361-62.

246 Heiting, *50 Years: Modern Color Photography*, p. 360; "Breakthrough in Color Prints," *Photography Year 1976* (New York: Time-Life, 1975), pp. 148-53; "Ed Scully on Color," *Modern Photography* 32(November 1968): 50, 54; "Ed Scully on Color," *Modern Photography* 38(May 1974): 22, 68; "Cibachrome Prints from Slides," *Modern Photography* 39(May 1975): 94-97, 142, 154. It is interesting to note that a public exhibition of Cibachrome prints by fifty-two noted photographers was mounted at the New York Cultural Center in 1970; "Gallery Snooping," *Modern Photography* 34(October 1970): 34.

247 Paul Farber, "1-2-3-4-5-6 Color Printing Papers Compared," *Camera 35* (January-February 1972): 39-41, 75-77.

248 "Slide Film Twice as Fast, No Grainer," *Photography Year 1979* (New York: Time-Life, 1978), p. 148.

249 "Ed Scully on Color," *Modern Photography* 35(April 1971): 22, 24, 120.

250 "Ed Scully on Color," *Modern Photography* 40(February 1976): 31-32, 151.

251 Wilhelm's research is summarized in his book *Permanence and Care of Color Photographs*. Many articles on this subject appeared in the photographic and general press of the late 1970s and early 1980s. For a sampling of these, see Henry Wilhelm, "Color Print Instability: A Problem for Collectors and Photographers," *Afterimage* 6(October 1978): 11-13; Nancy Stevens, "The Perils and Pleasures of Collecting Color," *Saturday Review* (May 12, 1979): 32-33; "The Imperfect Miracle," *Afterimage* 8(October 1980): 3; "Kodak and the Pros," *Afterimage* 8(January 1981): 5, 29; Gail Fisher-Taylor, "Exclusive Interview with Henry Wilhelm," *Photo Communiqué* 3(Spring 1981): 2-10, 13-14, 16-21; and Stephen R. Milanowski, "Notes on the Stability of Color Materials," *Positive* (Cambridge, Mass.: MIT Creative Photography Laboratory, 1981), pp. 28-40.

252 For example, in ca. 1980, the Center for Creative Photography "made a policy decision to no longer accept chromogenic/Ektacolor print materials." Milanowski, "Notes on the Stability of Color Materials," p. 34.

253 An important event in the history of photographic conservation was the opening of the first such dedicated center at the George Eastman House in 1975. See *Afterimage* 3(September 1975): 16.

254 Wilhelm, *Permanence and Care of Color Photographs*, p. 38.

255 Museum release, ibid.

256 Quoted in Louis Kronenberger, *Quality: Its Image in the Arts* (New York: Atheneum, 1969), p. 208.

257 Jerry L. Thompson, ed., *Walker Evans at Work* (New York: Harper & Row, 1982), p. 235. Judith Keller notes that Evans purchased an SX-70 camera as soon as it came on the market in the fall of 1972. He only began using it seriously in 1973, however, after Polaroid offered him free equipment and film. He went on to produce a body of more than 2,400 prints in this format. Judith Keller, *Walker Evans: The Getty Museum Collection* (Malibu, Calif.: J. Paul Getty Museum, 1995), pp. 357-58.

258 André Kertész, *From My Window* (Boston: New York Graphic Society, 1981). For an overview of artistic Polaroid work of the 1970s, see Belinda Rathbone, *One of a Kind: Recent Polaroid Color Photography* (Boston: David R. Godine, 1979).

259 See Milan R. Hughston's "Bibliography," in Martha A. Sandweiss, *Eliot Porter* (Boston: New York Graphic Society, 1987), pp. 257-59, 265-67.

260 See, for example, Margaret Weiss, "A Show of Color," *Saturday Review* (September 24, 1966): 45-52.

261 *Marie Cosindas: Color Photographs* (Boston: New York Graphic Society, 1978). See also Tom Wolfe, "The Polychromatic Mini-Microwave Projecting Astral Fantasist," *American Photographer* 1(August 1978): 28-35.

262 For an entertaining and informative profile of the artist, see Richard B. Woodward, "Memphis Beau," *Vanity Fair* (October 1991): 240.

263 Eggleston has explicitly acknowledged the importance of Frank's work. See, in particular, his comments in his *Horses and Dogs* (Washington, D.C.: Smithsonian Institution Press, 1994), p. 5.

264 John Szarkowski, *William Eggleston's Guide* (New York: Museum of Modern Art, 1976), p. 10.

265 As he observed in his catalogue essay: "These pictures are fascinating partly because they contradict our expectations." Szarkowski, *William Eggleston's Guide*, p. 13.

266 The show ran from May 25 to August 1, 1976.

267 For a representative sample of this criticism, see Hilton Kramer, "Art: Focus on Photo Shows," *New York Times* (May 28, 1976): C18; Dan Meinwald, "Color Me MOMA," *Afterimage* 4(September 1976): 18; Janet Malcolm,

"Photography: Color," *New Yorker* (October 10, 1977): 107-11; and Max Kozloff, "How to Mystify Color Photography," *Artforum* 15(November 1976): 50-51.

[268] Woodward, "Memphis Beau," p. 218.

[269] As Mr. Szarkowski confirmed in a letter to the author of June 29, 1998, the pictures for the *Guide* were selected well before the exhibition was assembled. He writes:

> By the time the book was locked up, Eggleston had done a great deal of additional work, both in dye-transfer (from Kodachromes) and also from negative color. It did not seem to me that there was any reason to restrict the exhibition to work that had been edited to make a book; in any case the exhibition was not only much bigger, but much less coherent than the book, since it was hung in two galleries and a connecting corridor that led to the cafe. Do not think I did not love that space, imperfect though it might have been.

[270] Szarkowski, *William Eggleston's Guide*, p. 8.

[271] Ibid., p. 9.

[272] Ibid.

[273] Ibid., pp. 9, 14.

[274] Kramer, "Art: Focus on Photo Shows," p. C18. The strangest criticism of Eggleston's work was based on its supposed emulation of Photorealist painting; see Janet Malcolm, "Photography: Color," *New Yorker* (October 10, 1977): 107-11.

[275] Thomas W. Southall, *Of Time and Place: Walker Evans and William Christenberry* (San Francisco: Friends of Photography/Fort Worth: Amon Carter Museum, 1990), p. 23. Significantly, Evans wrote a glowing appreciation of the 1973 exhibition.

[276] Westerbeck and Meyerowitz, *Bystander*, p. 401.

[277] *Cape Light: Color Photographs by Joel Meyerowitz* (Boston: New York Graphic Society, 1978), n.p.

[278] Green, *American Photography*, p. 188.

[279] Stephen Shore, *Uncommon Places* (Millerton, N.Y.: Aperture, 1982), p. 63.

[280] See Keith F. Davis, *Harry Callahan: New Color, Photographs 1978-1987* (Kansas City, Mo.: Hallmark Cards, 1988), esp. pp. 20-21.

[281] Callahan's first all-color show was at Light Gallery, March 29-April 22, 1978.

[282] See Sally Stein, *Harry Callahan: Photographs in Color, The Years 1946-1978* (Tucson: Center For Creative Photography, 1980); and Robert Tow and Ricker Winsor, eds., *Harry Callahan: Color 1941-1980* (Providence, R.I.: Matrix, 1980). For the venues of the CCP exhibition, see Davis, *Harry Callahan: New Color*, p. 128.

[283] Mark's photographs were made between October 1978 and January 1979; the book was published in 1981. Mark and Webb were two of the twelve photographers featured in Adam D. Weinberg's group exhibition "On the Line: The New Color Photojournalism," at the Walker Art Center in 1986. This show was accompanied by a catalogue of the same title.

[284] See, for example: Donna Nakao, *Spectrum: New Directions in Color Photography* (Honolulu: University of Hawaii Art Gallery, 1979); *Light/Color* (Ithaca: Handwerker Gallery, Ithaca College, 1981); and Dorothy Martinson, *Recent Color* (San Francisco: San Francisco Museum of Modern Art, 1982).

[285] Sally Stein, "FSA Color: The Forgotten Document," *Modern Photography* 43(January 1979).

[286] *Color as Form: A History of Color Photography* (Rochester: International Museum of Photography at George Eastman House, 1982). This exhibition was presented at both the Corcoran Gallery of Art, Washington, D.C., and the Eastman House in 1982.

[287] Interestingly, Rauschenberg began his artistic career in photography. He made life-size blueprint photographs of the human figure in 1949, and the first of his works acquired by the Museum of Modern Art (in 1952) were photographs made while studying at Black Mountain College. His straight photographic images are collected in publications such as Robert Rauschenberg, *Photos In + Out of City Limits: Boston* (West Islip, N.Y.: ULAE, 1981), and Robert Rauschenberg, *Photos In + Out of City Limits: New York C.* (West Islip, N.Y.: ULAE, 1982). For an overview of his work in photography, see, for example, Richard Gruber and Craig Allen Subler, *Robert Rauschenberg: Through the Lens* (Kansas City, Mo.: University of Missouri-Kansas City Gallery of Art, 1997).

[288] Robert Hughes, *The Shock of the New* (New York: Knopf, 1981), p. 345.

[289] The phrase "aesthetic of heterogeneity," coined by art critic Lawrence Alloway, is cited in Andy Grundberg, "Popular Culture, Pop Art," in Grundberg and Gauss, *Photography and Art*, p. 83.

[290] Significantly, of course, one of Warhol's most famous quotes was "I think everybody should be a machine." Warhol, in an interview with G. R. Swenson,

"What Is Pop Art? Answers from 8 Painters, Part I," *Artnews* 62(November 1963): 26.

[291] The publication date of this book has been variously listed as 1962 and 1963; the earlier date is given on the title page, while the copyright page carries the latter date. This was first published by the artist in an edition of 400 numbered copies. A second edition in 1967 (500 unnumbered copies) and third edition in 1969 (3,000 copies) were also released. Sidra Stich, *Made in U.S.A.: An Americanization in Modern Art, The '50s & '60s* (Berkeley: University of California Press, 1987), p. 75, note 17.

[292] For information on Ruscha's books, see, for example, John Coplans, "Concerning 'Various Small Fires'—Edward Ruscha Discusses His Perplexing Publications," *Artforum* 3(February 1965): 25; and John Miller, "Mnemonic Book: Ed Ruscha's Fugitive Publications," *Parkett*, no. 18 (1988): 66-73. This issue of *Parkett* contains essays on other aspects of Ruscha's work.

[293] For published collections of LeWitt's own photographs, see his books *Photo-Grids* (New York: Paul David Press/Rizzoli, 1978); *Sunrise & Sunset at Praiano* (New York: Rizzoli, 1980); and *Autobiography* (New York: Multiples, 1980).

[294] For a comprehensive recent overview of this era, see Irving Sandler, *Art of the Postmodern Era: From the Late 1960s to the Early 1990s* (New York: Icon Editions, 1996).

[295] Ibid., p. 12.

[296] Grundberg and Gauss, *Photography and Art*, p. 136.

[297] Ruscha stated at this time:

> Above all, the photographs I use are not "arty" in any sense of the word. I think photography is dead as a fine art; its only place is in the commercial world, for technical or information purposes.

Coplans, "Concerning 'Various Small Fires'—Edward Ruscha Discusses His Perplexing Publications," p. 25. For an elaboration of this idea, see Henri Man Barendse, "Ed Ruscha: An Interview," *Afterimage* 8(February 1981): 8-10.

[298] This influence is also due, in part, to Bernd Becher's career in teaching at the Art Academy in Düsseldorf. His students there include Thomas Struth and Candida Höfer.

[299] Carl Andre, "A Note on Bernhard and Hilla Becher," *Artforum* 11(December 1972): 59-61; repr. in Amy Baker Sandback, *Looking Critically: 21 Years of Artforum Magazine* (Ann Arbor, Mich.: UMI, 1984), pp. 122-23.

[300] Marc Freidus, et al., *Typologies: Nine Contemporary Photographers* (Newport Beach, Calif.: Newport Harbor Museum/Rizzoli, 1991), p. 15.

[301] Ralph Rugoff, *Scene of the Crime* (Los Angeles: UCLA at the Armand Hammer Museum of Art/MIT Press, 1997). While this observation is directed specifically at West Coast art, it is clearly relevant to larger currents of American art. This exhibition was presented at Armand Hammer Museum of Art and Cultural Center, Los Angeles, in 1997. Notably, these ideas were explored earlier in Desmarais, *Proof: Los Angeles Art and the Photograph, 1960-1980*; and Ann Goldstein and Anne Rorimer, *Reconsidering the Object of Art: 1965-1975* (Los Angeles: Museum of Contemporary Art/MIT Press, 1995). For a recent variation on this theme, see Sandra S. Phillips et al., *Police Pictures: The Photograph as Evidence* (San Francisco: San Francisco Museum of Modern Art/Chronicle Books, 1997). Of course, one of Ruscha's books— *Royal Road Test* (1967), a collaboration with Mason Williams and Patrick Blackwell—provides an explicit parody of the "forensic aesthetic."

[302] Rugoff, *Scene of the Crime*, p. 62.

[303] Charles Stainback, *Special Collections: The Photographic Order from Pop to Now* (New York: International Center of Photography, 1992), p. 5.

[304] Thomas Crow, *The Rise of the Sixties: American and European Art in the Age of Dissent* (New York: Abrams, 1996), p. 157.

[305] Cited in Stainback, *Special Collections*, p. 12.

[306] Perhaps the best known of this series is *Wrong* (1967), a parody of the simplest rules of photographic composition. In this work, a banal snapshot of the artist, standing on a sidewalk with a background tree rising directly above his head, is juxtaposed with the word "WRONG."

[307] His early work in this genre is documented in John Baldessari, *Close-Cropped Tales* (Buffalo: CEPA Gallery, 1981).\

[308] Baldessari was strongly influenced in 1976 by reading the chapter "The Logic of Signs and Symbols" in Suzanne K. Langer's *Philosophy in a New Key*. See Coosje van Bruggen, *John Baldessari* (New York: Rizzoli, 1990), p. 97.

[309] Cumming's early interests in photography are documented in "An Interview with Robert Cumming," in James Alinder, *Cumming Photographs* (Carmel, Calif.: Friends of Photography, 1979), pp. 49-55.

[310] Cumming's conceptual works first took the form of self-published books. The first of these, *Picture Fictions* (1971), was followed by *The Weight of Fran-*

chise Meat (1971), *A Training in the Arts* (1973), and *A Discourse on Domestic Disorder* (1975).

[311] Alinder, *Cumming Photographs*, pp. 5-6.

[312] By early 1982, for example, it was noted that

> Man Ray has appeared on the covers of three serious art magazines—*Avalanche*, *Artforum*, and *Camera Arts*—as well as on the cover of a Sotheby's auction catalogue. Johnny Carson played Wegman's videotapes on the "Tonight" show, and the dog has appeared both on tape and in person on Public Television, "Saturday Night Live," "Tomorrow," and David Letterman's "Late Night" show.

Laurance Wieder, *Man's Best Friend: Photographs and Drawings by William Wegman* (New York: Harry N. Abrams, 1982), p. 11.

[313] Peter Schjeldahl, "The Wizard in the Tower," in *Lucas Samaras* (New York: Pace/MacGill Gallery, 1991), n.p.

[314] Lucas Samaras, *Samaras Album* (New York: Whitney Museum/Pace Editions, 1971), p. 9.

[315] A large selection of these AutoPolaroids were published in *Art in America* (November-December 1970): 66-83.

[316] Judith Russi Kirschner, "Non Uments," *Artforum* (October 1985): 108.

[317] Joan Simon, "Gordon Matta-Clark: Reconstructions," *Arts Magazine* 62(Summer 1988): 85.

[318] This style of painting was variously described by the terms "Hyper-Realism" and "New Realism" and sometimes grouped with the work of sculptors such as Duane Hanson and John de Andrea.

[319] Laurence Dreiband, quoted in A. D. Coleman, "'From Today, Painting Is Dead': A Requiem" (1974), in *Light Readings*, p. 186.

[320] Various surveys of this subject have been made. See, for example, Robert Metzger, *A Second Talent: Painters and Sculptors Who Are Also Photographers* (Ridgefield, Conn.: Aldrich Museum of Contemporary Art, n.d.).

[321] See, for example, Steven Connor's entry "Postmodernism," in Michael Payne, *A Dictionary of Cultural and Critical Theory* (Oxford: Blackwell, 1996), pp. 428-32.

[322] To an important degree, postmodernism, and the theorizing project that has grown out of it, are products of the unique conditions of the academy. Both the ambitions and the limitations of postmodernist thought stem from the abstract, interdisciplinary nature of the theoretical enterprise. As ideas from widely varying disciplines are translated, simplified, synthesized, and recontextualized, their origin in actual historical and social contexts becomes progressively less clear. These second- and third-generation intellectual constructs are, themselves, endlessly glossed, critiqued, and modified in a kind of "virtual" discursive realm. This enterprise holds various kinds of rewards. In his article "Glass Houses—The Academicization of Activism" (p. 33), critic Michael Starenko has suggested one of them:

> A career as an academic theorist appeals to many artists and writers because it holds out the promise of worldly innocence and ideological purity. In this monastic ideal, innocence is the freedom to avoid contact with "the public" while presuming to speak on its behalf; and purity is the satisfaction of knowing that all other "subject positions" are hopelessly compromised by vested interest, ignorance, and false consciousness. In other words, innocence and purity are forms of power: in order to be innocent someone else must be guilty; in order to be pure someone else must be impure.

On this same note, see Steven Watts, "The Idiocy of American Studies," *American Quarterly* 43(December 1991): 625-60. From a sociological point of view, the changing nature of academic employment itself has some relevance to this issue. On this subject, see, for example, Francis Oakley, "The Elusive Academic Profession: Complexity and Change," *Daedalus* 126(Fall 1997): 43-66.

[323] Many overviews of modern art and thought have been published. See, for example, Malcolm Bradbury and James McFarlane, *Modernism 1890-1930* (Harmondsworth: Penguin, 1976).

[324] Ihab Hassan, *The Dismemberment of Orpheus: Towards a Postmodern Literature* (New York: Oxford University Press, 1982), pp. 267-68; cited in Steven Connor, *Postmodernist Culture: An Introduction to Theories of the Contemporary*, 2nd ed. (Cambridge, Mass.: Blackwell, 1997), pp. 118-19.

[325] This literature is almost endless. I have found the following overviews to be particularly useful in terms of scope, clarity, and critical insight: Silvio Gaggi, *Modern/Postmodern: A Study in Twentieth-Century Arts and Ideas* (Philadelphia: University of Pennsylvania Press, 1989); Hans Bertens, *The Idea of the Postmodern: A History* (London: Routledge, 1995); Michael Payne, ed., *A Dictionary of Cultural and Critical Theory* (Oxford: Blackwell, 1996); and Connor, *Postmodernist Culture*.

[326] Fredric Jameson, *The Prison-House of Language* (Princeton: Princeton University Press, 1972), p. vii.

[327] Eagleton, *Literary Theory*, p. 128.

[328] Ibid.

[329] Reprinted in Roland Barthes, *Image Music Text*, ed. and trans. by Stephen Heath (New York: Hill and Wang, 1977), pp. 142-48.

[330] It is important to note the selective nature of this influence. While Kuhn's text has been fundamental to postmodernist thinking in the humanities, it is considerably less revered in the sciences. For a powerful critique of this work from a scientific perspective, see, for example, Steven Weinberg, "The Revolution That Didn't Happen," *New York Review of Books* (October 8, 1998): 48-52.

[331] Clifford Geertz, *Local Knowledge: Further Essays in Interpretive Anthropology* (New York: Basic Books, 1983).

[332] Also of relevance here are Louis Althusser's writings on ideology and Antonio Gramsci's on hegemony.

[333] Herbert Marcuse, *An Essay on Liberation* (Boston: Beacon Press, 1969), pp. 6, 23, 30. In its hyperbole, irrationalism, and deep utopianism, this work reveals much about the countercultural mood of this era.

[334] As Terry Eagleton has astutely observed:

> Post-structuralism was a product of that blend of euphoria and disillusionment, liberation and dissipation, carnival and catastrophe, which was 1968. Unable to break the structures of state power, post-structuralism found it possible instead to subvert the structures of language. Nobody, at least, was likely to beat you over the head for doing so. The student movement was flushed off the streets and driven underground into discourse. Its enemies, as for the later Barthes, became coherent belief-systems of any kind—in particular all forms of political theory and organization which sought to analyze, and act upon, the structures of society as a whole.

Eagleton, *Literary Theory*, p. 142.

[335] Guy Debord, *The Society of the Spectacle* (New York: Zone Books, 1995), p. 12. See, in addition, Hal Foster, "Contemporary Art and Spectacle," in *Recodings: Art, Spectacle, Cultural Politics* (Port Townsend, Wash.: Bay Press, 1985), pp. 79-96.

[336] Cited in Bertens, *The Idea of the Postmodern*, pp. 153-54. For a spirited demolition of these notions, see Robert Hughes's essay "Jean Baudrillard: America," in Hughes's *Nothing If Not Critical* (New York: Penguin, 1992), pp. 375-87. For a valuable overview of the symbol of America in Continental thought, see James W. Ceasar, *Reconstructing America* (New Haven: Yale University Press, 1997).

[337] For an early overview of the ambiguities of the term, see Douglas Davis, "Post-Everything," *Art in America* (February 1980): 11, 13-14.

[338] Bertens, *The Idea of the Postmodern*, pp. 66-67.

[339] *October*, no. 8 (Spring 1979): 75-88; repr. in Wallis, *Art After Modernism*, pp. 175-87. For an overview of this period, see Michael Starenko, "What's an Artist to Do? A Short History of Postmodernism and Photography," *Afterimage* 10(January 1983): 4-5; and Bertens, *The Idea of the Postmodern*, pp. 82-97.

[340] This was first published in Hal Foster, ed., *The Anti-Aesthetic: Essays on Postmodern Culture* (Port Townsend, Wash.: Bay Press, 1983), pp. 57-82.

[341] Bertens, *The Idea of the Postmodern*, p. 83.

[342] Foster, *The Anti-Aesthetic*, pp. xi, xv.

[343] For example, "A Short History of Photography" was published in English in *Screen* 13(Spring 1972): 5-26; *Creative Camera International Year Book 1977*, pp. 162-65, 229-33; and *Artforum* 15(February 1977): 46-51. "The Work of Art in the Age of Mechanical Reproduction" was included in Hannah Arendt, ed., *Walter Benjamin, Illuminations* (New York: Harcourt Brace Jovanovich, 1968).

[344] Benjamin, "The Work of Art in the Age of Mechanical Reproduction," in Peninah R. Petruck, *The Camera Viewed: Writings on Twentieth Century Photography, Vol. 1* (New York: E.P. Dutton, 1979), pp. 265, 261. For discussions of Benjamin's thesis and its interpretation by later theorists, see, for example, John McCole, "Walter Benjamin, Susan Sontag, and the Radical Critique of Photography," *Afterimage* 7(Summer 1979): 12-14; Michael Starenko, "Benjamin, Sontag," *Exposure* 17:4 (1980): 20-31; and Paul Mattick, Jr., "Mechanical Reproduction in the Age of Art," *Arts Magazine* (September 1990): 62-69.

[345] Linda Andre, "The Politics of Postmodern Photography," *Afterimage* 13(October 1985): 14-17.

[346] Gerald Marzorati, "Imitations of Life," *Artnews* (September 1983): 82.

[347] Peter Schjeldahl, "Shermanettes," *Art in America* (March 1982): 110.

[348] Andy Grundberg, "Self-Portraits Minus Self," *New York Times Book Review* (July 22, 1984): 12.

349 Douglas Crimp, "The Photographic Activity of Postmodernism," *October*, no. 15 (Winter 1980); repr. in Diana Emery Hulick with Joseph Marshall, *Photography 1900 to the Present* (Upper Saddle River, N.J.: Prentice Hall, 1998), p. 268.

350 Notably, one renowned feminist critic of this era observed that "it is necessary to fly in the face of Sherman's own expressly non-, even anti-, theoretical stance." Laura Mulvey, "A Phantasmagoria of the Female Body: The Work of Cindy Sherman," *New Left Review*, no. 188 (July-August 1991): 137.

351 Lisa Phillips et al., *Richard Prince* (New York: Whitney Museum/Harry N. Abrams, 1992), p. 23.

352 Foster, *Recodings*, p. 68.

353 Abigail Solomon-Godeau, "Winning the Game When the Rules Have Been Changed: Art Photography and Postmodernism," *Exposure* 23(Spring 1985): 6.

354 Rosalind Krauss, "The Originality of the Avant-Garde," in Wallis, ed., *Art After Modernism*, p. 27.

355 Solomon-Godeau, "Winning the Game," p. 8.

356 Anne H. Hoy, *Fabrications: Staged, Altered, and Appropriated Photographs* (New York: Abbeville Press, 1987), p. 101.

357 One aspect of the postmodernist logic of these works is suggested in Baudrillard's influential 1983 essay "The Precession of Simulacra." Here, Baudrillard observes that

> genetic miniaturization is the dimension of simulation. The real is produced from miniaturized units, from matrices, memory banks, and command modules—and with these it can be reproduced an infinite number of times. It no longer has to be rational since...it is no longer real at all. It is a hyperreal, the product of an irradiating synthesis of combinatory models in a hyperspace without atmosphere.

Jean Baudrillard, "The Precession of Simulacra," in Wallis, ed., *Art After Modernism*, p. 254.

358 Kate Linker, *Love for Sale: The Words and Pictures of Barbara Kruger* (New York: Harry N. Abrams, 1990), pp. 14-15. Interestingly, Kruger also designed at least one issue of *Aperture* magazine (13:4 [1968]).

359 Linker, *Love for Sale*, p. 14.

360 Allan Sekula, "On the Invention of Photographic Meaning," *Artforum* (January 1975): 37.

361 See, for example, Hal Foster, "Whatever Happened to Postmodernism?" in *The Return of the Real* (Cambridge, Mass.: MIT Press, 1996), pp. 205-26.

362 See, for example, Gerald Graff, *Literature Against Itself*; and Charles Newman, *The Post-Modern Aura: The Act of Fiction in an Age of Inflation* (Evanston: Northwestern University Press, 1985). An earlier version of Newman's lively and idiosyncratic text was published in *Salmagundi*, nos. 63-64 (1984).

363 In 1982, for example, Carter Ratcliff wrote:

> Sherrie Levine claims to offer a critique of the "creative self" that strides in seven-league boots through our mythologies of freedom. Nonetheless, her "appropriations" are most effective as expressions of her resentment at the fact that her name will very likely never be as glamorous as Walker Evans's.

"Art & Resentment," *Art in America* 70(Summer 1982): 13.

364 The most important of these early essays include Michael Starenko, "Postmodernism as Bricolage: or, Can Cindy Sherman Act?" *Exposure* 21:2 (1983): 20-23; and Andre, "The Politics of Postmodern Photography."

365 By 1985, for example, Abigail Solomon-Godeau realized with some horror that postmodernist photography "had now been fully and seamlessly recuperated under the sign of art photography, an operation that might be characterized as deconstruction in reverse." "Living with Contradictions," in Carol Squiers, ed., *The Critical Image: Essays on Contemporary Photography* (Seattle: Bay Press, 1990), pp. 68-69.

366 For a brief recap of the "Theory-Weary" feeling of the late 1980s, see Sandler, *Art of the Postmodern Era*, pp. 544-46.

367 For an extended study of this theme, see Martin Jay, *Downcast Eyes: The Denigration of Vision in Twentieth-Century French Thought* (Berkeley: University of California Press, 1993).

368 Van Deren Coke, *Fabricated to Be Photographed* (San Francisco: San Francisco Museum of Modern Art, 1979). See also, Phyllis Plous and Steven Cortright, *Invented Images* (Santa Barbara: UCSB Art Museum, 1980).

369 Anne H. Hoy, *Fabrications: Staged, Altered, and Appropriated Photographs* (New York: Abbeville, 1987). Joshua P. Smith and Merry A. Foresta, *The Photography of Invention: American Pictures of the 1980s* (Washington, D.C.: National Museum of American Art, 1989).

370 For an overview of the importance of photographic formalism in the 1970s, see, for example, Janet Kardon, *Photography: A Sense of Order* (Philadelphia: Institute of Contemporary Art, 1981).

371 Groover's early use of photography is described in Laurence Shopmaker, *Jan Groover: Photographs* (Purchase, N.Y.: Neuberger Museum, 1983); and Susan Kismaric, *Jan Groover* (New York: Museum of Modern Art, 1987).

372 Richard L. Woodward, "David Levinthal," in David Levinthal, *The Wild West* (Washington, D.C.: Smithsonian Institution Press, 1993), p. 62

373 See Carol Squiers, "Entertainment and Distress: The Photographs of Sandy Skoglund," in Linda Muehlig et al., *Sandy Skoglund: Reality Under Siege* (New York: Abrams, 1998), pp. 28-48.

374 Quoted in Debra Heimerdinger, *Optiks: Photographs by Zeke Berman* (San Francisco: Friends of Photography, 1992), n.p.

375 See, for example, Joel Weishaus, "Patrick Nagatani & Andrée Tracey: Atomic Polaroids," *Artspace* (July-August 1989): 36-38.

376 From a 1981 interview, cited in Buzz Spector and Raymond Carver, *Jo Ann Callis: Objects of Reverie, Selected Photographs 1977-1989* (Des Moines: Des Moines Art Center, 1989), p. 7.

377 Owen Edwards, "Joel-Peter Witkin," *American Photographer* (November 1985): 42. See also Cynthia Chris, "Witkin's Others," *Exposure* 26(Spring 1988): 16-26.

378 On the popularity of these images in the marketplace, see Edwards, "Joel-Peter Witkin," p. 52.

379 The different values of these two camps forms the basis of such articles as Richard B. Woodward's "It's Art, But Is It Photography?" *New York Times Magazine* (October 9, 1988): 29-31, 42, 44, 46, 54-55, 57. For a sampling of the many articles published on the artists, see, for example, Nancy Stapen, "Still-Rising Starns," *Artnews* (February 1988): 110-13; Robert Pincus-Witten, "Being Twins: The Art of Doug and Mike Starn," *Arts Magazine* (October 1988): 72-77; and Francine A. Koslow, "New Life for Old Masters," *Contemporanea* 2(September 1989): 72-75.

380 Michael Sand, "Adam Fuss," *Aperture*, no. 133 (Fall 1993): 51.

381 See Scott MacDonald, "Patrick Clancy's Photoscrolls," *Afterimage* 8(May 1981): 13-16; and Edward Bryant, "The Recent Photoscrolls of Patrick Clancy," and "Patrick Clancy's 365/360," *Artspace* (Spring 1986): 11-14.

382 Bryant, "The Recent Photoscrolls of Patrick Clancy," p. 11.

383 This image, from Marey's book *Animal Mechanism*, is reproduced in Marta Braun, *Picturing Time: The Work of Etienne-Jules Marey (1830-1904)* (Chicago: University of Chicago Press, 1992), p. 27.

384 Eagleton, *Literary Theory*, p. 138.

385 See, for example, D. W. Meinig, ed., *The Interpretation of Ordinary Landscapes* (New York: Oxford University Press, 1979).

386 Ibid., p. 2.

387 William Jenkins, *New Topographics: Photographs of a Man-altered Landscape* (Rochester: George Eastman House, 1975), p. 5.

388 Ibid., p. 7.

389 For a contemporary discussion of these artists and ideas, see Carter Ratcliff, "Route 66 Revisited: The New Landscape Photography," *Art in America* 64(January-February 1976): 86-91.

390 See Baltz's commentary in "Notes on Recent Industrial Developments in Southern California," *Image* 17:2 (June 1974): 2; and his text in Carol DiGrappa, ed., *Landscape: Theory* (New York: Lustrum Press, 1980), pp. 24-29.

391 Significantly, Baltz's publication of these pictures contained no text at all beyond the precisely descriptive captions for each plate. Lewis Baltz, *The New Industrial Parks Near Irvine, California* (New York: Castelli Graphics, 1974).

392 One of Baltz's most extended comments on his ideas and working method is contained in DiGrappa, ed., *Landscape: Theory*, pp. 23-39.

393 It is interesting to note that Adams received a copy of *This Is the American Earth* from his parents in 1960, traveled through Glen Canyon in 1962, and purchased a print of Ansel Adams's *Moonrise, Hernandez, New Mexico*, in 1966. Cited in "Chronology," Robert Adams, *To Make It Home: Photographs of the American West* (New York: Aperture, 1989), pp. 166-67.

394 Robert Adams, *Why People Photograph: Selected Essays and Reviews* (New York: Aperture, 1994), p. 155.

395 In addition to the above volume, see his *Beauty in Photography: Essays in Defense of Traditional Values* (Millerton, N.Y.: Aperture, 1981).

396 Robert Adams, *Los Angeles Spring* (New York: Aperture, 1986).

397 See, for example, Richard Misrach with Myriam Weisang Misrach, *Bravo 20: The Bombing of the American West* (Baltimore: Johns Hopkins University Press, 1990); Richard Misrach and Susan Sontag, *Violent Legacies: Three*

Charles D. Arnold (U.S., 1844-1927)

Hales, Peter B. *Constructing the Fair: Platinum Photographs by C. D. Arnold of the World's Columbian Exposition.* Chicago: Art Institute of Chicago, 1993.

Horace D. Ashton (U.S., 1883-1976)

Kurt W. Baasch (U.S., b. Venezuela, 1891-1964)

Jessie Tarbox Beals (U.S., b. Canada, 1870-1942)

Alland, Alexander, Sr. *Jessie Tarbox Beals: First Woman News Photographer.* New York: Camera/Graphic Press, 1978.

Dr. Albert R. Benedict (U.S., 1873-1953)

H. H. Bennett (U.S., b. Canada, 1843-1908)

Bamberger, Tom. *H. H. Bennett: A Sense of Place.* Milwaukee: Milwaukee Art Museum, 1992.

Roth, Sara. *Pioneer Photographer: Wisconsin's H. H. Bennett.* Madison, Wis.: Tamarack Press, 1979.

Wilson Alwyn Bentley (U.S., 1865-1931)

Bentley, Wilson A., and W. J. Humphreys. *Snow Crystals.* New York: Dover Publications, 1962.

Blanchard, Duncan C. "Wilson Bentley, Pioneer in Snowflake Photomicrography." *Photographic Applications in Science, Technology and Medicine* 8 (May 1973): 26-28, 39-41.

Charles I. Berg (U.S., 1856-1926)

Jeanette Vogt Bernard (U.S., ca. 1860-?)

A. H. Binden (U.S., active 1880s)

Francis Blake (U.S., 1850-1913)

J. P. Blessing & Co. (U.S., active 1890s)

Anne W. Brigman (U.S., 1868-1950)

Ehrens, Susan. *A Poetic Vision: The Photographs of Anne Brigman.* Santa Barbara, Calif.: Santa Barbara Museum of Art, 1995.

Heyman, Therese Thau. *Anne Brigman: Pictorial Photographer/Member of the Photo-Secession.* Oakland, Calif.: Oakland Museum, 1974.

John G. Bullock (U.S., 1854-1939)

Beck, Tom. *An American Vision: John G. Bullock and the Photo-Secession.* Baltimore: Albin O. Kuhn Library and Gallery/Aperture, 1988.

Henry N. Cady (U.S., 1849-1935)

Henry Newell Cady: Warren, Rhode Island 1849-1935, From the Collection of Robert and Marjorie Catanzaro. Florence: Palazzo Strozzi, 1985.

John Chislett (U.S., 1856-1938)

Emilie V. Clarkson (U.S., 1863-1946)

Alvin Langdon Coburn (Britain, b. U.S., 1882-1966)

Gernsheim, Helmut, and Alison Gernsheim, eds. *Alvin Langdon Coburn, Photographer: An Autobiography.* London: Faber & Faber, 1966.

Weaver, Mike. *Alvin Langdon Coburn: Symbolist Photographer, 1882-1966.* New York: Aperture, 1986.

Edward S. Curtis (U.S., 1868-1952)

Curtis, Edward S. *The North American Indian: The Complete Portfolios.* Cologne: Taschen, 1997.

Davis, Barbara A. *Edward S. Curtis: The Life and Times of a Shadow Catcher.* San Francisco: Chronicle Books, 1985.

Lyman, Christopher M. *The Vanishing Race and Other Illusions: Photographs of Indians by Edward S. Curtis.* New York: Pantheon Books, 1982.

Dwight A. Davis (U.S., 1852-1944)

F. Holland Day (U.S., 1864-1933)

Clattenburg, Ellen Fritz. *The Photographic Work of F. Holland Day.* Wellesley, Mass.: Wellesley College Museum, 1975.

Crump, James. *F. Holland Day: Suffering the Ideal.* Santa Fe: Twin Palms, 1995.

Curtis, Verna Posever, and Jane Van Nimmen, eds. *F. Holland Day: Selected Texts and Bibliography.* New York: G.K. Hall, 1995.

Jussim, Estelle. *Slave to Beauty: The Eccentric Life and Controversial Career of F. Holland Day, Photographer, Publisher, Aesthete.* Boston: David R. Godine, 1981.

Baron Adolph de Meyer (U.S., b. Germany, 1868-1949)

Brandau, Robert, ed. *De Meyer.* New York: Alfred A. Knopf, 1976.

Ehrenkranz, Anne, et al. *A Singular Elegance: The Photographs of Baron Adolph de Meyer.* San Francisco: Chronicle Books, 1994.

John G. Doughty (U.S., active 1880s)

Arthur Wesley Dow (U.S., 1857-1922)

Dow, Arthur Wesley. *Composition.* Introduction by Joseph Masheck. Berkeley: University of California Press, 1997.

Green, Nancy E. *Arthur Wesley Dow and His Influence.* Ithaca, N.Y.: Herbert F. Johnson Museum of Art, 1990.

Moffatt, Frederick C. *Arthur Wesley Dow, 1857-1922.* Washington, D.C.: Smithsonian Institution Press, 1977.

Echard (U.S., active 1890s)

Rudolf Eickemeyer, Jr. (U.S., 1862-1932)

Panzer, Mary. *In My Studio: Rudolf Eickemeyer, Jr. and the Art of the Camera, 1885-1930.* Yonkers, N.Y.: Hudson River Museum, 1986.

Benjamin J. Falk (U.S., 1853-1925)

William A. Fraser (U.S., ca. 1840-1925)

Dallet Fuguet (U.S., 1868-1933)

Arnold Genthe (U.S., b. Germany, 1869-1942)

Genthe, Arnold. *As I Remember.* New York: Reynal & Hitchcock, 1936.

Tchen, John Kuo Wei. *Genthe's Photographs of San Francisco's Chinatown.* New York: Dover Publications, 1984.

James H. Hare (U.S., b. England, 1856-1946)

Carnes, Cecil. *Jimmy Hare, News Photographer: Half a Century with a Camera.* New York: Macmillan Company, 1940.

Gould, Lewis L., and Richard Greffe. *Photojournalist: The Career of Jimmy Hare.* Austin: University of Texas Press, 1977.

Paul B. Haviland (U.S., b. France, 1880-1950)

F. Jay Haynes (U.S., 1853-1921)

F. Jay Haynes, Photographer. Helena: Montana Historical Society, 1981.

Nolan, Edward W. *Northwest Pacific Views: The Railroad Photographs of F. Jay Haynes.* Helena: Montana Historical Society, 1983.

Lewis W. Hine (U.S., 1874-1940)

Curtis, Verna Posever, and Stanley Mallach. *Photography and Reform: Lewis Hine & the National Child Labor Committee.* Milwaukee: Milwaukee Art Museum, 1984.

Kaplan, Daile. *Lewis Hine in Europe: The "Lost" Photographs.* New York: Abbeville, 1988.

Kaplan, Daile, ed. *Photo Story: Selected Letters and Photographs of Lewis W. Hine.* Washington, D.C.: Smithsonian Institution Press, 1992.

Rosenblum, Walter, Naomi Rosenblum, and Alan Trachtenberg. *America and Lewis Hine: Photographs 1904-1940.* Millerton, N.Y.: Aperture, 1977.

Bertha E. Jaques (U.S., 1863-1941)

Clifton Johnson (U.S., 1865-1940)

Frances Benjamin Johnston (U.S., 1864-1952)

Daniel, Pete, and Raymond Smock. *A Talent for Detail: The Photographs of Frances Benjamin Johnston, 1889-1910.* New York: Harmony Books, 1974.

Glenn, Constance W., and Leland Rice. *Frances Benjamin Johnston, Women of Class and Station.* Long Beach: Art Museum and Galleries, California State University, 1979.

Kirstein, Lincoln, and Frances Benjamin Johnston. *The Hampton Album.* New York: Museum of Modern Art, 1966.

John Johnston (U.S., active 1880s)

Gertrude Käsebier (U.S., 1852-1934)

Homer, William Innes, et al. *A Pictorial Heritage: The Photographs of Gertrude Käsebier.* Wilmington: University of Delaware/Delaware Art Museum, 1979.

Michaels, Barbara L. *Gertrude Käsebier: The Photographer and Her Photographs.* New York: Harry N. Abrams, 1992.

Joseph T. Keiley (U.S., 1869-1914)

Edwin Hale Lincoln (U.S., 1848-1938)

Dimock, George. *A Persistence of Vision: Photographs by Edwin Hale Lincoln.* Lenox, Mass.: Lenox Library Association/Berkshire Museum, 1981.

John L. Lovell (U.S., 1825-1903)

Dr. Charles L. Mitchell (U.S., active ca. 1885-1905)

Frederick Monsen (U.S., 1865-1929)

C. W. Motes (U.S., 1837-1919)

William J. Mullins (U.S., 1860-1917)

Bibliography

The following list provides an introductory bibliography of American photography from about 1885 to the present, including monographs on the artists whose works are reproduced in this volume. The emphasis is on publications that are in print or generally available. Basic biographic information is given for all the photographers reproduced in this volume, including those without monographic references. Additional citations for many of these artists—including journal articles—can be found in the endnotes.

General Works

Baldwin, Gordon. *Looking at Photographs: A Guide to Technical Terms.* Malibu, Calif.: J. Paul Getty Museum, 1991.

Enyeart, James, ed. *Decade by Decade: Twentieth-Century American Photography from the Collection of the Center for Creative Photography.* Boston: Bulfinch/Center for Creative Photography, 1989.

Eskind, Andrew H., and Greg Drake, eds. *Index to American Photographic Collections.* 3rd rev. ed. Boston: G.K. Hall, 1995.

Fels, Thomas Weston. *O Say Can You See: American Photographs, 1839-1939; One Hundred Years of American Photographs from the George R. Rinhart Collection.* Cambridge, Mass.: MIT Press, 1989.

Goldberg, Vicki, ed. *Photography in Print: Writings from 1816 to the Present.* New York: Simon and Schuster, 1981.

Greenough, Sarah, Joel Snyder, David Travis, and Colin Westerbeck. *On the Art of Fixing a Shadow: One Hundred and Fifty Years of Photography.* Washington, D.C.: National Gallery of Art, 1989.

Hambourg, Maria Morris, et al. *The Waking Dream: Photography's First Century.* New York: Metropolitan Museum of Art/Harry N. Abrams, 1993.

Lyons, Nathan, ed. *Photographers on Photography.* Englewood Cliffs, N.J.: Prentice-Hall, 1966.

Newhall, Beaumont. *The History of Photography.* New York: Museum of Modern Art, 1982.

Newhall, Beaumont, ed. *Photography: Essays & Images.* New York: Museum of Modern Art, 1980.

Petruck, Peninah R., ed. *The Camera Viewed: Writings on Twentieth-Century Photography.* New York: E.P. Dutton, 1979.

Rosenblum, Naomi. *A History of Women Photographers.* New York: Abbeville, 1994.

Rosenblum, Naomi. *A World History of Photography.* 3rd rev. ed. New York: Abbeville, 1997.

Sobieszek, Robert A. *The Art of Persuasion: A History of Advertising Photography.* New York: Harry N. Abrams, 1988.

Sobieszek, Robert A. *Masterpieces of Photography from the George Eastman House Collections.* New York: Abbeville, 1985.

Szarkowski, John. *Looking at Photographs.* New York: Museum of Modern Art, 1973.

Szarkowski, John. *Photography Until Now.* New York: Museum of Modern Art, 1989.

Trachtenberg, Alan. *Reading American Photographs: Images as History, Mathew Brady to Walker Evans.* New York: Hill and Wang, 1989.

Travis, David. *Photography Rediscovered: American Photographs, 1900-1930.* New York: Whitney Museum, 1979.

CHAPTER I **A Reluctant Modernism 1890-1915**

General Works

Bunnell, Peter C., ed. *The Art of Pictorial Photography, 1890-1925.* Princeton: Princeton University Art Museum, 1992.

Carlebach, Michael L. *American Photojournalism Comes of Age.* Washington, D.C.: Smithsonian Institution Press, 1997.

Green, Jonathan, ed. *Camera Work: A Critical Anthology.* Millerton, N.Y.: Aperture, 1973.

Hales, Peter Bacon. *Silver Cities: The Photography of American Urbanization, 1839-1915.* Philadelphia: Temple University Press, 1984.

Homer, William Innes, ed. *Pictorial Photography in Philadelphia: The Pennsylvania Academy's Salons, 1898-1901.* Philadelphia: Pennsylvania Academy of the Fine Arts, 1984.

Lawton, Harry W., and George Knox, eds. *The Valiant Knights of Daguerre: Selected Critical Essays on Photography and Profiles of Photographic Pioneers by Sadakichi Hartmann.* Berkeley: University of California Press, 1978.

Naef, Weston J., ed. *The Collection of Alfred Stieglitz: Fifty Pioneers of Modern Photography.* New York: Metropolitan Museum of Art, 1978.

Panzer, Mary. *Philadelphia Naturalistic Photography, 1865-1906.* New Haven: Yale University Art Gallery, 1982.

Sandweiss, Martha A., ed. *Photography in Nineteenth-Century America.* New York: Harry N. Abrams/Amon Carter Museum, 1991.

Taft, Robert. *Photography and the American Scene.* 1938; repr., New York: Dover Publications, 1964.

Welling, William. *Photography in America: The Formative Years, 1839-1900, A Documentary History.* New York: Thomas Y. Crowell, 1978.

Wood, John. *The Art of the Autochrome: The Birth of Color Photography.* Iowa City: University of Iowa Press, 1993.

Individual Artists

John A. Anderson (U.S., b. Sweden, 1869-1948)

Doll, Don, and Jim Alinder, eds. *Crying for a Vision: A Rosebud Sioux Trilogy, 1886-1976; Photographs by John A. Anderson, Eugene Buechel, Don Doll.* Dobbs Ferry, N.Y.: Morgan & Morgan, 1976.

believe that there is nothing computers cannot do and should not be doing. The result has been the creation of a mystique of information that makes basic intellectual discriminations between data, knowledge, judgment, imagination, insight, and wisdom impossible.

438 See, for example, "Shoot First, E-Mail Photos to Grandma Later," *New York Times* (June 11, 1998): D1, D8.

439 For example, two items spotted in recent issues of the *New York Times*: Kodak's announcement that it had developed a system to deliver processed photos to consumers on the internet by e-mail (May 21, 1998, p. D3), and a report on the rising popularity of digital photo booths (September 10, 1998, p. D6).

440 This work was created with the technical assistance of Richard Carling and David Kramlich.

441 Kathleen Ruiz, quoted in Charles Hagen, "Photography: The Dawn of a New Age?" *Artnews* (March 1993): 75.

442 Charles Hagen, "Reinventing the Photograph," *New York Times* (January 31, 1993): 1, 29. On this subject, see, for example, Marnie Gillett and Jim Pomeroy, eds., *Digital Photography* (San Francisco: SF Camerawork, 1988); William J. Mitchell, *The Reconfigured Eye: Visual Truth in the Post-Photographic Era* (Cambridge, Mass.: MIT Press, 1992); Hubertus v. Amelunxen et al., eds., *Photography After Photography: Memory and Representation in the Digital Age* (Munich: G & B Arts, 1996); Frederick Murphy, "Photography in the Time of the Bit Weavers" (self published, 1996); and special issues of *Camerawork* 20:1 (Spring-Summer 1993); *Aperture,* no. 136 (Summer 1994); *On Paper* 1:1 (1998); and *History of Photography* 22:1 (Spring 1998). The first issue of *Artbyte,* self-described as "The Magazine of Digital Arts," is dated April-May 1998.

443 Hagen, "Photography: The Dawn of a New Age?" p. 75.

444 Hagen, "Reinventing the Photograph," p. 29.

445 The loss of this essential "truth function" has been the subject of broad interest and discussion. See, for example, such varied articles as: Barbara E. Savedoff, "Escaping Reality: Digital Imagery and the Resources of Photography," *Journal of Aesthetics and Art Criticism* 55(Spring 1997): 201-14; Amy M. Spindler, "Making the Camera Lie, Digitally and Often," *New York Times* (June 17, 1997): B8; and Kenneth Brower, "Photography in the Age of Falsification," *Atlantic Monthly* (May 1998): 92-97, 100-02, 104-11. This perceived threat to the truth function of "traditional" experience has other ramifications; for a report on the use of digital technology to falsify sound recordings, see Andrew Pollack, "Sounds Bites and Then Some," *New York Times* (April 21, 1997): C1, C8.

446 Nulty, "The New Look of Photography," p. 39.

447 Quoted in Jenkins, *New Topographics*, p. 6.

448 Wright Morris, "Photography in My Life," in James Alinder, ed., *Wright Morris: Photographs & Words* (Carmel, Calif.: Friends of Photography, 1982), p. 54.

Cantos (New York: Aperture, 1992); and Peter Goin, *Nuclear Landscapes* (Baltimore: Johns Hopkins Press, 1991).

398 On this theme, see Michael Barkun, "Divided Apocalypse: Thinking About The End in Contemporary America," *Soundings* (Fall 1983): 257-80; Eleanor Heartney, "The End of the World," *Arts Magazine* (February 1984): 99-1-1; and Suzi Gablik, "Art Alarms: Visions of the End," *Art in America* (April 1984): 11-14.

399 Connor et al., *Marks in Place: Contemporary Responses to Rock Art* (Albuquerque: University of New Mexico Press, 1988), p. 12. This volume presents a superb overview of work by her and others in this vein.

400 In an exhibition statement of 1987, Dingus observed:

One aspect of my awareness is grounded in the present, but another wanders forward and backward through time, searching for signs of where we came from and where we are going. In my imagination the immense span of geological time transforms the solid earth into a liquid and flowing event, hinting at a larger pattern than we can see and indicating that we are not separate from nature but are part of its process.

401 Lois Conner, *Panoramas of the Far East* (Washington, D.C.: Smithsonian Institution Press, 1993), p. 7.

402 Joel Sternfeld, *On This Site: Landscape in Memoriam* (San Francisco: Chronicle Books, 1996), n.p. ("Afterword").

403 The Dunmore & Critcherson photographs were commissioned by the painter William Bradford and were included in Bradford's publication *The Arctic Regions* (London: Sampson Lowe, Marston, Low & Searle, 1873).

404 Alexandra Anderson-Spivey, *Lynn Davis* (Overland Park, Kan.: Johnson County Gallery of Art, 1994), unpaginated exhibition brochure.

405 Beginning most memorably with Kasimir Malevich's Suprematist paintings of the late 1910s.

406 Cooper's interest in the literature of Blake, the paintings of Rothko, Newman, Martin, and Twombly, and the photographs of O'Sullivan, Stieglitz, Weston, and White, is outlined in essays such as Peter Bunnell, "Thomas Joshua Cooper: The Temperaments," in Thomas Joshua Cooper, *A simples contagem das ondas/Simply Counting Waves* (Lisbon: Centro de Arte Moderna José de Azeredo Perdigão, 1994), pp. 142-45. In addition, in collaboration with Paul Hill, Cooper interviewed many noted photographers in the 1970s. These interviews were published in *Camera* (Lucerne) and collected in Paul Hill and Thomas Cooper, *Dialogue with Photography* (New York: Farrar Straus Giroux, 1979).

407 In this context, it seems appropriate to note that Cooper is of Native American descent (his father was one-quarter Cherokee). At the age of seven, Cooper and his father were both inducted into the Ogalala (Sioux) nation by blood ceremony. See "Biographical Information," in Cooper, *A simples contagem das ondas*, p. 157.

408 In the end, an emphasis on the body was perhaps an inevitable result of modern philosophy's relentless project of demystification. In this light, it is instructive to consider how our collective notions of the Western self have changed. In the last several centuries, I would suggest, the central concept of individual identity has shifted progressively from *soul* to *character* to *personality* to *body*. This movement represents a profound series of changes in our "foundational" frames of reference: from religion (the cosmos) to society (the world) to psychology (the mind) to simple existential presence (mere matter). It should go without saying that much has been lost in this intellectual trajectory. For relevant photographic surveys of this era, see William A. Ewing, *The Body* (San Francisco: Chronicle, 1994); and John Pultz, *Photography and the Body* (London: Everyman Library, 1995). Of the nearly endless number of articles that could be cited, the following is particularly germane: Caroline Bynum, "Why All the Fuss about the Body? A Medievalist's Perspective," *Critical Inquiry* 22(Autumn 1995): 1-33.

409 Of course, there is an extensive history of self-portraiture in photography. For an introduction to this subject, see such collections as: Erika Billeter, *Self-Portrait in the Age of Photography* (Lausanne: Musée Cantonal des Beaux-Arts Lausanne, 1985); and Robert A. Sobieszek and Deborah Irmas, *the camera i* (Los Angeles: Los Angeles County Museum of Art/Abrams, 1994).

410 Fay Hirsch, "Odd Geometry: The Photographs of Francesca Woodman," *Print Collector's Newsletter* (May-June 1994): 45. See also Lorraine Kenny, "Problem Sets: The Canonization of Francesca Woodman," *Afterimage* 14(November 1986): 4-5.

411 In addition to the Blinderman catalogue listed in the bibliography, see Richard Martin, "The Expeditionary Photographs of Tseng Kwong Chi," *Arts Magazine* (September 1986): 94-97.

412 For a more detailed discussion of this work, see Kathleen McCarthy Gauss, *New American Photography* (Los Angeles: Los Angeles County Museum of Art, 1985), pp. 58-62.

413 Lisa Lyons and Martin Friedman, *Close Portraits* (Minneapolis: Walker Art Center, 1980), p. 34.

414 This episode is discussed in numerous articles of the following years, and in John Guare, *Chuck Close: Life and Work 1988-1995* (New York: Thames and Hudson, 1995).

415 Among his other achievements, Coplans was the founding editor (1962) and editor-in-chief of *Artforum* magazine, senior curator of the Pasadena Art Museum (1967-70), director of the Akron Art Museum (1978-80), and the author of books on Cézanne, Warhol, Roy Lichtenstein, Ellsworth Kelly, and Weegee.

416 Most of these are documented in *Jim Dine Photographs* (London: Alan Cristea Gallery, 1997).

417 For a lively introduction to this artist's work and ideas, see Michael Kimmelman, "Making Metaphors of Art and Bodies," *New York Times* (November 15, 1996): B1, B12.

418 These debates over censorship and arts funding stimulated a mountain of commentary. For an introduction to this literature, see, for example: Robert Hughes, "Art, Morals and Politics," *New York Review of Books* (April 23, 1992): 21-27; Steven C. Dubin, *Arresting Images: Impolitic Art and Uncivil Actions* (London: Routledge, 1992); Alice Goldfarb Marquis, *Art Lessons: Learning from the Rise and Fall of Public Arts Funding* (New York: Basic Books, 1995); and Elizabeth C. Childs, ed., *Suspended License: Censorship and the Visual Arts* (Seattle: University of Washington Press, 1997).

419 See Matthew Rose, "David Wojnarowicz: An Interview," *Arts Magazine* (May 1988): 60-65; and Lucy R. Lippard, "Out of the Safety Zone," *Art in America* (December 1990): 130-39, 182, 186.

420 Quoted in Lucy Lippard's overview of Serrano's work, "Andres Serrano: The Spirit and the Letter," *Art in America* (April 1990): 242.

421 Anastasia Aukeman, "Bill Jacobson: Coming Together and Letting Go," *Artnews* (October 1995): 95.

422 Bill Jacobson, "Songs of Sentient Beings," *See* 2:2 (1996): 31.

423 John Szarkowski, *Mr. Bristol's Barn* (New York: Abrams, 1997).

424 It is significant to note that, at the time he was making these photographs of his own barn and property, Szarkowski was working on a study of Stieglitz's late pictures: *Stieglitz at Lake George* (New York: Museum of Modern Art, 1995).

425 *Keith Carter Photographs: Twenty-Five Years* (Austin: University of Texas Press, 1997), n.p.

426 "In Progress," *DoubleTake* 4:1 (Winter 1998): 23.

427 Morell describes the technical details of this process in his book *A Camera in a Room* (Washington, D.C.: Smithsonian Institution Press, 1995), pp. 6-7.

428 Ibid., p. 61.

429 For an early statement on this work, see Milton Rogovin, "Six Blocks Square," *Image* (June 1974): 10.

430 See, for example, his book *Family Pictures* (Washington, D.C.: Smithsonian Institution Press, 1991).

431 Jeffrey A. Wolin, *Written in Memory: Portraits of the Holocaust* (San Francisco: Chronicle Books, 1997), p. 6.

432 Tina Barney and Andy Grundberg, *Tina Barney: Photographs, Theater of Manners* (Zurich: Scalo, 1997), p. 250.

433 Larry Sultan, *Pictures from Home* (New York: Harry N. Abrams, 1992), p. 114. Elsewhere in this volume, Sultan notes, "I realize that beyond the rolls of film and the few good pictures, the demands of my project and the confusion about its meaning, is the wish to take photography literally. To stop time. I want my parents to live forever" (p. 18).

434 Richard B. Woodward, "The Disturbing Photography of Sally Mann," *New York Times Magazine* (September 27, 1992): 36.

435 Sally Mann, *Immediate Family* (New York: Aperture, 1992), n.p.

436 Peter Galassi, *Pleasures and Terrors of Domestic Comfort* (New York: Museum of Modern Art, 1991), p. 22.

437 Peter Nulty, "The New Look of Photography," *Fortune* (July 1, 1991): 36. Of course, such enthusiasm is squarely in the American tradition of greeting most new technologies with absurdly utopian expectations. If there is any consistent trait associated with technology changes, it is the law of unintended consequences. New technologies never simply eliminate existing problems; they solve *some* problems and create new, unexpected ones. For a less enthusiastic interpretation of today's computer culture, see Theodore Roszak, *The Cult of Information* (Berkeley: University of California Press, 1994). For example, Roszak writes (p. xix):

The "data merchants"...find their careers or their investments tied to the extravagant promises that attach to computers; they have every reason to

Eadweard Muybridge (U.S., b. England, 1830-1904)

Harris, David, and Eric Sandweiss. *Eadweard Muybridge and the Photographic Panorama of San Francisco, 1850-1880*. Montreal: Canadian Centre for Architecture, 1993.

Hendricks, Gordon. *Eadweard Muybridge: The Father of the Motion Picture*. New York: Grossman, 1975.

Muybridge's Complete Human and Animal Locomotion. New York: Dover Publications, 1979.

Sheldon, James L., and Jock Reynolds. *Motion and Document, Sequence and Time: Eadweard Muybridge and Contemporary American Photography*. Seattle: University of Washington Press, 1993.

Robert E. Peary (U.S., 1856-1920)

Weems, John Edward. *Peary: The Explorer and the Man*. Boston: Houghton Mifflin, 1967.

William B. Post (U.S., 1857-1925)

William H. Rau (U.S., 1855-1920)

Perloff, Stephen, and Gerald Bastoni. *William Herman Rau: Lehigh Valley Railroad Photographs, 1899*. Bethlehem, Pa.: Lehigh University Art Galleries, 1989.

Robert S. Redfield (U.S., 1849-1923)

Jacob A. Riis (U.S., b. Denmark, 1849-1914)

Alland, Alexander, Sr. *Jacob A. Riis, Photographer and Citizen*. Millerton, N.Y.: Aperture, 1974.

Riis, Jacob A. *How the Other Half Lives* (1901). Introduction by Luc Sante. New York: Penguin Books, 1997.

Frank A. Rinehart (U.S., 1861-1928)

The Face of Courage: The Indian Photographs of Frank A. Rinehart. Fort Collins, Colo.: Old Army Press, 1972.

Harry C. Rubincam (U.S., 1871-1940)

George H. Seeley (U.S., 1880-1955)

Dimock, George, and Joanne Hardy. *Intimations & Imaginings: The Photographs of George H. Seeley*. Pittsfield, Mass.: Berkshire Museum, 1986.

Thomas O'Conor Sloane, Jr. (U.S., 1879-1963)

Ema Spencer (U.S., 1857-1941)

Edward Steichen (U.S., b. Luxembourg, 1879-1973)

Longwell, Dennis. *Steichen: The Master Prints 1895-1914, The Symbolist Period*. New York: Museum of Modern Art, 1978.

Niven, Penelope. *Steichen: A Biography*. New York: Clarkson N. Potter, 1997.

Steichen, Edward. *A Life in Photography*. New York: Doubleday & Company, 1963.

Alfred Stieglitz (U.S., 1864-1946)

Bry, Doris. *Alfred Stieglitz: Photographer*. Boston: Museum of Fine Arts, 1965.

Frank, Waldo, Lewis Mumford, Dorothy Norman, Paul Rosenfeld, and Harold Rugg, eds. *America and Alfred Stieglitz: A Collective Portrait*. 1934; rev. ed., Millerton, N.Y.: Aperture, 1979.

Georgia O'Keeffe: A Portrait by Alfred Stieglitz. New York: Metropolitan Museum of Art, 1978.

Greenough, Sarah, and Juan Hamilton. *Alfred Stieglitz: Photographs & Writings*. Washington, D.C.: National Gallery, 1983.

Norman, Dorothy. *Alfred Stieglitz: An American Seer*. Millerton, N.Y.: Aperture, 1973.

Stieglitz, Alfred. *Camera Work: The Complete Illustrations, 1903-1917*. Cologne: Taschen, 1997.

Whelan, Richard. *Alfred Stieglitz: A Biography*. Boston: Little, Brown, 1995.

Edmund J. Stirling (U.S., 1861-1948)

Karl Struss (U.S., 1886-1981)

Harvith, Susan, and John Harvith. *Karl Struss: Man with a Camera*. Bloomfield Hills, Mich.: Cranbrook Academy of Art/Museum, 1976.

McCandless, Barbara, Bonnie Yochelson, and Richard Koszarski. *New York to Hollywood: Photographs by Karl Struss*. Albuquerque: University of New Mexico Press, 1994.

Adam Clark Vroman (U.S., 1856-1916)

Mahood, Ruth I., ed. *Photographer of the Southwest: Adam Clark Vroman, 1856-1916*. Los Angeles: Ward Ritchie Press, 1961.

Webb, William, and Robert A. Weinstein. *Dwellers at the Source: Southwestern Indian Photographs of A. C. Vroman, 1895-1904*. New York: Grossman, 1973.

R. J. Waters & Co. (U.S., active 1900s)

Eva Watson-Schütze (U.S., 1867-1935)

Block, Jean F. *Eva Watson-Schütze: Chicago Photo-Secessionist*. Chicago: University of Chicago Library, 1985.

Keiley, Joseph T. "Eva Watson-Schütze." *Camera Work* (January 1905). Repr., *Camera* (March 1977): 4-13.

Clarence H. White (U.S., 1871-1925)

Bunnell, Peter C. *Clarence H. White: The Reverence for Beauty*. Athens: Ohio University Gallery of Fine Art, 1986.

Homer, William Innes, ed. *Symbolism of Light: The Photographs of Clarence H. White*. Wilmington: University of Delaware/Delaware Art Museum, 1977.

Ben Wittick (U.S., 1845-1903)

Broder, Patricia Janis. *Shadows on Glass: The Indian World of Ben Wittick*. Savage, Md.: Rowman & Littlefield, 1990.

Frank Lloyd Wright (U.S., 1867-1959)

Levine, Neil. *The Architecture of Frank Lloyd Wright*. Princeton: Princeton University Press, 1996.

Secrest, Meryle. *Frank Lloyd Wright*. New York: Alfred A. Knopf, 1992.

CHAPTER II Abstraction and Realism 1915-1940

General Works

Barnes, Lucinda, Constance W. Glenn, and Jane K. Bledsoe, eds. *A Collective Vision: Clarence H. White and His Students*. Long Beach: California State University Art Museum, 1985.

Coke, Van Deren. *Avant-Garde Photography in Germany, 1919-1939*. San Francisco: San Francisco Museum of Modern Art, 1980.

Daniel, Pete, Merry A. Foresta, Maren Stange, and Sally Stein. *Official Images: New Deal Photography*. Washington, D.C.: Smithsonian Institution Press, 1987.

Fiedler, Jeannine, ed. *Photography at the Bauhaus*. Cambridge, Mass.: MIT Press, 1990.

Fleischhauer, Carl, and Beverly W. Brannan, eds. *Documenting America, 1935-1943*. Berkeley: University of California Press, 1988.

Fulton, Marianne, Bonnie Yochelson, and Kathleen Erwin. *Pictorialism into Modernism: The Clarence H. White School*. New York: Rizzoli, 1996.

Hambourg, Maria Morris, and Christopher Phillips. *The New Vision: Photography Between the World Wars*. New York: Metropolitan Museum of Art/Harry N. Abrams, 1989.

Krauss, Rosalind, and Jane Livingston, eds. *L'Amour fou: Photography and Surrealism*. Washington, D.C.: Corcoran Gallery of Art, 1985.

Naumann, Francis M. *New York Dada, 1915-23*. New York: Harry N. Abrams, 1994.

Newhall, Beaumont, and Steven Yates. *Proto-Modern Photography*. Santa Fe: Museum of Fine Arts, 1992.

O'Neal, Hank. *A Vision Shared: A Classic Portrait of America and Its People, 1935-1943*. New York: St. Martin's Press, 1976.

Peterson, Christian A. *After the Photo-Secession: American Pictorial Photography, 1910-1955*. Minneapolis: Minneapolis Institute of Arts/Norton, 1997.

Pitts, Terence. *Photography in the American Grain: Discovering a Native American Aesthetic, 1923-1941*. Tucson: Center for Creative Photography, 1988.

Pultz, John, and Catherine B. Scallen. *Cubism and American Photography, 1910-1930*. Williamstown, Mass.: Sterling and Francine Clark Art Institute, 1981.

Read, Dennis. *Japanese Photography in America, 1920-1940*. Los Angeles: George J. Doizaki Gallery/Japanese American Cultural & Community Center, 1985.

Stott, William. *Documentary Expression and Thirties America*. New York: Oxford University Press, 1973.

Travis, David. *Photographs from the Julien Levy Collection Starting with Atget*. Chicago: Art Institute of Chicago, 1976.

Individual Artists

William H. Abbenseth (U.S., 1892-?)

Berenice Abbott (U.S., 1898-1991)

Abbott, Berenice. *Photographs*. New York: Horizon Press, 1970.

McCausland, Elizabeth, and Berenice Abbott. *Changing New York*. New

York: E.P. Dutton, 1939. Repr. as *New York in the Thirties as Photographed by Berenice Abbott*. New York: Dover Publications, 1973.

Sundell, Michael G. *Berenice Abbott: Documentary Photographs of the 1930s*. Cleveland: New Gallery of Contemporary Art, 1980.

Yochelson, Bonnie. *Berenice Abbott: Changing New York*. New York: New Press/Museum of the City of New York/W.W. Norton, 1997.

Ansel Adams (U.S., 1902-1984)

Adams, Ansel. *Examples: The Making of 40 Photographs*. Boston: New York Graphic Society, 1983.

Adams, Ansel, with Mary Street Alinder. *Ansel Adams: An Autobiography*. Boston: New York Graphic Society, 1985.

Alinder, Mary Street, and Andrea Gray Stillman. *Ansel Adams: Letters and Images, 1916-1984*. Boston: New York Graphic Society, 1988.

Newhall, Nancy. *Ansel Adams: The Eloquent Light*. San Francisco: Sierra Club, 1963.

Spaulding, Jonathan. *Ansel Adams and the American Landscape*. Berkeley: University of California Press, 1995.

Paul L. Anderson (U.S., 1880-1956)

Charles K. Archer (U.S., 1869-1955)

Fred R. Archer (U.S., 1889-1963)

F. Milton Armbrust (U.S., 1896-1964)

Herbert Bayer (U.S., b. Austria, 1900-1985)

Cohen, Arthur Allen. *Herbert Bayer: The Complete Work*. Cambridge, Mass.: MIT Press, 1984.

Ilse Bing (U.S., b. Germany, 1899-1998)

Barrett, Nancy C. *Ilse Bing: Three Decades of Photography*. New Orleans: New Orleans Museum of Art, 1985.

Ilse Bing: Vision of a Century. New York: Edwynn Houk Gallery, 1998.

Erwin Blumenfeld (U.S., b. Germany, 1897-1969)

Ewing, William H., and Marina Schinz. *Blumenfeld Photographs: A Passion for Beauty*. New York: Harry N. Abrams, 1996.

Frances M. Bode (U.S., active 1920s)

Margaret Bourke-White (U.S., 1904-1971)

Bourke-White, Margaret. *Portrait of Myself*. New York: Simon and Schuster, 1963.

Caldwell, Erskine, and Margaret Bourke-White. *You Have Seen Their Faces*. 1937; repr. Athens: Brown Thrasher/University of Georgia Press, 1995.

Goldberg, Vicki. *Bourke-White*. New York: International Center of Photography/United Technologies, 1988.

Goldberg, Vicki. *Margaret Bourke-White: A Biography*. Reading, Mass.: Addison-Wesley, 1987.

Silverman, Jonathan. *For the World to See: The Life of Margaret Bourke-White*. New York: Viking Press, 1983.

Maurice Bratter (U.S., 1905-1986)

Talbot M. Brewer (U.S., 1893-1981)

Anton Bruehl (U.S., b. Australia, 1900-1982)

Yochelson, Bonnie. *Anton Bruehl*. New York: Howard Greenberg Gallery, 1998.

Francis Bruguière (U.S., 1879-1945)

Enyeart, James. *Bruguière: His Photographs and His Life*. New York: Alfred A. Knopf, 1977.

Clarence Sinclair Bull (U.S., 1895-1979)

Pepper, Terence, and John Kobal. *The Man Who Shot Garbo: The Hollywood Photographs of Clarence Sinclair Bull*. New York: Simon and Schuster, 1989.

Arthur D. Chapman (U.S., 1882-1956)

Guy Gayler Clark (U.S., ?-1945)

Alfred Cohn (U.S., 1897-1977)

Will Connell (U.S., 1898-1961)

Coke, Van Deren. *Photographs by Will Connell: California Photographer and Teacher (1898-1961)*. San Francisco: San Francisco Museum of Modern Art, 1981.

White, Stephen. *Will Connell—Interpreter of Intangibles*. Birmingham, Mich.: Halstead Gallery/Stephen White Gallery, 1991.

Marjorie Content (U.S., 1895-1984)

Quasha, Jill. *Marjorie Content: Photographs*. New York: Norton, 1994.

Harold Haliday Costain (U.S., 1897-1994)

Imogen Cunningham (U.S., 1883-1976)

Lorenz, Richard. *Ideas without End: Imogen Cunningham, A Life in Photographs*. San Francisco: Chronicle Books, 1993.

Lorenz, Richard. *Imogen Cunningham: Flora*. Boston: Bulfinch, 1996.

Mann, Margery. *Imogen! ...Photographs 1910-1973*. Seattle: University of Washington Press, 1974.

Rule, Amy, ed. *Imogen Cunningham: Selected Texts and Bibliography*. Boston: G.K. Hall, 1992.

William E. Dassonville (U.S., 1879-1957)

Edward R. Dickson (U.S., 1880-1922)

James N. Doolittle (U.S., 1889-1954)

Harold E. Edgerton (U.S., 1903-1990)

Edgerton, Harold E., and James R. Killian, Jr. *Moments of Vision: The Stroboscopic Revolution in Photography*. Cambridge, Mass.: MIT Press, 1979.

Jussim, Estelle, and Gus Kayafas. *Stopping Time: The Photographs of Harold Edgerton*. New York: Harry N. Abrams, 1987.

John Paul Edwards (U.S., 1884-1968)

Walker Evans (U.S., 1903-1975)

Agee, James, and Walker Evans. *Let Us Now Praise Famous Men*. 1941; 2nd ed., Boston: Houghton Mifflin, 1960.

Evans, Walker. *American Photographs*. 1938; repr., New York: East River Press, 1975.

Fleurov, Ellen. *Walker Evans: Simple Secrets*. Atlanta: High Museum of Art/Harry N. Abrams, 1998.

Keller, Judith. *Walker Evans: The Getty Museum Collection*. Malibu, Calif.: J. Paul Getty Museum, 1995.

Maddox, Jerald C. *Walker Evans: Photographs for the Farm Security Administration, 1935-1938*. New York: Da Capo Press, 1973.

Rathbone, Belinda. *Walker Evans: A Biography*. Boston: Houghton Mifflin, 1995.

Szarkowski, John. *Walker Evans*. New York: Museum of Modern Art, 1971.

Thompson, Jerry L. *Walker Evans at Work*. New York: Harper & Row, 1982.

Walker Evans, First and Last. New York: Harper & Row, 1978.

Adolf Fassbender (U.S., b. Germany, 1884-1980)

Fassbender, Adolf. *Pictorial Artistry: The Dramatization of the Beautiful in Photography*. New York: B. Westermann, 1937.

Peterson, Christian A. *The Pictorial Artistry of Adolf Fassbender*. Nutley, N.J.: Fassbender Foundation, 1994.

W. Grancel Fitz (U.S., 1894-1963)

Laura Gilpin (U.S., 1891-1979)

Sandweiss, Martha A. *Laura Gilpin: An Enduring Grace*. Fort Worth: Amon Carter Museum, 1986.

Ben Glaha (U.S., 1899-1971)

Ruzzie Green (U.S., 1892-1956)

John Gutmann (U.S., b. Germany, 1905-1998)

Kozloff, Max, and Lew Thomas. *The Restless Decade: John Gutmann's Photographs of the Thirties*. New York: Harry N. Abrams, 1984.

Sutnik, Maia-Mari. *Gutmann*. Toronto: Art Gallery of Ontario, 1985.

Johan Hagemeyer (U.S., b. Holland, 1884-1962)

Lorenz, Richard, John P. Schaefer, and Terence R. Pitts. *Johan Hagemeyer*. Tucson: Center for Creative Photography, 1982.

Harold L. Harvey (U.S., 1899-1971)

Nicholas Ház (U.S., b. Czechoslovakia, 1883-?)

Florence Henri (Switzerland, b. U.S., 1893-1982)

Du Pont, Diana C. *Florence Henri: Artist-Photographer of the Avant-Garde*. San Francisco: San Francisco Museum of Modern Art, 1990.

Pulfer, Catherine, Giovanni Battista Martini, and Alberto Ronchetti. *Florence Henri*. Milan: Electa, 1995.

Antoinette B. Hervey (U.S., 1857-1945)

E. O. Hoppé (England, 1878-1972)

Hoppé, E. O. *Hundred Thousand Exposures*. London: Focal Press, 1945.

Hoppé, E. O. *Romantic America: Picturesque United States*. New York: Westermann, 1927.

Bernard Shea Horne (U.S., 1867-1933)

A Catalog of Design Photographs by Bernard Shea Horne. New York: Keith Douglas de Lellis, 1986.

Horst P. Horst (U.S., b. Germany 1906)

Kazmaier, Martin. *Horst: Sixty Years of Photography*. New York: Universe, 1996.

Tom Howard (U.S., 1893-1961)

Alfred Cheney Johnston (U.S., 1885-1971)

Yochelson, Bonnie. *Alfred Cheney Johnston: Women of Talent and Beauty, 1917 to 1930*. Malvern, Pa.: Charles Isaacs Photographs, 1987.

Consuelo Kanaga (U.S., 1894-1978)

Lowe, Sarah M., and Barbara Head Millstein. *Consuelo Kanaga: An American Photographer*. Brooklyn: The Brooklyn Museum, 1992.

Clarence Kennedy (U.S., 1892-1972)

Newhall, Beaumont. *Clarence Kennedy*. Northampton, Mass.: Smith College Museum of Art, 1967.

Swenson, Christine. *The Experience of Sculptural Form: Photographs by Clarence Kennedy*. Detroit: Detroit Institute of Arts, 1987.

Gyorgy Kepes (U.S., b. Hungary 1906)

Gyorgy Kepes: Light Graphics. New York: International Center of Photography, 1984.

Van der Marck, Jan. *Gyorgy Kepes*. Cambridge, Mass.: Hopkins Center Art Galleries, 1977.

André Kertész (U.S., b. Hungary, 1894-1985)

Bouchan, Pierre. *André Kertész: His Life and Work*. Boston: Bulfinch, 1994.

Ducrot, Nicholas, ed. *André Kertész: Sixty Years of Photography*. New York: Grossman, 1972.

Ducrot, Nicholas, ed. *Distortions: André Kertész*. New York: Alfred A. Knopf, 1976.

Enright, Robert. *Stranger to Paris: Photographs by André Kertész*. Toronto: Jane Corkin Gallery, 1992.

Houk, Edwynn, and Keith F. Davis. *André Kertész: Vintage Photographs*. Chicago: Edwynn Houk Gallery, 1985.

Kertész, André. *From My Window*. Boston: New York Graphic Society, 1981.

Phillips, Sandra S., David Travis, and Weston J. Naef. *André Kertész: Of Paris and New York*. Chicago: Art Institute of Chicago/Metropolitan Museum of Art, 1985.

Dorothea Lange (U.S., 1895-1965)

Davis, Keith F. *The Photographs of Dorothea Lange*. Kansas City, Mo.: Hallmark Cards/Harry N. Abrams, 1995.

Heyman, Therese Thau. *Celebrating a Collection: The Work of Dorothea Lange*. Oakland, Calif.: Oakland Museum, 1978.

Heyman, Therese Thau, Sandra S. Phillips, and John Szarkowski. *Dorothea Lange: American Photographs*. San Francisco: Chronicle Books, 1994.

Meltzer, Milton. *Dorothea Lange: A Photographer's Life*. New York: Farrar, Straus and Giroux, 1978.

Ohrn, Karin Becker. *Dorothea Lange and the Documentary Tradition*. Baton Rouge: Louisiana State University Press, 1980.

Reiss, Suzanne. *The Making of a Documentary Photographer*. Berkeley: University of California Press, 1968.

Clarence John Laughlin (U.S., 1905-1985)

Davis, Keith F., ed. *Clarence John Laughlin: Visionary Photographer*. Kansas City, Mo.: Hallmark Cards, 1990.

Laughlin, Clarence John. *The Personal Eye*. Millerton, N.Y.: Aperture, 1973.

Lawrence, John H., and Patricia Brady, eds. *Haunter of Ruins: The Photography of Clarence John Laughlin*. Boston: Bulfinch, 1997.

Alma Lavenson (U.S., 1897-1989)

Ehrens, Susan. *Alma Lavenson Photographs*. Berkeley, Calif.: Wildwood Arts, 1990.

Milton Lefkowitz (U.S., active 1920s-30s)

Leonard B. Loeb (U.S., b. Switzerland, 1891-1978)

George Platt Lynes (U.S., 1907-1955)

Crump, James, et al. *George Platt Lynes: Photographs from the Kinsey Institute*. Boston: Bulfinch, 1993.

Woody, Jack, ed. *George Platt Lynes: Photographs, 1931-1955*. Pasadena, Cal.: Twelvetrees Press, 1981.

Wendell MacRae (U.S., 1896-1980)

Wendell MacRae: Photographs, 1927 to 1949. New York: Witkin Gallery, 1980.

Ira W. Martin (U.S., 1886-1960)

Margrethe Mather (U.S., 1885-1952)

Justema, William, and Lawrence Jasud. *Margrethe Mather*. Tucson: Center for Creative Photography, 1979.

Hansel Mieth (U.S., b. Germany, 1909-1998)

Inouye, Mamoru. *The Heart Mountain Story: Photographs by Hansel Mieth and Otto Hagel of the World War II Internment of Japanese Americans*. Los Gatos, Calif.: M. Inouye, 1997.

Mieth, Hansel, and Otto Hagel. *Simple Life: Photographs from America, 1929-1971*. Stuttgart: Schmetterling Verlag, 1991.

Toyo Miyatake (U.S., b. Japan, 1895-1979)

Adams, Ansel and Toyo Miyatake. *Two Views of Manzanar: An Exhibition of Photographs*. Los Angeles: Frederick S. Wight Art Gallery, UCLA, 1978.

Lisette Model (U.S., b. Austria, 1906-1983)

Thomas, Ann. *Lisette Model*. Ottawa: National Gallery of Canada, 1990.

Tina Modotti (Italy, 1896-1942)

Constantine, Mildred. *Tina Modotti: A Fragile Life*. New York: Rizzoli, 1983.

Hooks, Margaret. *Tina Modotti: Photographer and Revolutionary*. London: Pandora, 1993.

Stark, Amy, ed. *The Letters from Tina Modotti to Edward Weston*. Tucson: Center for Creative Photography, 1986.

László Moholy-Nagy (U.S., b. Hungary, 1895-1946)

Haus, Andreas. *Moholy-Nagy: Photographs and Photograms*. New York: Pantheon, 1980.

Hight, Eleanor M. *Moholy-Nagy: Photography and Film in Weimar Germany*. Wellesley, Mass.: Wellesley College Museum, 1985.

Kostelanetz, Richard. *Moholy-Nagy: An Anthology*. New York: Da Capo Press, 1991.

Moholy-Nagy, Sibyl. *Moholy-Nagy: Experiment in Totality*. Cambridge, Mass.: MIT Press, 1969.

Rice, Leland, and David W. Steadman, eds. *Photographs of Moholy-Nagy from the Collection of William Larson*. Claremont, Calif.: Pomona College, 1975.

Arthur Mole & John Thomas (U.S. firm, active 1910s)

Barbara Morgan (U.S., 1900-1992)

Bunnell, Peter C. *Barbara Morgan*. Hastings-on-Hudson, N.Y.: Morgan & Morgan, 1972.

Carter, Curtis L., and William C. Agee. *Barbara Morgan: Prints, Drawings, Watercolors & Photographs*. Dobbs Ferry, N.Y.: Morgan & Morgan, 1988.

Morgan, Barbara. *Martha Graham: Sixteen Dances in Photographs*. Dobbs Ferry, N.Y.: Morgan & Morgan, 1980.

Patnaik, Deba P. *Barbara Mortan: Aperture Masters of Photography*. New York: Aperture, 1998.

William Mortensen (U.S., 1897-1965)

Dawson, Michael, et al. *William Mortensen: A Revival*. Tucson: Center for Creative Photography, 1998.

Irmas, Deborah. *The Photographic Magic of William Mortensen*. Los Angeles: Los Angeles Center for Photographic Studies, 1979.

Mortensen, William. *Monsters and Madonnas*. 1936; repr., New York: Arno Press, 1973.

Martin Munkacsi (U.S., b. Hungary, 1896-1963)

Morgan, Susan. *Martin Munkacsi*. Millerton, N.Y.: Aperture, 1992.

White, Nancy, and John Esten. *Style in Motion: Munkacsi Photographs of the '20s, '30s, '40s*. New York: Clarkson N. Potter, 1979.

Kentaro Nakamura (active 1920s)

Lusha Nelson (U.S., b. Latvia, 1900-1938)

Sonya Noskowiak (U.S., b. Germany, 1900-1975)

Bender, Donna, Jan Stevenson, and Terence R. Pitts. *Sonya Noskowiak Archive*. Tucson: Center for Creative Photography, 1982.

Sonya Noskowiak. Tucson: Center for Creative Photography, 1979.

Mortimer Offner (U.S., 1900-1965)

Paul Outerbridge, Jr. (U.S., 1896-1958)

Dines, Elaine, ed. *Paul Outerbridge, A Singular Aesthetic: Photographs and Drawings, 1921-1941: A Catalogue Raisonné*. Laguna Beach, Calif.:

Laguna Beach Museum of Art, 1981.

Howe, Graham, and G. Ray Hawkins, eds. *Paul Outerbridge, Jr.: Photographs*. New York: Rizzoli, 1980.

Edward Quigley (U.S., 1898-1977)

Edward Quigley: American Modernist. Essay by Robert A. Sobieszek. New York: Houk Friedman Gallery, 1991.

Man Ray (U.S., 1890-1976)

Baldwin, Neil. *Man Ray, American Artist*. New York: Clarkson N. Potter, 1988.

Foresta, Merry A., et al. *Perpetual Motif: The Art of Man Ray*. New York: Abbeville, 1988.

Man Ray. *Self Portrait*. Boston: Little, Brown, 1963.

Jane Reece (U.S., 1868-1961)

Vasseur, Dominique H. *The Soul Unbound: The Photographs of Jane Reece*. Dayton, Ohio: Dayton Art Institute, 1997.

Wynn Richards (U.S., 1888-1960)

Yochelson, Bonnie. *Wynn Richards*. New York: Photofind Gallery, 1989.

Walter Rosenblum (U.S., b. 1919)

Brown, Milton W. *Walter Rosenblum: Photographer*. Cambridge, Mass.: Fogg Art Museum, 1974.

Rice, Shelley, and Naomi Rosenblum. *Walter Rosenblum*. Dresden: Verlag der Kunst, 1990.

Arthur Rothstein (U.S., 1915-1985)

Rothstein, Arthur. *The Depression Years as Photographed by Arthur Rothstein*. New York: Dover Publications, 1978.

Morton Schamberg (U.S., 1881-1918)

Agee, William C. *Morton Livingston Schamberg (1881-1918): The Machine Pastels*. New York: Salander–O'Reilly Galleries, 1986.

Wolf, Ben. *Morton Livingston Schamberg*. Philadelphia: University of Pennsylvania Press, 1963.

Robert Seelig (U.S., active 1930s) and **Charles Hoff** (U.S., 1905-1975)

Ben Shahn (U.S., b. Lithuania, 1898-1969)

Pratt, Davis. *The Photographic Eye of Ben Shahn*. Cambridge, Mass.: Harvard University Press, 1975.

Weiss, Margaret R. *Ben Shahn, Photographer: An Album from the Thirties*. New York: Da Capo Press, 1973.

Charles Sheeler (U.S., 1883-1965)

Lucic, Karen. *Charles Sheeler and the Cult of the Machine*. Cambridge, Mass.: Harvard University Press, 1991.

Lucic, Karen. *Charles Sheeler in Doylestown: American Modernism and the Pennsylvania Tradition*. Allentown, Pa.: Allentown Art Museum, 1997.

Rourke, Constance. *Charles Sheeler: Artist in the American Tradition*. 1938; repr., New York: Kennedy Galleries/Da Capo Press, 1969.

Stebbins, Theodore E., Jr., and Norman Keyes, Jr. *Charles Sheeler: The Photographs*. Boston: Museum of Fine Arts, 1987.

Troyen, Carol, and Erica E. Hirschler. *Charles Sheeler: Paintings and Drawings*. Boston: Museum of Fine Arts, 1987.

Peter Stackpole (U.S., 1913-1997)

Stackpole, Peter. *The Bridge Builders: Photographs and Documents of the Raising of the San Francisco Bay Bridge, 1934-1936*. Corte Madera, Calif.: Pomegranate Artbooks, 1984.

Stackpole, Peter. *Peter Stackpole: Life in Hollywood, 1936-1952*. Livingston, Mont.: Clark City Press, 1992.

Ralph Steiner (U.S., 1899-1986)

Steiner, Ralph. *A Point of View*. Middletown, Conn.: Wesleyan University Press, 1978.

Zuker, Joel Stewart. *Ralph Steiner: Filmmaker and Still Photographer*. New York: Arno Press, 1978.

Albert W. Stevens (U.S., 1886-1949)

Paul Strand (U.S., 1890-1976)

Greenough, Sarah. *Paul Strand: An American Vision*. New York: Aperture, 1990.

Stange, Maren, ed. *Paul Strand: Essays on His Life and Work*. New York: Aperture, 1990.

Strand, Paul. *Rebecca*. New York: Robert Miller Gallery, 1996.

Strand, Paul, and Nancy Newhall. *Time in New England*. 1950; rev. ed., New York: Aperture, 1980.

William A. Strosahl (U.S., b. 1910)

Lewis P. Tabor (U.S., 1900-1974)

Max Thorek (U.S., b. Hungary, 1880-1960)

Peterson, Christian A. *The Creative Camera Art of Max Thorek*. Chicago: Dr. Max Thorek Memorial Foundation, 1984.

Thorek, Max. *Camera Art as a Means of Self-Expression*. Philadelphia: Lippincott, 1947.

Doris Ulmann (U.S., 1884-1934)

Clift, William, and Robert Coles. *The Darkness and the Light: Photographs by Doris Ulmann*. Millerton, N.Y.: Aperture, 1974.

Featherstone, David. *Doris Ulmann, American Portraits*. Albuquerque: University of New Mexico Press, 1985.

Niles, John Jacob. *The Appalachian Photographs of Doris Ulmann*. Penland, N.C.: Jargon Society, 1971.

James Van Der Zee (U.S., 1886-1983)

Willis-Braithwaite, Deborah, and Rodger C. Birt. *VanDerZee, Photographer: 1886-1983*. New York: Harry N. Abrams/National Portrait Gallery, 1993.

Carl Van Vechten (U.S., 1880-1964)

Byrd, Rudolph P. *Generations in Black-and-White: Photographs by Carl Van Vechten from the James Weldon Johnson Memorial Collection*. Athens: University of Georgia Press, 1993.

Davis, Keith F. *The Passionate Observer: Photographs by Carl Van Vechten*. Kansas City, Mo.: Hallmark Cards, 1993.

Margaret Watkins (Canada, 1884-1969)

McCulloch, Margaret, ed. *Margaret Watkins, 1884-1969: Photographer*. Glasgow: Street Level Photography Gallery, 1994.

Brett Weston (U.S., 1911-1993)

Newhall, Beaumont. *Brett Weston: Voyage of the Eye*. Millerton, N.Y.: Aperture, 1975.

Weston, Brett. *Master Photographer*. Carmel, Calif.: Photography West Graphics, 1989.

Edward Weston (U.S., 1886-1958)

Bunnell, Peter C., and David Featherstone, eds. *EW:100, Centennial Essays in Honor of Edward Weston*. Carmel, Calif.: Friends of Photography, 1986.

Conger, Amy. *Edward Weston: Photographs from the Collection of the Center for Creative Photography*. Tucson: Center for Creative Photography, 1992.

Conger, Amy. *Edward Weston in Mexico, 1923-1926*. Albuquerque: University of New Mexico Press, 1983.

Maddow, Ben. *Edward Weston: Fifty Years*. Millerton, N.Y.: Aperture, 1973.

Newhall, Beaumont. *Supreme Instants: The Photographs of Edward Weston*. Boston: New York Graphic Society, 1986.

Newhall, Beaumont, and Amy Conger, eds. *Edward Weston Omnibus*. Salt Lake City: Gibbs M. Smith, 1984.

Newhall, Nancy, ed. *The Daybooks of Edward Weston: Volume I. Mexico* and *Volume II. California*. Millerton, N.Y.: Aperture, 1973.

Wilson, Charis, and Edward Weston. *California and the West*. 1940; repr., Millerton, N.Y.: Aperture, 1978.

Wilson, Charis, and Wendy Madar. *Through Another Lens: My Years with Edward Weston*. New York: North Point Press, 1998.

H. I. Williams (U.S., 1886-1965)

Marion Post Wolcott (U.S., 1910-1990)

Hendrickson, Paul. *Looking for the Light: The Hidden Life and Art of Marion Post Wolcott*. New York: Alfred A. Knopf, 1992.

Hurley, F. Jack. *Marion Post Wolcott: A Photographer's Journey*. Albuquerque: University of New Mexico Press, 1989.

CHAPTER III From Public to Private Concerns 1940-1965

General Works

Green, Jonathan. *American Photography: A Critical History 1945 to the Present*. New York: Harry N. Abrams, 1984.

Harrison, Martin. *Appearances: Fashion Photography Since 1945*. New York: Rizzoli, 1991.

Livingston, Jane. *The New York School: Photographs 1936-1963*. New York:

Stewart, Tabori & Chang, 1992.

Traub, Charles, and John Grimes. *The New Vision: Forty Years of Photography at the Institute of Design*. Millerton, N.Y.: Aperture, 1981.

Turner, Peter. *American Images: Photography 1945-1980*. Harmondsworth, U.K.: Penguin Books/Barbican Art Gallery, 1985.

Individual Artists

Diane Arbus (U.S., 1923-1971)

Arbus, Diane. *Untitled*. New York: Aperture, 1995.

Arbus, Doon, and Marvin Israel, eds. *Diane Arbus*. Millerton, N.Y.: Aperture, 1972.

Arbus, Doon, and Marvin Israel, eds. *Diane Arbus: Magazine Work*. Essay by Thomas W. Southall. Millerton, N.Y.: Aperture/Spencer Museum of Art, 1984.

Bosworth, Patricia. *Diane Arbus: A Biography*. New York: Alfred A. Knopf, 1984.

Richard Avedon (U.S., b. 1923)

Avedon, Richard. *An Autobiography*. New York: Random House, 1993.

Avedon, Richard. *Evidence, 1944-1994*. New York: Random House, 1994.

Avedon, Richard. *Portraits*. New York: Farrar, Straus and Giroux, 1976.

Lillian Bassman (U.S., b. 1918)

Harrison, Martin, et al. *Lillian Bassman*. Boston: Bulfinch, 1997.

Ruth Bernhard (U.S., b. Germany 1905)

Alinder, James. *Collecting Light: The Photographs of Ruth Bernhard*. Carmel, Calif.: Friends of Photography, 1979.

Mitchell, Margaretta K. *Ruth Bernhard: The Eternal Body*. Carmel, Calif.: Photography West Graphics, 1986.

Ruth Bernhard: The Collection of Ginny Williams. Santa Fe: Tallgrass Press, 1993.

Wynn Bullock (U.S., 1902-1975)

De Cock, Liliane, ed. *Wynn Bullock: A Way of Life*. Dobbs Ferry, N.Y.: Morgan & Morgan, 1973.

Dilley, Clyde H. *The Photography and Philosophy of Wynn Bullock*. Philadelphia: Art Alliance Press, 1984.

Wynn Bullock. *The Enchanted Landscape: Photographs 1940-1975*. Poems by Ursula K. Le Guin; biographical essay by Raphael Shevelev. New York: Aperture, 1993.

Harry Callahan (U.S., b. 1912)

Bunnell, Peter C. *Harry Callahan*. New York: American Federation of Arts, 1978.

Callahan, Harry. *Water's Edge*. Lyme, Conn.: Callaway Editions/Viking Press, 1980.

Davis, Keith F. *Harry Callahan: New Color, Photographs 1978-1987*. Kansas City, Mo.: Hallmark Cards, 1988.

Davis, Keith F. *Harry Callahan: Photographs*. Kansas City, Mo.: Hallmark Cards, 1981.

Greenough, Sarah. *Harry Callahan*. Washington, D.C.: National Gallery of Art, 1996.

Johnson, Diana L. *Callahan in New England*. Providence: List Art Center, 1994.

Shaw, Louise, Virginia Beahan, and John McWilliams. *Harry Callahan and His Students: A Study in Influence*. Atlanta: Georgia State University Art Gallery, 1983.

Szarkowski, John. *Callahan*. New York: Museum of Modern Art/Aperture, 1976.

Irving Canner (U.S., b. 1924)

Robert Capa (U.S., b. Hungary, 1913-1954)

Capa, Cornell, and Richard Whelan. *Robert Capa: Photographs*. New York: Alfred A. Knopf, 1985.

Whelan, Richard. *Robert Capa: A Biography*. New York: Alfred A. Knopf, 1985.

Paul Caponigro (U.S., b. 1932)

Caponigro, Paul. *Megaliths*. Boston: New York Graphic Society, 1986.

Caponigro, Paul. *Seasons*. Boston: New York Graphic Society, 1988.

Fulton, Marianne. *The Wise Silence: Photographs by Paul Caponigro*. Boston: New York Graphic Society, 1985.

Benjamen Chinn (U.S., b. 1921)

Ed Clark (U.S., b. 1911)

Van Deren Coke (U.S., b. 1921)

Coke, Van Deren. *Secular and Sacred: Photographs of Mexico*. Albuquerque: University of New Mexico Press, 1992.

Larry Colwell (U.S., 1911-1972)

Jerry Cooke (U.S., b. 1922)

Carlotta Corpron (U.S., 1901-1988)

Sandweiss, Martha A. *Carlotta Corpron: Designer with Light*. Austin: University of Texas Press/Amon Carter Museum, 1980.

Ralston Crawford (U.S., b. Canada, 1906-1978)

Agee, William C. *Ralston Crawford: Painting and Visual Experience*. Pasadena, Calif.: Twelvetrees Press, 1983.

Geske, Norman A. *The Photographs of Ralston Crawford*. Lincoln, Neb.: Sheldon Memorial Art Gallery, 1974.

Haskell, Barbara. *Ralston Crawford*. New York: Whitney Museum of Art, 1985.

Jerde, Curtis D., and John H. Lawrence. *Music in the Street: Photographs of New Orleans by Ralston Crawford*. New Orleans: Historic New Orleans Collection, 1983.

Ralston Crawford: Abstracting the Vernacular. New York: Laurence Miller Gallery, 1995.

Ted Croner (U.S., b. 1922)

Bruce Davidson (U.S., b. 1933)

Bruce Davidson Photographs. New York: Agrinde/Summit, 1978.

Davidson, Bruce. *Central Park*. New York: Aperture, 1995.

Davidson, Bruce. *East 100th Street*. Cambridge, Mass.: Harvard University Press, 1970.

Roy DeCarava (U.S., b. 1919)

Alinder, James, ed. *Roy DeCarava, Photographs*. Carmel, Calif.: Friends of Photography, 1981.

Galassi, Peter. *Roy DeCarava: A Retrospective*. New York: Museum of Modern Art, 1996.

Hughes, Langston, and Roy DeCarava. *The Sweet Flypaper of Life*. New York: Simon and Schuster, 1955.

Margaret de Patta (U.S., 1903-1964)

David Douglas Duncan (U.S., b. 1916)

Duncan, David Douglas. *This Is War!* 1951; repr., Boston: Little, Brown, 1990.

Duncan, David Douglas. *Yankee Nomad: A Photographic Odyssey*. New York: Holt, Rinehart and Winston, 1966.

Morris Engel (U.S., b. 1918)

Elliott Erwitt (U.S., b. France 1928)

Erwitt, Elliott. *Between the Sexes*. New York: Norton, 1994.

Erwitt, Elliott. *Elliott Erwitt: Photographies, 1946-1988*. Paris: Nathan Image, 1988.

Erwitt, Elliott. *Personal Exposures*. New York: Norton, 1988.

Louis Faurer (U.S., b. 1916)

Tonelli, Edith A. *Louis Faurer: Photographs from Philadelphia and New York, 1937-1973*. College Park: University of Maryland Art Gallery, 1981.

Nat Fein (U.S., b. 1914)

Andreas Feininger (U.S., b. France 1906)

Alexander, Stuart. *Andreas Feininger, Early Work*. Tucson: Center for Creative Photography, 1983.

Feininger, Andreas. *Andreas Feininger, Photographer*. New York: Harry N. Abrams, 1986.

Robert Frank (U.S., b. Switzerland 1924)

Alexander, Stuart. *Robert Frank: A Bibliography, Filmography, and Exhibition Chronology, 1946-1985*. Tucson: Center for Creative Photography, 1986.

Frank, Robert. *The Americans*. 1959; repr., New York: Aperture, 1969.

Frank, Robert. *Black White and Things*. Washington, D.C.: National Gallery of Art/Scalo, 1994.

Frank, Robert. *The Lines of My Hand*. New York: Pantheon, 1989.

Greenough, Sarah, and Philip Brookman. *Robert Frank: Moving Out*. Washington, D.C.: National Gallery of Art/Scalo, 1994.

Tucker, Anne Wilkes. *Robert Frank: New York to Nova Scotia*. Houston: Museum of Fine Arts, 1986.

Lee Friedlander (U.S., b. 1934)

Friedlander, Lee. *Factory Valleys*. New York: Callaway Editions, 1982.

Friedlander, Lee. *Letters to the People*. New York: D.A.P., 1993.

Friedlander, Lee. *Self Portrait*. 1970; rev. ed., New York: D.A.P./Fraenkel Gallery, 1998.

Lee Friedlander: Nudes. New York: Pantheon Books, 1991.

Lee Friedlander: Photographs. New City, N.Y.: Haywire Press, 1978.

Slemmons, Rod. *Like a One-Eyed Cat: Photographs by Lee Friedlander, 1956-1987*. New York: Harry N. Abrams/Seattle Art Museum, 1989.

Oliver Gagliani (U.S., b. 1917)

Coke, Van Deren, and Leland Rice. *Oliver Gagliani*. Menlo Park, Calif.: Ideograph, 1975.

William Garnett (U.S., b. 1916)

Garnett, William. *The Extraordinary Landscape: Aerial Photographs of America*. Boston: Little, Brown, 1982.

Sandweiss, Martha A. *William Garnett: Aerial Photographs*. Berkeley: University of California Press, 1994.

Herbert Gehr [after 1950: Edmund Bert Gerard] (U.S., b. Germany, 1910-1983)

Leslie Gill (U.S., 1908-1958)

Freeman, Tina, and Frances McLaughlin-Gill, eds. *Leslie Gill: A Classical Approach to Photography, 1935-1958*. New Orleans: New Orleans Museum of Art, 1983.

Sid Grossman (U.S., 1913-1955)

Grossman, Sid, and Millard Campbell. *Journey to the Cape*. New York: Grove Press, 1959.

Dave Heath (U.S., b. 1931)

Heath, Dave. *A Dialogue with Solitude*. Culpeper, Va.: Community Press, 1965.

William Heick (U.S., b. 1917)

Paul Heismann (U.S., b. 1912)

Bob Hollingsworth (U.S., b. 1918)

Philip Hyde (U.S., b. 1921)

Hyde, Philip. *The Range of Light*. Salt Lake City: Peregrine Smith, 1992.

Yasuhiro Ishimoto (Japan, b. U.S. 1921)

Ishimoto, Yasuhiro. *Chicago, Chicago*. Tokyo: Japan Publications, 1983.

Yasuhiro Ishimoto: Remembrance of Things Past. Tokyo: National Museum of Modern Art, 1996.

Joseph Jachna (U.S., b. 1935)

Klindt, Steven. *Light Touching Silver: Photographs by Joseph D. Jachna*. Chicago: Chicago Center for Contemporary Photography, 1980.

Lotte Jacobi (U.S., b. Germany, 1896-1990)

Jacobi, Lotte. *Theater & Dance Photographs*. Woodstock, Vt.: Countryman Press, 1982.

Wise, Kelly, ed. *Lotte Jacobi*. Danbury, N.H.: Addison House, 1978.

N. Jay Jaffee (U.S., b. 1921)

Baro, Gene. *Inward Image: Photographs by N. Jay Jaffee*. Brooklyn, N.Y.: Brooklyn Museum, 1981.

Jaffee, N. Jay. *Photographs, 1947-1955*. Glen Oaks, N.Y.: Jaffee, 1976.

Pirkle Jones (U.S., b. 1914)

Baruch, Ruth-Marion, and Pirkle Jones. *The Vanguard: A Photographic Essay on the Black Panthers*. Introduction by William Worthy. Boston: Beacon Press, 1970.

Kenneth Josephson (U.S., b. 1932)

Warren, Lynne, and Carl Chiarenza. *Kenneth Josephson*. Chicago: Museum of Contemporary Art, 1983.

Charles Kerlee (U.S., 1907-1981)

William Klein (U.S., b. 1928)

Heilpern, John. *William Klein: Photographs*. Millerton, N.Y.: Aperture, 1981.

Klein, William. *Close Up*. London: Thames and Hudson, 1989.

Klein, William. *New York 1954-55*. Manchester, U.K.: Dewi Lewis, 1995.

Saul Leiter (U.S., b. 1923)

Leon Levinstein (U.S., 1913-1988)

Gee, Helen. *Leon Levinstein*. New York: Photofind Gallery, 1990.

Shamis, Bob. *Leon Levinstein: The Moment of Exposure*. Ottawa: National Gallery of Canada, 1995.

Helen Levitt (U.S., b. 1913)

Levitt, Helen. *Mexico City*. New York: Norton/Center for Documentary Studies, 1997.

Levitt, Helen, and James Agee. *A Way of Seeing*. 1965; repr., New York: Horizon Press, 1981.

Phillips, Sandra S., and Maria Morris Hambourg. *Helen Levitt*. San Francisco: San Francisco Museum of Modern Art, 1991.

Weiermair, Peter. *Helen Levitt*. Munich: Prestel, 1998.

Frank R. Levstik, Jr. (U.S., 1908-1985)

Jerome Liebling (U.S., b. 1924)

Halley, Anne, and Alan Trachtenberg. *Jerome Liebling Photographs*. New York: Aperture, 1982.

Jussim, Estelle. *Jerome Liebling: Photographs 1947-1977*. Carmel, Calif.: Friends of Photography, 1978.

Liebling, Jerome. *The People, Yes*. New York: Aperture, 1995.

O. Winston Link (U.S., b. 1914)

Garver, Thomas H. *The Last Steam Railroad in America: Photographs by O. Winston Link*. New York: Harry N. Abrams, 1995.

Ghost Trains: Railroad Photographs of the 1950s by O. Winston Link. Norfolk, Va.: Chrysler Museum, 1983.

Hensley, Tim. *Steam, Steel, & Stars: America's Last Steam Railroad, Photographs by O. Winston Link*. New York: Harry N. Abrams, 1987.

Danny Lyon (U.S., b. 1942)

Lyon, Danny. *The Bikeriders*. 1968; repr., Santa Fe: Twin Palms, 1997.

Lyon, Danny. *Conversations with the Dead*. New York: Holt, Rinehart and Winston, 1971.

Lyon, Danny. *The Destruction of Lower Manhattan*. New York: Macmillan, 1969.

Lyon, Danny. *Pictures from the New World*. Millerton, N.Y.: Aperture, 1981.

Nathan Lyons (U.S., b. 1930)

Lyons, Nathan. *Notations in Passing*. Cambridge, Mass.: MIT Press, 1974.

Lyons, Nathan. *Verbal Landscape/Dinosaur Sat Down*. Buffalo, N.Y.: Albright-Knox Art Gallery/CEPA Gallery, 1987.

Lyons, Nathan, Syl Labrot, and Walter Chappell. *Under the Sun: The Abstract Art of Camera Vision*. New York: Braziller, 1960.

Rose Mandel (U.S., b. Poland 1910)

Ehrlich, Susan, ed. *Pacific Dreams: Currents of Surrealism and Fantasy in California Art, 1934-1957*. Los Angeles: UCLA at the Armand Hammer Museum of Art and Cultural Center, 1995 (p. 144).

Tosh Matsumoto (U.S., b. 1920)

Ralph Eugene Meatyard (U.S., 1925-1972)

Hall, James Baker, ed. *Ralph Eugene Meatyard*. Millerton, N.Y.: Aperture, 1974.

Tannenbaum, Barbara, ed. *Ralph Eugene Meatyard: An American Visionary*. New York: Rizzoli/Akron Art Museum, 1991.

Ray K. Metzker (U.S., b. 1931)

Tucker, Anne Wilkes. *Unknown Territory: Photographs by Ray K. Metzker*. Houston: Museum of Fine Arts/Aperture, 1984.

Woodward, Richard B. *Ray K. Metzker: Composites*. New York: Laurence Miller Gallery, 1990.

Duane Michals (U.S., b. 1932)

Kozloff, Max. *Duane Michals: Now Becoming Then*. Altadena, Calif.: Twin Palms, 1990.

Livingstone, Marco. *The Essential Duane Michals*. Boston: Bulfinch, 1997.

Michals, Duane. *A Visit with Magritte*. Providence, R.I.: Matrix Publications, 1981.

Wright Morris (U.S., 1910-1998)

Alinder, James, ed. *Wright Morris: Photographs and Words*. Carmel, Calif.: Friends of Photography, 1982.

Phillips, Sandra S., and John Szarkowski. *Wright Morris: Origin of a Species*. San Francisco: San Francisco Museum of Modern Art, 1992.

Wright Morris: Structures and Artifacts, Photographs 1933-1954. Lincoln, Neb.: Sheldon Memorial Art Gallery, 1975.

Wydeven, Joseph J. *Wright Morris Revisited*. New York: Twayne, 1998.

Arnold Newman (U.S., b. 1918)

Newman, Arnold. *Artists: Portraits from Five Decades*. Boston: New York Graphic Society, 1980.

Newman, Arnold. *Five Decades*. San Diego: Harcourt Brace Jovanovich, 1986.

One Mind's Eye: The Portraits and Other Photographs of Arnold Newman. Boston: David R. Godine, 1974.

Marvin E. Newman (U.S., b. 1927)

Richard Nickel (U.S., 1928-1972)

Cahan, Richard. *They All Fall Down: Richard Nickel's Struggle to Save America's Architecture.* Washington, D.C.: The Preservation Press, 1994.

Ruth Orkin (U.S., 1921-1985)

Orkin, Ruth. *A World Through My Window.* New York: Harper & Row, 1978.

Ruth Orkin. New York: International Center of Photography, 1996.

Homer Page (U.S., 1918-1985)

Gordon Parks (U.S., b. 1912)

Bush, Martin H. *The Photographs of Gordon Parks.* Wichita, Kan.: Edwin A. Ulrich Museum of Art, 1983.

Parks, Gordon. *Half Past Autumn: A Retrospective.* Boston: Bulfinch/Corcoran Gallery, 1997.

Parks, Gordon. *Voices in the Mirror: An Autobiography.* New York: Doubleday, 1990.

Irving Penn (U.S., b. 1917)

Penn, Irving. *Passage: A Work Record.* New York: Alfred A. Knopf, 1991.

Szarkowski, John. *Irving Penn.* New York: Museum of Modern Art, 1984.

Westerbeck, Colin, ed. *Irving Penn: A Career in Photography.* Chicago: Art Institute of Chicago/Bulfinch, 1997.

Eliot Porter (U.S., 1901-1990)

Porter, Eliot. *Intimate Landscapes: Photographs by Eliot Porter.* Afterword by Weston J. Naef. New York: Metropolitan Museum of Art, 1979.

Porter, Eliot. *Eliot Porter.* Foreword by Martha A. Sandweiss. Boston: New York Graphic Society, 1987.

Joe Rosenthal (U.S., b. 1911)

Thomey, Tedd. *Immortal Images: A Personal History of Two Photographers and the Flag Raising on Iwo Jima.* Annapolis, Md.: Naval Institute Press, 1996.

Arthur Siegel (U.S., 1913-1978)

Grimes, John. "Arthur Siegel: A Short Critical Biography." *Exposure* 17 (Summer 1979): 22-35.

Grimes, John. *Arthur Siegel: Retrospective.* Chicago: Edwynn Houk Gallery, 1982.

Art Sinsabaugh (U.S., 1924-1983)

Smith, Henry Holmes, and Sherman Paul. *The Chicago Landscapes of Art Sinsabaugh.* Chicago: Art Sinsabaugh, 1976.

Aaron Siskind (U.S., 1903-1991)

Chiarenza, Carl. *Aaron Siskind: Pleasures and Terrors.* Boston: New York Graphic Society, 1982.

Conkelton, Sheryl. *Aaron Siskind: The Fragmentation of Language.* New York: Robert Mann Gallery, 1997.

Lyons, Nathan, ed. *Aaron Siskind Photographer.* Rochester, N.Y.: George Eastman House, 1965.

Places: Aaron Siskind Photographs. New York: Light Gallery/Farrar, Straus and Giroux, 1976.

Henry Holmes Smith (U.S., 1909-1986)

Bossen, Howard. *Henry Holmes Smith, Man of Light.* Ann Arbor: UMI Research Press, 1983.

Enyeart, James, and Nancy Solomon, eds. *Henry Holmes Smith: Collected Writings, 1935-1985.* Tucson: Center for Creative Photography, 1986.

Rice, Leland. *Henry Holmes Smith, Photographs 1931-1986: A Retrospective.* New York: Howard Greenberg Gallery, 1992.

W. Eugene Smith (U.S., 1918-1978)

Hughes, Jim. *W. Eugene Smith: Shadow & Substance.* New York: McGraw-Hill, 1989.

Johnson, William S. *W. Eugene Smith: Master of the Photographic Essay.* Millerton, N.Y.: Aperture, 1981.

Mora, Gilles, and John T. Hill, eds. *W. Eugene Smith: Photographs 1934-1975.* New York: Harry N. Abrams, 1998.

Willumson, Glenn G. *W. Eugene Smith and the Photographic Essay.* Cambridge: Cambridge University Press, 1992.

Frederick Sommer (U.S., b. Italy 1905)

Conkelton, Sheryl, ed. *Frederick Sommer: Selected Texts and Bibliography.* New York: G.K. Hall, 1995.

Glenn, Constance W., and Jane K. Bledsoe. *Frederick Sommer at Seventy-Five.* Long Beach: Art Museum and Galleries, California State University, 1980.

Sommer: Words and Pictures. Tucson: Center for Creative Photography, 1984.

Weiss, John, ed. *Venus, Jupiter and Mars: The Photographs of Frederick Sommer.* Wilmington: Delaware Art Museum, 1980.

Roland G. Spedden (U.S., ca. 1896-1966)

Joseph Sterling (U.S., b. 1936)

Louis Stettner (U.S., b. 1922)

Louis Stettner's New York, 1950s-1990s. New York: Rizzoli, 1996.

Stettner, Louis. *Early Joys: Photographs from 1947-1972.* New York: J. Iffland, 1987.

Charles Swedlund (U.S., b. 1935)

Charles A. Swedlund Photographs: Multiple Exposures with the Figure. Cobden, Ill.: Anna Press, 1973.

John Szarkowski (U.S., b. 1925)

Szarkowski, John. *The Face of Minnesota.* Minneapolis: University of Minnesota Press, 1958.

Szarkowski, John. *The Idea of Louis Sullivan.* Minneapolis: University of Minnesota Press, 1956.

Szarkowski, John. *Mr. Bristol's Barn.* New York: Harry N. Abrams, 1997.

Val Telberg (U.S., b. Russia, 1910-1995)

Coke, Van Deren. *Val Telberg.* San Francisco: San Francisco Museum of Modern Art, 1983.

Edmund Teske (U.S., 1911-1996)

Edmund Teske. Los Angeles: Los Angeles Municipal Art Gallery, 1974.

Teske, Edmund. *Images from Within.* Carmel, Calif.: Friends of Photography, 1980.

Jerry N. Uelsmann (U.S., b. 1934)

Enyeart, James L. *Jerry N. Uelsmann, Twenty-Five Years: A Retrospective.* Boston: Little, Brown, 1982.

Uelsmann, Jerry N. *Process and Perception.* Gainesville: University of Florida Press, 1985.

Uelsmann, Jerry N. *Silver Meditations.* Dobbs Ferry, N.Y.: Morgan & Morgan, 1975.

William Vandivert (U.S., b. 1912)

David Vestal (U.S., b. 1924)

Todd Webb (U.S., b. 1905)

Davis, Keith F. *Todd Webb: Photographs of New York and Paris, 1945-1960.* Kansas City, Mo.: Hallmark Cards, 1986.

Webb, Todd. *Looking Back: Memoirs and Photographs.* Albuquerque: University of New Mexico Press, 1991.

Weegee [Arthur Fellig] (U.S., b. Poland, 1899-1968)

Barth, Miles. *Weegee's World.* Boston: Bulfinch, 1997.

Coplans, John. *Weegee's New York.* New York: Grove Press/Schirmer/Mosel, 1982.

Stettner, Louis, ed. *Weegee.* New York: Alfred A. Knopf, 1977.

Weegee. *Naked City.* 1945; repr., New York: Dover Publications, 1985.

Dan Weiner (U.S., 1919-1959)

Capa, Cornell, and Sandra Weiner, eds. *Dan Weiner.* New York: Grossman, 1974.

Ewing, William A. *America Worked: The 1950s Photographs of Dan Weiner.* New York: Harry N. Abrams, 1989.

Minor White (U.S., 1908-1976)

Bunnell, Peter C. *Minor White: The Eye That Shapes.* Princeton: Princeton University Art Museum/Bulfinch, 1989.

Hall, James Baker. *Minor White: Rites and Passages.* Millerton, N.Y.: Aperture, 1978.

Garry Winogrand (U.S., 1928-1984)

Szarkowski, John. *Winogrand: Figments from the Real World.* New York: Museum of Modern Art, 1988.

Winogrand, Garry. *Public Relations.* New York: Museum of Modern Art/New York Graphic Society, 1977.

Bill Witt (U.S., b. 1921)

Max Yavno (U.S., 1911-1985)

Maddow, Ben. *The Photography of Max Yavno.* Berkeley: University of California Press, 1981.

CHAPTER IV The Image Transformed 1965-Present

General Works

Burgin, Victor, ed. *Thinking Photography*. London: Macmillan, 1982.

Coleman, A. D. *Light Readings: A Photography Critic's Writings 1968-1978*. New York: Oxford University Press, 1979.

Desmarais, Charles. *Proof: Los Angeles Art and the Photograph, 1960-1980*. Laguna Beach: Laguna Art Museum/Los Angeles: Fellows of Contemporary Art, 1992.

Foster, Hal, ed. *The Anti-Aesthetic: Essays on Postmodern Culture*. Port Townsend, Wash.: Bay Press, 1983.

Gauss, Kathleen McCarthy. *New American Photography*. Los Angeles: Los Angeles County Museum of Art, 1985.

Goldstein, Ann, and Anne Rorimer. *Reconsidering the Object of Art: 1965-1975*. Los Angeles: Museum of Contemporary Art/MIT Press, 1995.

Grundberg, Andy. *Crisis of the Real: Writings on Photography, 1974-1989*. New York: Aperture, 1990.

Hoy, Anne H. *Fabrications: Staged, Altered and Appropriated Photographs*. New York: Abbeville, 1987.

Jenkins, William. *New Topographics: Photographs of a Man-Altered Landscape*. Rochester: George Eastman House, 1975.

Smith, Joshua P., and Merry A. Foresta. *The Photography of Invention: American Pictures of the 1980s*. Washington, D.C.: Smithsonian Institution Press, 1989.

Sontag, Susan. *On Photography*. New York: Farrar, Straus and Giroux, 1977.

Wallis, Brian, ed. *Art After Modernism: Rethinking Representation*. Boston: David R. Godine, 1984.

Individual Artists

Robert Adams (U.S., b. 1937)

Adams, Robert. *Beauty in Photography: Essays in Defense of Traditional Values*. Millerton, N.Y.: Aperture, 1981.

Adams, Robert. *From the Missouri West*. Millerton, N.Y.: Aperture, 1980.

Adams, Robert. *Los Angeles Spring*. New York: Aperture, 1986.

Adams, Robert. *The New West: Landscapes Along the Colorado Front Range*. Boulder: Colorado Associated University Press, 1974.

Adams, Robert. *Summer Nights*. New York: Aperture, 1985.

Adams, Robert. *To Make It Home: Photographs of the American West*. New York: Aperture, 1989.

Adams, Robert, and William Stafford. *Listening to the River: Seasons in the American West*. New York: Aperture, 1994.

John Baldessari (U.S., b. 1931)

Davies, Hugh M., and Andrea Hales, eds. *John Baldessari: National City*. San Diego: Museum of Contemporary Art, 1996.

Tucker, Marcia, et al. *John Baldessari*. New York: The New Museum, 1981.

Van Bruggen, Coosje. *John Baldessari*. New York: Rizzoli, 1990.

Lewis Baltz (U.S., b. 1945)

Baltz, Lewis. *The New Industrial Parks near Irvine, California*. New York: Castelli Graphics, 1974.

Baltz, Lewis. *Rule without Exception*. Albuquerque: University of New Mexico Press/Des Moines Art Center, 1990.

Baltz, Lewis, and Gus Blaisdell. *Park City*. Albuquerque: Artspace Press/Castelli Graphics/Aperture, 1980.

Lamarche-Vadel, Bernard. *Lewis Baltz*. Paris: Editions de la Différence, 1993.

Tina Barney (U.S., b. 1945)

Barney, Tina. *Friends and Relations*. Washington, D.C.: Smithsonian Institution Press, 1991.

Barney, Tina, and Andy Grundberg. *Tina Barney: Photographs, Theater of Manners*. Zurich: Scalo, 1997.

Thomas F. Barrow (U.S., b. 1938)

Gauss, Kathleen McCarthy. *Inventories and Transformations: The Photographs of Thomas Barrow*. Albuquerque: University of New Mexico Press, 1986.

Bernd Becher (Germany, b. 1931) and **Hilla Becher** (Germany, b. 1934)

Becher, Bernd and Hilla. *Blast Furnaces*. Cambridge, Mass.: MIT Press, 1990.

Becher, Bernd and Hilla. *Framework Houses of the Siegen Industrial Region*. Munich: Schirmer/Mosel, 1977.

Becher, Bernd and Hilla. *Industrial Facades*. Cambridge, Mass.: MIT Press, 1995.

Becher, Bernd and Hilla. *Pennsylvania Coal Mine Tipples*. New York: Dia Center for the Arts, 1991.

Becher, Bernd and Hilla. *Watertowers*. Cambridge, Mass.: MIT Press, 1988.

Richard Benson (U.S., b. 1943)

Benson, Richard, and Lincoln Kirstein. *Lay This Laurel*. New York: Eakins Press, 1973.

Zeke Berman (U.S., b. 1951)

Davis, Keith F. *Zeke Berman Photographs*. Kansas City: University of Missouri–Kansas City Gallery of Art, 1992.

Heimerdinger, Debra. *Optiks: Photographs by Zeke Berman*. San Francisco: Friends of Photography, 1992.

Trachtenberg, Marvin. *Zeke Berman Photographs*. New York: Lieberman & Saul Gallery, 1989.

Michael Bishop (U.S., b. 1946)

Desmarais, Charles. *Michael Bishop*. Chicago: Chicago Center for Contemporary Photography, 1979.

Donald Blumberg (U.S., b. 1935)

Blumberg, Donald. *In Front of St. Patrick's Cathedral*. Cambridge, Mass.: Flower Mountain Press, 1973.

Larry Burrows (England, 1926-1971)

Larry Burrows: Compassionate Photographer. New York: Time Inc., 1972.

Nancy Burson (U.S., b. 1948)

Burson, Nancy. *Faces*. Houston: Contemporary Arts Museum, 1992.

Burson, Nancy, Richard Carling, and David Kramlich. *Composites: Computer-Generated Portraits*. New York: Beech Tree Books, 1986.

Jo Ann Callis (U.S., b. 1940)

Spector, Buzz. *Jo Ann Callis: Objects of Reverie: Selected Photographs, 1977-1989*. Des Moines: Des Moines Art Center, 1989.

Peter Campus (U.S., b. 1937)

Campus, Peter, Wulf Herzogenrath, and Roberta Smith. *Peter Campus*. Cologne: Kölnischer Kunstverein, 1979.

Rubin, David S., and Judith Tannenbaum. *Peter Campus: Selected Works, 1973-1987*. Reading, Pa.: Freedman Gallery, Albright College, 1987.

Keith Carter (U.S., b. 1948)

Carter, Keith. *The Blue Man*. Houston: Rice University Press, 1990.

Carter, Keith. *Bones*. San Francisco: Chronicle Books, 1996.

Carter, Keith. *From Uncertain to Blue*. Austin: Texas Monthly Press, 1988.

Carter, Keith. *Heaven of Animals*. Houston: Rice University Press, 1995.

Carter, Keith. *Mojo*. Houston: Rice University Press, 1992.

Carter, Keith. *Photographs: Twenty-Five Years*. Austin: University of Texas Press, 1997.

James Casebere (U.S., b. 1953)

Berger, Maurice. *Model Culture: James Casebere, Photographs 1975-1996*. San Francisco: Friends of Photography, 1996.

Cross-References: Sculpture into Photography: James Casebere. Minneapolis: Walker Art Center, 1987.

James Casebere. Tampa: University of South Florida Art Museum, 1990.

James Casebere. Nevers, France: APAC, 1991.

Carl Chiarenza (U.S., b. 1935)

Chiarenza, Carl, Estelle Jussim, and Charles W. Millard. *Chiarenza: Landscapes of the Mind*. Boston: David R. Godine, 1988.

William Christenberry (U.S., b. 1936)

Christenberry, William. *Southern Photographs*. Millerton, N.Y.: Aperture, 1983.

Gruber, J. Richard. *William Christenberry: The Early Years, 1954-1968*. Augusta, Ga.: Morris Museum, 1996.

Southall, Thomas W. *Of Time and Place: Walker Evans and William Christenberry*. San Francisco: Friends of Photography/Amon Carter Museum of Art/University of New Mexico Press, 1990.

Spencer, Mark J., and J. Richard Gruber. *William Christenberry*. St. Joseph, Mo.: Albrecht-Kemper Museum of Art, 1994.

Stack, Trudy Wilner. *Christenberry Reconstruction: The Art of William Christenberry*. Jackson: University Press of Mississippi/Center for Creative Photography, 1996.

Patrick Clancy (U.S., b. 1941)

Larry Clark (U.S., b. 1943)

Clark, Larry. *Teenage Lust*. New York: Larry Clark, 1983.

Clark, Larry. *Tulsa*. New York: Lustrum Press, 1971.

Chuck Close (U.S., b. 1940)

Guare, John. *Chuck Close: Life and Work, 1988-1995*. New York: Thames and Hudson/Yarrow Press, 1995.

Lyons, Lisa, and Martin Friedman. *Close Portraits*. Minneapolis: Walker Art Center, 1980.

Lyons, Lisa, and Robert Storr. *Chuck Close*. New York: Rizzoli, 1987.

Poitter, Joechen, Helmut Friedel, and Robert Storr. *Chuck Close: Retrospective*. Baden-Baden: Staatliche Kunsthalle, 1994.

Storr, Robert, et al. *Chuck Close*. New York: Museum of Modern Art, 1998.

Lois Conner (U.S., b. 1951)

Conner, Lois. *Panoramas of the Far East*. Washington, D.C.: Smithsonian Institution Press, 1993.

Conner, Lois. *Photographs of China: In the Shadow of the Wall*. Taichung: Taiwan Museum of Art, 1992.

Linda Connor (U.S., b. 1944)

Connor, Linda. *Luminance*. Carmel Valley, Calif.: Woodrose Publishing, 1994.

Connor, Linda. *Solos*. Millerton, N.Y.: Apeiron Workshops, 1979.

Connor, Linda and Charles Simic. *On the Music of the Spheres*. New York: Library Fellows of the Whitney Museum, 1996.

Livingston, Jane. *Linda Connor*. Washington, D.C.: Corcoran Gallery of Art, 1982.

Solnit, Rebecca, and Denise Miller-Clark. *Linda Connor: Spiral Journey, Photographs 1967-1990*. Chicago: Museum of Contemporary Photography, 1990.

Thomas Joshua Cooper (U.S., b. 1946)

Cooper, Thomas Joshua. *A Handful of Stones*. Docking, U.K.: Coracle Press, 1996.

Cooper, Thomas Joshua. *A simples contagem das ondas/Simply Counting Waves*. Lisbon: Centro de Arte Moderna José de Azeredo Perdigão, 1994.

Cooper, Thomas Joshua. *Dreaming the Gokstadt*. Edinburgh: Graeme Murray, 1988.

John Coplans (U.S., b. England 1920)

Coplans, John. *A Body of Work*. New York: Printed Matter, 1987.

Coplans, John. *Foot*. New York: Galerie Lelong, 1989.

Coplans, John. *Hand*. New York: Galerie Lelong, 1988.

Coplans, John. *A Self-Portrait, 1984-1997*. Long Island City, N.Y.: P.S. 1 Contemporary Art Center, 1997.

Petah Coyne (U.S., b. 1953)

Dreishpoon, Douglas. *Petah Coyne: Photographs*. New York: Laurence Miller Gallery, 1996.

Robert Cumming (U.S., b. 1943)

Alinder, James. *Cumming Photographs*. Carmel, Calif.: Friends of Photography, 1979.

Davies, Hugh M., et al. *Robert Cumming: Cone of Vision*. San Diego: Museum of Contemporary Art, 1993.

Paul, Frédéric. *Robert Cumming: L'oeuvre photographique/Photographic Works: 1969-80*. Limoges, France: Fonds Régional d'Art Contemporain du Limousin, 1994.

Lynn Davis (U.S., b. 1944)

Weiermair, Peter, ed.; *Lynn Davis, Bodywork, 1978-1985*. Zurich: Stemmle, 1994.

Joe Deal (U.S., b. 1947)

Johnstone, Mark, and Edward Leffingwell. *Joe Deal: Southern California Photographs, 1976-86*. Albuquerque: University of New Mexico Press, 1992.

Jed Devine (U.S., b. 1944)

Devine, Jed, and Jim Dinsmore. *Friendship*. Gardiner, Me.: Tilbury House, 1994.

Jim Dine (U.S., b. 1935)

Feinberg, Jean E. *Jim Dine*. New York: Abbeville, 1986.

Jim Dine Photographs. New York: PaceWildensteinMacGill Gallery, 1997.

Livingstone, Marco, and Jim Dine. *Jim Dine: The Alchemy of Images*. New York: Monacelli, 1998.

Rick Dingus (U.S., b. 1951)

William Eggleston (U.S., b. 1939)

Eggleston, William. *Ancient and Modern*. New York: Random House, 1992.

Eggleston, William. *The Democratic Forest*. New York: Doubleday, 1989.

Eggleston, William. *Horses and Dogs*. Washington, D.C.: Smithsonian Institution Press, 1994.

Szarkowski, John. *William Eggleston's Guide*. New York: Museum of Modern Art, 1976.

Mitch Epstein (U.S., b. 1952)

Epstein, Mitch. *In Pursuit of India*. New York: Aperture, 1987.

Epstein, Mitch. *Vietnam: A Book of Changes*. New York: Norton, 1997.

Wendy Ewald (U.S., b. 1951)

Ewald, Wendy, et al. *I Dreamed I Had a Girl in My Pocket: The Story of an Indian Village*. New York: Norton, 1996.

Ewald, Wendy. *Magic Eyes: Scenes from an Andean Girlhood*. Seattle: Bay Press, 1992.

Ewald, Wendy. *Portraits and Dreams: Photographs and Stories by Children of the Appalachians*. London: Writers and Readers, 1985.

Adam Fuss (England, b. Australia 1961)

Parry, Eugenia. *Adam Fuss*. Santa Fe: Arena Editions, 1997.

Tannenbaum, Barbara. *Adam Fuss: Photograms*. Akron: Akron Art Museum, 1992.

Ralph Gibson (U.S., b. 1939)

Gibson, Ralph. *Days At Sea*. New York: Lustrum Press, 1974.

Gibson, Ralph. *Deja-Vu*. New York: Lustrum Press, 1973.

Gibson, Ralph. *Light Years*. Zurich: Stemmle, 1996.

Gibson, Ralph. *The Somnambulist*. New York: Lustrum Press, 1970.

Emmet Gowin (U.S., b. 1941)

Bunnell, Peter C. *Emmet Gowin: Photographs 1966-1983*. Washington, D.C.: Corcoran Gallery, 1983.

Chahroudi, Martha. *Emmet Gowin, Photographs*. Philadelphia: Philadelphia Museum of Art, 1990.

Gowin, Emmet. *Emmet Gowin, Photographs*. New York: Alfred A. Knopf, 1976.

Gowin, Emmet. *Petra: In the Hashemite Kingdom of Jordan*. New York: Pace/MacGill Gallery, 1986.

Jan Groover (U.S., b. 1943)

Groover, Jan. *Pure Invention: The Table Top Still Life*. Washington, D.C.: Smithsonian Institution Press, 1990.

Kismaric, Susan. *Jan Groover*. New York: Museum of Modern Art, 1987.

Shopmaker, Laurence, and Alan Trachtenberg. *Jan Groover*. Purchase: State University of New York, 1983.

Szarkowski, John. *Jan Groover, Photographs*. Boston: Bulfinch, 1993.

Robert Heinecken (U.S., b. 1931)

Enyeart, James, ed. *Heinecken*. New York: Light Gallery/Friends of Photography, 1980.

Evelyn Hofer (Britain, b. Germany)

Favrod, Charles-Henri. *Evelyn Hofer*. Lausanne, Switzerland: Musée de l'Elysée, 1994.

Pritchett, V. S., and Evelyn Hofer. *New York Proclaimed*. New York: Harcourt, Brace and World, 1965.

Bill Jacobson (U.S., b. 1955)

Bill Jacobson, 1989-1997. Santa Fe: Twin Palms, 1998.

Mark Klett (U.S., b. 1952)

Hales, Peter Bacon. *One City/Two Visions: Eadweard Muybridge & Mark Klett, San Francisco Panoramas, 1878 and 1990*. San Francisco: Bedford Arts, 1990.

Limerick, Patricia Nelson, and Thomas W. Southall. *Revealing Territory: Photographs of the Southwest by Mark Klett*. Albuquerque: University of New Mexico Press, 1992.

Les Krims (U.S., b. 1943)

Les Krims. *Fictocryptokrimsographs*. Buffalo: Humpty Press, 1975.

Barbara Kruger (U.S., b. 1945)

Kruger, Barbara. *Remote Control: Power, Cultures, and the World of Appearances*. Cambridge, Mass.: MIT Press, 1993.

Linker, Kate. *Love For Sale: The Words and Pictures of Barbara Kruger*. New York: Harry N. Abrams, 1990.

Owens, Craig, et al. *We Won't Play Nature to Your Culture: Works by Barbara Kruger*. London: Institute of Contemporary Art, 1983.

William Larson (U.S., b. 1942)

Larson, William. *Fireflies*. Philadelphia: Gravity Press, 1976.

Marincola, Paula. *William Larson: Photographs 1969-1985*. Philadelphia: Institute of Contemporary Art, 1986.

Annie Leibovitz (U.S., b. 1949)

Annie Leibovitz: Photographs. New York: Pantheon/Rolling Stone Press, 1983.

Photographs: Annie Leibovitz, 1970-1990. New York: HarperCollins, 1991.

David Levinthal (U.S., b. 1949)

Levinthal, David. *The Wild West*. Washington, D.C.: Smithsonian Institution Press, 1993.

Levinthal, David, and Garry Trudeau. *Hitler Moves East: A Graphic Chronicle, 1941-43*. Kansas City, Mo.: Sheed Andrews and McMeel, 1977.

Stainback, Charles, and Richard B. Woodward. *David Levinthal: Work from 1975-1996*. New York: International Center of Photography/D.A.P., 1997.

W. Snyder MacNeil (U.S., b. 1943)

Janis, Eugenia Parry. *W. Snyder MacNeil: Daughter/Father*. Boston: Photographic Resource Center, 1988.

Sally Mann (U.S., b. 1951)

Mann, Sally. *At Twelve*. New York: Aperture, 1988.

Mann, Sally. *Immediate Family*. New York: Aperture, 1992.

Mann, Sally. *Mother Land: Recent Landscapes of Georgia and Virginia*. New York: Edwynn Houk Gallery, 1997.

Robert Mapplethorpe (U.S., 1946-1989)

Danto, Arthur C. *Mapplethorpe*. New York: Random House, 1992.

Kardon, Janet. *Robert Mapplethorpe: The Perfect Moment*. Philadelphia: Institute of Contemporary Art, 1988.

Marshall, Richard, Ingrid Sischy, and Richard Howard. *Robert Mapplethorpe*. Boston: New York Graphic Society, 1988.

Morrisroe, Patricia. *Mapplethorpe: A Biography*. New York: Random House, 1993.

Mary Ellen Mark (U.S., b. 1941)

Fulton, Marianne. *Mary Ellen Mark: 25 Years*. Boston: Bulfinch, 1991.

Mark, Mary Ellen. *Falkland Road: Prostitutes of Bombay*. New York: Alfred A. Knopf, 1981.

Sullivan, Constance, ed. *The Photo Essay: Photographs by Mary Ellen Mark*. Washington, D.C.: Smithsonian Institution Press, 1990.

Gordon Matta-Clark (U.S., 1945-1978)

Diserens, Corinne, Mariane Brouwer, and Judith Russi Kirshner. *Gordon Matta-Clark*. Valencia: IVAM Centre Julio Gonzalez, 1993.

Jacobs, Mary Jane, Robert Pincus-Witten, and Joan Simon. *Gordon Matta-Clark: A Retrospective*. Chicago: Museum of Contemporary Art, 1985.

David McDermott (U.S., b. 1952) and **Peter McGough** (U.S., b. 1958)

Durant, Mark Alice. *McDermott & McGough: A History of Photography*. Santa Fe: Arena Editions/D.A.P., 1998.

Fetz, Wolfgang, and Gerald Matt. *Messrs. McDermott & McGough: Some Modern Photographers and Their Work*. Bregenz: Vorarlberger Kunstverein, 1993.

Messrs. McDermott & McGough. Kyoto: Kyoto Shoin/Art Random, 1990.

Roger Mertin (U.S., b. 1942)

Desmarais, Charles. *Roger Mertin, Records 1976-78*. Chicago: Chicago Center for Contemporary Photography, 1978.

Sheila Metzner (U.S., b. 1939)

Metzner, Sheila. *Objects of Desire*. New York: Clarkson N. Potter, 1986.

Joel Meyerowitz (U.S., b. 1938)

Meyerowitz, Joel. *Cape Light*. Boston: Museum of Fine Arts/New York Graphic Society, 1978.

Meyerowitz, Joel. *Creating a Sense of Place*. Washington, D.C.: Smithsonian Institution Press, 1990.

Meyerowitz, Joel. *St. Louis & The Arch*. Boston: New York Graphic Society/St. Louis Art Museum, 1980.

Meyerowitz, Joel. *A Summer's Day*. New York: Times Books, 1985.

Arno Rafael Minkkinen (U.S., b. Finland 1945)

Minkkinen, Arno Rafael. *Frostbite*. Dobbs Ferry, N.Y.: Morgan & Morgan, 1978.

Minkkinen, Arno Rafael. *Waterline*. New York: Aperture, 1994.

Richard Misrach (U.S., b. 1949)

Misrach, Richard. *A Book of Photographs*. San Francisco: Grapestake Gallery, 1979.

Misrach, Richard. *Desert Cantos*. Albuquerque: University of New Mexico Press, 1987.

Misrach, Richard, and Myriam Weisang Misrach. *Bravo 20: The Bombing of the American West*. Baltimore, Md.: Johns Hopkins University Press, 1990.

Misrach, Richard, and Susan Sontag. *Violent Legacies: Three Cantos*. New York: Aperture, 1992.

Richard Misrach: Photographs 1975-1987. Tokyo: Gallery Min, 1988.

Andrea Modica (U.S., b. 1960)

Modica, Andrea. *Minor League*. Washington, D.C.: Smithsonian Institution Press, 1993.

Modica, Andrea. *Treadwell*. San Francisco: Chronicle Books, 1996.

Charles Moore (U.S., b. 1931)

Durham, Michael S. *Powerful Days: The Civil Rights Photography of Charles Moore*. New York: Stewart, Tabori & Chang, 1991.

Abelardo Morell (U.S., b. Cuba 1948)

Gaston Diana. *Abelardo Morell and the Camera Eye*. San Diego: Musuem of Photographic Arts, 1998.

Morell, Abelardo. *A Camera in a Room*. Washington, D.C.: Smithsonian Institution Press, 1995.

Morell, Abelardo. *Face to Face: Photographs at the Gardner Museum*. Boston: Isabella Stewart Gardner Museum, 1998.

Grant Mudford (Australia, b. 1944)

Patrick Nagatani (U.S., b. 1945) and **Andrée Tracey** (U.S., b. 1948)

Patrick Nagatani and Andrée Tracey: Polaroid 20 x 24 Photographs, 1983-1986. Tokyo: Gallery Min, 1987.

Nicholas Nixon (U.S., b. 1947)

Galassi, Peter. *Nicholas Nixon: Pictures of People*. New York: Museum of Modern Art, 1988.

Nixon, Nicholas. *Family Pictures*. Washington, D.C.: Smithsonian Institution Press, 1991.

Nixon, Nicholas, and Bebe Nixon. *People with AIDS*. Boston: David R. Godine, 1991.

Coles, Robert, and Nicholas Nixon. *School*. Boston: Bulfinch, 1998.

Tod Papageorge (U.S., 1940)

John Pfahl (U.S., b. 1939)

Bryant, Edward. *Picture Windows: Photographs by John Pfahl*. Boston: New York Graphic Society, 1987.

Jussim, Estelle. *A Distanced Land: The Photographs of John Pfahl*. Albuquerque: University of New Mexico Press/Albright-Knox Art Gallery, 1990.

Leland Rice (U.S., b. 1940)

Millard, Charles W. *The Photography of Leland Rice*. Washington, D.C.: Hirshhorn Museum, 1977.

Rice, Leland, and Charles E. McClelland. *Up Against It: Photographs of the Berlin Wall*. Albuquerque: University of New Mexico Press, 1991.

Eugene Richards (U.S., b. 1944)

Richards, Eugene. *Americans We*. New York: Aperture, 1994.

Richards, Eugene. *Cocaine True Cocaine Blue*. New York: Aperture, 1994.

Richards, Eugene. *The Knife and Gun Club: Scenes from an Emergency Room*. New York: Atlantic Monthly Press, 1989.

Milton Rogovin (U.S., b. 1909)

Doherty, Robert J., and Fred Licht. *Milton Rogovin: The Forgotten Ones*. Seattle: University of Washington Press/Albright-Knox Art Gallery, 1985.

Rogovin, Milton. *Triptychs: Buffalo's Lower West Side Revisited*. W.W.: Norton, 1994.

Rogovin, Milton, and Michael Frisch. *Portraits in Steel*. Ithaca, N.Y.: Cornell University Press, 1993.

Judith Joy Ross (U.S., b. 1946)

Ross, Judith Joy. *Portraits at the Vietnam Veterans Memorial*. Washington, D.C.: Smithsonian Institution Press, 1993.

Kismaric, Susan. *Judith Joy Ross*. New York: Museum of Modern Art, 1995.

Sheron Rupp (U.S., b. 1943)

Lucas Samaras (U.S., b. Greece 1936)

Lifson, Ben. *Samaras: The Photographs of Lucas Samaras*. New York: Aperture, 1987.

McEvilley, Thomas, et al. *Lucas Samaras: Objects and Subjects, 1969-1986*.

New York: Abbeville, 1990.

Larry W. Schwarm (U.S., b. 1944)

Andres Serrano (U.S., b. 1950)

Wallis, Brian, ed. *Andres Serrano: Body and Soul*. New York: Takarajima, 1995.

Fazal Sheikh (U.S., b. 1965)

Sheikh, Fazal. *A Sense of Common Ground*. Zurich: Scalo, 1996.

Cindy Sherman (U.S., b. 1954)

Cruz, Amada, et al. *Cindy Sherman: Retrospective*. New York: Thames and Hudson, 1997.

Krauss, Rosalind, and Norman Bryson. *Cindy Sherman, 1975-1993*. New York: Rizzoli, 1993.

Schjeldahl, Peter, and Lisa Phillips. *Cindy Sherman*. New York: Whitney Museum, 1987.

Stephen Shore (U.S., b. 1947)

Stephen Shore, Photographs 1973-1993. Munich: Schirmer, 1995.

Shore, Stephen. *Uncommon Places*. New York: Aperture, 1982.

Sandy Skoglund (U.S., b. 1946)

Muehlig, Linda, and Ann H. Sievers. *Sandy Skoglund: Reality Under Siege*. New York: Harry N. Abrams, 1998.

Roegiers, Patrick, and Gloria Picazo. *Sandy Skoglund*. Barcelona: Fundacio La Caixa, 1992.

Kiki Smith (U.S., b. 1954)

Posner, Helaine. *Kiki Smith*. Boston: Bulfinch, 1998.

Michael Spano (U.S., b. 1949)

Doug Starn (U.S., b. 1961) and **Mike Starn** (U.S., b. 1961)

Grundberg, Andy. *Mike and Doug Starn*. New York: Harry N. Abrams, 1990.

David Stephenson (U.S., b. 1955)

Stephenson, David. *Cupolas*. New York: Julie Saul Gallery, 1996.

Joel Sternfeld (U.S., b. 1944)

Grundberg, Andy, and Anne W. Tucker. *American Prospects: Photographs by Joel Sternfeld*. San Francisco: Friends of Photography/Chronicle Books, 1994.

Sternfeld, Joel. *On This Site: Landscape in Memory*. San Francisco: Chronicle Books, 1996.

Sternfeld, Joel, Richard Brilliant, and Theodore E. Stebbins. *Campagna Romana: The Countryside of Ancient Rome*. New York: Alfred A. Knopf, 1992.

Hiroshi Sugimoto (Japan, b. 1948)

Brougher, Kerry. *Sugimoto*. Los Angeles: Museum of Contemporary Art, 1993.

Kellein, Thomas. *Hiroshi Sugimoto: Time Exposed*. Basel: Kunsthalle Basel/Hansjörg Mayer, 1995.

Larry Sultan (U.S., b. 1946)

Sultan, Larry. *Pictures from Home*. New York: Harry N. Abrams, 1992.

Ruth Thorne-Thomsen (U.S., b. 1943)

Miller-Clark, Denise. *Within This Garden: Photographs by Ruth Thorne-Thomsen*. Chicago: Museum of Contemporary Photography/Aperture, 1993.

Arthur Tress (U.S., b. 1940)

Livingstone, Marco, ed. *Arthur Tress: Talisman*. New York: Thames and Hudson, 1986.

Lorenz, Richard. *Fantastic Voyage: The Photographs of Arthur Tress*. Washington, D.C.: U.S. Information Agency, 1994.

Minahan, John. *Arthur Tress: The Dream Collector*. Richmond, Va.: Westover Publishing Co., 1972.

Tress, Arthur. *Theater of the Mind*. Dobbs Ferry, N.Y.: Morgan & Morgan, 1976.

Tseng Kwong Chi (U.S., b. Hong Kong, 1950-1990)

Blinderman, Barry. *Tseng Kwong Chi: The Expeditionary Works*. Houston: Houston Center for Photography, 1992.

Tseng Kwong Chi. Tokyo: Kyoto Shoin, 1989.

Andy Warhol (U.S., 1928-1987)

Koch, Stephen. *Andy Warhol: Photographs*. New York: Robert Miller Gallery, 1987.

Rosenblum, Robert, and David Whitney. *Andy Warhol: Portraits of the 70s*. New York: Random House/Whitney Museum, 1979.

Rosenblum, Robert, Benjamin H. D. Buchloh, and Marco Livingstone. *Andy Warhol: A Retrospective*. New York: Museum of Modern Art, 1989.

Warhol, Andy. *America*. New York: Harper & Row, 1985.

Alex Webb (U.S., b. 1952)

Webb, Alex. *Hot Light/Half-Made Worlds: Photographs from the Tropics*. New York: Thames and Hudson, 1986.

Webb, Alex. *Under a Grudging Sun: Photographs from Haiti Libere, 1986-1988*. New York: Thames and Hudson, 1989.

Carrie Mae Weems (U.S., b. 1953)

Kirsh, Andrea, and Susan Fisher Sterling. *Carrie Mae Weems*. Washington, D.C.: National Museum of Women in the Arts, 1993.

Weems, Carrie Mae. *Then What? Photographs and Folklore*. Buffalo, N.Y.: CEPA Gallery, 1990.

William Wegman (U.S., b. 1942)

Kunz, Martin, ed. *William Wegman*. New York: Harry N. Abrams, 1990.

William Wegman: Photographic Works, 1969-1976. New York: D.A.P., 1994.

Henry Wessel, Jr. (U.S., b. 1942)

Ishiwata, Maya, ed. *Henry Wessel*. Tokyo: Gallery Min, 1987.

Wessel, Henry. *House Pictures*. San Francisco, Fraenkel Gallery, 1992.

Joel-Peter Witkin (U.S., b. 1939)

Celant, Germano. *Witkin*. Zurich: Scalo, 1995.

Coke, Van Deren. *Joel-Peter Witkin: Forty Photographs*. San Francisco: San Francisco Museum of Modern Art, 1985.

Witkin, Joel-Peter. *Gods of Earth and Heaven*. Pasadena: Twelvetrees Press, 1991.

David Wojnarowicz (U.S., 1954-1992)

Blinderman, Barry, ed. *David Wojnarowicz: Tongues of Flame*. Normal: Illinois State University Galleries, 1990.

Wojnarowicz, David. *Close to the Knives: A Memoir of Disintegration*. London: Serpent's Tail, 1992.

Jeffrey A. Wolin (U.S., b. 1951)

Wolin, Jeffrey A. *Written in Memory: Portraits of the Holocaust*. San Francisco: Chronicle Books, 1997.

Francesca Woodman (U.S., 1958-1981)

Chandes, Herve, ed. *Francesca Woodman*. Zurich: Scalo, 1998.

Gabhart, Ann, Rosalind Krauss, and Abigail Solomon-Godeau. *Francesca Woodman: Photographic Work*. Wellesley, Mass.: Wellesley College Museum, 1986.

Lux, Harm, and Kathryn Hixson. *Francesca Woodman: Photographic Works*. Zurich: Shedhalle Zurich, 1992.

Index